ART: A NEW HISTORY

ART
A NEW HISTORY

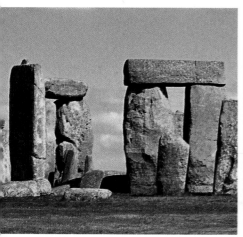

PAUL JOHNSON

WEIDENFELD & NICOLSON · LONDON

TO DIANE LEVER
with whom I have looked at
many treasures.

First published in Great Britain in 2003 by Weidenfeld & Nicolson

A CIP catalogue record for this book is available from the British Library.

ISBN 0 297 82928 9

Printed and bound in Italy by Pizzi

Weidenfeld & Nicolson
The Orion Publishing Group Ltd
Orion House
5 Upper Saint Martin's Lane
London WC2H 9EA

CONTENTS

PREFACE

This book is something I have wanted to write all my life, for I write books to educate myself, and my thirst for knowledge about art and artists has been growing since my earliest consciousness. My father was an artist and head of an art school, and I remember, as a small child, trying to overhear his conversations with his friend L. S. Lowry. This meant hiding in a piece of Jacobean furniture, called the Court Cupboard, in my father's Art Room (he never used the word 'studio'). But all they talked about was cricket.

My father did not want me to become a painter, though he admitted I drew well, and he took me with him when he went out to draw churches. When I was six, in the mid-thirties, he said to me: 'I can see bad times coming for art. Frauds like Picasso will rule the roost for the next half-century. Do something else for a living.' So I became a writer, and have remained one for more than fifty years. But I have continued to draw and paint, and have even held one-man exhibitions in London in the last decade. I have also, over many years, built up a formidable art library. My work has taken me all over the world and I have lost no opportunity to see the great collections, public and private, and to talk to many artists, celebrated and obscure.

I have put everything I know and feel deeply into this book. It tries to cover all time and the world and, in the process, threatened to become prohibitively expensive and bulky. So I was obliged to cut it, for the first time in my life as a book writer, and the pain has been acute. I have left out source notes and bibliography for the same reason. I beg readers to forgive the omissions. If they have any complaints about my accuracy or opinions, I would welcome letters to my home address, 29 Newton Road, London W2 5JR (fax: 020 7792 1676). David Esksurdjiaan, from the kindness of his heart, has read the text and corrected many egregious errors, and I am also grateful to my ingenious picture researcher, Elizabeth Loving; my patient editor, Benjamin Buchan; and my loyal publisher, Cass Canfield Jr., as well as to many others who have helped in this vertiginous enterprise.

PAUL JOHNSON

ART: A NEW HISTORY

INTRODUCTION

UNDERSTANDING ART HISTORY

W riting a history of art from its earliest origins to the present day is an immense task, and reading it is a daunting exercise too. It may therefore help both myself, as an author, in organising the work, and the reader in comprehending it, if I set down certain principles which I hold to be essential in understanding art and making sense of the way it has evolved.

The first point to grasp is the immense fecundity of humans in producing objects of art. I argue here that art predated not only writing but probably structured speech too, that it was closely associated with the ordering instinct which makes society possible, and that it has therefore always been essential to human happiness. The artist was the first professional. The number of art-works produced in world history is beyond computation, and sufficient numbers have been preserved, each of them unique, to make it impossible for anyone, however assiduous and devoted, to glimpse more than a tiny fraction of them. Today, a huge proportion of these objects have settled in museums all over the world, of which I calculate that there are now over 1,000 housing first-class collections. They almost invariably contain in their basements at least three or four times the number of objects it has space to display (the Hermitage in St Petersburg has over 3 million, the British Museum has 30 million). Whether seeing quantities of fine art massed together in public collections is the best way of understanding art is debatable, and certainly it is a mistake to try and comprehend more than three or four—or at most half a dozen—works of high art at a time. Perhaps the best way of enhancing one's understanding is to see art in private collections, especially those accumulated by one person or family, and of these there are perhaps 10,000 in the world of some significance. Those who love art and seek to understand it will always be anxious to see more, and if they are wise will look at certain objects they admire again and again. But they must avoid the sin of art greed, restrain the appetite to enjoy more than a digestible number of artistic sensations, and resist the temptation to engulf all the forms of art in their minds. In

a world where beautiful and virtuous objects are numbered in the millions, the most judicious approach is to acquire a penetrative knowledge of one aspect of art, and on this basis develop a judgement which promotes a general capacity to evaluate quality. In art, a discerning if limited taste is preferable to enthusiastic voracity.

Despite the vast quantities of art produced by humans, the highest art has always been scarce and the losses inflicted by time and chance have been immense, in some cases total. Only a tiny percentage of the European prehistoric cave paintings and etchings—the supreme achievement of the societies which occupied two-thirds of the time during which humanity has practised the arts—have survived and are known. Of these, a significant proportion, as a result of exposure, have deteriorated or disappeared completely since they were brought to light, and much of what remains has therefore been made inaccessible to the public.

Again, only a minute portion of the finest objects created in antiquity has survived. The Egyptian art system was particularly fortunate until recently because the warm dry climate of the country and the fact that many of its treasures were buried protected them from spoliation and decay. But even there, the building of the Aswan High Dam in the mid-twentieth century, producing changes in the behaviour of the Nile and humidification of the climate, has done great harm. Other ancient societies which produced fine-art systems have also suffered catastrophic losses. The number of Greek or Roman buildings of merit which are reasonably intact today can be counted on the fingers of one hand. Not a single Greek easel painting has survived and not a single one of the works of Apelles, the Raphael of ancient Greece, has come down to us, though at least twelve are described in the sources. Of the four greatest sculptors of classical and Hellenistic Greece, Polykleitos, Pheidias, Praxiteles and Lysippos, all highly productive, not one original work remains. In a few cases, we have the base (sometimes signed), and copies, usually Roman, of uncertain accuracy. Let one figure suffice to make the point. In the fourth century AD, there were 3,785 bronze public statues listed in Rome. A millennium later, only five were left.

Painters who lived much more recently survive more by their reputation than their works. Giorgione, one of the most significant painters of the Venetian Renaissance, is represented today by only four works we can be entirely confident are wholly his. Only ten authenticated paintings by Leonardo da Vinci are now in existence. A small fraction of Mantegna's majestic output survives in reasonable condition. We have forty-eight paintings by Hieronymus Bosch; literary sources indicate there were once at least twice as many. Only a third of the works lovingly described by Vasari in his *Lives of the Painters* are now known. We have thirty-six Vermeers. He was a slow worker, to be sure, but he made his living as a painter for nearly a quarter of a century and is believed to have finished nearly a hundred. So where are the rest? Virtually all the great Italian masters of the fifteenth century produced major works which have disappeared without a trace. This is true of about half of the sixteenth-century masters, and a surprising number of those who flourished in the seven-

teenth century too. The great potters and ceramicists suffered severely. Probably two-thirds of the output of Italian bronze sculptors in the fifteenth and sixteenth centuries was melted down to make cannon. Works of silversmiths and goldsmiths were confiscated for bullion in hard times. We have only one fine gold-and-silver piece by Benvenuto Cellini, the greatest of them all.

We should remember that a large proportion of surviving great works of art has been damaged, in most cases irreparably, and sometimes to a degree which makes them aesthetically almost worthless. Leonardo da Vinci's *Last Supper* was ruinous within half a century of its completion. Mantegna's masterpiece, *The Triumph of Caesar*, at Hampton Court, is a partial wreck. Velázquez's *Rokeby Venus*, his only female nude, was degraded by cleaning in the twentieth century. Of Rembrandt's two greatest paintings, *The Night Watch* had its composition spoiled by the hacking-off of two sections on either side and *The Conspiracy of the Batavians Under Claudius Civilis* was cut down to its central figures, leaving only about one-sixth of the original work. One of Turner's virtuoso canvases, *Frosty Morning*, has lost through 'cleaning' all its power to thrill. It is important to grasp that very few paintings can be seen in the state in which they left the painter's studio, and that hardly one of those on walls retains its original lustre. Age and human folly, compounded by ignorance and arrogance, are a fatal combination. Who knows whether Michelangelo's paintings in the Sistine Chapel, 'restored' at vast expense, display the colours and tones in which he painted them? To understand art, it is often necessary to peer through what is now displayed to see the palimpsest beneath the varnish and new paint.

An even bigger exercise in imagination has to be made to restore meaning to the thousands of fine paintings and sculptures ripped out of the churches, cathedrals, palaces and homes—and frames—for which they were originally created by the artist. We live in a society where artists work for the market and what they do is designed to be seen and, as a rule, publicly exhibited. For most of the history of mankind, art had other ends. Palaeolithic artists often painted their animal studies in almost inaccessible parts of deep caves, requiring artificial lighting to be seen at all. Much of the finest art of ancient Egypt was designed to be placed in tombs where no one saw them save the gods to whom they were directed. Western art, for two-thirds of its existence, served religious purposes and about eighty per cent of it was designed to be seen in public churches or private chapels. Thousands of these works, happily, are still in place, and this is obviously the way to view them. The rest have been incongruously placed in collections, often in fragments. The first question one must ask oneself in confronting a work of art is: for what purpose was it created? Until the nineteenth century, there are comparatively few art-works which do not require a process of mental and visual readjustment by us. Few people are capable of this, and the work cries to them in vain. So we should try to see a work of art in its intended context.

However, even if we succeed in recovering the context, we still have to see through the work into the mind of the artist who made it. This is where the real business of appreciating art begins. Artists are real people. There is no such person as a disembodied genius. The better they are, the more likely it is that they will be emotional, hypersensitive, volatile, susceptible to all kinds of external influences, intellectual, aesthetic and moral, self-questioning, riddled by internal contradictions and unresolved problems—difficult, in short. We need to know about these things. Why did Leonardo da Vinci find it so hard to finish any major undertaking he started? Why did Michelangelo, despite his astonishing energy and record of accomplishment, also leave important sculptures unfinished? Why did Pontormo try to live like a hermit and cut off communication with the outside world? Why was Domenichino so terrified of life—did he suffer from agoraphobia? Why did Vermeer, that man of mystery, who had at least twelve children of his own—some accounts say fifteen—never allow a child to appear in any of his canvases? What was the fury which drove Caravaggio to create so much trouble for himself, and was it in some way linked to his innovatory genius? Why did Rubens live such a calm, successful, unruffled and cherished existence, while Rembrandt, who was equally prolific, gifted and profound, experienced life so torturing, committed acts of great cruelty which contrast with the humanity of his work, and slid into bankruptcy and near despair?

Vermeer too died a bankrupt, Tintoretto was forced to appeal to the public authorities for aid, and Frans Hals ended his long and productive life in destitution. Luca Giordano, a careful man, left the immense sum of 300,000 gold ducats to his heir. On the other hand, Guido Reni was a compulsive gambler and his huge studio and vast output were a frenzied attempt to finance his vice and beat off creditors. His art suffered accordingly. Guercino had a squint, Pietro da Cortona and Renoir painted in old age with hands crippled by arthritis, Menzel was tiny (four and a half feet). Mary Cassatt slowly went blind, and all these physical factors affected their art. When we know about the life of an artist, we see his work in a different light, and it is right that we should. If paintings could speak, they would have strange and illuminating tales to tell. We cannot know them all, but we can know some. It is part of the endless mystery and enchantment of art that however much we find out, more remains to be discovered.

Of all the problems which afflict artists, and afflict them more intensely the stronger their skills and passions, the most important is choosing between conformity and freedom. In prehistory and most of antiquity, artists, like ordinary craftsmen, had no choice but to conform. They were prisoners of whatever was currently the canon, just as the statues they carved or the figures they drew were locked into the canonical grid. When the great Achaemenian kings of sixth-century-BC Persia built their vast palaces at Susa and Persepolis, they recruited the leading artists from Greece, Lydia, Egypt and all over what we now call the Middle East. But these proud

men had to put aside their own culture and follow in detail canonical instructions laid down personally by Darius and Xerxes, and by their cultural advisers. The artists did so, for they were well paid. In every age, not least our own, artists have been obliged, to some extent, to do as they are told by society or the market. Artists have always found it hard to make a living. Many, despite outstanding skill, have failed to do so. Often their innovations were the cause of their financial failure. John Sell Cotman, whom many would now rank as the greatest of all watercolourists, could not sell a single one of the works we now admire most, and was forced to adopt a more routine style merely to save his family from starvation. When we look at works of art, we must remember that often their creator was a prisoner of his time and culture, albeit a willing one as a rule.

The history of art is also the story of exceptionally gifted, obstinate and wilful artists breaking free of the canon and its restrictions, carrying society and the public with them—not necessarily immediately, but in time—and thus eventually creating new canons. It is in the nature of the greatest artists to do things in a new way, and to carry their point. Hence, to understand art, we must look for the moments of tension before a creative innovator rejects the present and shapes a new future, study what precedes, accompanies and follows the revolution, and weigh its balance of gain and loss. These climactic moments in art history are what make it so exciting to study, and so rewarding, because it is precisely the contrast between the intervals of canonical calm, in which artists bring a particular mode to perfection, and the dramatic caesurae leading to a new way of working and seeing, which enables us to penetrate deep into the nature of art. For art is Janus-faced, tradition and novelty fighting for supremacy. But it is not always clear when these climactic moments arrive, and who makes them happen. Art history is changing all the time, and in this account the canonical version of the seismic shocks in the development of art will be challenged at many points—and no doubt will be challenged in turn. But such arguments help us to open our eyes wider and so enjoy art more.

While the struggle between the canonical and the innovatory is essential to art, it must never be forgotten that art was instinctively created by humanity to assist the process of ordering, and so understanding and mastering, the wild world of nature. Art is fundamentally about order, whether the canonical or the new currently has the upper hand. We must always look for the underlying order which runs beneath the surface of the battle, to see that it is healthy and intact, and strong enough to sustain the dynamics of change. For once art loses its fundamental order, it becomes disorderly and therefore ceases to sustain a moral society and may, in fact, become a menace to our happiness.

Following from this, we need to beware of the enemies of order, and particularly mere fashion, especially when it becomes so powerful as to constitute a system of disorder in itself. There was a memorable and tragic instance of this in the story of

ancient Egyptian art, the most consistent system of artistic order which has ever been created. During the New Kingdom, the Pharaoh Akhenaten, suffering from the delusion that he was the incarnation of a new high god, or even sole god, worked out the canonical implications of his new fashion in theology, and imposed them on artists. This was the first instance in history of fashion being raised to the level of a compulsory artistic system. It produced grotesque and revolting physical distortions of the way the body was represented, slavish conformity by some artists, revolt by others, the isolation of Akhenaten and his court in a new-built capital, which has been called a 'royal concentration camp', and the eventual resolution of the crisis by violence, after which order was restored. Fashion plays a useful but necessarily subordinate part in art. When it usurps order and tries to become art itself, the result, sooner or later, is a culture war, and culture wars are perhaps the cruellest and most demoralising of all wars.

It is therefore essential that society defend itself against cultural breakdown. The best way it can do this is by grasping the importance of art to the well-being of mankind: as many people as possible making it their business to examine art constantly, inform themselves about it and develop their faculties of understanding and loving it. For the love of art is a subjective phenomenon, which comes to us through our sympathetic eye, and no expert should be allowed to mediate. In the end, our own eyes are the key to making art our guide and solace, our delight and comfort, our clarifier and mentor—in short, the God-given staff of life in this vale of tears. We should use our own eyes, train them, and trust them. This book is specifically designed to aid the process.

1

PAINTED CAVES
AND GIANT STONES

The human personality has been in existence for about 200,000 years, when *Homo sapiens* first evolved. His ancestor or *doppelgänger*, Neanderthal man, being less efficient at learning new things, disappeared, and the thinking man was left alone on the planet, to conquer, adorn and exploit it. He has been learning ever since, first almost infinitesimally slowly, then at gathering speed, which is accelerating all the time. Acquisition of knowledge and the ability to create are inseparably connected, and man, becoming sapient, began to create as fast as he learned. Thus art is virtually as old as humanity. By art I mean three things: useful art, concerned with survival; fine art, concerned with beauty; and fashion art, concerned with conformity to social rules.

The earliest art was body adornment, which included all three forms of art. Humans early discovered that they could impress other humans by certain calculated actions, of which clothing and painting their bodies was the easiest and most effective. Thus cosmetics was the earliest type of art, followed by primitive forms of jewellery and clothing, and this body art filled all three functions: it was utilitarian, it was aesthetic and it was social. Unfortunately, by its very nature, body art has disappeared. We do not know its salient characteristics or how it evolved. It is little help to study peoples who still practise it, as in Borneo, because these examples of *Homo sapiens* who have remained locked in the Stone Age self-evidently lack the dynamism which enabled primitive man, using his art-creating capacities, to break out of his predicament.

However, it is clear that skill in art, beginning with body adornment, was a precondition of human progress, including the production of tools and the forming of successful societies. Art came before everything. It certainly came before writing—a comparatively recent development, all forms of writing originally evolved from pictograms. It almost certainly came before speech, at least forms of speech expressing notions which were at all complex. By learning to record visible objects, and express

ideas, by engraving or painting on relatively flat, two-dimensional surfaces, humans produced visual aids to such speech noises as they were originally able to make; these aids in time were reflected in refinements in speech noises, expansion of vocabulary and the evolution of syntax. The evolving genetic coding which made humans rationalise themselves into art was the same force which produced rational speech noises, so that the two processes were intimately connected from the start.

Once art took a non-bodily form, it began to survive, and it is possible for us to study it. This objective art took many forms, since humans began to decorate their tools as soon as they made them, but its most important and illuminating—and beautiful—expression is in cave or rock art. This consists of engraved or painted works on open-air rocks or on the floors, walls and ceilings of caves, some of them in deep and almost inaccessible crannies. They were created during the Upper Palaeolithic period (40,000 to 10,000 BC), and the best were done by what we call the Magdalenians (from the name of a site), peoples who flourished in Europe from 18,000 to 10,000 BC. Such works have a unity, and can be described as the Magdalenian art system, the first in human history. It was also the longest, lasting for more than two-thirds of the total time when humans have produced art.

In any history of art, then, the Magdalenian system must occupy a place of importance. Alas, of all the forms of art practised on the planet, it is the one about which we know the least. But our knowledge is by no means derisory, bearing in mind that the first cave art was only discovered in the 1860s, and it was not until 1902 that it was accepted as a fact by anthropologists and art historians. By the end of the twentieth century, there were 277 agreed examples in Europe, 142 in France, 108 in Spain, 21 in Italy, 2 in Portugal, 2 in Germany and 2 in the Balkans. Unfortunately, most of these works of art are extremely fragile. When a cave is 'opened', and the conditions which enabled paintings to survive are altered, deterioration can be rapid. The superb paintings found at Bédeilhac in the Pyrenees during the First World War disappeared completely within six months of the cave's discovery. Thus except in places where expensive air-conditioning has been installed, caves are no longer open to the public. Even the Altamira Cave in Spain, finest of them all, is now open only to small parties for brief periods. Scholars themselves find it difficult to gain admission. Some of these works are photographed but the camera gives a poor idea of their nature and quality. Some are difficult to see anyway: the best part of Altamira has to be studied lying down. Hence inaccessibility is a real and growing obstacle to unlocking the secrets of the Magdalenian art system.

However, here are a few items of knowledge on which we can build, beginning with subject matter. Cave art portrays human hands; large numbers of animals in different activities, including various species, such as the woolly rhinoceros, which are now extinct, and a few which were extinct even at the time they were painted; geometric figures and signs. Humans are also portrayed but these instances are rare.

Next we come to methods and materials. The earliest and most rudimentary images are finger-drawings in soft clay on the rock surface, the artist following the example of claw marks made by animals. Then came engraving, by far the commonest method, using flakes of sharp flint and in some cases stone picks. Different types of rocks, and rock formations, were used to give variety, add colour and produce depth, so that some of these engravings are akin to sculptural low-reliefs. Fine engraving is rare and late. Clay engraving on the cave floors has usually been obliterated by the feet of modern visitors, but some good examples survive. Finally, and most impressively, we get painting. The first colours were red, iron oxide (hematite, a form of red ochre) and black (manganese dioxide), though black from juniper or pine carbons has also been discovered. White from kaolin or mica was used occasionally. The only other colours available to Magdalenian painters were yellow and brown.

However, great ingenuity was displayed by artists. At Lascaux we have found pestles and mortars in which colours were mixed, together with no less than 158 different mineral fragments from which the mixtures were made. There seems to have been no shortage of pigment—large lumps have been found at some sites. Shells of barnacles were used as containers. One master employed a human skull. Cave water and the calcium it contained were used as mixers, and vegetable and animal oils as binders. The artists had primitive crayons and they applied the paint with brush tools, though none has survived. All kinds of devices and implements were used to aid art. Important lines were preceded by dots, which were then joined up. Sometimes paint was sprayed. Stencils were used. Blow-pipes made from bird bones served as tubes for applying paint. By these means, the more experienced Magdalenian painters were able to produce polychrome art.

Now let us look at sites. Stone Age peoples did not live in caves, except occasionally in cave-mouths or natural rock shelters. All the major sites which we know of were special places, not human habitations. Magdalenian artists did produce work in the open air, six examples of which, all engravings, have survived. But the vast majority of open-air work has of course disappeared. Caves were used because they were shelters and the art executed in them would be preserved. This brings us to duration. Some of the Magdalenian art-work was ephemeral or the result of practise exercises by apprentices. But the fine-art engravings and paintings were evidently made to last, and did last, in some cases for hundreds or even thousands of years, during which they were available for delight and use. A big cave gallery thus contained work done over a long period, available for comparison or instruction to people who had some notion of historical time and were developing a sense of their ancestry. The best Magdalenian art, especially the polychrome paintings, was the work of professionals. Indeed, it is likely that art was the first of the human professions.

We can say this with confidence, for cave art at its best was difficult and expensive

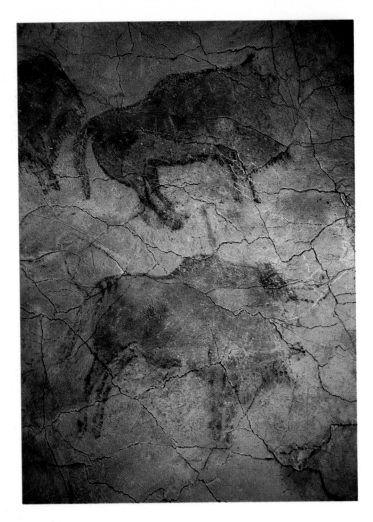

Painting of bison in a cave, Altamira, Spain. Communal art in the Stone Age, the professional artist supported by the tribe.

to produce. In the first place, it required lighting. Some eighty-five certain and thirty-one probable examples of Palaeolithic lamps have survived but less than one-third of them were found inside caves. The conjecture, therefore, is that artists usually worked by torchlight. Both lamps and torches consume animal fats in large quantities. Second, while it is true that some of the best cave paintings, especially at Altamira, were painted by artists standing up or in some cases lying down or squatting, others required elaborate scaffolding, no different in principle from that used by Michelangelo when painting the ceiling of the Sistine Chapel. Some of the paintings were done on a gigantic scale or at heights many feet from the cave floor. At Labastide in the Pyrenees, an immense horse is found 14 feet above floor level. At Bernifal in the Dordogne, the mammoths are painted 20 feet up. Some of the bulls at Lascaux are over 20 feet long. The famous painting of a woolly rhinoceros at Font-de-Gaume, whose accuracy was first disputed but then confirmed when a well-preserved example of this supposedly mythic creature was unearthed in 1907 in a bitumen deposit in Poland, is found high up on a huge cave wall. The sheer scale of the art is daunting. The big cave vault at Lascaux, known as the Picture Gallery, is over 100 feet long and 35 feet wide. Caves were specially chosen for their size as well

as for their security. Niaux in the Pyrenees is over half a mile in length, and this is by no means unusual. The big cave in Rouffignac runs over 6 miles into the mountain, and some of its huge collection of drawing-engravings are nearly 7 feet long.

The professional artists, then, needed not only platforms and scaffolding, whose existence at Lascaux, for instance, is betrayed by sockets cut into the walls, but assistants. They mixed the paints, some of which had to be used quickly before they dried, filled the lamps or held the torches, put up and secured the scaffolding, and made the brushes, from twigs, feathers, leaves and animal hairs, to the satisfaction of the master. These assistants graduated into painters themselves. It is not going too far to speak of a studio system as the basis of Magdalenian art. After all, there is positive evidence that art studios, where important works were fabricated and apprentices trained, existed in Egypt from at least as far back as 3000 BC. That still leaves a gap of 7,000 years from the end of the Magdalenian period. But the quality and consistency of the best painted work in caves, and the evidence of the time, expense and skill required to produce them, does suggest that artists needed the collective support of something very like a studio. The probability is that the leading cave artists were great men who gave themselves airs. And why should they not?

This brings us to quality. To modern eyes, accustomed to 5,000 years of continuous development in the depiction of living forms, from the Old Kingdom of ancient Egypt to the modernist art of the twentieth century, the best of the Magdalenian paintings are magnificent. Indeed, seen in the depth and total silence of the caves, the images are awesome. Human forms are rare and often quite unsophisticated. But the variety of animal forms is impressive. In the eight galleries of the great cave at Les Eyzies, there are multiple examples of mammoths, reindeer, horses, stags, bison and wolves, as well as humanoids and abstractions or signs. These interlocking galleries, unfolding one by one, are meant to impress, and they do. The art is both detailed and monumental, oscillating designedly between simplification and elaboration, between stasis and extreme dynamism. Some Magdalenian artists clearly understood both the anatomy of the animals they depicted and their principles of motion, the result of intense observation over many years and of a self-discipline in rendering which suggests a long apprenticeship and extensive study.

There is nothing premeditated, amateurish or provincial about this high art. The sheer bulk of these wild creatures, their untamed ferocity, their liberty of movement, their power but also their elegance, expressed in the tapering balance and apparent lightness of their limbs, is conveyed with masterly precision and economy of line. The tonal qualities, and the ingenious use of surfaces in the rock, suggest depth and even a kind of perspective. If we take into account the freshness of the pigments when the work was just done, and the impact of the lines and colours under the flickering light of primitive oil lamps, or *flambeaux*, we can imagine the force of the impact which this first artistic experience had on primitive humans, whose innocent eyes were unaccustomed to visual forms outside nature itself. That

helps to explain why Magdalenian societies were prepared to devote such a high proportion of their scarce surplus resources to the creation of these art galleries.

But what were these deliberately engineered and carefully contrived experiences designed to convey? What was the purpose of Magdalenian art? The answer is: we do not know, and we may never know. The earliest explanation was that they were the evening doodles of hunters, with no systematic purpose, spiritual, religious, utilitarian, totemic or even aesthetic. Then, throughout the twentieth century, eminent scholars—the Abbé Henri Breuil, Max Raphael, Annette Laming-Emperaire, André Leroi-Gourhan, Reynaldo González Garcia and others—devoted many years to formulating, elaborating and proving theories of use. These are contradictory and often mutually exclusive, and all have been eventually invalidated by fresh discoveries which do not fit. The utilitarian theory has been most generally held. But if the art was designed to teach the science of hunting, why did it include creatures already extinct or others that were never hunted? Why did it not include specific hunting scenes? In any case, anyone who has actually hunted knows that its skills are acquired not by studying pictures but by practise, something in which primitive peoples engaged from earliest youth, indeed childhood. Non-utilitarian theories see the art as shamanistic, or magical or religious. But none of these fits all, or most or even many of the facts. There are no sacrifices depicted. Humans, almost always the central point of early religious art systems, scarcely figure at all. With one possible exception, the art shows no priest or sorcerer or witch-doctor. There is nothing which could be termed a ceremony. An immense amount of classification and taxonomy has been performed on the caves and their contents, and elaborate time-schemes have been worked out. But these chronologies provide the appearance of knowledge rather than its reality. The earliest explanation seems as likely to be true, or untrue, as the later ones. We are a huge distance from Magdalenian society and its mentality, and finding answers to its mysterious actions requires an effort of imagination which may be beyond us.

The most likely reason why these societies devoted so much attention and resources to cave art, over so long a period, is that they found satisfaction in it. It gave them entertainment, fun, excitement, sensual and spiritual relief, and added to their knowledge. In a long age which moved forward with excruciating slowness and in which few perceptible gains were made in a whole lifetime, the development of art was proof that life did not stand still. As the best artists were professionals, and required support and materials provided by the community, the art galleries they created in caves were communal possessions, to be visited as a right but also as a privilege, in a spirit of reverence and loyalty, dignity and gratitude, for the benefits which organised society brought. They were a cohesive factor.

Art thus created by gifted individuals—the main 'ceiling' at Altamira seems to have been the work of one artist—on behalf of the entire settlement was also an intellectual instrument, which encouraged discussion or storytelling, accounts of

exploits and the history of the community. It played a creative role not merely in general education but more specifically in the development of sophisticated language, being capable of communicating thoughts on an ever-widening range of subjects. It is likely too that cave art promoted the birth of a religious spirit. There is nothing in these art-works as such to suggest religious purpose. But the conditions in which they were viewed, flickering torches bringing to life these fine representations with their deep colours out of the surrendering darkness, induced a sense of wonder and reverence. And as the people marvelled at the way artistic skills could re-create nature, they became aware of the even greater miracle of nature itself, in the vast world beyond the cave, and asked themselves: who could it be who created *that*? Thus cave art was thought-provoking, and the thoughts it provoked provided the impetus for men and women to lay the foundations of theories of life, and of the universe. Precisely because of its non-material, its metaphysical qualities, art became the father of religion.

If this be so, it is logical that the next series of masterworks created by human hands—the huge stone structures or megaliths of ancient Europe—should have had, in all probability, a religious purpose. In moving from cave art to megalith architecture we are taking a huge jump in time. It is important to note that human art, even in its earliest origins, has its declensions as well as its ascents. The great age of Magdalenian cave art came to an end about 10,000 BC, with the last ice age. Its cycle was complete. Nothing of this quality was ever

A horse from the Lascaux Caves, France. Such high art may have preceded regular speech.

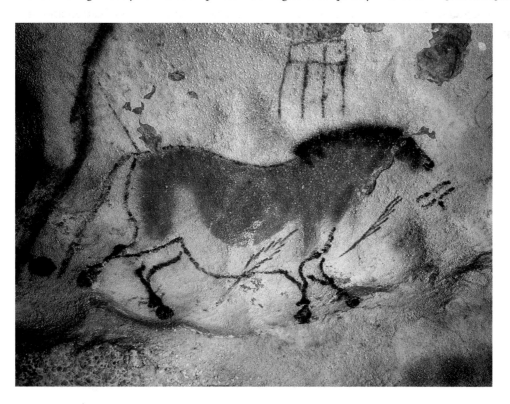

produced again. During the Mesolithic or Middle Stone Age, dated in Europe 10,000 to 3000 BC, great material improvements came about. The dog was domesticated and used for hunting in far more systematic ways than had been possible before. Fishing became systematic too, and a wide variety of stone instruments and weapons came into regular use. But art, so far as is known, did not scale the heights again.

The Neolithic or New Stone Age, dated in Europe up to 2000 BC, marked the biggest improvement yet in human welfare: the regular practise of farming. Societies became sedentary and built houses and villages. Thus human architecture was born, and in the rude structures which emerged, arts such as pottery were practised in an elementary form. It is a revealing fact, which tells us a lot about human attitudes to art, that at a time when the use of stone for building was known but houses were small, uncomfortable, by no means weatherproof and, as a rule, squalid, communities went to enormous trouble to put together vast blocks of stone for common artistic purposes. These megalithic monuments are of two main types: menhirs or upright stones, arranged in regular formations usually on high ground; and a development of this form, called henges, which are stone circles surrounded by a bank and ditch. These art forms are a European Atlantic phenomenon, ranging northwards from the coast of the Pyrenees up to the islands and highlands of Scotland: one of the largest, the Ring of Brodgar, is in Orkney. The epicentre of this artistic-religious cult was Brittany.

Megalithic art has formidable characteristics. It is so called to distinguish it from the Cyclopean walls of the Mediterranean, in which huge stones were carefully dressed and fitted. True megalithic architecture was of rough stone, not dressed but chosen for its purpose and, of necessity, dragged long distances. The Neolithic architects and craftsmen knew how to work stone. Occasionally they carved their megaliths in decorative patterns, and they sometimes shortened or shaped them for convenience. Moreover, when they created henges, they sometimes excavated the surrounding ditches 3 feet deep into the living stone foundation. But they preferred their decorative or sacred main stones to be unhewn, as though they were deliberately selecting a natural artefact and then, by human ingenuity, placing it in a special position and formation as a creative act of worship. Stone was clearly chosen, as in ancient Egypt, for its durability and apparent indestructibility, a symbol of timelessness or, if the concept were grasped, of eternity.

The effort involved in megalithic art was enormous, and the results were correspondingly impressive. At Carnac in Brittany there is a huge complex of megaliths, with five major avenues, each of which has a number of stone rows. One of these sculpture parks, Menec, has eleven parallel megalith lines stretching over 1,000 yards, with a total of 1,099 stones, all of granite. The whole site covers thousands of acres. Some of the stones are colossal, rivalling anything found in Egypt. At Plouarzel in Brittany, there is an upright stone well over 30 feet high. At another Breton site, Locmariaquer, a megalith which is now broken and on the ground, known as the Grand Menhir Brisé, is calculated to weigh 350 tons.

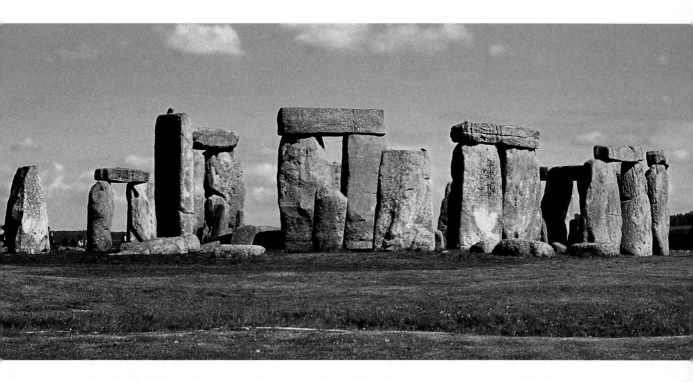

Megalithic architecture can be dated between 5000 and 1500 BC. Like cave art, it was an extraordinarily durable expression of art and science. Stonehenge in England was constructed in three distinct phases, between approximately 3200 and 1600 BC. Not even old St Peter's and new St Peter's in Rome, put together, can match that period of construction. The original alignment of its entrance passages was to the most northerly rising of the full moon in midwinter, and it could only have been determined by careful observations throughout six lunar cycles, each lasting nearly twenty years. We have here, then, an artistic construct which, like a cathedral, was the work of generations even in its basic design. Much of the henge is constructed of giant bluestones, each weighing at least 4 tons, brought by a glacier from their home in the Preseli Mountains in Wales. A number of huge sandstone megaliths had to be dragged to the site over a distance of 20 miles. The resources involved were large, all the time-spans were long, and the degree of professionalism was notable. Most of the Stonehenge megaliths are not in their natural shape but carefully hewn and matched, all originally topped by lintel stones. The first building at Stonehenge was of wood, and as in ancient Egypt, the stonemasons of Neolithic Wiltshire treated their stone material as if it were timber, with bevels and chamfers, mortice joints and tenon joints, and produced the effect of planing. Thus in England as well as in Egypt, stone architecture evolved its patterns from its organic predecessors, demonstrating the immense forces of conservatism and conformity which tend to mark all early human art.

The degree of social determination needed to sustain the efforts of the megalith-builders over many years underlines the importance Neolithic societies attached

Stonehenge epitomises the first climax of monumental religious art: its survival testifies to the sophistication of its architecture and masonry.

to such structures. At Avebury, for instance, one of the largest sites in England, excavation of the ditch and raising of mounds involved shifting hundreds of thousands of tons of earth and chalk. Why did they do it? That some element of astronomical calculation was involved seems certain, but that may not have been the primary purpose of the construct. This may even have changed during the two or three millennia in which these menhirs and henges were in use. We know that in some cases henges switched from lunar to solar orientations, or vice versa. Some were certainly associated with cemeteries and burial rituals.

What they all seem to have had in common was the desire to order. Indeed, it may well be that the chief aim of early art was to make sense of a chaotic universe. This of course is the acknowledged aim of science, and perhaps the best approach to early art is to see it as a precursor of science, conjured out of the human imagination. Art was a form of, or a substitute for, or a visual aid to, knowledge, and as scientific knowledge became available—at Stonehenge in the shape of celestial observation and mathematics—it was incorporated in the art. All was part of a unified search for truth. In this sense art was about truth, as Keats rightly perceived: 'Beauty is truth, truth beauty.' The men and women of the Stone Age were surrounded by, subjected to, the forces of nature, overwhelming in their power, unpredictable, operating in terrifying spasms, death-dealing, relentless yet also quixotic and eccentric. Was it all aimless, purposeless, unmeaning, as it sometimes seemed? Humanity could not accept this nihilism, which reduced them to the level of the animals or even the insects. So it turned to art to fashion a sense of order, to introduce regularity, predictability; to distinguish between the seasons, the months; and to reflect on earth the regularity of the heavenly motions.

Religious belief and observance are part of that order. Disposal of the dead in seemly fashion is another part. So is the calendar, the careful study of the seasons for agricultural purposes. So is the organisation of society itself, the arrangement in hierarchies and trades, the division of labour. Communal art, the summation of all these ordering processes, is the visual symbol of order. The point was made with extraordinary force at Stonehenge, where the immense bluestone blocks, which the chaotic power of nature, in the form of a glacier, had strewn haphazardly about the Wiltshire countryside, were gathered together by human muscles and arranged in disciplined patterns by the human brain to achieve a rational purpose. The huge megaliths, standing scores of feet high and dominating the surrounding countryside, or arranged in precise circles to fit in with certain spectacular events in the heavens, were order writ in stone. Art, involving carefully acquired skills, immense effort and long time spans, was the proof that humanity was in charge of its destiny, could hold that chaos at bay and provide some security for itself. In an ordered world, men and women had some chance of achieving happiness, and that is the main reason why art was so important to them.

2

ANCIENT EGYPT AND
THE ORIGINS OF STYLE

We have so far looked at art systems which came to a natural or mysterious end and had no continuity at all with what followed. Societies stopped producing cave art. Megalithic art ceased to be practised. From about 1000 BC, for instance, Stonehenge was deserted. In the ancient Middle East, however, civilisation, though rude, took a permanent grip very early in history, and a continuity in the production of art, however tenuous, was preserved. It is in the Middle East, with its arid plains and occasional dense oases, and above all in its rich river valleys, that it is possible to trace the far-distant roots of our own civilisations and systems of art.

Half a century ago, in the 1950s, archaeological investigations established that at Jericho in Jordan and at Catal Huyuk and Hacílar in Turkey, there was clear evidence that the Neolithic Revolution—crop cultivation, widespread domestication of a variety of animals, and settlement in permanent communities—occurred as early as 6000 BC. Thus was established the economic and social basis on which civilisation could be built, and the arts be practised. By the middle of the fourth millennium (3500 BC), in what is now southern Iraq, the Sumerians had built sizeable cities. By this time they had developed a common language and culture, which endured for fifteen centuries. They manufactured goods and traded them, had a civic government and large city temples. Their great stepped multiple platforms, or ziggurats, were formidable examples of engineering and even sophisticated architecture. The one at Ur shows an understanding of the principles of entasis: the sides of the lowest stage were made slightly convex, to give the optical illusion of appearing straight, a trick which, until Ur was excavated, we thought had been invented by the classical Greek builders of the fifth century BC. These temples contained statues. The richest graves discovered were filled with precious objects, metals, jewellery and pottery. Some of the grander houses had, en suite to the bedroom, tiled bathrooms and lavatories. By 3200 BC, if not earlier, the Sumerians had devised a form of writing,

cuneiform, impressed on sun-dried clay tablets, some of which have survived. Most deal with administration, but some are historical or literary documents, which include the great epic of Gilgamesh. As part of their writing equipment, the Sumerians developed large and elaborate cylinder seals, of a variety of durable materials, decorated with humans, animals, mythical creatures, plants and trees, religious forms and the names of the owners. Many have survived and in some cases are objects of beauty, testifying to the skill and sensitivity of these ancient town-dwellers.

Meanwhile, a far more remarkable civilisation—among the most enduring and artistically productive in world history—was emerging in the Nile valley of Egypt. If the Egyptians were late starters compared to the Sumerians, still living in villages when Sumerians were building large towns, once they achieved political unity, they progressed with remarkable speed. Indeed, they skipped an entire evolutionary form of government, moving from the village or group of villages, to a unified country, leaving out the city-state entirely. First, the country evolved into two states, Upper and Lower Egypt, each with

Ziggurat at Ur: early example of a religious art form designed to awe, and so successful it remained standard from *c.*2500 to *c.*500 BC.

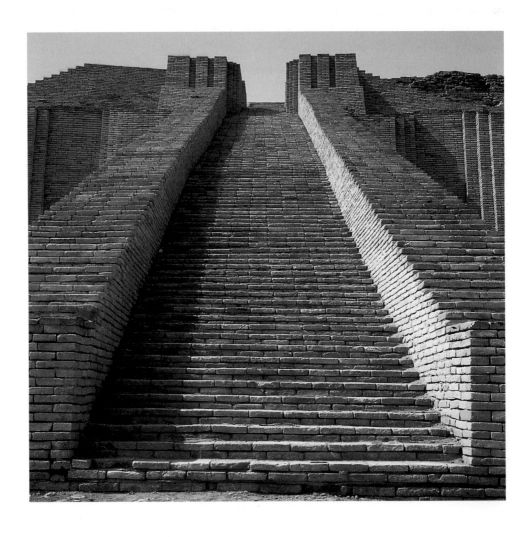

kings. About 3100 BC, a king called Narmer united the two Egypts, built a capital city, Memphis, near the site of modern Cairo, and set up a vast white-walled palace there, called the *pharaoh*, being henceforth referred to after his house, as the Pharaoh.

Egypt, then, was the first country, as we would understand it; its unity underscored by the Nile valley and its appendage, the delta, and the intense agricultural system on its banks, which the regular flooding and recession of the river made possible. The Nile made Egypt rich, the richest of all early societies, and in gratitude to their gods the Egyptians became, as the Greek historian Herodotus later remarked, the most religious people in the world. Their priests discovered from contact with Sumer the principles of cuneiform writing, and they transformed them into their own system, part ideogrammatic, part alphabetic, which was known as hieroglyphics, that is, priestly carving on stone. (They later developed an additional script written on papyrus leaves, known as hieratic, and a trading, popular script called demotic.) These hieroglyphs are the perfect demonstration of how, in early societies, letters and pictorial art merged, were almost indistinguishable in fact, and combined together in visual presentations. That remained true of Egyptian art for 3,000 years, and is still true of traditional Chinese, Korean and Japanese art today. It produces art-work, part-painting or carving, part writing, which the Western tradition abandoned with the end of illuminated manuscripts. But it has the disadvantage that the writing explains things to the viewer/reader which the artist thus need not illustrate, and so acts as a disincentive to artists to communicate more and more complex and expressive images.

The Egyptians had entered the Neolithic Revolution more than two millennia later than the Sumerians, and during the first two dynasties of pharaohs, 3100–2686 BC, they were catching up. The unified state was of enormous consequence because it enabled the pharaohs to undertake great public-works programmes—one of the earliest titles of honour in ancient Egypt was Canal Builder, bestowed on senior officials—which increased production and productivity, and so disposable wealth. By the time of Pharaoh Djoser of the Third Dynasty (2686–2613 BC), Egypt was a rich country. Djoser, under the guidance of his chief minister, Imhotep, who seems to have been both an administrative and artistic genius, embarked on a public works programme unprecedented in history. His Step Pyramid at Sakkara, in which the problem of stability in these vast stone erections was finally solved, was the immediate predecessor of the great pyramids built at Giza 200 years later. More important, perhaps, he constructed a stone palace on the site, the first of any size. It featured a large range of architectural devices, including rows of pillars and pilasters, which the Greeks were credited with inventing nearly two millennia later. And, yet more important, Imhotep forged the patterns of the hieroglyphs, the forms of architecture and the methods of carving statues and low-reliefs into a uniform and canonical style of intense elegance and beauty, which remained the predominant expression of Egyptian art for 3,000 years. This was the first example in history of an aesthetic

revolution which took place during a single lifetime, and it is no surprise that Imhotep was later revered as a god, being in due course credited with many ingenious and life-saving inventions, and conflated with the Greek god of healing, Asclepius.

Imhotep's career and achievement illustrated, once again, the close relationship between art and technology in early times, and the impossibility of drawing distinctions between them. There was no other culture in antiquity where cultural unification was carried to such an intense pitch: in Egypt, the canons of art were strictly laid down and always enforced from the beginning. Beyond and above this, however, was the phenomenon we have already noted: the way in which art embodied for early men and women the principle and the reality of order. The ancient Egyptians were devoted to order to a degree which no other people have manifested, before or since. Their economy depended on the orderly behaviour of the Nile; their religion revolved round principles of order; their art was orderly because it was ordained, canonical and unchanging. The strength of their artistic order was immense because it reflected their temperament, but also the moulding influence of a single commanding mind, Imhotep's. By means of this strength, the Egyptian culture was able to survive two chaotic collapses of royal authority, known as the First and Second Intermediate periods, which occurred under the Seventh to Tenth Dynasties and again under the Fourteenth to Seventeenth Dynasties, and re-emerge virtually intact, and with new accretions of skill. The art of the Old Kingdom, the Middle Kingdom and the New Kingdom was similar in all essentials. For sheer tenacity, durability and dedication, there has never been anything to match the art system of ancient Egypt.

Yet Egyptian art is very remote from ours. We can immediately grasp many aspects of its beauty—the superlative quality of its stone-carving, for instance, made with bronze tools (Egypt entered the Iron Age late). But to understand its real depth and quality requires an effort of imagination. The ordering process achieved a wonderful clarity of form, almost from the start, and retained it almost to the end—whether the magisterial simplicity of the monumental sculpture and architecture, or the simple elegance of the merest everyday utensil; the objects produced at every level of expression, irrespective of cost and material, were bound together in aesthetic unity by the same manifest style. However, when we use the word 'aesthetic' we must beware of giving it a non-functional significance. All art in ancient Egypt, even the shaping of an ordinary spoon in the form of a goddess, had religious, social or political meaning and purpose. We can understand it best if we regard art as an enormous system of communication. An art object was a message, usually a message to the gods. The artist encoded it; the gods—or we, if we know the rules—decode it. The language of art was not divided into strict compartments. Almost without exception, for instance, sculpture and its architectural setting were designed together; or, to put it another way, the architecture meant nothing without its sculp-

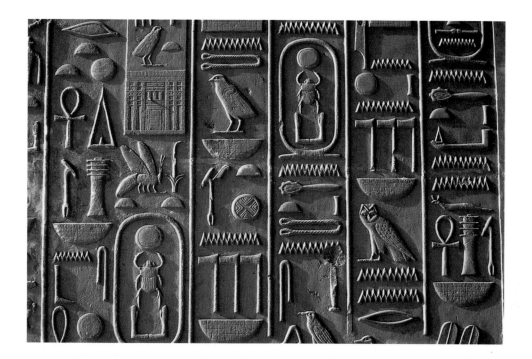

tural adornment, as that was a key part of the message. There is an analogy here with the façade of a cathedral. Hence we must remember that the figure of a pharaoh or a god seen in a Western museum, even if complete in itself, was a severed fragment in Egyptian eyes. Equally, a great tomb complex, temple or palace, shorn of its statues,

Hieroglyphics (Karnak, 1950 BC), stone-carved by master-sculptors from canonical rules by a designer of genius. No one has ever matched the Egyptians for style.

is blind and lifeless according to the criteria of its creators. The unity would have been blazingly apparent if we could have seen these creative ensembles in their pristine state, not least because all was painted, the colours having meanings and being part of the communication system.

Above all, we must not distinguish between hieroglyphs and purely plastic art, since that is not a distinction the Egyptians could or would have made. During the formative period of Egyptian art, these two forms of expression or communication advanced with the same deliberate speed in the direction of clarity. The axis on which Egyptian civilisation revolved was the mastery of stone-carving; it is significant that the basic hieroglyph for arts of all kinds is the sign for the borer, used in hollowing a stone vase—marking the first unequivocal victory in Egypt of skill over matter. Hieroglyphs began as raised carvings on stone—brushmanship and pen-work followed much later. During the Second Dynasty, the signs were first arranged in harmonious lines, acquired well-defined relative sizes, and were gradually grouped in elegant squares or rectangles, at precisely the same time that Egyptian sculptors were mastering the human form and giving it order in stone. The artistic process was the same in each case and possibly the same hands were at work. The great ceremonial palettes of early dynastic times, with their combination of raised

low-relief sculpture and raised glyphs, are plainly the work of single artists. In New Kingdom times, professional scribes, working with the brush, were taught to sneer at the labours of sculptors, but there is no evidence that the contempt was reciprocated. On the contrary, sculptors always carved the hieroglyphic messages on their work; whether on statuary or low-relief, they do not seem to have regarded word-carving as in any way inferior or even different to image-carving.

Nor, granted their approach to art, *was* it different, whether the medium were stone or papyrus. If we could get inside the mind of a literate Egyptian at an epoch before the first millennium BC, we would find that he did not distinguish between words and art. Both were seen as the process of communicating and clarifying. So intense was the clarifying urge that there is hardly a picture, sacred or profane, in the whole corpus of Egyptian art, without an accompanying text—often an integral part of the picture—which tells us what is happening, who the people are, the speeches they address to each other, and much other information, often superfluous when the paintings or sculptures are self-evident. In three-dimensional sculpture, the hieroglyphic lines are ordered with immense and delicate skill so that they gently and unobtrusively emphasise the principal forms of the mass, without losing their own significance. On the great wall-paintings and low-reliefs, the writing often plays a central role in the organising of space, the balance of masses and the conveyance of meaning. That is why the script, as it were, retained its protean character: travelling in either direction horizontally, and vertically too—though it is notable that the signs always face in the direction in which the person to whom they are attached is speaking, moving, looking or performing.

The integration of script with art is of course the reason why the hieroglyphs never lost their pictorial element and became a pure alphabet. By a curious paradox, they could not escape from their primitive origins because they were part of a sophisticated artistic process. And, equally, in their intense search for clarity and their desire to communicate, the Egyptians never allowed the purely pictorial forms to escape from their primary task of communicating information. If, for instance, an Egyptian artist wanted to show the contents of a basket, he drew the objects—bread, vegetables, fishes and so forth—in such a way, and so arranged in relation to each other, as to give the impression almost of an artistic code, having more in common with hieroglyphic signs than, say, a European still life of the eighteenth century.

Hence we should see the ancient Egyptian artist as a communicator. To understand what he is doing it is necessary to learn the code within his art just as we need to know what the signs of the hieroglyphs stand for, alone or in combination. Egyptian art was dominated by an immensely powerful studio tradition, perpetuating itself from generation to generation. There was no distinction between art-work and craft work, and a young boy went into a studio to learn his trade like any other craftsman—or, indeed, like the scribes. In many respects, the studio of a successful

artist patronised by royalty was like a scribal school, though not officially organised to the same degree. Scribes wrote about their training, so we know quite a lot about it: we possess sheets of apprentice drawings on gesso board or papyrus and trial pieces of sculpture, some of them incomplete. At Amarna, German archaeologists found the ruined studio of the royal sculptor Tuthmosis, together with a large number of carved fragments, including the famous head of Queen Nefertiti, now in Berlin.

The evidence suggests that Egyptian artists were subjected to a highly disciplined and somewhat mechanical training. Able and successful ones enjoyed a very high status in Egyptian society. This is not so surprising, considering how important artists were to the achievements and therefore to the self-esteem of the ruling class. But we should not see them as individuals, achieving self-expression. They were much more like officials, part of the pattern of court life and politics. In the Old Kingdom, in fact, they almost certainly lived and worked within the patriarchal community of the palace. Long after they acquired their own separate studios and households, they remained the servants of the conventional wisdom and the prevailing idiom of their day, as the senior priests did. Of course, just as gods might rise and fall, and priests bend to the new mood accordingly, so artists conformed to any modifications of the basic pattern laid down by official court policy or pharaonic whim. Egyptian art did not shift much, but to the trained and informed eye the styles and periods can be recognised as clearly as Louis Quatorze, Louis Quinze and so forth.

The 'artistic revolution' of Akhenaten began as a continuation and heightening of the style of his father, Amenophis III. But he pushed it to the point where he set up in the minds of his artists a conflict between their loyalty to pharaonic direction and leadership, and their even deeper loyalty to their immemorial studio tradition, a loyalty (we must always remember) which was religious as well as national. When that point came, the artists behaved exactly like the other officials of the regime. The leading establishment figures do not seem to have followed Akhenaten to Amarna, any more than did the leading religious and secular court ministers. But from the lower ranks of the artistic hierarchy Akhenaten was able to recruit a number of talented men whose names we know—the architects Parennefer and Paatenemheb, his mother's sculptor, Yuti, the sculptor Tuthmosis and others. Their spacious studio villas testify to their prosperity and the warmth of the king's patronage; their funeral stelae are eloquent on the subject of the king's beneficence.

It is plain that Akhenaten directed his artists in a more detailed manner than any of his predecessors and raised up a collection of time-servers, albeit gifted ones, to carve and paint in his own image. They flourished mightily while he lived, then met their nemesis when his regime ended. Tuthmosis's studio was not merely abandoned: someone evidently went through it smashing or disfiguring the model heads

of Akhenaten. Tuthmosis had clearly done a good business in such things while Amarna flourished: it may have been *de rigueur* for a member of the Amarna ruling class to have the king's head prominently displayed in his villa. When the regime collapsed, the hammer men—agents of that grim Egyptian injunction: 'Wipe Out His Name'—got to work. The model heads of Amarna dignitaries, left behind as unsaleable now they were thrown out of office or killed, were also found in the rubbish. Nefertiti's famous head was left, literally, on the shelf. When the shelf, centuries later, collapsed, the head fell safely onto a soft pile of mud rubble from the walls, and so was preserved, minus one eye.

Occasionally an Egyptian artist allowed himself a flicker of individuality. There is a unique self-portrait of a painter, Huy, a man who, despite an apparently high social position, chose to paint himself with his hair loose and in a dress and posture of unusual informality. But the artistic temperament was usually subordinated to the official role. The greatest of all the Egyptian artists, the sculptors who carved the portrait statues of the sombre Middle Kingdom monarchs, were completely self-effacing as artists, if not as dignitaries. To judge from the funeral stele of one Middle Kingdom sculptor, he made no distinction between his own skill and that of the divinities for whom he laboured. This is not surprising because to his mind the sculpture, in the process of being fashioned, acquired an independent life of its own. When complete it was, in some real sense to him and to others, a living being. That was why the Egyptians made so many of these portrait-statues, with such loving and painstaking deliberation, searching for the hardest and most beautiful stones, uniting their humble, human skills with the life-giving power of the divine. And that was why the Egyptians felt authorised to worship them or compelled, in certain circumstances, to destroy or disfigure them. The completion of a statue was marked by the carving of its name in hieroglyphics: at that point it was ready for the 'Opening of the Mouth'. Once the statue's mouth was 'opened', it ceased to belong to the sculptor—it was on its own. The heads on the floor of Tuthmosis's wrecked studio, and Nefertiti on her shelf, were dead things; they had never lived.

The ceremony of opening gave life to a statue but it was the carving of the hieroglyphic name—not the carving of the features—which conferred identity on it. When the Egyptians desired, for political, religious or personal reasons, to destroy the life of a statue, they usually mutilated the features, but it was the hammering out of the hieroglyphic name which was decisive. Equally, when a pharaoh wished to appropriate the statue of a predecessor for himself, as Rameses II frequently did, he simply replaced the name with his own—he did not alter the features. Now this suggests that, in some deep notional sense, Egyptian sculptures were not portraits but archetypes. The evidence is confusing. In the first place, each pharaoh created his own archetype, or certainly some did. It bore a resemblance to his own physiognomy, although it was stylised and idealised. It is impossible not to believe that the kings of the Twelfth Dynasty did not bear some likeness to their magnificent carved images—

even if their uniformity of mood and expression makes us a little suspicious. Again, there appear to be family traits in certain kings of the Eighteenth Dynasty—we recognise in the youthful Tutankhamen, for instance, something of his father (or grandfather) Amenophis III; and the sculptures and paintings of Akhenaten, the outstanding example of the imposed personal archetype, reflect a hideous distortion of family features.

The Tuthmosis models show that even a successful official sculptor like himself did not follow in private, or for his own professional purposes, the line of official Amarna art, with its blatant distortions. He regarded it as royal 'fashion art', not fine art. Here is proof that the 'revolutionary art' of the Akhenaten regime was not something which flowed upwards from the artists but was a style dictated from above as official policy. And it is apparent from much other evidence, drawn from several periods, that there was always a court art which reflected religious politics, and a private art. The geographical structure of Egypt, with the Nile providing a superb system of communications, had a centripetal effect, submerging provincial tendencies beneath a dominant metropolitan style; it emanated especially from Memphis, of which the court, reflecting the single will of an all-powerful monarchy, was the arbiter. But it is notable that, when the grip of the monarchy was relaxed, as during the Intermediate periods, Egyptian art did not flourish in provincial or individualistic fashions; it simply declined. Private art could not survive without its public or court expression.

Nor was this the result of purely material factors. Egyptian painters, sculptors and architects did not have the self-confidence of the modern individual artist. Their art, at its best, is immensely assured

The Giza pyramids (2600–2500 BC) originally sparkled with their reflective limestone casing, pillaged in antiquity. Their continuing stability is a miracle of Bronze Age engineering.

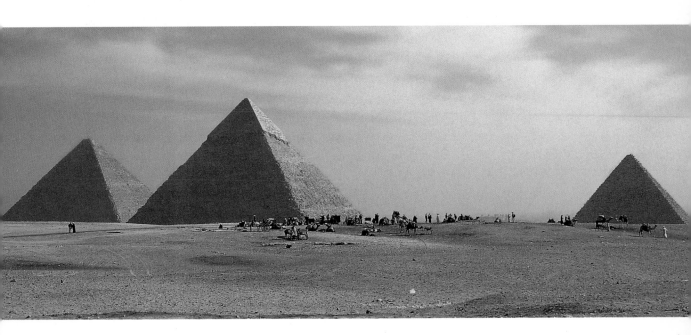

and confident but it is the confidence of the collective. An Egyptian artist saw himself as part of a powerful tradition which had always existed and always would exist, and which was followed by all his colleagues. In individualism lay disaster; in the collective lay strength and security. This professional approach itself reflected the social and religious beliefs common to all Egyptians. Man arrived at knowledge and so justified himself not by exercising his critical faculties and by his own perception but by the acceptance of dogmatic truth. The artist is obedient and submissive before the divine order. He does not express a personal viewpoint, his own order as it were, but seeks to integrate himself with the universal order, or *maat*, laid down by a god.

All this implies a code and in fact the Egyptian artist worked within the restraints of an immensely comprehensive and authoritative code, taught by example and in the studios and so passed on, and occasionally modified, from generation to generation. As an individual, the artist could not change the rules any more than a scribe could alter the hieroglyphics. First there were the restrictions imposed by the material. Egyptian sculptors worked in stone as a rule, and by preference in very hard stone, using tools of comparatively soft metal. They eventually coped with this difficulty very successfully, but their initial strivings were inevitably reflected in their traditions, which sought to reconcile treatment of the human figure with the rectangular solidity of the block. The backboard and the seat, originally employed (we presume) to help overcome the problem of rendering a free-standing figure, remained part of the artistic idiom long after they had ceased to be necessary. Conforming to and expanding this tradition, sculptors during the Middle Kingdom introduced the device of the squatting figure, which aligned itself even more closely to the block of undressed stone. This marrying of plastic shapes to the demands of the material was conducted with immense elegance and an authority which rested on faith. Indeed, it *was* faith, for Egyptian art was in no way anthropocentric. The object was more important than the man looking at it. Gold was for the gods, stone for eternity. A particular stone was never selected arbitrarily but according to well-known religious criteria—its very availability might be the result of divine intervention, as the claims of many stone-quarrying expeditions testify.

The sculptor thus had duties towards his material. He had the supreme duty to vivify it, to make it come to life when he had finished his work: he and the material cooperated in achieving the divine purpose. This compulsion helps us to understand why Egyptian artists, whenever possible, fashioned the objects they made in organic shapes—men and women obviously, but animals, flowers, reeds, grasses, woods and trees, fishes and insects; no aspect of Egypt's fauna and flora failed to find itself in their artefacts. Columns were papyrus plants or lilies, a wine cup was a lotus flower, a mirror handle a papyrus stem, a spoon handle a girl, a boy holding a mussel shell on his head an ointment ladle; the three beds in Tutankhamen's tomb each had their sides carved in the shape of a complete animal—a cow, a panther, a hippopotamus.

Thus each object, humble or grandiose, was in some way brought to life and the demands of the material satisfied.

Then there were social restrictions, inevitable in any court art, but in Egypt of peculiar power and complexity—so complex that we, in our ignorance, cannot know them all. If the artist owed duties to his material, he also owed respect, in varying degree, to his subjects. The Egyptians seem to have regarded themselves, in a state of nature, as highly emotional and volatile people—mercurial, excitable, galvanic. The essence of civilisation, as they saw it, was the subordination of these wild instincts to order, conformity, self-discipline; *maat*, in short. They would have agreed with Yeats's definition of civilisation as the search for self-control. Hence a human form possessing a plenitude of *maat*—a god or goddess, a pharaoh or, in descending order, a member of the royal family, an aristocrat, a priest or high official—had visibly to exercise restraint by an absence of motion, a fixed, stationary, self-consciously 'noble' posture. From this necessity came the dominant idiom of the standing figure, left foot forward in arrested motion, arms to the sides in alert repose. We imagine that the pharaoh himself in real life—at any rate when he was on public show—was so burdened with his stiffened linen robes and top-heavy ceremonial headgear that he had no alternative but to adopt statuesque postures and slow, magisterial gestures. 'Ladies,' said Lord Curzon, instructing his new American wife in the ritual of English sexual congress, 'never move.' Pharaoh never moved either, on any occasion, or only to the minimum extent necessary. In art at least, members of the ruling class took on the pharaonic immobility.

However, at a certain point down the social scale, movement became permissible, almost mandatory, and artists portrayed it. Stone monumental sculpture did not, of course, deal with the lower classes, but the group models, or miniatures, placed in tombs often show them in vigorous motion. In two-dimensional paintings and reliefs, servants, peasants, workmen, artisans, soldiers and sailors, dancers and musicians could be supple, dynamic, even frenzied, jumping, running, leaping and fighting, hammering and pulling. They were imprisoned in much less rigid conventions of depiction. So, too, were enemies and foreigners, whatever their rank. The artist owed them little or no respect and could show them in unusual or uncanonical postures, old and ugly, obese or starving, ill, wounded, dying or dead. It was part of the heresy of Akhenaten that he forced his artists to ride roughly over these traditional class distinctions. He had himself portrayed, even in official monuments, in relaxed or dynamic postures which no previous monarch had permitted, and in familiar situations, playing with his children, embracing his wife, which may well have represented his actual behaviour in public or semi-public audiences and which, therefore, in traditionalist eyes was even more reprehensible. The mannerism he encouraged or dictated was not just an affront to the conventions; it was a positive assault on the magisterial presentation of *maat* as an ordered hierarchy which was the very essence of Egyptian style.

Of course the conventions which underpinned the style were supplemented by more mechanical devices. The Egyptian artist was the first to develop a systematised canon for the human form. The human canon was a metrological concept in origin, the Egyptians having noted the reliability of human proportions. But this was an aesthetic and religious observation as well, the artist perceiving that, in the divine wisdom, the diversity of human forms was contrasted by their proportional unity and that it was the harmony of the latter which made humanist art so satisfying. The artistic canon was very likely worked out at the same time as the system of measurement and was certainly in existence by the beginning of the Old Kingdom. Its accuracy and strict observation had a religious sanction, since the usual purpose of Egyptian art was to guarantee the immortality of the body, whose appearance therefore had to be rendered correctly.

For this purpose, the earliest Egyptian sculptors of the dynastic period used a grid which was a geometrical projection in measured squares of the agreed proportions of the body set out in the metrological canon. The rough-hewn blocks used for sculptures were squared on at least two sides—possibly on all four and on top as well. The axis ran between the eyes, down the nose, across the navel and between the feet. Thus, for sculpture, the body was divided into two identical halves. For the two-dimensional low-reliefs and paintings, grids were also used stretched over the surface (sometimes strings dipped in paint), but, except for the shoulders, the figure was turned round on its sculptured axis, so that head, trunk and legs were shown in profile. If these parts are then turned back on their axis, the figure resumes the appearance of a three-dimensional sculpture seen from the front. The same canons of proportion and the same basic outline applied, therefore, to the rendering of the human form in both two and three dimensions.

The way in which the human form, or space or distance, or any objects whatever were portrayed, was determined precisely and logically by the application of their canonical code.

It is important to remember, when we look at Egyptian works of art, that if our response to these works is instinctive, we will, as it were, be seeing Egyptian art as an emotional aberration from our own code, instead of as the normative product of theirs. We have to learn how to look at Egyptian art, and this is not easy because it involves deliberately suppressing the powerful dictates of our code. But at least the methods to be employed have been authoritatively set down by Heinrich Schäfer, the great Berlin Egyptologist, in his *Principles of Egyptian Art*, one of the most remarkable books ever written about aesthetic history. He provides a detailed explanation of the Egyptian visual code which, though open to challenge in certain respects, unlocks most of the doors for us.

Among primitive people—and for this purpose we must include the Egyptians—there is little or no distinction between a created image and the reality. Indeed, as we have

The pharaoh Mycerenus, his goddess-mentor and wife: Egyptian strongmen were touchingly dependent on women, divine and human.

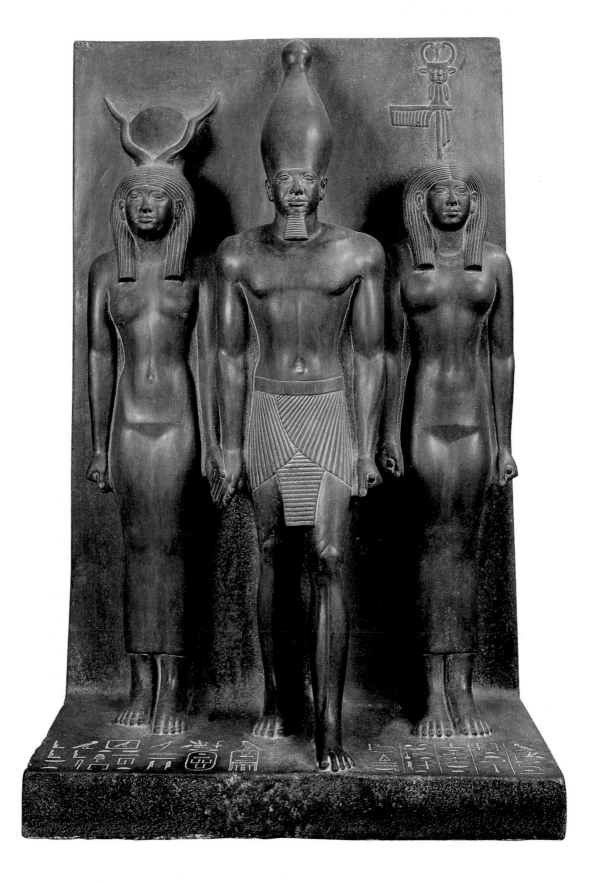

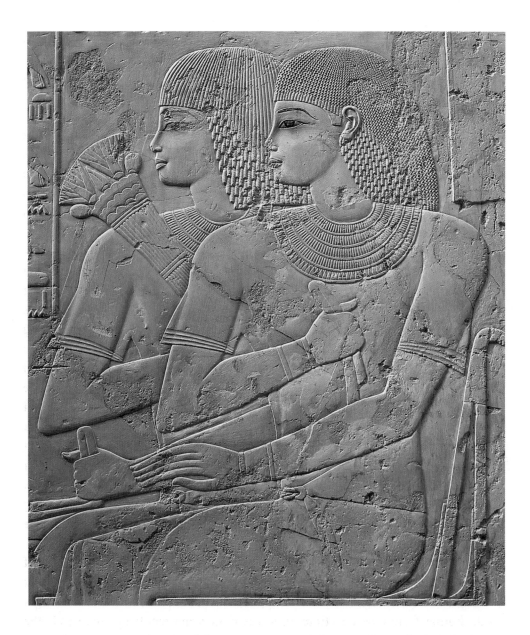

Low-relief carving in the New Kingdom reached a level of skill and delight unequalled before Donatello in the fifteenth century AD.

seen, it was of the very essence of the Egyptian cult that the image was the god. This being so, it was essential that the rendering of the image should approximate as closely as possible to reality—not the illusory reality seen by the fallible human eye, from one viewpoint only, but the true reality of the actual appearance of the person or object, as known intellectually and by experience. Usually this takes the form of rendering the frontal image, irrespective of the artist's viewpoint, chosen because it is the one which most immediately conjures up reality to the viewer. Or, to put it another way, it is most characteristic of the object concerned, and conveys the most information about it.

Hence, when we look at Egyptian art, we must remember that the artist is not

striving primarily to present, whether in two or three dimensions, what he sees with his eyes, but to give the maximum information, in pictorial or plastic shorthand, about what he knows intellectually to be there. Once again, we have to see the artist as communicator and his work as closer to hieroglyphics than to photography. Hence, when we look at the Egyptian rendering of human figures in two dimensions, we should never judge them as human forms, comprehended in one glance from a single viewpoint. They are in fact composites, jigsaw puzzles of frontal images and characteristic images, put together with right-angle turns in the axis, to provide the archetypal human form, rather than the one seen by the artist. The Egyptians reduced all this to a code which laid down these multiple viewpoints and the images of reality judged to be most characteristic.

Every part of the body was shown from the side which revealed it most characteristically. Thus the head was shown in profile, because that told us more about the nature of the face than the frontal image; but the eye was shown frontally, because it was the only view giving the complete circle of white, iris and pupil. The neck was also shown in profile as part of the head, but it had to be presented in a twisting motion (which was in fact natural) because the shoulders were most characteristic when shown full frontally. The legs, feet, hips and bottom were in profile, chest and stomach acting as transition between them and the frontal shoulders. Here the code became a little awkward, the chest being, as it were, pivoted at forty-five degrees. In the case of a man, one nipple may be shown frontally, the other in profile. With a woman, both are covered by the straps of her dress, which is shown frontally; but one nipple is also, as a rule, shown exposed and in profile. This is a contradiction and a visual impossibility, but it did not seem wrong or absurd to the Egyptians, since it conformed to the code of giving the maximum information by portraying the characteristic profile shape of the female breast—the fact that it could not be seen under the dress was irrelevant since everyone knew it was there.

The two-dimensional rendering of the human form, with its multiple points of reference, involved the axial shifts in the canon we have already examined. It remained absolutely standard for the Egyptians for 3,000 years, and all other images of the human form were variations on it. The more important the person was in the social or divine hierarchy, the more closely the rendering had to conform to this pattern (workmen, being relatively unimportant, were often shown in strict profile or even with their backs to the viewer). With work in three dimensions, the human form, in addition to conforming to the canonical proportions, could only move on fixed axes. The plane in which it was set was unalterable: it could bend forwards or backwards, but not sideways at the neck or at the hips; and it could not turn within its axis. Sometimes angles of around eighty degrees were considered permissible, but any drastic variation from the right-angle approach was ruled out. Hence, Egyptian sculpture is basically composed of four views, each at right angles to the others. Schäfer calls this 'the law of directional straightness'. It enclosed the statue in an

invisible rectangular box. Seen from the front, as it was meant to be, it does not, to our eyes, give an impression of depth. The Egyptian viewer apprehended the frontal image, then viewed the image at right angles from the side; then, in returning to the front, superimposed the two images in his mind to acquire depth and reality. Modern photographs which show Egyptian sculpture at an oblique angle, so that both front and side images are combined in distorted form, defeat the purpose for which the sculptor was striving and wrench the statue out of the code in which it was composed.

The same principle of providing information, and of presenting objects in their most characteristic shape, rather than rendering the image from the fixed viewpoint of a 'subjective' artist, applied to all forms of Egyptian art. A table was shown with its legs and top, irrespective of what could actually be seen from the angle of vision subjectively chosen; and if there were loaves and fruit on the table, these were simply piled vertically on top of the table and presented frontally to bring out their characteristics. If the artist is painting a pool surrounded by trees, the shape of the pool seen vertically is chosen, because that is the pool's characteristic shape; but the trees surrounding it are shown from a horizontal angle, because that brings out their characteristics. Again, a storehouse is shown by portraying its doors and the horizontal profile of the roof; but the grain within is also shown in its jars because the picture would otherwise be meaningless to Egyptians.

Egyptian low-reliefs and paintings must therefore be 'read', as well as looked at. They were designed to convey information but they also demanded from the viewer a series of intellectual reactions or, rather, a continuous process of analysis as his eyes moved over the surface and translated the pictorial code into the realities as he knew them. In the big compositions combining hieroglyphics with strictly pictorial forms, the mental process involved in 'reading' and 'looking' was roughly the same. The art of viewing them intelligibly lies in being able to isolate each point of reference or unit, and its overriding unity, in the mind. This is not easy: it requires a fierce intellectual self-control.

3

PALACE ART IN THE ANCIENT NEAR EAST

One reason for the extraordinary stability of Egyptian society and culture over 3,000 years was its relative isolation from the rest of the world. This was underlined by the regular, predictable rhythms of the rise and fall of the Nile. There is a calm self-confidence about Egyptian art which reflects this uneventful continuity. It was a different matter for the rest of the ancient world, and especially its earliest core, Mesopotamia, the lands between the two great rivers, the Euphrates and the Tigris. These rivers themselves were a source of profound instability, being wild, undependable and woefully destructive, sometimes sinking down to a muddy trickle, at others breaking their banks and flooding thousands of square miles, engulfing and demolishing entire cities made mainly of dried mud bricks. The reality of the Flood, which survives both in Gilgamesh and in the Old Testament (and other sources) overshadowed entire civilisations with its memory and future threat. The area later became known as the eastern horn of the Fertile Crescent, the western horn being anchored in Damascus and Byblos (Beirut), but the truth is that weather and abrupt changes in climate were more likely to destroy a civilisation than create it.

In this unstable geography and ecology, empires rose and fell, not with the regularity of the Nile but often with stunning speed. Such culture as there was tended to be conscripted to expansion and imperialism, in a continual attempt to give legitimacy to precarious power structures. Religion and its artistic expressions were closely linked to individual dynasties and particular monarchs. This bleak concentration on the source of brute power, both earthly and divine, each identified with the other, led to the first series of judicial codes in world history, of which the Laws of Hammurabi, king of the first Babylonian dynasty (in the second millennium BC), are the outstanding example. These dreadful laws are notable for the ferocity of their physical punishments, in contrast to the restraint of the Mosaic Code and the enactments of Deuteronomy and Leviticus, which sprang from it. Accompanying

them was an enforcement structure symbolised by the awesome monumentality of temples and palaces.

In contrast to the architectural ingenuity, artistic grace and human variety of Egyptian temples, their Mesopotamian equivalents were ugly and monotonous, aiming at terror rather than beauty. They took the characteristic form of what was to be called the ziggurat, from the Assyrian *ziqquratu*: huge platforms, of diminishing size, piled one on top of another. Archaeologists are not sure whether this peculiar form evolved from building new temples on the ruins of the old. Very likely it did. But in any case the form became canonical, and it suited the mechanics of Mesopotamian power, for it made possible celestial height: the endless flights of steps needed to gain the sacrificial summit underlined the manner in which the high king-priest levitated above the servile multitude. The giant ziggurat finds its first historian in the author of the Book of Genesis, who stresses both the vaunting arrogance of power, and the ultimate futility, of the Tower of Babel. He got it right too, for the most ambitious ziggurats were incomplete and had to be abandoned when the sovereign who ordered them, or his entire dynasty, was swept away.

All the same, they were a persistent form of architecture. The first were built by the Sumerians, from about 2500 BC at Ur, Eridu, Urik, Kish and Nippur. The Babylonians, coming to power, took over the form, as did the Neo-Babylonians, the Assyrians and the Neo-Assyrians, as well as the Elamites and the Kassites. The technique was to build a solid core of crude sun-dried bricks, covered by skins of fired bricks which were less pervious to the fierce weather. Woven reeds, matting and ropes were inserted at intervals to bind together these unstable masses, on the same principle as ferroconcrete. The area covered varied from less than 1,000 square yards to the nearly 11,000 square yards of the biggest, at Babylon, which had eight stages, the average being three. The Babylon ziggurat was over 300 feet high, and was presumably the model for Babel. Herodotus describes it as 'a solid tower of one furlong's length and breadth; a second tower rises from this, and from it yet another, till at last there are eight. The way up to them mounts spirally outside all the towers: about half way in the ascent is a halting place, with seats for repose. . . . In the last tower there is a great shrine. . . .' But it was subject to a building collapse, or *katastrophe*, probably because it was overambitious.

The largest surviving ziggurat structure, at Aqar Quf, is only half the size. Ziggurats continued to be built until at least the sixth century BC, giving the form a life span of over 2,000 years. Indeed, near Abu Salabikh there is even an Islamic example, from the tenth century AD. But, compared to the great pyramids of Giza, their survival rate was low. Most are mere heaps of disintegration. The Susa ziggurat was decorated with blue glazed bricks and huge copper horns for its altars, but little is left of such features. Built as 'stairways-to-sacred-heaven', as the ziggurat at Larsa was called, they took their builders nowhere except to oblivion. It is hard to think

of any monumental form of architecture, involving such prodigies of construction and multitudes of labour over so long a period, which has left so little mark on later cultures.

It is a different matter with the royal palaces, the other principal form which Mesopotamian culture took. The peoples of this area were the first builders in history—part of a circular wall survives at Zagros from before 8000 BC. From about 4000 BC we get walled cities with towers, made of mud, to be sure, not of stone or even baked brick, but formidable and large. At Ur there is evidence of large buildings in addition to the massive ziggurat of 2112–2095 BC. At Wilayah, Kish and Eridu as well as Ur there were palaces, used for defence and as storage centres (an important point) but also including ceremonial suites of rooms, for processions. The palace at Kish (2500 BC) even had a pillared portico.

The first monumental palaces we know of were built at Ur around 2100 BC, evidently by professional architects and craftsmen working to a formal design. From about 1800–1500 BC, especially at Tell El-Rimah, enough survives to show that the builders knew how to construct a vault, with corbelled springs and radial voussoirs, using wooden centring and other sophisticated devices. They also knew how to avoid all the business of centring by employing the so-called pitched brick technique, each line or ring of bricks sloping backwards to rest on its predecessor. By such means, quite large spaces could be covered (and of course an upper storey added), and elaborate throne rooms built.

These societies, whose ruler and structure were alike precarious, sought at all costs to impress—their subjects and other rulers—and they did this chiefly by ceremonial approaches and processions. The road to the city, the entrance to it through a monumental gate, the outdoor route to the palace, and the procedure within the building until the throne room was reached—all these aspects were carefully planned. They determined the architecture and, increasingly, its decorative features. Thus, to keep the king invisible until his actual throne room and its splendour were reached, the internal axis of the palace was bent, so the visitor got an awe-inspiring shock when he turned the corner. This feature emerged at the palace of King Zimri-Lim at Mari (about 1750 BC). It was destroyed by Hammurabi and another palace put on top of it, so that its walls survived underneath, and were excavated in the twentieth century. By contrast, Hammurabi's own, much grander palace, if it still exists, cannot be got at because of the layers of debris on top.

Other palaces had what are known as 'broad room plans' or 'long room plans', which speak for themselves, the object in every case being to maximise splendour and induce fear. The decorative content, so far as we can see, was disappointing, and was largely confined to temples (as opposed to ziggurats) which had a variety of mud-brick columns in the form of palm trunks and the like, and glazed tiles. There were big courtyards, and the rooms inside the palaces grew bigger as time passed and

empires became larger. But the internal rooms only had beaten-mud floors and any note of luxury was provided by carpets and matting. Everything was sacrificed to size.

Of all these increasingly vast and varied building programmes, stretching over thousands of years, tragically little remains. We can grasp the ground plan in many cases, and occasionally discover the building technology, but visualising what the palaces actually looked like, and estimating their artistic merit, is virtually impossible. Take, for instance, Babylon. The great, sardonic archaeologist, Sir Mortimer Wheeler, was fond of quoting, on this subject, the prophesy of Isaiah about the city:

> Wild beasts of the desert shall be there, and their houses shall be full of doleful creatures, and owls shall dwell there, and satyrs shall dance there. . . . I will also make it a possession for the bittern, and pools of water, and I will sweep it with the besom of destruction, saith the Lord of Hosts.

Actually the site, which used to be known simply as Babylon Halt on the little railway out of Baghdad, is considerably less romantic, and much dustier, than Isaiah's poetical description. When you get there, you find the older historical levels have disappeared almost without a trace. The Tower of Babel is a mere hollow in the ground. Some traces of Nebuchadrezzar's New Babylon, from the early sixth century BC, remain. The sites of his main palace, processional way, Gate of Ishtar, the Hanging Gardens, the South Palace, the Summer Palace and the Temple of Marduk have been identified. But the visitor has to use his imagination. Anything remotely artistic has been vacuumed up by the West. The famous animal reliefs from the Ishtar Gate are now in the Berlin State Museum. Other interesting bits and pieces are in the British Museum and the Louvre. That these palaces were splendidly decorated is clear from literary sources. But how? Compared with dynastic Egypt, what has survived is pitiful. The local museum has to make do with models.

Moreover, the art we still have from ancient Babylon and other cities is of mixed quality. It all has the same object: to impress with kingly power and inspire fear. Like the Egyptians, the various Mesopotamian peoples created ruler-figures with an amalgam of human and animal features. But whereas the Egyptians brought grace and style to this process, the Sumerians, Assyrians and Babylonians concentrated almost exclusively on muscles and rending-capacity. Lion kings and bull kings, winged gods and royal-divine birds of prey: these are the most frequent motifs, to be found on pottery, in stone for city gates and ceremonial arches—often of huge size—and most of all in low-reliefs. Where the art-work tells a story, the tale is almost invariably one of victory and conquest, of subject peoples being brought to capital cities in chains, of terrified foreigners coming to make obeisance and offer presents, and in general of kings lording it over multitudes and nations.

In the British Museum there is a characteristic set of reliefs dating from the time of Ashurnasitpal II, about 865 BC, which once adorned the walls of his palace at Nimrud. These are in alabaster (low-relief carving on very hard stones scarcely exists outside Egypt) and show the king fighting and conquering. The quality of the figures and design is high, if repetitive, muscle power is predominant and force is the theme. The Egyptians did this kind of thing too, especially in the New Kingdom, but then they did a great many other things, and they somehow contrived, even in their war-and-triumph scenes, to suggest beauty and display grace. Mesopotamian art was, in a word, muscle-bound. It never broke free from its need to show, awe and impress. The British Museum's two colossal human-headed winged bulls, which once framed the gateway of Sargon II's citadel at Khorsabad, are overwhelming— each weighs 16 tons—but they do not please, let alone endear. Their object is to create fear.

Mesopotamian art also suffers from the repetitive ramming home of the royal line, which is the ubiquitous weakness of the culture. It is

Bull relief (sixth-century BC) shows Assyrian art in characteristic posture: direct, aggressive, masculine, muscular, unsubtle, power-obsessed, like their kings.

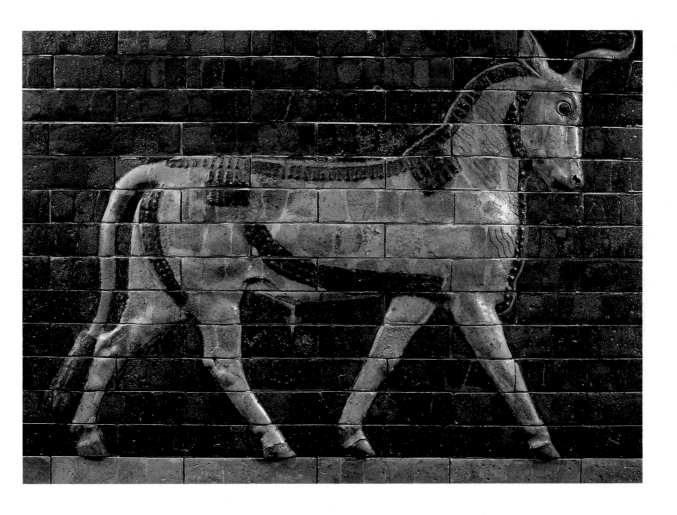

the characteristic of any art whose main purpose was political propaganda and, however skilled the craftsmanship, it fatally undermines our interest in it. Hence, except for specialists, whose agenda is different, it is hard to penetrate deeply into the art of this region without repletion. Whereas it is possible to spend a lifetime learning and loving the language of Egyptian art, you grasp the point or points of Mesopotamian aesthetics quickly, and pass on.

Excessive repetition is also the flaw of the culture created by the first Persian Empire, built on the ruins of the Neo-Babylonian state in the sixth century. There are important differences, however. The Persians were, or became, one of the great art-producing peoples of the world, creating and modifying, preserving or renewing their culture over two and a half millennia, right up to the present day, and enjoying in the process several distinct epochs of astonishing achievements, each different and unique in itself. The Persians, and the Medes, whom they incorporated, were ancient peoples who had achieved nothing of note until, quite suddenly, the Achaemenian dynasty, led by its founder, Cyrus, first of the Great Kings, as they called themselves, established an enormous empire, and then fabricated for it an imperial system of art.

As we have seen, in deep antiquity, the vast, sprawling empires of the Babylonians and Assyrians, and their successors, rose and fell, usually the result of unpredictable events rather than deliberation. They were fragile concerns, and a single lost battle might produce disintegration, just as floods of the Euphrates might demolish one of their biggest ziggurats. The Persian Empire was different, the first to be woven together on tough strands of administration and transport. From the very start, it pursued a positive policy of virtually limitless expansion. In a little over fifty years, Cyrus and his successors put together an empire which ran from the Aegean to India, and from the southern shores of the Black Sea to the Nile. Its system was absolutist and, so far as could be contrived, centralised. Yet in some ways it was a liberal empire, as is testified by the Old Testament, in which Cyrus is portrayed as wise and generous in his treatment of the Jews. It seems to have been a characteristic of the Persians to respect the way in which other peoples lived and did things, and especially to note their strengths and, where possible, imitate them. Herodotus stated: 'There is no nation which so readily adopts foreign customs as the Persians.' The Greek historian dutifully records the hubris which, in due course, brought the Great Kings to disaster and the vast empire to its end, but he presents its founders as open-minded and tolerant. The Persians emerge from his account as the most agreeable of ancient peoples, just as he presents the Egyptians as the most religious.

It is as well we have the Old Testament and Herodotus to correct the impression left by silent stones. For the two greatest monuments of the Achaemenian kings, Bihistun and Persepolis, are about art as the expressions of merciless and unflinch-

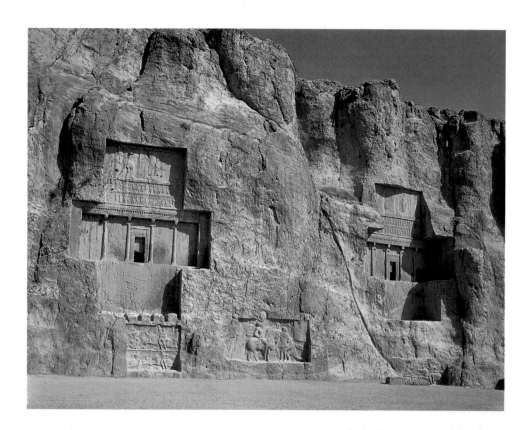

ing power. In no essential way did the Persians differ from the Sumerians, Assyrians and Babylonians in the political uses to which they put art. Their art, especially at its most grandiose, was designed to impress, terrify, warn and exult. Bihistun is one of the most remarkable artefacts of all antiquity. It is essentially a rock-carving on a vast scale, set hundreds of feet up the cliff face on the eastern edge of the Zagros mountains, overlooking the Great Khorasan highway or Old Silk Road, which formed the main route into Central Asia. This prime site formed in publicity terms the best billboard in the then known world. It was perfectly adapted for Darius's purpose, which was to show him to all who passed as an emperor of colossal power triumphing over his enemies. To underline the point that this is an international message to the world community, he caused the accompanying inscription to be written in Elamite, Persian and Babylonian—a gesture for which modern philologists are eternally grateful. This then is the Rosetta Stone of the Middle East, but it is also a vainglorious display of the title deeds of his empire. Its success as a political advertisement is attested by the fact that it became a public noticeboard for two millennia, on which many rulers stated their claim. It has inscriptions in Greek from 148 BC and 49 AD and many further additions, up to the eighteenth century. It is sublime and impressive, magnificent, even beautiful in its way. Who said that an advertisement cannot

The tombs of Persian kings (at Naqsh-i-Rustam, Iran) were carved deep and high in the rock and embellished with political propaganda.

be great art? Darius proved otherwise, 2,000 years before Pears Soap bought Sir John Millais's *Bubbles*.

The palaces, of which Persepolis is the largest and best preserved, were also built to impress, and they do impress. I first saw Persepolis in the early 1960s, before the last Shah of Iran decided to turn it into a tourist attraction and an advertisement for his own regime, an ill-fated one as it turned out. In those days it appeared to emerge suddenly, mirage-like, out of a featureless desert. The shock was considerable, for the scale of the ruin is colossal and some of the columns are over 70 feet high. With the possible exception of Baalbek, it is the most sublime of all the monuments of antiquity. It is also a trifle vulgar—the Persians, as imperialists, were *nouveaux riches*. They had no monumental building style of their own, little culture, no artistic system. They were short of artists and craftsmen. Darius, in the new palace he built at Susa, laid a foundation stone which records how these deficiencies were met. He says he recruited distinguished artists and craftsmen from Lydia, Egypt, Greece and many other countries, and that to satisfy his and their fastidious tastes he also imported materials of the highest quality from a similarly wide area.

Persepolis (*c.*500 BC), the grandest surviving palace-ruin of all antiquity, testifies to the power of the Persian kings and the repetitive monotony of their art.

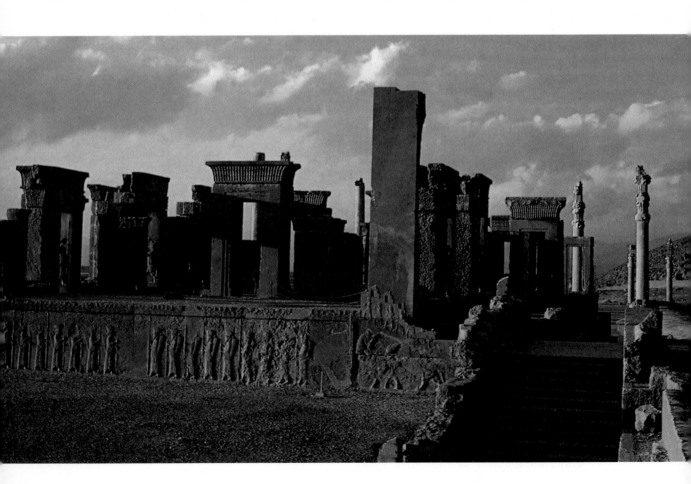

The foundation stone describes in great detail the materials which went into the palace. They included gold, teak, cedar, cornelian, lapis lazuli, turquoise, silver, ebony, specially made bricks, pre-carved pillars of hard stone and high-quality ivory. It lists as their provenance Egypt, Nubia, Babylon, Sind, Arachosia, Ionia, Chorasmia, Sardis, Carmania and Bactria. The craftsmen included men from as far away as India. In short, the agents of the Great Kings combed the entire known world for the best, bringing about an amalgam of East and West, North and South, in style, motifs and methods, on a scale which was entirely new and perhaps has never been equalled since.

However, there was a qualification to this cultural eclecticism. At Persepolis and other palaces, the sculptors and other skilled craftsmen, whatever their fame or provenance, were obliged to work under certain overall rules of art, laid down personally by the Great Kings. They were what the later twentieth century called 'control freaks'. The artists were allowed some latitude in introducing their foreign art forms and they certainly made the fullest use of their native technology. But beyond a certain point they came up against what might be called the iron laws of the new cultural code set down by the Medes and Persians.

The result is both good and bad. Persepolis takes your breath away. It impressed Lord Curzon, whose two-volume work on Persia is still the best general introduction to its culture. He acquired the special qualification, as Viceroy of India at the apogee of the Raj, of looking at mere mortals from the same social perspective as the Great Kings (like Darius, he invariably referred to the people as 'subjects'). He called Persepolis 'the most splendid platform in antiquity'. But it has similar salient weaknesses to Babylonian and Assyrian palace art. It is sublime without being beautiful, and grand without having grace. It is decorated by armies of figures which betray the contradiction at the heart of its conception—recruiting the best artists, then telling them how to do their work. Whereas the Egyptians, left to themselves, had a genius for following their own canons strictly while introducing infinite personal variations, whether in paintings, low-relief or sculpture, and whereas the Greeks, by the sixth century BC, were already revolutionising the nature of canonical art by allowing freedom of movement and individuality of expression to leading sculptors, the conscript craftsmen of Persepolis, closely supervised by their overseers and the Great King himself, responded in the only way which was safe: they created archetypes, then endlessly repeated them. Lord Curzon described the results thus:

No one can wander over the Persepolis platform, from storied gateway to stairway, from sculptured doorway to graven pier, no one can contemplate the 1,200 human figures that still move in solemn reduplication upon the stone, without being struck by a sense of monotony and fatigue. It is all the same, and the same again, and yet again.

Needless to say, all this work was originally painted, as were the vast majority of carved figures and many stone surfaces in antiquity. But there is no reason to suppose that colour would have relieved the monotony. On the contrary, since the chromatics followed a strict royal canon too, the effect would have been reinforced.

There was a further weakness. One reason the Egyptians avoided repetition was the ubiquity of their large number of gods, who entered and enlivened the artistic scene at every point, and were always helping to tell an individual story within a canonical context. The Achaemenian Empire was certainly not a secular state—no such society could have existed in antiquity—and all its inscriptions began with an invocation of Ahura Mazda, the bird god who hovers over cult altars and stretches its wing protectively over images of the Great Kings. But the art and sense of hierarchy at Persepolis concentrate so overwhelmingly on the Empire and its autocrat, the palace is so purposely designed, with every stone and gesture, to enhance the majestic power of its earthly ruler, that the building constitutes a secular statement. There are no metaphysics. The numinous is banished. It is the *Roi Soleil* in an earlier incarnation, enthroned in a desert Versailles. And is not Versailles too, with its eighty identical bays on its main front, monotonous in its repetitions, making its point by size, extent and gilt? The point is powerful in a political sense at both Persepolis and Versailles, but it is not an artistic one.

Concentration on the absolute monarch and the total exclusion of 'subjects', except as sterile motifs or extras in decorative friezes, helps to explain the depersonification of Persian art, which lowers its artistic appeal, not fatally but sharply. And, as we shall see time and again in the course of this book, a serious artistic weakness is often the external, visible sign of political, economic and social weaknesses. The perennial tendency to centralise everything in the person of the king, all-powerful in theory but only too fragile in fact, has been the deadly sickness of Persian regimes throughout history, ending with the last Shah but beginning with the Achaemenian Empire; seemingly indestructible but, in reality, shattered by Alexander the Great in a few terrible blows. With it went the imperial art system, for ever.

That the Great Kings employed Greek artists, as well as Egyptians, to create their palaces and to form the first example of an International style, is suggestive. In the sixth century BC, the Greeks were on the verge of carrying through the most important revolution in the history of art, and of creating an art system which, while less extensive and all-pervasive than the Egyptian style, was to produce, at its best, works of far higher quality and enduring appeal. But to reach this point, the Greeks had to undergo an accompanying social, political and economic revolution, which was equally influential in world history and which was intermeshed with their cultural development.

The process effectively began around 2200–2000 BC, when migrants from the steppes of Central Asia invaded and conquered huge stretches of territory, now modern Turkey, Iran, Syria, the southern Balkans and Greece. Once established, they adapted to the regions where they settled and, having destroyed virtually all existing civilised structures, set up their own. Thus arose the Hittites and Hurrians and Mitanni, the Medes and the Persians and not least the Greeks. Scholars knew little of Greek history until, in 1876, the German archaeologist Heinrich Schliemann opened up the shaft graves of the ruling class in what had been the city of Mycenae in about 1550 BC. He correctly identified this culture, hitherto mythical, as the material from which Homer fashioned his epics, the *Iliad* and the *Odyssey*. This did not mean that all in Homer was factual, but it was clearly based on an actual civilisation, and a rich one, 'an entirely new and undreamed-of world', as Schliemann put it. In the Athens Archaeological Museum today we can see what he found. The number, weight and quality of gold objects alone is stunning—in glittering value of bullion, the find was only later equalled when Tutankhamen's tomb (about 1350 BC) was opened by Howard Carter in 1922. In one tomb, occupied by the remains of three princesses, Schliemann found 710 golden plates, decorated with flowers and animals, butterflies and fish. Elsewhere he unearthed gold belts, sceptres, boxes, chalices, rings, bracelets, necklaces and tiaras. There were also ornamental daggers, inlaid with enamelled damascene and, most spectacular of all, the gold death-masks once placed on the faces of the royal bodies. When Schliemann dusted down one of these masks, a foot high, of a moustachioed and bearded ruler, he exclaimed: 'I have seen the face of Agamemnon!'

Mycenae, it turned out, was merely one of a number of cities—others were at Pylos, Athens, Tyrins, the island of Gla in Boeotia and Iolkos in Thessaly—each of which controlled a small independent kingdom-state. It was the military coalition of these states which formed the Greek army, of which Agamemnon was commander-in-chief, described in the *Iliad*. They spoke a language whose written script, found on tombs and on artefacts, was called by scholars Linear B. It was finally deciphered in the 1950s by the British cryptographer of genius Michael Ventris and found to be an early form of Greek. Thus the first flowering of Greek civilisation was literate and skilled in working precious metals. It also produced handsome pottery, likewise found in the tombs, and monumental architecture. At Mycenae, buildings show some degree of sophistication, though of elementary quality compared with what was being produced in Egypt, on a far greater scale, at the same time.

However, in 1899, it emerged that this newly discovered civilisation, henceforth known as Mycenaean, was culturally an appendage to another, alien culture, which had emerged in Crete several centuries earlier. Our knowledge of it began when the English archaeologist Sir Arthur Evans excavated what he called 'the Palace of Minos' at Knossos, near modern Heraklion. Whether Minos was an actual ruler, or a

god, or a mythical animal, usually referred to as a bull or minotaur, is unclear. But this Cretan civilisation of the early and middle second millennium is known as Minoan. Evans not only excavated Knossos but largely rebuilt and even repainted it. Whether his actions were wise or not, he certainly made it one of the most intellectually accessible of all the sites of antiquity. It actually looks like a palace, and it requires little effort of the imagination to see kings and courtiers walking about, or even engaging in unspeakable ceremonies—sacrificing maidens to the bull—in the basement. Its total size, by Babylonian or Assyrian standards, is modest. But its decoration survives. There are wall-paintings in Knossos which show competitive youths engaging in a form of bullfighting by leaping over the creatures' horns, and others showing maidens in distress and being rescued.

After Evans's find, other palaces emerged at Mallia, Phaistos, Ayia Triadha, Tylissos, Amnisos and elsewhere, each of which was the centre of a sizeable town. Homer says that Crete had 'ninety towns' and 'countless men'. Evans calculated that Knossos had about 80,000 inhabitants, and if its harbour (modern Heraklion) was added, the total came to 100,000. As always in antiquity, luxury and squalor coexisted, not only in the cities, where the four-storey dwellings of the rich rubbed walls with hovels, but within the palaces themselves. Knossos, for instance, had over 1,300 rooms on five storeys—or so Evans believed—but most of them were tiny, and probably led to the legend of the Cretan labyrinth. But equally, the wall-paintings and objects found tell of widespread trading (the Cretans had a strong navy and merchant fleet) and elaborate workshops. Minoans ate from elegant pottery, ornamented with motifs which survive to this day. They drank out of cups and goblets which were sometimes as thin as one millimetre, evidence of fine workmanship and technology. Small female figures were unearthed at a shrine, Petsofa, which shows vainglorious women wearing low necklines, huge horned headdresses and high-fashion hats, skirts of every design and length, and fancy jewellery. At Kamares, a fine hoard of pottery was unearthed, of excellent workmanship and design, decorated with plants and spirals, which can stand comparison with anything produced in the whole of antiquity.

Evans conjectured that Cretan society was originally tribal, and then was unified in a kingdom centred on Knossos. It spoke its own language, which appears in a script scholars call Linear A. This has not yet been deciphered, and perhaps never will be, but it is most unlikely to be Greek. Indeed, the Minoans were pre-Aryan, and their relative power held the Aryan invaders at bay. But the Aryans, or Greeks as they had become, eventually absorbed enough of Cretan or Minoan civilisations, including the use of naval power, to stage an invasion. Around 1400 BC all the major cities of Crete were destroyed, its civilisation collapsed, its cultural forms disappeared, unless absorbed in Mycenae, and when Crete re-emerged into the light of history again, it was Greek-speaking, and using a form of the Linear B script, not its own Linear A.

This painting from Santorini (sixteenth century BC) has no religious context and gives us a rare glimpse into the secular lives of Minoan teenagers.

For a time a Minoan–Mycenaean culture existed in both mainland Greece and conquered Crete. It was less elegant than Minoan art at its best, but more grandiose. As in Mesopotamia, it was essentially a palace civilisation, made possible by its concentration of economic resources in kingly hands. And it was equally designed to impress by size and fear. The palaces proper, and the fortresses which accompanied or surrounded them, were built of masonry on a gigantic scale, with carefully hewn blocks (not the megaliths of the extreme west of Europe), forming Cyclopean walls, as they are called. The Treasury of Atreus at Mycenae (it is actually a tomb) has a 15-foot doorway whose lintel is composed of two vast stone blocks, one of which weighs 120 tons. The chamber within is 15 feet high and nearly 60 feet in diameter. It is vaulted, with a brilliantly conceived and beautifully constructed stone roof which has kept aloft for nearly 4,000 years without any internal pillars to support it—the largest enclosed and unsupported space in all European antiquity until the Emperor Hadrian built the Pantheon in Rome. The Lion Gate at Mycenae, made of monolithic blocks, one of them weighing 20 tons, holds two facing lions, the first surviving example of monumental sculpture in Greece, harbinger of the marvels to come. The palace at Tiryns is even more advanced, technically and architecturally, and contains features which in time evolved into the *Pyrgos* (platform), the *Propylaia* (a monumental roofed gateway) and the *Enneapylon* (literally, nine-gated entrance

or fortified gate-tower) of classical Greece. Again, the scale is impressive. The forti-fied enclosing wall at Tiryns is built of stone blocks over 10 feet long. There is a stone circular hearth in the palace which is 11 feet in diameter, capable of roasting half a dozen whole oxen at a time, for the kingly feasts of which a lip-licking Homer wrote.

But it must again be emphasised that this was essentially a palace civilisation, like the ones in Mesopotamia, with a similar fragility and weakness, dependent for survival on autocrats capable of impulsive and foolish behaviour, no more secure than their last victory in battle. We are fortunate that so many of the art treasures, large and small, of Minoan and Mycenaean culture were buried for millennia and thus survive to adorn our museums. For Mycenaean Greece met the same fate as Minoan Crete. Quite suddenly, in the early twelfth century BC, the society and cul-ture went into a precipitous decline, then vanished completely. The so-called Warrior Vase, found at Mycenae and depicting badly painted soldiers, who look childish and ridiculous, reflects a culture in rapid degeneration. The cities were torched and became ruins. Men and women ceased to be literate. A Dark Age followed, and when Greece re-emerged from its shadows, it was a different world, with the first, firm, solid foundation of a fine art tradition which survives to this day.

The Lion Gate at Mycenae symbolises the strength, stability and artistic force of the Greek cities which combined to overthrow Troy.

4

GREEK ART:
IDEALISM VERSUS REALISM

About 1200 BC, Mycenaean Greece and its colony, Minoan Crete, alike vanished into the darkness of unrecorded history. A later age blamed this catastrophe on an invasion by aliens mysteriously referred to as the 'Sea Peoples', who also figure in Egyptian history as the destroyers of the Middle Kingdom. When Greece re-emerged into the light of history, around 700 BC, fundamental changes had taken place, which have a direct bearing on the art which humans have produced ever since.

First, the theatre of progress in the arts, and the political and economic arrangements which shaped them, had ceased to be the three great river valleys of the Nile, Euphrates and Tigris. It had shifted instead to the Eastern Mediterranean and its contingent waters, and was still shifting, rapidly, to embrace the Mediterranean as a whole. Despite the Dark Ages, there had been a critical improvement in the design of ships, and the confidence with which men sailed them. As a result the sea, far from separating societies, linked them.

Civilisation thus clustered on or near the sea, and its business was increasingly to foster commerce and colonisation. The empires of deep antiquity simply conquered and ruled, more or less brutally and so precariously. The new societies which ruled the sea, as opposed to the land, were based on maritime towns which lived by trade and reproduced themselves on distant shores, sending out settlers and with them their culture. This cloning process was immensely beneficial to the arts, in quantity and quality, for it meant that wherever settlers set up a colony, it was a matter of imperative policy to re-create the physical elements of the native culture—the temples and other public buildings, the workshops and studios which supplied the furnishings and utensils of the settlement—at the earliest possible moment. Large numbers of artists, architects, builders and engineers had to be trained and motivated. The fact that they worked over a large and expanding area, in varying climates and with a variety of materials, encouraged the formation of different schools and the emergence of individual artists.

This was one reason why canonical art control grew weaker. The other was that the palace was no longer the sole or even the main source of patronage. Kings and princes, tyrants and autocrats remained, and lived in palaces. But the basis of society had ceased to be monarchical. The key unit was not the empire or the realm but the commercial city, or *polis*. This was the reason why the Greeks flourished in the new era, and were able to make their particular forms of culture normative, indeed the standard of excellence, first in their native waters of the Aegean, then in the Mediterranean and finally throughout the known world of antiquity.

For the Greeks were individualistic. They showed, over and over again, that their ideal state was one in which all the resources of civilisation—commercial port, manufactories, government buildings, schools, theatres and opera houses, temples and sports stadia—were within easy walking distance. The venues where political decisions were taken, where sports trophies were won and where the performing arts took place were designed to accommodate all free persons, and even slaves too in many cases. City populations might be 20,000 or even less, or 100,000 or even more, but the idea of universality of access and participation was pushed forward with remarkable energy. This was the primitive pattern in Mycenaean Greece, where a number of self-governing city-states flourished alongside one another. They came together under Mycenaean leadership when necessary to advance common interests. The Greeks believed that during the Trojan War, which their historians dated to the thirteenth century BC (a date confirmed by evidence of Troy's destruction by fire at the archaeological level of VIIa, *c.*1250 BC), all their major cities contributed troops to a common army under the command of Agamemnon, King of Argos (Mycenae). This was enshrined in the national epic, or bible, of greece, the poems of Homer, which reached written form before 700 BC and became the standard by which Greeks judged their virtues and cultural characteristics.

Greek art, then, was not palace art. It was city-state art, like the art of the Italian Renaissance. The city-state on the Greek model, with universality of access to and participation in culture, is the ideal social environment for art. Of course, the cities must share a sufficiently common notion of the good life, or civilisation as it came to be called, to give them collectively sufficient economic and demographic mass. In antiquity, Greece, so long as it remained free, was never united. It was deeply divided by its mountainous geography, so that most travel between cities was by sea. It lacked a common coinage and calendar. Its cities had radically different and often changing systems of government: Aristotle summarises 157 distinct Greek city constitutions. Inter-city wars were almost the norm, and their destructiveness was reinforced by the formation of city leagues (another aspect in which Renaissance Italy resembled classical Greece).

On the other hand, Greek cities shared a common language, spoken and written, a common literature, dominated by Homer, a common religion and, perhaps most important of all, a common competitiveness, reflected in their commercial

success and in such institutions as the Olympic Games, which traditionally dated from 776 BC. This competitiveness also led the cities to compete culturally. Each, however small (there were about five hundred mother cities and colony cities at one time or another, a few of them tiny), had to build a specific place for all the civic, commercial, sporting, musical, educational and theatrical activities proper to the *polis*, in the absence of which the place was sub-Greek, even barbarous. And these buildings, and their decorative statues and paintings, had to conform to certain utilitarian norms. But within these norms there was ample room for fierce artistic competitiveness, and distinguished artists were free to move from one city to another in search of richer rewards and greater freedom.

The Greeks, however, were not necessarily the first to practise this new kind of culture and art. They had rivals and competitors in the Phoenicians, who likewise emerged from the Dark Age to create, early in the first millennium BC, the important commercial towns of Byblos, Tyre, Sidon and Arwad on the Eastern Mediterranean coast south of what is now Turkey. They set the pattern and prepared the way for Greece. They were the first to engage in large-scale and long-distance trade, based upon a substantial manufacturing sector, especially in textiles. They made high-quality cloth and cotton goods, and specialised in a famous purple dye, associated with luxury. They also produced and exported art goods made of ivory, metal and glass. They handled all currencies, and bullion money of the kind used in Egypt, and minted their own gold and silver coins of great purity and high value. To facilitate this trade, they invented the alphabet, a highly simplified and extremely economical digest of existing scripts, which the Greeks were quick to copy, and which became the norm all over the civilised world, and remains so.

The Phoenicians were the French of antiquity, in that they specialised in the luxury goods the rich of all peoples found irresistible. They exported toiletries and high-class furniture, fashionable clothes and wigs, scents and medicines, handsome objects to put on altars and in living rooms, and titillating erotic statues and devices to promote fertility. The Phoenicians were adept at producing goods wherever they could perceive a demand, and would sometimes mass-produce their luxury goods in cheap versions if they came across a viable popular market. As they exported to all the known world, they adopted the designs and forms of all the world, where suitable for their purpose. Thus a superb bowl in gold-plated silver, exported to Cyprus in the early seventh century BC and now in the Louvre, has a central design taken from Egypt and other elements copied from Assyrian and Babylonian models. Typical Phoenician luxury products were scent-bottles in the shape of a fertility goddess. An outstanding example, in alabaster, now in Madrid's Archaeological Museum (it was dug up in Alicante), is of a haughty female deity with a gigantic decorated ear-flap headdress, whose breasts have pierced nipples so that the unguent in her body could flow into a bowl held by her extended hands. This ingenious object was clearly designed for rich women who already had all the standard dressing-table

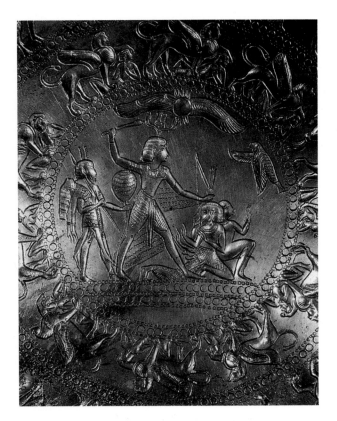

Silver-gilt bowl (seventh century BC), an outstanding example of the luxury goods the Phoenicians sold to the rich throughout the Mediterranean.

fittings. It is characteristic of Phoenician market-led design in its ingenuity, its salacity or perhaps one should say sophistication, and in its eclecticism.

These skills, amounting to passion, led the Phoenicians to pioneer the colonising process which became such an important part of Greek culture and its spread. The Greeks themselves had founded cities in western Anatolia at the very beginning of the first millennium BC, or possibly even earlier. But these were emergency cities of refuge for Greeks fleeing whatever horrors the Dark Age had inflicted on their homeland. By contrast, the first Phoenician colonies were founded to promote trade and they were highly successful business propositions. Eventually a score of these colonies emerged, most of which produced their own offspring. The earliest date from the ninth century BC, and the most important and vigorous of them, Carthage, has been calculated with reasonable certainty to 814–13 BC. To boost its trade, it founded daughter colonies in Ibiza in the Balearics, and in Sicily and Sardinia. The Phoenicians colonised Malta. They created in Libya what became the enormous city of Leptis Magna. They set up four important colonies in southern Spain, and placed cities on either side of the Straits of Gibraltar, on the Atlantic Ocean. As the original Phoenician cities came under increasing pressure from the imperial East, and eventually succumbed to the new Persian Empire of Cyrus and Darius, their commercial power shifted further and further west, so that Carthage became the successor-state and, in addition to its commerce and industry—and fleet— acquired a magisterial army, something the original Phoenicians never possessed.

What Carthage did not acquire, however, was an artistic style of its own, despite all its military power. It remained eclectic, plagiaristic and undynamic. Punic craftsmen were clever at using ivory, until all the elephants of Syria were exterminated in the seventh century BC, and they specialised in masks, which suggests that they picked up ideas from Saharan and sub-Saharan Africa, as well as Egypt. The Phoenicians had manufactured masks for all kinds of erotic, histrionic and magical purposes, but Carthaginian masks suggest darker thoughts. The Carthaginians also made use of ostrich eggs from Africa to make dishes and cups, which were painted

with abstract designs and were sold as luxuries, being too fragile for common use. In short, the legacy of Phoenician-Punic art is meagre and its appeal weak. Some of its cultural ploys or gimmicks survived in the Western Mediterranean area, but the culture as a whole, if we can call it that, vanished at the first whiff of military defeat. As Lord Curzon said of Achaemenian palace art, it had no organic strength. But it is no mean thing to have given the world its alphabet.

The contrast with the durability and life-renewing energy of Greek art is therefore striking and leads one to ask: wherein lay the vivacity of the Greek *oikumene*, the civilised universe of Greek culture? Whole books, indeed entire libraries, have been written on this topic, and I cannot compete with them. Here I want to concentrate on three important characteristics of Greek art which were novel and interrelated, and which I call the tripod of the Greek aesthetic: flexible form, artistic responsibility and ocular realism. By flexible form I mean the extraordinary gift the Greeks possessed of establishing a normative image for any work of art they wished to produce, so that it becomes unmistakable, but also creating within its outline a creative space in which individual artists could express their understanding of the form, by personal genius.

The way the Greeks created flexible form is best seen by studying the evolution of the temple, their chief type of religious building. The temple evolved from an unroofed outdoor altar, facing east, to an altar within a large house, to a special-purpose building using large numbers of wooden columns, to (in the seventh century BC) an all-stone structure. This mature temple had a heavy roof and triangular cornice, which was supported internally by columns, but with an additional range of external columns, known as a peristyle, placed outside to give further support. Greek mastery of stone sculpture, evolving at the same time, made possible the adornment of the outside of the temple on a monumental scale, and the peristyle handled this extra weight with ease. It was thus an engineering device. But it gave to the Greek temple its significant form, which proved so popular, being both elegant and majestic, that the Greek world used it for as long as it built temples, the Romans adopted it for half a millennium, and it has been employed all over the world with few interruptions, ever since, housing everything from banks to bureaucrats to certified lunatics. It is by far the most successful and durable architectural form ever conceived.

Now it is curious that the Egyptians, involved in stone architecture 2,000 years before the Greeks, who were much more efficient stonemasons, and who could place immense blocks of stone in free layers so accurately that it is impossible to slip even the thinnest coin into the jointures, were unable to sell their architectural forms to the world. They created the pillar and pilaster, and the Greek column is an Egyptian export. But these were functional devices. Their own temple forms, though delectable to themselves, were far too ponderous, expensive and cluttering to be attractive to foreigners. The only exportable form the Egyptians created was the pylon, and

this, apart from being a large-scale noticeboard for vainglorious statements, was functionally useless, being solid, except as a processional gateway.

The Greek temple form proved popular partly because it was democratic in origin. Herodotus insists, in the case of Samos for instance, that its public works, especially its temple, were built by the community, not the local tyrant. That was generally true all over the *oikumene*. Thus the temple form evolved through a process of trial and error, corrected by public discussion and voting, until it reached what all or most agreed was normative perfection. Then it could be built bigger or smaller, in cheap or expensive stone, according to means. However, because it was the result of public taste in a polycentric culture, it contained flexible decorative areas where architects and artists could exercise their creative powers. Though the evolved temple had a distinctive canonical form, it had a dozen main areas, and many minor ones, where designers, sculptors and painters could go to work. We all know how first Doric, then Ionic, then Corinthian capitals evolved. But fluting and *mutule,* echinus and corona offered chances to vary the appeal and inspire genius. Even the *akroterion*, the carved beast on each corner, invited invention. And the colouring, without and within, reflected the choice of the artists and the hues of the local ochres, umbers and chalks.

It is important to grasp that Greek art did not reach canonical form in mainland Greece and then get exported to the colonies. Art development and colonisation proceeded simultaneously, one reason why Greek art was so adaptive, vigorous and successful. The colonies in western Anatolia, some of the most important, were established long before the Dark Age ended. Greek colonisation in Sicily, southern Italy and Cyrenaica proceeded energetically in the eighth, seventh and sixth centuries BC. Thanks to aggressive commercialism, the Western Greeks, as we call them, had the means to compete successfully with the homeland, in numbers and often in size and quality. For instance, the group of vast Doric temples at Paestum south of Naples are unique in monumentality and sublime impact, despite their early date of 600–480 BC. They radiate power. Lost power, to be sure, but power which was once awesome. There is nothing like Paestum in mainland Greece except on the Athens acropolis, and even the Parthenon itself seems etiolated by comparison.

It comes as a surprise to modern visitors that there are more temples in a reasonable state of preservation outside Greece than within it. Agrigento in Sicily comes close to Paestum, in the richness and magnificence of its surviving buildings (though, being now a mafia town, it can be unpleasant for unaccompanied visitors). Here, and also at Paestum and Metapontum in the instep of Italy, there survive portions of an open-air building known as an *ekkesiasterion*. The one at Metapontion could seat in circular form up to 8,000 people and is by far the oldest monument of its kind in the entire Greek world. It was essentially a debating chamber in which not only all the citizens, but people from the surrounding area (who might not hold full citizenship but who had certain participatory rights) would attend and speak. In the

centre was a rectangular area, or *orchestra*, where the orators debated. The Greeks were skilled at creating open-air auditoria with superb acoustics—the perfectly preserved theatre at Epidaurus still has the best acoustics of any place of entertainment in the world—and someone sitting in the top tier at the back could hear what was said in the orchestra. These debating areas were also used for sports and dances but their main purpose was to allow all citizens to express views and let off steam about public projects, especially building programmes, for which they had to pay.

The fact that these purpose-built platforms for free speech functioned alongside tyrannies and autocracies gives us pause for thought about the nature of power in ancient Greece. The truth is, there were too many clever, educated, pushy and opinionated people in any Greek city for a tyrant to get his unrestrained way with spending programmes which involved artistic judgement and employed vast numbers of people. The age of the Giza pyramids, where incarnated god-kings could employ conscript multitudes within the framework of a rigid set of religious beliefs which none dared challenge, had gone for ever—or at least until the Hitler–Stalin–Mao regimes of the twentieth century. In Greece and its colonies, rulers or ruling groups in populous cities had to make themselves liked, especially in their artistic ventures.

This, for instance, was the policy of Dionysius I (430–376 BC), Tyrant of Syracuse, probably the richest city in the Mediterranean about this time. Syracuse had, since its foundation (734 BC according to Thucydides), used its wealth to promote architectural

Epidaurus theatre seated 2,000 people, each of whom could hear perfectly what was said on stage: acoustics were a Greek architectural strength.

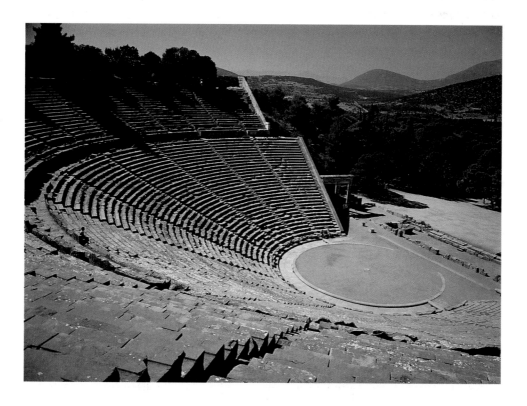

innovation. Its temples of Apollo (565 BC) and Zeus (550 BC) are among the earliest temples made entirely of stone and in the peripteral mode, and though ruinous still look impressive. Syracuse also put up the only peripteral Ionic temple in Sicily. It had a go-ahead city plan, well adhered to at the time and clearly demonstrated today in the city's Paolo Orso Archaeological Museum. Dionysius I enclosed not only the city, but the neighbouring countryside in a gigantic new wall, a thing of great and sublime beauty, as well as (it was hoped) being impenetrable to the catapult, most important of the new siege-engines coming into use. Anyone who marvels at Greek temples should study Syracuse to appreciate the organisational abilities and infrastructure which made them possible.

The wall of Dionysius I was the largest but not the first monumental defensive system created in Sicily. As early as 540 BC, the colony of Selinus (now Selinunte) embarked on a defensive monumentalisation of its Acropolis which involved the transporation of millions of tons of sand. The sand mound was stabilised by the creation of a retaining wall around it, 35 feet high and heavily stepped, so that the base is 60 feet broad. The way in which this immense construct is contoured and designed to fit into the natural features of the place makes it one of the most brilliant and original designs in antiquity. Within this defensive complex are five temples, one of which has all its columns still standing. An eighteenth-century traveller described it as 'the most extraordinary assemblage of ruins in Europe'.

Of all the temple sites of ancient Greece, however, the most moving is Segesta, inland in the west of Sicily. Its vast (though unfinished) Doric temple, standing on a hill outside the city, with a background of rolling heights and forests, has a strong claim to be considered the most perfectly situated and designed building in the whole of antiquity. Apart from the vanished roof, it is virtually intact, though the columns are unfluted. The stone has weathered well and is of a most delicate colour or series of colours. Seen from close to or afar in its hilly amphitheatre, the temple shows, as no other example can, exactly why this architectural form has been so successful and permanent. In Segesta we glimpse the reality of Greek genius. And the people who designed and built this masterpiece were not even Greeks! They were the Elymi, a people native to Sicily—said to have been refugees from the fall of Troy c.1200 BC— who loved Greek forms and adapted them with relish and reverence. The point is worth making for it illustrates what was to be the global ubiquity of Greek architecture.

Yet although Magna Graecia contains all the best temple buildings still standing, it is also true that certain sites in Greece itself evoke the majesty and mystery of Greek civilisation with unsurpassed force. The Greeks were particularly skilful at blending art with nature, and choosing dramatic, soulful, apt or serene sites for their finest buildings. Thus Sunium, or Sounion, a forceful promontory overlooking the sea, at the south apex of Attica, was the perfect place for the Athenians to build a temple to Poseidon, god of the sea, around 440 BC. The white marble glitters in the

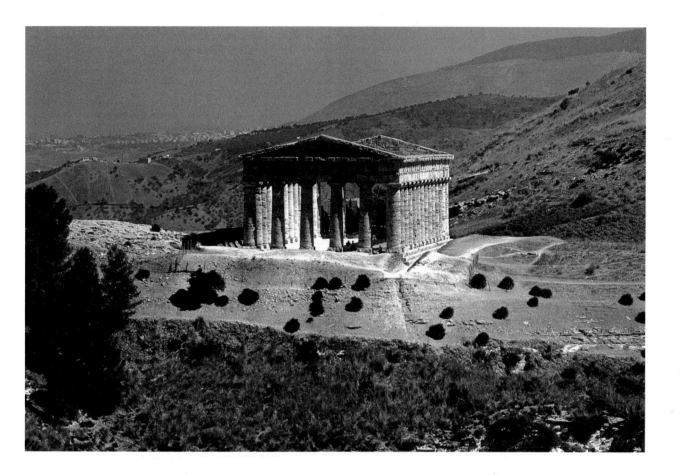

sun, the sea is dark wine-coloured, as both Homer and Byron agreed, and the latter, sitting there, wrote some of his finest lines on Greek freedom (and carved his name on the marble). Again, Olympia, the main sanctuary in Greece of Zeus, king of the gods, is in a beautiful hollow between low hills on either side of the River Alpheus, and was the ideal site for the great stadium in which the Games were held. It generates an intangible but powerful atmosphere of peace and relaxation, and to wander around the tumbled columns and grassy mounds of marble is to experience 'the pleasure of ruins', an art form in itself, to an exceptional degree. The great temple of Zeus is now a ruin; its sculptured metopes were taken by the French (1829) and are in the Louvre. But the feeling of majesty is there, and though Pheidias's colossal painted statue of Zeus has vanished, the workshop in which he created the vast gold-and-ivory figure has been excavated, so that it is possible to see his foundry for casting glass, the moulds used for hammering out Zeus's golden drapery and even the vessel from which he drank, which has 'Pheidias's Mug' inscribed on it.

A more dramatic site is Delphi, where the Oracle functioned. It is high up on the lower slopes of Mount Parnassus, 2,000 feet above the Gulf of Corinth. The pilgrims walked up a Sacred Way to the walled sanctuary and the Temple of Apollo beside it, and at almost every step the many cities of the *oikumene* built commemorative

The temple at Segesta in Sicily, in its perfect setting, illustrates the paradox that the finest Greek architecture is found outside Greece.

buildings, offertories and 'Treasuries', each striving to surpass the others in generosity, technical skills and aesthetic bravado, a striking instance of Greek artistic competitiveness at work. At its cultural climax in the fifth century, Delphi was a kind of museum of Greek art, with work by all the leading masters. But it naturally attracted predators—Persians in 480 BC, Gauls in 279 BC and, not least, the Emperor Nero, who stole over five hundred statues to adorn his palace. All this loot later disappeared without a trace. There was an earthquake too in 373 AD. But the romantic desolation and savagery of the site compensates for the looting, and enough remains in any case to make Delphi a place of sublime beauty and salutary terror.

Finally, we must include the Athenian Acropolis, and its Parthenon, centrepiece of what was the most elaborate building scheme in Greek history. It was carried out by Pericles at the height of his power in the second half of the fifth century BC, in conjunction with his supporter and friend, the great artist Pheidias. The building material, a particularly fine and radiant white marble, was brought at great expense from quarries in Mount Pentelicus, northeast of Athens, and the temple itself, dedicated to Athena Parthenos ('maiden'), was on the largest possible scale. It is generally cited as the perfect expression of the Doric temple form, but it includes—characteristically—significant variations from the norm. Thus, it has eight columns at each end instead of the normative six, and seventeen on the sides instead of thirteen. This gives it a measurement of 101 by 228 feet, a size enabling it to dominate not only the Acropolis itself but the entire Athens skyline, even today, and to redeem this ugly and polluted modern city by its mesmerising silhouette. Nothing remains of Pheidias's giant statue of Athena, but early in the nineteenth century, thanks to the generosity of Lord Elgin, who bought them from the occupying Turks, some of the finest sculptures were saved from destruction and placed in the British Museum, where artists and scholars have been able to study them ever since. Had they been left *in situ*, the probability, amounting almost to certainty, is that they would have been broken up and sold as separate fragments, as had already happened to many sections of the Parthenon's decorations.

What Elgin brought to safety includes, first, 247 feet of the frieze from the interior of the colonnade, which shows the grand procession to celebrate Athena's birthday, the climax of which is the presentation to her of a superbly embroidered dress; second, the metopes or panels of the exterior, depicting the mythic fight between the drunken Centaurs and the Lapiths; and finally, the sculptured figures from the pediments on the east and west gables. Since we know from literary sources that Pheidias directed the whole decorative enterprise—and prepared the designs and cartoons, possibly *modelli* too—it would be agreeable to conclude that some or all of the finest sculptures in this grand haul are his. But nothing is signed and there is no direct evidence that he is responsible for any of it. The project was beset by political and cultural disputes, for in order to finance it, Pericles raided the funds provided by Athens's allies to build a new fleet to fight the Persians. The allies naturally objected,

as did many frightened Athenians, who put defence before art, and there were other prominent voices raised against the style of the work, regarded as too elaborate and even frivolous. These disputes culminated in Pericles's fall from power. Pheidias fell with him and had to flee into exile to save his life: the Greeks took art sufficiently seriously to kill for it, a thought always worth bearing in mind when we look at the marvels such deadly passion produced.

The Elgin Marbles, then, must be regarded as an anonymous or collective work, inspired by Pheidias and Pericles, who held the official title of Building Commissioner and dealt directly with the artists, many of whom were among his personal friends. As such, the creation of the Parthenon, and its associated structures, can fairly be ranked as the most ambitious and successful artistic enterprise in antiquity, testifying to Greek sculptural skill as a whole. The metopes are in deep-relief, thus casting shadows, and give an impression of extraordinary vivacity and ferocity. We see here the point at which low-relief carving reached perfection, for deeper incisions come too close to sculpture-in-the-round to look effective and, worse, make destruction easy, as has happened in almost every case in which deep-relief was used.

The frieze, in low-relief, is even more remarkable, for it shows the virtuosity which the Greeks had developed in a form of art not far removed from engraving. One of the metopes shows a four-horse chariot travelling at speed. John Ruskin, on studying this, pointed out that the four horses, one behind the other, do not project

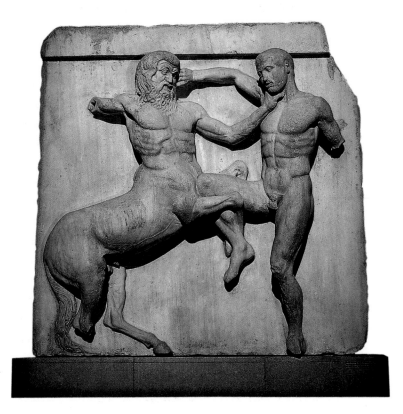

Parthenon frieze figures of Centaur and Lapith raise the question: should such masterworks be restored to hazardous Greece or kept safe in Western museums?

from the ground more than three-quarters of an inch, and that the lead horse does not in fact project more than the one behind it:

> Yet by mere drawing you see the sculptor has got them to appear to recede in due order, and by the soft rounding of the flesh surfaces and modulation of the veins he has taken away all look of flatness from the necks. He has drawn the eyes and nostrils with dark incisions, careful as the finest touches of a painter's pencil; and then, at last, when it comes to the manes, he has let fly hand and chisel with their full force.

The pedimental sculptures are virtually free-standing, so we have all three forms of sculpture displayed at their best in these marbles. The rendering of drapery of the female figure reclining at the extreme right of the east pediment has never been excelled for sheer virtuosity, even by Bernini at his most flamboyant. At the extreme left there is the powerful, if heavily damaged, figure of a reclining nude male which combines muscular grace and elegant dignity to make even Michelangelo (who never saw it, of course) envious. Torn from their architectural context they may be, battered and decimated by time and chance, but these marbles still constitute an encyclopaedia of sculpture in its highest forms. Plutarch, writing nearly half a millennium later, in his *Life of Pericles*, marvelled at the speed at which this many-faceted collective masterpiece was put together, and summed up for all of us the way in which great art transcends the ages: 'They were created in a short time for all time. Each, immediately it was done, assumed the dignified air of antiquity, and now that they are old, they seem fresh, as though done only yesterday. They have about them the bloom of eternal youth, so that time cannot age them, they are replete with life that fades not, and a spirit which never grows old.'

How had the Greeks of the fifth century BC reached this sculptural apogee? This brings us to the second of the fundamentals of their art: the responsibility of the individual artist. The Greeks had always carved in stone, ivory or other substances, or moulded figures in pottery. There are small carved statues from the Cyclades, the islands which circle round the sacred isle of Delos, going back perhaps as far as 2500 BC. They include a harp-player and a flute-player, a vase in the shape of a bear, and a smooth idol-head with a prominent nose which reminds one of Brancusi. (The first three are in the Athens Archaeological Museum, the last in the Louvre.) Half a millennium later, Cretan faience-makers were producing striking statuettes of goddesses holding snakes (Heraklion Museum). The gold masks from the Mycenae tombs (Athens), though governed by canons determining the presentation of eyes, lips and noses, are also highly suggestive of originality and individualism in the artist. There is an embossed cup, from about 1500 BC, featuring ploughing and hunting, which shows the ability to create in three dimensions figures and animals against a landscape—quite a sophisticated work (Athens).

Then came the pre-medieval Dark Ages. When they receded, we find a process of continuous development in sculpture from the eighth century BC onwards. The origins of Greek sculptural art are plainly Egyptian. A finely carved limestone maiden, about 30 inches high, known as *La Dame d'Auxerre*, and now in the Louvre, has the stylised tresses, almost dreadlocks, full-frontal aspective presentation and forceful passivity which suggests that the sculptor had seen Egyptian sculpture though had not been in Egypt. On the other hand, an ivory carving called *The Daughters of King Proteus* (New York, Metropolitan) shows certain characteristics, including nudity, which ignore the Egyptian canon almost entirely and suggest an artist anxious to break free of all such restraints. By the early sixth century BC, Doric temples in the Sicilian colonies displayed deep-relief metopes of astonishing vivacity such as *Perseus Slitting the Throat of Medusa* (Palermo Museum)—Perseus's muscular self-confidence suggests the shape of things to come.

By this date, the Greeks had evolved a sculptural art form which, while plainly derived from Egyptian canonical tradition, constituted an important event in art history: the *kouros*, or upstanding naked boy-figure (there are clothed female figures, *kore*, but much rarer). Most of these *kouroi* have the Egyptian forward stride with the left foot, the military hands-at-attention-to-the-side rule, canonical hair and full-frontal face, with what is called the Archaic Smile. Some, such as the *Strangford Apollo* (so-called) in the British Museum, are of great beauty and exhibit immense sophistication in carving. A pair, *Cleobis and Biton*, from the Apollo Sanctuary in Delphi, now in the museum there, are actually signed by the sculptor, Polymedes. One *kouros*, from Melos, now in the Athens Museum, is plainly of a slender youth; another, from Volomandra, which can be seen alongside it, is of a mature, powerfully developed and thickset man. It is evident that some of these *kouroi*, if not all, were carved from actual models, something Egyptian sculptors would not have dreamed of doing. These archetypes were the work of headstrong individual artists who found a strict canon intolerable. Moreover, they come from the mid- or late sixth century BC, when Greece was on the verge of a sculptural revolution. It was hastened by the increasing freedom and versatility with which artists rendered the thin, clinging, pleated garments worn by women. The headless *Ornithe* from Samos, who clutches a handful of her garment, is an exercise in sculptural virtuosity which I cannot see the Egyptians even attempting. The headless *Kore with a Hare*, also from Samos and probably by the same artist (both have been dated 560 BC and both are in the Berlin State Museum) strikes the same note of daring innovation.

By about 520 BC, these sculptured women were baring one or both breasts, tilting their heads, forgetting to smile, indeed scowling like modern fashion models, wearing every conceivable kind of garment and accessory, and tossing their dreadlocks. Twenty years later, even the standing statues were showing signs of mobility—using their legs freely, raising their arms and bending their elbows, lying down, shooting arrows, slashing with their swords and holding shields, as can be seen

in the west pediment of the Temple of Aphaea at Aegina, 510–509 BC. These magnificent works, carved at the very point when Greek archaic art yielded to the classical, are now in the Glyptothek in Munich. There are still canonical restraints, especially in the eyes and other features of the face, and a new canon governed the ratio of arms, legs and body-lengths and many other aspects of free-standing statues. But these ratios themselves were based on actual measurements producing real averages rather than artistic-religious dogma, so it is clear that the revolution in presenting the human form was artist-led and increasingly based on observation. Once the artist creates what he sees, rather than what he is told he ought to see, his individualism inevitably asserts itself.

In the first half of the fifth century BC, therefore, we enter for the first time an age of individual artists, or masters, leaving behind the regulated multitude of skilled craftsmen. So events moved fast. Over the next fifty years, Greek classical sculpture reached its zenith. The process was accelerated by the widespread introduction of bronze-casting for life-sized or colossal standing statues, for a hollow bronze was lighter than solid marble and could thus be made to perform more energetically or engage in more extravagant gestures. In the 'lost-wax' (*cire-perdue*) process, the figure is moulded in clay, then covered in wax and linked to an outer mould by chaplets, so that the wax can be melted away and replaced by liquid bronze, the chaplets being sawn off when the bronze cools. It was not invented by the Greeks. On the contrary, it goes back to the fourth millennium BC, as a hoard of maceheads, sceptres and crowns found near the Dead Sea and now in the Jerusalem Museum shows. The technique was widely used for a variety of small objects like brooches, as well as statuettes. What the Greeks developed was a proficiency in wrought bronze, using hammers, producing (in Mycenaean times) such sophisticated objects as the hammered sheet-bronze suit of armour now in the Nauplion Museum. The Greeks were also the first to use a lost-wax technique, of an improved kind, to produce life-size statues, for which they credited the eighth-century Daidalos of Crete. The large works, possibly by him, which survive and are now in the Heraklion Museum, suggest that he was an armourer who had the genius to bring wrought- and cast-bronze techniques together on the scale of life.

From the seventh century BC, the Greek sculpting community and their patrons seized eagerly on this new form of statuary. During the next two hundred years sculptor-foundrymen developed it to a point, in the actual skill of casting and the brilliance of finishing, which has never been excelled. We know from the casting-pits which have been excavated in the Athenian Agora exactly how the Greeks set about the lost-wax process. Though the overwhelming majority of the statues thus produced have disappeared, melted down in war over two millennia, a few have been

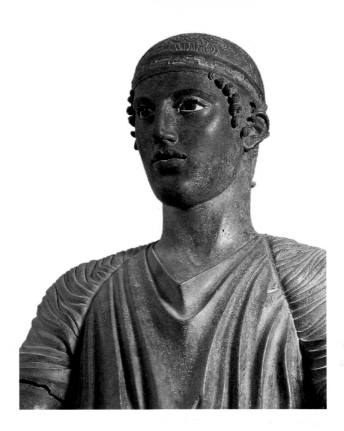

The *Boy Charioteer* (*c.*475 BC) is a rare survivor from the golden age of Greek sculpture, which exists mainly in Roman copies.

dug up and more found at sea in a fine state of preservation. There is the *Boy Charioteer*, *c.*475 BC, disinterred at Delphi, a 6-foot-high marvel of erect dignity and tension, with his powerful shoulders and biceps, brilliantly suggested under his thin robe, a model of design economy and artistic assurance (Delphi Museum). By contrast, there is the monstrously fierce, indeed snarling, *Warrior*, one of a pair (455 BC), hauled up from the sea off Riace, Calabria, and now in the Reggio Calabria Museum.

Even more arresting is the 7-foot bronze figure of a god found in the sea off Cape Artemision, and now in the Athens Museum. The concept is unforgettable, with the left arm stretched out to its fullest extent for balance and aiming, the right pulled back equally, to hurl either a thunderbolt, in which case the statue is Zeus, or a trident, which makes him Poseidon. The god is wonderfully in control of his body and his space, and the right leg is delicately balanced on the ball of the foot. The composition would have been impossible in marble, even if made in pieces, something the best sculptors detest, and the use of bronze gives the work an almost diabolical intensity and terror, as though it had just emerged from the furnace in which it was cast. The fringed, bearded figure lacks its coloured marble eyes and has a contemptuous impersonality, as if the god had no feelings about the creature he is to slay, merely a sense of its inferiority. Masculine power and arrogance have never been epitomised so sublimely—the work irradiates the dull museum room in which it stands and is surrounded, as a rule, by a transfixed circle of heavy-breathing young women.

The fact that we do not know the name of the sculptor who created this masterpiece, perhaps the finest single work to come down to us from antiquity, is part of

the frustration which any study of Greek sculpture produces. Of Pheidias's two masterpieces, the colossal *Athena* from the Parthenon survives only in two small copies (Athens), which gives no conception of the dramatic power and majesty of the work, described more often and in greater detail, than any other work of art before the Renaissance. Of his giant statue of Zeus at Olympia nothing remains except bits of moulds. You can see his *Apollo* in the Kassel Museum, but it is only a copy, and none can say how good the original was. There are various copies of his *Anakreon*, including one in the Copenhagen Sculpture Museum. But which is best? There is no defining such when the original is lost. Among the many innovations which Pheidias made standard was the *contrapposto*, in which the balance of the standing posture is achieved with the flexed leg set firmly in front. This pose has been imitated ever since. But we know all this only through copies.

Pheidias's great contemporary, Polykleitos, who was active throughout the second half of the fifth century BC, has fared a little better. His treatise on art lists the ideal bodily proportions for a human statue, reflecting the Greek belief that perfection rested in fixed mathematical relations, which could be measured and which the artist

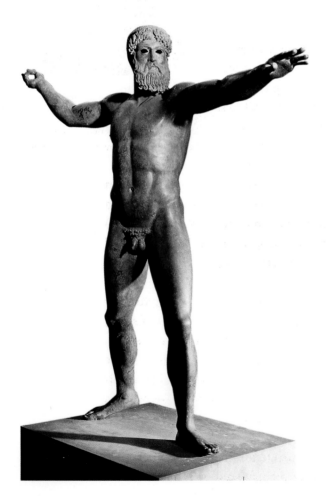

must follow. But it survives only in summaries, and the statue he created to illustrate his principles and ideal ratios, known as 'The Canon', has been lost too. What does exist, in the Naples Archaeological Museum, is a copy of his *Doryphoros*, a magnificent work in its own right, which shows the *contrapposto* in its fully developed, classical form, designed to show how the muscle system of the body worked by means of the perfect distribution of weight. This *Youth Holding a Spear*, as it is also known, was widely copied at the time and since. There are also copies of Polykleitos's young athlete, binding a sweat-rag round his head, called the *Diadoumenos*, and of his *Amazon*, which he made for Ephesus in competition with Pheidias. But his masterpiece, the colossal cult statue of Hera made for the Heraion at Argos, has vanished. Like Pheidias's two lost

This bronze man (*c.*450 BC), rescued from the sea, is the noblest of all Greek works, and still radiates terror and sexuality. Is he Poseidon? Or Zeus?

colossi, it was of chryselephantine and other materials which were valuable in themselves, and was therefore broken up in an early looting spree.

Pheidias had many famous followers among the large sculptural community of fifth-century and early-fourth-century Greece. They included Kresilas, Agoràkritus and Alkamenes, none of whose works have survived except in copies, though the cult statue of *Nemesis* by Agoràkritus (430 BC) has been reconstructed from fragments found at Rhamnous. In the case of Kresilas, the bases of six statues, inscribed with his name, still exist—three in Athens, one in the Argolid, one at Delphi and one in Pergamon, the last supporting a later copy. Such evidence, together with the writings of Pliny and of the travel writer Pausanias, who described all the cities and shrines of Greece and its world, help to establish these sculptors as artistic individuals. But in establishing an identity there is nothing like the actual work.

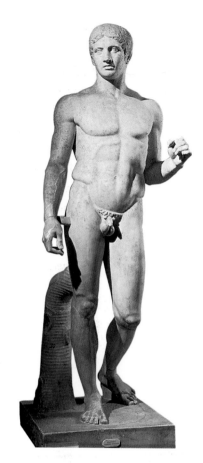

Doryphoros or spear-carrier, by Polykleitos (active 450–420 BC). This epitomises a canon of male beauty embodied in mathematical proportions.

Using literary sources, archaeological evidence, signed bases, copies and fragments, it is possible to build up a detailed chronology and taxonomy of Greek sculpture during the classical period, which distinguishes between the various schools and styles and individual masters, their pupils and followers, rather as we can do with artists of the Renaissance. But it is all *Hamlet* without the prince, for the works are not there. It is also possible, in the case of the Parthenon, where even the surviving fragments are in different places, to create a photographic reconstruction and *continuum*, based on drawings made by Jacques Carrey in 1674 (now in the Bibliothèque Nationale, Paris) shortly before the building, then used as a powder magazine, was badly damaged by an explosion. This has been done, more or less effectively, by several different publishers.

More, however, can actually be learned about Greek classical sculpture by spending a morning at the British Museum than by almost any other form of study, for there it is possible to see the largest collection of the Parthenon fragments plus, for purposes of contrast, the sculptures from the Temple of Apollo at Bassae in the Arcadia of southern Greece. This great temple, designed by Iktinos, the chief architect of the Parthenon (under Pheidias and Pericles), is remarkable for various engineering innovations, including perhaps the first earthquake-resistant foundations in history. It is also remarkable for the absence of the five features which both ancient writers and modern scholars agree are essential to temple architecture: entasis, upward curvature, inward column-leaning, outward entablature-leaning and extra-

thick corner columns. We will come to the significance of these devices (and their absence) shortly. Here the point to note is that when the ruins were excavated by the German architect Haller von Hallerstein in 1812, he took down and auctioned off the temple's sculptural reliefs; the highest bidder was the British Museum, where they are displayed today. They are twenty years or more later than the Parthenon sculptures and of astonishing vitality, showing Lapiths and Centaurs fighting (as in the Parthenon metopes) and Hercules and other Greeks battling Amazons. The quality may not be as high as that of the Parthenon carving, but the freedom of invention and movement is much more daring and the composition more accomplished. It is illuminating to be able to see such a vast quantity of first-class work set out in a single museum, for it shows how fast Greek art moved at its zenith and how free and anxious the artists were to push forward the frontiers. Nothing reveals more clearly the relentless dynamism of art than the relaxation of canonical restraints. The Greeks were the first to release this dynamism, and it has since been a characteristic of art in all its periods of greatness.

Of course dynamism, by its nature, produced not only upward movement but decadence, the word literally meaning a falling-off or descent to a less frenzied plane of innovation. It was the received wisdom, in the nineteenth and for most of the twentieth century, to see late classical and Hellenistic art, notably sculpture, as a decadent phase of high classical art. The reasons for this judgement are as much political as aesthetic. Nineteenth-century liberal scholars associated the fifth century BC and its art with Athenian freedom, and later Greek art with the despotism of Philip of Macedon and the imperialism of his son Alexander the Great. Now it may be that the comparative freedom of opinion and speech which Athenians enjoyed at the time of Pericles had something to do with the casting-off of canonical restraints by Pheidias and his artistic contemporaries. But neither Philip of Macedon, nor Alexander made life difficult for strong-minded artists—quite the contrary. Alexander not only favoured Lysippos (*floruit* 328 BC), the outstanding sculptor of his age, but gave him sole rights to his portraiture. This was said to be because only Lysippos could convey the king's lion-like look combined with his soft eyes and beautifully turned neck. However, none of this is apparent in the copies of Lysippos's presentations of Alexander which we possess. Lysippos was famous in his day for making men look slender and graceful, and some hint of this appears in a statue of Agias now in the Delphi Museum. It is a noble work but much damaged, and the attribution is only a conjecture.

The later Greek sculptors were as innovatory as the masters of the late fifth century. Lysippos had a brother, Lysistratos, who was, says Pliny, 'the first person to model a likeness in plaster of a human being from a living face. He created the method of pouring wax into a plaster mould taken from the face, then making final corrections in the cast wax from the living model.' Pliny claimed that, before

Lysistratos, true portraiture did not exist, as the object was to make the face (and body) as beautiful as possible. Here is an instance of realism triumphing over idealism, and if we want to summarise the difference between classical and Hellenistic sculpture, we can say that classical strove for the ideal, Hellenistic for the real. The ingenious Lysistratos also began the practise of taking casts from statues, to produce exact copies.

The move from idealism to realism was marked by full-length portraiture, of which one outstanding example is the *Demosthenes* in the Copenhagen Sculpture Museum, a marble copy after Polyeuktos of Athens, which conveys some of the majesty and serenity of the individual. Hellenistic sculptors also produced images of women, both goddesses and real-life portraits. They were led by Praxiteles, the fourth-century Athenian master, who used his beautiful mistress Phryne as his model. He specialised in emotions and he created his statues to be seen from the back as well as the front, indeed from any aspect. But apart from a *Hermes* in the Olympia Museum, none of the originals, bronze or marble, has survived, and even the *Hermes* is doubtful. In the Louvre there is a beautiful marble copy of Praxiteles's bronze *Apollo Saurokortonos*, so called because he appears about to kill a lizard climbing up the tree trunk on which the statue leans for support. A copy of his *Aphrodite of Knidos*, in the Vatican Museum of all places, is the first fully-realised female nude statue in history, certainly in Greek monumental sculpture, and was evidently modelled on Phryne, as the bracelet on her left arm reveals. This voluptuous work is the basis for the later

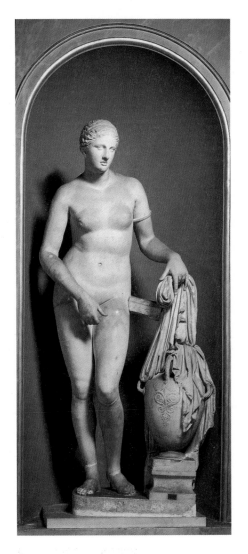

Aphrodite of Knidos (mid-fourth century BC), by Praxiteles, the first female nude statue to survive. In marble but probably a Roman copy.

cult of Aphrodite or Venus as the arch-image of female sexuality, though Praxiteles's lady modestly covers her genitals with her hand. But the lifeless face betrays the copy. Praxiteles, the sources say, was particularly admired for his heads and likenesses. Even from various copies we can reconstruct the features of the delightful Phryne. We gather that Praxiteles was uniquely skilful in exploiting the coloured properties of marble, suggested by the blurred muscular gradations created by light both direct and reflected in his works, by in fact a three-dimensional chiaroscuro, most successful when they were seen by candlelight, and by sensationally delicate chiselling of the flesh. But none of this comes across in the copies. Much of the superlative

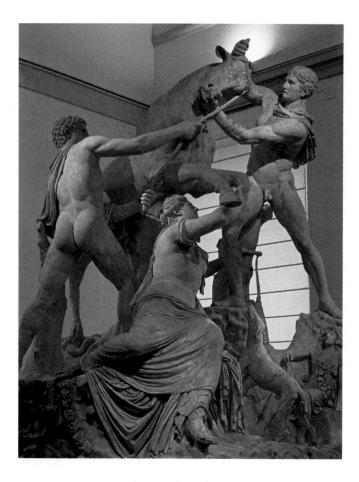

So-called *Farnese Bull* (third century BC) shows the virtuosity of Greek sculpture in Hellenistic times, able to produce realistic groups of great complexity.

quality of Greek sculpture has to be taken on trust. That is one reason why the Elgin and Bassae fragments are so important—they are the originals.

Nevertheless, from the Hellenistic period we have a number of ineffaceable sculptural images, which have had a powerful and lasting impact on the practice of art in the West. There is the fragmentary *Belvedere Torso* (first century BC, Vatican Museum), whose musculature and strength hugely impressed Michelangelo, the *Farnese Bull*, which he likewise loved, and the great *Laocoön*, dug up at the beginning of the High Renaissance, the pride and joy of Pope Julius II and the centrepiece of his art collection. This is a Roman copy of a Hellenistic bronze original, which Michelangelo used as an encyclopaedia of heroic sculpture, and it too is in the Vatican. Another striking image is the *Crouching Aphrodite* by Daidalos, which survives in a Roman copy (Rome, National Museum). The Hellenistic sculptors were much readier than their classical forebears to portray emotion, and far more skilful at doing it. Although only part of her face is left, Aphrodite, in her crouch, conveys her anxiety at what is happening—we can only guess what it is—with some force. Another Aphrodite, known as *The Capitoline*, in the museum of that name in Rome, is wantonly prudish and seductively modest as she waves her hands about in front of her breasts and pubis (third century BC; Roman copy). *The Dying Gaul* (third century BC; Capitoline) is expiring with touching pathos and impressive elegance, and the sensa-

tional *Gaul Slaying Himself and Wife*, a marble copy of the original third-century bronze (Rome, National Museum), is a deliberate tear-jerker, but one with class.

If we want to make another simple but valid distinction between classical and Hellenistic work, we might say that the earlier artists celebrated the ideal joys of man, the later ones his real tragedy. This contrast reflects the extinction of Athenian democracy and freedom under Macedonian rule and the subsequent death of Greek independence as the Romans took over. The enactment of tragedy culminated in the Great Altar at Pergamon, erected under the direction and influence of Phyromachos, a highly original sculptor credited with the famous *Dying Giant* in the Naples Museum. It is the nearest equivalent, from the Hellenistic period, to the sculptures of the Parthenon. Unfortunately, the fragments that are left are more scattered. Much of the East Frieze, for instance, is in the Berlin State Museum. The *Nike*, symbolising victory, is in the Louvre. Some of the rest is in Pergamon itself. Also in the Louvre is the *Aphrodite of Melos*, the work once regarded as the finest statue in the world and once called the Venus of Milo, a 6-foot-6 armless goddess, nude to the waist, made of Parian marble. It is actually a second-century-BC copy. The lady's slipping vesture is ingeniously carved but the torso is of no great interest and the face is insipid. She became world famous because so many copies, large and small, were made of her that her image became impressed on the public mind, just as a pop song is made a hit by endless repetition. In art, image is not all, but it is often ninety per cent of the battle for recognition. Why did people want to buy copies of this Venus in the first place? 'You may well wonder', as Dr Johnson said. Ignorance, perhaps.

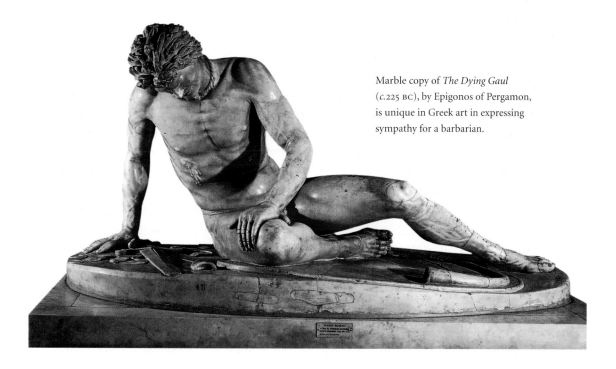

Marble copy of *The Dying Gaul* (*c.*225 BC), by Epigonos of Pergamon, is unique in Greek art in expressing sympathy for a barbarian.

All these works listed above, the *Nike* in particular, have complicated histories or are the subject of continuing debate among scholars. This acts as an obstacle to our enjoyment. Because so few originals have survived, even in fragments, we need to know about the authenticity of objects we see in museums. But the disputes of scholars are not our business, which is to look at, try to understand and love these precious survivors. We must never forget this. That is why it is not good to spend too much time in museums, looking at bits and pieces, however noble, wrenched out of their contexts. The Elgin and Bassae marbles are special cases. As a rule it is best to get out into the open air and examine ancient Greek marbles, where they still cling on, in the pediments and friezes and metopes which they originally constituted, in their temple settings under the blue skies, amid the savage hills and mountains and delectable islands which make up the *oikumene*. When seen thus, it is possible to catch a glimpse of the aesthetic order their creators sought to impose on wild nature. By trying to appreciate the contrast, you make some kind of contact with the minds of these artists who flourished over 2,000 years ago.

The ancient Greeks were a civilised people who took immense pride in their culture, which they saw as a rational construct from start to finish. Other societies acted on impulse or from credulity and emotion—the Greeks used their minds. St Paul put his finger on this when he wrote: 'The Greeks ask for a reason, the Jews look for a sign.' The Greeks were quite capable of looking for a sign too, when they were frightened and all else failed. But generally they attempted to intellectualise every problem, not least in art. They were interested in mathematics. So they measured arms and legs and torsos, and constructed canonical ratios. They were fascinated by optics. So they pondered deeply the problem: why is it that an object looks different to what we know in reality it is? And why do some man-made objects look right and others wrong? They asked for reasons, and their writers and philosophers provided them. Thus the first scientific works on aesthetics came into existence.

Vitruvius, a practising architect and engineer who lived about the time of Christ, in his treatise *De Architectura*, the only one which has come down to us more or less in its entirety, provides a long list of works by Greek experts on every aspect of architecture. But they have all vanished. What we do know is that the Greeks engaged in various forms of illusionism to produce the effects they wanted. These deliberate attempts to deceive the eye for aesthetic reasons were commonest in architecture. The Parthenon, for instance, employed five tricks or 'refinements', as they are called. It has a small but regular convexity in the overall horizontal lines, so the platform and stylobate is a bulging curve by up to 3 feet, and this is repeated on entablature and pediment. To obtain this effect, the architect rejected standard blocks, and insisted on custom-carved ones made to his specifications, an expensive demand. The main vertical refinement, called entasis, took the form of an outward

swelling on the column shafts. Third, the axis of columns was tilted towards the building's centre by several degrees from the vertical. Fourth, corner columns were made thicker than the rest, and tilted towards the diagonal axis of the building. Fifth, the walls of the interior parts of the temple were made thinner towards their top, and lean inwards, and their upper sections were set back.

Two comments are worth making on this illusionistic system. First, the distortions were deliberate, not accidental as was once believed. They were clearly designed to avoid the mechanical, to put a bit of life into buildings to make them breathe, flex their sensuality and give them organic existence. The keen-eyed sensitive soul might not notice how the effect was achieved, but he was subconsciously aware of it, and it increased his relish for the art. Second, not all temples had all five of these refining devices. Some, like Bassae, had none at all. They were not canonical, even in the relaxed way in which the Greeks applied the canon. Clearly, some architects dismissed them as nonsense or unnecessary, and no doubt some communities refused to sanction the extra costs involved. It is notable that the Parthenon, where all five devices were incorporated with great skill and panache, was built regardless of expense—and that was one reason why Pericles and Pheidias, the 'big spenders' of late-fifth-century Athens, fell from power. The best temples (e.g., Segesta) did employ at least some of them, and they certainly helped to sensualise the severity of the Doric order.

To what extent, then, did the Greeks extend illusionary devices to work in two dimensions? This brings us to a highly controversial matter. Did the ancient Greeks 'discover' perspective? They certainly thought long and deeply about the problem of creating pictorial spaces, something which had not bothered any of their predecessors. They did not trouble themselves about artificial perspective as such, whether linear or aerial. Granted their love of theory, of science and of 'answers' to 'problems', this is significant. Perspective does not figure in their work on optics, let alone constitute the subject matter for special treatment as happened time and again in the Renaissance. Greeks were obsessed by many things, and paranoid about some, but perspective was not among them.

What the Greeks did care about, increasingly, was realism, and it was this that led them to try to conquer pictorial space and employ, among other tricks, a form of perspective. All Greek sculpture was a march towards realism, even if it encumbered itself with a good deal of idealism and emotionalism on the way. The chief object was to stun the viewer, to make him almost jump out of his skin when he first saw a statue and exclaim, involuntarily: 'Is that a real man? Does he move?' This may seem childish, but then the Greeks were childish in many ways. But they were also, at the same time, mature: they wanted to look the world straight in the eye, to see it whole, in all its multifarious aspects, and artistic realism was part of this process.

Making a lifelike statue, then, was one form of Greek realism, and the easiest one. More difficult was achieving realism in two-dimensional works. We have

noticed that, as Ruskin recognised, Greek skill in very low-relief sculpture, akin to drawing, was striking. But no drawings as such have survived. There are very few paintings either. What we do have is the tale, or legend, of Apelles, and this is worth examining. Apelles, an Ionian from Kos, flourished about 380–320 BC, and worked for Philip and Alexander of Macedon, and the first Ptolemy in Egypt. As Pliny and many other ancient writers agreed, he was by far the greatest painter of antiquity. Nothing whatever by him—or even by his pupils—survives. There are no copies of his works either. His treatise on art has disappeared without a trace. He is one of the great black holes of art.

But there are stories. One says that while painting a portrait of Alexander, something he did often, Apelles was annoyed when the great man held forth on art. The painter, who was doing Alexander's mouth, shut him up by saying his views were so ridiculous that even the boys who mixed the paints were laughing at him. Alexander also got Apelles to do a nude of his favourite concubine, a slave girl called Pankaspe. The painter fell in love with her, and when Alexander perceived it, he made Apelles a present of the floosie. A third story describes his masterpiece, *Alexander Holding the Thunderbolt*, which was in the Temple of Artemis at Ephesus. To make the thunderbolt stand out, Apelles deliberately darkened the figure of the king, thus inventing an early form of chiaroscuro. Pliny, who wrote a lot about this artist, said he also invented the three-quarter-face portrait, a device to hide the missing eye of Alexander's famous general Antigonus, known as One-Eye or Monopthalmos, later King of Macedonia. Indeed, Apelles, whose specialty was portraits, in effect did a prosopography of Alexander and his entourage, rather as Sir Thomas Lawrence painted all of Bonaparte's victors. At least a dozen of Apelles's famous works are described in the sources. They include a nude hero and a painting of a horse so realistic that it won a competition of equine portraits (it is said) judged by horses themselves.

Apelles used the lascivious Pankaspe as his model for the *Aphrodite Anadyomene* (Venus Rising from the Sea), in which apparently she was shown wringing her hair dry as she left the waves, a cunning touch, later imitated by numerous sculptors. This painting was so successful that it was taken to Rome where, it was, so the story goes, damaged to such an extent that no one in the city could restore it; Apelles, appealed to, was painting a new version at his retirement home in his native Kos when he died. Apelles also produced a painting called *Calumny*, the first known exercise in allegory. Calumny, with Jealousy, Treachery and Deception, is seen with Ignorance and Suspicion, who are on either side of a credulous fool whose huge ears denote his willingness to listen to wild rumours. Behind Calumny, however, comes Repentance, weeping copiously and appealing to Truth. This was a comment on the attempt by a painter-rival, Antiphilos, to destroy Apelles by telling the authorities that he was involved in an anti-Ptolemy plot. The work has not survived but its fame persisted long enough for Botticelli, sixteen centuries later, to create his *Calumny of Apelles*,

now in the Uffizi in Florence, which inaugurated the Early Modern genre of allegorical painting.

It is not clear what exactly these 'paintings' were. Did Apelles create them on an easel? If not, how were they transported? Was a section of wall cut away? Painting in ancient Greece certainly began on walls, as a mere adjunct to architecture and sculpture. There is, in the Athens Museum, part of a fresco from Thera, early second millennium BC, showing beautiful blue-grey monkeys gracefully cavorting against a splendid background of pink clouds and orange-red sky, a delightful conceit. On the other hand, the same museum has a sacrificial procession, from a thousand years later, painted on wood. It is hard to be positive because the evidence is fragmentary, but what seems to have happened is that Greek painting began as wall decoration, then progressed to the creation of large works on wood, which could be fixed to the wall. Fresco and other forms of wall-painting never died out, however, especially in tomb buildings. These wooden wall-decorations had the advantage that they could be transported from one house or palace to another, put up in tents, carried in victory processions, and so forth. They could also, when the Romans came, be stolen, as many actually were. Both Vitruvius and Pliny the Elder (*Natural History*) cite examples of detached wall-paintings set in wooden frames and used as decoration. We come across the word *pinakotheke*, picture gallery, from about 200 BC. Collectors built them. Delighted strangers visited them. Collectors' items from Greece, hanging on the walls of the houses of the rich, are hinted at in the wall-paintings of Pompeii and Herculaneum. But they are rare now and, when they exist, disappointing. Indeed, what survives of Greek painting is usually poor.

Far more common, and interesting, are the portrait heads painted on Egyptian mummy-cases in Ptolemaic times, especially in the Fayum south of Cairo. These are realistic images of the Greek ruling and commercial classes, men and women, which may perpetuate their actual appearance or more likely how they looked in their prime. They are the work of provincial artists or possibly mere beauticians from the undertakers' shops who supplied portraits as part of a mummy package. They are not great art, by a long way, but they are sometimes soulful, evocative, even moving, whispering to us with their big dark eyes down a long, long corridor of time. From Italy we have Greek-inspired paintings on wooden Etruscan sarcophagi, such as the so-called *Sarcophagus of the Amazons*, found in Tarquinia, which is now in Florence's Archaeological Museum: again, routine stuff, with periodic flashes of skill and inspiration. Tomb frescoes at Paestum, dated 340–320 BC, tell the same story: artistic tradesmen at work, earning an honest drachma.

Mosaics, which often reproduce paintings by masters, were created for a richer clientele and, when they survive at all, tend to be beautifully preserved. There are two late-fourth-century examples in the Pella Museum, of *Dionysus Riding a Spotted Panther* and *Two Men Hunting a Lion*, which are superior works by any standards, given the notorious limitations of the medium. A hundred years later, Greek

mosaicists in Sicily invented a new type of pavement for luxury houses, composed of black-and-white and coloured marble fragments, stone and tile *tesserae*, woven into an abstract composition with a realistic picture in the middle. Some good painters and designers dabbled in this art. Pliny says that the famous mosaicist Sosus of Pergamon specialised in *trompe l'oeil* effects such as a floor strewn with the debris of a meal, or doves drinking from a wine cup. These survive in Roman copies, evidently poor ones, for it is hard to imagine what eye they deceived.

There is one exception to the deplorable absence of painted masterpieces in Greek art. Painted vases have survived in considerable quantities, bearing in mind their fragility, and some of them are remarkable, not just for their historical interest—they are a prime source of reference for many aspects of life, being detailed, easily dated and of clear provenance—but for their beauty. They stretch out over a vast tract of time, from the Mycenaean period, when they were much influenced by Minoan vase-work, through the Dark Ages, then cover the whole development of classical and Hellenistic art, down to the magnificent polychrome ware of Centuripe in the third century BC, when this art form comes to an end. There is nothing archaeologists and prehistoric historians like more than pots, as they provide perfect academic exercises in taxonomy. The Greek vase, therefore, has attracted modern scholars and they have almost buried the subject in mountains of dense tomes—here is a classic case of expertise suffocating delight. To recover the aesthetics of the Greek painted vase, and to sort out the beautiful and significant from the merely informative, is not easy.

These vessels came in a wide variety of shapes and were used for widely differing purposes. Indeed, some of them were not vases at all. The rhyton, for instance, usually in the shape of an animal's head, was a ritual drinking vessel used for all-male feasts. Sipping or gulping from such a capacious receptacle, which could not easily be put down, turned Alexander the Great into an alcoholic, and then killed him. There was the pyxis, or pyx, a cylindrical box with a lid which, in Byzantine times, was to pass into Christian ritual as the container for the consecrated host. The kylix was not a vase either but a wide-mouthed cup with horizontal angles, a handsome piece of tableware. Other cups included the primitive phiale, a shallow, handless libation bowl, a skyphos or small, two-handled cup you could also use for soup, and a kantharos, a grand and elegant drinking cup with two enormous handles, very awkward to drink from, especially when drunk. The true vases were the amphora, which was tall and two-handled, the loutrophorus, of similar design but heavier in the shoulders, and the krater, a large-scale vase with a wide mouth, in which wine was mixed with water. It came in numerous varieties, the kalyx, the column, the berll, the volute, the stamnos, etc. There was also a handleless krater, the dinos, held upright by a metal stand. The lebes gamikos was a vase with a high foot, rather ugly and unstable. There were similar vessels, not strictly vases but jugs—the oinochoe, a one-handled affair with a trefoil mouth, used to pour wine straight into the mouth like a Spanish wicker jug, the extremely elegant hydria, or water jug,

with three handles, two for lifting, one for pouring, and the pelike, with a bulging body. The biggest of all was the nestoris amphora, the curve of whose handles were decorated in relief, but this was late and came from Italy.

Scholars have divided and subdivided vases into schools and identified scores of artists. The schools include Vigorous Style, Delicate Style, Corinthian, Chalcis, Laconian, East Greek, Rhodian, Pontic, Clazomenian, Rich Style, Paestan, Etruvian and so on. Many vases were signed, so we know the painters' names, but these artists are supplemented by masters linked with a vase in a particular museum, and known as Berlin Painter, Chicago Painter, etc., or with particular places, subjects and individual masterworks. Greece was an entrepreneurial society and vase art was particularly vigorous and varied because pottery was entirely in the private sector in most cities, especially Athens, which by 550 BC was producing over seventy-five per cent of the total output. These pot banks were often jointly owned by a group of potters and artists but the potters nearly always came higher in rank and controlled the capital invested. This suggests that business came before art, quantity before quality (as a rule) and that competition was fierce. The potters were the bosses, the patrons, the artists were employees, contract workers. Sometimes the same man was both. An example was Exekias who, along with Kleitias, Lydos and Nearchos, formed the quartet of artists who raised black-figure painting, as it is called, to its zenith in the period from 560 to 540 BC. Among Exekias's masterworks was his *Suicide of Ajax* on an amphora now in the Boulogne Museum, an intriguing picture of Achilles and Ajax playing draughts on an amphora now in the Vatican, and a blissful study of Dionysus in his boat in the midst of a sea of dolphins, which Exekias painted on a kylix, now in the Munich Glyptothek. Of the rest of the quartet, Lydos was the monumental decorator, Nearchos was the artist who first learned to draw perfect horses, as witness his kantharos in the Athens Museum, and Kleitias was effectively the founder of the school.

Soon after 530 BC, however, the rival Athenian firms of Andokides and Kokosthenes both introduced a new kind of vase decoration, which we know as red-figure. They left the figures in the natural red of the clay, and painted the background with black glaze. The artist no longer had to incise the details of his figure with an engraving tool but, using a brush or pen, painted them in black glaze on the red clay. This allowed for much greater fluidity and freedom of expression. Black- and red-figure vase-making coexisted for a time, and some vases combine both. There is a funeral or loutrophoros vase in the Louvre in which the cavalry escort in the procession is in black-figure, and the female mourners in red-figure. But red-figure gradually took over because the artists preferred it, led by the great Euphronius, who flourished in Athens at the end of the sixth century BC. He was a painter-potter and knew the art as perhaps no one else did, not only pushing the new freedom for all it was worth, but introducing new devices (and clichés) and contrasts, between tragedy and comedy, and between monumentality and the purely

decorative. His horseman on a cup (Munich, Glyptothek) is one of the best examples of this theme in all Greek art. His Hercules krater (Arezzo Museum) is an exercise in the monumental still worth copying today. Red-figure work showed a new concern with human anatomy and an ability to depict it in line. The rival of Euphronius, Euthymides, produced an amphora depicting a male drinking party which comes close to an anatomy lesson, and the artist was so pleased with it that he signed it 'Euthymides painted me, as never Euphronius could'. Signatures were common—Euphronius signed at least fifteen works of art which have come down to us—and it is possible to build up a surprisingly detailed picture of the Athenian pottery trade in the fifth century BC.

It was in the fifth century that Athenian red-figure painters introduced elements of perspective. They showed foreshortened figures. They showed faces obliquely. This had the effect of concentrating the interest of the viewers beyond and outside the plane of the painted surface of the vase. The effect was reinforced by putting the figures at different levels and raising them according to the distance from the foreground, a clumsy form of aerial perspective. In a red-figure krater of about 460 BC, by an artist called the Niobid Painter (Athens), showing Apollo and Artemis

Ajax and Achilles playing draughts.
Vases, 4,000 of which survive out of
about 1 million made, tell us more about
ancient Greek life than any other source.

shooting down Niobe's children, the notion of perspective is strongly developed by an artist who clearly grasped the possibilities which the control of space opened up in art. In the British Museum there is a magnificent hydria by the Midias Painter, perhaps the most spectacular work of vase-painting which has survived, carrying perspective as far as the Greeks appeared anxious to take it. The top sector shows Castor and Pollux kidnapping the daughters of Leucippus, while in the bottom half Hercules rests after his labours in the Gardens of the Hesperides. The use of three-quarter views of heads, and the setting of figures at different levels, all to enlarge and deepen the space in which they move, is highly successful in presenting to the viewer not just the subjects of the story but the background, and blending them together in one coherent picture.

This was potentially a major step forward in art. But it lacked any kind of intellectual rationalisation—the world had to wait for the Italian Renaissance for that. The Greeks did not give the conquest of pictorial space priority. Indeed, some Greeks deplored the drift away from aspective art, either in sculpture or in painting. Plato in particular was violently opposed to it. In his *Laws*, he praised the Egyptians for forcing young people to study 'fine figures in art and fine music', which were laid down by authority and strictly enforced. He noted that in all essentials, Egyptian figure-sculptures had not changed in thousands of years, and that they were still executed in the traditional manner and with the same marvellous skill. He equated aspective art, revealing all the details you need to know, whether or not you can see them, with truth itself. No one, so far as we can see, took any notice of Plato. But it is likely that many agreed with him. The kind of dynamic forward movement, especially in sculpture, which Greece developed in the fifth century BC, was not kept up, in vase-painting anyway.

Indeed, the production of elaborate decorative vases comes close to being a failed art form. There was always something a little meretricious, even vulgar, about it. Virtually none of the vases was created for artistic display, as opposed to use. The more elaborate ones were produced for male drinking parties, in the later stages of which male or female prostitutes were introduced. Thousands of pots have survived, and perhaps a million were made, in a highly commercial exercise which was the closest the Greeks came to mass production. Modern potters, who have studied the methods used by the Greeks, describe them as barbarous. The clay was often of poor quality. Many pots are wobbly on their bases. The handles are often unsymmetrical and sometimes push in the line of the neck. One side of the lip is higher than the other side. There were other basic faults. Although, in the best pots, great care and occasional genius went into the figures, the decorative friezes were often clearly done in haste. With few exceptions, these were cheap products. It is significant that the Romans, who valued quality and luxury, and who collected and copied Greek sculpture with avidity, showed no interest in Greek pottery. Renaissance artists and collectors likewise ignored it. Collecting vases started only in the eighteenth century,

the first major connoisseur being Sir William Hamilton, whose four-volume record of his collection stirred scholarly interest in the subject. It is the modern academics who have made Greek pottery into an art form.

This brings us to a general point about Greek art. That the Greeks produced great sculptors and architects—as well, be it remembered, as great philosophers, poets and dramatists—is universally acknowledged. No educated person can be without some knowledge of Greek culture, and any person of taste must find something to respond to in the Greek aesthetic. But it is not necessary, or even desirable, to embrace Greek artistic production as a whole. On the contrary. The wise connoisseur is selective. There are times when we, in the twenty-first century AD, feel an instant rapport with a Greek statue, and link our thoughts with the man who made it in perfect fellow-feeling. But there are also times when the Greeks seem a very long way from us, in emotions and values and appetites. The Greeks, from goat shepherd to rulers like Alexander, saw Hercules as the epitome of the hero—the perfect valorous, successful, triumphant male who, as a result of his labours, deifies himself. Greek women were educated to worship him as the perfect embodiment of the male principle. Lysippos, finest of the Hellenistic sculptors, created a Herculean archetype: huge, muscle-bound, all-powerful, noble in his energy and strength. Lysippos bristled with creative dynamism. He specialised in the heroic, indeed in the colossal. It is significant that it was a pupil of his, Chares of Lindos, who created the largest statue of antiquity, the Helios or lamp-bearer of Rhodes, a lighthouse which lit up the harbour and was 200 feet high. This muscular type survived in the twentieth century in the body-building school of a man who called himself Charles Atlas, and whose slogan was: 'You too can have a body like mine.' Here is one aspect of Greek art, and an important one, which raises problems today, like the fleshy overweight goddesses of Rubens.

Greek art, then, need not be taken as a whole. But it had a unifying theme, or rather a unifying tension—the oscillation between realism and idealism. The Greeks recognised ideal forms, and tried to create them. They also had a huge passion for portraying man and the world as they are. In a sense, that is what Greek art came to mean: the courage to see life whole, without flinching, and to put up with it while endeavouring to improve it, but also the vision to picture in the mind and in art a perfect world of heroism and virtues and forms. When this point is firmly grasped, it is natural to pick and choose among the objects the Greeks produced while oscillating fruitfully between the two poles. That is something their successors did not fully understand until the Italian Renaissance. But the successors also had skills and ideals which the Greeks lacked, and to these we now turn.

5

ROME:
AN ART SET IN CONCRETE

The enormous Roman Empire which emerged towards the end of the second half of the first millennium BC absorbed and transmuted virtually all the lands of the ancient world where art and civilisation flourished. It was the climax of a cannibalising process. In 335 BC the Macedonian king Alexander III (the Great) swallowed all of Greece, which became a united kingdom for the first time. He destroyed Persian power in 331 BC and by the time of his death in 324 BC had conquered Persia and its dependencies. Meanwhile, the city of Rome, founded according to its own traditions in the mid-eighth century BC, had been absorbed by the emerging power of the Etruscans, a league of city-states in what is now Tuscany and Umbria, which dominated much of Italy in the first half of the first millennium BC. In 510 BC, however, Rome threw off the Etruscan yoke, and in the next 250 years incorporated not only Etruria but the whole of Italy into the Empire. By 275 BC this process was complete, and Italy had been bound together by the construction of a universal road system and the foundation of Roman, Latin-speaking colonies. Through her wars with Carthage, ending in its total defeat and destruction, Rome acquired Sicily in 241 BC, Sardinia in 238, Spain in 206 and northern Africa in 146. Greece was finally absorbed in 147–146 BC, and the conquests of Alexander in Egypt and Asia were added in due course. Rome 'pacified' (i.e., occupied) Cisalpine Gaul in the early second century BC and had swallowed the Dalmatian coast by 129 BC.

In this cannibalisation process, which made Rome by far the largest and most durable empire the world had yet seen, two elements were more important culturally than any others. The first was Etruria. Who the Etruscans were was a matter of debate throughout antiquity and it has never been resolved. Archaeology, however, suggests they were probably an indigenous people of central Italy with their own language and religion. No major Etruscan city has yet been systematically excavated, but we possess sufficient of their artefacts to realise that they were one of the most

gifted peoples of the first millennium BC. They made beautiful jewellery of great virtuosity. There is, for instance, in the British Museum a pair of gold bunch earrings from Populonia (about 350 BC) which is finer than anything we have from classical Greece. Etruscan bronze-casting was delicate and ingenious, and they used bronze extensively for high-quality furniture, such as the rod-tripod, supporting a huge circular pot, now in the Copenhagen Museum. They also specialised in finely cast and wrought toilet mirrors and other accessories. Outstanding examples include one with an elegant rape scene (*The Rape of Mlacuch by Herkle*) in the British Museum, another in the Louvre featuring a panther (fifth and sixth centuries respectively). These toilet goods were designed to be placed in a container called a cist, a round upright canister, engraved on the sides and surmounted by a lid with bronze figures constituting a handle. The one in the National Museum in Rome, found at Palestrina and datable from about 320 BC, is of superlative quality, both in its engraving and its bronze sculpture-handle, and must be considered perhaps the finest dressing-table item to have come down to us from antiquity.

We have about a hundred of these cists, not always of high quality, which suggests they were exported, for the Etruscans had in the sixth century a powerful fleet and export trade and at one time controlled Corsica and other islands. They also exported painted terra-cotta, on which they executed fine-quality sculpture, using it to decorate the wooden roofs of their temples. From the fourth to the third century BC, they used terra-cotta for life-sized figure-groups, though not on the same scale, or with the same proficiency in depicting faces and features, as the Chinese of this period, culminating in the army of 6,000 figures buried in the mound of the first Emperor of China, Qin Shi Huangdi, 'the Tiger of Qin, created in 212 BC. However, it must be said that some Etruscan terra-cotta heads, such as that of a young man from a temple pediment (about 150 BC) in the Florence Museum of Archaeology, are as sensitive as anything their Chinese counterparts produced. The Etruscans also cast life-size figures in bronze, like the one of Mars in the Vatican Museum (about 420 BC), a sophisticated piece of work, clearly influenced by the Greeks but with a distinctive smooth and felicitous style of its own.

The Etruscans did not carve much in marble, like the Greeks; more in hard-stone, like the Egyptians, fashioning massive and impressive sarcophagi—the lime-stone one in the Vatican *c.*450 BC is a good example. It too shows a strong Egyptian influence, as does their tomb-work as a whole. The Etruscans followed the Egyptians in using the large wall-surfaces of rich men's tombs to depict jovial scenes of every-day life, which cheered up the departed and persuaded them that pleasure was not all over. In the Tomb of the Leopards at Tarquinia, a riotous banqueting scene is in progress, while leopards prowl on the pediment above. Also at Tarquinia is the Tomb of Hunting and Fishing, where Etruscans in boats scatter and kill waterfowl. We find, in the Tarquinian tombs, all of which date from 550 to 450 BC, a vivid picture of

Etruscan entertainments, dancing, sport, wrestling, racing, romancing, feasting and conversation pieces, while animals and devils circle the living in menacing postures. None is as good as the highly sophisticated painted tombs of Egypt. On the other hand, much of it is better than Greek painting, though granted the pitiful nature of what survives in this medium, that is not saying much.

The Etruscans copied or were influenced by Greek vase-painting, producing both black and red work in considerable quantities. They took their vase designs from a wider variety of sources than the Greeks, including oriental models. They also had a type of their own, known as the *bucchero*, made from an impasto-type clay and fired to a lustrous black tone which looks like bronze or even iron. They adapted the standard Greek forms for large-scale pottery and often copied Greek figure-motifs. But they handled these themes, both in potting and painting, with considerable panache. Some of the hydrias and other big pots in the Florence Archaeological Museum, which has the best collection of Etruscan ware, are better made and finished than their Greek equivalents.

In due course, the Romans absorbed all the Etruscan workshops, in bronze, silver and gold, terra-cotta and pottery, especially the last. One of the reasons the Romans were not much interested in Greek pots is that they had as good or even better at home. It is significant that, by the second century BC, Roman potteries were using techniques which were well in advance of Attic methods. They also excelled the Greeks in high-quality glassware, especially for presentation pieces. They imported from Syria an entirely new method of blowing glass, and could blow it in two layers. For instance, an opaque white layer was placed over a translucent one of cobalt, and the white layer was then cut away like an ivory cameo, leaving a decorative frieze of figures against a forest, rocks, seashore and mountains, with the deep blue infill of the cobalt. This was how they produced the so-called Portland Vase, now in the British Museum, which dates roughly from the time of Julius Caesar—it may even have belonged to him for it is a fine piece, dug up near Rome in the sixteenth century. The theme of the decoration is Peleus and Thetis, but what is depicted is a muddled Roman version of the original Greek myth, which would have caused Greeks of the period to look down their cultural-superior noses at it as

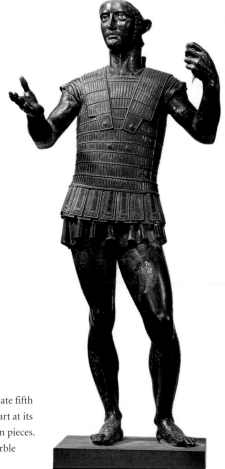

This bronze statue of Mars (late fifth century BC) shows Etruscan art at its best. Hollow and cast in seven pieces. The left eye is Traventine marble with a black resin pupil.

a typical example of Roman barbarism. But the quality of this famous pot, which once belonged to the Dukes of Portland (hence its name), is well beyond anything the Greeks could produce, thanks to superior technology—visible proof of why Rome cannibalised Greece and not vice versa.

If Etruscan culture underlay much of what became Roman sophistication, the bulk of Rome's culture, both under the Republic and in the burgeoning Empire, came from Greece, especially from Athens. Roman Republicans recognised Greek cultural superiority. They spoke and read Greek—it was the language of the leisured class throughout the Mediterranean from the third century BC to the fourth century AD. For a time they revered Greek political institutions and would have been prepared to allow Greece a measure of independence if its leaders, by now petty men, had been co-operative. But once Greece was swallowed up, the Romans plundered it of its best artefacts, especially statues, and continued to do so until most of the temples and shrines, holy places and cities had been stripped of their treasures, which went to Rome, whence in time they mostly disappeared. What Elgin was later to do on a tiny scale, Augustus and Nero, Trajan and Hadrian did on an enormous one, and whereas Elgin paid for his marbles and preserved them, the Romans simply stole, and then lost them all. But they also copied, assiduously, and on an immense scale, and some of these, as we have seen, survived all vicissitudes to adorn Western museums today.

Roman culture, then, had a largely Etruscan base and an overwhelmingly Greek superstructure. But it had Roman elements too. What Romans were good at were law and justice, war and defence, communications and transport, the conquest of dangerous and destructive barbarians, and the suppression of organised brigandry on land and piracy at sea. Hence, once the Romans were established in power all over the Mediterranean, it became a pacific inland sea bordered by huge, prosperous towns and splendid estates and vineyards, a vast area where the rule of law prevailed, where trade, industry and commerce begat vast wealth, and where men could hang on to their wealth, bequeath it and lavish it on civilised living.

Thus if the Romans did not as a rule do things better than the Greeks, they did them much more often, on a larger scale and over a much wider area. The Greeks spread their culture over Magna Graecia and the fringes of the Levant and North-East Africa. The Romans did all this and more—they added most of Europe. Indeed they effectively created Europe as the 'natural' centre of civilisation, a position it held virtually to our own times. Moreover, they added one man-made material which was central to all this grandeur and monumentality—concrete.

The reader will have become aware by now that a determining factor in the progress of the arts is the quality and availability of raw materials, and the success of human beings in making use of them. Animal bones and wood, pebbles, boulders and flints were the materials of the Stone Age, and early men and women made remarkable use of them as we have seen. Then followed the smelting of copper, of bronze,

and of iron. That meant far more efficient and plentiful tools for the manipulation of stone which, since the Old Kingdom in Egypt, had been universally recognised as the best material both for monumental buildings and for sculpture. In addition, the discovery and, more important, the refinement of the lost-wax process raised cast bronze to the level of the best marble, especially when it came to life-sized figures. What first the Egyptians, then the Greeks, did with stone was truly marvellous and was not surpassed until the closing centuries of the European Middle Ages. But stone had its limits as a building material, especially in the large-scale enclosure of space. The Greek temple form, based on timber roofs supported by columns, remained the basic unit for monumental building because there was no obvious alternative to it. Architecture was, literally, petrified, its stone externals concealing a good deal of long-beam or scarfed timber support-work within the entrails of the buildings.

The merit of concrete was that it offered an alternative both to stone and wood, and combinations of both. Like bronze, it is a synthetic material. It is composed of aggregate—that is, small pieces of hard materials, such as stone, broken brick, flint and clinker, with sand added, the whole bound together by mortar, usually made of cement and lime mixed in water. A mortar made of lime, obtained by burning calcareous rocks, was certainly known to the Egyptians, who used it as a kind of plaster for tomb walls. From Egypt it became known to other ancient peoples and reached central Italy in the third century BC. Almost by accident, it seems, the Romans started to use, as sand, a volcanic ash of a siliceous kind, which they found at Pozzuoli near Naples, and discovered that it made a lime mortar of such power and versatility that it set solid immediately, and hardened even under water. Without being quite aware of how it worked, the Romans began to use pozzuolanic mortar as a binding agent with a mixture (*caementa*) of stone chips, brick nuggets, broken tiles and other hard materials, the operation being carried out on the building site itself, and the product slapped on quickly. This *opus caementicium*, as they called the method, was put into timber shuttering or formwork, and laid out as courses running continuously across major buildings, and especially for piers, arches, vaults and main walls. In time the Romans learned to dispense with the shuttering, using stone instead, and as concrete was hideously ugly—it still is over 2,000 years later—they put a film of stuccoing on both exterior and interior.

Concrete proved immensely strong, cheap and easy to use, and the Romans, as they strengthened their grip on Italy, and expanded their Empire, employed it in ever-increasing quantities for the infrastructure of roads, bridges, aqueducts, viaducts and harbours, which was the secret of their success. Their troops, absorbing all the lessons of Alexander's conquests, and adding a sense of discipline which the Greeks never possessed, were the wonder of antiquity. Concrete helped the Roman authorities to get the troops wherever they were wanted, in the largest possible numbers, at the maximum speed, and with their heavy equipment. Once Roman military power was established, the excellence, uniformity, relative impartiality and

honesty of Roman law ensured that the inhabitants of Romanised provinces were, on the whole, well content. Concrete, then, was an essential element in the material structure of the Roman Empire, which reflected its strength and durability.

But was it something more? The Romans took their culture from Greece, their openly admitted superior in this respect, but in time concrete—and the added wealth and universal transmission of goods which it made possible—enabled the Romans to do things which the Greeks had never even contemplated. Thereby the Romans were able to give architecture a grandeur which is their principal achievement in the arts. The salient element in grandeur was size. In the twentieth century we became accustomed to dismiss mere size as an artistic element, though it is often impossible to achieve sublimity without it. But to our forebears size was a key component of art, if for no other reason than that it was so difficult to achieve. In the Dark Ages after the fall of Rome in the West, ordinary people judged the greatness of Rome by size, so that every ruin which impressed by its magnitude was referred to as 'Caesar's Camp' or 'Caesar's Tower' or 'Caesar's Fort', whatever its age or provenance or, indeed, purpose. For a thousand years, until the sixteenth century, Rome was the standard of achievement, power and majesty, so that men and women, seeking encouragement to excel, looked backwards to the fallen Empire. It was the sheer size of Rome's ruins which caught their imagination.

Concrete, then, was the foundation of both the reality and the myth of Rome. Rome, and its empire, were indeed set in concrete. The Romans were a practical people. They thought, first and foremost, in terms of infrastructure. Four needs were particularly important to them: fast travel, pure water, good sewers and personal cleanliness. All had a direct bearing on the arts. The Roman Empire was expanding fast during the last decades of the Republic, and continued to expand for the next 150 years. It embraced what are now thirty different countries of Europe, North Africa and the Middle East. Trade was conducted on an enormous scale, along roads which permitted fast wagons to travel over 100 miles a day, and in ships which were sometimes 200 feet long and could carry a cargo of 500 tons. The radius of trade was over 6,000 miles. Its scale was vast. Pliny in his *Natural History* says that 50 million sesterces went annually on imports from India and twice that amount on Chinese and Arabian products. The trade in marble was particularly important, for as Rome's wealth expanded, the custom grew of clothing brick buildings almost entirely in marble, on concrete foundations, with porphyry and coloured granite as variations. Of the thirteen principal marble quarries of the Empire, only Carrara, famous for its white *marmora lumensium*, was in Italy. Mount Pentelikon, which supplied the huge blocks used in the Arch of Titus, Thasos and Thessaly, famous for green *verde antico*, were in Greece; Prokonnesus and Dokimeion, which provided violet and white *pavonazzetto*, were in Asia Minor; Chemtou, yellow *giallo antico*, was in Tunisia; and Mons Porphyrites, Mons Claudianus and Aswan were in Egypt. As land transport was at least ten times as expensive as shipping, prices depended largely on accessibility to

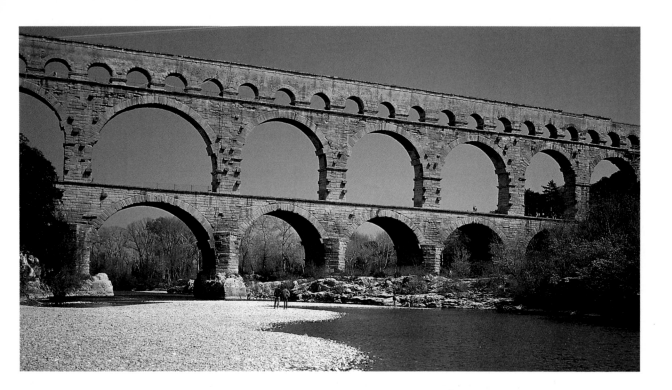

water—Dokimeion marble was the most costly of all simply because its quarries were so far from the sea.

To cheapen land transport, the Romans built heavy weight-carrying bridges as well as roads. Given the means available, these were the best bridges in history. Caesar, in his *Gallic Wars*, describes how rapidly the army could cut trees and erect a bridge of piles and beams to cross the Rhine. With concrete, they could lay underwater foundations capable of supporting huge arches in the roughest weather. The tolerances of their hewn and carved voussoirs were so exact, in the best Egyptian tradition, that they could be put in place, and hold, without mortar. For the larger bridges, the Romans put down cofferdams, an invention of theirs. Of the thousands of bridges they built, over a hundred survive in whole or in part, often concealed beneath medieval and later repairs. The Ponte Sant' Angelo in Rome, 134 AD, a graceful and much-decorated concept, is one of three which still carry traffic across the Tiber. Likewise, the bridges at Salamanca and Mérida in Spain are still doing good service on main routes.

Rome's success at bridge-building with the arch made the authorities much more ambitious in supplying major cities with fresh, pure water. From 312 BC onwards, no less than ten water-supply systems carried water over long distances to Rome, and aqueducts had to be built to bridge the gorges between Tivoli and Palestrina and to cross the low-lying Campagna. The scale of these operations was impressive: one continuous section near Rome was over a mile long. In general, Roman monumental architecture was built on strength and quality of materials, rather than ingenious contrivance. But the imperial aqueduct at Segovia, built in the mid-first century AD, employs a nice calculation of stresses, as do later examples at

Mérida and at Cherchel in Algeria. The most impressive of all, and virtually intact, is the Pont du Gard in Provence, which supplied water from the Fontaines d'Eure to Nîmes, a distance of 30 miles.

Nearby, in Nîmes itself, is one of the most perfectly preserved of all Roman buildings, the Maison Carrée, which was turned from a temple into a church in the early fourth century and so survived. This is in the Corinthian-column style, the favourite mode of the late Roman Republic and early Empire, but its plan and appearance are essentially Greek and it illustrates the strength of the Greek way of doing things, especially sacred things, even under the Empire. When the Roman ruling class raised their minds to higher things—religion, poetry, philosophy—they thought in Greek. But as the Empire spread, and the rulers grew richer, the essence of Greek *civitas* was watered down. The ideal Greek city, in which every citizen participated in cultural, sporting and political events, and buildings were designed to accommodate all of them, was no longer possible under Rome. A third well-preserved building at Nîmes is the amphitheatre, which could seat 25,000 people comfortably and probably accommodate 100,000 for a grand event. It is out of scale with Greek city life. It had solid concrete foundations and concrete, brick and stone piers, with radial vaults underneath the seating and sixty arches on each of its two tiers. It is hugely impressive in size and solidity but built as much for grandeur as for use: a comparison with the

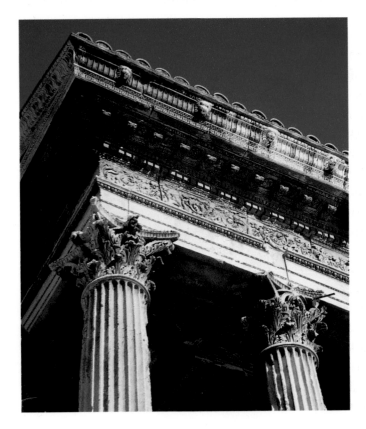

Details of the Maison Carrée at Nîmes (4 AD) form a perfect example of Roman Corinthian style. It owes its survival, virtually intact, to its use as a Christian church.

simple, perfectly functional Greek theatre at Epidaurus illustrates the important distinction between Roman superabundance and Greek balance.

There is a similar amphitheatre at Arles nearby. Such structures—about a hundred in number, possibly many more—dotted the shores of the Mediterranean when Rome ruled. The biggest of all was the Colosseum, built in Rome by Vespasian and his son Titus, 70–80 AD. It has an elliptical shape about 600 feet by 500 feet on its chief axes. There is a huge basement for the wild beasts and gladiators, a central open space of about half the total dimensions, and three tiers of seats, linked by perhaps another 100,000 standing (the population of Rome was by then 1 million, rising to 2), though it is hard to give exact figures as virtually all the seating is gone. There was special accommodation for the emperor, the head of the games, the Vestal Virgins, consuls and other officials, millionaires and about six other categories of citizens. The material was concrete, brick-and-concrete, stone and tufa, the Roman equivalent of modern breeze-blocks. Cheaper materials were usually concealed. Everything was strongly, indeed massively, built, which helps to explain why so much of this enormous building has survived Rome's numerous enemies, external and internal. It is undoubtedly more beautiful as a ruin than it was in its functional glory, and its ruinous state would have been more pleasing had not the authorities patched it up with yet more concrete in places.

Tens of thousands of artists—virtually all who have dwelt in Rome since the fifteenth century—have found the Colosseum a wonder worth drawing. But it is essentially a utilitarian building. It was equipped with enormous nets and cranes, for lifting up the ferocious beasts and depositing them at the access points of the arena. It had thousands of square feet of canvas awnings, and a system of ropes and pulleys which allowed them to be spread like a series of huge sails to shade the audience. There were no fewer than seventy-six numbered exits and entrances, which enabled the public to present their tickets, or leave the building, with all possible speed. Regiments of fully-armed soldiers preserved peace and order, and about a thousand sailors from the fleet operated the awning system. It was a place of blood and squalor, of unspeakable pride and pointless courage, and some of its seedy grandeur still clings to the walls. The Colosseum was in operation for about 700 years and remained virtually intact even after the iron clamps which bonded its huge stones together were removed at the end of the seventh century AD. Indeed, it took the earthquake of 1349 to do it serious structural damage. After that, however, the stone-plunderers set to work, and much of the Colosseum's original mass now forms part of St Peter's and its monumental surrounds.

Concrete also played a key part in the construction of the building which is, perhaps, the most remarkable survivor of all the arts of Rome, the Pantheon. This, like the Maison Carrée, is intact thanks to its early role as a church. Here is the place to make a general point about the architectural ideas of Greece and Rome. Although they form a continuum, it is important to grasp that the Greeks thought very largely

The Colosseum, Rome, held 45,000 spectators and was the Empire's largest amphitheatre. Built with speed and economy using concrete vaults, brick ribs, and paying attention to sightlines and circulation.

in terms of straight lines and oblongs. The Romans did so too, but they were also attached to curves, arches, ellipses, ovals, circles and semicircles. They broke away from the tyranny of the essential column and contrived to enclose vast spaces without any visually obvious means of support. It was achieved in a characteristically strong-arm way, with a lot of muscle and size and little invention, but it was achieved none-the-less. The Pantheon shows this approach at its most successful. It was built by the Emperor Hadrian when the Empire was at its zenith, and was erected on the site of an earlier building dedicated to the many gods of Rome by the piety of the ruling family. It was designed to shock—that is, the Romans entered through what appeared to be the porch of a traditional straight-line temple supported by tall columns. Then vast bronze doors opened into another world—a gigantic circular space, roofed and crowned by a hemispherical dome which rose to a height of 150 feet and seemed to be held in place by nothing. There was a vast amount of interior decoration: magnificent columns of rare marbles, statues, free-standing and in niches, a chequerboard floor of marble in squares and circles, and a sculptured series of cornices. But the eye was drawn irresistibly upwards, to the 140 square coffers of the dome, arranged in five superimposed rows and, in Hadrian's day, decorated by rosettes of gilded bronze.

Except for the entrance and decorations, the entire building is in concrete. That is its secret. Or rather, there is no secret. The key elements are size and strength. The vast

circular building was erected by superimposing endless horizontal layers of concrete (just like brick courses) and then constructing a concrete dome over a complicated framework of wood. The stability of the whole was reinforced by radiating brick vaults, which are double-tiered, go right through the thickness of the walls, and span the niches within the structure, thus distributing the vast load above onto eight huge piers below. The structure, though audacious—nothing like it had been attempted before—was essentially simple. But great attention was paid to the details in order to provide strength. Analysis of the concrete shows that it was made on the spot in different consistencies, using varying aggregates, very heavy ones near the bottom, lighter ones in the dome. Armies of unskilled, possibly slave, workmen put it up under close supervision from a few-score expert engineers and craftsmen—a typical Roman arrangement.

The Pantheon is the apotheosis of the dome in antiquity, but of course it was not the first to be built. We have already noted the tholos tombs of Mycenae, such as the 'Treasury of Atreus', where the covering was provided by a corbelled beehive roof. Curiously enough, the classical and Hellenistic Greeks were not interested in domes, any more than in curves—they were 'uncanonical', a concept that was associated with a straight line. But the Romans liked curves, and concrete made them love domes, curved vaults and arches of all kinds. Such devices were particularly useful in their pursuit of routine cleanliness and health. Thus, when Marcus Vipsanius Agrippa decided in 33 BC to reconstruct the Roman drainage system, originally an open canal running through the city, past the Forum into the Tiber, but enclosed in the second century BC, he created a gigantic vaulted drain known as the Cloaca Maxima, the model for bricked-in city sewer systems ever since. This was the kind of thing the Romans were not only good at but delighted to make enormous and monumental, with low risks and high finish. In the Alps and Apennines, and in many other mountainous regions, they drove tunnels of varying length through the living rocks, sometimes reinforcing the interiors with brick and adding concrete for strength. Some of these tunnels, like their bridges, are still in use—there is one at Posillipo near Naples almost a mile long—albeit added to and strengthened in places. The Romans also carved viaducts through mountains, facing them with concrete to keep rocks and soil stable.

Sewers and tunnels were, of course, essentially works of engineering, rather than art. But the successful use of arches, vaults and long-distance space enclosure persuaded Roman architects—who were many and honoured, says Cicero, on the same level as lawyers and doctors—to go for grand projects which involved the enclosure of space for pleasure and luxury. Soon after the Great Fire of Rome in 64 AD, the architects Severus and Celer were commissioned by the Emperor Nero to create for him a vast palace between the Oppidan, Palatine and Caelian hills. It covered a site of over 200 acres and embodied the latest architectural technology, being the first palatial building to use concrete. The entrance court, opening from the Forum Romanum, was dominated by a colossal 100-foot-high bronze statue of

Nero, as big as the Colossus of Rhodes. Within were a number of spectacular buildings, including a hall with a rotating dome, used for banquets, and a large octagonal hall, crowned by a dome, with vaulted chambers, one containing a cascade, opening off it. Some of the painted decorations on the ground floor, by the master Famulus, survived and were uncovered in the years 1480–1520, when collectors and artists of the High Renaissance, searching for statuary, removed vast quantities of rubbish. Excavation of the site continues but the chances of big finds are small.

Much more survives of the vast palace and retirement home which the Emperor Diocletian built at Split (Spalato) on the Adriatic, about 300 AD. This was an ambitious project, since it needed to combine the luxury of a palace, the transport services of an administrative centre, the delights of a country village, and the security of a fortress. It also served to house the emperor's mausoleum, in a circular domed structure (containing what are believed to be the portraits of him and his wife, Prisca). It adumbrates, indeed, the great mid-sixteenth-century palace-monastery, the Escorial, which Charles V and Philip II built near Madrid. With its endless arcades and steps leading to the sea and docks, it is exactly the kind of classical building which inspired the Claudian visions of antiquity. It was so big that, after the collapse of Roman power, locals moved into it for security and it became a rambling, ruinous town. They ensured that a good deal of it survives, including three out of four of the massive corner towers, though the private apartments were thoroughly robbed. The palace covers well over 10 acres and nothing that is left of imperial Rome is more calculated to set the imagination resurrecting its immensity and splendour. Robert Adam, the Scottish architect, visited it in the early 1760s, took copious notes, published a book on the subject and used its motifs and ideas in launching his classical revival. There is a splendid re-creation of it in Rome's Civic Museum, enough to make any dictator's mouth water.

All such palaces incorporated elaborate bathing suites and pools, and so needed plumbing of the highest possible quality and elaboration. Indeed, next to concrete itself, sophisticated plumbing was the great Roman contribution to architecture. Emperors and rich men, seeking popularity, built baths for the public. These gradually increased in size and were set in elaborate gardens, with restaurants, drinking houses and brothels adjoining. We know the sites of over a hundred of these places, and some have survived remarkably intact. But only the Baths of Caracalla in Rome still give a clear idea of how Roman benefactors combined monumental public architecture with gardens and the latest plumbing. They were built from 216 to 230 AD and were still in use 300 years later.

Before the Caracalla Baths could be built, a huge work of earth-moving was needed to build up a platform, abutted by giant cisterns, which received water from a special aqueduct linked to Rome's main water supply, and fed the bathing system. The cisterns were masked by tiered seats serving a

The Pantheon, built by Hadrian, demonstrates Roman skills at space-enclosure. Its survival, as a Christian church, showed Renaissance architects how to do it.

theatre. Nearby was a library. Around the baths and in the surrounding gardens, a series of buildings provided every kind of cultural and social activity. But it was the baths themselves which excited wonder—with their gilded stucco and glass mosaic vaults, marble walls and marble floors incorporating mosaics. Many of the decorative features—the rare marble columns and capitals, for instance—were of the highest quality, and were eagerly cannibalised for the buildings of medieval Rome, such as S. Maria in Trastevere. Statues were dug out of the ruins as late as the mid-sixteenth century (e.g., the Farnese *Hercules*) and in 1824 excavations recovered the so-called Athletic Mosaics, now in the Vatican Museum. Again, the Civic Museum in Rome has a huge scale model reconstruction of the Caracalla Baths, which reveals the immensity of the domed concrete *caldarium*, or lounging room with hot pools, a circular monstrosity over 120 feet in diameter.

Models apart, most Roman cities have disappeared beneath the modern accretions of which they were the foundation—Paris and London being obvious examples. But where cities ceased to be inhabited, and were covered in sand and debris, it has sometimes been possible to reconstruct them. An outstanding example is Leptis Magna, near Tripoli in what is now Libya. This large city was silenced by the Arabs in 643 AD and then engulfed by sand dunes. It had been a Carthaginian commercial port trading in olives and grain, was rebuilt on a larger scale by Augustus early in the first century AD, and 200 years later was glorified by Septimus Severus, who was born there. With a surface area of 1,200 acres it was four times the size of Roman London. Its public bathhouse was of great magnificence. Septimus, early in the third century, laid out a splendid new colonnaded street, created a new forum or marketplace, of 600 by 1,000 feet, surrounded by porticoes and shops, with a vast basilica or King's Hall as its climax. The hall had three aisles, an apse at each end and was 100 feet high in the middle. Although its strength lay in its concrete frame, it had marble columns from quarries all over the Empire: red and pink Egyptian granite from the Nile, green marble from Euboea, white marble pilasters from Carrara and a mass of statues and carvings.

Septimus also set up a four-way triumphal arch, adorned with notable sculptures, though these are no longer on site but in the Tripoli Museum. An entire harbour of 24 acres, complete with quays, lighthouse, watchtower, warehouses and a temple has been excavated from its silt, and nearby archaeological teams have uncovered a superb hippodrome and amphitheatre, linked by a bridge-cutting. This is engineering on the largest possible scale, conjuring up the visions of the Venetian architect Piranesi. But the city also sports an exercise in Roman concrete engineering in miniature: an almost perfectly preserved small bathhouse, called the Hunting Baths because it was used by a club of commercial huntsmen (as we know from wall decorations) whose trade was to capture wild animals alive and transport them to Rome for use in the Colosseum. Here, the working structure of the baths, a succession of two domes and three half-cylinders, is not concealed, as in grander Roman

baths, by pitched roofs. They are laid bare for all to see, which gives the building a modernistic look.

Leptis Magna provides a clear idea of what a Roman city looked like because its uncovering from the sand did not take place until the inter-war period, when Italian archaeologists set to work as part of Mussolini's programme of re-creating the Roman Empire. Ephesus, in western Turkey, by contrast, has been picked at and altered by semi-trained enthusiasts over nearly 200 years. A British Museum team found the main temple, a Hellenistic affair, in 1869, after spending 6 years looking for it. It was sunk 30 feet deep in a swamp. With the aid of traction-engines, which pumped out the mud, its foundations were finally revealed. They contained a hoard of over 3,000 gold, silver and ivory votive offerings, from jewellery to statues. Ephesus was the cult city of the goddess Diana, and gave rise to one of the most dramatic scenes in the Acts of the Apostles, when the devotees of Diana of the Ephesians were marshalled to shout down St Paul and his Christian missionaries. During the last half-century, further investigations by an Austrian team have confirmed the impression that Ephesus was one of the richest cities in the Empire. It is also the most accessible and evocative to modern eyes, especially for those who want to get a clear impression of what a major city looked like in Roman times.

By contrast, the great site of Baalbek in the Lebanese mountains, on the road from Beirut to Damascus, was not a town but a religious unit, dominated by three large temples, including one to Jupiter which is among the biggest ever constructed. The Romans began to pile up an artificial mountain on which to build it almost as soon as the area was colonised in *c*.16 BC. This provides a podium nearly 60 feet high, gained by a magnificent flight of steps. The temple has ten columns across the façade (of which six remain), and nineteen down each side, all of limestone, unfluted but set on massive pedestals, with huge Corinthian capitals above. The shafts are nearly 70 feet high and must be the highest ever erected even by the Romans. As Lord Curzon correctly observed, this temple platform is the only rival to Persepolis. The setting, high in the hills, with spectacular views on all sides, is incomparably grand. The English traveller Robert Wood explored the site in 1753, and the details he published on his return had an immediate and lasting effect on the building of country houses throughout Britain.

Baalbek contains lessons for all students of Roman engineering and architecture. Given a wealth of manpower, both slave and free, but lifting equipment which was comparatively primitive even by the standards of the men who built Europe's medieval cathedrals, the Romans were extraordinarily skilful in overcoming difficulties of size, scale, weight and volume. The chronology of this and other huge structures they completed suggests that they worked at remarkable speed. They saw, they planned, they built: no committees, no arguing, no cost-conscious second thoughts. What resulted usually impressed succeeding civilisations and ages. No one who wants to grasp the grandeur that was Rome can miss seeing Baalbek. There is

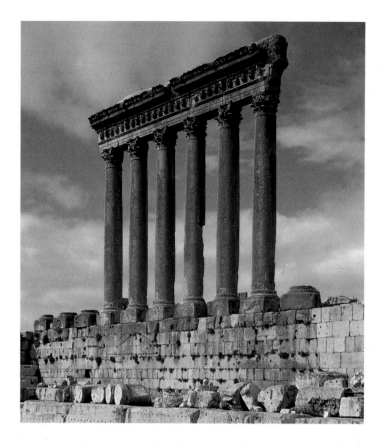

The Sanctuary of Jupiter at Baalbek has columns 60 feet high, the tallest of any classical temple. Built around the time of Christ, it towers 3,500 feet above the Bekaa Valley, Lebanon.

great, though less obvious, refinement too, both in the giant Jupiter Temple and in the smaller temples of Bacchus and Venus. But the scale is what you remember. Size is certainly not everything in architecture. But it is a great deal, as witness the pyramids of Giza and the Empire State Building. Baalbek ranks alongside them.

Much Roman building was the result of the desire of Rome's great men to perpetuate their memories. Baalbek's Jupiter Temple and the huge bathworks in Rome were part of Caracalla's programme of self-aggrandisement. The Empire, as it expanded and flourished, was an opportunity for its rulers to enrich themselves 'beyond the dreams of avarice', and public building was both an excuse to justify those riches and a genuine attempt to benefit the public. Julius Caesar, with his loot from the conquest of Gaul, rebuilt the Roman Forum. His younger contemporary, Herod the Great, rebuilt the Jerusalem Temple, to please the Jews (unsuccessfully, for they were stiff-necked), and also built a port at Caesarea and half a dozen new cities to expedite the Hellenisation of Judaea. He paid for public buildings all over the Near East to ingratiate himself with the Emperor Augustus. Pompey built a great theatre in Rome to please the citizens. Augustus himself made artistic adornment and the provision of elegant amenities his main domestic policy.

One way in which these great men hoped to keep their memory fresh was by erecting mausolea and triumphal arches. The original mausoleum was built by Queen Artemisia at Halicarnassus in memory of her husband (and brother) Mausolus, Satrap of Caria under the Great King. He died in 353 BC and his white

marble tomb, designed by Pytheos, was one of the Seven Wonders of the Ancient World. Some time before the fifteenth century, an earthquake caused its collapse, its site was investigated by Sir Charles Newton in 1857 and many fine pieces of marble from it, including colossal statues of Mausolus and Artemisia, were brought to England and are now in the British Museum. Roman emperors were particularly anxious to have grand mausolea of their own. Hadrian, one of the most successful, rich and powerful of them, began his in 130 AD on the right bank of the Tiber, opposite the Campus Martius. It took nearly ten years to complete and was made of concrete and travertine faced with marble, with a podium-like square base, an enormous circular drum and a top adorned with statuary and cypress trees. To complete the project a new and grand bridge was built across the river. The bridge is now the Ponte Sant'Angelo, the drum has become the Castel Sant'Angelo, and its massive walls, with a spiral ramp within, have served as a papal fortress for a millennium and a half. The essential structure remains, but endless alterations have robbed it of whatever beauty it once possessed. I have drawn and painted it on many occasions and cannot make it look anything other than ugly. But it has an unforgettable profile, made even more illustrious since new St Peter's was built, 1,300 years later, to rival it and complete the panorama. But Hadrian is remembered not so much for his mausoleum as for his purely military wall across northern England, which in places creates an unsurpassed man-altered landscape, and for a statue now in Rome's Capitoline Museum. This is a fine copy of a cult statue by the Athenian sculptor Alkamenes, done in about 420 BC, on the shoulders of which Hadrian's helmeted head has been incongruously stuck. He is naked but his penis is missing.

The triumphal arch was a Roman invention, one of many they added to the vocabulary of celebratory architecture. There are a large number of these arches scattered through the Empire—more than fifty are mentioned in written sources—and three of particular importance in Rome itself. The Arch of Titus, erected chiefly to celebrate his victory over the rebellious Jews, is a classic exercise in architectural proportion. It occupies the key spot at the highest point on the bottom end of the Forum and is a simple piece of design in high-quality Pentelic marble. The decorations within the arch are of unusual sophistication and great historical interest—no one ever carved high-relief horses better and the spoils of Jerusalem are rendered in fascinating detail. This panel, on the north side, had it been preserved intact, would have ranked as one of the finest products of antiquity, and it is amazing to think it is still *in situ*, exposed to all the hazards of a vast modern city. By comparison, the Arch of Septimus Severus, at the top end of the Forum, though bigger, grander and far more heavily decorated, with three arches, free-standing columns on elaborate plinths and other innovations, is an inferior work of art.

However, we must not deceive ourselves into thinking that Roman art, even at its zenith, improved on or even equalled Greek classical work. The nearest equivalent to a masterpiece on the scale of the Parthenon Marbles which imperial Rome was

able to produce is the triumphal column which Trajan erected to himself. He set it up in the new quarter of the city with the proceeds of the spoils he brought back from his victorious campaign against the Dacians in 106 AD. Designed by his pet architect, Apollodorus of Damascus, this forum and the adjacent markets were deliberately more magnificent versions of the earlier forums of Caesar and Augustus. To build this huge complex it was necessary to cut away the saddle connecting the Quirinal and Capitoline hills, which was 100 feet high. Trajan's Column, as the inscription on its base makes clear, was deliberately raised to the same height. What makes the column remarkable, however, was the decision to cover its entire surface with a stone rendering of a papyrus scroll illustrating the history of the Dacian conquests in 155 scenes. The low- and medium-relief narration is notable for its skill and continuity in handling over seventy episodes, some of them extremely complex and not easily illustrated, for its accuracy and for its objectivity. The suicide of the defeated Dacian prince, Decebalus, is treated with dignity and accorded an importance second only to the triumph of Trajan himself. Everything from the construction of a military encampment to the crossing of the Danube by a pontoon bridge is set down in realistic detail, and the minutiae of uniforms, footwear, weapons, armour and construction techniques provide information which is often available from no other sources. One may ask: how could the public look at the sculptural history thus put before them? The answer is that a nearby library provided ample reference material about the war, including scroll copies of the *Dacicia*, the monograph Trajan himself wrote about his two campaigns, the text of which has since been lost.

Nevertheless, it is true that no scaffolding was available to make it possible for the public to look at the actual scenes, except near the bottom—that would have spoilt the symbolic effect of the column. It is unlikely that any single human being has ever been able to study the entire frieze in detail. Even recording and following it with photographs poses severe practical problems. It is, therefore, akin to the innumerable low-relief sculptures and paintings in Egyptian tombs which were created to be seen not by human eyes but solely by the gods to whom they were dedicated. The column is also the first in a long process of human masterpieces which, because of their scale, size, accessibility and position, were designed to be admired from afar but not scrutinised in detail. The ceiling of the Sistine Chapel and the interior of the dome of Parma Cathedral are other obvious examples—we will examine many more later—but whereas Michelangelo deliberately painted his prophets and sibyls on a huge scale, and Correggio was a master of the *di sotto in su* technique, which uses cunning distortions automatically corrected by the eye at ground level, the head of the team which created the Column of Trajan made no such concession. But at least their artistic standards were high. The column erected in the 160s AD to celebrate the reign of Antoninus Pius shows a marked declension in skill and an unresolved confusion of styles.

The column to Marcus Aurelius, finished about 196 AD, shows a further deterioration in realism. Erected on the north of the Campus Martius, it was clearly

designed to invite comparison with Trajan's Column. But a careful examination of the two narratives shows a precipitate decline in technique and hints at the reasons for it. One spectacular scene, 'The Miracle of Rain', depicts a hirsute rain-god four times as big as the soldiers he astonishes by his benevolent downpour. Victory obtained by Roman arms, the artist declares, was thus due to the intervention of the supernatural rather than the soldiery—a point which an old campaigner like Trajan would never have permitted on a public column. The stress throughout the art-work is on the irrational, the illogical, the inconsequential and the power of magic. The great merit of the Greek classical tradition was that it faced life squarely and flinched not: it accepted the real world, portrayed it, and tried to improve it. Marcus Aurelius, gifted and sophisticated, saw life with the detachment of a philosopher, and one of a pessimistic and disillusioned bent. He wrote in his *Meditations*: 'It is a terrible thing that the soul becomes weary of life before the body is even tired.' We sense here the mood of a great society which is poised on the first gentle slope of a spiral of decline.

However, the Roman Empire was an enormously powerful entity which had impressive resources of self-sufficiency and could function even under uncertain leadership. Its wealth increased steadily in the second century AD, and any materials or skills the antique world possessed were at its command. There were still major artists in Rome when Marcus Aurelius reigned. The magnificent bronze of him on horseback is classical art at its confident best. It is the only equestrian statue of

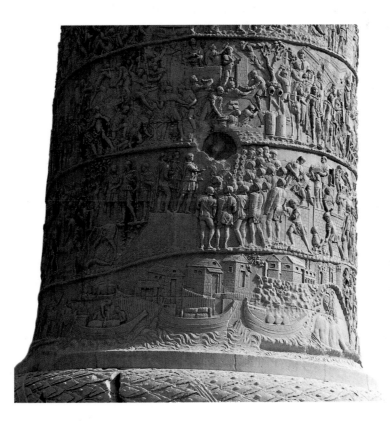

Trajan's Column, erected in 113 AD to mark his victories, has a continuous low-relief record of the campaigns nearly 700 feet long, in realistic, objective detail.

antiquity which survived the successive meltdowns of the Dark and Middle Ages. It originally stood in front of the basilica which became St John Lateran but in 1537 Pope Paul III gave it a far grander setting on the Capitol, which had been brilliantly redesigned by Michelangelo to receive it. It thus became a symbol of the way in which Italy had restored the artistic grandeur of Rome, but a symbol which concealed a mysterious abyss.

We have to face the fact that imperial Rome was never a creative artistic centre like Athens had been in the fifth century BC, or as Rome herself would become from 1450 to 1700. It was an administrative, legal and military capital which generated stupendous works of engineering but which produced few native artists. In the second century BC, after the absorption of Greece into the Empire, there was a migration of Greek artists and craftsmen to Rome, where they could make a far better livelihood. They were responsible for most of the vast trade in copies and casts of Greek statuary which soon adorned the city houses and country villas of Rome's enormous possessing class. Rome was not wholly without artists of her own. As far back as the fifth century BC, they had produced a famous image of the she-wolf which suckled the city's founders, Romulus and Remus, a gruesome object more like a lioness, now in Rome's Museo dei Conservatori (the two infants were cast by Antonio Pollaiuolo in the 1490s). But Roman patrons, once they had the money and opportunity, always preferred Greek work to Roman. Whatever the native origin of the artists, the output in Rome during the best centuries of the Republic and Empire was prodigious, as we know from the number and size of studios, supplying statuary to the entire civilised world. Some was of exceptional quality. The two marble greyhounds, male and female, dating from the first to second century AD, found at Mount Cagnalo and now in the British Museum, constitute the finest animal work to come down to us from antiquity. But such items are rare. Less than one per cent of the total has survived.

Survivors we think of as Roman, if they are of high quality, often turn out to be Greek. As we have noted, the first-century-AD *Laocoön*, unearthed in the sixteenth century and now in the Vatican, was the work of the studio dominated by three Greeks, Polydorus, Athenodoros and Hagesandros, and was a copy anyway. In some cases, I suspect, Egyptian or Greek-Egyptian sculptors were used, especially for the ultra-hard stones in which Egypt had always specialised. Two colossal statues of Bacchus and Hercules, part of a set of twelve from the imperial palace on the Palatine, and now in the Parma Museum, are of Bechen or basanite stone from the Wadi Hammamat in the Eastern Desert of Egypt. Pliny likened it to iron, and it is probable that Egyptians were brought from Alexandria at the same time to work it. Another Bechen stone work, of a youth, which dates from the time of Augustus, and is now in Rome (National Museum), also looks Egyptian. Roman artists themselves tended to work more in precious metals, such as gold and silver, which were generally used for emperors and other front-rank personages. We know from literary sources that Augustus caused eighty public statues of himself in silver to be melted

down and sold to buy gold for a statue to Apollo in the Palatine Temple. It was evidently considered bad taste to use gold except for emperors and gods.

Imperial bronzes were usually gilded, one instance being Marcus Aurelius's equestrian statue. He is also the subject of the only gold bust to escape later meltings, a clumsy work now in the Roman Museum in Avenches. The Romans did a great deal of bronze-casting but they did not improve on Greek techniques, as careful examination of a sculptor's foundry in Switzerland shows. Indeed, with few exceptions, Rome was a muscle-bound, low-technology society, which always had a huge surplus of manpower. Its rulers had no intention of adding to unemployment, potentially dangerous, by introducing labour-saving inventions. Roman sculptors in stone and marble used the same tools as their Greek predecessors. Rome, unlike the Greeks, always operated in terms of quantity rather than quality. When Greek artists came to Rome, they were welcome, and well rewarded. But after the supply from Greece dried up—and the arts in Greece were in irreversible decline by the late first century AD—surprisingly little effort was made to train Romans or provincials.

The instinct of Roman governments was to control labour, and especially wages (and prices), rather than to educate and to promote initiative and novelty. Diocletian's edict from the early fourth century, the first documented case in history of a government price-and-income policy, shows that the arts were well rewarded. A decorative craftsman got fifty per cent more than an ordinary skilled workman, and those in the category described as 'artists' got 100 per cent on top of that. There was a category of artists above this rank, but they were paid by individual negotiation and the state did not attempt to regulate their rewards. But the fact is that the practitioners of the visual arts, unlike writers of note, did not have high profiles in Roman society, even in its glory days. Great men did not defer to them, as the Greeks did and as the princes of the Renaissance were to do. In Rome, you achieved an effect by piling on the marble and porphyry, by doubling the size, by raising the gold and silver content, by gilding and embedding jewels in it, by importing immense quantities of rare plants, exotic trees and animals. The trend towards this kind of luxury living had become established under Alexander's successors, the Ptolemies in Egypt, the Seleucids and Attalids in the Near East, who built ostentatious palaces which became models for the Julian and Flavian emperors. Rome ordered the best, then doubled it. There was an ineffable whiff of the *nouveaux riches* about the top echelons of Roman society which time's patina could never quite cover.

This I think helps to explain why Rome, lacking any strong example from the Greek world, never developed a first-class school of painters. Of course we are arguing here from largely non-existent objects. The amount of Greek painting which has survived is inexplicably small and of pitiful quality. The Roman survival rate is no higher and the quality, if anything, is worse. The wall-paintings uncovered at Herculaneum and Pompeii are dull and commonplace. Later we get a lot of catacomb work which is no better. We hear of movable paintings designed to be hung on

a wall—easel paintings we would call them—but we never see them. Again, as in Greece, we are driven back to regard mosaics as the standard of two-dimensional art. The mosaic was just the sort of art form the richer Romans liked. It was labour-intensive. It used rare and costly materials. It was durable, and it could be washed and made to sparkle and astonish visitors. It was particularly suitable for their bathhouse-and-villa culture which took over from the first century AD. It also appears in the better-ordered catacombs, especially those associated with the early papacy.

A few mosaics have survived in excellent condition. There are, for example, two naked polychrome athletes which were originally part of the floors of the side exedra of Caracalla's Baths (Vatican Museum). One of the houses at Pompeii supplies a delightful floor-picture of marine life of stunning realistic detail (Naples Archaeological Museum), which contrasts with the fanciful *Triumph of Neptune* floor of black-and-white sea horses and mermaids in the baths at Ostia. The mosaic seems to have lent itself with particular success to animal life. Animals feature in the fine mosaics in Hadrian's villa at Tivoli, which also has some vivid theatrical devices, masks and so forth. These compare well with the few wall-paintings which have survived in reasonable condition, but none of them is, on the most generous estimate, great art.

Indeed, Rome from the last quarter of the second century AD was a society which could no longer provide inspiration or direction for first-rate artists. The city continued to have plenty of workshops and studios, but it had no academy or art schools, no art guilds or unions. It also had two fundamental problems, both of concern to artists and craftsmen. One was inflation, the other was external security. Both these problems increased dramatically in the third century AD. The drain of gold to pay for expensive imports from Asia, which included high-quality artefacts and manufactures (such as silk) which Roman crafts and industry could not supply, led to successive devaluations of the currency. This in turn meant that the army could not be paid regularly or in coin acceptable to the soldiers. There are three tasks which any government must perform: external security, internal order and maintenance of an honest currency. These are almost invariably interconnected, and by the mid-third century Rome was failing to perform any of them well. Two desperate and ultimately unsuccessful measures were taken. In 270–275 AD the Emperor Aurelian began a gigantic project to build a wall around Rome itself, hitherto for hundreds of years an open city. These walls, with a circumference of 12 miles, still exist in many places and have determined the shape of the modern city. They incorporated in their structure a number of much earlier buildings, such as the white pyramidal Tomb of Cestius, dating from the time of Augustus. By the standards of Roman monumental engineering, the walls were not of the best, though they were in military use as recently as 1943. Nor did they eliminate the problem of paying soldiers to man them.

Diocletian, who came to power in about 284 AD, by getting a grip on most of the army, launched a series of structural reforms. His quasi-socialist edict on prices and

incomes did not succeed in halting inflation, no more than did his successors in the twentieth century, but his decision that the Empire was too big to be run by one man from one centre, and ought to be divided up among four tetrarchs or mini-emperors, pointed the way ahead. There survives, on the façade of St Mark's, Venice, a porphyry sculpture of the tetrarchs which, though probably made in Rome, found its way to what became Constantinople, and was removed from there by looting Frankish soldiers of the Fourth Crusade, in the early thirteenth century. What is striking about this political work of art is not the affectionate embraces of the colle-giate emperors, which are no more convincing now than they were at the end of the third century AD, but the sheer poverty of the concept and the ineptitude of the carving, as though the glories of Greece had never happened, and society was back where it had been in the second millennium BC. This miserable work signals the end of the great centuries of antiquity and the beginning of a new era of narrow hori-zons and cramped visions.

A generation later, the Emperor Constantine (285–337 AD) drew an emphatic line under the old, Rome-dominated ancient world. By 324, Constantine had eliminated all his co-rulers and reunited the Empire under his sole rule. He had also decided to embrace Christianity and make it in effect the state religion. The conclusion he drew from this was that the administrative centre of the Empire ought to be moved from Rome to the junction of Europe and Asia. He therefore declared that the small town of Byzantium on the Bosphorus was to be the 'New Rome', and laid the foundations there of an enormous city, formally inaugurated on 11 May 330 AD. This was the point at which the Roman Empire began to dissolve, and the Byzantine Empire to take its place, though nobody, from start to finish, ever called it that. The population of Rome, though increasingly composed of Christians, was an obstinate centre of the old paganism. Byzantium, by contrast, was a Christian city from the outset of the move, and a convenient centre from which a new state church, totally subservient to the civil power, but accepted by the great majority of the inhabitants, could be created.

This move from pagan Rome to Christian Constantinople, as the new capital was soon called, introduced a profound change in the loyalty and identity of the arts practised under its protection. The last elements of liberty and diversity were extin-guished and art became the subservient handmaiden of the state, with an exclusively religious or rather Christian subject matter and vocabulary.

Before leaving Rome, Constantine set his mark on the Eternal City by setting up a triumphal arch. It tells a sinister tale of its own. The Arch of Constantine, erected next to the Colosseum in 315 AD, is essentially the same design as the Severan one but with an important difference. Artistically, it is the first example in history of a collage, or perhaps we should call it a sculptural anthology. When it came to the decoration of the arch, Constantine found it impossible to recruit sculptors to meet his standards, and he therefore raided monuments erected in the second century AD, when low- and high-relief sculpture still flourished in Rome. Collateral reasons for

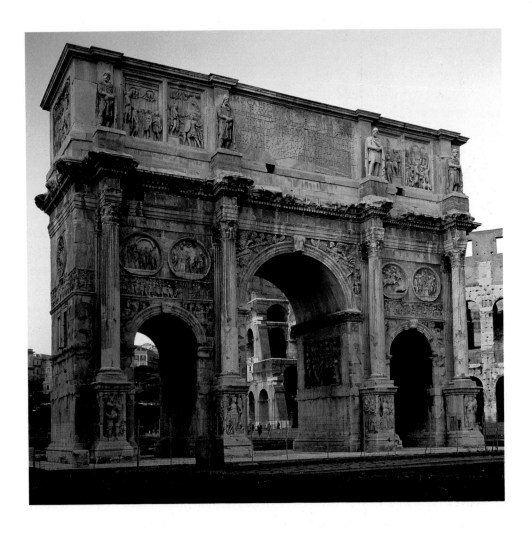

The Arch of Constantine (315 AD) is a sculpture gallery robbed from earlier monuments. Its original portions show Roman art in precipitous decline.

this unprecedented step were Constantine's anxiety to stress the legitimacy of his rule and the continuity of Roman imperial history, in particular by associating the present time with the glories of the emperors Trajan, Hadrian and Marcus Aurelius. Constantine's Arch was thus an exercise in conscious archaism, a return to a past when sculpture of a high standard was still being produced in Rome. Where sculptors of Constantine's own day were employed on the arch, especially in the narrative series which describes his conflict with Maxentius, there is not so much a degeneracy in style and symbolism as a reversion to pre-classical forms of perspective. Much of the narration is in social perspective—that is, the figures are graded in size in accordance with their hierarchical importance, five distinct sizes being used. Other archaisms or reversions to primitive art include the use of full-frontal views of key figures such as emperors. In short, the Arch of Constantine is a remarkable illustration of the extent to which, by the early fourth century, the classical tradition of humanism and realism had already been abandoned, in favour of representations of the human form which made fewer demands on an artist's skill and fitted in better with the political-religious absolutism which was taking over society.

6

MONOTHEISM: BASILICA, MOSQUE AND TOMB

The move from pagan Rome to Christian Constantinople had profound consequences for the arts which were to last for a thousand years. In deep antiquity, the arts were practised in an exclusively religious context. In Greece, and still more in Rome, the grip of religion on the arts was prised loose as secular forces, including the individualism of the artist, asserted themselves, and as more and more religious sects, including Christianity, sprang up and competed for attention, making some degree of *de facto* tolerance inevitable. In any case, polytheistic religions encouraged artistic freedom, since they lacked a compulsive single focus, and public and artists alike could select which god or goddess they chose to honour. Moreover, religion and myth, which was itself a primitive form of history, intermingled freely, so that the doings of gods and mortals were alike the subject of art.

With the adoption of Christianity, first as an option then in effect as the official religion, Constantine ended this freedom. Henceforth, devotion was focused on a monotheistic god. It is true that the new god was trinitarian in personality, and one of his persons had a mother, so that the iconology of Christianity had some of the variety of the old pantheon and a strong element of femininity too. But essentially it was one god to worship and to obey, and one to portray, and this monotheistic spirit was deepened by a panoply of dogmas enforced with increasing severity. Moreover, from the very start, Constantine adopted Christianity as a spiritual and social aid to central government. It rapidly became a state religion, and more than that: Church and state formed a seamless garment, which the population wore whether they liked it or not.

The emperor was Christ's administrator on earth. The patriarchs and bishops were senior officials of his court. It became impossible to imagine secular and clerical arms acting independently of each other. They operated, stood or fell together. That is not to say Byzantium was a theocracy. In one respect it was the reverse of one. The Church did not rule: it was ruled, absolutely. It was merely the throne in its religious capacity. But this made no difference from an artistic viewpoint. It was

essential to the practise of Byzantine government that the Church and its teaching coloured every aspect of society and gave it a uniform moral tone. In this effort all the arts played leading roles and banished from their subject matter any purely secular element. Art existed to house God, to portray him and his saints and martyred servants, and to describe his relationship with man.

Constantine thus had an ideological programme which directly determined the purpose and form of all artistic effort. From the start he embarked on an enormous programme of church-building, which was carried on by his son Constantius II, and by their abler successors, Anastasius, Justin I 'the Great' and Justinian, who came to the throne in 527. In the creation of a new church architecture, the key to all other arts, all the available resources of civilisation were employed. These included patterns developed by Judaism, first of all the monotheistic religions. The Jews had had a temple culture, in which all adherents directed their gaze to a central shrine. But the Romans had dealt the Temple two hammer-blows: the first, in 70–72 AD when the great Jewish revolt was put down; the second in 134, when Jerusalem was totally destroyed and a new Roman city built on its ruins. Thenceforth, the Jews fell back on the synagogue, a congregational meeting place serving a local community, established wherever and whenever the numbers of observant Jews justified it. The early Christians took from the Jews many of the essentials of their forms of worship, and the synagogue became the model for the earliest Christian churches. The Jews had never been great artists. By comparison, the Philistines were a more cultured race in this respect, as their artistic heritage reveals. Matthew Arnold, in coining the adjective philistine to describe one indifferent to the arts, merely revealed his own historical ignorance. As the Book of Kings shows, in building his temple, Solomon was obliged to look abroad for artists and craftsmen, and King Herod did much the same a thousand years later.

This backwardness in the visual arts is partly explained by the Mosaic Law, which forbade graven images either of God or of the creature made in his likeness, man. It constituted a problem for all the monotheistic religions which inherited Mosaic Law. But there were ways of getting round it, and the Jews did. In 1932, at the Roman caravan city of Dura-Europos on the right bank of the Euphrates, excavations uncovered the remains of a synagogue, dated 245 AD. The architecture is Hellenistic, after the Macedonian pattern. The inscriptions are in Aramaic, Greek and Parthian, as well as Hebrew. But the most remarkable aspect of the find were thirty painted panels (now removed and in the Damascus Museum) which systematically narrate the Messianic idea of the Return, the Restoration and Salvation. The imagery probably reflects that used in Jewish illustrated Bibles, which apparently circulated in the second and third centuries AD, though none has survived. The paintings digest the great events in Jewish history—Abraham and Jacob, Moses and Exodus, the loss of the Ark and its return, the reign of David, and the story of Esther and Ahasuerus. To tell the story of the Jews in pictures was not strictly orthodox, and

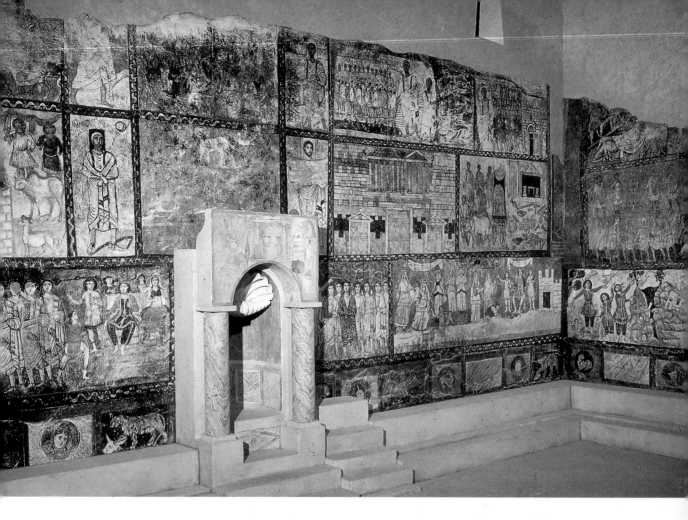

the Jews themselves abandoned the practice later. But we have here direct evidence that the Christian tradition of narrative art, centring on the events in the Old and New Testaments, was built on a Jewish foundation.

The second element in Christian architecture was supplied by the Greek temple and its successors. The oblong shape was attractive and durable; so much so that the Romans used it not only for their own temples but for a wide variety of public buildings. Under the Empire, this usage consolidated itself into the basilica, to give it its Greek name, where the emperor had his throne, if he presided in person, and where the higher offices of government were found. It was natural for the early Christians, when they came in from the cold and resumed an above-ground existence, to take buildings created for the secular king as the model for churches designed for the worship of their divine one. In some cases actual basilicas were taken over and transformed; in others the oblong shape, and the colonnades without and within, were imitated.

All the early Christian churches in Rome conform to the basilica type. They include old St Peter's, which Constantine himself began building in 330 AD, St John Lateran, also dating from 330, St Paul-Beyond-the-Walls, which dates from 380, and St Mary Major, founded in 432. These were all large and important churches, but

The Nativity Church in Bethlehem is a prototype of Christian church history: Constantine foundation (339 AD), Justinian enlargement (592 AD), twelfth-century towers and cloister.

the visitor in search of early Christian architecture can now see little of the original buildings. Old St Peter's is buried beneath the vast sixteenth-century church. St Paul was destroyed in 1823. It was then rebuilt and is certainly the most impressive of all Roman early churches, but it is a replica. St John Lateran has been so much altered that virtually nothing visible remains of its origins. There are a few touches of the imperial past in St Mary Major, which was once a secular basilica, but it requires a strong effort of the imagination to pierce through the accretions of a millennium and a half. S. Clemente in Rome, with its interior arcade of arched columns, is the most authentic, though it is much later, sixth century. There were thirty-one basilican churches in Rome alone, and more outside the walls. But in most cases only bits and pieces—including splendid marble columns—remain aboveground.

Much better preserved, indeed most noble in essence despite countless restorations, is the Church of the Nativity, Bethlehem, also begun by Constantine in 330 AD. It is one of many basilican-type churches put up in Syria during the fourth, fifth and sixth centuries. Indeed, the Syrian churches evolved a distinct type of their own, rectangular but with an entrance flanked by two towers, with columned stone arches inside and a semicircular east end. The charming, half-ruinous sixth-century church

at Qalb Louzeh in Syria is an archetype of these churches, humble but strong and dignified.

This brings us to the third element in the concoction—the use of the curve, the circle, the dome. Where the Greeks originally thought in oblongs and straight lines, the Romans were moving decisively towards the curve even before their centre of government and religion was exposed to the oriental. Vitruvius says that ancient domes existed in Georgia, and traces of them have been found, dating from the third millennium BC. But the scale was small. That was also true of Assyrian domes, of which we heard. The Egyptians and the classical Greeks hated domes as uncanonical, and one of the greatest reversals in the entire history of art came about when the classic Greek temple-oblong was replaced by the Greek orthodox dome and circle. As we have seen, the Romans came to the dome through concrete because its use made it possible to build domes over vast spaces, and so to design new kinds of major buildings which were free to include circles and half-circles as well as squares and oblongs in their ground plan. Thus the dome evolved in the search for greater freedom; it is typical of what often happens to architecture in conformist societies that this breakthrough ended in a self-imposed straitjacket of domes, large and small, which makes so many Eastern churches seem monotonous and repetitive.

From Constantine's day onwards, circular or domed churches were built in Byzantium, and along or around its main artery, the Via Egnatia, which ran from Constantinople to Thessalonika, the second city of the Empire. Most have disappeared, in whole or in part. One survivor is the Church of the Holy Sepulchre in Jerusalem, which Constantine began in 330, though this is a domed apse, containing the actual tomb of Christ, superimposed on a short, basilica-type nave. The whole is so full of moth-eaten wonders, and so scarred by two millennia of sectarian warfare, that the nature of the church hardly appears through its accreted trappings, without or within—but the uncertain touch of the fourth century, still hovering between East and West, is dimly felt.

By the sixth century, when the Emperor Justinian decided to launch his military and judicial reforms with a grand new church dedicated to St Sophia, the patron of wisdom, all doubts had disappeared. He began work on it at the beginning of his long reign, in the years 532–537, and from the start it was an exercise in circularity and curvature, crowned by an enormous dome. This effect externally is damaged by the four minarets which Islam subsequently placed at non-existent corners, and internally by the hanging prayer-circles which swing out over the vast open space. All the same, it is a highly successful effort to give Christianity the mark of the monumental and the sublime. Essentially, St Sophia is a huge, flattish dome enclosing an even larger central space, covered by two half-domes on either side. Other domed space-enclosures lead off the central abyss, and the enormous concentric structure is built up by yet further domed abutments, most of them barrel-vaulted, to enhance the theme of curvature, and walled in on the exterior by arcades. The ability to enclose

space by doming was much enhanced by the invention of the pendentive, which can be defined as an internal pier springing into semicircular arches. Thus instead of one vast dome, as in the Pantheon, there is a system of domes, capped by a dominant one, and this became the standard Byzantine pattern for all major buildings.

The build-up of these heavy, spreading structures was made possible by extensive use of concrete laid in courses and treated almost as brick. Concrete was the key to all stress-bearing domes and pendentives. But brick was used extensively too. What happened was this. The brick-and-concrete bones of the building were put up first, and allowed to settle. Then, the interior of the building was sheathed in vast slabs of decorative marble to provide an unyielding exact covering for all the settled spaces. This marble interior, the curved spaces of which were covered in mosaics, was matched on the exterior by an elaborate brickwork skin. All Middle Eastern architectural systems in antiquity made extensive use of brick but the Byzantines were the first to turn it into an art form. The bricks were about an inch and a half in depth and laid in thick beds of mortar, carefully prepared to set very hard and straight; as in many cases the original mortar remains, a source of durability as well as beauty. These fashion-bricks, as they might be called, were laid not only horizontally but in zigzags and herringbones, obliquely and in chevron, in what is known as meander-fret, serpentry and chessboard, in ovoids and lozenges. Patterned brickwork gives, initially, great variety to the external façades, but in the end produces the same monotony as endless domification. Gradually, as the art of circular building became more sophisticated, concrete was replaced in the domes by bricks or light porous stones such as pumice, or even pottery.

Both the strength and the weakness of Byzantine architecture was its concentration of decorative overkill. Here was another drastic departure from the classical Greek taste. In theory and usually in practice, every square inch of the interior of a Byzantine place of worship was decorative or capable of becoming so. The aim was to dazzle, to overwhelm, to overawe with surfaces that were exotic or luxurious, or reflective or glittering in one way or another. Simplicity was the enemy, and when a simple effect was indeed sought it was obtained by gigantism. But though ornamentalism was the aesthetic ideology, this was balanced by an underlying stress on strength. With very few exceptions, the Byzantines built well and to last, and some of their churches have successfully survived a great deal of battering, which continues to this day, especially in the Balkans. St Sophia's interior is crowded with working columns, with utilitarian capitals, springers and arches, ornamental too, but each doing definite carrying tasks. The shafts are often strengthened by bronze annulets, above the base and just beneath the capitals. One of the functions of these rings was to prevent marble from splitting, and a consequence of their strength was that architects were able to use ever more exotic, and febrile, varieties of coloured marbles—it was government policy, enforced by the Theodosian Code, to open up new quarries producing fanciful marble. Byzantine churches, especially of the grander kind, are

worth examining closely, for a great deal of careful thought and contrivance went into the business of combining strength with decorative fantasy.

St Sophia is the model and archetype of all Byzantine monumental work, but it is by no means the only building to be looked at. Its fault is that its ambitious size led to an impression of squatness, which no amount of external ornament can quite remove. That is avoided in the earlier big church of St Irene, which Justinian rebuilt at the same time as he was putting up St Sophia, and which was again rebuilt in the eighth century. St Irene is much taller in relation to its floor area, and its drum is much bigger than its dome, so it has a nobler, more masculine silhouette. SS Sergius and Bacchus provides another alternative, for Justinian built it (527 AD) with a half-melon dome, over an almost square floor space. Later, in the ninth, tenth and eleventh centuries, Byzantine architects avoided large central domes, chiefly because they presented more problems than they solved, and concentrated instead on a

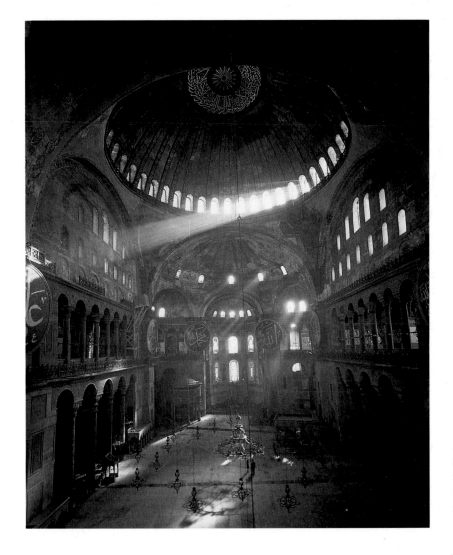

Justinian's St Sophia (537 AD), a masterpiece of space enclosure, is the key monument of Byzantine art and, as a mosque from 1452, gave new direction to Islamic building.

number of smaller domes. This was the idea behind St Theodore, Constantinople, a work of the late eleventh century, which in some ways is Byzantine architecture at its mature best; it uses the stratification principle of external brickwork with great emphasis and skill, and its straight lines contrast pleasurably with the curves of its four domes, each resting on clusters of arched windows. This new kind of small dome became the commonplace of Greek Orthodox-Byzantine architecture. It is to be found in the Little Metropole Cathedral, Athens, in both the Church of the Apostles and of St Theodore, Athens, at St Mary Pammakaristos, Constantinople, and in countless small churches wherever the writ of the patriarchs ran or runs. For the true intent of their cunning designers to be realised, these combinations of horizontal striping and tiled doming, whose charm cannot really be conveyed by photographs or rarely even in paint, need to be seen, and their rich colouring enjoyed, under a hot sun; indeed their warmth should be felt by hand and the smell of their baked tile and brick eagerly sniffed up.

The hot sunlight without was balanced by internal gloom, glitter and gorgeous glints inside these purposeful caverns full of reflective surfaces, which made the most of any light which penetrated. For this purpose, of course, the ideal was the mosaic, and if we have to choose one art in which the Byzantines excelled, it is their patient ability to turn hundreds of thousands of tiny squares of glass, china, and marbled and painted terra-cotta into monumental schemes of decoration. They continued to use the natural colours of stone and marble for hands and faces, and for pavements which had to be durable. But for high-class pictorial work, specially prepared glass was used more and more, giving an unlimited range of colours and providing opportunities for glitter-enhancement by using metal foil—gold, silver or tin—as backing or embedded in the glass. The Byzantines made particular use of gold to suggest the light emanating from God. Glass was cast in huge *linguae* or tongues at the foundry and then taken whole to the church and chipped up as required (at St Mark's, Venice, two of these *linguae* survive, unused). Greek workmen/artists were always the best and were sometimes hired to work thousands of miles from their home, for instance in tenth-century Moslem Córdoba in Spain. The very highest quality gold glass *tesserae*, of the kind used in the eleventh-century cathedral in Kiev, were made only in Constantinople and exported.

Mosaic techniques varied. At its best the mosaicists worked in much the same way as the early fresco painters, using outlines or *sinopia*, and sometimes large-scale cartoons. A lot of plaster was employed. Systems of large nails helped to keep the *tesserae* and their backing in place. In some cases the finest work was set in the work-shop and fixed into the wall or ceiling as a unit. Paint was used to touch up the finished mosaic. Early Byzantine mosaics aim at boldness, size, deep colour and strong sensations. Later ones display a persistent search for subtlety, especially in facial expressions. The individual pieces of the *tesserae* grew much smaller; linear effects and hard contours were dropped in favour of infinitely graded colours and

shadows. A spectacular example is the thirteenth-century *Deësis* mosaic in the south gallery of St Sophia in Constantinople, where the faces rival in realism the Christs and Apostles which Florentine painters in fresco were producing at much the same time. But this was about the limit to which mosaic, as an art form, could go, whereas painting was just beginning its long ascent into the stratosphere of art. Moreover every square foot of mosaic cost four times as much, on average, as fresco.

Constantinople was not always the leading centre of mosaic work, and many of its finest productions have vanished. Most of the best and largest surviving mosaics are in Ravenna, which replaced Rome as the capital of the Western Empire under the Emperor Honorius (reigned 395–423 AD) and later, in 493, was taken by the Ostrogoths and became capital of their kingdom. Later still it became the property of the Byzantines, the Lombards, of Charlemagne and the papacy. It was thus a frontier city, and an important one. At one time it had as many churches and monasteries as any other city, Rome and Constantinople excepted. (We know this from a ninth-century list of the city's ecclesiastical buildings compiled by the scribe Agnellus.) The buildings themselves, both in Ravenna and in nearby Classe, reflect the clash of styles which frontier cities produce. All the most important surviving buildings date from the fifth and sixth centuries but they are of three distinct types. The Orthodox Baptistry (400–500 AD) is octagonal and domed. The Mausoleum of Galla Placidia (425–450 AD) is cruciform. The Mausoleum of Theodoric, the Ostrogothic king (*c.*525 AD), is octagonal, of huge, perfectly carved blocks of unmortared ashlar, crowned by a monolithic circular dome weighing over 300 tons. Sant'-Apollinare in Classe (534–555 AD) and Sant'Apollinare Nuovo (early sixth century) are straightforward Roman-style oblong basilican churches with colonnades. San Vitale (521–532 AD) is a central octagon with a square-apsed chancel supported by six piers—mainly Byzantine but with a Roman touch and probably designed by a local architect.

These churches and tombs, of brick, stone and marble, are a delight to painters, students of architecture and simple aesthetes, but what they all (except for Theodoric's Tomb) have in common is spectacular displays of mosaics. In the churches, particularly, mosaics virtually displace all other forms of interior decoration such as sculptured cornices, lunettes and friezes. In one way or another every kind of mosaic technique is used. Although the overall effect of the mosaics at their largest and densest is the ultramarine impression produced by combinations of blues and greens, in fact every colour then known to the artist is used, and there are also massive quantities of silver and, above all, gold. The mosaics run through the whole range of iconography and symbolism of the Church in the East, both in its orthodox, Aryan and Latin forms. In one way or another, about forty scenes from the Old and New Testaments are presented. There are patriarchs, prophets, evangelists, apostles, saints and martyrs, virgins and widows, doctors and confessors.

The Virgin is there in great power, but Christ in Majesty, the Pantocrator, is the dominant epiphany. In the Mausoleum of Galla Placidia there is a ceiling of golden stars in a blue sky of crystalline perfection. In the Baptistry, St John baptises Christ surrounded by a multitude of approving saints. Emperors and empresses make imposing appearances, as do founder-bishops and local ecclesiastics almost without number. There are chi-rho signs, fishes and birds, countless lambs, fiercer animals and flowers. The theology is conflicting, and the artistic quality variable. What chiefly emerges from a careful inspection of the wonders of Ravenna is the sheer power of the mosaic in these centuries in concentrating the artistic effort on a single medium: its power—but also its limitations.

The art has become static, immovable, supine. Canonicism has reasserted itself almost completely. Perspective has gone, or rather been replaced by aspective presentation in which one sees the fronts of bodies rather than their natural profiles, and the entirety of faces, hands and feet. Social perspective is triumphant. The ruling Christ is enormous. The Madonna is a large lady, to put it mildly. The height of saints and other spiritually important personages is determined by their standing in piety (and popular iconology). Mere mortals and non-saints

Ravenna contains the largest collection of high-quality mosaics in the world, mainly fifth to sixth century, and marks the climax of Byzantine figurative art. This picture shows the Four Wise Virgins.

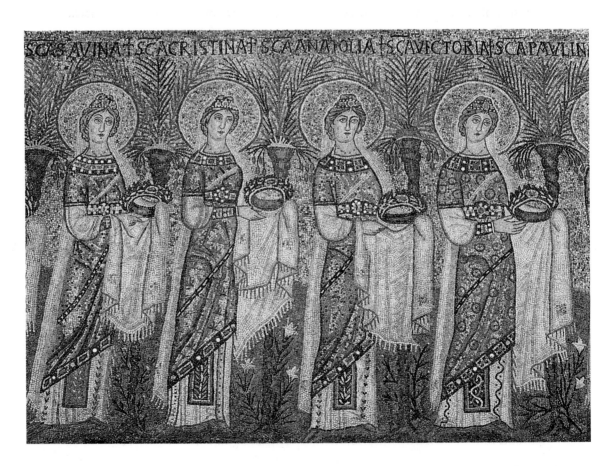

are tiny, unless they are emperors or their families. Bishops are big Brothers-in-Christ, while priests are small functionaries. The artist is working within a strait-jacket of forms, traditions, ideograms and theological rules. He is not a free agent, merely a conscientious servant of the canon.

Although Ravenna has the greatest concentration of mosaic work, especially of the early periods, there are other 'frontier' examples of significance. Palermo in Sicily, capital of the kingdom which the Normans carved out for themselves, shows some wonderful examples of Byzantine craftsmanship mediated by Latin direction. The cathedral typically fuses the circular Byzantine and the oblong Latin plan. The chapel built by the Norman King Roger II, about 1123, as part of his royal palace, the Cappella Palatina as it is known, contains a complete set of Byzantine mosaics, executed by Greek craftsmen, including a dome which radiates powerfully from Christ Pantocrator, thoughtfully scowling from the apex. Greeks also worked nearby at the cathedral-monastery of Monreale, whose interior is almost completely covered with mosaic decoration, symbols and separate images running alongside narrative series in staggering profusion. The cathedral contains the largest surviving series of New Testament scenes, on a monumental scale, to be found anywhere in Europe, east or west. They dazzle the eye and oppress the mind with their number, density, illogicality, their stylised repetitions of gestures, garment-folds, facial expressions and symbols, their decorative verbosity and Byzantine frontality, the Latin rulers being unable or unwilling to get their Greek employees out of their bad Eastern habits.

The culmination of Byzantine mosaic work in the West or near-West, occurs in St Mark's Cathedral in Venice, though with a difference. Venice, founded in 774, owed its early medieval rise and prosperity to trade with the East, and its links with Byzantium and its Empire were always loose. But it was a love-hate relationship, punctuated by intense rivalry, culminating in the Fourth Crusade, stage-managed by Venice to capture Constantinople and break its economic power. The mosaics of St Mark's were mainly created over 200 years, from the eleventh to the thirteenth centuries, and cover an enormous area. We must make allowances for the fact that only about one-third are original, the rest being the work of later restorers, though efforts were always made to stick to the pristine concept. Granted this, St Mark's can fairly be said to have the largest set of mosaics of any church. It covers, of course, in obsessive detail the story of St Mark, his remains, their discovery and transfer to his patron city of Venice, but it also deals with almost every aspect of the Christian faith, the stories of the Old Testament, and Christ's ministry.

Individual mosaics vary considerably both in quality and invention. Some are entirely original and unique to the building. Thus the huge mosaic on the west wall of the south transept, *Venetians Praying for the Discovery of the Relics of St Mark's*, is a mesmeric presentation of the way early medieval man prayed, against the background of the five-domed cathedral. There is nothing like it anywhere else, even in

illuminated manuscripts. Again, in the south vault of the entrance bay to the narthex, we are shown a splendid bird-loving Noah leading and carrying his feathered friends into the Ark—pelicans and peacocks, swans and toucans, cockatoos, water-fowl, pheasants, ortolans, partridges and game birds of every variety, as well as strange spotted creatures whose existence is not recorded elsewhere. On the other hand, the domes contain standard stuff: routine Christs, cliché Virgins, Baptists, evangelists and apostles we have seen many times before, and better.

In frontier cities where we can compare and contrast Latin and Greek work, it has to be said that Byzantine compositions and treatment of figures were much less lively than art which is plainly Western. There was a reason for this. As we have noted, the Mosaic ban on graven images was liable to bedevil art under any of the monotheistic creeds which acknowledge the Ten Commandments. At the end of the seventh century, a movement emerged among the clergy of the Byzantine Empire which sought to ban representations of the human form and face altogether. Various heresies, which took a fundamentalist line on this point—the Monophysites who denied the human side of the Incarnation, the Manichaeans who taught that all matter was evil, and not least the new doctrines of Islam which followed Judaism on images—were eating away at Christian populations, and the Iconoclasts, as they were called, hoped to rehabilitate the faithful by imposing bans themselves. The controversy which followed was prolonged and bitter, and involved not only all the Eastern patriarchs but the papacy too, and Western rulers as well as Eastern emperors. The storm broke in about 725 and did not die down until 842. Indeed, it was never finally resolved, for many forms of imagery, notably sculpture, which came closest to the 'graven' veto, remained banned in the Orthodox East, and artists working in other media, such as mosaic, felt they had to stick closely to the stationary and beatific, leaving any form of liveliness, especially movement, to the Latin West. This, then, was a very important limitation on the freedom of Byzantine artists. It is one reason why the art of the Eastern Empire lost whatever dynamism it had and failed to progress.

For the ordinary Christians of the Byzantine Empire the most important aspect of religious art affected by the iconoclast controversy was the icon itself, which was often the chief focus of their devotions in church as well as the commonest form of religious artefact in the home. Painted images of Christ, the Virgin, the Virgin and Child and other stock figures in Christian worship, usually executed in tempera on panel, were a product of the catacombs and became common in the Byzantine Empire from its foundation. They were a universal feature of the Eastern Church which never became important in the Latin West. They were popular and help to explain why the Byzantine form of Christianity spread so rapidly in the Balkans, north of the Black Sea, and deep into 'the land of Rus'.

By the ninth century, Kiev, in what is now the Ukraine, was a second Constantinople in religious intensity and importance. In 1037, its ruler, Yaroslav the

Wise, founded a vast new cathedral whose original design was much influenced by St Sophia itself. Yaroslav's sarcophagus in the cathedral was probably made in Constantinople, and Greek masons and artists helped in the building and adornment of the church, which had thirteen domes representing Christ and his twelve Apostles. In the interior there are 760 square yards of mosaics and over 3,500 square yards of wall-paintings, all eleventh century, in which again the Greeks had a hand. They follow the usual subject matter and biblical narratives found in Byzantium, though there are also incongruous hunting scenes—the chasing of bears, wild horses and the like—and paintings of Byzantine court life.

More pervasive than the grandeur of cathedral art, however, were the small, comparatively cheap and ubiquitous icons which came to represent the everyday form of Orthodox devotion, both in its Greek and Russian incarnations. They constituted the commonest form of art throughout a vast region embracing nearly twenty modern countries. It is important to grasp, however, that in Orthodox eyes, the icon never has been, and is not to this day, a mere artistic representation of a religious personage or event. It is a physical part of the act of worship, like altar furniture,

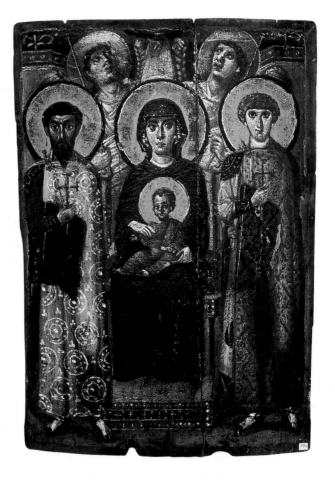

Icon from St Catherine's Monastery, Sinai. Icons, an art form developed from the fourth century in the Orthodox Church, were liturgical instruments.

vestments, banners and sacred vessels. It springs from the Orthodox concept of the doctrine of salvation: 'God became man in order that man might become God.' Painting an icon is thus itself a spiritual act. The painter realised the divine within himself and re-created, in a real sense, the image of Christ or the events depicted: the Incarnation, the Nativity, the Visit of the Three Kings. The spiritual state of the artist was, therefore, a key factor in the quality of his work, and iconists were most esteemed when they belonged to the schools of mysticism or devotion. During the later Middle Ages (thirteenth to fifteenth centuries), mysticism, taking various forms, was a powerful force throughout Europe. In both Byzantium and in Orthodox Russia, one of its forms was the mystically enhanced icon, such as those produced in Russia by Andrey Rublyov in the 1420s, where the faces of Christ were as sensitive and reflective as any painted in Florence and Siena by his contemporaries.

The spiritual concept of the icon also had a restrictive effect on the artist. The object of the painting is to produce not so much what the eyes see as what the spiritual impulse creates. Perspective is of no significance, for events are not presented in earthly space. Time has no existence, so vigour, activity, dynamism, getting from here to there, cannot form the subject matter. The world depicted is timeless, suspended, silent, motionless. Light and shade are by iconic definition unnatural, for Christ and his saints are themselves the source of illumination. If the icon degenerates into realism and illusionism, it loses its spiritual property and ceases to be an icon at all. Moreover, the icon, as created by the Byzantines, was in a state of continuous creation. The painter, with his brushes, paint and skill, merely began the process. Praying in front of the icon continued it. Thus the visible marks of such devotion—drippings of wax, the oleaginous layers created over centuries by oil lamps set in front of the image, and other stains of use—were essential accretions, becoming an integral part of the object. This point was not fully understood when a visiting exhibition of icons, some of great age, was held at the Royal Academy in London in 1998. The organisers, to mark their gratitude for the loans (and with, it must be said, the agreement of the state authorities in Moscow), arranged for the icons to be cleaned and restored. Devout Orthodox visitors were deeply shocked by what they regarded as an act of vandalism, which in their eyes reduced both the spiritual and the artistic value of the objects.

Icons of great beauty were produced in Constantinople for an entire millennium. There were production centres elsewhere, in Greece proper, in Bulgaria, in Serbia, for example. Some of these have more originality than the workshops in Constantinople which, operating directly under the eye of court and patriarchal inspectors, had to comply strictly with the religious restraints on artistic exuberance. Hence, one of the greatest schools of icons grew up in Crete in the fifteenth and sixteenth centuries. There exists, in a private collection in London (it was seen in the British Museum's 1994 exhibition, *Byzantium: Treasures of Byzantine Art and Culture in British Collections*), a superb icon of the *Deësis*, which was painted in Crete about 1430; and, from a little later, there is a Cretan icon of the Ascension, now in the Victoria and Albert Museum, which has enormous power and fertility of invention. An icon of St George killing the Dragon, belonging to St George's Chapel, Windsor, dates from the mid-sixteenth century, a time when El Greco was an apprentice icon-painter in Crete, and may possibly be his work. But by this point, it was overwhelmingly obvious to any Orthodox artist of ambition that the future of art lay in the West.

Indeed, the Byzantines had been able to progress as far as they did only because they produced a compromise over iconoclasm. This, while it deprived them of figure-sculpture (an ivory carving of an archangel, done to mark the accession of Justinian in 527 and now in the British Museum, a true masterpiece in miniature, shows what we have lost), it allowed them painting, mosaics and the illustration of

manuscripts. Other forms of worship in the Near East and Western Asia were much more fundamentalist. But they were not necessarily consistent. Of the various forms of Christianity which grew up in the Levant and its radiations, the Egyptian Copts, the Syriacs and the Anatolian Armenians tended to be Monophysites—that is, they questioned the dual nature of Christ; this in turn tended to make them strict about 'graven images' and all that the phrase implies. The Armenians, for instance, who were the first self-designated 'nation' to adopt Christianity, and who lived in northeast Turkey, the Caucasus and western Persia—persecution made them mobile—showed little interest in icons. But, having deliberately created their own script and alphabet, they produced illuminated manuscripts in great profusion, and they continued to carve with enthusiasm.

It may be that they could not help themselves. The Armenians were among the finest of all stonemasons and carvers. To handle and make elaborate use of stone was to them a delight of nature. The churches, chapels, cathedrals, monasteries and elaborate tombs they built from the fourth century on—followed later by huge and formidable fortresses—are in a remote part of the world, and until quite recently were little visited and rarely photographed. But on those who do inspect them they have, whether ruinous or functioning, a powerful impact because the stonework produces unique sensations.

The architecture is akin to Byzantine or Orthodox. It is centrally planned and domed, with any number, from three upwards, of rectangular arms each ending in an apse. The dome often rested on a huge octagonal drum, and had octagonal ridges, as if tiled, though actually heavily built of stone. What strikes the visitor are two strongly marked characteristics. First, the building as a whole has a sculptural quality, as though carefully carved out of a colossal rock. There are deeply recessed arches and windows, eaves and doorways. Scholars suggest that, before a church was commissioned, the designer had to make a model of what he proposed to build, and this was added to and altered at the whim of the great lord or bishop who was paying for it. One consequence of this was that sculptured decorations were applied to the outside of the church, so that deeply carved crosses and patronal figures became regular accretions, adding to the sculptural impression. Where the Byzantines embellished their churches externally with fantastically elaborate brickwork, the Armenians used sculpture, and very powerful it looks.

The second characteristic, which enhances the first, is the use of varicoloured stone. The Armenians took the fullest possible advantage of the fact that their existence was spent amid spectacular mountain scenery. They searched for, found and shaped rock-cut ashlars of amazing variety. Indeed, no ancient race, except the Egyptians, paid more attention to stone quality than the Armenians. Hence black-and-white photographs, which until recently were the only ones widely available as a rule, do not do justice to early Armenian church architecture. In some cases, the crystalline content of the stones supplies refractive qualities, so that time of day,

weather and seasonal variations are echoed in stone colours (rather as, to give an accessible example, the Chilmark limestone of Salisbury Cathedral reflects varying Wiltshire skies).

Availability of stone in a wide range of colours was exploited in two ways. One was to produce a chequerboard effect, as in the late-fifth-century Church of St John the Evangelist near Yerevan. This has yellows, deep browns verging on black and powerful orange-reds, arranged to give the impression of a glowing fire. At Ateni in Georgia, the church of St Sion has its bottom courses in deep orange, surmounted by yellows and pale blues, as though it were ascending from the inferno into the sky. The big church at Marakavank, from the early thirteenth century, has a beautiful west door built up of alternating green and purple stones, the effect reinforced by deep carving in abstract patterns.

These chequerboard churches alternate with others where a single tone of varying intensity is used. Thus the church of Ojun in Gogarin, founded in 720 AD, is an explosion in deep gold. The church of St Cross in Altamar, Vaspurakan, which is heavily sculptured on the exterior, appears to be made entirely of terra-cotta. The convent of St John at Zincirclu in Sion is a cream-white protuberance from its grey-green rocky valley bottom. The convent of Harlacin, Arcax, is blue-grey, the Chapel of the Resurrection, part of the Kekaris Convent, is smoky grey, while other parts of the foundation are pink. This tradition has persisted, so that the seventeenth-century church of St Stephen in Berkri, Vaspurakan, is pale purple; the nearby church of St John the Ktuk, which is eighteenth century, is rich gold.

The subtleties of some of these colour concentrations and contrasts defy description—as, on occasion, does the sheer provocative boldness of the way violently coloured stone is thrust in your face. Colours are also enhanced or contrasted by the naked mountain rock against which these remote churches are sometimes silhouetted or cluster for shelter. There has been much restoration in places, often misguided, or desperate attempts to keep the buildings up after spasms of religious violence—the Armenians have been persecuted as often, if not quite so long, as the Jews—but what impresses most is the quality of the original stonemasonry and carving. These churches have proved difficult to destroy completely or even to reduce to ruin. They were built by a sturdy race, one of the great survivors of history, and most still stand today, erect and proud in their conical caps.

Of all the religious groups which sprang from the Judaeo-Christian tradition of monotheism, Islam was the most strongly opposed, in theory and usually in practice, to the representation of living creatures in art. Mohammed (*c.*570–632) experienced his first visions in 610. By 710, Islam ('submission') had spread all over Arabia, Syria, Egypt and North Africa, Iraq and Iran. In 711, Moslem troops crossed the Straits of Gibraltar and began the conquest of Spain. Simultaneously, they crossed

the Oxus, entered Central Asia and began the conquest of the Indus valley. Islam eventually split into a number of tendencies, some more fundamentalist than others, and it was always liable to revolutions and takeovers, which enforced Koranic law fiercely after periods of 'decadence'. As with Byzantium, there was no absolute distinction between Church and state, all rulers exercising spiritual functions and all legal systems reflecting the teachings of the Koran. So Islamic art, with some exceptions, was non-figurative and tended towards decorative abstraction. As in Judaism, which it resembled more closely than Christianity, Islam paid particular attention to 'the Word'; words, properly inscribed, had spiritual properties, rather like icons in Orthodoxy. Hence, the only form of art universally approved by Moslem theologians was calligraphy. Islamic art had a *horror vacui*, and sacred writings, plus their decorative appendages, tended to fill in any blank space left on the walls of buildings. Expressive writing was as central to art in Islam as it was in China. Calligraphers had a status accorded to no other kind of artists. But artists were not an anonymous class of skilled tradesmen. Designers of mosques and elaborate tombs sometimes signed their works. So did the carpenter-designers of pulpits.

Architecture was by far the most important of Islamic arts, and the mosque easily the most numerous of public buildings in all Islamic lands. In theory it was simple, just 'a place set apart for public prayer'. It was modelled on the house Mohammed built for himself in Medina in 622: an open square, surrounded by four walls, one of which, the qubla wall, was oriented towards Mecca, whose sanctuary or Ka'ba was considered God's house on earth. Apart from a sun-shelter area along the walls, there was nothing in these enclosures. Indeed, every aspect of primitive Islam was utilitarian and austere. But power brought wealth and wealth led to ostentation. Mu'awiyah, the first of the Umayyad family, which held the caliphate from 661 AD, said openly that the object of his building programme in Syria was to compete with Byzantium: 'We are at the frontier and I desire to rival the enemy in martial pomp so that he may witness the prestige of Islam.' The result of this policy was a series of magnificent buildings of which the Great Mosque at Damascus, the Umayyad capital, was the most influential.

This mosque (706–715) was built on the site of a succession of pagan temples, crowned by a Christian church of St John the Baptist. The Moslem architect demolished this last, except for its propylaeum, which he used as an entrance, and then created an enormous open space, with a prayer hall on the qubla side and covered arcades on the three others. The prayer hall was like an oblong Christian basilica, with a minbar or pulpit for the preacher, and a royal enclosure for the caliph, surmounted by a small dome. The decoration consisted of a marble dado surmounted by glass mosaics. These were supplied by Byzantine craftsmen working to landscape designs (presumably from the same source) depicting the Moslem notion of Paradise, with cityscapes of Mecca and Medina. In a genuflection to Islamic fundamentalism, the qubla wall was ornamented with Koranic inscriptions dealing with

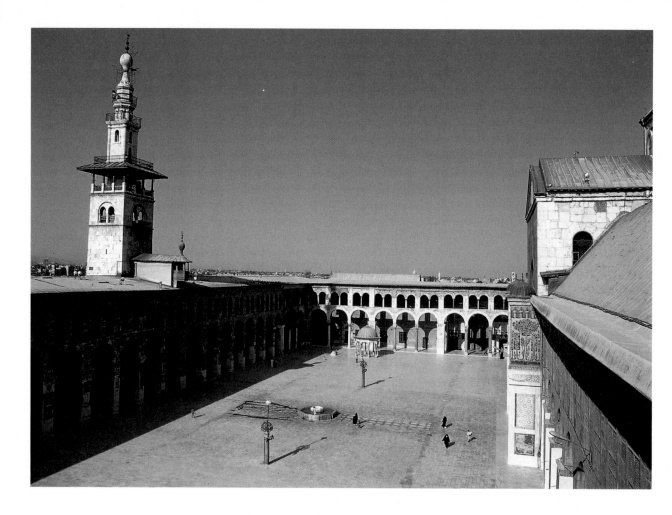

The Great Mosque of Damascus (706 AD) is the prototype of the largest Islamic sacred buildings: rectangular court, aisled prayer hall, muezzin tower.

death, judgement, hell and heaven. Only a portion of these designs, on the west wall, has survived. Later, a minaret, a new feature of Islamic architecture, a slender tower from which the muezzin called the faithful to prayer, was added, and three more in due course. The Damascus Mosque evolved over six centuries, thanks to fires, restorations and additions, but it retains its elegant simplicity. It is hard to think of any religious building, of any faith, anywhere in the world, which has more spiritual atmosphere, of a restful and contemplative sort. How this was acquired is a mystery. The mosque is curiously quiet and is said to be the only building in the Middle East where spiders cannot or do not live.

Second in importance to the Great Mosque of Damascus is the Dome of the Rock built in Jerusalem a decade earlier (691–692). It was sited on what was then the vast empty space where the temples of Solomon and Herod had been cleared by the successive demolitions of Jewish holy places by the Romans. Jews and Christians had piously refused to build there, but the Moslems erected a spectacular pilgrim shrine or mosque which took full advantage of the site and remains to this day one of the most successful monuments to Islam. It is a domed octagon surrounded by a double ambulatory, and is in essence a form of Roman-Byzantine tomb-architecture.

But it contains no tomb and its original purpose is a matter of unresolved dispute. What is notable is its triumphant dome, its lavish external decoration and its orthodox internal epigraphic mosaics and ceramics, consisting of long quotations from the Koran. Jerusalem itself is a natural site for great architecture, and the Temple Rock is its natural centrepiece. By failing to build on it when they could, both Jews and Christians missed the opportunity of a millennium, and by seizing on it the Moslems established at a stroke their historic right to call Jerusalem one of their holy places, which otherwise would have been shaky. In art it is sometimes essential to give a site or a position priority over any other consideration, and the Dome is a case in point.

The success of these two magnificent structures in Damascus and Jerusalem enabled them to constitute a joint canon of Moslem ecclesiastical architecture. It is hard to think of any historic mosque which does not borrow from one or the other, or both. Some are of peculiar beauty and interest. In Córdoba in Spain, work began on the Great Mosque in 756 and continued for twenty years; and the building was enlarged periodically over the next two centuries. Essentially it is the Damascus Mosque in plan, though the covered area embraces two-thirds of the whole instead of one-third, and the arcading is much more complicated. The arches, indeed, themselves became prototypes for those in mosques throughout Islam and models for many Christian churches (the mosque was Christianised when the Kingdom of Granada was conquered by Spain). They probably derive from local Roman aqueducts, especially the majestic one at Segovia, though the pink and white striping of their stonework—their most conspicuous feature—is original. To wander among these arcades is a unique experience, a feature of all great buildings which have strong individuality. It is an irresistible temptation to painters to sit down on the spot and try to capture the infinite gradations of light and shade, and of varying densities of chiaroscuro, which the arcading produces.

These mosques or cathedrals all make the point that architecture at its best has an organic element—that is, founder-architects are only one in a long chain of creators who have enabled the building to realise its peculiar personality. It matters not that Córdoba Cathedral (as it now is) has had over twenty major alterations which give it endless incongruities. Such buildings have a life of their own which defies taxonomy or logic. Another example is the majestic ninth-century mosque at Kairouan in Tunisia. One of its two main domes was put there as recently as the nineteenth century, supposedly a restoration of the original. Its main structure resembles Damascus, but the minaret in the middle of the north wall is a three-storey tower modelled on the ruins of a Roman lighthouse on the nearby shore.

By their rapid conquests, the Moslems inherited a vast amount of architectural booty. To construct the interior arcades of the Kairouan Mosque, the builders used masses of marble and fine-stone columns, capitals and bases from civilisations stretching over an entire millennium. But with all this, and perhaps because of all this, the building has a wonderfully pleasing character of its own and is a delight to

visit and study. It should be contrasted with the huge mosque at al-Mutawakkil in Samara, now in Iraq, which is ruinous but spectacular. It is a century later than the Kairouan Mosque, though still clearly reflecting the structure of the Damascus prototype. But its huge minaret, instead of being modelled on a Roman lighthouse, is an unselfconscious imitation of a local Babel tower, built solid with a circular ramp leading to the top. This gives the visitor a shock, as though he had stepped backwards in time five millennia to the age of the ziggurat. But it is not incongruous—it springs directly from the traditions of Mesopotamia. One of the reasons why Islam was so successful and so adhesive was that its architecture always drew deep sustenance from the building life of every country it conquered.

Curiously enough, though more mosques were built in Cairo than any other city, none drew consciously on the distant traditions of the pharaohs, though pharaonic architecture, with its powerful open spaces demarcated by stone avenues, was peculiarly suited to assist Islamic art. But Cairo's Moslem builders took full advantage of the vast quantities of spoils from many layers of earlier works, pagan and Christian, to be found in Egypt. The Mosque of 'Amr in al-Fustat (Old Cairo), built in 641, was piled up from spoils, rather as a child uses wooden bricks to construct a precarious edifice. It is about 400 feet square, the prayer hall having seven arcades of old columns running parallel to the qubla wall. It sports carved bits of decorative stone and marble, originally reflecting the taste of the vulgar rich in late antiquity. But the mosque was rebuilt and enlarged many times and its architectural history is as murky as some of its dark recesses. Much more attractive is the ninth-century Ibn Tulun Mosque in Cairo proper, though it too has a complex architectural history: its salient features, such as the domed pavilion in the centre of the court, and the striking minaret, were Mamluk constructions of the late thirteenth century. The endless arches have a remarkable congruity, and some of the vistas through them, and into the court, are mesmerising. Like the mosque in Damascus, it has the capacity to induce calm; when one enters its great spaces the horrific hum and clash of Cairo fades away, and 'the peace which passes all understanding' descends. Why is it that some mosques have this capacity, absent in Christian cathedrals? Perhaps it is their stress on the horizontal as opposed to the vertical, horizontal space acting as a *cordon sanitaire* against the noisy world.

The al-Azhar Mosque, originally built in the tenth century, with changes and restorations beyond human contemplation, also has a quality of otherworldliness, though it is not exactly quiet: it has been the principal centre of Islamic education in Egypt for over a thousand years and a centre of political activity for almost as long. Its name means 'the Radiant', and it does seem to radiate a kind of stillness conducive to contemplation and speculative ideas. It also has some of its original ceramic decoration, flowers, trees and living things rather than calligraphy and abstracts. Koranic inscriptions, in stone and stucco, and dating from the early eleventh century, are found in abundance in the Mosque of al-Hakim, which was

created for state religious occasions as well as daily prayer, and is a formidable building, whose minarets appear to grow from immense masonry bases and which has served in its day as a fortress as well as a museum. It is now heavily restored, and looks gay, almost garish, and is much visited; but there is no tranquillity within its walls.

From the earliest times of Islam, as we have seen, Moslem rulers showed readiness to make use of any learning, technologies and arts which their conquests had brought them, and their architects in particular were ingenious both in using spoils and adapting buildings. Many of them indeed were former secret Christians, and in a few cases Jews. In time, of course, Islam not only developed its own artistic forms but began to export them to the West. In the thirteenth century, Islamic influence is apparent in the vast building programmes of the Holy Roman Emperor Frederick II in Italy and Sicily. Venice, as the West's chief trading partner with Islam, shows to this day innumerable marks of Islamic motifs and ideas in its medieval architecture: the Fondaco dei Tedeschi, for instance, warehouses and grain stores, façades on the Riva degli Schiavoni and not least the palaces built by successful merchants

Dome of the Rock, Jerusalem (692 AD), based on a Byzantine martyr-shrine, is the earliest major Islamic building to survive. Originally covered in exquisite mosaics, outside and in.

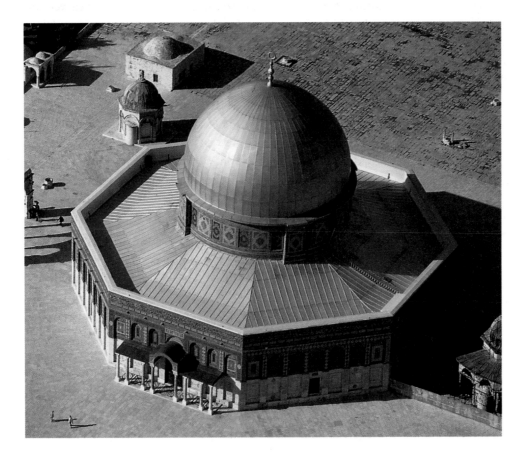

in the fourteenth and fifteenth centuries—men who had been East and admired
what they saw in Cairo, Damascus, Aleppo and elsewhere. The Doge's Palace, rebuilt
in the fourteenth century, reflected the work taking place on the huge Cairo Citadel,
then being erected. But the Citadel likewise embodied hard-won lessons learned in
Venice and elsewhere in Italy. Moreover, Islam continued to seize and make use of
Christian places of worship when it could, especially after the advent of the Ottoman
Turks began a second great phase of Moslem conquest. The chief victim, this time,
was St Sophia itself which, after the Fall of Constantinople in 1453, was converted
into a mosque.

The acquisition of this masterpiece of Byzantine architecture introduced a new
phase of Islamic religious building, as its sheer scale and management of internal
space were absorbed. It also shaped the career of Islam's greatest architect, Koca
Sinan (c.1500–1588). Sinan was a Greek-speaking Christian from central Anatolia
who was conscripted into state service and became a member of the élite corps of
Janissaries in 1521. In numerous campaigns he rose to the top, specialising in military
engineering—bridge-building, forts and entrenchments. To do so he converted to
Islam, though it is possible that he remained a secret Christian: if so, he kept it dark,
for the punishment of apostasy was death. From 1538 to his death half a century later
he was *mimarbasi* or chief architect to the Ottoman court, at a time when the sultans,
led by Suleiman 'the Magnificent', were spending more on building than even their
Western contemporaries, Francis I of France and Charles V of Spain.

Sinan's mosques in Istanbul (as Constantinople now became) are the finest, and
among the largest, ever created in Islam. The Sehzade Mehmed Mosque, his earliest
great work (1543–48), elevates the principal characteristic of Byzantine monumental
architecture, and especially St Sophia—the use of a vast central dome surrounded by
a dome cluster, to create the largest possible enclosed space—into a system over-
whelming in its power and majesty. This is used on an even larger scale in the
Edirnekapi Mihrimah Sultan Mosque (1548), where the huge drum of the dome rests
on four gigantic arches, each a nest of smaller arches. In the smaller Rüstem Pasha
Mosque (1562–63), he took ideas from another Byzantine church, SS Sergius and
Bacchus, and in one of his last mosques, built for Sokollu Mehmed Pasha in 1571–72,
he introduced new principles of centrality and invisible support. But Sinan's grandest
building is the Süleymaniye Mosque, built for the magnificent sultan himself in the
1550s, on a crowning site overlooking the Golden Horn—the only building in
Istanbul which successfully challenges St Sophia itself. The mosque was merely the
centrepoint of a cluster of scholastic and charitable foundations, and it appears
to arise in the shape of a vast triangle of domes regimented by an immensely tall
double set of minarets. The central dome is nearly 100 feet in diameter and rises to
170 feet from the pavement, while the two half-domes which shoulder it give a
space-enclosure which was never exceeded until the twentieth century.

In this and other mosques, Sinan lights his huge spaces with ingenious large-scale fenestration, accompanied by monumental tiling (especially from the Izmir factories), which often reflect the external sunshine and internal illumination. His aesthetic aim was clear enough: to stun the viewer with the colossal majesty of the external silhouette on its grand hillside, and then overwhelm him, once he stepped inside, with the magic of limitless space covered by a ceiling which appears unsupported. These great buildings of Sinan are remarkably clean—we would say modern—in their lines, for his utilitarian training in military architecture made him contemptuous of unnecessary decoration and insistent that every feature serve a purpose. This characteristic made Sinan very influential in the West in the late nineteenth and early twentieth centuries, and he could be called the ultimate founder of functionalism. He taught the lesson that the eye could often best be delighted by space and light, and the simplicity of the forms that created them, rather than by detail.

Sinan's mosques, both in Istanbul and Edirne, have survived fairly intact, and they are the best-known part of his legacy. But he was not just a mosque-builder. He ran an entire department of state, or Ministry of Works, responsible for building and maintenance throughout a vast empire. He designed a total of 476 major buildings, 196 of which have survived. He is thus easily the most prolific architect of all time, and if he merely prepared the plans for some of his works, supervising the building operation from afar and rarely seeing the results, the same can be said of Alberti in the fifteenth century. Moreover, Sinan was a conscientious master of sound construction, taking immense care over siting, foundations and weight-carrying problems, as is testified by the high survival rate of what he built. Those works of his which have disappeared were mostly secular constructs inevitably replaced in the course of time. In fact he built anything and everything which the state and its faith (and a large clientele of rich men and their wives) required, and his *oeuvre* contributed substantially to the infrastructure of the enduring Ottoman state at almost every point.

We must not see Islamic architecture entirely in terms of mosques, where the survival rate is highest. Architects also had to be expert and ambitious palace-builders, for the sultans and other great men of Islam, once they became the super-rich of the early and late medieval world, spent lavishly on their own houses. But most of the palaces, especially the earlier ones, have disappeared. We know of eighty sites of early palaces, including what were evidently spectacular establishments at Khirbat al-Mafjar, Qusayr 'Amrah, Ukhaydir and Jabal Says, and two at Qasr al-Hayr. But aboveground there is little to see. In the big urban centres, palaces were demolished and rebuilt, changed beyond recognition, added to and transformed in a fashion which baffles the architectural historian. One important point can be made, however. The desert Arabs, who formed the leading cohorts of Islam and founded

most of its great dynasties, came from regions where urban life was unknown, where the most precious commodity was water, and where creating a garden was the summit of human activity. These factors set their stamp on Islamic palatial architecture. So did the peculiar situation of Damascus, Islam's first capital, which is on the edge of the desert but fed by innumerable streams from the Lebanese mountains. Water was thus made to trickle continuously through almost every street of the old city (it still does). The sight and sound of moving water, even if only in tiny quantities, thus became one of the characteristics of Islamic architecture, as much concerned with settings and outdoor spaces as with interior ones. Sinan, for instance, a master of water-movement and conservation, provided water-splashed gardens for his mosques wherever it was possible, and water played a central part in the creation of every major Islamic palace. It is especially integral to the finest one which survives, the Alhambra in Granada.

The Moslems occupied Granada in 713 and held it, under various dynasties, until it was surrendered by its cowardly last ruler to Spain in 1492. There are, in this magnificent and complex fortress-palace, various layers and outcrops dating from Iberian, Roman and Christian times, as well as walls or buildings put up by the Zirid, Almoravid and Almohad dynasties. But it was under the Nasrids, who reigned for the last 250 years of the Islamic period, that the Alhambra was transformed into the most beautiful palace on earth, which later additions, by the Habsburg Emperor Charles V for instance, have embellished rather than spoiled. The Alhambra was a fortress, built for defence with high walls and strong towers, so that it conveys an impression of enclosure. But a counterpoint to this is provided by the openness of its major gardens, especially the Generalife—the most subtle of architectural gardens outside Italy—and the orchards and minor gardens on the surrounding slopes. The contrast between enclosure and openness is resolved artistically in the various courtyards at the heart of the palace, which provide both at the same time. The visitor sees and feels the sky—its warmth is on his cheek—but he is simultaneously aware of the security and beauty of surrounding marble arcades.

The second chief feature of the Alhambra is the presence of water, which flows, drips, splashes and spouts in dozens of different ways, and in scores of places, throughout the immense complex of buildings, though it is visible chiefly in the courts. The Patio de los Leones, or Court of the Lions, built in the 1370s, summarises everything the Islamic world had learned about water-architecture. It has a central fountain resting on the backs of twelve white marble lions. The water trickles away in narrow canals beneath systems of twin-pillared arches, forming arcades on which rest four magnificent reception rooms on the first storey. They overlook the court, but are remarkable also for their starry vaults, lit by great windows which admit and discipline the sunlight.

Court of the Lions, Alhambra, Granada, is the epicentre of the greatest concentration of high Islamic art, through which runs the perpetual trickle of water that Moslems thought essential to architecture.

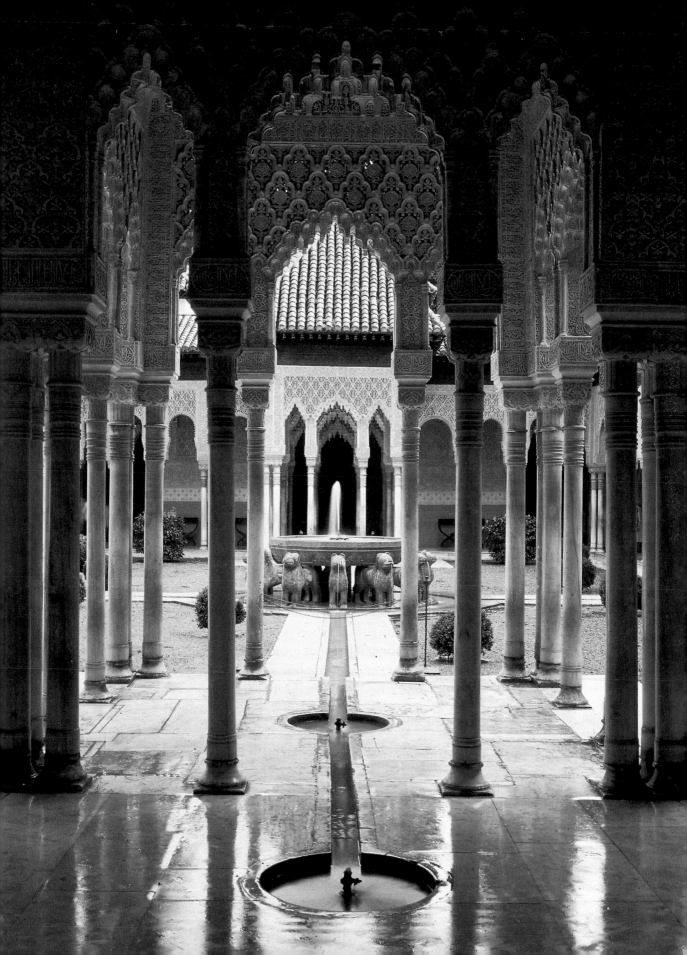

The decoration is provided by Kufic patterning and by poetry in brilliant cursive script, and a poem also adorns the fountain itself. Font and arch, marble and glass mosaic, paint, stone and script, tile and open window, grass and herb, light, shade and brilliance all combine together to create a sense of airy lightness, reassuringly underwritten by marmoreal solidity. When the throng of visitors departs, water is the only sound, broken occasionally by the cries of ravens above. This use of water to produce sounds and vistas integral to architecture has never been surpassed and is mightily infectious, as witness the modernistic palace built nearby in the 1920s by a rich admirer: this shows what can be done to enclose and display volumes of water, and to make it move and sound, within straight white lines and sharp angles softened by antique statuary. Long before that, Spanish-Moorish water vistas had passed into the basic vocabulary of all systems of European architecture which aim primarily to delight.

Delight, indeed, is the word which best describes the object of Islamic art. It seeks to build an earthly paradise, whether religious or secular, to make true believers antici-pate the pleasures of Heaven and long for them in all their plenitude. The place where this concept came closest to realisation, over a long stretch of time and in many different ways, is Isfahan in Iran. It is a city of art in the same way as is Venice or Florence or Rome, since it was famous even in Achaemenid times; it was succes-sively beautified by the great Sassanian dynasty (224–651 AD) and by a long series of Islamic rulers, from 771 to 1722, after which its creative period ended. For much of this time Isfahan was the capital and a centre of commerce and wealth. Indeed it could be said that more money has been spent on art, over the centuries, in this comparatively small place than anywhere else on earth. The successive archaeological layers of beauty and expense can be best measured in the so-called Friday Mosque, which rose from a mud-brick and stucco building of the late eighth century into a palatial collection of double arcades and immense recessed enclosed arches, grouped round a central court. The most splendid work was done in the fifteenth century, at any rate in terms of decorative magnificence, entirely abstract or calligraphic. The work was added to and restored up to the year 1796, so it is the creation of an entire millennium—though curiously enough it does not seem so, the sense of the fifteenth-century master-hand being pervasive.

To Isfahan in 1598 came Aqa Riza (1565–1635), the greatest of Persian painters, who drew shahs and huntsmen, soldiers and dervishes, courtly types and ordinary working-men and -women with masterly finish and riotous colours. No artist in the West ever painted draperies better than he did. Riza was building on the work of earlier painters, notably Kamal Bihzad (c.1460–1535), who had been keeper of the first Safavid royal library. Nearly a score of his best miniatures are in the British Library. By contrast, the best paintings of Riza are in the Topkapi Palace in Istanbul or

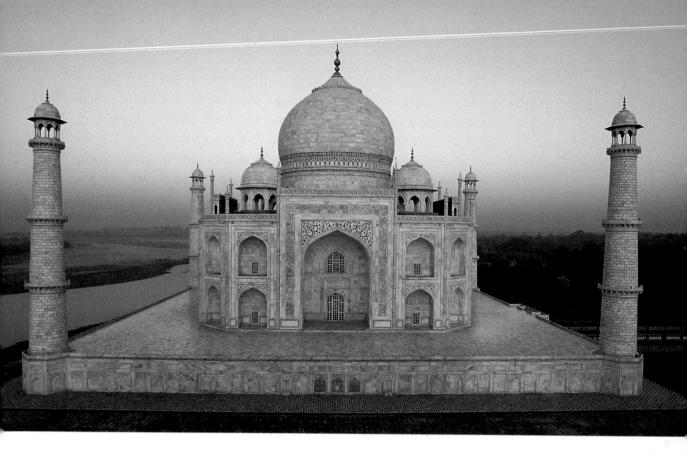

the St Petersburg Hermitage, though one of his finest works, *Youth and an Old Man*, is in Washington's Sackler Collection. These superb paintings, remarkable both for their overall concept and their fascinating detail, are a world in themselves, but open to the eyes of all cultures; not only do they represent Islamic art in its most accessible form, but one which strikes the paradisiacal note with most conviction.

Taj Mahal in Agra, India (1631–48), built by the Emperor Shah Jahan, in memory of his long-suffering wife who died giving birth to her fourteenth child on campaign with him.

Next to the mosque, the tomb is the key to Islamic architecture in all its regions and phases. That is curious in one sense, for Mohammed himself forbade elaborate tombs and funerals. But then what form of art did he not, explicitly or implicitly, rule out? Prophets propose, but it is the artist and his patron who dispose. One of the most striking of Persian miniatures, dating from 1526 and now in the New York Metropolitan Museum, folio 135v, is called *The Allegory of Drunkenness*, and shows a great, unknown artist sinfully satirising the even greater sin of alcohol consumption. Elaborate tombs thus begin to appear within a century of Mohammed's death in all regions where Islam held sway. They are of a beauty, size and elaboration akin to the mausolea of Hellenistic and Roman societies, rather than the comparatively simple tombs of the West, limited by the restrictions of the cathedral and churches in which they were sited. Grand Moslem tombs were separate entities, some squared and domed with an entrance door and designed to be inspected from the inside as well as the outside, others tower tombs, with spectacular exteriors which could be seen from

miles away. As early as 920, at Bukhara in Uzbekistan, there arose a brick, tile and mosaic tomb mausoleum of astonishing sophistication and beauty, a domed brick cube with identical openings on each side. No one ever built a finer monument to the dead, anywhere. Some tower tombs, however, are even more striking. At Gorgan in Iran there is an eleventh-century octagonal ribbed and circular tower, with a conical cap, built of brick and exceedingly well preserved. Known as the Gunbad-i Qabus, it is nearly 200 feet high and well-sited. When I saw it I could not at first believe it was nearly a millennium old.

No one, however, paid more attention to tomb architecture than the Moslem rulers of India, who produced some outstanding monuments, both to themselves and to their favourite wives. The finest of them is the Taj Mahal at Agra, which Shah Jahan, who reigned 1626–58, built in memory of his beautiful wife Mumtaz, who died in 1631. Work started immediately and seventeen years later the central building and its minarets, and the surrounding gardens, were complete. What makes the architecture so magical, so that even those who come to sneer go away entranced, is the balance between the mausoleum as a whole and its component parts of big and small domes, kiosks and minarets, straight lines, curves and recessed arches. Equally crucial is its siting, which not only gives a sense of isolation, essential to the concept, but prevents the all-important silhouette from mingling with any other object on the horizon. The building looks white from afar but, closer to, its subtle and innumerable colours and colour combinations reveal the intricacies of the design and the care taken to seek out rare materials from afar. The principal stone, a fine white marble, was quarried in Makrana in Rajasthan, and carried by cart to the site at great expense. Also used, in the exterior and inlay decorations, are coral, amethyst and turquoise, onyx and cornelian, chalcedony, agate, jasper and lapis lazuli. Coloured glass gives a subdued light to the interior. Granted the audacity of the overall design, the treatment throughout is restrained, and the combination gives the tomb its unique nobility.

By the time the Taj Mahal was complete, the Mughal Empire and, indeed, most of the independent cultures of Afro-Asia, were already under pressure from advancing European commercial interests—Portuguese, Dutch, French and English. This was the first serious hint, in Asia, of what was to become a cultural globalisation on European lines. The triumph of the West was beginning, and it is now time to turn to the origins of the artistic systems which were to play so conspicuous a part in the clarity of vision and the self-confidence which was to make this triumph possible. We look first to the glint of northern light on ideas and objects.

7

DYNAMICS
OF THE DARK AGE NORTH

In the three centuries after the conversion of Constantine, virtually the whole of Europe was opened to Christianity, and this had profound affects on its art which lasted for over a thousand years. But much of this area had never been Romanised, and its peoples—the North and South Slavs, the Norse, the Anglos, Saxons and Jutes and other Germanic tribes, and the Celts of the British Isles and France—had vigorous pagan beliefs, and artistic means of expressing them. These were barbarous but not primitive peoples. They traded widely. One of the largest hoards of coins ever found, dug up in the 1990s at Ralswick on the island of Rügen in the Baltic, numbers 2,270 silver and gold items, most of them from Asia and Arabia, which had arrived via the River Volga and Lake Ladoga. A hoard uncovered in Kent in 2000, dating from a period not long after the Jutes settled there, includes items from Coptic Egypt and Byzantium. And almost from its inception, the Byzantine Empire recruited Norsemen as mercenaries. Not only in classical times but throughout the Dark Ages, men and goods travelled much further than we are accustomed to think, and we must bear this in mind in considering the art which such travel influenced.

These northern peoples also had a vigorous social, intellectual and artistic life of their own, which can best be characterised in one word: dynamism. They enacted law codes which, in equity and sophistication, were superior to almost all the codes of classical Eurasia and which, when they were eventually put into writing by Christian clerics, became the basis of the judicial systems which regulate more than half of the world's advanced societies today. They had a democratic and even parliamentary instinct which set a high value on the views as well as the liberty of the individual. Their art systems reflected this individualism. But pitifully few of their products survive from before the time when Christianity took over courts and centres of production and, with its self-perpetuating monasteries and cathedrals, provided safer custody for them. What we do have are belt buckles and mounts, sword hilts, helmets and other display items of the wealthy, made in semi-precious

and precious metals, ornamented with stones and, more important, decorated in the most intricate fashion. The skill in metal-carving and inlaid work was often of a high order, and the patterning, involving abstract forms and animals (rarely humans), was of such dynamic density that it baffles the efforts of twenty-first-century eyes to unravel its pattern, which has to be read like a hieroglyph.

For instance, with the decoration of a belt mount, found in Germany and datable to *c.*500 AD, it is necessary to realise that parts of the animals which make up the pattern—mouths, legs, eyes, bodies and tails—form isolated elements, but are combined in the design into a sophisticated whole. Again, a cross-shaped ornament from Germany, of the same date, is so complex that analysts have had to make five separate drawings of individual items—the animal's head, eye-socket and eye; neck; foreleg and foot with four toes; lower end of body; upper end of body—in order to understand what the artist is doing. The apparent chaos is totally misleading. In fact, what this kind of art attempts is precisely the imposition of order on the disorder of nature which, as we have seen, is one of the most primitive and enduring objects of art, springing from the deepest instincts of the human mind. The skill required to create these dense but ordered patterns in the first place, and then to impress them on recalcitrant metal in the space of an inch or less, was dazzling. And it is an entirely individualistic skill, for no two designs are alike.

These artistic instincts and skills were in due course Christianised, and put to work in the monastic scriptoria which were springing up all over western Europe. The result was a kind of art which, in its intricacy of line and colour, has never been excelled. In the British Isles, with its Celtic fringe and its Anglo-Saxon-Jutish core in England, there is argument about the priority and progression of artistic ideas, and the places of production. Ireland was Christianised early in the sixth century by St David from Wales, where the faith had been implanted in Roman times. Thence, Irish missionaries took Christianity to Iona in the Hebrides. Meanwhile, Rome had sent St Augustine to evangelise England. He landed in Kent in 597 and became the first Archbishop of Canterbury. The two streams met at Jarrow in Northumbria, a monastery founded in 681, which became the intellectual and artistic centre of Christianity in the north and produced, in St Bede, the first great European historian.

These monasteries began, from the early seventh century, to produce illuminated manuscripts of great beauty and elaboration. It is not always possible to discover which house produced which book, and scholarly argument, reflecting modern nationalism, rages round the provenance. The first, from about 610, and now in Trinity College Library, Dublin, is the Codex Usserianus Primus, which merely has a decorative title page, though a fine one, using the labyrinthine techniques already described. The next, from *c.*625, is a copy of the Psalms, the Cathach of St Columba (Dublin, Royal Irish Academy). It has enlarged initial capitals, integrating crosses and fishes copied from Roman manuscripts with native Celtic exuberance. Then follow the three 'luxury' manuscripts, prepared by great artists as

a feast for the eyes of Dark Age kings: the Book of Durrow, from about 670 (Dublin, Trinity), the Lindisfarne Gospels, *c.*700 (British Library) and the Book of Kells, *c.*800 (Dublin, Trinity). These three masterpieces have never been excelled in the history of book production: the concentrated skill they display astonishes, mystifies, overwhelms and even alarms modern eyes. It is hard for us to get inside the mind of the scribe-artist who spent months, perhaps years, decorating a single page with a combination of abstract motifs, zoomorphic or terrestrial stylised figures, major initials and elaborate script, all integrated in designs which are self-perpetuating patterns of dynamic movement.

The workmanship is so close to perfection that it is almost impossible to detect signs of fatigue or flagging invention. The Durrow Book was the first to introduce what scholars call a 'carpet-page', that is a page consisting entirely of abstract zoomorphic decoration which announces the beginning of an important section of the book. The finest carpet-page in Durrow, in green, red, gold and black, has a few crosses, themselves linked in a lace-like integrated pattern, but mainly consists of stylised animals, snakes, fishes, horses and lions, swallowing each other and so producing a stream of decorative consciousness which weaves its baffling but determined way up and down and across the page. The carpet-page in the Lindisfarne Gospels which

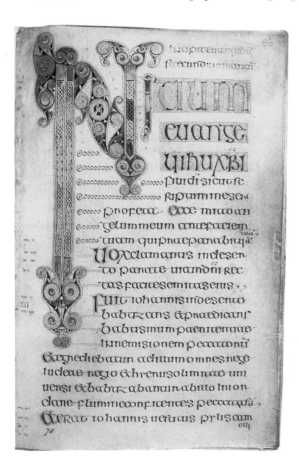

introduces the narrative of St John (folio 210b) is even more dense and elaborate, using a much greater range of colours, impressed on the vellum with varying and carefully calculated gradations of power. It has a rectilinear framework, and abstract panels within it, but the background is the same swirling, whirling, ordered maelstrom of curves embodying animals which is almost beyond modern contrivance to break down into component limbs, heads and mouths. The beauty is mesmerising. It is not exactly out of this world. But it is out of our world. It is designed not so much to give an overall impression—it is the total reverse

The Book of Durrow (seventh century) is a masterpiece of calligraphy, drawn from late Roman models, and merged into Celtic passion for abstract decorative forms.

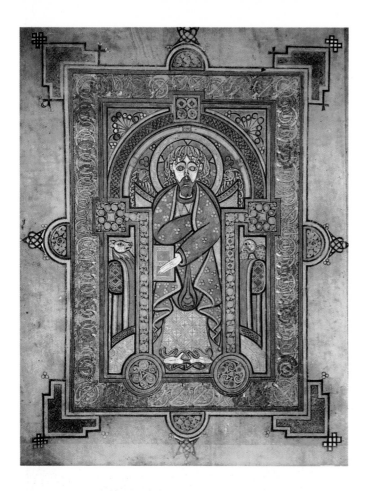

The Book of Kells (eighth century) is the climax of the Celtic art of illuminated manuscripts in which nature (here in the shape of St Mark) emerges from abstraction.

of 'impressionist' art—but to entice the eye, and in the eighth century that would have been a trained eye, to follow the artist in all his deliberate meanderings across the page to reach the end which also proves to be the beginning.

By the time we come to the Book of Kells, *c.*800, the human figure is beginning to play a more important part. There are five full-page pictures. The one of St John the Evangelist shows him sitting in his scribal chair, holding his writing-stick and his gospel, and surrounded by a fantastic display of abstract and zoomorphic art in a series of panels; the whole is held in the hands of a mysterious presenter, whose feet protrude at the bottom of the page, but whose head has been cut off by a barbarous nineteenth-century trimmer. This is high art, of a sombre and mysterious kind, imaginatively superior to anything then being produced in Byzantine scriptoria. The book was begun in Iona and finished (to escape Viking raids) at Kells in Ireland. With its full range of decorative motifs, iconic images and narratives, such as the Temptation and Betrayal of Christ and the Virgin and Child, it is a comprehensive encyclopaedia of what Celtic-Christian-English art could produce. It has been more battered by time than the Lindisfarne Gospels but some of these splendid early works have fared even worse.

The so-called Lichfield Gospels, now in the cathedral archives, retain their original sequence of decoration only in St Luke's Gospel, which has a carpet-page of a complexity and beauty that has never been surpassed in decorative art. It is a triumphant labyrinth of zoomorphic forms made even more impressive by its quasi-monochrome red-and-black painting. This amazing work was produced *c.*730, but we do not know where (certainly not Lichfield). What we do know is that a Welsh nobleman called Gedhi, early in the ninth century, gave his best horse for it, so that he could gloat over it and then present it to the church he founded near Carmarthen. This tells us something of the esteem in which high art was held by the ruling class of Dark Age Britain.

But this is more than religious art. It is art *per se*. One is almost tempted, at times, studying a fantastical carpet-page, to say it is art for art's sake. But that would be to go too far. These artists were monks, dedicated to a life of poverty, chastity and obedience, and using their skills—and their overwhelming energy and imaginative invention—for the glory of God and to edify and inspire the laymen who ruled a rough society. It is important to remember that, though our eyes focus on the carpet-pages, illuminated initials and figure-paintings of these marvellous books, for Dark Age scribes and readers the essence of them was the text itself. One of the chief objects of Dark Age artists was to recover, copy or evolve really noble and legible scripts. In this field they had a magnificent heritage, for Roman scripts were clear, uniform and dignified. Some of the text lettering produced in Lindisfarne is of superb quality.

When Charlemagne, the Frankish king (742–814), established a united European monarchy on either side of the Rhine, and had himself crowned Holy Roman Emperor during Christmas Mass in Rome in 800 AD, he decided to devote a great proportion of his vast wealth to creating a court culture, on what he believed to be Roman lines. This was a proto-Renaissance, an attempt to resurrect the glories of a Roman civilisation which Dark Age societies regarded as the apogee of the Golden Age. In Aachen, the capital of his heartlands, Charlemagne built a palace made from materials brought there from Rome and Ravenna. He had himself taught Latin and a little Greek. He appointed a cultural minister, Alcuin, who on royal instructions in 785 wrote his *Epistola de Litteris Colendis*, which outlined a programme for the study of Latin, and of Latin texts, sacred and profane, in all the monastic and cathedral schools throughout the Empire. The scriptorium in Aachen set the standard of book production, and in the process it developed what became known as the Carolingian minuscule, a clear, elegant and highly readable script which spread and became standard in the early Middle Ages.

We see this development in two important manuscripts now in the Vatican

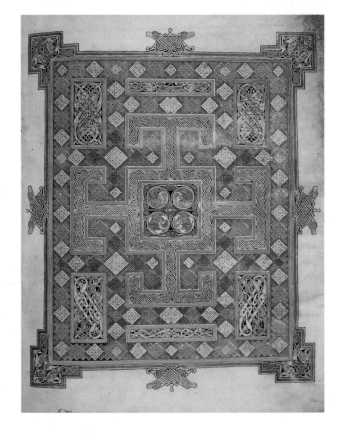

'Carpet page' from the Lindisfarne Gospels (seventh century) symbolises infinity, for the lines which make up the composition have no beginning and no end.

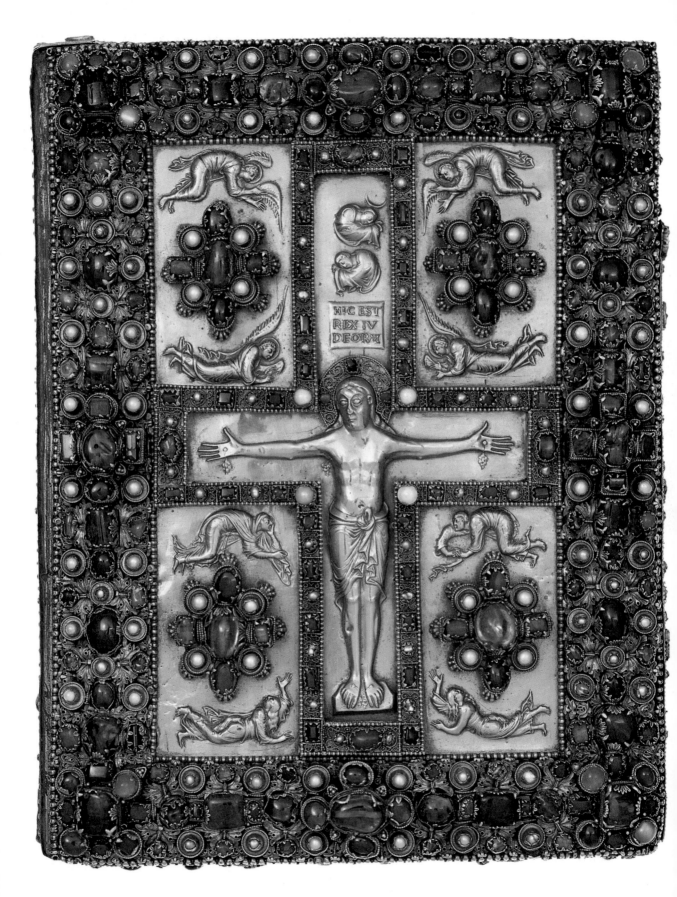

Library. The first is the Sacramentary of Gelasius, from *c*.780, which is written in a fine uncial, though Charlemagne's minuscule makes its appearance in places. Instead of the carpet-pages, we have whole-page initials adorned with barbarous fishes, fowl and plants—sometimes deer too—which are in flaming red, green and yellow, full of vigour but with scarcely a trace of the sophisticated artistry of the Lindisfarne scriptorium. The script, however, in capitals and lower case alike, is wonderfully clear and firm, as readable as anything to be found in a modern newspaper. Here was artistic progress, for a definite purpose—conveying the Word. And this progress continued. From a few years after Charlemagne's death we have a copy of Terence's *Comedies*, also in the Vatican Library, which is written entirely in excellent Carolingian minuscule, and illustrated by paintings of actors performing the plays. The figures of actors in folio 55 recto, with their powerful gestures, are exact renderings of skills supposedly lost for centuries, but what impresses even more is the sheer quality of the text. It was smoothly and rapidly transcribed by professional clerks who were turning an ancient art form into the fluent means to educate and entertain many thousands of literates. They thus prepared the way for the change to moveable type which, in the course of time, would cater for hundreds, even thousands, of millions. By contrast, in China and Islam, indeed in all literate Asian societies, script was still very much a specialist art and failed to develop its utilitarian functions for a considerable time, during which the West advanced relentlessly.

Here, then, was art for man's sake. It was also, of course, art for God's sake. Of the codices or bound books produced between the seventh and the fifteenth centuries, the overwhelming majority, about ninety-five per cent, were religious in content. This output of art was not confined to two-dimensional illustrations. Adorning the cover of a great book offered a challenge to ivory carvers and they took it up with vigour. The craftsman who carved the cover of Charles the Bold's Psalter (*c*.850) with a deep-cut rendering of Psalm 57, 'Among the Lions', was a great sculptor. The back panel of the book, now in the Bibliothèque Nationale, Paris, showing scenes from the Life of Christ, is even finer: the shepherds tending their flock in the foreground form a masterpiece of animal art, and the affection between men and beasts casts a new light on this supposedly rude time. From Belgium, in St Martin's Church, Genoels-Elderen, there is an eighth-century book cover, in exquisite ivory and blue glass (now in the Royal Museum, Brussels), showing Christ with strange animals (front) and the Annunciation and Visitation (rear), which still has the power to move with its delicacy and pure sentiment. More precious is the silvergilt and bejewelled cover of the Lindau Gospels (*c*.825) now in the Morgan Library, New York, a masterpiece of English labyrinthine zoomorphology. Amiens Museum has a *Miracles of Saint Rémi*, dated 880, which illustrates three miracles on its cover, in ivory inlaid with bronze, in the liveliest possible manner. These masterly works are among scores of their kind which show how the business of creating fine

FACING PAGE: Precious manuscripts, such as the Lindau Gospels (*c*.825), were protected by stout wood-and-leather covers embossed with precious stones set in gold.

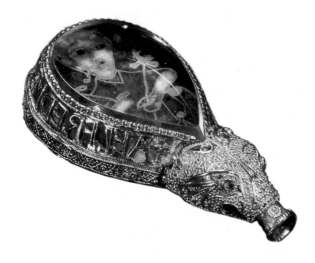

This jewel (ninth century), a commission of Alfred the Great, is of gold with a cloisonné enamel portrait, symbolising 'Sight' or 'Christ as the Wisdom of God'.

codices spurred on artists working with a wide variety of materials.

Such books survived because they were in church libraries and thus under the protection of God, a concept which worked preservative wonders even in the most desperate times of the Dark Ages and the early medieval period. In the last 200 years we have found many works of secular art, including swords, jewellery, ornamental belts and clasps, in the form of hoards, dug up by treasure-seekers or professional archaeologists. The only other chance of a portable work of high art surviving was if it was deposited in a religious institution. This is what happened to the jewellery of Queen Arnegund (*c*.565), now in the Louvre. It consists of a superb belt buckle, ring, earrings and pins, in niello, gold and silver, with garnets and glass, which were buried with her in the royal church of St-Denis, near Paris. Similarly, a small cast and gilded bronze statue of Charlemagne has survived because it was deposited in Metz Cathedral. Equally, the magnificent and mysterious early-eighth-century Franks Casket (British Museum), which is both beautiful and stylish, and carved from whalebone, owes its survival to its use as a reliquary in a monastic establishment; with its scenes from Jewish, Christian, Roman and Germanic tradition and runic writings, this work has been described as 'ostentatiously erudite'. Where brooches survive (except in hoards), they were almost certainly used to clasp together the heavy vestments of a bishop. This is true, I think, of the Strickland Brooch (British Museum), of silver with inlaid gold and niello ornament, its deeply carved decoration pierced to give an openwork effect—perhaps the finest Anglo-Saxon jewel to come down to us. Its only competitor is the Alfred Jewel in the Ashmolean, Oxford, of pure gold with rock-crystal enamel, which dates from *c*.890. It is perhaps the most beautiful bookmark ever made, and survived because it was so used in monastic libraries. As a final illustration of the protective power of the Church over magnificent secular objects, we have the so-called Suger's Eagle in the Louvre, a concoction of silver-gilt and antique porphyry which, like Arnegund's jewels, found safety in St-Denis (though it was finally stolen from there by Bonaparte).

The Church, therefore, preserved secular, especially royal, art. But it was, of course, itself overwhelmingly the chief patron of artists throughout the Dark Ages and early medieval period in western Europe. In England alone, from the sixth to the sixteenth centuries, about 15,000 parish and collegiate churches were built, of which nearly 8,000 survive. In France, the number reached over 20,000, though the survival rate is lower. If we take in the Low Countries, Germany, Italy and Spain, the

total number of churches built during this millennium is not far short of 100,000. The churches were often fine works of art in themselves—we will come to that soon—but they also required a wide variety of furnishings, equipment and decorative features, which kept artists busy in large numbers, generation after generation, and led to the evolution of innumerable art forms of great power and beauty.

In the first place there was the altar itself, its cloth and the vestments of the priests celebrating Mass. Early altars rarely survive, as the clergy were always 'improving' them, but there is in the Musée de Cluny, Paris, an Anglo-Saxon portable altar (lateish, *c*.1020), which is a magnificent work of art: a fine porphyry slab, with oak base, framed by a niello-decorated silver surround, subtly gilded in places. The engraving is highly sophisticated and up to the highest standards of book illumination. It is rare too for early vestments to survive. But the Los Angeles County Art Museum has an exquisite ninth-century strip of braid, about a foot long, made of gold and silver thread mounted on silk, coloured red, deep brown and yellow, which formed one of the infulae or fanons which hung from a bishop's mitre. This was preserved at the archiepiscopal abbey of St Peter, Salzburg. There is an even earlier strip of vestment found in the tomb of St Cuthbert at Durham, and now in the Cathedral Museum, but it is far less elegant. From later examples of vestments which have somehow managed to escape time's ravages, it is clear that some of the very greatest artists designed them. The Sion Cope, now in the Victoria and Albert Museum, London, dating from *c*.1300, is a huge and stately garment, worn like a cloak by a prelate. Embroidered with saints and angels in coloured silks and silver thread, it is a major work of art.

The Sion Cope, embroidered in England in the fourteenth century, made lavish use of silver thread, gilded silver and silk embroidery on a linen base.

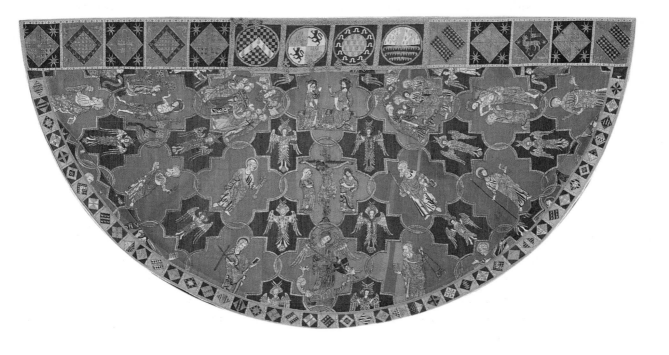

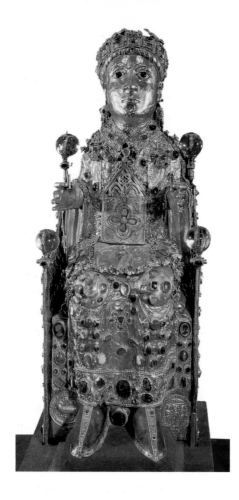

This reliquary statue of St Foi at Conques in France is a supreme example of early medieval (late ninth century) goldsmith's work, with later additions.

Then there were the reliquaries: elaborate standing jewels or monstrances specifically designed to preserve and display portions of the True Cross, saints' bones or other holy substances. Emperors and kings and other rich men (and women) paid more attention to relics than to any other aspect of religion—they were highly superstitious—and churches and abbeys fought fiercely for the more valuable ones, as they attracted fee-paying pilgrims by the thousand. Fashionable relics altered the whole pattern of Christianity and introduced immense artistic changes. Thus the supposed body of St James the Great, taken in the ninth century to Santiago de Compostela in Spain, not only gave rise to one of the greatest of medieval cathedrals, a reliquary in itself, but a pilgrim route from France and central Europe along which were built hundreds of churches, chapels and shrines, plus wayside crosses, which together constitute a continuing museum of early medieval art. The putative relics of Mary Magdalen at Vézelay created another great pilgrimage object, with attendant artefacts, as did the shrine of the murdered St Thomas in Canterbury Cathedral. St Louis, King of France, built his Sainte-Chapelle in Paris (1243–48), that exquisite work of architecture and stained glass, as a gigantic relic to house what he believed was a thorn from the Crown of Thorns. But reliquaries and pilgrimage centres attracted the greedy. Henry VIII plundered the shrine of St Thomas in 1534, taking away twenty cartloads of works of art in fine silver and gold to be melted down to feed his wars. The Puritan deans of Durham in the sixteenth century destroyed the reliquary and tomb of St Cuthbert in their cathedral, once a museum of the finest Anglo-Saxon and early medieval art, and the French revolutionaries ransacked the Sainte-Chapelle and scores of other pilgrim churches in the early 1790s.

One important pilgrimage church which managed to keep its treasures intact was at Conques in the south of France. It is worth a special expedition. The church is a magnificent example of early medieval architecture, and contains many fine

objects and relics. The pride of its collection is an astonishing full-length seated figure of a third-century girl, St Foi or Santa Fe, martyred at the age of twelve. It is of almost solid gold, adorned with a variety of precious stones, mostly of eleventh-century workmanship. The head, which contains part of the girl's skull, is modelled on a fifth-century Roman parade helmet, enclosing a gold face with jewels for eyes. There is nothing like it anywhere in the world. It exudes mystic power and majesty and is almost barbarous. But like all really great art it is an unforgettable image. Other reliquaries survive shaped as arms, legs, heads of busts, containing the appropriate part of the saint's body. And in Trier Cathedral there is a large and precious nail (c.980) of gold, richly enamelled, which was made to contain a nail of the True Cross.

Next in importance come the liturgical objects and vessels used in the daily services of churches. Chalices, containing consecrated wine, were made in huge numbers, originally of glass or earthenware (St Boniface, the Englishman who evangelised Germany, used a wooden one), then increasingly of gold. Only a small proportion survive, especially from early times. One such is an eighth-century masterpiece of Anglo-Carolingian workmanship, in gilded copper alloy, now kept in the abbey of Kremsemünster, Austria. Nothing can exceed in elegance the pure lines of this sacred cup, or the pathos of the suffering Christ which decorates it in niello.

Of the principal items of church furniture, many of them immovable, we shall have more to say later, for some of them challenged the skills of the greatest artists in the late medieval and Early Modern periods. They include the tabernacle, the cynosure of all devoted eyes in church; the baldacchino, which covered the whole altar in the grander churches; the fixed ciborium—such as the magnificent creation of Arnolfo di Cambio, made in 1285, which adorns St Paul-Without-the-Walls in Rome; the lectern used for reading the Gospels, of which a fascinating sixth-century pair survive in Rome's San Clemente; the *pulpitum* of stone, which separates the nave from the choir, and was often surmounted by a crucifix or rood as it was called in England—an object of peculiar hatred for iconoclasts and puritans; the altar rails, the confessional, the reredos, backing the altar, the pulpit itself, the font and the altarpiece, usually a painting. These last four items stood out in all churches and as the Christian era progressed, artists of the highest genius were employed to create and decorate them. There were also the items used to illuminate the church: plain, tinted or stained glass, another source of the very highest art, sanctuary lamps and candlesticks, which came in every conceivable size and shape, some ten feet high. Before the Reformation, the congregation were rarely provided with chairs, or even benches, but in collegiate churches the canons or monks had stalls in the choir which gave the carpenters of the later Middle Ages the opportunity to excel themselves. There were also episcopal chairs, of which the outstanding early example is the so-called Throne of King Dagobert (reigned 629–639), which was preserved in Saint-Denis until seized by revolutionaries in 1791, then handed over to the Louvre

(now in the Cabinet de Médailles, Bibliothèque Nationale). It is of gilded bronze, with lion-headed legs, and is very powerful.

The apse, or eastern end of the church, provided endless opportunities for the artist. Mosaics are rare in western and northern Europe, but they do occur, notably the beautiful apse mosaic of the Ark of the Covenant, Cherubim and the Mystical Hand of God, which Theobald, Bishop of Orleans, had made, c.800, for his private chapel, now the parish church of Germigny-des-Prés (Loiret). This is a work of the highest art. It was more usual, however, to use fresco, and this often spread from the apse all over the church, especially into the crypt, as we find in the abbey church of St-Germain, Auxerre, which has scenes from the life of St Stephen, painted 841–59. Churches were also hung with paintings of various kinds, notably Stations of the Cross, fourteen in number, which punctuated a liturgical ceremony of prayer, performed by individuals or the congregation as a whole, commemorating the detailed events of Christ's Passion.

If we include church attachments, such as belfries or bell-towers, the bells themselves, the church crosses before which outdoor sermons were held for large congregations, as at Old St Paul's in London, bench-ends, ceiling bosses on vaults, choir lofts, tomb statuary, porch fittings, often major works of carved furniture, and the porch or portico itself, I calculate that the Christian church in western Europe provided at least seventy-five distinct opportunities for a variety of artists and craftsmen to exercise their skills—in textiles, stone, wood, ivory and marble, gold and silver, brass and bronze, paint, gilding and enamel, vellum, parchment and precious stones.

Granted the large number of churches, the employment provided for skilled labour was immense, almost beyond computation over the millennium when church-building flourished. For not only were parish churches constantly rebuilt, extended, redecorated, gutted then embellished anew, but extra churches of growing size were put up in the new or expanded towns. Each time an order of regular priests or brothers was founded, whether rural, like the Benedictines, Cistercians, Carthusians, Carmelites and scores of other contemplative monks, canons and brethren, or urban, like the Franciscan and Dominican friars, and their many imitators, both male and female, a new set of churches had to be built. They were designed in a highly competitive spirit, which provided rich pickings for good artists, and endless delight for us who relish the results. The last great order to unleash a major (in this case global) building programme was the Jesuits, founded in the mid-sixteenth century. Since they believed in huge churches, and in decorating every square inch of their interior wall-surfaces (often ceilings too), they employed large numbers of fine craftsmen, as well as great masters. There were further immense monastic building programmes pursued in Counter-Reformation Germany and Austria in the seventeenth and eighteenth centuries and, then, following the Industrial Revolution, a massive church-building programme in the new 'satanic mill' cities it produced.

Christianity can thus be called the greatest single historic fact in the whole story of human art.

The porch or portico was the connecting link between the interior and the exterior of the church. Apart from the overall profile of the architecture, the porch was the usual identifying feature of the style and period, for it was, almost always, the most elaborately decorated part of the outside. It was also peculiarly dear to the ordinary members of the congregation, and for that reason embodied survivals from the past, nostalgia being the most common human instinct in art. In Norway and Sweden, Christianisation, far from erasing pagan styles, especially in timber-work and wood-carving, sometimes prolonged them. It produced, for instance, the stave church, as it is known, an all-wood building with a high pitched roof, of which the outstanding example is the superb twelfth-century church of St Andrew at Borgund in Norway. Over a thousand stave churches were built in Norway alone. But only twenty-eight survive since, in all the early examples, the principal poles of the framework were driven straight into the ground and soon rotted (later a timber-and-masonry foundation was provided).

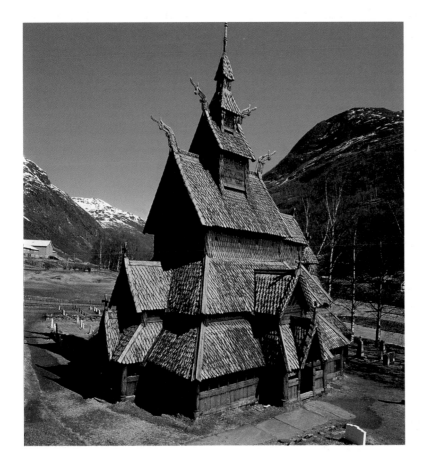

Stave Church of St Andrew at Borgund, Norway, is an outstanding illustration of Scandinavian carpentry using upright timbers. This twelfth-century example is one of twenty-eight to survive from over a thousand built.

At Urne, in a remote site in southwest Norway, the twelfth-century stave church contains, built into its north wall, the portal and door of its much earlier predecessor. These are decorated with deep-incision wood-carvings which have never been excelled in technical audacity or imaginative design. They reflect the labyrinthine zoomorphism which we have already noted to be characteristic of so much Dark Age art in the northern lands. Composed of interpenetrating open loops, with two intersecting figures-of-eight, or even more complicated multiloops, they incorporate stylised snakes, an animal in the shape of a ribbon, and an abstract quadruped. The swelling and tapering of the endless curves, and the amazing virtuosity with which they are separated from the base—together with the almost insane complexity of the design—are mesmerising. Urne-type designs, as the scholars now call them, are to be found on runic stones in Sweden, especially in Uppland, and very impressive they are. But there is nothing like the Urne doorway itself, a masterpiece of the woodcarver's art. How it came to be found in this remote church serving a penurious community is a mystery.

Almost as baffling are the superlative carvings in the sandstone of the parish church of Saints Mary and Paul at Kilpeck in a remote part of Herefordshire. It seems to date from the 1130s, but the motifs of the carvings, especially on the south door, with their swirling, slithering, intermingling animal forms, are echoes of an earlier age, as well as of influences as far apart as Santiago de Compostela, southwest France and the Phrygian caps of antiquity. As with Urne, scholars take the patterns apart and delve deeply into provenances, but to ordinary visitors, the carvings produce sheer, uncomprehending delight, just as they must surely have delighted humble parishioners 1,000 years ago.

We come here to an important point about art and religion. All great religions begin in absolute simplicity. All, with gathering speed, find that religious enthusiasm expresses itself in exuberant art, whose complexities are liable to break the bounds of decorum. Art is an ordering process. So is true religion. When religion sets strict bounds on human activity, as Christianity certainly did as soon as it had the power, the artist is liable to celebrate its truth by creating his own scheme of disorder-within-order which (he assumes) delights God Almighty, while pleasing himself by exhibiting his skills and exercising his imagination. We no longer believe, as it was common in the days of Carlyle and Ruskin, that the great works of Dark Age and early medieval art were created by enthusiastic amateurs, monks, priests and the like who built elaborate churches and cathedrals by sheer faith and willpower. Art is the oldest profession, and no great art, in any age or any place, was produced by mere amateurs. We can be certain that, even in the backwoods, such high-quality work as at Urne and Kilpeck was produced by men born to their craft and paid for their labour, artists who were proud of their talents.

Such men, and occasionally women, served God with varying degrees of devotion, but their service to their art was a more consistent element in their motivation.

That great scholar of early European art Meyer Shapiro, in his *Collected Papers*, draws attention to a passage written by Abbot Witicus in 1169, in the *Chronicles of St-Trond*, an abbey near Liège. 'So much care did the industrious architect devote to the decoration of the monastery that everyone in our land agrees that it surpasses the most magnificent palaces by its varied workmanship . . . By the beauty of the work he gave immortality to the author of the enterprise.'

Shapiro links this passage to the famous diatribe St Bernard wrote to Abbot William of St-Thierry, denouncing the artistic excesses of the Cluniac monks. St Bernard was a Western-style iconoclast whose own Cistercian order, radiating from the mother house he founded at Cîteaux, was designed, among other things, to return to the pristine purity of the primitive Church, with no images and no non-utilitarian decorations. It is important to note that Bernard is attacking not art as such but the irrelevances of what he regarded as secular, if not pagan, fantasy. Even in protesting against such excesses, he does not deny their strange appeal. He writes:

> In the cloister, under the eyes of the brethren who read there, what profit is there in these ridiculous monsters, in that marvellous and deformed beauty, in that beautiful deformity? To what purpose are those unclean apes, those fierce lions, those monstrous centaurs, those half-men, those striped tigers, those fighting knights, those hunters winding their horns? Many bodies are seen under one head, or again, many heads to a single body. Here is a four-footed beast with a serpent's tail; there, a fish with a beast's head. Here again the forepart of a horse trails half a goat behind it, or a horned beast bears the hindquarters of a horse. In short, so many and so marvellous are the variety of shapes on every hand, that we are more tempted to read in the marble than in our books, and to spend the whole day wondering at these things rather than in meditating the law of God.

Then he adds, exasperated: 'For God's sake, if men are not ashamed of these follies, why at least do they not shrink from the expense?' St Bernard, be it noted, is not denying the force of this non-Christian art. On the contrary, he is afraid of the power of its beauty and fascination over men's minds. He is pleading, not so much for a policy of inhibiting art, as for didactic art, which directly and obviously served God's purpose.

Senior churchmen found it difficult to staunch this torrential flow of exotic images, not only because most of them shared the enthusiasm of the artists for strong religious meat, but also because their own building plans, to enhance their personal status and win credit with the powers of Heaven, were the reverse of pristine simplicity. By senior churchmen I mean, chiefly, the priors and abbots of the great monasteries. In western Europe, the fifth to the twelfth centuries were the age of the monks, and the cloistered orders, which included growing numbers of nuns. The monastery was a central pillar of society. Rich lords found it convenient to

endow them, thus establishing a family connection: younger sons became abbots and other senior functionaries, while widows and unprotected womenfolk of the family could find safety and dignity as abbesses and prioresses in strongly built institutions which were additionally sacrosanct. Monastic farming, on the whole, proved highly successful, especially in transforming frontier districts into productive estates. In Ireland, abbots, closely linked to the regional kings, were more important than the bishops, who were mere officials. In England, most of the bishoprics were monastic foundations, with the monks forming the chapter which appointed the bishop.

In France, monasteries which made a profit from large-scale farming set up colonies or daughter houses with the proceeds, and in time became great powers in the land. The outstanding example was Cluny in Burgundy, founded in 909 by the Benedictine monk Berno, an effective reformer of slack monasteries. As Cluny stood on the main route between northern Europe and the pilgrimage centres of Rome and Santiago de Compostela, it formed important connections. Soon, kings and ruling dukes competed to endow the institutions with further lands and to adorn their buildings. Between the late tenth and the early twelfth centuries, Cluny was in terms of wealth and influence a great power in Europe. It had three hundred monks in its main monastery, five large daughter houses, including one in Paris and one in England, and more than a thousand priories and affiliated outposts. Its wealth was so enormous, and the commissions of its abbots so many and elaborate, that it became the most important patron of art in Europe. It was the carved extravagances in the main cloister at Cluny which provoked St Bernard's wrath. He became a reformer in turn. But his Cistercian monks, being strictly disciplined and well-organised, proved to be successful landowners too. They founded houses all over northern and central Europe, especially in frontier districts like Hungary where large tracts of land could be recovered from nature and turned into productive farms. A Cistercian house might easily farm 100,000 acres, and one of them in Hungary owned a quarter of a million square miles. So they in turn built magnificent monasteries and employed the best architects and decorators.

In what had once been the Roman Empire, church architecture continued to follow the main basilica pattern of oblong shapes with lines of pillars supporting the roof. The arcades had round arches, as in Roman times. This distinction between the rounded arch, in piers and windows, and the later pointed arches, led early-nineteenth-century architectural historians to distinguish between a Romanesque style and the Gothic. But these categories are misleading. There was in fact a continuous development from the sub-Roman buildings of the early Dark Ages, to the magnificent and enormous cathedrals of the twelfth to fifteenth centuries. The progression was in quality and weight-carrying. Here the abbot patrons and the monasteries took the lead. The monks thought in terms of planning, design, the long-term. They

built to last. The stones used in Dark Age churches and other buildings were little better than rubble, unless partly constructed with the spoils from collapsed Roman edifices. The abbots, especially the rich ones of Cluny and the like, insisted on employing and training skilled masons, who carved accurately and uniformly.

The tenth century produced millions of small, well-shaped blocks, called *petit appareil*, which could be laid accurately in courses. These gradually yielded to much larger blocks, with a high degree of finish and accuracy, called *grand appareil*. The amount of mortar used could thus be reduced, and this in turn enlarged the surfaces available for carving, moulding and capitals. And because the quality and reliability of the stonework carried more weight, buildings could become larger and more complicated. That was as well, for the increasing complexity of the liturgy, and the importance of relics, each with its own shrine, in the larger monasteries and churches, made more chapels and subdivisions of the building necessary. It became customary to vault the roof in stone, although until the later Middle Ages, the stonework was covered by a wooden ceiling, painted and carved. At the east, high-altar end, the main performing area was raised, with a columned room below which, because hidden, was called a crypt. This was a place for treasures. At the other end of the church, plain façades were replaced by westworks of many storeys, eventually ending in towers and steeples.

A further factor in the development of church architecture was the influence of secular castle-building, a product of the system of feudalism which operated in the West during the seventh to tenth centuries. Castles too, to be secure, had to be built increasingly of high-class masonry, regularly laid. Great attention was paid to windows, thickness and strength of walls, staircases (curved and winding, known as newels) and passages built into the thickness of the walls. The same expert architects designed and built both castles and churches, and the two forms of architecture, stressing strength and quality, progressed together. But monastic churches took the lead, for abbots often had more to spend than secular lords, or even kings.

Thus it was that the Dark Ages yielded place to the early medieval period, a gradual change reflected in the growing wealth of society and the size and quality of the buildings it could produce. At Cluny itself a huge and complex church evolved (historians distinguish between Cluny I, II and III) between 927 and 1157. Its glory was financed by its own vast revenues, supplemented by princely donations from such monarchs as Alfonso VI of Spain, who hoped to curry favour with both Almighty God and the influential abbot. Henry I of England provided the vast annual sum of 133 pounds sterling. His daughter Matilda donated the bells of its westwork and a great seven-branched candlestick to light the high altar.

The Cluny nave was 300 feet long, 150 feet wide (including aisles) and 100 feet high. The total external length of the church, including the narthex, was nearly 600

feet. It had a double transept, which created astonishing internal perspective views, a vaulted roof, four bell-towers and five other towers, forming a forest of nine steeples, and clusters of fifteen side-chapels at the east end. Its decoration was highly disciplined, carving being confined chiefly to the portals and capitals, and the arches of the cloister. So far as we can tell, from surviving fragments, the quality of the sculpture was exceptionally high. Throughout the construction period, the best architects available were secured. The last of them was an expert mathematician called Hezello, a canon of Liège, who worked out the dimensions systematically and was apparently familiar with the architectural treatise of Vitruvius. The French revolutionaries suppressed the Cluniacs in 1790 and seized their property. In 1809 the Emperor Napoleon, supposedly the greatest patron of art on earth, who had gathered artistic loot from all over Europe to endow his Louvre, renamed the Musée Napoleon, had the church blown to pieces by tons of gunpowder, leaving only the skeleton of the southwest transept. It was the greatest act of deliberate artistic vandalism in history.

Hence this great edifice which spans the junction between darkness and the light of medieval Christendom has to be judged from old prints. But other monastic structures, of small size and lesser importance, do survive in considerable numbers. There is, for instance, the church of San Vicente at Cardona in northeast Spain, which has in miniature all the characteristics of the new artistic culture, as they developed while the church was being built, 980–1040 AD. It has eight huge columns or piers, forming four bays on each side, with aisles, and half-cylinder apses at the end of the nave and each aisle transept, with a westwork at the other end. Built into the westwork (or narthex) are spiral and rectangular staircases, castle-fashion, and the whole edifice is buttressed outside by ancillary buildings which give it an impressive pyramid shape on the top of its rock. This is an exciting church to be gloried in from afar with its harsh silhouette, and closely inspected within because the vaults of the westwork (late twelfth century) were painted with a complex and dramatic series of scenes from the New Testament dominated by a Western version of Christ Pantocrator.

Close to Cluny itself are the great abbeys, which have the same cluster-effect but vary widely in detail and size. In the western Pyrenees, for example, is the magnificent abbey of St-Michel-de-Cuxa (960–970), with its twenty-two distinct tiled roofs, its long pillared nave and its massive seven-storey tower-campanile, which springs out of the wooded mountainous setting like a huge blunt sword. Conques is another great collegiate church, a fit setting for its marvels, and almost untouched by time, which makes a visit to it a soothing retrogression into the early medieval period. There is a massive westwork, and at the east end, seven semicircular chapels group themselves around a semicylindrical two-tiered apse crowned by its dome and its octagonal drummed spire, with a wide transept separating it from the public nave. The stone is a magnificent golden-brown, and

Hildesheim Cathedral contains a masterpiece of Saxon art, c.1015: two brass doors decorated with powerful figures and embodying profound theological concepts.

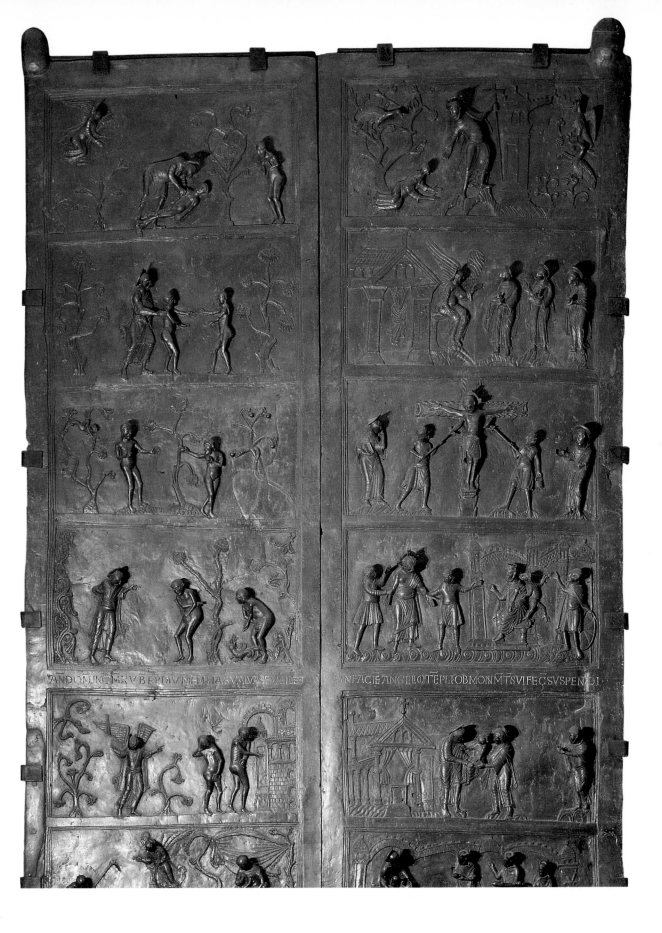

the masonry illustrates all the stages from the first departure from sub-Roman rubble to the *petits* and *grand appareils*.

Towers, often crowned by spires, were becoming common, not only in the west-works but often crowning the centre of the church where nave and choir joined—a perilous procedure for it involved planting a huge weight of masonry at precisely the point where the church was widest and the walls and columns under the most strain. But risk-taking was a characteristic of early medieval society. The abbots, and the mason-architects they employed, believed that God was on their side when they opted for grandeur, and would see them through. It was a hope often dashed, the dramatic collapsing of insecure central towers being a feature of the Middle Ages. At St-Martin at Chapaize in Burgundy (1000–1020), the central tower looks too big for the church, and its intact survival is surprising. At St Maria of Barbara near Barcelona (late eleventh century), the tower, though tall, is just right and has been moved, for safety, to the side of the apse. The stonework here is of exceptional quality, in a variety of colours, rather like the polychrome churches of Armenia, and it is in a splendid state of preservation, so that the painter, at sight of it, hastens to get out his brushes.

There was much grand-scale eleventh-century building in Germany too. St Michael's in Hildesheim (1010–33) placed equal stress on the apse and the west end, joined by a massive nine-bay arcaded nave, with two towers on each side. Its creator, Bishop Bernward, was the leading aesthete of these times as well as a powerful man of business, with wide royal and noble connections, and considerable personal wealth. He visited Rome, and took artistic notes, and also St-Denis near Paris, already a centre of art. In his own fief he created a fine library, a scriptorium and an art centre where craftsmen of all kinds worked and were trained. He himself was a skilled goldsmith and metal-caster, who made the silver candlesticks for his own tomb (two survive), the church's bronze doors, and a 'Column of Christ' which adorns the interior and is an early example of classical revival. It was typical of this fastidious man that he rejected the elaboration of Corinthian columns and invented instead a simple form known as a cushion capital. It was clean, beautiful and not widely adopted, the trend being towards detail and fuss.

In contrast to Bernward's cathedral were the works of the Emperor Conrad II (reigned 1024–39), another German aesthete, though not a professional artist, who caused to be built the vast abbey of Limburg auf der Haardt, with its innovative and complex arcading made possible by the introduction of half-shafts and pilasters. There is impressive play with space in this fine church. Conrad built on the lessons he learned at Limburg to set up the new imperial church of Germany at Speyer, a self-conscious attempt to create a grand building on Roman lines, which borrowed ideas from the ancient Roman Porta Nigra at Trier and the basilica there. It is because enlightened men like Bernward and Conrad copied ideas and forms from Rome, just as Charlemagne had borrowed scripts, that I think it can be misleading to speak of a

Renaissance in the centuries to come: the rebirth of Roman forms, as reinterpreted by Dark Age and early medieval patrons and artists, was going on all the time.

As one studies the arts in these centuries—from the eighth to the twelfth—one is impressed almost equally by the skill with which the best of what was known of the past was seized upon and used, and by the sheer inventiveness and imagination by which this recovered past was transformed and improved upon. At this great game of art there was no one to match the Normans, one of the most vigorous and gifted small peoples of history, on a par with the Jews and Armenians, the Venetians and the Dutch. They were Scandinavian pirates, chiefly from Denmark, who ravaged the coasts of northwest France from the eighth century, and had settled there in force by about 900, founding what became the rich Duchy of Normandy. They were amazingly adaptive, learned French, converted to Christianity, recruited fine Latin scholars who trained more, and quickly rose to the front of those who patronised the arts and advanced the interests of the Church. When Hildebrand became Pope Gregory VII and started his thoroughgoing reformation of the Church in the eleventh century, the Normans, instead of opposing it, like the foolish emperors of Germany, gave it their wholehearted support, and thus prospered in law and wisdom, piety and art. They are an interesting example of how wild barbarians, origi-nally apes of disorder, became ordering agents themselves, using the arts as their instrument. While acquiring culture and wisdom, they retained many of their aggressive, risk-taking instincts, being ruthless, forceful, violence-loving, crafty, cunning, resourceful and wonderfully daring and courageous. Thus they ranged far afield from their Norman base, conquering England, Wales, Scotland and Ireland (up to a point, in the last three cases), Sicily and part of Italy.

Everywhere they established themselves, the Normans allied with progressive forces in the Church, chiefly clever and well-educated monks and monk-bishops, and built magnificently. In castle-building they were incomparable. The castle at Rochester, in Kent, was the strongest in the world in its day, an enormous four-square citadel, 150 feet high, which was never taken by assault. The Tower of London, on the Thames, was equally formidable and has lasted even better. Characteristically, it contains a fine, monumental chapel, small but massive, which encompasses all the elements of the new architectural system in miniature, and was a perfect setting for the deep devotions of the strong early Norman kings of England. In Rouen they laid the foundations of what was to become one of Europe's most impressive architec-tural cities. Throughout their duchy they built grand abbeys, as at Jumièges. Now ruinous, its still upright skeleton of towers and walls testifies powerfully to its strength and elegance. It is built of an almost white limestone, strong and carveable, fruit of a great series of quarries the Normans opened up near Caen. When they conquered England, they brought this marvellous stone with them, in countless shiploads, and it became the means by which their first king, William the Conqueror, cast over the country, in the admiring words of the Anglo-Saxon

Chronicle, 'a white robe of churches'. Church and castle nearly always went together wherever the Normans settled. The Conqueror made Durham, on its peninsula carved out of the surrounding moorland by the River Wear, high and defensible, the capital of a prince-bishopric, always run by someone close to his family. There, on its high rock, which frowns fearsomely on the river and people below, the Normans built a castle-cathedral complex, without rival in Europe for noble and godly beauty, and for sheer military strength. It was also Janus-faced; it pretended to be highly conservative but was actually revolutionary.

The mastermind behind this remarkable work was Bishop William of St Calais, a determined and gifted cleric typical of the Norman ruling class at its best. He had been a close friend of the old king, the Conqueror, who died in 1087. His son, the irascible and greedy Rufus, who hated clergymen, quarrelled with the bishop and sent him into exile. During his three-year absence, William examined various buildings in Normandy and the Ile de France, and came back, Rufus now needing his support, with plans for a gigantic new cathedral on the latest lines, or better. He tore down the existing Saxon church at Durham and began work, which continued for forty years until all was complete, long after his death. This is a mystery cathedral. When you enter the nave, you think you are in a typical church of the period, built on the largest possible scale. What shouts for attention are the gigantic piers and columns. They are grouped in twos, each of an alternating pillar and compound pier which form a 'great bay' or duplex bay, of exactly the same width as the massive supports of the crossing. The designer adapted the supportive formula used to enclose the space of the crossing to make the nave as high as possible. Why was this?

The liturgical demands of the cathedral, which were complicated and exacting and continually becoming more so, meant that it had to be designed from the inside outwards. The dynamic force pushing the designer against the frontiers of his technology was the insistence of bishop and chapter, backed by the public, that he provide an ever-larger enclosed space in the middle of the church. This was reinforced by a religious and aesthetic urge to let in more light by building the walls higher and higher. To the early medieval man, the church was an epitome of his cosmology. The stone with which it was built symbolised eternity. The walls upheld the firmament above. There God dwelt to receive his voice and prayers ascending upwards. Worship was a rising motion and the higher the ceiling the closer man's prayer and song, which filled it with sound, would come to God. And the higher the roof, the more detached it was from the clayey prison of the earth beneath. Height was therefore an escape from earth to Heaven, and that was why the cathedral had to provide it.

The old timber roofs posed no problem. What raised the technological stakes was the desire to complete the stone cosmos by adding a stone ceiling or vault, thus giving also a satisfying unity of material, texture, colour and decoration. In the eleventh century, the architect had at his disposal the old Roman barrel vault, which had been intermittently in use even in the West throughout the Dark Ages, and a newer, groined

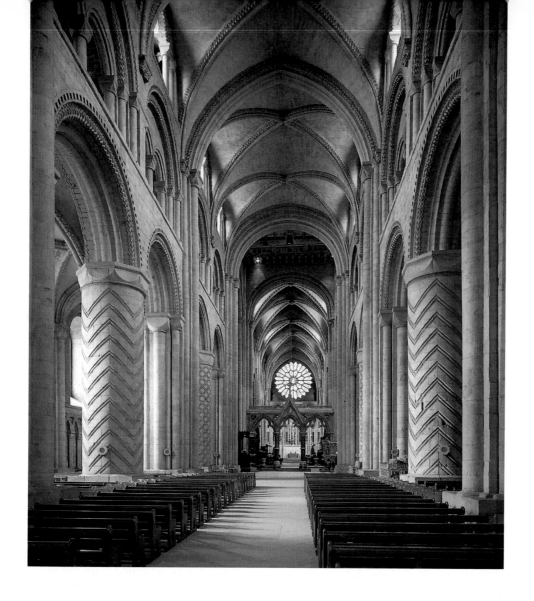

vault, which was becoming common in France and the Rhineland in small churches and in the narrow aisles of bigger ones. At Durham, St Calais decided to provide a high stone vault throughout the nave, constituting a huge weight of masonry. To construct it, his architect devised a new type of vault. First, a skeleton of ribs was put up, using wooden centring to lend initial support, which was taken down when the mortar had set. Then the spaces were filled in with a much lighter shell, which meant less weight to carry and which did not require expensive centring. The architect was clearly making up his own rules as he went along, for close inspection shows that his vault at the east end, where he began, was inferior (it had to be replaced in the thirteenth century), and that he learned by experience to improve his performance. Towards the west end the workmanship became noticeably more confident and precise.

All the same, the architect was taking risks for which he had no precedent. With the barrel vault, the weight from the top is distributed downwards and evenly all along the walls. With the ribbed-vault, the forces move diagonally and outwards,

Durham's massive patterned columns hold aloft the finest cathedral in northern Europe, built (between 1093 and 1128) to symbolise the power of the conquering Normans, and embodying revolutionary technology.

concentrating on the single point where each group of three ribs meet when they touch the wall, thus threatening to push it outwards. The architect countered the threat by designing a new kind of buttress, a half-arch, built on the outer wall of the aisle, which delivered an inwards thrust at precisely the point where the convergent ribs pushed outwards. This was what we now call the flying buttress, a striking feature of many later cathedrals, visible as it is for all to see. But at Durham, it was and is concealed under the covering of the aisle. The high stone vault involved a further technical innovation. Existing churches were largely composed of verticals, horizontals and curves, a pattern which had not changed since Roman times. The ribbed vault added to this pattern. The ribs were essentially arches, and though the diagonal ribs were semicircular, the transverse ribs had to come to a sharp point to reach up to the same height. Thus, of structural necessity, was born the pointed arch. From high in the vault, its stylistic influence was soon descending lower and lower in the church until it superseded the round arch completely.

Hence at Durham, one of the most original buildings in history, the engineering was moving decisively in a new direction, and its three innovations—the ribbed vault, the flying buttress and the pointed arch—mark the historical change from an architecture based on sheer strength to one which manipulates and cancels out rival forces. It marks the point where the muscle can do no more and the intellect takes over. Hence the absurdity of the old terms: development from Romanesque (implying approval) to Gothic (implying disapproval). What we have, in fact, is a progressive leap into the future of architectural sophistication, which would make possible the construction of the most marvellous buildings. At the same time, Durham looked conservative. It was an example of the habitual desire of the English to conceal dramatic change beneath a reassuring traditional skin. No one knew the flying buttresses were there. Even today, a visitor, asked whether Durham has flying buttresses, will answer confidently: 'no'. No one saw the pointed arches either. And attention was diverted from the amazing vaulted roof by the massiveness of the pillars, much stronger than they need have been. They were incised in four striking patterns—flute, diaper, spiral and chevron—which in those days were made the beds for gleaming brass, the whole being painted in strong colours.

Thus Durham was a revolutionary wolf in the architectural clothing of a customary sheep. Some sheep, however! To those not in the know, Durham Cathedral and its complex on the hill were the apotheosis of the familiar: the largest, strongest and most dramatic of the churches built from the ninth to the early twelfth centuries. It was the apotheosis of the early medieval style. But apotheosis implies change, and the architect, as he progressed, found himself moving deeper and deeper into a new technology which made existing methods and aesthetics quite archaic. Thus, almost unintentionally—he was merely seeking to please his exigent masters—he took the world into a new era of fantastic buildings, which in turn enclosed new and spectacular kinds of art.

8

THE CLIMAX
OF CATHEDRAL ART

The medieval cathedrals of Europe—there are over a hundred of them—are the greatest accomplishments of humanity in the whole theatre of art. They are total art on the grandest scale, encompassing architecture at its highest pitch, and virtually every kind of artistic activity, from carpentry to painting. They make use of the natural *chiaroscuro* of the atmosphere more successfully than any other artefact so that to visit the great minster in York, which has England's largest collection of stained glass still *in situ*, is to witness a profound drama of colour. In their time, they dominated not only the towns in which they were mostly built, but the surrounding countryside: the cathedral of Lincoln, on its high hill, and with its three tall towers then crowned by immense steeples, could be seen across the lowlands to the south 100 miles away on a clear day. Even now, the steeple-towers of Chartres loom with mysterious immensity across the wheatfields of the Beauce, stretching for 50 miles to its north. An entire lifetime can be profitably spent in visiting cathedrals and in the minute examination of their beauties and treasures. Moreover, they are still in daily use as the most holy places of the Christian God, a span of nearly an entire millennium: no other works of art have been in service so continuously and for so long. Hence, despite their immense cost—in some years cathedral-building absorbed about ten per cent of the entire gross national product of the societies which created them—they have given good value, judged even by utilitarian standards. And they are still here, better maintained than ever before, for our distant progeny to use for worship and enjoyment.

Durham adumbrated the new system of architecture whose structural innovations were needed to build these vast new cathedrals. While it was under construction, a great ecclesiastical statesman and artistic impresario was demonstrating the decorative opportunities the system made possible. This was Abbot Suger (1081–1151), one of the most important figures in art history. While still a boy, he joined the royal abbey of St-Denis, outside Paris, and remained there for the rest of his life, the last thirty years as its abbot. He so impressed his pupil and friend King Louis VI of

France that, when the king went on crusade, he made Suger regent of the country. Unlike most medieval patrons and builders, Suger wrote copiously, in prose and verse, on art and architecture, and what he was trying to accomplish at St-Denis. He became one of the most famous figures in Europe, so that grand personages with money to spend on art came to see him, and his works, from throughout Christendom. In less than a generation, his notions were being applied elsewhere, notably at the mother church of England, Canterbury, the *cathedra* (literally, 'chair') of its archbishop-primate.

Suger was a child of the Hildebrandine revolution in the life of the clergy, which was making them more disciplined, efficient and respected. Through their influence, secular society too was becoming law-abiding and better educated, and so increasingly prosperous. Suger was perhaps the first man to grasp the importance of what future historians were to call the twelfth-century economic revolution and to apply some of the new wealth to the civilising process, of which great churches were the symbol and centre. The maintenance, repair and improvement of churches was a continuing process. As the east end, the sacramental heart of the church, was always the first to be built, so it was the first to look out-of-date. Hence it was the first to be rebuilt when new methods became available and the desire to create new wonders filled the minds of the people. The system of which Suger became the propagandist was about two connected senses of the word 'light'. A proper understanding of balanced stress in weight-carrying lightened the load which architectural supports, whether columns or walls, had to carry. This meant they could be thinner and more decorative. For instance, the nave pillars at Durham, made massive more for show than from need, are 30 feet high and 7 feet in diameter. Their cross-section covers seventeen times the area of the new-style thin piers set up at Canterbury in 1175, though the weight they carry is similar.

The impact of the lighter burden on the walls was equally dramatic. They could be made thinner but, more important, the windows could be made larger. This expansion of the window wall-space, at the expense of stone, beginning in the twelfth century, and then accelerating, was to produce, in the late fifteenth century, buildings in which windows were to occupy up to nine-tenths of the space, so transforming them into houses of glass. Hence the second use of the word 'light'. The lightness in the burden could beget a new church of light, an enormous illuminated reliquary for the holy treasures it contained—both the bones of the saints and the sacramental grace of its services.

Glass had been made since antiquity. Painted or stained glass had been known too for a millennium. But the methods of producing both the glass and the staining were improving all the time. It was Suger's great merit that he grasped the astonishing properties of the stained glass now available. With its powerful, translucent colours, and granted a penetrating source of illumination from without—the sun—stained glass could create within a cathedral far more vivid effects than

anything possible with mosaic, let alone wall-painting. Suger loved precious stones and all forms of jewellery, and he knew a lot about them. He realised that, with a bigger window area, he could transform a stone cathedral into an enormous jewel, within which the congregation could enjoy its internal radiance. The choir especially would become a coloured glass reliquary of jewels, held together by ribs and columns of stone, just as enamelled gold and silver held together a portable reliquary or a monstrance. Reliquaries were already being created by goldsmiths in the shape of churches—see, for instance, the spectacular container for the bones of St Taurin, in the shape of a three-bay church of silver, copper-gilt and enamel plate (1240–55) in the Church of St-Taurin, Evreux. Now, architects could turn cathedrals into holy jewel-boxes with the help of radiant glass.

The great art scholar Erwin Panofsky believed that Suger had absorbed the esoteric light-metaphysics of a fifth-century writer known as the Pseudo-Dionysius the Areopagite, a copy of whose treatise was in the abbot's library. Suger, it is argued, wanted to create a new kind of light-church which would bring these metaphysical concepts into the reality of a form of worship dearer to God than the old rituals lit by candlelight. But there is no direct evidence for such a theory. What Suger undoubtedly relished was the way in which stained glass appealed directly to the senses with great power. He saw such windows as the jewels of the people as well as of God.

Suger introduced other innovations. He brought sculpture into the portal, a move that had dramatic consequences all over Europe. By exploiting the lighter burdens which walls and pillars had to carry, he was able to give the architectural structure of St-Denis a clarity it had hitherto lacked, thus elevating its utilitarian details of stone and stress-carrying into a profound system of order, which also became a system of beauty. The eye travels methodically over all the internal surfaces of the church, conscious of a homogeneity and regularity which comforts the senses and appeals strongly to our ordering intellects. This is art at its most profound. Alas, Suger has not been well treated by posterity. To visit his great church is essential, for it houses so much of history and beauty. But there was a fundamental rebuilding scheme carried out in the thirteenth century. It involved a stupendous exercise in structural engineering, including underpinning the ambulatory from below while the chancel above it was bodily raised from 60 to 100 feet. In the process, much of Suger's work was obliterated. The sculptures on the westwork went. So did the northwest tower. St-Denis was roughly handled by the French revolutionaries and by Bonaparte, who stole Suger's eagle for the Louvre. The golden panels on the high altar, the royal throne by its side, the Great Cross which hung over it, and the cross of St Eligius were all destroyed. The gold chalice was rescued or stolen and is now in the National Gallery of Art, Washington, D.C. Suger's thirty stained-glass windows survived after a fashion: some pieces got into the market and are now scattered in museums throughout the world. Thirty smaller pieces are in storage. Forty-two of the panels are more or less authentic, but the rest were repainted or replaced

completely by the leading nineteenth-century restorer Viollet-le-Duc and his followers. These include, in the central chapel of the ambulatory, a window showing Suger himself presenting one of his windows to the church, and a beautiful 'Tree of Jesse', to which Suger refers lovingly in his writings.

Suger obviously knew a good deal about the arts of his day. But he was more of a patron, a co-ordinator, an amateur enthusiast, than a creator like Imhotep. He employed professional glass-makers and artists for his windows, and for the fabric he used master masons of such skill, and who undertook such onerous responsibilities over calculated stresses, that they are entitled to be called architects. Nineteenth-century Romantic writers like Victor Hugo believed medieval cathedrals were the work of priests and people, the apotheosis of spiritual inspiration, the creation of the community. On the contrary: they were entirely the work of experts directing craftsmen and labourers. It is likely that never before in history had so many workmen of fastidious talent been brought together in single projects, and certainly the experience will never be repeated. All the copious evidence of accounts, both religious and secular, confirms the need to pay going rates to professional artificers at every stage, and indeed to compete financially over wage rates when an intense period of cathedral-building coincided with the castle-building needs of kings and their feudatories.

In the years 1270–1300, for instance, Edward I of England, who was pinning down conquered Wales by a series of immense concentric castles—Conway and Caernarvon, Harlech and Beaumaris, to name only the most important—fought a tense behind-the-scenes battle with bishops and cathedral chapters who were proceeding, coincidentally in six cases, with extensive rebuilding plans. The competition produced wage inflation, which in the following century, when the Black Death thinned the ranks of master masons and their assistants, threatened to take off into hyperinflation. And in the fifteenth century, the continuing rise in the cost of wages (and in some cases materials) in cathedral-building led to the extensive sale of indulgences, one of the most bitterly resented abuses which provoked the sixteenth-century Reformation. In short, cathedral-building was tied to the resources of society by the cash nexus, like everything else in art.

There was, however, one exception. In 1066, the same year as the Battle of Hastings, the chronicler of Montecassino abbey in Italy, Peter the Deacon, recorded that his abbot bought a cargo of marble for the new monastery church. When it arrived near the site by cart, 'a group composed solely of the faithful carried up the first column on the strength of their necks and arms'. This was a symbolic act of public support, probably based on an episode in antiquity when the congregation dragged columns from the beach at Gaza in Palestine, where the boats had dumped them, to the site of the new cathedral, 402–407 AD. Suger heard about it, however, and probably about a similar episode at the Benedictine abbey of St-Trond, some time between 1055 and 1082, when 'the people of the nearby villages' not only carried building material but, 'their voices raised in hymns, took it up with a most eager

enthusiasm, pulling ropes attached to wagons, without the least use of oxen or pack-animals'. Hence, when a 'miraculous' discovery of Roman columns at Pontoise made them available for his project at St-Denis, Suger says that he and his workmen 'and the faithful of all ranks' tied ropes round their waists and pulled the columns, loaded on to carts, to the site. This public participation in cathedral-building, to save money and to identify the people with the project, occurred on four other occasions in France between 1150 and 1170.

One of these was at Chartres, significantly a place with its own intense cults of piety. Its crypt contained a holy well into which saintly virgins had once been thrown, and a piece of the tunic of the Virgin Mary herself. The cathedral can also be regarded as the successor to Suger's St-Denis. It made strikingly successful use of his sculptured portal and his overwhelming display of stained glass. To many, it is the most famous of all the medieval cathedrals. But its building history is dauntingly complicated, for a fire in 1194 destroyed most of it and the church as it now exists is a construct of the thirteenth century or later. The royal portal, which contains the best of the statues, survived, however, though fierce scholarly argument swirls around its date. The finest figures on it, symbolic and elongated to an extraordinary degree to reflect the overall design and mathematics of the west front, have astonishingly lifelike faces, expressing a variety of solemn emotions, and they betray the first hints—the time is 1140–60—of the humanisation of art which was later to transfix Italy and sweep all over Europe. The unnamed sculptor is known as the Headmaster, and although work elsewhere has been attributed to him, only in the central portion of the Chartres portal does his wonderful genius express itself in full. These figures have become images of the medieval church, by constant photographic repetition, and unlike most such enforced images, they do not pall, but haunt.

The original lancet windows of the west façade, like the column sculptures beneath it, survived the 1194 fire. Otherwise, 164 out of a total of 176 windows in Chartres Cathedral, covering over 3,000 square yards, were glazed and put in place from 1200 to 1245. This enormous operation involved importing panels from successful stained-glass workshops in Sens and Canterbury, but most of it was produced on the spot by a specially created workshop, which developed technology in two important respects. First, it perfected sturdy horizontal saddle-bars which secured the whole frame of the window and embedded it firmly in the stonework, and iron internal frameworks which held together the multiform lead 'lines' constituting the main design of the glass pieces. Second, it developed deep reds and blues which give fiery power to the windows and produce the most striking light-effects. But since their density eliminates a high proportion of the sunlight, the workshop needed to offset this by introducing pale green or white fillets and by using grisaille glass which both lets in light and, more important, 'liberates' important figures by setting them against a lighter background. The workshop produced the most elaborate and inventive glass, especially the enormous rose windows of the transepts.

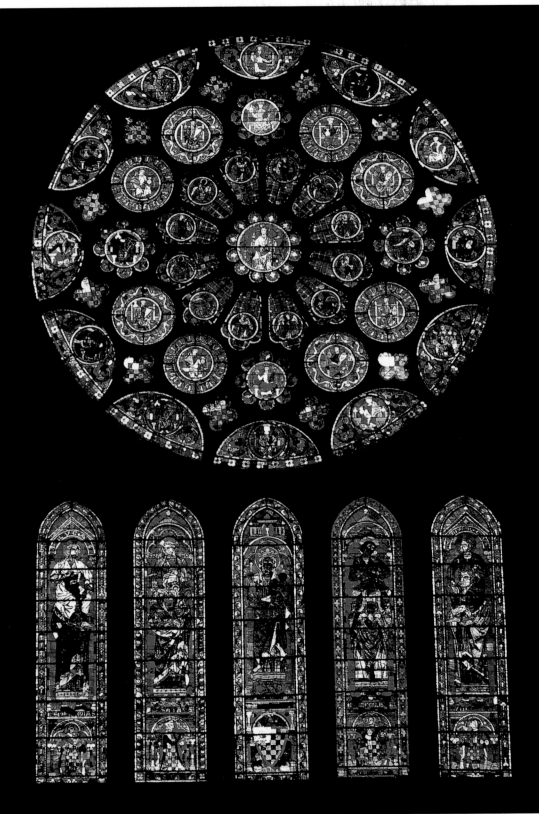

In the south transept, the rose window overhangs five lancets, with the Virgin and Child in the centre and the four evangelists on either side, each perched on the shoulders of the prophets Jeremiah, Isaiah, Ezekiel and Daniel. This imaginative conceit, brilliantly executed, reveals the hand of a master, probably a mere blower's assistant when the work started around 1200, who had learned his skills during thirty years' service to the cathedral.

The work at Chartres was financed by a number of devices. The king himself donated the north transept while a local nobleman, the Comte de Dreux, paid for the south rose window and its lancets, as we know from his coat of arms included on one of them. Other windows were donated by middle-class trades guilds—carpenters, innkeepers, furriers, shoemakers, money-changers, chemists, armourers and plumbers. There are two ways of looking at the glass in Chartres. One is by studying each window individually and by trying to work out the subject matter and iconography, an exhausting but ultimately rewarding method. The other is simply to take in aesthetically the effect as a whole, wandering through the changing polychrome atmosphere and delighting in the experience of living within a reliquary, as Suger would have put it. Ideally, a whole day should be spent in Chartres Cathedral, using the first method in the morning and the second in the afternoon, after a copious lunch, when the aesthetic experience is less cerebral and more penetrative. But the glass at Chartres should be seen in conjunction with two other sets of stained-glass windows. The first is at Bourges, where the windows of the choir, created a little before the Chartres set, are the work of three great artists, known respectively as the Good Samaritan Master, the Relics Master and the Classical Master. They were highly sophisticated artists, each very different from the others, but fiercely competitive. The Classical Master specialised in unusual colour combinations, the Relics Master in refined drawings. Each produced enthralling processions of iconography and occasionally brilliant pictorial compositions (i.e., the Good Samaritan Master's powerful tondo of the traveller being savagely mugged by four brutal thieves).

Leaving the glasswork aside, Bourges is perhaps the most enthralling of French cathedrals for space-visual reasons. It is built on the end of a sharp limestone spur, which produced stone of superlative colour and quality almost on the spot. The subtle colour harmonies of Bourges stone, part natural, part the work of clever master masons, are strongly felt throughout a visit. The spur, however, created acute structural problems, forcing the architects to take drastic measures, such as underpinning at both ends, and made it extremely difficult to add towers at the west end. The south tower had to be propped up by an ungainly buttress of vast size, and the north tower collapsed, being replaced by a sixteenth-century tower, which is incongruous and the first thing you notice when the cathedral comes into sight. The interior, however, is uniquely beautiful for France. Unable to build transepts because of the site, the architects added instead two aisles, one higher than the other and both of

FACING PAGE: Chartres Cathedral, mainly twelfth century, is the largest depository of high-quality stained glass in France, epitomised by the south rose window.

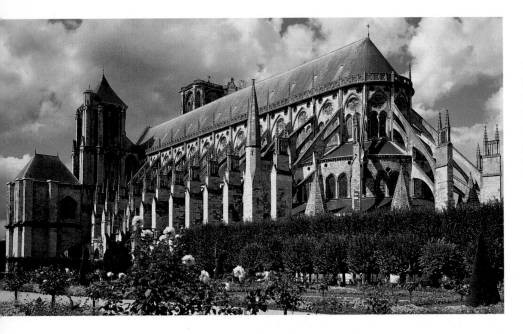

Bourges Cathedral (late twelfth century) is a compendium of French Gothic at its best, with splendid proportions, superb stone, fine sculpture and noble setting.

which encircle the whole building. This gives a homogeneous effect and, making a virtue of necessity, the architects cemented nave and choir into one vista, of six and a half double bays. Nave, inner aisle and outer aisle form a triangle, since the nave is very tall and the outer aisle very low. These triangular cross-sections east to west are echoed and contrasted by the three-storey arcading elevations of the nave and inner aisles. By zigzagging in and out of the nave, the visitor enjoys the thrilling visual sensations the architects were trying to create, and a mysterious *trompe l'oeil* effect which makes the whole top storey of the church appear to be suspended in mid-air with no visible means of support.

The other collection of stained glass to be seen in conjunction with Chartres is in the Sainte-Chapelle in Paris, which Louis IX built in the mid-thirteenth century to house his unique (as he thought) collection of relics. They included not only part of the True Cross but also the Holy Lance which pierced Jesus' side. The building is remarkable for many things, but its fifteen huge windows, each about 60 feet high, establish its essential interior character, which is the feeling of living in a glass-and-gold-ribbed jewel casket. The iconography, taken with that exhibited in Chartres and Bourges, is an encyclopaedia of what men and women, at the summit of the Middle Ages, knew about the history and practise of their faith. It was created by gifted master-glaziers, known not only by name but by their works, a team specially brought together by Louis's generosity, which afterwards dispersed to work at cathedrals throughout France. French revolutionary and Bonapartist looters removed some sections, now in five public collections in London (Victoria and Albert Museum), Paris (Musée de Cluny) and elsewhere—one is in the parish church at Twycross in England. But in general the chapel's glass is preserved and damaged portions were well restored in the nineteenth century. Nearby Notre-Dame, alas, lost all its original glass except (in parts) in its three rose windows.

* * *

Stained glass, and its internal light-effects, were to the people of the time the most spectacular aspect of the cathedral. Granted the skill of the artists, who kept pace with contemporary developments in manuscript illumination and painting, it is surprising how few of the earlier masters are known by name. Later in the Middle Ages, especially in England, some emerged from obscurity. William of Wykeham, the immensely rich Bishop of Winchester, who founded Winchester College and New College, Oxford, had a favourite artist called Thomas of Oxford, who specialised in portraiture and whose work can be seen in York Minister (south choir aisle) and the Victoria and Albert Museum. An even more exciting and distinctive artist-glazier was John Prudde, who painted the glass in the magnificent chapel of the Beauchamp family in St Mary's, Warwick. York Minister, the vast English cathedral

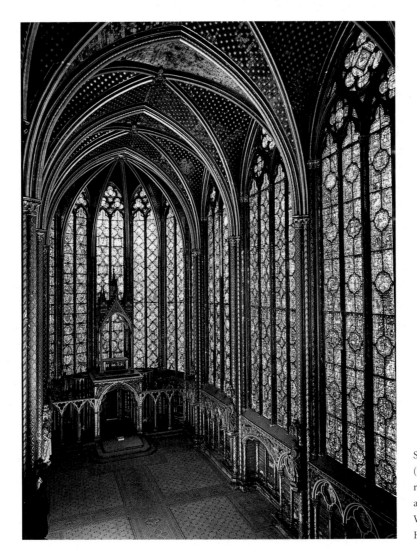

Sainte-Chapelle, Paris (thirteenth century), is a reliquary on a giant scale, and a model for St Stephen's Westminster, later the first House of Commons.

of the later Middle Ages, with thousands of square feet of coloured glass, employed John Thornton of Coventry in the years 1400–35 to create its great east window and most of the best work in the two transepts. In the next decade, an artist known as John the Glazier created a fine new window in the chapel of All Souls' College, Oxford. Some of the faces fashioned by these masters are touching and even sentimental, a distinct adumbration of the pre-Raphaelites, and their handling of dress and draperies is notable. But once stained glass moved away from the brilliant-and-sombre colour-effects of the thirteenth century, with powerful blues and reds predominating, and began to concentrate on line and narrative, the medium lost much of its point and its artists found themselves competing, less and less successfully, with wall- and panel-artists.

Stained glass also had to compete for attention, and the available funds, with sculpture, the output of which increased steadily after the portals of Chartres showed the superb possibilities of the medium. The new sculpture displays crept up

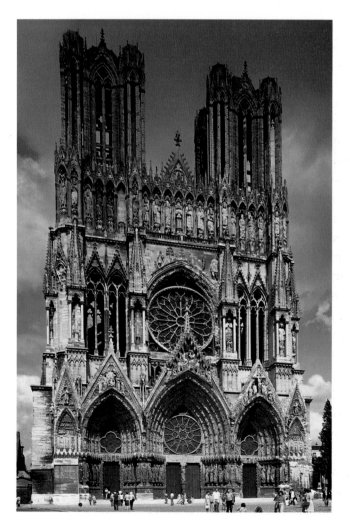

Rheims (thirteenth century) was the coronation cathedral of the French monarchy, and its west front is the prototype of French Gothic at its grandest.

from the portals to cover large portions of the façade, which was heightened to accommodate them. Displaying sculpture, especially on the west end, which with the nave belonged to 'the people'—the choir was the preserve of the chapter clergy—became one of the primary functions of the Church, and the architecture was altered accordingly. The cathedrals at Laon, Amiens, Senlis, Rheims and Paris, all of which were substantially rebuilt in the thirteenth century, displayed enormous and deeply recessed west fronts and hundreds of stone figures. At Rheims, the figures reached into the high third storey, 100 feet above the ground. At Notre-Dame, Paris, the number of stone figures on the façade multiplied to the point where they include a series of portal-mouldings, running continuously up and down the six successive recesses of the three porches, a delightful conceit, much imitated all over Europe. Like the stained-glass iconographies and narratives, these porch sculptures were encyclopaedias of the faith. At Notre-Dame it is easy to spend an entire morning studying the contents of the porches, and more profitable than queuing to get into the overcrowded church.

France was, from the late eleventh to the early fourteenth century, by far the most populous country in Europe, and the wealthiest. So the deeply recessed, twin-towered façade became the hallmark of scores of cathedrals, and the image by which we recognise them even today. The creation of these immensely tall west fronts inevitably had its impact on the nave, already soaring upwards relentlessly under the influence of Suger and his style. At Notre-Dame, the interior of the remodelled thirteenth-century church was four storeys high and rose to a total of over 100 feet above the pavement. The piers became a forest of slender trees, ending in a vault canopy, often painted blue with golden stars, to give an image of the heavens. Other cathedral chapters and patrons tried to compete with Paris, building their naves or choirs higher and higher, often at considerable risk to the entire structure. Chartres, as rebuilt, was higher than Notre-Dame, 106 feet, Bourges 117 feet, Rheims 140 feet, Amiens nearly 144 feet. At Beauvais, a fire in 1225 made a new cathedral necessary, and in the following half-century a choir was constructed to the unrivalled height of 154 feet. But the superstructure added on top collapsed twelve years after the inauguration in 1272, and this disaster, plus the ravaging of the Hundred Years War, meant that, apart from the transepts, the rest of the cathedral was never completed. In 1573, a crazily high lantern, erected over the choir and reaching a height of nearly 500 feet over the pavement, came crashing down in its turn. The Wars of Religion made building difficult, the bishop apostasised to the Protestants, and almost in despair the chapter closed off the unfinished nave. The cathedral at Beauvais was left as we see it today, a monument to overweening ambition, one of those *monstres sacrés* in which the French specialised: but well worth seeing, indeed going to see, for the aesthetic shock it administers.

The competition to raise the highest cathedral scarcely affected the English, who were particularly insular in their medieval architecture. The closest to the French pattern was Westminster Abbey, the royal foundation, which was the English equivalent of the abbeys of St-Denis and Rheims (where the French kings were crowned) combined. In the thirteenth century, Henry III, a poor ruler but an avid aesthete and close follower of French artistic fashions, had the nave rebuilt to a height of 102 feet, and he followed the French again in building his own elaborate chapel, St Stephen's, on the model of the Sainte-Chapelle—a building which became the home of the first House of Commons in the fourteenth century, as it still is, albeit much rebuilt, today. Westminster Abbey is only partly Henry's church, for the fantastic chapel at the east end is the work of his distant successor Henry VII, first of the Tudors, in the early sixteenth century; the west front, with its towers, is an early-eighteenth-century exercise by Nicholas Hawksmoor, and the visible transept on the town side is a nineteenth-century reconstruction by Sir Gilbert Scott. In short, a characteristic English muddle, made dear by familiarity. Inside, however, the dim mysteries created by the great height are the result of French clarifying logic, for Henry III followed the French theoretical notions for the height and proportions of the nave.

The English, however, did not follow the fashion of erecting west fronts specifically to display sculpture, with one exception. This was at Wells Cathedral, where what is in effect a vertical sculpture gallery has the largest surviving collection of English medieval stone-carving. But Wells is unique in several other respects. It has, adjoining the church, the only moated medieval Bishop's Palace, where live swans come to be fed when you press a bell. It has the only ground-based strainer-arches (to prevent piers from collapsing inwards) in the world, strikingly modernistic pieces of stoneware from the fourteenth century. It has the greatest of England's medieval clocks, still working. And it has the finest, and one of the loftiest, lady chapels in Europe, which comes on you unexpectedly at the top of a curious divided staircase leading from the north transept.

England has far fewer medieval cathedrals than France, but as a group they are of superlative quality and striking individuality. None are at all alike, though Beverley is a copy of York reduced to two-thirds of the dimensions. All are mixtures, built over four or five centuries, so taxonomy is happily impossible. The only one built in a single campaign, thirteenth-century Salisbury (except for its magnificent spire, added 200 years later), has an exterior of surpassing elegance and changing beauty, for its Chilmark stone reflects the changing light and weather, the times of day and the seasons of the year. The enormous and beautiful close, ending in water-meadows, is the perfect frame. Turner, Constable and other great masters have done it justice.

But Salisbury has a disappointing interior, with too much cold basalt in it. It is one of the delights of cathedral-visiting, especially in England, that you can never be sure from outside what you will find within. Exeter, for instance, is externally a muddle, with two towers straddling the nave like a man's legs on a horse. Within,

however, is the most magnificent interior of any medieval cathedral in Europe—warm, perfect stone, admirably selected for its banding by a master mason with an eye for colour and texture, and crafted into clustered piers, arcades and vaults to create a strong sense of unity. The soaring, protecting and comforting stone makes nave and choir together beat with the warmth of the sacred heart.

Lincoln, capital of one of the largest and richest dioceses in England, is a grand church, with its three tall towers, and a spectacular west front which forms a vast screen: 175 feet wide, with a high gable and corner turrets—a splendid backdrop to a solemn processional entry on an important saint's day, and a curtain-raiser to prodigious events within. For the cathedral, nave and choir together, presents a vast tunnel, twenty bays long, with the spiky shape of the organ silhouetted against the far-distant, but enormous, east window. When the sun is rising in the east, this is one of the overwhelming shock-views of European architecture. French critics have argued that English naves are too low, sometimes scarcely 60 feet, and that Lincoln, which is 80 feet, looks lower than it actually is; this is because the piers of the main arcades are widely spaced and the columns from which the vault springs are carried down only to the top of the pillars, thus missing an important vertical opportunity. They contrast Lincoln with its contemporary, Bourges, where the vertical effects are indeed impressive. But the answer is that

English architects preferred to emphasise the length of the nave, thus suiting the quality of the English light, which is not so much intense as lingering. At Norwich and Ely, for instance, there are long naves, seen in conjunction with choirs which form a continuum. Winchester, which in medieval times was the richest English diocese of all, relies for its effects on its long nave, punctuated by splendid monuments and chantry chapels of which it has (after Westminster Abbey) the finest collection in Europe.

Effigy of William Wykeham in Winchester Cathedral, which (as the richest English see) has the largest collection of bishops' tombs.

Each of these cathedrals has a feature unique to itself, often arising from its geography or function. St David's in Wales is beautiful but tiny, nestling among rocky hills on its rude peninsula, hidden from the ocean so that the Viking pirates could not see it. You descend thirty-nine steps to enter it, and the slope continues throughout its length. Kirkwall, the cathedral of the Orkneys, was built by

Norwegians, who then owned the islands, and looks it. Southwell has the finest stone-leaf carving in the world. Canterbury was a pilgrimage cathedral. You ascend through five different levels to reach the corona, which once housed the shrine of St Thomas Becket, and you are then 20 feet higher than the west-front entrance. Glasgow is a church built on top of a church, which produces amazing effects once you enter this unprepossessing building. Hereford, not one of the richer dioceses, none-the-less has the world's largest chained library. Chester, another poor diocese, somehow found the money to provide the cathedral with the finest carved choir-stalls in Britain. Worcester, a finely placed church with its setting on the River Severn, has a superlative interior, not so warm as Exeter's, not so graceful and appealing as that of Wells, but assured, rhythmical, well-proportioned and ingenious, with a brilliantly designed triforium level. Rochester has much of its original statuary on its west front, rare in England, indeed anywhere, which makes it England's modest answer to Chartres. Moreover, Rochester has a fine white spire and a bishop's palace and garden of surpassing loveliness. Norwich has a tremendous semicircle of flying buttresses around its choir and looks, across the grasslands which fence it off from the town, like a great ship riding the sea, with its wonderful crossing-tower and soaring spire as the mainmast.

The Spanish cathedrals have a similar individuality. Córdoba, as we have already noted, is a converted mosque. Its superstructure has been Christianised dramatically and, seen from the river, this silhouette is one of the finest of all. At Toledo too a mosque was originally used as the cathedral, but was then demolished and a huge basilica-type church built, with five aisles, a double ambulatory and fifteen radiating chapels. The internal spaces are spectacularly grand and exciting, and the building, being the seat of the primate of Spain, is crowded with treasures of every description: superb steelwork, bronze and iron, brass and woodwork, paintings by El Greco, Luca Giordano and Van Dyck, and a mass of the finest late medieval sculpture, including masterpieces by Juan Alemán and Hanequin de Bruselas. Its external appearance is powerful too, though upstaged by the city's fortress, the Alcázar, one of the most dramatic buildings in Europe. Seville is the largest of all the medieval cathedrals, again built on the site of a mosque. The mosque tower was preserved and topped by a fine belfry, which provides the cathedral's most notable feature, and the bronze *giralda* or weather-vane, a sixteenth-century figure of faith, gives the tower its name. The wonders within are almost without number since, during the cathedral's construction and adornment (from the early fifteenth century onwards), Seville, queen of the Indies trade, was one of the richest cities in the world. The main retable, designed by the Netherlander Pieter Dancart in 1482 (he was still at work on it when he died five years later), is of stone and 60 feet high, with 45 large sculptured panels, each of about 9 square feet. It is a gigantic sculpture gallery in itself, elaborately gilded, and quite overwhelming.

By contrast, the cathedral at Burgos, capital of Castille, the historic core of Spain, is mainly a thirteenth-century building, much influenced by French examples, especially Bourges in its basic structure. But it also has a cloud of flying buttresses, copied from Notre-Dame, two spires on the German model, high galleries on the external façades filled with statuary, as at Rheims, and high narrow windows in places borrowed from Sainte-Chapelle. It is not, however, a collage because all is overlaid by the pungent mixture of extreme piety, enthusiastic over-decoration and sheer God-fearing *diablerie* so characteristic of Spain. Moreover, it has a pure Spanish touch: a *cimboio* or lantern over the crossing, two storeys high, octagonal in shape, placed upon four colossal drum piers, and sumptuously decorated with stone statuary and mouldings, up to and including its fantastic vault. It is possible to spend four or five hours in this building, just beginning to get a grip on its design purpose and components.

Spain's most sensational cathedral, by far, is Santiago de Compostela, object of the largest and longest-lasting pilgrimage of medieval Europe. After the ardours of a heroic journey, the supposed resting place of St James the Greater has to make a fine impression, and it does. Indeed, as a work of art, it reflects the characteristics of Roman Catholic piety at its most effusive. It has the unity of intense faith—remarkable considering that the building history of the cathedral stretches over 700 years. Leaving aside the Dark Age foundations, which go back to the ninth century, the present church was started in the eleventh century and the basic interior is twelfth century. The fine cloister was not finished until 1590, by which time the Middle Ages were a memory, and the wonderfully intricate west façade, exuding power and majesty, was added in 1738. But the cathedral is built of granite, a source of unity in itself, and the sculpture, which includes over 2,000 individual pieces, forms a uniform encyclopaedia of the faith, though dating from the twelfth to the nineteenth centuries. Some is of the highest possible quality, especially on the Portico de la Gloria, from the late twelfth century, which rivals anything at Chartres in its intensity and strikes a note of grim realism which is not to be found in France, or indeed anywhere else, at this time.

Salamanca has a different kind of singularity for it has two cathedrals and Spain's most important historic university. Indeed it is artistically the most remarkable town in Spain, spectacularly beautiful as the sun warms and illuminates its golden sandstone. The Old Cathedral was built in the twelfth century and completed round about 1200 with a monumental, rather grim, crossing-tower called the Torre del Gallo. It is wrongly referred to in architectural histories as a lantern tower as it admits little light. The interior is full of sculptural marvels on capitals and vaulting, ribs and springing—grotesque faces and animals—as well as grandee painted tombs, with fiercely naturalistic images of those who lie there. But the city fathers decided in the 1480s that it was not good enough, and decided to build another, enormous medieval cathedral, started in 1512 when most benefactors in Europe had turned their backs on such a style. The result, then, is a historical anomaly, in concept rather like Seville, of great

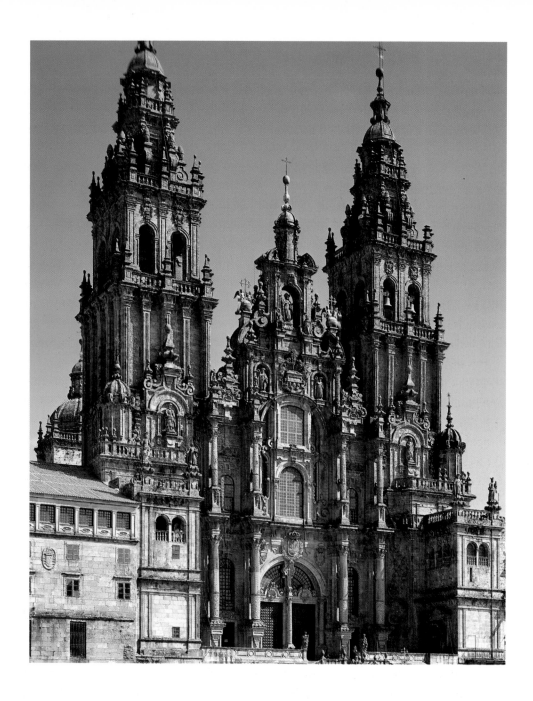

height, created by enormous piers of arboreal beauty, which soar up into the strato-sphere of the canopy. The carved ornament of the church, inside and out, is of rare virtuosity and matches the superb wood-carving of the choir-stalls, though this work is much later, early eighteenth century.

The Old Cathedral had a famous school, and by the mid-thirteenth century the students, who came from all over Europe, were calling it a university. By 1569, indeed, the student body numbered 7,683 out of a total population of 20,000. It was in fact Spain's university town, with a central building, six other main

Santiago de Compostella (twelfth century), housing the relics of St James, was the largest pilgrimage centre in Europe, and so had a cathedral of unusual size and splendour, built and adorned over half a millennium.

university buildings, four later separate colleges, and dozens of lodgings, houses and chapels connected with the academic world. The main façade of the Escuelas Mayores, a mixture of medieval and Renaissance, is one of the most striking decorative features in the whole of architecture, and worth going to Spain to see.

The willingness to keep and slowly modify and update, rather than replace, is of course one of the chief merits of academia, which otherwise has many faults. Salamanca is the most handsome of the medieval university towns, though Oxford and Cambridge, in their different ways, compete with it. Both, like Salamanca, contrive to give the visitor some idea of what it was like to live in a medieval town, with narrow lanes and cobbled pavements soared over by towers, pinnacles and spires. All three have rivers, and Salamanca's has an almost intact Roman bridge over it. In Cambridge, however, the river comes close to the collegiate centre, so that its noble buildings back on to vistas of water-meadow and sliding stream. There are more distant water-meadows at Oxford, which have the merit of providing grand vistas of the towers and steeples. The collegiate system ensured that each institution had its own medieval hall and chapel. The halls are often of great beauty, whether small, as at Oriel, Oxford, or enormous, as at Christ Church, a grand concept of Cardinal Wolsey, who at roughly the same time built the most sumptuous house in England at Hampton Court. The chapels often had campanili. Merton, Oxford, housed its bells in a fine squat tower of great power. At Magdalen, Oxford, the fifteenth-century tower soars to the skies. At King's, Cambridge, one of the twin foundations of the saintly Henry VI (the other is Eton College), the chapel has no tower but a high nave of incomparable beauty and grandeur. What all three university towns prove is the long-lived versatility of the medieval style of architecture, for it was still being used to create sumptuous and stylish effects in the sixteenth century, not only in Salamanca New Cathedral but at Christ Church, Oxford. There, Christopher Wren's later helmet-domed Tom Tower is a masterpiece with a unique silhouette—which fascinated Turner, forcing him to paint it again and again. Indeed at All Souls', Oxford, medieval architecture was still modifying itself in the seventeenth and even in the eighteenth centuries.

Unfortunately, Germany's most famous university city, Heidelberg, was almost completely demolished during the Thirty Years War of 1618–48 and further conflicts in 1689 and 1693. What is called the Old University dates only from 1712. The original university library, the Bibliotheca Palatina, housed in the fifteenth century university church, was fortunately saved by transfer to the Vatican in 1623. To see what medieval Germanic university buildings looked like you have to go to Prague, which was often the capital of the Holy Roman Emperors and is a spectacular and largely unspoilt late medieval city. The German-speaking people in medieval Europe built many large and elaborate cathedrals which are quite unlike their French counterparts. Their culminating feature developed into a great spire, as in Freiburg, c.1300, which became the model for a dozen grand churches and cathedrals in southern Germany. Sometimes

there were twin spires, as in Cologne; these colossal constructs were not completed till the nineteenth century. The tendency was to embellish the spire with tracery, to give the cathedral as a whole its strongly German architectural flavour. At Prague (1356–85), the Freiburg style was carried further by Peter Parler, Germany's greatest medieval architect. With its wonderfully lofty site on a hill overlooking the river, Prague has one of the finest silhouettes of any cathedral, and its south tower and spire, smothered in tracery, became the source for many other magnificent spires in Germany, including Ulm (1392), Strasbourg (1399), Vienna (1400) and Frankfurt am Main (1415).

Prague Cathedral, mainly fourteenth century, on its dramatic site overlooking the city is the most splendid cathedral in Central Europe, and holds the remains of Good King Wenceslas.

These soaring buildings were all built in stone, which was plentiful in south and central Germany. Further north, however, brick was the vernacular material, and as the cities of the German littoral, dominated by the towns of the Baltic Hansa, became rich in the later Middle Ages, they provided the funds to build enormous cathedrals and churches in brick.

The virtue of brick was that it provided opportunities for colour, and for polychrome decorative schemes both inside and out. The prototype here was the Marienkirche (see page 173) at Lübeck, capital of the Hanseatic League, an enormous church, much bigger than Lübeck Cathedral, which was imitated not only in Germany, at Stralsund, Rostock and Wismar, but in Estonia, Sweden and Denmark. Such architecture became a feature too of what is now Poland, thanks mainly to the German trading minorities who built the cities and the Teutonic knights who created the castles and forts. The cathedral of Gdansk or Danzig, for instance, is a brick masterpiece which is very late medieval indeed, so late that it was actually built by Protestants, though now Catholic. It is the only cathedral I know of in which Catholics were able to take advantage of Protestant industry (the reverse is true, of course, in scores of cases in England, Germany and elsewhere). The knights, not having stone, perforce built in brick, often to stupendous effect. Indeed, their magnificent castle at Malbork, which alone makes a journey to Poland worthwhile, is arguably the most beautiful castle in existence built entirely for military purposes.

Baltic brick cathedrals often had iron or lead-and-wood spires to top their huge walls. In fact it is hard to think of any cathedral built in the ambit of medieval Germany which did not have a spire of some kind. To the Italian mind, spires were associated with a kind of spikiness they disliked, and their antipathy was aggravated by the German association, for the Germans, Italians believed, were at the root of the devastating inter-city wars which kept much of medieval Italy in destructive uproar in the thirteenth and fourteenth centuries. It was an Italian scholar, Lorenzo Valla (1407–1457), who first coined the abusive term 'Gothic' to describe an architecture he thought of as German and barbarous. Although it is used in a number of Italian medieval cathedrals, the truth is that only one great Italian church was built in what can more accurately be called the medieval style of northern Europe. This notable exception is Milan, the new cathedral of which was begun in 1386 as a joint enterprise by the Visconti ruling duke, Gian Galeazzo, and the city fathers. It was set up next to the ducal palace, and Gian Galeazzo saw it as a kind of private chapel for his rule, as in Paris or Prague. Hence his choice of a northern design, and his decision to call in architects from beyond the Alps.

This led to one of the most vicious culture wars of the Middle Ages, which raged for more than two centuries and helps to explain why Milan Cathedral took so long to build (as with Cologne, work was still going on in the nineteenth century). The argument was partly mathematical, for the German and French experts involved used different measurements and systems of calculation to the Italians. Cultural racism was to the fore, not for the first or last time, the French in particular claiming they had intellect on their side, the Italians taste. There was no winning this kind of argument, which ended in various embittered compromises so that the cathedral has some odd aspects. It is nearly as high as Cologne, and the aisle and clerestory windows are small, so it seems dark, despite a late-fifteenth-century dome, which was

incongruously added. The dome makes the interior, at its highest point, rise to nearly 230 feet, and the tower gives the building an external height of 360 feet. There is no objectionable spire to raise Italian racial feelings. On the other hand, the most important single feature of the cathedral's exterior, its 98 high pinnacles, provides a northern look to the whole, supplemented by more than 2,000 external statues, something which the Italians, if left to themselves, would never have tolerated.

There was another factor in the construction of medieval cathedrals which is often overlooked: the importance of accidents. Most of them experienced a serious miscalculation of weight-bearing at one time or another, leading to a collapse of the fabric. When such holes appeared, chapters and their architects were forced to improvise, occasionally with felicitous results. Bourges, as we have seen, had two such accidents and emerged a finer building in consequence. An even more striking example is Ely. This rich Fenland church, which became a pilgrimage centre because of its shrine containing the bones of St Etheldreda or Audrey, had a fairly typical history until the beginning of the fourteenth century—that is, it had a long eleventh–twelfth-century nave, with a spectacularly rebuilt east end for its shrine. It had three towers, the biggest and heaviest over the crossing. In 1322 the crossing piers which had to carry it buckled and collapsed, and the great central tower came crashing down, bringing with it much of the transepts and the first three bays of the choir. Thus a huge hole appeared in the centre of the church. How to fill it?

Ely's sacrist, who was in charge of the fabric, was a genius called Alan of Walsingham, who seems to have known a lot about the work of both stonemasons and carpenters. Like many thoughtful clerics, he must have been puzzled by the evolution of the crossing space. In a Byzantine church it would have been covered by a dome and used by the congregation. But English cathedrals had a nave for that. The nave terminated (as a rule) in a rood screen. The choir, the monks' or priests' part of the church, began with the choir-screen. The space in between was an ambulatory or no-man's-land. Alan conceived the idea of making the crossing the climax of the church. He would not fill the hole: he would turn it into an asset, and roof it in. The roof could not be a dome, since no one in northern Europe wanted big domes or knew how to construct them. It could not be vaulted, since stone could not be used to cover so wide a space. Indeed, at Ely the six surviving bays of the choir were covered in painted wood. Alan noticed a further factor. Since the transepts were double-aisled, the basic supports for an octagonal structure already existed. What this suggested, therefore, was an enormous piece of carpentry, providing a roof cover of the same basic type as the polygonal English chapter house, several of which already existed, but without a central pillar. And to provide light, this high octagonal roof cover would be punched through by a tall lantern with a matching lantern on the west tower.

Alan of Walsingham's head is carved on the splendid octagon he inspired. The

Marienkirche, Lübeck, thirteenth century, is a brick masterpiece, typical of Baltic ports, and reigns over the handsomest brick city in Europe.

function of his crossing is not liturgical, though he provided an altar for it, but emotional and metaphysical. We move up the long, twelve-bay nave, which is narrow and therefore seems high, and pass under the great end-of-nave arch into infinite space. This is the same effect the Romans achieved with their Pantheon, only on a bigger scale. The light streams in diagonally from four different sides, and it also pours in from the lantern at the top. We have a circular vaulting structure with an airy hole in the middle and a brilliant display of eight enormously high clustered pillars. The effect is so unusual for an eye accustomed to medieval formulae that one experiences a certain disorientation. The lantern, soaring above the darkness of the vaulting that supports it, looks even higher than it really is. Not even the high vaults of France contrive this stratospheric effect. The light impact varies radically according to the time of day, season and sky quality, but I have never known it fail to be striking because of the variety of angles of the vaulting and the different levels of perception. Moreover, it changes continually as one advances or retreats along the

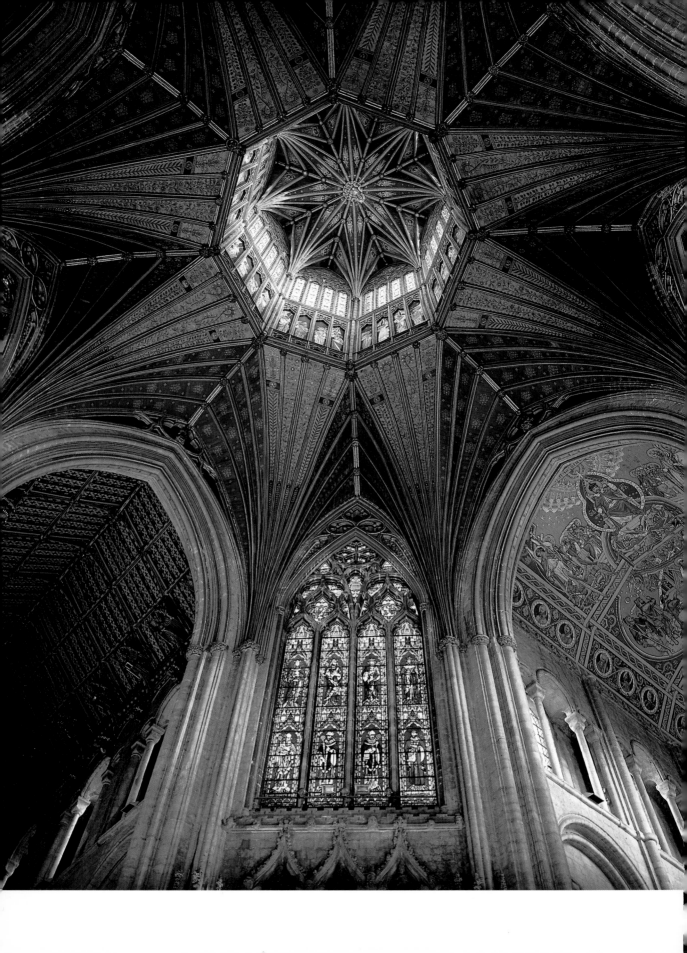

four axes of approach—nave, choir and transepts—where the four principal arches provide stupendous framing.

Cathedral architecture was also determined in some cases by quite another kind of accident, a sudden access of money. There are a dozen or so examples from France and Spain, but probably the best is again English. Gloucester was not built as a cathedral but as an abbey church, becoming an episcopal seat only when Henry VIII seized the monasteries in the 1530s. In the second quarter of the fourteenth century, however, it was the epicentre of another revolution, this time an architectural one. In 1327, Edward II, a homosexual, had been brutally murdered at Berkeley Castle by agents of his wife, Isabella, and her paramour, Earl Mortimer. A red-hot poker was thrust up his anus, and his screams could be heard even through the castle's thick stone walls. No one wanted the body of the dishonoured king, but Abbot Wigmore of Gloucester, out of pity, took it in and gave it seemly burial in his church. His piety was rewarded. By one of those inexplicable movements of popular fancy—the death of Diana, Princess of Wales, in 1997, was another such—Edward's pitiful body became the object of pilgrimage from all over Britain, and even Europe. An astonishingly large income suddenly accrued to the abbey. As a result, the monks not only created a sumptuous tomb and canopy over Edward's remains but were able to rebuild the entire east end of their church. This effort coincided with the opening of the Hundred Years War with France, and the cutting of the umbilical cord which linked English and French church architecture. Hitherto the English had tended, rather tardily, to create their own version of new styles from France. Now they thrust forward entirely on their own.

Abbot Wigmore, a masterful man, decided to take advantage of the opportunity to create a new English way of building the east ends of churches. He got down from London John Ramsay, head of a family of stonemason-architect-designers already responsible for a new kind of window, with a pronounced rectilinear shape, in Norwich Cathedral. John's son, William, had also designed rectilinear windows for Old St Paul's. John Ramsay's first work at Gloucester was to design the canopy of Edward's tomb. Then he and the abbot, and an up-and-coming local stonemason, Thomas of Gloucester, started work on the plans for the new choir. Wigmore was a staunch patriot and supporter of the war against France, and he and the masons celebrated the great English victory at Crécy in stained glass. They took off the whole east-end roof, demolished the apse and part of the chancel walls and slipped in a new wall-casing, made of thin walling and glass, which carried the height up to over 90 feet. The effect of the casing was to extend the chancel by two bays and add an extra 20 feet of window space on both sides. The new east end was completed by adding a high lierne vault and turning the huge open space there into a gigantic window. It is 38 feet wide and 72 feet high, with the two main vertical mullions carried to the top and rectangular panelling throughout. It is actually bigger

The lantern-tower of Ely Cathedral, the most intricate piece of large-scale carpentry in England, is the answer of fourteenth-century technology to the collapse of its central tower.

than the wall-space it had to fill, for it is canted outwards at the sides, an engineering device which gives it added stability when the wind is strong. Its glass is an exercise in heraldic and nationalist bravado and it is known as the Crécy Window. It remains the biggest church window ever created in England and had no rival in Europe for a century. The effect is dazzling, even on those who have visited the church many times and know what to expect. What, then, can have been its impact on fourteenth-century men and women?

The window was finished by 1350 and the choir vaulting in 1357, but money was still flowing in from pilgrims. So the monks decided to turn Gloucester Abbey into a prodigy church. They transformed the north transept. They rebuilt their cloisters with glass fenestration and a new kind of vaulting, by inventing an inverted half-cone, which spreads out like a fan. Each fan is carved out of one solid block of stone, which the monks got from an oolite quarry in the nearby Cotswolds. The effect is dazzling. The monks took an ancient but noble and challenging art form, the cloister square, which went back 800 years, and created from it a masterpiece in stone design. Nor did the monks stop there. The lierne vault over the choir was adorned by boss-carvings so large and noble, though 80 feet above the ground, that we must call them sculpture. They included sixteen angels playing musical instruments. The vault was then carried across the space to the far side of the crossing, and to do this the clever West Country masons invented a support in the form of an ogee arch, suspended in mid-air across the lateral crossing arches, and soaring up into the vaulting-cones. It was a cunning piece of structural engineering illustrating the fine tolerances with which masons now worked out their force-structures.

This vast programme of rebuilding at Gloucester, taken slowly and systematically and carried out with extraordinary attention to the quality of the design and workmanship, was only completed in 1499—150 years after the Crécy Window. But by then the new style it introduced had spread all over the country and had become the quintessentially English style of medieval architecture. Based on the dominance of the upwards vertical, on rectilinear shapes, on enlarging the glass area at the expense of its stone supports to the very limits of tolerance, on complex vaulting and with the overriding purpose of admitting as much light as possible, it suited the English climate perfectly. We find it at Winchester, in the great west front and the towering nave, at York almost throughout, we find it at Canterbury, that showcase of all the styles and fashions of the Middle Ages, and we find it especially in such prodigy buildings as Bath Abbey, the great chapel of King's College, Cambridge, and in Henry VII's chapel at the east end of Westminster Abbey. It occurs too in literally hundreds of parish churches, chapels, chantries and manor houses throughout the realm.

In the nineteenth century, that age of classification, taxonomy and neologistic nomenclature, the architectural historians called it Perpendicular. In 1820, one Thomas Rickman divided the entire medieval period into four styles: Norman, Early

English, Decorated and Perpendicular, the first beginning in about 1050, even before the Norman Conquest, the last ending about 1550. But of course this did not fit the Continental pattern. In the 1830s, Arcisse de Caumont in France produced a new system, using the term 'Romanesque' for the early period, 'Rayonnant' for the middle period and 'Flamboyant' for the French equivalent of English Perpendicular. The German-speaking scholars Allois Riegl and Heinrich Wölfflin produced a string of terms of their own to divide and subdivide German cathedral styles—*Sondergotik*, *Reduktionsgotik* and so on. I have long thought that these taxonomies, which art students are forced to learn and inwardly digest, cause more trouble than they are worth and in most cases generate confusion rather than clarity. Needless to say, like the abusive Italian term 'Gothic' itself, they were not known to the stonemasons who built the cathedrals. They did not use any terms at all, though they doubtless thought in terms of 'new' as opposed to 'old', and regarded the new as an improvement; or at least the younger master masons did.

What is true, and particularly true of medieval architecture, is that designers

and workmen had an almost irresistible urge to move from the simple to the complex, to begin by making plain statements of form, and then elaborate them to the point of hysteria. Early medieval designers were obliged by the force of nature to be simple: there is nothing more elementary than an eleventh-century nave, with its thick round columns and wooden ceiling. But as the mastery of stress construction increased, and it became possible to reduce the amount of stone needed to carry the building, every opportunity for elaboration, whether in glass or in and on the stone itself, was eagerly seized. Columns became complex works of art, and mouldings wriggled themselves all over the exteriors and interiors of churches like energetic snakes. The stonemason ceased to be a mere builder and became a pictorial artist. The triumph of decoration of course gave a unity to the whole, for the repetitive motifs of late medieval architecture spreading all over the building bound it together, so that as the eye runs over the west façade or internal bay of a cathedral, it reads the contents like a book, and this gives enormous satisfaction.

But by the early sixteenth century, madness was not far away. In Spain, for instance, stonemasons were becoming like silversmiths, in their anxiety to carve that noble material, stone, as though it were merely a precious metal, designed for luxuries. Hence this final phase of the medieval style in Spain, the equivalent of Perpendicular in England or Flamboyant in France, is known as Plateresque, or silversmith's. When this point is reached, the aesthetic urge of more gifted and sensitive human beings is suddenly to reverse the process, and return to simplicity and purity. We shall witness these abrupt switches again and again, as the history of art continues. Hence, by 1500, northern Europe was ready for one of these great reversals in visual psychology. Perpendicular, Plateresque and Flamboyant unconsciously prepared the way for the revival of classical forms which the art experts call the Renaissance.

I prefer to ignore the jargon of the academics and stick to a purely chronological approach, giving dates whenever possible. It has to be remembered that all medieval cathedrals, without exception, and about ninety per cent of medieval churches and secular buildings of any size, were a mixture of styles, being built over centuries, in many cases over half a millennium. Thus it is never strictly correct to speak of any of them as Norman or Romanesque or Rayonnant or Perpendicular or *Sondergotik*. Each is individual and unique. It is, in my view, much more pleasurable and illuminating to dismiss the study of art objects, whether tiny bracelets or vast cathedrals, in large categories, and concentrate instead on seeing each item as the work of a single artist, or a group of artists, or—most fascinating of all—of many artists working in successive generations on a building which thus has an organic life of its own and whose existing shape influenced the designs of each generation charged with adding to it. That is why the medieval cathedral is the greatest of all art forms. Each cathedral has an artistic personality which transcends and renders nugatory systems of taxonomy. To understand a cathedral, and in the process deepen one's love for it, it is necessary to visit it again and again, to absorb its persona.

Absorption, indeed, is a necessary process in studying medieval art. That age is a long way from ours, and was fundamentally a religious and metaphysical society, as ours is a secular and materialist one. So a huge gap has to be bridged. Absorbing oneself in medieval artefacts is one way of bridging it, and the process becomes easier in a place where many of these artefacts, in the form of buildings, are brought close together. We have already noted Oxford, Cambridge and Salamanca as places where the arts of the Middle Ages are concentrated, and therefore more powerful than the sum of their parts. These were university cities. But there are other types. One is the fortified town. Hundreds of them were built in the Middle Ages, usually as completely new towns, grouped around a castle whose walls were extended to encompass the *bourg* and whose purpose was to consolidate the power of a lord or king over a new stretch of territory he had acquired. The Spanish conquistadors built them continually. The French built them in the southwest, in their long struggle to absorb the Angevin Empire. The English built them to conquer Wales, one such being Caernarvon where the magnificent castle (designed by an architect called James of Savoy, who had actually seen the high-banded walls of Constantinople which inspired his decorative conceit) and the late-thirteenth-century planned town are still standing, though nearly all the medieval houses have been replaced.

A much more spectacular example is provided by Carcassonne in Languedoc. This is not a new medieval town, strictly speaking, since geography gave the site obvious strategic importance by placing it on the edge of a plateau dominating the plain of the Aude. So it was occupied from the sixth century BC onwards, and still has traces of Roman walling. But in medieval times its importance to the French Crown, which was trying almost desperately to consolidate its holdings in south-west France, both against the English and against local warlords, led to the erection of a complete system of inner and outer walls, with a moat beyond, around the entire town, thus enclosing an area of 600 by 300 yards. By good fortune rather than deliberate policy, the walls were never demolished, or even seriously breached by commercial development. It became a *ville morte*, as the French put it. There is still an inner wall, complete, with twenty-nine towers and an outer wall, also complete, with a length of 1,400 yards. There is a medieval fortress within the walls, built to keep the townsmen in awe, with three curtain walls of its own, and with a building history from the twelfth to the eighteenth centuries. A medieval cathedral (demoted to a parish church under Bonaparte) was built in the twelfth century and rebuilt in the fourteenth. It has a fine interior with spectacular stained glass and twenty-two superb statues evidently created by the royal stonemasons who worked on Notre-Dame and the Sainte-Chapelle. There are many other ancient buildings in the little town, progress having been banished to the 'new' or 'Lower Town' below. There is a formidable gateway with its original barbican, and five of the forty-seven towers are notable pieces of medieval fortification.

Carcassonne was restored between 1852 and 1879 by the great French medievalist-

architect Viollet-le-Duc who was later criticised for inserting crenellations and using roofing slates (now replaced by tiles). The impression got around that his work was altogether too creative and that the place was a fake. That is not true, and there is no place in Europe which conveys more authentically the atmosphere of a small medieval town, a work of art in itself. It should be visited in conjunction with Aigues-Mortes in Gard, once a port on the Rhône delta. This was a medieval 'new' town, like Caernarvon, though built a century earlier, 1190–1246, when it got its charter. It is built almost entirely of fine limestone, on a grid plan, in imitation of a Roman *castrum*, the walls, still intact, totalling about 1,800 yards. There are six main gates, each with two towers and two portcullises, secondary gates, and various towers, including a huge circular one, equipped with a lighthouse, known as the Tour de Constance. It is 150 feet high, on four floors, which retain their original vaulting and fireplaces. Here again, royal masons from Paris were evidently employed because the internal decoration of capitals and corbels is of the highest quality. A whole day can easily be spent absorbing Aigues-Mortes, including its outer works, which guard the land and sea routes, and its original deep-water dock. The town's life came to a virtual end in the 1480s, when Marseilles, newly part of France, became the chief port of the region.

Carcassonne (twelfth century on) is the best-preserved fortified town in France, with inner and outer walls stretching nearly 2 miles, and a total of 47 towers. A masterpiece of restoration by Viollet-le-Duc.

During these closing centuries of the Middle Ages, especially the fifteenth, there was a huge and continuing increase in prosperity, interrupted only briefly by the Black Death in 1348. Wealth and importance shifted from the countryside to the towns, especially those connected with long-distance commerce. In northern Europe, the chief beneficiary of this golden upsurge was the Duchy of Burgundy, a semi-independent principality ruled in succession by members of

two of the great royal houses of Europe, the Valois of France and the Habsburgs of Austria. Burgundy's importance to the arts was paramount because not only were the ruling dukes munificent and discerning patrons—playing an equivalent role to the Medicis in Italy—but the cities of their territories nurtured a rising middle class of merchants, clothiers, bankers and dealers in luxury goods. As individuals and through their guilds, they were donors to local cathedrals and churches and gave a growing number of secular commissions to artists and craftsmen of all kinds.

Dijon, capital of the Duchy for much of this period (1363–1477), was the seat of the most splendid of the dukes, Philip the Bold and Philip the Good, who built its grand palace with its high tower. Philip the Bold also founded the magnificent charterhouse as a burial place for his line, and it became the most sumptuously decorated of all the monasteries of later medieval Europe. Under ducal patronage, Dijon was an art work-shop famous for its sculptors but even more renowned for its carpenters and wood-carvers, who made luxury furniture for the rich all over Europe. The citizens built grandly in imitation of the dukes, so Dijon has many fine medieval bourgeois houses, such as the Hôtel Chambellan, as well as early modern ones such as the Bouhier de Chevigny and the Bouhier de Lantenay (notable for a fine folly in its garden). In the nineteenth century, Dijon lost its castle and walls, but within the circle they once enclosed, the town has preserved its artistic integrity and is a haunt of fascinating beauty.

Ghent, though ruled by Burgundy, was part of Flanders, and closely associated artisti-cally both with the great city of Antwerp and with Bruges. Indeed, scholars often speak of a Ghent–Bruges school of illuminated manuscripts. The burghers were made rich by trade of every kind, including a great tapestry industry. They were markedly independent, not only resisting the powers of the dukes but building them-selves fortified town houses, of fine Tournai limestone, some of which (the Gerard Duivelsteen of c.1245 is the outstanding example) survive. So do later unfortified mansions like the Grote Moor, and dozens of medieval buildings—churches, guild-houses, a sumptuous town hall, hospitals and nunneries, as well as the cathedral of St-Bavo, originally a mere church. The medieval abbey of St-Bavo, one of the great ecclesiastical landmarks of Europe, was destroyed by Charles V in 1540, who built a fortress on its site, an act of vandalism unparalleled even for those disturbed times.

Ghent, then, is another place where the Middle Ages can still be sensed. But even more powerful is the medieval atmosphere of Bruges, which flourished mightily from the thirteenth to the fifteenth centuries, then saw its harbour silt up and its leading commercial enterprises flee to Antwerp. As a result, it became Bruges-le-morte and is thus today one of the best preserved medieval cities in the world. In its prime Bruges attracted all the best northern painters, including Jan van Eyck, Petrus Christus, Gerard David, Rogier van der Weyden and Hans Memling, leading sculptors, gold and silversmiths, tapestry-makers and book producers—first scribes and miniatur-ists, then printers. In many ways it was like Venice, though much smaller, for it had

canals and waterways which meandered through the heart of the city. Late medieval Bruges specialised in sensationally tall buildings and spires, and we know exactly what it looked like because the skyline features in a painting of 1490 by the Master of the Legend of St Lucy (Groeningemuseum), in another by Peter Claesens the Elder, called *The Seven Wonders of Bruges* of about 1550 (Beguinage), and in a bird's-eye view by Marcus Gheeraerts of 1568. Most of these landmarks are still there, though the wonderful church of St Donatian was yet another victim of the French revolutionaries. Particularly important was the Poortersloge, the gathering place of the Poorters, as the wealthy citizens of Bruges were called. They were so rich that they dared to have their own jousting society, the Société noble et chevaleresque de l'Ours Blanc, and a stone white bear, holding its crest, is still in his niche in the Poortersloge, under its tower and spire. Alongside the Belfry, one of the tallest buildings in Europe, the magnificent Wool Hall, the town hall with its spires, the Great Crane—also prominently featured in paintings—and the eight principal churches of the city, were hundreds of fine houses built by successful merchants, the great majority of which are still there. Bruges was the first city since Roman times to have a proper water system. It was built in the mid-fourteenth century at the same time as the river-and-canal quays. Bruges still has its inner and outer water circuit, then a transport system and water supply, controlled by sluices, and originally a moat, now a thoroughfare for tourist barges.

Bruges was an international town, probably the most cosmopolitan in Europe after Venice and Paris, with large colonies of foreign traders, known as 'nations' after the practise of the University of Paris. When the merchants of Bruges lined up to receive Philip the Good in 1440, he rode in accompanied by 136 Hanseatic merchants on horseback, 48 Spaniards, 40 Milanese, 40 Venetians, 12 Lucchese, 36 Genoese, 22 Florentines and various others. Each nation had its consul. Between 1462 and 1470, William Caxton acted as consul of the English in Bruges, learning printing there, and carrying his skills back to England. One of the Lucchese was Giovanni Arnolfini, whose wedding portrait, now in London's National Gallery, was painted by Jan van Eyck. Indeed the foreign merchants of Bruges, like the local rich, were ambitious and competitive patrons of the arts. Because the merchants who paid for statues and altarpieces in the churches, and portraits and other easel paintings for their grand homes, were so much closer to the social level of the leading artists than reigning dukes and kings, painters and sculptors began to emerge as individuals. We know their names and can recognise their hands. For the first time, the artist himself becomes a potent factor in European art and, having surveyed the cathedrals and the townscape, we now turn to him.

9

THE RISE OF CREATIVE INDIVIDUALISM UNDER CHRISTIANITY

Just as the bent of the medieval architects was towards light, so medieval artists in the north of Europe strove for realism. They wanted to depict, within the framework of the honour and worship of God, the world as it was, and men and women as they were. For people were not ideal creatures, as the Greeks thought. They were not ripe for apotheosis, as the Romans agreed. They were sinful and, without divine grace, Hell-bent. We must bear this sombre view in mind in any consideration of medieval sculpture and painting.

Indeed, the outstanding two-dimensional artefact of the early Middle Ages, the Bayeux Tapestry, was not only a secular document designed to hang in a regal hall for nobles and their ladies to study, and describing a historical event of the highest importance—the Norman conquest of England; it was also a morality tale of sin and punishment, the story of how Harold, the last Saxon king of England, broke his oath, and of the tragic consequences. It was embroidered, almost certainly in England, by a group of high-born ladies, who took over a year to complete this large-scale artistic document, well over 200 feet long. It may well be that the artist was also a woman, working daily with the team, for no cartoon survives, nor any tracing from one on the fabric. What is clear, however, is that a vast amount of information was supplied to the embroiderers, not only by eye-witnesses of the Battle of Hastings and related events, but about a vast range of activities during the 1060s. There are 1,515 different persons, animals and objects in the works, including hunters and their horns, dogs and deer, carts and wagons, arms, ships, towers and castles, churches and farms, ploughs and harrows, reliquaries and coffins, horses and their trappings, arms and armour and all the regalities which surround a king. Among other things, Panel 37 portrays citizens hauling a marble column to a building site. The prevailing note throughout is vigour and energy—a point we have already noted much earlier about the art of the north—and the object is total realism, for which purpose every tiny detail is as accurate as it can be made. The tapestry is thus a wonderfully clear window into the actual world of the late eleventh century.

Panel of the Bayeux Tapestry (1066–77) showing Normans stocking their ships with swords and suits of armour. One of 79 scenes from this 230-foot-long pictorial history of the Norman invasion.

It has one weakness: all the faces and figures are stereotypes. The early medieval world was extraordinarily inhibited about portraying human personality, either in art or in literature. It dealt in types. Often it merely reproduced models from antiquity, where texts or artefacts were available. Why this should have been so we cannot discuss here. But this anonymity ran against all the forces of northern realism. And the spirit of the north in due course overcame it, in a series of gigantic leaps. The first occurred around the middle of the thirteenth century, in a series of sculptures at Rheims and the German cathedral of Bamberg, culminating in a set of masterpieces at another German cathedral, Naumburg. They include, at Naumburg, the first equestrian statue since antiquity. Scholars have been arguing fiercely about the priorities and chronology of these developments, and the movements of individual sculptors from one site to another. What concerns us here is the sudden appearance at Naumburg, in the decade beginning 1250, of a sculptor of genius. He was responsible for the rood-screen, which depicts the events of the Passion with a degree of realism and emotion entirely new in European art. They centre round a life-size stone crucifix, with the Virgin and St John alongside—three shocking studies in pain and grief. These figures have the power to move the emotions in a way that nothing created by the sculptors of Chartres and their imitators could do. But the Master of Naumburg then added, in

the west apse, life-size statues of the twelve founders of the cathedral, which are Europe's first sculptured portraits.

I say 'portraits', but this is not technically correct. All the founders had been dead over a century before the sculptor set to work. But there is no question that he used living models, just as he took immense pains to get every detail of the dress and accoutrements right, so that historians of costume draw heavily from this source. They are, or were, real people. The well-to-do of the day were only too happy to pose for the glory of the Church, and we now have them fixed for all time in their best clothes, the colours of which survive in many places, laughing or staring or looking condescendingly at us, thanks to the chisel of a master who was more interested in how people actually looked than in how they ought to look. It is the first powerful hint that European artists were on a course, in realism at least, to excel anything that had been achieved in antiquity.

The note of realism was powerfully reinforced by events, for the Black Death of the late 1340s, reducing the population in some places by a third or even a half, forced men and women to recognise the fragility of life, and to scrutinise it more closely while it still flickered. The fear of Hell became horribly real and the chances of Heaven seemed remote. Educated rich men and women read about the Day of Judgement, shuddered, and thought carefully of making a *bona mors* or, if that were not possible, at least having a sumptuous funeral and tomb. Funerals, especially of princes, became major acts of state, and with their elaborate trappings works of art too. The tombs in which they were laid to rest were miniature cathedrals. The bodies of the great Angevin dynasty, who ruled half of western Europe—Henry II, his mother the Empress Matilda, and his eldest son, Richard the Lionheart—are placed side by side in the family sepulchre at Fontevrault, monuments of modesty. By contrast, the fourteenth-century royal tombs in Westminster Abbey are increasingly elaborate and grandiose: major works of art. When the great and good Philip the Bold of Burgundy died in 1404, it was found that he had made the most elaborate provisions for his funeral and monument, and commissioned the greatest sculptor in northern Europe, Claus Sluter (*c.*1360–1406), to immortalise him.

Sluter had worked for the Burgundian dukes all his life, though he was a Dutchman who trained in his birthplace, Haarlem, and in the great art centre of Brussels. Most of his time was spent working on the magnificent new Charterhouse at Champmol, near Dijon, which the dukes were creating as a family religious centre. It was devastated by the French revolutionaries, so what still remains at Champmol is incomplete and torn out of context, and many of the best bits and pieces are in the Archaeological Museum of Dijon. We have still, however, two separate masterpieces of northern realism. On the Charterhouse portal Sluter carved a superb and moving Virgin and Child, attended by portrait sculptures of the donors, the Bold Duke and his wife, Margaret, and their patron saints. The couple are portrayed as they were in life: by no means a handsome pair, but God-fearing and anxious to do the right

thing. We feel we have met them. Far more splendid was Sluter's decorative scheme in the courtyard, dominated by a crucifixion ensemble. This was smashed to bits by the revolutionaries, but the *Body of Christ*, one of the fragments, showing the dead Saviour, his eyes closed and his mouth twisted and open in pain, is a work of unforgettable terror. One central portion of the scheme, known as *The Well of Moses*, survived. It is the hexagonal pier of a fountain, now covered for protection, and is crowded with sculpture, six grieving angels and six Old Testament figures: Moses, David, Jeremiah, Zachariah, Daniel and Isaiah. These are all of the highest quality, and the prophets, clearly wrought from actual models (in superior Asnières stone) confront the world with astonishing realism. Their faces are alive, their hands grip, their hair floats and hangs wispily, their beards stir in the wind.

Sluter was obliged to interrupt his work to attend to Philip's tomb, a grand affair mainly in alabaster and originally in the choir of the Charterhouse. It was broken up by the French and is now scattered. Some of the best pieces are in the Cleveland Museum of Art, Ohio. Sluter was bidden to attend the funeral and observe it, and his contact specified that he had to provide, in addition to the effigy of Philip, fifty-four angels and forty 'images pleurants'. The angels are lost but the 'weepers', as they were known—cowled figures common in late medieval art—were all done from life, and may have been actual participants in the obsequies. Sluter was a master of the draped figure and its folds, in which he took exquisite delight, especially when working in a soft, luminous stone like alabaster. But he also put in wrinkles and beards, even the stubble, and all the details of costume under the drapes, down to buttonholes and laces. What strikes one most, however, is not such details as rosary beads, important though they are in creating verisimilitude, so much as the facial expressions, which convey shamelessly the mixed emotions of a funeral: genuine and feigned grief, joy that one is still alive, sharp observation of how other people are behaving. Even funeral fashions are attended to, for each figure is clothed according to rank and personality, and each has a distinctive, often slyly observed, life of its own. After looking at these works, we feel we have a clear idea of what a grand early-fifteenth-century funeral was like. And that was Sluter's intention, for he did not want to change the world, merely to record it truthfully. If only all great artists were like him!

Realism meant stressing individuality. The artist's perception of how people differ, in body, mind and soul, the essential foundation of any great art based on human beings, inevitably made him more self-conscious. The fifteenth century, especially in northern Europe, is the first occasion in history (so far as we know) in which the self-portrait becomes frequent. Even as far back as the 1380s, Conrad von Einbeck had presented himself, glowering and truculent, on the walls of the Moritzkirche in Halle. The architect of Regensburg Cathedral, whoever he was, showed himself wearily supporting the weight of the universe, for architects were often the epicentre of furious rows even in those supposedly Christian times, just like today. Even more sorrowful and impressive is the tomb effigy of Hans von

Burghausen, chief mason of St Martin at Landshut, a masterpiece of grief, worry and disgust with life, massive forehead, wrinkles, tiny, ancient chin—no teeth left—a fine artist with a grievance, above whose weary head, appropriately, is a pedestal on which he has carved Jesus as the Man of Sorrows. Another great sculptor, Nicolaus Gerhaert, presents himself in a fragment now in the Cathedral Museum, Strasbourg, as a shrinking violet, right hand clutched to chin, a left-handed man who found the world altogether too much for him. And there is yet another sculptor, a tonsured monk this time, who did his head (New York, Metropolitan) c.1465, a piece of cruel self-examination and a little masterpiece of stone-carving, which few artists of any age could contrive. In the 1490s, Adam Kraft portrayed himself at work, bending on one knee, mallet in hand, anxious bearded face peering at the tabernacle he was carving (Nuremberg, St Lorenz). These self-portraits were not only in stone. Adriaen van Wesel, a superlative wood-carver, has portrayed himself as a worried and weary St Peter, presiding over a trio of beautiful but naughty musical boys, in an oaken chunk now in the Rijksmuseum, Amsterdam.

The wood-carvers of the north were one of the glories of the later Middle Ages. There are a pair of folk-dancers by the Bavarian carver Erasmus Grasser, now in the Munich Stadtmuseum, which for sheer energy and movement—and humour—take one's breath away. There is nothing 'wooden' about these lithe bodies, nor in the beautiful faces of women carved at this time. The great Swabian sculptors Michel

Philip the Bold, Duke of Burgundy, was the leading art patron of fourteenth-century France. His tomb, by Claus Sluter and Claus de Werve, is inhabited by alabaster hooded figures, known as 'weepers'.

Erhart and his son Gregor, who worked mainly in polychrome limewood, specialised in feminine serenity, which they employed repeatedly in their splendid altarpieces, misericords and other church furniture. For Ravensburg, the father did an enchanting statue of the Virgin (now in the Berlin State Museum), whose face radiates kindness and who shields with her cloak ten prayerful men and women, tiny but with real faces of living people, who have come to her for protection. The son used the same conceit, but this time including the Emperor Maximilian, his wife and leading courtiers under the cloak, in a magnificent *Enthroned Virgin*, which is still in the place for which it was carved, the pilgrim's church of Frauenstein in Austria. Gregor Erhart did a ravishing Magdalen for Augsburg Cathedral—it is now in the Louvre and known as *La Belle Allemande*—and an extraordinary triple piece of naked woman-hood yielding to age, known as *Vanitas,* which is a shocking combination of grace and pain (Augsburg). He repeated the point in a different way by carving a youth and maiden, naked and fragile, also known as *Vanitas,* which is in the Vienna Kunsthistorisches Museum. No one in the entire Middle Ages conveyed a sense of grief more poignantly than Gregor Erhart, as we can see from the separate figures, wrenched from a crucifix ensemble, which gaze with impotent pity at the suffering Christ, and are now in the Bayerisches Museum in Munich.

The greatest of these artists was the Hanseatic townsman Bernt Notke (*c.*1440–1509) who worked in all materials, including metal, and who also painted. For Lübeck Cathedral, in 1477, he produced a Crucified Christ and attendant mourners, on a monumental scale and of intense emotional power, which imprints itself fiercely and lastingly on the mind. Here is the reality of crucifixion: the horror, the agony, the excruciating pain, the hopeless anguish of the bystanders, all made palpable, a powerful sermon addressed directly to the senses. But Notke could sound a trumpet-note of triumph too, as in the elaborate representation of St George slaying the dragon, which the rulers of Sweden commissioned him to do in 1483 to celebrate their liberation from Danish rule. In the Storkyrka, Stockholm, this enormous ensemble—there is an enchanting princess

This naked Magdalen, in polychrome limewood, may be as early as 1500 and marks a giant leap into realism by its creator, Gregor Erhart. Late-medieval German sculpture in wood has never been equalled.

watching and praying, and other elements of theatre—is a masterpiece of what can only be called fantastic realism.

The art of northern Europe during the last period of the Middle Ages is among the most satisfying ever produced by man, and for three reasons. First, it exudes faith: it is created by and for people who believed in God, and the existence, terrors and hopes of the afterlife as unquestioningly as they expected night to follow day. Secondly, this did not prevent them from embracing the business of life—chiefly getting and spending, quarrelling and litigating, pushing themselves up the social ladder as hard as they could—with all the energy and cunning they could command. And, thirdly, the artists responded to this duality, which they shared, by presenting the divine and miraculous as actual events, but decking them out with as much worldly detail as they could cram into their space.

The carvers were restricted by the nature of their craft, though they pushed the bits and pieces with which they surrounded their central figures up to, and sometimes beyond, the limits of credibility—the great Notke is a case in point. The painters, however, were under no such restrictions. They put everything in, but the best of them contrived to subsume this mass of fascinating particulars into powerful designs which kept the subject clear and the main figures overwhelmingly central. This ability to balance theme and detail is a sophisticated gift, and was not easily achieved. It was something, for instance, which those working on manuscripts, from the seventh to the end of the fourteenth century, found difficult. Of all the miniaturists, the most ambitious, gifted and dedicated were the three Limbourg brothers, who flourished in the last decade of the fourteenth century and the first two of the fifteenth, working for Philip the Bold and his brother the Duke of Berry. Their masterpiece, the *Très Riches Heures du Duc de Berri*, which they finished c.1413, is the grandest and many would say the most beautiful of manuscripts. It involves an ability to create landscapes, townscapes and castlescapes of a high order, and constitutes an encyclopaedia of knowledge about the life of the times—the period covered by Shakespeare's *Henry IV*. It includes a calendar of the seasons, agriculture in all its forms, peasant life, courtly life, the castle and town, the way rulers lived and workers toiled, what they all wore and what they ate and drank. It is done with grace and gusto but without the slightest touch of artistic vulgarity, and the themes of each full-page illustration are conveyed with éclat. Yet the figures themselves are curiously tall, the heads too small, and the faces more stereotyped than one would expect from major artists at this time. In short, the Limbourgs were still learning—and teaching.

Among those who learned from them were Hubert and Jan van Eyck, who worked for the counts of Holland and the dukes of Burgundy in the early decades of the fifteenth century, both in their administrative capital, Lille, and their great art city, Bruges. That Hubert was an important part of the firm is clear, but Jan was the

dominant figure. He produced alone after Hubert died in 1426 and made himself one of the greatest and most beloved of all creatures. He had one salient advantage. Oil, usually linseed, had been used by Norwegian artists for painting wooden statues at least as far back as the early thirteenth century. It made its way slowly south. It took a long time to dry, even when used with a drying agent such as turpentine, and it worked best on a well-primed sheet of wood or stretched canvas, though it could also be applied to suitably prepared walls. Its merit was that it allowed the painter to take his time, to use brushes of amazing delicacy, to achieve effects hitherto confined to draughtsmen using sharp-pointed tools, to employ the entire range of colours then available, at choice, and above all to achieve effects of transparency which seemed close to miracles. It was the perfect agent for the verisimilitude the northern artist sought. The Van Eycks were not the first artists, even in Flanders, to use oil, and Jan did not 'invent' oil painting, as later writers, like Vasari, alleged. But he was the first to explore its possibilities to the full, and he did so with the self-confidence and professionalism which marked every aspect of his work.

The great altarpiece at Ghent, *The Adoration of the Lamb*, is a joint work of the brothers. It has twenty panels, eight on the doors closed, and twelve inside. The two donors are on the closed wings; there are also three townscapes tucked away at the rear of sacred events and seen through windows, and a meticulous presentation of a fifteenth-century washing-cabinet, together with its kettle and towel hanging on a rail. The inside includes a choir singing, while an organ is being played at full blast. The background towers and gardens which frame the hundreds of figures in the central event—whose exact significance is mysterious and has been the subject of scholarly debate for centuries—are rendered in a detail which enables the viewer to identify scores of different flowers and plants and parts of buildings which have long since disappeared. About sixty different kinds of textiles and materials are worn by the figures in this work, each rendered with exact regard for truth. Nor are any of the twenty main figures lost in the detail: the design is always coherent and balanced.

Men and women have wondered at this work, in the fifteenth century and ever since. It became a crucial part of Europe's artistic heritage. Yet Jan added to it other masterpieces, as well as minor works. *The Virgin and Chancellor Rollin* (Louvre) is a study in character. The greedy, watchful and ruthless state minister had himself put on a state of equality with the Virgin, almost as though he was her spouse, and she modestly averts her gaze, tact concealing her contempt. It is also an exercise in space control. The distances are vast. The river, city and countryside, seen clearly through the three-arched window, set high above the view, occupy miles of vision, all painted with hallucinatory clarity and with a complete mastery of ground and aerial perspective.

In the third masterpiece, *The Madonna and Saints with Canon van der Paele* (Bruges, Groeninge), the Virgin's carefully curled and waved tresses are sumptuous, contrasting pointedly with the parchmenty wrinkles of the battered old churchman.

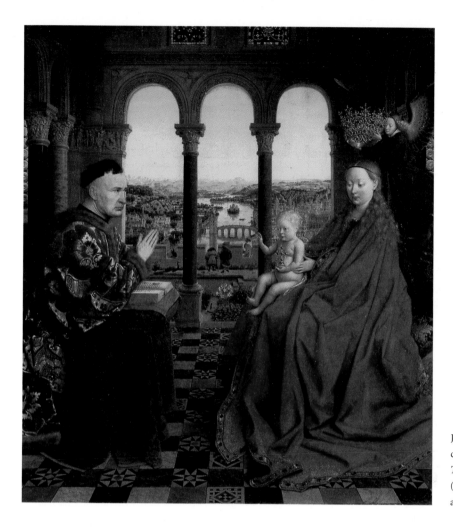

Jan van Eyck, greatest of fifteenth-century painters, combined in *The Virgin and Chancellor Rollin* (*c.*1434–36) astonishing distance and minute detail.

It is a glorious amalgamation of hair and skin, of velvet, cloth of gold, linen, a wool scarf (the canon's), gilded bronze armour (St George's), the dark green silk of the Virgin's dress and the heavy rich damask of her red cloak, together with an ankle-deep garment resting on a polychrome marble floor. The pleasure Van Eyck got in painting these objects and textures, especially the bishop's blue-and-gold outfit, seen both from the outside and within, is evident. He also delighted in weaving it all into a close-knit composition, in which all four adult figures have their exact and rightful place, yet which still leaves room for a perspective foreground setting the scene firmly, and a mysterious background behind the Virgin's throne, which gives a strong sense of space to the whole. This is artistic workmanship at its highest pitch. Yet as always Van Eyck adds more: character. St George is a roving-eyed Lothario, the old canon is on the threshold of eternity but determined to use his closely guarded cash to immortalise himself, the bishop is an ex-courtier manifestly on the make, and the Virgin herself is a worldly innocent set among thieves. Or that is one reading—the charm of this master's work is that one can always make up stories to enliven his astonishing command of people and things.

That is particularly true of his wonderful double portrait said to be of the merchant Arnolfini and his wife (London, National Gallery). A painter should never be afraid of tricks, for in a sense all art is a series of tricks to create the illusion of reality. In this picture, Van Eyck used every trick in the repertoire he inherited, and invented many more. He was a master of the artist-seen-in-the-mirror trick, a certain delight for viewers of all ages at all times. He uses the little dog trick to huge effect, to get the 'oohs' and the 'aahs' as viewers move closer to inspect its fur and eyes. The work, beautifully painted throughout and conceived with a brilliant blend of formality and intimate domesticity, has scores of symbolic points hidden in its details. Some we can only guess at. But the painter's main points about marriage—that it is a big step in life as well as a risky one, that the man may command but the woman often gets the last laugh, relished under her modestly downcast eyes, that the bed must never be left out of the picture, that a child (enigmatic in this case) is the true bond of union, and that in the end God's help is urgently needed to make any marriage a success—all these insinuations come across, if one looks at the painting carefully. Like all great works of art, it is something to cherish and study, to return to repeatedly and to worm out its secrets over time.

Van Eyck's other works include a grisaille of St Barbara seated in front of a half-finished tower, complete with crane and multiple building operations. This is not a drawing, as many think, but an unfinished painting made with a very fine brush on a prepared panel. Someone, almost certainly not the artist, has coloured in the sky with blue and ochre-yellow, in a blotchy and unfastidious way. The rest remains monochrome, grey on grey. The work is beautiful, for St Barbara radiates Van Eyck's accustomed serenity, and the study of how fifteenth-century stonemasons set about erecting a major piece of architecture—possibly the unfinished tower of Cologne Cathedral—is full of marvellous detail, which has been closely studied by historians of technology. It is, in a sense, finished, for every square inch of the wood is filled, and the fine brush has been used to give depth and solidity to St Barbara's enormous robe and its fold, and to create a strong sense of perspective in the tower and the countryside behind it. It may be that Van Eyck meant to leave it as it is. Hence the frame, which he perhaps marbled himself. Or maybe he intended to return to it some day, and paint over his brush-drawings. As it is, it testifies to his superb draughtsmanship, in a way no painting ever can, and to his skill in creating another dimension without colour to help him.

An artist of Van Eyck's skill was in constant demand for portraits, and he did, one presumes, many. They include a sinister and saturnine one in Berlin of the Governor of Lille, Badouin de Lannoy, who was an important man and looks it, in his huge hat, official collar of the Golden Fleece, and holding his rod of office. The eyes are cold, the mouth cruel. Also in the Berlin Museum is a portrait of a sitter in a brilliant red headdress, who looks remarkably like the Arnolfini in the marriage portrait. This is a powerful work. It is hard to like the subject. Van Eyck put truth

before any other consideration and painted exactly what he saw: a hard man on the make. He also painted Cardinal Albergati, an important grandee from Rome, whose features survive both in the finished work (Vienna, Kunsthistorisches) and in a magnificent preliminary drawing (Dresden Gallery). Here, but especially in the drawing, Van Eyck conveyed both the shrewd worldliness of the prelate and a certain benignity and humour. And finally, he painted his wife, and on the frame are these words: 'My husband Johannes completed me in the year 1439, June 17. My age is thirty-three years.' The lady is watchful, self-possessed, sensible and mature, intelligent and quite sensitive enough, unfussy, becomingly but modestly dressed. This superb work, now in the Groeningemuseum, has always been in Bruges and almost certainly hung in the dining room of the Van Eycks' own house.

From the uniformly fine, and often unexpected, nature of Van Eyck's work, one would expect to descend to a lower pitch. Not so: such is the richness of northern art at this time that, in the realm of portraiture at least, the progression is upwards. There is in the Berlin Museum a portrait of the courtier Robert de Masmines by a master usually referred to as Robert Campin, a contemporary of Van Eyck's whose dates are given as *c*.1375–1444. This man, also known as the Master of Flémalle, gave Robert a treatment which another age would call savage. The supposedly fashionable court haircut, which consisted of hacking everything off except a crowning thatch, is rendered pitilessly. So are the chapped lips, the cauliflower ear, the bad shave and the worried brow. Campin was evidently as faithful a servant of truth as Van Eyck. But in addition he evidently admired Claus Sluter's portrait heads and sought to give solidity and depth by keeping the light down in the background and crowding the faces into the frame. His success in this technique, an improvement on Van Eyck's, can be seen in a pair of portraits in the London National Gallery. The first, a handsome but worried man, wears the red turban of which Van Eyck himself was fond, and peers out of the panel as though he was in court hearing his death-sentence read out. The second, of his wife, a young woman in a white headdress, is also watchful, but truthful in presenting her evident beauty and innocence.

Campin was the teacher of an even greater artist, Rogier van der Weyden (*c.* 1400–1464), who became the official painter in Brussels, travelled to Italy and back, was in endless demand and was the first northern artist to run a big studio with dozens of assistants. He improved on his master's woman in a white headdress, not once but twice, and both versions (in the Washington and London National Galleries) are of exquisite beauty. He reduces the headdress to an accessory in the London portrait, showing more of the face, and investing it with a subtle, melancholy beauty, though the obstinate lips presage trouble to come. Rogier, a clever and highly commercial workman, built on his predecessor's efforts, in using space more freely, in inventing rich-coloured backgrounds for portraits, indeed in the use of colour generally, which he made less brilliant but more subtle. The greens are soft and sagey or limey, the crimsons become a glowing plum, there is a suggestion of grey in blues and

greens, there is a diaphanous mauve, a deceptively pale lemony yellow, a faint salmony pink. All his women look sad, even when they have such marvellously red hair as his Magdalen in the Louvre. Rogier introduced many cunning innovations in presenting his work—shifting the angles, moving the main figures closer to the viewer, then pushing them back, framing them in architectural fantasies, windows and painted surrounds, devices which then become standard in northern art.

But in one respect, Rogier was faithful to his tradition. He loved detail, and it was always contemporary detail. Of his many large-scale works, the one which brings this out best is his *Scenes from the Life of John the Baptist* in Berlin. These three pictures

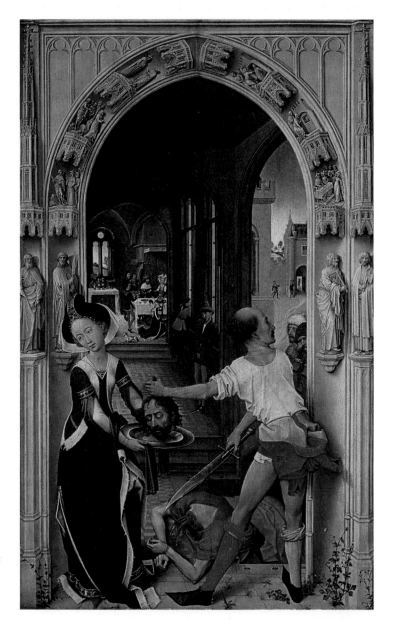

Rogier van der Weyden, in his *Beheading of John the Baptist* (c.1455–60), transforms a horrific act into a scene of elegance, subtle feeling and beauty-in-depth.

convey an enormous amount of information. Salome has certainly not been performing a dance. She is dressed in the height of Brussels fashion, c.1450, and holds the dish to receive the severed head disdainfully, as though she was not accustomed to handling platters of any description. Every detail of her presentation is perfect. The executioner must have been done from life at a ceremonial chopping, of which there were many the artist could have witnessed. The way the man has stripped himself of most of his garments to get a perfect swing to his sword, itself rendered in fearsome detail, is unforgettable. Behind the pair and the ghoulish head, which glows with recently dead pallor, is a passageway, closely guarded, which opens into the banquet scene itself, in the far distance but lovingly rendered so that we have a good idea of what was being eaten before the head made its entrance. The story of the head, which never failed to arouse interest anywhere in Europe for a thousand years—it was still going strong in the days of Oscar Wilde and Aubrey Beardsley—is here used as an excuse for a piece of dramatised genre painting. The details told the viewers two things. First, 'All this is true', and secondly, 'Take note of these events, they are part of your life also.'

There were so many gifted and wonderfully hardworking artists in those times! Hugo van der Goes, from Ghent, active in the 1460s and 1470s, created the great Portinari Altarpiece in the Uffizi, which is, in effect, an enormous landscape peopled by New Testament figures, the control of space being masterly for the age. His work is impressive whether you grasp each of his paintings as a whole, or peer into them to look for the character actors. There are two old men in his *Dormition of the Virgin* (Bruges) who look as though Hugo had dragged them into his studio from the crowded streets of Ghent and told them to look sad. They are trying, not quite succeeding, and the painting lives in consequence. In the Uffizi altarpiece there are, likewise, two enchanting small boys, doubtless his own, whose clothes and haircuts and anxious little faces delight. Hugo was strong on trees, on beards and hair, on flowers, pots and pans, metal cups, containers of all kinds, flower-pots and the like.

Petrus Christus (d. 1472/3) is likewise an accumulator of minute details, as in his mysterious work *St Eligius and the Two Lovers* (New York, Lehmann Collection, Metropolitan). Here, a money-weighing transaction is going on and over 150 objects are crammed together in a small space. The painting, with its three figures, is well-balanced none-the-less, and riveting—Christus was a master of eye-lines and painted staring eyes better than anyone of the age. Hans Memling (c.1430/40–1494) is more restful. His mesmerising *Portrait of a Man with an Arrow* (Washington), though manifestly truthful, arouses no uncomfortable feelings. The young man is well-born, self-possessed, content with his station and space, gazing out at life with serenity, holding his arrow to make some unfathomable point which need not concern us now. The beautiful faces in Memling's Diptych of Maarten van Nieuwenhove (Bruges, Memlingmuseum) are full of love and devotion, unworried, prayerful, content and composed. There is another young man, this time in the Venice Accademia,

wearing a superb fur hat, who looks as though he has not a care in the world. But none of these evidently happy people smiles. It was not done to smile, let alone laugh, in the fifteenth century, or rather to be seen and recorded doing so. That was one aspect of the truth the painters did not tell.

Yet there was laughter in art, even if double-faced. It is a common modern view that Hieronymus Bosch (*c*.1450–1516) painted the horrors of life and death, and aimed to terrify and to enforce repentance, by his alarming compositions—*The Garden of Earthly Delights, The Haywain* (both in the Prado), *The Temptations of St Anthony* (Lisbon National Museum) to name just three. But that covers only part of the truth. Bosch was an outsider, a member of one of the quasi-heretical congregations which flourished in the later Middle Ages, and was anxious to stay on the right side of the church courts. He thus emphasised, in innumerable ways, his meritorious intentions, which made his pious works fit to hang in ducal halls or churches. But he also aimed to excite, to thrill, to fascinate and to amuse. There is literary evidence, unearthed by that sharp reader of texts as well as pictures Ernst Gombrich, that collectors bought Bosch for that reason. He made them laugh at folly and its consequences, as Hogarth was to do 250 years later. The minute events of his gruesome tales were fantasies and obviously so. Yet by painting them in the Flemish tradition of realism and attention to detail, he made them seem credible at a certain level, and because credible hilarious. So the men laughed uproariously when, alone with their wine, they collectively considered a Bosch work, and put on straight faces and didactic expressions when their women folk appeared and asked to have the painting 'explained'.

Medieval people of all classes liked to 'read' art, whether an array of sculptures in a cathedral portico, which taught them their faith, or a painting which placed an exciting miracle or story, such as St Ursula and her 10,000 virgins, in a contemporary setting with countless details they could recognise and relish. For the educated, there was another dimension of meaning produced by symbols, so that a painting could be solved as we solve a crossword puzzle. Bosch offered all these opportunities in full measure—his *Garden of Earthly Delights* contains over 400 distinct incidents and symbols—but his humanity and voracious zest for life added an extra, unexpected dimension of humour. His humans, often young and beautiful, are held up to ridicule as they find themselves poised between Hell and Heaven and subjected to extraordinary humiliations.

It would be wrong to suppose that all the notable painters came from Burgundy-Flanders. There was a huge arc of artistic talent running from northern France up into Holland, across the German Baltic coast, then down into central Germany. Geertgen tot Sint Jans, for instance, came from Leiden, and was a precocious and prolific painter who died, much lamented, at the end of the 1480s when he was twenty-eight. His multi-panel pictures have been broken up, sawn in half and subjected to other mutilations, but a famous panel in the Berlin Museum, *Saint John the Baptist in the Wilderness*, gives some idea of the intensity and high seriousness with which he

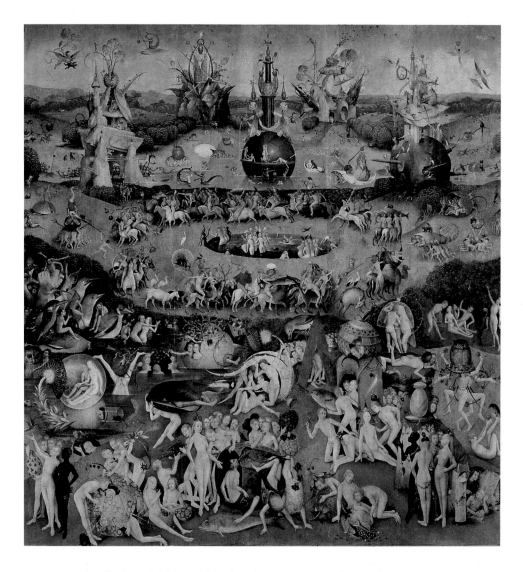

explored his religious faith in paint. St John, with bony feet and wrists, enveloped in a cloak, and with an expression of intense melancholy, sits, brooding, attended only by his lamb, not indeed in a wilderness but in a tree-studded landscape of exquisite beauty—and a city of domes in the background—which Geertgen clearly spent many months of his brief life elaborating down to the tiniest leaf and bird-feather.

The Garden of Earthly Delights (1503–1504) by Heronimus Bosch, the best of his forty works that survive, uniquely combines medieval and renaissance, horror and humour, religious and secular values, and figures and landscape.

　　There were numerous fine German painters too. One of the most impressive works of the time is the Landsberger Altar in the Berlin Museum, by Hans Multscher (*c.*1400–1467), which presents eight panels, one of them inscribed: 'Pray to God for Hans Multscher of Richenhfen, Burger of Ulm, who made this in the year of our Lord 1437.' The detail is amazing, up to the highest Flemish standards, but there is a robustness, almost clumsiness, in the figures which takes us a long way from Flemish emaciation. Not that the Germans were lacking in sensitivity: far from it. The Nuremberg Museum has the right half of a diptych by Hans Pleydenwurff (*c.*1420–1471), done in 1456. It is of the well-connected Count von Löwenstein, who

became rich through a multiplicity of benefices, including a canonry of Bamberg Cathedral. He was now nearly eighty, anxious to save his soul, and commissioned this work in which he faced (in the left panel) *Christ as the Man of Sorrows*. The canon is shown just as he was, an old, old man, wrinkled and parchment-skinned, his hair a few thin wisps of white—superbly painted—but his eyes clear and gazing steadfastly at his Redeemer. His arms of nobility are on his surplice, but his left hand tightly grasps his breviary (in its green velvet cover) from which a sheet of plain-chant protrudes. This is great portraiture.

The existence of work of this quality in Germany renders less surprising the advent of a man of artistic genius, Albrecht Dürer (1471–1528), one of the greatest painters and draughtsmen of all time. He inherited the grand tradition of detailed, meticulous northern painting. But he also inherited a technological revolution, of direct relevance to his work as a black-and-white illustrator who produced woodcuts and engravings as well as paintings. Nothing divided the medieval world more decisively from the Early Modern period than printing from moveable type. It was a German invention and the culmination of a complex process which was making it easier to spread words and images among the multitude. The world of antiquity had recorded its writings mainly on papyrus. Between 200 BC and 300 AD, this was supplemented by vellum, the skin of a young calf soaked in lime, then smoothed by pumice stone. To this in late Roman times was added parchment, similarly made from the scraped and smoothed skin of sheep (or goats). Throughout the Middle Ages, vellum was the material for luxury books, like the Lindisfarne Gospels or the *Très Riches Heures*. Both vellum and parchment were durable, but parchment was much cheaper and was used for important routine documents, chiefly legal, until about 1590. In the early Middle Ages, Europe imported an industrial process from China, which turned almost any kind of fibrous material, straw, wood, old linen or cotton—any old rags in fact—into pulp, which was then spread in sheets over a wire framework. This was known as cloth parchment. By about 1150 the Spanish had developed the first mill for making cheap paper (a word contracted from papyrus which became the standard term). This stamp-mill had a primitive mechanism whereby a wheel and tappets raised and dropped pestles in mortars to produce the pulp. Water-mills, the world's first cheap source of energy, were spreading in Europe from the tenth century and by 1200 were numbered in scores of thousands. They were soon applied to paper-making. Leadership in the industry shifted to Italy, which by 1285 had introduced the device of sewing a wire figure into the mould to produce a watermark. Hence one of the most important phenomena of the later Middle Ages was the growing availability of cheap paper. Even in backwards England, a sheet of paper, or eight octavo pages, cost only a penny by the fifteenth century.

The Gutenberg Bible (1455), the first book made from moveable type, shows the high quality of early printed books. But cost reductions meant that volumes in circulation rose from under 100,000 to 9 million within fifty years.

In the years 1446–48, two Mainz goldsmiths, Johann Gutenberg and Johann Füst, made use of cheap paper to introduce a critical improvement in the way written pages were reproduced. Printing from wooden blocks was an old method. The Romans used it in textiles. It was the means by which the Mongol Empire ran a paper currency. By 1400, on both sides of the Alps, devotional pictures and playing-cards were being mass-produced by this method. What the Mainz team did was to invent moveable type for the letterpress. It had three merits: it could be used repeatedly until worn out. It was cast in metal from a mould and so could be renewed without difficulty. And it made lettering uniform. In 1450, Gutenberg began work on his Bible, the first printed book, known as the Gutenberg, or Forty-Two-Line Bible, from the number of lines on each page. It was completed in 1455 and is a marvel. As Gutenberg, apart from getting the key idea, had to solve a lot of practical problems, such as typefounding and punch-cutting, devices for imposing paper and ink into the process, and the actual printing itself, for which he adapted the screw-press used by vintners, it is amazing that his first product does not look at all rudimentary. Those who handle it are struck by its clarity and quality. It is a triumph of fifteenth-century German craftsmanship at its best. Indeed, it is a work of art, in the true sense: the application of manual and intellectual skills to produce a thing of beauty, as well as use. Gutenberg was an artist, and a very important one in the history of art, for the spread of black-and-white reproductions in books, which could be hand-coloured, did more to internationalise art than any other factor.

Printing was one of those technical revolutions which developed its own momentum at extraordinary speed. Christian Europe in the fifteenth century was a place where intermediate technology, as we now call it—that is, workshops with skilled craftsmen—was well-established and spreading fast, especially in Germany and Italy. Such workshops were able to take on printing easily, and it thus became Europe's first true industry. The process was aided by two factors: the new demand for cheap classical texts, which were becoming available anyway, and the translation of the Latin Vulgate Bible into 'modern' languages. Works of reference were also in demand. The first printed encyclopaedia, the *Catholicon*, appeared in 1460. The next year, the first printed Bible for laymen appeared, quickly followed by the Bible in German, the first printed book in the vernacular. Presses sprang up in several German cities, and by 1470, Nuremberg had established itself as the centre of the international publishing trade, printing books from twenty-four presses and distributing them along trade routes and at trade fairs all over western and central Europe. The old monastic scriptoria worked closely alongside the new presses, continuing to produce the luxury goods that moveable-type printing could not yet supply. Printing aimed at a cheap mass sale. In 1471 the first best-seller appeared, Thomas à Kempis's *Imitation of Christ*, which by 1500 had gone through ninety-nine editions.

Though there was no competition between the technologies (at Augsburg, the printing presses and the old monastic scriptorium were in the same building), there was rivalry between nations. The Italians made energetic and successful efforts to catch up with Germany. Their most successful scriptorium, at the Benedictine monastery of Subiaco near Rome, quickly imported two leading German printers to set up presses in their book-producing shop. Italian printers had one advantage. German printers worked with the complex typeface the Italians sneeringly referred to as 'Gothic' and which later became known as Black Letter. Outside Germany, readers found this typeface offputting. The Italians had their own clear version of the Carolingian minuscule. This became known as Roman, and was the type of the future. In 1458, Charles VII of France, impressed by the Gutenberg Bible, sent his leading artist-craftsman, Nicolas Jenson, master of the royal mint at Tours, to Mainz, in order to learn 'the art of printing'. But Jenson, having become an expert printer, refused to return to France. Instead he went to Venice and set up what became the most famous printing press in the world. The fonts of Roman type he cut were exported and imitated all over Europe. From 1490 he had a rival: Aldus Manutius, whose Venice press designed and used a practical Greek type for printing the classics, now available and in huge demand among scholars. He also introduced and made popular, *c.*1501–20, a slanting type based on the cursive hand used in the papal chancery. The international trade called it Italic, and entire books were printed in it before it slipped into its modern role of use for emphasis and quotation.

Hence, although the Germans made use of the paper revolution to introduce moveable type, the Italians went far to regain the initiative by their artistry and their ability to produce luxury items. By 1500 there were printing firms in sixty German cities, but there were 150 presses in Venice alone. However, the trade quickly became international. All nations and governments wanted their own presses, as they did airlines in the twentieth century. The Dutch had got printing by 1470, the Hungarians and Spanish by 1473, the Poles by 1474, the English by 1476. The cumulative impact of this industrial spread was spectacular. Before printing, only the very largest libraries, of which there were a dozen in Europe, had as many as 600 books. The total number of books on the entire Continent was well under 100,000. By 1500, after only forty-five years of the printed book, there were 9 million in circulation.

Albrecht Dürer, born in Nuremberg, was at the epicentre of this profound revolution in art, learning and civilisation. And he was almost divinely favoured, by his gifts and good fortune, to take the fullest advantage of it. In addition to printing, Nuremberg was a leading European centre of craftsmanship of all kinds, in precious metals, base metals, wood-carving, furniture-making, pottery and glassware, painting, sculpture, engraving, enamelling and coining. It was also a resort of scholars of the most advanced kind. Dürer's father was a goldsmith, the type of craftsman who came closest to fine art. As Dürer's godfather, he chose Anton Koberger, a leading German

printer and publisher, who taught the boy all about illustration work. When Dürer was fifteen he was apprenticed to the city's top book illustrator, Michael Wolgemut, who was himself the friend of many exponents of what men called 'the new learning'. Dürer's own father had taught him, from the earliest age, to draw with silverpoint, and in 1484, aged thirteen, he drew a superb self-portrait (now in the Vienna Albertina).

This was the first of a long series of self-portraits, rivalling Rembrandt's in their truth and intensity, with which Dürer punctuated his career. He also portrayed his family. His beloved father, a wise, capable, serious and good-hearted man, was superbly painted in 1497, in oil on limewood (London, National Gallery). He drew his mother in charcoal, when she was sixty-three, toothless and shrunken, a work of love and truth, an uncompromising rendering of an old woman just before her death (Berlin). We know a lot about Dürer and his family. Some of his letters and other writings survive, including many documents, legal and personal. They reveal the enthusiasm with which first the boy, then the man, embraced a career in art; the assiduity with which he studied its techniques and absorbed any knowledge relevant to its practise; the humility with which, despite his obvious and overwhelming gifts, he approached art, and the generosity with which he helped others who shared his love of it.

Dürer was the archetypal man of art. He loved the world and nature, and

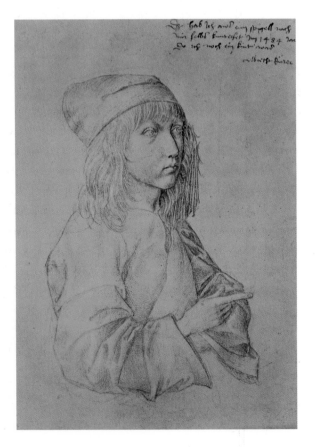

Self-portrait at thirteen (1484) by Albrecht Dürer shows the child-prodigy who grew to be Germany's finest and most versatile artist, an unusual combination of genius and modesty.

sought to reduce it to orderly truth by his skill at putting real things and creatures in two dimensions. No artist ever drew or painted with more affection, a point made strongly by the British Museum's great exhibition, 2002–2003. He drew on his letters and on scraps of paper, both sides. He made a brilliant sketch of six pillows, to show how the folds went (Metropolitan). He drew his wife, Agnes, many times, from the briefest of sketches to notable portraits within his religious works. He drew girls and boys and babies. His self-portrait in the Prado, showing his long curly red hair, and a fascinating landscape in the background, ending in snow-covered Bavarian alps, is the finest ever done. He drew boats and buildings, churches and cathedrals and townscapes. He painted his *The Virgin and the Infant Christ,* a work of such touching simplicity and tenderness that it can make strong men, like the late Kenneth Clark, weep. He carved *The Triumphant Chariot of the Emperor Maximilian*, an enormous woodcut which spread over eight large sheets of paper.

Dürer's educative woodcuts included *Variations on a Face, Movements of the Shoulder,* anatomical studies of *Stout Man, Nude Woman, Nude Seen in Profile* and other aids to figure-art. He made architectural studies, designs for sundials, city plans, elaborate drawings of helmets and body and horse armour, goblets, maps of the world and the skies, triumphal arches and columns, watercolours of places in and around Nuremberg, and of industrial plants like wire-mills. He painted the emperor, looking regal and supercilious, in oil on canvas, and drew him many times. He drew his scholarly friends, from Erasmus to the heresiarch Philip Melanchthon. He illustrated dozens of books with woodcuts and steel engravings. He copied old paintings, drew them in ink to teach himself how to produce better work, and then engraved them so that other artists could benefit likewise. Whenever he travelled, his watercolour box came out and he recorded everything interesting he saw—towns, mountains, people.

Dürer painted the exquisite *Feast of the Rose Garlands* (Prague, National Gallery), his most accomplished large-scale work, marked in all its countless details by tenderness, sensitivity, delicate colour compositions and fine draughtsmanship. If ever a work deserved the title of masterpiece, it is this one. He drew hands and feet, cloaks and skirts, garments of every kind, in order to get the details of folds and the feeling of textures exactly right. He drew lions and dogs, pigs, horses and a rhinoceros. His watercolour study of a young hare (Vienna, Albertina) is itself a masterpiece. So are his renderings of *The Wing of a Blue Roller* (Albertina) and *A Lobster* (Berlin), *Head of a Stag* (Bayonne, Musée Bonnat), *A Stag Killed by an Arrow* (Bibliothèque Nationale) and *A Hanging Duck* (Lisbon, Gulbenkian). He drew, in amazing detail, trees and leaves, grasses and flowers, and coloured them with dedicated accuracy. His fantastic oil-on-wood *Martyrdom of the Ten Thousand* (Vienna, Kunsthistorisches), evidently one of his favourite works since he mentions it often in his letters, is a spectacular piece of late medieval fantasy and realism, with scores of separate incidents and 127 figures including a self-portrait. On the other hand, the magnificent

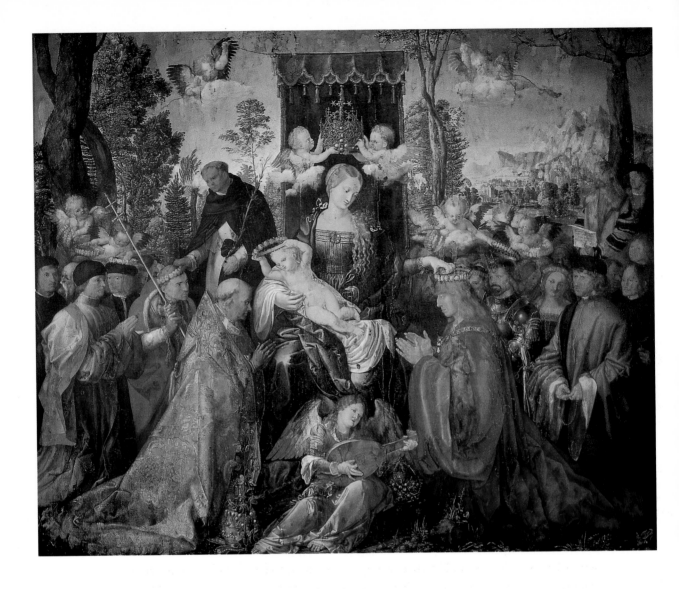

Dürer's *Feast of the Rose Garlands* (1506), painted in Venice, shows how much he learned from Italy, especially Giovanni Bellini. But it remains a masterpiece of Germanic soul-art.

Landauer Altarpiece (also Kunsthistorisches) shows that, by 1511, Dürer had learned everything the new art had to teach.

Dürer was one of the most accomplished artists who ever lived, and hugely productive. More than a hundred paintings have survived, most of superlative quality. He produced over a thousand drawings, with vast quantities of woodcuts and engravings. No German artist, before or since, has actually known more about how a three-dimensional object is reduced to two dimensions. Yet in 1494, at the earliest possible opportunity, just after he had married a beautiful wife of nineteen and before he had even set up his own workshop, Dürer set off for Italy and Venice. The watercolours he painted on the way there and back are miracles of atmosphere and sensitivity (Louvre; British Museum). But he did not go for the sake of travel. He went to learn. What did Italy have to teach him that was so important, even to a superlatively gifted artist like Dürer, who knew so much already?

10

REDISCOVERY AND
TRANSFORMATION OF
GRAECO-ROMAN CULTURE

When Dürer travelled so ardently to Italy in 1494, he certainly did not go to see 'the Renaissance'. The term was only invented in 1858, by the French historian Michelet, and popularised two years later by Jacob Burckhardt in his famous book *The Civilisation of the Renaissance in Italy*. But perceptive people knew that something extraordinary had been happening in Italy. Fifty years or so after Dürer's arrival, the painter Vasari, in the first edition of his book *Lives of the Artists*, described how the glories of antiquity, in painting, sculpture and architecture, had been revived in Italy by the achievements of its artists. Thus another age of greatness had dawned, and the period in between he dismissed contemptuously as 'the middle ages'.

The 'Italian Renaissance' can be looked at in two different ways. The first way is to see it as merely the culmination of long-maturing processes. The Italian towns, such as Genoa, Pisa, Siena, Florence, Bologna, Milan and Venice, had been growing richer through commerce and banking, and the manufacture of fine goods and luxuries. They contained thousands of highly professional workshops where skilled artisans competed in fashioning marvels. The rich citizens were highly competitive with each other in adorning their houses and churches, and the cities competed even more strenuously in building or rebuilding their cathedrals and public halls. The result was an irresistible acceleration in the skills of every kind of artist, the culmination of a process which had been going on for hundreds of years.

But all this was equally true of northern Europe. By the fifteenth century there were as many skilled craftsmen and artists in Germany and Flanders as in the whole of Italy. There was as much wealth too, probably more. What made the Italian artistic advance different was its intellectualisation. It was seen in the context of a transformation of the human mind. This had two aspects. First was a growing consciousness, among educated citizens, of national culture, centred on language. This was occurring all over Europe but the Italians were the first on the scene. Dante Alighieri (1265–1321) not only gave Italy her national epic, as Homer had given it to Greece and

Virgil to Rome. He also invented Italian as a national written language, by giving the Tuscan dialect such prestige and status that the rest of the country was gradually obliged to follow Florence. Dante's success was confirmed by the literary skills of Giovanni Boccaccio (1313–1375) whose *Decameron* became the most successful secular book published so far, and by Francesco Petrarch (1304–1374), who invented that most popular of all verse forms, the sonnet. In the fourteenth century, then, Italy acquired a national literature and a pride in her language, a process which was pushed forward in England by Chaucer and Langland, in France by Villon, Ronsard and Rabelais, in Spain by Cervantes and in Germany by Martin Luther, whose translation of the Bible effectively established modern German.

These developments, beginning in Italy, undermined the authority of Latin, the linguistic cement of medieval culture, by offering alternatives. By the sixteenth century, for example, Italian was replacing Latin as the language of diplomacy. Printing accelerated the process. The great majority of the early printed works were in national languages. Of the ninety or so books published by William Caxton, the first English printer, seventy-four were in English. The demand for national translations of the Bible became overwhelming, and when such texts were widely distributed in print men and women read them with new eyes. National languages, plus printing, began the self-education of both the ruling class and the middle class of the towns, bringing with it a new spirit of inquiry and scepticism.

This process was strongly reinforced by the second factor: the rediscovery of ancient texts in Greek and Latin, and their re-editing. It went hand in hand with the emergence of national literatures, and again Italy was the precursor. Petrarch in 1333 went on a tour of European monastic libraries, looking for forgotten manuscripts. In Liège he discovered copies of two lost speeches by Cicero. At Verona in 1345 he unearthed Cicero's letters to Atticus, Brutus and Quintus, which became the basis of his own epistolary style. These, and other, discoveries bred a contempt for the medieval dog-Latin which the Church used as its *lingua franca* both in its day-to-day administration and in its universities. A new kind of scholar followed in Petrarch's footsteps, typified by Leonardo Bruni (*c.*1369–1444), who insisted that Petrarch had 'opened the way for us to show how to acquire learning', and who first used the term *umanista* (humanist), to describe himself. The rediscovery of 'correct' Latin was followed by the acquisition of Greek, virtually unknown in the West during the Middle Ages. Greek was still spoken, in a debased form, in Byzantium, which also had depositories of ancient texts. In 1397 the Greek scholar Manuel Chrysoloras was invited to lecture in Florence. In turn the Italian scholar Guarino da Verona went to Constantinople to learn Greek, coming back in 1406 with a library of ancient Greek works, including part of Plato, hitherto unknown in the West. In the 1420s, Giovanni Aurispa retrieved the rest of Plato's works. There was a further access of texts when a Greek delegation attended the ecumenical Council of Florence in the 1430s, and a fourth arrived in the baggage of refugees escaping from the Turks after the fall of Constantinople in 1453.

Armed with these rediscovered texts, encompassing the learning of antiquity, the humanist scholars re-examined all the received wisdom of the Middle Ages, and found it wanting. They were not, for the most part, men of the universities, where the rule of the Church was strong. They were private scholars, working in the commercial market: after the arrival of printing, most successfully. They were extremely clever at infiltrating courts and getting the ear of educated princes. By such means they were sometimes able, as in Florence, to found private colleges, where new learning was pursued without restraint. The Italian princes, in turn, were the first to grasp that patronising learning and the arts brought them prestige and magnificence which armies and wealth alone could not provide. The humanists often had brilliant pens and could write powerful propaganda on behalf of their patrons. Coluccio Salutati (1331–1406), a private scholar who was made Chancellor of Florence, defended his city fiercely and the rival Visconti of Milan grumbled that his pen had done more damage 'than thirty squadrons of Florentine cavalry'.

The pattern of patronage of the new learning was set by Cosimo de' Medici (1389–1464), head of the family which, beginning as physicians, had made a huge success in international banking. Cosimo's annual income, it was said, could pay the wages of 2,000 skilled wool workers. He paid for Marsilio Ficino (1433–1499) to translate Plato, presented in one of the finest manuscripts of the entire medieval period. At one time he employed thirty-five professional scribes copying classics for his library. And it was a short step from employing scholars to commissioning artists on important projects, which in Cosimo's case included the restoration of the family church of San Lorenzo in Florence and the building of the family's palace. His grandson Lorenzo 'the Magnificent' (1449–1492) not only continued this patronage of scholars and artists on an enlarged scale but was himself a poet of distinction. There were few great painters or sculptors of his day he did not employ, and most of them he treated as his friends and equals.

It was one of the virtues of the Italian ruling class, and a great source of strength for her artists, that rulers loved them, understood their work, gave them not only money but friendship and support in times of need—indeed, often put up with tantrums and rages. Not only bankers like the Medici, but professional soldiers and mercenaries, like the Visconti of Milan and Federigo da Montefeltro (1422–1482), who ran Urbino for many years, showed astonishing munificence and genuine friendship towards the men of the brush, the chisel and pen. Federigo transformed a crumbling medieval fortress into one of the finest palaces of Italy, the heart of which was his *studiolo*, or learned sanctum, a masterpiece of inlaid wood arranged as a series of *trompe l'oeil* scenes. There he talked to scholars, received artists and discussed their commissions. Italy was blessed with a ruling class which combined, often in the same man, ferocious cruelty and huge greed with the most sensitive and enthusiastic love for the arts. If one had to define the success of Italian art during these times in one sentence it would be: a

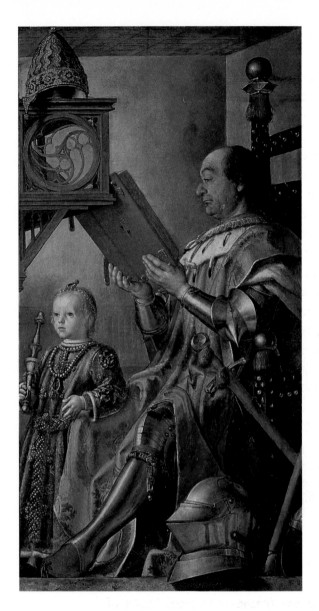

cultural climax occurs when a superb work-
shop tradition of craftsmen is led by a ruling
elite of discernment, taste and imagination.

Imagination—the conjuring of images
in the mind—was an important element
because what, in effect, educated Italians did
in the later Middle Ages was to look at exist-
ing culture with critical eyes, reject it as inad-
equate, and use the wisdom of antiquity as a
guide in creating a new one. They conjured
up, in the Italy in which they lived, the image
of antiquity as a golden age, and sought to
reproduce it in stone and paint, glass and
metal, words and forms. The rejection of the
Middle Ages was the essential preliminary.
Here the key figure was Lorenzo Valla (*c*.1407–
1457) who embodied the new spirit of criti-
cism. He re-examined all the old Latin texts
on which the Church based its universal
power with the scepticism of an exact scholar.
He proved, for instance, that the Donation of
Constantine, in which the founding emperor
of Byzantium had conferred immense powers

and property on the popes, was a blatant forgery. He compared St Jerome's Latin
Vulgate translation of the Bible with the original Greek New Testament. To him, all
texts were guilty until proved innocent by scholarly scrutiny. He was the model on
whom all subsequent scholars, like Erasmus, Thomas More and John Colet, based
themselves. Valla's enemy was medieval complacency and its easy assumption that
everything it did was right. This applied particularly to the arts. As already noted, he
invented the term 'Gothic', which to him summed up all that was barbarous and
destructive in Graeco-Roman civilisation. To him, the millennium between the fall of
Rome and the present was a lost age, and everything it produced was worthless. By
Gothic, of course, he meant essentially all the art north of the Alps. He was a cultural
nationalist of a new kind, and his hatred of the medieval and his artistic prejudices
were shared by many of his most gifted countrymen, not least the 'universal man' of
the High Renaissance, Michelangelo.

However, men like Valla were not purely destructive. They had their own form of knowledge: the works of the ancients, which it was the task of contemporaries to build upon and improve. He and others who worked after him saw art not as something traditional which fathers handed down to their sons, but as the object of close study and measurement, rule and science. This applied particularly to architecture. The Italians were unhappy with the way of building which Valla denounced as Gothic. They sometimes used its form, as in Milan, but they never embraced its spirit. One suspects that the rows over Milan Cathedral, between the Italians working there and the French and Germans, were not so much about science and mathematics and the measures of art as about its underlying psychology. The medieval art of the north was not a system which could be explained in words and quantified in numbers. There was something organic about it that Italians found unreasonable. They adopted it only in an aberrant form and longed, perhaps unconsciously, to replace it with something better, derived from the roots of their culture.

These roots were there all the time, for people to see and marvel at, in the ruins of Rome. They were far more extensive in the Middle Ages than they are today, and they testified to the gigantic scale on which Roman builders worked. Some, like the Colosseum, were partly upstanding and some, like the Pantheon, were complete. The north, the Italians felt, had nothing to match them. With the revival of Greek and Latin scholarship, the expansion of knowledge of the ancient world, and the recovery of texts, including the writings of Vitruvius, the time had obviously come to make those old bones live; to resurrect the tumbled stones and the ways of putting them together, for the love of God and the honour and glory of their country and its richer towns.

This feeling was particularly strong in Florence, where local roots were deep and stretched to Roman times. The cathedral went back to the fifth or even the fourth century. The separate Baptistry was originally a sixth- or seventh-century work, modelled on the Pantheon. It was altered and reconsecrated in 1059 but its Roman bones shone through. The great painter Giotto di Bondone (c.1266–1337), made Master of the Cathedral Works in 1334, had designed the campanile, or bell-tower, and his plans survive, but he died before they could be put into stone. The actual building, constructed in turn by Andrea Pisano, the sculptor (c.1290–1348), and Francesco Talenti (c.1310–1369), looks neither medieval nor Roman. It is *sui generis*. Florence was an ambitious city, with a thriving artistic community, looking for a style.

A generation before, in 1294, the city fathers decided to pull down their old cathedral and build a new one. The idea was to use brick and face it with white, green and pink marble. The Italians had plenty of marble, and regarded it as infinitely more beautiful than the limestone beloved of the north. The campanile was the first part of the complex to be put up in this fashion, and the old cathedral was not actually pulled down till 1375. By then a new design was ready: a vast, oblong church, with four immense bays between the west façade and the sanctuary, itself to be a vast octagonal space surmounted by a huge drum, with a dome on top. This design had echoes of

antiquity but it was an original concept and the Florentines were proud of its novelty. A member of the planning committee, Andrea da Firenze (active *c*.1337–1377) painted an elaborate fresco, *The Church Triumphant*, showing this vast church as it would be. But it was one thing to imagine it in paint, quite another to put it up in fact. It raised engineering problems which had never been tackled before, even in antiquity.

There was no real difficulty in putting up the mass of the church. The piers for the crucial octagon were complete by 1410 and the drum begun. But how was the dome to be put on top of it? In 1418 a competition was held for the dome contract. Here it is important to stress three points which have a direct bearing on Italian art at this period. First, Florence was a self-governing, independent city, where a good deal of freedom, including freedom of speech, was permitted. Things were done in the open. In one way or another, the citizens participated in most important decisions. This spirit of freedom had an immense impact on the quality and variety of the art produced. Second, there were a large number of artist-craftsmen, working from busy workshops, capable, alone or in combination, of taking on big projects. That was a luxury few places have enjoyed at any time, and it recalls the golden period of Attic Greece. Third, Florence was a trading city with a strong commercial sense. It believed in doing things in a business-like manner. Hence strict and enforceable contracts were insisted upon for major artistic undertakings and, given the wide spread of craftsmen, holding a competition made excellent sense. In short, one reason why Italian, and especially Florentine, art was so successful was because it embodied the well-tried methods of sophisticated commerce.

The contract was won by Filippo Brunelleschi (1377–1446), a former goldsmith— as were over fifty per cent of the leading artists, sculptors and architects practising in Italy—who had then gone to Rome to study classical architecture. He specialised in mathematics, was familiar with many ancient texts on the arts and was generally credited with evolving a theory of perspective. In 1401 he had taken part in another competition, to make a pair of elaborate bronze decorative doors for the Florence Baptistry. This had been won by Lorenzo Ghiberti (1378–1455), another goldsmith-trained artist-craftsman. Ghiberti had now been working on the doors for over fifteen years and Brunelleschi found it convenient to take him and his workshop into partnership. Italian artists of this time, like the best kind of entrepreneurs everywhere, accepted that success involved risk-taking, often on a dangerous scale, and one reason why Brunelleschi won the contract was because he stipulated that he would not need expensive centring, of the kind used in erecting stone vaults. Carpentry was one aspect of the arts he knew nothing about, and he had probably never heard of the Ely lantern. But he had seen and examined the Pantheon, in company with Donatello, who was now becoming the greatest sculptor of the age, and a master at judging the capabilities of heavy material. He concluded that the dome could be built by science, putting his trust in stone.

Brunelleschi was an intellectual and a scientist, who brought to the dome-problem considerable knowledge, based on analysis of existing buildings, of the

theory of stress. Strictly speaking he was not the architect of the dome, whose size, form and curvature had been decided ten years before he was born, in 1367. The dome he designed was not an imitation of the Pantheon, a miracle of concrete, but an original concept, resting on eight major ribs which continue the work of the piers beneath, assisted by sixteen minor ones, linked together by horizontal strainer-arches and reinforced by metal tension-chains. To keep his contractual promise about centring, Brunelleschi made the angle of the dome as steep as its form permitted, so that its construction was self-supporting. He then invented a completely new device: an outer and an inner skin for the dome. This added to the expense but it markedly reduced the weight carried during the construction period, thus minimising the risk. All in all it was a skilful combination of advanced existing techniques with novelties put together with élan and judgement. It substituted the sophisticated lessons of stress learned during a millennium of large-scale building for the Roman brute-strength, frontal-assault methods of the Pantheon. It worked, and the dome was completed in 1436. The real test, however, was its reception by the Florentine public, who judged not just the dome's stability but its actual appearance. They loved it. They liked it even better when Giuliano da Maiano's lantern was put on it in 1462. So did the non-Florentines who came from all over Italy to see it, and the foreigners who had heard about it from afar. It became a potent symbol of Italian artistic supremacy. Indeed, it still dominates the city in a way few cathedrals do nowadays.

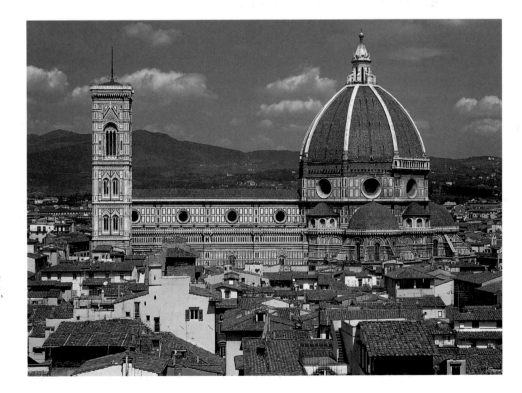

The dome of Florence Cathedral (1417–32) was the masterpiece of Brunelleschi, who studied Roman methods to enclose space on a huge scale, without support or even centering during construction.

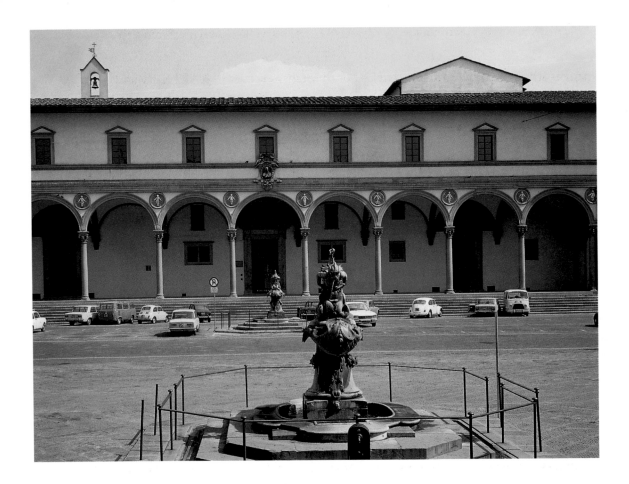

Brunelleschi also invented the Renaissance loggia, as in Florence's Foundling Hospital (1419), one of the most useful and durable ideas in architecture.

If the dome really had nothing to do with the antique, nor did the beautiful building which Brunelleschi was creating at the same time: the home for orphans, the Ospedale degli Innocenti (1419–24). Its famous loggia of slender Corinthian columns, supporting semicircular arches, with glazed terra-cotta medallions in the spandrels, and with a deeply recessed entablature over them, had some echoes of Florentine traditions. But in essentials it was a completely new design. Not only had nothing like it been built in Italy before, let alone in the rest of Europe; nothing like it had been built in antiquity either. Brunelleschi studied all the ancient decorative schemes he could get his hands on—he was especially fond of Etruscan work—and incorporated them in his designs, but his mind was original and creative. He might be called the first proper architect, as distinct from the senior stonemasons or craftsmen who had created the cathedrals. He was commissioned by the patron, and took charge, directing and often employing the workmen himself. Once such a commanding figure emerged, the old system of having the designs worked out by a committee fell into disuse, and the architect did it all. It was part of the process whereby the individual artist was moving up the social and creative ladder. And this upwards movement was secured on merit. The Ospedale has been called 'the first Renaissance building'. Its loggia was certainly a model for hundreds, perhaps thousands, of other

designs which followed. Brunelleschi had produced a new prototype of beauty and usefulness, rather like the Greek temple form, which is with us still.

This gifted, sensible and decent man—we never hear anything to his discredit—went on to reinforce and extend the new vocabulary of architecture in the fine Sacristy and other work he undertook at San Lorenzo, and the Pazzi Chapel he designed for another great Florentine church, Santa Croce. At San Lorenzo, and also at Santo Spirito, yet another church on which he worked late in life, he kept the basic cruciform shape of the old medieval churches, but introduced a strict law of proportion, either 1:2 or 1:4, which is repeated in all the main measurements. This was intellectualisation, science, the rule of mathematics. And once a great architect had laid it down, the rule would be followed by many, in a way that no medieval cathedral could be copied. In the Pazzi Chapel, however, Brunelleschi went a big step further, introducing a central-planned building, in which the circle replaced the rectangle. This was, in a sense, a return to Roman circularity, but there was nothing Roman about this chapel.

As with the dome and the Ospedale, the Pazzi Chapel was an original creation, and instantly popular. Airy and elegant, wonderfully proportioned, in delicate colour-schemes of grey and white, together with the natural colours of marble and brass, stone, wood and iron—and, in the case of the chapel, with ceramic roundels by a great artist, Luca della Robbia—these buildings produced an effect of princely simplicity. The old, self-proliferating, organic clutter was gone. Here was sumptuous plainness, directness, light and openness. After all the old complexity, the artist was firmly reasserting the basic principle of art: order. It was one of those recurrent

The central-planned building was introduced by Brunelleschi with the Pazzi Chapel in Florence's Santa Croce, begun in 1429 (ceiling shown). This innovation too is still with us.

moments in the history of art when the old way had come to seem like chaos and it was time for complexity to be banished.

So far as we know, Brunelleschi, though an intellectual, did not produce, or did not write down, any theory behind his innovations. They spoke for themselves: the complex parts of medieval church design were simplified. Instead of an endless variety of inventions, what we have is an orderly repetition of forms, and wherever possible a single system of lighting. There is a nice balance between the various elements so that there is no paramount feature but rather a pervading style, that pulls the whole building together. To achieve this transcendent style, Brunelleschi invented a series of devices, such as alternations between the pillars and pilasters, scroll buttresses, pendentives and volutes as punctuation marks in the repetitions, arches over columns in the form of curved entablatures, and alternations of triangles and curves, usually flattened, over windows. These devices, and others, were easy to imitate and quickly became standard in Italy—then spread, at varying speeds, everywhere. They were clichés, but, being neat and elegant, acceptable clichés until, in the course of centuries, they too became encrusted with complexity.

In short, Brunelleschi showed *how* to practise the new architecture. But he did not explain *why*. That was left to Leon Battista Alberti (1404–1472). He was not merely an intellectual but an academic—that is, he studied classics in Padua and took a full degree course in Bologna. He was much closer to the humanist scholars than to the goldsmiths and iron-founders of the workshops. He wrote all his life—essays, comedies, treatises on behaviour and on riding horses, philosophy and ethics, and on a wide range of scientific subjects. In the 1430s he was secretary to a cardinal who, on becoming Pope Eugenius IV, took him to Rome where he became an expert in the art of communication. He also became, as did all artists and intellectuals in Rome, an amateur archaeologist, unearthing, cleaning and copying bits and pieces of Roman design. This in turn led him to write two important treatises covering most aspects of art, the first writer to do so since Roman times. His works were set down in Latin and then, if the demand was sufficient, put into Italian, rather as today books go first into hardback, then paperback. By the 1470s, Alberti's circulating manuscripts were reaching printed form. They culminated in a first-class book on architecture, *De re aedificatoria*, the first such treatise since Vitruvius's. To be honest, Vitruvius's book, though important historically and endlessly referred to, is a fairly hopeless undertaking, and not of much practical use. By contrast, Alberti's is well written, orderly and systematic, clear about theory and helpful about practise. He starts with definitions, moves to concepts, discusses construction methods of the actual building and the materials with which to carry them out, and then deals with design: first, town planning, then all the kinds of building which make up a town. He tries to define beauty and show how it applies to religious, secular and domestic buildings. He had been a great student of Aristotle, and had a similarly encyclopaedic mind. So he put in everything, from cost to water supply and sewage, not forgetting restoration and archaeology. His book reached printed

form in 1485, a year before Vitruvius's was printed, and was, in its own way, a best-seller because it was exactly the kind of work a young architect or builder wanted to get his hands on. It remained in print for two centuries as a practical manual, and its approach, especially the distinction between basic functional design and ornamental superfluities, still governs the way we study architecture and look at buildings.

Was Alberti a good architect? The answer is not easy. At the great medieval church of Santa Maria Novella in Florence, he put on a new façade (1456–70) in which he used flanking scrolls to connect the aisles and nave into one large design. This is highly successful and much imitated, but the idea is really Brunelleschi's. At Sant'Andrea, Mantua (1472–94) he designed an imposing Roman façade, which was almost a trial run for the new St Peter's. But the top of the barrel vault peeps over the façade and makes it look ridiculous. He also supplied the designs for San Francesco, Rimini (1446–50); this church has since suffered many misfortunes, so it is perhaps unfair to blame Alberti for its present appearance, which is heavy, dull and blind. Another Alberti design, San Sebastiano, Mantua, also had bad luck: anyway, the basic floor plan, a Greek cross, is really taken from the Pazzi Chapel. Alberti's best design is the Rucellai Palace in Florence, which has a clear concept for each of the three storeys, surmounted by a matching cornice, tremendous discipline in the bays, and unity of the whole. But the unity, and the details which compose it, are academic rather than artistic. The building smells of the textbook and the midnight oil.

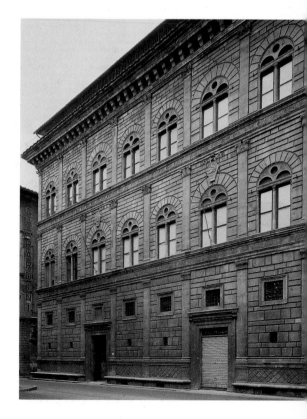

Leon Battista Alberti started Florence's Rucellai Palace in 1446, the first Renaissance design in which the façade of the building is articulated by classical-order pilasters.

So Alberti was not an artist in the sense that Brunelleschi was. He had a mind that could analyse beauty but not a gut feeling which enabled him to produce it out of nothing. He was full of praise for Brunelleschi's dome. He cited it as an example of how the present-day could not only imitate the ancients successfully but surpass them. But he regarded Brunelleschi as a man of the past who had not succeeded in tearing himself away from medievalism—his ground plans were non-classical. By making his own designs classical from start to finish and from top to bottom, Alberti made the break with medievalism complete, and once his book began to circulate, it became rare for Italians building entirely new churches to use the old cross or the east–west axis. The old westwork became a classical façade, opening into a central space, circular, octagonal or polyform. The choir disappeared, and the liturgy centred round a point directly under the dome.

* * *

Architects good, bad and indifferent, innovative and conventional, swarmed over Italy in the fifteenth century, where more money, in relation to gross national product, was spent on grand buildings than at any time before or since. Rome itself may once have enjoyed more, 100 BC–200 AD, but the Italy of these times was a region with many artistic centres, large and small: what Rome had once absorbed virtually alone, the peninsula now divided among a score of major cities and many minor ones. New ideas and tricks were springing up all the time. At the Palazzo Guadagni, Florence (from 1490), Il Cronaca (the nickname for Simone del Pollaiuolo, 1457–1508) introduced what became the popular contrivance of black plaster overlaid with white and cut away to show patterns, the first *sgraffito*. And he put the loggia on the top of the building, with an overhanging roof, a device beloved of Italian hotel-owners to this day. His Palazzo Strozzi in Florence—attributed by some to Michelozzo—became the standard for rich men's houses. Antonio Filarete (*c*.1400–*c*.1469) was the first to insert terra-cotta into his

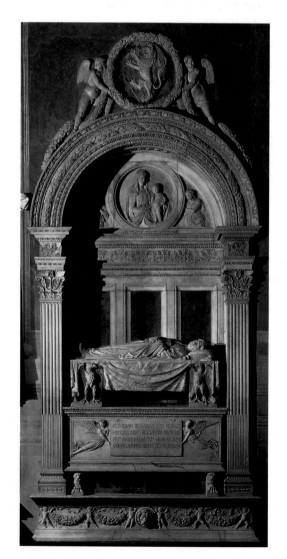

designs, one of the most useful and durable of architectural inventions: see the courtyards of his Milan Hospital, begun in the 1450s. Bernardo Rossellino (*c*.1410–1464) revolutionised the tomb, with the one he did for Leonardo Bruni in Santa Croce, Florence.

All these men were in the top rank in their day. There were also hundreds of journeymen-architects who turned their hands to anything, particularly fortifications for which the demand was huge and growing. And there were one or two heavy-duty wheelhorses of the kind that set standards in every age and culture. An example was Cosimo de' Medici's personal architect, Michelozzo di Bartolommeo (1396–1472). He was, significantly, the son of a tailor who cut clothes for the very rich. He worked first at the mint, on coin design, then with Ghiberti, then under the fierce Donatello. Michelozzo could design and make bronze fittings, marble-and-precious-metal tabernacles, candlesticks and lanterns, church fittings and tombs. When Brunelleschi died, Michelozzo became head of the architectural profession in Florence by taking over the job of Master of the Cathedral Works. In addition, he created many buildings for private clients who liked the way he adapted himself to their ideas. And what is wrong with that?

The tomb of the great humanist Leonardo Bruni (1446–47), in Florence's Santa Croce, is the masterpiece of Bernardo Rossellino. The figure of Bruni is the most exquisite of all funeral effigies.

All artists, not least architects, are usually all the better for a bit of guidance from those who pay. Michelozzo had no theories. He loved the antique, as all Italians did in those days. But a lot of his practise was rebuilding, mending or enlarging existing buildings, so he learned to respect the past. He did not see medieval buildings as the work of Goths or Vandals. They were merely old. He merged them with the new ideas. When he came to build a town hall at Montepulciano he simply reproduced on a smaller scale the façade of the Palazzo Vecchio in Florence. Asked to modernise the beautiful Medici villa at Trebbio, he put in some classical touches but it still, in essentials, looks like a castellated medieval fortress. He built another villa at Cafaggiolo from scratch and included medieval asymmetry and other 'barbarous' details. But villa and garden are pleasurably integrated in a way which would have been impossible with a working fortress. That was something which became characteristic of Italy (and in due course of all Europe) from about 1440 and proved one of the best and most enduring ideas in all architectural history.

Another heavyweight was Donato Bramante (1444–1514), from Urbino, who worked for the great Duke of Montefeltro in his palace of marvels and then pushed on to Milan. He was a painter in those days, a master of *trompe l'oeil* work. Some of his frescoes survive, and an engraving he did of a romantic fantasy of architectural form. He used his *trompe l'oeil* skill in Milan's church of S. Maria presso S. Satiro (1480), where he created, in the choir, an amazing illusion of depth in a part of the building only twelve feet long. He worked from the centre outwards, could do domes and barrel vaults, and in Santa Maria delle Grazie, Milan (1488–99), he invested Alberti's classic heaviness with consummate lightness and delicacy. He did the magnificent cloister of Milan University, before the arrival of French troops (1499) drove him to Rome. There he soon became the artistic *bonne-à-tout-faire* to the much-building Pope Julius II.

Bramante was the first of the big builders, a man who thought in terms of the gigantic legacy of imperial Rome. He went round taking elaborate measurements of ancient buildings or their foundations, not only in Rome but in Naples, and in the pleasure-gardens of Caserta and Tivoli. He expressed his architectural grandeur not in terms of height and thickness but according to the amount of space that could be enclosed. In Vigevano, he demolished an entire quarter and cleared a huge space as a setting for the cathedral—a crucial step in a process which was soon to cover European capital cities with vast squares and oblongs, from the Piazza del Popolo and Piazza Navona in Rome to the Place des Vosges in Paris and St James's Square in London. He rebuilt Pavia Cathedral round a vast octagonal centre, and he developed a type of massive square column which was to become the chief support of the space-enclosure programme in Rome.

Yet, oddly enough, Bramante's masterpiece is tiny. On the exact spot where, it was believed, St Peter was martyred in Rome, he built a circular stone chapel which is known as the Tempietto di Sant'Andrea. It is based on features drawn from a range

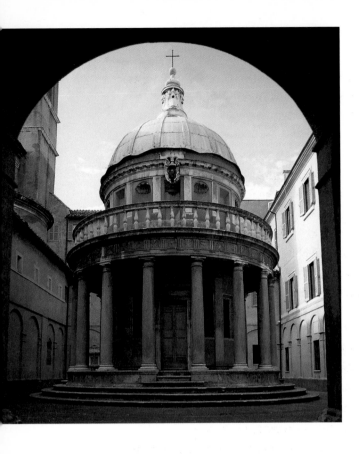

The Tempietto (1502) in Rome, often called the World's Most Beautiful Small Building, is a clever adaptation by Bramante of a pagan temple designed for Christian use.

of Roman temples and follows strictly the Vitruvian rules of proportion. The measurements of the elevations and units are multiples of the diameter of the columns, themselves becoming the nodal norm. The columns are Doric and are the first in the sixteenth century to be equipped with metopes and triglyphs above, in a regular classical way. But it is not a Roman building at all. The outer columns are echoed by the pilasters supporting the inner drum, something which would have completely mystified the Romans. It does not look Roman. It is *sui generis*, or rather it is the epitome, in miniature, of the new style. Though small, it has all the dignity of a building on the largest scale—the architect's ideal of achieving monumentality by minimal means. In short, it comes as close to perfection as any work of those glorious years.

Almost as perfect is the Cortile del Belvedere in the Vatican. To delight the ambitious eyes of Julius II as he peered through his bedroom window as soon as he awoke, Bramante designed some grand terraces. The external vistas are supplemented by internal views which do not so much *trompe* as astound the eye. There is a massive and ingenious spiral ramp or staircase, which takes visitors from bottom to top of the building, sweeping up not so much through space as through architectural history. At the bottom the columns are Etruscan, then they become Doric. Further up they are Ionic, then Composite, and these order-themes are repeated throughout the various floors they introduce. That is characteristic of the intellectual caprice of the new style. An unlettered man, or a woman—then assumed to be ignorant—would not get the point, as they always could with a medieval cathedral, which was organic and therefore in a sense natural: it did not have to be 'explained'. Bramante gave the same treatment to the Palazzo Caprini (1510). The street or ground floor was heavily rusticated, as though it were a fortress, and above it the *piano nobile* is decorated by slender Doric twin columns which framed elegant windows clearly belonging to a palace. So here was Bramante presenting a new trick: two different buildings designed for the space of one, another case of profusion produced by modest means. This particular trick was so good that it was imitated in thousands of formal buildings all over Italy and Europe, becoming one of the most

common architectural clichés of all. In 1517, Raphael bought this superb building as his town house—a sign of the times, and of how high artists were now ascending the ladder of society and wealth.

Who was Raphael? Raffaello Sanzio (1483–1520) was born in Urbino. His astonishing powers as a painter had caused him to be summoned, at the age of twenty-five, to help Julius II with his grandiose schemes. Another such recruit was the great Michelangelo Buonarroti (1475–1564). Raphael was primarily a painter, and Michelangelo was primarily a sculptor. But just as an Italian workshop of those times produced art in almost every medium and for every purpose, so artists of genius were expected to set themselves to any high task their patrons commanded. Thus in the famous parish church off the Piazza del Popolo, we find that both Bramante and Raphael had worked on its wonders. Bramante had created the plain but elegant apse behind the high altar, and Raphael produced a side-chapel, working out its architectural design and its decorative features, and managing a team of craftsmen-artists who carried out his plans. In the vast project which Julius II now laid down, the replacement of old St Peter's by a new basilica on a gigantic scale, Bramante, Raphael and Michelangelo— and scores of other artists, most of them not yet born—were to be involved.

The architectural history of St Peter's, the grandest church in Christendom, is complicated. At the beginning, Julius II's ideas and Bramante's coincided. The old church had to be pulled down completely. Bramante was all the more confident because his work on Pavia Cathedral and Santa Maria delle Grazie in Milan had indicated the way to solve the problems of building St Peter's. The only difference was size. Bramante grasped that while size may not be the most important element in architecture in general, it is paramount in buildings intended to inspire awe. Hence size was the salient feature of Bramante's original plan. It was later modified by numerous people. But the characteristic which Bramante imposed from the beginning—sheer size, inside and out—retained its paramountcy. Once you are within the visual orbit of Rome, you cannot escape it. Ten miles away, it dominates the city's skyline. Within the city, you grasp its immensity from the way it dwarfs its largest neighbours and demonstrates, with brilliant clarity, the principles of aerial perspective. From within, as Turner's beautiful watercolour and Panini's sumptuous oils make plain, it is a church for giants. It is the crowned monarch of ecclesiastical architecture. There is nothing like it anywhere, and size is the key to its singularity.

But it was built not so much by popes and architects as by time. There is a rule about great cathedrals. Man proposes but the Ancient of Days disposes. A truly magnificent church seems to have a vigorous life of its own, and at times the architects connected with it are little more than flies buzzing round the site. It has to be remembered that work on the St Peter's site had begun back in 1452. The foundations then laid, by Bernardo Rossellino, had a permanent effect on the structures later erected on

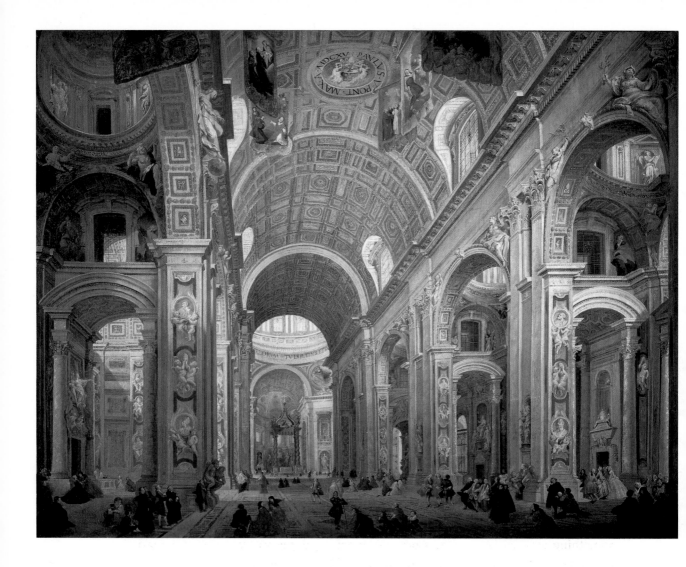

Interior of St Peter's, Rome, the sumptuous heart of Catholicism, cannot be captured by photographs. It requires a great artist like Panini (*c*.1727).

them. Like that persistent thing, a palimpsest, they peered through for centuries, as they still do today. In the half-century before Bramante got to work, other people had taken a hand. Bramante's first plan (1506), a beautiful drawing in orange wash and brown ink, has survived: a centralised, square church, with four subsidiary domes as well as a main one. He had a pushy assistant, Giuliano da Sangallo, who ventured to criticise this design. So Bramante scrapped it, and produced an oblong shape. Then Julius II died. The new pope, Leo X, was a Medici, who had all kinds of ideas about art. The central piers were reduced in size. Building went ahead and the piers were complete when Bramante himself died in 1514. Sangallo and the other assistant, Fra Giocondo, then scrambled themselves into office. But Raphael was put in overall charge. He reverted mostly to Bramante's original plan but added his own ideas. Then he too died in 1520. Sangallo produced a new scheme, which survives as a wooden model. But all building stopped when Rome was occupied by the Emperor Charles V in 1527, and sacked. Lack of cash, and a general weariness, became the problem. Sangallo then died

(1546) and was replaced by the seventy-year-old Michelangelo, who was told to get on with it. His response was to pull down portions completed under Raphael and Sangallo, and to revert to Bramante. The awesome interior, then, is Bramante's idea, but the actual work is of Michelangelo, building on it.

There were two other key features to be considered: the dome and the façade. Michelangelo had been brought up to revere Brunelleschi's dome in Florence, and all his various plans were essentially inspired by it. His final plan is more monumental, and a more complicated piece of engineering. It has a series of huge articulated curved buttresses, which give it stability by each descending into twin columns outside the drum. These give the dome its character and make it such a pleasure to draw or paint because they create shadows. But when Michelangelo in turn died in 1564, no work had yet been done on the dome, though his drum was complete. The pope was now Pius IV. He engaged two architects, Pirro Ligorio and Jacopo Vignola. He told them to carry out Michelangelo's plan without change or argument. Pirro slyly disobeyed, and started his own modifications on the attics inside the dome. He was detected and sacked. Vignola also disobeyed, and reintroduced the idea of subsidiary domes which Bramante had scrapped sixty years before. Then he went, and his successor, Giacomo della Porta, an energetic and forceful man, compromised by reducing the minor domes to two, and building them—they are there today.

Della Porta demolished Bramante's partly built choir and other bits he did not like. He decided to vault Michelangelo's dome, and he increased its rake, so that the outer shell, which we see today, is much steeper than Michelangelo's broad hat, and 30 feet higher. By this time, architecture and engineering were bifurcating, and Della Porta had to employ a stress expert, Domenico Fontana, to supervise the engineering, something alien to his predecessors. However, the dome was put up (1593) and has stayed up and given no trouble, so here is a lesson for present-day architects who think they can do it all themselves. What matters in architecture is what is actually put up and stays up. Della Porta's dome-silhouette was quite different to Michelangelo's. But it has been there for over four centuries, has become a familiar image, and therefore looks right, indeed inevitable. Michelangelo's dome, by contrast, looks peculiar because it is unfamiliar to us. So it is Della Porta's dome shape which was imitated throughout the world. Though not a great architect, he became a notably influential one.

Thus the new cathedral took over two centuries to build even in just its main structure. It was the work of a dozen chief architects, and scores of minor ones, under thirty-two popes, some of whom interfered directly, adding positive ideas or imposing vetoes. If one uses the categories of academic taxonomy, it is fifteenth-century Renaissance, High Renaissance, Baroque and Rococo. But of course it is all and none of these. Such terms are unhelpful when we are dealing with real stone and lead, plaster and paint and timber. This wonderful building, while bearing the marks, under close examination, of its long evolution and numerous progenitors,

is *sui generis*. Yet, as with its dome, it looks right because we are used to it, and the endless disputes, changes of plan and demolitions might never have been. Medieval architecture was organic. New St Peter's, because it was so big and difficult to build, turned out to be organic too. It illustrates the problem of writing architectural history, indeed of being an architect. He can never be in quite the same control of his work as a painter is, or a sculptor. So who built St Peter's? The answer is that God and time built St Peter's. In so far as any one man built it, that man was Bramante.

Nature did not make Michelangelo an architect at all, certainly not a classical one. He had no interest in rules or mathematics. I doubt if he read Vitruvius, or Alberti's treatise. He was a sculptor by instinct and training, and he saw architecture as essentially a setting for sculpture. He did not come to building to learn, but to teach. He worked, first, upon the Hadrian-tomb-turned-fortress, and it was his idea to put an angel on the top, thus making it the Castel Sant'Angelo. The next work he did in Rome was to provide a setting, on the Capitoline Hill, for the famous antique equestrian statue of Marcus Aurelius, which Pope Paul III wanted to move there. Michelangelo could think on any scale, small or large, but he tended to plan on his feet, as it were, moving from one stage to another empirically, depending on his visual appreciation of what he had done. In fact, all Paul III originally asked him to do was to design a new base for the statue. Michelangelo did this, and a fine base it is too. He liked it so much that he felt the setting was inadequate. So he designed and laid a decorative surrounding pavement. He liked the so-called Senator's Palace at the top of the hill, so he designed a monumental staircase to link the pavement to the Senate. That made it necessary to have flanking buildings, so he produced a scheme for those too. Then he thought the Senate looked wrong. So what was eventually produced included a redesign of the Senate, completed by Girolamo Rainaldi, many years after Michelangelo's death. In short, here was one of the grandest squares in the world—the Piazza del Campidoglio as we know it—which came into being organically, as it were, at the whim of a master of *bricolage*. How shocked Alberti would have been! But the master masons of the great northern cathedrals would have seen the point of it, for that was the way they tended to work also. Wherein lay an irony, for none of the Italian masters of the new art detested the Gothic, or anything which came from Germany, more than Michelangelo did.

In the meantime, Michelangelo had been working on the Medici church of San Lorenzo in Florence. He first designed for it a new sacristy, which is really a depository of tombs of the Medici grandees. This suited the great man, who was a tomb designer turned architect. He had a wonderful eye for detail, and was always noting little bits of antiquity which could be turned into beautiful and useful ideas. He thus enlarged the vernacular still further, making it up as he went along. Nothing like it had been done before, even by himself, and his contemporaries found it disconcerting. Vasari criticised him severely for ignoring the rules. Michelangelo's devices

are wonderful in themselves, but in the sacristy they tend to overwhelm the whole, which is not a unified building—more like, say, bits of Seville Cathedral. On the other hand, when Michelangelo turned his attention to creating a library, attached to the church, and its vestibule (1524–62), what he taught himself in the sacristy was useful.

The Laurentian Library and its approach is notable not least for its pure colours, which reflect a fastidious taste in the choice of materials and the ways in which they are put together. There is a cool purity and a highly disciplined richness in the blends of marble, slate, stone, plaster and wood which makes everything look inevitable. Yet it is in fact highly inventive. The master turned architecture outside in: he used the structural features usually found on the outside of a building as decorative features for the interior. Windows, oblong or square, become blind recesses or tabernacles. Entrances become doors or mere punctuations in blank walls. Pillars or pilasters, instead of supporting the roof, frame the non-windows. The ceiling reflects the decorative non-functionalism of the walls rather than indicates how it hangs there and what architectural machinery it conceals. These ingenious inventions catch and delight the eye. It is all classical, of course. But it is the classical world reinvented by Michelangelo, and put to strange tasks. We cannot help feeling he was following the same route—unconsciously of course—as the old medieval stonemasons, who turned functional forms into wildly exuberant ornaments.

The staircase of the Laurentian Library in Florence (*c.*1524) is Michelangelo's masterpiece of interior design, brilliantly combining marbles of different colour and radiance.

The visitor ascends from the cloister of the church into the library by a vestibule staircase. This leaps still further from use into fancy. The complexities of the three-pronged staircase serve no purpose other than to delight, the columns are of superb marble but they support nothing, and the windows let in no light, being merely decorative. Asked to explain why the staircase trifurcated, Michelangelo coolly replied that the servants would line the outer steps on each side while their masters went up or down the middle. But this was not a reason. It was an excuse for making something enchanting. Colour, form, detail—all is hugely satisfying. There is a crispness about the marble which reveals the master of the chisel. It is fundamentally simple, which allows you the rational pleasure of taking it in as a whole before settling down to the sensual delight of examining the details. No work I have ever examined demonstrates more clearly the difference between great architecture and routine competence. But it also illustrates the sheer dynamism of the new art. It had already put Greece and Rome far behind it and was hurrying into an unknown future. This staircase hall is the distant ancestor, for instance, by direct descent, of the vast Treppenhaus in the Bishop's Palace at Würzburg, which Tiepolo turned into the largest painting on earth.

Michelangelo was a man who, by instinct, saw buildings in sculptural detail, as much as in outline. If he often left things unfinished, as we shall see again in examining his sculpture, he never stopped work either, and drove himself relentlessly until he was in his eighties, an immense age at that time. All the while he was producing new ideas, which shine out like bright points of light in his buildings. Rather like Shakespeare, he gathered everything into his language of building: coats of arms and crenellations from the Middle Ages, egg-and-dart, dentils and acanthus leaves from antiquity, triglyphs too, and all the orders for columns and pilasters, lions' heads and grinning masks, swags galore. He used Doric, Ionic and Corinthian capitals, and composite ones of his own invention, as internal decorative features. He experimented with receding and overlapping planes. He used broken pediments, or closed ones supported by sphinxes. His was a restless talent which proceeded through disorder to a new order of his own. Thus he used his characteristic device of inversion to turn façades into profiles, and made up a façade out of a side-view. His fertility of invention was such that he could have built and decorated a medieval cathedral single-handed. But it would never have been finished. All these crowds of inventive details swirled away into history to become the clichés of professional mediocrities for centuries. But they were also used, by a few men of genius in the seventeenth and eighteenth centuries, to create marvels. Indeed, Michelangelo's rich legacy is permanent, and we are still rummaging around in it today to pluck out ideas.

It is sad that Michelangelo never worked in Venice, for the city shared his exuberance, inventiveness and passion for detail. It was the only big city in Italy which embraced the medieval architecture of the north. But it was likewise the only one to import ideas and forms from Byzantium and the Orient. The medley that resulted

was compounded by the fact that Venice was built on islets reinforced by wooden and stone piles. It could not take a castle or sustain the heavy masonry of rustication we find all over Florence. Its buildings were of brick, as on the Baltic, but sheathed in marble. Few were further than a dozen feet from water, which cast up reflections under strong sunlight and illuminated all the details and colours. So Venice was a city where hue and décor were salient, and they helped to shape its delicate forms. Space was expensive, palaces were small, balconies jutted out to make houses seem larger and were a treasured part of life. There was only one big square but a number of tiny ones, hundreds of small bridges, miles of quayside. All was crowded together, nothing could be seen in isolation, and the architect therefore had to see himself as adding to a picture which was already at least three-quarters done. It was unusual to tear down an entire building to start afresh, let alone an entire quarter.

Despite or perhaps because of the Fall of Constantinople, Venice was richer than ever in the period beginning 1450. It was content with its medieval styles and the new art came late. Indeed, some passionate lovers of Venice, such as John Ruskin, always contended that what came after the fifteenth century was an abomination. But it did come, and some of the finest churches and palaces were built in the years after 1470 by Pietro Lombardo (c.1435–1515) and his family, and Mauro Codussi (c.1440–1504). Lombardo built the Scuola Grande di San Marco and the beautiful little church of Santa Maria dei Miracoli, while Codussi was responsible for Santa Maria Formosa and San Michele in Isola. The Palazzo Loredan, the Palazzo Corner-Spinelli and many other grand houses were their work.

Much of the visual furniture of Venice we now enjoy was also the work of two men, one a gifted wheel-horse, the other a genius. Jacopo Sansovino (1486–1570) was a Florentine sculptor who married into the Sangallo family of architects, and joined the trade. Forced to flee from Rome by the sack of 1527, he came to Venice and was eventually made city architect. He set about reconstructing the entire San Marco area, which was then a medieval clutter. He built the Mint or Zecca, the Loggetta at the bottom of the campanile, he completed the great Piazza and he cleared the Piazzetta. On the new space he built the superb library, the Libreria Marciana, which faces the Doge's Palace. In 1537, Sebastiano Serlio published a work of architectural theory, Venice's contribution to the science, and its influence on Sansovino is demonstrated in his Palazzo Dolfin (1538), one of the city's grandest palaces. By this date Venice had plenty of fine architects. Michele Sanmicheli built two more magnificent palaces, the Veronese Palazzo Grimani and the Palazzo Corner at San Polo. Antonio Scarpagnino built a third, the Palazzo dei Dieci Savi, and also the most remarkable of the warehouses, the Fondaco dei Tedeschi, and the best of the scuole, the Scuola di San Rocco. He was also responsible for the Fabbriche Vecchie. A new bridge was required over the Grand Canal at the Rialto, and the contract for this was won by Antonio da Ponte (1588), against competition not only from Sansovino but from the one true genius of Venetian architecture, Andrea Palladio (1508–1580).

This wild and attractive man came from Padua, where he was put to work as a boy chipping stones. According to his first biographer, Paolo Gualdo, he had a gift for friendship and was 'an extremely social man'. He broke his articles and fled to Vicenza, where he worked as a decorator in rich men's houses and got to know his patrons. He met poets and scholars, who taught him about the new learning and all its artistic implications. Giangiorgio Trissino, a poet, called him 'Palladio' after the angel in the epic he was writing, and the name stuck. He met the writer Alvise Cornaro, whose palace in Padua had a classical odeon and a loggia designed by Giovanni Maria Falconetto, built in 1524–30 and one of the earliest examples of the new art in that part of Italy. He was taken to Rome (1541) by Trissino to study the antique, and also to inspect what was then being built there—a fine array—and he later returned to Rome four times. He helped to translate Vitruvius into Italian, providing delicate illustrations. He was, in fact, an inspired draughtsman, and his drawings are crucial to his work.

Palladio had two virtues of immense importance, the one visual, the other practical. He loved drama. He believed in settings. So he placed his buildings in their surroundings in his mind's eye, and with the help of sketches, before he set to work actually designing them. They all have a strong spatial and geographical context. As opposed to Michelangelo, who pictured a carving or a detail, and expanded the building outwards, he saw a landscape or a townscape, and got to the building by an inwards progression. His skill in drawing and watercolour washes led him to see the scene as a whole, and then paint the building in.

Palladio's work on the island of San Giorgio Maggiore, across the basin from St Mark's, transformed the visual skyline of Venice permanently, and helped to make it the city of magic we love. First he was asked by the monastery there to build them a refectory. He did so, and made it simple, severe and even monumental (1560). The monks liked it so much that they asked him to rebuild their church. He must have visualised his design when looking at the site from the Piazzetta, across the water. That was the right way to do it, for the transaquine view is the one most Venetians, and all visitors, see first. It is the key view. Thanks to Palladio, it is magnificent, one of the greatest views in all art: dramatic, elegant, almost ethereal, and changing constantly depending on the season and the weather, a view calculated to excite a Canaletto or a Turner. That is the effect Palladio sought to create.

Palladio's other great Venetian church, the Redentore, is more carefully designed for use, and has been and is used with great success. He was told to produce a votive church, where rich and poor could give grateful thanks for mercies received, often processing there in the grand manner in flotillas of gondolas. The water façade, from which it is entered, is a brilliantly conceived display of the classical orders, which ascends in a series of flattened triangles to the summit of the delightful whorl-supported cupola with its flanking towers and spires. This, and other key points, are surmounted by statues. So here is another of the great sights of Venice, with the

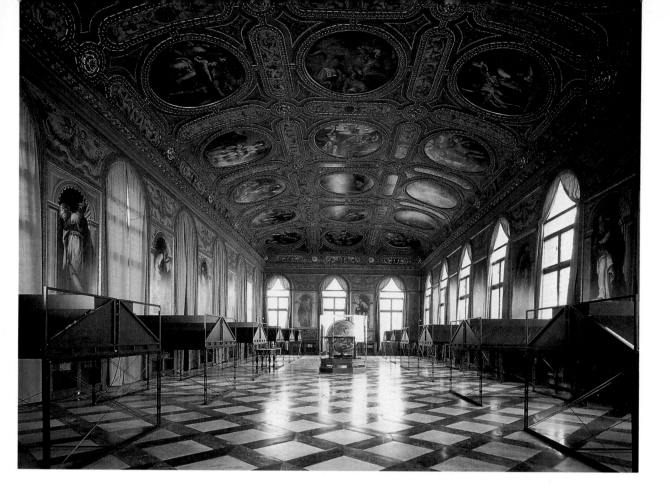

dome and spires crouching behind and constantly changing their relationship to the front as you approach and pass it by gondola.

Palladio certainly enjoyed creating theatrical effects and glittering townscapes, and he could sometimes be quite ruthless in achieving them at the expense of function. But his second great quality, surprisingly, was a love of utility. He was a practical architect. He may not always have built churches to be prayed in, but he worked mainly on houses and he certainly designed them, for all their beauty, to be lived in. He published his principles in 1570. It is called *I Quattro Libri dell'Architettura*. These four books deal with general principles and technology, private houses, public secular buildings and antique temples. He was chiefly interested in villas, the ancient form of country house created by the Romans. We have seen that it had been resurrected in Tuscany as a kind of demilitarised castle, integrated with the garden. Palladio's conception of the villa was much closer to the Roman model in some ways. First, it was the centre of an agricultural estate, not just a pleasure-dome. He insisted that it ought to be placed near the middle of the land so that the owner could supervise the farming operations properly. Second, though it was essential to make it beautiful and imposing, the practical needs of the farm must be met in the structure.

With these principles in mind, Palladio built the most delightful and varied set of country houses in existence. No two are alike. Each is a self-contained world of utilitarian fancy. The Villa Godi-Malinverni near Vicenza, the Villa Rotonda at Vicenza,

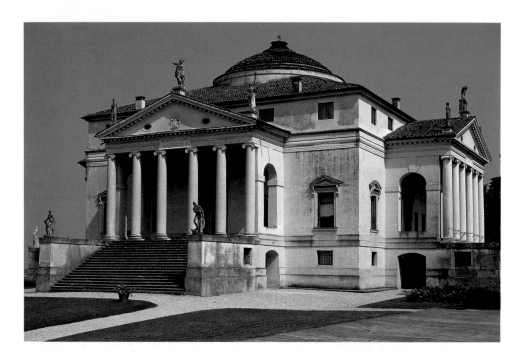

The Villa Rotonda in Vicenza by Palladio was built in 1550 as a summer residence and working farm for a grandee art-lover who also counted his *scudi*.

and the Villa Cornaro near Treviso are each quite different. And each is easy to live in. The most famous of them, the Rotonda, with its imposing Ionic façades on each side of a domed square block, looks like mere display. In fact it works well as a building. Palladio was surprisingly expert at making the best of climate and setting, at using sun and shade, at selecting materials for use as well as beauty. He sought to impress from outside, and to offer service and comfort within. His villas radiated economy and order as well as utility. He made his façades wonderfully varied; he was a genius at sighting angles; he made it possible for the house to melt into its surrounding gardens and plantations, to produce the maximum delight in vistas and walks.

In due course these buildings, together with what Palladio wrote about the subject, became known all over Europe, and were adapted to different climates and latitudes by careful imitation and variation. Thus the Palladian style was born and spread all over the Western world, and even went so far as India. He was the only one of the architects in the new manner to give his name to a particular style that has lasted and still delights. He was effectively the last of what we call the Renaissance architects, that is designers of buildings who were inspired by a love and knowledge of the antique, especially the Roman past, who sought to re-create its best features and, in the process, produced something new and marvellous suited to the sunny cities and countryside of Italy in the fifteenth and sixteenth centuries. It is a testimony to their varied talents, amounting to genius in some cases, that the architectural language they created is still spoken in the twenty-first century. But of course one of the reasons their buildings succeeded was that they were intimately united, within and without, with an astonishing array of fine sculpture, another triumphant aspect of the times, to which we now turn.

11

THE APOTHEOSIS
OF THE STATUE

The story of sculpture in Italy towards the end of the Middle Ages has a quite different dynamic to that in northern Europe. Remains of Roman splendour existed north of the Alps but they were few and mostly inconspicuous. Few working sculptors in France and Germany were aware of them except by hearsay. But in Italy the crumbling relics of Rome, in the thirteenth and fourteenth centuries, were everywhere. The quantity of Roman masonry above the ground was at least twenty times what is now left; perhaps a hundred times. And a stonemason or a worker in a goldsmith's shop who developed a taste for the antique could rummage among the debris and find remarkable things. All Italian artists lived on an enormous ruin of the past, and the past meant far more to them than it did to the rest of Europe because it was peculiarly their past, their glory. The Italian rebirth, then, was a form of nationalism as well as an aesthetic endeavour.

Having said this, it also remains true that Italian sculptors, like those north of the Alps, were moving relentlessly in the same direction: the discovery and representation of the individual human being, with truth and dignity. It was a move away from mere human symbols and archetypes towards actual flesh-and-blood men and women. For the Christian faith taught that humans were not types. Each had an immortal soul, and the carvers began to look for it in the faces and bodies they saw. But whereas the northern sculptor had no theory and worked by instinct—and his instinct for realism, as we have seen, was overwhelmingly strong—the Italian sculptors were beginning to learn about humanism, the knowledge from the past which directed fierce attention on the human body and psyche, created in God's image and the potential master of the universe and all it contained. The human being was all-important and sacrosanct, and to portray him accurately and vividly was a God-like act, worthy of the utmost pains and the highest genius.

There was, thus, ideology in the air in the rising Italian cities, especially Florence, where there lived more skilled artisans, and more enlightened patrons, than anywhere else. But Florence was not alone, even in the thirteenth century. There were Siena and

Pisa, Bologna and Perugia, and other towns with a market for art. Nicola Pisano (*c*.1220–1284), the first great artist in the new style, was a stranger, born in distant Apulia in the heel of Italy, but he spent most of his working life in the central Italian towns I have listed. We have seen already that, even in the Dark Ages, let alone the early Middle Ages, clever, educated men, and gifted artists, were always striving to re-create the glories of the antique past—the whole of those centuries was a conscious if sporadic rebirth of antiquity. In Nicola's case, the roots of his personal contribution to this process went deep. He was a product of the proto-Renaissance represented by the glittering but precarious court culture of the Holy Roman Emperor Frederick II, known as *stupor mundi* or 'wonder of the world'. Why did he astonish? Because, though a German, he lived in the south of Italy, built castles there which were palaces too, patronised artists and skilled craftsmen of all kinds, welcomed ideas and imported technology from the Orient; on top of all this, he studied classical forms and sought to revive them in the art he patronised. Nicola was clearly trained in one of the emperor's southern workshops and he brought to Tuscany something new. This was not merely the acute desire to render the human form accurately—that was already beginning to be present—but distinct notions of how to do so.

Nicola Pisano was by any chronological criterion a medieval artist. His first recorded work, the pulpit in the Pisa Baptistry (1260), was carved two years after the Sainte-Chapelle in Paris was finished and work was just beginning on the cloisters of Westminster Abbey and Cologne Cathedral. He was a contemporary of the master carver who produced the astonishing statues of the founders at Naumburg Cathedral. The Naumburg man was a greater artist in that his figures are virtually free-standing and life-size, where Nicola was working on a low-relief of smallish figures, albeit a deeply carved one. On the other hand, the scenes Nicola depicted, of which the *Adoration of the Magi* is the most sophisticated, involved a skilful organisation of space and the ability to create a complex design. There was a further difference of great significance. The Naumburg sculptor was working from the life. Nicola may have used models too but his inspiration was the antique. He worked from a Roman sarcophagus in the cemetery at Pisa, which depicted the legend of Hippolytus. For his pulpit scenes, he cleverly transformed a nude Hercules into a personification of Christian Fortitude, a Phaedra into the Virgin Mary in the manger, and Dionysus into Simeon at the presentation of Christ. All the same, his figures from the New Testament are real—human beings who express care, anxiety, joy and sorrow. He incorporates much that could be learned from French sculpture earlier in the thirteenth century. How he was aware of it we know not—but his figures are living, a whole art epoch away from the elongated saints and angels of the Chartres portico, which, beautiful though they are, seem inanimate archetypes by comparison. Five years later, Nicola carved the pulpit of Siena Cathedral (1265–68), including a striking *Last Judgement*. There is much medieval devilry and torturing going on here, but he has captured the humanity which was the strength of classical Greece.

By this time Pisano had built up a large workshop, and after his death (*c.*1284) his son Giovanni carried on his work, improving all the time on Nicola's foundations. He carved real statues, many of them free-standing, and these are actual people too. Now in the Cathedral Museum, they once swarmed over the façade of the west front. They are energetic and lively but they did not make this a sculpture gallery like that of Rheims Cathedral. It was, rather, a strong wind from the sunny south, with whispers of Attic Greece. Pisano's work culminated in three statues done for the Arena Chapel in Padua, or *Madonna with the Child and Two Angels*, the first distinct masterpiece in the new style (1305). These figures might almost have sprung from the Acropolis.

We come now to an important technical point. The art of bronze-casting had never been lost. It had been used on a big scale for the creation of bells, some of them of vast size and requiring extensive skills in metallurgy to produce pure and distinctive tones. But the lost-wax technique for creating hollow statues of bronze had fallen into disuse in the West. In the fourteenth century, craftsmen foraging among the debris of Roman ruins came across pieces of cast bronze and admired them. How to do it themselves? In 1329, Andrea Pisano (*c.*1295–1348/9), no relation to Nicola but a sculptor too, got a commission from the Florence fathers to make a pair

Madonna with the Child and Two Angels (*c.*1305) in the Arena Chapel, Padua, is a masterwork by Giovanni Pisano, re-creating the free-standing figure as an element in Western art.

of bronze doors for the cathedral baptistry. He performed this commission admirably: twenty-eight reliefs in all, made up of twenty scenes from the life of the Baptist, and eight Virtues. But all were modelled in wax, and sent to a bell-foundry in Venice to be cast. Being a goldsmith by training, as was virtually every artist in Florence at this time and for long after, he did not have the skill to work in heavy metal but stuck to carving in marble, in which he made some admirable free-standing figures, notably a *Madonna* in Santa Maria Novella, Florence, and the splendid *Virgin* in SS Giovanni e Paolo, Venice. But slowly the artistic workmen of Florence and other big commercial towns learned to cast bronze for themselves.

By the end of the fourteenth century, an artist-craftsman trained in a busy workshop, especially in Florence, by now the richest and most art conscious of the major Italian towns, was expected to become proficient in working almost every kind of stone, from limestone and Carrara marble to semi-precious and precious stones. He also had to deal with most heated metals, from gold to copper alloys such as bronze, which had a mixture of tin. The traditional skills of goldsmiths were absorbed by the sculptors, and their facility in designing was taken up by the painters. The rich in Florence and elsewhere liked to flaunt their wealth. They probably spent much more on jewellery than on art, and they expected the painters they employed to record in exact and realistic detail the jewellery worn by their sitters, male and female. We can learn a lot about the jewellery of the time from the portraits that have survived, while the jewels themselves have in almost every case been broken up, melted down and so lost. If a jeweller's apprentice was really good at design, he tended to move on to painting, where his skill in depicting jewellery was as essential as the ability to get a good likeness. There was also a close connection between jewellery and bronze-casting. Bronze doors, with superb panels depicting scenes from the Old and New Testaments, were the jewels of the Church.

Hence the Florentine fathers decided to spend a great deal of money giving their cathedral and its baptistry a set of jewels in the shape of bronze doors with finely worked panels—a picture gallery of the faith which would last a thousand years or more. As with major architectural undertakings, the fathers took the financial arrangements seriously. Drawing up and signing a contract was a solemn business. The contract which Nicola Pisano signed for the pulpit of Siena Cathedral has survived, dated 29 September 1265. It set down in binding detail exactly what he undertook to do, what materials he was to use, and how much time he guaranteed to spend on the site. Such a contract involved much risk on the artist's part. On the other hand, it plucked him out from the mass of anonymous craftsmen and selected him for fame. Contracted sculptors began to sign their work, self-consciously. When Andrea Pisano got the contract to do the Florence Baptistry doors, and finished them in triumph, he signed them ANDREAS UGOLINO NINI DE PESIS ME FECIT. Just as the individual figure was emerging in the works, so the artist was emerging as an individual too.

Again, the contractual system, as in architecture, produced open competitions

for important sculptural projects. At the end of the fourteenth century, Florence was at peace, money was flowing in, and the city fathers decided to commission a second set of baptistry doors. Taking Andrea Pisano's as a standard of excellence, they announced a competition for a new set in 1401. Historians have often cited this event as the real start of the rebirth of art in Florence. It was of course nothing of the sort. The process was already under way. But it was certainly a notable occasion. The thirty-four judges included cathedral officials and grandees not only from the city but from the surrounding countryside, which helped to raise the funds. The contest was advertised all over the peninsula and masters and young high-fliers arrived from all its parts. The judges narrowed the field down to seven, which included three of the greatest artists of the time: the future master of architecture, Brunelleschi, Jacopo della Quercia (1374–1438) and Lorenzo Ghiberti (1378–1455).

Everyone on the short-list was given four sheets of bronze and told to submit a design. The subject: 'The Sacrifice of Isaac'. The two by Brunelleschi and Ghiberti have survived. It was not easy to decide between them. Indeed, the judges took two years. This is not surprising. The project was huge and the cost staggering. It eventually amounted to 22,000 florins, equal to the entire Florentine defence budget (a good indication of the importance of art in early-fifteenth-century Italy). They eventually picked Ghiberti, not so much on artistic merit as on character. They felt he was more likely to carry through a vast and difficult job to its conclusion. They were right. Ghiberti himself boasts in his autobiography that he always put art before 'the quest after lucre'. This is not really boasting but the simple truth. He was not the greatest of artists. But in the entire history of art it is impossible to find a more conscientious one. He took his duties with the highest possible seriousness. He was a perfectionist. No one like him exists today, or could exist. He seems to us a slow worker. But the standards of craftsmanship then insisted on were something today's artists would find impossible to meet. Ghiberti had been accustomed to spending a year, if necessary two, on a single piece of jewellery. To create a large marble statue, he regarded three years as normal.

In 1403, when he started on the bronze doors, Ghiberti was still a young man. He completed the original contract twenty years later. He was then given a commission to create a third set of doors, which an admiring Michelangelo later christened *The Gates of Paradise*. Ghiberti finished them in 1453, a few years before his death. Thus he spent virtually his entire working life, over half a century, on the Florentine doors. Ghiberti had many gifted assistants, of course. To work in his shop was not only an outstanding apprenticeship but an honour. His young men included names which were a roll-call of genius: Benozzo Gozzoli (c.1420–1497), Paolo Uccello (1397–1475), Antonio del Pollaiuolo (c.1432–1498), perhaps Luca della Robbia (c.1399–1482) and, above all, Donatello (1386–1466).

In this historic creative workshop of the new art, it was Donatello who absorbed Ghiberti's teaching most productively, and built on his achievements most confidently. Donatello's life and and work are not only fascinating in themselves, they also

Ghiberti spent fifty years working on two sets of bronze doors for the baptistry of Florence Cathedral, of which 'The Gate of Paradise' (c.1425) is one of the panels.

tell us much about the nature of what happened to art in Italy during this wonderful period. Of all the artists of fifteenth- and sixteenth-century Italy, Donato di Niccolo di Betto Bardi, born in Florence in 1386 just as it was coming into its full glory, and dying there eighty years later, came closest to pure genius. During this time he effected a psychological revolution among the men of the chisel and the brush. Before him, artists were uneasily conscious of definite limits to what could or ought to be done in art. Donatello was so consistently and shockingly original that, after him, all the limits seem to have melted away, and an artist was constrained only by his powers.

In the years 1404–1407, when he worked as Ghiberti's apprentice, his well-read, socially-at-ease and kindly master, recognising his pupil's astonishing talents, tried to get him to broaden his education. But Donatello, the son of a humble wood-carver, was interested in nothing but the skills of his trade, or trades. He could do anything with his hands. He read only to improve his manual capacity. He had no

social pretensions, no aesthetic pride, no swagger. Like the craftsman he was, he spoke and lived in a rough way. When given fine clothes by a patron who wanted him to 'better' himself, he wore them once, then put them aside. He never made much money, and in his old age he lived on a pension from Cosimo de' Medici, who worshipped him. The fact that, in his time, artists began to move in the best society, and were becoming important individuals, famous men, did not interest him. To that extent, one of the central facts of the new art—the ascension of the artist to celebrity—did not affect him at all.

The truth is, Donatello did not think he was the equal of a Medici prince. He saw himself in a different world altogether. A prince was called by God to rule over foolish men and women. An artist was called by God to make beautiful and precious things, to God's praise and the world's edification. Let Cosimo rule and Donatello create, each in his ordained sphere. He possessed artistic integrity to an unusual degree. He was unbiddable. His sense of humour as a craftsman-artist was overwhelming. He would do what he knew to be right, at his own pace, in his own way. Princes and cardinals did not impress him when art was the subject. Plebeian he was, but in artistic matters he spoke to them with authority. His patrons, to their credit, respected him. What others might call insolence they recognised as the eccentricities of genius. Great and rich men, in those enlightened days, were willing to bow the proud knee to artists who knew their minds and their worth. That was why so many marvellous things were produced. Donatello led the way in educating the élite to a true spirit of co-operation with artists. By a strange paradox, he—the obstinate plebeian—played a historic role in raising the social status of the creator of beauty from craftsman to artist. First in Florence, soon in all Italy, the artist was a personality, who commanded not just respect but attention, reverence, admiration and honour.

Yet Donatello remained a craftsman as well as a *maestro*. He ran a studio, had assistants when need, but essentially he liked to do things himself. He hated furnaces, and working close to hot metal, except when unavoidable. Otherwise he was omniscient. He could work in clay, in marble and every kind of stone from the softest sandstone to the hardest granite. He loved to use glass, and wood was his first skill. He liked stucco too, and wax. His skill in hand-finishing bronze was as great as his master's. He liked to paint and to gild. He had a habit of sucking in whatever materials seemed to fit his artistic purposes without any consideration for the rules of the trades. He raised it to the level of a technique. Half a millennium later the French gave it a name: *bricolage*. Thus, to make the *Madonna dei Cordai*, now in the Museo Bardini, Florence, he improvised in a way that had never been done before. He carved the Virgin and her Child out of pieces of wood, fitted them together like a jigsaw, covered the result in setting material, put it on a flat background over which he put a mosaic of gilt leather, then painted everything, with a final layer of varnish to give it unity of tone. This was an outrage. It scandalised fellow creators brought up in a tradition of strict demarcation lines between guilds and techniques and

materials. But they had to admit the result was admirable. It worked. That was the key to Donatello's technology. He sought for effects that worked. Another example: he embarked on a carefully planned and deliberate extension of the existing techniques of low-relief carving. His new method, *rilievo schiacciato*, is not far from drawing. This worked too, as any visitor to the Victoria and Albert Museum in London confronted by his *Christ Giving the Keys to Saint Peter* can see. Thus, though slow and ultra-conscientious when required, few artists moved more confidently among their materials, or invented more daringly, than Donatello.

Is daring the right word? He was a risk-taker. He was always doing things which had not been done before. He completed the revolution which, as we have seen, began in the thirteenth century, of moving away from the collective presentation of human beings, first by portraying them as individuals in high relief of bronze or stone, then pulling them right out of the background and making them standing statues. Once and for all, Donatello put humans on their own feet, as they had stood in ancient times, not in rows, like the founders of Naumburg, or the Pisano group, but as separate entities, alone. This involved a good deal of technical innovation. He found ingenious ways to prevent statues falling over. Almost instinctively, he applied scientific principles to visual presentation.

Here are some of the ways in which Donatello changed sculpture. His earliest masterpiece, done in 1410 for the great western façade of Florence Cathedral, is a rendering of *St John the Evangelist* (original in the Duomo Museum). He worked it with deliberately distorted proportions so that, seen directly as in photos, it looks unstable and over-elongated, but when you get underneath it, to the position from which he designed it to be seen, it looks overwhelmingly solid and powerful. No one had done this so convincingly before and it became one of the greatest tricks of the trade. Next, he made use of ancient patterns to give weight and authority to his statues. An early example (1411–13) is his marble *St Mark* in the Drapers' niche

Trained in Ghiberti's workshop, Donatello emerged to create *St Mark* (1411–13), first of a revolutionary series of standing figures he made for Orsanmichele and Florence Cathedral.

in Orsanmichele, Florence, a truly 'modern' figure compared to Ghiberti's work, which still looks medieval. Third, and perhaps more important: he made a statue live. As Vasari noted, the humanity of *St George*, carved for the Guild of Armourers' niche in Orsanmichele (it is now in the Bargello) seems to come through the armour. His face and hands are alive.

There were times, indeed, when Donatello did things with bronze which have never been attempted, before or since. Take his bronze of David, which he created to stand in the court of the Medici Palace, but is now in Florence's Bargello. The sculptor had recently been in Rome, and he was full of antique spirit. But there is nothing in antiquity remotely like this exquisite work. David is naked, and with his long hair and broad-brimmed hat, which looks as though it is made of straw, he is as beautiful as a girl. He is also a startlingly real youth, wielding a mighty sword and with a severed head to prove it. Even the greatest of the Greeks would not have dared to create this work of fantastic imagination. The audacity of the concept is shocking, exciting, highly suggestive. One wonders what even the Florentine élite thought when it was first unveiled. Not that Donatello would have cared. He was serving his art and his God in the way that his own genius—not society, or any other authority—dictated.

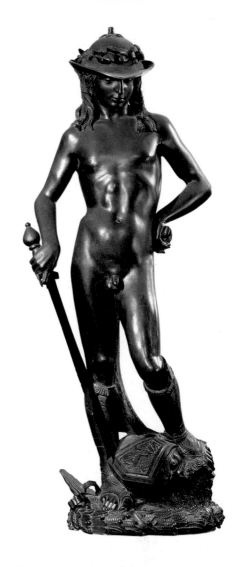

Despite the fantasy, David is deliciously alive. Liveliness was something Donatello could achieve in the most unlikely contexts. His *Jeremiah* and *Habakkuk* (1423–25) done for the Campanile, Florence, and now in the Cathedral Museum, are in experimental settings and look as if they have sprung, not from the dusty pages of the Old Testament, but from the streets of Florence itself. To create life in another way, Donatello revived the Roman portrait-bust, or rather invented his own version of this wonderful genre. He did an exceptionally fine one, in terra-cottta, of Niccolò da Uzzano (Bargello), one of the earliest true portraits in the history of European art. This was another innovation. Then he created, some time after 1419, the first 'humanist' tomb, for the anti-pope John XXIII. He cast the effigy, then gilded it, and put it in an architectural setting—the Florence Baptistry—with a bier, sarcophagus, sorrowing Virgin and other bits and pieces, Michelozzo again being the caster. This tomb ensemble, adopted and improved upon by Michelangelo, became the pattern for innumerable others, right up to the end of the eighteenth century, when Canova was in his prime. Donatello used elaborate decorative surrounds for beautiful exercises

Donatello produced his bronze *David* in 1430–32, after visiting Rome and absorbing the lessons of classical sculpture. It incarnated the new classical spirit of the Renaissance.

in the *rilievo schiacciato* he invented. For this kind of work he introduced a new kind of aerial perspective, employing stratified marble for clouds. He would place ruler and set-square in damp stucco, then cut back the material with a spatula to suggest receding planes. Having created a new kind of low-relief, he then hit upon the further idea of offsetting it by novel architectural surrounds, as in his fine bronze *Feast of Herod*, made for the font of the Siena Cathedral Baptistry. He would also reverse the process, as in the Singing Gallery of Florence Cathedral, where the souls of the innocent perform an ecstatic dance in Paradise.

This was itself a new form of art. Donatello was always producing novelties of subject matter, then combining them with a fresh trick of the trade. In the Old Sacristy of San Lorenzo, Florence, the four evangelists peering out of their roundels are not prototypical saints but lifelike old men astonished at their celebrity. The four roundels that deal with the Life of St John the Evangelist have yet another trick. Many of their figures are shown only in part, cut off by the frame of the roundel, to give immediacy and freshness, as if we were looking through a window at a real scene. No one had thought of this bit of conjuring before. Yet Donatello was not primarily a magician or a fantasist—though magic and fantasy illuminate some of his greatest works. He was a realist, like nearly all great artists. The bronze panel he did for Cosimo de' Medici of St Lawrence's martyrdom (San Lorenzo) presents the saint's death-agony with hideous truth. Equally horrifying, in a different way, was the wooden statue of St Mary Magdalen in her hideous old age, perhaps his last work (Florence Cathedral Museum). Yet there is a beauty about it too, as there is of the shocking life-size bronze of St John the Baptist, done about the same time and still in its place in Siena Cathedral, and the bronze *Judith and Holofernes*, another late work, which makes the maximum realistic use of this fearful story.

In the age of Donatello, highly gifted but still lesser artists tended to be overshadowed. But they were not overwhelmed. And often, as happens throughout the history of art, an artist not quite of the first rank can produce an unrivalled masterpiece. Thus it happened that in one field even Donatello was outmatched. One of the most difficult forms of bronze statue to produce is the man on horseback. The Romans could do it, on occasion, as the Marcus Aurelius on the Capitol shows. To prove his mastery, Donatello had to produce an equestrian statue, and he finally did so, in Padua, where his *Gattamelata* stands in front of the great church of St Anthony. It is a noble work, in a superb setting. But a few years later it was quite outclassed by one of the *condottiere* Bartolommeo Colleone, by Andrea del Verrocchio (1435–1488), commissioned *c*.1479 and completed after his death. This man ran one of the most important workshops of the entire period, and was of formidable and varied talents, but he was not in Donatello's class. Why, then, does he carry off the prize? The answer to this question tells us a lot about art. The workmanship in both cases is of the highest order. The settings are equally splendid, for the Colleoni was put in front of the church of SS Giovanni e Paolo and its adjoining *Scuola*. But Verrocchio has succeeded

in creating an image of power and ferocity which epitomises the fearsome trade of the mercenary, and that image fixes on the mind like glue. Image is not the whole of art by any means, but it is the most important single element in it.

Another skilled creator of images, though more gentle and sentimental ones, was Luca della Robbia (c.1399–1482), a younger Florentine contemporary of Donatello's who worked with him on the Singing Gallery of the cathedral. He too studied the antique intently, but was happy to draw on medieval sources just as deeply. He was one of the best marble-carvers of the day, but he was inspired by Donatello's revival of terra-cotta to move a technical step further. In the 1430s he invented a clever way of glazing terra-cotta, using a tin-based agent. It was one of the prime artistic discoveries of the period, indeed of all time. Having experimented with a number of glazes, increasing their power and transparency, Luca realised that they had huge commercial-artistic possibilities. For they both protect and intensify the colours, give the figures under them depth and luminosity, and bring out the beauty of the forms: what, unglazed, looks plain, becomes significant and touching simply for reasons of visual psychology. The first documented work in this new manner is dated 1441. But within a few years the technique was fashionable. It was immediately attractive. It was quite cheap. Luca and his nephew Andrea set up a busy workshop. It did not exactly mass-produce this ware, but it was highly productive and sold all over Europe. The bigger pieces had the singular virtue that they could easily be taken to bits and reassembled on arrival, so were easily and safely transported.

The importance of trade and commerce in the arts of these times should never be underrated. Verrocchio, for instance, was a businessman as well as an artist. His father made bricks, probably decorative ones, for sale in bulk. His son ascended another step of the ladder by training as a goldsmith. Then he turned to sculpture, and in time to painting too. He was a capitalist. He undertook important projects, borrowing money to finance the work, and taking on experts whom he paid. The common theme was metallurgy. Thus he got involved in making the giant copper ball for the lantern of Florence Cathedral. He set up his own workshop, which became the most famous of the age. It was retail as well as wholesale and bespoke. You could go in there and buy pretty things as well as commission them to your specifications. He and his assistants, who included at various times Leonardo da Vinci, Perugino and Lorenzo di Credi, to name only three of the more famous, worked in virtually all media and materials, from jewels to huge bronzes and marbles, and monumental paintings. It was extremely hard for a talented young teenager to get a foothold in the shop, and a man who entered it to buy had to be self-confident as well as rich: Verrocchio could freeze with a glance.

One can probably learn more about the art of the day from a detailed study of this industrious man's shop than from any other institution. The people who ran

shops were highly competitive, and they were encouraged to be more so by their patrons, public and private. Verrocchio was always looking over his shoulder to see what the Ghirlandaio family was doing, or the Pollaiuolo brothers. A good shop-keeper in the new style ran art and commerce in double harness; neither was allowed to outpace the other. Verrocchio had a careful eye for what he knew he could sell. His *Boy with a Dolphin* (Florence, Palazzo Vecchio) was a deliberate revival of one of the

most popular images of antiquity. It did extremely well. His *David* was a deliberate challenge to the charm and beauty of Donatello's fighting boy, and may have been the more admired in its day, for it is far more virile, and the detail is superb. Verrocchio seldom undertook a major project without being pretty sure he could make a profit on it, and the prices he charged for individual works, up to 350 florins, were high by any standard. Of course, he had large overheads and a hefty wage bill. There was no corner-cutting in his shop. Behind the output were countless preparatory drawings, for in Florence it was thought essential to get the *disegni* absolutely right before going a step further—one reason why the draughtsmanship in that magical city has never been surpassed.

In certain technical respects, these top Italian studios were no more in advance of their northern equivalents, the places, for instance, which Dürer would have known in Nuremberg. But if the antique was important—and, by the mid-fifteenth century, everyone agreed it was—then the Italians had the advantage, for they were surrounded by it. Arms and legs and heads of broken Roman statues were still to be found in most parts of the peninsula, though in rapidly diminishing numbers. Rich collectors paid good money for them. An art lover would acquire heads and tor-sos and set them up on stands in the courtyard of his town house or palazzo or in the gardens of his country villa. Artists studied and copied them, and some were employed by collectors to mend broken antiques or carve fresh bits to complete fig-ures. Artists rummaged through the ruins of Rome in search of sculptured loot, just as scholars ransacked the libraries of old abbeys for manuscripts. But whole statues of stone or marble were rare and bronzes almost unobtainable. In any case, the best were likely to be Roman copies of Greek originals, or copies of copies.

A bronze that did survive entire and in a near-perfect state was the so-called *Spinario*, a first-century AD marvel of a nude boy taking a thorn from his foot. When found it was put on a column outside St John Lateran, near the *Marcus Aurelius,* until it was moved to the Capitol. This work could have given Donatello ideas for his *David*, and *Marcus Aurelius* certainly

Verrocchio, a Donatello pupil, created his revolutionary *Boy with a Dolphin* (c.1470) to demonstrate how bronze sculpture could express movement and display the beauty of curves.

influenced both the *Gattamelata* and the *Colleoni*. By the end of the fifteenth century, finds were rare and wealthy men were prepared to invest heavily in excavations on likely sites. That was how the *Apollo Belvedere*, a genuine Greek work, was dug up in Rome in the 1490s, followed in 1506 by the *Laocoön*, instantly recognised as one of the greatest of antique works. Both were acquired by Pope Julius II and were the prize exhibits of his sculpture collection, which later formed the nucleus of the present Vatican Museum.

Studying these antique shapes, especially at Julius II's palace, was the inspiration of the three masters of what modern art historians call the High Renaissance—Leonardo, Raphael and Michelangelo. The last in particular made no bones about learning or stealing from the Old Masters of Rome and Greece, and in a variety of ways. They helped him with subject matter, they guided his selection of materials, they were an aid to his designs (the real foundation of art, as the Florentines believed), they improved his actual carving, the finish, the balance between the parts and the whole, and, not least, they assisted him in developing a sense of monumentality, of grandeur, what the Italians called *terribilità*, and Edmund Burke, in the eighteenth century, would term the sublime—that is, the ability of art to inspire sheer awe.

More has been written about Michelangelo than about any other artist. His contemporaries had a lot to say. He wrote much himself, chiefly poetry. But he remains impenetrable. He was born in Florence in 1475 and died in Rome eighty-nine years later. Working as sculptor, painter and architect, he never rested and had more than seventy years of active artistic life. It is said he was neurotic, a neoplatonist, a mystic, a homosexual. More sensational rubbish has been written about him than about any other artist, though Caravaggio is now running him close in this respect. In fact Michelangelo was no more than a skilled and energetic artist, often a harassed one, who got himself into contractual messes, not always through his own fault. He thought of little else but getting on with his work as best he could, and worshipping God.

His wet-nurse was a stone-carver's wife from Settignano, and Michelangelo told Vasari that he 'sucked in the chisels and mallet' with her milk. This has been challenged but I believe it. His father did not want him to sculpt, dismissing it as manual work, demeaning to the son of an ambitious Florentine bourgeois like himself. He kept the boy at school until he was thirteen, and in 1488 apprenticed him to a painter, Domenico Ghirlandaio. But next year, the teenager got himself into the Medici sculpture-garden near San Marco. There he attracted the attention of Lorenzo the Magnificent by copying the head of an antique faun.

There is little doubt that Michelangelo wielded the chisel, at any rate on his chosen material, marble, better than any of his predecessors; better than anyone at all until Bernini came on the scene. He developed his astonishing skill very early and at seventeen produced his first masterpiece, a marble relief, *The Battle of the Centaurs*. It is an exciting work. The nude male figures display extraordinary energy in pushing

the narrative on to the viewer. It is done with alarming facility and an economy of means which was to become characteristic of all the master's work. But it is unfinished. We do not know why. This was to become one of the hallmarks of Michelangelo's career. He did, however, complete his first important commission, a *Mary with the Dead Christ*, or *Pietà* (St Peter's). He began it at the age of twenty-two and finished it, to an extraordinary state of polish, three years later. A strong case can be made that it is the finest marble ever carved, and the best work of his life. It is an entirely original design, and a work which mysteriously blends realism with idealism. The carving is so good that the flesh looks real.

Having astonished Rome, Michelangelo returned to his home town and astonished the Florentines by showing that he could portray David more strikingly even

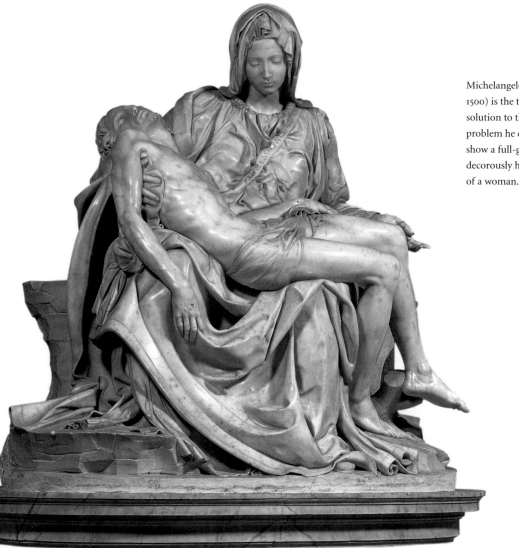

Michelangelo's *Pietà* (1498–1500) is the triumphant solution to the most difficult problem he ever tackled: to show a full-grown man decorously held in the lap of a woman.

than the two champions, Donatello and Verrocchio. His *David* (1501–1504; Florence, Accademia) is a nude youth 18 feet high, heroic and calculated to inspire fear. Here, indeed, is *terribilità*! The mastery of human anatomy is complete, and the sculptor has scrapped all the accessories, such as sword and armour and Goliath's head. Though colossal, it is a real youth, but also an idealised presentation of naked male power. It disturbed the Florentines; it was meant to disturb them, and continues to disturb us. People were alarmed by the impact, but they were also overwhelmed—as the Romans had been overwhelmed by the virtuosity of the *Pietà* group—and wondered what sort of a superman was dwelling among them. Was he a human being, or a god?

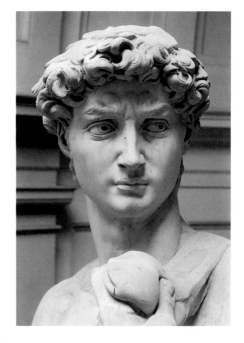

Whether it helps an artist to have this kind of reputation, especially so young, is doubtful. When he finished his *David*, the great Julius II summoned Michelangelo to Rome to create, for his own vanity and the admiration of posterity, an enormous tomb, with a multiplicity of life-size figures and a dramatic architectural setting. This was exactly, of course, the kind of commission the sculptor relished and he accepted with joy. The original contract provided for forty figures. But only three were actually finished. They include Moses, the central figure in the Old Testament. Michelangelo, in what many would claim is his finest effort, shows him as a God-like prophet and judge, seated in splendour as he lays down the law. Then the project languished.

If Michelangelo had produced an *apologia pro vita sua*, we might discover why so many of his projects remained unfinished. But he was too proud. Art historians have offered theories, but it is better to leave it a mystery. Why was the Julius II tomb not completed? We do not know. Two marble tondos of the Virgin and Child with the Infant Baptist, one in the Bargello, the other the prize possession of the London Royal Academy, the princely gift of that generous old man Sir George Beaumont, are also incomplete, the superb faces and limbs emerging tentatively out of rough working. Why did he not finish them either? He contracted to produce a set of *Apostles* for Florence Cathedral. Only *St Matthew* was even begun. Why? He contracted to make a huge tomb for the Medici. But only the powerful figure of the seated, pensive Lorenzo, and the two supporting nudes beneath, are complete. An air of desolation hovers over the whole. Well might the thoughtful Lorenzo wonder why the master left him in lonely isolation. We do not know the answer either.

It is no use arguing that Michelangelo suffered from some sickness of the soul. He was never willingly idle and his total accomplishment, if totted up, is enough even for a life as long as his. He was often angry with himself, as well as with others. He was quarrelsome.

A gigantic statue of *David* (1501–1504), 18 feet high, was carved by Michelangelo to assert the new self-confidence of Renaissance art, though the head reflects his inner turmoil.

He seems to us an isolated figure, just like Lorenzo, alone in his greatness, in his lack of a private life, or privacy, his heart empty of consummated love, his only competitor and measuring mark the Deity Himself. It should be said that Michelangelo imposed severe limitations on himself. He did not like working in bronze. For him it was an unlucky metal. His one great bronze effort, a gigantic effigy of Julius II for Bologna, was later melted down in war and made into cannon. He made a wooden crucifix and painted it. He worked well in stone when necessary. But he was at heart a marble-carver and one who worked to a high finish. He needed an architectural setting for his best efforts, which meant they are intended to be seen from the front. All these self-imposed limitations increased his difficulties, already mountainous because of his high standards. We can see how hard he strove for perfection from his drawings, which permit us to observe how a great artist moved through every stage of a work. Altogether, over five hundred Michelangelo drawings survive, in the Uffizi, in the Royal Collection at Windsor, in the British Museum, the Ashmolean in Oxford, and in other places. They go a long way to compensate for the lost and unfinished masterpieces, or the great works which were imagined but never carried out.

While he lived, and he seemed to live for ever, Italian sculptors quailed in terror at the idea of competing with Michelangelo. Foreigners were not so scared. The Fleming Jean de Boulogne, better known as Giambologna (1529–1608), came to Rome in 1554 and then settled in Florence, where he had the audacity to call himself Michelangelo's successor. But that was easier said than done. At one time, he was undoubtedly regarded as Europe's leading sculptor. His *Rape of the Sabines* (1583), now standing in the Loggia dei Lanzi in Florence, was hailed as a masterwork up to Michelangelo's standard. He produced elegant bronze statues of Mercury, large and small, which were imitated all over Europe. His great equestrian statue of Cosimo de' Medici, first Duke of Tuscany, in the Piazza della Signoria, is one of the sights of Florence. His patrons delighted in him, laughing at his near-illiteracy and inability to speak Italian, but respecting his business-like methods and his invariable capacity to deliver on time exactly what was ordered. But today he is best loved for his fountains: the Neptune in Bologna (1563), the Boboli Fountain in

Giambologna created *Neptune* in 1566 as part of a systematic campaign to dominate first Florentine, then European sculpture, and take over Michelangelo's role.

Florence (1570) and the Appenine at Pratolino (1577), a huge piece of rustic confectionery, later much imitated in Europe's gardens.

This emotional declension from the *terribilità* of Michelangelo, with its overwhelming demands on both the artist's strength and the patron's patience, was inevitable and natural. Art thrives on contrasts. Indeed, it is significant that, of Michelangelo's near-contemporaries, the most accomplished, and the one whose reputation has held up best over the centuries, was totally unlike him, both in character and in the work he produced. Benvenuto Cellini (1500–1571) came from that rich depository of skills, the Florentine artisanate. His grandfather was a skilled mason; his father a carpenter who specialised in scaffolding—he worked for Leonardo da Vinci on his major projects. But he also carved fine musical instruments. Cellini was trained as a goldsmith and, unlike so many others thus trained, remained one. The skills he acquired in the jeweller's workshop—that Aladdin's cave and Sorcerer's den of the new art—became the basis of an encyclopaedic knowledge of how to turn materials of all kinds into beautiful things. Precious stones, rare pebbles, glass, bronze, copper, lead, gold and silver, iron and ivory, marble and stones of every kind—Cellini could fashion them all, and blend them into elaborate pieces for cardinals and princes.

Goldsmithery remained the centre of his practise. But gold is a dangerous material for an artist to invest his skills in. Families melt down precious pieces in hard times, or they are stolen and meet the same fate. Nearly all Cellini's early work vanished in the 1527 sack of Rome. But he later had the good fortune to work for Francis I of France, a big spender who also had excellent taste. The gold-and-enamel salt-cellar he made for the king somehow survived, and is now one of the greatest treasures of the Kunsthistorisches Museum in Vienna. Cellini, despite his humble origins, acquired an unusual love and knowledge of the antique. He put it all into this extravaganza. It took him two years and contemporaries were amazed that he produced it so quickly.

This *Salt-cellar* (1543) in gold and enamel, which Benvenuto Cellini made for the French king Francois I, is one of the few large-scale Renaissance works in gold to survive.

No individual or team could produce it today in a century. If one work of art, with its fecundity and brilliance of invention in the treatment of classic themes, its innovative technology, and its deep love of art and humanity, sums up the virtues of the age, it is this controlled explosion of precious metal.

But Cellini also aspired to a bit of *terribilità*, and once or twice he came close to it. The climax of his career, in his view, was the creation, for Duke Cosimo, of a large-scale bronze, *Perseus and the Head of Medusa* (Florence, Loggia dei Lanzi), which

was designed to stand in the Piazza della Signoria, alongside Michelangelo's *David* and Donatello's *Judith and Holofernes*, for purposes of comparison. We know all about its fabrication, for Cellini himself described it in exciting detail in a personal record known as his *Autobiography*. This circulated in manuscript but was not printed until 1728. It is a highly readable work, a source of much information about the artistic life of the sixteenth century. It is also an essay in literary art, which confirms the long process by which the humble and anonymous craftsman of the Middle Ages raised himself to the status of a hero-figure.

Cellini, as it happens, was more in the nature of an anti-hero. He could be violent. He was often boastful and disgusting. Like a number of artists of the sixteenth century and later—we shall meet them soon—he seemed to be two personalities: the conscientious craftsman and the public nuisance. There were so many things he could do, which required prodigies of skill and patience to do at all, and which he did superbly. He could make elaborate candlesticks and beautiful ewers for ceremonial use, the finest altarware and luxury furniture for churches, exquisite dies for seals, dies for gold coins, presentation medals with the finely sculpted heads of rulers on one side and ingenious reverses, gold and silver tableware, and decorative pieces of every description, all finely wrought and in the highest taste. Nothing he did that has survived was skimped or has the least suggestion of the second-rate.

That was one Cellini. On the other hand, there was a rash, hot-blooded, difficult and overweening adventurer, with all the vices of flamboyance to be found in the most successful artists of the time, plus nasty hints of turpitude peculiar to himself. He was always having to flee the law. Surviving court records show him in various degrees of trouble all his adult life. He was guilty of at least two murders. He was twice accused of sodomy, then a capital offence. Sometimes he was pardoned 'for artistic services', a gesture typical of the times. Sometimes he had to flee. After the second sodomy charge, when he was engaged on the *Perseus*, he fled to Venice, where he met Titian and Sansovino. He was none-the-less convicted and sentenced to four years in prison, and actually endured a lengthy house-arrest, which he used to write his memoirs. These tell us that Cellini was a collector as well as a producer of art. Vasari relates that he brought together several big cartoons which Michelangelo drew while preparing his Sistine Chapel ceiling. He also, it seems, copied out a treatise by Leonardo on the three arts of painting, sculpture and architecture, and a study of perspective. He was industrious in all things, even in his vices. He was a scoundrel and a great man and he brings the age to life in all its wonders and horrors. By trade a sculptor, he insisted he loved painting and was glad to live at a time when it was brought to such a pitch of excellence. That is the claim we shall now examine.

12

THE GREAT MASTERS
OF ITALIAN PAINTING

In the process of creating the new art in Italy, painting lagged behind sculpture and architecture. That is not surprising. It is intrinsically more difficult. Sculpture and architecture, the 'heavy arts', involve grappling with intractable materials and all kinds of practical problems. Buildings fall down. So do statues. Mortar does not set properly. A bronze cast turns out hopelessly defective. Marble splits. But none of these trials involves visual psychology. The painter, by contrast, has to translate three-dimensional objects into flat, two-dimensional surfaces. You are not looking at a real thing, like a church or a statue. You are looking at an illusion of a real thing. That illusion has to be created by intellectual means dictating the hands holding the brush or stylus. The sculptor of the Naumburg founders in the mid-thirteenth century could make them look totally real because he was operating in the three dimensions where real people live. It took painters much longer to achieve effects of realism because they had to translate everything from three to two dimensions, and the only way to do this is by compiling a vocabulary of illusionist tricks. These take time and originality to work out.

A great and sophisticated painting in the first half of the seventeenth century—Velázquez's *Waterseller*, for example, in Apsley House, London, a brilliant but comparatively simple work, exhibits a knowledge of hundreds of painterly tricks, worked out over the three preceding centuries, which Velázquez learned as a youngster and improved upon. By contrast, the artist behind the Bayeux Tapestry, *c.*1090, though wonderfully gifted and imaginative, had only a handful of illusionistic tricks at his disposal. The English historian and monk Matthew Paris, to judge by the drawings he made in the margins of his mid-thirteenth-century chronicle—the time of the Naumburg statues—had not many more.

The rediscovery of the past and its achievements, a continuous process from the Dark Ages onwards, which reached its climax in the late fourteenth and fifteenth centuries, was far more helpful to the architect and the sculptor than to the painter. Buildings from antiquity were there, in a few cases complete and in hundreds

ruinous, to be inspected, measured and learned from. Statues too existed, or frag-
ments of arms and legs from antiquity could be dug up. But paintings from ancient
Greece did not exist. Roman paintings in Pompeii were still buried under the ashes
of Vesuvius. Greek vases were not yet collected or studied. Mosaics were known,
especially in Ravenna, but they did not give away many two-dimensional tricks. In
any case, though the Greeks and Romans had a lot to teach about architecture and
sculpture, and indeed about decorative design, their two-dimensional work was
much less impressive.

Take, for instance, the most important trick of all: the way in which the two-
dimensional artist locates persons and objects in space. This is the central problem
of visual psychology. As the prime function of drawing or painting is to convey
information, the Egyptians, the first great artists, used—as we have seen—a form of
representation we call aspective art. That is, they conveyed the maximum amount
of information about the objects they depicted. They put down what they knew to
be there. They varied this system by what we call social perspective, in which the size
of persons shown varies according to their status.

As we have also seen, Greek artists, and their Roman successors, made limited
use of perspective. In any event, in the West such illusionary skills as the Romans
bequeathed were lost during the Dark Ages. Artists reverted to primitive aspective
art both in illuminated manuscripts and in wall-paintings, as well as low-reliefs.
But in Byzantium, some elements of illusionism survived. From the twelfth and
thirteenth centuries, there was a classicising revival, most notably expressed in wall-
paintings in the church of St Nicholas at Boyana, in what is now Bulgaria.

In Italy, the most advanced part of the West in two-dimensional work, progress
was later and slower. But it came, artists effectively teaching themselves. First
Cimabue (1240–1302), then Duccio di Buoninsegna (c.1255–1318) and Giotto di
Bondone (1267–1337), in Siena, Florence and elsewhere, began to use various clumsy
forms of perspective and the foreshortening of bodies and limbs which goes with it.
These developments can be seen in Cimabue's wall-paintings in the Upper Church
of San Francesco at Assisi, in Duccio's great *Maestà* altarpiece (now in the Cathedral
Museum, Siena, the National Gallery, London, and elsewhere), and in Giotto's work
in the Arena Chapel at Padua, and in the Bardi and Peruzzi Chapels at Santa Croce
in Florence. It was only a matter of time, and concentration by patient industry on
the problems involved, before these central Italian painters became better than the
Greeks and Romans had ever been.

Moreover, those devoted to the new learning systematically intellectualised this
problem and others in visual psychology. While artists like Masaccio pushed practical
knowledge further in two dimensions, and sculptors such as Ghiberti and Donatello
used it extensively in low-relief, employing instinctively acquired skills although they
obviously thought a good deal about the problem, other great men got to work with
words and diagrams. Early in the fifteenth century, Brunelleschi produced what were

called 'demonstration panels', based on the Florence Baptistry and the Palazzo Vecchio, showing how correct perspective could be scientifically determined. These have since disappeared, but we know about them through his biography. Then, in 1435–36, the architect and theorist Alberti, using these panels, and the work of Donatello and

Masaccio, produced the first detailed description of perspective technique in his treatise *Della pittura*. From the 1430s onwards, nearly all the leading artists in Italy familiarised themselves with perspective technique, until it was taken for granted and became instinctive, and any other form of presentation looked barbarous. As a result, they could organise space within their pictures in the natural manner, as seen, and could take on in consequence a much wider range of subjects. More important, they could treat them in a far more adventurous and imaginative way than in the past.

Although freer in this respect, the artist was still chained to his tools. We have to weep at the poverty of materials and techniques available to great artists of the quality of Duccio and Giotto. Throughout the Middle Ages and well into the Early Modern period, the finest artists often spent most of their careers covering wall-spaces in churches and palaces, using methods employed in Roman times and often much earlier. The basic procedure was as follows. The wall surface was smoothed. Then a preliminary layer of lime-and-sand plaster was applied. The Italian painters called this the *arriccio*. If they wished, they could sketch in the outlines of the work (*sinopia*), followed by the application of layers of lime and powdered marble (or similar mixture) to give a final smooth surface, or *intonaco*. The paint, a mixture of earth colours with some kind of binding agent, was applied while the plaster was still wet, *a frescoes*. The paint was then bonded to the wall by the carbonisation of the calcium hydroxide in the plaster as it dried.

Fresco was the most satisfactory and permanent technique. But it involved a good deal of trouble and disciplined organisation on the part of the painters, who had to work rapidly while the plaster was wet. In large wall-paintings this usually meant dividing the work into strips, with scaffolding to correspond. Each day or session was allotted its area of the wall, and the painter had to stick to the timetable prepared in advance. If the paint was applied on dry plaster, *a secco*, the painter could take his time. But *secco* was less durable. The surface was more likely to crack and flake. Pliny's *Natural History* says that the Romans polished the surface of frescoes to get the effect of veneering. They also applied wax as a preservative. But we hear little of this in medieval times. The old Roman methods seem never to have passed wholly out of use in the West, though they lost much of their complexity and sophistication.

However, from this crude base, techniques were gradually improved. By the time of Giotto, the artist worked in this way. He smoothed the surface, as before. Next, he put on the *arriccio*, using one part lime, two parts water. He then drew the outlines in charcoal, and went over them with a brush to produce the *sinopia*. Then he divided the work into sections, each to be finished in one day. These were called *giornate*. At the start of each day's work, the portion was covered by the *intonaco*, the outlines were drawn in again, and the painting proceeded. If mistakes were made, they could be corrected in *secco*, but with all its disadvantages. Moreover, the tonal surface was lost, and the painting might look patchy. A famous treatise by Cennino Cennini, *Il libro dell'arte*, written around 1390, describes this technique in detail. It had one daunting and obvious disadvantage and one less obvious but important advantage. Once the *sinopia* was complete and the daily portions measured up, no major changes in composition were possible. Even minor adjustments raised difficulties. Spontaneity was ruled out. As the painter saw his work emerge, he must have been agonised as the faults emerged too. As a rule, he could only correct them by starting all over again. Hence, despite the growing freedom of treatment which artists were beginning to enjoy thanks to foreshortening and perspective, a certain formality and woodenness persisted, even in the works of the best artists.

On the other hand, in Florence in particular, which always insisted on fresco as a better medium than any other, artists were forced to think out their projects carefully in advance, and to prepare for them with detailed drawings, of the whole and of its parts. This was the advantage of the system. It made the artist concentrate mightily on his *disegno* and eliminate faults early on. This explains why Florentine artists, or those trained in Florence, produced so many drawings, thousands of which survive, and some of which—the drawings of Raphael, for instance—are among the greatest treasures of Western art. Moreover, to make the drawings, the Florentine artists turned increasingly to life. They hired models and sketched them in every kind of position in the workshop. This involved studying the human form intently, not to say with passion, and learning to draw it, in repose and in motion, with wonderful fidelity. Thus another kind of humanism was born. The glorification,

the sanctification almost, of the human body, which came to a climax in the early years of the sixteenth century, with the style historians call the High Renaissance, was based upon this tradition of meticulous draughtsmanship.

All the same, wall-painting in fresco imposed irritating limitations on excitable and volatile painters. All kinds of agents were used for mixing the colours, none entirely satisfactory. As a result, some earth colours had to be excluded. The paint had to be applied thinly, using a delicate hair brush with a point. It cannot be applied thickly, *impasto*. If the artist wants this effect, he has to put on repeated layers. He cannot apply the paint smoothly, so that his brushwork becomes invisible, but has to produce a hatched or stippled effect, which is monotonous on close inspection. He cannot blend or mix or fuse his colours and tones on the surface, which rules out any of those delightful accidental effects which rejoice the heart of an artist. It also rules out a whole series of deliberate strategies. He has to decide in advance what colours he is using in every tiny part of the work. To introduce subtleties and gradations of tone is a major undertaking, which involves complex procedures. Shadows produce a fresh set of problems. In general, attempts at darker effects—any kind of *chiaroscuro*—end in muddiness and despair. Working in fresco involves much waiting and perpetual patience.

These obstacles also oblige the painter to use a high palette, which has its attractions. The light colours of the fourteenth and fifteenth centuries, and the large areas of white or near-white, appeal strongly to many people. On the other hand, the range of colours is narrow, and they become tedious in consequence. The inability to mix or overlay them while painting aggravates the monotony. The limited range of hues was reflected in the palette of those days. It was little more than a narrow oblong, compared to the huge curved palettes of the second half of the sixteenth century, when painting in oil had taken over. Moreover, all the lower and darker tonalities are excluded. Not only is *chiaroscuro* ruled out, but the highly effective *sfumato* that Leonardo da Vinci exploited so successfully when he took to oil.

The early Italian paintings, then, were much less appealing than they might have been because they were using an inferior medium. Many artists who were used to it, and coped (as they thought) with its drawbacks, defended it hotly at the time of transition. But it is a fact that, once it passed out of use, few professionals have ever sought to return to it. Attempts to revive fresco-painting in the nineteenth and twentieth centuries did not prosper. Tempera was probably at its best when used for easel-painting or painting on wood panel for use in big altarpieces. The panel was first prepared with ground and priming. Charcoal was used for the *disegno*. Watercolour was used for shading. Gold background or gilding followed. The drapery was painted next, the pigments being mixed with egg yolk. Any architectural background followed. The flesh was the last to be painted, sometimes on top of a *terre verte* under-painting. All this was described by Cennini, who added that town hens produced the palest and best yolks.

When Van Eyck's wonderful work in oil became known in northern Italy through the mediation of Antonello da Messina (*c*.1430–1479), most Italian painters were hostile to it. Such a painting as *Arnolfini and His Wife*, with its natural colours and blending, its modulations into light, shade and space, its transparency and atmosphere, depth and subtlety, could not conceivably have been done in tempera. But outside Venice, the adoption of oil was slow and grudging. It was seen as 'German' and uncivilised. Even when the Tuscan painters experimented with oil, they adopted all the preliminaries and precautions of tempera, which destroyed most of the point. Whereas the Italian book producers were sharp and expeditious in adopting printing, and had come near to beating the Germans at the new game in a single generation, the artists took a long time to accept that oil as a vehicle for paint was an invention of equal importance.

Hence, during the period of what is called the Italian Renaissance, the two most important technical innovations, moveable type and oil-painting, had nothing to do with antiquity and both came from north of the Alps. That is not a reason for dismissing the term 'Italian Renaissance' altogether, but it is grounds for using it with care. The fact is, the Italian painters would have been more productive, and produced better work, if they had used oil from the start, or even if they had not been quite so conservative in adopting it. In central Italy, among the first masters to use it was Perugino, Raphael's teacher, in the 1480s. His medium was a mixture of oil and tempera. Venice was the first school of art to use oil with anything approaching enthusiasm. It had a lasting effect. It helps to explain the explosion of colour we associate with Venetian painters, and which enabled them to push the school of Florence out of first place. The Florentines, of course, accused the Venetians of paying too little attention to drawing. But that was not entirely true. Two albums have survived of drawings by Jacopo Bellini (*c*.1400–1471), father of Gentile and Giovanni. One in the Louvre, one in the British Museum, they contain over 230 drawings and show how accomplished and imaginative Venetian draughtsmen could be. But the Venetians never had an obsession with drawing, as did some Florentines. One reason they adopted oil with such fervour was that they liked to change their minds while at work. X-rays of Giorgione's masterpiece, *La Tempesta* (*c*.1505), show the lines of erased forms, or *pentimenti*, marking important changes of detail. His co-worker, Titian, made such changes extensively all his life. Like perspective, the move from tempera to oil-painting was a liberating process, giving the artist and his imagination greater freedom to create. By the end of the sixteenth century, as we shall see, this freedom from the restraints of preparation enabled a self-confident artist like Caravaggio to stand up to a bare canvas and paint on it directly, from living models.

The canvas—that was another step to freedom. Dutch and Flemish artists, painting from the easel, initially used wood panels for oil-painting. There was, and is, nothing wrong with this. Provided the right type of wood, of the right size, can be obtained, and properly prepared, an artist can deploy all the resources of oil paint on

it with as much success as on any other surface. Some painters still use panels today; I have used it myself, and found it gratifying. But the right wood is hard to find, liable to be expensive and can be very heavy. It never seems to be the right size. Canvas comes in great rolls, is cheap and can be cut to any shape or size required. It is easy to mount on a simple wood frame, and can then be stretched tight and turned into a working surface by applying size, a kind of glue. It can also be used as a permanent backing to oils painted on paper. The canvas is the perfect complement to the easel.

Once the artist could make a living from painting smallish canvases or panels on his easel, in oils, he could go in for portraits, then as now one of the most remunerative forms of art, always in demand. He could either carry his easel about with him, even into the countryside, which made *plein air* landscape-painting possible, or he could work from his studio. In the privacy of the studio, he could get models to sit more readily, including nude ones, male and female, and he could store all kinds of accessories, dresses, armour, etc., to suit his subject. Above all, once the artist had a working studio, as opposed to the old-fashioned workshop—though the French name, *atelier*, is the same for both—he was a liberated man. He escaped from the time-consuming tyranny of wall-painting. That involved much less church work. Artists continued to create altarpieces in their studios, but this kind of product was now only one of several. The result was a commercial impetus to ending the quasi-monopoly of art exercised by religious bodies, such as monks and cathedral chapters. It was taking place anyway, especially after the artistic effects of the Reformation began to be felt in the 1530s, and the demand for purely religious art in the new Protestant countries dropped abruptly.

A further result, since the artists escaped from the tyranny of palace walls too, was to break the aristocratic and princely stranglehold on secular art patronage, and allow the rising bourgeoisie to enter the market on a large scale. It happened much sooner and faster in the Low Countries than elsewhere, but it eventually began to happen in Italy too. It was a mixed blessing, especially for Italians. The kind of princely patron who flourished in Italy in the fifteenth and sixteenth centuries, be they Visconti or Medici, popes and cardinals, or members of the Venetian oligarchy, had a breadth of sympathy for artists, an understanding of their work, a patience and a generosity which, collectively, is unique in the history of art. Italian painting was never quite the same after its dissolution, and the liberation of the artist into the chill winds of the open market.

The right kind of patronage was one principal reason why Italian art was so strong between 1350 and 1550, two centuries during which about a thousand painters of high quality achieved professional eminence. Another factor was the dynamic of progress. The practise of art cannot be separated from other aspects of society, and its changes reflect more fundamental shifts in the way men and women organise their activities and make their livings. Towards the end of the Middle Ages there was

the beginning of a momentous shift from the countryside to the towns, from the feudal system, based on status, to the commercial or capitalist system, based on contract. There was a constant tendency for these changes to accelerate, all the time. The more enterprising men in society no longer regarded stability as the norm but began to see it as the enemy of happiness, and change—improvement—as a friend. Artists were inevitably affected, directly and indirectly, by this tendency towards change.

We have seen, in the case of ancient Egypt, a society which made stability the supreme virtue. Their stoneworkers, for instance, maintained their standards, despite occasional vicissitudes, for over 3,000 years. On the other hand, they were no better at working stone at the end than they were at the beginning; worse, if anything. By contrast, there was in ancient Greece, itself an increasingly commercial society, a distinct idea that man should seek to better himself. The Greeks sought self-improvement and set targets to be met, and spread these notions through their *oikumene*. They certainly infected the Romans under the Republic. But under the Empire, the authorities, like the Egyptians before them, became more concerned with stability and conformity than with changes for the better—which might, they thought, be for the worse. This attitude necessarily depressed the arts, which regressed rather than improved. The deadness of art in the Dark Ages has its roots in imperial decadence. As we have seen, there was a periodic desire for a rebirth of ancient glories, which became stronger and stronger until the past was indeed recovered, and what it had to teach absorbed, during the so-called Italian Renaissance. But from this time—that is, from the fourteenth century onwards—the notion grew that modern men (as they saw themselves) not only should learn all that the ancients had to teach in the days of Greece's glory and Rome's grandeur, but should build on that knowledge to reach even higher standards of learning and writing, of architecture, sculpture and painting.

Thus the notion of progress was born, or reborn. It spread from commerce to art. The artistic contract, and the public competition, motivated artists to surpass their rivals, in money and fame. Cities, especially Genoa and Florence, Milan and Venice, Pisa and Siena, Bologna and Rome, competed with one another, and expected their artistic sons to do likewise. As the cult of the individual artist spread, it became a race between generations, and among them. Dante himself first made the point that Giotto's fame had obscured Cimabue's. Two centuries later, Leonardo da Vinci made the same point: 'He is a poor pupil who does not surpass his master.' The image emerged of a gigantic pyramid of men reaching up to the heights, each on the shoulder of his forebear. E. H. Gombrich, in a famous essay, 'The Renaissance Conception of Artistic Progress and its Consequences', resurrected a forgotten text of 1473, in which the Florentine humanist Alamanno Rinuccini wrote a dedication to that famous old warrior and patron Federigo da Montefeltro. In it he argued that progress in the arts had been such that men no longer had to abase themselves before the ancients. He cited the work of three artists, Cimabue, Giotto and Taddeo Gaddi, as being progressively of so improving an order as to make them worthy to stand beside the

best artists of the ancient world. Since then, he added, Masaccio had done even better. And what about Domenico Veneziano? And Filippo the Monk (Fra Filippo Lippi)? And John of the Dominican order (Fra Angelico)? He added to his litany Ghiberti, Luca della Robbia and, most of all, Donatello. He insisted that over a whole range of achievements—he included oratory and Latin prose—artists and scholars had built steadily on earlier efforts to reach standards never before attained in all history.

Such innovators were bound to be individuals. They were, in the proper sense of the word, eccentric, outside the circle, egregious, apart from the herd. Cimabue (*c.*1240–1302), a younger contemporary of the Naumburg sculptor, is known by that nickname, which means 'Ox-head'. Like Donatello, he was proud of his skills, self-motivated, obstinate and determined to do what he thought right. His frescoes in the sanctuary and crossing of the Upper Church of San Francesco at Assisi were an attempt to absorb anything valuable in the recent Byzantine revival of Roman skills. It was an expansion of the two-dimensional artistic vocabulary; new gestures of arms, new facial expressions, new leg movements, new presentational tricks for vestments and backgrounds. It rejected the existing canon, mainly derived from Orthodox art, which both told the painter what to do and also how to do it. The Orthodox Church not only laid down the 'correct' way to render sacred personages, but imposed strict limits on permitted subject matter, something the Roman Catholic Church did not do until the end of the Council of Trent in 1563. Cimabue revolted against such chains, and broke them. He was the first painter in the West who deliberately strove for some element of realism.

Mosaic of St John (*c.*1302) by Cimabue is the only work we can be certain is by him. But his place as founder of the Florentine school is secure.

He is badly documented, however. The only work we can be sure is Cimabue's is the figure of St John in a mosaic at the Duomo in Pisa. I am assuming he was responsible for the work at Assisi, but there is no proof. His work there shows he was a man of drama, even a sensationalist. The condition of the narratives at Assisi is pitiful. But some power comes through the decay of ages and the earthquake of 1997. In the lower walls of the transept there is a scene of the destruction of Babylon which makes the hair stand on end. There is an image of the lamenting Magdalen which portrays grief in a way no Western painter had contrived to do before. Even in the *Saint John*, using that stiffest of all media, mosaic, there is elegance and sympathy. Can one love these things? It is hard, without a mental

adjustment. Cimabue, as with other early masters—the Sienese in particular—was a pioneer. He was creating the basic vocabulary of two-dimensional art. Each of his novelties, or tricks as I call them, was a creative act. But later artists quickly learned and repeated them, until they became routine, stale, clichés.

There was a big leap from Cimabue to Giotto, a leap much bigger than the twenty-seven years which separated their births. We do not know much about Giotto. Not one of the works believed to be his is documented, though the narratives in the Arena Chapel in Padua are generally accepted as being by him. Contemporary sources mention other works of his but they cannot be identified with certainty. It is worth going into a little detail about our documentary knowledge of Giotto to show on what slender grounds we base our pronouncements about these early masters. We know that he had a house in Florence in 1305; he joined the painters' guild there in 1311; in 1313 he was in legal dispute with his landlady in Rome; he was in Florence in 1318 and 1320; he was in Naples as court painter from 1329 to 1333; in 1334 he was *capomastro* of the works at Florence Cathedral. The foundations of 'his' campanile were laid the same year. In 1335–36 he was working for the Visconti in Milan, and he died the next year. Antonio Pucci, writing forty years later, says Giotto was sixty-nine when he died. That is all.

On the other hand, the tradition is clear that he was the founder of Italian 'modern', as opposed to medieval, painting. Matteo Palmieri, writing in the 1430s, said that painting before Giotto's time was 'full of amazing stupidities', that it was 'lifeless' and its figures 'laughable'. He writes of Giotto 'resurrecting' painting from the dead. Commenting on his work, Ghiberti, Alberti and Leonardo all treat him as the head of the apostolic succession of great painters, the man who banished Byzantine lifelessness from Italian art, and made nature his model. Vasari in his *Lives*—written, be it remembered, 200 years later—divided the history of art into three periods, the first started by Giotto, the second by Masaccio, the third by Leonardo. It is not hard to see what Vasari meant. In the best parts of the Arena Chapel narratives (1303–1306), the *Betrayal of Christ*, the *Lamentation* and *Joachim and the Shepherds*, we find genuine pictures as we understand them today, with figures grouped in an intelligible and skilful way, making the narrative point clearly, located firmly in space and set against a background which looks something like the real world. In *Joachim*, the sheep are rat-like and the trees ridiculous. But the dog is real enough. The shepherds are people one can see actually tending their flocks on the hillside. What is more, in these three frames, there is deep intensity of feeling, conveyed by convulsed, anxious, even tearful faces. They are recognisably akin to those you see in the streets and fields of ordinary life.

Two decades later, at Santa Croce in Florence (the Bardi and Peruzzi Chapels), Giotto was clearly painting his figures with greater freedom—he was finding it easier too—and he placed them in increasingly complicated perspective settings, so that there is considerable depth in the composition. He is the first Western painter whose pictures you feel you can scramble into and wander around in. He did better work

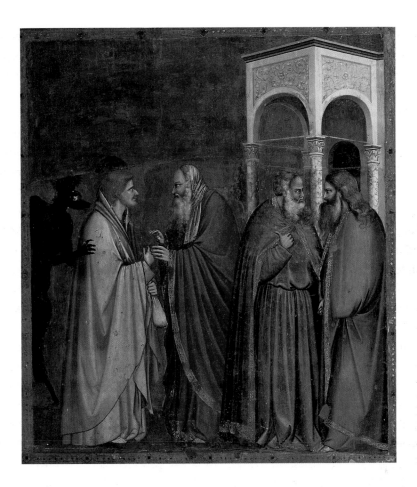

Betrayal of Christ
(1303–1306) by Giotto.
In his wall-paintings Giotto
created new modes of
expression, and vested his
figures with moral power.

still, but his later masterpieces have not survived. Indeed the work in the Padua chapels is in a poor condition, and there is not much that restoration can do except, I fear, falsify. We all accept Giotto as a great artist. We all feel, though most of us are reluctant to admit it, that his work still looks wooden. Part of the trouble is that it is difficult to judge Giotto's *oeuvre* as a whole, even if we can agree what it is, except from photographs, not usually satisfactory in his case. It is widely scattered and cannot be moved and is often inaccessible, and much of it can never be examined close-to. A special exhibition of fragments and moveable works by Giotto, held in Florence in the year 2000, went some way towards remedying this omission, and there is no doubt that our understanding of the master improves on closer acquaintance. You can see what he was trying to do, and he was usually doing it well. All of us who love art, and recognise the indispensability of the early conjurors, should be grateful to him.

With Masaccio (1401–1428) we are on firmer ground, up to a point. He was born near Florence and worked there until he moved to Rome in 1428, dying shortly after, aged twenty-seven. Only four works can be definitely attributed to him, and two of these were joint efforts with an older and more conservative man, Masolino da Panicale (*c*.1383–1447). His two undoubted masterpieces, the polyptych for the

Carmelite church in Pisa (1426) and the Trinity fresco in Santa Maria Novella, Florence, are revolutionary. The first has been broken up and scattered, but the second shows that Masaccio benefited both from the perspective work of Brunelleschi and the figure rendering of Donatello, older contemporaries of his. This was a point made by Vasari, and it indicates how far painting in Italy had lagged behind sculpture and architecture. Indeed, writers in Italy admitted at the time that, following Giotto's death, there had been a lull or even a decline in the standard of painting, and that Masaccio had been obliged to re-establish it. Thus in some accounts he is listed as the first of the masters, though that title properly belongs to Giotto. He benefited from the new learning. By his time, in Florence, the recovery of the virtues of antiquity—the texts and everything else—was proceeding fast. He was seized with the idea of 'progress' in art in a way impossible for Giotto.

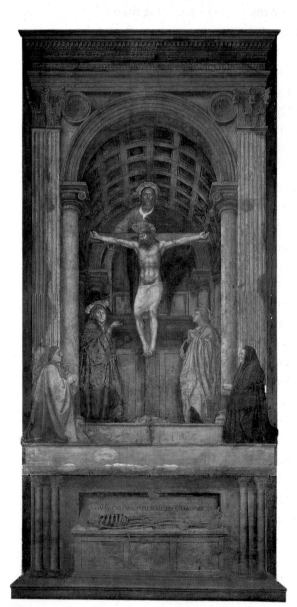

Masaccio's working life was desperately short at most, a mere ten years. Two isolated panels of his in London's National Gallery, the *Virgin and Child* and *Saints Jerome and John the Baptist*, both tempera on poplar wood, display an ability to mould bodies and faces in paint, to create shadows and tonal gradations, and to express character and emotions, which were quite new in Italian art. The perspective in the first is good, and in both the figures are confidently placed in their setting. But if we bear in mind that these are the work of 1426–28, and that Jan van Eyck's *Arnolfini Marriage* is signed and dated 1434, only a few years later, we can see—just by walking from one room in the National Gallery to another—the infinite superiority of oil paint, and the far greater dexterity with which the Flemings used it.

Again, in his beautiful panel *Saint Paul*, from the Pisa altarpiece, Masaccio produced a lifelike three-quarter-length portrait of the saint, the face and hands rendered with grace, confidence and sensitivity. This is fine painting. The influence of Donatello's statues is apparent enough, but Masaccio adds a softness and sympathy which Donatello did not possess at that time (1426). All the same, as a portrait it

The Holy Trinity (c.1425–28). Masaccio restored Florentine painting to brilliant life with four masterpieces, the only works we can be sure are his, of which his Trinity altarpiece in Santa Maria Novella, Florence, is the finest.

lacks the clarity and depth which the Flemings were producing in their head-and-shoulder renderings. The Italians were closer to them in the rendering of landscape backgrounds, to judge by the beautiful fresco *The Tribute Money*, which Masaccio painted on the walls of the Brancacci Chapel in the Florentine church of Santa Maria del Carmine. But there was still a huge gap. Masaccio's house and mountains are uneasily set in space and do not blend with the foreground figures. They are a long way from the certitudes and delight of Van Eyck's in *The Adoration of the Lamb* and the astounding depth of the enormous aerial view in his *Chancellor Rollin*.

Masaccio was clearly loved by those who met him. They lamented his early death and revered his memory. The stern Alberti, no sentimentalist, had him in mind as the ideal painter of the age, though when he wrote (1436), the young man had been dead eight years. That effectively ended the apostolic succession. Thereafter Florentine art, and Italian painting as a whole, darts in different directions. Paolo Uccello (1397–1475) was a little older than Masaccio and lived a great deal longer— he died the year Michelangelo was born—but had a much narrower vision. He was obsessed with perspective, and used it to work up extensive scenes of vigorous activity. They have a charm and appeal to us today which, strictly speaking, Uccello's limited gifts do not warrant. He was a slow, conscientious worker, like Ghiberti, and it took him a long time to master his chosen field.

Uccello's first masterpiece, *The Flood*, a fresco in Santa Maria Novella, was the work of his early fifties. It is an ambitious composition, executed with verve. It excites you and makes you linger over its details. In this sense he was like the northern realists, though on close inspection the details rarely look as real as they might. There is an ineradicable lack of skill. *The Battle of San Romano* (1455) has now been split into three pieces, in London, Florence and Paris, of which the section in the National Gallery is by far the best. This is an arresting and enormously popular work, a piece of almost abstract composition, in which Uccello, consciously or not, has used all the limitation of tempera on poplar to create intriguing patterns of colours and shapes which strike the twenty-first-century mind as 'modern'. But the perspective, though technically correct, does not look right. Nothing looks right. The knights are like toy soldiers riding rocking-horses, the battleground is a floor rather than a field, the armour and dead bodies on the ground are waiting to be put back into the nursery box. Why then does it delight? That is one of art's mysteries.

Another Uccello painting in the National Gallery, *Saint George and the Dragon* (1460), is a joke picture, good for a laugh, down to its floor of linoleum and the dragon's amazing aircraft-markings. Yet all these works are memorable. The image created works. It sticks in the mind. This is particularly true of a late work in Oxford's Ashmolean, *The Hunt by Night*. The delightful dogs and the elegant huntsmen flit in and out of the trees. Here is a classic case of art imposing an order on the chaos of nature. It is not a real forest or an actual hunt. But it is art—a beautiful picture which one returns to again and again with delight, and longs to own. It makes

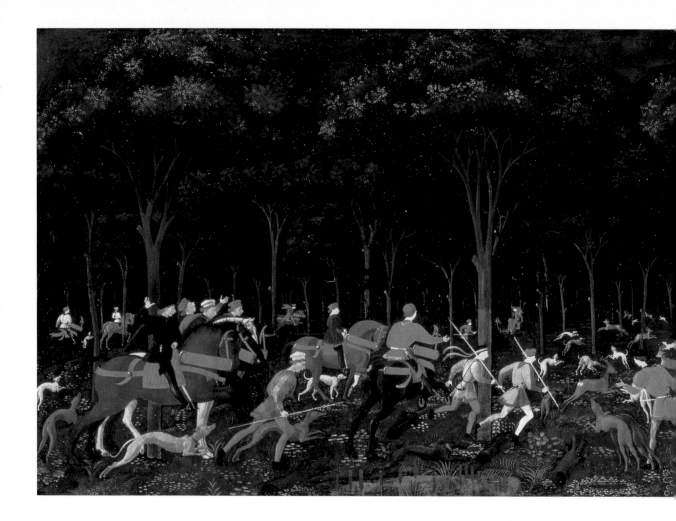

other paintings in the same room, some of much superior quality, seem uninteresting by comparison. It is a reminder of one of the great lessons of art—a painting is an image, an imaginative personality: it can work magic.

This point is well brought out by one of the finest Italian paintings done about this time, though by a Venetian who was a good deal older than Uccello. Gentile da Fabriano (*c.*1370–1427) was brought to Florence by the head of the Strozzi banking family to create a sumptuous altarpiece for their private chapel in S. Trinita. He was an important man, historically, for he was the master of Jacopo, founder father of the Gentile family, and thus the fount of mainstream Venetian art. But most of his work has been destroyed. The altarpiece, however, now in the Uffizi, has survived, and its central panel, *The Adoration of the Magi*, is a jewel of the new art, glittering with gold and sumptuous filigree work, a reminder that many painters started in a jeweller's workshop. It is a huge, two-dimensional jewel to hang on the wall, its sacred subject matter being an antidote to luxurious worldliness. The artist was a man from the north, in a sense, and from the east, in another sense—for Venice was north and east in its affiliations—and he could do things Florentines could not manage. The three kings, with their scintillating garments and their splendid gifts,

Uccello painted his *Hunt by Night* (1465–69) to demonstrate his mastery of perspective, but produced an unforgettable scene of men, horses and hounds in vibrant action.

gave Gentile an excuse to display his workshop technique in rendering shiny surfaces, but it was also an exercise in landscape perspective and observation of nature, for the royal procession wanders away into the distance. There is another skill which contributes to the success of the work: the lighting is brilliantly rendered and highly naturalistic. A further merit is that, though the principal figures are idealised, the crowd of courtiers and followers behind them might have been picked out of the streets of Florence or the *fondamente* of Venice. They are in turn coarse, smug, devious, curious, shrewd, happy—the physiognomy of life as it exists. Thus, amid all the glitter, there is the reality of daily existence.

As their skills increased, so Italian painters looked more closely at the individuals they saw, and sought to reproduce them, not so much as Virgins or Christs, but as the indispensable onlookers, who gave the pictures mundane truth. Fra Angelico (1387–1455) stands high on our list of favourite painters because he had the gift of putting his sacred scenes into settings we can recognise. He was a Dominican friar by vocation. He should have been out preaching in one of the big town churches the friars built all over Europe. But he preached with his brush. He could paint the Virgin,

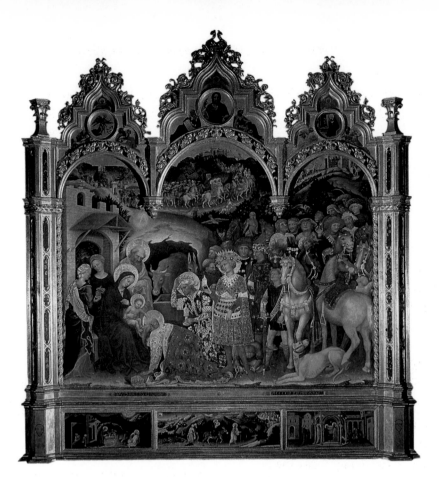

Gentile da Fabriano painted his *Adoration of the Magi*, or Strozzi Altarpiece, in 1423. Its grandeur, three-dimensional rendering of nature and figures and realistic lighting had a profound effect.

whether being told she was to bear God's child, or actually holding the baby in her arms, with a new kind of tenderness and holy simplicity, so that he incites the viewer to prayer. It was said of him, 'He bends the knee.' So he ran the busiest workshop in Florence and was summoned to Rome to paint for the pope. All the evidence shows that he was fully aware of new developments in the art world and used them when he wished. But Fra Angelico was not a humanist. His order, the toughest of the medieval foundations, the power behind the Inquisition, and the sternest upholder of doctrinal orthodoxy until the Jesuits emerged in the mid-sixteenth century, was highly suspicious of the new learning. In all his paintings, the Angelic Brother expressed the corporate teaching of his order, down to the smallest detail. Yet in the backgrounds, which make no doctrinal point, he was his own master, and displayed his humanity to the full. Every face he painted is that of an individual, closely observed. His *St Mark Preaching* (1433), part of what is known as the Linaiuoli Tabernacle, and now in Florence's Museo di San Marco, shows a group of people, each wrapped in his or her own thoughts—none apparently listening to the sermon—as though all were sitting for portraits. The background has become the foreground. A marvellously lively group of beggars in *Saint Lawrence Distributing Alms* (1448), in the Vatican, shows the same determined grasp of personality.

Not all clergymen-painters were as angelic. Fra Filippo Lippi (*c.*1406–1469) was an orphan brought up in a convent, who was persuaded by his elders to take vows. He

then caused a scandal by running off with a nun. Happily, the Medici family had always observed his talent and bent their powerful muscles to get the couple laicised. Their child, Filippino Lippi (1457–1504), also became a highly successful painter. Filippo's majestic frescoes in the cathedrals of Spoleto and Prato gave him the opportunity to paint crowd scenes. His Madonnas and saints are holy, serene and unworldly, but his crowds are common clay, men, women and children as he saw them. Moreover, they became more and more realistic, as a comparison of three works in the London National Gallery shows. The first two, lunettes, painted for the walls of the Medici family palace in Florence, an *Annunciation* and a group of *Seven Saints*, are charming and decorative and lively, and in admirable perspective. The third, *The Trinity and Four Saints*, is part of an altarpiece made for a community chapel in Pistoia ten years later. It is incomparably the best of the three. In realism and authority, in dignity and grace, it is a huge advance. The explanation is that the first two were executed entirely in tempera, used in the traditional way, while the third was painted in egg tempera with oil as the vehicle. That explains the precision, depth, fluidity and sheer bravura of this grand work.

Like most monks and friars, Angelico and the Lippis had a childlike streak of innocence, which makes it seem as though, while embracing the new art, they kept one foot in the Middle Ages. Angelico's best pupil, Benozzo Gozzoli (*c*.1420– 1497) was the same. His altarpiece, *Virgin and Child Enthroned among Angels and Saints*, which hangs near the Lippi *Trinity* in the National Gallery, was actually painted several years later, but looks much earlier, partly because it is pure tempera but mainly because it is full of childish (though delightful) touches: little painted birds, fantastically elaborate vestments, amazing beards and shaving effects, virtuoso toenails and veins, and attempts to render marble which, four hundred years later, bowled over the great marble-painter of the age, Alma-Tadema. When, in 1459, the Medici asked him to do a fresco of the *Procession of the Magi* for the chapel in their palace to rival Gentile da Fabriano's *Adoration*, Gozzoli was in his element. His goldsmith's training and his näivety joined hands with his meticulous skills to produce another great

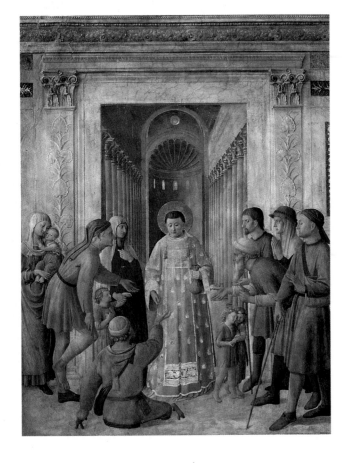

Fra Angelico in his *Scenes from the Lives of Saint Stephen and Saint Lawrence* (1447–49) in the Vatican— here St Lawrence distributes alms—achieved a new clarity and realism in telling a story.

jewel-painting on three walls of the chapel. This work must be seen. No reproduction can do it justice. The kings have not one procession but three—one for each wall—presented in sumptuous detail, in gold, vermilion, purple and olive green, and a variety of other colours. All is done to astonish and dazzle. They meander through fields and in and out of towns, with camels, horses, asses, mules and dogs, leopards chasing deer, a multitude of birds and flowers, while exotic trees and castles rise into the skies. Many of those in the processions are portraits of the Medici family and their followers, and there is a head of Benozzo himself too. Here is a celebration of the joy of living in a world of beauty and fun, of a lightness which, say, the great Rogier van der Weyden, Benozzo's contemporary and a much better painter, could never have contrived, even though he visited Italy to learn *joie de vivre*. This is Italian religious entertainment at its innocent best. Moreover, the work has been well preserved and recently restored with care, and is one of the best things in Italy because you can get near enough to it to relish the details.

There is a similar but far more formidable work in the Palazzo Ducale, Mantua, the *Camera degli Sposi* of Andrea Mantegna (*c.*1431–1506). It was finished in 1474, a decade and a half after Gozzoli's masterpiece, but its characteristics reflect not so much the passage of time as the difference between an accomplished artist of the second rank, like Gozzoli, and a great master. This amazing room was decorated by Mantegna as part of his duties as court painter to the ruling family of Mantua, the Gonzaga. They were anxious to put themselves right at the head of the new culture and he was exactly the man to do it. He came from Padua, a great university town where ancient learning was studied more passionately, perhaps, than anywhere else in Italy. He was a scholarly man, who mastered not only perspective—better than any other Italian fifteenth-century artist—but the science of foreshortening. He studied the decorative motifs of antiquity with passion and frequently used them for surrounds within his paintings. He knew all about Roman arms and armour, and the sumptuary of the Republic. His processional scenes at Hampton Court Palace, though much battered by time, are an encyclopaedia of classical lore, at any rate as it was understood in fifteenth-century Italy. Few painters have ever been more learned. But he loved the presentation of reality too. He met old Donatello and they became friends, despite the fact that both were exceptionally difficult men.

I suspect Mantegna had secret longings to be a sculptor. His teacher, Francesco Squarcione, said his painted figures looked as if they were made of marble or stone. They do. His famous *Dead Christ*, now in Milan, a daring exercise in foreshortening, looks as if it were carved with a chisel instead of painted with a brush. His *Presentation in the Temple*, an autobiographical work since (we are told) it shows his own wife and firstborn, is done in tempera on canvas, but it looks as solid as granite. In his grand works, like the wonderful *Agony in the Garden* in the London National Gallery, and the *Crucifixion* in the Louvre, the figures seem to spring out of, and be anchored in, the rock. His scenes from the Bible are presented against an antique background

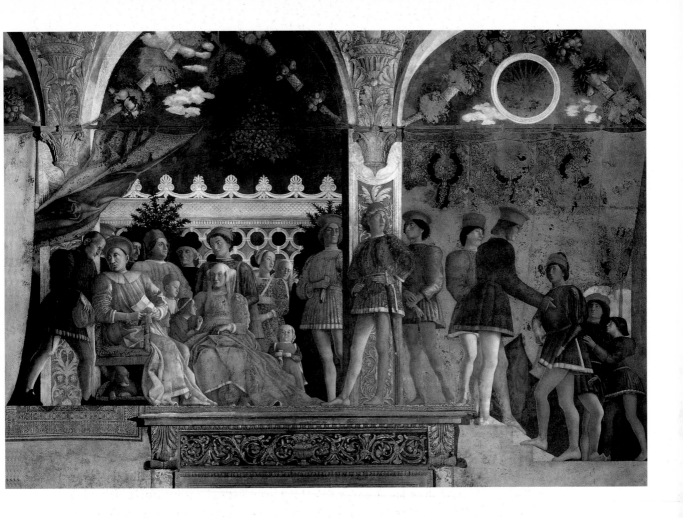

which is authentic in every detail, for Mantegna had a strong histori-cal sense, and this distances his superhuman figures still more from everyday fifteenth-century life.

Mantegna painted for the Gonzaga rulers of Mantua a decorated room, the *Camera degli Sposi* (1474), which provides a close-up of Italian court life in all its complexity, intrigue and glamour.

The *Camera degli Sposi*, being an exercise in contemporary realism, is perhaps the most authentic presentation of court life in Italy's golden age that we possess. The painter actually witnessed it, and the two main scenes, one outdoors (*The Meeting*), one indoors (*The Signing of the Contract*), take us straight into the world of marriage diplomacy, ceremony, intrigue and secret manoeuvring we read about in letters and chronicles. That world was later described by Machiavelli in *The Prince* and by Castiglione in *The Courtier*. But Mantegna's cold brush brings it horribly to life. I say horribly because, though there is exquisite beauty in the room, particularly in the rendering of the young, their elders have hearts of ice. There are many marvellous things in this enchanted room, includ-ing an eye or painted lunette in the ceiling, which introduces the new technique of *di sotto in sù*, whereby figures are deliberately distorted to look natural when seen from the ground looking up—something Mantegna discussed with Donatello, whose original trick it was. It prefigures the work of Correggio in the next generation. Yet there are no tricks about the figures, which have a Flemish realism. They are the

actual faces of living people—fifteenth-century Italians of the urban, courtly breed, whispering in ready ears, hiding their deepest thoughts, making honeyed speeches, dissimulating and boasting, cutting a *bella figura* while keeping their poignards sharp, strutting for effect and feigning every kind of emotion—the women less numerous but more cunning than the men. The vicious-looking dogs are authentic too. Castles, houses, churches and countryside vividly depict the north of Italy. As in all Mantegna's works, one learns a great deal because, though a master of illusionistic devices, he always tells the truth.

Mantegna was a man of iron-hard integrity. Like Ghiberti and Donatello he was monumentally conscientious, slow, unbiddable. One admires the heroic patience of the proud Gonzagas, who put up with his ornery ways and maddening pedantry. Piero della Francesca seems to have been another incorruptible, though little is known about him: his birth-date could have been any time between 1400 and 1420, though we know he died in 1492. His father was a tanner and his own first job was to paint the striped poles used to carry candles in religious processions. Yet such was the upwards mobility of the times, intellectual as well as social, that he made himself a master mathematician and played a bigger role in the spread of Euclid's geometry than anyone else. He wrote a number of learned treatises, three of which survive, including an exposition of the rules of perspective, *De prospectiva pingendi*, which demanded more mathematical skills than most painters have ever possessed.

Perspective and geometry figure both prominently and subtly in all Piero's works. He liked to organise large, plain masses of colour in patterns which suggest an underlying geometrical scheme. That gives his paintings the unfinished look which moderns like. He made a positive virtue of the light palette which the use of old painting methods forced on artists. There are always large areas of white or near-white in his works, the skies are big, light and sunny, and this pleasing radiance, combined with the absence of meticulous clutter, makes his paintings enormously attractive to our eyes. All this was carefully considered and deliberate. If we compare the two sections of altarpieces in the National Gallery, London—*The Baptism of Christ* (1459–60), and *The Nativity* (1475–80)—the light-tone colour scheme is the same in both, though for the first he used egg tempera and for the second oils (both are on panels of poplar). His *Saint Michael*, in the same gallery, is also light-toned and the saint is framed by his white wings and a white marble balcony. Yet this is an oil-painting too.

Piero always, as it were, goes against the grain of expectation. He never seems to have belonged to a workshop and travelled over a large part of Italy, a freelance, perhaps a lonely figure. He made no attempt to please his contemporaries by doing what they expected. In *The Baptism of Christ*, attention is likely to centre on the unknown background man taking his shirt off, a beautiful piece of painting which has no point other than the love of fine design, or on the angels gazing suspiciously at the near-naked Christ. In the *Nativity*, the Christ-child is insignificant compared

with the chorus and orchestra above him, and their male conductor. In the *Resurrection*, set in Piero's home town of Sansepolcro, Christ emerges somnambulistically from a sarcophagus against which the sleeping guards lie—a strange and disturbing image. In his finest work, the wonderfully light and sparkling *Flagellation* in the Ducal Palace, Urbino, Christ and his tormentors have been pushed into the background, while three unrelated figures, who are not even watching the scourging, dominate the scene.

Piero's only rival, indeed, is Sandro Botticelli (1445–1510), another great painter who died in obscurity. He remained unloved until, in the mid-nineteenth century, John Ruskin and the Pre-Raphaelites rediscovered him and Walter Pater wrote a highly rhetorical eulogy in his book *Studies in the History of the Renaissance* (1873). Botticelli is superficially an easy, substantially a very difficult painter, whose work has not yet been made coherent by the historians. Perhaps it is incoherent. It is certainly discrete and unstable. Like Piero, he came to use oil and tempera, but with dark backgrounds which bring out the white flesh of his subjects in a luminous and enticing way. But where Piero was static, Botticelli was fluid, sinuous, dynamic, with a strong, elastic line, so that his figures are put down onto the surface rather than built up out of it. Both artists believed in strong outlines, Botticelli to the point of passion, and this is one source of his power to create ineffaceable images.

As a young man, Botticelli had no alternative but to carry out standard religious work, including frescoes in the Sistine Chapel, and a superb *Adoration of the Magi*

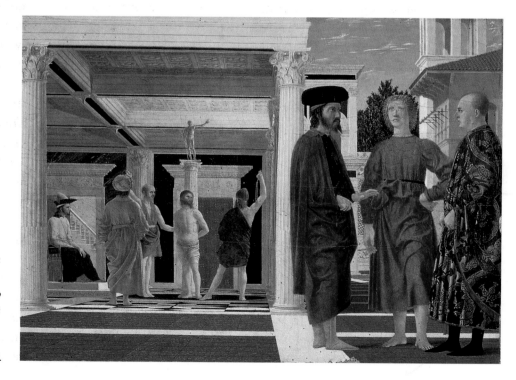

Piero della Francesca was so fascinated by perspective he pushed the subject of this work, *The Flagellation of Christ*, into the background.

(Uffizi), which showed he was as good as any of his contemporaries at this kind of hack-work. Then came his first conversion, to the magic world of the antique myth. It has been argued that it was the writings of Marsilio Ficino and the neoplatonic philosophy fashionable in the late 1470s, especially in the Medici circle in Florence, which led Botticelli to switch to secular subjects, containing deep and hidden meanings. Who can say? The evidence is not there, either way. It may be that the artist merely pounced on the myths as marvellous new subject matter which exactly suited his talent. His mythical paintings, *The Birth of Venus*, *Primavera*, *Minerva and the Centaur*, and so on, most of them now in the Uffizi, are astonishingly attractive, and again testify to the power of the image. Botticelli's beautifully clean-outlined figures wriggle and dance and weave themselves into undulating patterns interwoven with flowers and trees, sea, sand and grass. His long poplar panel *Venus and Mars*, in the National Gallery, perhaps done for a marriage celebration of the Vespucci, is lovable and funny. Four enchanting fauns tease and mock the sleeping Mars, while Venus, who sees no joke, is not merely virginal but looks like the Madonna herself. It may be that Botticelli believed that Beauty is the visible token of the Divine, using Thomas Aquinas's 'Fourth Proof' of God's existence, 'the proof from beauty', and that therefore there was nothing incongruous in making the Virgin and Venus interchangeable.

That was doubtless an acceptable view among the Medici but it did not go down well with the stiffer element in the Church. In the 1490s they captured power in Florence, in the person of the noble Dominican preacher Girolamo Savonarola. Christianity was on the verge of the greatest convulsion in its history, the Reformation, which might well have occurred in late-fifteenth-century Italy, rather than in the Germany of the 1520s. The demand for the reform of a frivolous, corrupt and increasingly secular world was there, and Savonarola could command frenzied mobs by his impassioned sermons against excess and his pleas for a return to apostolic simplicity. In the 1490s he set up a Florentine Republic, what he called a Christian Commonwealth, a proto-puritan theocracy which, in the next century, Jean Calvin would successfully create in Geneva. During this decade he held two public 'bonfires of the vanities', in 1495 and again in 1498, just before he was driven from power by a conspiracy of the powers-that-be, secular and clerical, strangled and burnt. At these bonfires, society ladies and hysterical gallants cast their finery and jewels onto the flames, while the crowd howled in approval, torches whirled and choirs sang the Miserere. The atmosphere was infectious and had a devastating effect on the close-knit artistic community of the city, which felt it was under indictment. We know, for instance, that one aspiring artist, Baccio della Porta (1472–1517), decided there and then to drop his secular pursuits and join the Dominicans, thus becoming Fra Bartolommeo, one of the sternest depicters of Virgins and saints.

Lorenzo di Credi (*c.*1458–1537), who took over Verrocchio's shop, the largest in Florence, destroyed all his secular paintings. Vasari insisted that Botticelli did the same. Indeed, it may well be that Savonarola's bonfires were the greatest conflagra-

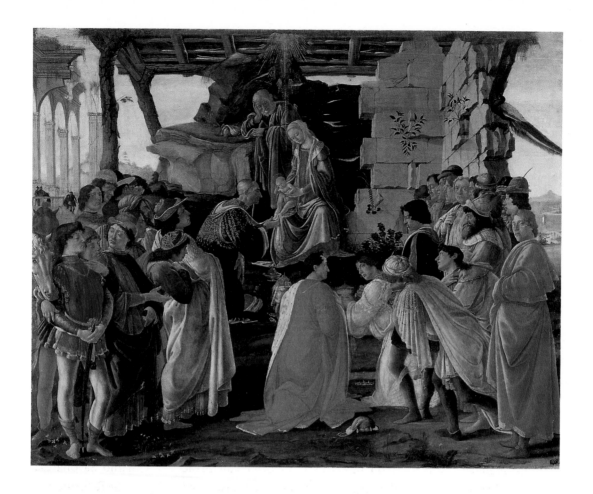

tion of high art in the whole of history. Botticelli's role is in dispute. We know his brother was an ardent follower of the friar. On the other hand, after Savonarola's execution, Botticelli went on working for his opponents among the Medici family. It was not the same work, however. It became ecstatic, peculiar, mystic and credulous. As art, it degenerated in the most tragic and distasteful way. The National Gallery has two examples of this last phase, both from the early years of the new century: a *Mystic Nativity*, in which inebriated angels dance wildly, embrace and squat all over an ill-composed manger scene, cast in a distorted form of social perspective with a huge Virgin; and two primitive scenes of miracles from the life of St Zenobius, in which Botticelli (for it is clearly he) has reverted to old-fashioned tempera and cringing piety. It is a sad fall.

Botticelli's declension coincided with the end of Florence's paramountcy in art. Lorenzo the Magnificent had died in 1492. His city was never the same again after the Savonarola episode, which aggravated the depressing effects of the French invasion of 1494. Florence was a proud city with a strong corporate identity which, in the arts particularly, revolved around the universal assumption of its citizens that it was the centre of civilisation. The pillars of this certitude were the big workshops with their fantastically high standards and fierce spirit of competition. They were never so strong as on the eve of Savonarola's irruption. There was, for instance, the shop run

Botticelli painted the *Adoration of the Magi* (1473–75) in his twenties, using members of the Medici family as live models with a naturalistic setting.

by the Pollaiuolo family, mainly by Antonio (*c*.1431–1498) and his brother Piero (1441–1496). Antonio specialised as a goldsmith and practised this craft to the end, though he did many other things too. He designed embroidery, for instance, made stained glass and cast superb bronze statuettes. Both brothers painted, and together they produced the gigantic *Martyrdom of Saint Sebastian*, one of the glories of London's National Gallery, a brilliant exercise in the presentation of the nude or semi-clothed male.

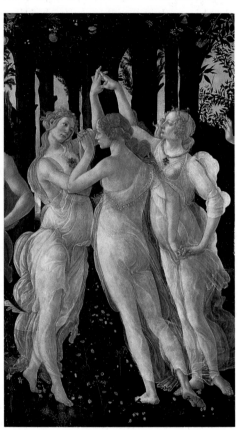

Antonio was perhaps the first painter to focus on the male nude. Medieval artists had kept well clear of nudity, except for Hell scenes. But from the 1470s it became a subject in which the Florentines, with their tradition of expert draughtsmanship, specialised. Not only did they draw from the nude (males chiefly; women, except prostitutes, willing to pose nude were rare) but, as in Antonio's case, they studied anatomy. His remarkable engraving *The Battle of the Nude Men*, which displayed his knowledge proudly, was much copied and proved immensely influential among younger artists. It was also, no doubt, the kind of thing the friar wanted to cast on his bonfire. 'Male nudes—what next? We will be having female nudes soon!' In fact, the study of how the body worked was precisely the kind of exact, scientific knowledge which humanists sought. A large workshop, like the Pollaiuolos', not only employed models regularly but kept stocks of anatomical casts in plaster. The brothers did a lot of drawing of bodies, often engraved for the new printing industry. But they did countless other things. They made banners for tournaments, and material for state ceremonies and triumphal entries—arches and the like. Both, and especially Piero, were among the first in Florence to use oil on panel.

Detail from *Primavera* (1477–78), or *Spring*, by Botticelli, which shows his development into a painter of poetic allegories and classical fantasies.

A much bigger workshop was run by the Ghirlandaios, Domenico (1449–1494) and Davide (1452–1525). They came from a background of humble craftsmen working in a variety of soft goods—leather, cloth, tapestry, cushion material and upholstery—and employed numerous members of the family

in skilled work of all kinds. The turnover was vast. Domenico was the business brain. But he was also the shop's senior artist and technician. He organised it so well that he could occasionally afford to leave it; thus, he worked in Rome, producing the best of the lower-range frescoes in the Sistine Chapel. For Santa Maria Novella in Florence he painted a grand series of frescoes remarkable for their durability. Indeed, he was probably the most accomplished master of this difficult medium in history. He took it seriously at a time when younger artists were switching to oil, and his care ensured that his work in it still looks fresh. His maxim was: quality first and all the time. His shop produced a wide range of the highest quality luxury art goods, even including mosaics, something which the Florentines usually left to Venice. More important, he drew beautifully. Large numbers of his drawings have survived and can be examined in the British Museum and Berlin. For the first time we can see exactly how a conscientious Florentine craftsman built up a finished picture. He was the epitome of all that was professional and disciplined in Florentine art in the broadest sense, always striving to excel and experimenting with new media and techniques. He tried oil, oil and tempera, brush-tip drawing like Van Eyck, chalk, pen and ink, and metalpoint. He did drawings with white highlights and brush drawings on prepared linen. Vasari lists Michelangelo among the many artists who learned drawing in the Ghirlandaios' workshop.

The most famous shop of all, however, was Verrocchio's. His figure-sculpture and bronze-casting were particularly good, and the shop can fairly be described as a powerhouse of ideas and a technical college teaching a wide variety of skills in different media. We have already noted that the shop made full use of every kind of aid to high performance. We see this in Verrocchio's own painting, *Tobias and the Angel*, in the London National Gallery, an exemplary response to a competitive work on the same subject by the Pollaiuolos. The painting is delightful and deservedly popular. Nothing illustrates better the freshness and joy of art at this time. But it is trade. The masters only did the angel. Young Leonardo da Vinci, who was in the shop for several years and learned a lot, both from the *patron* and from Lorenzo di Credi, was entrusted with Tobias. He also did all four hands, the two left hands, which are identical, being done from studio casts. The right hands are a bit suspicious too. None of this detracts from the excellence of the work. But it is a reminder that we must not take too elevated a view of the Florentine art shop. It was a business venture, whose chief object was to get lucrative commissions, execute them at a profit, and excel or fend off the competition. It was part of a Florentine commercial continuum, from the counting-house through the wholesale cloth warehouse, to shops selling embroidery and coloured shoes. It catered to the sometimes vulgar taste of rich parvenus as well as producing works of genius we now venerate.

Verrocchio was killed by overwork, in my judgement. He just lived to finish his Colleoni statue in Venice, which he must have regarded as his finest effort—it was certainly the most arduous and technically difficult—but he died the same year,

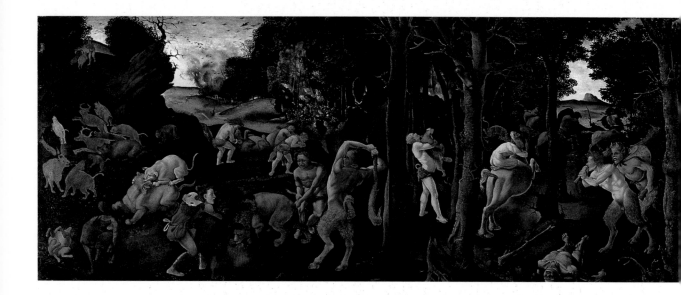

Piero di Cosimo, an eccentric bohemian, produced strange fantasies such as this *Hunting Scene*, showing men, animals and satyrs in confused but enchanting conflict.

1488. Domenico Ghirlandaio died six years later, only forty-five, the year the French invaded and the friar first established his grip. Both the Pollaiuolo brothers succumbed during the Dominican anti-art terror. That was the end of the era of the all-powerful Florentine studios. Fra Bartolommeo was always a conformist, though a good one. Lorenzo di Credi became one—he had never been much of an individualist anyway, though his grand *Madonna and Saints* altarpiece in the cathedral of Pistoia is well worth going to see as an exercise in high Florentine craftsmanship. There were some curious survivors. Piero di Cosimo (1462–1521) was an outsider, a hermit. He specialised in animals and landscapes, which he drew and painted with a skill and sympathy almost unknown among his fellow Florentines, who were obsessed with *Homo sapiens*. One gathers that Piero would not have minded much if men were eaten by wild beasts. There is, in the Metropolitan, New York, a *Hunting Scene* which depicts a savage struggle for existence in prehistoric times. Piero was interested in the dark past, not in a scholarly but in a saturnine, imaginative way. He painted pictures with titles like *The Discovery of Wine*, in Harvard's Fogg Museum, and *The Discovery of Honey* (Worcester, Mass., Art Museum). Mythology fascinated him but he made it up to suit his mysterious purposes. His weird *Death of Procris* (London, National Gallery), with its long-eared faun, magnificent dog and other animals, and its desolate estuary, combines his obsessions. Vasari says Piero lived on hard-boiled eggs, preparing them fifty at a time while boiling glue for size. He loathed noise, especially children crying, flies buzzing, church music and bells, old men coughing. He could paint memorable portraits when he chose—see his *Simonetta Vespucci* in the Musée Condé at Chantilly—but he did not so choose, as a rule. It is not surprising that he taught another hermit oddity, Jacopo da Pontormo, whom we will come to presently. Thus the Golden Age of Florentine art ended in eccentricity.

13

THE ROMAN CLIMAX OF ART
AND ITS CONFUSED
AFTERMATH

Art history teaches that, with the decline of Florence in the 1490s, leadership shifted to Rome, and its ambitious, free-spending popes, whose enlargement of the papal dominions, and still more its revenues, gave them funds which even the Medici had not possessed. Thus, goes the scenario, there occurred the 'High Renaissance'—to which all that had happened in art had been leading; this constituted the climax of Europe's artistic greatness, from which there has been nothing but descent. The heroes of this version are Leonardo da Vinci (1452–1519), Raphael or Raffaello Sanzio (1483–1520) and Michelangelo (1475–1564). Each has been described as the greatest artist who ever lived, and the fact that, though of disparate ages, they were briefly contemporaries, and in Rome together, gives the eternal city a unique glow at this time. But the true story is much more complicated, and essentially sad, determined not so much by the power of genius as by its weakness, and the frailty of human flesh.

That all three men possessed astonishing gifts is obvious. Let us take Raphael first. He was indeed a child of fortune, and in the exquisite self-portrait he did in pen and ink when he was fourteen (Oxford, Ashmolean) he looks it. He was born in Urbino, where the great Federigo de Montefeltro had created the most civilised court of the age. He was taught to paint by Pietro Vannucci, known as Perugino (c.1446–1523), than whom it would be hard to find a better master. Perugino was a product of Verrocchio's shop and of the college of artists set up by Sixtus IV to do the lower walls of his Sistine Chapel. He had a sentimental eye and a lush contour, and it is sometimes said that careful comparison of his drawings with those of the youthful Raphael reveals all kinds of inadequacies. Yet he could paint a lovable Madonna and an elevating saint as well as anyone of his generation. Better indeed. A study of his finished work, especially his two masterpieces, the *Pietà* in the Accademia, Florence, and the *Assumption* in the Uffizi, makes one see why contemporaries called him the best painter in Italy, even while admitting he was 'too sweet'. He taught Raphael everything he knew, and that was a great deal. It says a lot for the young man's

aesthetic and emotional integrity, and his cool, calm taste, that while he avoided all of Perugino's faults, he also absorbed his undoubted strengths and built on them.

Raphael, indeed, was always what Jane Austen called a 'sensible man'. He was industrious, well-organised, good-tempered, patient, modest, while quite properly self-possessed, respectful to his superiors, kind to his inferiors, a decent man it was a pleasure to have dealings with, whether you were a pope or a woman. His output was large, continuous, invariably of the highest possible quality, and finished. Patrons found him the perfect painter: truthful, reliable, always doing exactly what he said he would do, and on time. He ran what became a large studio, using his assistants efficiently and in ways which were fair both to them and to his patrons. His one fault was that he did not sufficiently control his followers. His work falls into two main categories. There is the large-scale fresco and decorative work that he did for the Vatican Palace under the direction of Pope Julius II. And there are the devotional easel works and altarpieces, mainly of the Virgin and Child, sometimes with minor figures. He did portraits too, notably a fine presentation of Castiglione, which has taught generations of portrait painters how to set about it. The drawings on which he based his work are numerous, elegant or powerful, true to nature without exception, and have never been surpassed in quality, before or since.

There is, about Raphael, a kind of confident ability which transmits itself to the viewer. There is no pretentiousness or mystery. With Raphael, what you see is what you get. His paintings in the Vatican, such as *The School of Athens*, are intelligent large-scale organisations of superbly modelled figures which have guided 'history painters' from the sixteenth to the late nineteenth centuries. There are no obscurities. Raphael never went in for hidden meanings, shocks, nastiness, horror or thrills. On the other hand, they are a wonderfully inventive set of variations on a theme that is absolutely central to Western religious art. Together with Michelangelo's *Pietà*, a copy of which every religious house or Catholic school possesses if they can afford it, Raphael's Madonnas are the most effective forms of devotional aid.

These beautiful paintings do exactly what they set out to do: inspire piety in the religious-minded and rapture in the aesthete. The Madonnas are real, loving women who are also queens of Heaven, painted with consummate skill, never repetitious, without the smallest hint of vulgarity, always serene and tender, devoted and reverent. Julius II summoned Raphael to do God's work in paint, and that is exactly what he did. Over the centuries, first in black-and-white prints, then in chromolithographs, oleographs and in coloured photogravure and offset, down to the almost miraculous reproductions we enjoy today, these holy pictures have been reproduced more often than any other, for hanging, all over the world, in every religious institution and the homes of the pious. They are familiar enough to risk boring us but never actually do so. To study these noble paintings close to, as they still exist after half a millennium, is to appreciate what enduring art is all about.

There was one thing wrong with Raphael: his health. He took on too much,

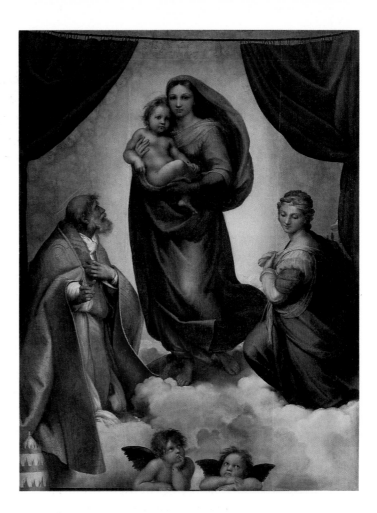

Raphael sought perfection in his short life and sometimes achieved it. Of all his presentations of Mary and Jesus, *The Sistine Madonna* (1512–15) comes closest to pure spirituality, with Mary ascendant but the two cherubs earthbound.

never let anyone down, exhausted himself and died pitifully young, only thirty-seven. This adds a dimension of tragedy to the fact that there was an element in him which does not fit into this model of decorous proficiency. One part of him rejected serenity and sought transcendence. One of his Vatican frescoes, *The Fire in the Borgo* (*c.*1514), presents terror and anarchy and the mob appealing for a miracle. Raphael was a materialist who longed to believe in the supernatural with all the absolute credulity of the medieval world, which was now slipping away. Medieval painters could present the supernatural and did it all the time. But they could not convey it by painterly technique of atmospheric light and subtle suggestiveness. Raphael could. Normally he did not choose to do so. His Madonnas and 'sacred conversations', with saints posed together in seemly adoration of the divine, are tender and elevating but stick to nature. However, in *The Sistine Madonna*, now in the Dresden Gallery, Raphael depicts a Virgin and Child of astonishing beauty and absolute solidity and reality, who nevertheless are not of this world and seem to be levitating upwards by spiritual power. They are poised between earth and Heaven. It is the painting of a vision and astonishingly successful.

Raphael followed this trend in his magnificent last painting, the huge *Transfiguration*, completed in the year he died, 1520, and now in the Vatican Museum.

Christ floats above the astonished apostles, realistically painted yet a mass of light and air. But at the bottom of the painting there is a scene of chaos, as his disciples try and fail to cure a frantic boy whom demons have seized. It is not surprising that this work awed contemporaries and made them revise their opinions of the 'sensible man'. By this point Raphael had widened his range anyway. He had succeeded Bramante as architect of St Peter's. He was involved more and more in 'total art', embracing building, sculpture and decoration as well as painting. While working at the Vatican he was befriended by the delightful Pinturicchio (Bernardino di Betto, 1454–1513), a master of decorative pictures, who did the Borgia Piccolomini Library at Siena Cathedral. He taught Raphael a lot. Indeed, the decorations Raphael was producing at the end of his life were astonishingly original and of a rich beauty which was quite new to him. But the last paintings suggest he was driving far deeper as well as moving wider, and there are no limits to what he might have achieved had he lived a normal span. His early death is the biggest single loss in art's history.

Leonardo da Vinci had died the year before Raphael, a much older man in his sixties, his work incomplete for quite different reasons. Raphael was a 'sensible man'. Leonardo was not, and never could have been if he had lived to be a hundred. He ought to have learned how to organise himself in Verrocchio's shop, where everything was in its place and done according to plan. But though he learned about art in that disciplined school, he did not take in the need for order in his life. He was a middle-class intellectual, not a craftsman. He came from a background of well-to-do Tuscan notaries, though he was illegitimate and brought up by grandparents in a large, extended family. We do not know much about his education but it was clearly extensive. His time in the shop taught him how to earn his living in a variety of ways, and he did some good work while he was there. But there are also hints of the disasters to come. While still in the shop, in 1478, he was given an independent commission to do an altarpiece in a chapel of the Palazzo della Signoria. But he never got round to it, or never began serious work on it. Filippino Lippi had to be called in to carry it out.

What was the trouble? Leonardo's gifts were enormous, and obviously so. Nobody ever doubted them, at the time or since. No one who saw anything he did, even a mere drawing, failed to admire him. He was in constant demand by the mightiest patrons, from leading Florentines to the Sforzas of Milan, the Medici pope Leo X, and two kings of France, Louis XII and the fastidious Francis I. He was the universal man, the embodiment of the questing spirit of the age and its desire to excel in every way. But his weaknesses were also obvious. He was interested in every aspect of the visible world. His earliest surviving dated work is a brilliant Tuscan landscape drawing, unusual in itself for the times. He was fascinated by the varieties of nature. His interest in the human body, in all its forms and moods, was obsessive. But he was interested in these things as phenomena and viewed them with scientific

detachment. There was not much warmth in him. He may have had homosexual inclinations. In 1476, when he was twenty-four, he was accused of sodomy. In any case nothing came of the complaint, which was anonymous. There is no evidence that Leonardo ever committed himself to anybody, man or woman.

Leonardo's huge range of preoccupations meant that his time and energy were thinly spread. He studied weather and waves, animals and vegetation and scenery, machines of all kinds, invented and imaginary. He was particularly keen on weapons of war and fortifications. Note-taking and diagram-making seem to have occupied him more than any other activity, and they covered everything from articulated flying machines, muscular power, optics, geometry, hydraulics, siege engines, bastions and fields of fire, facial expressions, human physiology, the traction-powers of horses, the parabolas of flight, the ways in which organic forms grow; indeed almost anything which came within the purview of science in the sixteenth century. Leonardo's priorities were unclear. We do not know whether he regarded painting an easel portrait like the *Mona Lisa*, or an important commission like the *Last Supper*, done on a Milan refectory wall, or designing an impregnable fortress as the thing he most wanted to do or felt was most worth doing.

The comparison with Samuel Taylor Coleridge is inescapable: notes took the place of finished work, and speculation became a substitute for settled opinion. That Leonardo, like Coleridge, was an expansive talker goes without saying. That was one reason great men competed to employ him: they loved to hear him expound and answer their queries about the limits of human knowledge. As he grew older, and sprouted a long white beard, people held Leonardo in awe: he was the sage, the magus, the Man of Genius, the prophet of the age. But he was a difficult man to employ on something specific. His glittering career was punctuated by rows over intolerable, inexplicable delays, disputes over money, presumably arising from his un-business-like methods, and repetitive, simple failures to do what he had promised. He acquired a reputation for non-delivery. As one pope put it: 'Leonardo? Oh, he is the man who does not finish things.' He was certainly not lazy, as some artists are, or tiresomely perfectionistic. Rather, he lacked the will to single out what mattered most and tackle it. His final output was meagre. There are only ten surviving paintings which are generally accepted as his. Three others are unfinished. Yet more were completed by other hands.

In Leonardo's favour it must be said that, when he did finish something, it was work of the highest quality, interest and originality. When Vasari said he started the second great wave of painting, he was right in the sense that all artists of the day, even the greatest, were stimulated by something or other in Leonardo's work. Raphael, for instance, though a far better draughtsman, adopted his device of using red chalk, especially in nude studies. Such inventions quickly became clichés. He broke out of traditional poses, groupings and compositional devices for religious paintings, and invented alternatives, which were quickly copied. Occasionally his work approached

perfection. In 1490 he produced his *Lady with an Ermine*, now in the Czartorychi Museum in Cracow, Poland, which many would nominate as the finest of all easel paintings. It is an oil on panel, beautifully composed and full of fascination—the woman was a favourite of his Sforza patron. It combines charm, dignity, indeed majesty and mystery in equal proportions. The right hand, and the exquisite creature it is stroking, are painted with a decisive skill that testifies to Leonardo's devotion to nature. The gaze of the girl, enigmatic as always with Leonardo, is unforgettable.

Yet the fact remains that this panel is one of the rare occasions that a patron got what he had ordered from the maestro. Who commissioned the *Mona Lisa*? Whoever he was, he must have been disappointed. Leonardo worked on the portrait over many years, intermittently. It shows his unsatisfactory methods of working—the face and the hands are woefully inconsistent. The London National Gallery's *Virgin of the Rocks* also had a long and disrupted history. So did the *Virgin and Child with Saint Anne* in the Louvre. Those who are not so overwhelmed by the universal adulation heaped upon Leonardo that they are still capable of examining his work objectively find much to criticise. Leaving his delays apart, his passion for experiment produced disasters of a different kind. The Sforzas asked him to paint scenes on the walls of the refectory of Santa Maria della Grazie and he actually completed the *Last Supper*. It

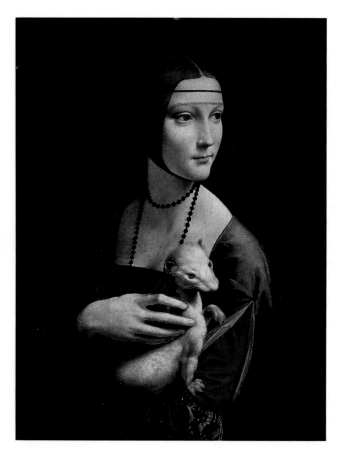

was instantly applauded for its highly original composition and the sheer interest of the faces. But his experimental techniques led to its rapid deterioration and the beginning of a long, tragic history of decomposition, botched repairs, and the virtual disappearance of his original work. Other ambitious wall scenes in Milan, and in Florence too, came to nothing, or only fragments survive.

Yet Leonardo somehow found time to work on a huge bronze equestrian statue, accepted the appointment of 'architect and general engineer' to the ruffianly warlord Cesare Borgia, produced a design for the crossing-tower of the controversial cathedral in Milan, and did various large-scale cartoons, of enormous interest and great beauty—or so we are told; only one

Lady with an Ermine (1490) by Leonardo da Vinci is his most perfect work. The woman speaks for herself but tells us no more than her pet.

survives—for projected paintings which were never done. At least two contemporaries complained that geometry prevented him from painting at all. The dominant theme of the last years of his life was his obsessive interest in the prospect of catastrophic storms and other extreme weather conditions.

It is worth repeating that Leonardo's influence on his contemporaries and immediate successors was immense. This applied both to the organisation of large-scale paintings, where his *Last Supper*, which could then still be seen in all its glory, was determinative, and to painting techniques. His *sfumato* method, combined with the adoption of oil-painting, led to a move away from hard outlines, of the kind Botticelli employed with such success, and towards a more rounded, painterly technique in the sixteenth century, with more attention to shadowing, the systematic use of highlights, and *chiaroscuro*. This was one of the most significant innovations in Western painting. Nothing was published of Leonardo's extensive writings on painting until the seventeenth century, but they must have circulated in manuscript and were known in a wide artistic circle. His discovery, for instance, that 'correct' mathematical perspective did not actually produce what we think we see and needed adjustment, had an impact. Raphael was not the only painter who followed Leonardo's practice of drawing in black and red chalk, often with white highlights, on various shades of paper. Thousands of artists made use of it after him, often with spectacular results.

It is also regrettable that we know so little of the interrelationships between the three great artists who dominated Rome at this time. It is fair to assume friendly relations between Raphael and Leonardo, though they cannot have met often. What Michelangelo thought of Leonardo we do not know. But he seems to have been jealous of the rapid success of Raphael, a younger man who was working in Rome at the same time. His friend Sebastiano del Piombo, also in Rome from 1511, used to feed Michelangelo anti-Raphael anecdotes. Why? Presumably because he thought the master wanted to hear them. The difficulty for Michelangelo in his relations with Raphael was that he considered himself, and was, primarily a sculptor. He painted little before he came to Rome to produce his three great series of frescoes (the Sistine Chapel ceiling, the *Last Judgement* on the altar-end wall, and the Pauline Chapel). What little he did in two dimensions raises insoluble problems. The National Gallery owns an early work, *The Entombment*, in oil on wood. Like everything Michelangelo did, in any medium, it is full of interest. But it is unfinished. Two years later he painted, in tempera, a panel known as *The Virgin and Child with Saint John and Angels* (also as the Manchester *Madonna*). This too has great charm. For no clear reason, the artist bares the Madonna's right breast, though she is not suckling. But at that point, painting from right to left, he appears to have lost interest, and nothing more was done. His only documented painting on panel, the *Doni Tondo* in the Uffizi, is a powerful work, quite unlike Raphael's Madonnas, but obviously competitive with them. Perhaps that is why it is (more or less) finished.

When he came to the Sistine Chapel ceiling, he was obviously on show and on

his mettle. Julius II's idea, when he first asked Michelangelo to paint the ceiling, was much simpler and maybe more appropriate. The painter replied that it was a 'poor' idea, meaning it was not big enough for a man of his talents, and did not allow him to cut a *bella figura*. Hence when the pope enthusiastically accepted his enlarged project, he was hoist with his own spectacular complexities. He had to go through with it. The Sistine Ceiling is a great physical achievement, apart from anything else, given the intrinsic difficulties of the medium, the area to be covered and the awkwardness and height of the location. It took four years, with one long and other minor interruptions, so it was painted at speed, which produced both simplicity and crudeness—but then it was done to be seen from the ground, not in close-up colour photographs. So Michelangelo, when under pressure, could carry through an immense undertaking. But one is bound to ask: what might not the artist have produced had he not spent so much time and energy on this controversial undertaking? There are some memorable images, such as God giving Adam the touch of life, which was thrilling until endless photographic repetitions turned it into a stale cliché. But in general Michelangelo was trying to achieve idealised forms with his prophets and sibyls and other figures, so there is little attempt to portray character or individuality. Because of the distance between surface and viewer, there is no arresting detail or subtlety in tone, colour or light. Much might be unkindly described as superior scene-painting.

Looking up at this huge mass of biblical adventures, smiling sibyls and hirsute prophets, one sometimes feels that it fits Dr Johnson's put-down of Milton's *Paradise Lost*: 'No one ever wished it longer.' No one ever wished the ceiling larger. At least it has unity—Michelangelo completed it in two tearing campaigns, the second much more successful. The scheme has power. In places it has beauty too. Everyone liked it, or said they did, a mark of conventional approval that has continued to this day. (There is more argument about whether its recent restoration has improved or degraded it.) Artists admired it, then and ever since, relieved that they themselves were spared such a horrible and difficult task, glad that a mighty art warrior like Michelangelo took it on and made it work. It has all the artist's *terribilità* and set new standards of heroic history-painting in the grand manner. As such, it was an important event in European art. What more can one reasonably ask?

The *Last Judgement* is a different matter. It makes much more practical artistic sense than the ceiling—a major, unified subject on a single wall, like a giant canvas. It is much easier to look at and into. The congregation of cardinals and other prelates, attending Mass, would find their eyes drifting upwards during the *longueurs* of the ceremony and exploring the writhing pyramids of bodies ascending the wall to Heaven or tumbling down it to Hell. The impact is frightening, as it should be, and therefore edifying. The colour is gruesome, as is also right. The work is the apotheosis as well as the damnation of the human form, or perhaps one should say the human male form. Michelangelo, already old, worked with a forceful energy and a grim determination which gives the painting dynamism and even a sinister glory.

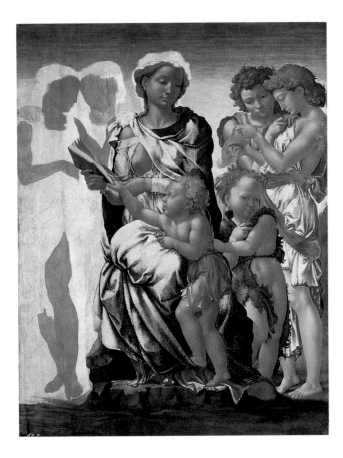

Michelangelo's *Virgin and Child with Saint John and Angels* is unfinished, like so much of his work. It is the effort of a sculptor to create ideal forms in two dimensions and radiates divine dissatisfaction.

It cannot be judged from photographs or TV sequences and must be studied and endured on the spot, no easy task in view of the jostling crowds which throng the chapel at all public times.

There is a salient weakness in all these grand projects. Michelangelo was a true humanist. He was man-centred. He never showed any interest in landscape painting other than to denounce it. It was German nonsense. All his attention was devoted to the body. He never showed any desire to locate his figures. While Leonardo was fascinated by all natural phenomena and used realism and dream-worlds for backgrounds, and while Raphael gives us some delectable glimpses of early-sixteenth-century Italy peering out from behind his Madonnas, Michelangelo would not demean himself (as he saw it). In this sense he was the quintessential painter of the new art. But his refusal to put the world into his paintings means that a large part of reality is missing. On the Sistine Ceiling, God creates the sun and moon as geometrical abstractions, round lumps. In the *Last Judgement*, the blessed ascend into nothing and the damned plunge down into a vacuum. All these great decorative schemes consist of closely woven human vignettes existing in aether. Michelangelo regarded the human form as the most beautiful entity in the universe. Maybe it is, but there are other things too. In the end, the sheer quantity of human musculature makes you wish to pass on.

The sack of Rome in 1527 was a blow from which the 'High Renaissance', which was essentially a matter of papal patronage, never recovered, even though

Michelangelo himself, its embodiment, lived on until 1564. The papacy itself was increasingly embroiled in the struggle to contain the Protestant Reformation, which became a serious threat in the 1530s, with the defection of England and much of Germany. It also needed to reform itself, a process begun by the Council of Trent (1545–63), and to regroup its resources in the Counter-Reformation. This began in the 1520s with the formation of three new orders, the Capuchins, Theatines and Barnabites, and continued in the 1540s with the creation of the Jesuits, who in an astonishingly short time spread across the world, building churches and schools. All these events had their effects on art, as we shall see. For the moment, however, it meant that Rome had a different order of priorities from the agenda compiled by Julius II, on which artistic patronage came immediately after the extension of papal power and wealth.

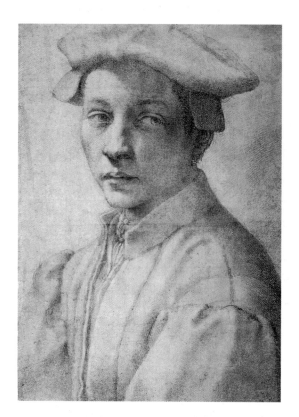

That left the artistic paramountcy in Italy to Venice. Economically it was in long-term decline as the Ottoman Turks slowly absorbed its once-extensive possessions in the Mediterranean. It was on the military defensive in the Adriatic. But the city itself bore a charmed life in the sixteenth century. It also escaped the ravages of the religious wars, remaining Catholic but keeping papal authority at bay.

Hence Venice was the natural setting to carry on the work of Florence and Rome. It had, as we have seen, a long tradition of artistry of all kinds. From the second quarter of the fifteenth century, it had begun to produce great painting, thanks mainly to the Bellini family. Its patriarch, Jacopo, whose brilliant draughtsmanship we have already noted, married his daughter, Nicolosia, to Mantegna. Jacopo himself, the son of a pewterer, was taught by Gentile da Fabriano, so we have here one of the most densely woven artistic networks of the times. His elder son, Gentile (c.1429–1507), was a Venetian court painter of eminence who used the Venetian background to great effect in his work. He also worked in Constantinople, painting a portrait of the sultan, Mehmet II (London, National Gallery), and used his Eastern notes to produce an exotic background to his superb townscape, *Saint Mark Preaching in Alexandria* (Milan, Brera), which features camels and a giraffe. His *Miracle of the*

Michelangelo's portrait of a boy explains why his drawings are the first by any artist to be treated as major works of art in their own right. As many as five hundred survive.

True Cross at the Bridge of St Lorenzo (Venice, Accademia) is a superb depiction of his native city, in which the buildings, painted in minute detail, including the tulip chimneys, are really the chief characters.

Indeed, as a townscape painter, Gentile Bellini was surpassed only by his disciple, the great Vittore Carpaccio (*c*.1460–1525), whose many identifiable Venetian back-grounds, including the marshes and lagoons as well as the city itself, make him one of the most fascinating realists of the time. He specialised in cycles from the lives of the saints—St George, St Augustine, St Jerome, St Ursula—which are now to be found in Venice's Accademia or in the *Scuole* which originally commissioned them. As in the northern tradition which Venice absorbed, Carpaccio combined an element of fantasy with immensely naturalistic detail of background, dress, human quirks, features, animals, trees and vegetation. He could show exactly what a scholar's sanctum contained (*Saint Augustine in His Study*) or what it was like to shoot fish with arrows at dawn in the lagoon. He was particularly ingenious at introducing dogs into his pictures. St Augustine has one. So do the two ladies of Venice who, in a notable painting, full of mystery, watch events from a balcony (Museo Correr). Between them, Gentile Bellini and Carpaccio laid the foundations of the Venetian school of townscape which culminated in the eighteenth century with the work of Canaletto and Guardi. Gentile's *Procession of the True Cross in the Piazza San Marco* gives us the façade of the basilica, while Carpaccio's *Miracle of the True Cross* (Accademia) displays a wonderful panorama of people and events, in, around, across and on both sides of the old Rialto Bridge, which makes it one of the world's most popular paintings.

However, it was Giovanni Bellini (*c*.1430–1516), the younger brother, who became, in Vasari's view, the foundation figure of the Venetian school. Vasari says he was ninety when he died and Dürer, on another of his visits, testifies to his painting as well as ever in extreme old age. He never left Venetian territory and seems to have had a passionate attachment to its scenery, which peers out from behind and sometimes towers over the figures in his altarpieces and other paintings. It is often a rustic landscape, with farmers working in their fields and cattle browsing. It has echoes of Flemish work and of the Limbourg brothers. Bellini argued robustly that it was not necessary to travel to improve his work. Venice was still the busiest crossroads in Europe, and Bellini could see there Dutch, Flemish, French and German work—and often painters, such as Van der Weyden and Dürer—as well as what was being produced in Lombardy, Tuscany and Rome. He absorbed and transmuted all these influences into a highly personal and distinctive style that nonetheless constantly progressed, as his skills, always formidable, developed and his interests widened. He was at the centre of the technical revolutions which made oil-painting dominant, which introduced easel-painting and made portraiture popular. He had a wonderful eye for a face and huge skill at getting it down on panel. He broke the old Venetian tradition that a ruler could only be presented in a formal 'medal' profile, by showing the Doge Leonardo Loredan in an almost frontal position (*c*.1502–1503, National

Gallery), a faultless work which many would rate one of the best half-dozen portraits ever painted. At the same time, his renderings of the Madonna and Child made bishops and canons flock to employ him. He applied prodigies of inventiveness and imagination to renderings of hackneyed subjects like *The Drunkenness of Noah*, *The Repentant Magdalen* and *Saint John the Baptist.*

Giovanni was in his lifetime, and remains to this day, one of the most popular artists, and the reasons are obvious. He drew with all the grace of his father and brought his paintings up to a high finish that delighted all. His women seem the essence of tenderness. He put in many charming touches, such as the boy instrumentalists seated at the foot of the Virgin's throne in his San Giobbe altarpiece (Accademia), a device imitated many times. His fame all over the region attracted many students to his studio—Titian, Sebastiano del Piombo and Lorenzo Lotto were probably among them—and he was regarded north of the Alps as the greatest painter in Europe. But he was still willing to learn, absorbing new ideas, picking up tricks from the next-generation-but-one, in the person of Giorgione.

That even the aged Bellini was willing to learn from Giorgio da Castelfranco (*c*.1476/8–1510) is not surprising, for Giorgione was a special kind of artist, full of new and surprising desires, who specialised in small oils done for a select circle of

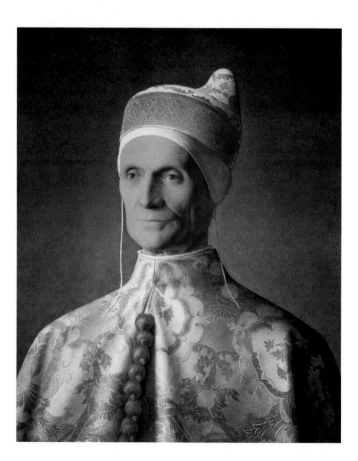

The *Doge Leonardo Loredan* (1501–1505) by Giovanni Bellini shows how a great master can turn a formal state portrait into both a penetrating study of character and an image of beauty.

admirers and private patrons. Bellini must have watched him carefully when the youth was still in his shop, for Giorgione early developed a capacity to set a mood by creating atmospheric backgrounds. Sometimes the background takes over, as in *La Tempesta* (Accademia), where a sultry storm hovers over an almost-naked woman suckling a baby, watched by an armed man. X-rays show that he changed the composition several times and we know that, as early as 1530, people were wondering what it all meant. It was Byron's favourite painting precisely, as he said, because it had no laid-down subject and those who saw it could make up their own tale. At least we know that Giorgione painted it. We can be equally certain about only three more works: a grimly pensive portrait of a girl, *Laura* (Vienna, Kunsthistorisches), another work in Vienna, *Boy with an Arrow*, and a brilliantly supercilious *Portrait of a Young Man* (Munich, Alte Pinakothek). Half a dozen other pictures are usually accredited to Giorgione. The *Madonna*, in San Liberale, Castelfranco, shows the Virgin seated loftily above and quite detached from two saints—a weird composition, which almost by accident becomes a powerful image. In Vienna there is another mystery picture, *The Three Philosophers*, which may be, as some claim, the Magi looking for the star, though half a dozen other explanations have been suggested. Again, the image is arresting. About *The Sleeping Venus* (Dresden Gallery) there is no

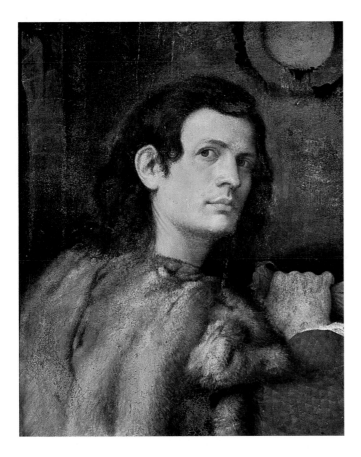

Bellini's pupil Giorgione painted this *Portrait of a Young Man* to break new ground in depicting sensuality, drama and atmosphere. But the plague ended his short life.

mystery; it is simply a superb nude, painted obviously for the love of women. The only question is whether the hand is Giorgione's. *The Fête Champêtre* (Louvre) also has a mystery subject. Two naked women are picnicking with two clothed musicians in a bosky setting. What are they doing? No answer. Is it by Giorgione? Possibly. Or it may be by Titian. Or by both. Giorgione died suddenly of the plague at the age of thirty-five, leaving many unfinished pictures. They were completed by those who had worked with or under him, including Titian.

At one time, sixty-six works were classified as by Giorgione, an output on about the same scale as Raphael's, who died at a similar age. But most have been gradually eliminated by modern art historians. Yet it was Giorgione who pointed to the future, for without him there could have been no Titian.

Tiziano Vecelli (*c*.1485–1576) was the first truly international painter, and during his time painting became an international business. From his base in Venice, where he absorbed all that was most accomplished and saleable in the 'modern' school founded by Giorgione, Titian worked first for patrons in the Veneto, then in the north of Italy, then for such world figures as the Emperor Charles V and his son, Philip II of Spain. In its early stages, his work was a compendium of Italian art as it existed at the end of the first quarter of the sixteenth century. Gradually, it bound together most of what was fashionable in European art, so that for the first time we can see it as a whole.

The power that made Titian the most sought-after painter in Europe is well illustrated in his great oil on canvas *Bacchus and Ariadne* in London's National Gallery (1522–23). It was one of three works Titian created for Alfonso d'Este, duke of Ferrara, for a *camerino* (small room) in his castle. The duke's idea was to make the room a setting for all the leading painters of the day, but Raphael, Fra Bartolommeo and Michelangelo failed to contribute. So Titian, never lacking in self-confidence, supplied a *tour de force*, incorporating, besides his own ideas and those of Giorgione, what he thought the missing painters might have contributed. The *Bacchus* is a stunning work, wonderfully vivid and lively, full of innovations. Painters mined it for a century and a half. Its beautiful Mediterranean sky of blue with clouds, painted from life, became a cliché and was still being imitated by Poussin in the mid-seventeenth century. The trees, also taken from nature, are superlative and dominant. There is a wide, distant landscape, leopard and a lion and a barking dog, an enchanting child faun, a writhing snake, rich vestments, a lady clashing her cymbals, another rattling her tambour, a vast amount and variety of movement, a score of classical allusions which the educated would perceive as they read the picture like a book—in short, Titian provided good value for money, as he always did. The duke must have been pleased. Indeed, we know he was.

Building on the work of Raphael as well as Bellini, Titian laid down the parameters within which portraiture would be conducted. He moved from the old-style head-and-shoulders, often in profile, to the half-length, three-quarters and even full-

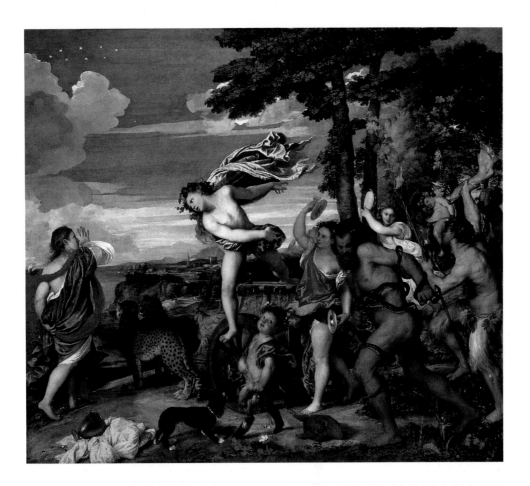

length. He painted the face from all angles. He got the most out of the richest possible draperies in strong, warm colours. He painted the Emperor Charles V on his warhorse with huge success, thus setting another fashion which lasted until the age of Bonaparte. He painted Pope Paul III, specialising in conveying shiftiness, piety and auster-ity. He painted scores of beautiful women, clothed and unclothed,

dwelling on their voluptuousness and sensuality, and occasionally their intelligence. His portraits filled the rich, the powerful and the famous with awe, and made them anxious to sit for him. They drove other painters back to their studios itching to use the brush in emulation. The brushwork was the key, for though we know Titian drew well in his youth, few drawings from later periods survive, he seems to have worked directly on the canvas with only slight under-drawing and often with no preliminary sketches at all. The Florentines did not like this, for they thought a work should be composed not of lines but of forms, and that colour is an intrinsic part of them. He built up the forms with colour, not lines. It allowed for spontaneity, abrupt changes of mind or atmosphere. It unleashed the genius of a master painter. You could argue that it was as great a change as the use of oil paint itself. But it was open to abuse.

Titian painted for over three-quarters of a century, and his style, methods, sub-ject matter and presentation changed periodically during this long professional life.

During the 1540s he was in violent mood, as the three large ceiling canvases he did for Santa Maria della Salute in Venice, *The Sacrifice of Isaac*, *Cain and Abel* and *David and Goliath*, indicate. In the 1550s he painted for Philip II, a generous patron, a series of erotic works, *Venus and Adonis* and *Danaë* (both in the Prado) and the beautiful *Perseus and Andromeda*, now in London's Wallace Collection. He himself called these works *poésie*. In a way they are poetry; both mystic and misty.

Towards the end of his life, like many great painters, Titian became convinced that what mattered most in art was light, and the way it determined shapes and colours. His *Shepherd and Nymph* (Vienna, Albertina), done *c*.1570, is an example. Shapes dissolve, lines disappear, light and colour combine to determine what is going on, not always clearly, for the old man often dropped his brushes and carried on painting with his fingers. Titian had more influence on future painters than any other artist of his time,

Titian's *David and Goliath*, a ceiling painting in Venice's Santa Maria della Salute, is an exercise in violent action to shock the spectator gazing up from below.

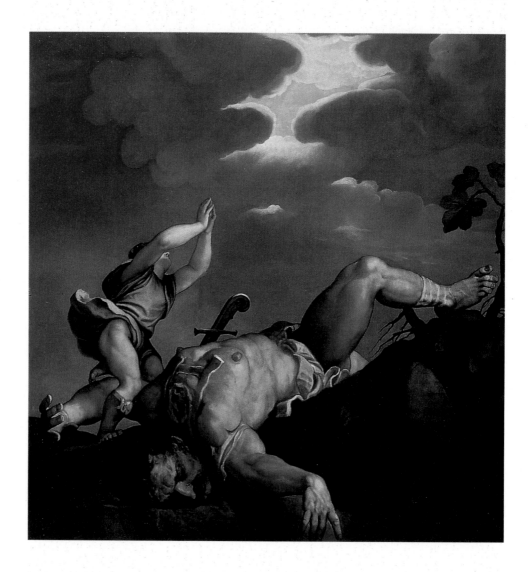

except Leonardo, and his influence was more direct because painters learned from close examination of his work. But it would be untrue to say that painting was the most important thing in his long life. His chief passion was money, and the way in which he gouged it out of patrons probably contained more valuable lessons for artists than his technique.

Titian, like Michelangelo, tended to overshadow his contemporaries, though two contrived to achieve a distinct style. Lorenzo Lotto and Palma Vecchio were both born about 1480. Palma—his real name was Jacopo Negretti—lived only till 1528 but his specialty of rich, sensuous, colourful female half-lengths made him highly popular among the Venetian middle class. These ladies could be either Virgins or female saints, or mythological goddesses, according to the desires of the patron. The same models, Venetian women picked out of the markets, served for both. The London National Gallery's *Flora* is typical of this type. Palma turned them out by the score, but few have survived. He never signed or dated them. Lotto lived to be nearly eighty, travelled widely and varied his style. He had a marked sentimental streak, which makes his religious paintings cloy occasionally, though it must be added that later artists constantly imitated his favourite facial expressions. He was ultra-Venetian in his rich colouring, and very Italian in his religiosity. His real skill was in portrait work, where he learned from Titian and sometimes surpassed him—his *Man on a Terrace* (Cleveland Museum of Art, Ohio) is a masterwork.

Sebastiano del Piombo (*c.*1485–1547) was born five years later than these two but was also a graduate of the Bellini shop. It is a pity he did not write an autobiography, like Cellini, for it would take us into the heart of the sixteenth-century art world, its rivalries and vendettas. His was a case of a painter who lacked self-confidence, perhaps without real reason. His practice as an independent artist in Venice faltered, for he faced stiff competition from Titian, Giorgione, Palma and many others. His half-length of Salome, *The Daughter of Herodias*, in the London National Gallery shows, in fact, that he had power and originality, but he decided otherwise, and went to Rome in 1511. There he found the competition even fiercer, not so much from Raphael himself, as from his followers, who froze him out of big commissions. He turned, therefore, to Michelangelo, and formed a kind of partnership with him. The master gave him a hand with his powerful *Raising of Lazarus*, done in fierce competition with Raphael's *Transfiguration*. This work, in the London National Gallery, has to be supplemented by drawings in the British Museum which Michelangelo produced for the figure of Lazarus. The master may have drawn the Christ figure too. In short, Sebastiano's best work is suspect. But some of his portraits, with which Michelangelo had nothing to do, are remarkable, especially his *Clement VII* in the Naples Museum.

The only Venetian artist who challenged Titian—he was an entire generation younger—was Jacopo Robusti, or Tintoretto as we know him (*c.*1518–1594). He came from a local family of painters, stuck to Venice all his life and covered the walls of

many of its public buildings, including the Doge's Palace, with his work. The number of square yards he produced was enormous. There are at least eight *Last Suppers* by him, some on a monumental scale. He is not to everyone's taste. His colouring can be harsh. At times he is tremendous. His *Last Judgement*, painted in his own parish church, the Madonna dell'Orto (where he is buried), excels Michelangelo's in the Sistine Chapel by far, both in terror and majesty.

Tintoretto was able to create such works by what is usually said to be a development of Titian's painting technique but may well have been entirely his own invention. This is called *prestezza*—a series of rapid brushstrokes, creating impressions of faces and objects rather than working them out in detail. Tintoretto was an impetuous man, fretfully impatient of detail and the labours of verisimilitude—the exact opposite of a Van Eyck. He dashed at his work, dabbed furiously at the canvas, then stood well back to see the effect. His major paintings are designed to be seen from a distance rather than minutely inspected from close-up. But of course most people, especially patrons who are paying for it, want both. They survey from afar the general effect, then move in close to inspect the workmanship. Many of them in sixteenth-century Venice considered Tintoretto's paintings unfinished. It is a charge which, from now on, occurs periodically in the history of art. They wanted Tintoretto to have another go. He refused. So they went away discontented.

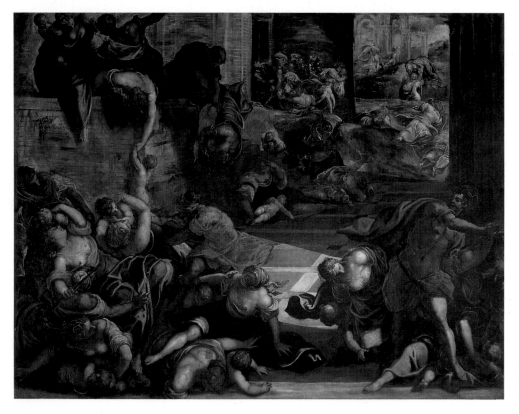

Last Judgement (1536–41) by Tintoretto, painted in his parish church in Venice, surpasses Michelangelo's version in the Sistine Chapel in its horror and fury.

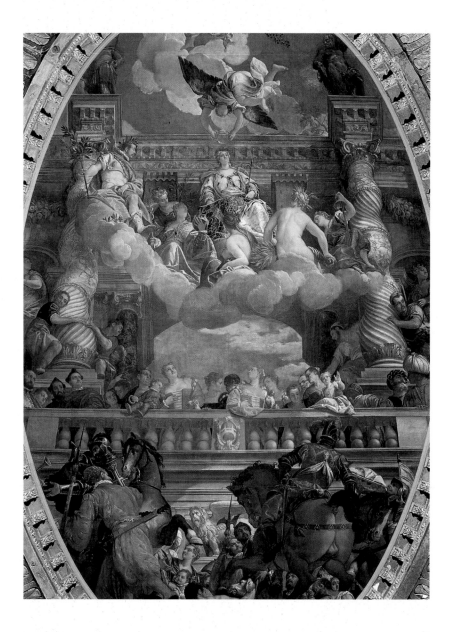

The Triumph of Venice (1585), a magnificent ceiling painting in the Doge's Palace by Veronese, set the fashion in luxury decorative art for a century.

By contrast, Paolo Caliari (*c.*1528–1588), who came from Verona and is known as Veronese, did all he could to satisfy the market. His father was a sculptor, and there is something exceptionally solid and three-dimensional about all his carefully moulded figures. He might have been an architect, for his elaborate architectural settings, in which figures peer over balconies and look up into huge buildings, showed how deeply he loved stone, marble and space. He was made for Palladio, who became his friend. The Villa Barbaro, at Maser, is a masterpiece they built and decorated together. Veronese is king of the sumptuous. His big pieces, whether religious like *The Marriage Feast at Caana* (Louvre) and *The Feast in the House of Levi* (Accademia), or secular, like *The Family of Darius Before Alexander* (National Gallery), are theatrical, indeed operatic, presentations of how the rich live. The rich loved them. The authorities loved them. His ceiling in the Doge's Palace, *The Triumph of Venice* (1585), is the

archetypal state painting, and a prototype for hundreds to come over two centuries. So Veronese ran a vast studio, helped by his brother, three of his sons and scores of assistants. He died rich. Tintoretto, by contrast, died so poor that his widow had to petition the community for help.

Thus Veronese and Tintoretto neatly, as it seems to us, rounded off one long phase of Venetian painting, beginning with Bellini. But art history is rarely so tidy. We now have to switch back from Venice to the rest of Italy. If the sack of Rome in 1527 ended the High Renaissance, what followed? Art historians, so fond of taxonomy, reply: Mannerism. The term was first used by writers early in the twentieth century, in imitation of other 'isms' then current—Post-Impressionism, Cubism and so forth. The ideology behind the use of the term was supplied by study of the Reformation and Counter-Reformation. I prefer to think of the time as a period of confusion. Between them, Michelangelo, Leonardo and Raphael—and other artists of the High Renaissance—had set alarming standards. If art was the story of progress, from good to better, whither did the artist travel when the best had been achieved? The answer is that he searched his mind and examined his skills, decided what he could do with particular effect—and what he wanted to do—and did it. Artistic individualism had now come of age. Each man had his own distinctive way of seeing things and of putting them down on panel or canvas—his *maniera*. But once artists emerged from medieval anonymity, they all developed mannerisms. It would be hard to think of a more mannered (though delightful) painter than Antonio Pisano or Pisanello (1395–1455), whose delicate paintings of birds and animals intrude unrealistically in many of his paintings, as though he could not keep them out. His amazing *Saint George* in the London National Gallery, in his mostly silver armour, and wearing an enormous straw hat to protect him from the sun-radiance of the Virgin and Child, is the most mannered picture of evil in existence. Equally mannered is Cosimo Tura (*c.*1430–1495), who makes everything he paints seem as though it was made of coloured metal—see, for instance, his Muse Erato, sitting on her metallic dragon-throne, also in the National Gallery. And there is the Venetian Carlo Crivelli (*c.*1435–1495), who places every subject, such as his *Annunciation, with Saint Emidius* in the National Gallery (1486), in a highly decorated architectural setting seen in crystalline light. If the taxonomy is right, these were Mannerists before Mannerism.

All the same, there were some particularly idiosyncratic painters in sixteenth-century Italy. The word 'idiosyncratic', which comes from the Greek Orthodox Church, signifies a man who works out his own individual way to salvation. That certainly applies to Jacopo da Pontormo (1494–1556). He was a product of the shop run by Andrea del Sarto (1486–1531), an accomplished painter of the 'classical' school, who worked up the methods of Raphael and Fra Bartolommeo into a system of normative art. He was thus the 'perfect' painter, as Vasari said, and it may be that Pontormo revolted against such perfection. Or it may be that he was appalled by

Andrea's subordination to his wife, said by Vasari to have been a horror—Robert Browning wrote an acerbic poem on the subject. At all events, there was nothing normative about Pontormo or his works. Or rather, people had their own peculiar faces and expressions which were normative to him. He does not seem to have worked from models, but invented humans in his mind. This is not so disturbing in his mythological works, which can be delightful. The fresco *Vertumnus and Pomona*, which he did around a lunette in the big salon of the Medici villa at Poggio a Caiano, is one of the most blissful entertainments of the time, though thought-provoking on close inspection. But his sacred scenes inevitably invite comparison with the established versions, and the results are disturbing. In his *Visitation* (Florence, Santissima Annunziata), three holy ladies are closely grouped together in swirling unity, unlocated in space, or time for that matter. The image is indelible and so the picture must be rated successful. But it prompts the query: what is Pontormo trying to tell us? The bigger group in the *Lamentation* (Florence, Santa Felìcita) is also enmeshed. Bits are tender and moving. The sorrowful faces are beautiful. The colours are radiant. He took the high tints of Michelangelo's Sistine Ceiling and made them glow. But it is not natural. Everything is unlocated, drifting in space.

Another product of Andrea's shop, Rosso Fiorentino (1494–1540), fled that temple of normalcy to set up his own visions. He too rejected drawing or painting from life. His great oil on panel, *The Deposition* (Volterra Art Gallery), is another piece of surrealism, elegantly conceived and painted with tenderness, but bearing no relation to what actually happened. The setting is not abstract; the faces are peculiar, though in quite a different way to Pontormo's, and the bodies are whimsical. It is Rosso's way of seeing things. These languid and strange reactions to the muscular energy of Michelangelo or the confident serenity of Raphael might, in a different context—the late nineteenth century for instance—be described as decadence. But how can this term be applied to two exceptionally hard-working and conscientious artists who believed passionately, during a time of religious trouble, in the faith they had inherited?

Both were peculiar men, though, Pontormo particularly—more of a hermit than the usual kind of gregarious artist. According to Vasari, he built for himself an upper-room studio, to which the only access was a ladder. Having stocked it with food and water, he would pull the ladder up after himself. Even his favourite pupil, Agnolo Bronzino (1503–1572), was sometimes denied access, or even a response when he shouted up his greetings. The pupil was more 'normal' than the master and became the most successful painter of his generation, at least in Florence. He did not disdain painting from life. He was court artist to the Medici dukes and painted society portraits for thirty years. He was admired for his superb draughtsmanship, for his lucid and transparent finish and for his virtuoso treatment of rich garments. Then came his peculiarity. His flesh tones were light and chilly. He froze faces in time and paint and made them peer out at us through an ice age. The rich of his age,

which saw the ravages of the Reformation and the beginning of the Wars of Religion, are made to seem stiff, unsmiling, inhuman, bloodless, as though sheathed in armour. Above all, he captured their haughtiness. But they liked to be seen that way, evidently. Now, once more, we in the twenty-first century like to see them thus, so Bronzino is fashionable again. Moreover, he could show a different side. His oil in the London National Gallery, *An Allegory with Venus and Cupid*, whatever it is supposed to say or mean—as with Giorgione's *La Tempesta*, the problem is probably insoluble—is one of the most intriguing, lovable and erotic works to emerge from the entire period. It hovers on the edge of bathos and failure. If Bronzino, during the actual painting process, had not radically changed the body position of Cupid, the whole delicate, flimsy construct would not have worked. As it is, hot blood races through those rosy limbs, there is naughtiness in every inch, and humour—so rare in great art—raises its smiling face. We have, as a result, a masterpiece of wit. No wonder the Medici, anxious to appease France at an ill hour, gave it to the lustful and sophisticated Francis I!

It was the Rabelaisian age. One suspects that many of these strange painters produced erotica, for which there was a rising demand. Certainly, Francesco Mazzola, or Parmigianino as he is known (1503–1540), worked for the trade. His numerous drawings of everyday life, including love-making, were prized, then and now, and occasionally he painted in the same vein: his *Cupid*, now in the Vienna Kunsthistorisches Museum, is a lubricious morsel, calculated to appeal strongly to both sexes. He died as young as Raphael and we cannot say where his prodigious talents would have taken him had he lived as long as Titian. Nowhere perhaps. His last major work, and his most celebrated or notorious, is a *Virgin and Child* attended by a group of delectable angels. The 'child' is an elongated creature 4 feet high and the Virgin's head is so far from her shoulders that this oil on panel (Uffizi) has always been known as *The Madonna with the Long Neck*.

Parmigianino came to maturity under the shadow of the great Antonio Allegri (*c*.1489–1534), known as Correggio after the town where he was born. Even the most hardened taxonomist does not class him as a Mannerist, though he was certainly mannered in some ways. The old art historians used to class him, along with Raphael, Leonardo, Michelangelo and Titian, as one of the Big Five of the Renaissance. Today his position is more precarious but rising again. We know hardly anything about him. Vasari says he was miserly, virtuous and prayerful. He was clever at picking up ideas. He took a lot from Mantegna and he was the first artist to use Leonardo's discovery of *sfumato* with originality. He also picked Leonardo's brains about light and its sources, and how to use *chiaroscuro* effectively. He took no notice of what contemporary painters were doing and, being highly original, this put him well ahead of his time. So everything he took from the artists before him he paid back with interest to those who came later. He did things no one had thought of doing

before, either because they could not be done or perhaps because they were not worth doing. In Vienna there is his *Io*, a strange picture of an ecstatic woman about to be seduced by Jupiter, who appears as a smoky cloud. It is painted as well as it could be, given the nature of the conjunction, but it requires a strong effort of the imagination to find it erotic, which presumably was Correggio's intention. His extensive knowledge of mythology led him to present other naked women in interesting situations. He decorated part of the Convent of San Paolo in Parma, on the orders of its abbess, a high-born bluestocking, with an elaborate umbrella vault, in which ovular glimpses of *putti* appear over semicircular classical fictive reliefs. It is entirely original

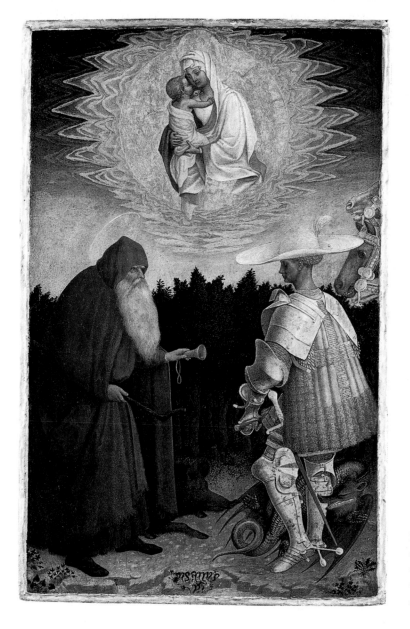

Pisanello, one of those gifted eccentrics who enliven art, painted this *Virgin and Child with Saint George and Saint Anthony Abbot* to display his personal taste in armour.

and done with ingenuity; and it gave ideas to successive generations of decorators right up to the eighteenth century. But it looks incongruous in a house of nuns.

Correggio was obviously conscientious, superlatively gifted, doing everything with skill and always hard-working. Was he deficient in a sense of humour? His oil on canvas in the London National Gallery, *Venus with Mercury and Cupid*, sometimes known as *The School of Love*, is unquestionably good-humoured—not the same thing—and deservedly popular. His lighting schemes were quite new. He used them for altarpieces and similar works. In *The Adoration of the Shepherds* (Dresden), the

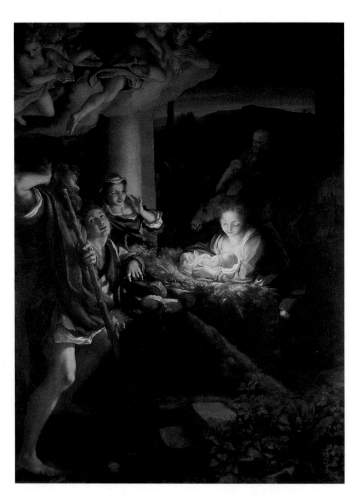

immensely powerful source of light appears to be the Christ-child himself, a brilliant new idea, carried out with enviable skill. It still leaves a strong impression on first being seen, so its impact at the time must have been prodigious. In fact, Correggio's discovery by the Carracci brothers half a century later led to a transformation of their work. But at the top left of the painting, a distinct floating cloud of heavenly bodies, quite outside the light-system of the work, is awkward and incongruous (and unnecessary). If Correggio had been able to laugh at himself he would have painted it out. He won a contract to fresco the dome, apse and choir of Parma Cathedral, the biggest task of his life. For the dome he painted the *Assumption of the Virgin*, and he worked it out in immense detail, with colossal supporting apostles, tiers of clouds and hundreds of swirling figures carrying the Virgin upwards. This immense work, which might have daunted even Michelangelo, is of course meant to be seen from beneath the dome at floor level, and Correggio used a range of illusionistic tricks and special perspectives to create his visual effects. It is the first time *di sotto in sù* was employed on such a large scale. The technical ingenuity and inventiveness are admirable, and the scheme made later artists marvel and seek to emulate the achievement. But it requires willing suspension of disbelief, indeed of mirth, to get by.

Correggio, master of *chiaroscuro*, invented the device, in *The Holy Night* (1513–15), of the Christ-child being the source of light.

Even more mannered, though quite impossible to classify, was the strange phenomenon known as El Greco. Doménikos Theotocopoulos (1541–1614) signed himself thus all his life, in Greek characters, usually followed by *Kres*, the Cretan, for he came from there. He studied at the Byzantine school on the island, intending to be an icon painter, but in his twenties he fled to the grander opportunities of Venice and Rome. It is said that he was a pupil of Titian; he certainly studied Michelangelo; and Tintoretto, above all, gave him ideas. Thus armed, he painted some remarkable works in Italy, *The Healing of the Blind* (Parma, National Gallery) and the striking presentation of Christ flogging the money-lenders in *The Purification of the Temple*, now in the Minneapolis Institute of Arts. Then, in 1577, he went to Spain where he spent the remaining thirty-seven years of his life. They liked him, called him 'the Greek' and gave him plenty of commissions. Each of his works is strange in a different way. His painting of a storm over Toledo, in the New York Metropolitan, has some claims to be considered the first monumental landscape. His *Burial of the Count of Orgaz* (Toledo, S. Tomé) is a masterpiece of sepulchral art. His portraits seem peculiar to us but were evidently popular, since forty survive. He was an obsessive and painted over one hundred versions of St Francis. His light is harsh and crude; his colours are icy-blue and tormented yellow; he elongates and elasticises his figures, as Parmigianino did, though his object in doing so was to produce an effect of spiritual anguish rather than beauty. It has been argued that his tendency to show limbs as longer and thinner than they are was the result of astigmatism. But he said he did it deliberately, arguing: 'The worst thing that can happen to a body is to be undersized.' Some consider him an uplifting genius. Others find his works garish and repellent. It is part of the richness of European art that it can accommodate oddities like El Greco. But he does not fit into any box.

And why should any of these gifted men? In the sixteenth century, art broadened and deepened, the number of artists increased dramatically, they travelled further and more frequently. Women joined the confraternity. We hear of women involved in the arts even in the Middle Ages, and they become much commoner in the sixteenth century, though nearly always the daughters of men in the trade. In 1566, Vasari visited Cremona and met the Anguissolas, a noble family that included six girls, all painters. Of them, Sofonisba (c.1532–1625) had a powerful talent, was permitted by an enlightened father to study with two masters, Campi and Gatti, and thanks to two tolerant husbands in turn practised painting all her long life, both in Spain and in Italy. She had the valuable gift of image-making. She herself looks up from the early keyboard instrument she is playing, a watchful duenna in the background, dimly seen (Northants, Althorp House). It is a memorable piece of work. Again, there is in the Academy of Fine Art in Poznan a remarkable triple portrait of three of her sisters playing chess—a vivid moment of concentration and suspense, captured by a sharp eye, and successfully recorded in two dimensions. Third, there is a brilliant and touching full-length of an unhappy ten-year-old boy, perhaps her

brother Asdrubale, one of the most penetrating child images of the entire century (1555, Baltimore, Walters Art Museum).

As artists travelled more, both to see and learn and teach, so ideas spread to constitute an ever-increasing international pool of methods, technologies, subjects and theories. Illustrated books circulated new notions even faster. The print, slowly increasing in quality, became an important source of artists' incomes and a means whereby they could study what was going on hundreds, even thousands, of miles from their studios. There is no doubt that, in the century 1450–1550, the main source of new ideas was Italy. Recent historical scholarship has suggested that artistic interaction north and south of the Alps was a two-way process rather than a simple acquisition of Italian ideas by still medieval northerners. This was the message, for instance, delivered by the Lorenzo Lotto exhibition at the National Gallery, Washington D.C., in 1997, the display of Renaissance art in the Netherlands at the Metropolitan Museum, New York, in 1998, and the exhibition 'Renaissance Venice and the North' at the Palazzo Grassi in 2000. The weighty catalogues which marked these important displays presented evidence of a northern contribution to the new art in Italy in considerable detail.

As against this, however, we have the direct contemporary evidence of Albrecht Dürer. We have given the reasons why, as a young man, he was determined to go to Italy. He learned a great deal, and he returned to learn more between 1505 and 1507. Dürer, I repeat, was an exceptionally hard-working and productive artist, with a range of techniques and a record of accomplishment which has seldom been equalled by anyone. There are 189 paintings by him listed in the complete catalogue compiled by Fedja Anzelewsky in 1991. Not all these documented works have survived; on the other hand, he undoubtedly painted others which we do not know about. There are also over 1,000 drawings by Dürer, about 350 woodcuts and 130 engravings and etchings, and the list of these works on paper is far from complete. Dürer engaged in many public activities, such as the creation of triumphal arches and festival material. No one in his day knew more about the practical aspects of art.

Late in life Dürer set down his impressions, notably in his 'Treatise on Measurement'. He said that Germany was full of budding painters, 'able boys' who were simply handed over to a master and told to copy his work. 'They were taught without any rational principle and solely according to the old usage. They grew up in ignorance like a wild, unpruned tree.' Dürer added that he had discovered in Pliny that the masters of antiquity, such as Apelles, Pheidias and Praxiteles, had studied the crafts of painting and sculpture scientifically and had written books about them. But these had been lost, and with them 'the foundations of art'. Hence, 'art was extinct until it was restored to life again in Italy, a century and a half ago'. He said that in Italy he learned the importance of mathematics, the need to measure every part of the human body to get accuracy, to apply oneself to perspective systematically,

so that properly drawn bodies could be placed realistically in space. Dürer was a modest man but he was also a determined one. He aimed by his book, he said, to show people outside Italy how art ought to be conducted.

Yet though the northerners learned a good deal from Italy when they chose, there was never any question of the artistic personality of the north being submerged, either in general or in particular. Some painters of the highest calibre remained almost impervious to the new art. Matthias Grünewald (*c.*1470–1528), whose real name was Gothart Nithart, was a contemporary of Dürer. He was by profession a hydraulic engineer and an expert on mining. He held important jobs in this capacity. But he also painted altarpieces and other oils on panel. Virtually nothing was known of him until he was rediscovered by German Expressionist painters at the end of the nineteenth century, to whom he became a cult figure. Since then he has become the subject of intensive scholarship, thirty-five of his drawings have been identified—excellent ones too—and one or two paintings have come to light.

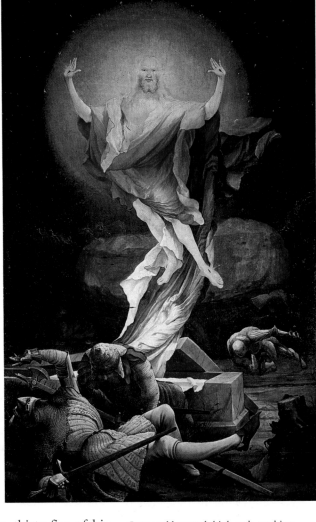

Grünewald created this breath-catching Isenheim altarpiece (1513–15) by intensifying the fierce emotions of late-medieval German art and expressing them with Italian skills.

Essentially, Grünewald was an artist of the old school—that is, he pushed medieval methods of depicting images in two dimensions as far as they could be carried without recourse to antiquity. There are two beautiful oil panels of saints in Karlsruhe, a remarkable oil on panel called *The Meeting of the Saints Erasmus and Maurice* (Munich, Alte Pinakothek) and one or two other works. But essentially he created altarpieces centred on the Crucifixion. Most have disappeared. We know that three were stolen and sunk at sea during the Thirty Years War. One was destroyed in 1729. Two have survived in a poor state. There are various bits and pieces in Munich, Karlsruhe and Dresden. A *Small Crucifixion* is in the National Gallery, Washington, D.C. The most important and best preserved survivor is the Isenheim Altarpiece in Colmar (Musée d'Unterlinden), which has a startling crucifixion scene. It is also a work of mystery. The outer wings open to reveal the Virgin, an enchanting, very south German lady, hugging her child who has just emerged

from his bath. There is a tremendous mountain-and-storm background. All kinds of realistic touches, in true northern manner, abound: a bed with well-used sheets and pillows, a chamber-pot and a rough wooden bathtub. But this last object intrudes into an amazing scene of delectable blond angels vigorously performing a concert, set against a late Gothic architectural background which, considering that the work was done 1512–15, was a deliberate rejection of the new art of the south. Art historians have puzzled over this work for a century and failed to solve its enigmas. Anyone who takes the trouble to journey to Colmar can reach a personal verdict on one of the most enigmatic masterworks of Western art.

Other northern artists, of whom there were a large number, many of exceptional talent, throughout the sixteenth century, reacted in different ways to the new art. While Dürer was on his second visit to Italy in 1506, another contemporary of his, Lucas Cranach the elder (1472–1553), was painting an altarpiece, *The Martyrdom of Saint Catherine*, in oil on limewood, which is now in Dresden. Cranach is an uneven painter, known chiefly for his emaciated high-breasted nudes, Eves and the like, which would have disgusted Michelangelo and made Titian laugh. But in this triptych, he produced a masterpiece which neatly combines references to the new learning with old German artistic customs.

Albrecht Altdorfer (c.1480–1538) was another eccentric German, from the upper Danube, who made his living as a practical architect, building slaughterhouses, warehouses and city walls. But he also did paintings, on panel and parchment, of which nearly eighty survive. Most are small, done for friends, but there are some big altarpieces, notable for outlandish compositional ideas. His *Birth of the Virgin* (Munich), for instance, shows that the birth has taken place in a huge four-poster set in the choir of a church, shown in superb perspective, with rings of cherubs encircling the columns. What Altdorfer really cared about, however, was landscape, especially the deep, dark forests of Germany, and the mountains and lakes of the Alps. The background of his enchanting work, *Rest on the Flight into Egypt* (Berlin), is not the East but Upper Austria, presented in elaborate details and with skilful love, though the fountain in the foreground is Italianate. That is a typical touch of the times. Altdorfer was a considerable artist on paper—120 drawings, 125 woodcuts, 78 engravings and 36 etchings survive—and he introduced landscape material not only when appropriate but on every possible occasion. He was the first major artist to use printing as a means of persuading collectors, all over Europe, to take an interest in the depiction of nature. The places he drew can be identified: he had the German passion for accurate detail. He seems to have been one of the first artists to look at clouds carefully and speculate on their composition, to relate trees intelligently to landscape and townscape, and to recognise that inanimate nature was a living force as fascinating as the men and women moving in it. All this was new, and promising; but it did not come from Italy.

Printing was the powerful but invisible factor in the spread of artistic ideas at this

time. A good example is the Holbein family of Augsburg, founded by the elder Hans (*c*.1460–1534), and culminating in his marvellous son, another Hans (*c*.1497–1543), but also embracing a dozen other members who worked in the arts. So far as we know, none of them ever went to Italy, though they travelled a lot on and around the axis of the Rhine. But from woodcuts in books, and prints and drawings, they were able to absorb as much of Italian art as they wished, and the younger Hans showed himself an accomplished master of all the tricks and techniques of the new art, as well as a man who sipped cautiously at its spirit. He was a northern painter, first and last, conscientious, serious-minded, totally dedicated to reproducing the exact truth by a meticulous use of his wonderful skills. He used antique motifs for surrounds and decoration, but his heart was in the tradition of the Flemish masters. As a young man

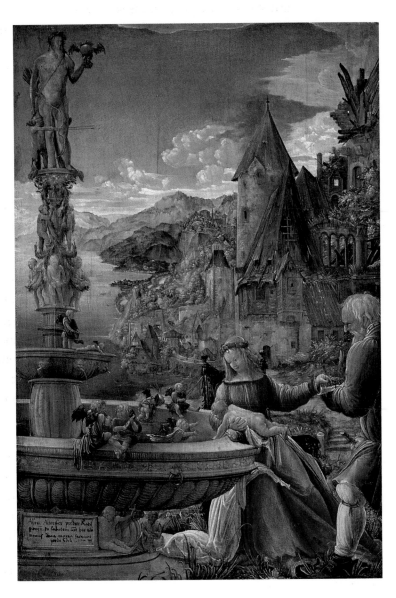

Rest on the Flight into Egypt (1510) by Altdorfer displays his northern brilliance in setting biblical events in landscapes combining realism and fantasy.

he worked for religious bodies. His so-called Meyer Altarpiece of 1526–30, now in the Grand Ducal Palace, Darmstadt, is the culmination of the great work which Van Eyck had begun and Rogier van der Weyden continued. The radiant Madonna, as beautiful as any which Raphael had produced in the two previous decades, gazes down with her babe—a real child—on the pious Burgomeister Meyer and his family, lustrous in soft velvets and crackling in starched linen. It is hard to say anything useful about this fine work, for its virtues speak so clearly for themselves. Holbein never skimped a detail or omitted a painterly effect when he saw the opportunity. His works, like this one,

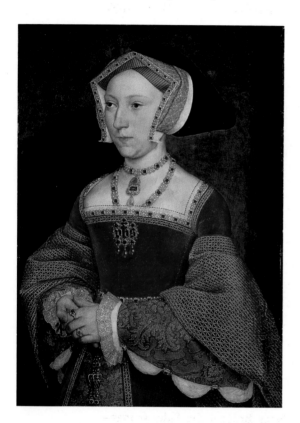

demonstrate the sheer quality of his skills and the endless trouble he took to employ them generously in every part of a painting. His touch was light and also invisible—he anticipated Vermeer in this respect—and it was sympathetic and tender too, especially to women. His likenesses were exact, without any sacrifice of truth, yet always considerate. He was the perfect portrait painter.

Portraiture, indeed, became his speciality, especially in England, which he visited twice: in 1526–28, and then from 1532 until his death, as court painter to the ambitious Henry VIII. Holbein's career spanned the early phases of the Reformation. His sympathies were clearly with reform, as some superb woodcuts testify, but he could see the point of both sides: in the Frick Museum, in New York, his speaking likenesses of Thomas More and his enemy Thomas Cromwell gaze intently at each other across a fireplace. Holbein did not care if a man was Protestant or Catholic, provided he was intelligent, educated and conversable. One of the finest and most interesting paintings of the entire sixteenth century is his double portrait, now in London's National Gallery, of the French envoys, Jean de Dinteville and Bishop de Selve, which Holbein did in 1533. The two full-length portraits are as penetrating as Titian ever managed but in addition the painting is full of northern detail to be unravelled. The famous anamorphic representation of a skull in the foreground has attracted most attention, but far more revealing are the various instruments of the new learning, from globes to musical scores, which mark the men as paragons of knowledge and taste. The work, as always with Holbein, gives a strong impression that he loved painting, not just as a living but as an endless adventure in

Hans Holbein, in this 1536 portrait of Henry VIII's favourite wife, Jane Seymour, displays his ability to combine accuracy with penetrating insight into character.

exactitude. He could convey power—none better—as well. His great mural of Henry VIII and his family, which survives only in a cartoon, was so impressive a feature of Whitehall Palace that Henry's matchless daughter, Elizabeth, used to stand in front of it when in her haughtiest moods, so that the grandees she sought to overawe would catch the likeness. His small oil on panel of Henry, the star item in the Thyssen Collection in Madrid, is perhaps the best portrait of a monarch ever done. It presents the man so accurately, and with such regard for his royal dignity, that Henry could not possibly have complained—indeed he was delighted, and loved to study the skill with which Holbein had rendered his magnificent clothes. Yet the self-ishness, arrogance, self-indulgence and malevolence of the subject's character are there for all to see.

Holbein's work is a prosopography of the early Tudor ruling class, aristocrats and adventurers, women and children, rendered as truthfully as decorum allowed. The three-quarter-length of Jane Seymour, the only one of Henry's wives to give him an heir, is one of the most moving documents of the age, done with a tenderness even Raphael would have found hard to match. Great ingenuity has been exercised by scholars in showing how Holbein produced such fine portraits. Over eighty pre-liminary portrait drawings survive, most of them in the Royal Collection at Windsor Castle. All are fine. Some are so good that they form major works of art in their own right. For drawing, Holbein used metalpoint and coloured chalks, sometimes water-colour, as in his touching little portrait on parchment of Henry's godson, the 2nd Duke of Suffolk, also at Windsor. This is a miniature, a form of art in which Holbein also excelled, and in which he instructed the artless English: portrait miniatures, by Nicholas Hilliard (1547–1619) and others, were the only form of high-standard work they produced until well into the seventeenth century. Indeed, inside the master of the new art was a craftsman of the old art, for Holbein could also do marvellous illu-minated capital letters, as a book in Oxford's Bodleian Library, given to Henry VIII as a birthday present, elegantly shows. But then everything he did has class.

Although born a generation later than Holbein, Pieter Bruegel the Elder (c.1525–1569) was at least as rooted in the old art; more so, indeed. On the other hand, he not only travelled to Italy, in a most pertinacious and all-absorbing manner, but did what few visitors had the hardihood to do: travelled its whole length and into Sicily. We think of him as 'Old Bruegel', but in fact he was only forty-four when he died, not old enough, alas, to instruct his tiny sons, Pieter and Jan, who thus never came near him in skill. I wish we knew more about him or that he had made some effort, like Dürer, to tell us what he was trying to do, for any detailed examination of his art reveals fascinating points of interest. To study him you have to go to Vienna, for the Kunsthistorisches Museum has twelve of his most important works. Of his large output of paintings only forty survive, most of them from the last decade or so of his life, more than thirty of them in the last five years. Considering the complexity

and finish of these works, his industry was phenomenal. It was as though he was preparing and learning, and then pouring forth all he had to give in one tremendous, concentrated effort, just before death swept him away.

Bruegel inherited the Flemish tradition of detailed 'reading' pictures, in which scores of separate incidents, illustrating a common theme, have to be read like chapters in a book. He was seen as a follower of Bosch, but that is misleading. Only one of his paintings, the striking *Dulle Griet* (Antwerp, Mayer Museum), a white witch character from folklore, presented on a plundering expedition to Hell, is truly in the Bosch vein. Most of his reading pictures, *Netherlandish Proverbs* (Berlin), *Children's Games* and *Battle Between Carnival and Lent* (both Vienna), for example, are mainstream storytelling, done with extraordinary ingenuity and skill. As a painter, Bruegel was a genius: his colour is exquisite and varied, his line elegant, the composition clear and firm, the lighting exactly cast for his purpose. These works were simply intended to give delight, and have succeeded, over four centuries.

As Bruegel matured, he showed a more sombre side. His *Triumph of Death*, in the Prado, is a set of variations on the theme that death wins in the end. He returned repeatedly to the futility of man's striving against nature—his *Tower of Babel* (Vienna) is a sensational image of the crumbling building and the despair of the ruler and his workmen. Yet it is clear that Bruegel also had a sharp eye for the enjoyments of life, and loved using his talents to illustrate them vividly. He painted ordinary people with affection and great attention to the details of their lives. Research shows that his *Peasant Wedding* (Vienna) is a precise visual account of how such a ceremony was conducted. His *Peasant Dance*, the second in a series on peasant life, and also in Vienna (the rest are missing), is of compelling interest to historians of folk-dance. No artist ever rendered human movement more convincingly. Even when the scene is apparently static, as in the London National Gallery's *The Adoration of the Kings*, there is a lot of movement going on which gives the picture a peculiar restless unity, reinforced by the twitching, grinning facial motions of the men, and by a colour composition of exceptional sophistication.

For a painting of movement, indeed, it is hard to excel the wonderful *Hunters in the Snow*, where sportsmen and dogs hurry down the slope to the welcoming warmth of the village below. This is one of the dozen best-loved pictures in the world. It is part of a series of six (one lost), three in Vienna, one in the Prague National Gallery and one in the New York Metropolitan, which depict *The Seasons*. It is a tragedy they cannot all be seen together, because even the best colour prints do not do them justice, and Bruegel evidently devoted much thought to the composition, tonal values and colours, to show the precise effect of the different seasons on the countryside. These are not pure landscapes by any means, for the figures are salient and impressive. Bruegel was a true humanist in the sense that he cared passionately about the appearance of ordinary individuals. All the same, they mark an important step towards the landscape, as a prime form of art, in that they

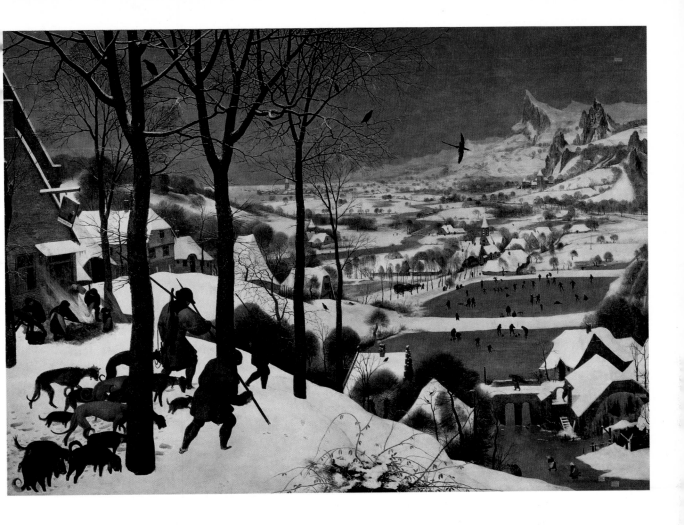

combine a precise rendering of its particular features with a powerful drive to present the essence of a view. Like Dürer, Bruegel studied nature intently, loved it, and succeeded in conveying this love in paint and line, so that his enthusiasm emerges repeatedly, especially in many of the sixty-four etchings and eighty drawings which have survived. But, unlike Dürer, he brought the landscape right into the centre of his work, and applied to the depiction of nature all the scientific principles of humanism.

Hunters in the Snow (1565) by Pieter Bruegel the Elder creates an unforgettable image by using snow to illuminate winter twilight.

We shall never know the extent to which Bruegel's work, especially on landscape, guided his successors. His paintings were in one or two princely collections and were not much seen by artists. He was largely forgotten or treated as a mere humorist, an exponent of peasant buffoonery, until right at the end of the nineteenth century. On the other hand, his etchings must have circulated. Merit and influence are not always connected. Much earlier in the century, Dürer described Joachim Patenier or Patinir (active 1500–1524) as 'a good landscape painter'. The words are significant and certainly this man from Antwerp not only made landscape his dominant interest—he often painted landscape backgrounds to other artists' religious figure-paintings—but actually devised a schematic colour system:

brownish foregrounds, greenish middle distances and blue backgrounds. His depiction of places, as in *The Flight into Egypt* (Antwerp, Koninklijk Museum), *The Baptism of Christ* (Vienna) and *St Jerome* (Karlsruhe, Staatlichen Kunsthalle), bear little relation to the reality of nature, but his system stuck and was adopted for generations by artists for whom painting in backgrounds was a duty rather than a pleasure. One might say the same for an even more influential artist at the end of the century, Adam Elsheimer (1578–1610), whose small settings of figures in landscapes, illustrating themes from Ovid and Virgil as well as the Bible, meticulously painted, often on copper, were much prized, imitated and studied. He spent most of his professional life working in Rome, an artistic crossroads where much patronage was still to be had and where painters went to learn. He depicted trees in leaf with skill and had stimulating new ideas about outdoor *chiaroscuro*, reflections, moonlight and firelight, as in his most successful oil on copper, *The Flight into Egypt* (Munich). His tricks left a mark on many greater men, such as Rubens and Rembrandt.

The case of Elsheimer, a minor painter by objective standards, shows the extent to which northern ideas were welcome in Italy by the end of the sixteenth century, at least if the painter was willing to travel there to expound them. But in general what the century witnessed was a gradual spread, all over Europe, of Italian classicism, or adaptations from antiquity. Three factors in particular pushed the process. The first was printing which, from the early years of the century, took the new art into workshops everywhere, so that by 1550 Italian visual techniques and patterns were to be found in silverware, pottery, tapestry, silks, rich cloths, painted wall surfaces (inside and out) and, not least, furniture.

The second factor was gunpowder, which encouraged campaigning over long distances. In the wake of armies came curious princes eager to collect. From the 1490s the French were in Italy, ravaging and looting but also learning and acquiring. Then came the imperial Germans, who marched up and down the peninsula, knocking over duchies and principalities but also keeping their eyes open for anything new. States were growing more powerful and centralised, so rulers had access to more money to spend on display and self-glorification. Architecture, the most visible of all the arts, led the way in employing new Italian forms and decoration to enhance the splendour of princes. Between the 1490s and the 1550s, the French Crown grew rapidly in strength and quadrupled its spending power, so it flexed its muscles not only in war but in building. Francis I was one of the most extravagant builders of all time, and along the banks of the Loire Italian ideas made their spectacular appearance, brilliantly transmuted by French taste and tradition, in a series of château palaces of huge size and elaboration—Blois, Chenonceaux, Azay-le-Rideau and many more.

Chambord in particular became one of the most remarkable buildings in Europe. These palaces had to be adorned and filled with beauty, so in the wake of the builders came the decorators, the furniture-makers and *tapissiers*—and the painters. Francis brought to his court not only Leonardo but two important working artists,

Rosso Fiorentino and Francesco Primaticcio, who made the latest Italian art the official court style and Fontainebleau its headquarters. French painting itself had languished since the death of Jean Fouquet (c.1420–c.1481), a superb draughtsman whose portraits, altarpieces and *pietàs* were up to the highest Flemish standards. But the school of Fontainebleau inspired French painters to compete with the foreigners, and the Clouet family (Jean, c.1485–1541, and his son François, c.1510–1572) produced some memorable portraits, including the son's *Lady in her Bath* (Washington, D.C., National Gallery), one of the great erotic images of the sixteenth century.

Henry VIII of England sought to compete with Francis, his rival, in all things, and this led to a good deal of imported art. Sometimes he was lucky. The Florentine sculptor Pietro Torrigiano (1472–1528), who had quarrelled with Michelangelo and broken his nose, could get no work in Rome and, after serving as a mercenary soldier, came to England in 1511. Henry got him to make the tombs of his parents in Westminster Abbey, and these gilt-bronze figures and their settings turned into a masterpiece, the most splendid of the Abbey's unique tomb collection. But Henry's taste was not, as a rule, so reliable. Francis himself sneered that, in art, Henry's instinct was always 'to add more gold'. The palaces he built were gimcrack and over-decorated, and have not survived. His only other piece of good fortune was to employ Holbein, introduced to him by Thomas More (whom he later beheaded).

A third factor in the spread of Italian art was the rise of the Habsburgs to pan-European power. Charles V, indeed, was virtually a world ruler and, by choice and necessity, an art patron on an unprecedented scale. It was natural for him (and his son Philip II) to try to monopolise the services of whichever painter was regarded as Europe's best, like Titian. For him, art had no frontiers, Europe was a cultural unity and artists of all kinds were recruited wherever they lived and sped at his bidding. In the heart of the old Moorish palace of Granada, Charles V set the stamp on the new art by erecting an incongruous classical building, a columned circle within a square, to show how Christian art had absorbed the antique to surpass Islam. Later, in the palace-monastery of the Escorial, outside Madrid, he and his son created an enormous complex in which ideas imported from Italy were transmuted into dramatic Spanish forms to produce one of Europe's architectural masterpieces. Artists came too. Some, like El Greco, fitted in perfectly to Spanish piety and orthodoxy. Others did not. Torrigiano fell foul of the Spanish Inquisition, and starved himself to death in prison.

Italian ideas penetrated central and eastern Europe superficially but rapidly, in some cases well before the end of the fifteenth century. Hungary was the first country outside Italy to build in the revived styles of antiquity. King Matthias Corvinus (reigned 1458–90) was a warrior and conqueror who used the antique—which he associated with Alexander the Great—to celebrate his triumphs. In 1467 he imported the engineer and military architect Rodolfo Fioravanti, known as 'Aristotele', who was 'skilled

in moving heavy objects'. He had worked with Alberti on the Vatican Obelisk in St Peter's Square. In Buda, the Hungarian capital, he built a famous bridge. Matthias got Pollaiuolo to design the drapes for Matthias's throne-room, Caradosso to produce gold altarpieces for the cathedral at Esztergom and Filippo Lippi to supply two beautiful panels—this according to Vasari. The importation of Italian craftsmen continued after the king's death. At Esztergom Cathedral, the Bakócz Chapel, built from 1506, is one of the most dazzling early examples of the new architecture outside Italy.

Many more examples from central and eastern Europe could be cited to show how far and fast the new classical style travelled. By the third quarter of the sixteenth century it was established everywhere as the normative way in which buildings were designed, sculpture created and objects placed on two-dimensional surfaces. The Greek and Roman past had been revived, learned from, transformed and re-created in new and exciting ways which had captured the imagination of civilised people everywhere. Now, in the last quarter of the sixteenth century, the searchers after novelty were looking for a new source of visual pleasure.

It eventually emerged, but in an unexpected manner, which illustrates what the philosopher Karl Popper called 'the law of unintended effect'. In medieval times, the Catholic Church, having a virtual monopoly on art, had never specially laid down what artists were to produce or not produce. That was left to the good sense of bishops and abbots, and to the pressure of public opinion. There were iconoclasts, to be sure, like St Bernard, but no censors as such. When the new art came to Italy, and the pagan myths of Greece and Rome were revived and illustrated, it is amazing what the Church put up with in terms of nudity and frivolity. In fact, popes and cardinals were among the most lavish patrons of this kind of non-Christian art. But in the 1530s, the unity of Christianity was shattered for ever. The Catholic Church found itself competing desperately with a militant reforming Protestantism which took the fullest advantage of vernacular translations of the Bible and vernacular settings for hymns and psalms, to appeal to the public. The Protestants were often iconoclasts too, and where they had the power they swept away much of the artistic heritage of medieval Christendom. Monks were expelled, their properties confiscated, their stained glass smashed, their high crucifixes pulled down, their elaborate altars turned into 'communion tables'.

The Catholic Church was slow to respond to the threat of Protestantism, except by the use of military force from the princes who supported the old faith. Nevertheless, by the 1540s they were beginning to construct a programme of reform and counter-attack, which found formal expression in the Council of Trent. In its final session, in 1563–64, the Council tackled the problem of art, both as an aid to devotion and as a form of *propaganda fidei*. Its rulings were both negative and positive. On the one hand, it swept away a mass of marginal beliefs which its critics condemned as superstition and which it was itself beginning to find embarrassing. It ruled that stories about sacred personages which were not to be found in the

canonical texts, and saintly miracles that the Church had not officially certified as probable, were not to be placed in churches or other religious buildings. It was not an act of iconoclasm because it was prospective, not retrospective, and few existing images were removed and destroyed, as had happened in Protestant-controlled areas. But it put an immediate stop to any future work of that kind and thus robbed religious artists of one of their favourite sources of subject matter. It spelled the end of the Middle Ages, abolishing at a stroke the labyrinthine inventiveness and swarming imagination that had produced so much delightful work, both in the old style and indeed in the new art too. It affected not only the great masters working in the cities but also, perhaps more so, humble artist-craftsmen of the smaller towns and villages, whose wall-paintings, shrine figures, bench-ends and the like had been encyclopaedias of Christian folklore, now all forbidden.

Even more important, however, were the most positive doctrines of the Counter-Reformation, which the final session of the Council of Trent made obligatory. In response to the Protestant cult of the vernacular, and its moral-aesthetic code of simplicity, austerity and puritanism, the Catholic Church decided to make a virtue of what many regarded as its weaknesses, and promote them. From its earlier defensive and guilt-ridden response to aesthetics, it embarked on a deliberate policy of emphasising the spectacular. With the Jesuits in the vanguard, churches and other religious buildings were to be ablaze with light, clouded with incense, draped in lace, smothered in gilt, with huge high altars, splendid vestments, sonorous organs and vast choirs. The liturgy was to be purged of its medieval nonsense but made essentially triumphalist in its content and amplitude. Thus Rome, putting its trust in the good sense, devotion and love of magnificence of ordinary people, especially peasants, decided to defy the Protestants and bid the Puritans do their worst. Catholicism would respond to simplicity and primitive austerity with all the riches and colour and swirling lines and glitter in its repertoire, adding new visual effects as artists could create them.

In this response, there was a particular point which became of enormous artistic significance. The Church narrowed the range of subject matter which artists were bidden to portray. But in narrowing the range it deepened the emotional power. It insisted that artists were to show only what the Church knew to be true. But that truth was to be portrayed with all the power and verisimilitude the artist could command. Thus, perhaps without quite wishing to, Roman Catholicism put its whole weight behind a drive towards realism. The miracles were still miracles, the faith was still metaphysical, but the representation of it was to make it seem credible in terms of everyday existence. The miraculous truth was to shock by its immediacy and relevance. The new art created by the recovery of the past had been humanist, essentially centred on man. The art now being encouraged by the Church was the art of realism, centred on life as it was actually lived—life which would be recognised by the poorest worshipper in the pew. An artist arose who was to carry out this commission with astonishing power, and in so doing to begin a new epoch of European art.

14

THE NEW REALISM OF THE
SEVENTEENTH CENTURY

Michelangelo Merisi, known as Caravaggio (1571–1610) achieved one of the most important revolutions in the history of painting. He inherited a world where the classical idealism of Michelangelo was still normative, especially in the depiction of the human body, and where the eccentricities of his successors, who did not paint from life at all, distorted the popular notion of what the eye actually sees. He rejected both utterly. He painted with an intensity of realism never before equalled, and his impact was so immediate, profound and lasting that it affected all the great painters of the first half of the seventeenth century. The genius of each transmuted the new realism in a variety of ways, making it both the climax and the golden age of European art.

Caravaggio was so-named after the ancestral seat of the Sforzas from which the Merisis also came. But he was probably born in Milan. North Italian painters, with their transalpine connections, had always had an element of realism, which Caravaggio naturally inherited. But he had no precursors. The only painter who may have set him on his chosen path was Giovanni Battista Moroni (*c.*1525–1578), the brilliant portrait painter from Brescia, whose penetrating studies (*Il Cavaliere dal Piede Ferito, The Tailor, The Lawyer*) are among the treasures of London's National Gallery. Essentially, however, Caravaggio created himself. He was antinomian, despising all laws of life and art. But his fatal propensity to break all the rules, which turned his life first into anarchy, then tragedy, also made him an artist of astonishing originality and creative power. He destroyed the old order and imposed a new one.

Caravaggio was always in trouble. In 1592, when he was not yet twenty, he fled Milan after 'certain quarrels' and the wounding of a police officer. He went to Rome and was there, for the most part, until 1606, when he again had to flee. His life in Rome was of growing financial and professional success, but it was also punctuated with crime. In the years 1600–1606 alone, he was brought to trial no less than eleven times. The charges covered a variety of offences,

Crucifixion of St Peter (1600–1601) takes the viewer right into the horror. Caravaggio used live models from the streets, painting them directly onto the canvas, to achieve ultra-realism.

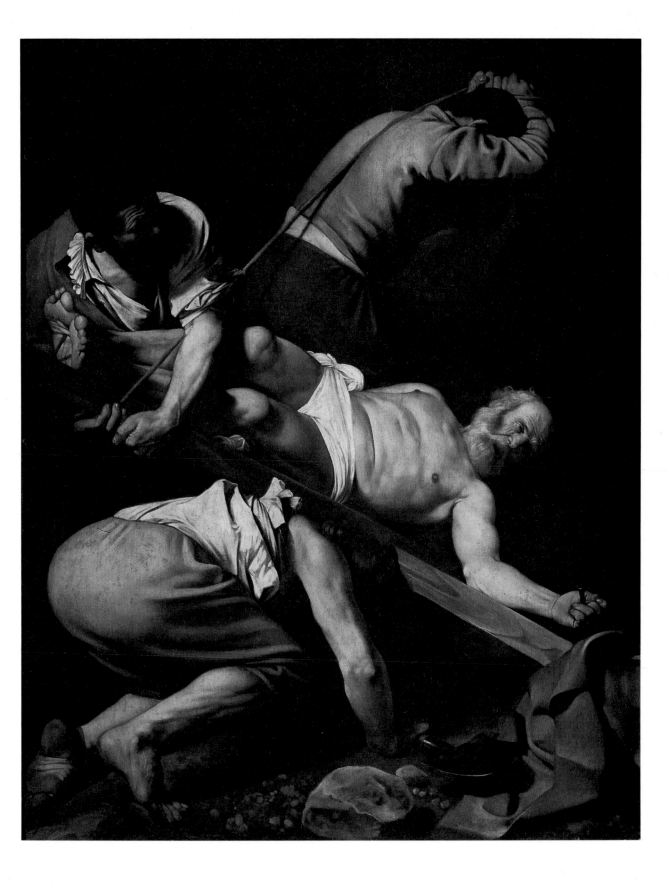

most involved violence. It is significant that, despite his posthumous reputation for homosexuality, and his endless brushes with the police, he was never charged with sodomy, then a capital offence. But he was charged with murder. On 29 May 1606 he killed one Tommasoni in a brawl after a disputed game of royal tennis, and had to flee to escape execution. He went first to Naples, then to Malta, where he was fêted and made a Knight of St John. Then, after 'an ill-considered quarrel' with a senior knight, he was on the run once more, all around Sicily, then on to Naples again. But this time there was no hiding place. The knights, known for their relentlessness, pursued him, and Caravaggio, now thirty-nine, in an attempt to seek forgiveness and refuge in Rome, tried to get there, but died at Porto Ercole, apparently of a fever.

Caravaggio's *Rest on the Flight into Egypt* (1594–95), an early work, displays his exquisite sense of beauty before worldly troubles beset him.

What is remarkable is that the artist, despite his hunted and, in the end, desperate life, always contrived to go on painting, often without a proper workshop of any kind. He was variously described, even by admirers, as a man of '*stravaganze*', as '*uno cervello stravagantissimo*' (exceptionally odd) and a '*cervello stravolto*'. His father died when he was six, his mother when

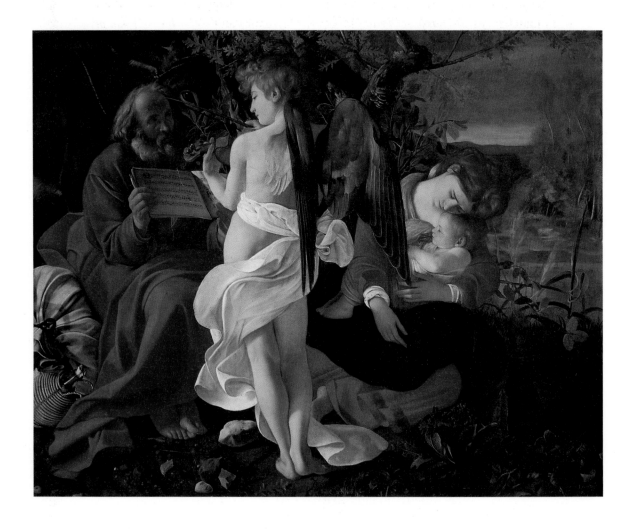

he was eighteen, which may help to explain his anger. His paintings show that he was a man of the most profound religious convictions, of a humble and contrite heart, and with a fanatical devotion to his art. His fundamental ideas were always absolutely clear, though he continually changed and improved his techniques. He believed in total realism, and he always painted from life, dragging poor people in from the street if need be. Only two of his surviving paintings are on wood, which he hated, preferring canvas which he could treat himself and cut to his exact specifications. Analysis shows that he experimented with various oils for his paints, to achieve the smoothness, luminosity, transparency and *chiaroscuro* he required.

He began to make himself a great realist by painting flowers and fruit, in a variety of lights, sometimes pure still lifes, sometimes with street boys (*Sick Little Bacchus* in the Uffizi; *Boy with a Basket of Fruit* in the Borghese, Rome; *Boy Bitten by a Lizard*, in the Longhi Foundation, Florence, though he painted a replica of the last, which is now in the National Gallery). Like all the greatest artists, Caravaggio loved painting from nature. There is no direct evidence that he ever tried pure landscape, but he painted leaves, fruit and flowers with a truth and delicacy that has seldom been matched, as his *Basket of Fruit* (Milan, Ambrosiana) and *Boy with a Basket of Fruit* demonstrate. In two early masterworks, the enchanting *Rest on the Flight into Egypt* and *Penitent Magdalene* (both Rome, Doria-Pamphili), he got his current mistress, a beautiful young golden-redhead, to pose as the Virgin and the Magdalen, and it seems quite possible that in the *Rest* he painted her outdoors, for the light on her flesh is so delicate and natural. Normally, however, he made studio arrangements to get the light exactly as he wanted it. To achieve realism, he liked to pull his subject out of surrounding darkness into strong lateral or overhead light, as close to the viewer as possible. In some cases this was simple—*The Lute-player* (New York, Metropolitan), for example. It was one of a number of works showing handsome boys (in this case a castrato singer from the Vatican choir) which Caravaggio did for the Florentine ambassador in Rome, Cardinal del Monte, a dissolute man who in old age had turned from women to youths. To get the right tones on the boy's flesh, contrasting with the score of the music in the front, Caravaggio needed a simple light behind himself and to the left. But when he did realistic genre scenes, such as *The Cardsharps* (Fort Worth, Kimball Art Museum), *The Gypsy Fortune-teller* (Rome, Capitoline) and *The Concert of Youths* (Metropolitan) he would put up a studio stage-set and light it with elaborate care, both naturally and artificially.

This was a new kind of art, which was to have momentous consequences. It has led some modern writers to speculate that, born into the twentieth or twenty-first century, Caravaggio would have been a photographer or a film-maker. But that is nonsense. Caravaggio, it is clear, adored the feel and line of a brush on a slightly springy surface, prepared with grey (as a rule), and the sheer creative excitement of using the brush to bring the real world out of the darkness of the canvas. Not a single drawing by him has survived and it is likely that he never did any. He simply stood

up to the canvas and painted directly onto it, from the living model. He also enjoyed the sensual pleasure of working up his colours to match not necessarily nature but the effects of light he had conjured up through his spectacular illuminations.

The word 'spectacular' is not amiss because, although Caravaggio aimed at total realism, he wanted drama too. It was the secret of his instant, direct appeal to the Church, to collectors, to fellow artists, to the public, then and since. He depicts dramatic moments, whether cheating at cards or the very second a miracle occurs, in such a way that the viewer feels he is present and can step into the picture. The Church, which bought more than half his output, recognised the huge popular appeal of his vivid presentation of the faith. But it sometimes found Caravaggio too real for comfort. It rejected at least five of his commissioned works or forced him to repaint them, because (as one cardinal put it) he 'crosses the borderline between the sacred and profane'. His *Death of the Virgin*, a work of marvellous sadness and pity (Louvre), shows her as an old woman, already a corpse. This was done from life, from the body of a prostitute found in the Tiber. His two versions of *The Supper at Emmaus* (National Gallery; Milan, Brera), each in different ways essays on truth, show ordinary people rather than holy figures. His Christ in *The Crowning with Thorns* (Prado) is in horrible pain. In his *St Matthew and the Angel* (Berlin, Kaiser-Friedrich-Museum, destroyed), the evangelist looks too stupid, the angel dictating to him too delicious. *Judith Beheading Holofernes* (Rome, Barberini) is a terrifying mass of blood and horror. Even in the most touching of his works, *The Madonna of Loreto* in St Augustine, Rome, showing the Virgin accepting with reverent gratitude the prayers of two old peasants, the soles of the man's feet are filthy. The Counter-Reformation accepted this new realism as exactly what it wanted—in general. And ordinary people loved it because it made them part of the dramas. But sometimes the cardinals and bishops shuddered at what Caravaggio was doing: it was *too* close to life.

On the other hand, Caravaggio told the story of Christianity as it had never been told before, as an actual happening. In Santa Maria del Popolo, Rome, two great canvases in a family chapel—hard to see properly without breaking the rules of the church—St Paul tumbles off his horse at Damascus almost into the lap of the spectators, who feel in genuine danger of a kick from the frantic animal, while the men crucifying St Peter upside down are so close that the viewer is tempted to try and stop them from doing it. In perhaps Caravaggio's most popular canvas, *The Entombment* (Vatican), the viewer can peer into the yawning sepulchre. The viewer again feels personally present in *The Calling of St Matthew* (Rome, S. Luigi), a masterpiece of lighting and narrative drama. In its companion, *The Martyrdom of St Matthew*, he is appalled at the horror of the murder, and made to feel a guilty participant.

What in effect Caravaggio is doing systematically and deliberately, for the first time in the history of art, is destroying the space between the event in the painting and the people looking at it. He is giving us direct windows into life, whether religious life or ordinary life. Indeed, they are more than windows; we are in the same

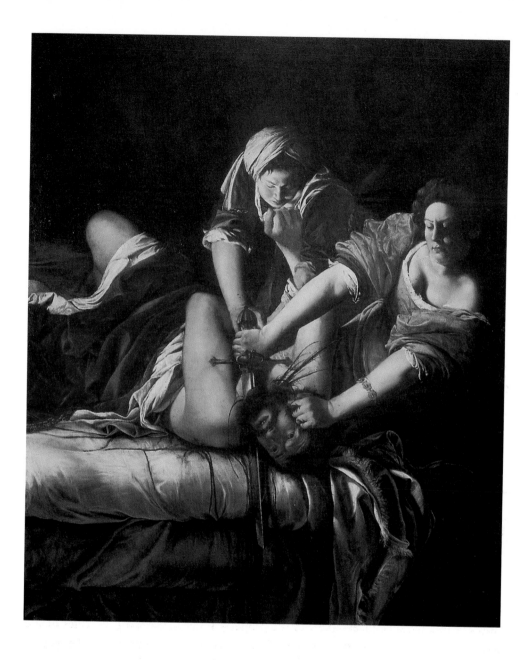

Judith Beheading Holofernes (1620) by Artemisia Gentileschi, one of Caravaggio's many disciples, reflects the fury of a woman-artist who had been raped.

room or manger or tomb or prison where the events are taking place. Even we, whose vision and sense of reality has been blunted and distorted by television and the cinema, still get tremendous impressions of participating when we see his great canvases close to. What then must it have been like in the early seventeenth century, for people who had never come across anything approaching this blast of actuality, to be brought face-to-face with a re-enactment of sacred events in two dimensions? Artists were particularly struck, or perhaps shocked is a better word; but horribly stimulated too, and stirred to find out exactly how the man did it. This was no easy matter, either, for Caravaggio's work was already becoming scattered in his lifetime. He was changing all the time, and in his last canvases, such as *The Beheading of*

St John the Baptist (Valletta Cathedral) and *Adoration of the Shepherds* (Messina, Musée Regionale) he was using black space as a powerful character in the composition, threatening to overwhelm the lit areas, sometimes crowded into a mere quarter of the canvas. These experiments were the most important happenings in art, at least so far as artists themselves were concerned, since Leonardo painted. Moreover, Caravaggio, despite all his difficulties, always finished each piece of work if he possibly could, then went directly on to another, with fresh ideas and new experiments.

There is no doubt about the impact Caravaggio's work had on other artists. In the years immediately after his death, he was imitated by more artists than any other master of whom we have records. Caravaggism was a kind of fever which spread over the art world. In the last century, the art historian Benedict Nicolson spent much of his life collecting photographs of early-seventeenth-century works in the Caravaggio manner which eventually filled three large volumes. Caravaggio had a direct or indirect influence on all the greatest spirits of the century: Rubens, Hals, Rembrandt, Vermeer, Velázquez and Bernini.

Caravaggio's difficult life meant that he never kept a regular workshop where followers gathered to absorb his teaching. He had, rather, partisans, of whom Orazio Gentileschi (1563–1639) was the most interesting. The son of a Florentine goldsmith, and eight years older than Caravaggio, he was brought up in the traditions of elaborate *disegno* before he came to Rome in the late 1570s. His first enthusiasm was for the small oil-on-copper works of Adam Elsheimer, then very fashionable, which taught him how to achieve a high finish. But Gentileschi was swept away by the realism and drama of Caravaggio. They became fellow roisterers and Caravaggio is recorded lending him a pair of swan's wings to paint angels. His striking work, *Saint Christopher Carrying the Christ Child Across the River* (Berlin, Gemäldegalerie), in which the river is the chief character, superbly painted with a jeweller's glitter, shows him still in the Elsheimer mode. Thereafter, however, he concentrated on one or two figures, brought close up to the viewer, in the Caravaggio way, and with almost excessive attention paid to the rendering of surfaces—furs, fabrics, hair, silks, skin and leather.

His daughter Artemisia (1593–1652/3) was a much more independent spirit, even if she continued to practise the Caravaggesque realism. Working in Rome, Florence, Naples, Genoa and London, she broke through the taboo which confined gifted women artists to portraiture and domestic scenes, and painted whatever she chose. The personal cost was bitter. Her father hired Agostino Tassi, a successful teacher of the young, to instil into her the full range of skills. In 1611 he raped her. A searing public trial ensued the following year but Tassi, after eight months in prison, used powerful connections to secure his release, and the girl was married off. The next year she produced her best-known work, *Judith Beheading Holofernes* (versions in the Uffizi and Naples National Gallery), generally supposed to be her hate-revenge over men for the rape. In fact it is a highly successful imitation of a treatment of the

theme Caravaggio had himself produced ten years earlier. It is less daring but in some ways better. Artemisia, not a meticulous painter like her father, avoided Caravaggio's attempt to show blood spurting out of Holofernes's neck, and confined herself to splashing it all over the bed. Like her father, she replaced Caravaggio's hideous old maidservant with a beautiful young woman, so here are two handsome girls killing a man-monster. She conjures up a drama and activity of which her father was incapable, and which rivals the master's feeling for a grand scene.

Artemisia's weakness was that she was overweight. Her *Self-Portrait as an Allegory of Painting* (Royal Collection, Kensington Palace) is cleverly angled to conceal the fact. But she was obsessively tempted, when posing heroines, to present them as herself. Even the two in the beheading scene are on the heavy side, and in the quite separate canvas of the two ladies with Holofernes's severed head, now in the Detroit Institute of Arts, Judith's heavy chin and fleshiness are the first things the viewer notices. It is the same with her *St Cecilia* (Rome, Spada), a large lady with a Doric column neck, strumming away. Equally Junoesque, indeed magisterial, is Artemisia's version of *The Penitent Magdalene* (Florence, Pitti). Her self-dramatisation was not without Caravaggesque overtones, for the master, when painting David, liked to put a self-pitying head of himself as Goliath. But her main purpose, in showing women of power and muscle, was to make an ideological point. In the twentieth century, after over 300 years of total neglect, she was seized upon as a feminist emblem. That is the wrong approach to evaluating her art, which undoubtedly has great merit. Her letters testify to the daunting difficulties she had in obtaining commissions, in a world where female artists were feared and detested by male colleagues and treated with suspicion by patrons. But some canvases attributed to her are too poor to be by her hand. She figures in a biographical sketch appended to the life of her father, but otherwise her career is poorly documented and when she died she was dismissed as of no importance. Careful and non-ideological scholarship will eventually re-create this gifted and remarkable woman as she really was, and then we can judge her properly.

The Gentileschis carried the message of Caravaggio far and wide, and it carried itself in his works and countless copies. But in Italy, his impact was conditioned by the fact that another force was active at the same time, determined to 'reform' painting. This was the Carracci family of Bologna, a numerous tribe of whom the most important were Ludovico (1555–1619) and his two cousins, Agostino (1557–1602) and Annibale (1560–1609). These were not men from an arts workshop. On the contrary. The first was the son of a butcher and was known as Ox; the cousins were sons of a tailor, and indeed, Agostino started life in tailoring until he saw that art was the thing. In the 1570s, Bologna was emerging as an important centre for the art of the Counter-Reformation, and the Carraccis decided to reinforce this trend by imposing discipline and order. In 1582, in Ludovico's studio, they created an informal meeting place for artists, called variously the Accademia del Disegno, the Accademia del Naturale and finally the Accademia degli Incamminati or 'those who are on the

right track'. They were short on equipment but high on ideology. Their motives were both religious and professional. They wanted the subject matter to be strictly in accord with Counter-Reformation principles and the treatment to conform to the best traditions of Italian art, combining the naturalism of the north with the careful *disegno* of Florence. They drew from life and they built up their paintings from scores, sometimes hundreds, of preliminary studies. Everything they did was careful, exact, painstaking and highly accomplished. They hated eccentricity and egregious-ness, which they identified with the 'bad' art they wanted to 'reform'. They thought the individual artistic personality should be repressed.

The three men worked together, often with other members of the family; when decorating rooms with fresco, one might do the designs on paper and another put them on the walls in paint. Asked who had painted the frieze in Bologna's Palazzo Magnani-Salem they replied: 'It is by the Carracci family—all of us painted it.' Of course this kind of thing had happened in medieval times, anonymously. What distinguishes the Carracci was that they were the first group who self-consciously made a point of working on the same lines to carry out a 'progressive programme'. Alberti had been an ideologue. The Carracci were ideologues too but they were also collectivists. They believed there was not only safety but power in numbers. That was often true in an Italy where the art market was enormous but, among the hundreds

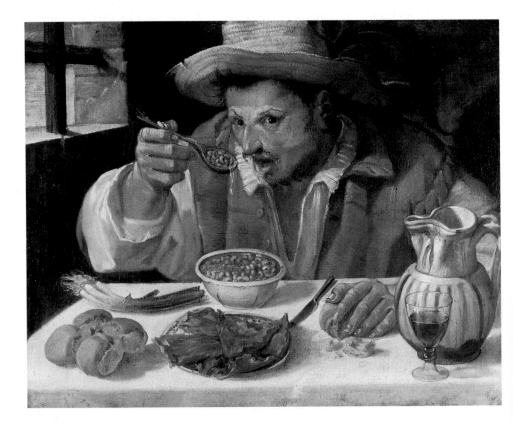

Annibale Carracci did this early example of genre, *The Bean Eater*, as a studio exercise. We find it more arresting than his elaborate religious works in the grand manner.

of fine artists, often fiercely competitive. Thanks to the Carracci, in part at least, more than half of the most successful seventeenth-century Italian artists came from Bologna, and none was untouched by their academic approach.

Both Ludovico and Annibale were taken up by the powerful Farnese family and transferred operations to Rome, the centre of the art world, though Ludovico returned periodically to Bologna to confirm his position as head of the Academy. Sometimes he would organise an artistic team to carry out a major project, such as the decoration of the cloisters at S. Michele in Bosco outside the city. And he and his cousin Annibale used team-work to carry out the enormous undertaking of painting ceilings and walls in the Farnese Palace. From 1602, Annibale organised the biggest workshop training young artists which Rome had seen since the days of Raphael, and his pupils included men who went on to become important masters, like Domenichino Lanfranco, Cristoforo Solari and the landscapist Giovanni-Battista Viola. They carried on the Carracci message, so the family's impact on Italian art lasted two centuries.

It is arguable, however, that Italian painting in the seventeenth and eighteenth centuries would have flourished more healthily if the Carracci methods had never been taught. They upheld strict workshop discipline, always welcome, but their discouragement of individualism was depressive. All three main Carracci drew well but their sense of colour was defective, their composition painstaking but ultimately dull, and none of them seems to have been capable of creating an arresting image. When they do, as in Ludovico's National Gallery work, *Susannah and the Elders*, it is only to raise a laugh, Susannah's face being an inappropriate study in lubricious idiocy. The same gallery has Annibale's best painting, *The Dead Christ Mourned*, or *The Three Maries*, which might be described as a powerful work were not Caravaggio's tremendous *Entombment*, on the same subject and done in the same year, 1603, available for comparison. None of the Carraccis habitually painted from life, the only way to achieve natural effects. Only one of Annibale's works has a real feeling for nature, and this is his much larger oil on canvas, *River Landscape* in the National Gallery, Washington. In addition, there is a pretty lunette in the Doria-Pamphili, Rome, of an Appenine town, called *The Flight into Egypt*, certainly based on a sketch from life.

The academic tradition which the Carracci family set up, their studios and workshops, the men they trained and, not least, the writers they inspired, sang the praises of their achievements and methods almost throughout the seventeenth century. They did this positively, by directing young painters to follow the Carracci example (an attitude still upheld by the lectures of Sir Joshua Reynolds in the closing decades of the eighteenth century), and negatively, by attacking Caravaggio. As has been justly observed, such writers on art as Carducho (1633), Baglione (1642), Scanhelli (1657), Bellori (1672) and Scaramuccia (1674) damned Caravaggio's works as too realistic, his methods as slapdash and unacademic, and his example as danger-

ous; he was, as one of them put it, the 'anti-Christ of art', who had betrayed the legacy of Michelangelo.

This kind of ideological abuse did not necessarily turn either artists or patrons against Caravaggio's methods, for the results of using them wholeheartedly were there for all to enjoy. The finest Italian artist of the seventeenth century, Bernini, adopted them with enthusiasm, as we shall see, on the road to achieving his own style. But classicism is, inevitably, deeply rooted in Italy, and Caravaggio, as an ultra-realist, was seen as an opponent of the classical ideal, so that any Italian artist who was not totally confident in himself (as Bernini was) tended to edge away from the 'Caravaggisti', as the master's followers were known.

A good example was Guido Reni (1575–1642), a few years younger than Caravaggio, who succeeded him as the most popular painter in the country. He came from Bologna, of course, but would not bow the knee to the Carracci, thus earning their hatred and jealousy. He worked in Rome from 1601, but from 1614 based himself in his home town. He eventually ran perhaps the largest workshop in artistic history, through which over three hundred assistants and pupils made their way. At one time he had over seventy on his premises. One of his account books survives (New York, Morgan Library) and shows that large sums passed through his hands. It also indicates that Reni was constantly involved in financial disputes. He was highly successful because, during the period 1601–30, he followed the advice of the Cavaliere d'Arpino (Giuseppe Cesari, 1568–1640), a mediocre painter but a grandee of the Roman art world who acted as intermediary between artists and patrons. This advice was to absorb some, but not too much, of Caravaggio, to be natural and dramatic, and to try to create beautiful forms summoned up from a dark background. Reni interpreted it in his own way and created some wonderful images. He toned down Caravaggio's rendering of St Peter's Crucifixion to produce a more refined and acceptable version (Vatican). He used fresco to decorate the ceiling of the Casino Ludovisi (1613) with the story of Aurora, a graceful and delicate work. His *Massacre of the Innocents* (1611, Bologna, Pinoteca Nazionale) is a magnificent series of images of fear and pity, and his *Atalanta and Hippomenes* (1618, Prado) is one of the most memorable duos, man and woman, both naked, in the entire history of art. Reni is at his best when he is simple, dispensing with the multitudes of figures and general clutter of so much religious art in the sixteenth and seventeenth centuries. Then his realism and his strong sense of design, both in form and colour, show themselves bravely. He produced for the Santa Maria della Conciliazione in Rome a masterly image of St Michael driving Satan from Paradise—direct, simple, muscular but graceful, in clear, harmonious colours, showing the church militant as a living symbol of beauty. It proved so popular that his workshop reproduced it dozens of times, so that *Saint Michael* is to be found in religious institutions throughout Europe as well as in the hands of individuals, including the author of this book.

The art historians say that, after 1630, Reni changed his manner, becoming more

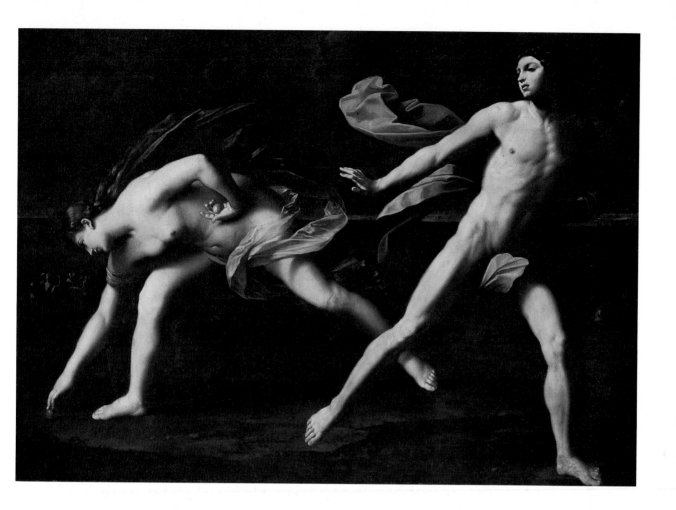

sketchy in his brushwork and using lighter colours. The point at which he began to switch to his later manner is the magnificent *Charity* (1628) in the New York Metropolitan, a work of singular charm and sensuous appeal. The truth about the switch in style is more prosaic. Reni's life was a tragedy, though in quite a different way to Caravaggio's.

Far from being brave, he was a coward, though always argumentative and quarrelsome. When he went to Naples, he quickly withdrew following threats from local painters, many with Spanish connections, who had a collective message to any intruders: 'Keep out!'—a threat they backed with swords and knives. Reni was an only child, always a sad fate for an artist, especially a male one. His father died young, and Reni's relationship with his mother, who lived to be seventy-five, was so close that she went everywhere with him and there was never any room for another woman. Indeed, he was terrified of them. His great *Atalanta*, perhaps unconsciously, expresses his feelings with dramatic power. The wonderfully handsome Hippomenes rejects the woman with a splendidly scornful gesture, and she averts her face. He would never allow himself to be alone with a female model.

If Reni had homosexual leanings, and most people who have studied his life and

work agree that he did, he suppressed them. The flesh, which was his life-work to paint, was abhorrent to him. He was a faithful son of the Church—this is plain in all his religious works. But his rejection of any kind of sexual life obviously set up stresses, which he habitually relieved by the adventure of gaming. He quarrelled with everyone sooner or later, usually about money. About 250 paintings of his have been catalogued, and there are nearly 300 drawings in existence. The paintings of his 'later style', when he was working too fast and always pressed for cash, are markedly inferior to his earlier work. He himself complained that his early Caravaggesque canvases, sold by him for comparatively little, were changing hands at hundreds of times their original prices (a familiar complaint of artists who become famous). For his later works, wrote his biographer Malvasia, he was 'paid more for his art than any other painter had been in the past'. It was said that the moment he received a new commission he began to sketch it out on paper so that, if he died, the law would ensure that the down-payment would not have to be returned. Patrons complained that he had so many people in his workshop that he never even touched some of the commissions they had paid for. He replied indignantly that he had trained his assistants to do exactly what he wanted and that, in any case, he always supervised their work closely. One of them, however, Ercolino de Maria, was so skilled that even the master could not tell the difference between Ercolino's touch and his own. All the same, Reni left many dissatisfied clients, and when he died the inventory lists scores of works as *una copia, non finito* or *abozzato*. But this tortured man, whose *oeuvre* has endured both eclipse and rediscovery, nevertheless has left many delightful works to adorn our great collections.

By the time Reni died in 1642, Rome, Italy and Europe in general are said to have been in the grip of a style called the Baroque. This, with its appendage Rococo, applied to the first half of the eighteenth century, is a catch-all taxonomic term used to describe the period between the post-Renaissance age of Mannerism and the classical revival in the second half of the eighteenth century. But none of these terms, except possibly the last, was ever used by the artists of the day to describe their own work. All were later expressions of abuse, Baroque especially so. It was a word of Portuguese manufacture used by jewellers to describe an uneven row of pearls. It was applied by supporters of the classical revival in the 1750s to describe the taste which the new mode was supplanting. The German art historian Johann Winckelmann, a passionate supporter of classicism, coined it as an art term in 1755. Baroque was first defined by Denis Diderot in his *Encyclopédie* (1758) as 'the ridiculous taken to excess'. This is undoubtedly what it then meant to fashionable connoisseurs, but it bears no relation at all to a style allegedly founded by Caravaggio, a grim ultra-realist, and the Carracci, classicists of humourless stamp. It is a confused and confusing term which merely makes it even more difficult to understand the blinding miracles of seventeenth-century art. 'Counter-Reformation art' would make more sense, at least as applied to Italy and other parts of Catholic Europe, but even that is questionable

since in 1648 the Counter-Reformation came to a decisive halt when the secular powers of the old faith deserted the papacy and signed a peace which left Protestant and Catholic territories exactly as they were. Thereafter the papacy ceased to be a force in European politics and religion was pushed right into the background until the second decade of the nineteenth century. In short, I repeat that it is better not to use such misleading terms, whose convenience conceals blatant falsehood. Instead it is more truthful to analyse art in terms of strict chronology and artistic personalities.

What did mark the seventeenth century in one important respect was the elaborate and large-scale decorating of church and palace ceilings and domes. This was, by its very nature, anti-realist and involved the *di sotto in sù* technique honed by Correggio a century before. What you painted in these high and usually curved spaces bore no relation to the real world in the first place and had to be deliberately distorted to look right from ground level. They were decoration, and they were extremely expensive, obviously, but they were popular among both high and low at this time, princes and plebs sharing a taste for grandeur. Painted ceilings and domes performed an important religious function too, replacing Abbot Suger's image of Heaven using high vaults and stained glass by the more modern techniques of sophisticated figure-depiction.

The process got under way in the work of Giovanni Lanfranco (1582–1647). He was born in Parma and as a child gazed earnestly up into Correggio's splendid 'frogs' legs' cupola. He learned how to do ceiling work under the Carraccis at the Farnese Palace, and then carried out a magnificent scheme for himself in the dome of S. Andrea della Valle, Rome, 1621–25. Like Correggio, he chose the Assumption as the best subject for this kind of large-scale miracle decoration, and he used it again in Naples Cathedral (1641). The topic repeatedly crops up in the big schemes of Pietro da Cortona (1596–1669), though he also employed an elevating mix of secular and religious motifs, as in the huge frescoes on the ceiling of the Barberini Palace in Rome, appropriately entitled *The Allegory of Divine Providence and Barberino Power* (finished 1639). Once one big cathedral had such a work, the others wanted it; once one Roman or Florentine palace paid for such a treasure, rivals felt obliged to buy one too. So here was a fashion which gave well-paid employment to masters courageous enough to undertake these difficult and exhausting schemes. They in turn subcontracted out work to lesser men. That is how another hard-working Bolognese, Domenico Zampieri, or Domenichino (1581–1641), got his start, in the Farnese Palace and S. Andrea, and then went on to decorate palaces, villas and cathedrals on his own account. Lanfranco, Cortona and Domenichino were all gifted men, with plenty of novel ideas and huge skill.

Lanfranco contrived to produce a *Notte*, a delightful sub-Correggesque nativity scene, using heavy *chiaroscuro* and pool-of-light technique (Northumberland, Alnwick Castle). Domenichino did some fine landscapes, his real passion one suspects, and his drawing was always true to nature, firm and highly disciplined. Cortona also was

a skilled and prolific draughtsman, and at least five hundred of his drawings survive, scattered chiefly among the British Museum, the Royal Collection, Windsor, the Louvre, the Uffizi and the New York Metropolitan. Some are purely working drawings, as one would expect from a man trained in the Florentine way, but others are meticulously finished in pen, wash and white highlighting, or delicately drawn in red chalk, or in black chalk on grey paper. These drawings tend to be far more vivid than the finished frescoes, which (to tell the truth) were often done at excessive speed. The design for a big fresco by Cortona in the Pitti, Florence, executed in black on grey and now in the Uffizi, has been described as 'one of the most beautiful graphic works of the seventeenth century'. It is not surprising that Cardinal Leopold de' Medici bought up all the surviving drawings from Cortona's Florence workshop.

The greatest draughtsman of them all, however, was Giovanni Francesco Barbieri, known as Guercino (1591–1666), yet another member of the Bolognese school. His nickname comes from the squint he developed as a result of a childhood accident. It did not affect his eyesight, however, to judge by his work, which moved in accordance with fashion from an early naturalistic style, rather like Caravaggio's, with heavy *chiaroscuro* backgrounds, to a much lighter version in the Reni mode. Anyone who wants to judge his work, which was so highly regarded that he was invited to Paris to finish commissions for Maria de' Medici left incomplete by the death of Rubens, should take the trouble to go to Reggio Emilia to see his *Crucifixion* altarpiece in the church of the Madonna della Ghiara: in power and virtuosity it is one of the finest works of the seventeenth century. However, it is the great merit of Guercino that he can be enjoyed in comfort. He is one of the best documented of all seventeenth-century painters, for his family kept his workshop virtually intact until well into the next century, and thus preserved the bulk of his enormous output of drawings. These include working studies, mainly in pen and wash but done with such a high regard for lighting and tonal effect that they constitute real works of art, a wide selection of landscapes, some done on the spot, others *capriccios* made up in the studio, and caricatures and genre studies. Some are done in a hurry, others are carefully composed and executed with love: all are highly characteristic, and there is no such thing as a dull Guercino drawing. There are over eight hundred sheets of attributed drawings in Windsor alone, though many are no doubt by his workshop. Few artists have used pen and ink with greater skill and success, and studying these delightful sketches takes one deep into the heart of life in seventeenth-century Italy, in town and country, and indeed into the head of a masterful artist. Guercino has been much studied in the last half-century and there is now little we do not know about him. He was well-adjusted, happy except for poor health in his last decade or so, successful and industrious. There is no moral to be drawn from his life and work, which exists simply to be enjoyed.

15

THE FIRST GREAT
LANDSCAPE PAINTINGS

We have seen that Titian was the first international figure in art, though he remained at heart an Italian, indeed very much a Venetian. His eventual successor in the international role was Peter Paul Rubens (1577–1640), who bestrode the art world of the early seventeenth century like a genial colossus. He was not only one of the greatest, he was also one of the happiest of artists. He came from the ruling class of the great commercial city of Antwerp, was well educated and bore his considerable learning lightly but with quiet pride. Unlike many artists, he was neither bitter and rebellious nor overweening and arrogant. He wanted to learn, and then to create.

Rubens began by copying works by the Flemish and German masters, thus acquiring all the skills of the north; then in 1602 he went to Rome, to Genoa, to Spain, to Rome again, copying and studying the works of Michelangelo and Tintoretto, Titian and Correggio in particular. Then back to Antwerp in 1608, which thereafter became his base, though he made important forays to Paris, London and elsewhere. He had 'perfect manners' (wrote a contemporary) and 'an agreeable mode of talking' so he made friends of all, from kings, who showered honours on him, to fellow artists, who were grateful for his kindness and help. As often happened in those days with successful artists who moved between the courts, he was asked to undertake diplomatic missions, and from 1623 he did so, on many occasions. He spoke fluent Dutch, French, Italian and Latin and knew the ways of governments, so he was much in demand in this role, to the point where he had to protest that it took up too much of his painting time, which he grudged. He was a passionate man of peace—hatred of war alone stirred him to anger—and his efforts were always to prolong truces or arrange permanent settlements between the distracted combatants of the Thirty Years War. His love of peace found artistic expression time and again, notably in his *Peace and War* (London, National Gallery) and in his gigantic biographical series in honour of Marie de' Medici, now in the Louvre. The struggle for frontiers was, to

him, the epitome of human folly. 'I regard all the world as my country,' he wrote, 'and I believe I can be at home anywhere.'

Born a Protestant, Rubens converted when still young to Catholicism, but he had no religious bigotry. Even his strictly Catholic work, like the marvellous pair comprising *The Miracles of St Ignatius Loyola* and *St Francis Xavier* (both in Vienna, Kunsthistorisches), are essentially spiritual rather than sectarian, stressing the nobility of the true saint. His altarpieces and Crucifixion scenes, especially in Antwerp, show all the benefits he derived from Caravaggio: intense realism, pure and powerful colour, impressive lighting and a strong sense of drama, but they also have a delicacy and a serenity which are Rubens's special gifts. Rubens suffers from the fact that many of his religious paintings have been lost (forty of his greatest in a single fire at the Jesuit Church at Antwerp in 1718) and still more have been wrenched from the church settings, for which he designed and executed them with meticulous care, paying particular attention to lighting. They are not at their best in secular public galleries. The reason his *Adoration of the Magi* looks so splendid in King's College Chapel, Cambridge, is precisely because it is once more in a reverent ecclesiastical framework.

Rubens's mythological works, featuring his famous or notorious naked beauties, are an important part of his *oeuvre*, and ought to be inspected carefully, rather than just taken in by one fleshy glance. For instance, his *Judgement of Paris* (London, National Gallery), in oil on oak, is a masterly composition, painted with both power and intense tenderness, with a poetic sky darkening a landscape background of wonderfully observed trees. Paris, for once, is a gentleman; Mercury is sympathy itself; the details—aggressive peacock, patient dog, naughty cherub, mystic owl—hold our attention, and the attitude of the ladies to what they are being obliged to do is worth study: Rubens had obviously thought a lot about the propriety of the story. This big work is by any standards a masterpiece, and like nearly all Rubens's major enterprises, our admiration increases the more closely we look into it.

Rubens's total output was immense. In one commission alone, he painted over a hundred scenes from Ovid for Philip IV's hunting lodge, the Torre de la Parada, near Madrid (some are lost). Each was preceded by one or more oil sketches, executed with great panache and in considerable detail, which Rubens used to get the colour, composition and lighting to his satisfaction. These oil sketches reveal a great deal about Rubens's methods, and are often considerable works of art themselves, as anyone who has seen the fine collection in the Munich Pinakothek will agree. Rubens never made things easy for himself. Like Caravaggio, he loved to eliminate the space between the viewer and the action of a painting, so that the participation is complete, even alarming. In one of his finest works, *The Rape of the Daughters of Leucippus* (Munich), we feel we can touch the naked bodies of the girls as they are hoisted struggling onto the towering horses by strong, fierce men. The scene is highly realistic, but it might have seemed ridiculous had not Rubens composed this intricate writhing with such consummate skill—and pains—that he makes it all seem not just

natural but beautiful. He was always working hard at his art; and when not working, thinking about it. It is well to remember this. No Rubens work, however slight, is dashed off; it is thought out first. His great triptych *The Descent from the Cross*, in Antwerp Cathedral, which many would rate his finest work, bears the marks of searching ratiocination in every square inch—nothing got there by accident.

Once Rubens had thought a project through, and proved to himself that it would work by drawings and oil sketches, he created the finished painting at impressive speed. He drew on the canvas with a special brush as though it were a piece of chalk, putting in the lines with total accuracy without hesitation or pause. When he applied the paint, the brushstrokes were fluent and long—sometimes 3 feet—but firm or delicate at will. These great, sweeping strokes, marvellous to watch, and filling up the canvas with almost miraculous speed, involved a meticulous manufacture and choice of brushes, careful preparation of a huge palette, and a skill in measuring

In *The Descent from the Cross* (1612) Rubens gave an exemplary display of his skills in composition, colour, contrast, emotional expression and humanity.

the quantity of paint, and placing it on the brush, which was a personal technology in itself. When the master was going at full stretch, clambering up and down his stepladder, striding from one corner of the vast canvas to another, shouting for more, and yet more, paint while the fit was on him—or rather while he could feel the power radiating from his hand, for he was always calm and in control—he must have been an amazing sight, one which a young artist would retain to the end of his life.

The Rubens output, then, was so vast that it has never been completely catalogued, though efforts to do so began as long ago as 1886, and a new attempt, started in 1968, continues. It includes, besides wall oils and easel works, oil sketches and drawings; some important sets of designs for tapestry series, then rated of the greatest importance by courts; an architectural pattern book of plans and façades taken from palaces in Genoa and based on careful drawings; many designs for silver works, frontispieces for books, visual decorations for sculptors, architects and decorators; and detailed plans for arches, banners and placards used in official triumphal entries, whose execution Rubens oversaw down to the last swish of the conquered dragon's tail. For all these activities, Rubens needed a large, efficient workshop. In Antwerp he created the first large-scale shop, on Italian lines, north of the Alps, and attracted there artists of the highest quality, including the young Anthony van Dyck, a genius nearly on his own level. The young men came not only to watch and learn but to experience working in an atmosphere of civilised order as well as intense artistic concern. All was disciplined, neat, carefully planned and rigorously executed, by clever young men anxious to please a master they revered, and who loved them as if they were his sons.

We have noted repeatedly that art is the reduction of the beautiful chaos of nature to an equally beautiful order. Rubens's studio was an epitome of this process. His life is well documented; many letters to and from him survive, in various languages; contemporaries high and low registered their impressions. There is never any hint of meanness or jealousy, undue pride or anger over money and commissions: just fair dealing, good fellowship and endless kindness. Rubens worked hard all his life, and spent or kept his earnings wisely; but he also banked his treasure in the hearts of his friends.

At the centre of this orderly existence was the entity which Rubens saw as the talisman of order: house and family. He was a chaste but uxorious man. He worshipped his first wife, Isabella, and drew and painted her repeatedly with great tenderness. To celebrate his successful marriage, he painted one of the warmest and most joyful double portraits we have, *Rubens and Isabella Brant in the Honeysuckle Bower* (Munich). When Isabella, the brunette beauty, died in 1626, Rubens was desolate. It was the one dark episode in his charmed life. It took him four years to recover. Then in 1630 he met and married the sixteen-year-old Hélène Fourment, daughter of a tapestry dealer, a blonde beauty who might have stepped out of one of his own pictures. She was soon starring in them, in innumerable roles—no artist drew or painted his wife with more love, or more often—and anyone who dismissed

Rubens's mastery of the nude as excessively fleshy and unreal should look carefully at the full-length nude of Hélène in a fur wrap, *Het Pelsken*, now in Vienna, which presents her body exactly as it was, in all its beauty and with all its natural defects in full view. He also produced—it is now one of the delights of London's National Gallery—a dashing half-length of her sister, Susanna, with her huge eyes and ostrich-feather felt hat, maddeningly known as *Le Chapeau de Paille*. He loved to paint Hélène alone or with their children, or with himself hovering paternally in the background, deeply happy in the reciprocated love of this delightful girl. His *Rubens and Hélène Fourment Walking with Their Child* (New York, Metropolitan) sums it all up. He did many other portraits, especially towards the end of his life, and they too often involve intimate glimpses of families. Unlike many artists who can get a likeness easily but despise the skill, Rubens loved portraiture, as is shown by the amount of his precious time he spent on them often without payment. He conveys the feeling, even when depicting the plain, everyday features of the Antwerp mint-master Jan van Montfort (London, Courtauld), that he has a strong regard for the human race and all the individuals who compose it.

Hence it is no accident that Rubens's most gifted pupil, Anthony van Dyck (1599–1641), became the most celebrated portrait painter in the history of art. This pious Christian and modest man was born into Antwerp affluence but lost his mother when he was six and watched his father go bankrupt when he was eighteen. Already skilled and hard-working, he set up his own business for legal reasons but was obviously relieved when Rubens recruited him for his splendid workshop on the Meir. There the two men, though separated by an age gap of twenty-two years, worked together in harmony. Rubens gave him access to his famous *Pocket-book* of sketches, and the right to steal ideas he found in it. He himself used Van Dyck's work in a celebrated bargain he made with the English ambassador to The Hague, Sir Dudley Carleton, whereby His Excellency gave him his collection of Venetian antiquities in return for what Rubens called 'the flower of my stock' of studio paintings, including a grand affair of Achilles, '*fatto deli meglioti mio discipolo*' (Van Dyck), which he had touched up himself. When Rubens died, eight treasured early works by Van Dyck were found in his home, and the younger man always feasted on Rubens's drawings and cherished his friendship.

It says a lot for Van Dyck's strength of character and formidable skills, natural and acquired, that he was able to spin himself out of Rubens's all-absorbing orbit and become a powerful painterly intellect in his own right. He was a youthful prodigy. On his first, brief visit to England, when not yet twenty-one, he was accorded an annual stipend of £100 by James I. Both his portraits and his other works, religious and secular, were eagerly bought—*The Continence of Scipio*, now at Christ Church, Oxford, is an outstanding example. He was naturally anxious to ascend to the heights by painting grand historical or religious works, competing with his master. When still in his early twenties he did a magnificent *Saint Sebastian*

Bound for Martyrdom (Edinburgh, National Gallery) and two pictures of Christ's passion (Prado), which instantly put him in the running against anyone in Europe. But it is a curious fact about Van Dyck, something of which he was aware and which caused him intense irritation, that in telling a tale he could never strike a memorable image, in the way Rubens always could, whereas in portraiture the image sprang out of the canvas like a wild beast. Thus an artist proposes and God disposes.

Indeed, once Van Dyck, at first reluctantly, and then with growing enthusiasm, embraced portraiture as his main life-work, he never made a mistake of profession or taste. On the contrary, he raised portrait art to the sublime, in a way not even Titian had contrived. In Genoa, aged only twenty-two, he began to evolve a new monumental style of portraiture, with men or women at their full height, in powerful and dramatic poses, against palatial backgrounds. He almost apotheosised the future doge, Agostino Pallavicini (Malibu, Getty) and he made the Marchese Elena Grimaldi (Washington, National Gallery) look as if she was empress of the world. But he tackled other problems even more successfully. About 1625 he painted the three Balbi children, in their best clothes, standing on the steps of a classical building. This is a work of the grandest possible style, yet the youthful, indeed childish, faces of the trio are captured with such delightful sympathy that we are not surprised to hear that the work won the affection of all who saw it, men and women. No one ever painted childhood and youth better than this sensitive and engaging Fleming.

Of course it goes almost without saying that Van Dyck, as was his professional duty, painted velvet and lace, silk and satin, embroidered gloves and glittering bracelets with easy mastery. He was particularly good on hair, whether of old men (see *William Fielding, 1st Earl of Denbigh* in the London National Gallery) or young women

Van Dyck, Rubens's pupil, excelled in every branch of portraiture. *The Balbi Children* (*c*.1625) shows no one has ever put the young onto canvas with more success.

with tiresome ringlets, so difficult to do naturally (*Lady Elizabeth Thimbelbly and Dorothy, Viscountess Andover,* also National Gallery). He does not paint each hair separately, always a mistake, but produced what might be called a meticulous impression, which makes the tresses glow and the short hairs at the temple mingle imperceptibly with the white flesh. This can be seen in yet another National Gallery masterpiece, *Portrait of a Woman and Child,* where the hair of both sitters is reproduced with astounding veracity. This fine work, done when he was still in his early twenties, shows another of Van Dyck's strengths: the ability to paint hands of exquisite beauty and sinewy verisimilitude. No one has ever done hands better. The two hands of the child, and the right hand of his mother holding him, are miracles of contrasting observation and delicate recording. In one of his greatest paintings, which he did in Genoa for the English diplomat and collector, *Portrait of George Gage with Two Attendants* (National Gallery), the two hands, one dangling limply, the other clutching convulsively, both the essence of poetry, are the real subject of the picture.

Perhaps it was this unique skill in making hands speak that underpinned the immense success of Van Dyck's second visit to England, from 1635 to his death. Charles I became king in 1625, and immediately expanded his artistic activities, both as patron and collector. His taste was not only exquisite but sure, in such contrast to his faltering rule, and the great treasury of works of art he built up was the wonder of Europe until the ignorant Parliamentarians squandered it. Not even the Medici were more gracious to men of art, more understanding of their difficulties or more generous in rewarding their efforts than Charles I. His French queen, Henrietta Maria, endorsed his tastes. She took Van Dyck to her heart, and had him painting her husband on foot in hunt gear (Louvre) and on horseback, with his head in three positions, with her and with their children in hunting costume with her dwarf (Washington), and all of them together, family groups (Royal Collection, Windsor; Turin, Sabauda; National Portrait Gallery). She noticed Van Dyck's extraordinary skill with hands, and noticed also the hands of her husband's chief minister, 'Black Tom' Wentworth, Earl of Strafford, 'the most beautiful pair of hands in all the world', as she called them. So Van Dyck painted Strafford more than once; he is seen notably, dictating to his secretary, pensive, almost fearful, in one of the great psychological studies of the seventeenth century, as if he knew his king would desert him and authorise his execution. These form one of the greatest collections of royal and official portraits ever done, and Van Dyck was rightly rewarded in princely fashion, though in his growing financial difficulties Charles was sometimes in arrears. What he could not pay for promptly in cash, he rewarded with unusual courtesies. The king even chose Van Dyck a bride, a lady of high rank, and organised the wedding, giving away the lady with his own hand, an unprecedented honour.

Van Dyck's inner thoughts we know not. But he delighted in drawing. That is evident from his portrait studies and preparatory sketches for his history and religious pictures, but still more so from his drawings of nature, done for his own

pleasure. He loved trees, plants, flowers and vegetation of all kinds; he put them into his finished works, as in the tremendous *Penitent St Jerome* (Dresden, Staatliche Kunstsammlungen), an encyclopaedia of natural history. But the drawings, usually done in pen and ink, are of a different order, for their meticulous rendering betrays the fanatic. If Van Dyck could have made his living as a landscapist, I suspect he would have done so. This is strengthened by the fact that he often used watercolour. There is a delightful sketch, in the Barber Institute, Birmingham, of a wood and a harbour, with sails on the horizon, evidently done in Sussex or Kent, which ranks as the first English watercolour by a master hand, progenitor of a historic tradition. This work of his last years indicates that Van Dyck knew exactly what he was doing, and would have done to his heart's content, had he been spared. As it is, the exhibition of his landscape drawings assembled by the British Museum in 1999 showed that he produced at least twenty-six of them in watercolour.

The evident fondness of Van Dyck for landscape he almost certainly acquired from his great master, Rubens, who drew from nature all his life, though it was only in the last two decades of his tremendous career that he was able to take pure landscape art seriously. And where Van Dyck merely sketched, Rubens painted, on a monumental scale, again and again, to satisfy a burning passion which had always (one surmises) been in him. The big exhibition of Rubens landscapes at the London National Gallery 1996–97, showed that he did eight up to the year 1627. Then in 1635 he wrote a letter which indicates that painting nature, in the open air, was the thing he enjoyed most, and intended to indulge now he was rich and famous, had acquired a fine country château and estate, Het Steen, and could do as he pleased. He celebrated its acquisition the following year with a joyful picture showing it all (National Gallery). It is early morning and a huge sky is just lighting up. The castle is seen through a parting between trees painted with delicacy and skill. Just inside the gates, Rubens and his wife sample the morning air with their growing children. A cart rolls past on its way to market. A hunter, with gun and pointer, creeps up on some partridges. The thickets in the foreground display all Rubens's ingenuity in weaving an intensely realistic mixture of thorn and briar, leaf, twig and grasses. Beyond, an enormous landscape unrolls itself to the distant blue horizon, broken by steeples and by trees which cast long shadows in the rising sun. All this is not an imaginary world but the real one Rubens had created for himself by his industry. Impossible not to believe that much of this magical work was painted on the spot. One can even see the track from his front door along which Rubens and his boy lugged his materials.

Rubens painted sixteen such landscapes in the last phase of his life, all almost equally splendid. The next three finest are in the Royal Collection, Windsor, the Birmingham Barber Institute, and the Wallace Collection in London, the last lit by a rainbow. Like everyone else who has dared to paint this phenomenon, Turner and Constable included, Rubens failed, but his attempt is noble. In this group of paintings, done with love and enthusiasm, Rubens tried his hand at every aspect

of country life, and one can spend hours exploring the details he brought to light. As a young man he had seen the Elsheimers in Rome. He was probably familiar with Joachim Patinir. In Rome too he saw the clever landscapes of Paul Bril (1554–1626), who may have taken some of them from nature. Indeed, in 1610 he collaborated with Bril in painting landscapes. But all these men re-created nature in accordance with rules. They thought they knew, better than God, what nature should look like.

Autumn Landscape with a View of Het Steen by Rubens. Rubens made a fortune from his grand commissioned work, bought the Château de Steen, then spent his retirement painting it and other landscapes for pleasure.

Rubens took nature, broadly, as he found it. His real master, if he had one, was Bruegel, and he had a chance to see the six *Seasons* then complete. He liked peasants, and even had fun painting them dancing, as works in the Louvre and the Prado show. But he had no need of Bruegel's example. His own senses and instincts told him how to do it. Rubens embraced life as a whole, and recorded it heightened, epitomised, in all its astounding magnificence, but essentially as he saw it. And landscape was the framework of life, the infinitely complex and beautiful stage, made by the Creator, on which life is played. So he ended his days setting it down in paint, his final and finest legacy to posterity.

Rubens was a well-read and thoughtful man but he never allowed his learning or his pondering to chain down his physical instincts as a painter. It is a thousand pities that Nicolas Poussin (1594–1665), a surpassingly clever and dedicated artist, did not read and think less, and look at life more. He was a Norman, who failed in France (twice) and in Rome, as a grand historical painter. Then he decided to concentrate on smaller easel works, in which the inner spirit of Latin verse and the

ideals of the classical world as reflected in its mythology were carefully woven into elaborate designs of figures and landscapes. He worked at this business for forty years, almost alone (he had no elaborate studio) in his painting room and study, scarcely poking his nose outdoors except for exercise. His self-portrait in the Louvre shows him as a handsome, if concerned, man of the world, but an earlier chalk drawing, now in the British Museum, tells a different story: here is an obsessive, eaten up by his thoughts. But Poussin's story shows that in art, as in many other professions, it pays to keep on keeping on. By his persistence he gradually established his fame, even in France, indeed (in the end) especially in France, for his highly intellectualised approach struck deep chords in the heart of French rationalism and logic. A Poussin needs to be read, and read by a highly educated person, who has enjoyed a classical education and pondered its implications. He invites civilised commentary, and this is the secret of his appeal to collectors and galleries and, not least, to art historians who have examined and re-examined him through to the back of his canvases and written about him endlessly.

Dance to the Music of Time (1630–40) by Poussin is a favourite of literary folk and academic painters and critics. It suggests the studio rather than real life.

Approached in this highly rationalistic spirit, Poussin is rewarding. He appeals particularly to writers, notably Voltaire, Baudelaire, Hugo and Proust. His *Arcadian Shepherds*, with its sinister motto on the skull, 'Et in

Arcadia Ego' (Louvre), plays a key role in Evelyn Waugh's *Brideshead Revisited*, and his *Dance to the Music of Time* (Wallace) gave the theme to Anthony Powell's notable series of novels. There is, however, something abstract about Poussin's rendering of human beings. In his early exercise in classicism, *The Death of Germanicus*, much relished by French neoclassicists like David 150 years after (it is now in the Minneapolis Institute of Arts), hardly any of the faces can be seen: all the art goes into the elaborate design of their interlocking bodies. When Poussin paints faces, they appear interchangeable. In two major paintings in the London National Gallery, *The Adoration of the Golden Calf* and *The Finding of Moses*, and in his famous *Abduction of the Sabine Women* (two versions: Louvre and Metropolitan), all the women's faces appear to be identical. This was not because Poussin used the same model for each work. More likely, he used no model at all, but made do with lay figures.

The Caravaggio revolution thus meant nothing to Poussin. He did not look at life, he conjured it up in his head, according to rules. A case in point is his much-admired series *The Seven Sacraments*, now scattered (National Gallery, Washington; Belvoir Castle, Leicestershire; Edinburgh, etc.). These use the technique which Caravaggio invented, of pulling the central figures into a spotlight which picks them out from the deep *chiaroscuro* of the background. But instead of creating a full-scale set in his studio, using live models and fixing up candles, lanterns and torches to provide the actual illumination and real shadows, Poussin made little wax figures which he set on a miniature stage in a box. These tiny dolls were nude, though Poussin also made draperies for them of taffeta or paper. Then he could use the lantern to get the light-effects he wanted, after preliminary studies. But where was nature while all this was going on? Weeping, perhaps.

Did Poussin ever draw from the real world? As a youngish man he explored the Roman Campagna with his brother-in-law Gaspard Dughet (1615–1675) and Claude Lorrain. They did sketches from life, undoubtedly. Dughet's drawings, sometimes mistakenly attributed to Poussin, are of the highest quality, as can be seen from the collection of them at Düsseldorf and the superb *Landscape with Two Figures* in the Uffizi. Poussin's drawings, though plentiful (Chatsworth; British Museum) do not have an out-of-door look at all. The trouble with his miniature stage-set method is that it tended to present his material in strips. In his National Gallery painting in London, *The Triumph of Pan*, there are three strips: a background strip of trees, conceivably based on sketches of real trees though they do not look like it, a frantic maelstrom-strip of figures in the middle, all the women with identical faces, and a foreground of inanimate stage props such as masks. All that is missing is the orchestra pit, separating the painting from the viewer.

Poussin is so unlike Rubens, in his beliefs and his practices, that it is not surprising that Poussin, or rather Poussinisme, which triumphed in France as an ideology of art after the 1650s, was publicly debated with the minority adherents of Rubenisme, in French cultural circles around 1672–78. This was known as the Querelle du coloris,

and the leader of the Poussinistes was Charles Le Brun, Louis XIV's cultural director, so naturally that side won. It led to the definition of a hierarchy of worth in types of painting: history was pronounced the most honourable, then came portraits, then landscapes, with still lifes bringing up the rear. The consequences for France were dire, as we shall see. Poussin would have been too shy to participate in the debates but would have followed them avidly and applauded the result. Rubens would have laughed and dismissed them as nonsense.

What view of the matter would have been held by Claude Gelée, or Claude Lorrain as he is known (1600–1682)? That is a difficult question. Claude was as devoted to the world of antiquity as Poussin was, yet following the narrow line which divides idealism and realism, he tended to stray onto the side of the real world. His ambivalence was the result of prevailing taste; at heart he was entirely on the side of nature. This apart, his was a happy life. His parents were peasant-proprietors, more likely to be seen doing a rustic dance than painting one. He was trained as a pastrycook, and in his early teens went to Rome as one, to feed the hungry Tassi, rapist of Artemisia, who, to do him justice, recognised Claude's talents and put him on the right track. Thus he got a Roman training, and his ascent was rapid. He did not know Virgil, Ovid and Horace in the way Poussin did. But he knew that such writers provided incidents for a painter anxious to sell, and being methodical and persevering, he produced for the market. By the time he was thirty, says Filippo Baldinucci, an early biographer, 'cardinals and princes of all ranks began to frequent his studio' to buy up his paintings as he produced them, and those with wealth but no social pull could not buy them except by queuing. He always sold, all his long life, and when he died there were only four, recently completed paintings left on his hands.

Claude's enviable professional success was accompanied by a quiet, domesticated life, spent among family and friends and artist colleagues. He merely progressed along his chosen path, improving all the time. He is well documented, success coming early. He was much plagiarised, and to protect himself he kept careful records of everything he produced including sketches, bound together in a volume entitled the *Liber veritatis*. This has 195 pages, recording virtually all his works from about 1635/40 until his death. The total number of paintings he did is about 250, and he produced, besides etchings, thousands of drawings which were also originally bound in volumes, though all these, alas, were broken up and the contents sold separately. His drawing technique, on white or blue laid paper, in brown ink made from boiled wood-ash, using a quill pen or brush, with black chalk and white gouache to produce shadows and highlights, is of great consistency, accuracy and charm, so that those fortunate enough to be permitted to leaf through a Claude portfolio have an experience they will always remember.

Claude was unique in that, before painting a landscape with figures, he made separate sketches of the landscape and its inhabitants. That reflects the tragedy of his professional life: he could not draw or paint the human figure. A German artist in Rome, Joachim von Sandrart, who knew Claude well, described him as 'unhappy in

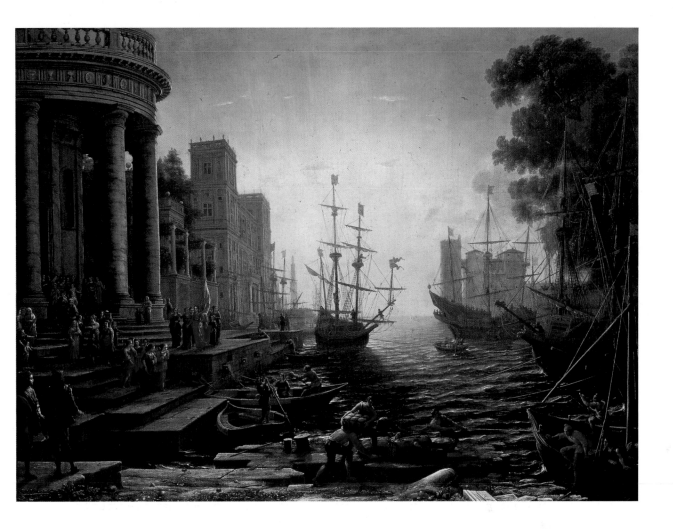

[painting human] figures and animals, be they only half a finger long'. They 'remain unpleasing despite the fact that he takes great pains and works hard on them, and drew for many years in Rome in the academies from life and from statues, and even applied himself more to the figures than to the landscapes'. Claude's drawing of figures was so bad, and his painting of them little better, though he could fudge things a bit with paint, that there can be no doubt he would have preferred to produce pure landscapes. But this was not what the market wanted and in any event it would have been beneath his dignity. Thus, his *Jacob with Laban and His Daughters* (two versions: London, Dulwich, and Petworth, England) was a history painting, despite the insignificance of the figures, and therefore at the top of the artistic league. Take away the figures, and it fell below portraits, and the price was quartered. In some of Claude's grand history tales the figures do matter. Thus *Seaport with the Embarkation of Saint Ursula* (London, National Gallery) contains a substantial element of storytelling with ships, boats being loaded, and so forth. In this case Claude made superhuman efforts to get the staffage right, though St Ursula and her ladies, on close inspection, still seem ghoulish or ridiculous.

Claude Lorrain loved to work in the open air, as his wonderful drawings attest. *Seaport with the Embarkation of Saint Ursula* (1641) reflects a lifetime's observation of light-effects.

Equally, in another grand masterpiece, *Seaport with the Embarkation of the Queen of Sheba* (National Gallery), the activity is important and the picture would be much reduced without it. But in one of Claude's most beautiful paintings, *Landscape with Psyche at the Palace of Cupid* (National Gallery), Psyche's removal would actually improve the painting, and it does not matter who lived in the palace—Keats, whose marvellous 'Ode to a Nightingale' this picture inspired, merely saw it as an archetypal palace with 'magic casements, opening on the foam / Of perilous seas, in faery lands forlorn'. In yet another painting from the National Gallery, *Landscape with Narcissus and Echo*, the naked figure of Echo is embarrassing and would be better absent, and Narcissus we do not need either; remove both and the charm and beauty of the scene envelops us. But if one had done so in 1644 when the work was painted, it would probably have been unsaleable. A cardinal or Roman prince, showing his paintings to guests by candlelight, would have wished to talk about the myth and the precise way in which Claude had brought it to life. The figures made it a 'talking point', the need for which drove many rich men, otherwise little interested in art, to spend their money and pay Claude what he asked. If Claude had refused to tell classical or religious stories, his studio, at his death, would not have contained four unsold paintings: it would have been stacked with them.

Like all good landscape painters, Claude had his special methods for producing the skies he favoured. The German painter Sandrart reported that Claude, in addition to making outdoor drawings on paper with ink and wash, and even doing oil sketches on paper in the open, would also spend 'whole days' observing light in the sky and the way it fell on objects and the ground; he would actually mix colours on his palette there and then, to get the exact tonal hue, then take it home and paint on his easel. I suspect that virtually all his surviving oil sketches were done in the open, and that entire paintings were finished there.

Claude looked forward to the eighteenth century, its serenity and stasis. By contrast, his younger contemporary, the Neapolitan Salvator Rosa (1615–1673), looked forward to Romanticism and the nineteenth century, and much else. Where Claude was industrious, self-effacing, consistent and quiet, Rosa was spasmodic, volatile, hugely ambitious, showy and violent. What he shared with Claude was an admirable passion for real landscape and a strong desire to people it with creatures of his fancy—not classical figures from Ovid and Horace, but *banditti* from the Naples countryside, witches and devils, and other creatures of the night. He learned to paint the landscape as a young man by making countless oil sketches near his native city; none has survived but they are echoed in a fine painting, *Coast Scene* (Althorp House, Northants). He worked from nature all his life—it shows—but there was no living in it, and putting in Ovidian figures he thought too tame. Not that he was against poetry. On the contrary; he was a poet himself, and mixed with others, in Rome and its bohemia which he joined when only twenty. He painted battle scenes, low-lifes, genre and the first of his *banditti*. He tried to cut a *bella figura* but succeeded only in getting into a

row with Gianlorenzo Bernini, then the most powerful artistic maestro in Rome, and in consequence had to flee to Florence (1640). A self-portrait from this time in the London National Gallery shows him scowling and melancholy, a proto-Byron. He was learned, bookish when not drinking and fighting, superstitious, a lifelong depressive, religious in fits, usually anti-clerical. He sometimes preached pictorial sermons on the vanity of human wishes and the futility of endeavour, examples being his gloomy composition *Democritus in Meditation* (Copenhagen, Statens Museum) and his even more despondent *L'Umana fragilita* (Cambridge, Fitzwilliam).

These, and other specialist pictures, which will always find some admirers, did not satisfy either Rosa or the public. He managed to re-establish himself in Rome but it was only in the 1650s and 1660s that he found his true *métier*—putting his *banditti*, or other figures telling a story (biblical, classical, historical) in rocky defiles and mountainscapes, in a visual atmosphere of strangeness bordering on the grotesque. What he liked, he said in a letter, was 'beauty that terrifies' and 'wildness to the point of savagery'. Thus he was working towards what, in the eighteenth century, would be called the theory of the sublime as a source of beauty. In the Glasgow Art Gallery there is a large painting of his *St John the Baptist in the Wilderness*, which shows extravagant rocks, water and amazing trees, against a huge and threatening sky. It is nature, closely observed but romantically transformed, in the studio, into horror and fear. Rosa did many such works, not so successfully on the whole. Some sold. Some were much admired, a hundred years later, when the first stirrings of the delights of terror were felt, when Edmund Burke published his *Philosophical Enquiry into the Sublime and the Beautiful* and the vogue for the picturesque took a grip. Rosa was before his time not only in subject matter but in attitude. While anxious to be famous, he scorned patronage, and wrote to one would-be buyer: 'I do not paint to enrich myself but purely for my own satisfaction. I need to be transported by enthusiasm and I can only employ my brushes when I am in ecstasy.' This is the first we hear of artistic inspiration. Indeed, at times Rosa came close to the later doctrine of 'Art for art's sake'.

Italy continued to produce gifted and important painters like Rosa and Giordano. But as the seventeenth century progressed, its old dominance of the art world disappeared. The days when Genoa and Florence ran great commercial empires, when Venice 'held the East in fee' and when Rome was a major power, had gone. Inevitably, this decline in economic and political influence affected every aspect of life, including culture. The more energetic European nations—first the Portuguese, Spanish and Dutch, then the French and finally the English—were pushing into the wider world, acquiring colonies and creating fortunes for the leading merchants and adventurers and the monarchs who sponsored them. In the sixteenth century, Spain acquired a world empire, and control of the largest silver mines so far known. That had important consequences for art.

16

THE GOLDEN CENTURY
OF SPANISH ART

The re-Christianisation of Spain by the conquistadors took half a millennium, and its progress is written in the golden stones of cathedrals, churches and abbeys. But once Granada passed into Spanish hands in 1492, the country's worldwide expansion was a mere matter of decades. The same year, in October, Christopher Columbus reached the New World. The next year Pope Alexander VI published his bull, *Inter cetera divina*, dividing it between Spain and Portugal. Portugal received most of what is now Brazil and Spain took the rest of the hemisphere. The Spanish began intensive colonisation immediately. They had occupied Hispaniola by 1494, Cuba by 1511. By 1520 they had reached the heart of the Aztec empire and taken what is now Mexico City. In 1524 the first expedition set off to conquer Peru. The empire of the Incas was rapidly subdued. By now the Spanish were also in Florida and California. It was the largest and fastest transfer of territory in history.

The Spanish were, on their own admission, bewildered by what they found. They attributed their good fortune to the favour of God, rewarding them for their aggressive defence of the faith against Moors and Turks. Hence their first object, having secured these new lands, was to stamp out paganism, Christianise the natives and impose European Catholic worship. Their second priority was to exploit the resources of their new property by establishing plantations and working its gold and silver mines. Since the indigenous peoples did not lend themselves easily to forced labour, African slaves were imported, the first arriving in 1501.

The Spanish approached the cultures they found, which were comparatively advanced in both Mexico and Peru, in exactly the same spirit with which they had dealt with Islam in Spain itself. They treated it as hostile but made use of it, where feasible, for both religious and secular purposes. *Homo sapiens* had been in the Americas since about 20,000 BC. In Meso-America, scholars have divided its history into five distinct periods: the Archaic period, the Pre-Classic up to 250 AD, the Classic, 250–900 AD, revolving around the great Maya civilisation of Yucatán, and the Post-Classic, leading up to the Spanish conquest of 1519–22, which forms the fifth

division. In South America, with Peru at its centre, there is a different academic clas-sification: the Early Ceramic period, the Formative period, the Regional Development period and the Integration period, leading up to the Inca Domination from 1450 until the arrival of the Spanish. In both cases there are regional divisions too, which in South America are termed 'horizons'.

The Spanish knew nothing of this history. But they could recognise gold and silver and fine workmanship. They collected booty and sent it home. In 1520, Dürer saw a collection of fine objects delivered to the Emperor Charles V at Brussels, and wrote: 'In all the days of my life, I have seen nothing that rejoiced my heart so much as these things, for I saw amongst them wonderful works of art, and I marvelled at the subtle *ingenium* of men in distant lands.' What were these things? Few, it appears, have survived. But a number made their way eventually into the great collections. Thus the British Museum has decorative helmets inset with mosaics of turquoise and shells, warriors' shields adorned with feathers and gilded *atlatls* or spear-throwers. Princeton has some wooden masks, and there are beautiful feather-headdresses in museums in Vienna and Stuttgart.

The most important finds sent back to Europe were not precious vessels and jewellery, which were almost invariably melted down (a surviving gold dish is to be found in the Fogg Museum at Harvard and gold pectoral ornament in the Oaxaca Museum), but manuscripts. The civilisations which the Spanish found had not emerged from the Bronze Age and could not produce iron. They had no phonetic scripts and were dependent on ideograms to convey information. But they had elab-orate cosmologies expressed in cosmograms, they compiled calendars, they kept accounts of many kinds and they produced administrative documents. These were bound in books or codices, of which the Spanish found hundreds when they arrived. The Spanish were not so foolish as to despise these strange documents. On the con-trary, at the beginning of their conquest they used local scribes to compile tribute and tax lists, make maps, register properties and list salaries. These administrative docu-ments were likewise bound into codices, the most famous of which, the Codex Mendoza, specially done for the Viceroy and sent to Charles V, is now in the Bodleian Library. For obvious reasons the Spanish looked after these codices, of which more than five hundred survive, until the practice died out towards the end of the sixteenth century and the languages and pictograms became extinct.

The more intelligent clergy also used ancient documents to investigate the habits of the native population, with a view to speeding their conversion. They even com-piled written reports on what they found. But, having done so, they destroyed their sources, believing them to be evil. The sixteenth-century Diego de Landa, Bishop of Yucatán, who wrote an account of Mayan civilisation, said he burned his documen-tary evidence as it was idolatrous. There was one exception, a pertinacious Franciscan friar called Bernardino de Sahagún, who was an ardent missionary but also an early ethnographer. He not only used the codices he came across, and verbal informants

among the Indians, to write descriptions of some Aztec arts and crafts, and a general history of the conquest; he also preserved his materials. As a result of his efforts, and chance, fourteen codices, which were unquestionably produced before the conquest, still exist and are scattered in public collections throughout the world.

Why did the clergy regard the indigenous cultures as evil? Of course, all infidelity and its products was evil by definition; but there were two particular reasons. First, human blood–sacrifices were practised. A fierce European detestation of human sacrifice went right back to the Romans, and had been steadily reinforced by Christian teaching. It took many forms in the Americas but one in particular made the flesh of the Spanish creep. From about 1200 BC right up to the conquest, a religious ritual game had been played, with a rubber ball, in which the players of the losing team were decapitated by the other side. It is possible that early Spanish arrivals actually witnessed such games. In the Leiden Museum there are pottery figures showing players grasping knives and trophies in the form of heads, and decapitating losing players. Stone relief panels and stone steles tell the same gruesome story. When found, these representations of unspeakable horror were instantly destroyed, though a few unearthed since the early days of the conquest have survived (Vega de Alatorre and Aparicio, Veracruz).

The truth is, much of the art that the conquerors came across was repellent to them. Streams of human blood in the form of serpents, sacrificial knives, beheading blocks, headless men, human bones and, above all, skulls figure largely in the imagery of pre-Columbian art. Spanish friars, who could stomach, indeed revere, the most realistic Crucifixion scene, 'the supreme sacrifice' as they termed it, would not permit the slaughter of the innocent in the name of paganism. And the forms which local art took, showing the human figure as squat, wide, short-legged or with no legs, without waistlines or elegance of any kind, made matters worse. There was a powerful cult of toads, reflected in imagery, which seemed especially loathsome. Where death-images were not paramount, repulsive animals were, but usually the two were combined. In the Mexico City Museum there is a basalt figure, with the head of a fierce animal but with human hands, which has a crown of skulls, a skull heart, sliced-off tongue and decorative bones. From the imagery found on wall-paintings, pottery vessels, stonework and low-reliefs, the Spanish clergy deduced that the blood-lust of these pagan gods was insatiable, even in regular events like harvests, and that the skull of a human victim was the archetypal symbol of this (to them) satanic art. So they destroyed whatever they found.

It might have been a different matter if the Aztec or Inca architects, or their predecessors, who were often more skilled and inventive, had understood space-enclosure. Then the Spanish would have happily taken over their temples, as they took over the Mosque of Córdoba, had them reconsecrated and used them as churches. But neither Aztecs nor Incas, nor the Mayas before them, seem to have been interested in constructing large roofed areas. They did not create the true arch.

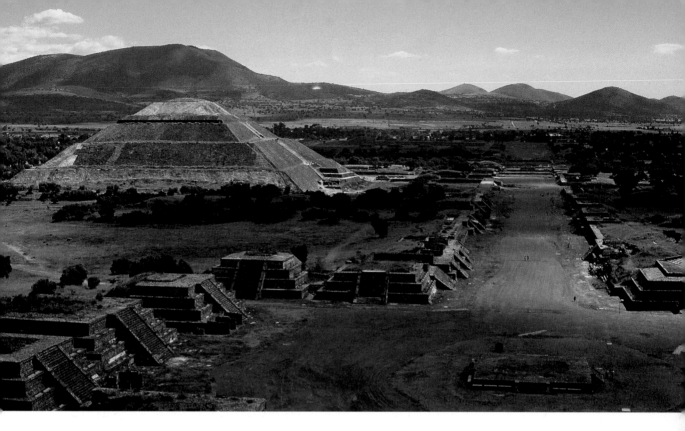

The nearest they came to it can be seen at Labná, in the Maya region, a precarious-looking affair, though as it has survived since the early tenth century AD, it must be stable. This diffidence about putting up buildings with huge interiors must have been at least partly ideological. It was certainly not for lack of skill. Both Aztecs and Incas seem to have understood vaulting. In some areas they were superb masons. At Cuzco in Peru and elsewhere, there are Inca walls of irregular polygonal blocks, some of great size, which are carved and fitted together to the point of perfection. It is not true, as is often said, that a knife blade cannot be passed between the stones—I have tried and it can. But it is clear that there was little that Inca workmen did not know about monumental masonry. The irregular polygonals were chosen for artistic purposes, for the Incas could build walls of perfectly coursed blocks too, both plain and with bevelled edges. In most forms of masonry, they were as good as the ancient Egyptians, than which there is no higher praise.

However, they were chiefly interested in platforms. They were a ziggurat culture, like the ancients of Sumer, except that they went on building platforms until the arrival of the Spanish stopped them. Platforms were a notable feature of palaces as well as temples. In Edzná, in the Maya region, there is a well-preserved building called the Palace of Five Flora, with a central stairway thrusting right up through the middle to the top, with tributary stairways linking it to each floor. That is a characteristically dramatic arrangement, dating from about 750 AD, the time of the great scriptorium in Northumbria. Even in its present state, it is a magnificent piece of monumental architecture. At Teotihuacán, the palace-temple complex has some

Teotihuacán in Mexico had a population of 200,000 in the sixth century, making it the sixth largest on earth, and a miracle of town-planning. It was destroyed in the eighth century.

remarkable parallels to Djoser's Step Pyramid and its accompanying buildings, with squared-off pillars supporting galleries, and a mass of right angles, the masterpiece of the great Imhotep. Indeed, most of the big Mayan temples were in the basic form of a stepped pyramid. But they were built not nearly 5,000 years ago but around 800 AD. With their main staircase and feeders, their terraces and causeways, esplanades and pseudo-archways, these were sophisticated structures, often designed to present dramatic silhouettes. Great attention was paid to detail. In the main stairs, the uprights are often treated as an excuse to install a sculpture gallery, of abstract designs, animal heads and pictograms, rather as medieval architects used the west fronts of churches to display figure-sculpture. Like the Greeks, the Aztecs employed illusionistic devices. For buildings, one storey was the norm, so walls were often made to incline inwards to give an impression of height. The size of blocks chosen for courses often decreased as the height rose, to reinforce this effect. It is argued that the masonry in the walls which now form part of the museum in Cuzco was designed or bevelled to produce special light-effects, though I find it hard to perceive. What is clear is that the masons, and the architects who directed them, knew exactly what they were doing. And they successfully built to last, as the survival of so much of Machu Picchu's magnificent stonework attests.

But such buildings were of no use to the Spanish. What they did use were the town plans, often in advance of anything available in Europe until the end of the sixteenth century when the cult of the square took hold. In places like Mexico City, the Spanish took over what they found and built over it, knocking down existing structures when necessary. Many platform or pyramid temples were not found in cities but were more akin to pyramid-centres in the country. When the Spanish came, such structures fell into disuse. They were sometimes looted for buried treasure, so that their rooms, platforms and staircases collapsed, or the jungle closed in and they became concealed ruins until modern archaeologists arrived. The first descriptions of Mayan ruins were written only in the late seventeenth century, when the Franciscan friar Diego López de Cogolludo worked on the temples of Uxmal and Chichén Itzá. Any kind of systematic archaeology had to wait until the late eighteenth century. Even in the 1850s and 1860s it was not uncommon for treasure-hunters to pillage ancient sites. If they found hoards of gold or silver they were melted down to provide value in bullion. During the twentieth century a good deal of money and scholarly time was spent on reconstructing these cultures, but it is a melancholy fact that not until 1986 did the U.S. National Geographic Society publish the first general map of Central America focusing on sites and cultures.

Hence, until quite modern times, artefacts from these great civilisations were rarely seriously collected and studied. Nearly all are interesting but they vary greatly in artistic quality. The palatial wall-paintings at Teotihuacán and the tomb paintings at Monte Albán, like the surviving manuscript paintings, suffer from the pervasive squatness of the human figures which is characteristic of so much of the sculpture too. The

surfaces are overcrowded, indicating that these works are all ideogrammatic rather than strictly artistic. On the other hand, some of the sculpture and metalwork is pleasing, to put it no higher. The Bogotá Museum has a wrought-gold raft, bearing a king and his attendants, which dates from just before their conquest and is dignified and charming—a lucky survivor from the melting furnace. Some of the stone-carving is fine, or at least impressive. In what is now Nicaragua there are giant stone heads, some of them 9 feet high, and in Costa Rica prodigious stone balls. A feature of Mayan stone-carving were reclining limestone figures, from 5 to 6 feet long, called *chacmools*, which belonged in temples and had a recess in the stomach, perhaps for offerings. (There is a fine one in the Mexico City Museum.) Another type is the stone tripod stool, often elaborately carved, on which reposed trays or dishes. Mayan portrait heads, in a variety of materials, are sometimes highly realistic. In the Brussels Museum there is a superbly carved conch, of colossal size (over 5 feet across) which comes from Tenochtitlán. But what was it for? The early Spanish friars who examined such objects were suspicious, and often rightly so. An innocent-looking tripod-rest might well turn out to be a skull-rack. A hole in a *chacmool* might exist to receive human blood.

Chichén Itzá in Yucatán, Mexico, is a conflux of pre-Columbian cultures, excelling in precision masonry, highly imaginative sculpture and dark rites.

The friars were particularly wary of elaborate pottery vessels, believing they might be involved in the cult of hallucinogens. It is a fascinating point of continuity that the fear and loathing of certain territories in Latin America which is felt by the white authorities of the United States today, on account of their illicit drug production centres, was anticipated 400 years before by the Spanish conquerors, secular as well as religious. In both Meso-America and the Inca empire, much of the pagan religion centred round the use of drugs to produce ecstatic communion with the spirit world. The Church did everything possible to stamp it out, and that meant destroying the sacred vessels used for ceremonies intended to produce hallucination. They included ceramic effigies, ceremonial pots and painted wooden shovels with drug-god handles (one such is in the San Pedro de Atacama Museum). But any elaborately decorated piece of pottery was suspect. The friars were the tracker dogs for an anti-drugs drive which had catastrophic consequences for the art of the region. For if existing ceramics and pottery with any claim to beauty were dangerous and must be smashed, how much more important

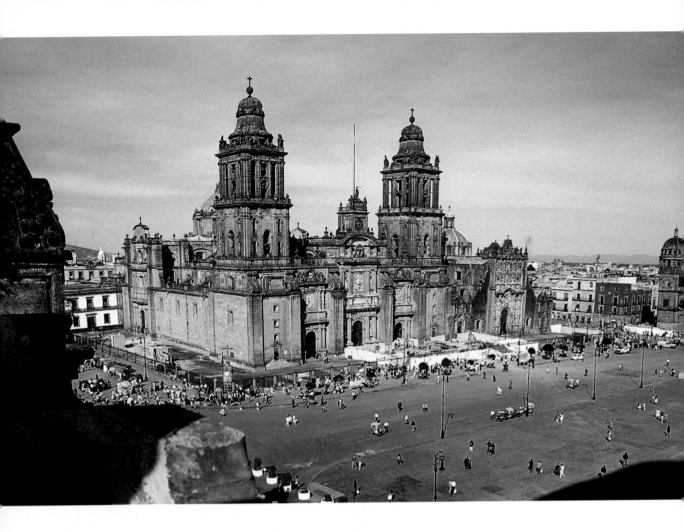

Building of the cathedral in Mexico City took from 1563 to 1813. It is on the site of Tenochtitlán, capital of the Aztec Empire.

was it to prevent craftsmen making new ones! The tragedy was acute, for one of the arts which was well-established in both Central America and the Andes was working with clay. Vessels were characterised by the so-called stirrup-spout, a beautiful and ingenious device, and were made in strange and elegant shapes. Some were heads with actual portrait faces, like the remarkable one at Harvard. The British Museum has one decorated with imitation feathers carved in clay. Some of these styles went back over a millennium, and when the Spanish banned them the continuity was irretrievably broken. Modern attempts to recapture these and other arts are not the same.

The historiography of the last century has placed the Spanish invaders in such a poor and destructive light that it is hard for modern minds to accept that they usually acted from the best motives. They believed they had overthrown cruel and oppressive empires, which revolved round human sacrifice, and that in taking away from the local peoples their freedom, they were also giving them the inestimable privilege of membership in the Church, 'the freedom that men find in Christ', to quote St Paul, the 'first missionary' with whom the friars identified themselves.

Though loot was shipped to Europe, as we have seen, and vast quantities of bullion, especially silver, were transported to Spain every year throughout the sixteenth and seventeenth centuries, much of the wealth produced, whether ill-gotten or not, was spent locally on the erection of churches and cathedrals.

The earliest stone churches in the New World were built within a decade of Columbus's first landing. Some of these were temporary structures of comparatively simple design, but they were rapidly replaced by permanent buildings, often of monumental size and stupendous grandeur, as opportunity offered. In Hispaniola, the cathedral of the capital, Santo Domingo, erected 1521–41, was the first architectural masterpiece of the Western Hemisphere, a splendid edifice in late medieval style, with ribbed vaults, chevet chapels, huge square nave bays and all the elaborations then current in Spain, including a fantastic Plateresque west front. The cathedral in Mexico City, the building of which began as soon as the Aztecs were ousted, was considered inadequate by mid-century and a new one was begun in 1563. This is of vast size, with two high west towers, an enormous central dome and all the architectural apparatus of the new art, including classic orders. It was much altered in the eighteenth and nineteenth centuries. It has distinctive local features and plainly did not come from Spain, but its original frontage, on the main square of what is now the largest city on earth, makes it one of the world's most formidable buildings, and a symbol of Spanish self-confidence in those expansive days.

Lima Cathedral, built shortly before (1543–51), had a timber ceiling in its original incarnation, but had to be rebuilt four times, in stone and brick, as a result of earthquakes. It is a work of great elegance and spaciousness. Cuzco Cathedral, built of andesite like many large buildings in South America (1560–1658), has a tremendous façade and dramatic portals. Before the sixteenth century was over, the Spanish had built two more major cathedrals in Mexico alone, at Oaxaca and Mérida. A network of large-scale convents, put up by Franciscans, Dominicans and Augustinians, spread across the colonies, supplemented, from the 1560s, by big Jesuit churches. It is not uncommon to come across, in the scrub or jungle of remote Latin American regions, the shattered columns and crumbling walls of a noble colonial mission station, built before the year 1600. The Mercedarians were particularly fine architects: their monasteries and cloisters in Cuzco (1650), Mexico City (1634) and Quito (1630) are among the finest buildings in the Western Hemisphere. Indeed, the Spanish architectural heritage across the Atlantic is, as a whole, magnificent—what is left of it. Until the second half of the twentieth century it was ill-restored and protected, and I saw for myself that seventeenth-century secular buildings were still being demolished as late as 1960.

The building of innumerable convents, churches, cathedrals and gubernatorial palaces in Latin America enlarged the demand for decorative artefacts, especially paintings, supplied by workshops in Spain. This helps to explain why a distinctive Spanish school of art emerged in the second half of the sixteenth century. The training ground was essentially the Escorial, the palace-monastery built by Philip II in

accordance with the will of his father, Charles V. It was the first of the great complexes which marked the revival of palace art. The building itself, begun in 1563 and completed in 1584, was—like so much else in Spain—the work of a council or committee, which employed five architects, though Juan Bautista de Toledo was the principal one until his death in 1567. Four more architects were later brought into the scheme. They all quarrelled, as architects invariably do. In view of its fraught design history, the enormous complex looks remarkably unified and consistent. But it may be that, like St Peter's, it looks right simply because we are used to it. Photographs, however, do not do justice to this grimly noble Spanish adaptation of Italian forms. The reality, when first seen, is overwhelming. It lies at the foot of a great spur of the Guadarrama Mountains, and no palace in Europe has such a dramatic setting. It is a tragedy that the rugged landscape which Rubens did of the building and its surrounds, painted from above, survives only in an uninspiring copy.

The palace was designed to house, in addition to books and manuscripts, 7,500 relics, set up in 507 reliquaries. It had about 500 altars, so the provision of altarpieces alone demanded artwork on an industrial scale. Italian artists were imported to work side by side with local painters. Juan Fernández de Navarrete got a commission (in 1576) for 32 altarpieces. A total of 33 retables were completed by a Spanish-Italian team consisting of Alonso Sánchez Coello, Diego de Urbina, Luca Cambiaso and Luis de Carvajal, Luca also supplying separate easel oils, frescoes on the chancel and choir vaults, and wall-paintings. The cloister walls and staircases of the Patio de los Evangelistas were decorated with 62 episodes from the New Testament and saints' lives, done by a team of 4 artists, 2 Spanish, 2 Italian, with sculptures by Juan Bautista de Monegro. Vaults had to be painted, huge reliquary cupboards made and decorated, funerary monuments for Charles V and other royals had to be designed and carved, big crucifixes—about 60 all told—provided, over 100 paintings and designs done for the library, itself on a colossal scale, and such items as holy-water stoups, confessionals, benches and doors, marble altars and a mass of ironwork for a dozen different purposes—all had to be designed, made and installed.

Up to the end of the sixteenth century alone, about sixty artists received major commissions, and as the years went by the number of Italians employed dropped sharply. But Italians got the key roles in the Sacristy, where the greatest treasures were kept. There hung in glory Titian's *Crucifixion*, while the superb grotesques on its vault were provided by Fabrizio Castello and Nicolás Granello. The crucifix, which had the place of honour, was by Benvenuto Cellini. On the other hand, the giant-size statue of St Lawrence which dominates the main façade, and the seven even bigger (16 feet high) Old Testament heroes on the front of the church, are all by Monegro; Juan Fernández de Navarrete became the principal decorative artist until his death. Philip II gave the monastery 1,150 paintings from the royal collection, including fine works by Bosch and Weyden and fourteen Titians, to hang throughout the complex (the best are all now in the Prado, of course). But after about 1590,

the overwhelming majority of artists employed in additions to the fabric were Spanish, an exception being Luca Giordano who contributed frescoes in the 1690s. In short, Spanish painting, as a self-confident, coherent entity, was born in this extraordinary building, the greatest single artistic enterprise undertaken by a European monarch until Louis XIV built Versailles.

However, for the artists who comprised and perpetuated the new Spanish school, professional life was not easy. There was no lack of work. Even without counting the colonies, the number of churches and convents built in Spain during the years 1550–1650 was numbered in the thousands, and under the influence of the Council of Trent rules, and the aesthetic-religious theories of the Jesuits, bishops, abbots and friars covered much of the wall-spaces with paintings. The demand, therefore, was enormous. But prices paid were low, and since the Church was overwhelmingly the principal employer—in many parts of Spain the sole one—artists could rarely bargain to raise their pay. The repetition and monotony of endlessly producing full-lengths of St Francis, St Dominic and other patron saints performing well-known miracles was something the Spanish artist had to accept as a fact of life. Moreover, it did not pay to be original, let alone adventurous. Mythological subjects,

The Escorial, at the foot of the Guadarrama Mountains, 30 miles from Madrid, is the masterwork of the Spanish Renaissance, combining monastery, palace, college, church and royal mausoleum.

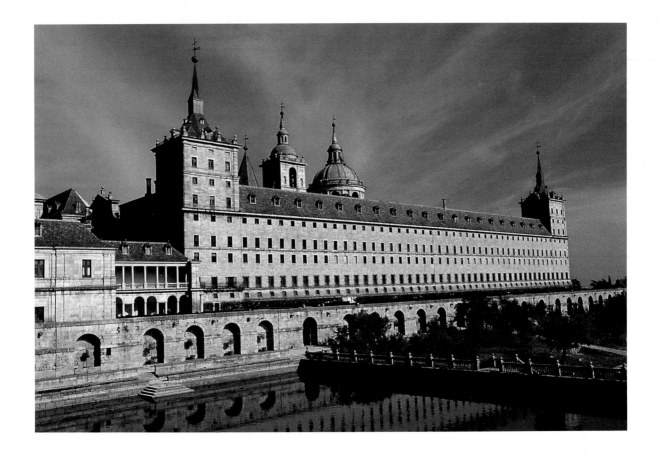

though not strictly forbidden, were frowned upon. The strictest orthodoxy was demanded not only by the Church but by secular authorities, such as Philip II. His successors were more liberal but officious busybodies at court who could be relied on to point out any deviations from Tridentine doctrine, and make a fuss. 'Delation' to the Inquisition, as it was called, was common and safe, for it never revealed who had made the complaint. Artists who felt themselves neglected or superseded were as likely to 'lay' information as anyone else. Torrigiano was not the only artist who died in the prisons of the Spanish Inquisition, which was much fiercer and more unrelenting than the one in Rome. The temptation to play safe was strong.

Hence it is not surprising that the first Spanish painter to establish himself as an individual, following his own bent, and so to climb to international status, Jusepe de Ribera (1591–1652), did so by breaking out of Spanish provincialism and establishing himself in Naples, capital of the Spanish viceroyalty in Italy. This enormous city, the largest in southern Europe, with a population rising to 450,000 during the seventeenth century, was three times as big as Rome or Madrid. It had the densest concentration of clergy and convents in the world but it also had many rich secular patrons (who owned 10,000 slaves), a liberal court and opportunities to do work elsewhere in Italy. Ribera was born near Valencia and trained in Spain. He always considered

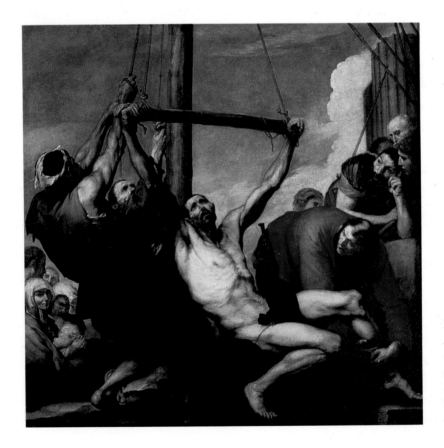

Ribera painted *The Martyrdom of Saint Philip* (1630–39) with the genius and relish he brought to depicting cruelty. No one has surpassed him at flaying-alive scenes.

himself Spanish (being short, he was known in Italy as *Il Spagnoletto*) but he went to Italy before he was twenty and, once established in Naples, vowed never to return.

Ribera brought to Italy a Spanish tradition of realism, especially in presenting the human body in pain, under stress or strong emotion, which he made the most powerful single element in his work. But he refined it by contact with the works of Caravaggio and his followers. He is said to have been strongly influenced by Van Dyck and others, but the truth is, once having absorbed what Caravaggio had to teach—chiefly the manipulation of dark backgrounds and intense lateral light—Ribera was very much the sole source of his ideas and methods. His brushstrokes, like Rubens's, were extraordinarily lengthy and fluent for so small a man, and he developed to an intense degree the Italian oil technique of *alla prima*, or 'wet on wet', which gave his paint surfaces a wonderful fluidity and made his flesh tones look absolutely real. Ribera was hugely successful in his day, especially among the mercantile aristocracy of Naples such as the Fleming Gaspar Roomer, his leading patron. But after the seventeenth century he sank into almost complete oblivion, chiefly because he acquired a reputation for cruelty. Ribera's rehabilitation began with the important exhibition of Naples seventeenth-century painting held at the Royal Academy, London, in 1982 and continued with the Metropolitan, New York, show in 1992. Authentic early paintings—including his magnificent *Five Senses* (Mexico City; Hartford, Wadsworth Atheneum; Pasadena, Norton Simon)—have come to light or been authenticated, copies have been sorted out from originals, and his entire *oeuvre* has been subjected to rigorous scholarly investigation for the first time. As a result, he is emerging as one of the most important and influential painters of the seventeenth century.

Ribera brought from Spain an absolute respect for truth. It had priority over every other aspect in his art. He never tried to disguise the horrors, privations and sufferings of this world. On the contrary, he insisted on emphasising them. In his *Crucifixion* (Osuna, Museo de Arte Sacro), his Christ is in agony, the womenfolk shattered by grief. His *Drunken Silenus* (Naples, Galleria Nazionale) is a loathsome object of self-indulgence. *Ixion* (Prado) is a horrific scene of pain and disaster. *Apollo and Marsyas* is a hair-raising study of agony and sadism. *The Martyrdom of Saint Philip* (Prado) makes the blood run cold. His *St Andrew*, in both versions (Budapest, Szepmuveseti Museum; Prado) is a weak, skinny old man about to be subjected to appalling sufferings. Ribera is saying: 'If you want to hear about these old tales of gods and saints, this is what actually happened.' He always insists on reality. His beautiful *Blessing of Jacob* (Prado), one of the finest works of the century, gives the actual mechanism of the deception in a way that other artists always funked. His *Old Usurer* (Prado) is a monster of hard cupidity. His *Saint Mary of Egypt* (Montpellier, Musée Fabre) is a ravaged, half-starved old woman. Even when he shows her in youth (Naples, Museo Civico), she is without charm or looks.

Ribera is not afraid to paint the unpaintable. In 1636 he produced *Duel Between*

Women (Prado), an imaginative reconstruction of an actual event of 1522, when Isabella da Carazzi and Diambra de Pettinella fought, with swords and shields, for the love of a young man, in the presence of the Viceroy. It was once, evidently, a beautiful painting, but was so badly damaged that recent restoration has been unable to restore its glory. The painting still shocks, though, and was meant to shock; and it is heroic, as Ribera also intended. More tragic, indeed infinitely pitiful, is the double full-length portrait in Toledo of *Magdalena Ventura with Her Husband*. It was commissioned from Ribera by the Viceroy, the Duke of Alcalá, and a Latin inscription on the canvas explains why. The lady came from the Abruzzi, had three sons by her husband, and then, when she was thirty-seven, began to grow a thick and bushy beard. This did not prevent her from having at least one more child. The painting is done from life (1631) and shows the heavily bearded woman suckling her child from a large, exposed breast, standing alongside her husband. They both look straight at the painter, grieving perhaps but impassive, baffled by what God has done to them, but accepting it. It is an astonishing painting, a superb work of art, stoical, Spanish, immensely powerful in its complete absence of sentimentality or prurience. It is hard to think of any other artist who could have painted this terrible subject without exciting disgust or ridicule.

Equally, Ribera handled, with complete success, another unpaintable subject: God himself. His *God the Father* (Naples) is both beautiful and convincing, a study in commanding age which makes Michelangelo's attempt on the Sistine Ceiling seem unimaginative by comparison. The truth is, Ribera at his best—and that is most of the time—is as good as anyone. His *Holy Family with Saints Anne and Catherine of Alexandria* (New York, Metropolitan) has a beauty of form and colour, and a feeling, both delicate and intense, which puts it on a par with Raphael. Another Nativity piece, *Holy Family in a Carpenter's Workshop* (Rome, Knights of Malta), recalls Leonardo. I suspect Da Vinci would have been proud to have produced this truthful and glowing work.

Considering that Ribera was a hard-working professional, always in demand, and with a fluent style, and that his working life spanned forty years, the 189 paintings now identified as his must be only a proportion of his total output. As recently as 1910, one expert thought only a tiny number of drawings could be confidently attributed to him. There are now 107, and more are emerging all the time. Indeed, it may well be that the corpus will eventually exceed a thousand. Who can say? The history of art is crowded with cases like that of Ribera, a great master, esteemed and collected in his day, then buried beneath a mountain of neglect and misrepresentation, but eventually and painfully resurrected. During this time of obscurity, of course, many of his paintings were cut down in size, damaged, scratched and repainted, neglected and abused. In the Real Academia de San Fernando, Madrid, there is a drawing by Ribera of *Saint Peter's Crucifixion* of such wonderful skill and artistry that no one, you would think, could possibly underrate it. Yet until

comparatively recently, no one took the smallest notice of it. You wonder: how many other Riberas are hidden under the dust of ignorance?

By contrast, Diego Velázquez (1599–1660) was not only quickly recognised by his king, and treated as a great master in his lifetime, but has never fallen out of favour. The reasons are obvious. He came from Seville, of the lesser nobility, and was properly educated and well-trained, but was so precocious that, by the age of eighteen, it was he who was teaching his master. Like virtually every other young painter in the first decade or so of the seventeenth century, Velázquez was transfixed by Caravaggio's work, which he knew from copies or followers, perhaps in one or two cases from originals. That is quite obvious from his early works. But, like Ribera, he did not really need the example of Caravaggio to turn him towards realism because he was rooted in a Spanish tradition which, however clumsy, always put truth first. Happily, Velázquez was not clumsy. He had from the start a brush of extraordinary delicacy and accuracy, which did whatever he commanded. He was born to be a realist. However, there was another factor. Though mythological painting was almost unknown in Spain, and dangerous, especially for a young man, the humbler kind of artist painted still lifes and what were called *bodegónes*, low-life or everyday subjects, often combined with flowers, fruit and other objects useful to display virtuosity. Such pieces came low down in the hierarchy of subjects but they were popular and sometimes attracted the notice of the great.

Between the ages of eighteen and twenty-one, Velázquez painted a series of masterworks in the *bodegóne* manner. *Three Musicians* (Berlin, Gemäldegalerie), done in 1617, shows he still has a lot to learn,

The Blessing of Jacob (1637) brings out Ribera's sensitivity in painting a scene of tenderness and deception— the blind old man, conniving boy, ambitious mother.

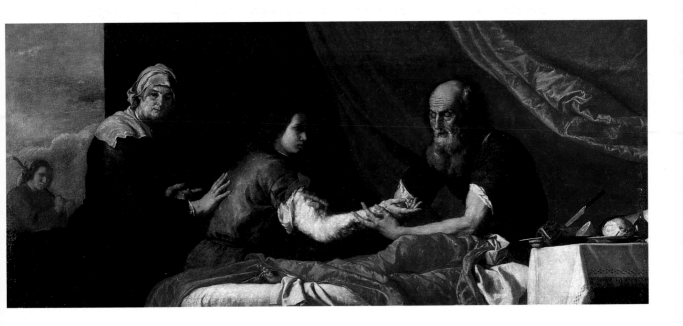

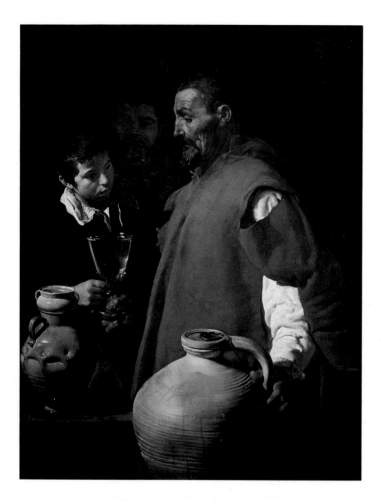

for the source of light is uncertain and the flesh tones crude. *Three Men at Table* (St Petersburg, Hermitage), done the next year, is a huge improvement, beautifully lit and composed, full of energy and joy. *Old Woman Cooking Eggs* (Edinburgh, National Gallery), also from 1618, is a major work of art, the woman and the boy emerging from the dark background as if by magic into a world in which every texture, surface, gleam and transparency, of pewter and brass, porcelain and terra-cotta, silver, white of egg, lace, cloth and glass, are painted with exquisite skill. But there is no mere virtuosity. Velázquez, even as a young man, never shows off. The woman is the picture, and irradiates it. Indeed, she and her miserable little stove are the sources of light. In 1620, Velázquez painted *The Waterseller of Seville* (London, Apsley House), one of his greatest pictures, in which all the virtues he had already demonstrated are brought to perfection. The poor old man selling water from his great jars (painted with enviable skill) is given a dignity and a monumentality which make him godlike. This is certainly no low-life picture. It has a religious aura, and reminds us that man, however humble and ragged his clothes, is made in the image of God. Velázquez was already marrying the *bodegóne* apparatus to the higher subject matter. His *Christ in the House of Mary and Martha* (London, National Gallery) has a *bodegóne* foreground, of great brilliance, showing a sulky kitchenmaid being bullied by an old crone, but through a square hole in the wall you see Christ with the two women. Again, *The Adoration of the Magi* (Prado) shows the same treatment applied to the Nativity. The baby and his mother have the faces and dress of peasants from the Spain of 1619: they are 'real-life' and superbly painted. But this is a religious work. In short, before he was twenty-two, Velázquez had already pushed a humble tradition, in which he excelled, right to the centre of Spanish high art.

At this point, Velázquez was noticed by the Count-Duke of

Velázquez was a prodigy who displayed virtuoso skills in scenes of everyday life, such as *The Waterseller of Seville* (c.1619–20), investing an urchin, an old man, a glass and a pot with dignity.

Olivares, chief minister to the young Philip IV of Spain, and brought to court. Thereafter he was famous, and soon world famous, as a painter of royalty. It is pointless to speculate whether Velázquez, who could have done anything, would have been better advised, from the viewpoint of posterity, to stick to painting the real world of everyday life. He was a hugely ambitious young man, conscious of great powers, and eager to go straight to the top. He captivated Philip the king as he had captivated his minister, and that meant he could demand and get all kinds of privileges, including the means to travel to Italy, to study and buy fine paintings for his masters. So he painted at court for the rest of his life.

That did not mean Velázquez was confined to royal work. His portrait of the poet-priest Luis de Góngora (Boston, Museum of Fine Arts), done when he was twenty-three, is one of the grimmest and most majestic presentations of a human face in the century. His full-length *Count-Duke of Olivares* (São Paolo Art Museum), from two years later, is an admonitory study in the rawness and futility of power. Velázquez painted the sour, formidable and pious *Mother Jerónima de la Fuente* (Madrid, Araoz) as she undoubtedly was, and the face is unforgettable. But, inevitably, Velázquez painted his king, head and shoulders, full length, on horseback, in armour, often and with great care, and in due course his wife, and his son, the delightful Balthasar Carlos, again and again. These are some of the most striking images in the whole history of royal portraiture. His Queen Isabella, standing in a black-and-silver dress (New York, private), eclipses all the other royal women painted in the seventeenth century—which is saying a great deal—and surpasses even Velázquez's own picture of the king's sister, the Queen of Hungary (Prado). Balthasar Carlos in hunting costume with his huge dog (Prado) is an enchantment. It is hard to find words to describe these images, so special are they. One gazes into Queen Isabella's huge, lustrous eyes with baffled rapture. The king was a fool, and is made to look it; but he did not mind—Velázquez was his hero. The boy Balthasar Carlos was bright, pert and cheeky—and looks all these things. Anyone aspiring to paint children should study these dozen or so portraits, often against adventurous settings or on horseback, and compare them with Van Dyck's presentation of Charles I's children at about the same time: two supreme masters, very different in approach, but united in one thing—they show, simultaneously, both the fragility and sturdy life-force of the prince-child. Then there are the girls: Queen Mariana, the Infantas María Teresa and Margarita, with their absurd hairdos and gigantic dresses of scarlet and silver, gold and yellow. Velázquez loved painting such creatures in their finery, and to create his unforgettable images he abolished all background except for a drape or two, and cut out any details not to do directly with the girl herself.

Velázquez did so many different things so well that it is hard to make even a summary list. There is the sad-eyed *Lady with a Fan* (London, Wallace), beautifully cleaned in 1975 and a blaze of sensitive brushwork. By contrast, there is his only nude, *Venus and Cupid*, or the '*Rokeby Venus*', bashed about in the eighteenth century,

slashed at by an enraged suffragette in 1914, then incorrigibly 'cleaned and restored' by the National Gallery in the 1960s: beautiful but a ruin. Velázquez painted a dozen portraits of dwarfs and buffoons: all totally truthful. None are making fun, condescending, proffering unsolicited sympathy or making a point. All say: this is God's will. His portrait of the dwarf holding a tome on his lap, *Diego de Acedo, 'El Primo'*, (Prado) is a masterpiece of dignity and composition. Velázquez also painted, with unforgettable foxiness, the cunning Pope Innocent X (Rome, Doria-Pamphili) and the ravishing, but unfinished, *Woman Doing Needlework* (Washington, National Gallery), which gives us unique insights into his brushwork and the way he built his pictures up.

Two major works merit special attention. In the mid-1630s, Velázquez did for the king a military piece, *The Surrender of Breda* (Prado), to celebrate an unexpected Spanish victory at a time when the national decline was gathering speed. It shows what an original man Velázquez was, and also the virtues of improvisation. The handing over of the key of the city never took place. He invented it. But it catches the spirit of the surrender, which was generous and gentlemanly. The picture is a hymn to peace and tolerance rather than a paean of victory. It is the least bellicose of all battle scenes, yet curiously ennobling and uplifting—generals love it as fervently as anyone else. And the pikes in the right background, which make the picture, were added at the last minute. All the X-raying of Velázquez's work points in the same direction: he changed his mind often, but he always got it right in the end.

The point applies equally to his other big picture, almost his last: *Las Meninas* (Prado). The composition of this masterpiece is unbelievably complex, skilful and in part mysterious. We do not know what it is supposed to be about. The ostensible subject is the princess in the centre. But it has always been called after her maids. The king and queen, standing behind the viewer, are merely reflected in a mirror. Velázquez himself, at work, is clearly not painting them: his canvas is too big. He himself is much younger than his actual age, late fifties. The palace marshal is framed in the doorway. Two courtiers whisper. Part of the foreground is taken up with a female dwarf and a dog. The picture has five planes of activity and three different light-systems. The top half is largely in darkness. It is a self-confident work by an ageing master who has done everything and wants to create something quite different, to make people think.

Why did Velázquez make himself young and handsome? He was accused of pride, even by the king. He lived like a gentleman and amassed a fine library. We know little of his private life. He had an illegitimate son in Italy. Much of his time was spent acquiring positions of eminence in the royal service, including the post of Mayor of the Palace. Among other things, he was responsible for buying and hanging royal paintings. These duties took him away from painting. Perhaps he was tired of producing endless royal portraits. He was also eager to raise the status of painters. That is why he lobbied for, and even openly demanded, membership in Spain's Order of the Knights of Santiago. Ribera had become a papal knight without

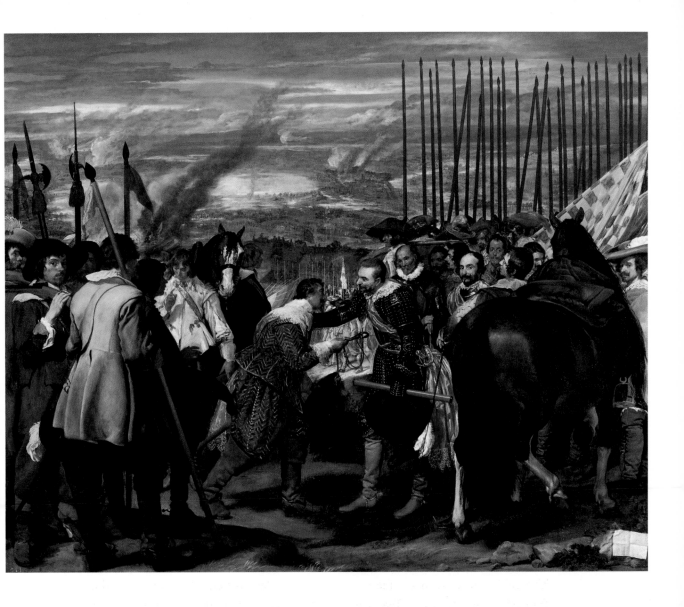

Velázquez contrived in *The Surrender of Breda* (1634) to mingle the proud heroism of the defeated with the magnanimity of the conqueror.

difficulty. But in Spain there were problems. The king eventually nominated Velázquez. But, as with everything else in Spain, a committee had to approve. The Consejo de Ordenes demanded proof that he had no Moorish or Jewish blood, and that he had never run a working studio or painted for money. The king, tiring of it all, got the Pope to issue a special bull which made further inquiry unnecessary. So Velázquez got his honour. His last role, in 1660, had nothing to do with painting. He supervised the summit meeting, on the Franco-Spanish border, of Philip IV and Louis XIV, which brought about the Peace of the Pyrenees and the marriage of Louis to the Infanta Maria Teresa, whom Velázquez had often painted. The effort killed him; his wife died a week later.

Francisco de Zurbarán (1598–1664), who regarded Velázquez as the head of his profession, lived and painted in his shadow. He was born a year earlier, in the remote

part of Spain called Estremadura, but came to Seville to make a living. Unlike Ribera and Velázquez, who in different ways freed themselves from the Spanish art system, Zurbarán was its lifelong victim. He might have been one of the greatest painters. He had a purer sense of colour than any of his contemporaries. His painterly touch was superb, as is shown by his magnificent still life in the Norton Simon Collection. He could individualise a figure without fuss, or produce dramatic *chiaroscuro*

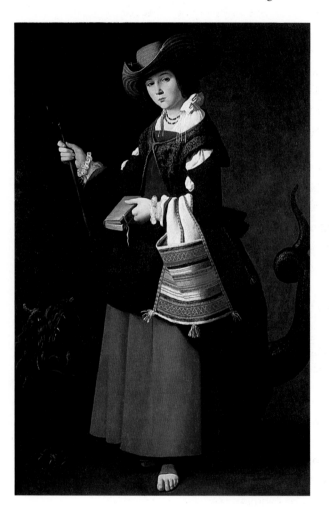

or extreme emotions and gestures simply by careful attention to pose and dress. His father was a haberdasher and his own clothes sense is exquisite. His *Saint Margaret* in London's National Gallery is a miracle of simplicity, an unforgettable image of a fashion-conscious middle-class lass with her curly straw hat, cloak and handbag. He did three pictures of *The Virgin as a Child*, one sleeping (Jerez, Collegiate Church), one awake (Hermitage), one with St Joachim and St Anne (Florence, Contini Bonacossi), which are among the tenderest images of childhood ever created. He was a man of simple faith, and it showed. His *Death of Saint Bonaventura* (Louvre), another striking image, explores the depths of his belief.

The tragedy is that Zurbarán was always chained to the galleys of religious painting. He lacked the spirit to fly to Naples, like Ribera. He got one opportunity to paint at court, but he had none of Velázquez's polish and did not flourish there. So he was condemned to work for religious houses, producing sets of Apostles, famous members of the order, popular martyrs. Virtually all were required to be uprights, full-length figures, in specified poses. They were ordered in sets of ten or twelve, sometimes twenty. He did at least seven paintings of St Francis, probably many more; the London National Gallery alone has two. One of them, *Saint Francis in Meditation*, is a superb piece of work and thought. It shows that Zurbarán never willingly allowed himself to drift into routine and boredom. He worked desperately hard: 567 paintings by him have now been catalogued, many in deplorable condition; he probably painted well over a thousand. Eventually he moved to Madrid, where things seemed no better. His needs

Zurbarán had to churn out saints for a living. But his *Saint Margaret*, a trim tradesman's wife out shopping, is arrestingly real.

forced him to work ever faster, for lower prices, and his work deteriorated. Any gaiety had long since gone. He died in poverty and want, four years after Velázquez.

Many painters made a decent living, however. One such was Bartolomé Murillo (1617–1682), son of a barber—like Turner—and a native of Seville where he lived virtually all his life. He was brought up in the same traditio of realism and *bodegónes* as the others, and he realised, shrewdly, that scenes of everyday life, treated with truth, humour or pity, would always sell if all else failed. He cultivated the church patrons, of course, and all his life painted sets for them, mainly done by his studio staff. But he specialised. He made himself master of Immaculate Conception paintings, of which he did perhaps twenty (the best is in the Prado). These were in constant demand and sold for good prices. There is no doubt that Murillo put a great deal of careful thought, and exquisite workmanship, into these semi-mystical miracle paintings. No one ever mixed angels and mortals together with more skill or dissolved reality more convincingly into heavenly vapour—this life and the next were a seamless garment to him. His *Saint Ildefonsos Receiving the Chasuble from the Virgin* (Prado) is a superb example of this kind of religious painting, composed, drawn and coloured as well as it possibly could be. Murillo's draughtsmanship, indeed, was superb. At his best he is as good as Guercino. His drawing in the Hamburg Kunsthalle, *The Mystic Marriage of Saint Catherine*, is a masterpiece. Over one hundred drawings by him have now been identified, and more can be expected to emerge.

Murillo used this skill to do many sketches of children, in the streets and at home. Again he specialised, making children the heroes or comic characters of his *bodegóne* work. There was a reason for this preference, quite apart from shrewd playing to the market. Murillo loved children. His wife gave birth to eleven. But of the nine survivors, five died in childhood, one by one. Then his wife died too. Shortly afterwards, his eldest son died, another son emigrated to the Americas, and his only surviving daughter entered a convent. One son was present at his own death, but his house was empty and stricken. He painted the children of his imagination. Looking at them, it is impossible not to be reminded of Charles Lamb's moving and wistful essay, 'Dream Children'. Yet Murillo's children are not, as he painted them, the stuff of dreams. They are earthy; that is their appeal. Two in the Louvre, *The Street Urchin* and *The Beggar Boy*, are of pathetic creatures he brought into his workshop from the Seville streets. In his best child paintings, such as *Two Peasant Boys* and *The Flower Girl*, both in the Dulwich Picture Gallery, and two in the Munich Alte Pinakothek, *Two Boys Eating Melon and Grapes* and *The Young Fruitsellers*, there is a touch of idealism, but they are still essentially flesh-and-blood creatures, dirty, fragile, capable of tears or irrepressible laughter. His *Two Women at a Window* (Washington) are in no way lascivious or even suggestive; but we can hear their giggles. This is not the highest art, but it is superb of its kind, full of genuine feeling, likely to appeal as long as humans have hearts. Murillo's dead children made him sad, but his painted ones

gave him a comfortable existence, though he continued to satisfy the clerics. While painting yet another *Saint Catherine* over the main altar of the Capuchin Church in Cadiz, he fell from the scaffold, dying soon after while in the act of making his will.

This takes us to 1682. The dramatist and poet Caldéron had died the year before but Murillo was not quite the last of the giants. One of Velázquez's successors as court painter was the aristocratic Juan Carreño de Miranda (1614–1685), who inherited much of the master's skill in presenting high-born ladies in their best clothes, plus some touches and twists of his own. His *Doña Inés de Zúñiga* (Madrid, Museo Lázaro Galdiano), which shows this stunning young woman with her long bushy black hair in a stupendously wide dress of blue, pink and silver, has a claim to be considered the most remarkable female portrait of the century. One looks at it transfixed by its audacity. Her right-hand index finger points to a tiny white dog, her exquisite left hand holds a lace-trimmed handkerchief, both finely painted. Hanging from her waist by a pink ribbon is a pistol. What does it mean? Mere fun, perhaps, a commodity in short supply in the Spain of the 1680s, nearing the end of the road as a world power. Samuel Pepys was there, shortly before Carreño died in 1685. He had long since given up his diary to save his eyesight, but he sent a bleak report. There were no drunks in Spain, he admitted, but no chamber-pots either; no chimneys, so houses were full of smoke; and they were overrun by fleas, 'a mighty plague'. He spotted the chief weakness—rule by committees—and its collateral, bad appointments. Everything was run by the clergy except the navy, which was run by soldiers: 'Never were a people so managed by fools in all departments as they are'. He said nothing of painters. By then Spanish art was asleep, to be wakened a century later by Goya.

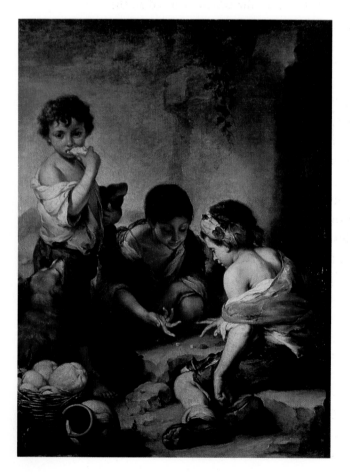

Murillo painted children he observed in the poorer streets of Seville. His *Young Beggars Playing Dice* combined realism and charm without sentimentality.

17

THE DUTCH ATTAIN 'THE PERFECTION OF PROFESSIONAL ART'

In the 1520s, commenting on the increasingly bitter battle between Catholic and Protestant writers, Erasmus had warned: 'The long war of words and writings will end in blows.' So it proved. From the 1550s to the Peace of Westphalia in 1648, the Wars of Religion divided Europe. A further dimension was added to religious conflict by the outbreak in 1618 of the Thirty Years War, which involved all the German-speaking lands, parts of Scandinavia and northeast France. The fighting was intermittent but often intense and horribly costly in life, both of soldiers (and their horses) and of non-combatant townsmen and peasants. The destruction of wealth was colossal, and in Germany took over a century to make good.

One fine artist achieved lasting fame from the carnage. Jacques Callot (1592–1635) was a printmaker and etcher of genius, who produced over 600 works on paper dealing with religious subjects, and also specialised in witches, dwarfs, phantasmagoria and ceremonial entrances. But he is known to the world through a famous series of 18 prints, published in Paris in 1633, entitled *Les Misères et les malheurs de la guerre*, which shows soldiers (and their victims) fighting, murdering, raping and looting, being hanged and tortured, and also rewarded. It was the first premeditated artistic exposure of war's horrors, and inspired an even more sensational series which Goya was to produce nearly two centuries later. Of Callot's 1,400 prints and 2,000 drawings, it is these 18 which are his chief heritage to us.

Callot came from Nancy in Lorraine, not then part of France and one of the border states over which armies repeatedly marched and fought. We have seen how, during these troubled times, great masters like Rubens and Van Dyck, with an international clientele, could bestride or avoid the conflicts. But it is a curious fact that artists who were not international stars but lived and worked in the vulnerable borderlands, also flourished according to their merits.

We will now look at two examples of the new realism sweeping European art, artists of the highest calibre whose true greatness is only now being recognised: Jacob Jordaens (1593–1678) of Antwerp and Georges de la Tour (1593–1652), also of Nancy.

Jordaens was sixteen years younger than his fellow townsman Rubens and has always been overshadowed by him. He followed Rubens in building a fine house-studio in Antwerp, though not on the same scale. Until recently he was dismissed as 'the poor man's Rubens'. Superficially there is some resemblance: they both liked ample ladies, certainly. Fundamentally they were very different. Rubens converted to Catholicism and was not merely at ease but outstanding in the great courts of Europe. Jordaens converted to Calvinism, never went near a court and was only happy among well-to-do townsmen, and working for them. The fact that he chose to become a Protestant in an overwhelmingly Catholic city shows he was a man of principle. But there is not a trace of principle or idealism in his work. He was a populist who liked to make people laugh and feel at home. His *Satyr and the Peasant* (of which there are versions in Munich, Kassel and Brussels) features a mythic creature but is essentially a genre painting of country people with their cocks, cows, dogs, cats and babies. His *Christ Driving the Money-changers from the Temple* (Louvre) is an uproarious Flemish crowd scene. His *Mercury and Argus* (Lyons, Musée des Beaux-Arts) is a farmyard idyll. So is his superb *Adoration of the Shepherds* (Stockholm, Nationalmuseum) and his even more

Jordaens had such a strong sense of realism that his *The Satyr and the Peasant* (1620)—a favourite theme— looks like a scene from everyday life.

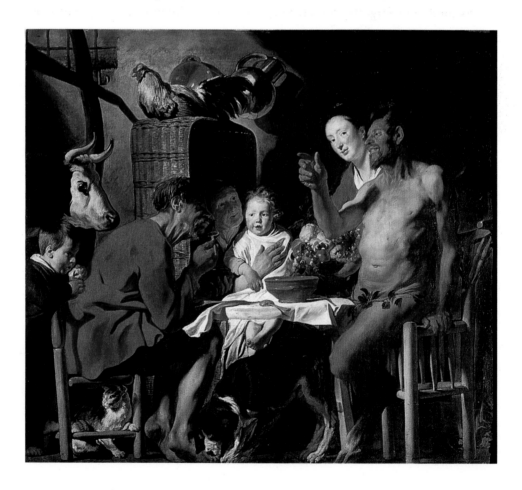

remarkable *Moses Striking Water from the Rock* (Karlsruhe, Academy of Fine Arts), a miracle of dense but unified composition, better than Rubens ever contrived, and the only painting of the century which successfully features a crying baby.

Jordaens's greatest work, *The Apostle Peter Finding the Tribute Money in the Fish's Mouth* (Copenhagen, Staten Museum for Kunst), is in fact a genre scene of a Flemish extended family, including babies and cow, being ferried across a turbulent stream. His interest in the common people, their moods and reactions, was inexhaustible. His nudes are often better than Rubens's. In *Homage to Pomona* (London, Wallace), he produced the best rear view of a naked woman done in the seventeenth century, which makes Velázquez's '*Rokeby Venus*' (even before it was ruined) seem tame by comparison. He worked hard and steadily all his life and produced over a thousand paintings, the best of which compose a body of work equalled by few of his time or since.

By contrast, Georges de la Tour, born in the same year as Jordaens and dying at sixty, who was apparently in full employment all his working life, left only a tiny *oeuvre*, or so it seems, though one of exceptional quality. Like Callot, he came from Lorraine, the son of a baker, and worked there all his life, with growing success. Towards the end he got commissions from the reigning prince. Once dead, however, he was completely forgotten until the 1930s. A French exhibition of 1972 popularised him. This was followed by a famous display at the National Gallery in Washington, D.C., in 1997, whose exhaustive catalogue listed and dated thirty-two works (there are also many copies). How many others have disappeared for good—a hundred perhaps—we shall never know. A few more may emerge to be authenticated. Once his works are seen together as a group, there can be no doubt about his status: he was a great artist whose distinctive characteristics leap out at you from the canvas. What are they?

The first is simple, strong composition, the search for a compelling image. Twenty canvases, the bulk of his work, are single figures. Of these, four are half-lengths of saints, of which *Saint Thomas* (Louvre) is outstanding, a sharp-faced, bald, suspicious old man. Each is an individual study from life, beautifully and fluently painted in warm, clear colours, quite unlike the saints being trundled out by the dozen from hundreds of European studios at the time. His full-length *Saint Jerome* (versions in Grenoble Museum; Stockholm Nationalmuseum), who is kneeling while he flogs himself with a rope, is one of the greatest images of the century, a bewildered old man mesmerised by the cross he holds, whose withered and spindly body exerts a strange kind of power. It is the same with *The Hurdy-Gurdy Player* (Nantes, Musée des Beaux-Arts), a dreadful old man by the look of him, full-length but seated, bawling out a horrible tune in a repellent voice; yet one wants to go on looking at him, taking in every detail of his noisome appearance. He appears again, standing with a dog (Musée de Bergues), with formidable power, as though pope or emperor, and in half-length (Prado), his majestic profile hinting that he hears not his own rude music but celestial sounds. La Tour obviously loved street musicians. One of his greatest

works, a complex composition of five figures handled with complete assurance in both the versions he produced (Malibu, Getty; Chambéry Museum) is *The Musicians' Brawl*, in which each of the five heads, four old, one young, tells a distinct story.

La Tour's second quality was the capacity to handle light, always with seemingly effortless skill, occasionally in quite new ways. Like every other enterprising painter of his generation, he was guided, directly or indirectly, by Caravaggio, in his case to the point where light became an obsession. Eleven of his pictures show the effects of a single source of artificial light: a candle, a lantern, a glowing coal. These are liable to degenerate into mere exercises in virtuosity, with La Tour's wonderful fluidity in applying paint toppling over into crude effects. But at their best, such as *Saint Peter Repentant* (Cleveland Museum of Art, Ohio), the strong light as it falls on face and robes generates a unifying warmth which brings all alive; and his *New-born Child* (Rennes, Musée des Beaux-Arts) is one of the finest, and simplest, of nativity scenes, turning an old idea of Correggio's—the child as the source of light—into a miracle of tenderness, for the baby actually looks as if it were born only a few hours before. However, more important than the special studies of light is the fact that, through them, La Tour learned to employ light magically in all his considered works, not only to illuminate but to pick out character and incident, as though he were roaming over the canvas with a searchlight. Few other painters have been able to do this quite so cleanly and crisply.

La Tour's third and most vital characteristic is a passionate interest in people. His subject matter is not original—low-life, card games, gypsies cheating, hackneyed religious themes as in *Saint Sebastian Tended by Irene* (Fort Worth, Kimball)—but he cast his scenes with an extraordinary eye for character. It is hard to say whether he was more interested in the gullibility of youth or the resilience of age. In his two best-known paintings, *The Fortune-Teller* (New York, Metropolitan) and *The Cheat with the Ace of Clubs* (in the Fort Worth version; *of Diamonds* in the Louvre), the elegant, rich, suspicious but nonetheless idiotic young man is the same. So is the solemn-faced, manifestly dishonest young woman who is orchestrating the fraud. These images, so well lit, so cleanly and lusciously painted, are branded into the mind, and they are as grimly ineffaceable as La Tour's portrayal of old age. In a splendid pair in San Francisco, *Old Man* and *Old Woman*, he gives us age in total simplicity. They are just two old people, and nothing more to be said. But, again, there is the hint of majesty, as though he were painting the king and queen of Spain. How did La Tour come to paint with such originality and power? What went on in his mind? Perhaps scholarship will eventually answer both questions, though I doubt it; there are many mysteries in art which have to be left unresolved.

The way in which some artists make fortunes and others come close to starving, another mystery, is one of the dramatic personal threads which runs through art history—the disparities often having little to do either with talent or the degree to

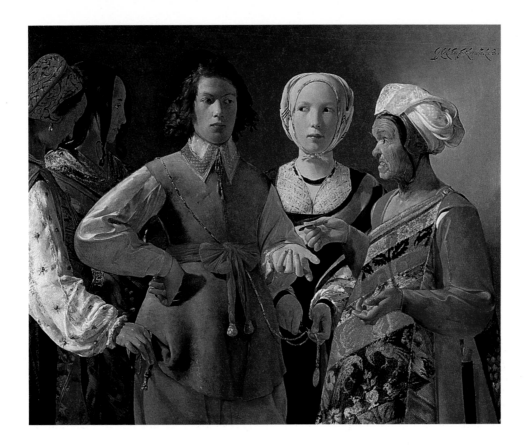

which an artist is willing to prostitute it. As in every department of life, money sticks to some fingers and slips through others. We find this again and again in looking at what has been rightly termed the Golden Century of Dutch Art, which opened effec-

Georges de la Tour made a monumental epic of *The Fortune-Teller* (1620–21) by superb lighting, clever eye-lines, attention to detail and dramatic grouping.

tively in the 1590s and closed in the 1700s. The country produced a score or more of truly great artists during this period, and perhaps two hundred lesser ones, most of whom, in any other time or place, would have been judged outstanding. Never before in the history of art has so much artistic talent, carefully taught and on the whole well patronised, been concentrated in so small an area—effectively in a few cities: Utrecht, The Hague, Delft, Haarlem and Amsterdam. The economics behind this carefully controlled and measured explosion of art are simple. The religious wars raised sharply the populations of the Protestant towns of the northern Low Countries, creating the republic of the United Netherlands, while the maritime-commercial contest with Spain, which the Dutch won in all essentials, made these expanded towns rich; by the standards of the seventeenth century, very rich. Thus at a time when churches were cutting right down on their artistic patronage—Dutch churches were, on the whole, bare of paintings—an expanded middle class came into being with surplus incomes to spend on pictures for their modestly luxurious homes. A market of this size had never existed before; painters worked to supply it handsomely and with all the more confidence because its needs were divided into distinct categories in which they could specialise.

First came portraits. The Dutch produced more first-class portraits in the seventeenth century than any other people at any time; plus innumerable routine and dud ones. There were also large, difficult and expensive group portraits, of boards of governors, officers of volunteer regiments and the like. These, from being mere records of self-importance, became, thanks to Frans Hals and above all to Rembrandt, major works of art: we have only to look at Rembrandt's *The Anatomy Lesson of Dr Nicolaes Tulp* (The Hague, Mauritshuis), *The Night Watch* (Amsterdam, Rijksmuseum) or *The Syndics of the Clothmakers' Guild* (Rijksmuseum) to see exactly how such dreary committees can be turned into prosopographies of high drama and even beauty. Then there were landscapes, both with and without cattle and/or people (Cuyp was the supreme cattleman); both of particular places and of ideal ones; both close-ups, supplied by Ruisdael, and 'extensive views', of which Philips Koninck was the master. Then there were townscapes, painted for their own sakes, almost a new form of art, of which Vermeer's *View of Delft* and *The Quiet Street* (Rijksmuseum) and Pieter Saenredam's *St Mary's Square, Utrecht* are the outstanding examples. Saenredam was also the leader in another new and distinct category, the church interior. Then there were the house interiors with figures, of Vermeer, Pieter de Hooch and others, and the low-life paintings of Jan Steen and his countless imitators. There was also a distinct category of winter skating pictures, and finally sea pictures, including battle scenes, to cater to a market in which every second Dutchman of wealth had some connection with the sea. At the same time, history painting, both religious and secular, and even to a diminishing extent mythological, continued. And of course one or two of the greatest painters tried their hand at other mediums, including print-making and etching, which in the seventeenth-century Netherlands reached celestial heights.

This small country, then, which knew how to defend itself and keep its many and powerful enemies out, and at the same time made huge fortunes on the high seas and in its burgeoning colonies, was the perfect place in which painters might flourish. Hundreds did, but it is daunting to find how many had a hard time of it. The outstanding case is Frans Hals (1581/5–1666), the founder of the seventeenth-century Dutch school, in so far as anyone was. He was born in Antwerp, his parents being clothworkers who emigrated to Dutch territory for religious reasons. Most of his life was spent in Haarlem. His brothers, five of his sons and at least one nephew were painters too, generating confusion about his works. Hals took in the work of Rubens and Caravaggio but he was essentially *sui generis*. When he was lucky he got commissions for big group portraits—*The Company of Captain Reynier Reael* (Amsterdam), *The Regents of the St Elizabeth Hospital of Haarlem*, the *Regents and the Regentesses of the Old Men's Almshouse* (both Haarlem, Hals Museum) and various others. He broke up the stiff formality of these tiresome ceremonial pieces and made them lively and interesting. But he was poorly rewarded, getting only 66 guilders per figure (Rembrandt was paid 100 guilders or more). By preference Hals painted genre scenes, which he proudly signed, with titles like *The Gypsy Girl* (Louvre), *The Pickled*

Herring (Kassel, Staatliche Kunstsammlungen), the brilliant *Mulatto* (Leipzig, Museum der Bildenden Kunst) and the flashy *Merry Drinker* (Rijksmuseum). He loved to make people laugh—one of the first artists with this aim in life—and often made his sitters for portraits smile, most unusual in those days: his *Isabella Coymans* (Paris, private) is wreathed in one. Sometimes his sitters, like *The Laughing Cavalier* (Wallace), appear to laugh when they are in fact merely self-satisfied. If Hals had been able to carve out a practice in jolly genre he would have lived a much more joyful life himself. But he could not do it.

Instead he spent most of his long life on portraits. There are mysteries here. Hals was an accomplished and innovative painter, who worked in a way most of us would call 'modern'. No drawings survive and it is likely that he painted straight onto the canvas, wet on wet. He was astonishingly fluent and must have worked at high speed, doing the faces and the hands more carefully than the rest, obviously, but giving everything a dashing air which is always appealing. No one ever looked at a Hals portrait—an authentic one, that is—without pleasure, and the best are wonderful to live with: *Pieter van den Broecke* (London, Kenwood) is a smiling delight and his lace collar, though done with *brio*, is a miracle of virtuosity. Yet Hals was always poor and often in financial trouble. Later tradition blamed this on drink. There is no evidence for the charge but he was, almost certainly, a bad manager of his money. At all events he was always in and out of the courts for debt. In 1652, when he was over seventy, his goods were seized for an unpaid baker's bill and he was still being dunned ten years later, by which time he was dependent on public charity, grudgingly and meagrely provided. It seems a hard fate for a painter whose technique was highly original and anticipated the slashing brushwork of Fragonard by over a century, and every trick the Impressionists performed by more than two.

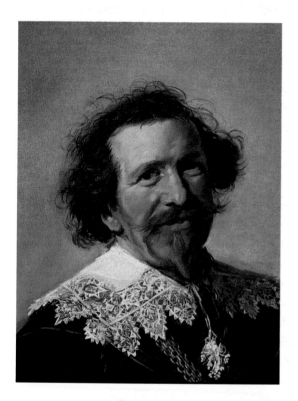

The fate of Hals *oeuvre* was even sadder. Between his death (1666) and the 1860s, he was completely forgotten. His works, authentic, copies or misattributions alike, changed hands for minute sums. This is when most of them disappeared. Even in his last years, Hals had been denigrated as a drunken old man whose stiff, rheumatic

Frans Hals had fluency, immense energy, loved faces and painted them with skill and virtuosity, as with his *Pieter van den Broecke* (1633). He died poor. A typical artist's story.

arms and hands were useless for accurate painting. In the 150 years after his death, few people wanted dingy old portraits of obscure Dutchmen on their walls. As Hals worked hard, and quickly, and was active for sixty years, his total output must have been huge. But modern catalogues of his works are all small in total though they vary widely: 109, 169, *c.*200, *c.*290 are among the figures produced. The most convincing recent catalogue lists 149 for certain. Of these, only one, *The Regents of the St Elizabeth Hospital*, is in its original frame, an ominous sign. Until quite recently, when paintings were taken out of their frames they were nearly always ill-treated, even if they were fortunate enough to be re-framed. They were cut to fit, divided into two or more bits, sometimes altered. With very few exceptions, works by Hals are not in their original state. In one, the head has been cut out and replaced by another, by an inferior hand. In a second, the same indignity has been practised on the hands.

Rembrandt invested *Belshazzar's Feast* (*c.*1635) with a breathless excitement that has eluded all other artists who have tackled this wonderful subject.

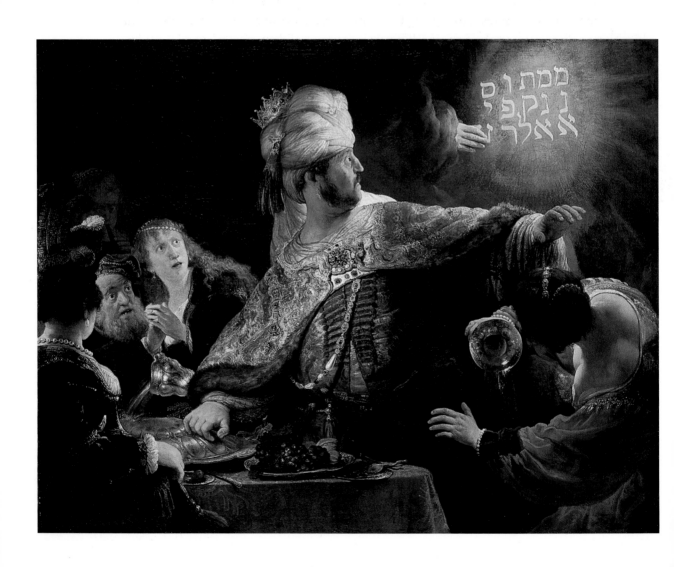

Hals himself did not help matters by occasionally collaborating with others to produce works quickly or allowing pupils or relations to finish off portraits after he had done the hands and faces. To earn an honest penny he also cleaned pictures and did them up, sometimes passing them off as his own. His picture-dealing confused things further. His reputation began to recover in the 1860s, thanks to the perceptive critic Théophile Thoré, whose praise led two leading collectors, Lord Hertford and Baron Rothschild, to bid openly against each other for *The Laughing Cavalier* in 1855 (Hertford got it, which is why it is now in the Wallace). The fifty or sixty paintings which form the unspoiled authentic core of Hals work now place him alongside Rembrandt and Vermeer at the head of the Dutch school. Many of them are well displayed in the Haarlem Frans Hals Museum, where his painterly power and craft can at last be appreciated.

By contrast, Rembrandt van Rijn (1606–1669) was famous in his lifetime and has never fallen from his rank among the world's greatest painters. That does not mean his life was easy—far from it. He was one of ten children of a substantial Leiden miller. He always loved mills and often drew them. He went to the Latin School, had two years at university but then opted to be a painter, being taught by a then well-known history painter, Pieter Lastman. It is clear the young man set his heart on being a history painter also: the trade carried more prestige and, if successful, more money than any other form of painting. His first authenticated and dated work, *The Stoning of Stephen* (Lyons Museum), done when he was nineteen, is vigorous but peculiar. But by the time he produced *Judas Repentant* (England, private), four years later, he had developed his characteristic approach: darkness lit by flashes of light and reflection, picking out faces which fascinate; an air of intense thoughtfulness behind the composition, which makes you wish to study and explore it. This painting elicited universal applause, and thereafter Rembrandt was always fully employed, moving to Amsterdam in 1630 and setting up a large studio. Four years later he married the beautiful Saskia, orphan daughter of a well-to-do Bürgermeister, and had a son, Titus. He set himself up in a big house, in the Rubens manner, and amassed an art collection, often bidding high at auction.

Why was Rembrandt so successful? The answer is not obvious. He could not make a woman look conventionally beautiful, a point made by the Scottish National Gallery's fine exhibition, *Rembrandt's Women,* in 2001. All his efforts to paint *Susanna and the Elders* fail. What did the old men see in her? In *Portrait of a Young Woman Seated* (Vienna, Gemäldegalerie), the non-chin is repellent. In *Flora* (National Gallery), he tried his best, but the girl comes close to fatuity. His *Susanna Disturbed* (The Hague) has a fairly pretty face but her hands are huge and red and the eye is irresistibly drawn to her ugly feet in their dreadful bedroom slippers. He is nearest to success in his Kassel portrait, *Saskia in Rich Apparel,* but most of his attempts to present his wife show he had other things on his mind than her beauty.

The famous *Woman Bathing* in the National Gallery is essentially a study in the way she lifts her dress to show her stocky legs. Yet all such works induce thought and promote careful scrutiny of what Rembrandt was doing. This remains true even of his manifest failures, like the dreadful early work *Balaam and the Ass* (Paris, Cognacq-Jay), *The Holy Family* (Munich, Alte Pinakothek), where the Virgin's exposed bosom dominates the picture, and the absurd *Diana Bathing with Her Nymphs* (Anholt, Museum Wasserburg). Even when Rembrandt produces something ugly and horrific, as in *The Anatomy Lesson of Dr Joan Deyman* (Rijksmuseum), he sets one's mind working furiously.

It is hard to think of any other painter who had this cerebral capacity to quite the same degree. Rembrandt is often thought of as reflective, but the fact is that many of his best paintings are full of vigorous action. Thus his *Blinding of Samson* (Frankfurt, Städelsches Kunstinstitut) brings home to us the sheer terror of the act—and its tumultuous accomplishment—more directly than the work of any other of the scores of painters who have tried to depict it. It is the same with his *Abraham's Sacrifice* (St Petersburg, Hermitage), where he concentrates brutally on the exposed throat, about to be cut from ear to ear. His *Belshazzar's Feast* (National Gallery) is a tremendous drama of action, down to the decollété beauty upsetting her wine goblet in her lap.

It is true, however, that Rembrandt is at his unequalled best when his subjects are thinking rather than doing, and elderly rather than vigorous. No one was more gifted at turning old women into great art. His *Old Woman Praying* (Salzburg, Residenzgalerie) is the apotheosis of mesmeric wrinkles. The same woman—sometimes erroneously referred to as 'Rembrandt's Mother'—appears in another masterpiece, *Old Woman Reading,* and in that superb painting, unusual in that it is well-coloured and lit, *Tobit and Anna with the Kid* (both Rijksmuseum). Rembrandt's old men, as the last picture emphasises, are no less noble and interesting. His *Jeremiah Lamenting the Destruction of Jerusalem* (also Rijksmuseum), with his exquisite head and beard resting on a skinny arm, is perhaps the best thing Rembrandt ever did. The air of despair pervades even the superbly painted detail; the light itself seems to shiver. Or again, *Saint Paul at His Writing Desk* (Nuremberg, Nationalmuseum) shows a noble old man so lost in thought as to be impenetrable. *The Apostle Peter Kneeling* (United States, private) is a miracle of elderly sadness.

The wealthy men of Amsterdam obviously treasured this unusual gift for evoking thought and sympathy even in the most improbable ways, although patrons must often have been surprised by what they got. Rembrandt took the deformalisation of the group portrait much further than Hals. Captain Cocq's officers were clearly surprised by *The Night Watch* (Rijksmuseum), for though Cocq himself cuts a reasonable figure, the scene is stolen partly by the dashing yellow-clad nonentity at his side and partly by the well-lit woman who emerges incongruously from the ranks. When the state commissioned his great picture on early Dutch history, *The Conspiracy of the*

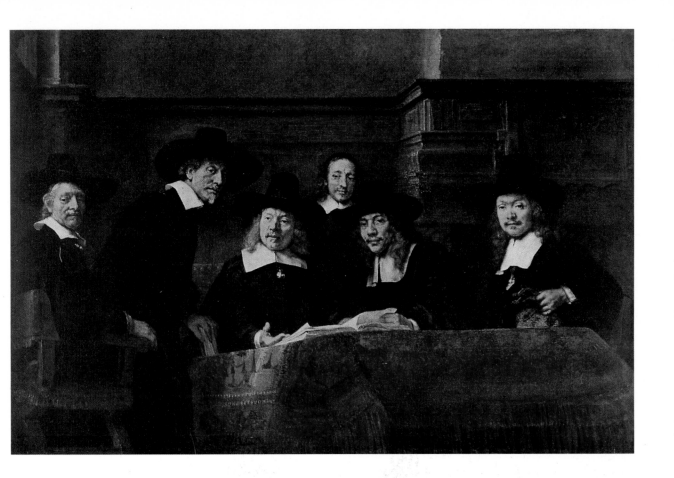

Batavians (Stockholm, Nationalmuseum), it was a shock to find that Rembrandt had concentrated on the leader's missing eye. *The Syndics* (Rijksmuseum) is perhaps the greatest group portrait ever painted, for each man's face is a study in growing alarm, and the six men look like a board of directors surprised by an unexpectedly difficult shareholders' meeting—one man is in the act of indignantly rising, which gives it all dynamic tension. This wonderful snapshot cannot be what the six thought they were paying for, yet, equally, Rembrandt often gave intense satisfaction, particularly in his portraits. It would be hard to think of a finer work than the *Portrait of Nicolaes Ruts* (New York, Frick), the pose majestic, each feature nobly wrought, the gaze penetrating, every tiny detail of his rich clothes wonderfully painted.

One reason why Rembrandt succeeded was that, when he chose, he could do almost anything. He never imprisoned himself in specialisation, like virtually every other great Dutch master. He skilfully alternated between history and portraiture, between religious, secular and even mythological subjects, between singles, duos and groups, small and large, between active and sedentary. He could paint the countryside; his *Landscape with a Stone Bridge* (Rijksmuseum) shows him applying his searchlight technique to picking out tree features with complete success. He could do impressive outdoor night-scenes, as in his *Rest on the Flight into Egypt* (Dublin, National Gallery).

Though he rarely chose, he could even do seascapes, as his tremendous *Christ in the Storm on the Sea of Galilee* (Boston, Gardner Museum) shows, and as the thieves who stole it in 1990 appreciated. Some patrons wanted virtuoso studies in light. Rembrandt provided them, as in *Simeon in the Temple* (Hamburg, Kunsthalle) and *Two Old Men Disputing* (Melbourne, National Gallery). He catered for the lower end of the market by making himself a great and versatile etcher. He produced about 290 etchings that we know of, covering all tastes from nudes to crucifixions. Some are of large size and huge dramatic power. So far as we know, Rembrandt did not sell his drawings, for virtually all were done as studies for current or prospective paintings. But he clearly

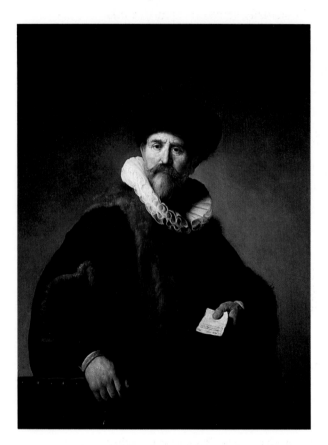

might have done. With few exceptions they are all of unmistakable quality, highly characteristic with their strong horizontal lines (landscape) and obsession with light and shade (figures). They were done in vast numbers too, for over a thousand authentic ones have survived and been catalogued. The real total must have been much higher, for Rembrandt produced over four hundred paintings for which they were preliminaries. They cover every conceivable subject, from the famous *Elephant* (Vienna, Albertina) to the copy of a Mughal miniature, *The Shah of Persia with a Falcon on Horseback* (Louvre) to *Four Negroes with Wind Instruments* (New York, Morgan Library).

Yet all this would not do. By the end of the 1640s, Rembrandt was desperately short of money. Obviously, the plague of 1649, which ruined Hals, did not help. But his troubles were mainly his own fault. He borrowed money not only to pay for his house but to finance his collecting habit, and when he had to move into a humbler one, and sell his collections, he found he had paid too much. In the twentieth century vast numbers of documents about Rembrandt's finances and other activities were unearthed, most of them being published in a comprehensive volume in 1979 (though more have emerged since). They show that at one stage Rembrandt effectively went bankrupt, transferring his visible assets to the state to avoid imprisonment, and that later he became an employee and lodger of his son Titus, for complicated financial reasons. His debtors were many and they went unpaid, and it is clear that, from

Nicholaes Ruts, a man of little importance, bought himself immortality when he paid Rembrandt to paint his portrait in 1631.

being an open-handed man in his first flush of success, Rembrandt became shifty, if not actually dishonest, in his dealings.

There is also a record of cruelty, after the death of his wife Saskia in 1642, when Titus was only nine months old. Rembrandt took into his household a peasant girl called Geertje Dircx, the widow of a ship's trumpeter, to look after the child. She became the painter's mistress, though they never married, as this would have meant a loss of property to Rembrandt under Saskia's will. When Geertje left in 1649, she took Rembrandt to court for breach of promise, and he was ordered to pay mainte-nance of 200 guilders a year. The next year, on the painter's deposition, she was committed to a labour prison for bad women. She actually served five years in this hell-hole, and Rembrandt tried hard, seeking the agreement of her estranged family, to keep her there for life. The reason for the breach with Geertje was that he had formed a liaison with Hendrickje Stoffels, who bore him an illegitimate child. The Reformed Church had her 'punished severely, ordered to penitence and banned from the Communion Table' for 'committing fornication with the painter Rembrandt'. These doings and misdoings must have disturbed Rembrandt deeply, for it is impos-sible to imagine him without a conscience. He was ambitious, morally as well as pro-fessionally, anxious to hold himself high. But his self-esteem slowly declined. This may be the reason why Rembrandt painted, drew and etched more images of himself than any other painter, some of them superb exercises in self-analysis: the 1999 London National Gallery exhibition showed nearly a hundred of them.

Rembrandt has never fallen out of favour. On the contrary, his reputation con-tinues to rise. His fame, however, did not save his work from many indignities. Even *The Night Watch* was severely trimmed on both sides, losing over ten per cent of its surface area. The *Batavian Conspiracy* in Stockholm is only the animated portion of a huge composition, five times the size, so that the lighting-system of the work has been entirely destroyed and we are left with a baffling enigma. One of his most beau-tiful paintings, the nude *Danäe* (Hermitage), had about a quarter chopped away at some stage. Thanks to Rembrandt's own working methods, question marks hang over many of his works. His *Portrait of Frederick Rihel on Horseback* (National Gallery) may be largely the work of an assistant. His *Good Samaritan* (Wallace) could be, in whole or part, the work of his pupil Govaert Flinck. His ever-increasing fame led to the establishment of the Rembrandt Research Project, a permanent body which has de-authenticated many of his finest works, including the Frick's *Polish Rider* (now re-admitted), *Young Girl at an Open Half-Door* at the Chicago Art Institute and the wonderful *Man with the Golden Helmet* in the Berlin Gemäldegalerie. We now know more about Rembrandt than ever before, and have never been so mysti-fied by him and his works.

Few painters have had such a distinguished group of pupils and followers as Rembrandt. They included Nicolaes Maes (1634–1693), who became a first-class genre

painter and whose *The Idle Servant* (National Gallery) is one of the most popular paintings in the world, a masterpiece of sound composition, quiet humour and scintillating detail. Another was Ferdinand Bol (1618–1680), a successful portraitist whose *Elisabeth Bas* (Amsterdam) was such a fine portrait that it was classed as a Rembrandt until 1911. But Bol went on to marry a rich widow and gave up work. A third was Carel Fabritius (1622–1654), who has almost as wide a range as his master and in addition could paint birds—his *Goldfinch* (The Hague, Mauritshuis) is the finest avian work of the century. But he, and most of his work, were blown to pieces in an explosion in the Delft powder factory. Another pupil, Samuel van Hoogstraten (1627–1678), specialised in peepshow cabinets, showing toy worlds through a hole, one of which is in the London National Gallery, a delightful object containing three superb interiors. Some of these assistants, especially Fabritius, are rising fast in public esteem. Jan Lievens (1607–1674), only a year younger than Rembrandt, sometimes painted just as well or even better. His *Smiling Girl* (Leipzig), with her exceptionally delicate skin and shining blond hair, is a masterpiece of sensitivity, the best head-and-shoulders of a child done in the entire seventeenth century.

The most successful by far of Rembrandt's pupils was another Leiden man, Gerrit Dou (1613–1675), who actually created his own school, the Leiden Fine Painters, specialising in small genre scenes done in microscopic detail. Dou learned everything Rembrandt had to teach but rejected his *omnium-gatherum* approach. He was not interested in history pictures and painted too slowly for portraits. He liked to work on small oak panels, framing his scenes with painted arches or within doors, and often adding painted shutters to protect them from dust (these, alas, have mostly vanished). Slow he might be, but he made a fine living. He charged 1,000 guilders even for a small work, and though he stuck to Leiden his clientele was national and international, and always enthusiastic. Charles II, who owned three of his works, begged him to come to England. But he stayed put. His *Self-Portrait Aged Fifty* (Kansas City, Nelson-Atkins) shows him handsome and prosperous, leaning against the porch of his mansion. He could sell everything he produced, at his own prices.

Nor is it hard to see why. Within his limited format, Dou covered a wide field. The Dutch were obsessed with health, and his *The Dropsical Woman* (Louvre), among others involving doctors, holding phials of urine up to the light, etc., catered to that. So did *The Quack* (Rotterdam, Museum Boijmans van Beuningen), an amazing denunciation of mountebankery, featuring the painter himself, a dozen other characters, an old lady having her pocket picked and a baby having its bottom wiped. It is a feast for the eyes of both sexes and all ages. There was very little Dou did not know about painting. His *Young Mother* (The Hague) shows a complete mastery of *chiaroscuro* and light-effects, plus a degree of tenderness in depicting the baby and his ravishing mother which was quite beyond Rembrandt's skill. His *Lady at Her Toilet* (Rotterdam) shows all these refinements and comes close to Vermeer in its placid intimacy and rendering of textures. Even his famous tavern scene, *Woman*

Asleep (Switzerland, private), featuring two soldiers and a whore, has a strange refinement. His portraits are dull, but then that was not his trade; and in his chosen *métier* he never produced a work which does not arouse admiration.

So the world thought, and continued to think. Dou fetched high prices throughout the eighteenth century and up to the 1860s. Then, at a time when Hals was being rehabilitated and Vermeer was emerging from total obscurity, Dou suddenly vanished. When mentioned at all, he was described as 'hard' and 'heartless'. By 1909, when the New York Metropolitan held a famous exhibition to introduce America to the full glories of Dutch art, the 150 paintings included 37 by Rembrandt, 20 by Hals and 6 by Vermeer, then only just coming into fame. But no Dou. He remained almost forgotten until the 1970s, when his fame was suddenly re-ignited and has blazed ever since. Who can explain these abrupt reverses of taste?

Who indeed? The story of Johannes Vermeer (1632–1675) is another instructive tale. He was the son of a Delft fine fabric worker who became an innkeeper and picture dealer, putting Johannes into the business on his own account. Vermeer was the

Gerrit Dou, with his *The Dropsical Woman* (1633), gives us a precise insight into seventeenth-century Dutch health, sickness and medicine.

master who carried the realism introduced by Caravaggio to its ultimate expression but he did not begin that way. We do not know who his teacher was (the theory that it was Rembrandt's pupil Carel Fabritius will not stand up, and there is never anything Rembrandtesque about Vermeer's work). Probably he worked for a history painter, for his two earliest efforts, *Diana and Her Companions* (The Hague) and *Christ in the House of Mary and Martha* (Edinburgh, National Gallery), look more like Titian than anything more recent. His third effort, *Saint Praxedis* (private), is no more than a copy of a similar Italian work, signed on the back 'Vermeer after Riposo'. Then suddenly Vermeer discovered the work of the Utrecht Caravaggistes. His fourth painting, *The Procuress* (Dresden, Gemäldegalerie), bears a clear relationship to the brilliant painting by Dirck van Baburen. Though the image is not so striking, the treatment is quite different and the paintwork superior. Vermeer, now twenty-four, had obviously found his *métier*, for it was an easy and natural transition from the domestic-sensational to the pure, non-erotic genre to which he devoted the rest of his career.

Vermeer's subsequent output has been investigated more exhaustively than that of any other painter, with the possible exception of Leonardo da Vinci. The scholarship only goes back to the 1870s, for Vermeer was forgotten until then, and therefore many trails were hopelessly lost between his death and eclipse, and his rediscovery. But in recent decades the scholarship has become more and more intensive and science-based, following the great Washington–The Hague exhibition of 1997–98. Analysis has told us a lot about his pigmentation, brushwork and procedures. This is vital in Vermeer's case, because his actual way of painting is the key to his work. His *oeuvre* has now been fixed, for the time being, at thirty-six works, of which three are still doubtful. If we take away the four early ones, that leaves twenty-nine, and it can be truly said that each is a masterpiece and each (though essentially similar in matter) is quite different. He never repeated himself and he never produced copies.

Opinions will always differ on what Vermeer did best. Some find most satisfying his *Girl with a Pearl Earring* (The Hague), partly for the exquisite beauty of her face, partly for its concentrated simplicity. Some prefer his virtuoso studies in textures, such as *The Milkmaid* (Amsterdam), in which, to create total tactile reality in the piece of bread and other objects, Vermeer used special brushwork effects of his own invention, becoming a *pointilliste* nearly 250 years before Seurat. A third group of admirers put first his domestic interiors making special play with light-effects, of which *Girl Reading a Letter at an Open Window* (Dresden), *The Glass of Wine* (Berlin) and *Soldier and a Laughing Girl* (Frick) are prime examples. Then there are the music paintings: *The Guitar Player* (Kenwood), *The Music Lesson* (Royal Collection, Buckingham Palace) and their companions, the two paintings dealing with geography and astronomy, and his highly cerebral *Allegory of Painting* (Vienna, Kunsthistorisches), all designed to appeal primarily to the intelligentsia in seventeenth-century Dutch cities. Finally there are the two townscapes, *The View of Delft* (The Hague) and *The Little*

Street (Amsterdam), which some rate as Vermeer's most perfect works. But all these groups have a central feature in common: extreme realism, not so much of meticulous depiction (as in Dou's work) as in optical illusionism. We are totally convinced of the existence, close to us, of the people and objects we see, and this appears to have been achieved not so much by brushwork as by magic, as if the paint invisibly floated onto the canvas like snow, then dissolved into it. The painting which perhaps epitomises this extraordinary gift of Vermeer's (for it is a gift of genius rather than a mere skill) is the tiny *Girl with the Red Hat* (Washington, National Gallery), where the sensuousness and liquidity

Vermeer presented *The Little Street* (1657–58) as it actually was, without emotion or tricks but with a cool skill never surpassed.

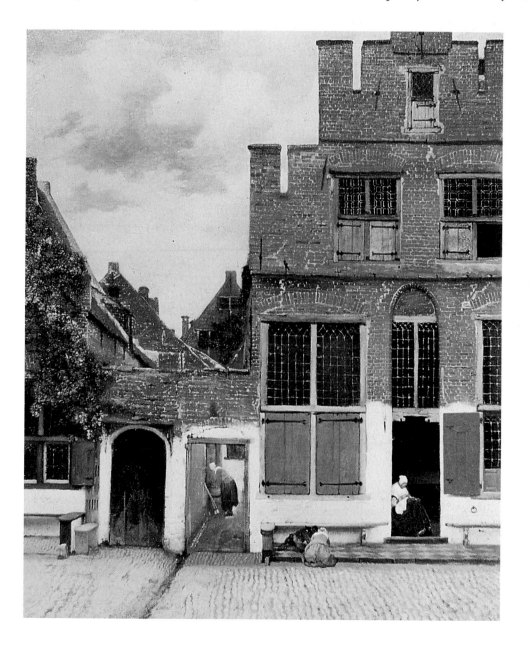

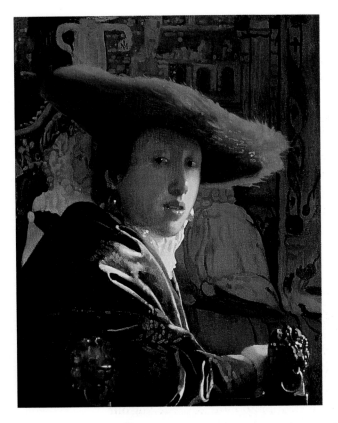

of the illusion is so strong as to draw viewers close to the painting to the point where they become dizzy. When Vermeers are on public show, attendants fight a constant and acrimonious battle to prevent highly educated admirers getting too close, as if these beautiful objects were pop stars.

Vermeer was not, so far as we know—and we know very little—an educated man who had read much about the art of painting. But he lived at a time and in a place where the art was practised as never before or since, and he could pick up a lot just by looking. The rest he taught himself, by instinct and genius. He achieved verisimilitude in five distinct ways. First by a highly sophisticated use of perspective, including bending, which puts everything firmly and exactly in space. No one ever reduced three dimensions to two more securely. Second, he dissolved contours and eliminated any sense of line completely, an ultra-advanced use of Leonardo's *sfumato*. Third, he made cunning use of alternating areas of dense *impasto* and thin glazes, so that objects were distinguished not merely by light, colours and shapes but by surface. Fourth, he constantly used slight but telling distortions of shape and light to reinforce the illusion. This is why his paintings never look like photographs, and attempts to produce 'photographic Vermeers' have failed completely. For the same reason, it is highly unlikely that he used a *camera obscura*, for which there is, anyway, no evidence, merely speculation. The *obscura*'s own distortions are quite unlike those he habitually deployed. There may be a fifth reason. Vermeer, however much cash he had or did not have, always used the highest-quality pigments then available (as did Turner), a point which has emerged from laboratory analysis. This shows sense and is one reason his works have survived so well.

Of course, many have not survived. Vermeer painted slowly, as we know, and indeed as we can see. He died when he was only forty-three. All the same, he must have finished more works, perhaps as many as sixty in total. His professional career, however, was a failure. Other artists evidently admired him greatly. He was the youngest man ever to be elected head of the Guild of St Luke in Delft. But his perfectionism, the source of his universal appeal today, was not of the

Paint seems to float onto the canvas in Vermeer's *Girl with the Red Hat* (1665). There are no evident signs of brushwork, even in the spectacular highlights.

saleable quality which made Dou a rich man. Patrons were not prepared to pay over the odds for it. Vermeer was always poor. He married a Catholic girl above his rank, against parental opposition, which was overcome when he converted; that cannot have helped his trade. She gave him fifteen children, eleven of whom were alive at the time of his early death. His widow, petitioning for public support, pleaded that the French invasion of 1672 had turned his struggling business into a complete disaster, and that she was destitute. It is curious that Vermeer, so prolific in producing children, never featured one in his entire output, the exact reverse of his equally philoprogenitive contemporary Murillo. But that is only one of many mysteries surrounding this cryptic man. The greatest mystery of all is how his works fell into a black hole of taste for nearly 200 years. He is now more generally, and unreservedly, admired than any other painter.

Vermeer's career coincided with the long climax of Dutch art, when there were more gifted and superbly trained painters at work in the five main towns than at any time in European history. Everyday life dominated their work in most cases. Gerard Ter Borch (1617–1681) at times painted almost as well as Vermeer: his rendering of various textures in his masterpiece, *Boy Ridding His Dog of Fleas* (Munich), makes this a work you can look at long and often. The dog is brilliantly rendered, and it is the same animal who appears under the table in his other major work, *An Officer Dictating a Letter* (National Gallery). Equally skilled at composing, and touching our feelings, was Gabriel Metsu (1629–1667), a pupil of Dou, though his actual handling of paint is quite different: bold, strong, almost coarse. His *Sick Child* (Amsterdam) is, for all its sentiment, quite the reverse of sentimental; a powerful work, rather.

The two most consistently successful genre painters, occupying the genteel and the jovial-plebeian ends of the market, were Pieter de Hooch (1629–1684) and Jan Steen (1626–1679). They differed not only socially but in their ends: Hooch analysed a moment, pictorially; Steen told a story. Hooch, a Delft man like Vermeer, painted conscientiously too, but much faster and ruthlessly. His output was many times Vermeer's, though he lived only twelve years longer. His subject matter was upwardly mobile too. In youth he painted a sub-department of genre known as guardroom scenes, because virtually every man in the country had done some kind of military service in the long war, and these things sold. Then he moved to domestic interiors or semi-outdoor views of family life, his real *métier* and passion. As he aged, his interiors grew more palatial and his figures grander, but most of these late paintings do not work. It is the middle-period scenes on which his fame rightly rests.

Hooch's father was a bricklayer, and no one ever painted bricks better than Hooch, or used them more effectively to make up his scenes. Indeed, his finest work, *The Courtyard of a House in Delft* (National Gallery), is dominated by bricks, of no less than eight different types. However, that was not the main object of the painting. Hooch was, like all the seventeenth-century realists, obsessed with light and what it

does to objects. He painted light with great subtlety, and what he does in this picture is to contrast three different light-systems. The main one, outside in the courtyard, is in shade. The middle one leads from this like a tunnel and shows the interior of the house, from back door to front. Finally, we see the area through the front door, which is in sunlight. The three figures add interest, and were essential to sell the picture, but they are little more than light-accessories.

Hooch could not do figures as well as Vermeer, and he knew it. He sometimes tried very hard, as in his last truly domestic scene, *Two Women Beside a Linen Chest* (Amsterdam). He helped himself out by having the mistress of the house wear a splendid dress, in which he excelled, even though she tucks it up to get on with the housework. But his faces are always a little coarse—the price of speed, which Vermeer never paid, however poor he was. The object of this fine painting, however, is not to display the women but to show how soft light, from a window and an open door, infiltrates the dark interior and makes some of its contents dimly shine. Hooch has been accused of hidden symbolism, and he was obviously making a general point of social morality—that a quiet, domesticated married life is the best one. But his interest was primarily aesthetic, and when he went up-market it was as much for painterly reasons, to find more luxurious objects and materials for his light-reflections, as for any other. Those anxious to discover how far he succeeded should compare his great brick painting with the best of his late works, also in the National Gallery, *A Musical Party in a Courtyard*, which has a dazzling light invasion from the sunlit street.

Jan Steen was a different type altogether: a broad-bottomed, broad-based, expansive painter in the old Low Country tradition, mixing Bruegel with Jordaens. He took in all the innovations of the new realism but always did exactly what he wanted in his own way. He was immensely prolific: about nine hundred paintings are catalogued as his, some very large, and nearly all complicated. A few are very bad, and many have patches of coarse or hasty painting. The best are superb. He came from Leiden, the son of a brewer, and all his life he was connected with the beer trade in one way or another. He drank a lot, or pretended he did, and often put himself, plump and laughing, into his works—he put both his wives, and his children in too, and some friends, not always to their relish. This led to a confusion between the man and his works, and damned his reputation in the eighteenth and nineteenth centuries, when he was written off as a drunkard who could barely hold his brush by the end. In fact, Steen was an exceptionally versatile and resourceful artist, with learning, energy, a wide range of gifts and huge powers of invention. He did over sixty religious paintings, for instance, and some of these, *Samson and Delilah* (Los Angeles County Museum) and *The Wrath of Ahasuerus* (Birmingham, Barber Institute) are arresting, the latter not far short of Rembrandt's mighty *Belshazzar* in the same vein. He did a lot of portraits, some excellent. He tried his hand at snow-and-ice scenes, a popular subdivision of landscape, in which Isack van Ostade (1621–1649) was the acknowl-

edged master—see his beautiful and lively *A Winter Scene* in the London National Gallery. But Steen's *Winter Landscape* (Bålsta, Skokloster Castle) is just as good; better, actually, for it has a huge sky of great subtlety and softness, and the painting as a whole shows there was little that Steen did not know about the fall of external light on surfaces.

Indeed, as a landscape/townscape painter he was right up among the leading specialists. His *Village Festival with the Ship of Saint Rijn Uijt* (private) is an idyllic scene: village church, trees, houses, horse and folk, a boat pulling in, big clouds massing. The *Burgher of Delft and His Daughter* (private) takes us right into the

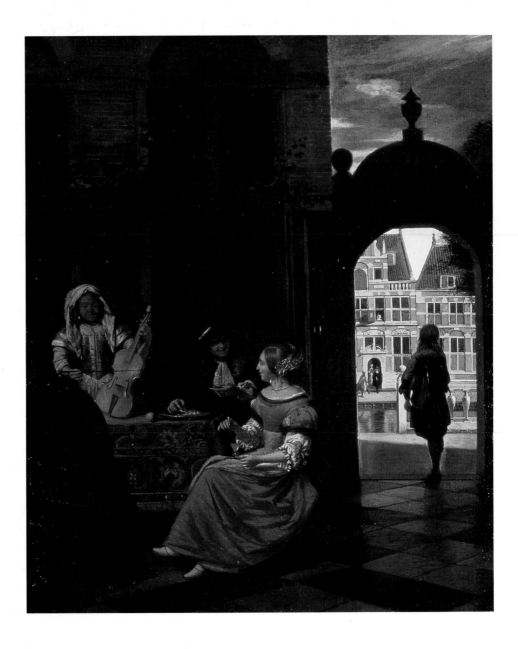

A Musical Party in a Courtyard (1677), a late work by the supreme Dutch genre painter Hooch, shows his delight in creating three different light-systems in each painting.

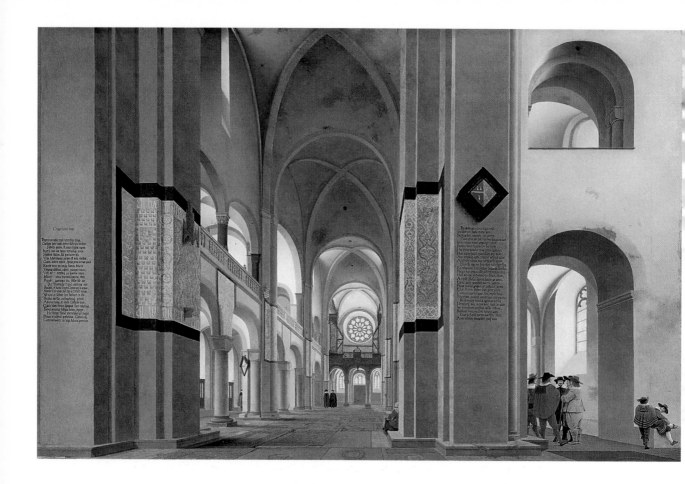

Saenredam, consummate painter of church interiors, had to distort strict perspective to make his *Marienkirche in Utrecht* (1638) look 'right'.

heart of the city. *Skittle Players Outside an Inn* (National Gallery) is a magnificent study of trees, which occupy two-thirds of the picture. He could also compete strongly with the purveyors of erotica: *Couple in a Bedchamber* (The Hague, Museum Bredius) is a masterful exercise in robust bawdy, and *Wine Is a Mocker* (Pasadena, Norton Simon) offers a revealing glimpse of a busty maid brought low by strong drink.

However, Steen's chief object was to show how ordinary Dutch people lived in the mid-seventeenth century, and no one did it better. He provides an enormous amount of fascinating information about life, more perhaps than all the other genre painters put together. He shows us a working kitchen (*The Fat Kitchen*, private), a marriage contract (*Tobias and Sarah*, San Francisco, Fine Arts Museum), a painter's studio (*The Drawing Lesson*, Getty), a middle-class woman's bedroom (*A Woman at Her Toilet*, Royal Collection, Buckingham Palace, which incidentally reveals that Steen could outdo Dou when he chose), medical science (*A Doctor's Visit*, London, Apsley House), a baker, his shop and his wares (*The Leiden Baker and His Wife*, Amsterdam), what exactly happened at village weddings, Twelfth Night feasts, celebrations of state events, oyster feasts, charity drives (*The Little Alms Collector*, Paris, Petit Palais), education (*A School for Boys and Girls*, Edinburgh), dinner parties and outings.

Sometimes Steen achieves a miracle of compression. His finest painting, in The Hague, is called *The Poultry Yard*, but actually shows a beautiful and richly dressed little girl feeding her pet lamb. There is a river, a servant, a dwarf delivery man, a dovecote, sixteen different kinds of birds from turkeys to pheasants, and through an archway a superb sunset landscape of a moated château. It is painting for the sheer joy of it, giving Steen evident pleasure and filling us with wonder at his art.

Steen's versatility was unusual, but most Dutch specialists could turn their hands to other kinds of painting when they spotted a chance to make money, or on a whim. Vermeer, indeed, did more. His *Little Street* shows he could outpoint Hooch on his chosen ground—animated brickwork. His *View of Delft* is the greatest Dutch townscape of the century, in which he combines his ability to depict total reality with a stillness and soundlessness which is almost palpable. The sky is a miracle-mystery too. The only townscape which comes close to it is Pieter Saenredam's Utrecht view of the church of St Mary in its square (Rotterdam). Of all the Dutch specialists, Saenredam (1597–1665) was the most dedicated and focused. He concentrated almost exclusively on churches and especially their interiors, largely in Haarlem. Indeed, he invented a new kind of specialty, the church interior. Others followed in his footsteps, such as the three 'church portraitists' of Delft, Emanuel de Witte, Gerrit Houckgeest (the best) and Hendrick van Vliet—and many others—but none rose to Saenredam's exalted level.

Life was both harsh and generous to Saenredam. He was born a hunchback and was always stunted, and his father, a highly successful engraver, died when he was tiny. But he left his only son a handsome competence, which enabled the boy to settle to his chosen specialty without having to worry about money. So Saenredam took his time, producing only about sixty paintings. But each was based upon elaborate drawings made on the spot, exactly dated and accompanied by notes. His professional life is exceptionally well documented in this respect, so we know exactly how he set about each of his works. His concentration, precision and relentlessness were striking. Sometimes, having made exact preliminary studies, often based upon measurements, he would put off the actual oil painting for decades. The Utrecht view, for instance, painted in 1662, was based on a brown-ink and watercolour drawing, now in the Teylers Museum, Haarlem, which he tells us he did 'from life' on 18 September 1636, a quarter-century before. Time meant nothing to this genius. He always waited until the precise moment he wished to paint, and took exactly as long as he needed.

The result is as close to perfection as is possible in art. Saenredam did a number of different churches but he concentrated on St Bavo's, Haarlem. He did twelve elaborate paintings of it, a fifth of his entire work, of which the three most remarkable interiors are in Malibu (Getty), Philadelphia and the Scottish National Gallery in Edinburgh. The last is the largest and best, into which he put all his skill and knowledge of this highly particular trade, and he (almost certainly) considered it his masterpiece. Drawing and painting interiors is always more difficult than exteriors,

for the perspective problems are much greater. Moreover, as Saenredam early discovered, if you follow strict perspective, the result looks wrong. What he had to do, therefore, was to torture the perspective slightly in places to get the right scream of reality. He engaged in this delicate 'bending' process with more theoretical knowledge than Vermeer but in the end it was the painter's instinct, based on experience and ocular gifts, which in both cases dictated the precise deviation from the norm.

Ocular, as distinct from strict, perspective, is not the only requirement, however, for success in this kind of painting. It is only the beginning. Having got everything in the exact place he wanted on his board or canvas (he used both), Saenredam then had to design or adapt a lighting system which would make the vast interior three-dimensional and bring it to life. As these great Dutch churches, whatever their medieval origins, were strictly Protestant, uncluttered and whitewashed, the colour-system was deceptively simple. Deceptively, because (I have counted) Saenredam had to learn how to apply twenty-nine different shades, one might even say colours, of white. He also had to perfect his treatment of oak, mahogany, brass and gilt to get in the occasional chunks of woodwork and gleams of metal which break up the whitenesses.

In the process, he created, as all the greatest painters do in their best work, a kind of poetry. We do not know much about Saenredam's religious habits or the state of his soul. Most artists who dedicate their lives to drawing or painting churches, like my father, are religious. It is right to assume that Saenredam was too. But the poetry he produced out of those whitewashed interiors is not religious; it is aesthetic. Or rather, an aesthetic hymn of joy which ultimately reaches out to God but is primarily concerned with the presentation of pure beauty. It is one of the glories of art that two totally different painters, Vermeer with his girl in the red hat, and Saenredam with his white internal spaces, ended by making the same point.

Marvelling as we do at the richness of Dutch seventeenth-century art, we can easily make the mistake of thinking that painting was the most important thing that happened in the Netherlands during this period. It was not, for most people. Even for painters it was primarily a living. Saenredam was unusual in that, despite his wealth, he pursued his art with unremitting industry. Others were less single-minded. Meindert Hobbema (1638–1709), for instance, found in mid-career that he could make a better living in administration, and stopped painting. Philips Koninck (1619–1688) became a painter while also engaged in developing a business running big passenger barges between Amsterdam and Rotterdam. This became highly successful and took up more and more of his time. So his painting stopped too. Aelbert Cuyp (1620–1691) came from a family of painters, of which he was the most famous, and many of the 850 paintings attributed to him must be by relations. He was only in the business up to the age of forty-five, when marriage to a rich widow made it no longer necessary, and he too put down his brush for good. The fourth

and greatest of this quartet of landscape painters, Jacob van Ruisdael (1628/9–1682), also came from a big painting family, of which he was the most celebrated. Knowing what a struggle even the most hard-working and accomplished painters, like Hals and Rembrandt, found it to make a living by art, he took the trouble to qualify as a doctor, and practised (this assertion has been disputed). He remained a bachelor too, and thus escaped the fate of the philoprogenitive Vermeer.

Of these four formidable painters of landscape, Ruisdael was by far the best. Very few drawings by him have survived, and even fewer relate to specific paintings. He may well have painted direct from nature, especially in his younger days. His roots lay deep in the northern tradition of Bruegel and Rubens and, broadly speaking, he sought to portray nature as it is, though he gradually introduced gentle subtleties and low-toned, silvery grey and olive greens into his colour compositions. Then he could use strips of gold, or the occasional splash of red, to bring exciting touches into his placid views. He did this with great effect in his various views of the bleaching fields near Haarlem. In the Zurich version, the sky is huge, occupying three-quarters of the canvas,

Ruisdael turned the ordinary Dutch landscape, as in *The Mill at Wijk Near Duursteede* (*c.*1670), into poetry and splendour without sacrificing realism.

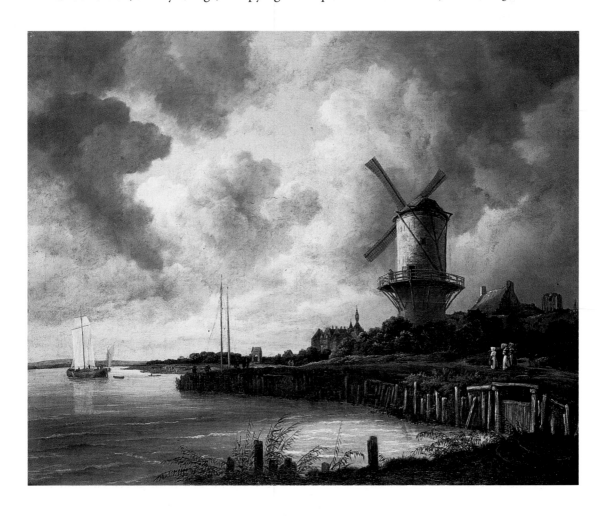

the great church dominating the horizon, the fields with their gold-and-white patches, and the red roofs of the three houses, giving the whole warmth. In the version in Gosford House, Lothian, he changes the angle and the time of day—it is almost twilight—but the compositional elements are essentially the same. Here too is a variation of this design, *Distant View of Alkmaar*, where the sky is again huge, a strip of wheatfields supplies the gold enlightenment, and a village church spire breaks the horizontal line. The London National Gallery shows this same basic pattern in three more variations, *The Shore at Egmond aan Zee*, where the sand supplies the gold, *Landscape with a Ruined Castle and a Church* and *An Extensive Landscape with Ruins*. The last two are the same view, but Ruisdael cleverly constructs two totally different skies to produce a contrasting range of colours, and varying colour-effects on the ground far below.

Other views are dominated by close-ups of trees, often fallen or ruinous, of which *Forest Scene* (Washington), with its collapsed silver birch plunged into the stream, is an outstanding example. Ruisdael used a birch tree as a character in what many find his most impressive work, *The Jewish Cemetery*, which survives in two versions in Detroit and Dresden, the first much the better.

Interpreting Ruisdael's landscapes became a scholarly industry in the twentieth century. Waterfalls and broken trees were seen as symbols of life's transience, the windmills which Ruisdael often introduced became metaphors of the spinning life of mankind driven by the windy spirit of the divine. But there is no evidence for such assumptions and nothing in the contemporary literature to justify them. It is manifest that Ruisdael loved the countryside and weather-effects, and delighted to paint them. Nature has its own moral tales, which are plain to see. Why add to them? Where man interferes in nature, he may add to the landscapist's delight. Ruisdael's *The Mill at Wijk Near Duursteede* (Amsterdam) is a powerful and beautiful painting of a grand mill towering out of the land and water into a huge sky. It is a splendid symbol of Holland itself, of Ruisdael's compositional skill and silvery brushwork, and a thing of beauty. In the words of Keats, 'That is all ye know, and all ye need to know.'

It is characteristic of a great artist like Ruisdael that his work provided food for thought for several others, who selected from areas in which to specialise. Philips Koninck took Ruisdael's 'extensive view' theme, emphasising the flatness of the country, and made it his aim to achieve spectacular depth, so that you go on looking into his views until the skyline vanishes, perhaps 30 or 50 miles away. He did this by introducing large numbers of horizontals, and gradually diminishing the distance between them, painting in the exact opposite way to Ruisdael, from front to back. And, to maximise the effect, he does not break his horizon with a church, as Ruisdael did, but leaves it plain or puts in a flat sheet of water. Then he introduces a diagonal feature in the foreground to break the monotony. The success with which he applied these techniques can be seen in his stunning *Extensive Landscape with a Road by a River* in the London National Gallery.

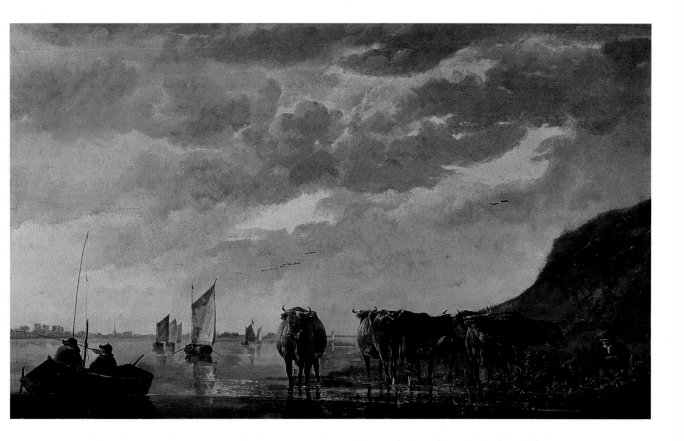

By contrast, Hobbema, who was actually Ruisdael's pupil, drove a road straight into the heart of the horizon, at right angles, and emphasised the contrast by lining it with tall trees. This can have spectacularly successful results, as in his famous National Gallery work, *Avenue of Trees at Middelharnis*, one of the most popular landscapes ever painted, much plagiarised by Impressionists two centuries later. But it is not a trick that can be repeated without fatigue. Hobbema's other device was to follow Ruisdael into closeup and make a big tree, or group of trees, the central hero of the view. He does this with success in *Road on a Dyke* (Dublin), where the main tree is carefully painted against the sun, allowing luscious areas of sunlight beyond it, the whole generating calm content.

Aelbert Cuyp's *Herdsman with Cows* (c.1660) combines lovingly painted cattle with water and huge sky to suggest a Dutch arcadia.

Calm content was the chief aim of Cuyp, who made frequent use of browsing or lying cows to achieve it. He could combine his cows and bushes, streams and hillocks, with wonderfully sensitive atmospheric effects. In the Dulwich Picture Gallery, *Herdsman with Cows* features not just admirable cows but a brilliant sun forcing its way into huge areas of misty air, an adumbration of Turner which is almost uncanny. Cuyp loved the sun, its mysterious epiphanies and its declensions and vanishings. This led him to the sea, for there he could produce wonderful reflections of his evanescent skies. The National Gallery has his *River Scene with Distant Windmills*, with the sails beautifully silhouetted against the rosy evening skyline, and in 2002 it staged a fine exhibition stressing Cuyp's versatility. Just before he gave up

painting, Cuyp did some magnificent coastal and harbour scenes at Dordrecht, such as his *Gathering of the Fishing Fleet* (Washington), a fine painting which persuaded Turner to go to Dordrecht and do likewise (the result is in the Frick Collection). Cuyp's case, in short, is a warning against too much categorisation: to make a great Cuyp, a cow is not essential.

The same point is made by the work of Philips Wouwerman (1619–1668), who loved landscape painting but could also do figures and horses with panache, and sometimes did staffage for Ruisdael and other landscapists. Nothing charmed him more than a quiet pastoral scene featuring hillocks and ruins, with a touch of the sunny south added. But he had evidently been in the wars too, and there were times when his hand itched to do a battle-picture. His *Cavalry Battle by Night* in the London National Gallery, one of the

The Burning of the Royal James (1665) by Van de Velde the Younger turns a horrific moment at sea into high art.

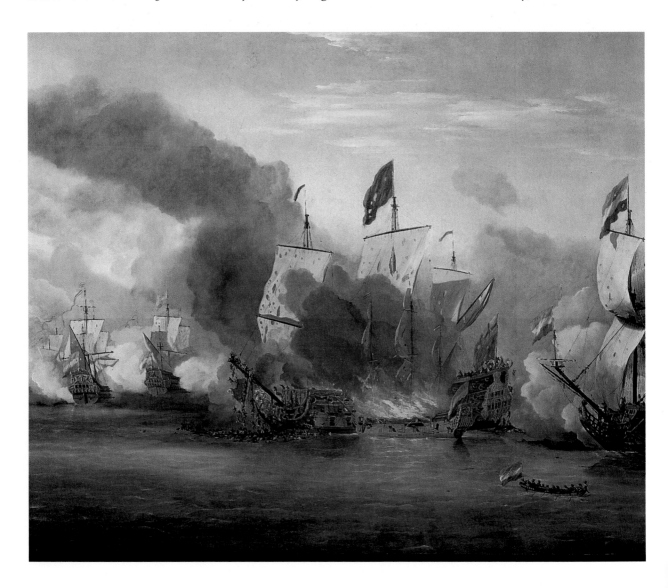

finest works in its entire collection, shows how well he could combine six of his main obsessions: horses, hillocks, gloom, flashes, violent action and frantic men.

Both Cuyp and Wouwerman engaged in, or came close to, yet another category of Dutch painting, the marine picture, by showing how exciting reflections in water could be. The family that brought marine painting to a fine art, literally, were the Van de Veldes, whose Flemish founder was a sea-captain. One of his sons and two of his grandsons took to the sea on canvas. Willem van de Velde the Elder (1611–1693) was often at sea with the Dutch fleet, and was present at five major engagements with the Royal Navy, recording them in sketches and *grisailles*. He was an absolute stickler for accuracy. His son, Willem van de Velde II (1633–1707), was a properly trained painter, Simon de Vlieger being his master, though his earlier oils are signed by his father as head of the family. There may have been some justice in this as the father's sketches were used in producing the son's oils. They were in fact a working team and moved from fishing boats and small ships to major warships. The son developed a rare skill in composing his pictures and giving character to individual ships, making them into personalities. His success can be seen in his great canvas *The Cannon Shot* (Amsterdam), which dates from 1670 and showed, for the first time, the dramatic and monumental possibilities of this form of art. Two years later, when the French invasion of the Netherlands, the *rampjaar*, struck the Dutch economy an almost mortal blow, inevitably hitting painting and impoverishing many artists, Charles II took the unusual step of inviting Dutch experts in different fields to emigrate to England.

The Van de Veldes were at the head of his list. They spent the rest of their lives in the royal service, working from a magnificently sited studio in the Queen's House, Greenwich. The son did not like seafaring, as it happens, and rarely stepped on a ship while his father was still alive to provide the details. When the father died, the son's accuracy declined sharply—his painting became dashing rather than descriptive—and the Admiralty objected. He was forced to go on a year's voyage in the Mediterranean with the fleet, and thereafter he relied mainly on his studio hands. Those eager to see the work of this team should visit the National Maritime Museum in Greenwich, which has wonderful paintings by the younger, many *grisailles* by the elder, and over 1,400 drawings by both. Charles II was well rewarded for his enterprise, and one is inclined to think that the departure of the Van de Veldes for better service abroad was a significant moment in the darkening of the Dutch golden age of painting.

After the *rampjaar* of 1672, no major new artistic talent emerged in any of the big Dutch towns. By the turn of the century, the best Dutch paintings were still lifes and flower studies. The country retracted from the fierce spotlight of history. England took over her leading economic role, France her role in the area. There is in Buckingham Palace a beautiful townscape by Jan van der Heyden (1637–1712), who survived into the eighteenth century to witness the decay of Dutch art. It shows the outskirts of the town of Veere: crumbling walls, a deserted gateway, traces of past glories, the end of an epoch.

18

TOWNS, PALACES,
CHURCHES, GARDENS

In the Netherlands, and throughout the richer parts of Europe, many artists were now making a living mainly or even wholly in the private market. That did not mean the end of grandiose concepts executed for heads of state. Quite the contrary. The seventeenth and eighteenth centuries saw the climax of this kind of art. Nearly a hundred palatial structures were created, extended and decorated during these two centuries, for popes, kings, princes, prince-archbishops and other reigning potentates. We will look at some of them, and the artists who made them possible.

Chief among these master operators, and one of the greatest artists of all time, was Gianlorenzo Bernini (1598–1680). He was supremely fortunate in his gifts and in his times. He was born in Naples but his father, Pietro, was a Florentine sculptor who taught his gifted son all he knew at the earliest age. When the boy was seven the family moved to Rome, to work for the powerful Borghese and Barberini families; and at eight he was already hard at it with his chisel. At ten he produced his first authenticated work, *The Goat Amalthea with the Infant Jupiter and a Faun* (Rome, Borghese), an astonishingly accomplished work for anyone, let alone a child of his age. In Rome, he was able to absorb not only the new realism of Caravaggio, which remained the basis of all his work—whatever the nature of his designs, he always sought to achieve total verisimilitude in their parts—but the revived classicism of the Carracci. He later paid tribute to their example and said that, as a boy, he had done endless drawings of the Greek and Roman statues then to be seen in Rome. Indeed, his feeling for Greek art was such that, until recently, one of his works was classified as Hellenistic from 300 BC.

Bernini's character and methods of work were formed early and remained constant until his death in his eighty-second year. He was deeply religious and a fanatic for work and duty. He believed that God had endowed him with unusual gifts and that, in return, he must make exemplary use of them to glorify his Maker and to make the world share his faith. No artist in history ever worked harder and longer. In addition to his genius with a chisel, which has never been equalled, he was an

accomplished draughtsman, who also produced over a hundred oil paintings, some of which are now beginning to re-emerge. A superb self-portrait in chalk, now at Windsor Castle, shows his long, lean face, huge, penetrating eyes, and unrelenting gaze. Of his eleven children, his sculptor son Domenico summed him up best: 'Aspro di natura, fisso nell'operazione, ardente nell'ira'—'stern by nature, rock-steady in work, warm in anger'.

Bernini demanded and expected the highest standards of everyone, particularly of himself. Until old age, he would work with his chisel for seven hours virtually without pause, throughout a long, hot day. His much younger assistants could not keep up. He attended Mass every morning, early, took communion twice a week, and in the evening would go to the Gesù, the Jesuit church, to say his prayers. He followed the *Spiritual Exercises* of the Jesuit founder, St Ignatius, about the most demanding in existence, and his favourite book was St Thomas à Kempis's *Imitation of Christ*. He was not perfect. He had a passionate affair, before his marriage, with the wife of another artist, Constanza Bonarelli, and the magnificent life-size portrait bust he did of her (Florence, Bargello) gives the marble reason why. But Bernini, though properly aware of the magnitude of his skills and achievements, always competitive and ready to fight for the honour and profit of his firm—his family studio and its many assistants—was a humble man. His only recorded praise of any of his works was 'it is the least bad'.

Bernini's early work shows a level of virtuosity in the ability to carve marble, and to assemble it together (from several blocks) to produce an effect of total realism, which has never been equalled. Like Michelangelo, he thought in terms of settings and intended his work to be seen only from one viewpoint, a stipulation often ignored by galleries today. Seen thus, he made his marble speak, laugh, sigh, even scream. His *Damned Soul* in the Palazzo di Spagna, Rome, a three-dimensional horror emerging from a Caravaggio scene of terror, seems to emit a blood-curdling shout of fear. His *David* (Rome, Borghese), unlike the images created by Donatello, Verrocchio and Michelangelo, is in the very act of using each muscle in his body to slay the giant, as the grim set of his jaw confirms: one can feel the sweat and strain in his whole frame. This is realism in sculpture taken to its ultimate. But it is exceeded, in the context of a miracle, by his even more extraordinary *Apollo and Daphne*, also in the Borghese, which shows the woman actually in the process of being turned into a laurel tree. Not even Bernini himself surpassed this combination of audacity and delicacy in the working of marble. What he did do, however, in his St Theresa in the Cornaro Chapel, in St Maria della Vittoria, Rome, was to produce a central marble duo for the altar showing the power and ecstasy of the Christian faith in a way it has never been demonstrated before or since. The power is in the design, of total heart-stopping, lung-gasping surrender to God. Cynical moderns have produced Freudian explanations of this unique work. But devout Christians saw it then, and see it now, as Bernini intended: as a premonition of the intensity of happiness which Heaven provides. It is the culmination of the Counter-Reformation in art.

Bernini was made a papal knight at the age of twenty-three. A year later his chief patron, Maffeo Barberini, was made Pope Urban VIII, and immediately summoned the sculptor: 'It is your great good luck, Cavaliere, to see Maffeo Barberini pope. But we are even luckier in that the Cavaliere Bernini lives at the time of our pontificate.' Urban reigned for nearly twenty-one years, during which Bernini was the most grandly employed, and richly rewarded, artist in the world. In the mid-1640s, under the new pope, Innocent X, Bernini was (probably unfairly) blamed for cracks in St Peter's bell-towers, which had to be pulled down. But he was soon back in favour and continued to serve the papacy under Innocent and his four successors, for another thirty-five years, making fifty-six in all.

During this long and intensive service, Bernini effectively completed the setting and interior of St Peter's. Indeed his contribution to the church as we see it today is greater than that of any other artist, including Michelangelo. He did three principal things. The main fabric was completed in 1626 and Bernini was charged with ennobling its interior. He did this first by constructing (1623–24) an enormous baldacchino over the high altar. He placed four immense marble bases at each corner, and on them constructed colossal gilt-bronze columns, wrought into spirals and joined by a cornice, with angels, each twice life-size, guarding its crowned superstructure. It is a work of complete originality, for nothing like it has been built before or since (apart from smaller copies). There are those who believe that Bernini's contemporary and (at times) rival, Francesco Borromini (1599–1667), provided some ideas. Maybe he did, but the work as it stands has the impress of Bernini's artistic character all over it. While working in and around the Vatican, Bernini also provided, as a setting for his wonderful St Teresa, the architectural and painted embellishments of the Cornaro Chapel (1644–55). This too was completely original, for no one before had combined together, in a single artistic design, and on the largest possible scale, marble and stone, brass and gilt, gold and silver, plain and stained glass, all wrought together to produce a single emotional spasm. The divine dove descends, skeletons arise from the pavement, angels swirl around and crown the scene with flowers, while all the time, in the centre, Teresa writhes with joy. It is an amazing composition which drew admirers from all over Europe, and was imitated by all who had the means.

It inspired the papacy to demand from Bernini a similar artefact, on an even larger scale, to complete the main decoration of the interior of St Peter's. This is the famous Cathedra Petri, or Peter's throne, in effect a gigantic reliquary, which forms the climax of the view along the nave, and is framed by the baldacchino columns. It is a complex piece of sculptural architectural confectionery, made up of red jasper, black Sicilian marble, masses of bronze, some gilt, stone, iron, marble statuary, a yellow glass eye, through which the light pours, and golden stucco clouds. The size is staggering but is perfectly in scale with the huge dimensions of the building. Bernini continued his work inside the church by shifting around various papal tombs, and designing new ones, and creating a suitably grandiose setting for the spectacular

papal collection of relics—for most visitors their main object in coming to St Peter's. Finally, he put into the Vatican Palace, adjoining the church, a regal staircase, the Scala Regia, through which princes progressed upwards to the papal apartments. In an ideal world, he would have pulled down the entire palace, externally an eyesore which remains to this day and spoils the total prospect. But this could not be done, at any rate in those days, without demolishing the magnificent frescoes, by Raphael and others, on its internal walls. So Bernini was left with an awkward site for his stairs, a problem he solved by a brilliant piece of *trompe l'oeil* foreshortening which makes the stairs seem longer, grander and steeper than they actually are, and has to be seen to be believed. It is even more ingenious than Michelangelo's stairs in the Laurentian Library, if not as beautiful.

Finally, Bernini transformed the small existing piazza in front of St Peter's into the largest and grandest square in the world, or rather a key-shaped device of colonnades, which branch out from the church in a narrowing stem, then form into two

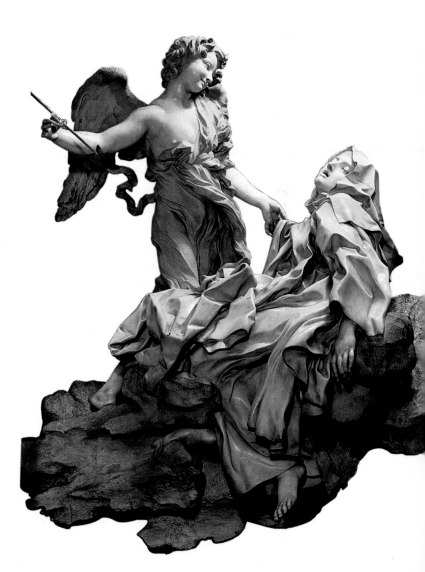

The Ecstasy of Saint Teresa (1647) by Bernini dominated the Cornaro Chapel, a blend of sculpture, painting and architecture in Rome's St Maria della Vittoria.

halves of a circle, which encompasses an obelisk and two fountains. The circle was intended by Bernini to be closed by a third colonnade, which screened the whole from the visitor approaching from the Tiber. But this was never built, and in 1939 Mussolini hacked through an avenue which spoils the surprise. Even so, there is nothing like it anywhere in the world, for the colonnades, despite their grandeur, are low by comparison with St Peter's façade, which thus continues to dominate the whole and appears to stretch out arms to gather in the faithful—clearly Bernini's master-idea.

It is important to realise that, in the seventeenth and eighteenth centuries, architect-designers thought in terms of settings for ceremonies, especially magisterial arrivals. What Bernini had done was to provide the greatest processional route in

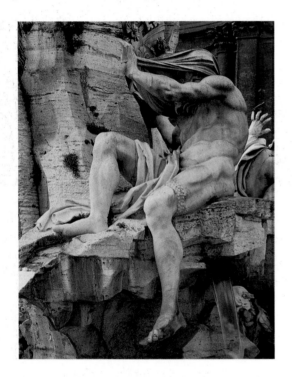

the history of art. The prince, coming to pay his respects to the pope, rode into the piazza at the bottom, took in all its extent and grandeur—including nearly a hundred statues all around him— then dismounted, ascended the steps, and went into the church, his first, breathtaking view being up the nave, through the baldacchino and into the Cathedra Petri which it framed, its blazing yellow eye fixing his own. Then he moved through the church into the palace and up the Scala Regia, at which point Bernini bowed himself out and earlier artists, notably Raphael and Michelangelo, took over.

Bernini's work on St Peter's, thus brought to a triumphant conclusion, would have occupied the entire lifetimes of half a dozen lesser men. But it was not all. He worked on many other churches, including that jewel, S. Maria del Popolo. He loved fountains, of which he said Rome could never have enough. So he produced, of travertine stone and marble, the *Four Rivers Fountain* in the Piazza Navona, a miracle of invention, strength and elegance, which everyone loves and regards as his outstanding work. Indeed, this wonderful piazza, as we see it today, is essentially Bernini's concept. He established other parts of Rome too. Rome is the work of countless hands over 3,000 years, directed by a score of the greatest artists, but the man who contributed most to its visual appeal is Bernini. His work is to be seen inside many of its secular buildings too, for if he did not invent the portrait-bust, he brought it to perfection, and examples of the master's work adorn many a Roman palace.

These busts are typical of his artistic character. He believed in total realism, so the likeness had to be exact. But he wanted

Detail from Bernini's *Four Rivers Fountain* in the Piazza Navona, Rome (1648–51), in which noble personifications of the Danube, Nile (shown here), Ganges and Plate support an obelisque.

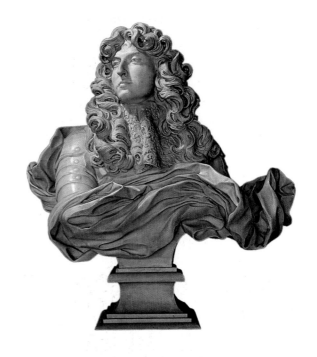

Bernini's innovative bust of Louis XIV (1665) became the prototype of imperious grandeur for over a century, for painters as well as sculptors.

the truthful face to emerge from a swirl of hair and upper garments, to give dynamism and movement to what is otherwise a static form of art. He was always thinking of how to make marble live and speak. In 1665, Louis XIV, who had set himself up as the greatest king in Europe, and wanted the assistance of Europe's greatest artist, summoned him to France, as Francis I had once summoned Leonardo da Vinci. Louis was lucky, for Bernini, after his usual thoroughness of testing ideas in sketches and models, produced the finest portrait-bust in marble ever done, the king's undoubted likeness framed in a mass of wig-curls and armour, and cut off from its stand by a flashing display of drapery, a brilliant invention of the sculptor's which rapidly became a cliché. Bernini was less lucky, for his design for a new Louvre, the ostensible reason for his visit, was discarded and his great equestrian statue of the king, eventually delivered at the end of Bernini's life, was dishonoured. Louis did not like it, got one of his hack sculptors to turn it into *Marcus Curtius Hurling Himself into the Flames*, and relegated it to the garden. There it slowly deteriorated until, in 1980, vandals damaged it so badly that it took eight years to restore. Three copies were made, one for the garden, one for the Louvre, and one for Jackson, Mississippi. The original is so weak it is stored away. Happily, Bernini knew nothing of these insults, dying in an odour of sanctity, having just sketched a projected Christ, which he did not live to sculpt. His chisel had not been idle for seventy-five years.

Who was this king who set himself up as Europe's arbiter of taste? Louis was only four when he came to the French throne in 1643, and his minority was punctuated by aristocrat-led usurpations of power, known as the Fronde. When Louis took personal power from 1661, he opted to take all government into his own hands ('L'Etat, c'est moi', as he told his council), and one key aspect of this policy was the centralisation of France's artistic efforts in his own person, which was transmuted into the symbol of the Sun King. This idea looked back to the Roman emperors, their deification and their monumental arches and palaces, and to the sun-symbolism of the Aztec god-kings, and it looked forwards to the secular deification of twentieth-century dictators like Hitler, Stalin and especially Mao Zedong, who also took the sun as his personal symbol, around which all art revolved.

Louis, or rather his chief minister, Jean-Baptiste Colbert, set up a new adminis-
trative structure for the use and control of the arts. This became the model for all
European courts which could afford it—or whose people did not forbid it—and is
still, to some extent, the exemplar for state supervision and patronage today. A
superintendent of the king's buildings, arts and manufactures controlled the entire
system and supplied it with money from the royal coffers. Colbert inaugurated the
post and held it for twenty years, 1664–83. Under him came the king's First Painter
and First Architect. Then there were two royal academies, to control painting and
architecture. The state took over and enlarged the Gobelin family's tapestry factory
to produce high-warp fabrics, and set up another at Beauvais to produce low-warp,
while the Savonnerie produced carpets. Another department, the King's Chamber
and Cabinet, under a Dessinateur, designed fittings and furniture, and yet another,
the Menus Plaisirs, arranged dinners, events and festivities.

Until the end of the 1680s, when Louis's military schemes foundered in defeat
and his money ran out, this bureaucratic structure produced an enormous amount
of work in the shape of buildings, their surrounds and contents. During this process
Louis eclipsed the popes, once and for all, as Europe's biggest patron. In general, the
materials used were of the highest quality and the craftsmanship was good. In some
fields the foundations were laid for a quality of production which had hitherto been
confined to Italy, and which France still retains in one or two cases. But the overall
artistic direction was another matter. Francis I had been a connoisseur and a man of
fine taste, a picker of great artists. This was reflected in the great Loire châteaus built
in his reign and after, which remain the chief architectural glories of France. Henri
IV had done some noble things, notably his fine Pont Neuf Bridge in Paris and the
first square in northern Europe, which is now called the Place des Vosges. Louis XIV,
by contrast, was uneducated and had, so far as we can see, no natural taste.

His artistic education effectively began in 1661 when he visited the recently
completed house and gardens of Vaux-le-Vicomte, northeast of Paris. This was the
creation of Louis's finance superintendent, Nicolas Fouquet, a crook on the grandest
scale but a man of taste. To build it, 1656–61, he assembled the team of Charles Le
Brun, painter and decorator, Louis Le Vau, architect, and André Le Nôtre, garden
designer. The work is not perfect, for Fouquet pushed it forwards with such speed that
the layout and outer shell of the château was completed in a single year, with 18,000
men working on the site. But the speed also gave unusual unity to the main building,
supports and gardens. The house itself is compact and isolated, though all its fea-
tures are echoed in the other buildings and the garden patterns. It is grandeur with-
out disgusting opulence, elegance without ostentation. All in all, nothing better was
put up in France throughout the seventeenth century, and Louis was overwhelmed
when he saw it. He promptly had Fouquet's conduct in office investigated, cashiered
him (he died in his prison cell nineteen years later), seized his property and took
over his design team.

Louis's plan was to create a great country palace for himself on the Versailles hunting estate where his predecessor, Louis XIII, had built a smallish hunting box of brick and stone. He had no difficulty in enlarging the estate, which swelled to 2,473 hectares (well over 5,000 acres). What he should have done was to follow Colbert's advice, tear down the original building, of no great merit, and give Le Vau instructions to build a princely version of Vaux-le-Vicomte. Louis Le Vau (1612–1670) was not a genius but his Hôtel Lambert, on the Ile St-Louis, and his Institut de France on the Left Bank, are two of Paris's most notable buildings. He would have served Louis royally. Instead, the king kept the existing building and got Le Vau to add two service wings, plus other bits and pieces. By 1669 this was again not enough, and Louis began a massive enlargement. Once more Colbert urged him to start from scratch, and once more Le Vau was told to keep the core. But his orders to provide additional accommodation were so imperative that he was forced to put the entire place in a three-sided envelope, leaving only one old façade, the Court de Marbre, exposed. On the garden front, the envelope stretches over twenty-eight bays, the middle eleven lying back behind a terrace terminating in an arcaded basement. This was bad enough but worse was to follow. In 1671, Louis decided he wanted a new grand staircase for receiving ambassadors, and Le Vau had to put that up, making no sense of most of his carefully planned internal arrangements. That killed him.

In 1678, Louis decided on yet another enlargement. The architect he picked was Le Brun's pupil, the young Jules Hardouin-Mansart (1646–1708), nephew by marriage of a much greater architect, François Mansart (1598–1666). Old Mansart was a highly original man, inventor of the famous steep mansard roof, designer of some of the most beautiful houses in Paris and of the dramatic Val-de-Grâce church there. He had built many fine châteaus including the one at Maisons. But he was dead, and young Mansart, who had changed his name to give the impression that he was old Mansart's successor, and was an assiduous flatterer to boot, got the commission. He went all out for size, virtually doubling the number of rooms, destroying whatever merit Le Vau's enlargement had by joining up the two wings in a straight line, and then adding new wings on the outside of them. This made the south front over 550 yards long, much too big to be taken in at a glance, and relentlessly monotonous. The height is diminished by the extreme length. The thing as a whole looks like an immensely extended, low-built luxury boardinghouse, which is what it was, for Louis moved the entire government and court there in 1681 and all the senior people had to have apartments. Yet luxury was a misnomer, for Mansart provided only limited sanitation. Many courtiers, and *in extremis*, their wives, became accustomed to urinating in the stairwells.

Le Brun (1619–1690) the painter, had a hand in the architecture and was wholly responsible for the interiors, though Mansart made an ungainly contribution in the later stages. Charles Le Brun was a child prodigy who seemed doomed by fate to be an official painter of the highest rank. He first trained in the studio of Simon Vouet (1590–1649). Vouet was a talented painter who might have been a great one. He was a

realist: indeed, apart from Georges de la Tour, the only French-speaking realist of any consequence. But he discovered that French taste, or rather French governmental taste, strongly favoured an arid classicism, a bastardised version of the artistic ideology taught by the Carracci. So he conformed, as did so many painters in seventeenth-century France. This did not mean the country produced no good work. But ambitious painters, like Philippe de Champagne (1602–1674), stuck to portraits. He was France's Van Dyck and his grand full-length of Cardinal Richelieu in the London National Gallery (there is another in the Louvre) shows his swaggering brilliance. By contrast, Le Brun was what we would now call an interior decorator. He became patron of a well-organised group of sculptors, tapestry-makers, engravers, embroiderers and cabinet-makers, whom he trained in his methods and taste and for whom he secured lucrative employment.

It is curious that Louis, who put Molière at the head of the theatre, chose Racine as his playwright, Corneille as his historiographer and made La Fontaine his First Poet, should have picked such a dud as his chief painter—or, rather, as his art dictator. For Le Brun accumulated jobs and titles. He was Rector of the Royal Academy. He was General Custodian of Paintings and Drawings, which meant he decided what went into the royal collection, an immense power of patronage. He was Director of the Gobelins tapestry manufactory, hitherto a family firm; that meant more patronage, for the Gobelins employed 250 people and required hundreds of designs every year. He provided the patterns for all the royal goldsmiths, for the scores of sculptors making statues for the royal properties, for chandeliers and fountains and, not least, for the immense quantities of furniture in the royal palaces. Le Brun was in charge of the decorations at the Louvre, both the old and the new parts. At Versailles, he was the prime mover in everything until his death. Effectively, then, Le Brun created *le style Louis Quatorze*, the first unified decorative style to establish itself in France, and then sweep across Europe. Or did he? The king played a part, perhaps a bigger one than is generally realised. Ignorant and uneducated he might be, but he cared about his houses, seeing them as projections of his own colossal egoism. He himself wrote a guidebook to Versailles, directing visitors exactly what to look at, and how, and in what order. He had views about everything, and Le Brun bowed to them. The king knighted, then ennobled his First Painter, made him the richest artist since Rubens—by far—but he expected obedience. As one observer noted, 'Neither Vouet nor Poussin himself would have proved obedient enough to allow Louis XIV to guide his hand.'

The truth is, Louis was not interested in painting as such. What he cared about was the content of paintings, what they said; their symbolism. The great series of battle pieces and glorifications, both actual and allegorical, which Le Brun painted, or caused to be painted, in all the palaces, were tantamount to mirrors, into which the king looked and saw himself as a hero. So he thought Le Brun the greatest living painter and said so, publicly, on many occasions. With his strong approval, Le Brun conducted the public debate on artistic theory in the 1660s and 1670s, which ended

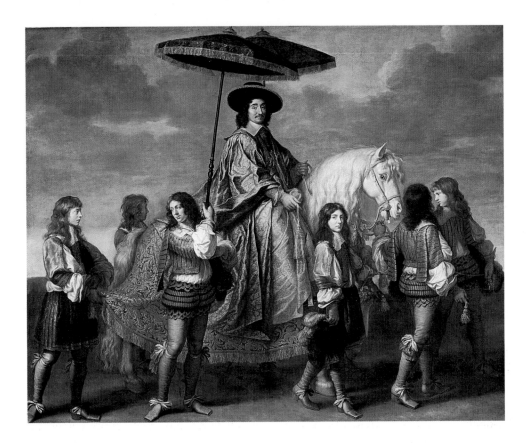

Le Brun, art dictator of Louis XIV's Versailles, influenced style, but only his *Chancellor Séguier* (*c*.1650), with his self-portrait as a page, shows genius.

in the prearranged total defeat of Rubensisme and the total victory of Poussinisme. The king also approved the way in which Le Brun used the Royal Academy to tell artists not only what to paint but how to paint it, providing detailed drawings of an instructive nature, showing how all the emotions and facial expressions were to be rendered. Le Brun's own paintings are lifeless. As with Poussin, his finest painting is his self-portrait (Uffizi), for in this, just for once, he was actually forced to look at what he was painting and work from nature. The only other work of his of any value is his remarkable portrait of *Chancellor Séguier* (Louvre), which shows that grand and sardonic man mounted and attended by pages, with Le Brun himself holding a parasol over his head. This has liveliness. It is an image, and a memorable one. It is fun. Even the horse is enjoying the occasion.

There was one exception to all this lack—not so much of talent: there was plenty of that—of original genius. This was André Le Nôtre (1613–1700), a great man who did things which had never been done, or thought of, before. Before his day, the outstanding gardeners of Europe were the Italians. They had learned, when the walls of the Castellos came tumbling down in the fifteenth century, how to merge architecture and nature in a ravishing relationship. But there was always about Italian gardens a certain informality, a willingness to let nature have her will up to a point. The French would not have this. They wanted reason to rule, absolutely. That meant nature must be a slave. The French were already working on this principle in the

sixteenth century, not least in Le Nôtre's family: both his father and his grandfather spent their lives creating the gardens of the Tuileries, which still bear the Le Nôtre imprint and where André's shrine is to be found. But they were humble men. The grandson aspired to higher things. He was not a gardener as we understand the term. He was an outdoor artist. He studied architecture with Old Mansart and painting with Vouet. He worked on mathematics, perspective and optics. He collected bronzes and paintings and acquired a notable haul, including Claude, Bril, Domenichino and Bruegel, most of which (amazingly) he gave to the king. The king, in return, knighted him twice over, and helped to make him a thorough gentleman. He never left France, except once (1679) to go to Italy, where what he saw seems to have had no influence on what he subsequently did. There is no evidence, indeed, that he was particularly interested in cultivating flowers or fruit, or acquiring rarities and exotics. He was a formalist and a colourist. His motto was: 'Forcer la nature.' He waged war against its randomness and disobedience. He imprisoned it. Nature was merely one subordinate element in the patterns he wanted to weave.

But these patterns were new, and they ravished. Le Nôtre worked first in the gardens of the Luxembourg, then in the Tuileries. He did big gardens for bishops. Then Fouquet pounced on him and gave him his chance. Everything at Vaux-le-Vicomte was splendid, but the gardens really amazed visitors. It is difficult for us to appreciate their impact for we are accustomed to aerial photographs of such huge projects. It was possible, even in the seventeenth century, to paint isometrical views of houses and their gardens but such imaginative efforts were inaccurate. In practice you had to go and see for yourself. That is where Le Nôtre's genius triumphed. He believed in huge scale—impossible to imagine a small flower garden designed by him—and a central axis, stretching to infinity from the house itself before and behind. He used the axis to orient the viewer. Then he proceeded to disorientate him by 'surprises'. He argued that, logically, gardens were projections of the house. They were composed of a series of rooms—an *enfilade*—like the house was, and you walked from one into another on your tour. Each must be different, each unexpected. He achieved this partly by the skilful use of water, in prodigious quantities, and in the shape of ponds, canals and jets, the last working on their own in series or sublimated in gigantic or intimate fountains; and partly by taking advantage of different levels in the landscape. This last was the secret of his surprises. From the house, the entire vast garden looked level, an impression accentuated by the central axis system. But when you got to individual 'rooms', each was on a different level, so you were going up and down all the time, but not steeply enough to make you weary—just enough to make possible all kinds of concealments and privacy. Hence Le Nôtre's gardens at Versailles never become tedious and repetitive, as the house and its rooms do. They are magic, and the ubiquity of the water, even when concealed, makes the magic refreshing and mobile.

The genius of Le Nôtre, then, like that of all the greatest artists, was in creating

apparent, or even real, order, and within it, effecting deliberate disorder to stimulate emotions and give pleasure. His study of optics made him an expert at arranging foreshortenings and illusions which deceived the eye, and caused shock and delight when the deception was discovered. He liked to hear visitors express the 'Ooohs' and 'Aahs' which mark all successful theatre. Moreover, there is mystery and density in his art. No big Le Nôtre garden can be taken in during the first visit. It requires several to see what he was up to; and familiarity, far from breeding contempt, raises one's admiration. Le Nôtre designed about twenty-five major gardens, a huge life-work. Unlike all the dull painters of the regime, he spent his days in the open air, looking and recording. It says something for Louis that he loved Le Nôtre more than any other of his employees. When the gardener was old and enfeebled and unable to walk, the king, middle-aged himself by now, would go round the Versailles garden with him, Le Nôtre in his wheelchair, the king sometimes pushing, the two laughing and talking—Saint-Simon gives a touching picture of them.

England weighed little in the scales of art in those days, though she was in the early stages of an economic and commercial upsurge which would make her, before long, the world's top trading nation. England was already creating the world's greatest literature, but in art she was a net importer by far. The Tudors had used Germans and Italians, the Stuarts mainly Flemish and Dutch. There were some exceptions, men of solitary genius. Robert Smythson (1536–1614) was the first Englishman to master the new style in architecture and Anglicise it thoroughly. He designed the earliest group of major country houses in England—Longleat, Wollaton Hall, Hardwick Hall, Burton Agnes, Worksop—as well as one or two minor ones in exquisite taste: Wootton Lodge, Staffordshire, is still the most beautiful small house in Britain. But outside the family, there was no continuity, no workshop tradition, whereby skills were automatically handed on and improved. Inigo Jones virtually England's only top-class architect in the first half of the seventeenth century, had no professional training. He began as a 'picture maker', progressed into designing court masques, and then drifted into architecture through his court connections. He picked up knowledge by visits to France and Italy, and eventually designed some important buildings, such as the Queen's House, Greenwich, and the Whitehall Banqueting House. His two churches, the Queen's Chapel, St James's, and St Paul's, Covent Garden, are striking, and everything he designed was new. His total output was meagre, the Civil War ended it, and he had no direct successors at all.

There was a real English tradition in only one case: miniature painting. Nicholas Hilliard established it in Elizabethan times, John Hoskins continued it, followed by his nephew and pupil Samuel Cooper (1609–1672). Within his limitations—he usually painted very small and never below the waist—Cooper was perhaps the most accomplished portraitist of the century, Van Dyck alone excepted. Cooper could get a perfect likeness, as all admitted. He was a superb presenter of character, from

giants like Cromwell, Hobbes, Monck, Ireton and Shaftesbury, to minxes like Lady Pye, Barbara Villiers and Margaret Lemon (whom he did *en garçon* with a high hat). He makes the fashionable portrait painters of the later Stuarts, Sir Peter Lely (1618–1680) and Sir Godfrey Kneller (1649–1723), both imports, look amateurish by comparison, producing dolls and elaborately dressed scarecrows. Cooper had a genius for eyes, a mastery of silken tresses; he was a man who—to use Elizabeth I's phrase—'carved windows into men's souls': see his sardonic rendering of that crafty prelate, Gilbert Sheldon (Portland Collection). But, as with watercolourists, miniaturists have to fight to get any recognition even on the lowest rung of the ladder of art. Otherwise, Cooper would stand near the top.

All that being so, it is not surprising to hear that Christopher Wren (1632–1723) never intended to be an artist of any kind, let alone an architect. Born on the eve of the Civil War, which disrupted his youth, he came from a clerical family, his father a dean, his uncle a bishop. His own passions were arithmetic, geometry and astronomy. As a boy he invented a 'weather clock'. At Oxford he mixed with a set of intellectuals who went on to be leading doctors and scientists. He became, aged twenty-five, a professor of astronomy. (Later, Sir Isaac Newton said Wren was one of the three best geometricians of the age.) He invented instruments for measuring, a new kind of pen, improved telescopes and, like Leonardo, he made sketches of mechanical problems. In 1662 he was appointed to a new chair of astronomy at Oxford and, as a cultivated man of science, asked to design the university's academic theatre. This was on Roman lines but with the addition of a roof, which posed difficult structural problems. Wren solved them brilliantly, his plan making use of Palladio's restoration of Maxentius's basilica. He then went on to design the new chapel which his uncle, Bishop Wren, gave to his old Cambridge college, Pembroke. By the time Wren visited France he was already moving from science to architecture, which he found employed all his skills in exactitude, plus exciting visual stimulation. The next year, 1666, the Great Fire of London changed the course of his life, and of art in England.

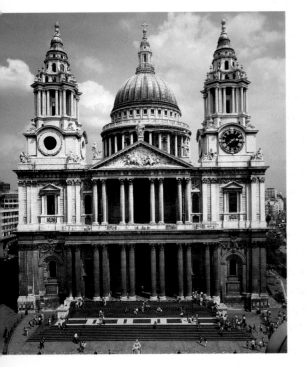

The fire, the most extensive in English history, destroyed 13,200 houses, 45 of the great halls of the London merchant companies, 87 medieval parish churches, many big public buildings and the ancient cathedral of St Paul's, England's largest. In France such a catastrophe would have led Louis XIV to set

Wren's St Paul's (1675–1710), with its forty-seven satellite churches, dominated the London skyline for two hundred years, an architectural achievement without parallel.

up an artistic dictatorship, with powers to rebuild the city on a new, classical ground-plan. There was no chance of that in England, a conservative country which preferred organic growth. Wren, who was involved in the reconstruction from the start, and in particular was made principal architect of the new St Paul's in 1669, quickly realised he had to carry with him Parliament and many other bodies to get anything at all done. The medieval style, or Gothik as it was now called, was still strong in England. Two years after his birth, a Gothik church was put up in Leeds; three years after his death, another was built at Fenny Stratford in Buckinghamshire; four years after that, his own Oxford college, All Souls, added two Gothik towers. Wren wanted a classical building with a dome. Others wanted to retain the medieval plan.

For the first time in history we can follow the construction of a great cathedral in complete detail. Wren's first design, a basilican type (the 'New Model'), was universally rejected. The second, a Greek cross with a huge central dome (the 'Great Model'), was accepted by Charles II but rejected by the rest as too revolutionary. The third was a compromise: a long, medieval-plan church with a dome but popping a Gothik spire on top of it. Wren sarcastically described it as an attempt 'to reconcile as near as possible the Gothik to a Better Manner of Architecture'. This was accepted, though Wren's warrant stated that he should have 'the liberty, in the prosecution of work, to make some variations, rather ornamental than essential, as from time to time he should see proper'. Wren interpreted this as *carte blanche* to do what he wanted. In an autobiographical note, he recorded: 'From that time the Surveyor resolved to make no more models, or publicly expose his drawings, which (as he found from experience) did but lose time, and subjected his business many times to incompetent judges.'

So Wren proceeded to build St Paul's as we know it. It is in the English tradition, with a cruciform shape and the main parts, chancel, transepts, nave, crossing, kept distinct. Its nave is long. It has a vast, Ely-type crossing, enclosing a stupefying volume of space. He kept his dome, which is huge and manifest, but in mechanical structure it is a concealed piece of medieval art, with an inner ceiling or vault of stone and an outer roof of wood covered in lead, a cupola replacing the proposed spire. It is a display church, a prodigy cathedral, intended to excite from afar, to dominate its urban surroundings, to overwhelm by its giganticism from a viewpoint immediately below its west front, and finally to present a series of shock-vistas within. Like St Peter's it is intended for the grandest ceremonies of a Caesaro-clerical state in the Byzantine tradition. The openness and marmorial frigidity of the interior are designed to be warmed by huge state ceremonies, in which sovereign and high priest are coadjutors and society is present in corporative form, each in its ranks, lay and hieratic. It has to be judged at one of these formal occasions for which it was primarily designed, as indeed does St Peter's. And as such it was and is a complete success, more so even than St Peter's, for it was the product of one man's mind, and built entirely under his direction.

The first stone was laid in 1675, the dome completed in 1710 and in 1711 Parliament declared the building complete. Wren had been twenty-nine when his connection

with the cathedral began and was seventy-nine when it was finished. No man has ever been so closely associated with a great building, from start to finish, than Wren was with St Paul's. He did everything, from designing a 40-foot giant battering-ram to demolishing the rubble on the site, from bullying the entrenched interests of the Portland quarrymen to supply the stone—and designing carts to carry the huge blocks—to working out the carrying power of the biggest cranes ever erected in England. He was on the site every day, keeping the masons up to scratch. When the fabric was finished, he found, almost created, great artists to adorn it, in particular Grinling Gibbons (1648–1721) to do its magnificent wood-carving in the choir-stalls and Jean Tijou (*fl.* 1689–1712), a Huguenot refugee ironworker from Louis XIV's France, whom Wren got to do the balustrades, altar rails and sanctuary gates. The work of Gibbons and Tijou is on an artistic level with Wren's own. The painting of the dome, by the fashionable artist Sir James Thornhill (1675–1734) is a different matter, but he was not Wren's choice—more the kind of artist Le Brun would have picked. But, considering the limitations of Wren's power compared to Le Brun's, his achievement in building and decorating St Paul's is incomparably finer and more substantial than the work at Versailles. It can be rated as the greatest single architectural achievement of the seventeenth century.

Moreover, if we take Wren's work as a whole, it puts him, for quantity as well as quality, in the class of Bernini. While he was building St Paul's, he was also in charge of the process to replace the eighty-seven churches lost in the Great Fire. Parishes were amalgamated, so only fifty-one needed to be rebuilt. No one, in the whole of European history, has built so many churches as Wren. In 1677, the peak year, thirty were in process of construction, and he kept a beady eye on all of them. By 1686 all fifty-one were complete, apart from a few steeples. All can be described as classical, but Wren's distinctive style, here employed in endless variations, is too peculiar to be categorised. They were, and are, 'Wren churches'. He defined his object as 'That all should hear the service and both see and hear the preacher.' He was limited by sites and costs, but this objective was attained in all his churches, which are light and airy with excellent vision and acoustics. His artistry shows most in his ingenious variations on the superstructure. Three, including St Stephen's Walbrook (the finest of all), got domes. The rest had steeples. These include the superb, many-storeyed tops of St Bride's, Fleet Street, and St Mary-le-Bow, pointed lead spires like St Martin's, Ludgate, stone steeples with columns ringed round a core, like St James, Garlickhythe, and open cupolas like St Magnus the Martyr, plus one or two other variations.

Until twentieth-century constructions destroyed the City of London skyline, Wren's churches ringed St Paul's vast and solitary bosom like a necklace of varied pearls, no two alike but collectively an expression of the architectural principles of clarity, order and functional simplicity, relieved by a cunning variety of detail. Since, by an Act of Parliament of 1667, the rebuilding of houses followed certain regular patterns, which transformed the residential areas from medieval lath-and-plaster

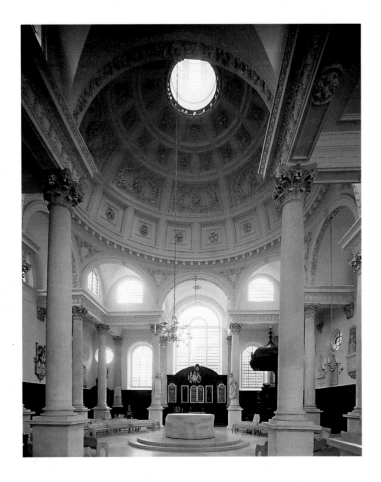

St Stephen's Walbrook (1672) has Wren's most original interior. But all fulfilled his aim that everyone should hear the service and both see and hear the preacher.

into brick—what came to be called 'Georgian'—and since Wren had a lot to do with these patterns, the whole of central London in the eighteenth century was very much 'Wren's city'. Of no other architect or planner can this be said. Nor was even this all. At either end of London he built on the monumental scale: the vast Chelsea Hospital to the west, the even bigger and grander Greenwich Hospital to the east. In both cases he was frustrated by limitations on his genius. But he had patience and determination and a rare skill in turning difficulties into advantages, and both these huge buildings express a unity of design.

Not surprisingly, then, Wren had his imitators, followers and pupils. He started a tradition himself, using the institution of the royal Office of Works, in effect a government department, as his school. It produced two men of genius, one a skyrocket the other a plodder. Nicholas Hawksmoor (1661–1736) entered Wren's office at the age of eighteen. He thus got a proper training but spent the first half of his career in the great man's shadow. Much of his work is subsumed in Wren's and cannot be distinguished from it. But we know he was responsible for three of London's greatest churches: St Alfege, Greenwich; Christchurch, Spitalfields; and St Georges-in-the-East. These, while in the Wren tradition, are better than all but the master's finest, partly no doubt because Hawksmoor, a meticulous craftsman and a perfectionist in detail, was able to give his whole mind to them. We can sometimes single out his

efforts in the Office of Works; thus, the beautiful Orangery in Kensington Gardens is undoubtedly by him. He became, under Wren's tutelage, a superb exponent of monumentality in brick, even when the overall scale is small, as can be seen from his dower-house for the Duke of Marlborough at Iver in Buckinghamshire. He worked wonderfully in stone too: his 'little palace' at Easton Neston in Northamptonshire, where Wren built the stables but the two planned wings were scrapped, is one of the most distinguished buildings of the time, the perfect background for what was once England's first sculpture garden.

We are now at the beginning of the great age of the English country house, whose historical take-off point is marked by the 1688 Glorious Revolution, in which a handful of powerful Whig families united to expel the Catholic James II and install his Protestant daughter and her Dutch husband. The Whig grandees needed country houses appropriate to their oligarchic status and wealth, and they were built. One copious provider was William Talman (1650–1719), like Wren a gentleman with no training as an architect, who learned from travel and experience. Taking in the lessons of Vaux-la-Vicomte and Versailles, but Anglicising them, he produced for the Cavendishes, grandest of the Whig families, their stately Chatsworth House in Derbyshire, surrounded by cascading water-gardens which Le Nôtre would have thought barbarous but which work well in their Peak setting. He did other work of this kind,

Vanbrugh built Castle Howard from 1699, using a Wren idea and Hawksmoor's technical skill. But the theatrical touch of the dominant central dome is entirely his own.

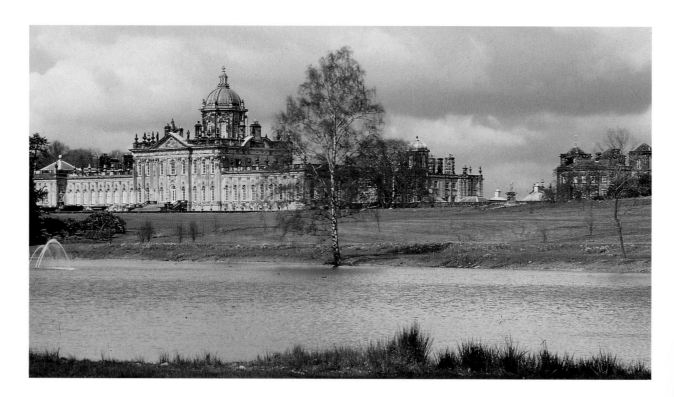

notably at Drayton, Northamptonshire, and Dyrham, Gloucestershire. But Talman was a quarrelsome fellow—like many architects, who live on their nerves and have to cope with a variety of inefficient fools—and rowed with all his employers to the point of dismissal.

Into his shoes stepped an unlikely successor, Sir John Vanbrugh (1664–1726). Yet another example of a gentleman with no artistic training, this grandson of a Flemish immigrant had a mother with aristocratic connections all over England, and it is through these that Vanbrugh became a great architect. He started, however, as a soldier, was imprisoned in France for three years for spying—which allowed him to study the architecture of the Bastille from the inside—then achieved enormous success as a playwright, writing in 1697 two of the most successful comedies in the English language. Two years later he suddenly appeared as an architect, taking over from the bad-tempered Talman a vast project by the Earl of Carlisle to build the grandest country house in England.

Vanbrugh took on Hawksmoor as his collaborator. It says a lot for his shrewdness that he picked the one real professional, to get all the technical things right. And it says a lot for Hawksmoor's self-effacement that he agreed to do it: perhaps he needed to be number two, and wanted a successor to the masterful Wren. The two men worked happily together until Vanbrugh's death. Vanbrugh brought to English architecture a dramatist's sense of theatre—something which Bernini possessed to the full and which Wren rejected as alien to the spirit of the national character. It certainly works at Castle Howard in Yorkshire, an immense domed house with a magnificent fountain in front, on a scale Bernini would have relished. The problem was, and is, to make it liveable in and to ensure its survival, for Vanbrugh, like other theatrical types, always damned the expense. All his great houses, such as Seaton Delaval on the Northumberland coast—the shock when you first glimpse it is unforgettable—have had trouble keeping the roof on at times. But no one ever beat Vanbrugh for sheer grandeur.

When Parliament decided to reward its most successful military commander to date, John Churchill, Duke of Marlborough, and do it in princely fashion, Vanbrugh was the obvious choice, and Hawksmoor his natural assistant. Just as Marlborough had beaten Louis XIV, so Blenheim Palace (1704–20) was intended to beat Versailles. Does it? It was the greatest thing of its kind ever set up in England, and was much envied by three successive kings, George I, II and III because (as one of them said): '*We* have nothing like this.' In the process everyone, from the irascible duchess to Vanbrugh himself, had rows with everyone else, especially Parliament, which soon regretted its generous impulse. It is epic but heavy, and lacks the reckless drama of Castle Howard and Seaton Delaval. The wonder is that the English put it up at all, and still more that it is still lived in by the original Churchill family—which says much about their cunning in adopting the Habsburg strategy and marrying heiresses, especially American ones. Blenheim was outmoded before it was finished, for the hallmark of the eighteenth century was delicacy.

19

SPLENDOURS AND MYSTERIES OF THE EIGHTEENTH CENTURY

In 1720, Jean-Antoine Watteau (1684–1721) painted a Paris art shop, *L'Enseigne de Gersaint* (Berlin, Charlottenburg), showing the old portraits of Louis XIV being dragged away. It was a symbol of the new age. Its spirit was agnostic, not so much against religion as unmoved by it; light-headed, frivolous (as its opponents said), unclassical—for it did not believe in rules—yet not realistic either, for it sought to escape from realism into pleasure. Watteau was its prophet. He came from Valenciennes, which had been conquered during Louis's wars, so he was not even born French. He never had an official job or worked for the powers-that-be. He owed his livelihood to the art dealer Gersaint, being the first major artist to put his affairs into the hands of one, another sign of the times. Such training as he had he received from Claude Gillot, a scene-painter from the troupe of Italian players, performing *commedia dell'arte*, who had been ignominiously expelled by Louis XIV both from Versailles and from their Paris theatre in 1697. They then lived on the fringe, scratching a living as best they could outside state patronage but increasingly popular with the Parisian public.

Thus Watteau came to artistic maturity in the theatrical underworld, doing bits of decorative work here and there and helping to stage big private parties or *fêtes*. He painted a lot of small pictures for private clients, first of ordinary genre scenes, then of pseudo-theatrical events in which young men and women danced, flirted and had fun. He may have done as many as four hundred of these ephemeral works. His inspiration came from repeated visits to the Luxembourg Palace, where great canvases hung in which the exuberant Rubens glorified events in the life of Marie de' Medici. Watteau, it seems, would sit around afterwards in the gardens, thinking about Rubens's high colours, his audacious brushwork, and making sketches. Watteau's figure studies, in red chalk or crayon, supplemented by black and white, are wonderfully attractive. He did over a thousand of them, and a large proportion has survived. Indeed, soon after his death the publisher Jullienne began to turn out etchings of them, culminating in the two-volume *Recueil Jullienne* (1735), which

celebrated all of Watteau's work, an unprecedented honour (and commercial compliment) for a dead artist who had never known official favour. Watteau tried, but failed, several times to win the state Prix de Rome, which would have enabled him to study art in Italy. He did eventually get exhibited in the Academy, for which he had to provide, for the official collection, his *morçeau de reception*. He came up with *The Pilgrimage to Cythera* (1717, Louvre), in which the light-hearted young people progress to the mythological pleasure-ground where Venus reigned supreme. To register this work, the Academicians had to invent a new category, which described Watteau as 'peintre de fêtes gallantes'.

So that is what Watteau became, and has remained. Almost by accident he invented not only a new category of painting but a new approach to art. The lightness of touch he used in his delightful drawings he somehow transferred to canvas. He made his figures small: they are more like staffage than principals, though the superb silken skirts of the women occasionally catch the light and flash out of the canvas like incandescent meteors. In the *Pilgrimage*, the picture's subject might almost be the immense, overhanging trees, which Watteau, combining nature and fantasy, painted in an entirely new way, and which eventually became standard for most eighteenth-century landscape painters. His men and women are, in fact, actors and actresses. His *fêtes* and 'pilgrimages' are crowd scenes. His trees are theatrical backdrops. This emerges clearly in his magnificent work *The Perspective* (Boston, Museum of Fine Arts), where the audience peers through the actors playing and singing in the foreground, into a dark avenue of immense trees, which frame a sunlit pavilion in the centre of the background. It is pure theatre, and it works. Watteau knew from prints that the pre-Lenten carnivals in Venice were the epitome of gallant feasting, so he produced some beautiful stagy Venetian scenes, like *Les Fêtes Vénitiennes* (Edinburgh, National Gallery); in some of these he enlarges his figures so that they perform prominently on a Venetian loggia or stone terrace, as in *Les Charmes de la Vie* (London, Wallace).

These works proved immensely popular, to the fury of the Academicians, who were all the more disgusted because they strongly disapproved of the way Watteau painted. He obeyed no rules about colours or brushwork, putting on the paint thinly or thickly as the spirit moved him, and often refusing to mix colours on his palette, preferring to put them on pure, in small *particules*, which the viewer's eye could mix at a distance. This was yet another of the 'discoveries' for which the Impressionists, 150 years later, got the credit. Some of the criticisms of Watteau's methods, however, were just. His lack of training shows today, for there are very few of his works which have not deteriorated and which do not now lack the light and subtle colours he applied. There is a certain dinginess about them which cleaning and restoration cannot remove. There are signs, too, that Watteau grew weary of painting his *fêtes*, and that he would have gradually dropped the genre and with it his pure theatricality, moving instead towards a more realistic form of genre, and presenting Parisian life

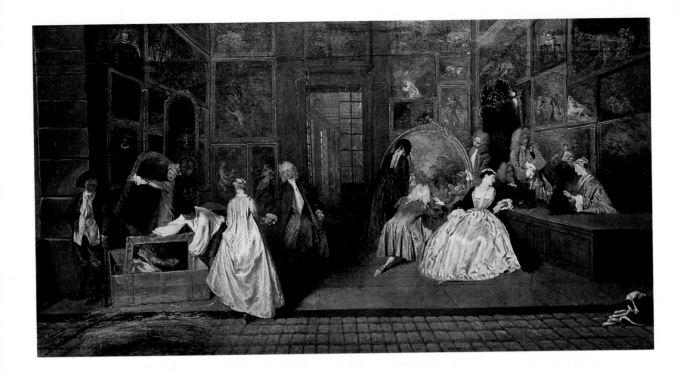

Watteau's *Shop Sign of Gersaint* (1720) symbolised a new era of frivolity in painting, which he led and epitomised.

not as a fantasy but as it really was. His *Shop Sign of Gersaint,* our first picture of what a smart Paris shop looked like, and how its customers were attended to, is a new departure, and Watteau's masterpiece. Unlike his *fêtes,* you want to look at it long and carefully, and come to it again and again. But within a year, Watteau had coughed his life out, and speculation about what else he might have done is pointless.

The biggest painting star of mid-eighteenth-century France, the man who best expressed the revolution in taste Watteau had brought about, and epitomised it, was François Boucher (1703–1770). Few painters divide art lovers more deeply. He arouses vicious antipathy among those who bring to the appreciation of art the spirit of secularised puritanism, radical aims and egalitarian notions. On the other hand, those who put ingenuity of craftsmanship first accord him a high place. He is always worth looking at—closely. His father was a lowly painter, probably living chiefly by sign and coach decoration. As a teenager, by sheer talent, Boucher won the Prix de Rome but was robbed of his reward—a trip to Italy—by jobbery (he had no grand connections). Thereafter he made his living the hard way: by book illustrations, prints and etchings; by designs for both the Beauvais and Gobelins tapestry works; by theatre work; by designing furniture (his son went into this increasingly important trade); by painting panels over doors in rich men's houses; by doing pictures of cherubs making love, playing games and posing—one of the lowest forms of art; by selling his exquisite drawings; in short, by turning his brilliant hand to any form of art which he could sell, historical and religious paintings included. In old age he claimed he had produced over 10,000 drawings and more than 1,000 paintings. This may just be francophone

boasting, like Simenon saying he had slept with 20,000 women. But it may be true, because Boucher was a very fast worker who sweated at his trade all his life.

Success came slowly but surely. Boucher had an original mind and invented a sub-category of the Watteau *fête* in which semi-mythical shepherds and shepherdesses had a good time. The origin of this invention, *The Gallant Shepherd* and *The Good Shepherd*, can still be seen in the over-doors where he painted them in the Hôtel de Soubise, Paris, a place well worth visiting for the overview it gives of high-society taste in Boucher's day. This theme proved so popular that it appeared in countless tapestries, porcelain produced by the Sèvres works, curtains (toiles de Jouy) and upholstery, prints and paintings, by Boucher's hands and those of countless others, ending up as the motif of Marie Antoinette's model farm at the Petit Trianon. He reinforced his success by turning out elaborate mythological nudes like *Venus in Vulcan's Forge* (Louvre), *The Triumph of Venus* (Stockholm, Nationalmuseum) and *Diana After the Bath* (Louvre). These were supplemented by smaller, more obviously erotic works for the cabinets of the upper classes, making a speciality of the female arse—*L'Odalisque blonde* (Munich, Alte Pinakothek) and *L'Odalisque brune* (Louvre; this is a copy, the original was destroyed). Boucher is often thought of as a man's painter but the fact is that his most generous and important patron was Madame de Pompadour, *maîtresse-en-titre* of the king. He did some superb portraits of her, two of them masterpieces and both in Munich (Bayerisches and Alte Pinako-

thek). She liked pictures of children doing adult things, and Boucher humoured her. As always, he put his heart into hack-work, as the pair at the Wallace Collection, the *Rising* and *Setting of the Sun*, admirably show.

Critics claimed Boucher's paintwork was often too sketchy, 'unfinished'; but that was the way he painted, according to subject, mood and his own spirits. He painted so much that his brushes must often have seemed mere extensions of his hands. He never did a bad job. He could be serious. His *Morning Coffee* (Louvre) is pure genre, beautifully executed in the grand manner. His *Madame Boucher*, which like most pictures in the Frick Collection, is a masterpiece, pays

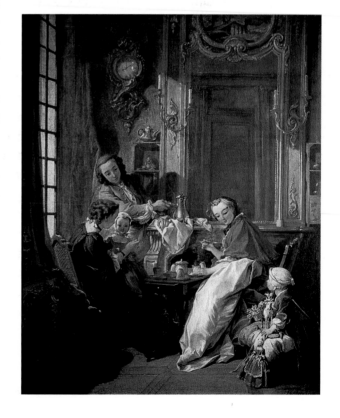

Boucher specialised in erotic nudes and was Madame de Pompadour's favourite painter. But he could do anything, including genre: *Morning Coffee* (1742) shows him at his best.

tribute to a beautiful lady who made him an excellent wife. He loved gardens and painted them with enviable skill, as can be seen by his two portraits of Pompadour seated and standing in a garden setting (London, Victoria & Albert; Wallace).

Moreover, from the world Boucher helped to shape there emerged three other artists of real genius. The first was his exact contemporary, Jean-Baptiste Simeon Chardin (1699–1779). Superficially no two men could have had less in common. It was Boucher's instinct, following the whim of fashion, to flee reality, in paint anyway, while Chardin clung to it tenaciously. What they shared was an absolute devotion to painting as an art and a self-discipline which kept them both hard at it all their long lives, though Chardin, who painted slowly, produced much less. He came from a family of artisans (although he married a lawyer's daughter) and his first effort was a shop sign for a doctor, on the lines of the one Watteau did for Gersaint, though much cruder. While engaged in the menial studio job of painting the musket in a portrait by a member of the Coypel dynasty, he discovered that objects were his strength—he could do them accurately, and he enjoyed the work.

Chardin was also encouraged by the success of the tapestry designer Jean-Baptiste Oudry (1686–1755), who specialised in paintings of dead game, for which there is always a market. He did *The Buffet*, of fruit, food and wine, and then *The Ray-Fish* (Louvre), which got him into the Academy. Thereafter he painted still lifes all his career, most of them varied combinations of pewter, copper, silver, fur, feathers, skins, fruits, wood, textiles, meat and fish, composed with growing mastery, painted with immense attention to detail, and with careful regard for lighting. It must be said that some of these works are dull, a few repetitive. He is at his best when he uses a grainy technique, applying the paint carefully but thickly, as Vermeer did when painting bread in *The Milkmaid*. There are two superb works in the Louvre, *Pipes and Drinking Pitcher* and *Débris d'un déjeuner*, done after an interval of nearly a quarter of a century, which shows that his methods did not change much. Both bring out the beauty and colour of fine porcelain and contrast it with gleaming silver. When painting well, Chardin had the capacity to evoke sympathy for his objects and to get them to project tenderness and discrimination. In this sense he was an ultra-realist who added a metaphysical dimension. Once in the Academy, his reliable skills, modesty and devotion to the profession, well brought out in his famous *Self-Portrait with Spectacles* (Louvre), made him a popular figure, who held the office of treasurer for many years and ran its finances with quiet efficiency.

This undramatic success encouraged Chardin to broaden his range and paint interiors with figures. He specialised in sensible, well-groomed but unpretentious women, and their relationship with children. *The Governess* (Ottawa, National Gallery), in which a teacher rebukes an errant ten-year-old in fashionable frock-coat, was an instant success when exhibited at the Salon in 1738 and he followed it with a score more. Some combine still-life special effects with genre, like *The Water Urn* (London, National Gallery), others are pure genre. Chardin loved to show children

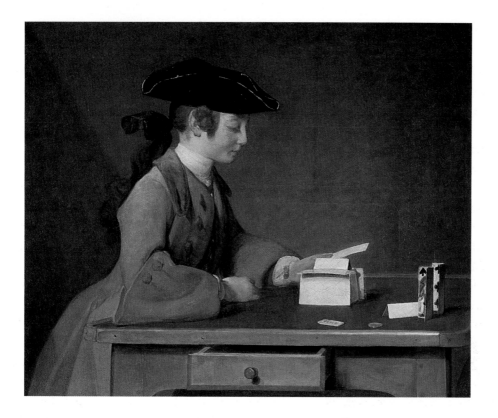

concentrating hard, either on the grim task of learning to read (*The School*, Louvre) or playing (*The House of Cards*, National Gallery). His object was to give life to a moment of stillness, or to turn an insignificant incident into a commentary on happiness—thus in the *Bird-Organ* (two versions, Louvre and Frick) a lady plays a tune to get her canary to sing. This last is perhaps his finest conceit, but there are perhaps a dozen of these figure-paintings which push the art of rendering domesticity as far as it can go. He never had Vermeer's brilliance but he was just as capable of creating a quiet image which the eye comes to love.

Then, suddenly, in the 1750s, Chardin abandoned figure-painting and returned defensively to still life. We do not know why. Perhaps he feared the strident voices of the neoclassical lobby which was striving to get a grip on French art, and which gave him a hard time at the Academy. Doing still lifes, where nobody could get at him, was about as far from the history-painting he detested as it was possible to go, and so he ended his days. Looking at Chardin's best work, his touching *Young Sketcher* (Stockholm) or *A Lady Taking Tea* (Glasgow, Art Gallery), where the fierce red of the table sets this quiet moment alight, it is hard to believe that as an artist he fell totally out of favour, not once but twice, both in the early nineteenth century and again in the first half of the twentieth. But so it was. This was partly due to the large number of inferior works wrongly attributed to him. But his *oeuvre* has been narrowed down from 1,200 (1933) to 400 (1970s) and now stands at about 300, and the triumphant success of the great London/Paris exhibition of his works in the year 2000 testifies to

Chardin's *House of Cards* (*c*.1737) combines his exquisite skill at still life with his love of young people enjoying themselves.

the popularity of his authentic output. In his quiet way Chardin speaks across the centuries, and intended to. He once said, to a chatty, superficial fellow Academician: 'Who said one paints with colours? One *employs* colours, but one paints with *feeling*.' Proust put it another way, surveying his work: 'If all that now seems a fine sight, it is because Chardin found it fine to paint. And he found it fine to paint because he found it a fine sight.'

Another genius was Jean Honoré Fragonard (1732–1806), who had the singular good fortune of studying with both Chardin and Boucher, thus nurturing

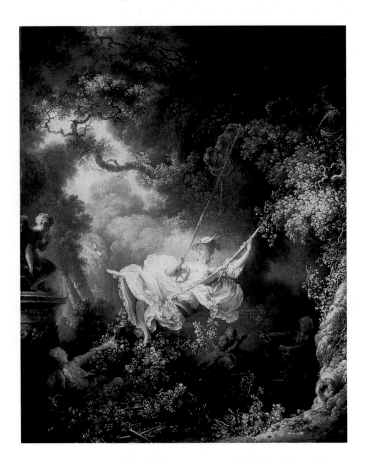

the combination of seriousness and light-hearted joy which makes him the greatest French artist of the century. Everything of Watteau and his followers is subsumed in Fragonard's work, but he also made two extensive visits to Italy (one of three years), where he learned and copied assiduously a wide variety of masters, not excluding the Dutch such as Rembrandt. He is the bridge between French and Italian art. He came from Grasse in Provence and loved the sun; in old age, indeed, he insisted on returning to Grasse and its warmth and scented flowers. His draughtsmanship was almost unparalleled for its fluency, intimacy, ingenuity and charm. He loved gardens, not in the way Le Nôtre did but in the way Italians did, and do—as subtle combinations of wild nature and civilised design. He spent some time at the Villa d'Este in Tivoli, and his drawings and paintings of the huge poplars, walks, rushing waterfalls and houses perilously clinging to precipitous hills provide the most enjoyable, and accurate, visual account of that artist-infested place. Fragonard has a sense of colour which was simultaneously bold, dramatic, sensuous and subtle, applying the paint sometimes with tremendous, sweeping dash—like Rubens—and sometimes with infinite care, as Chardin taught him.

Fragonard's were the talents all good painters would like to possess. His *Waterfalls at Tivoli* (Louvre) is the perfect demonstration of his *plein air* skill, the light organised with exquisite judgement so that you can feel the warmth of the sun and the

Fragonard raised delicate eroticism, as in *The Swing* (*c*.1767), to the level of great art. It reflects too his brilliance at landscape.

grateful shade, and smell the flowers and pinecones. Equally there is a drawing of a garden in the Morgan Library, New York, with a gardener and his wheelbarrow, and two lovers, which achieves the same effect in line and tone. He made his living chiefly from doing frivolous and erotic garden scenes, but as his little masterpiece, *The Swing* (Wallace), shows, the trees are absolutely real and the arboreal light rendered to perfection. The fact that the figure pushing the girl in the swing is a cleric, though not irrelevant, is made secondary by the artist's command of the forest.

Fragonard's work is best seen in the Frick Collection. It possesses his brilliant sequence *The Progress of Love*: *The Meeting* and *The Pursuit*, in which Fragonard epitomised all that eighteenth-century French art had to say about idealised sex among the upper classes, against a fantastic background of trees, flowers and statuary, painted with all the concentration of Chardin and the brio of Watteau.

The interaction between French and Italian artists was complex. The best French beginners went to the French School in Rome to be trained, and many Italians taught there. Venice was almost as influential because so many French artists—from Watteau and Boucher to Fragonard—were mesmerised by images of Venetian pleasure-seeking, especially the carnival. The Venetians, in turn, played upon this taste to sell their wares. Giovanni Battista Piazzetta (1683–1754) headed a connection which included his followers Pietro Longhi and Giovanni Battista Tiepolo, Tiepolo's son Giandomenico and his brother-in-law Francesco Guardi. Piazzetta did everything, and as is usual with great artists, he did everything well but in his own way. Art history is often presented as though artists are in the grip of irresistible forces, spirits of the age, trends, periods, Mannerism, Baroque, Rococo, etc., and create their works under compulsion. Nothing could be further from reality. The truth is, art is all, or mostly, a matter of self-confidence, which comes from the acquisition of reliable skills, and a major artist always possesses it. It allows him to follow his daemon, to the degree he wishes, consistent always of course with making a living, and a self-confident artist can usually do that.

Piazzetta's genre scenes come closer to the Venice of the eighteenth century than the work of any other painter: there is in the Accademia a back-view of a house and garden in the city which shows us exactly how the people lived. He showed the inhabitants too. If Piazzetta was an exceptionally fluent painter, he was an even better draughtsman. He used his skill to create a new form of art: presentation drawings, complete works in themselves, in black-and-white chalk—usually on blue paper—of 'character heads', *testes di carattere* as he called them, all drawn from life but not exactly portraits since the sitters are not named. The black chalk or charcoal is applied with an infinite variety of pressures, so that Piazzetta builds up a sense of *chiaroscuro* or deep shadow, as in his paintings, and then picks out the highlights in white chalk with wonderful delicacy. He was interested in the faces of the Venetians, especially the young—the good humour, resilience, sharpness and cheekiness of the

boys making a rough living. *A Boy Holding a Pear* (Malibu, Getty), which may well be his own son Giacomo, is a valuable lesson in how to draw, and render character. He did these drawings all his life and hardly ever signed them, so there is some confusion over attribution, and new ones turn up from time to time. Joseph Smith, the art-loving British consul in Venice, had the sense to buy them and they eventually went into the Royal Library at Windsor along with the rest of his collection. An artist who spends a day studying these, especially the beautiful *Child with a Dog*, will learn a lot.

As Piazzetta aged, enjoyed a modest prosperity and got more enjoyment out of life, his palette lightened. Giovanni Battista Tiepolo (1696–1770) moved in the same direction but started earlier, and his colouring became one of the lightest in the history of art, though very varied and altogether delightful. This has branded him as light-minded, if not frivolous. In fact, he was one of ten children whose father died when he was an infant and whose mother had a struggle bringing them up in decency. He married Maria Guardi, sister of the painter-brothers, and had ten children of his own. He was a devout Catholic of the strictest kind, and a fanatical worker, who spent much of his life perilously suspended from scaffolding as he painted enormous ceilings. He must have covered more square feet of wall- and ceiling-space in fresco and oil on canvas than any other artist in history. He had help with his special illusionist effects from a perspective expert called Girolamo Mengozzi-Colonna, and his accomplished son Giandomenico was ardent in his service. But as a rule Tiepolo did most of the work by himself, from the first schematic drawings to the final varnish, and his level of accomplishment is astonishingly high. He painted fast, but he never skimped. It is possible to dismiss his entire life-work as an insult to common sense and good taste, as Ruskin did, but none of it is second-rate. Of course, all painting is tricks to deceive the eye and persuade it that what is set down in two dimensions is actually three. In this sense Tiepolo had more tricks than any other painter, and performed them with greater confidence and flourish. He summed up, epitomised and triumphantly concluded the long Italian tradition of covering wall-spaces, which stretched back to Giotto and proceeded through Michelangelo, Tintoretto and Veronese. And he did it in style. There is no possibility of mistaking Tiepolo's work— and no chance of imitating him convincingly.

The rhythm of his work was undeviating. He did fresco cycles in Udine, Milan and Bergamo. He then worked for a decade in Venice, where (among other things) he turned the Palazzo Labia into a wonderland. He covered virtually the entire space of its Grand Salone with ravishing stories, chiefly of Antony and Cleopatra, who appear to walk about the room in front of your eyes. Just as he carried wall- and ceiling-painting to its ultimate conclusion, so Tiepolo developed the drawing technique of Guercino to a point where it is impossible to see how it could be improved. Yet those who know him only through these endless minor miracles do not grasp the artist in all his majestic creativity. To do that it is necessary to go to Germany and see on the spot his masterpiece, the decoration of the Prince-Bishop's Residenz at Würzburg,

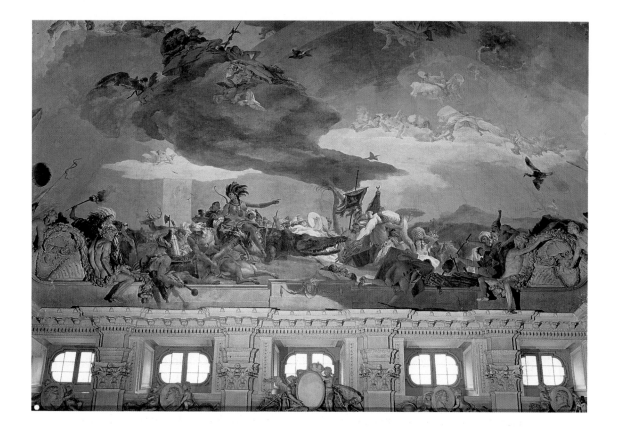

which he did in the four years 1750–53. By a stroke of fortune, the bishopric had come into a vast sum, and the new bishop spent it on building a new palace, designed for him by Balthasar Neumann, and then getting Tiepolo to decorate it. He first tried Tiepolo out on the main reception room, the Kaisersaal, where he painted three historical scenes on the ceiling and two on the walls. These proved so successful that he asked Tiepolo to cover the immense ceiling of the Treppenhaus, or stairwell. This is a work unique in the history of art, for it occupies over 20,000 square feet, and is perhaps the largest fine artefact ever made.

In 1750–53, Tiepolo decorated the palace of the millionaire Prince-Bishop of Würzburg: the ceiling of the grand staircase is the largest painting in history.

The palace decorations, which included two magnificent altarpieces in oil in the chapel, *The Fall of the Rebel Angels* and *The Assumption of the Virgin*, are an extraordinary mixture of secular and religious history, mythology and realism. The great ceiling, while revolving around a fantasy-apotheosis of the bishop, is really an attempt to present the entire world, in the shape of the Four Continents, each with characteristic natives, animals and buildings. Tiepolo searched through books and prints of travel to get his material, and the work is a summation of what educated people in Europe knew about the world in the mid-eighteenth century. It is so big that it cannot be seen in its entirety from any viewpoint, and Tiepolo cunningly turned this handicap into an advantage, for the visitor gets a series of new vistas as he advances up the stairs. It is rather like walking through a Le Nôtre garden getting 'surprises', one after another, except that in this case the impact is much closer and

more vivid. Fortunately the palace decorations as a whole are complete and *in situ*, and well preserved, and in the second half of the twentieth century a good deal of intensive research was carried out on how they were done.

It is evident that Tiepolo, before he even began his designs, inspected the building very carefully from without and within, and noted the effects of sunlight and shadow at all times of the day, and of candle- and lamplight in the evening. Large numbers of preparatory drawings were made, and revised, and coloured ones prepared on their basis, so Tiepolo knew exactly what he intended to do before the scaffolding was set up. It was the culmination of all the experience and skills that had been gained in 400 years of Italian large-scale painting. Thanks to the work of modern scholars, and the Tiepolo's meticulous preparations, we can follow his working methods from start to finish. The final drawings, each from 8 to 14 feet wide, corresponded to the old *giornate* system first fully worked out in Giotto's day, so we can tell how long everything took. Each of the four continents kept Tiepolo (and two of his sons) busy for a fortnight, and the central part of the ceiling up to fifty days, so the actual painting was three months' work. However, this was only possible because of the intensity of the preparation and Tiepolo's vast experience. The speed at which he eventually put on the paint was a huge advantage, ensuring unity of tone and the almost reckless display of genius only possible to an artist working with complete self-confidence, knowing exactly what he was doing.

There is a general feature of Tiepolo's work which makes him the greatest of all large-scale painters. He made clarity his first object. He displayed a wider range of colours and shades than any other artist, and he was not afraid to use deep tones of ochre, vermilion and dark cobalt to bring out depth and shadow. But his greens and roses, his lavenders and golds, his pale ultramarines and silver-greys are of the lightest density possible, and never lose their freshness. There is always plenty of white space, against which figures are silhouetted, and the many varieties of white and gold he used, and his careful attention to such natural light as the room received, gives the impression that all is bathed in sunlight, of that pale but clear kind which visitors to Venice find so perfect in viewing its outdoor panoramas. Most ceiling decorations, however grand the master who painted them, succeed only in places or fail completely because they are over-designed, over-composed, over-crowded and above all contain over-large areas of powerful colour and darkness. The viewer cannot see what is going on, and he strains his eyes and neck muscles trying to unscramble the vast array of brushstrokes. With Tiepolo there is never the smallest doubt about the story he is telling, so the viewer perceives it in one delighted glance and can then examine at leisure the wonderful details and colour combinations. Tiepolo turns the art lover's wearisome duty into pure pleasure.

Another famous Venetian family of painters were the Guardis, the great Tiepolo marrying the sister of two of them, Gianantonio (1699–1760) and Francesco (1712–1793).

The two brothers worked together supplying altarpieces for churches, then Francesco branched out on his own to produce cityscapes, *capriccios*, and scenes of Venetian life. He is compared to Canaletto to his disadvantage, perhaps unfairly, for Guardi was trying to do something different. He aimed at atmosphere, as opposed to accuracy. It is a curious fact that most women prefer Guardi and most men Canaletto. At Waddesdon Manor in Buckinghamshire (National Trust) there are two colossal scenes by him, of 9 by 14 feet, but usually he did small, delicious canvases, conveying the colour and grace of Venetian life, and the delicate tints of its views, rather than their grandeur. These are supplemented by drawings of tender beauty, from which any landscape painter can learn much (as Gainsborough undoubtedly did).

The Guardis were related to yet another Venetian art family, the Longhis, father and son, of whom Pietro (1702–1785) specialised in genre and his notably less talented son Alessandro (1733–1813) in portraits. Like Guardi, Pietro Longhi kept his pictures small, delicate, well-painted, funny or ironic. They tell the intimate tale of upper-class life in the decaying but pleasure-loving and delightful city just before Bonaparte destroyed the Republic for ever. Guardi and Longhi are often, inexcusably, confused: they can be distinguished perfectly in the London National Gallery, which hangs two typical small Guardis, *Venice: The Punta della Dogana* and *The Giudecca with the Zitelle*, and a big one, *The Doge's Palace*, in close proximity to two Longhis, *A Nobleman Kissing a Lady's Hand* and *A Fortune-teller at Venice*. These five, each delightful in its way, tell what late-eighteenth-century Venice was about, at the level of intimacy.

Meanwhile, of course, Canaletto, or Giovanni Antonio Canal (1697–1768) to give him his real name, had completed his life's work of painting and drawing Venice on the grandest possible scale and in the most detailed manner. Like many great landscape painters, he was the son of a theatrical scene-designer, who took him to Rome and taught him the trade. The rest of his life Canaletto spent in Venice, apart from ten years in England (1746–56). He was one of the greatest of artists, but his work speaks for itself. Most people enjoy it hugely, without difficulty or explanation, and there is not much more to be said—hence he has received comparatively little critical attention. He sold well over five hundred paintings during his lifetime, some small but mostly large, and when his three sisters inherited his estate they found only twenty-eight unsold in his studio. His greatest patron was Consul Smith, who sold his immense group of Canaletto paintings and drawings to George III in 1762, so his work can best be studied in the Royal Collection at Windsor. He also did a large set of Venetian views for the Duke of Bedford, and they can still be seen in all their magnificence at Woburn Abbey. Of his five hundred or so authenticated drawings, a large number of the earliest and best are in the British Museum. He must have done at least five hundred more, and they emerge from time to time.

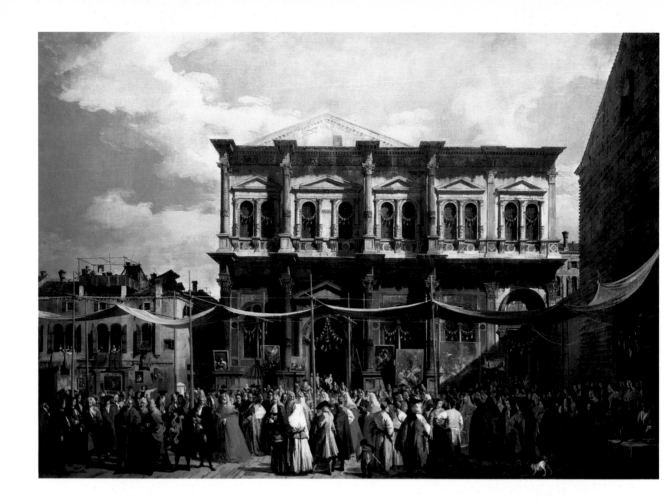

Canaletto's *Feast Day of Saint Roch* (1726) illustrates his matchless skill at depicting grand ceremonies against a backdrop of historic buildings.

Canaletto's big views of famous sights in Venice, the *Bacino*, St Mark's and its square, the Grand Canal, the Salute, S. Giorgio and the regattas, are so well known and have been reproduced so many thousands of times in countless publications, as Christmas cards and the like, that they suffer from the deadly modern art-disease of over-familiarity, for which there is no cure except a visit to a gallery where originals can be seen in good condition and closely studied. As a result, his works most often talked about today are the less familiar ones: the Dulwich Picture Gallery's romantic, overcast *Old Walton Bridge Over the Thames*, for example, or the dozen scenes from Venetian ceremonial life, of which *The Feast Day of Saint Roch* (National Gallery) is one of the best. This gallery also has his *Stonemason's Yard* which gives, as it were, the harsh underbelly of Venetian grandeur, painted with a breathless skill and a sensitivity to colour and texture which no other view-painter has ever approached.

Canaletto is always working towards an inner or higher truth, so that he never gives a snapshot of a view, rather its essence, the result of long gazings and study, in different lights and at all times of day. It is a measure of Canaletto's success that he hardly ever becomes mechanical, even in repainting the same view of Venice he has done a dozen times. You are always conscious not of a man making a living but of an

artist earning it, by loving his subject matter and constantly finding new ways to bring out its truth. His *capriccios*, both drawings and paintings, are numerous but never far from the truth because he was always noticing new aspects of Venetian reality and putting them together in interesting ways. He did this with his 'true' views too, for he sometimes took two viewpoints in line, then unified them in paint, concealing his artistry by a brilliant manipulation of the light and shadows. His so-called sketchbook in the Venice Accademia, with its 138 drawings on 75 sheets, in black and red chalk later intensified by ink, provides a wonderful insight into his work. He is sometimes attacked as 'facile', and it is true he never looks laboured. But all his works, without exception, show evidence in every inch of hard work embodying many years of experience. A tremendous amount of craftsmanship—and lore—can be learned from intense study of a big Canaletto canvas. Indeed, a lot can be learned from even his slightest drawing. But then, in truth, they are never slight; they are always careful, thoughtful and just.

Everything about the trade, then, could have been learned in Canaletto's studio. But it is not surprising that his nephew, Bernardo Bellotto (1721–1780), was anxious to leave it and strike out on his own, working mostly in Vienna, Dresden, Munich and Warsaw, where he died. Bellotto was quite happy to sign his work with the family name of his mother, if he thought it would help to sell it. But he was a different kind

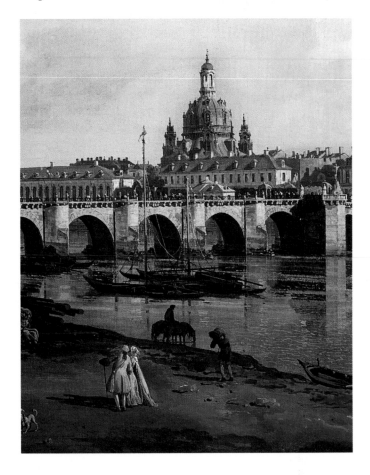

of painter to his uncle, albeit he practised in the same topographical category. He loved skies for their own sake, including gloomy ones. He liked grime and hard metal and the natural decay of weather to which all substances submit. His Venice views are dingier than Canaletto's, windier and darker, and not necessarily inferior, as his wonderful *Salute* (Cambridge, Fitzwilliam) shows. He did a masterly view of Rome, *The Tiber with the Sant' Angelo* (Detroit, Institute of Art), which reflects what I suspect was a melancholy temperament. Hence his love of the north and east. He painted with a skill close to perfection the Dresden that was emerging as the finest city in east-central

Bellotto, Canaletto's nephew, went to central Europe to escape his uncle's shadow, first working in Saxony, where he did this view of *Dresden from the Right Bank of the Elbe* (1751).

Europe. His magnificent cityscape *Dresden from the Right Bank of the Elbe* (Dublin, National Gallery) is a sombre version of similar scenes Canaletto took from the terrace of the Duke of Richmond's house, looking up and down the Thames (Goodwood House, Sussex). Saxony suited him. His greatest painting, *Fortress of Königstein* at Knowsley on Merseyside, is an absolutely faithful but dramatic presentation of an eighteenth-century fortress, in all its gritty ruthlessness, spoiling but somehow ennobling the landscape. At his best, Bellotto is a worthy northern pendant to the world's finest view-painter, and should be better known.

The eighteenth-century English loved Canaletto. But they also loved his equivalents in Rome, especially Giovanni Paolo Panini (1692–1765) and Giovanni Battista Piranesi (1720–1778). The first was yet another scene-painter who moved to *veduti*. He could do history paintings against a real or imaginary background of Roman architecture, such as *Alexander the Great Cutting the Gordian Knot* (Baltimore, Walters). But he found there was more money in real views, such as *The Interior of St Peter's*, which exists in over a score of versions (St Louis Art Museum has the signed and dated one), or *The Colosseum* (Berlin, Gemäldegalerie) and *View of the Forum* (Detroit), both again in multiple versions. These were all well-composed and carefully painted and Panini never sold a poor copy. He also enjoyed painting festivals, fireworks displays and celebratory events against a background of Roman buildings, as for instance his *Firework Machine* in the Victoria and Albert Museum, London. He did imaginary museums too, such as his *Gallery of Views of Ancient Rome* and of *Modern Rome* (both in the Louvre). He was an exceptionally hard-working man, who kept up his stage-design practice, worked occasionally in architecture, designed excellent furniture and used his ample means to give the best parties in Rome, attended over many years by the cream of British, French and northern visitors. There they might meet the wonderfully learned and eccentric Piranesi, a gentleman from Venice, brought up in the traditions of Palladio whose work he knew thoroughly, who had come to Rome to learn everything that was to be known about classical architecture. He became the leading expert, and propagandist, of classical models, and he imparted his hard-gotten knowledge to visiting British architects such as Robert Adam, William Chambers, George Dance and Robert Mylne, thus playing an important role in British architectural history.

What Piranesi really wanted to do was to design colossal buildings, but he never had the chance. Frustrated in his architectural ambitions, he turned as a *pis aller* to arches and floats for festivals, at which he excelled, and then to printing. His early etchings and prints of classical views and ruins began to appear from the 1740s, when they were bound up in a volume of fifty. Next came a volume of architectural fantasies, twelve etched plates of monumental semi-imaginary structures and imposing ruins (1743), followed by four magnificent *Grotteschi* (1747) and fourteen fantasies on the subject of monumental prisons, the *Invenzioni caprici di carceri* (1749–50). Driven

by enthusiasm and obsession more than by the quest for money and success, Piranesi went into publishing on his own account, especially after he married a well-endowed lady in 1753. As each edition of his prints sold out, he would put together a new and enlarged one, until his grand *Veduti de Roma* contained 135 larger-sized prints and his *Carceri d'invenzione* (1761) sixteen of the most beautiful, imaginative and indeed hallucinatory engravings ever made. He ran his own design and print showrooms in Rome, made archaeological expeditions to Herculaneum, Pompeii and Paestum to keep himself up-to-date with the latest discoveries, gave public lectures and engaged in shouting matches and other artistic controversies. A great toper and womaniser, Piranesi became one of the sights of Rome itself, and died from bladder failure.

From the 1750s on, the British gradually ousted the French as the visitors the Italians most sought to involve in their art. Most young men on their grand tour went to Venice and Naples, all to Rome and Florence. In Rome they had their portraits done either by the German Anton Mengs or by Pompeo Batoni (1708–1787), an immensely productive and rich stylist in the grand manner, who could do swagger portraits or

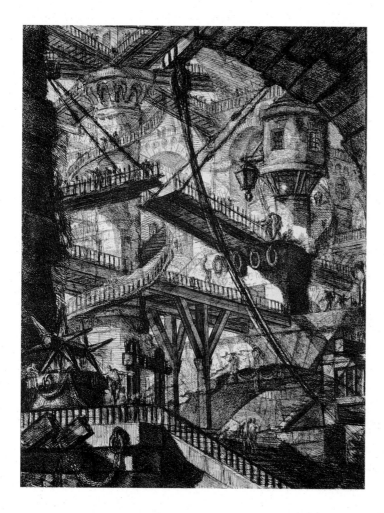

Piranesi's *Carceri VII* (1760), from an etched set of views of imaginary prisons, fascinated visitors to Rome, excited the early Romantics and later inspired the Surrealists.

introspective ones on request. Everyone from millionaire dukes to the pushy Scots adventurer James Boswell sat for him, and the National Gallery, London, has a superb example of his highly marketable skill, *Portrait of Richard Milles*, in which the subject wears a superb grey-silk waistcoat and red velvet fur-trimmed cloak. In Florence the thing to do was to look at paintings, and this activity of the well-born English became so famous that George III's wife, Queen Charlotte, sent out there the Anglicised German artist Johann Zoffany (1733–1810) to paint his masterpiece, *The Tribuna of the Uffizi*: this is a wonderfully executed panorama of goggling connoisseurs, led by Sir William Hamilton in his ribbon of the Bath, examining the greatest works of Italian art. It still hangs in Windsor Castle and sums up the whole place and period.

In the light of these activities it might be thought that eighteenth-century art was dominated by connoisseurs alone and that religion had been pushed to the sidelines. That was not true everywhere. Until the end of the seventeenth century, Habsburg Austria, one of the most important countries of the Counter-Reformation—its heart, in fact—had been hard-pressed by the Turks, who on several occasions threatened to take the capital, Vienna, and overrun central Europe. But in 1683 the last Ottoman siege ended in overwhelming victory for the Austrians, and a huge upsurge of triumphant economic energy followed. This took cultural form in what was later called 'Austrian Baroque', a swirling, dazzling explosion of joy and thankfulness to God, carrying the ecstatic visions of Bernini to their ultimate extreme. The decades 1690 to 1750 were good times for architecture in Austria. Many Italians were imported, but there were outstanding locals, like Johann Fischer von Erlach (1656–1723) and Jakob Prandtauer (1660–1726). Vienna re-emerged from a frenzy of building activity with a dozen of its city churches provided with splendid new façades, its nobles accommodated in new town houses, with country villas

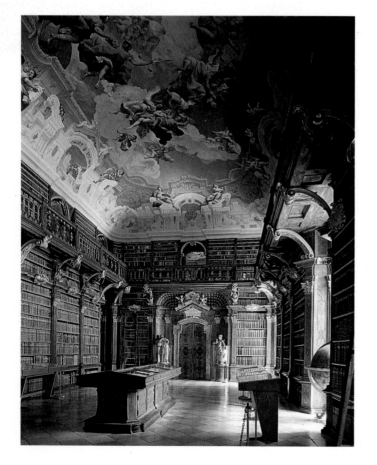

Melk Abbey, masterpiece of Austrian frivolity, contains a library where readers are entertained by Troger's fresco, *Divine Wisdom and the Virtues* (1731–32).

The staircase leading from church to library at Melk (1730s) is a spiral extravaganza devised by the abbot, Berthold Dietmayr, and his architect, Jakob Prandtauer.

and elaborate gardens in the suburbs, and an enormous new state church, the Karlskirche, designed by Fischer von Erlach and built 1716–37. It has a resplendent dome on a high drum, framed by massive columns, rather like Christ-ianised minarets, and flanked by wings which make it look as much like a palace as a church.

The old abbeys of Austria, mainly Benedictine, whose vast lands had tripled in value with the removal of the Turkish threat, entered into the spirit of this joyful building programme. The Prince-Bishop of Würzburg was not the only prelate to go in for grandiose schemes: there were some expansive abbots too who might be described as the last of the big ecclesiastical spenders. Göttweig Abbey, which had been damaged by fire, was completely redesigned by Johann Lukas von Hildebrandt (1668–1745). He had had extensive palatial experience in building various Belvederes for the successful general Prince Eugène, and conceived the new Göttweig as an updated, Germanicised version of the Escorial—a complex of five vast courts around a dramatic high-domed church. At Melk, on a high rocky ledge overlooking the Danube in lower Austria, Prandtauer designed what is perhaps the most magnificent abbey in the world. The great dome and two high towers of the church arise like stone flames from the naked rock, and their upwards thrust is magnificently balanced by the horizontal force of the abbey's living quarters, which stretch an endless fifty-seven bays across the hillside. On either side of the church are the Marmorsaal or Marble Hall, and the Library, which complete the clustering monumentality of this dramatic group of buildings dominating Europe's longest river.

The abbey's interiors, in various shades of red marble and cream-and-white stucco, match the splendour of the outline, and swarm with ecstatic saints and triumphant angels. It is not surprising that the ambitious abbot, Berthold Dietmayr, had to fight the outraged puritans of his order, and his own community, to get the project approved. There is an imperial staircase, giving access to the abbot's own lodgings, which rivals the one at Würzburg in magnificence, and the vaulted ceiling of the Marble Hall sports an enormous fresco entitled, with unconscious irony, *The*

Triumph of Moderation. In the euphoria of the new Austria, Melk set the fashion for vast monkish expenditure on huge buildings with ultra-elaborate decorative schemes. Among the abbeys embellished were St Florian, Garsten and Kremsmünster, the new Augustinian foundation at Herzogenburg, and Klosterneuburg, St Pölten, Seitenstetten and Dürnstein. To some at the time, and many since, it seemed holy madness. But it was certainly in the tradition of Abbot Suger, and countless other building-abbots of the Middle Ages. Indeed, Austrian Baroque, in its luxurious, elaborate detail, its swarming repetitions and sensual fussiness in rich materials, recalls the finest phase of the medieval style, a sanctified disorder, provoking, almost demanding, a stern recall to classical order.

However, it is foolish to approach this kind of eighteenth-century art in a puritanical state of mind. To do so is to miss an overwhelming aesthetic experience, which for some people can be a religious one too. To be understood, these great abbeys have to be glimpsed first from afar, rising from the Austrian plain or its immense river, wondered at from immediately below their precipitous façades, self-glorifying towers and overweening domes, and then entered in awe and trepidation, before the sheer white-and-gold splendour overwhelms you with its vastness, intricacy and profusion. You have to accept that this is one way in which men and women praise God, worship him and submit to him, with the kind of ecstatic surrender Bernini depicted so movingly in his St Teresa. It was certainly not a class response. Most of these free-spending abbots may have come from aristocratic families, but the vast majority of the craftsmen they employed were humble men, who worked with a will and to the limits of their skills to effect these extraordinary decorative schemes. You have only to examine with sympathy what they did to realise that such workmanship is not the result of training and skill alone: it can only be produced by love, whether love of God or love of art—almost certainly both.

Nor were such effusions of extravagant talent confined to a relieved and triumphant Austria. In southern Italy and Sicily there were also rejoicings at the discomfiture of the Turks. They found comparable expression in art. In Apulia, the heel of Italy, the grand little town of Lecce had long been famous for the ebullience of its architectural sculpture, made possible by the local stone, gold in colour, which is brought up from the earth soft—thus encouraging the most extravagant moulding and sculpting—and then hardens into durable rock. The exteriors of its churches had for centuries been embellished with clusters of flowers and fruit, cherubs galore and saints and angels clinging to the walls and pointing at the sky. The early eighteenth century brought this form of celebration to a dramatic climax in the redecoration of the Basilica di Santa Croce, the new façade of the Celestine monastery, the church of S. Maria del Rosario, and other buildings. Giuseppe Zimbalo—Lo Zingarello as he was known (1620–1710)—and his dazzling pupil Giuseppe Cino were the artists responsible for the dramatic efflorescence. Both were poor men, but they loved God and rendered thanks for the almost miraculous lime-

stone he had provided by turning it into golden streams of leaves, plants, apples, oranges, pineapples, snakes and animals, which surge across, around and above the walls of the streets and suddenly erupt into magnificent saints, virgins and martyrs, so alive they almost sway with joy on their pedestals and parapets.

In Palermo, capital of Sicily, there was no such rock. But there were *stuccatori*—the stucco workers—and especially the humble family of Serpotta. There were a dozen or so of these gifted artisans, over four generations, of whom Gaspare, Giuseppe, Giacomo and Procopio were the most important, active over a whole century, 1650–1750. Giacomo Serpotta (1656–1732) was the most inventive, imaginative and prolific, and his work in the various oratories in the city, especially S. Rosario, and the altars and transepts of the Carmine Maggiore, mark the climax of a very specialised and delightful art—stucco raised to the complexity and majesty of sculpture. There is nothing like it elsewhere in Italy, let alone in the rest of the world, and these stuccos, like the golden limestones of Lecce, have to be seen to be believed.

In central Europe, especially in Desden, Bellotto was there to record and immortalise some of the architectural extravaganzas of these optimistic years. In the Kunsthistorisches Museum, for example, there is the magnificent panorama he painted of the new city which had arisen after the end of the Turkish threat, *View of Vienna from the Belvedere*, which captures the joyful monumentality of the Karlskirche and other new features. Bellotto painted Dresden time and again, and with reason, for this beautiful city on both sides of the Elbe came close to becoming the artistic capital of Europe during the fruitful reigns of the elector Frederick Augustus I and his son, Frederick Augustus II, who together ruled Saxony for nearly seventy years (1694–1763). Artists from all over Europe came there. The buildings erected in the first half of the eighteenth century made Dresden uniquely beautiful as a city, surpassing even Prague and Cracow, its chief rivals. The art collections were equally distinguished. Dresden was the centre of fine craftsmanship of all kinds, and from 1707 the opening of a high-class porcelain factory at Meissen, just outside the city, soon produced some of the most beautiful and inventive china in Europe. Largely destroyed in the Second World War, a fresh start was made after German reunification in 1990 and we shall have to see how far delectable Dresden can be built up from its ashes. Certainly, the light-hearted *joie de vivre*, so characteristic of much of the eighteenth century, and epitomised in the Dresden of the 1750s, cannot be revived.

One competitor was Nancy, now merely a city in eastern France, then capital of a semi-independent duchy, with a civic pride and swagger not to be found in any other francophone city, Paris alone excepted. In the first three decades of the eighteenth century it was the subject of an early exercise in town planning, which not only laid out broad avenues but regulated the alignment and height of buildings, encouraged the construction of fine town houses, and provided tree-lined esplanades and other open features. The city's two main churches, the Primatiale and

St Sébastien, were handsomely rebuilt, and a new one added, run by the Pre-monstratensians with a grand façade like the Gesù in Rome. Then came the reign (1736–66) of Grand Duke Stanislas Leczinski, former king of Poland, whose resources, as father-in-law of Louis XV, were considerable. In the 1750s he carried out one of the most successful schemes of town development in history. In effect, what Stanislas did was to merge together existing structures, and build new ones, to form a processional set of three linked squares—the Place du Gouvernement, the Place de la Carrière and the Place Royale. With their arcades and gardens, parterres and walks, and immensely long, open vistas, this group of squares is unique. Moreover, some of the buildings are of wonderful quality. The Hôtel de Ville on the Place Royale (now called the Place Stanislas) by Emmanuel Héré (1705–1763), a local man who played a major role as adviser to the Grand Duke, has a strong claim to be considered the finest building erected in eighteenth-century France.

This enfilade of the squares links together, in spacious harmony, buildings of distinction from three centuries, and constitutes the most impressive urban stroll in Europe, worthy of the grandest capital. Stanislas embellished it still further by employing fine craftsmen to provide street-furniture of the highest quality, notably the wrought-iron gate-grilles which open on to each corner of the main *place*, done by France's best ironsmith, Jean Lamour (1698–1771), and its gilded lead fountains, the work of Paul-Louis Cyffle (1724–1806). Indeed Nancy is full of treasures of all kinds, but what makes it conjure up the essence of civilised living, as the eighteenth century understood it, is the relaxed rationality of the plan, which seems to impose urban order as if with the wand of magic.

'Order' was one of the unspoken watchwords of the eighteenth century as it progressed. The kind of exuberance expressed in Melk, and to a lesser extent in Dresden and Nancy, and which was later categorised by art historians as Rococo, was coming under increasing criticism by the 1750s and 1760s. Taste was undergoing one of its periodic evolutions from elaboration to simplicity, and as at the end of the Middle Ages, simplicity was associated with the architectural order of Greece and Rome. But it is wrong to see the transition as a series of pitched battles. In fact style tended to evolve smoothly, without incident, as we can see from the growth of Bath. In the eighteenth century it was the subject of an exercise in town planning not unlike Nancy's, except that, where the Grand Duke ordained all that was there, Bath was merely nudged into its shape by private enterprise and one or two enlightened locals.

Bath had three advantages. First, it was at the bottom of a saucer of surrounding low hills, which afforded glorious 'prospects', that key eighteenth-century word. Second, it had been endowed with a splendid late medieval abbey church, built of the golden local stone in a style of elegant simplicity, with agile angels scrambling up the celestial ladders on its façade, and a plain open square to its front to provide dis-tance. Third, it had its restorative hot baths and waters, which had been celebrated

for a millennium and a half and still possessed their Roman architectural setting. In the first decade of the century the spa had been revived by poor Queen Anne, desperate to conceive a living child, and the rich, new and old, had flocked after her. The society of Bath was managed by Richard 'Beau' Nash (1674–1762) who made its activities a matter of carefully graded and highly disciplined order—a work of art in itself—and its town development was under the supervision of John Wood (1704–1754), a local builder of rough but imaginative ideas, and his better educated son John Wood II (1728–1781).

Wood got his classical ideas from the origins of Bath itself and had no need of Piranesi's prints (not yet done, anyway) to stage a Roman revival. His object, as he said, was to provide well-to-do people with town houses having 'the appearance of a palace'. His inspiration was Inigo Jones's Covent Garden Piazza, then the busiest and most fashionable open space in London. He began with Queen Square in 1728. He was not the only entrepreneur of taste in Bath, for John Strahan set up Beaufort Buildings at about the same time. But Wood was more tenacious. He built on his own account but also bought land and then sold leases in lots, on which other builders could join the game, though their leases laid down strict rules for all elevations and room dimensions, as well as governing a lot of other things to produce order. What Wood sought, and obtained, was a series of superior boardinghouses where middle-class clients could live during their 'cure' and which gave them the impression they were enjoying the life of an aristocrat in a London town house. By this means the Woods caused to be built a number of splendid streets at quite modest cost, glorified by an occasional set-piece of splendour, such as Queen Square

The Royal Crescent, Bath, designed by John Wood and completed by his son (1767–75), is the key element in this greatest of Classical Revival cities.

(1732–36), King's Circus (1754–66) and the immense Royal Crescent (1767–75), perhaps the finest example of terrace housing in the world. The whole was crowned by the Woods' New Assembly Rooms (1771).

The expense was shared among the hundreds of builders and individuals who owned the leases, and thus cost the taxpayer nothing. As a result there came into existence, over a generation, a kind of classical city of white and gold stone, set amid bosky hills and relieved by large tree-lined gardens and lawns. As the city emerged in its bowl, more and more wealthy people built fine houses on or around its rim, consciously aping the villas of Roman times. Gifted architects moved in too. Robert Adam (1728–1792), the finest practitioner since Vanbrugh, turned up from Scotland to create the Pulteney Bridge (1769–74) across the carefully canalised river, cunningly using Palladio's rejected design for the Rialto in Venice. Another professional architect, Thomas Baldwin (1750–1820), who became city surveyor in 1776, built the beautiful Guildhall and laid out a whole series of classic streets on what had been the Bathwick estate. By the end of the eighteenth century, Bath was one of the most well-conceived and elegantly executed cities in the world, which enriched its citizens, delighted its visitors and functioned all the more efficiently in that neither government nor the Crown had anything to do with it.

The aesthetic force behind such developments in Britain was indeed classical order, but at one remove. In 1711, a seventeen-year-old prodigy called Richard Boyle, 3rd Earl of Burlington (1695–1753), began his art collection with the purchase of a landscape by Philips Wouwerman. This was the beginning of his lifetime's effort to 'reduce England to civility', as he put it, and in particular to honour the memory of his two heroes, Inigo Jones and Palladio. He made two grand tours (1714–15 and 1715–19), the second one attended by the professional architect and decorator William Kent (1684–1748), who shared his devotion to Palladianism. During these expeditions he bought works of art and relevant books, collected architectural drawings, including Palladio's own, and employed experts to make measured drawings of all the buildings he admired. As Kent put it, he was 'agoing towards Vicenza and Venice to get Architeks to draw all ye fine buildings of Palladio'.

Burlington was interested in every aspect of artistic activity, 'the Apollo of the Arts', as Horace Walpole put it: he befriended Alexander Pope and subsidised Handel. He fancied himself as a practical architect, and redid his own London residence, Burlington House (1717–20), with the help of a professional, Colen Campbell (d. 1729), on what he believed were the best Palladian lines. Burlington's next great project, Chiswick House, which he built for himself just outside London (1725–32), was directly modelled on Palladio's Villa Rotonda at Vicenza, Kent providing some of the expertise. Burlington also designed the Assembly Rooms in York (1731–32), again on Palladian lines, and after that he decided he had done enough and concentrated on propaganda and connoisseurship.

The truth is, he was in debt and had to sell off some of his lands. Walpole said of

him that he 'possessed every quality of a genius and artist except envy', but admitted that the houses he built in London were 'worse contrived on the inside than is conceivable, all to humour the beauty of front'. Probably Burlington's most practical contribution to raising architectural standards in Britain was his sponsorship of Kent, whom

Chiswick House, masterpiece of English Palladianism, was built by Lord Burlington to his own designs (1725–32). Kent did the interiors and furniture.

he helped to get the job of creating Holkham Hall, Norfolk, seat of the rich Earl of Leicester and one of the grandest of English country houses. Kent had started out humbly as a coach-painter, he learned every aspect of interior decoration the hard way and his 'total' designs for houses, including furniture, carpets, wallpaper and curtains, as well as doors and fireplaces, were highly successful. Indeed he could do more. Walpole wrote: 'He was a painter, an architect and the father of modern gardening. In the first character he was below mediocrity. In the second he was a restorer of the science. In the last, an original, and the inventor of an art that realises painting and improves nature . . . He leapt the fence and saw that all nature was a garden.'

It is a paradox that, while Kent's furniture was exceptionally heavy and formal, the keynote of his gardening style was informality, in strict contrast to the work of Le Nôtre and all that had followed since. Kent believed that nature was wiser than man—how true!—and that, when devising a landscape park, it was better to nudge and encourage nature in pleasing directions rather than to 'force' her in the Le Nôtre manner. When he was designing the park at Stowe in Buckinghamshire in 1740, one of the gardeners there, Lancelot Brown (1716–1783), watched him at work and decided he could do even better. He turned himself into 'Capability' Brown, so called from his habit of telling possible clients that their estates had 'great capabilities'. When the

owner gave him the go-ahead, he would descend on an old-fashioned formal garden of parterres, mazes and orderly rows of shrubs, root them all up ruthlessly, then start returning the ground to nature, chiefly parkland and vast lawns, though with a care for vistas. He planted trees in a disorderly orderly fashion and embellished them with careful schemes of 'natural' water—stream, lakes, ponds and waterfalls. The object was to re-create a rural Utopia, the Arcady of ancient Greece, and with this in view he went in for serpentine paths and waters, ruins and follies, a temple or so, an arcadian bridge, grottos, caves and picnic-towers. In 1764, George III took him on as gardener at Hampton Court and from this base he redid the grounds at Chatsworth, more or less as they are today, did vast works at Blenheim, including creating the lake, and the landscapes for Audley End, Wardour Castle, Bowood, Ashridge Park, Moor Park and Longleat. This was a body of work of which Le Nôtre would not have been ashamed, though he would have described the results as barbarous.

However, Brown did not go far enough towards informality for some tastes. He was not sufficiently barbarous or Gothik or, above all, 'picturesque'. By the last term was meant a landscape park which might be a picture by Claude Lorrain, Elsheimer or Salvator Rosa.

Chatsworth, symbolising the Whig supremacy, seen from its cascade, or water staircase, created by Grillet, a French hydraulic engineer (1694–95).

It was also one which, if possible, would correspond in places to the idea of the sublime or awesome, as defined by Edmund Burke (1729–1797), the brilliant Irish philosopher-politician. His entry onto the national scene had been signalled by his *Philosophical Enquiry into the Origin of Our Ideas of the Sublime and Beautiful* (1756), perhaps the most influential work on aesthetics ever to appear in England, which went into seventeen editions before Burke's death. Capability Brown's parks were admittedly beautiful—that is why they were so popular among rich landowners— but they were in no way sublime or even picturesque. Hence they were attacked by both the leading aesthetes of the last part of the eighteenth century, Richard Payne Knight (1750–1824) and Uvedale Price (1747–1829). Knight, in his book *The Landscape* (1794), produced engravings by Thomas Hearne to show that Brown's landscapes were too 'severe' and 'regular', each feature 'hard' and 'distinct'. He contrasted them with landscape designed in the picturesque manner, featuring wildernesses, 'roughness' and 'rusticity', the individual parts perhaps coarse but in combination forming 'the beauteous whole'.

We have here, of course, the beginnings of a conflict, in a British context, of the rising forces of classicism and what was soon to be called Romanticism. It is clear, indeed, that there were many cross-currents operating in eighteenth-century Europe as a whole. Some wanted simplicity, others the complex. For some, symmetry was the aim—for others, irregularity. Order was set against a pleasurable disorder and heightened emotions against calm, rational pleasure.

Robert Adam (1728–1792) often grumbled that many English country gentlemen were more interested in their parks, whether by Capability Brown or Humphry Repton (1752–1818), than their houses. It says a lot for the success of this son of a Scots mason that more houses are attributed to him than to any other architect. He began by a sensational trip to Italy in which he not only made friends with Piranesi but paid a visit to the famous ruined Roman palace at Spalato (modern Split) and published a book about it, *Ruins of the Palace of the Emperor Diocletian at Spalatro in Dalmatia* (1764). In it he made the point that the modelling of Palladio and others on ancient Rome was false because they based their classical houses on temples and public buildings. He claimed his houses were based on proper domestic models from Greece and Rome but the truth is he got his ideas out of his highly imaginative head and then simply labelled them 'classical'. He believed in what he called 'movement', defined by him as 'the rise and fall, the advance and recess with other diversity of form, in the different parts of a building, so as to add greatly to the Picturesque of the composition'. What that means is unclear, and Adam's own works do not explain it. He could be very grand indeed as at Kedleston Hall in Derbyshire, which is the delight of architectural historians who say it 'seems to float like a great ship on its sea of grass', but which Dr Johnson, visiting it, dismissed as 'very well for a town hall'.

The Adam terrace in the Aldwych, however, designed to combine gracious living with warehouses, did not work and was dismissed by Walpole as 'warehouses laced down the seams, like a soldier's trull in an old regimental coat'.

Right at the end of his life Adam had a prodigious success for the part he played in the creation of the New Town at Edinburgh, one of the biggest exercises in town planning in eighteenth-century Europe. The scheme to provide escape from the over-crowded medieval Old Town by building a new one on the other side of the Royal Mile was the work of George Drummond, the city's Lord Provost, in 1752, though the actual plan, which won an open competition, was by James Craig (1744–1795). It provided for straight streets and monumental squares, and it insisted that the two outer streets had houses on only one side so that Princes Street, looking south, was open to the tremendous view of the Castle and the Old Town, and Queen Street looked across open fields to the Firth of Forth. This design was stuck to, and is the key factor which makes present-day Edinburgh such a magnificent city, fit to be a capital. What the actual building needed, however, was distinction, and this was provided by Robert Adam in Charlotte Square, perhaps the finest square in northern Europe (1791). At his funeral, in Westminster Abbey, his pall-bearers were the Duke of Buccleuch, the Earl of Lauderdale, Viscount Stormont and the Earl of Coventry—not bad for a mere architect, and evidence that the British ruling class were at last beginning to take art seriously.

But how seriously? It was the view of William Hogarth (1697–1764) that the Burlington breed of connoisseurs did little for British art and artists and were keener on foreign celebrities and tastes. By contrast, Hogarth himself was by far the most important figure in British art. He found it nothing. He made it—something. His father was a scholar, schoolmaster, failed coffee-house proprietor and author of a Latin dictionary which was never printed because, his son said, he had received 'cruel treatment' from publishers, and as a result spent four years in a debtors' prison. The boy was apprenticed to a silver-plate engraver and at the earliest possible moment set up for himself as a businessman-artist. His absolute determination to make himself financially independent, and free of untrustworthy patrons or publishers, was right at the heart of his proud, quarrelsome, hard-working genius. He got a bit of regular training, first at a school in St Martin's Lane, run by Dutch and French masters, then at James Thornhill's Free Academy in the Covent Garden Piazza (he later married Thornhill's daughter). By the age of twenty-five he could do anything he wanted with pencil, pen or brush, or any kind of engraving tool.

It is hard to think of any great artist whose personality and work makes more nonsense of such terms as Baroque, Rococo, etc. Hogarth was *sui generis*. He was a moralist and a satirist. He was also a realist. He thought the world was a dreadful place but that men and women were fundamentally good, and could be marginally improved—perhaps more—by mocking vice. He first tried this by engraving, attacking financial cupidity with *The South Sea Scheme* (1721) and *The Lottery* (1722). By

1724 he was printing and marketing his engravings himself. His *Bad Taste of the Town* was an attack on the Italian opera, the Palladian taste, Lord Burlington and William Kent, the last attacked again in 1725 for designing an Italianate altarpiece for St Clement Dane's Church in the Strand. By contrast, he strongly approved of John Gay's popular *Beggar's Opera*, as it was thoroughly English, and his first success as a painter came when he painted a scene from Act III (1729–31), now in the Tate. He had to copy it over and over again to meet the demand, and as a result he was in request for 'conversation pieces' of wealthy families set in their houses, of which his *Family Party* (New Haven, Conn., Yale Center for British Art) is the outstanding example. At the same time, as a realist (in both senses) Hogarth found there was a good market for low-life 'action' paintings. He did a prostitute about to be arrested by a magistrate in her bedroom, and again had to copy it several times. He continued, throughout his life, to do these rather coarse, anti-vice paintings, such as *A Debauched Man Vomiting* (Norwich), *A Night Encounter* (Yale Center), a pair on sex, *Before* and *After* (Cambridge, Fitzwilliam), *Charity in the Cellar* (private) and *Sir Francis Dashwood at his Devotions* (private), the last being an attack on the founder of the notorious Hell-Fire Club.

However, the success of his prostitute pictures gave Hogarth the idea of bringing the two sides of his art, engraving and painting, together, by telling the story of vice, pride and folly in series, first sold as paintings to the rich, then run off as prints to the rest. The six prints of *A Harlot's Progress* (1732) were an immense success, selling 1,240 sets, at a guinea each, almost immediately. The paintings too were sold but were, alas, destroyed by fire (1755). Piracies soon appeared, and Hogarth replied by putting out a cheaper version. He also set up an agitation in Parliament which produced the Engravers' Copyright Act of 1735, making unauthorised copies unlawful for fourteen years from original publication. As a result the finances of the trade were transformed, and it expanded rapidly. Hogarth went on to do the eight pictures of *The Rake's Progress*, an even bigger success, and this time the originals have survived among the treasures of the Soane Museum, London. Other series include the beautiful set of Vauxhall, *The Four Times of Day* (divided between Upton House, Warwickshire and Grimsthorpe Castle, Lincolnshire) and the most successful of all, the six scenes from *Marriage à la Mode* (National Gallery).

By now Hogarth had become a genre painter of extraordinary skill, huge inventiveness and (when needed) great delicacy and refinement, the details being sharp and sometimes enchanting but always well built into the dramatic composition—Hogarth, like Watteau, was very much a man of the theatre. And, as Hogarth painted to be engraved, the prints were of a quality never before seen in England and rarely anywhere else. Sometimes Hogarth did not choose to paint first but went straight to the engraving. This happened with his biggest best-seller, *Gin Lane*, its companion *Beer Street*, and *The Four Stages of Cruelty* (all in 1751), and with *Industry and Idleness* (1747). When Simon Lovat, the Highland rebel peer, was executed on Tower Hill in

1747, Hogarth immediately issued a print which became Lovat's image ever since and sold in thousands. And when the popular hero-scoundrel John Wilkes attacked Hogarth, the painter replied with a popular print of him, which likewise made his scheming, crafty face his image for ever after.

Hogarth's prints entered into English life in the same way that Shakespeare's plays have. They are part of the visual furniture and are relished and taken for granted, from infancy up, to the point where no one ever bothers to ask why they are so loved. The reasons are crispness and freshness of image; superb balance between the parts and the whole; clarity of message; and, not least, the gift of being able to combine the harshest condemnation with heartfelt pity. Hogarth, for all his strident xenophobia—powerfully expressed in the painting he did after going to Calais and being arrested for 'spying', that is sketching: *The Gate of Calais* (Tate Britain)—had a deep love for all humanity.

This comes out in many ways. In the delicious feeling for show-business people and their hard life, *Strolling Actresses Dressing in a Barn* (original now destroyed), which was actually a protest against Walpole's Censorship Act. In his touching *The Painter and His Pug* (Tate Britain). In his extraordinary study of child life, with a singing bird and a ferocious cat, *The Graham Children*, as good as Van Dyck at his best. In the dashed-off *Shrimp Girl* (National Gallery), surely the finest oil sketch ever made, demonstrating something we take too much for granted: Hogarth's virtuoso handling of paint. And, not least, in the superb portrait-heads he did of his household servants, the finest tribute a kind master could have paid.

Hogarth's real aim, first and last, was moral education. That was why he did not, on the whole, dabble much in politics. He did one four-painting *Election* series, criticising political corruption, *An Election Entertainment*, *Canvassing for Votes*, *The Polling* and *Chairing the Member* (London, Soane Museum), and these should be seen in conjunction with his attack on war, *The March to Finchley*, which many judge his finest work. But most of his combativeness went into rows. There were issues big and small. Hogarth hotly opposed the formation of a royal academy, on French lines, believing it would subject artists to government control. He thought art should be taught on a private-enterprise basis. He refounded the St Martin's Lane Academy as his own shop, and then as an artistic circle, but eventually quarrelled with its members. He was elected to the Academy's precursor, the Society of Artists, but promptly attacked its doings in print. He was always at the centre of culture wars.

By the time Hogarth died in 1764, a 'British school' existed, and in a real sense he founded it. It had a much broader base than would have seemed conceivable when Hogarth was a young man. For he was the first genuinely popular artist, known through his prints to a vast multitude. Charles Lamb, another quintessential Englishman, lived all his life in a series of rooms whose walls were papered with them. That was typical of countless middle-class collectors. But there were many

more who studied Hogarth's *Gin Lane* and other prints in inns and tap-houses, perhaps the only works of art they ever scrutinised in the whole of their lives.

Hogarth was always conscious of the fact that British art was held back by the absence of any high-quality art teaching. His own attempt to put the St Martin's Lane Academy on a permanent basis had failed. But we can be sure he would have bitterly opposed the formation of the Royal Academy four years after his death. Why? Such princely institutions were far from new. We know from Vasari that, in the 1480s, Lorenzo de' Medici, anxious to bypass the old craft guilds, with their ferocious conservatism and trade union mentality, had set up a 'school and academy' in conjunction with Ghirlandaio's workshop, for apprentice sculptors who would have access to the Medici collections. In 1593 the papacy set up the Accademia di S. Luca in Rome, with a rotating academic staff of twelve professional teachers, prizes, debates and life-drawing. This was in addition to the private-enterprise academy established by the Carracci in Bologna (1582).

Certainly, the French Académie Royale de Peinture et de Sculpture (1648; detailed regulations adopted 1664) was closely associated with royal control and laid a particular stress on history-painting. From 1666 the power and patronage of the Académie was

In his *The Graham Children* (1742) the girls and their brother reflect Hogarth's delight in youthful high spirits, the cat and the bird his sardonic realism.

reinforced by the foundation of the French School of Rome, and an annual prize to allow favoured pupils to go there for three years. Finally, by statute members of the Académie had the monopoly of royal commissions, a huge benefit (not always enforced). In Louis XIV's day, and for long after, the Académie was part of France's foreign policy. Its school in Rome gradually pulled the Rome Accademia into its orbit, often insisting that Frenchmen taught there or even directed it. At home, French artists could not appeal to the public over the head of the Crown as the Académie did not hold annual exhibitions. The fact that it started to do so in 1737 was one of the signs that the monarchy was losing its grip, though it is odd to think of the Salon being a step towards the French Revolution fifty-two years later.

Despite its obvious disadvantages, however, artists generally were in favour of following the French example. It and most of its rules became the model for the Vienna Academy in 1726, for Madrid in 1744, for Copenhagen in 1754, St Petersburg in 1757, Brussels in 1762 and Stockholm in 1768. Many of these schools even had French directors to begin with. By 1800 over a hundred painting academies existed, worldwide, the vast majority French clones. Though God was usually brought into the foundation document, and art spoken of in the most exalted terms, there was a certain amount of grubbiness too. Christian von Hagedorn, who organised the Dresden Academy for Saxony (then virtually a French satellite) in 1762 admitted: 'Art can be looked at from a commercial point of view. It is honourable for a country to produce great artists but useful to raise the exports of our industrial products.' (He was thinking of Meissen.)

Britain was one of the last major European countries to introduce the system, in 1768, following an abortive effort in 1698 under William III and two failures, in 1749 and 1755, under George II. It was no accident that the successful creation of the Royal Academy came in the early years of George III, a king anxious to reassert the principle of royalty in every sphere of life. The Academy had forty members, each of whom had to be a professional painter, sculptor or architect (engravers were admitted as Associates—ARAs—from 1769). Amazingly, two women, Angelica Kauffman and Mary Moser, were among the founder members, though women were not admitted to the schools until the 1860s. No other women were elected even ARA until 1922 and, until the 1970s, women artists, even if full RAs, were not allowed to attend the dinner until the port had circulated, but were made to wait outside (I have seen it). The great point about the Royal Academy (which was essentially English: the Royal Scottish Academy in Edinburgh did not come into existence until 1826, a year after the National Academy of Design in New York, both following RA lines) was that it held an annual exhibition. It was open to all artists on merits, and the proceeds were used to fund the schools. Thus no state subsidy was required, though George III exerted some degree of control until he went mad, as we know from *The Diaries of Joseph Farington RA*, 1793–1821, which provided a detailed inside record of Academy affairs over three decades. The three men who played the most

important part in founding the Academy, Sir Joshua Reynolds who was its first president, 1768–92, Benjamin West who succeeded him, 1792–1805, 1806–20, and Sir William Chambers who was its first treasurer, 1768–96, were all closely connected with the king since they sold him their services. Who were these men?

William Chambers (1723–1796) was George III's chief architect for much of his reign and rebuilt Old Somerset House to create the first vast block of government offices in London. This involved pulling down Inigo Jones's north front, but the result is London's most imposing classical courtyard work, now that all its competitors have been destroyed. In youth Chambers had gone out to China as a supercargo, made drawings and published *Designs for Chinese Buildings* (1757), following this up in practise by building oriental structures at Kew, including its famous pagoda. However, his attempt to introduce Chinese gardens as an alternative to Capability Brown, which he launched with his *Dissertation on Oriental Gardening* (1772), merely excited ridicule. Otherwise his career was smoothly successful and included some splendid town houses in London, Dublin and Edinburgh (including the Albany) and important work at Blenheim and Wilton. He was the establishment figure *par excellence*, becoming rich, knowing everyone and living proof that British art, by British artists, was respectable.

What had also arrived was American art, for Benjamin West (1738–1820) was a Quaker from Swarthmore in Pennsylvania, and had learned to paint as a child prodigy in Philadelphia. His rise was one feature of the leisured culture now emerging in what were still the Thirteen Colonies, and expressed chiefly in architecture. There were fine town houses of brick, almost as good as anything in London, in Williamsburg, whose William and Mary College had its main building designed by Sir Christopher Wren; in Annapolis, where the work of the local architect-craftsman William Buckland in designing splendid town houses—the chimneys of James Brice's mansion towered 70 feet above street level—led to its label 'the Athens of the North'; and Baltimore, the boom town, whose Indian Queen Hotel was reckoned to be the most beautiful and luxurious in the empire.

American country houses were in the Georgian-Palladian style, as in England, but with characteristics of their own: the wharf was as important as the drawing-room and they were not plonked artificially in the middle of the countryside, like Blenheim, Chatsworth or Althorp, but arose naturally from the economic activities which sustained them. This was true even of the grandest, like Rosewell (1726) on the York River, using designs in Colen Campbell's *Vitruvius Britannicus*, and Hampton, near Baltimore (1783), in the centre of the iron-ore deposits, fast horsepower-producing streams and hardwood for charcoal which gave Charles Ridgeley the fortune to build it. Drayton Hall (1738–42) on the Ashley River in South Carolina, was based on Palladio's Villa Pisani, and Homewood, near Baltimore, now part of Johns Hopkins University, was a grand classical villa which might well have been the work of Robert

Adam. The American rich imported huge architectural folios from Europe for their libraries—William Byrd II's at Westover included 'nearly 4,000 volumes, in all Languages and Faculties, contained in 23 double-presses in black walnut . . . the Whole in excellent Order'—and got local craftsmen to build from them. Or they became architects on their own account, like Thomas Jefferson, whose own Palladian-style house occupied him all his life.

In such a culture, a gifted boy like West was unlikely to be neglected. But he had to go to Italy to learn and chose to stay in London to better himself. He encouraged his compatriots, John Singleton Copley (1738–1815) and Gilbert Stuart (1755–1828), to do likewise. Copley established himself as a portrait painter while still in America, introducing a new and sophisticated realism—his *Paul Revere* (Boston) is a striking work and 'an excellent Likeness'—but was glad to leave Boston after his father-in-law, the intended recipient of the tea in the Tea Party, took the 'wrong' side in the War of Independence. Stuart, almost as gifted, did the thing in reverse; he learned portraiture in England, then went back to specialise in portraits of George Washington, of which he painted 124, a sizeable chunk of the over 1,000 portraits with which he is credited.

Mr and Mrs Thomas Mifflin (1773) exhibits the polish and penetration which made Copley the leading American artist of the Colonial period.

In England, what West and Copley did together was to create a new kind of history-painting, one which dealt with modern, topical subjects, chiefly death-scenes of heroes, in a historic manner but with scrupulous attention to contemporary detail.

When West painted *The Death of General Wolfe* (Ottawa) he refused the king's advice to clothe Wolfe in Roman or Greek attire, and had him and everyone else pictured as they would have been at the Siege of Quebec. The picture became a sensational success and started a vogue for up-to-date realism in history art. Copley followed up with *The Death of Major Pierson* (Tate Britain), and West responded with *The Death of Nelson* (Liverpool, Walker). One of West's religious paintings, his giant *Christ Healing the Sick in the Temple* (Tate Britain), which is over 100 square feet, he sold to the British Institution for 3,000 guineas, the largest sum paid for a single work anywhere in the world at that time, and resold it, in 'improved' replica, to the Pennsylvania Hospital, Philadelphia. Copley was a better painter, by far, but he tailed off, as painters sometimes mysteriously do (though his son lived to be Lord Chancellor and shared a mistress with Disraeli). Most of West's work was bought by the royal family, and after his death immured in Windsor cellars while his reputation plummeted, seemingly for ever. But his works have now been properly catalogued, and some have been unearthed and are now shown in Spencer House, London, so there is a possibility that this Anglo-American behemoth may yet return to favour.

Joshua Reynolds (1723–1792) was probably better prepared than any other painter of note to be an artistic leader, and his judicious personality made the Royal Academy, right from the start, a formidable institution, which it remained for over 150 years. His father was a Devon headmaster, and Reynolds was well-educated, widely read, thoughtful and articulate. He learned the elements of painting under Thomas Hudson, who specialised in accurate but unadventurous portraits, then got himself to Italy where he studied the Big Four, Raphael, Michelangelo, Correggio and Titian, who remained for him the evangelists of the artistic gospel. From 1753 he set up a portrait practise in London, run in a highly professional manner, which made him rich. His output was enormous (the latest catalogue, 2001, gives 1,961 paintings) and though he employed assistants, some of them able, like James Northcote (1746–1831), all his works were essentially his own. He charged 48 guineas for a whole length (94 by 58 inches) in the 1750s but by 1780 his price had risen to 200 guineas, sometimes more. He also did heads, busts, kit-kats (36 by 28 inches) and half-lengths, the prices being scaled down accordingly. Reynolds painted everyone of importance: writers like Laurence Sterne (National Portrait Gallery), society beauties like the Duchess of Hamilton (Liverpool, Lever), heroes like Admiral Keppel (Greenwich, Maritime Museum), personalities such as Horace Walpole and politicians like Edmund Burke (National Portrait Gallery) and a number of leading actresses and comedians. Many of his successes were repeated in four or five versions and were made into best-selling prints.

It is not easy to see why Reynolds was quite so successful. Among his contempo-

raries, the Scots master Allan Ramsay (1713–1784) could beat him, easily, both in sensitivity and power. Reynolds could never have done Ramsay's beautiful *The Artist's Wife (Mrs Anne Ramsay)*, with its infinite grace and delicacy, or his penetrating study in intellectual effrontery, *Jean-Jacques Rousseau* (both in the National Gallery in Edinburgh). Another great Scotsman of the day, Henry Raeburn (1756–1823) was also Reynolds's superior. He could create an indelible image, such as *The Rev. Robert Walker Skating* (also Edinburgh), which was quite beyond Reynolds's gift, and for sheer monumentality of portraiture, Reynolds never got even close to

Raeburn's magnificent *Sir John and Lady Clerk of Penicuik* (Dublin, National Gallery), that magical double-portrait. He was surpassed too in the sphere which was often thought his forte, literary portraits, by George Romney (1734–1802), whose presentation of Cowper (Grasmere, Wordsworth Museum) peers into the very soul of the poet. All this was true enough, but Reynolds was a great all-rounder who handled his sitters well, made them happy, struck fine and sometimes fancy poses for them, got their likenesses and made them into talking points. There was always something to say about a Reynolds, for almost every face and posture contains hidden allusions, to the Great Masters, mythology or literature. In his man-of-the-world way, he was quite an intellectual: not for nothing did he belong to Dr Johnson's Club, which he helped to found, and made firm friends with Gibbon, Burke, Goldsmith, Adam Smith and other luminaries. His famous image of David Garrick being tugged by the cheerful Comedy-Goddess in one direction, and soulful Tragedy in the other, which perhaps gave more pleasure to more people than any other portrait of the age, was characteristic of his highly anecdotal style. He could epitomise too, always an important skill in art. His *Lord Heathfield of Gibraltar* (London, National Gallery), firmly holding the garrison key of Gibraltar, and defying the rage of the French and Spanish enemies, was the summation of all the Empire stood for in Reynolds's day, and was relished accordingly.

The fact that Reynolds commanded respect both from the art world and from the intelligentsia undoubtedly helped to ensure the Royal Academy's successful debut. Reynolds reinforced its intellectual appeal by a series of public Discourses, fifteen in all, which he delivered on ceremonial occasions and

Reynolds's *Girl at Window*, from the 1770s, is an exercise in informal studies of children in which he delighted and showed enviable skill.

which were then published in book form and translated into Italian, French and German. They were a highly self-conscious attempt to elaborate a general theory of art, not just for students, at whom they were supposedly aimed, but for the enlightened public. The students listened, took no notice and went on painting in their own way, as was to be expected. The *beau monde* attended, not indeed to listen and learn but to be seen, and in so doing helped to strengthen the bridge Reynolds had flung across the gulf which had hitherto separated the English ruling class from the world of art.

Opinions vary about Reynolds's character. He was extraordinarily ungenerous to his gifted sister and effectively prevented her from becoming an artist. The great art historian R. H. Wilenski wrote: 'No English artist of his eminence is so unattractive as a personality.' On the other hand, Dr Johnson, no mean judge, regarded Reynolds as the noblest of his many friends. In his penultimate Discourse, Reynolds went out of his way to pay a generous tribute to his great rival, Thomas Gainsborough (1727–1788), who had just died. He extolled 'the powerful impression of nature, which Gainsborough exhibited in his portraits and in his landskips, and the interesting simplicity and elegance of his little ordinary beggar-children'—praise all the more notable in that Reynolds customarily did all in his power to keep nature in her place. He, like his friend Dr Johnson, and like his precursor Hogarth, was essentially a townsman, for whom a visit to the country was an 'expedition', a 'ramble' (Johnson's favourite word), a deviation, however pleasurable, from normality. Gainsborough, by contrast, stood for the 'country' principle in English art.

That principle was strong and persistent, and there was no equivalent to it in French, Italian or Spanish art, though there was, as we shall see, in Germany and the north. Although even in Reynolds's day the British Industrial Revolution was beginning and a huge movement from countryside to town was in progress, the English ruling class was rooted in the countryside and remained so until the First World War. Their country houses were much more important to them than their town houses, and they valued their 'prospects', horses and dogs more than any other of their possessions. This preference took many forms. George Stubbs (1724–1806) came from Liverpool, where his father dressed tanned leather, so he was accustomed to seeing and smelling dead animals from earliest childhood. That was why he had no abhorrence at studying the bodies of horses, and so learned more about them than any other painter in history. He also studied human and animal anatomy in York Hospital, though his artistic training (apart from etching) was non-existent. He was self-taught, self-made, self-inspired, and became the most single-minded artist of his day. During a decade of studying live horses, including eighteen months of solid dissection of dead ones, he accumulated a mass of detailed knowledge which he presented in his book *The Anatomy of the Horse* (1776), illustrated by his own superb plates. No one has ever put animals into two-dimensional form with such accuracy and understanding of their muscular dynamism. It is not surprising that the original drawings for the work were the most prized single possession of Sir

Edwin Landseer, the greatest animal painter of the nineteenth century, or that the book was the lifetime study of Sir Alfred Munnings, his equivalent in the twentieth.

If Stubbs had merely been accurate, however, he would be of little account today. In fact he was a formidable and sensitive artist, with a strong imagination and breathtaking delicacy in brushwork. The circulation of his book led all the richest landowners in England to demand his services for portraits of their favourite mares, stallions, hunter and carriage horses. He could and did paint horses naked, as it were, like Venus or Apollo, positioning them in space with the tiniest touch of shadow: this is what he did with *Whistlejacket* (National Gallery), the greatest horse picture in the world. Or he could do them with a groom and trainer, as with his *Hambletonian Being Rubbed Down* (Mount Stewart House, County Down, Ulster). Or, as in the superb *Milbanke and Melbourne Families* (National Gallery), he painted four full-length portraits of different generations, with a top carriage horse, two splendid hunters, and a King Charles spaniel, under a strikingly painted oak tree and against a misty background, all these varied creatures comfortably grouped, relaxed and at home—a marvellous piece of work. He could even do a horse in tragic drama, as in *Horse Attacked by a Lion* (Tate Britain), based on an episode he had actually witnessed in Morocco.

Stubbs's *Whistlejacket* (1762), painted for Lord Rockingham, then Prime Minister, was intended to have George III 'up'. The PM's dismissal allowed Stubbs to create his masterpiece, showing only the horse.

Moreover, the settings in which he placed these magnificent creatures were so convincing, the figures of countryfolk so real, the owners, their trainers, grooms and servants so full of character, that Stubbs should properly be termed a portrait and genre painter, not just of animals but of people, a poet of nature as a whole. It is not surprising that the English aristocracy revered him and paid him higher fees than they did to Reynolds. It was not so much that they valued their horses more than their daughters—though they often did—as that no one ever came close to Stubbs. It was not for want of trying either. Benjamin Marshall (1767–1835) learned from Stubbs and sometimes painted racehorses and hunters with a miraculous feeling for their beauty and musculature, but he could not do the totality of the countryside as Stubbs did. The brilliant Swiss animal painter, Jacques-Laurent Agasse (1767–1849), came to England to make his fortune in the Stubbs manner, and worked at it with admirable earnestness and skill, but could not win the confidence of country owners. In the end he was lucky to get a commission from the Royal College of Surgeons to paint wild animals at £10 a time. The truth is that everyone else was compared to Stubbs: he had a magic brush, not least for wild animals—no one ever painted a leopard better and his *Zebra* (New Haven, Yale Center) is a masterpiece of quiet, sympathetic exoticism.

During Stubbs's lifetime, English painters also carried through a revolution in the way they depicted the countryside as a whole. The process began with Richard Wilson (1713–1782), the son of a Welsh clergyman, who as a boy was so stuffed with classical lore that he could quote verses by Horace off the top of his head, 'on any subject mentioned'. With a view to making a living from portraits, he had a trip to Italy financed by rich relations but it was inevitable that, once in the Roman Campagna, he should fall under the spell of Claude. For a quarter of a century, in Italy and England, he painted Claudian scenes, in Rome itself, at Tivoli, amid the hills and lakes of central Italy. He could paint figures better than Claude and his light-effects were more varied. His *Rome from the Villa Madama* (Yale Center) and *St Peter's and the Vatican from the Janiculum* (Tate Britain) are as good as such things can be, granted the limitations of the genre. His *Destruction of the Children of Niobe* (Yale Center), really an Italian landscape, was one of the outstanding London successes of the 1760s, selling in at least three versions and making a best-selling engraving. But what we most treasure now are his English landscapes, done towards the end of his life—when alcoholism was already overshadowing it—in which he engagingly blends the crystalline Italianate with the English and Welsh mistiness. *Holt Bridge on the River Dee* (National Gallery) combines acute observation of nature, a classical sense of composition and a scaled-down cosiness of subject which produce a new magic in British art. Horace is forgotten, Claude fades, a true British landscape is born.

The new genre was carried several steps further by Joseph Wright of Derby (1734–1797), a lawyer's son who refused to Londonise himself and carried on from his native town. He would certainly not have regarded himself as a landscape painter,

not least because he refused to paint in watercolours, which he regarded as an art form 'fit only for women and children'. He was an arrogant, difficult man, but highly original, learned in strange ways and hard to fit into any neat category. He came from an area which was being rapidly industrialised and he was on friendly terms with many of the giants of the new technology, like the potter Josiah Wedgwood, the steam inventor James Watt and the machinery tycoon Matthew Boulton, as well as intellectuals like Erasmus Darwin. In the 1760s he painted some outstanding and exciting canvases describing not only industrial processes like *Iron Forge Viewed from Without* (St Petersburg, Hermitage) but scientific experiments, such as *A Philosopher Lecturing on the Orrery* (Derby Art Gallery) and *Experiment on a Bird in the Air Pump* (Tate Britain).

No other artist, anywhere in Europe, had hitherto attempted to describe in paint the huge revolutions, first scientific, then industrial, which were to transform the world beyond recognition. Moreover, to the creation of this grand set of paintings, no more than a score in all, Wright brought three exceptional qualities. First, he was not only the last of the Caravaggistes but in many ways the best, employing spot-lights, extreme *chiaroscuro*, careful composition with a view to brilliant contrasts of light and shade, and a strong sense of drama, all with masterly assurance and superb brushwork. No one has ever before—or since—not even Leonardo, conveyed the sheer mind-racing excitement of science and technology. Second, Wright knew about what he was painting: the accuracy with which he presented scientific research, its instrumentation and industrial machinery, was well-nigh perfect. These were things he had witnessed, carefully studied and understood. Third, Wright had a profound grasp of character. The heroes of his scientific-industrial pictures are real thinking men (sometimes women), pushing their minds and bodies to extremes of performance. If Wright had concentrated all his energies and skills on portraiture he would have outdistanced all the others—Ramsay, Reynolds, Raeburn; the lot. As it is, his portraits of the industrial pioneers, *Richard Arkwright* (Derby) and *Samuel Oldknow* (Leeds, City Art Gallery), convey powerfully their gritty determination and commercial ruthlessness. At the same time he portrayed the aristocratic intellectual *Brooke Boothby* (Tate Britain), reading Rousseau by a country stream, in an oblong image which is both one of the outstanding portraits of the century and a rational celebration of country values.

Superficially, Thomas Gainsborough had nothing in common with Wright, but there were intellectual links. He came from Suffolk, where his father made woollen goods, specialising in shrouds for corpses. The family were eccentrics, fertile in mechanical inventions—one brother made 'a cradle which rocked itself, a cuckoo which sang all the year round, and a wheel which turned in a still bucket of water'; another was a friend of James Watt and produced elaborate steam-machinery 'far in advance of its time'. Thomas, the painter, was fascinated by ocular experiments all his life. So Wright

Gainsborough's *The Mall in St James's Park* (1783) brought together his two specialties, stylish ladies and sylvan landscapes, in his most successful picture.

would have been at home with them. (The British Museum has an experimental sundial made by Thomas's brother Humphry.)

Gainsborough's artistic mother taught him flower-painting and gave him an intense love of every tiny thing which grew in the countryside. He drew faces because they seemed to him like natural growths. His landscape and portrait painting were thus organically connected. He got some training as an engraver (prints from his eighteen etchings and three aquatints are great rarities), then at the age of nineteen married a beautiful girl called Margaret, who in time gave him two beautiful daughters. He painted all three constantly, with love and astonishing feeling—his oil sketch of his two young daughters, with underpainting of a cat, is one of the delights of the Tate. He 'liked nothing so well of an evening as sitting by his wife making one rapid sketch after another'. Alas, his wife suffered from mental instability, and transmitted it to both her girls, and these sorrows clouded the painter's life. He had to work hard to succeed at portraiture, first in

Ipswich, then in Bath, finally in London, for he had none of Reynolds's instinctive savoir-faire, and gift for friendship. He was obstinate, unbiddable and determined to go his own way. He began by doing couples amid their properties, in the style made fashionable by that charming but repetitive specialist Arthur Devis (1711–1787). Gainsborough's *Mr and Mrs Andrews* (National Gallery) with its big landscape itching to take over from the young couple has long been one of the most popular pictures in any British gallery. He progressed to doing portraits of fashionable people in London, such as *The Honourable Mrs Thomas Graham* (Edinburgh) and a superbly smart couple, *Mr and Mrs William Hallett*, '*The Morning Walk*' (National Gallery) painted mainly in his studio but given a country setting for effect. Gainsborough is popularly associated with beautiful society women but in fact his portraits cover a wide range of types and he saw himself as a realist who never flattered.

It was the same with his landscapes. He said himself that 'I paint portraits for my living and landscapes for pleasure', and there is truth in that: by choice he would have been a landscape painter pure and simple, as perhaps would Rubens. But behind his elegance was a concern for truth above all things. Gainsborough's beautiful women often tell the truth with their faces despite themselves. With landscapes the verisimilitude is more deliberate, though equally subtle. Gainsborough's superb canvas *Harvest Wagon* (Birmingham, Barber Institute) is often seen as a

The Painter's Daughters Chasing a Butterfly (1759), a loving miracle of fatherly pride by Gainsborough, overshadowed by the fact both Mary and Margaret inherited their mother's mental instability.

country idyll, with handsome rustic girls and young men enjoying a drink after work. It can, however, be variously interpreted as a sharp insight into bucolic vice. With *Going to Market* (London, Kenwood House), perhaps Gainsborough's finest landscape, the criticism of what goes on in the countryside rises to the surface. The travellers are migrating—perhaps they have been dispossessed by the Enclosure Laws, as have the old woman and her granddaughter, who are soliciting alms in vain.

Gainsborough was a thinking painter, like Rembrandt, always trying to do something new or something old in a new way. He was much impressed by the landscape work of Philippe Jacques de Loutherbourg (1740–1812), an emigrant from Alsace, whose fierce depictions of the sublime, the tenebrous and the explosive still shock and had a galvanic effect on generations of English painters, from Gainsborough to Turner. Gainsborough loved his Alsatian invention, the Eidophusikon, a panoramic peep-show which moved and was exotically lit, and came back to it again and again in search of inspiration. What he liked about it, and about life and landscape in general, was its dynamism. Gainsborough's ladies are always moving, like his trees. There is no stasis in his work. In what is his greatest picture, which combines his love of human beauty and his devotion to nature, *The Mall in St. James's Park* (Frick), trees and society ladies move together, the one wafted by wind, the others by fleeting emotions. Gainsborough was always trying to get motion into his line, as we can see from studying his drawings. His hand was never idle, and vast quantities (over 2,000) of these survive—there is a large section in the British Museum. The pencil quivers on the paper, like an aspen in the wind, and this applies equally to figures and vegetation.

Gainsborough's palette management and pigmentation were equally novel and often varied. He experimented with drawing paper of different colours, made in new ways by altering the wiring, not hesitating to tell the paper manufacturers how to do it. For his work on paper he mixed pencil and watercolour, chalk, oil paint, gouache and almost anything else that came to hand, and varnished the results. A typical effort is *Rocky Wooded Landscape* (Buscot Park, Oxfordshire), which is a subtle drawing masquerading as an oil painting. He produced such work on specially stretched paper using skimmed milk, Indian ink and Bristol white lead—among other ingredients. It is a curious fact that Gainsborough's work, whether oil or watercolour or simply drawing, is quite unlike anyone else's. No one thoroughly familiar with his immense *oeuvre* can possibly be deceived by imitations. He was a loner, and not popular. A founding member of the Royal Academy, he treated it with disdain, took no part in its corporate life and was often rude to Reynolds. But on his deathbed, sick, old, disillusioned and saddened by his many sorrows, he summoned Reynolds to apologise, and the good old trouper came. He told Reynolds that he regretted not so much leaving life as leaving art, to which his life was subordinate, adding that he was at last learning how to paint properly. 'If any little jealousies had subsisted between us,' added the tearful Reynolds, 'they were forgotten in those moments of sincerity.' Then Gainsborough whispered his last, unforgettable line: 'We are all going to heaven, and Van Dyck is of the party.'

20

CLASSICAL AND
RELIGIOUS REVIVAL

What is so striking about British art in this period is the absence of serious ideological conflict, the bickering between Richard Payne Knight and Uvedale Price on the one hand, and Repton on the other, being of no great importance. The catalyst who might have started a fundamental debate in London was Henry Fuseli (1741–1825), a fierce Zurich intellectual who was among other things a spoiled priest. He first came to England in 1765, spent most of the 1770s in Italy studying Michelangelo, opened his own London gallery and was elected professor of painting at the Royal Academy (1799). His first act on coming to England was to publish a translation of Johann Winckelmann's (1717–1768) manifesto for a classical revival, *Reflections on the Painting and Sculpture of the Greeks*. Little notice was taken of this book, which had been a sensation on the Continent. The trouble with Fuseli was that, though he believed in classicism intellectually, his emotions were romantic. He had a powerful influence on William Blake (of whom more later) and at one point proposed to go on a tour of Europe with Blake, with Mary Wollstonecraft, the first English feminist, to make up a third. If this had taken place it might have been a major, certainly a picturesque, event in English life and letters, and possibly art too. But Mrs Fuseli, a former model, put a stop to it. She was a dominant, not to say aggressive, lady who inspired in Fuseli sado-masochistic fantasies, which found expression in curious drawings, showing elaborately dressed females inflicting torture on naked men; these supplement Fuseli's dream-drawings, culminating in *The Nightmare* (Detroit, Institute of Arts), his most famous painting, endlessly reproduced in prints, then and since.

At the Academy, the students loved Fuseli for his funny accent and his highly emotional approach to painting. They quoted him saying: 'First I sits myself down. Then I works myself up. Then I throws in my darks. Then I pulls out my lights.' His swearing was famous. There is a record of an exchange between the sculptor John Flaxman RA and Blake. Flaxman: 'How do you get on with Fuseli? I can't stand his

foul-mouthed swearing. Does he swear at you?' 'He does.' 'And what do you do?' Blake: 'What do I do? Why, I swear back, and he says, astonished: "Vy, Blake, you are swearing!" But he leaves off himself.' Fuseli's popularity at the Academy was curious until it is realised that he was treated there not as a dangerous ideologue but as a harmless eccentric, whose name no one could pronounce (they still can't) and who was good for many laughs.

The man who translated the old Renaissance desire to re-create the classical past into reality was not a scholar but an artist of the highest gifts. It is always thus. All new styles in art are launched not by words but by the touch of hands on brushes and chisels. Antonio Canova (1757–1822) was the humble son of a poor stonecutter in the Veneto. He got some training from his grandfather, an altar-carver and sculptural handyman, and then studied antique statuary in Venice, moving steadily away from the old style of Bernini to classical postures and severity. But he resembled Bernini in the most important thing: his work with a chisel was superlative. In Rome to further his classical studies, Canova achieved a sensation, in 1783–87, by designing the monument to Pope Clement XIV in SS. Apostoli. You can get an illuminating insight into what stylistic change means by comparing this brilliant artefact with

Fuseli's *Nightmare* (1781) typifies his bizarre but influential output, ranging from Shakespeare illustrations, fetishistic drawings and mythology to obsessive portraits of his model-wife.

the earlier papal tombs of Bernini in St Peter's. It keeps the essential structure which Bernini invented but eliminates about ninety per cent of the decoration. The triumphalism is replaced by two virtues: Humility and Temperance. There are virtually no curves, and the work is defined by eight prominent straight lines and ten right angles. The effect is to underwhelm rather than to overwhelm, to produce a feeling not of glory but of rightness, not of power but of purity. The actual modelling is superlative and the proportions admirable. One can imagine the effect it had on the sophisticated Roman art public and the international connoisseurs who visited the city in the spring: it seemed to breathe fresh, cooling airs, after nearly two centuries of overheated imagination and frenzy.

Canova carried the change further in his monument to Clement XIII in St Peter's itself. It has a striking male youth, who figures as the Genius of Death, and who was hailed by observers as the marble incarnation of classicism. Canova was soon going further yet, and designing tombs in which the writhing pyramidal form of Bernini was replaced by an actual pyramid, thus completing the linear transformation into simple lines.

A similar process was taking place in Paris in the shape of Jacques-Louis David (1748–1825), who early broke away from his relation, Boucher, and after a visit to Italy immersed himself in classical subjects. David was a passionate and violent man, of superlative gifts both as draughtsman and brushman, who knew exactly how to compose his paintings with a view to producing the maximum effect. He was not the first to return to classical subjects: in Rome, the Scots painter Gavin Hamilton (1723–1798), a member of the circle of Winckelmann and Mengs, picked on subjects from ancient history to point modern morals. Hamilton's works impressed both Canova and David, and he can be considered the father-guru of the classical revival. But it was in Paris that David really transformed the art scene by two big, striking works: *The Oath of the Horatii* (1784, Louvre) and *The Death of Socrates* (New York, Metropolitan). These were essentially simple and severe pictures about great events, conveying elementary morals of sacrifice, duty, patriotism and the need to subordinate the flesh to great ideals. On the eve of the French Revolution, that was exactly what the educated public wanted to see, and almost overnight David became the most fêted and followed painter in Europe, joining Canova on the topmost rung of the European art-ladder.

However, it is debatable whether either can truthfully be called classical artists. What they were was great artists, with the temperament and force of intense individualism. Canova did not believe in classical paganism; neither Stoic nor Epicurean, he was an old-fashioned Catholic very much in the spirit of Bernini, with pious practices and strict morals. He found the grand world into which his chisel introduced him, and which showered him with lucrative commissions, abhorrent in many ways. It was one thing to design the tomb of Maria Christina, in Vienna's Augustinian

church—a triangle into whose tomb-like entrance a weeping procession of mourners enters—quite another to service the whims of potentates who believed in nothing save money, power and success. He was particularly disgusted by the Bonapartes, who ruled Europe during a major chunk of his professional life. In 1808 the Emperor Napoleon's prettiest sister, Pauline, married to the head of the Borghese family, decided she must perpetuate her fine body while it was still comely, and so asked Europe's greatest sculptor to do her naked as Venus Victrix, the archetypal sex goddess. Horrified, Canova offered to present her as Diana, who could be naked but who personified chastity. But Pauline insisted on Venus and Canova submitted. He concealed her private parts but her back, of which she was proud, is naked to the cleft of her buttocks and there is no doubt about the eroticism of the work. Moreover, though she lies on a mattress sculpted of marble, the plinth is a real bed of painted wood which conceals a mechanism to turn round the entire statue for closer inspection. Canova thought his work was best seen by candlelight, and it was Pauline's custom to take guests after dinner to look at her body, holding candles, so that she could instruct them on her finer points. The work is wonderfully alive and fine, Canova's masterpiece of portrait sculpture. But it is not a classical work: romantic-erotic, rather.

For Josephine, Bonaparte's first wife, Canova carved *The Three Graces*, which he did in three versions (the best is in the Edinburgh National Gallery) and which he considered to be his finest work, if only because of the technical problems involved. It was reproduced, in the nineteenth century, countless times, life-size and in small replicas, so that it was devalued by overexposure, but it is a work of wonderful lightness, grace and style, radiating purity and charm despite the nakedness and clearly the product of a great and innocent mind. But it is not essentially different to the nudes of Jean Houdon (1741–1828) or even Augustin Pajou (1730–1809), merely more refined and magical. It is not so much a classical work as a work of individual genius. Again, in Canova's most sensational image, *Cupid Awakening Psyche* (Louvre), in which Cupid spreads his enormous wings to form an X-shape, and the work dissolves into a series of triangles, softened by the voluptuous rotundity of the limbs, the theme may be classical but the sensuousness and the emotions are more romantic than anything else. It should be added that Canova, like any sculptor aiming at the classical ideal, exposed himself to laughter in a modernising world. He almost despaired of making modern heroes look 'right' in their ordinary clothes or uniform, especially after trousers came in during his last decade. But the alternative was liable to evoke coarse laughter. West and Copley, by insisting on doing modern battle pictures in up-to-date uniforms, undoubtedly represented overwhelming opinion in the United States. When North Carolina commissioned Canova to do a statue of Washington for its capitol in Raleigh, Canova refused to do him in anything except a toga, and it is a pity the original was destroyed (a plaster model is in the Canova Museum,

Possagno). For those who like this kind of humour, however, there still exists, tucked away in an obscure corner of the Naples Museum, a colossal Canova statue of the unlovable Ferdinand IV of Naples, which puts his ugly head and body, truthfully portrayed, into the woman's clothes of Minerva, goddess of wisdom.

David also constantly exposes himself to ridicule by his undeviating anxiety to strike classical postures. He can of course create an image which sticks in the mind—as he did with the Horatii holding up their swords for their father to bless. Thus his *Napoleon Crossing the St Bernard Pass* (Versailles), while absurd, especially to anyone who knows about horses (he actually rode across on a mule, but had to walk most of the way), is memorable. Equally, his *Intervention of the Sabine Women* (Louvre) is a picture hard to push out of the mind, though it bears no relation to how women would actually behave in such a situation. But his genuflection to imperial greatness—and David could bow deeper than anyone of his age—*Napoleon Distributing the Eagle Standards* (Versailles) is mere loud-mouthed propaganda. Antoine-Jean Gros (1771–1835), the former pupil and rival David despised, came closer to the military truth in his *Napoleon at Eylau* (Louvre), with his ghastly images of men frozen to death at the emperor's feet. David was obsessed with death, which dominates his history-painting: *The Death of Seneca* (Paris, Petit Palais), *Antiochus and Stratonice* (Paris, private), *The Funeral of Patroclus* (Dublin, National Gallery) all glorify death but without arousing any sympathy because one is unconvinced that anyone was alive in the first place. His *Dead Hector* (Montpellier, Musée Fabre), shown naked and upside-down, merely provokes disgust. Twice David succeeded with death. His *Death of Marat* (Brussels, Musées Royaux des Beaux-Arts), though a travesty of truth, is the most successful image to emerge from the Revolution, rivalled only by his *Death of Bara* (Louvre). In both cases the appeal springs from David's decision to eliminate the complex figurative superstructure of his history pieces and focus on a single person. The background of the Bara picture is strikingly scumbled (unfinished) in a modernistic manner, and for once David paints the nude seriously (though the homoerotic overtone is disturbing). Usually his nudes only evoke a laugh, as in *Leonidas at Thermopylae* (Louvre), the pseudo-erotic *Cupid and Psyche* (Cleveland, Museum of Art, Ohio) and the awkward love-scene *Mars Disarmed by Venus and the Three Graces* (Brussels).

The case of Jean Auguste Dominique Ingres (1780–1867) is akin to David's in that he is also ranked as a classical painter, yet somehow does not quite fit. He worked in David's studio alongside Gros, but the three had nothing in common, temperamentally or visually. Between them, however, they had a prodigious amount of talent. Like the others, Ingres served the Bonapartist regime, though only half-heartedly. His state pictures, whether they be iconoclastic, *Napoleon on His Throne* (Paris, Musée de l'Armée), cultural exaltation, *Apotheosis of Homer* (Louvre), or self-consciously religious, *The Virgin with the Host* (Paris, Musée d'Orsay) are, without exception, unconvincing. The skill is always there, but one's response to it is: this

painter does not believe in what he is doing. And it is impossible to create a classical art without sincerity. Ingres also seems to have believed that, to fulfil the classical ideal, he had to paint nudes, rather as Canova sculpted them. He took enormous trouble to do so, intermittently, all his long life. And no one ever drew and painted nude women better—from the neck down. It is the vapid faces, with a choice of three monotonously rendered expressions—self-pity, self-indulgence or self-conceit— which destroy all the art of the body. It is significant that his finest nude, utterly convincing and pleasurably memorable, *The Bather of Valpinçon* (Louvre), is seen from the rear, her face hidden, the best-painted back-view of a nude since Jordaens.

Yet Ingres was a genius, and since the grand exhibition of his portraits at the London National Gallery in 1999 has been recognised as one. It is likely, for instance, that he did paint a superb front-view nude, of his own first wife. For most of his life, Ingres had to make his living in Rome, and this fine woman was shipped out to him, unseen, from France: he married her by letter. She proved an admirable consort, the love of his rather gloomy, grim life, and he painted her in all her voluptuous beauty, as we know from a print. But she died, and Ingres, who remarried after years of suffering, seems to have allowed his second wife—a manageress—to destroy the original. Coming from a family of artists, Ingres said, 'I was raised in a cloud of red chalk.' But it was the pencil he made his most reliable instrument. Indeed, the pencil portraits of visitors to Rome he did for a living are of incomparable skill, total accuracy and consummate beauty. They fill even the most gifted artists with admiration. On this foundation, Ingres raised himself to a position of eminence in the world of oil portraits which few have scaled since—perhaps Sargent alone. They stir all kinds of emotions. The pair, *M. Philibert Rivière and Mme Philibert Rivière* (Louvre), evoke sheer happiness: a devoted couple lovingly presented in all their placid content. *Madame Devauçay* (Chantilly, Condé) is a powerful study in suppressed sexuality. The *Comtesse de Tournon* (Philadelphia, Museum of Art) is a perky old dame who tells you that old age need not be a burden. Ingres's portrait of his first wife (Zurich, Kunsthaus) which he would not allow the second to burn, is an uninhibited demonstration of love for the creature who radiates it back from the canvas.

Just occasionally, Ingres makes a mistake of posing. His *Madame Moitessier* (National Gallery), perhaps the best-painted of all his works, has a silly spread-fingered hand under her chin which draws all the attention, and reminds one of Ingres's disastrous state picture of *Jupiter and Thetis* (Aix, Musée Granet), who is having his chin chortlingly chucked by funny female fingers. On the other hand, when Ingres gets the hand-under-chin right, as he does in the *Comtesse d'Haussonville* (New York, Frick), the result is enchanting. In this and in many other cases, all the preliminary drawings, and often oil sketches, survive, so we can see how hard and intelligently Ingres worked to build up his pictures. He worked hard on the pose too. His greatest portrait, of the media magnate *Louis-François Bertin* (Louvre), has its origins in a luncheon at which Ingres caught this bulky man, fists on knees, lunging

aggressively forward, and so got the image which has since gone down in history as epitomising the new, self-confident middle class. But what is classical about all this? It is, in fact, the reverse of the classical ideal, of beauty, manhood or anything else.

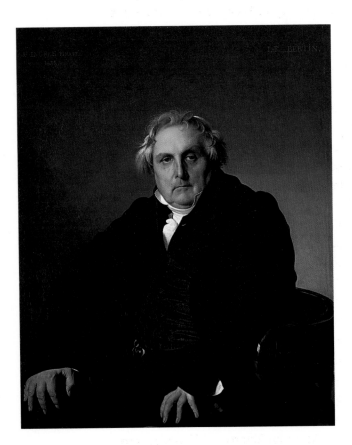

It is realism: seeing men and women as they really are, and getting them down on canvas.

The man who tried most desperately to conform to the classical mode, Pierre Paul Prud'hon (1758–1823), and who came closest to Ingres in sheer skill, also raises awkward questions of taxonomy. No one served the Bonaparte regime more assiduously. He taught drawing to both the imperial wives. He designed the Paris street decorations which celebrated the imperial triumphs, on a colossal scale and using mainly cardboard, then a material just coming into fashion. He designed the imperial cradle of Bonaparte's son, the King of Rome, now in the Kunsthistorisches Museum, Vienna, from a confection of silver, gold, brass, mother-of-pearl, velvet and sumptuous embroidery. Where was the ancient Roman virtue in that? Or Greek idealism either? Prud'hon admired Canova to the point of idolatry, but the work which first brought him fame and imperial patronage was *Justice and Divine Vengeance Pursuing Crime* (Louvre), a muddled romantic concept in classical undergarments, which might have been inspired by Fuseli. What remains to delight us, in the work of this sad and neglected master, are his drawings of the female nude, the bodies as good as Ingres's, the heads more truthful, done from life: for his *Venus and Adonis* (London, Wallace) he persuaded the Empress Marie Louise to strip (and why not?—he had designed her bridal suite). His front-faced female nude in the New York Morgan Library is one of the best things of its kind ever done and helps to explain Gros's admiring comment, otherwise mysterious: 'He will bestride the two centuries with his seven-league boots.'

If the classical revival never took a convincing grip on painting and sculpture, it was a different matter in architecture. It gripped hard, everywhere. The rising United States took to classicism for ideological as well as aesthetic reasons, for its founding

Ingres achieved fame (and obloquy) with his nudes and Napoleonic propaganda, but this portrait of *Louis-François Bertin* (1832), a newspaper owner, is his masterpiece.

fathers saw themselves as ancient Romans reincarnated. The man who wrote the Declaration of Independence, Thomas Jefferson, was a classical architect too, with marked Palladian longings. In 1791, Pierre-Charles L'Enfant (1754–1825) was given the job of designing the world's first government city in Washington on the most uncompromising classical lines. He and Benjamin Latrobe (1764–1820) had already been busy classicising Philadelphia, then the effective capital, but in Washington they had a *tabula rasa*. From 1803, Latrobe was appointed architect of the Capitol, to which he brought a wealth of construction experience hitherto unknown in America, and by the time he died this immense and difficult building was near completion. It became the model for government buildings across America, so that immense domes with columnar façades became the basic pattern and were widely copied all over Latin America, for the first time breaking away from Spain and Catholic Church architecture. Almost equally important was the preference of the governor of the First Bank of America for the classical temple-mode. All the Reserve Bank branches were built in this way, and other financial institutions followed suit. So Wall Street was initially built to the memory of ancient Athens, the columned portico and architrave became symbols of financial integrity and security, and temples of mammon everywhere were erected in classical style.

God followed where mammon led. All the men of power, from 1780 to 1820, whether kings or populist dictators, like Bonaparte or Símon Bólivar, liked the classical style because it symbolised imperial authority more completely than any other, and all of them eventually got round to building churches of their fancy. Bonaparte classicised the right bank of Paris by building the Rue de Rivoli; he imitated Trajan's Column in the Place Vendome, and he built the Arc de Triomphe, on the lines of the Arch of Titus, as the centrepoint of an entirely new radiation of wide avenues. But he also laid the foundations of the vast, severely Athenian Temple de la Gloire, now known as the Madeleine, which became the archetype for temple-church building not only in France but throughout the world, including many Protestant countries. It is an extraordinary fact, showing that fashion goes deeper than ideology in its day, that Louis XVI, the men who executed him, the 'Corsican Adventurer' who sent them packing and the restored Bourbon king who eventually displaced him, were all passionate classicists, who thought no other style of architecture remotely tolerable. Thus powered by God and mammon, legitimacy and democracy, the classical style of building was everywhere the stamp of firm government.

In St Petersburg, the city was completed classically by Thomas-Jean de Thomon's Stock Exchange (1805) and Andreyan Zakharov's Admiralty Building (1806). In Edinburgh and Glasgow there was a rash of Athenianism courtesy of William Henry Playfair and Thomas Hamilton. Other cities, like Birmingham and Liverpool, Marseilles and Bordeaux, Milan and Turin, followed the same columniated path back to temple form. So did the overwhelming majority of the two hundred Protestant churches financed, after 1815, by Act of Parliament, to provide spiritual

care for the new urban millions of industrialising Britain. In Berlin, now capital of a great power which had pushed to the Rhine at the Congress of Vienna (1814–15), Karl Friedrich Schinkel (1781–1841) built a series of classical buildings, some in the severest Greek style, which gave a classical feel to the city and its surroundings; these began with his powerful and elegant Neue Wache (1817–18) and ended with the Altes Museum (1822–30), both stressing the centrality in design of the columned portico.

The Prussian decision to build this huge museum was no accident. In London the same kind of building was going up, from 1823, to house the British Museum. Its architect, Robert Smirke (1781–1867), was not the finest classical exponent in England. That position was held by his master, John Soane (1753–1837). But Soane had a passion for the flattened curve, both inside and out, and was in addition too difficult an architect to manage for government officials, so he had to be content to design another temple of mammon, the Bank of England, and create his own museum in Lincoln's Inn Fields, in the classic house he designed for himself. The modern art museum had its origins in the cultural imperialism of Bonaparte, just as the teaching academy arose from the cultural imperialism of Louis XIV. But it also had an antique connection. The original Greek museum was a temple dedicated to the muses of the arts and sciences, though it acquired a secondary meaning as a place where objects were stored for use in teaching, this kind of museum being linked to a lyceum or academy.

The first such museum built on a grand scale was in the new Greek city of Alexandria in the third century BC. The idea, naturally, was resurrected in the Renaissance. The earliest Italian museum, properly speaking, housed from the 1570s the collection of the Medici in the Uffizi, where it remains to this day, though the Vatican Museum in Rome and the Kunstkammer (art room) of the Emperor Rudolph II in Prague were close behind. But access to these and similar princely collections was limited. In 1683, however, the Ashmolean in Oxford, endowed by Elias Ashmole for the 'public good', was opened to the university in term-time and to any well-dressed persons in the vocation. This became the general pattern in the eighteenth century, led by the papal Capitoline Museum (1734), the Uffizi (1743), the British Museum, founded on Alexandrine lines in 1753, and the main Habsburg museum in the Belvedere (1781), forerunner of what is now Vienna's Kunsthistorisches Museum. All these institutions began to develop the modern taxonomy of dividing arts and sciences into subjects, themselves divided into periods, 'schools' and so on.

The French Revolution and Bonaparte changed the museum as they changed so many other aspects of cultural life. Access to the Louvre collection had been one of the issues in 1789; in 1792 the Louvre and its contents were nationalised, and opened to all the following year, followed in 1801 by fifteen new museums in the provinces. As the revolutionary armies penetrated Italy, the Low Countries and central Europe, the destruction and looting of churches, castles and royal and national collections

began; and to put it on a legitimate basis, Bonaparte decreed that all European art, including great collections like the Uffizi, the Papal Museum and the Austrian royal museums, should be centralised in Paris. The Louvre, renamed the Musée Napoléon, was to be the main recipient, with big provincial collections like those started in Marseilles (1804), Lyons (1806) and Rouen and Caen (1809) taking any surplus. About 2,000 major works of art, and uncounted minor ones, were wrenched from altars and other church fittings, many being damaged in the process, or from their original setting in palaces, and carted to Paris. They included all the prize possessions of the Austrian emperor; his daughter Marie Louise, when she was married in the Louvre, was forced to walk under them to the altar. Another haul was the key contents of the new Berlin Akademie der Künste, opened in the 1790s.

Some art lovers welcomed this forcible concentration; William Hazlitt, for instance, argued that students and artists could now see all the glories of European art in one visit. Vivant Denon, Bonaparte's culture boss and director of all French museums, declared that the French nation was ideally constituted to be the custodian of European art. The owners, naturally, had other ideas, and when Bonaparte was finally defeated in 1815, Canova, with the help of the Duke of Wellington, secured the return of most of the art treasures of the Italian Church, though the duke was obliged to use troops to get the Louvre to disgorge them. Thus the four antique bronze horses of St Mark's, Venice, were put back on its west front, and about a thousand of the most important paintings and sculptures found their way back to Italy, Germany and Holland.

When Joseph Bonaparte, made 'king' of Spain by his brother, was evacuating what was left of his army in 1813, his baggage train, containing vast quantities of art loot, fell into Wellington's hands. Most of it he contrived to return, but the legitimate king, heartily glad to see the last of the French and profoundly grateful to Wellington for expelling them, insisted he keep some of the finest treasures, including Velázquez's *The Waterseller of Seville*, all of which are now in the Wellington Museum, Apsley House. Individual owners of stolen property found it extremely difficult to reclaim their own, especially works distributed in provincial French museums, where more than a thousand, some of great value, remain to this day. Other art-works, privately looted, disappeared without a trace, an adumbration of the process which was to take place, on an even larger scale, under the Nazis and communists in World War II and its aftermath. Thus the Revolutionary and Napoleonic Wars resulted in a net loss to European art, quite apart from the churches, palaces and art collections destroyed in the fighting. When considering France's uniquely large contribution to European culture, France's wars of aggression, including the invasion of Italy in the 1490s, Richelieu's invasion of Alsace-Lorraine, Louis XIV's invasion of the Netherlands in 1672, which effectively ended the Golden Century of Dutch Art, and the imperialism of Bonaparte—all of which inflicted damage which could never be made good—should be thrown into the balance.

However, though the Louvre was a mass recipient of stolen goods (some of which remain), it was still regarded, by the cultural élites, as an example to follow in many respects. Hence when the King of Prussia, Frederick William III, got his art collection back in 1815, he decided to extend the collection, and Schinkel's Altes Museum in Berlin was the result. Not only the new building of the British Museum but the National Gallery (1824) followed the same lead. This was extended to the British Empire in due course, the Melbourne and Ottawa galleries being founded in 1856 and 1880. America had already followed suit, with the Brooklyn Museum in 1823 and the Wadsworth Atheneum (Hartford, Conn.) in 1842. The New York Metropolitan (1870), the Boston Museum of Fine Arts (1870), the Philadelphia Museum of Art (1876) and the Art Institute of Chicago (1879) made the 1870s a notable decade for American art collections, and indeed for Japan too, where the National Museum opened in Tokyo in 1872. Thus the French, having set the pattern for academies which taught art and displayed artists, also launched the age of mass museums, of which there are now over 10,000 major examples in the world. Whether state academies improved art, and whether national museums display it to the best advantage, are open questions, and we will consider them in the context of the twenty-first century. In the meantime, the Louvre phenomenon opened a century in which France was to be the leading nation in determining the direction art took.

A further consequence of war for the history of art, which is often overlooked, is the revival of Christianity, which became a central feature of Europe in the first half of the nineteenth century. The decline of religious practice, and thus of art patronage, from about 1750 was marked and cumulative, especially in France, where rationalism was almost universal among the cultural elite on the eve of 1789. The revolutionary excesses, however, and the attempt to abolish Christianity and substitute a cult of reason, accompanied as it was by terror, destruction of churches and religious colleges, and the murder of the clergy, had the effect of demonstrating the importance of religion in the lives of ordinary people. Bonaparte was forced to restore *le culte*, as it was called, and François-René de Chateaubriand analysed the intellectual, spiritual and emotional reasons for its necessity in his strikingly successful book, *Le Génie du Christianisme*, published in 1802.

There were other factors making for a religious revival: Methodism and the campaign against the slave-trade in Britain, the effect of the Quietist movement in Germany, the Second Great Awakening in the United States and varieties of mysticism in northern Europe and Russia. Moreover, the two decades of warfare which the Revolution detonated, conducted on a scale hitherto unknown, and with commensurate ferocity, led many people, not least imaginative artists, writers and musicians, to judge reason as inadequate in itself as the source of human actions, and to seek for metaphysical explanations. The religious revival, or rather the rejection of pure reason—and with it classical idealism—was one of the foundation forces of

romanticism in art and culture. When Bonaparte was overthrown and went to St Helena, there to cultivate a garden in miniature on Le Nôtre principles—his last genuflection to classical forms of order—and Louis XVIII took up his old family throne, the restored king found that his most vociferous supporters were young men like Victor Hugo. Hugo rejected totally the cult of Greek and Roman forms which had been his own conditioning, and instead wished to bring back all the visual complexities and irrationalities of medieval Christianity.

The only major artist who bridged and commented upon these conflicts, and who made some kind of aesthetic sense of the long wars, was Francisco Goya (1746–1828), who suddenly emerged from a Spain everyone thought artistically dead, and then just as suddenly departed, shutting the door behind him. Goya came from Saragossa,

Goya's *Family of Charles IV* (1800) benefited from a Spanish belief that God made us all and nobody was ridiculous: all that mattered was truth.

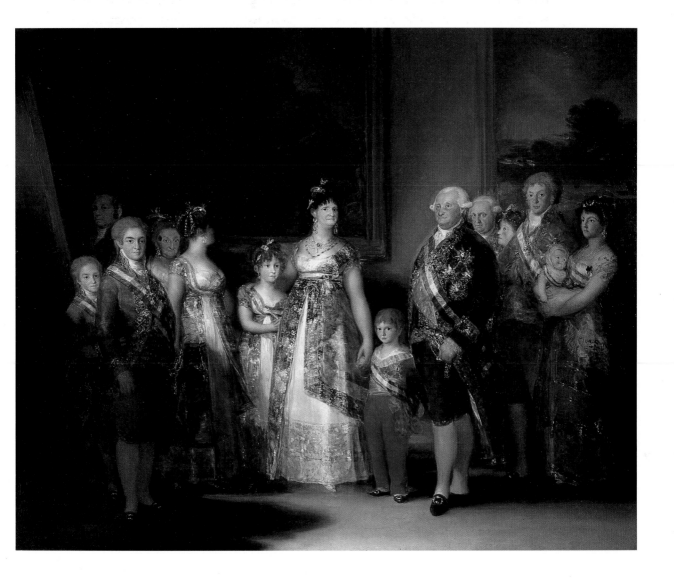

where his father was a gilder, and he took an unusually long time, for such a masterful painter, to find his personal style. Perhaps that was because he had so many different ways of painting. His first success came in 1776 when he began to draw cartoons for the royal tapestry factory, light-hearted scenes of ordinary life painted in bright colours, reminiscent of Tiepolo—*Blind Man's Bluff* (Prado) is typical. He also did portraits, religious pictures, prints and etchings, all with growing skill. Some were light-hearted, if with a satirical edge, like *Blanket-tossing* and *The Wedding* (Prado). Others were darker, like his etching *The Blind Guitarist*, or totally black, like another big etching *The Garrotted Man*. Tapestry-cartooning had some kind of chemical hazard: in 1793 one of his co-workers died of it, and Goya was stricken too. When he recovered, he was totally deaf. Thereafter he was obsessed with his health, fearing blindness too, and his anxieties are reflected in numerous self-portraits.

In 1795, Goya showed himself painting, wearing the candle-rimmed hat he put on as daylight faded (Madrid, Real Academia) and the series ended a quarter-century later, when he movingly painted himself, desperately sick with fever, being attended by his doctor (Minneapolis, Institute of Arts). Goya took everything hard, and many

The Thieving Horse (*c.*1820) is from an album in which Goya celebrated his draughtsmanship, grim humour, obsessive notions and irresistible appeal.

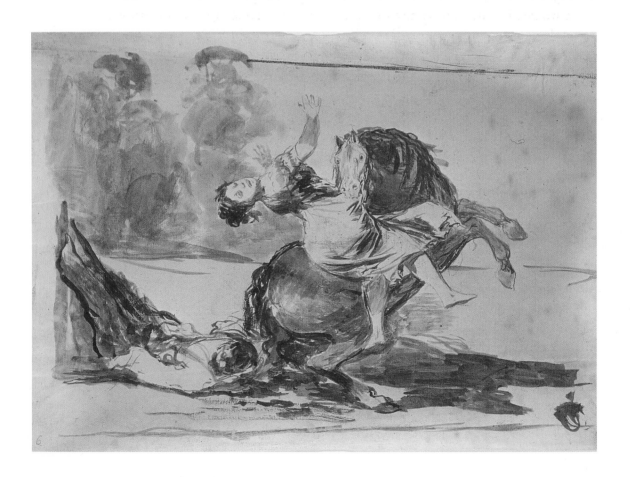

grim things happened in his life, to him and his country. He always worked assiduously, and with success, but for reasons not clear he was always short of money, and never secure. There were many things he found intolerable: the Inquisition, the system of justice, bullfighting (he did a beautiful but savage set of prints, *Tauromaquia*), the way the insane were treated. *The Village Bullfight* and *The Madhouse*, two of his best paintings, both in the Real Academia, reflect his detestation of the thoughtless cruelty he saw everywhere. In a bitter comment on the way some painters, like Rosa, romanticised bandits, he produced two paintings (Prado) showing a beautiful woman undressing, about to be raped, and her murdered body afterwards.

But Goya's horror was always intermingled with laughter, which makes him such a difficult artist to grasp intimately. In 1799 he published a huge set of eighty-two *Caprichos*, imaginative comments on contemporary society and customs which, like dreams, switch abruptly from comic bliss to nightmare. The same year he was made royal painter and in 1800 he produced his tremendous *Family of Charles IV* (Prado), in which the fat, stupid but well-meaning monarch, his hideous and dominant wife, and eleven other members of their tribe are shown together, in all their unease or smirking, like an unfortunate wedding snapshot; the painter-photographer is hovering in the left background, as Velázquez did in his *Meninas*. Goya worked for the royal family for over forty years, and always told the truth about them, as he saw it. It is amazing to us that they never criticised him for showing them plain or even ugly, stupid, awkward and unlovable. Passionate Catholics, they argued: 'God made us like this, and Goya, in obedience to God, is showing His handiwork truthfully.'

It was not that Goya despised beauty, when he found it. The main figure in *Young Women with a Letter* (Lille, Palais des Beaux-Arts) is exquisite. His *Doña Isabel Cobos de Porcel* (National Gallery), resplendent in her enormous black mantilla, is sensual, stunning and overwhelming—one of the greatest images of womanly beauty ever conceived, and executed with dazzling skill. Deafness and misery did not curb Goya's sex-life, reflected in his famous portrait of his mistress, *The Duchess of Alba* (New York, Hispanic Society), and in his two studies of female invitation to lust, the *Maya Clothed* and the *Maya Naked* (both Prado). These last two were cabinet pictures, not to be shown in public, for the Inquisition forbade nudity, and Goya's uneasiness is reflected in the awkwardness of the pose—the woman is obviously uncomfortable. Goya loved painting handsome or distinguished men too. His *Gaspar Melchor de Jovellanos* (Madrid, Irueste) is a superb study in thoughtfulness, and his *Sebastiano Martinez* (Metropolitan) radiates distinction. What is notable about Goya's best portraits—there are over a score in the highest class—is not just their penetration of character but his highly original colouring. There are greys, silver, deep greens mixed with blue, and exquisite pinks which had never appeared on canvas before, and these delicate combinations always allow Goya to touch the heart, when he chooses.

But when did he choose? No painter is more difficult to pin down about his intentions, which were often contradictory anyway. From his letters and other writings we know that he held, first, that truth was of the essence in painting, for God made all and he endowed Goya with gifts precisely to reveal all to the utmost limits of his skill. This made Goya one of the great realists of art, whether in genre or violent actions, such as *The Forge* (New York, Frick), a mesmerising study of strong men at work. But he also said that the crowning virtue of an artist is his imagination, which allows him 'to ascend into the skies like a bird' and fly above the horrors and meanness of sordid existence. He used this belief to justify many of his prints, not done from life, or drawn on the spot, but plucked out of his feverish mind. This makes him a romantic, and perhaps the very best of his paintings are exercises in poetry, like his beautiful full-length of his pathetic little studio-hand, *Asensio Juliá* (Paris, Sachs). The truth is, Goya was a divided soul: the painter in him was a realist, wanting always to see life unflinchingly, and the poet in him wanted to exaggerate both its delights and its unspeakable depths.

The French occupation and the long struggle to liberate Spain placed another cross of division on Goya's groaning shoulders. By intellectual conviction and even by temperament, he initially welcomed the fruits of the Enlightenment brought in the baggage of the French army, as did his great German contemporaries, Beethoven and Hegel. But the Spanish uprising and the drastic measures the French took to suppress it, followed by the long wars in which Wellington drove them out, produced scenes of such horror, over so many years, that Goya was driven to record them. His mind was divided and remained so, however. His actual conduct, in serving first one side then the other, will not bear close examination; and after the Bourbon restoration, which he seems to have hated almost as much as the French conquest, for it involved restoring the Inquisition too, he spent much of his life in Bordeaux, pleading ill-health. He was not brazen, like David, had none of the Frenchman's psychopathic innocence. He knew when he was doing wrong, or being weak, and was furtive about it. There were secrets Goya did not like to face up to even in the privacy of his mind—perhaps especially in his mind.

Goya obtained relief from his internal conflicts in his savage *Disasters of War*, a series of prints begun in 1810 and perhaps the most telling comments on the whole savage era. He also painted, though six years after the event, when it was safe to do so, the two big canvases which many regard as his finest works. *The Second of May 1808* shows the citizens ferociously attacking France's Moorish cavalry; *The Third of May 1808* (both Prado) depicts France's response: execution without trial, by night. This second work is so well known as almost to defy comment, except: why didn't Goya paint it at the time, when the events (he was a witness to the uprising) were fresh in his mind? He waited two years even to begin the *Disasters,* which continued through a hundred prints and many more drawings, until 1820. And the series was not published till 1863. These works are not wholly, or even mainly, anti-French.

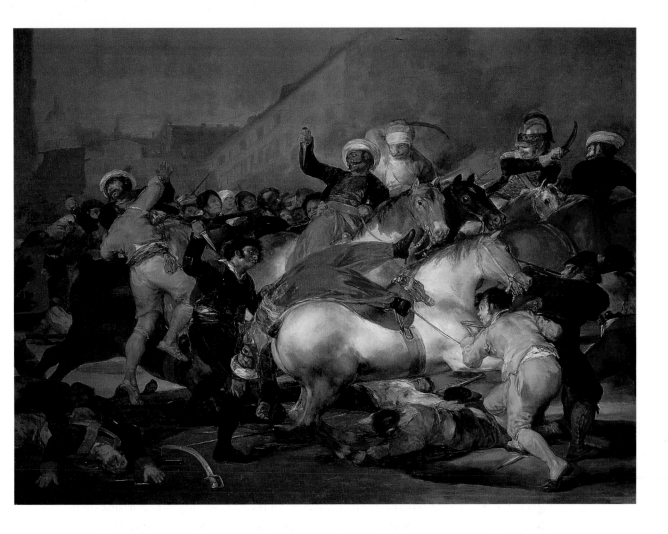

What they show is more fundamental: the general collapse of morality under the impact of total war, and the inability of organisations like the Catholic Church to do anything, except make things worse. There were clearly times when Goya, isolated by his deafness, came close to despair. He bought a farmhouse outside Madrid, and on its walls painted images of black grief which have never been surpassed for their capacity to inspire genuine fear—an insane, ferociously empty *Saturn Devouring His Children*, for instance, and the pathetic head of a dog, apparently about to disappear for ever in engulfing quicksands (transferred to canvas: Prado).

Goya is so complex and difficult as a painter that no single work can be properly judged in isolation. Everyone must make up their own minds about him, and to do that his work needs to be studied as a whole. But it is enormous, encompassing virtually every kind of surface known to art, all its pigments, vehicles and materials, and every possible instrument, from the broadest brush to the tiniest needle. One of his last phases involved painting twenty portrait miniatures on ivory. His *oeuvre* is in some confusion. A 1950 catalogue of it lists over 900 paintings, more than 700 drawings and 350 prints, lithographs, etc. The 1973 catalogue reduced the paintings

The Second of May 1808 was actually painted six years after the event, when the brutal French (and their Moorish cavalry) had left and it was safe to attack them.

to 740 but listed a total of 1,870 works. Goya often complained of lack of money, shortage of paints, canvas and paper, and painted on both sides of whatever came to hand, often over-painting old canvases. He drew best to please, terrify and exorcise himself. He filled at least eight big private albums with drawings, which scholars have listed alphabetically from A to H. Album C, for instance, contained 133 drawings, and 120 of them are in the Prado. But each was broken up and dispersed all over the world. Unknown drawings and prints sometimes turn up, and the parameters of Goya's works are always changing. What cannot be obscured, however, is the universality of his art: almost every aspect of life, as it was endured in Spain in the years 1790–1820 particularly, is depicted and usually commented upon. It is possible to spend a lifetime immersed in this output, at any rate long years of fertile study, emerging at the end perhaps not any wiser but certainly better informed about the sad, serious and sly business of humanity.

Goya did not have the last word on Bonaparte and his wars. Nor did poor Baron Gros with his battle scenes: he made a mess of decorating the triumphalist cupola of the Panthéon and committed suicide in 1835. The ultimate battle comments were made by a man only born in the year of Waterloo, Ernest Meissonier (1815–1891), who reproduced Bonaparte's battles in paint, including the mesmerising image of 1814 (Louvre), in which the emperor, lost in thought, leads his staff on horseback through the mud and snow to inevitable defeat. At the time, the last word in paint was produced by the brilliant English portraitist, Thomas Lawrence (1769–1830), who was able to bring together the victors in triumphant assembly. He was well fitted for this task, being a child prodigy who rose above his humble circumstances (his father was an improvident tavern-keeper) and lack of education to become, with amazing speed, the smartest society portrait painter England had ever known. Lawrence loved everyone, but he had the softest spot for beautiful creatures on the threshold of life. Unsurpassed in the entire European canon of portraits are two ravishing works: *Arthur Atherley* (Los Angeles, County Museum), a long-haired Etonian schoolboy in a flush of teenage glory, about to seize a privileged life with both his slender hands; and *Rosamund Hester Elizabeth Croker* (Buffalo, Albright-Knox Art Gallery), a young girl so exquisite and so endearingly painted that, for the first time, the Academy had to put up a rail around her at the Summer Exhibition to keep the crowd in order.

When Bonaparte was finally floored, the Prince Regent chose Lawrence as the obvious man to paint a prosopography or collective portrait of the politicians, sovereigns, soldiers and other potentates who were now filling the vacuum left by the emperor's huge departure. There was that great survivor, Pius VII, and his Secretary of State, Cardinal Consalvi, Marshal Blücher and his colleague Wellington of course, the Emperor of Austria, the King of Prussia, Metternich, Prince Schwarzenberg, the Archduke Charles of Austria, Count Hetman Platoff, the Russian commander—all of these portraits now hang as intended in the Waterloo Chamber of Windsor

Castle, being completed by images of Castlereagh (National Portrait Gallery) and Canning (private).

Lawrence painted the coda to the Bonapartist era, but its epitaph was built in Vienna. No country had been beaten, humiliated, occupied and trampled on by Bonaparte more often than Austria. It emerged with its territories expanded but with its taste for glory extinguished. It now wanted a quiet, comfortable life, and that desire found expression in what was later called the Biedermeier style. The term was originally contemptuous but is now accepted as complimentary. Hitherto, for more than two centuries, style had been set by French taste, usually after the name of their kings, and coinciding more or less with their reigns. Now, suddenly, the defeated French had no style, and they were not to recover their style-setting élan until the advent of Art Nouveau towards the end of the century. Into the vacuum stepped dowdy Vienna with a style which had neoclassical elements but essentially reflected the comforts of unadventurous middle-class affluence.

Biedermeier was based on family, church, villas and country walks, domesticity, quiet entertainment, simple balls, picnics, well-behaved children, modest men, virtuous women and respect for age. In painting, it expressed itself in group portraits. Thus we have Leopold Stober's *Self-Portrait with Family* (1827, Lichtenstein), David Sulzer's delightful trio *Three Young Ladies* (1822, Winterthur, Kunstmuseum), Karl Begas's *The Artist's Family* (1821, Cologne, Wallraf-Richartz-Museum), the epitomising image of homely delights, and Emilius Baerentzen's *The Winther Family* (1827, Edinburgh), where only the little dog is misbehaving—all else is demurely innocent. This mood of virtuous content is reflected in suburban villas and modern town mansions, and their contents: superbly crafted furniture, polished and even lacquered but with little or no gilt; beautiful needlework boxes; firescreens; clocks for the master of the household to wind regularly; wine-coolers for local wine; Meissen and Fürstenberg tea-services, Nymphenburg cups and vases, coloured Bohemian tumblers for beer or lemonade, often with fine leather cases in red, blue and black; finely carved wooden boxes, candlesticks and knickknacks; textiles and wallpapers in charming but not luxurious patterns; and silver coffee sets which sparkled with simplicity and decent pleasure in its lustre. All this laid the aesthetic foundations of what was to be the golden epoch of the middle-class family—Victorianism. It was, in a sense, the last age of innocence, for the world was expanding fast, revealing its fascinating immensity, and the days when Europe had only itself to consider, explore and portray, were now over. Globalisation set in two centuries before it acquired a name.

21

THE WESTERN PENETRATION OF ASIA: INDIA, CHINA, JAPAN AND THEIR ART

The expansion of world commerce on a huge scale in the eighteenth century began or hastened artistic developments which continue to this day. Globalisation really started in the fifteenth century when the first world travellers, the Portuguese, having conquered the Azores and Madeira as stepping stones to the north and south Atlantic, began building forts, which enclosed trading depots, on the west coast of Africa. Many of them remain, often in isolated places, and they seem to us now creations of great beauty. From the late fifteenth century, having claimed Brazil as their territory, they put up forts on the coast there, especially near what was to be the capital till the end of the eighteenth century, Salvador. Most of the early forts disappeared or were replaced, but later ones like Lage (1606), Reis Magos (1614), Natal (1620) and Salvador itself (1630) remain. These are splendid buildings, often with elaborate doorways, windows and staircases, built to endure but also to please, with characteristic Portuguese decorative motifs, which moved effortlessly from late medieval elaboration, known as the Mañuelesque style, into the Bernini-like rhythms of seventeenth-century excess. There were exotic local elements in the European mode thus transported. What is now the cathedral of Salvador, one of the most striking towns in the entire Western Hemisphere, and little visited, was originally the Jesuit collegiate church, completed in 1672, the first major example of Luso-Brasilian architecture. At first glance it looks European; a longer look reveals key surrenders to the *genius loci*.

The Jesuits, under the inspiration of Francis Xavier, explored all Catholic America, India, China and Japan in the second half of the sixteenth century, and soon had mission stations throughout the world, with a distinctive Missionary style of architecture. There were plain and functional college buildings linked to churches of the utmost elaboration, every square foot of wall and ceiling space within covered in paintings and decoration. But the Jesuits from the start believed in acculturation. They learned the local spoken tongues, acquired, studied and preserved sacred texts, adapted their preaching and school-teaching to local mores, and tried to make their

architecture seem familiar to local taste, without in the smallest degree sacrificing doctrinal orthodoxy. They often wore local clothes and were keen at all times to recruit educated natives to their order.

The original Portuguese conquest of Goa in India, which they made the capital of their spice trade, was pre-Jesuit, and the Franciscans were much in evidence during its transformation into one of the most dazzling cities of the sixteenth century, laid out on a grid plan, with churches, public buildings, villas and palaces grouped round a series of piazzas and public gardens. But the Jesuits fashioned the cathedral, 1562–1652, which is modelled on the Gesù church in Rome, and more important, they built the greatest of Christian churches in India, the Bom Jesus, 1594–1605, which is really an enormous reliquary enclosing the tomb of Francis Xavier in the south transept. The marble tomb itself was a gift from the Tuscan grand duke, Cosimo III, and was carved by Giovanni Battista Foggini, but the silver casket which holds the relics is local, a typical Jesuit compromise. But equally, Hindu temples which continued to be erected under Portuguese rule soon showed signs of acculturation too: two late-sixteenth-century temples, at Korgaon and Mhalsa near Goa, have Roman domes, and the latter also sports Corinthian columns and what look like medieval pointed arches.

The Jesuits got on well with the local Mughal emperors, Akbar and Jahangir, who reigned in the years 1556 to 1627, and Indian artists such as Basawan and his son Manohar learned to copy sacred works of art by Dürer and others. The Jesuit architect Roberto de' Nobili built churches almost entirely in the local style, and dressed as a Brahmin. A Jesuit sculptor, Constanzo Beschi, specialised in presenting the Virgin in Tamil dress. The Jesuits were extremely adept at keeping up-to-date not only with the latest European art styles but with scientific advances and instrumentation, especially in astronomy. The great Jesuit mission to China, led by Fr Matteo Ricci in 1583, won the hearts of the Chinese court with its scientific inventions, and thereafter, for two centuries, the Jesuits acted as a bridge between the two cultures, bringing to Europe chinoiserie and porcelain—there was a special import known as Jesuit ware—and transmitting to China the enamel technique needed to make *famille rose*. Jesuit writings on Asia encompassed a wide variety of subjects—to give only one example, in 1724, Fr Matteo Ripa SJ published the first book of engravings of Chinese gardens. But the Jesuits were not alone in patronising Asia.

In 1520, Cardinal Wolsey, then the most powerful man in England, spent two years negotiating the supply of sixty fine Turkish carpets as part of a diplomatic agreement. They were avidly seized by Henry VIII when the cardinal fell and one of them features in Holbein's great painting of 1543, *Henry VIII and the Barber-Surgeons Company* (London, Barber-Surgeons' Hall). The Turks also supplied opium, contained in wooden boxes of surprising beauty, now exceedingly rare. China imports, for both palatial and everyday use, date from the early seventeenth century, and Jesuit ware was not the only type the Chinese learned to produce for the Western market: there was also Chinese Delft for the Dutch and Chinese Lowestoft for the English.

There were imported building types too. William Chambers was by no means the first to discover and imitate pagodas, perhaps the most graceful and spectacular oriental image. The pagoda is Buddhist in origin and first appeared in China during the Han period, 206 BC–220 AD, though the earliest surviving one of brick dates from 669 AD and of wood from 1056. Five years later the Pagoda de Porcelain was put up at Versailles, thus beginning a new vogue. It was, however, an expensive one. The most spectacular example was the brainchild of the Duc de Choiseul, who had made himself a millionaire while directing French policy under Louis XV, and who employed the years after his fall erecting a colossal pagoda of stone, with fashionable classical trimmings, on his estate at Chanteloup (1775–78), something well worth seeing. There is another in the Labyrinth Gardens, Philadelphia, modelled on Chambers's one at Kew, which William Strickland built in 1823.

If proper pagodas were expensive, 'Chinese pavilions' could come in all sizes to suit every pocket, and by the end of the eighteenth century few big European gardens were thought smart without one. The Prince of Wales (later Regent and George IV), the first English royal with taste since Charles I, went one better at Brighton and got Henry Holland (1745–1806), a former assistant to Capability Brown, and the architect of the ultra-fashionable Brooks's Club, to update a modest house into a setting for Chinese interiors, supplied by the firm of Crace & Crace. In due course he went a step further, and instructed his chief architect John Nash (1752–1835) to orientalise the exterior as well. Nash, a protégé of Humphry Repton who specialised in rustic villages for 'reforming' landlords, built in the picturesque mode. Under the prince's patronage he became the biggest transformer of London since Wren, laying out and building huge vistas of roads, parks and stucco-covered grand houses the whole way from the Mall and Carlton House Terrace, up Regent Street, past All Souls' and Park Crescent, to Regent's Park with its spectacular terraces.

In Brighton, Nash inspired another terrace-city of palatial houses, still glorious despite many dilapidations by philistine local government which has knocked many pearly white teeth out of the glittering and complete set left by the prince, Nash and his followers, chiefly C. A. Busby (1786–1834) and Amon Wilds (1784–1857). But the Pavilion was at the heart of it all. It assumed its present shape in 1815–22, an amazing *confiture* of Indian onion domes, Islamic minarets and arches, oriental crenellations, Persian loggias and, indoors, dragon-encrusted chandeliers and assorted chinoiserie. The whole might have turned out extremely vulgar but, like most things in which the Regent was the guiding spirit, it works visually. It is totally unscholarly, eclectic and brings together every kind of cultural incongruity. But that, perhaps, is the reason for its success and continuing popularity over two centuries, for academically correct buildings do not, as a rule, charm.

Brighton Pavilion, like much else, was built on European ignorance of the Orient. But in the second half of the eighteenth century, and with growing enthusiasm

thereafter, many were trying to dispel it. The great world voyages of Commodore Anson (1740–44) and Captain Cook (1768, 1772–75, 1776–79) had geopolitical motives but were primarily scientific and cultural in object, with experts from the Royal Society as supercargo, a form of naval science which was to culminate in Charles Darwin's famous world voyage in the *Beagle*, on which he formed the theory of natural selection. The supercargoes were trained observers and recorders, and the Anson–Cook voyages were the first European introduction to the arts of the Indian and Pacific Oceans, covering half the earth's surface. It was to the credit of Bonaparte, whose early ambition had been to enter the Royal Navy, that he noted these things. When he decided to invade Egypt in 1798 he took with him a team of 175 savants, including philologists, engineers, mathematicians, archaeologists and many artists, one of them Vivant Denon (1747–1825), whom he was to make his chief museums administrator and art director alongside David.

From 1798 to 1801, the experts worked immensely hard, exploring, copying, excavating and studying every aspect of Egyptian life and art, ancient and modern. This was the earliest large-scale and scientifically conducted analysis of oriental art ever undertaken, and the outcome was impressive. The first results, written by Denon, were published as *Voyage dans la . . . Egypte* in 1802; the full and magnificently illustrated account of the discoveries appeared in 1809–22, in twenty-four volumes, under the title *Description de l'Egypte*. This grand demonstration of French artistry and scholarship set the pattern for all future work, and it also inspired, or rather enlarged, an Egyptian Revival style of decoration in the West. The consequences range from the notorious Tombs Prison in New York City to the magnificent Service Egyptienne, produced under Denon's direction by the Sèvres factory in 1810–12. With its superb purity of line and its astonishing centrepiece based on the Luxor Temple, it is perhaps the finest dinner service ever made (St Petersburg, Hermitage; duplicate at Apsley House, London).

The British applied the same kind of survey to the immensities of India, which they gradually took over after their victory at Plassey in 1757. They were interested in every aspect of Indian life and society, and dug their way into every tiny cranny of Indian custom, but understanding Indian art was not high on their list of priorities. The most important cultural transfer, the Europeanisation of the bungalow, came about for administrative reasons. This was originally a primitive dwelling place erected by Bengal peasants (hence the name), with a raised plinth and a roof structure made from two bent bamboo poles and thatch. It was easy to build and well adapted to local conditions, and the English had apparently spotted it as early as 1659, long before they became dominant—that was when the term was first used in English. By the 1790s the British were building, on a huge scale, one-storey bungalows, on raised brick supports or plinths, 3 feet from the ground to deter ants, with an enormous room in the centre for eating and sitting, and rooms at each corner for sleeping, the

spaces between the angle-rooms being used as *varandas*, for sitting in the evenings. A large sloping thatch roof covered all, including the veranda space. The bungalow became the economical means whereby life was made tolerable and healthy for thousands of British administrators and military officers. It not only spread all over India (and other parts of the East) but became a classic Indian art form and was the basis for the planning of New Delhi in 1911 (of which more later).

The bungalow reached Britain in the first half of the nineteenth century and proved so popular, in its brick-and-slate English version, that not only were entire suburbs, like Bungalow Town in Shoreham, erected to accommodate the 'escapist' middle class, but the Arts and Crafts movement adopted the form for highly sophisticated dwellings. Dante Gabriel Rossetti was the first person of note to die (1881) in an English bungalow and the young H. G. Wells hailed it as the 'fruit of the reaction of artistic-minded and carelessly living people against the costly and uncomfortable social stiffness of the more formal seaside resorts...a fashion with a certain Bohemian-spirit class' (1906). By this time, in an American version, the original plinth having developed into a spacious basement-workshop or games room, the bungalow had become even more popular in the United States and is by far the most widespread form of domestic architecture in all the countries of Anglo-Saxon origin, as well as much of northern Europe. Indeed, in the twentieth and twenty-first centuries, virtually all forms of housing acquired a bungalow element. Out of small and primitive acorns do such overarching trees of architecture grow, and here was a case of a form being demotically inspired from below, for no architect touched it until it was well established.

In general, however, the British made little use, and acquired even less understanding, of South and Southeast Asian art. Some of their great men, like Lord Clive, Warren Hastings and Stamford Raffles loved it; indeed, Raffles made the first really large and comprehensive collection of Malaysian art, much of it, alas, lost at sea on its way to England. Indian art appeared baffling in the West. There were some connections, of course: Alexander the Great had carried into part of India Greek structures and motifs, which were absorbed, making the north of the subcontinent a salient part of the great arc of

Female figure, possibly ritual dancing-girl, in bronze, from Mohenjodaro, Pakistan, *c*.2000 BC. About 4 inches high, solid cast, using the lost-wax process.

Islam which stretched from southern Spain as far as the Philippines in the western Pacific. Moghul art in India was part of the general system radiating from the Middle East in which European art had its remote roots, and there was no difficulty, therefore, in understanding monuments like the Taj Mahal, as we have noted. But Buddhist temples going back to the third century BC, and Hindu temples reflecting patterns from the third millennium BC, were a different matter. To begin with, there were huge gaps, for the Moslem conquerors had systematically destroyed an immense number of temples and unimaginable quantities of Indian sculpture, for religious reasons, believing it to be the work of the devil. What the Spaniards did in Latin America was nothing compared to this wholesale annihilation of art, a process which continues, intermittently, to this day, as the decision of the Taliban government to dynamite two 90-foot rock-cut Buddhas at Bimayan in March 2001 testified. Then again, the Indians could not explain their art themselves, in terms Europeans could understand, seeing it as a religious phenomenon, defying cultural progression and taxonomy: Indian art historiography was virtually non-existent before the twentieth century, though it now flourishes mightily. The first comprehensive account, *The Hindu Temple* by Stella Kramrisch, did not appear till as late as 1946.

The truth is, temple art as a whole was not easily accessible to Western eyes. It is, and always was, not difficult to value individual pieces. Thus the bronze *Dancing Girl* from the Indus Valley, dated *c.*2300–1750 BC and now in the National Museum, New Delhi, is a fascinating work of art. The wonderful *Seated Buddha*, in grey schist, about 150 AD, which is a glory of the Royal Scottish Museum, Edinburgh, is a mesmerising study in total meditation. The Gupta period, in what we would call the Dark Ages, the greatest epoch of Indian art, produced many remarkable forms, both beautiful, like the clay seated Bodhisattva in the Paris Musée Guimet, and astounding, like the massive sandstone boar-headed Vishnu, with attendant Venus-girl, which stands in Sagar University Museum park. But these are wrenched from their surroundings, which give them meaning, and to think we understand them without their context is a delusion. Buddhists and Hindus built temples of ever-increasing size and elaboration as long as they were permitted to do so. Many of the Buddhas and Vishnus are gigantic, and do stand out strikingly, but they are nonetheless surrounded by an infinity of lesser forms, all significant in their religious context. Most temples, however, are covered with an infinity of statuary, often repetitive, whose variations lack obvious meaning, and getting to grips with their religious and aesthetic import is like, say, trying to understand a fifteenth-century Mañuelesque façade without any knowledge of, let alone sympathy for, Christianity. And without understanding, Westerners and many Indians too tend to find the proliferation of forms over huge surfaces oppressive, sometimes repulsive.

The most attractive form of both Hindu and Buddhist art in India was, and is, the rock-cut tomb temple and its accessories. At hundreds of sites in India (as elsewhere in Asia) Buddhist artists took over deep and roomy caves, or dug into the living

Maitreya, 'The Buddha of the Future', in 'reassuring' posture, Kushan period, second–third century BC, from Gandhara, Pakistan.

rock, to create religious shrines, sometimes of immense size. The process spread over an entire millennium, from 200 BC to 900 AD and beyond, and produced a colossal quantity of sculpture, some figures being over 100 feet high. There are vast preaching-halls or *chaityas*, the Indian version of a basilica. There are also dormitory caves called *vihāras*, often linked to the temples to form monasteries. These cave-clusters, at places like Kondane, Karle, Kanheri, Bhaja, Nasik, Pitalkhora and, above all, Ajanta, are great depositories of carving and painting. The Ajanta caves are rightly world-famous for they contain enormous numbers of wall-paintings, the best 1,500 years old, and include some of the most beautiful ever done. These relate Buddhist stories, as a rule, and combine the powerful drawings with endless inventiveness. Cave X at Ajanta is the largest area of continuous narrative painting in the entire world. There are also high-relief and standing sculptures of the most forceful, and occasionally beautiful, kind. In the Deccan there are many impressive cave temples of the Hindu religion, containing embracing couples by the hundreds—indeed thousands—sometimes in erotic poses, and on a huge scale. In the Ellora caves, there is the gigantic Kailas temple, a free-standing monolith on a scale which staggers the unprepared visitor. Near Bombay, at Elephanta, there is the astounding sight of the three-headed bust of Shiva, the Trimurti, which is not only vast but frightening. At a superficial level, indeed, Indian art is about scale and numbers, both calculated to overwhelm rather than enamour. The detail may ravish and excite too, but it is orphaned without its setting. That is one reason why museums do not help much towards an understanding of the art of India, best grasped at the cave-face.

* * *

The problems posed by Chinese art were quite different. China, like India, was a very ancient civilisation, with a long tradition of central government and specific and rigid ideas about the role of art, as a distinct entity, in the national life. The Chinese had, in short, a philosophy of art, which can be explained and grasped. It evolved slowly from the teachings of Confucius (*c.*551–479 BC). It centres round the word *wen*, meaning 'pattern', and applies to music, dancing and speech as well as all the visual arts. It often involves lists, like 'the five notes' and 'the five colours', and is highly didactic, but in general it posits art as one of the activities which creates order from chaos and is not, therefore, all that different from the theme which, as we have seen, runs through all art as practised further west. However, the Chinese had distinctive views as to what constituted art, which they defined rather more widely than in Europe. Thus, the 'six arts' in 120 AD are listed as 'ritual, music, archery, charioteering, writing and mathematics'. An eighteenth-century encyclopaedia keeps this list but adds juggling, crossbow-shooting, building and aspects of literature. However, the Chinese had for many centuries introduced social distinctions into the practices of art. The 'gentlemanly arts' for the mandarin class of scholar-rulers were poetry, calligraphy and painting, known as the Three Perfections, and in these the artist's personality was expressed, as was not required in more artisanal activities like entertaining, sign-writing and interior decoration. A gentleman was also expected to be expert in divining the 'patterns' behind all art, by working out cosmic diagrams not unlike astrology. These higher arts were unitary. The Chinese did not distinguish fundamentally between poetry and painting, for instance: they had a saying, dated from about 1100 AD, that 'poems are formless paintings, paintings are poems in forms'; and since poems were written in calligraphy, which also formed an essential part of most paintings, the three were all one. Certainly, all great gentlemen-artists were expected to, and in fact always did, write poems and high-quality calligraphy, and paint.

It can be seen, therefore, that the Chinese hierarchy of arts was by no means the same as that in the West, and that some things they included, we exclude, and other things which we consider artistic, they despised; moreover, absolute distinctions between the visual and other arts were not valid for the Chinese. However, for the purpose of this book it is necessary to apply the Western grid of art categorisation, and when this is done three particular areas of interest emerge. The first is casting in bronze, developed at a very early period and practised with the greatest possible skill and artistry. The Chinese mastered bronze-casting early in the second millennium BC and used it extensively for weapons, agricultural and mechanical tools, coins, personal adornment and sculpture. But it had a special significance for them in the creation of a variety of huge vessels used in rituals. These containers were of great importance in the conduct of politico-religious ceremonies. They had originally been made of fired clay, and when the Chinese learned how to cast bronze, a more

efficient and magical substitute since it was so durable and symbolised eternity (as did stone in ancient Egypt), they quickly took the opportunity to devise ritual forms and decorative motifs, some of which pay tribute to the holy and wise ancestors who had devised the pottery forms in the first place.

The first ritual bronzes date from about 1600 BC and they continued to be made in large numbers until about 100 BC. From the early first millennium BC the lost-wax process was employed in many cases. They were of three basic types: first, wine containers; second, cooking vessels and food-storage pots; third, washing vessels for ritual ablutions. The wine vessels seem to have been the most important for ceremonial use and came in up to a score of different types, some of them sprouting feet in the form of tripods, some with spouts, others with handles, either central or on either side, some with lids. All have some element of decoration and many are covered with motifs and signs. The food vessels came in about ten distinctive shapes and became more numerous as time went on. They were in more unusual and interesting shapes, often squat and formidable, usually with lidded handles, sometimes in the shape of divided spheres or enormous chalices with matching tops. The water vessels were simpler, usually large bowls or sauceboat-shaped.

It is tempting to compare these early Chinese bronzes with the black and red Greek vases of the first millennium BC, and certainly the same basic principles of taxonomy can be applied to their classification and dating. But the bronzes were not artefacts in household use. The Chinese always had pottery for that. They were expensive creations of high art, used for solemn religious purposes, the paying of reverence to ancestors. They were holy vessels and were often buried with their owners. Indeed, that is how many of them came to light again in the twentieth century. Few of the earliest bronzes were known until excavations in the 1930s at Anyang, the capital around 1300 BC, and even earlier bronzes were found in graves at Zheng Zhou in the 1950s. The earliest bronzes were made in moulds, and they are often the finest. Indeed, it is a curious fact that, to our eyes, the quality of the design and shape appears to deteriorate as time passes. Or, rather, their power to hold our attention diminishes. Unlike anything else from deep antiquity, these big, heavy, indestructible artefacts seem determined to over-awe us with their metallic menace and their threatening shapes. It is as though the sacred ancestors, to and for whom they speak, were somehow within, and alive. To be in a room with them, as at the British Museum, is a strange and not entirely agreeable experience. But at this distance of time, over 3,000 years, it is impossible to be sure of their creators' intentions. The varying tones are clearly deliberate, for the Chinese from the earliest times were cunningly aware of the effect of different temperatures on metal and clay. But the patination from exposure, which we moderns value so highly, may have been accidental and not esteemed. There are many—perhaps most—things about these bronzes which remain guesswork for us.

One thing we are aware of, however, is the enormous scale of the Chinese copper and bronze industries. There was nothing like it anywhere else in the world. In recent

times, strip-mining for iron exposed an ancient copper-mine dating from the second century BC, and covering nearly a square mile. This was an elaborate and, for its time, highly efficient mine, much more so than comparable Roman ones. There were seven furnaces to make the copper into ingots, a few of which have been recovered, and from the slag heaps it is possible to deduce that the amount of copper produced from this one mine was perhaps 100,000 tons. The scale of the bronze production was correspondingly large, involving a prodigious number of workshops often of vast size, employing thousands of workers. Bearing in mind that only a fraction of the grave-sites which contain bronze vessels has been excavated, there is abundant evidence that we have here one of the largest art industries of antiquity. For instance, in Hubei Province, investigation of the so-called Tomb of Marquis Yi of Zeng, at Suizhou, which is dated 433 BC, yielded bronze artefacts weighing a total of 10 tons. They included a superb set of eight ritual wine vessels and, most startling, proof that the Marquis was a musical gentleman. From the earliest times the Chinese had punctuated their ancestor rituals with rhythmic and polytonal sounds. At first they used stones, sets of which have survived. When they learned to work and cast bronze, however, they soon developed bells, usually clapperless, each of which emitted two distinct sounds depending on where it was struck. Bell-making gradually became extremely complicated and sophisticated, and a feudal lord's status was in part determined by the size and capabilities of his court orchestra. The Marquis Yi's tomb yielded a complete set of sixty-five bells, which made sounds over an immense range and tonality, depending on how they were hung and manipulated. The

The Chinese mastered the art of bronze working about 1800 BC and their large ritual pieces to hold wine, water or food (such as this Shang dynasty example) were their chief glory in the second and first millennia BC.

tomb also contained drum shafts and stone chimes, but bronze was at the heart of the Marquis's impressive band.

Early bronzes on exhibition are now so fine and numerous that it is hard to select outstanding examples. The Arthur M. Sackler Collection, distributed between Washington, D.C., and Cambridge, Massachusetts, has a wonderful fourteenth-century BC food container (Washington), analysis of which has revealed exactly how it was cast and put together. In Minneapolis there is a wine vessel, dated vaguely from the sixth to the third century BC, which is covered from narrow neck to base in six friezes of decorative figure-work of fascinating intensity. In the Freer Collection, in Washington, there is a pair of big water vessels whose shape, dignity and sheer power demonstrate, as no words can, the formidable capabilities of the Chinese bronze art industry about 450 BC, at exactly the time when Athenian civilisation was at its height. The Greeks were great artists in many spheres where the Chinese did not compete, or lagged behind, but no Greek craftsman could have produced such an object.

On the other hand, it must be said that Chinese bronze work, while capable of inspiring a salutary terror, as intended, could also be repugnant. There is in the Marquis Yi hoard a bronze jar and basin, cast by the lost-wax process, of such elabo-ration, with tigers and dragons, seething and writhing over a decorative background of written scrolls, like a boiling of insects, as to inspire satiation and disgust. This is an art form reaching the limits of virtuosity, and falling over them into artistic chaos. Moreover, there were sinister elements amid the art. Not only animals but human beings, especially women, were slaughtered alongside great landowners to accom-pany them in death. Alongside his 10 tons of bronze artefacts, one over 4 feet high, the Marquis was accompanied by eighteen musician-concubines, who were killed or buried alive to enhance his afterlife felicity. The Marquis's tomb, like those of the Old Kingdom of ancient Egypt, was a multi-room dwelling, where facilities, including human contact, existed for him to disport himself—or so it was believed. Only grad-ually did the Chinese stop killing real women to serve as tomb goods, substituting instead replicas in wood or clay.

There is much about the art of ancient China that we do not know or are only just beginning to discover. Everything now emerging tends to stress the scale of the art industries. During the 1970s, the tomb was discovered of the soldier-tyrant who made China into a unitary state, the First Emperor of Qin, as he is called, ruling 221–210 BC. This man was a Bonaparte, a ruthless warlord, who destroyed a great deal of the then civilisation, 'burning books and slaughtering scholars', as one text has it, to end what was known as the Warring States period, and introduce central rule, with standard-ised weights, measures and, not least, a single writing system which was the basis of Mandarin. The excavations beginning a quarter of a century ago revealed, to the astonishment of Chinese academic experts as well as the world, that the burial of Qin had taken the principle of reproducing life in death to its ultimate conclusion, since

the dead emperor was provided with an imperial army of thousands of life-sized baked clay warriors. This was burial on a scale not attempted since the Fourth Dynasty pharaohs were placed within the great pyramids of Giza. Though no comparable buildings were attempted, the underground works were on a prodigious scale which the Egyptians never matched and the fabrication of the figures alone involved industrial efforts of which no civilisation of the ancient Near East was capable.

Terra-cotta soldiers, some of thousands, from the tomb of the Chinese emperor Qin Shi Huangdi (reigned 221–210 BC), excavated in the 1970s, and still counting.

The thousands of figures were assembled from prefabricated parts: a head, a torso, a leg section, two separate arms, and two hands, to make a figure of between 6-foot and 6-foot-3. Each had a plinth, which came in three different types, and there were two types of leg sets, eight of torsos and eight of heads. Moreover, each head had its features and hair individually modelled, so all the figures look distinctive. Is this art? The figures were not designed to be seen, except by the invisible power to whom their existence was, presumably, important in awarding happiness to the dead titan. The same factor applies to all the vast quantities of two- and three-dimensional work in ancient Egyptian tombs, some of which we rank among the highest art ever produced by humanity. Photographs and still more the actual sight of these massed ranks of silent tomb-followers, in their thick winter coats, topknotted hair and grim earnestness, produce a daunting and unsettling effect in a way which

art on a vast scale sometimes does. Moreover, the burial as a whole conforms to the basic notion of art, as understood both by the ancient Chinese and by those in the Western tradition—the imposition of order on the chaos of death. Yet this was an industrial operation. The kilns had to be kept heated at between 950 and 1,000 degrees Centigrade, and there must have been hundreds of them, specially built for the occasion. How many thousands of tons of fuel had to be provided to produce these temperatures during the months, perhaps years, of activity? The clay had to be dug up and transported too. What was the total workforce involved? We can only guess. Here was a demonstration not so much of art as of centralised power to mobilise and set to work the elements of a vast design. At the same time, to our eyes, the creation of the Qin army, which may eventually total 7,000 figures—perhaps more—cannot be separated from what we understand of art, any more than we can dismiss the Tomb of Tutankhamen as a mere superstitious display of wealth.

If such a royal burial was a display of art as well as industry, Qin's unification of language was an even more important contribution to art. For calligraphy is at the heart of all the higher forms of Chinese culture. Indeed, it is more, for in Chinese history writing was inseparable from authority. What in fact the first emperor did was to systematise Seal Script, which first appeared about 1200 BC, and was thereafter used for formal occasions and documents. At about the same time, 200 BC, as a result of centralisation, Clerical Script began to emerge, for use in the keeping of records and all the actions of the government. From about 200 AD, Regular Script was developed, for general educated use, which became the basis for printed characters and is still the most widely used script today. However, during the fourth century AD a Cursive Script emerged, which proved to be the most effective form for artistic expression. Chinese traditional art history teaches that the most beautiful of all calligraphic documents emerged at this time, the work of Wang Xizhi (303–361), his teacher, Lady Wei (272–349) and his son, Wang Xianzhi (344–388). We cannot judge the merit of this view for the work of all three has totally disappeared. It is just possible that some will re-emerge; in the meantime, the only authentic fourth-century writing is a scroll letter composed by Wang Xun, a nephew and student of Xizhi, five lines of which survive as part of a much later document. This is the style that has been most persistently imitated by art calligraphers ever since, though some practitioners of the art regarded it, perversely, as 'too good'.

Writing was power, and the mandarin class of officials, in their nine grades, which ruled China until the twentieth century, whatever dynasty was on the throne in Peking, was essentially one of writer-scholars. China, in fact, was a cathedocracy, ruled from the scholar's chair. All officials had to be literate, and were recruited by a series of examinations, graded in difficulty according to the responsibility exercised. The higher exams demanded a deeper and more extensive knowledge of Chinese literature, the ability to contribute to it by writing poetry and, not least, expertise and artistic skill in calligraphy. As the summit of the administrative pyramid was

approached, ancient rituals, involving all the higher arts and religious texts and prac-tises, became more important, and the most important official of all was the Minister of Rites, or prime minister, who was closely associated with the emperor as supreme ritualist. Writing and associated arts were thus above all an activity of the élite, and the ruler himself or herself was expected to display calligraphic skill of a high order, and to write poetry: orders to subordinates were often issued in the form of poems, not always very 'accessible' ones either. It is significant that the last 'emperor' of China, the Communist potentate Mao Zedong, issued specimens of his calligraphic skill and composed poetry.

If writing was power, beautiful writing was greater power. In the West, painters were sometimes fussy about their brushes and the way they used them, varying from Rubens's vast, sweeping strokes to the systematic background scumbling of David, for example. But all this was elementary stuff compared to the Chinese philosophy of the brush, which was used for both calligraphy and painting. Brushes were made of bird feathers or of animal hair, chiefly rabbit, fox, wolf, goat or deer. The brush was the first of the Four Treasures of the Study, the other three being paper, ink and inkstone. It is likely that the Chinese thought more seriously about the brush and what it could do than about any other thing they made, and it is amazing how long some of them were in use. One brush which survives dates from about 500 BC and another from 200 BC. Both have lost their hairs, however. There is a beautiful brush, also hairless, of wood coated with carved lacquer, from the late sixteenth century, in the Victoria and Albert Museum. The early brushes which do survive with their hair intact have low ink capacity and make one wonder how it was possible to create high art with them. But the brush was art itself and was sometimes signed by its proud maker. A large number of technical terms was applied to it: its head was the 'heart' or 'pillar', there was an outer layer of 'cover' bristles, surrounded by a 'skirt', and there are also references to its 'skeleton'. Art theories laid down that in the perfect brush 'the heart is hard, the cover-bristles fine, the point like an awl and the whole is smooth like a mirror'.

There is an enormous literature in Chinese, extending over nearly two millennia, about the way the brush should be dipped in the ink, the manner of holding it, the angle of its application, which produces two distinct methods, known as centre-tip or oblique-tip, and the precise way in which the brush is employed to begin, continue and finish a character. Each character has an 'essential' art form of its own. Unless the rules are strictly followed, the calligraphy is defective, and seen to be. In follow-ing the rules, the writer also employs his mentality, philosophy, emotions and per-sonal character, all of which are exposed in the strokes. Hence the quality of a poem depends only partly on its contents; the way in which it is put on the paper is at least as important, and can be perceived clearly by the close student of art and literature. Chinese theorists refer to the 'heart prints' and 'mind prints' of the calligrapher, reflecting his or her intentions and state of mind.

Since in Chinese theory writing is merely a systematised form of painting—or perhaps we should put it the other way: painting is a less formal kind of writing—the rules of calligraphy inevitably spread over the art of painting. The painting of persons, animals, flowers, birds, trees and landscapes involved the truth of nature, but it was never (as it might be in Western realist art) the truth, the whole truth and nothing but the truth. Quite the contrary: Chinese art, like its religion, was always retrospective, there was always a sacred element in works by earlier masters, so their way of seeing nature was part of its truth, and rules were drawn up accordingly. They affect, for instance, the depiction of certain flowers, which was akin to a ritual—the way in which the trunk, the branches, the leaves and the fruit of trees were painted, and the methods of rendering grasses, moss, butterflies and bees. If an object was 'worth' painting, there was sure to be a rule, or various often-conflicting rules, about how to paint it. Or instruction manuals laid down different ways to suit different moods, occasions and artistic purposes. One writer from what we would call the Early Modern period (Ming dynasty), Wang Lo-Yu, lists twenty-six ways of painting rocks and twenty-seven ways of doing leaves. In one way or another the Chinese wrote more extensively about art theory and techniques than any other culture, and instruction manuals became more comprehensive as the centuries rolled by. They eventually included wood-block pictures demonstrating the points made, which in due course appeared in colour. But behind all this practical and detailed advice lay a philosophy of art which saw the written word (as did the Jews also) as more than a visual means to convey information, being an entity in itself with living, quasi-religious characteristics. Equally the brush was not a dead object but, wielded by the hand of the artist, became part of the body, a living extension of the hand, so that it was proper to refer to the 'flesh', 'bone' and 'sinews' of the brush and how they were used.

Many of the distinctions we make in the West, our compartmentalisations, seem artificial or meaningless in terms of Chinese philosophy, which turns art, religion and politics into a continuum. And, just as calligraphy, painting and poetry form a continuous unity, and indeed are customarily found together on a single sheet of paper, created by the same person, so various aspects of art, which we would separate, fall naturally together in Chinese custom. They found it hard to accept that an artist would not collect art, or that a collector would not practise it, or that an artist-collector would not study the history of art and write about its philosophy, in poetry as a rule. The central importance of unity and continuity in art is well exemplified by the life of Dong Qichang (1555–1636), who flourished towards the end of the Ming period and left a deep impression on Chinese culture then and since. He was probably the most important writer on Chinese art, and its most influential historian until quite modern times. He not only classified and evaluated the various historical periods, especially in painting and calligraphy, but pinpointed basic distinctions between the Northern School and Southern School and other regional categories which remain valid even now. Yet he was also a distinguished poet, a calligrapher of

exceptional skill and one of the best landscape painters of the Early Modern period. Examples of his work can be seen, for instance, in the Walter Hochstadter Collection, New York, in the Nu Wa Chai Collection and in the British Museum. Dong was a great collector, and had also taken opportunities to inspect paintings and calligraphy of the highest class in most parts of China. In his poetry and other writings, he laid down his philosophy of art. He agreed that painting, calligraphy and poetry were the summit of civilisation, but he put in a special plea for landscape. This should not merely imitate nature but express the peculiar intrinsic qualities of brush and ink in realising its inner essence as well as its outward appearance. Art was thus expressive, but it was expressive of the artist as well as of the things he depicted. And to be meaningfully expressive, the artist must be a man of calm reflection, of superior moral character, of wide education, high intelligence and deep understanding of what life and nature were all about. These qualities took many years of application to acquire. Such civilised men had to be free both of material ambition and of the vulgarity of the people; they should be unsentimental (though with refined sentiment), and should practise their art serenely, scorning any desire to impress by flashy work.

What makes this approach more significant is that Dong was not a private person but an official of the highest class. For a time, indeed, he was President of the Board of Rituals and effective ruler, under the Emperor, of the entire country. Here again we come across a Chinese continuum, of art and government. It may be—there are hints of it at all periods—that political parties or factions at court were also literary and artistic factions. Dong eventually fell from power, or chose to retire from it, and instead became the Examiner-in-Chief of his home province, which still gave him considerable patronage over recruits to the mandarin class. His poems and writing exercises about the pleasures and consolations of retirement from the bustle of politics in the capital, to a more reflective existence in the countryside, are moving, or designed to be. We would like to know more about this polymath and Pooh-Bah because it would help to explain how the cathedocracy was run and how art and politics interacted at the highest level.

However, we do know a certain amount, and it is disconcerting. In 1616, Dong's compound was surrounded by an enormous mob of the local inhabitants, and after prodigies of valour on both sides, it was successfully stormed, the house burned to the ground and all its contents, including Dong's collections, destroyed. In the subsequent inquiry, it emerged that the mob had been inflamed to violence by Dong's high-handed behaviour and cruelty over a long period. He had kidnapped, imprisoned and raped two beautiful young servant-girls belonging to a high-born local family. When two senior lady members of this family arrived at his compound to complain and get the girls back, Dong, helped by one of his sons, and his servants, had seized these elderly dames, grossly insulted and ill-treated them, flung them out of their sedan chairs and then hurled them into the river, from which they escaped with difficulty. Other complaints included oppression of the peasants, cheating the townsfolk, tax

evasion and general lawlessness. It is true that we do not exactly hear Dong's side of the story. What we do know is that Dong's friends in central government ensured that no action was taken against him: on the contrary, it was his assailants and critics who were investigated. But the whole episode casts a suggestive light on the real character of this philosopher-artist-historian-politician, and leads one to think that the order and serenity which Chinese art, at its highest level, sought to create sometimes concealed all kinds of incongruous happenings. It also suggests that Mao Zedong's habit of writing poetry and calligraphic characters, while he was responsible for more violent deaths than any other man in history, was also part of a Chinese continuum.

As we have noted many times in this book, art can never be completely dissociated from technology, though aesthetes often try to do so. Gentleman scholar-artists in China tried hard to push technology into the background, placing arts which were the least susceptible to technological change at the apex of the pyramid of esteem. The technology of calligraphy and painting (as of poetry) did not change in China for thousands of years. The Chinese written language itself was artistic rather than efficient. By rejecting the alphabet it lent itself to superb calligraphy but made widespread literacy difficult and the development of cheap printing, as in fifteenth-century Europe, impossible, though the Chinese were first in the field in producing both paper and type. Equally, artistic importance was never accorded to areas in which China was technologically advanced: bronze-casting in the first millennium BC and pottery thereafter. The Chinese were the greatest potters the world has ever known but potters were excluded from China's artist élite.

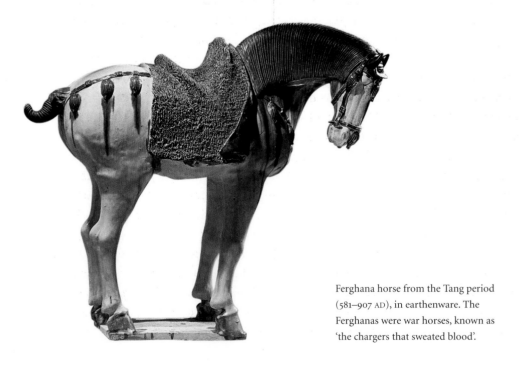

Ferghana horse from the Tang period (581–907 AD), in earthenware. The Ferghanas were war horses, known as 'the chargers that sweated blood'.

It is important to grasp the hierarchy of ceramics, which is the art of hardening clay by heat, having shaped it for use. It is almost the oldest human artefact, since clay can be made into pots by sun-heat alone. The Chinese were making high-quality earthenware—that is, unpurified clay, containing iron oxide which reduced firing-temperatures to about 800 to 1,100 degrees Centigrade—as early as 3000 BC. The shapes of the fine Black Ware pottery made in the early second millennium make it clear that the great ritual bronzes were modelled on earthenware vessels. But the bronzes were so impressive that, during the Shang and Zhou dynasties, 1600–221 BC, potters enjoyed less esteem than metal-workers and their designers. During the Han period, 206 BC–220 AD, however, the potters made a technological comeback. Earthenware found in Han tombs shows that potters had learned, by careful mixing of the clay with lead, to produce the first true glazes, coloured in shades of green and brown, and that enabled them to make handsome pottery figures, non-porous drinking cups or plates with pictorial raised reliefs. They also learned to move on from earthenware to stoneware—that is, pots shaped from material called secondary clay, which has been removed by nature from its rock origin and so acquired impurities, thus needing a higher temperature, 1,200 to 1,300, to bring about firing.

Stoneware offers more variety. Depending on the raw material used, to some extent under the potter's control, it can have a rough or smooth finish, be pale or dark in its colour (mainly yellows and browns), and opaque or slightly translucent. It can also be made non-porous, thus not requiring a glaze for use, and its satiny surface can then be highly polished. It will not take a lead glaze, for lead has a low melting point, but requires instead salt, alkaline, feldspar or other high-temperature glazing material. Chinese potters, about 100 AD, discovered a feldspar source which produced extremely tough glazes, sticking closely to the fired clay beneath, and achieving a magnificent olive-brown and grey-green lustrous finish. It is at about this point, we think, that the élite, while never conceding the right of potters to be true artists, began to take their work seriously and collect it.

Moreover, about 450 AD, the potters discovered how to make hard-paste or true porcelain of a brilliant white. This hard vitrification process is achieved partly by the mix of the clay, which contains flint, kaolin and china stone, as we call it, in China *baidunzi*, or 'little white bricks'. The unglazed pots are fired like cooking biscuits (hence biscuit-fired) at about 1,300+ degrees Centigrade, then dipped into the feldspar/lime glazes, and refired at up to 1,250 degrees, to obtain full vitrification. The body and the glaze are similar in composition, which gives unity of substance, and the result is very fine grained and translucent (unless the potter wants opacity). Hence at a time when the Roman Empire in the West was disintegrating, and the arts were in precipitous decline, Chinese potters were turning out a product which for sheer delicacy had never been seen in the world before. It was highly adaptable too, for although the nature of the clay-and-glaze mix produced white rather than coloured forms, the vitrified ware can be gilded or enamelled after the second

firing, and the decoration then fixed by firing again at low temperatures. Thus the tea service, in all its glory, and countless other superb artefacts, were born.

Ceramics is essentially a technology-led art, for without control over the substance, the designer can do little. But what is control? In some ways, the manufacture of high-quality ceramics is akin to steel-making in its early days. When Andrew Carnegie began to build up U.S. Steel, he knew nothing about the process and quickly discovered that the actual foundry-masters knew nothing either, in all essentials. They could not explain what exactly went on in the furnace or why it produced the material it did. Not until he recruited expert chemists from Germany and put them to work, was a scientific analysis and explanation of steel-making produced, and this of course led to huge improvements in the process. The Chinese potters never understood the chemistry of their trade, and from the invention of porcelain in 450 AD to the decline of the industry in the nineteenth century, they proceeded entirely by trial and error. The secret lay mainly in their kilns, and the way their design produced the right temperatures and draught. A comparatively sophisticated Chinese kiln has been discovered at Banpo, Shaanxi Province, which may go back as far as 5000 BC, and shows that a great deal of ingenuity, using endless experiments, was already in operation. We can connect the various improvements, and colours of fine earthenware, and the evolution first of stoneware, then of hard-paste porcelain, with evolving varieties of kilns which have been identified and examined. Once the kiln was properly sited, and siting was vital to ensure the colour required in many cases, and capable of producing the right temperature, the potter could start to experiment, first with his clay compositions, then with his glazes, finally with repeated firings.

From about 200 BC potters built dragon kilns: brick tunnels built up the side of a hill, with a fire at the bottom but with a series of holes in their length to allow additional stoking for particular pots, according to need. One medieval kiln was over 200 feet in length and was used to fire up to 50,000 pieces at a time to temperatures of 1,250 degrees Centigrade. The potters learned to design and build kilns to suit the nature of the ware they were producing, and to use them in a variety of ways to create colour-effects. During the Ming period, 1368–1644, when some of the best ceramics were produced, potters developed a variation of the dragon kiln called a step kiln; this was a rising series of separate firing chambers, each of which could be separately stocked and its temperature controlled with a remarkable degree of accuracy, for an exact temperature of 1,280 degrees Centigrade was required for the most translucent porcelains. An alternative was the egg-shaped kiln, which has a single enormous chamber, like a teardrop, with a high funnel poking out of it at one end and the furnace at the other. With a controlled temperature range of 1,000 to 1,320 degrees C, it could fire a great range of products together, and at the same time ensure high productivity because it could be fired and then cooled in two days. This design was so successful that it was still in use in the 1950s, when oil and coal down-draught kilns

Brushpot cylinder (on the left), celadon glaze, beautifully carved, made in the years 1662–1722, and a jardinière, pale lavender glaze, from the same epoch, carved with a pair of dragons.

finally came into use. Because the potters could produce routine high-quality ware quickly, cheaply and in large quantities, both for the domestic and export markets, they could use the profits to finance the laborious production of specialty art-ware, on which their claim to world importance is based.

For over 1,000 years, Chinese potters produced ceramic masterpieces in an astonishing variety of shapes, colours and decorative modes. Some of their finest effects were achieved by accident and could never be repeated. Indeed, exact repetition was impossible in many wares, so each piece was unique. The potter rarely knew what he would discover when the kiln cooled. There were constant disasters, and heart-lifting surprises. About a thousand different types can be distinguished. In the Tang period (618–907), there were marvellous tomb-figures—horses, alone or mounted, camels, spirit-soldiers, courtesan entertainers. A howling camel in the Shaanxi Provincial Museum carries on its back a variety of provisions for the rider, and its hair and mane are superbly crafted. The Song period, 960–1279, produced improved versions of the magical white porcelain first seen in Tang times, but added to them wares in deep ivory, blue-green of extraordinary delicacy, moonlight and midnight blues, and an entire family of green celadons, an almost mythic shade of willow, first produced in China. These carefully prepared colours were sometimes varied by splashes of crimson and other strong tints, which the potter added with trembling fingers, not sure what would happen to it in the kiln. Some of the finest multi-coloured results, initially at least, were pure chance, or deliberate accident. These colours were laid on finely carved designs of flowers and animals, and sometimes they were enlivened by effects known as 'partridge feather', 'hare's fur', 'strong liquid', 'wine' and 'oil spot'. The British Museum has a Sung narrow-necked vase, dated about the time of the Domesday Book, of such exquisite shape, surface and colour as to suggest that these

potters probably knew more about the mixing of glazes and control of kiln temperatures than any of their fellow craftsmen, before or since. There is no decoration at all—the art lies entirely in form and technology management.

By contrast, the Ming period (1368–1644) produced every conceivable kind of decoration, helped by importation of special cobalts from Persia and Afghanistan which were used for 'underglaze' paintings in blue. Constant experimentation produced miraculous shades of blue, contrasting with the purity of the whites, and later every kind of polychrome effect was secured with dazzling reds, yellows and a special kind of turquoise which has never (until recent, chemical, times) been equalled outside China. It was at this point that landscapes, populated by dragons and birds as well as people, made their exciting appearance, to dominate decorative China-ware to the end. At the same time purity was maintained with deep reds and blacks for stoneware, especially finely shaped teapots, and what the French called *blanc-de-chine*, an off-white so translucent and luminous as to make any finely shaped vessel seem a masterpiece. There were figures as well as dishes, and colour-groups: *famille jaune* and *famille noire* vases, *famille verte* ornaments, and specially intense colours produced by very high-temperature firings: wondrous deep *sang-de-boeuf* and a delicate yellowy pink known as 'peach-bloom', plus the sinister but irresistible 'mirror-black', with its bottomless depths of lustre. Fine-quality work was often signed. Thus a thirteenth-century ceramic pillow, with a dramatic scene from the 'Romance of the Three Kingdoms' on its top, is stamped 'Made by the Wang Family of Fuyan'. And some of the finest ware came from specific towns, or even particular kiln families.

Jingdezhen, in Jiangxi Province, produced over hundreds of years masterworks such as the superb fourteenth-century wine-jar, with a drama painted in the purest cobalt blue, which is now in the Victoria and Albert Museum.

High-quality porcelain enabled China, at times, to become the world's leading exporter of art-work. Trade with Europe in silk and spices had been intensive even in Roman times. In the eighth century AD a special ministry, called the Office of Trading Junks, was established in Chang'an, the Tang capital, then by far the largest town in the world. Under the Ming dynasty, though trading policy was erratic—at times all exporting was forbidden—high-quality ware was sent abroad as diplomatic gifts in huge quantities, 19,000 porcelain pieces in the year 1383 alone. With the creation of the English East India Company (1600) and the Dutch version two years later, Chinese ceramics began to reach Europe on a regular basis, often specially manufactured to meet Western

Green-glazed and enamelled bottle-vase (9 inches high), with red lotus and peony sprays, made in the years 1662–1735.

tastes. It reached its height after 1729, when Canton (modern-day Guangdong) was designated by the imperial court as a trading centre. Investigation of the wreck of the *Geldermalsen*, sunk in 1751, showed that a single vessel might carry up to 50,000 pieces. The effect upon the European arts was wide, deep and continuous. Chinese porcelain was first successfully imitated at Florence in 1575, and the Dutch version of it, Delftware, became a European best-seller in the early seventeenth century, quickly followed by factories in England and France.

Chinese originals were collected and housed in *cabinets chinois*, lined with shelves and vitrines, and there were even porcelain rooms decorated *à la chinois*—Mary II had one at Hampton Court. From about 1710 the Sèvres factory in France began to turn out large quantities of hard-paste porcelain, used in panels to decorate rooms at Versailles and other royal and princely palaces. At Naples, one of the royal palaces had a chamber lined with 3,000 porcelain pieces, with painted chinoiserie figures on them, made at the local Capodimonte factory. The various Chinese styles invaded wallpaper and furniture, and to see the results one can go to Chatsworth to inspect its misleadingly entitled Japan Closet (the word refers to Chinese lacquerwork) or to the Victoria and Albert Museum to examine the magnificent examples of 'Chinese Chippendale', as it was called, including a bed in red, black and gold lacquer, made by the Linnell family. Both Watteau and Boucher designed wallpapers in the Chinese taste, including a special type featuring mischievous monkeys known as *papier singerie*, and Chinese motifs continued to feature in European decoration until superseded by ideas from Korea and Japan in the mid-nineteenth century.

The distinctiveness of Korean art is still little appreciated in the West, even in America, though the Brooklyn Museum, New York, has a fine collection of Korean ceramics. Indeed, it is depreciated by the Chinese and Japanese too, who tend to regard Korean arts as derivative of their own systems, though there is evidence from all periods of Korean individuality, and a good deal of proof that Japanese cultural imports from China often came through Korea and were transformed in the process. Anyone who goes to the superb museums in Seoul, especially Kansong Art Museum, the Ho-Am Art Museum and the National Museum of Korea, is aware of the high quality of Korean metalwork and ceramics and, especially, of the paintings produced in Korea from about the sixth century AD onwards. In particular, during the Early Modern period, towards the end of the seventeenth century, Korean artists abandoned the Chinese system of landscape painting, based upon formulae of the type preferred by Tung Ch'i-ch'ang, and took to open-air life paintings, known in Korea as *chin'gyǒng*, or 'true

Qing dynasty baluster vase (lustrous glaze), in copper red, from about 1736–95. This enchanting object was designed to hold a single stem of cherry blossom.

view'. One artist, called Chŏng Sŏn, developed this style to perfection. It is not exactly realist, since the landscape is studio-composed, almost like a Western *capriccio*, but all the individual elements in it are entirely naturalistic, especially the trees which are clearly taken from life-studies. In such works as *Cool Breeze Valley* (Kansong), which is watercolour on silk, or *Dwelling on Inwang Mountain* (Kansong), watercolour on paper, Chŏng established himself as the most powerful and yet also sensitive tree-and-foliage painter in the entire Orient.

Korean figure-drawing was also very fine, especially in the eighteenth century—see the Kansong's *Young People's Picnic Journey* by Sin Yun-bok (watercolour and ink on paper), which has a liveliness and charm rarely found in Chinese genre art. There is an elegance too in Korean ink-painting which is comparable to the best Chinese work: the Seoul National Museum possesses a fifteenth-century ink-painting by Im Hŭi-jae, called *Ink-orchid*, which is among the finest such things in any museum, though it may well be there are even better examples in private collections, where much of the older Korean work on paper is found. What we can deduce, from a study of Korean paper-watercolours and ink-drawings in the seventeenth and eighteenth centuries, is that the extraordinary flowering of Japanese graphic art from 1750 onwards had a large Korean input.

Japanese art took many forms, most of them (as in China) practised by and for the élite. But in the eighteenth century, under the influence of the fantastically popular theatre of Edo (Tokyo), and the development of cheap colour printing, it became highly demotic and transcendental, to the point when it could be understood and relished all over the world. Actor prints can be dated almost precisely to the year 1765 (infamous in the American colonies for the introduction of the Stamp Act). The innovator here was Mamoru Buncho, who flourished from 1750 to 1790. He made his name by elegant and salacious presentations of a famous tea-house waitress called O-Sen, but then took up doing well-known actors, in the 'cross-eyed, fierce-mouth' style. He was so good at getting their appearance right that, for the first time, he could sell prints without names attached. A group of them made up, in 1770, one of the best of Japan's colour-print books, *The Stage Fans' Bumper Gallery*. The colouring was unsubtle, mainly yellow, green, orange, mid-blue and sometimes red, but the printing was clear and the actual portraits vivid, requiring no commentary, then or now. The drawing was portraiture, in one sense, caricature in another, and the artists liked to create names for themselves, as cartoonists always have. Thus we get Shunsho, Shunei, Shunro, Shunjo and Shunko, and most artists used more than one name. Katsushika Hokusai (1760–1849), the greatest of all Asian artists, used at least twenty, one of them being Shunro.

Who was Hokusai and whence did he come? It has to be remembered that he was an older contemporary of Turner, and lived almost as long. By the time he was born, Japan was ceasing to be a hermit state, closed to the outside world. Another

century was to go by before it would deliberately enter the modernising world and deflect colonisation by becoming a great military power, but by the second half of the eighteenth century it was absorbing intermediate technology, including art production, in growing measure. What the Japanese called 'Dutch learning' was studied by artists, who now knew about the 'vanishing point' and basic perspective, something the Chinese had discovered for themselves a millennium before, and had decided was unimportant. In Hokusai's childhood, the artist Utagawa Toyocharu (1735–1814) founded a school of landscape artists who used perspective, and the technique, employed subtly and almost invisibly, but usefully, entered the repertoire of Japanese artistic tricks at this time. Western influences were apparent too in the improved techniques of colour reproduction and book printing, which brought high-quality art within the means of thousands of ordinary citizens of Edo and thus ensured a livelihood for a growing number of artists.

These were modern, hard-working men, spouting none of the nonsense of the Chinese élites. Torii Kiyonaga (1752–1815), the best of the new engravers working in the colour-print book trade, was, it is true, a fourth-generation adopted member of the Torii family of artists. But none of them had made much money and he had to earn his living chiefly by painting signboards and dashing off theatre posters. He lived near the big fish-market, where his father was a caretaker in a set of tenement houses, and he spent all his life among the poor. Yet he made himself a master of what were termed 'famous beauties', fashionable or at least fashionably dressed ladies, whom he drew and painted with astonishing elegance, not unlike Gainsborough.

Another great artist who rose from a humble background to specialise in 'beauties' was Kitagawa Utamaro (1753–1806). He had hitherto specialised in insects, and his volume on this subject, published in 1788, recalls similar studies by Dürer. He was thirty-nine when Kiyonaga suddenly retired (as Japanese artists often mysteriously did, without explanation), and he immediately turned to 'beauties' to fill his place. He did them in many different ways: in boating parties, promenading across exotic bridges, in kitchen and bedroom scenes, in diptychs and triptychs (such as his

Tsujigimi, a 'famous beauty' of Edo, woodblock from the 1790s by Utamaro; what is known as a 'large head' portrait. It had a profound effect on Mary Cassatt.

Catching Fireflies in Boston, Museum of Fine Arts) and in a superb album called *Physiognomies of Ten Women* (1794) which for sharp and sometimes uncomfortable observation puts him in the class of his younger contemporary, Thomas Rowlandson. There were bird specialists too, such as Kitao

Masanobu (1761–1816), whose *Call of the Cuckoo* was a much-prized print, though it made him little money. He lived by running a cake shop, selling tobacco and pharmaceutical products. Another bird man, Kitao Masayoshi (1764–1824), also found it hard to live by art, though he was incredibly industrious, producing over 160 print-books in his short life. Art was not only badly rewarded but risky too. Utamaro broke the law which protected the privacy of the élites, by printing names and crests on his drawings, and found himself in gaol. That was the end of him.

Another modest and humble artist was Andō Hiroshige (1797–1858), son of a fireman, a prolific class in a city built of wood and paper where fires broke out every day (not to speak of the frequent earthquakes). He was the Japanese topographical artist *par excellence*. His set, *The Fifty-three Stages on the Tokaido Highway* (1833), followed by *The Sixty-nine Stages of the Kiso Highway* and *One Hundred Famous Views of Edo*, represent a body of work unrivalled by any European artist then working, even those (like the young Thomas Girtin) who tried to live by painting views of Paris or London for panorama machines or other quasi-mechanical entertainments.

Hiroshige's *Waitresses Soliciting Travellers* (1833–34) is one of hundreds of full-colour prints depicting every aspect of travel in early-nineteenth-century Japan.

But he could also do superb bird-and-flower paintings, such as his *Red Plum Blossom and Bird*, one of the treasures of the Boston Museum.

Against this frenzied background of hard-working activity by a multitude of gifted men (women painted too but their work was never allowed to be identified), Hokusai stood out on account of his long life

spent in art—about seventy years of drawing and painting—his extraordinary versatility, his arrogance, *chutzpah*, impudent sayings and sheer ebullience. He started early but was a late developer, being content with actor prints, under the name of Shunro, until he was thirty-four. He then did 'beauties' and ghosts (another favourite type), calling himself Kako, and was nearly forty by the time he began his mature career as Hokusai, specialising in landscapes like *Eight Views of Edo*. Like Watteau and Hogarth, he used theatre as a springboard to what he saw as the high art of animated figures. Unlike Turner, who could do landscapes but was hopeless at figures, Hokusai could do both, superbly, melding them together in perfect harmony. And, like Turner, he delighted in weather-effects. This is one reason why, next to Hiroshige, he is the most popular landscape painter among the Japanese, because Japan is a country of weather extremes, being rainy, windy and turbulent, no two consecutive days alike.

Hokusai loved nothing better than to sketch from life beauties, or ordinary working women for that matter, having their kimonos blown and hair dishevelled by a sudden squall of wind or a shower, or getting wet in a ferry or on a punting picnic, or picking up shells on a damp beach. He is best known in the West for his *Thirty-Six Views of Fuji* (1823–29), a set of forty-six prints based upon open-air sketches around Japan's magic mountain. The most famous of all is *The Wave*, almost an abstract form towering above the tiny volcanic cone, but this is not the best of his work by any means. He is strongest when he is close to the truth, less sensational and concentrating on the details of human behaviour and nature. The best print in this fine series is *Fuji Seen from Mishima Pass*, where the group of bewildered travellers stretch their arms round giant trees, which the artist sketched into the foreground.

Hokusai was quite clear that art was a difficult business and that he had only got the hang of it late in life, long after his *Fuji* series. When aged seventy-five, he wrote, dismissing his prints completely:

> Since the age of six I have had the habit of drawing the forms of objects. From about fifty I have published my drawings, but none was of much value until I was seventy. At the age of seventy-three, I began to get a slight grasp of the forms of birds, animals, insects and fish, and how grass and trees grow. When I am eighty my art may improve, by ninety it may be really worthwhile, and at a hundred divine. At a hundred and ten every dot and stroke will live.

This is joking and boasting, of course. But we can see what he means. From 1814, Hokusai, who was in his mid-fifties, began publishing his drawing-books, the *Hokusai Mangwa*, fifteen of which appeared in all, some long after his death. Together with individual prints they constitute both an extraordinary record of Japanese life and an inventory of the draughtsmanship of this consummate artist.

Old Man with Hammer and Mice by Hokusai, who showed greater powers of draughtsmanship than any other Japanese artist, especially in his studies of life in the streets.

Hokusai was of course a contemporary of Goya, and the two men had much in common, including an omnivorous interest in, and a huge capacity to sketch, the real activities of human beings, together with a vivid imagination for inventing them, and a sardonic, not to say black, sense of humour. He was as fond of drawing women washing themselves, or their clothes, as Degas, and he liked to show them putting on make-up and brushing their teeth too: the background was as likely to be a palace as a brothel. He was fond of music, or rather of drawing musicians trying to perform: one of his best drawings (Melbourne, National Gallery) shows an agonising old man singing lustily to a young, fascinated girl—possibly a self-portrait. Palanquin bearers fording a difficult river, men fishing, erotic drawings including two octopuses performing acts with a woman pearl-diver, a multitude of stormy and placid seascapes with figures, children playing games, blind men crossing a river, men training monkeys, dinner parties and drinking scenes, women and men bathing and scrubbing, theatre queues and buskers, boys jeering at drunks, and drunks making nuisances of themselves in tea parks—Hokusai recorded all these activities, punctuated by occasional scenes of tremendous phenomena in nature, such as whirlpools and earthquakes.

When he drops any attempt at stylisation or mannerism, and draws strictly from life, Hokusai is as good as Goya, sometimes better. Indeed, his cumulative picture of Japanese life in the early nineteenth century is just as rich and evocative, and one suspects closer to the strict truth than the picture of Spain presented in Goya's private notebooks. Our only complaint is that not enough of Hokusai's life-drawings have survived. But those that did had a profound influence on Western art, and continue to do so.

22

THE WATERCOLOUR
AND ITS GLOBAL SPREAD

Whether J. M. W. Turner (1775–1851) ever studied Hokusai's work is conjecture. They shared a fascination for atmosphere and its effects on landscape, and each had much to teach the other. But Turner never went further east or south than Italy. Some artists went further than this even in the eighteenth century. Thomas and William Daniell visited India in 1786, and during the years 1795–1808 they put out an enormous work, *Oriental Scenery*, in six volumes, with 144 colour plates, which brought Indian scenes to the European public for the first time. The English, in particular, were much more interested in what India looked like than in its customs, art and religion, which they found repulsive. The work of the Daniells, which was detailed, exact and charming, detonated an explosion of India-sketching, among visitors and members of the Indian administration and army, the delightful results of which can be seen in the vast art collection of the Indian Office Library in London. George Chinnery (1774–1852) also went to India, in 1802, but never came back, pushing on to Canton and recording Chinese life with all the minuteness with which the Daniells encapsulated India.

Such artists, travelling around difficult country, made open-air sketches, using watercolour, ink and pencil. The pencil, or graphite, was an English specialty, for until the nineteenth century plumbago, from which it was made, was found only in Borrowdale, Cumbria, and was a closely guarded trade. From the late seventeenth century, artists made increasing use of graphite, which was handier for line and tone than chalk or crayon, especially for landscape. The English employed it in conjunction with watercolour, using it to produce a faint outline, which then disappeared as the colour washes were applied. It was held in various forms of pens (hence its name), but this was a wasteful and unsatisfactory method. In 1794 the French minister of war Lazare Carnot, finding English graphite scarce, and even its German ersatz substitute made of graphite dust, sulphur and glue, hard to get, asked the thirty-nine-year-old inventor Nicolas-Jacques Conté to design a graphite-efficient pencil. Within a year this ingenious man, himself a frustrated artist, had produced the kind

of pencil the world has used ever since, with a lead-plumbago centre and wooden walls, which can be cut away by knife. This was the instrument Ingres used with such subtle skill for his pencil portraits in Rome. The centre portion was soon composed of a mixture of milled graphite and china clay, kiln-fired then dipped in wax, to increase smoothness. Since the mixture could be varied, the English, when they adopted the new pencil, devised a range of pencils, depending on the proportion of clay in the mix, which went from 1 to 8 'Hard' and 1 to 8 'Black', H and B, plus number, being stamped on the wood. Architects and design-engineers used H, artists the Bs.

Watercolourists pounced on these invaluable new tools. They also took advantage of improvements in paper. In about 1750, the English printer John Baskerville, dissatisfied with the rough 'laid' paper produced by a mould, demanded, and got, a finer kind by persuading the manufacturers to use a wire mesh, which was termed 'wove' paper. As a result, by 1800 the watercolourist could chose between a score or more thicknesses, textures and grades of paper, which he could buy in huge sheets, of up to 6 feet in length, and cut to size. Or he bought them handily stitched together in cloth-bound books for travelling. Some twenty-three of Turner's sketchbooks survive. Turner also took advantage of a key development in 1780, when the firm of Reeves produced an alternative to viscous watercolour paints supplied in tubes, like oil-paints, and designed a box containing small hard cakes, which became instantly usable by dipping the brush in water. We have several of Turner's paintboxes, showing the development of this handy aid over half a century.

It was in the second half of the eighteenth century, helped by these simple but revolutionary changes in technology, that a British school of watercolourists emerged. By right it ought to be called the Windsor school. The pioneer was Alexander Cozens (1717–1786), who was drawing master at Eton College and, from 1778 to 1784, taught two of George III's sons at nearby Windsor Castle. He invented a way of composing monochrome landscapes by what he called 'blot drawing', using ink blots to stimulate the imagination, setting out his theory in *A New Method of Assisting the Invention in Drawing Original Compositions in Landscape* (1785). His son John Robert Cozens (1752–1797) pushed landscape watercolours further by undertaking special sketching trips to Italy and Switzerland, in company with such connoisseurs as Richard Payne Knight and the millionaire-collector William Beckford. The younger Cozens first established the procedure of placing many thin, superimposed watercolour washes on top of a pencil or water-resistant ink outline, which became the essence of the English watercolour school.

Two more watercolourists connected with Windsor were Paul Sandby (1725–1809) and his brother Thomas, who was Deputy Ranger of Windsor Park. They lived there in the open, Paul in particular producing over two hundred views of Windsor Castle and its surrounds, many of which can be seen in the Victoria and Albert Museum and the Royal Collection. Most of George III's children, including the Prince Regent, became competent watercolourists, and Queen Victoria (and her children

but full of faith. A fellow artist, John Linnell (1792–1882), was responsible in 1821 for commissioning Blake's greatest work, his watercolour illustrations for *The Book of Job*, completed in 1826, for which he received £150 for twenty-two engraved plates and the copyright, the largest sum he ever earned. Like Tung Ch'i-ch'ang, Blake was a poet as well as an artist and calligrapher, and drew no distinctions between these forms of art. In the late 1780s he developed a system he called 'relief etching', which enabled him to produce durable copperplates of text and drawings, in as few or as many copies as he chose, so he could become his own publisher and hand-colour the prints to order. Although he could colour-wash almost as well as Towne and Rowlandson when he chose, he actually used watercolour quite differently, to build up a nutty, dense, often luminous and rich texture of paint, which has some of the power of fresco. He invented a medium he called fresco, which was in fact a glue-based tempera, and this is how he produced his famous painting of the Canterbury Pilgrims (Glasgow). But all his finest effects were produced in watercolour or in prints based upon it.

At Yale there is an immense collection of Blake's work, chiefly printed in books hand-finished in watercolour, and it is not easy to grasp his mind and art without seeing them. Copy F of his poems *Songs of Innocence*, with its spectacular colours,

both bold and subtle, stands high among the world's hand-coloured books. Blake's output was vast and, now that it has been fully catalogued, invites deep study. For all his naïvety (he disliked soap and water, Kate explaining, 'You see, Mr Blake's skin don't dirt'), Blake had a gift for the striking image, which sticks in the mind. His monotype *Newton* is reproduced endlessly when science is discussed philosophically. His *Ghost of a Flea* is a standby for horror-illustrations, and almost equally frightening is his *Nebuchadnezzar* (all Tate Britain). On the other hand, his *Ancient of Days* is one of the few attempts, in the whole of art history, to present God successfully. Blake and his wife often danced about their London garden naked, to work themselves into an Adam-and-Eve mood. When

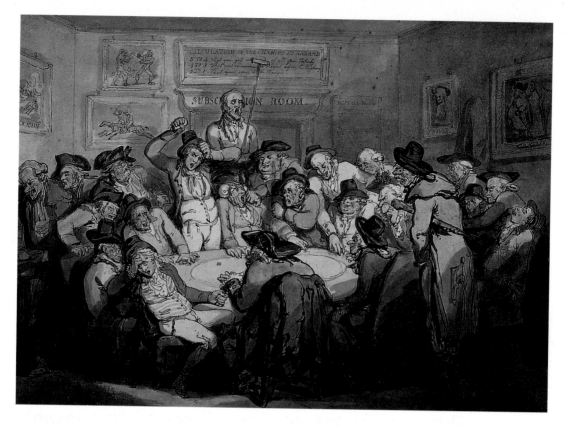

Rowlandson's *The Hazard Room* (*c*.1795) reflects his obsession with gambling, of which he was himself an addict, and a loser, forcing him to turn out pornography as well as his superb wash-drawings.

hundreds of which are superb, none contemptible, and which have been eagerly gathered into American collections, such as the Huntington Library, the Getty Museum in California, and the Yale Center. What is badly needed is a complete *catalogue raisonné*, and then we could proceed to a fair assessment of this much-misunderstood master.

William Blake (1757–1827) was an exact contemporary of Rowlandson, and it is a tribute to the versatility of watercolour that these two incomparable artists had nothing in common except their medium (both refused to touch oils). Blake's father made socks in Soho, and apprenticed his son to an engraver. All his life, Blake went deeper and deeper into the technology of hand-engraving and printing, and at the great London Blake exhibition of 2001 it was possible to see one of the machines which turned out his work. He trained his illiterate but willing wife, Kate, to help him, and together they painted, engraved, printed, bound and sold his books. Blake is often seen as unique but in fact there are important parallels between him and other great painters. Like his contemporary, Goya, he saw no absolute distinction between the real world of nature, which he copied exactly on occasion ('I can look at the knot in a piece of wood until it frightens me,' he would say), and the world of his imagination.

Both Blake and Kate were Christian fundamentalists. Before he began to paint, he would fall on his knees and ask for God's help. As he recounted to his friend George Richmond RA, '"When the vision forsakes us, what do we do then, Kate?" "We kneel down and pray, Mr Blake."' He saw himself often as Job, a man of misfortunes

insist on calling them) is not always easy. However, modern methods of colour reproduction of watercolours are now so accurate and sympathetic to the medium, that well-produced art books are now an acceptable substitute, particularly since they can be examined closely and in full light; rarely displayed watercolours in galleries are now spoiled for many by subdued, minimalist lighting.

The first of the masters was Francis Towne (1739–1816), from Exeter, often dismissed, then and now, as an amateur, but in fact one of the most innovative and exciting landscapists, whose genius is at last beginning to be appreciated. Towne loved mountains and monumental ruins, and his best work was done on the spot in the Lake District, Switzerland and Italy. His composition was superb, because he organised these large shapes into absolutely simple but subtly interlocking masses, which gave depth and importance to even his smallest works. He put the outlines in, very minimally but distinctly, and having got them right, he proceeded to cover them in plain washes, each of them smooth without attempts at gradation, but becoming complicated when overlapped. By these means he produced effects of pale sunlight and living shadow, often conveying a sense of movement as the clouds shifted, which have never been improved upon by anyone. Indeed, the magic of his art emerges the moment you try to imitate his effects. It is a secret, which he did not pass on.

Thomas Rowlandson (1756–1827) is linked to Towne by a similar gift for applying plain but subtle washes over ink or pencil outlines. Rowlandson is known for his humorous, sometimes outrageous and often erotic genre scenes—he engaged in outright pornography to finance his unconquerable gambling habit—and his skill in depicting grotesque men, horrible women and dazzling beauties has never been surpassed by an Englishman. But then, neither has his skill in getting a perfect wash on paper, the magic of which can only be appreciated when the sheet has been largely protected from exposure. His *Skating Scene* (Victoria and Albert), with its almost miraculous handling of pale washes, has a claim to be considered the best drawing produced in England during the eighteenth century and, as with Vermeer, you cannot detect how he actually got the paint onto the surface of the paper—it appears to fall like dew. The same skill comes out in two beautiful drawings, *Gambling at Devonshire House* and *The Sharpers* (both sold at Sotheby's in 1997), the first of which features the beautiful duchess and her sister, the second Rowlandson himself in the role of the Sharper. The boldness and cunning with which these two brilliant drawings were composed and finished, and the silky radiance of the washes, make them masterpieces.

Rowlandson was self-destructive and had some rum friends. He was heavily dependent on print-making to keep alive. He employed Rudolph Ackermann, who had a posh print-shop in the Strand, to sell his quality work, and a man called Tegg in the City to sell his porn. When he had the leisure, he did landscapes and village scenes too, chiefly in the West Country where he had a landowner friend, and these are of great interest and beauty. But as a rule he was too busy in London for such work, and managed, despite his dissipations, to produce, at a rough guess, over 5,000 drawings,

and grandchildren) carried on the tradition, her watercolours being in many collections and her box of paints (*c.*1840) on display at the London Royal Academy. At least three members of the British royal family paint in watercolours today.

The younger Cozens, alas, went mad in 1792 but his skills were passed on by a fortunate coincidence. He was treated by Dr Thomas Monro (1759–1833), chief physician at the London hospital for the insane, Bethlem or 'Bedlam'. Monro was an amateur painter and avid collector and patron, and when Cozens died in 1797, he not only arranged the enormous collection of watercolours which he left but encouraged young artists to learn by copying them at his house in Adelphi Terrace. Thus the Monro Academy came into being, the artists being provided with a free supper. Among those who took advantage of it were Turner, his friend Thomas Girtin, Paul Sandby Munn (1773–1845), Louis Francia, John Sell Cotman, members of the Varley family (John, Cornelius and William Fleetwood), William Henry Hunt and John Linnell, all of whom became important and distinctive members of the English watercolour school. Monro's influence, therefore, was great, for all these young men were poor and lacked teaching. The Tate Gallery has about five hundred of the 'Monro School' drawings, and it is almost impossible to tell with certainty which were produced by Turner, Girtin or others. More important, however, was their absorption of the Cozens techniques, their mutual help to each other, and the way in which their competing together accelerated their own evolution. Seldom in art history has such a circle of talent been formed.

Why was the English watercolour school so important? There are four reasons. First, they aroused a wide, and eventually global, interest in landscape as such. Second, they improved landscape painting by making it a universal practise to sketch in the open air, usually with watercolour, thus producing material which could be turned into large-scale oils in the studio. Third, they encouraged a much more subtle and accurate study, and reproduction, of natural colour. And finally they promoted atmospheric painting—that is, accurate and sophisticated rendering of skies, clouds, sunlight and other weather-effects. The ease with which watercolours could be carried about in remote and fascinating mountain districts, for instance, aided all these objects. So did the subtlety in washes, single or superimposed, which painting with water made possible. All these achievements entered the mainstream of painting and worked themselves out in the efforts of countless artists in the nineteenth century and beyond, not only in landscape but in every form of art. So the 'English Watercolour Episode' is a key moment in the history of painting.

There are nine major artists and a host of minor ones. Their works can be seen copiously in the British Museum, the Tate, the Victoria and Albert and in Norwich, so I do not, as a rule, indicate the provenance of pictures mentioned. But such is the modern curatorial suspicion of air, let alone sunlight, that none is permanently displayed, even under covers, and permission to inspect drawings (as museums still

Blake painted the naked body, in a style that can only be called inspired serenity, and in colour combinations so unusual that they fix on the memory as tenaciously as his shapes, he produced great art.

Blake is never dull. He is sometimes, not always deliberately, frightening. He is always sincere, in his own way (not necessarily our way). Byron's mistress, Caroline Lamb, wrote in her diary (1820) after talking to Blake at a party: 'An eccentric little artist, by name Blake, not a regular professional painter but . . . full of beautiful imagination and genius . . . He looks careworn and subdued, but his countenance radiated as he spoke.' That is Blake exactly, and it explains why Richmond said after their first meeting: 'I felt as if I were walking on air and had been talking to the prophet Isaiah.' Blake was not without admirers among the RAs, but it was a fault of that institution that it could not accommodate his kind of work. He was not without followers, however, including one major artist, Samuel Palmer (1805–1881), who together with John Linnell, the Varleys and other artists formed a group known as 'The Ancients'. These artists painted landscapes, chiefly moonlit, in watercolour over heavy sepia ink. Some of them, like Palmer's *Moonlit Landscape with Sheep* (Tate Britain) and *A Shoreham Garden* (Victoria and Albert), are overwhelming in their power. This is English romanticism at its most potent, rivalling in line and colour Keats's great odes.

The romantic note in English watercolours was the legacy of Thomas Girtin (1775–1802), whose short and sad life was a losing struggle against poverty and tuberculosis. His father was a brushmaker. He got some training in topographic drawing but was unable to attend the Academy Schools because he had to earn a living. He was paid three shillings a night by Dr Monro to copy his pictures. The most money he was ever offered was £30 a year to accompany Lord Elgin as draughtsman on a mission to Constantinople. In one year he had ten watercolours in the Royal Academy, but to get on there it was necessary to paint in oils. In fact he painted two oils, one of which has disappeared; the other, *Gainsborough Priory*, in the Yale Center, is essentially painted in the watercolour technique of thin washes, using oil instead of water. In 1800, in a desperate attempt to earn money, he painted a circular panorama of London from a high roof at Blackfriars. This too was done in oils, and exhibited, but is now also lost, and only some watercolour sketches—very fine indeed—survive. The Academy scorned his efforts and when he applied for Associate membership he did not receive a single vote. He tried etching and some were published after his death, but they do not impress. He was a watercolourist, nothing more—nor less.

Some would rate him the greatest watercolourist of all. Turner said: 'If Tom Girtin had lived, I would have starved.' That was hyperbole. What Turner meant was that Girtin excelled him in the salient virtues of watercolour painting: transparency, clarity, atmosphere, the organisation of large shapes on small pieces of paper. Girtin is reported as rejecting a view in France, saying: 'The objects did not form masses. They were scattered. And water was wanting, to me an almost insuperable defect.' Turner reinforced his rating of

FACING PAGE: *Ancient of Days* (1824), used as the frontispiece of Blake's work, *Europe: A Prophesy*, shows God the Newtonian artificer.

Girtin on another occasion, when a patron came to his studio, inspected his work, then remarked nastily: 'I have seen something better than any of these.' Turner instantly responded: 'Yes, and I know what it is—Girtin's *White House at Chelsea*.' This wonderful view across the Thames, at sunset, the 'masses' formed chiefly out of clouds in shadow, the White House and its reflection standing out on the low, dark horizon, is a work of pure genius, executed with the most astonishing delicacy of touch. The paint has floated down onto the paper and there is no sign of a human hand in the brushwork. It is so fragile that the Tate rarely exhibits it, and reproductions, now as a rule so successful with watercolour, cannot do it justice.

Girtin's skill can be analysed under six heads. He drew the inspiration for his designs not from his imagination but from nature, searching around in the countryside until he found what he wanted. Then he rearranged forms, but not so drastically as to dim the natural effect. Most of his best work was done in Yorkshire, thanks to the generosity of the Harewood family, *Kirkstall Abbey* (Victoria and Albert) being the archetypical example of his favoured shapes: a central ruin, a curving foreground river, a background of hills. Second, Girtin was economical of light. Spectacular light-effects can be obtained in watercolour by treating paper as pure light, but Girtin aimed at more subtle effects in which the light is mainly subdued but occasionally spreads out in places which appear to move. These effects linger longer in the memory because they set up poetic resonances. Third, Girtin achieves a delicate counterpoint between earth and sky,

The White House at Chelsea (1800) by Girtin was reckoned by Turner to be unequalled in technical skill, perhaps the best of all English watercolours.

which are not so much divided by a horizon as united by the overall light-system (*Lindisfarne Castle*, New York, Metropolitan). Fourth, Girtin eliminates detail except when he needs to emphasise a significant small shape and patch of colour. His pictures have remarkable breadth, depth and area, which make them seem much bigger than they actually are. Fifth, Girtin's exact colouring, created by many washes when needed, brings out the actual texture of the ground, whether moss, furze, grass, rock, peat, heather, bracken, all seen from a distance, with reassuring fidelity, so that one is at home within the depths of his paintings. Finally, Girtin was full of tricks—no one had more, considering his youth, and he was constantly inventing new ones—but they are never evident and seldom deployed except from strict necessity, in the cause of nature.

It was Girtin's ingenuity and creative power—his capacity for growth—which led Turner, who had the same kind of gift, to believe his rival would have surpassed him. Indeed we cannot possibly know what he would have done, and his death at twenty-seven was one of the supreme tragedies of art. A different kind of tragedy was enacted in the life of John Sell Cotman (1782–1842), a shopkeeper's son from Norwich, and thus (though he came to London at sixteen) a member of the most important provincial landscape school in English history. As a boy, Cotman rejoiced in the broad, airy works of John Crome (1768–1821), and as a man he followed the advice which Crome had given to a pupil: 'Do not distress us with accidental trifles in nature, but keep the masses large and in good and beautiful lines, and give the sky, which plays so important a part in landscape, and so supreme a one at our low level of lines of distance, the prominence it deserves.'

As a young man, at the Monro Academy, Cotman learned from Girtin, who was seven years his senior, the importance of simple masses in composing. But he painted quite differently. First, he moved in closer, and sometimes picked on a single object, as in *The Drop Gate* or *Landscape with Viaduct* (Victoria and Albert). Second, he was chary of using superimposed washes, except for a particular reason—to achieve great depth. Usually he painted with a much drier brush than Girtin and often achieved a nutty texture, with tiny particles of white paper exposed, to give glitter, lightness and luminous intensity of colour (especially when using buffs and yellows). He adopted Girtin's belief that subtlety in depicting English light was essential but he was not scared to produce powerful lighting-effects by using dense masses of trees to create a *chiaroscuro* contrast, as in *On the River Greta* (Norwich). He also used higher and brighter colours, sometimes in their pure essence, avoiding half-tones and gradations, so that some of his best paintings have only two or at most three distinct colours. As with Towne and Girtin, there is a tendency to simplify masses almost to the point of abstraction, but Cotman was ready to go much further, and move into a visual realm in which the shapes are more important to him than the nature they represent. He is, in short, an abstract realist.

In the decade up to 1810, on various sketching trips, especially in Yorkshire—the long, low, majestic shapes of the Dales were critical in his development, as also with

Girtin and Turner—Cotman painted over a hundred watercolours of great distinction, twenty or so of which rank among the best ever produced. They have precisely the qualities listed above, taken in some cases to the extreme. They ravish our eyes, having the power of a Vermeer in their perfection and grace, and of course those that survive are now unobtainable, being all locked up in public collections. But at the time Cotman could not sell them, however far he lowered their prices. He knew he was giving his best—that his best was something new and glorious—and yet nobody wanted it. This commercial failure helps to explain his growing melancholy. He painted watercolours intermittently, but no longer in his pure style—he had been too discouraged by their failure. There were huge pits of depression when, as he said, his mind was 'one chaos of agony'.

In the 1830s, Cotman returned to intensive watercolour work in a new style, using opaque mixtures, with huge, simple, very powerful colour effects, especially of deep blues, with brilliant touches of white. These are now prized too, but they are cruder than his masterpieces of 1800–1810. Seldom in the history of art was a genius so forced by public indifference to spend most of his life working at mediocre stuff. Given the circumstances of his life, it is almost incredible that three of Cotman's five children elected to become artists too. But the urge to paint, when felt strongly and in the blood, is irresistible. Fortunate for us that it is; less fortunate, sometimes, for those who feel it.

There were many such penurious families of artists at this time, the Varleys for instance. John Varley (1778–1842), the eldest of five, painted and taught. His sister Elizabeth also painted and married the artist William Mulready. Two of the brothers, Cornelius and William Fleetwood Varley, did watercolours, though Cornelius moved off into optical instrument-making, where he was a success and earned a better living. Of John Varley's ten children, two became artists, and three other members of the family earned a meagre living from the brush and the pencil. Why did they do it? Enthusiasm. Varley was probably the greatest art teacher England has produced, and enthusiasm was his method. He exuded it; he inspired it. 'Clear skies, distances, water!' he would explain. 'Those are the beauties of watercolour!' Among those he taught were William Henry Hunt (1790–1864), who did beautiful semi-miniatures, of flowers, birds' nests, potting plants and other natural objects, all in exquisite detail; John Linnell and Samuel Palmer, 'the Ancients'; his brother-in-law Mulready, who went on to become an outstanding genre painter, and Francis Oliver Finch.

Two of Varley's watercolour pupils, David Cox (1783–1859) and Peter De Wint (1784–1849), were among the greatest practitioners of the art. Both found it hard to make a living just by selling their watercolours. Since the RA was contemptuous of the medium, various attempts, then and later, were made to found exhibiting bodies, but none acquired the royal and aristocratic patronage which made being an RA so profitable (as a rule). Cox spent much of his life teaching drawing at an academy for young ladies. He was in his way a powerful painter. He loved high winds, massed clouds,

broad expanses, low horizons, the seaside in North Wales and Morecambe Bay, with small figures struggling against the elements—*Rhyll Sands* (Victoria and Albert) is typical of his best work. To achieve his rough, windy effects, he tried to get paper which was coarse and nutty, which could absorb a tremendous amount of water yet still leave highlights or speckles. He finally settled on an elemental shopkeeper's paper, used to wrap Scotch herrings. He was hard-working, fought against ill-health, but lived to be a patriarchal head of his artistic family, keeping his chin just above the water.

De Wint was a struggler too, who scorned teaching, though he wrote manuals about the art, another source of income (so did Varley). What De Wint liked was sunlight, hot August days, when the corn was ripe and sturdy rustic figures, men and women, were busy with the harvest, often wearing bright red or blue cloaks, to contrast with the golden corn. He did these endlessly, but with infinite variations, so each is new and fresh, and his figure-sketching is brilliant. He could do trees too, at a distance and close to, with a few quick flicks of the brush, in luminous blue-green colours which are devilishly hard to imitate. And, when he chose, he could do velvet mountains in high summer, golden in sunshine, deep mauve in shadow. De Wint's delicate magic went with a hard character. He made his living entirely by selling his wares, and he became in time an effective salesman. A scrap of his talk has come down to us. In those days, all self-respecting artists tried to sell in guineas (21 shillings), not pounds or sovereigns (20 shillings). Patron: 'Shall we then, Mr De Wint, say ten pounds?' 'No, Sir, guineas.' 'Come, come, Mr De Wint, let us not argue about a trifle. Say pounds.' 'No, Sir, it must be guineas. For the extra shilling goes to my wife and it is all the money for her pocket she gets.'

Examining the lives of these early watercolour painters, one becomes profoundly disturbed by the power even quite small sums of money—or, rather, the lack of them—exercised on the art of those who come close to genius. In the case of Richard Parkes Bonington (1802–1828) there can be no argument about the genius. Right from the start he drew and painted with consummate mastery, absolute self-confidence and a delight which communicates itself. He came from a painting family but his father, disgusted at the sums he earned, switched to lace-manufacturing, exporting machinery illegally to France and setting up a trade there. At fifteen Bonington was in Calais, learning from the gifted French marine painter Louis Francia, and a group of fellow enthusiasts who worked there exploiting the possibilities of the Channel and the foreshore. Bonington excelled at seascape; his *Dismasted Brig* (Victoria and Albert) is the best thing of its kind ever done by an Englishman. You can smell the salt wind, yet the design is almost abstract. Thence Bonington passed into the atelier of old Baron Gros, who looked at his work in a shop-window and said, 'That man is a master.' Gros taught him oil-painting, and it was one of Bonington's strengths that he could switch from oil to watercolour, and back again, at will, suffusing his oils with all the freshness and apparent spontaneity of watered paint.

In Paris Bonington met the young Eugène Delacroix and his friend Théodore Géricault and introduced them both to watercolour paintings in the new English manner. For a time Delacroix and he shared a studio. The Frenchman was mesmerised by Bonington's technique, which was bold and bright in colour, using every device from saturated, superimposed washes to dry-brush, and leaving tiny portions of white paper as highlights. 'He makes things glitter like brilliant jewels,' Delacroix said, and truly. When Bonington painted, he made the paper appear to contain vast reservoirs of bright light, which thrust through the surface as he applied his darker washes and spots of black and brown. But Delacroix gave the tall, pale Englishman the worst possible advice and encouragement. He said he should do small historical scenes, of genre and fantasy, which would sell well and make his reputation all over Europe. So Bonington slaved away at such oil pictures as *Henry IV and the Spanish Ambassador*, an elaborate joke showing the merry king playing with his children while the stiff Don looks on disapprovingly. It is beautifully done but not worth doing. (There are several such works in the Wallace Collection, together with fine landscapes in both watercolour and oils.)

Bonington also painted landscapes and townscapes, and his love of such art, in which he felt at home and happy, fought a constant struggle with his fear of poverty, especially when his health began to deteriorate in the mid-1820s. Fortunately for us, love usually conquered fear, and the landscapes, seascapes and townscapes poured out. His genre paintings helped in one respect; they improved his figure-drawing, already good, and made it superlative, so that such inshore scenes as *Boulogne Fishwives on the Beach* are done in great style, the figures mingling with sand and sea, cloud and distance, in total harmony. One never has with Bonington, as with so many landscape masters, the feeling that human life intrudes. He did some French country scenes too, though usually with water in them (like Girtin he found it indispensable), such as his brilliant *Château of the Duchesse de Berry* (British Museum), and the *View of the Institute from the Quai* (Victoria and Albert) which provides tremendous monumentality and power in a small area. Then came his visits to Italy, especially to Verona and Venice. His views of the grain market and of a religious procession in Verona are two of the finest of all watercolours, from which any artist, however skilled, can learn much. He followed this up with dazzling views of the Doge's Palace and the *Bacino* in Venice. All these great works (some done in oil as well as watercolour, using slightly different compositions) show Bonington's genius for picking a viewpoint which gave him exactly the right foreground, with a powerful middle-distance for his chief feature. He liked strong contrasts and shadows, so he was at the opposite end of the brightness scale to Girtin. Hence, if you are lucky enough to be in a room where fine works by both are on view, you turn from one to the other, and back again, in bewilderment but also with intense pleasure that watercolour can accommodate such a wide spread of genius, effortlessly.

Bonington had one gift-habit Girtin did not possess: he used his very fine,

pointed brushes like a pencil, so often the tiniest details of his water-colours are pure paint, with no pencil underlay. No one, not even the best Chinese or Japanese, used small brushes with such accuracy, neatness and flourish—as Delacroix said, he was a jeweller of the trade. In the summer of 1828, Bonington painted his last work, on the beach. It is called *The Undercliff* (Nottingham, Castle Museum) and shows more power and depth than ever. A month later he was dead. His gifted pupil, Thomas Shotter Boys (1803–1874), who himself had to turn to lithography for a living, and who was a hard-headed businessman, wept bitter tears on hearing the news. Tuberculosis had recently killed Keats, Weber and Géricault as well as Girtin. But in Bonington's case we regret also Delacroix's unwise praise of the history pictures—'You are king in this class and even Raphael did not do what you have done.' Those little canvases, which few now care for, cost us, by my calculation, about fifty great watercolours.

The Undercliff (1828) by Bonington is his last work, before tuberculosis killed him at age twenty-six. Delacroix, his studio-partner, said his watercolours sparkled 'like jewels'.

Turner, by contrast, never followed bad advice, or any advice at all. He attended schools, listened and watched and copied but in all essentials he was self-taught, self-directed, self-contained and self-judged. No one in the whole history of painting knew more about the art, or practised it with such complete absorption over seventy years. From the very beginning he knew what he wanted to do, and did it all his life. And he never did anything else. His private life, secret at the time, mysterious ever since, involved at least two women and two children, and a number of houses, some

secret. But all these were marginal and scarcely worth investigating, since everything he had he put into his work, and his services to the Academy, though considerable, were also a means to that end. His father was a barber in the Covent Garden district and Turner was, and remained, a Londoner of the lower middle class. His mother died when he was young, making him more of a loner than ever. His father was sensible and generous and as soon as he was aware of the boy's genius gave up his own work to foster it. That was important. The father looked after the material side of the studio until his death in 1827.

From the very first Turner sought to free himself from the tyranny of money by working as hard as he could, bargaining even harder, saving hardest of all (his only liberal use of money was to buy the finest paper, canvas, brushes and paint obtainable) and thus accumulating vast sums of money (he left the enormous sum of £140,000 in ready money). He set his own prices and never lowered them (sometimes he increased them). He etched and engraved and supplied materials for endless publications, imposing hard bargains on the men of business with whom he dealt, but all these were ancillary to his major trade, which was to sell large oil paintings at the highest possible prices. For this he ran and designed his own studio, with Etruscan-red walls and proper overhead lighting. He guarded it like a gold-vault, with peepholes to ensure that no persons took advantage of his absence to copy or make notes. His output was enormous. The latest full catalogue of his oil paintings (1996) lists 541, plus 19 rejects. The real total is probably nearer 900, though that is a question of definition. Many are very large and elaborate. His drawings have never been fully catalogued and probably never will be. One catalogue (1979) lists 1,569 of the most important finished watercolours. There are many sketchbooks still intact. He certainly created over 20,000 drawings, many with watercolour, in his long life. The vast majority of these were done in the open air.

Turner was a severely practical man. He had inherited from his mercantile family the concept of the 'trade secret', and he was usually secretive about his art. But the interest in him was such that we possess a good deal of information about how he painted, except when he was locked in his studio. He had the strong propensity of his age to take every possible advantage of modern inventions. Hence his concern with studio lighting, and optics generally. He worked closely with colourmen like Reeves and paper suppliers like Whatman, insisting they sold him their latest products at the earliest time they became available. He was among the first to use three newly developed colours: emerald green, cobalt blue and chrome yellow. His paintbox, at the Tate, contains ten yellows, four of them developed in his lifetime. Another box of his, at the Academy, had six yellows, four reds, four browns, two blues and two greens. Yellow, the most susceptible to chemical advances, was always the basis of his colouring. Like many artists, even today, he regarded the greens as false and used them as little as possible. He told the artist J. B. Pine that he 'wished he could do without trees'. When rebuked by an oriental traveller for the yellow colour of his

palm trees, saying 'Mr Turner, a palm tree is always green', he replied: 'Umph! I can't afford it—can't afford it.'

Whether Turner worked out-of-doors or in the studio depended entirely on practical considerations. To get his basic visual material he had to draw out-of-doors, which he did with great speed and accuracy. If the weather was good he painted watercolours out-of-doors too, as in the superb series of Lakeland hills, Yorkshire moors, Welsh scenes and cityscapes (especially at Oxford) he did in the late 1790s and early 1800s. On outdoor location, however, Turner sometimes resented the time taken up by colouring. (You can draw in the rain but you cannot paint, especially in water-colour.) On his first trip to Venice (1819) he only had five days. On the first day he took a gondola ride from the entrance to the Canale di Cannaregio, upstream to where the station now is, then slowly down the Grand Canal to the Salute and beyond, with pauses to sketch. In this way he produced eighty sketches in one day, possibly two. He sketched 'as though he were writing', his hand never still, taking in details with every second. All this could later be used to build up pictures. Turner told Sir John Soane's son that he calculated he could do fifteen or sixteen pencil sketches in the same time it took to do one colour sketch. So he trained himself to memorise colours, a difficult feat. But he always had a small box of paints handy: thus, when his coach was overturned in the Alps, and its passengers marooned in the dark and snow, he set to and painted the scene as a magnificent watercolour, ignoring his freez-ing hands. No great painter will ever mind physical discomfort for a grand effect. When he was sixty-seven, Turner wanted to make accurate sketches for *Snow Storm: Steam-Boat off a Harbour's Mouth* (Tate Britain). So he had himself lashed to the mainmast of the *Ariel*, in what turned out to be a gale.

Eyewitness accounts of his 1813 painting tour of the West Country show the craftsman at work: quick, economic of time and effort, all-observant, always painting or thinking about it; never idle. At Rame Head, he and his companions went out in heavy seas in a small boat; all were seasick except Turner, who sat in the stern-sheets 'intently watching the sea', making mental notes and sometimes pencil ones too. We have another picture of Turner creating a ship, using his enormous experience and tenacious memory. In 1818, staying with his patron Walter Fawkes in Yorkshire, an incident occurred which Fawkes's daughter-in-law recorded:

One day at breakfast Walter Fawkes said to Turner 'I want you to make me a drawing of the ordinary dimensions that will give some idea of the size of a man of war.' The idea hit Turner's fancy, for with a chuckle he said to Walter's eldest son, then a boy of about fifteen, 'Come along, Hawkey, and we will see what we can do for papa.' The boy sat by his side the whole morning and witnessed the evolution of *A First Rate Taking in Stores*. His description of the way Turner went to work was very extraordinary. He began by pouring wet paint on to the paper until it was saturated, he tore, he scratched, he

scrubbed at it in a kind of frenzy, and the whole thing was chaos—but gradually as if by magic the lovely ship, with all its exquisite minutiae, came into being, and by luncheon time the drawing was taken down in triumph.

Painting with oils was a totally different technique, and Turner was never observed using them in the studio. But he was often watched at Varnishing Day, either at the RA or the Royal Institution. Strictly speaking, on these occasions artists were only supposed to use varnish, but Turner often took the opportunity, depending on what hung on either side of his work, to transform it. Sir John Gilbert recorded his astonishment at watching Turner alter the lighting-scheme of his *Regulus*, painted at Rome in 1828, and now in the Tate:

> He was absorbed in his work, did not look about him, but kept on scumbling a lot of white into his picture—nearly all over it. The picture was a mass of red and yellows of all varieties. Every object was in this fiery state. He had a large palette, nothing on it but a huge lump of flake white. He had two or three biggish hog-tools to work with, and with these he was driving the white into all the hollows and every part of the surface . . . The picture gradually became brilliantly effective, just the effect of brilliant sunshine absorbing everything, and throwing a misty haze over every subject. Standing sideways at the canvas, I saw that the sun was a lump of white, standing out like the boss of a shield.

Turner began his painting life as a topographical artist, drawing, then washing over, grand buildings like cathedrals with tremendous accuracy and flair, then moving to more monumental forms, including mountains, and seeking effects of sublimity with waterfalls, glaciers, ravines and precipices. But, though not much schooled, he was extremely well read, especially in matters affecting his trade, and he had taken in Goethe's optical observations, especially one: that we perceive the visible world through light, shade and colour, rather than by our actual knowledge of solid forms. This exactly accorded with Turner's own experience, and he decided that what we see is essentially created by the light which falls on it; to paint in truth, the artist must paint light and its effects. This discovery, which he made soon after 1800, he pursued all his life, and it meant abandoning much of the lore of the Old Masters.

It was on his first visit to Venice (1819) that Turner finally released himself from the straitjacket of conventional painting. In his four months in Italy he filled nineteen sketchbooks with tiny drawings, of the kind he 'wrote' on the Grand Canal, plus many watercolour studies on blue paper or on a grey wash. Twice on Lake Como and four times in Venice, immediately after his arrival, he did on-the-spot watercolour studies while the impact of the North Italian light, which he had never experienced before, was still fresh. These studies recorded dawn and misty light, full sunlight, and sunset,

all set down in translucent colour for purely naturalistic purposes, something which no one, not even he, had ever done before. None of these studies was seen by anyone else for many years, or even developed by Turner into finished paintings. But they marked the point at which he applied Goethe's discovery to the full, and he never looked back thereafter. Henceforth Turner was concerned not so much to draw or paint objects, as to capture light itself—its translucence and opacity; its manifestations in cloud, water, fog, mist, snow and steam; and its capacity to turn the solid world into strange manifestations of the celestial, to enable and terrify, to explain and inspire wonder. As he grew older, he developed a profound interest in photography, spending hours questioning the American expert J. J. E. Mayall who said: 'He came again and again, always with some new notions about light.' Light was his life, and art.

Turner's work went through many phases, which can be conveniently divided into six main ones. First came the topographical watercolours, some of them large and immensely beautiful and detailed, such as *The Lantern of Ely Cathedral* and *South View of Salisbury Cathedral from the Cloisters* (both Victoria and Albert). Then came big, elaborate oils, often seascapes or Alpine scenery, such as *Calais Pier* (London, National Gallery), though he

Calais Pier (1803), Turner's first masterpiece in oil, reflects his watercolour training in light, space, atmosphere and weather-depiction.

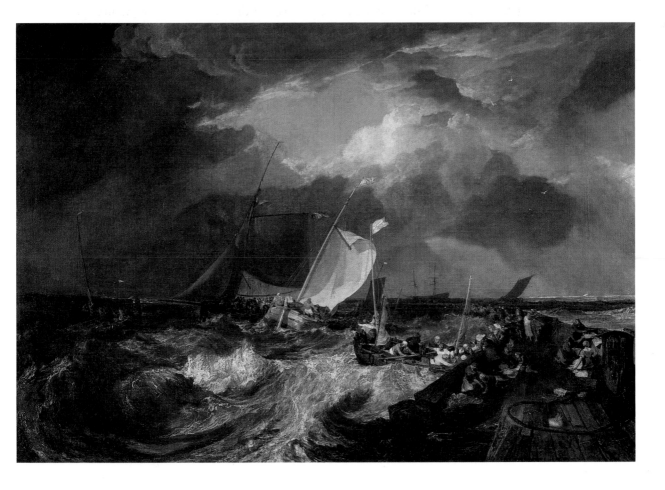

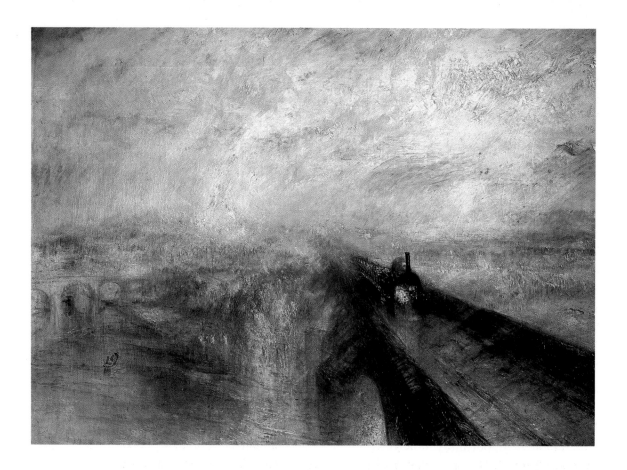

Late Turner, *Rain, Steam and Speed* (1844) displays solid objects only to the extent they reflect or refract light.

continued with his watercolours such as *The Reichshoffen Falls*, the epitome of the sublime (Victoria and Albert). Then followed a period of simplification of subject matter, with one or two prominent features in immense distances, such as *Crossing the Brook* (Tate Britain). Next came hundreds of watercolours, oils and oil sketches for various illustrated books, such as *Picturesque Views on the Southern Coast of England*. A fourth phase introduced classical subject matter on a large scale, such as *Ulysses Deriding Polyphemus* (National Gallery). Overlapping this was a series of important Continental views, which some consider Turner's finest work, examples being *Cologne: The Arrival of a Packet Boat* and *The Harbour of Dieppe* (both New York, Frick). Intermittently there were works over which Turner took particular care and to which he attached special importance. Such were *Sun Rising Through Vapour*, a railway picture, *Rain, Steam and Speed*, all of which he refused to sell and which he made sure went into the National Gallery. Finally there were, in the 1830s and 1840s, light-coloured, misty and cataclysmic scenes of Venice, storms and sunsets, some of which aroused great controversy. Examples are the *Boston Slavers Throwing Overboard the Dead and the Dying* (Boston, Museum of Fine Arts), *Keelmen Heaving in Coals by Moonlight* (Washington, National Gallery) and the previously mentioned *Snow Storm*.

There is an immense literature on Turner (at the latest count I had fifty-two books on him in my library) and a quarterly entirely devoted to his art. But it is

difficult to take it all in comprehensively. In a way, it constitutes an entire history of painting, or rather of humanity's efforts to understand light. It was immensely well-publicised even in Turner's lifetime, all over the Continent and on both sides of the Atlantic, by display, and through his publications. All painters who came to London visited his gallery. Thus he entered into the mainstream of art and his influence continued to exert itself as the century progressed. Indeed, it is impossible to imagine art in the second half of the nineteenth century, and throughout the twentieth, if you take away the Turner factor. Nevertheless, to enjoy Turner to the full, you have to be conscious of his faults: his appalling figure drawing and vacuous faces, his sudden collapses of taste, his refusal to paint trees properly, his spasms of mania in seascapes, and his overuse of white and yellow when the frenzy took hold. It is only by admitting his imperfections that the full power of his genius, going at top speed and fury, and sweeping all before it in dazzling displays of mastery, enters through the eyes into the depths of the soul.

Turner and John Constable (1776–1837) were compared and contrasted in their lifetimes and ever since. They did not like each other. Turner was a power in the Academy, which Constable hated, even after he was belatedly elected RA. They had a famous clash on Varnishing Day. Constable, showing his *Opening of Waterloo Bridge* (1817), took the opportunity to heighten it with vermilion and a crimson lake. Next to it was Turner's *Helvoetsluys*, described as 'a grey picture'. Turner came into the room several times to compare the two. Then, wrote C. R. Leslie (also a painter and Constable's biographer), he brought his palette, 'and putting a round dab of red lead, somewhat bigger than a shilling, on his grey sea, went away without saying a word. The intensity of the red lead, made more vivid by the coolness of his picture, caused even the vermilion and lake of Constable to look weak.' Hence Constable's bitter comment: '[Turner] has been here and fired a gun.' It is often said that no one can like both. That is nonsense. After seeing an exhibition of Turner's, you are tempted to say: 'This man was the greatest of landscape painters.' But you have the same urge after seeing a roomful of Constables. They are best not seen together, which draws attention to the weaknesses of both.

Constable came to professional painting late, for his father, a rich Suffolk miller, wanted him to go into the business. But he had always sketched, with extraordinary enthusiasm and minute attention to detail. Like Wordsworth, he was nature- and self-obsessed, and linked the two. Asked by Leslie if he ever painted with a person in mind, he replied that he always painted for 'a very particular person, the person for whom I have all my life painted'. This helps to explain his resistance to advice or criticism and his dislike of other artists. To him, nature and God were identical, and painting was his form of worship, to be conducted alone. He eventually got some good teaching but his painter's vision had been formed long before. He was right outside the academic tradition. His God was a local god too. Although he visited the

Lake District for inspiration, did some magnificent pictures of Salisbury Cathedral for his patron Archdeacon Fisher, and worked in and around London, especially on Hampstead Heath where he studied clouds, Constable was never really at ease except on the banks of the Suffolk Stour. He said: 'I paint my own places best—painting is but another word for feeling.' The Stour banks, he said, 'made me a painter, that is I had often thought of pictures of them before I had ever touched a pencil'. He told Fisher: 'The sound of water escaping from the mill-dams etc., willows, old rotten planks, slimy posts, brickwork, I love such things . . . As long as I do paint, I shall never cease to paint such places.' Painting was a moral action for him. He saw each tree, each leaf, as a living part of creation, and as he worked he quoted, 'I am the resurrection and the life', which he said was verified by what he saw, and put down in two dimensions.

Now that Constable's work has been properly catalogued, and we can examine it comprehensively in the four huge volumes, we can see that he was not merely a landscapist—he did many portraits and other work—but we can also see that three-quarters of his most significant work was done within a range of 3 miles: there, he said, 'my limited and restricted art may be seen under every hedge.' Thus it is possible to compare, for instance, the view of Dedham Vale he did in 1802 (Victoria and Albert) with the one he did in 1828 from the same spot (Tate Britain). The second showed how much he had learned, or taught himself, in a quarter-century. But both have in common an intense desire to render nature with all possible fidelity. And Constable included in 'nature' all the tackle with which humanity handled it. His carts, as in *The Hay Wain* (National Gallery), are always exact. Any agricultural implement is superbly accurate. The sea-views he painted at Brighton (as in the Tate's *Brighton Beach* and *Chain Pier*) contain small craft rendered with all Turner's painstaking fidelity to rigging and rudders. His brother Abraham, who went into the family business, said, 'When I look at a mill painted by John I see that it will *go round*.'

No painter ever saw more totally with his own eyes, and no one else's. Not that Constable did not admire fine paintings. When he stayed with the amateur painter and collector Sir George Beaumont, whose treasures later formed part of the original National Gallery, he was 'bowled over' by the thirty superb Girtins. He said in an excited letter: 'Only think, I am now writing in a room full of Claudes, Wilsons and Poussins . . . the Claudes, the Claudes are all I can think of here.' Owners were more easy-going with their paintings in those days. Constable said he 'dragged' pictures up to his bedroom, so that he could look at them first thing when he woke up. That is how he came to love Rubens's *Château de Steen*, from which he learned a lot.

Constable was a master of the pencil, and used it with wonderful sensitivity, unlike Turner to whom it was a mere tool. He also enjoyed watercolours, as his magnificent dashed-off views of the Lake District show—never to be made into finished works. When he chose, as with his great and stormy *Stonehenge* (Victoria and

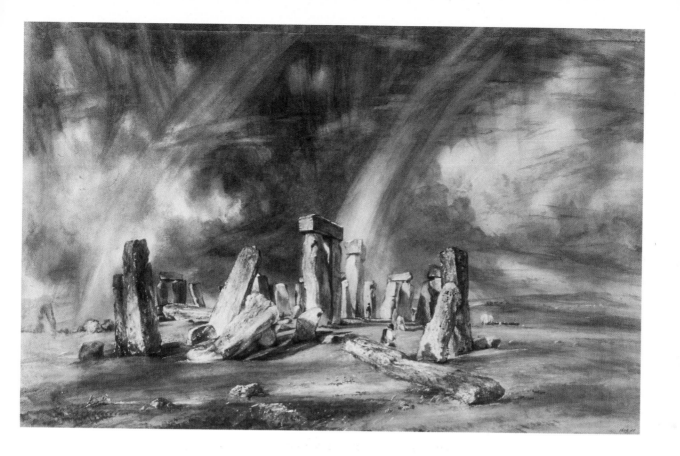

Albert), he could do watercolours with all the power and majesty of Turner. He must have done, I calculate, about 3,000 sketches, many in watercolour, which alone constitute a lifetime's work. But he was determined to conquer the public with his big oils, what he called 'my six-footers'. Hence drawings, watercolours, were only a means. Next came oil sketches, another device he adopted from Rubens. These can be of the greatest beauty, fresh, colourful, spontaneous, sparkling with the excitement of what he called 'nature being *seen*, on the spot', such as *The Valley Farm* (Tate Britain) and *View on the Stour Near Dedham* (San Marino, Calif., Huntington Library & Art Gallery). And *Weymouth Bay*, in the National Gallery, though technically a sketch, is one of the finest things he ever did, and might have been painted yesterday.

Indeed, the dividing line between his sketches and his finished pictures is often difficult to draw. Constable believed it was a sin against art and God to silken down the roughness of nature into a glossy smoothness. So, in his lifetime, the perpetual complaint about him was that his works lacked 'finish'. They were hard to sell. When Fisher bought his *White Horse* (Frick) and gave him £100 for it, Constable was pathetically grateful—it seemed a magnificent sum, his first real earnings. Lack of money meant he could not marry the woman he passionately loved until he was forty, and she died a mere ten years later, a blow from which he never recovered. His progress was slow work: ARA in 1819, RA a decade later. He got his big *View on the*

Stour into the Academy in 1819 and his most famous picture, *The Hay Wain* a year later. Both were taken to Paris in 1824, exhibited at the Salon and won gold medals— the French were much more appreciative of Constable's originality than the English were. But he would not go to Paris himself; it was 'abroad' and he hated it. The London criticism continued. During his lifetime, Constable was never given his due in the art world; indeed, he was written off as a cantankerous egoist, a difficult, unclubbable man, always criticising and quarrelling with other artists.

How did a man devoted to presenting nature as it was, 'finish' a landscape? Claude's skies were 'finished', Constable admitted, but England does not provide such serene entities. He first became fascinated by clouds in the Lake District and when he took Albion Cottage, Hampstead, he spent weeks sketching skies in watercolour and oils. He worried about skies all his life. 'The difficulty about painting [skies] both as to composition and execution is very great, because with all their brilliancy and con-sequence, they ought not to come forward or be as hardly thought about in a picture any more than extreme distances are.' Yet, 'that landscape painter who does not make his skies a very material part of his composition elects not to avail himself of one of his greatest aides . . . [Skies] must and always shall with me make an effectual part of the composition.' He said there was no landscape 'in which the sky is not the *key note, the standard of scale and the chief Organ of Sentiment* . . . The sky is the *source of light* in nature and governs every thing.' No one ever painted skies with more confidence. His *Hadleigh Castle* (Yale Center) has a claim to be considered the greatest of all cloudscapes, for unlike the skies of Ruysdael and Koninck, Constable's clouds actually seem to move, and the wind rushes across the foreground.

If Constable had been less of a xenophobe and established himself in Paris, he might have been world-famous before he died. The great strength of French painting in the nineteenth century was that Paris was a world centre not just for teaching but for the exchange of art ideas, where foreigners were welcome to contribute. When Constable's pictures were shown there, Eugène Delacroix (1798–1863), after examin-ing their colours, went straight back to his studio and repainted the entire back-ground of *The Massacres at Chios* (Louvre), to many his finest painting. The French spoke of 'the Constable effect', which guided the development of Théodore Rousseau (1812–1867). He helped to found the school of painters who lived in the forests near Barbizon, to paint from nature as Constable did. They included great artists like Jean-François Millet (1814–1875), whom we will come to presently. They got the point of Constable perfectly: open air, intense study of nature, fidelity to what God has made—truth. By admitting the Constables to their Salon, and then shifting them to the *salle d'honneur* in response to public interest, French art did itself a shrewd favour. French generosity, contrasting with the insularity of the RA, where no living foreigners were ever exhibited, had short- and long-term results, all positive. It was part of the process whereby French art was enriched from abroad and Paris became the place where original and gifted artists—above all its advance guard—came to

learn and teach and show, and of course develop. So Constable's work was an important milestone along the road to the modern international school, more so indeed than a mere episode in English art.

It is significant that, for a long time after the advent of Bonington and Constable, the best French artists used watercolours intensively. Delacroix, indeed, was a born watercolourist: his efforts in the medium are much fresher than his finished oils. He was burdened by the history-picture tradition of David, and felt he had to perform in it. He laboured long and hard and, given the mentality of the time, with eventual success, becoming a grand old man of French art, alongside Ingres. Sometimes, as with *Massacre of Chios*, his efforts moved. Sometimes, again, he created a popular image, as with his *Storming of the Barricades* (Louvre), in which a naked-to-the-waist Liberty leads the mob in the 1830 revolution. More often, with us, he raises a laugh, as in *The Death of Sardanapalus*, where the weary tyrant gazes on sleepily as his harem is slaughtered. His religious paintings, such as those in a side chapel at St-Sulpice in Paris, are deplorable daubs. But when Delacroix took his watercolour box and sketching stool, and travelled abroad, as he loved to do, in North Africa, he came to life. He did many oils on his return from these trips, but the hundreds of watercolours painted on the

Delacroix's *Massacre at Chios* (1824) presented a contemporary tragedy with the dignity and nobility of a historical event.

spot are his real legacy: Arab cavalry, on parade and in action, the berbers and tribesmen of the desert, lions and other savage beasts, marvellous flower studies and sunsets (some done in pastel, in which he also excelled, or in a combination of coloured chalks and watercolour), street and harem life, the whole scented, sizzling Orient comes alive at the touch of his rapid brush.

Théodore Géricault (1791–1824) also learned from the English watercolour technique and made himself a master. This brilliant, sad man, a martyr to tuberculosis and his burdensome homosexuality, made himself a world-figure by constructing one of the largest canvases ever painted, *The Raft of the Medusa* (Louvre),

commemorating a horrible maritime disaster. It has always been a brutal work and is now in a sorry state and cannot be moved. Géricault was driven by his fears to tackle such gruesome subjects. He haunted hospitals and lunatic asylums, painting for instance *Two Severed Arms and Legs* (Lyons, Musée des Beaux-Arts) with consummate skill, and incarcerated lunatics, men and women, with pitiless realism—his *Gambling Mania* (Louvre) is a haunting masterpiece. But what he really loved was horses, which he associated with England, and their—to him—terrifying women riders, or *amazones* as he called them. He loved watercolour technique. He came to England to paint horses and some of his sketches were used by him to construct an oil of the rears of twenty-five horses, called *Cruppers* (private), which is the finest horse-painting since Stubbs himself.

The only other country which produced a school of watercolour painters was Austria. Two major masters emerged from this school, Jakob von Alt (1789–1872) and his even more gifted and productive son, Rudolf (1812–1905). The father was an assiduous, scrupulously accurate, enterprising and well-informed man, who adopted lithography when it was a new science and then moved on to chromolithography. He must have produced about 1,500 elaborate drawings, mostly with watercolour over ink, or pencil, and

Géricault came to England to study horse-painting and became its greatest Continental master, as *The Horse Race* (1821) shows.

he gave Rudolf the best possible art education. From the age of six, the boy went with his father on drawing expeditions, and at home was taught how to colour his father's work (his brothers and sisters did this also). Rudolf lived well into his nineties, travelled widely in Italy and central Europe, and worked as hard as he possibly could all his life, having a terror of poverty and revolution.

As a topographical record, his *oeuvre* has seldom been improved upon, even by Canaletto and his nephew, for though Alt worked fast he was exceedingly accurate. Anyone who doubts this should look at his grand architectural views of Vienna, such as *St Stephen's Cathedral*, now in the Munich Graphical Museum. But his real love was of nature, and some of his Alpine and forest views, such as *The Great Pine Tree Near Gastein*, are of wonderful power and sublimity, almost on a level with Turner at his Alpine watercolour best. This remarkable sheet is part of a huge stock of his works in the Vienna Albertina. However, Alt could also do something which Turner could not: mingle nature with genre. His figure-drawing was excellent, and in what is perhaps his masterpiece, *Promenade at the Spa of Teplitz* (Munich), he succeeds in combining society ladies with arboreal beauty in a way which had not been done before in watercolour, or indeed in any medium, since Gainsborough painted *The Mall*. Alt ought to be regarded as one of the greatest painters of the nineteenth century, and that is certainly how young men such as Gustav Klimt, around 1900, saw him. But he is perhaps too open; there are no secrets, psychological or other, in his work: what you see is what you get; and artists without conundrums do not attract writers.

One German artist whom Alt befriended and who was devoted to him in return was Adolf Menzel (1815–1905). This tiny man, who was barely four and a half feet high, was the most important German artist since Dürer and we shall be coming to his work in oils. Menzel was devoted to the pencil, used it with greater skill than any other nineteenth-century artist except Ingres or Constable, always carried two or three tiny sketchbooks in his pockets, and drew—anything, anyone—when he was not actually engaged in any other activity. So tens of thousands of his sketches survived, most deposited in that vast emporium of Menzel materials, the Berlin National Gallery. In one sketchbook, which he used intermittently from 1839 to 1846, there are no fewer than forty sketches of horse-drawn carriages, with watercolour added. (Menzel also used mixtures of watercolour, gouache and pastel.) One, of a sleigh, in the snow, waiting for a fare outside a Berlin hotel, and done in 1846, is among the most perfect watercolours imaginable, painted in a flash, from the curious angle which the artist's lack of height dictated, peering over the window-sill of the first storey, and bringing to life in an instant the two wretched nags shivering in the cold (Menzel Berlin cat. 121).

If Continental Europe, with exceptions of which the above are the most notable, underplayed watercolour, the Americans always practised it, from the first beautiful drawings of John White in the 1580s. In the nineteenth century it was particularly

favoured by artists exploring the west, including the greatest, such as Church and Bierstadt, though it was also sometimes used by the Luminists of the east, such as William Trost Richards in his magnificent *Calm Before the Storm* (Brooklyn). In the steps of John White came Karl Bodmer (1809–1893), to draw the Indians in watercolour, this Swiss master being a nephew of the leading Zurich watercolourist Jacob Meier, who had been taught by the great Ducros himself. Bodmer's full-length of a chief, *Maker of Roads*, deserves to stand alongside Lewis's *Sheikh* as a masterpiece of exotic portrayal, and his *Indian Burial Scaffold* (both in the Joslyn Museum, Omaha) is a superb piece of genre. Of the landscapists, Thomas Moran (1837–1926) was the most persistent in using watercolour (sometimes with gouache added) in finished work of mountain scenery. His *Cliffs in the Rio Virgin* and *Looking Up the Trail at the Grand Canyon* (both New York, Cooper-Hewitt Museum) show that, as Turner always maintained, watercolour could be used to present the most dramatic effects of the sublime, sometimes more powerfully than oils. Equally, for figure-studies, Thomas Eakins (1844–1916) used infinite layers of transparent watercolour to build up ultra-realism in a series of crystalline paintings: *John Biglin in a Single Scull* (New York, Metropolitan), *Whistling for Plover* (Brooklyn), *Drifting* (private) and *Baseball Players Practicing* (Providence, R.I., Museum of Art), a brilliant trio of works which showed that, by the 1870s, American artists had now matured in all departments and were moving centre-stage.

There were, however, four American artists who pushed watercolour to the limits of deftness and beyond, and produced those gasps of astonishment which only this ultra-difficult and fragile form of art can evoke, even from hardened collectors. The first was James McNeill Whistler, a delicate practitioner from teenage years. Now that his *oeuvre* has been fully catalogued we can see how large a percentage of his time was spent using watercolour. The Freer Collection in Washington, D.C., has a number of his best and most scintillating sheets, including quick sketches of waves and seashore figures, beautiful studied drawings of old shops in Chelsea, and colourful studio work. The last includes one of the great watercolours of the century, his favourite model, Millie Finch, lounging in a grey dress on a red sofa, and holding up a fan. Whistler, of course, we will return to again, as we will to two other men who produced outstanding watercolours, Winslow Homer and John Singer Sargent. All three illustrate one of the salient characteristics of watercolour art: the willingness to take enormous risks, and the skill to pull them off. Without risk-taking, watercolour is nothing. But the risks are real, for one false stroke of the brush can spoil a sheet for ever. There is, as a rule, no retracing your steps in watercolour, and any elaborate drawing underneath is a total loss too. Whistler's *Millie Finch on the Sofa* took him an hour and it could all have been ruined in the last breathless seconds. Indeed, we know he often did mess up and then destroy his sheets. But he also pulled off some spectacular gambles, as in this instance, and these successes helped to build up his confidence in his major experiments in oils.

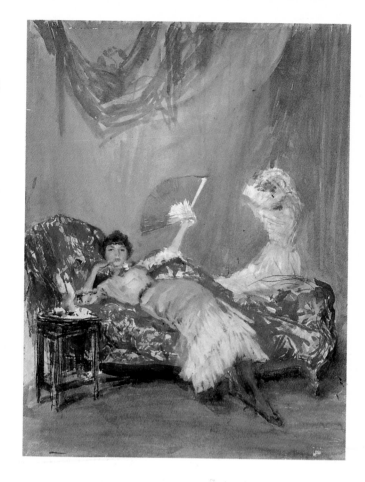

Whistler's delicate skill, as in *Millie Finch on the Sofa* (*c.*1870), was supremely suited to watercolour. He painted in oils to please patrons and show he was 'serious'.

Equally, Homer was a daring man who took spectacular risks, in beginning watercolours from life without having any idea how they would end. A particular example is his delicious horizontal, *The New Novel*, where he portrayed a girl (or a boy dressed as a girl; there is a continuing argument on this point) lying on the ground in such a way as to provoke fascinating effects of indirect sunlight. Homer, a natural artist and self-taught, with all the consequential virtues (and few of the vices), realised that, although the English founders of the school used watercolour chiefly to render subdued light, it could, if applied with the right kind of reckless bravado, be used to create dazzling and liquid light in ways which oils could not rival. Towards the end of his life he did two large groups of watercolours, the first canoeing in the Adirondacks, the second on beaches and in the shallow waters of Bermuda, which demonstrated this light supremacy in the most comprehensive way, producing in the process about fifty pure masterpieces on paper. *The Turtle Pound* (Brooklyn Museum) is an exercise in virtuosity which has never been equalled, and a work of formidable power too. Homer must have been mightily relieved when he finished it without making one tiny, ruinous mistake.

That was the approach of Sargent too, who preferred watercolour to oils (except for making a living) for precisely the reason that it involves desperate risks. It is, as he said, 'the gambler's medium'. Again, there are two groups: Venice in sunshine and rain, and some World War I scenes of camp life. They have the same virtuosity as Homer's sheets but with a totally different colour range and with much less under-drawing in pencil, thus increasing the risk. When Sargent was using watercolour, he 'groaned, swore (if no ladies were present), exclaimed, whistled to keep his spirits up, growled in rage when things went wrong, and then shouted in triumph as he completed his work to his satisfaction. It was a noisy performance'. Another eyewitness said he talked to himself: 'This is impossible. You can't do it. Why do you try these things? You know it's hopeless. *It can't be done*.' Then: 'Yes, it can, yes it can, it can be done—my God, I've *done* it.'

One major American artist, Maurice Prendergast (1858–1924), though he did many other things, specialised in watercolours of a peculiar kind, and did them better than one would have thought possible. Between 1895 and 1905 he painted about a hundred watercolours over pencil, showing men, women and children, massed together in complicated settings, in France, Italy—Venice and Rome in particular— and in New York and his native Boston, often in windy or wet weather (he loved painting open umbrellas). A typical one is *The Mall, Central Park* (Chicago Art Institute), which shows an Easter parade, but in overcast weather, with sunshades only for show. This would be difficult to paint satisfactorily in any medium, but to do it in watercolour, in perhaps three hours, is something to marvel at. Prendergast did it again and again—on the seashore, in children's picnics and tea-parties, in snow-filled Boston streets, in St Mark's Square and along the canals, often with thirty or forty figures, each given equal value, but massed together—crowd scenes of individuals. But living by watercolour work is a tremendous strain. Prendergast suddenly tired of it all and moved into disastrous decline. That, as we shall see, is the story of watercolour painting in the twentieth century. In the nineteenth century it was a means whereby good painters became superlative ones and the merely mediocre improved their performance beyond their dreams.

Winslow Homer loved light on water and was happiest in the West Indies, using watercolour: *The Turtle Pound* (1898) shows his power.

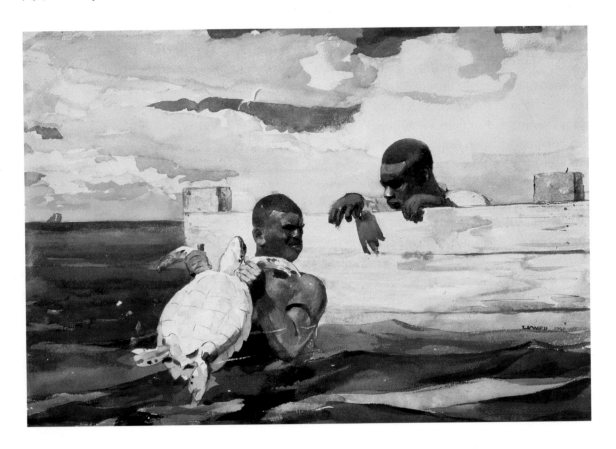

23

ROMANTICISM
AND HISTORY

The Romantic movement was the central fact of art for most of the nineteenth century but it was not a simple phenomenon. It had three main ingredients: religion, nationalism and literature, all interconnected. It was most creative in German-speaking lands, where the arts enjoyed a resurrection from long national slumber. In 1809 in Vienna Friedrich Overbeck (1789–1869) and a group of Christian painters founded the Lukasbund, or Brotherhood of St Luke, to resurrect medieval ideals, based on their study of Italian primitives—they went to Rome for this purpose and were derisively known as the Nazarenes. Overbeck's masterpiece is significantly called *The Triumph of Religion in the Arts* (Frankfurt, Stadelsches Kunstinstitut). An important symbol was Cologne Cathedral, work on which had ceased in 1560. Much of the building had only a temporary roof and part had no roof at all. It became the fashion among German artists to call for its completion and many volunteered to help in the task. Work began in 1823 and continued steadily: the vast interior was completed in 1860 and in 1880 the last stone topped out the 500-foot-high southwest spire.

Gothic shapes, especially spires, loomed large in the symbolism of German art. The architect-painter Karl Friedrich Schinkel (1781–1841), whose work as a classicist we have already examined in Berlin, became an enthusiastic Gothicist as well. During the Wars of Liberation, he produced two remarkable Gothic landscapes, *The Cathedral* (1811, Berlin), and *Gothic Cathedral by the Water* (1813, Munich), designed to refute the notion that Gothic was barbarism, presenting it, rather, as the ideal shape of beauty, and essentially German. The ideologist of the movement, he designed and built Gothic churches, published a book of essays, *The Gothic Revival* (1829), and compiled handbooks of Gothic motifs and designs for the use of crafts-men and architects employed on the new Gothic churches being built all over central Europe. It is significant that in the memorial Schinkel designed to commemorate the dead of the Wars of Liberation, the shape is Gothic but much of the detail is classical—for the ideals of Greece were an important part of the artistic cause.

Schinkel used his architectural skills to invent fantastic images, as in *Cathedral by the Water* (1823), with spectacular light-effects.

When it was decided to build a German national monument, where the heroes of the race could be commemorated, the Parthenon was chosen as a model. Such buildings were a feature of the new nationalism. The French had the Panthéon, the Scots the temple on top of Calton Hill in Edinburgh, and later in the century the Americans acquired the Statue of Liberty and the Italians the Victor Emmanuel Monument in Rome. (The nearest the English came to it was Trafalgar Square; the Spaniards lacked one until General Franco built the Valley of the Fallen outside Madrid in the 1950s.) The huge German replica of the Parthenon was designed by Leo von Kleuze (1784–1864) and built on a high spur overlooking a magnificent stretch of the Danube near Regensburg, where the Holy Roman Emperors had been crowned. But it was called Walhalla, after the heavenly palace of heroes in the German legend—Christianity and paganism mixed freely in German romantic nationalism. Turner delighted in this work, attended the opening (1842) and painted it. And it was the sight of this imposing creation which inspired Richard Wagner to turn the cause into a musical epic.

Germany, indeed the whole of northern Europe, including Denmark in particular, abounded in gifted painters at this time. Caspar David Friedrich (1774–1840) was by birth a Swede, and trained in Copenhagen, but identified himself with the German romantic-nationalist spirit. He translated it into a series of highly realistic

and meticulously painted images. There was the fir tree (*View of the Elbe Valley*, 1807, Dresden), the mist (*Winter Landscape with Church*, 1811, London, National Gallery) and Christianity itself (*The Cross in the Mountains*, 1808, Dresden, Staatliche Kunstsammlungen). There was nothing belligerent or bombastic about him; he loathed the roar of the crowd, the bonding of the collective mass. He stressed the solitary or, at most, the couple; a lonely monk on a seashore, the back of a girl gazing out through a window, a wanderer amid lonely hills (*Mountain Landscape with Rainbow*, 1810, Essen, Museum Folkwang). Often there was no life at all, just wild nature (*Morning Mist in the Mountains*, 1808, Heidelberg), rocks (*Rocky Reef on the Beach*, 1824, Karlsruhe, Staatliche Kunsthalle) or winter (*The Sea of Ice*, 1823, Hamburg, Kunsthalle). This last picture, with its essentially Gothic image of jutting spires of ice, is the icon of German romanticism, its summation. Friedrich's was a world of chill and sadness; he painted the moon, constantly, never the sun, and he avoided sunlight. His last years were mad and violent.

By contrast, Karl Blechen (1798–1840), loved light and warmth. His oil sketches done in the open air, often on paper or card, are among the finest of the century: he is the German Turner. In *Wide Valley and Blue Mountains* (1829, Berlin, National-galerie), the sun creates deep blue shadows, contrasting with the gold of rock. In *Boats and Lighthouse Near Genoa*, *The Gulf of La Spezia* and *The Bode Valley in the Harz*, all painted around 1830 and now in Berlin, he creates a sparkling world of brilliant colours and dazzling sunshine. These sketches, of which about a hundred survive, give delight, pure and simple. Among his more finished pictures, *A Ravine Near Amalfi* (1831, Berlin) shows he could paint a waterfall quite as well as Turner and, unlike Turner, he could do remarkably fine figures too, as *Girls Bathing in the Park at Terni* (Schweinfurt, Museum Georg Schäfer) demonstrates with panache. Of course Blechen genuflected to the symbols of the time, as is shown by his *Ruined Gothic Church* (1826, Dresden). He was a romantic; it was the fashion. But essentially he was a painter who loved the real world under the sun, and wanted to get it on his canvas with joyful fidelity—*The Building of the Devil's Bridge* (1833, Munich, Neue Pinakothek) is an exclamation of delight at the warmth of the earth.

These splendid painters loved skies as much as Constable did, and studied them no less intently. Carl Gustav Carus (1789–1869) painted a memorable portrait of his leader, *Caspar David Friedrich in His Studio* (1811, Hamburg), and he specialised in the window-paintings these men loved so much, sometimes to the point of irritating us today; but what he really worked at was skies. *Misty Landscape* (1824, Berlin) and *Evening Clouds* (1850, Görlitz) display a profound knowledge of the atmosphere. Another master in this field was Johan Dahl (1788–1857), a Norwegian from Bergen, who met Friedrich and his friends at what had become their base in Dresden, and exchanged ideas and techniques. His *Drifting Clouds* (1835) and *Cloud Study over the Elbe* (1832 both Oslo, National Gallery) are masterpieces of the art.

Of the Scandinavian painters, however, the most gifted was Christen Købke

(1810–1848), the brightest star of what is now recognised as the golden age of Danish painting. The child-prodigy son of a baker, he attended the Copenhagen Academy at the age of twelve, and made his way to Italy as quickly as he could, as did virtually all northern painters in those days. On his return he painted a series of views (some oil sketches) or Frederiksborg Castle, at different times of day, in contrasting weather and in varying lights, which constitute one of the great achievements of European art in the nineteenth century, so beautifully do they combine acute observation, superb painting technique and a deep sense of place and monumentality. They are worth going to Copenhagen to see, especially as the visitor to the Statens Museum for Kunst can also examine an enchanting street scene, *View at Osterbro in Morning Light* (1836), which shows cattle and villagers moving slowly through this quintessential small Danish suburb, under an evening sky of meticulous truth and elegance (for Købke also did many cloud sketches, with great profit to his art). Købke did portraits too, and genre scenes, and landscapes and tree studies; he painted the solitary lakes and inland waters of his country with pathos and pleasure. His *Autumn Morning at Sortedamssoen* (1838, Copenhagen, Ny Carlsberg Glypothek), showing a lonely figure under trees at the water's edge, brings time, place and nature very close. This young man loved nature, and paint, and life, and showed his love in everything he did; unfortunately pneumonia wiped him out before he was forty.

What impresses one about these northern painters is their sheer technical proficiency, the immense care they took to make preliminary sketches in pencil and oils, building up their pictures like a fifteenth-century Florentine; and the wonderfully clear and accurate brushwork of their finished surfaces. Probably the best of them in this respect was Eduard Gaertner (1801–1877), whose majestic view of Notre-Dame (1826, Potsdam) ought to be studied intently by anyone attempting townscape. The figure-work and stonework, linear and aerial perspective, sky and light and shadow are all of superb quality, and the composition takes you right into the centre of a painting, which sums up Restoration Paris with formidable truth. Gaertner could make a mere building live, could give it character, pathos even. His plain study of stone in sun and shadow, *Corner of the Courtyard in the Berlin Palace* (1830, Potsdam), extracts poetry out of a most unpromising subject. Even at his most topographical, as in his sensational 1836 *Panorama of Berlin from a Church Roof*, where he presents the entire city from the top of Schinkel's new Gothic church, the Friedrichswedersche, he stirs uncommon emotions. Only three of the original six panels of this great work survive, featuring the artist's own children clambering about the roof; they sparkle with light and colour and make that grimmest of cities, Berlin, seem almost paradisiacal. He did some fine pictures of the Prussian capital and its formal occasions, which can be seen in the Schinkel Pavilion of the Charlottenburg Palace, and no city ever had a more faithful visual biographer.

Gaertner is complemented by Carl Hasenpflug (1802–1858), perhaps the greatest church painter of the time, whose *Garrison Church at Potsdam*, (1827, Berlin), painted

in oils on copper, positively glows with sunlight. It is a magnificent rendering of an ecclesiastical image, which lifts the spirit and calls to prayer, but it is also a work of unashamed virtuosity, for these hard-working men took pride in their skill. The most accomplished of them was Johann Erdmann Hummel (1769–1852), who created for the 1832 Berlin Academy exhibition a masterpiece of verisimilitude in three parts, which even by the standards of the nineteenth-century realists was an exceptional performance. They show the polishing, erection and location of an enormous granite basin, made for the front of Schinkel's new art museum in Berlin.

In what way is it romantic? That is more difficult to answer. The truth is, these labels, like all the other labels in art—without a single exception—will not bear close examination. Artists are free spirits, who follow their bent, and cannot be put into boxes. In German romantic art there is always more than meets the eye at first glance. Behind its exactitude and realism are dark pools of the spirit. And one is struck by the tragedies which overcame so many of these gifted men. The joyous Blechen went mad and died young, as did Købke. Those who lived were often forgotten during their lifetimes, and their works buried after their death for generations. There was a brief resurrection of Friedrich under the Nazis, for all the wrong reasons, and true appreciation came only with the 1960s. Now these northern painters are seen as a formidable school, with reason; but they are essentially individuals, all different, each to be savoured as an independent master.

It is important to grasp that all true romantic artists studied the past, especially the medieval past. The archetype here was Victor Hugo (1802–1885), who, though primarily a writer, was also an imaginative artist of unusual power, whose ink and sepia sketches, which he produced by the hundreds, were often used for frontispieces and covers of his works, and supplemented his powerful poetic images with dark visions. He tried to bring the Middle Ages back to

In *Paris, Rue Neuve Notre-Dame* (1826), Gaertner, Germany's greatest city-painter, shows the cathedral from an unusual angle in a cunning system of light.

life in the minds of men, women and children, and in such books as *Notre-Dame de Paris* came close to doing so. The cathedral itself was his real hero and heroine, as Cologne was for so many Germans. And what he did in the imagination, Eugène Viollet-le-Duc (1814–1879) tried to do in fact. This extraordinary scholar-architect, author of an immense work, *Dictionnaire raisonné de l'architecture française du XIe au XVIe siècle* (1854–68), was also a senior expert employed by the French ministry which had charge of ancient monuments. France's medieval past had been brutally battered by the revolutionaries, who destroyed many medieval buildings and damaged countless others.

Le Duc was involved in close to a thousand different projects of restoration, saved a number of important buildings from destruction, like St Madeleine and, Vézelay, and put his stamp on hundreds more. He also drew them, and contributed nearly 250 beautiful topographical drawings to the most important survey of its architectural heritage ever conducted in France, as well as teaching at the Paris École de Dessin. He knew about medieval architecture from the inside, for he climbed over its ruins and sometimes had to rebuild portions. All his knowedge was essentially practical, gained on the spot, by swarming up and down old buildings on ladders and by rope. He claimed he worked an eighteen-hour day, and we can believe it from the amount of work he actually produced, in drawings, plans, reports, reconstructions and original work in the Gothic mode, especially village churches but also town houses, châteaus and public buildings. He was famous for his rages and attitudinising, saying that it was those who tried to destroy medieval buildings who were the true heirs of the Goths. He knew more about the subject than anyone else, before or since, though his equivalent in England, the restorer-architect Sir George Gilbert Scott (1811–1878) came close. Le Duc could design almost anything: stained-glass windows (not painted glass, which he hated), chimney-pieces for châteaus, altars for churches, Gothic windows, church plate, vestment and reliquaries. He supplemented his architectural publications by his important *Dictionnaire du mobilier* (1858–75) and there was almost no sphere of art in mid-nineteenth-century France in which he did not have a finger, usually an entire arm.

Scott, in Britain, was subject to the same kind of criticism as Le Duc, and in the first half of the twentieth century 'very Scott' or *très Viollet-le-Duc* were sneering expressions used for botched restoration work. In the second half of the twentieth century we learned better. Scott was as productive as Le Duc. As one of his critics put it, 'During a working career of forty years, Scott built or interfered with nearly 500 churches, 39 cathedrals and minsters, 25 universities and colleges and many other buildings besides.' Even so, he was not the most prolific of the English Gothicists. That title goes to Augustus Welby Northmore Pugin (1812–1852), son of an architect, who was hard at work designing a Gothic church at the age of nine (the beautiful drawing survives). Thereafter he never stopped—drawing, painting, designing, inventing. There were two cathedrals, a score of churches—including Cheadle in Cheshire, the

finest church building created anywhere in the nineteenth century—and much public work. Although Sir Charles Barry (1795–1860) was the official architect of the Houses of Parliament (1835–52), now recognised after cleaning as the greatest of all Gothic revival buildings, Pugin did the drawings, supplied most of the Gothic detailing, and was largely responsible for the House of Lords section. Virtually all the interiors of this grand ensemble were his own work, down to the last library chair and roll of wallpaper.

Victorian England used to be seen as a world of titans in politics, imperialism, business and engineering. We have learned to appreciate the titanic aspect of her artists too, and Pugin was an outstanding example. One of his contemporaries wrote: 'Genius and enthusiasm in every line of his face.' Another: 'His

A. W. N. Pugin collaborated with Charles Barry to make the new Houses of Parliament the ultimate masterpiece of the Gothic Revival, the Queen's Throne (1847) being its core.

energy was boundless, his powers of application almost unrivalled and the versatility of his powers inexhaustible.' He could barely write a business letter without beginning it with a beautiful painted initial capital. He designed altars and vestments, holy vessels, jewellery, frames, tapestry, book bindings, tiles and plates, furniture from the royal throne in the Lords to the humblest stools, carpets and scarves, cushions and bedcovers, ceilings, candelabras, stained glass, goblets, swords, forks, fireplaces, tombs—cradles and graves, and everything in between. The great house he designed in Lancashire, Scarisbrick Hall, and decorated throughout, is a monument to his dedication to quality and detail. Cheadle may have cost his patron, the Earl of Shrewsbury, £40,000 rather than the £7,000 he had budgeted, but no matter: a billion dollars would not buy it today, so rich is it in the highest craftsmanship and genius. Pugin was particularly skilful at discovering and training brilliant collaborators, in wood and porcelain, metal and stonework. He also designed and built his own house and church at Ramsgate, a miniature Escorial.

Pugin's devotion to the Gothic was a transcendental passion. He was brought up on it. His father wrote a book which Pugin completed, *Examples of Gothic Architecture*. He wrote his own tract, *Contrasts*, which he illustrated, showing how the Gothic style was in every way, aesthetic and practical, superior to 'the present Decay of Taste' (1836). He followed it with *The True Principles of Pointed or Christian*

Architecture (1841), which became a bible for enthusiastic artists throughout the world, and supplemented it with a *Glossary of Ecclesiastical Ornament and Costume* (1844). His love of Gothic frogmarched him into the Roman Catholic Church, and even chose for him, as his third wife, a beautiful woman called Jane: 'I have got,' he exulted, 'a first rate Gothic woman at last.' From his lair in Ramsgate he ran a succession of sizeable boats, engaging in contraband, wrecking and treasure-hunting. He dressed like a sailor, favouring a navy-blue overcoat with colossal pockets in which he could conceal folio volumes, brass crucifixes, chalices, monstrances and other items he picked up on his voyages; and also his one spare shirt (he travelled light). He was an odd figure. Landing at Dover and entering, 'as was his custom', a first-class carriage, he was greeted with 'Halloa, my man, you have mistaken, I think, your carriage.' Pugin: 'By Jove, I think you are right—I thought I was in the company of gentlemen.' He was not easily crossed in the matter of manners, having high Gothic ideas of proper behaviour, and though only five-foot-four, he was quite capable of 'decking' a man with his huge fists.

It was part of Pugin's genius that he made his form of Gothic light and airy, at times aethereal, almost gossamer. His lines have grace, elegance, sometimes gaiety. In his church screens he used an ultra-light-grey background which brings out the power of his rich greens and reds. His tables, even at their most massive—see his dining table, now in the Houses of Parliament—seem spare and springy. His tiles glow; they are never heavy. His pulpits are reverent without being over-elaborate. The Victoria and Albert Museum has his sample-book, which shows how ravishing were his wallpapers. The Gothic service he designed for Mintons, the potters, was in use for eighty years, 1844–1924, and has since been revived. He could design a ceramic garden seat of great charm and a lych-gate with miraculous economy of line. The Pugin Parure is perhaps the finest set of jewels made in the 1840s. His Westminster is the greatest decorative work of its kind ever done in England and it is tragic that security makes it almost impossible of access. And then, after working non-stop all his life, Pugin suddenly vanished in 1852 in a puff of madness and death.

He left behind, however, a significant monument, as well as a tradition. His last major work was to design the Medieval Court for the 1851 Great Exhibition. The prototype world fair, the brainchild of a group of businessmen and Prince Albert, Victoria's consort, was entirely financed by private subscription and did not receive one penny of public money. It was designed to promote modern science and industry, as well as the arts, and proved immensely popular in its Crystal Palace setting. This great structure of iron and glass was the work of Joseph Paxton (1801–1865), the former head gardener to the Duke of Devonshire, for whom Paxton had built the Great Conservatory at Chatsworth. He followed this with the Palm House at Kew (1844), built to the designs of Decimus Burton (1800–1881), one of Nash's collaborators in Regency London. The Crystal Palace was on an altogether more grandiose scale: a floor area of 772,284 square feet, with an additional 217,100 square feet of

galleries. It was a prefabricated structure, built in standard units which were multiples of twenty-four, and was put up in Hyde Park in an astonishingly short time. It doubled the attraction of the show but it was notable that, amidst all the latest technology—there were over 100,000 exhibits—the Medieval Court, stressing the science and modernity of Gothic, as well as its religious power, proved the single biggest attraction.

The exhibition made a profit of £186,437, and the money was invested in buying a vast tract of Kensington, on which was built the world's first 'culture campus'. It included the Albert Hall Concert Room, the Royal Colleges of Art and Music, the Victoria and Albert Museum, the National Science Museum and the Natural History Museum, the last an architectural masterpiece (1879) by Alfred Waterhouse (1830–1905), in pink and grey-blue-coloured tile and terra-cotta. Just north of this grand collection of monumental buildings, aligned with the Albert Hall, a site was selected for the Albert Memorial, and Scott was asked to design it and pick a group of craftsmen-artists to create it (1863–72). The design took the form, as Pugin would have wished, of a giant monstrance, with Albert himself, in gilt, occupying the place normally reserved for the consecrated host. Victoria herself picked the sculptor, John Foley, and she had a hand in choosing other similar images to those Tiepolo painted on the Treppenhaus ceiling in Würzburg. Around the podium was the Parthenon Frieze. Scott picked Henry Hugh Armstead to do the poets, musicians and painters on the south and west side, and John Bernie Philip to do the architects and sculptors on the north and west. An astonishing monument emerged, perhaps the greatest single artefact created in the entire nineteenth century, a collective achievement of gifted artists and craftsmen, on a level with anything done in fifteenth-century Florence.

Gothic in its new form became the predominant Victorian architecture of Britain, her enormous overseas empire, and to some extent in the United States, where it was favoured for churches. In Britain alone, over a thousand major Gothic buildings, ranging from cathedrals like Truro and Edinburgh to town halls, schools and office buildings—the Law Courts (1874–82) by G. E. Street (1824–1881) was an outstanding example—were erected between 1825 and 1890. The style, with its ability to accommodate vast quantities of wrought iron and glass, was thought particularly suitable for main railway stations, Scott's own St Pancras terminal in London (1866–71) being an example. Spurred on by Scott, Frederick William Stevens (1847–1900) designed for Bombay the Victoria Railway Terminus (1878–87), a colossal amalgam of Gothic and Indian-Saracenic styles, which is the greatest of all Gothic Revival creations, certainly in India, perhaps in the world. It makes brilliant use of polychrome and is crowned by a fantastic quasi-oriental dome. Indeed, nineteenth-century Gothic cannot really be studied without a visit to Bombay, which has twenty-four large-scale and glorious examples, in a variety of modes and east-west combinations—docks, markets, schools, colleges, public buildings, offices, all richly decorated and resplendent in the

sun. Bombay was the greatest Gothic city of the Victorian Empire, closely followed by Melbourne, though there the exuberant Gothic of its cathedral and railway station mingled with a good deal of classical forms.

Some eighteen Gothic Revival cathedrals were built in the Empire and countless churches. Indeed, in the United States, Gothic continued to flourish as an ecclesiastical style until well into the twentieth century. In both England and America, Catholics and Protestants tended to build in different styles. As the nineteenth-century Protestants in England almost invariably used Gothic, the Catholics chose basilica-mode churches or, in the case of Westminster Cathedral, a superlative creation by J. F. Bentley (1839–1902) in the Venetian-Byzantine mode (1895–1903, though its interior mosaics have never been finished). In New York, by contrast, the success of the Catholics in building the graceful St Patrick's Cathedral in fourteenth-century French Gothic led the Episcopalians to plan their Cathedral of St John the Divine in a kind of Romanesque, but they were so uncomfortable with it that they reverted to Gothic in 1910. In northern regions, as Pugin often said, Christianity and Gothic were not easily separated.

Against the background of the Gothic Revival occurred the first of the artistic revolts against the ruling orthodoxy. That it should have occurred in Britain, a country where empiricism ruled and ideology was always suspect, is curious. But the year was 1848, 'the Year of Revolutions'—on the Continent, that is. Britain escaped such turmoil but made an artistic gesture of sympathy. Like most such labels, 'Pre-Raphaelites' was a sneer, though in this case happily accepted by the members of what they called the Brotherhood. Of the original members, the most important were William Holman Hunt (1827–1910), the leading spirit, Dante Gabriel Rossetti (1828–1882) and John Everett Millais (1829–1896). Rossetti and Millais were only twenty, and still students; Hunt was twenty-one but already had his own studio. They were soon joined by another established painter, Ford Madox Brown (1821–1893), who was twenty-seven. At the last major exhibition of Pre-Raphaelitism, in 1984, it was calculated that no fewer than twenty-nine artists were loosely connected to the PRB, the mystic initials which appeared on some of their paintings.

The Pre-Raphaelites had nothing against Raphael. The name arose because Millais and Rossetti were mocked for admiring engravings of the Campo Santo frescoes at Pisa, and because Millais used to say of Academicians who unthinkingly worshipped the artists of the High Renaissance, 'Slosh!' They were really protesting against those they saw as holding a monopoly of power and choice in the art world. Rossetti's brother, William, wrote what was the first manifesto of an art revolt. The members pledged themselves to produce 'genuine ideas'; to 'study nature'; to 'express sympathy' to those in need of it; and to aim for quality, to 'produce thoroughly good pictures and statues'. They were to draw their subject matter from three areas: Christian doctrine and medieval life; themes expressing moral values based on reli-

gious belief, but with contemporary settings; and the finest literature. These ideals were compatible with the romantic spirit, no longer new. All the same, the PRB was the first *avant-garde* movement in art, and its foundation in London is significant.

To some extent the PRB stuck to its ideals. They certainly produced religious pictures. Millais's *Christ in the Carpenter's Shop* (Tate Britain) was a sensation—some, such as Dickens, thought his presentation of the young Jesus as a mere apprentice furniture-maker was blasphemous, but the work was highly original and beautifully painted, and was snapped up for £150, a huge sum for a twenty-year-old to earn. But then Millais was, first and last, by far the most gifted of the Brotherhood. Rossetti produced *The Girlhood of Mary Virgin* and a version of the Annunciation, *Ecce Ancilla Domini*, both now in the Tate, early indications of his obsession with languishing women. Hunt's contribution was *Sheltering a Christian Missionary* (Oxford, Ashmolean). There were also 'social' pictures, as promised. Two, Rossetti's *Found* (Wilmington, Delaware Art Museum), in which a rustic husband recovers his city-strayed wife, and Hunt's *The Awakening Conscience* (Tate Britain), treated a subject which was soon to obsess the Victorians: 'fallen women' and prostitution. Millais produced some notable drawings attacking gambling and arranged marriages, and his striking and sensitive *Lorenzo and Isabella* (Liverpool, Walker), one of the most memorable images of the Victorian age, was an attack on marriage for money. Hunt's *Rienzi*

Bombay Station (1878–87) by F. W. Stevens is the climax of the taste for exotic versions of Gothic which spread throughout the British Empire.

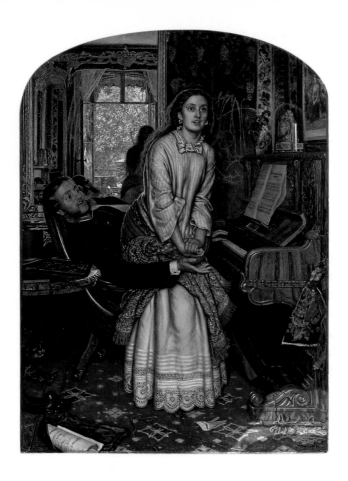

Holman Hunt's *The Awakening Conscience* (1853) features Annie Miller, whom the artist loved and attempted to turn into a lady.

(a theme which also appealed to the young Wagner) was a plea for better government, Rossetti posing for the hero.

All these pictures aroused keen interest, and launching the PRB certainly succeeded in attracting public attention to these clever young men. Their light colours, lack of shadow and *chiaroscuro*, and painstaking attention to detail were distinctive. They became a talking-point, a prelude to sales and fame—something not lost on other launchers of movements later. Moreover, Hunt's definition of their aim, 'to eschew all that is conventional in contemporary art', won the approval of the man now emerging as the most eloquent and influential writer on cultural subjects, John Ruskin (1819–1900). Ruskin had begun his career with a defence, almost a deification, of Turner, in the first volume of his *Modern Painters* (1843), which he continued to add to until 1860. He had exalted medieval art in his *Seven Lamps of Architecture* (1849) and his *Stones of Venice* (1851–53). His doting parents had caused him to live a sheltered, indeed isolated life. He was not allowed to play with other boys, or to have a normal school life, and the parents followed him even to Oxford, where he was denied collegiate 'promiscuity'. This had the beneficial effect of forcing him to learn to think for himself.

Ruskin developed novel and profoundly interesting ideas about the relationship of art to religion, morality and justice, and expressed them in a rhetorical prose which has never been equalled for sonorous beauty. He was beginning to attract a huge public of serious-minded people, who needed new buttresses for their faith, challenged by science and materialism, and thought a social-conscious art might be the answer. Ruskin found the PRB's aims good. He shared their admiration for the Ghent Altarpiece of Van Eyck. He approved of their mixing pigments with resinous varnish to keep their colours fresh, and the way in which they used a ground of white lead and varnish, often painting on it while still damp, like fresco. In a public lecture (November 1853) he gave them his apostolic blessing: 'I thank God that the Pre-Raphaelites are young, and that strength is still with them, and life, with all the war of it, still in front of them.'

In fact, by the time these words were spoken, the PRB was splitting up. The same month Rossetti announced: 'So now the whole Round Table is dissolved.' It had lasted five years and had served its purpose. Ambitious and gifted artists must pursue their own individual missions. There were jealousies over sales, quarrels over models and mistresses. Rossetti himself was an acrimonious man, tormented by insomnia and becoming, slowly but surely, dependent on alcohol and drugs. He came from an eccentric and tormented family; his sister, Christina, was a great poet, but an agonising solitary; he himself found it difficult to remain friends with anyone and eventually broke with all he knew. He concentrated on following the PRB's aim of painting from literature, from Dante and Shakespeare in particular. But his work was very uneven in quality, and what he really liked to paint were close-ups of exotic women with long, spectacular hair, in what he took to be medieval dress. They are dramatically appealing to some tastes: he got £2,100 for *Astarte Syriaca* in 1875. The best are *Proserpina* (1871, private) and *La Ghirlandata* (1873, London, Guildhall). His masterpiece, *Monna Vanna* (1866, Tate Britain), is a mesmerising work, to which the eyes are irresistibly drawn as you enter the room, whatever the competition. But she is not a real woman, of course: like the *Mona Lisa* she is the embodiment of a mood. Photographs of Rossetti's women—his models—tell a different story to the one he embellished in paint.

Brown and Hunt stuck to the PRB's aim of truth to nature. Brown too was a very uneven painter, but two of his works will always be remembered. *The Last of England* (1852, Birmingham, City Art Gallery) is a haunting comment, in oval shape, of the distress which was leading so many to emigrate—the design perfect, the detail horrible and exquisite. *Work* (Manchester; City Art Gallery) was begun in the same year and is an encapsulation of Victorian notions of industry and idleness, the class system and social comment (Carlyle looks sardonically on from the sidelines), set in salubrious Hampstead, where Brown lived. It is a painting to which one returns again and again, puzzling out its fascinating muddle and unexplained inconsistencies. Indeed, all the major works of these two dedicated men provoke thought, puzzlement, anxiety, sometimes fury and passion. Hunt went to more extreme lengths to achieve verisimilitude than any other artist in history. The story behind *The Scapegoat* (two versions: Manchester; Liverpool, Lever) is well known: how he went to the Dead Sea, taking a goat with him, to paint it on the spot; how the goat died; how Hunt was forced to paint with his brush in one hand and his rifle in the other, to fend off hostile tribesmen and bandits; how he was obliged to return to the Dead Sea again, and get another goat, and many other remarkable details. Hunt left his own account, as did a clergyman who was with him. It is an epic of Victorian devotion to duty, and got a mixed response, for the colours and atmospheric effects Hunt included in his extraordinary painting were simply not believed by most Londoners who saw it, nor indeed are they today, though the evidence suggests they are exact.

Hunt was a hard man; hard on himself, hard on other artists who had not his dedication or his faith. He believed; he wanted desperately to persuade or force others

to believe. In 1851–53 he painted *The Light of the World* (two versions: Keble College, Oxford, and Manchester), an iconic fantasy of Christ knocking at the door, which Academicians and critics hated but the public loved—it eventually went on a world tour. He shocked the right-thinking again with *The Shadow of Death* (1870–73, Manchester), showing an adolescent Christ stretching and casting a shadow of the Cross, and again with *The Finding of the Saviour in the Temple* (1854–60). This last was eventually sold to the dealer Gambart for £5,500, then a record price for a living artist, which gave Hunt financial security. He painted some striking watercolours, including an astounding rear-view of the Sphinx at Giza, and cliff-top scenes in England which have to be seen to be believed. Hunt was a curious-looking man with a switchback nose and huge sexual appetites, which led to blackmail and an illegal marriage. But everything he put on paper or canvas, though often ugly, is arresting.

Millais, by contrast, chose the smoother course of academic and popular success. This did not make him a lesser painter. On the contrary. He used the Academy shop-window to produce, in succession, a score of the greatest works painted in the second half of the nineteenth century. Ruskin was devoted to him. The two, and Ruskin's wife Effie, went on holiday in Scotland, and there Millais painted a wonderful full-length of the great man, against a background of a waterfall (Wilmington). He also painted Effie sitting by the same rocks, with meticulous finish. That was what Ruskin wanted painters to do: render nature as if seen through a microscope. It is what Ruskin did himself, in hundreds of drawings and watercolours, of Venetian buildings as well as natural phenomena, with love and devotion and, it must be said, fanaticism. Ruskin seized on two artists who moved close to the PRB circle, John William Inchbold (1830–1888) and John Brett (1831–1902), and bullied them into complying with his passion. With Inchbold, a promising landscape artist—Rossetti thought him 'the best'—it did not work. His beautiful, early watercolours (for example, *The Lakeside of Geneva*, Victoria and Albert) were succeeded by artistic silence, and poetry. Brett responded to the bullying by producing two astonishing works, *The Stonebreaker* (Liverpool, Walker) and *The Val d'Aosta* (private), the greatest mountain landscape of the Victorian era; and his *Cliff of Sorrento* (private) is a watercolour of almost magical glory.

Millais was not a man to be bullied. He was handsome, self-confident, fully aware of his powers, a man who loved painting, as opposed to religion, theory, social purpose or duty. He fell in love with Effie, and she with him. Ruskin, it seems, had been deceived by endless contemplation of classical nudes into believing female bodies were like them; his bridal-night shock of seeing Effie's pubic hair was something from which he never quite recovered. She divorced him on grounds of non-consummation, and married Millais, and Ruskin afterwards sadly remarked: 'I wish my parents had let me play with other boys, for now perhaps I might have a son of my own.'

Millais became a grandee of the Victorian art world, entirely on merit. He had what every great painter needs, the gift for conceiving an image, and realising it.

All his paintings are striking, memorable, keys which open doors into the ordinary imagination, nothing exotic but full of feeling: *The Black Brunswicker* (Liverpool, Lever) about young love; *The Blind Girl* (Birmingham) about affliction; *Autumn Leaves* (Manchester) about transience; *The Order of Release* about devotion; *The Vale of Rest* about death, *Ophelia* (all Tate Britain) about suicide. He was an extremely conscientious artist. Anthony Trollope, whose novels he illustrated, regarded him as by far the best: he read the books carefully and realised the incidents portrayed with complete fidelity to the text and spirit of the book. But there was none of Hunt's fanaticism. He made up to £40,000 a year and enjoyed being rich. He sold the rights to his *Bubbles* to the soap manufacturers, Lever Brothers, and has been held guilty of philistinism ever since, because he probably knew they would use it in their adver-

tisement. But it is a beautiful picture and deserved to be seen by poor people who would otherwise have been unaware of its existence. And the money from Lever's Sunlight Soap went to create both one of the world's first model housing-estate towns, Port Sunlight, and a privately endowed art gallery of the greatest distinction. Millais, like Rubens, always thought in such practical terms.

There was a new giant to take Millais's place in the lighted circle of enthusiasm: William Morris (1834–1896). He was no painter but, like Pugin, he could do virtually everything else. He was perhaps the most important designer who ever lived, in the sense that his patterns, in carpets, curtains, textiles generally, pottery and furniture, have penetrated all over the world and are still in vogue, more than a century after his death. His characteristic motifs, taken from nature but transformed into an unmistakable style, are one of the great certitudes in art history: inim-

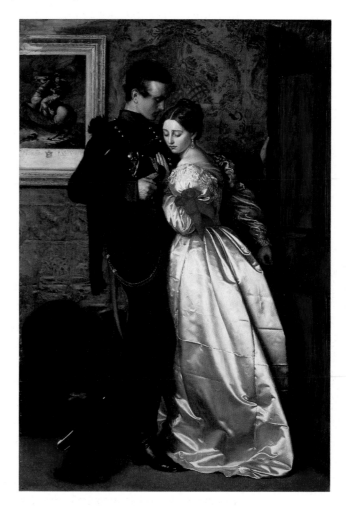

itable, infinitely adaptable, in impeccable taste. It is not quite true to say that Morris never made mistakes, but no other designer, working on such a broad range, achieved such a consistently high level of production.

Millais had an exceptional capacity to create images which stick in the memory, and all his paintings, like *The Black Brunswicker* (1860), tell a story.

His career tells us two important things about art. The first is that, in seeking to improve taste, financial independence is important. Morris was both *rentier* and a capitalist. The Morris children inherited from their father 272 of the famous Devon Great Consuls, shares in a copper-mine which rocketed with the age of the steamship. Morris Senior bought them at a pound apiece, and they multiplied in value eight hundred times. Even as an undergraduate Morris had £900 a year, and he was able to create his own design and manufacturing firm by investing a capital of £15,000. This brought him an income of £1,800 a year, with which he was able to run two beautiful houses, Kelmscott Manor, near Lechlade in Gloucestershire, and Kelmscott House in west London, filling them with enchanting things. The fact that Morris ran the firm, and ran it with great commercial acumen, allowed his taste and ideas to prevail absolutely. His partners were not in a position to overrule or even argue with him, and his workmen, though the best available, were willing slaves to his masterful ways, since he could do anything they could do with even greater assurance and virtuosity. His skill with his hands was phenomenal. He could carve, cast, weave, sew, print, dye and construct furniture particularly, as well as draw all the design plans. He was a brilliant cook, a most unusual activity for a gentleman of his time and class.

Along with Morris's business skill, which ensured the widespread success of his designs, went a hard, insensitive and thick skin—perhaps they were connected. His biggest fault as a designer is that his chairs and settees, though beautiful, are uncomfortable—a point brilliantly made by the cartoons of Max Beerbohm (1872–1956). When people complained of this, Morris (who never exactly sat down himself) said: 'They can go to bed.' His selfishness was at the root of the trouble with his beautiful wife, Janey, who figures prominently in the art of the time. Though the daughter of an ostler, she quickly took to sophisticated ways, proclaiming she 'couldn't exist' without 'at least' three servants, was nervy, had constant 'migraines' and colds, slept badly and rose late. Morris, by contrast, rejoiced in what he called 'roaring and offensive' health, opened doors and windows wide at all times of year, talked, sang and shouted day and night, rose at 5.30 A.M. and was soon shaking the house with the clattering of his loom. No wonder Janey took lovers, the first of them Rossetti; immediately she was with them she picked up tremendously, enjoyed perfect health and went on long walks. There is always a price to be paid for perfect art and the only question is: who pays it?

On the positive side, Morris brought with him Edward Burne-Jones (1833–1898), husband of the beautiful and soulful Georgiana, who gave the type-cast to the women in his paintings. Burne-Jones came to art late and took a long time to find and polish his personal style but, once done, it became one of the most pungent and resilient in the history of art. Burne-Jones had intended to be a clergyman, and remained devout. He first saw art clearly in terms of stained glass. This was not unusual. One of the most striking and practical aspects of the medieval-Gothic revival was the enormous quantity of high-quality glass made at this time, particularly in educational establishments.

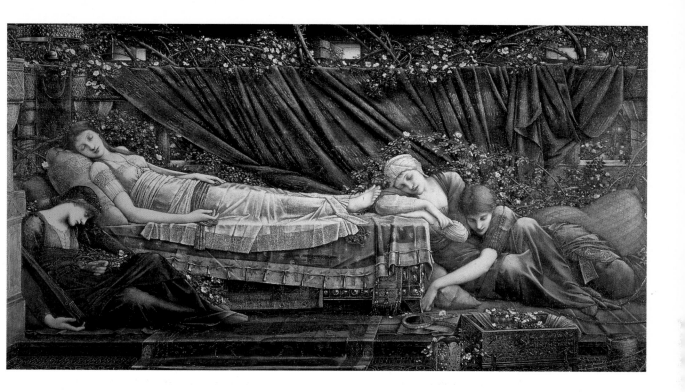

Burne-Jones's work in glass began with Clayton & Bell, the biggest stainers of the Victorian era, but he then worked exclusively for the firm Morris founded, Morris, Marshall, Faulkner & Co. Morris's favourite colours, deep blues, ruby, green and yellow, passed into Burne-Jones's own repertoire, though they were progressively transformed as he reached maturity. What he did was to combine a slender, mournful woman of exquisite grace, with pale flesh, and men dressed in garments of a curious but powerful colour combination of grey, green and blue, mixed in varying quantities, but giving continuity to almost his entire *oeuvre*. He got his linear ideas at first from Rossetti, but he also had links with a remarkable Belgian painter, Fernand Khnopff, whom we will come to later. Burne-Jones had views about relations between the sexes which struck contemporaries as peculiar. His exquisite watercolour *Phyllis and Demophöon* (1870) appeared to show the woman chasing and grabbing the man, whose genitals were showing. There were complaints and the Royal Watercolour Society had to withdraw it from their exhibition. He later repainted it in oils as *The Tree of Forgiveness* (Liverpool, Lever), but this time with the genitals covered in drapery, which passed muster. Generally, however, though the women were often nude or semi-nude, sex made no appearance in his paintings. One of Burne-Jones's greatest works, *King Cophetua and the Beggar Maid* (Tate Britain) is romantic but totally unsexual, and *The Beguiling of Merlin* (Liverpool, Lever), in which a woman is seen as temptress, and which might have been lubricious, is tender, though also worrying. In *The Wheel of Fortune* (Paris, Musée d'Orsay) and *The Golden Stairs* (Tate Britain) the difference between the sexes is rather one of form than of their respective

Burne-Jones's obsessive version of late-Romantic art culminated in his *Briar Rose* (1879–90) series (here, *The Sleeping Beauty*), with which he decorated Buscot Park.

functions in sexual reproduction. In the end, the principal theme of Burne-Jones is melancholy, best expressed in the grand and memorable series of pictures, *The Briar Rose* (1874–90), which he did for Buscot Park in Oxfordshire and which are still in place in this National Trust house.

It is often supposed that the PRB and their followers and successors, and the medieval-Gothicists generally, were in mortal conflict with the classicists who tended to dominate the Royal Academy in the last decades of the nineteenth century. It is true that Lord Leighton (1830–1896), President of the Royal Academy in the 1890s, Sir Edward Poynter (1836–1919), who held the post from 1896, and Sir Lawrence Alma-Tadema (1836–1912), all rejected the Middle Ages and turned to Greece and Rome for themes. But what both groups had in common was much more important than their varying choice of history. They all loved paint, the actual physical business of painting, and they loved the patterns it made on the canvas. Most of them were extremely well trained or became highly proficient in what they could do with paint. They made elaborate studies. The drawings of Burne-Jones, Poynter and Leighton are of the highest standard, each in its way, and Leighton also made superb oil sketches, like Rubens, to get his colour combinations exactly to his liking. Their priority was the visual impact rather than the story behind the shapes and colours. When Burne-Jones painted *The Wheel of Fortune* he was creating a series of shape-designs and colour patterns in paint. When Leighton painted his masterpiece, *Flaming June* (Ponce, Puerto Rico, Museo del Arte), he was trying to see if it was aesthetically possible to create a large swirling mass of orange filling most of a big picture; what the girl is actually doing, or who she is, matters very little.

This tendency in art, to go for visual effects within the tradition of total realism, reached its extreme form in the work of Albert Moore (1841–1893), whose settings for classical ladies, usually clothed, combine Roman and Japanese elements. Again, what they are doing, and why—holding racquets or balls or jugs—is of no consequence and was never explained. Moore simply wished to use the female form, and accessories such as flowers, rugs and curtains, to create beautiful arrangements in paint. He devoted his life to the task, did nothing else, wanted to do nothing else, and did it superbly. Thus combining intense verisimilitude with a total absence of content or message, he can only be called an abstract realist. That was the direction in which one grand tradition in British art was heading at the turn of the twentieth century, before events elsewhere changed everything.

It could be said, indeed, that Morris and his designs were abstract realist too, for they consisted, in one way or another, of turning nature into regularities of colour and shape. From this, and from his passionate belief that civilised men and women should use their hands (as well as their brains) to create, sprang the Arts and Crafts movement, the only self-contained style to be wholly created in Britain. A summation of the work of Pugin, the Great Exhibition, Ruskin and Morris, it sought simplicity,

truth to materials, functional elegance, sincerity and humility. In one sense it was a protest against the machine, increasingly dominant in everyday production. In the *Seven Lamps* Ruskin had drawn attention to the wonder of architectural ornaments carved by hand radiating 'the sense of human labour and care spent upon it'. In 1871 he had founded the Guild of St George, to resurrect medieval standards of personal craftsmanship, and as professor at Oxford he had encouraged his undergraduate followers to undertake manual labour, constructing a road, to teach them its dignity.

Long before that, Morris had started a trend by getting the young designer Philip Webb to make him a house which would 'be true to its materials'. The result, the Red House in Upton, Kent, was not based on any historical style, was entirely functional and took its name from the bricks of which it was built. Morris followed this by getting Rossetti to design the Sussex Chair (1865) in the same spirit, and sold it through his firm. By then he had already produced his first wallpaper, *Trellis* (1862). Others soon liked and expanded the idea. In 1872 the Royal School of Art and Needlework was set up to create 'suitable employment for poor gentle-folk' and restore 'ornamental Needlework to the high place it once held among the decorative arts'. It joined the Ladies' Ecclesiastical Embroidery Society and many regional craft workshops. It is easy to laugh at such ventures, but the object, to enlarge the number of those gainfully employed in the arts, was sensible. In 1884 the Home Arts and Industries Association, which organised professional and amateur work done at home and provided big-city premises where the products were sold, began the process of setting up craft centres all over the country, and soon covered Wales, Scotland and Ireland too.

Two years before, the Century Guild was created by A. H. Mackmurdo (1851–1942) to give practical effect to the philosophy of Ruskin and Morris by rendering 'all branches [of craftsmanship] no longer the sphere of the tradesman, but of the artist' and to 'restore building, decoration, glass painting, pottery, woodcarving and metal-work to their rightful place besides painting and sculpture'. In practical terms, this group probably did more to raise design standards in ordinary things than any other force in the 1880s and 1890s, as witness its superb work, in all disciplines, in Henry Boddington's house, Pownall Hall in Cheshire. It was joined in 1884 by the Art Workers' Guild, founded by pupils of the leading 'new' architect, Norman Shaw (1831–1912). Shaw had built the first garden suburb, Bedford Park in west London (1878), and London's first big block of flats, Albert Hall Mansions (1879), next to the culture campus, and he made a point of employing superlative craftsmen. The Guild sought to spread his methods and it is one of those organisations which, despite much mockery, has survived. It became the centre of the Arts and Crafts movement, and recruited men of high talent, such as Walter Crane (1845–1915), who did the design and typography at the Essex House Press, operating from the Guild's premises, and C. R. Ashbee (1863–1941), who wrote many of the Press's publications as well as designing houses, jewellery, metalwork and textiles. Some of his silver-

work, such as his Decanter in the Victoria and Albert (1904), is superlative, and countless beautiful objects, still in use, issued from these busy centres of fine craft. Anyone who wants an overview of what they did should examine the interior of Holy Trinity, Sloane Street, known as 'the Cathedral of the Arts and Crafts movement'. It is full of hand-made treasures in wood and iron, glass and precious metal.

In Scotland, the movement produced a clutch of fine craftsmen and one genius. Charles Rennie Mackintosh (1869–1928), follower of Ruskin and Pugin but Glasgow-trained, was another of those multi-faceted Victorian men of ideas. Primarily an architect, he also painted in oils and watercolour, created designs for every kind of object and made furniture, for which his wife, Margaret, provided decorative panellings. In 1895, Mackintosh won a competition to create a new Glasgow School of Art, and his towering edifice, on a steep bluff, has a strong claim to be considered the first successful modern building in the British Isles. In fact Mackintosh was fundamentally a Gothicist, and drew his inspiration from a Scots tower-house of the seventeenth century. One of his gifts was the ability to project the past into the future, simplifying ancient forms into strong, noble lines. It is this hint of the past in his modern elongated verticals which makes his furniture so exciting, combining elegance with monumentality. Mackintosh insisted on totality of design, as all good architects do if they can, and his interiors, including furniture, wall-decorations, carpets, curtains and, not least, lighting, were as important to him as external shapes, and created down to the last detail.

A typical *ensemble* for a private client is Hill House, Helensburgh (1904), but Mackintosh's best-known work of this kind are the four tea-rooms he designed for a catering firm in Glasgow, one of which (199 Sauchiehall Street, 1903) has been splendidly restored. It was hung with paintings of the new efflorescence of Scottish art, a group known as the Glasgow Boys, including W. Y. Macgregor (1855–1923), the Irishman John Lavery (1856–1941) and Thomas Millie Dow (1848–1919). In Glasgow, Mackin-

The doors at 199 Sauchiehall Street, Glasgow (1898), survive to testify to the genius of C. J. R. Mackintosh, Scotland's most versatile artist.

tosh's School of Art became the epicentre of a frenzy of artistic activity and laid the foundations for a respect for the arts which, during the twentieth century, transformed this commercial city into a great cultural centre notable for its splendid museums, collections, restored buildings and universities. It also inspired competition from Edinburgh, which responded with the group of outstanding painters, led by S. J. Peploe (1871–1935), known as the Scottish Colourists—a curious term since their greatest expertise was in the brilliant handling of white—and included Leslie Hunter (1877–1931) and Francis Cadell (1883–1937).

Mackintosh and his work were widely admired on the Continent, particularly in Austria, where the painter-designer Gustav Klimt was an enthusiastic follower. Artists there, and in Hungary and Germany, were impressed by the way in which the Arts and Crafts movement had enlarged the artistic community, and brought into the circle of enlightenment countless thousands of people who had not hitherto thought seriously about art. The movement's magazine, *The Studio* (founded 1893), circulated among artists and its articles were translated. In Vienna, young artists broke away from the Academy to form the Sezession, under the motto 'To the Age its Art, to Art its Freedom'. One of its founders, the architect Josef Hoffmann, laid down its goal as the unification of the arts, as in 'the English systems'. The Puckerdoft Sanatorium, which he built and furnished near Vienna (1904–1905), has strong affinities to Mackintosh's work, especially in its furniture. He insisted that designers like Ashbee, Mackintosh and his wife were prominently represented in the Sezession's exhibitions, and declared: 'Our aim is to create an island of tranquillity in our own country, which amid the joyful hum of arts and crafts, would be welcome to anyone who professes faith in Ruskin and Morris.' To this end he created a network of craft centres. The Morris and Ruskin doctrines also spread into Scandinavia, where the Swedish Handicrafts Society (1899), the Friends of Finnish Handicrafts (1879), the Viking Revival in Norway (from 1890) and new museums and schools of arts and crafts, modelled on British prototypes, were opened. To promote the alliance between art and industry, and to marry past to future, Sweden took the innovatory step of creating the world's first open-air museum in Stockholm (1899), where ethnographic treasures were displayed in new vernacular buildings—an idea widely imitated throughout America and Europe.

Arts and crafts centres soon flourished in the United States too, where utopian communities had always been welcome. The most successful, lasting from 1895 to 1938, was Roycroft in New York State, founded by the soap manufacturer Elbert Hubbard (1856–1915). Exactly like Morris, Hubbard was a proclaimed socialist who, in practise, used strict capitalist methods. At Roycroft he successfully established hand-printing on the lines of Morris's Kelmscott Press, branched out into binding, decorative leather, stained glass and metalwork, importing English and Continental experts and eventually employing four hundred workers. His slogan was 'The World

of Commerce is just as honourable as the World of Art—and a Trifle More Necessary'. He had a genius for promotion (including self-promotion) and marketing, using his journals, *The Philistine* and *The Fra*, and he invented the premium method of selling. His workers got an eight-hour day, almost unknown then; on the other hand they were paid minimum wages—Hubbard was not a Morrisian for nothing. But the project survived and made a profit. By contrast, the Byrdcliffe Colony in Woodstock, New York, created by Ralph Radcliffe Whitehead (1854–1929), carried Arts and Crafts principles to their ultimate extreme. Its main product, furniture, was too labour-intensive to be sold profitably, and the project lasted not much more than a decade, 1902–1915. Another community took as its model Ashbee's Guild of Handicraft at Chipping Campden in the Cotswolds. It was set up at Rose Valley near Philadelphia, where its founder, William L. Price (1861–1916), converted old textile mills into craft shops. At one time there were over a hundred craft-workers there, producing furniture, pottery and books, running their own journal and taking democratic votes. But the life-span was short: 1901–1909.

Such projects, and there were scores more, showed that improved design was more likely to be achieved, at least in America, when backed by big firms run on commercial principles. One of the movement's greatest successes was to infiltrate Grand Rapids, Michigan, then the centre of the furniture industry, which produced such Arts and Crafts designs as 'Lifetime', 'Handicraft' and 'Quaint'. David Kendall (1851–1910), designer to the Phoenix Furniture Company, turned out a superb range of such products, including a special chair bought by the President (1894) and thereafter known as the 'McKinley Chair', a best-seller for decades. It was the same story in pottery. At the Gates Pottery in Terra-Cotta, Illinois, William Day Gates (1852–1935) used his successful business making terra-cotta for builders to create some superb glazes and to produce what he called 'art pottery having originality and true artistic merit at slight cost'. Similarly, the big firm of Rockwood Pottery produced the brilliant designer Artus Van Briggle (1869–1904) who created magnificent vases which could be produced in large editions.

Arts and Crafts methods took deep root in America. Local designs and products, and British ones too, were powerfully represented at the big trade fairs, such as Philadelphia in 1876, Chicago in 1893, St Louis in 1904 and San Francisco in 1915. William Morris societies were founded. Ruskin's book on the decorative arts, *The Two Paths*, went through nineteen editions up to 1892. It is arguable indeed that the great trio of Pugin, Ruskin and Morris had more widespread and lasting influence in America than in Britain. But it would be wrong to give the impression that the explosion of art which took place in nineteenth-century America was British-led. Quite the contrary: the genius of American artists sprang directly from the monumentality of the land from which they came.

24

PAINTING THE AMERICAN WORLD AND ITS WONDERS

The history of American painting has yet to be written, for it is only recently that the magnitude of the work done by American artists in the nineteenth century has begun to be recognised, even in the United States itself. Some of them are now looming as true giants on the world scene, and what they did and how they did it has to be reinvestigated and reassessed in that light. High-quality painting took a very long time to push deep roots into America, and even in the age of Gilbert Stuart, John Singleton Copley and Benjamin West, American painting was an appendage of the British body, itself largely disparaged in terms of European art. By 1850, however, it was a force in its own right, drawing its strength from the colossal power of its native scenery, and producing what must now be seen as one of the greatest schools of landscape in the whole history of art. How did this come about?

The bridge between dependency and independence was the work of Thomas Cole (1801–1848). Cole was almost entirely self-taught and had many obvious limitations. But he had the vision and drive of a Hogarth, and Hogarth's powerful moral sense too, and these qualities enabled him to found a new school of art. Cole came from Lancashire and did not arrive in the United States until he was seventeen; and since he had two long trips to Europe, in an almost desperate attempt to learn about great art, only half his life was spent in America. Nevertheless, his first shock on seeing this almost inconceivably vast land, and recognising its fragilities as well as its strengths, remained with him all his life and gave him the resolution to paint it. Cole quickly grasped too that, to arouse a passion for art in American minds, moral points had to be made and he acted on this realisation as Hogarth had. He painted in the open air whenever he could and his early landscapes celebrated American immensity. *Landscape with Tree Trunks* (Providence, R.I., Museum of Art) and *The Clove, Catskills* (New Britain, Conn., Museum of American Art) are studies in weather and immensity, and attracted little notice. To gain attention, Cole used American backgrounds to produce biblical scenes, such as *The Garden of Eden* (Fort Worth, Amon Carter Museum) and *Saint John the Baptist Preaching* (Hartford,

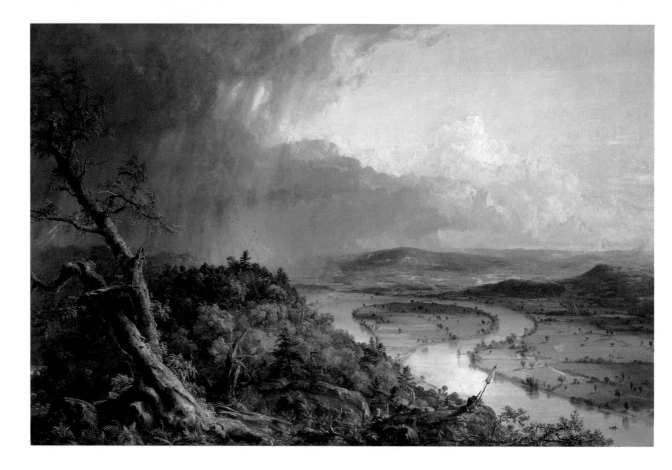

Thomas Cole, with *The Oxbow* (1836), broke away from history painting to found America's school of landscape.

Conn., Wadsworth Atheneum), and he also attached himself to the bandwagon of Fenimore Cooper's best-selling tales by painting *Scene from 'The Last of the Mohicans'* (Cooperstown, New York State Historical Association).

Such works enabled him to finance his first trip to Europe, where he saw the Turners and, in Rome, occupied Claude's studio. The combination gave him the idea for what he thought of as the first large-scale series in American art, which he realised on his return. He called it *The Course of Empire*, and it traces the rise, prosperity and ruin of a great nation, from obscurity to oblivion, in five tremendous canvases, painted between 1833 and 1836 and now all in the New-York Historical Society, along with the originals of those other great icons of American art, James Audubon's *Birds of America*. The influence of Claude and Turner is plain enough in these grand scenes, which combine Cole's knowledge of the American wilderness with his fervent imagination. Moreover, the moral message—they are a five-part sermon against pride—comes over much more strongly than in its prototypes and was correspondingly more effective among an American cultural élite which loved sermons. Cole's reputation was thus made, and though he continued with his moralising series on the lines of Hogarth—his four-part *Voyage of Life*, on Christian resignation, is in Utica, New York—he could now expect the public to look carefully at his pure landscapes.

Cole's *Falls of Catskill*, painted in 1826 (Tuscaloosa, Ala., Warner Collection), had

already shown what drama he could create out of the depth, immensity and fierce colour of the American wild. But now, a decade later, he produced what is the founding picture of the large-scale American landscape tradition: *The Oxbow*, which presents a thunderstorm view from Mount Holyoke in Northampton, Massachusetts (New York, Metropolitan). Shattered pines and dense woods lead the eye over the hill into the great bends in the river; and above, a tremendous cloud-formation hurls torrential rain into the sunlit scene. The painting did not attract much attention at the time and sold for a modest $500, but American artists who saw it were transfixed and inspired by this sudden vision of what their country offered them to paint.

Cole followed *The Oxbow* with the other side of the picture: the huge serenity of the American scene. *Early Autumn View on the Catskills* (Metropolitan) and, still more, *Schroon Mountain, Adirondacks* (Cleveland, Museum of Art) offer immensity and calm, in red-gold colours which excite the eyes and warm the heart. When Cole first saw the Schroon, he grasped the immensity of the task nature had set American art:

> The hoary mountain rose in silent grandeur, its dark head clad in a dense forest of evergreens, cleaving the sky, a starry pointing pyramid, [and] below, stretched to the mountain's base, a mighty mass of forest, unbroken but by the rising and sinking of the earth, on which it stood. Here we felt the sublimity of untamed wildness, and the majesty of the eternal mountains.

Cole completed this great trio of works in the last year of his life with *Genesee Scenery* (Providence), done in western New York: a towering waterfall emerging from a turbulent hillside under a limitless sky of clouds, moist and crystalline blue. Like Constable, he needed big skies, and he wrote of this work:

> Not in action, but in *repose*, is the loftiest element of the sublime . . . [In the sky] is the illimitable . . . All is deep, unbroken repose up there—voiceless, motionless, without the colours, lights and shadows, and ever changing draperies of the lower earth. There we look into the uncurtained, solemn scene—into the eternal, the infinite—towards the throne of the Almighty. These are the true accents of the American landscape painter.

Cole's closest friend was the New Jersey artist Asher B. Durand (1796–1886), the two men going on sketching expeditions together, though where Cole looked for the moral as well as the scene, Durand cared only for nature in its simplicity. Durand took a long time to create his personal style and he was nearly fifty when he produced *The Beeches* (1845, Metropolitan), a grand mingling of Claude and Constable, with Cole metaphorically peering over the artist's shoulder. There is great truth to nature in the painting; much drama too, and a sense of America's vastness. More subtle and cool is his deep-searching picture *Dover Plains, Duchess County*, in which he conjured

up the soft gold-green of sunlight filtered through thin cloud on limitless meadows. This was painted the year Cole died, 1848, and the following year Durand produced his tribute, *Kindred Spirits* (New York Public Library), showing Cole and his friend the nature poet William Cullen Bryant standing on a ledge overlooking a deep ravine in the Catskill Mountains. Durand held the view that only when an artist had visited a particular region many times, studying nature there 'intimately', could he 'approach her on more familiar terms, to choose and reject some portions of her unbounded wealth'. Knowing the Catskills so well, he included every main feature of their beauty in this icon picture, beautifully composed and painted, which became instantly popular and was, for countless Americans, their first introduction to the glories of American landscape.

Having paid this tribute to Cole, Durand could then go his own way, which was to study nature, especially woodland, from no more than a few feet, and render it objectively with total accuracy. Thus we get some wonderful close-ups: *Interior of a Wood* (1850, Andover, Conn., Art Gallery), rendered with Ruskinian exactitude, and *Rocky Cliff* (1860, Winston-Salem, N.C., Museum of American Art), perhaps the best geological-art study ever to emerge from America. When he pulled back his point of vision, as in *In the Woods* (1855, Metropolitan), Durand showed how much he had learned from experience, in rendering the forest; and pulling back still further, in

Kaaterskill Clove (1866, New York, Century Association), his last work, he left a golden, misty testament to American immensity. It was Durand's view, by the end of his life, that American artists should concentrate on landscape. As he put it: 'Why should not the American landscape painter, in accordance with the principle of self-government, boldly originate a high and independent style, based on his native resources?'

The high and independent style—that is exactly what Frederic Edwin Church (1826–1900) created, and in the process he made himself not only America's most consummate artist but one of the world's greatest landscape painters, on a level with Turner and

Durand's *Group of Trees* (1855–57), done from nature in the open air, shows the dedication which made him leader of the Hudson River school.

surpassing all the rest. He came from a wealthy family, which enabled him to study early and long, notably with Cole himself. As a tribute to his master, in 1844 when he was eighteen, Church painted *The Oxbow* (private), from exactly the same viewpoint, showing how much he, and American art, had learned since then. From Cole he grasped the importance of doing many detailed studies of chosen locations, and he improved upon this procedure to the point where his pictures were built up with all the care and discipline of a Raphael. His preparatory drawings, taken from his lovingly preserved archives, have now been published in two massive volumes, and they show the trouble Church took to get everything exactly as nature intended, from skies to fallen logs and stones. He was not a visionary, like Turner; he was, rather, a man who recorded the visible, to the limits of human perfection.

Success came early. Church achieved a sensation with his first 'phenomenon' picture, the pink-tinted *Above the Clouds at Sunrise* (1849, Tuscaloosa), one of eight pictures he sold that year. Another, *West Rock, New Haven* (New Britain), marks his maturity as the classic painter of American landscape, though he was only twenty-three: a peerless sky of placid cumulus, distant hills and rock, the forest on the valley floor, the bend of the placid river, harvesting in the meadow, all organised in superb aerial perspective and painted with a combination of strength and delicacy. It was enough to make his competitors despair; as the American Art-Union's *Bulletin* observed, it fulfilled all Ruskin's criteria of excellence: to make 'art the perfect mirror of nature'. Church followed this with a succession of grand scenes: large-scale views at all times of day and in all seasons, dominated by a spectacular evening view, taken in autumn, *New England Scenery* (1851, Springfield, Mass., Smith Art Museum), which summarised his efforts to create verisimilitude with feeling. The monumentality, the detail, the subtle colouring, the air of sympathy which this big 'six-footer' generates, were in conjunction beyond the powers of any artist then living (Turner had died the year before). One contemporary, Henry Tuckerman, wrote of it: 'His great attribute is skill; he goes to nature not so much with the tenderness of a lover or the awe of a worshipper, as with the determination, the intelligence, the patient intrepidity of a student; he is keenly on the watch for facts, and resolute in their transfer to art.'

These shrewd words apply to all of Church's career, and he now began to turn his hand to the re-creation in art of some of the outstanding sights of the American hemisphere. In judging Church's work it is important to grasp that landscape, even at its most monumental, is not the reproduction of nature on canvas. For in any view there are, literally, millions of visual units, each distinct on close inspection. Even before the artist begins to apply his art, he has to select, at most, a few hundred, or a thousand of these. Church was extraordinarily gifted at this basic editing, which is anterior to the composition and which, in combination with his superimposed compositional skills, makes his pictures even more powerful, if possible, than the sights themselves. This is because they emphasise not totality but saliency, which makes the phenomenon, however complex, simple and understandable.

The Great Falls, Niagara (1857) made Church the world's leading landscape painter and the successor of Turner. He painted for the paying public rather than individual patrons.

By the early 1850s, Church, like Michelangelo, knew he was destined to do great things, and took his work with earnest seriousness. The Niagara Falls were then considered the greatest sight in America and Church felt compelled to epitomise them. He first sketched the Falls in 1845, visited them again in mid-1851 and on another three occasions, each for several weeks, in 1852, looking for the best possible viewpoint and making countless sketches, of which twenty-one large ones survive. The master-painting evolved slowly from a succession of oil sketches, culminating in a prototype, *The Great Falls, Niagara*, in 1856 (private), and followed by the final sketch in February 1857. The actual painting took six weeks more, an eyewitness adding: 'The perfect accuracy in the drawing was accomplished in a way solving to some degree the mystery of the success. The artist prepared two canvases of the same size. On one he experimented until his critical eye was satisfied with a line or an object; then placed it on the other.' The procedure involved not just deliberate patience but space, for in addition to picking exactly the right viewpoint, one big key to success, Church prepared the dimensions of the canvas to suit the nature of the phenomenon. This meant that although each was less than four feet high, they were seven and a half feet long.

The finished work can no more be described than Niagara itself, for it is Niagara, or rather the Falls, made understandable. It went on view at Williams & Stevens' Manhattan Gallery on 1 May 1851, to 50,000 people, then toured the British Isles, where it was hailed, by Ruskin and others, as the moment when American art 'took a leading place' on the international scene. *The Great Falls* is in truth an awesome painting, for the many hundreds of details seem to fit naturally into the monumental conception, which is essentially simple. The light radiates from the power of the water, not the sky, which is otherwise lit purely by a rainbow arising from the spray (the only rainbow in art ever perfectly painted). What is more, the whole canvas has tremendous movement, following the huge volume of water rushing over the brink, so that viewers feel themselves travelling with it into the abyss (the picture is

notorious for provoking wild dreams). It is possible to challenge the concept, but not the execution.

With Niagara conquered, Church turned to Latin America, which has the highest mountains in the hemisphere, the largest forests and, not least, immense and active volcanoes. Church first visited the Andes, to prepare himself, in April–October 1853, doing pencil and oil sketches of the Magdalena River, the Falls of Tequendama and the active giant volcanoes Cotopaxi and Chimborazo. This produced three huge canvases (1855): *Tequendama Falls*, *La Magdalena* and *The Cordilleras: Sunrise*. In 1857 came a further four-month visit, concentrating on Chimborazo, Cotopaxi and Sangay. On both trips Church worked frantically hard in the most difficult conditions, producing hundreds of drawings and oil sketches, packed up on his train of nine mules. He was already planning what he termed 'my great canvas', *Heart of the Andes*, which he put down in all essentials on a little travelling canvas only 10 by 18 inches, describing the idea in words:

> Behind us at the West towered the distant Chimborazo which, like all these mountains, seem to increase in magnitude as we recede from them. Surrounding us were lower snow peaks, some of which are not clad in perpetual snow. Among the most conspicuous was the Tuna range exactly in front of a very irregular sierra but comparatively not very high. The lack of trees gives a singularly lonely effect increased by the absence of birds; the river contains no fish.

The completed canvas, done in 1858–59, was nearly 6 foot by 10, and must be reckoned one of the world's greatest paintings. The scale is prodigious, the depth unnerving, the variety of detail almost infinite, the effect stunning, even today, after a century of modern art, among those who come to jeer. At its first showing on Broadway, 27 April 1859, Church presented it in a specially constructed 13 by 14-foot free-standing dark walnut frame, which he designed to produce the illusion of a 'vision through a palatial window or castle terrace upon an actual scene of picturesque mountains, tropical vegetation, light and loveliness'. It was accompanied by a forty-three-page guidebook and was probably seen by more people than any other painting in the nineteenth century. However, *Heart*, which made its way to the New York Metropolitan in 1909, is not the most sensational of Church's Andean paintings. That title goes to *Cotopaxi* (1862, Detroit, Institute of Art), which shows the immense volcano in a smoke-eruption near sunset, so that the entire canvas, 48 by 85 inches, is suffused in brown-red vapour, broken only by blue patches in the sky and river, an amazing vision. Its companion picture of the same size, *Chimborazo* (Boston, Museum of Fine Arts), done in 1864, shows the snow-clad cone, detached from and suspended above the lower mountains, clouds and tree-festooned river, something which almost defies belief, though it is in fact an accurate representation,

With *Cotopaxi* (1862) Church recorded the astonishing effects of Latin American volcanoes, elaborated from on-the-spot oil sketches.

again at sunset. The drawings, oil sketches and complex studies which accompanied these works of the late 1850s and 1860s constitute a formidable body of work. And from time to time Church added a coda to his South American views, such as his sweating, dripping, steaming *Morning in the Tropics* (1877, Washington, National Gallery), which evokes the atmosphere of the high rain-forest in a way no other artist has ever matched.

There were more than a score of first-class American landscape painters in the second half of the nineteenth century, perhaps the greatest assemblage of talent ever to devote itself to this form of art. The terms 'the Hudson River school' and 'the Luminists' have been used about them, the first a nineteenth-century label of derision, the second an invention of late-twentieth-century art historians. Neither is quite accurate. It is true that the grand Hudson River, thrusting up from New York City into the heart of the highlands of northeast America, offers wonderful opportunities to painters. In 1866, the painter Samuel Colman (1832–1920) produced *Storm King on the Hudson* (New York, Smithsonian), a magnificent picture, worthy of Turner, which combines the famous mountain, said to 'make its own stormy weather', a huge troubled sky, the vast expanse of the river, and the industrial crafts floating down it, in a virtuoso display of light and atmosphere. Colman was a pupil of Durand and this work is an emblem of the Hudson. It is certainly luminous too, but then, of what good landscape is this word not appropriate? Again, there are some fine landscape paintings featuring life on the river, especially those by George Caleb Bingham (1811–

1879), whose work stressed the hardship and courage of Americans living in the wilderness or on the frontier. Bingham's *The Jolly Flatboatmen* (Washington, National Gallery), showing a man doing a jig on the cabin roof of a river barge, is another emblematic picture. But the river is the Missouri, at whose university Bingham was professor of art.

What is true is that some American landscape artists, especially those working on the coast of New England, were exceptionally impressed by the clarity of light which may be experienced there, and became wonderfully proficient at recording it on canvas. In this respect they had strong affinities with the painters of the Baltic regions, working a generation before, though there appears to be little evidence that they were aware of the work of Kølbe or Friedrich. Fitz Hugh Lane (1804–1865), who worked mainly around such ports as Gloucester and Boston, evolved a highly effective personal style, showing coastal ships at anchor on pellucid, barely troubled waters against enormous skies, sometimes misty, often calm, occasionally stormy. His *Entrance of Somes Sound down Southwest Harbour* (1852, private), presents the golden close of a perfect, still summer's day with overwhelming clarity. By contrast, *Ship Starlight* (1860, Youngstown, Ohio, Butler Institute) is a monumental picture of a becalmed three-master waiting while the sun disperses the mist, a work Turner would certainly have admired. The same year he presented his habitually calm waters about to be troubled in *Ships and Approaching Storm off Owl's Head* (New York, Rockefeller).

Raftsmen Playing Cards (1847) by Bingham displays the joy and labour of America's pursuit of 'manifest destiny' against the New World's dramatic background.

Off Mount Desert Island (1856) displays the clarity and luminosity that Fitz Hugh Lane brought to depicting offshore life in New England.

Lane's concentration on a small number of designs for horizons, foregrounds and backgrounds, all similar in composition, might, in the hands of a lesser artist, be a formula for tedium. In fact it adds to the interest since we love to study the ways in which he varies his obsessions. No painter ever invited close study more successfully. In his masterpiece, *Brace's Rock, Brace's Cove* (1864, Gloucester, Mass., Cape Ann Historical Museum), there is total calm and clear sky; the sea is a mirror; a wrecked boat the only evidence that humanity has ever disturbed the pristine creation. We have here a form of art, limited in its aims, which approaches perfection.

Lane's evocation of stillness and clarity obviously impressed his younger contemporaries, John F. Kensett (1816–1872) and Martin Johnson Heade (1819–1904), though it would be wrong to call either of these great and highly original artists Lane's followers. Kensett was an extraordinarily versatile worker. His fine canvas, *The White Mountains, from North Conway* (1851, Wellesley College Museum, Mass.), is a classic evocation of the American landscape, with Mount Washington dominating an immense stretch of meadow and woodland. Its companion, *Sunset, Camel's Hump, Vermont* (Princeton University), is an evening view of what was then still a wilderness, which indicates the young Church had real competition in what he was attempting at this time. Kensett could paint wild woodland, close up, as well as Durand, as his *Bish Bash Falls* (1855, New York, National Academy of Design) shows. In *Lake George* (1869, Metropolitan), he took a familiar place of beauty, painted by scores of American artists, and turned it into a virtuoso study of soft greys, greens and browns, lake, sky and mountains blending in perfect harmony. Yet perhaps his most satisfactory painting, certainly his most popular—it is one of the stars of the New York Metropolitan—echoes Lane: *Eaton's Neck, Long Island* is a study in total

tranquillity. But its real merit lies in the way it expresses the theories of Girtin and Towne, two generations before—that skill in landscape is expressed by the careful massing of forms in divine simplicity.

Heade varied these themes. His *Sunrise on the Marshes* (1863, Flint Institute of Arts, Mich.) is an astounding evocation of early light on flat water-meadows punctuated by spherical trees, almost an abstract. Heade painted every variety of weather, but loved the catastrophic best, or rather the ominous stillness before nature's blow falls. His *Approaching Storm: Beach near Newport* (1866, Boston), *Thunderstorm over Narragansett Bay* (1868, Fort Worth) and *Thunderstorm at the Shore* (1870, Pittsburgh, Carnegie Museum) all capture this moment but in radically different ways. There is no repetition. One of the glories of nineteenth-century American landscape art, at its best, is that, though artists returned again and again to aspects of nature which they found transcendent, they always worked conscientiously to find new things to say in paint. Each of the last seven works mentioned here has in common that salient characteristic of great art: if you owned one of them, you would wish to look at it every single day of your life, as soon as you got up in the morning.

Once you begin exploring American landscape art, there is no end to it. The most important artist, next to Church himself, was a man born in Germany, who came to America aged two, went to Düsseldorf to train, then returned to conquer the West: Albert Bierstadt (1830–1902). This wonderful draughtsman and colourist, like Church, was immensely industrious. Not only did he travel widely, roughly and frequently in peril (like Holman Hunt) in search of the exact location, but he built up his often

A leading member of the Luminist School, Heade specialised in weather. *Summer Showers* (1865) is characteristic. He loved impending storms, sunrises and sunsets.

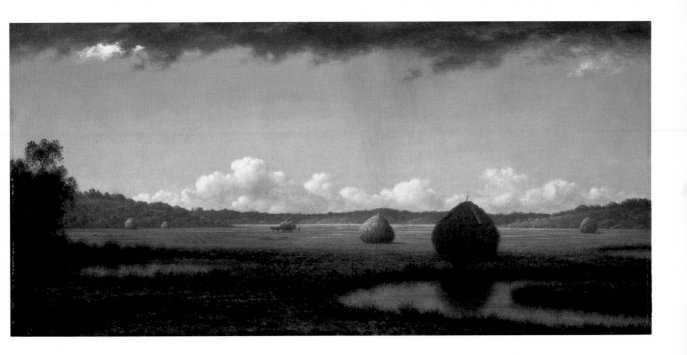

gigantic pictures by prodigies of studies and sketching. He won American fame in 1858 when he showed works done during his Continental studies—he produced the best painting of that overworked subject, Capri, ever seen, on either side of the Atlantic—but the following year he went to Colorado and Wyoming as part of a survey team. This enabled him to sketch and paint the one really important phenomenon of the hemisphere which Church never saw: the Rockies. He went west again in 1863 and again in 1871–73. These were not just sketching trips but immensely well-organised expeditions, often in virgin territory, producing thousands of drawings and notes, oil studies, and elaborate analyses of what was to be seen. From this material, in his Ten Street Studio Building, New York City, he constructed enormous canvases, which were then publicly shown, like Church's, to thousands of people who paid entrance money, and turned into prints and booklets. The last big presentation of Bierstadt's works, at the Brooklyn Museum in 1993, was termed 'Art and Commerce', as though there was something special (and by imputation dishonourable) about the way he first invested time and money, then amassed the profits. But that was exactly what Turner did, or indeed any great painter who has an atom of sense. Provided he is conscientious, a painter with a good sense of business always produces more, and usually better, work than those who lack it.

Bierstadt went to the West to record spectacular scenery on the spot. *The Rocky Mountains: Lander's Peak* (1863) is the results of one of his risky journeys.

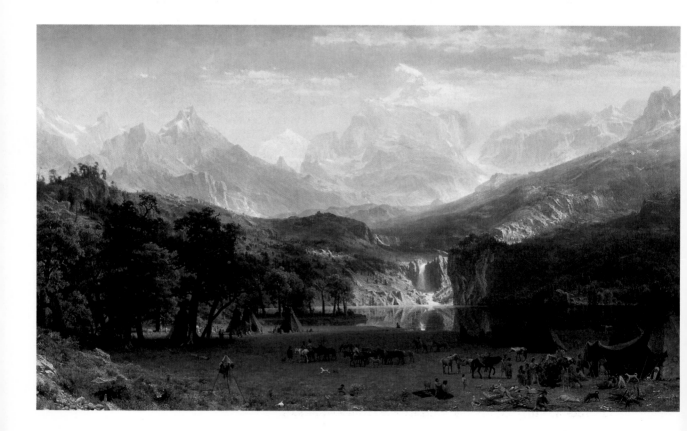

Bierstadt was certainly conscientious. You can examine one of his massive works, such as *The Rocky Mountains: Lander's Peak* (1863, Metropolitan), which is 6 foot by 12, inch by inch and will not find one iota of shoddy, slapdash or fraudulent painting. As the preliminary work shows, all is true to nature and rendered with the utmost fidelity and earnestness (the skill, which is unequalled, except by Church, goes without saying). All six of Bierstadt's big Rockies scenes are masterpieces. Indeed, the huge Brooklyn one, *Storm in the Rocky Mountains: Mount Rosalie* (1866), deserves to rank alongside Church's *Heart* and *Niagara* as one of the six greatest landscapes painted in the century (the other three are by Turner and Constable).

Bierstadt's poetry was expressed in his treatment of two of America's greatest natural phenomena, which he was the first to paint (and to date the best): the Yosemite Valley and the giant trees of California. When Bierstadt and his party got their first glimpse of the Yosemite, in 1863, few had seen it before then and it was as though they were opening the Book of Genesis: 'a new heaven and a new earth into which the creative spirit had just been breathed', as one said, 'I hesitate now, as I did then, at the attempt to give my vision utterance.' Bierstadt was under no such inhibitions—he instantly grasped how to paint this astonishing place: by emphasising the contrast between the verticality of the cliffs and the level horizontals of the river bottom. It was the tenacity with which he perceived and clung to such fundamentals which made him such a powerful painter. He shows himself doing it, as a tiny painting figure, in *Looking Up the Yosemite Valley* (Stockton, Calif., Hagging Collection), and it recurs in all his Yosemite views, large and small (one is 15 feet high).

The big trees were a different matter. These sequoias, concentrated in seventy-five groves, of which the Mariposa is the most sensational, were first seen by Bierstadt in 1863, and he returned to them twice, thinking about them deeply and wondering how he could paint them. He eventually picked on the Grizzly Giant, believed to be the oldest at Mariposa, and still the cynosure of visitors. He did a number of big tree pictures, one of which has completely disappeared, but *The Great Trees* (private), which he worked on 1874–76, is a portrait of the giant. The problem with tall trees, as Rubens, Gainsborough and Constable all discovered in turn, is that it is impossible to create a well-composed picture in which the tree is truthfully given its relative, let alone absolute, scale. Naturally, with the tallest trees on earth, the problem is compounded. What Bierstadt did was to let the Giant occupy nine-tenths of a canvas nearly 12 feet high (by less than 5 feet), so that its peak is within an inch of the top, by allowing an ample foreground in which four horses and five men are rendered minute, before the eye even reaches the bottom of the trunk. The tree itself is then tilted backwards at an angle, following the eye looking upwards, and its immense height is emphasised by painting in a rival at a distance, topping all else though it only comes up to the halfway mark on the canvas. All is superbly painted, the spongy bark of the giant rendered with mesmeric verisimilitude, and the grove vanishes in sun-gold mist to contrast with its inky recesses.

Clearly, Bierstadt employed all his remarkable skills (and keen intelligence) on this task, and some people at the time thought the result his masterpiece. Certainly no one, before or since, could have done it better. But was it a wise thing to do? Yes: because Bierstadt's life as a painter was based on challenge and response; he stood beside his easel, like Luther in Wittenberg, 'and could do no other'. Once seen, it is not a painting anyone is likely to forget. By the time it was shown, however, Bierstadt's immense fame was waning. He had sold his best *Rocky Mountain* picture for $25,000, then the highest price ever paid for a painting by an American, and could usually command $15,000 for a 6- or 10-footer. With the proceeds he built, like Church, a grand house, Malkasten, overlooking the Hudson. But it burned down, just when his fame was slipping, and he had not the heart to rebuild. By the time Bierstadt died he, like Church, was totally ignored. But today, *The Heart of the Andes* and *Rocky Mountains* hang almost facing each other in the American Wing of the Metropolitan, and mighty do they both look to the crowds who come to wonder.

One reason why Church and Bierstadt were pushed into the background during the 1880s was that American art, having matured as landscape, was now moving on to other things. Not, we hasten to add, as substitutes but in addition. It remained rooted in realism, however; indeed, one of the outlets for young artists was the growing number of illustrated papers which, increasingly competing with photographs, insisted on truth to life. That was how Winslow Homer (1836–1910), who was virtually untaught, got his start during the Civil War, working for *Harper's Weekly*. He did a painting of a group of proud Southern captives being nonchalantly guarded by Northerners who were not as unconcerned as they wished to appear, *Prisoners from the Front* (Metropolitan), which struck many as so moving and judicious a comment on the agony of the conflict that it was sent, as a representative American painting, to the Paris Exposition of 1867. Homer had a curious knack of striking the authentic American note. His wonderful painting *Snap the Whip* (1872, Butler Institute), of barefoot boys playing a game in front of a log cabin and wilderness mountain background, is extraordinarily successful in invoking the world which Mark Twain described in *Tom Sawyer* and *Huckleberry Finn*. It is not surprising that Homer was the painter Twain admired most.

When Homer had the money, he travelled to the Caribbean, where he conceived the idea for *The Gulf Stream*, finally painted in 1899, showing a black sailor hopelessly lost at sea in a dismasted boat, surrounded by sharks—one of the great paintings of the century. He also went to northeast England, where the Tynemouth coast made him realise how bitter was the daily struggle against the elements by fishermen and their families. On his return he settled on the Maine coast, and painted the hard life there for the rest of his life (punctuated by sunlit holidays in Bermuda, which produced the wonderful watercolours already discussed). Homer had a zest for living things close to their extremes of effort, an example being what is perhaps his best

picture, *Fox Hunt* (Philadelphia, Academy of Fine Arts), showing great black birds pursuing a fox across a snowscape—a most enviable concept, superbly carried out.

Homer said, however, that he was not interested in painting morals, as such, merely recording nature truthfully, though his viewpoint was always personal and could be tendentious. His summation of himself was: 'When I have selected a thing carefully, I paint it exactly as it appears.' He loved fogs and shapes emerging from them: one of his most memorable images is *The Artist's Studio in an Afternoon Fog* (1894, Rochester University, N.Y.), where the sun fighting to appear and the grim silhouette of his house and studio contrast with a clear, strongly painted foreground of white sea foam and dark brown rocks—a work which was to be echoed by the great twentieth-century American painters Hopper and Wyeth. Homer loved storms too, and the response they drew from struggling humans: *Northeaster* (1895, Metropolitan) is one of many successful efforts to paint elemental forces. In his oils as in his watercolours, Homer was always looking for difficulties, and what makes him such a satisfying painter to get to know, and return to time and again with increased zest, is the honest, practical brilliance with which he solves them.

If Homer became a great painter without any training at all, Thomas Eakins (1844–1916) became great despite being, if anything, over-trained, chiefly in France. His early work concentrated on sculling: *The Pair-Oared Shell* (1872, Philadelphia, Museum of Art) and *Max Schmitt in a Single Scull* (1871, Metropolitan) were ultra-realist efforts, of astonishing truth and luminosity, built up very slowly from a vast number of preliminary drawings, oil sketches

Homer's *Huntsman and Dogs* (1891) expresses his fascination with raw nature and man's struggle for survival.

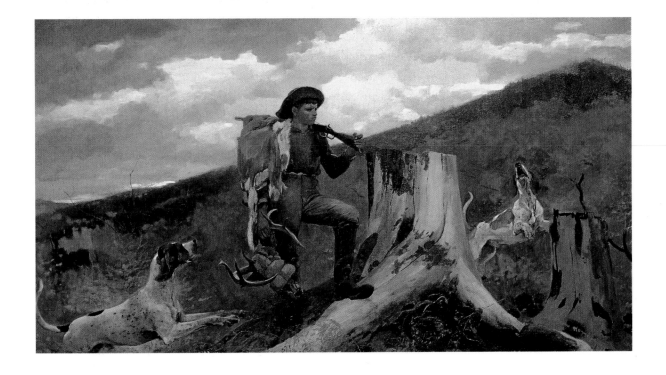

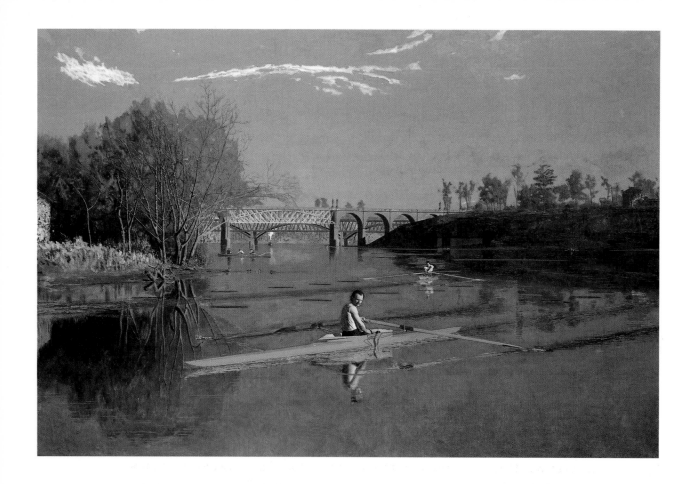

Max Schmitt in a Single Scull (1871) was the product of intense observation and meticulous studies by Eakins, the master-realist.

and even sculptures, supplemented by endless photographs, in which Eakins worked out such problems as the way waves affected the surface of the water. He was in fact a fanatic, sometimes called a 'scientific realist', and it is hard to think of any painter, at any period—even Holman Hunt—who took more seriously the problems of presenting nature accurately. As Chief Instructor at the Philadelphia Academy, he taught his students to do the same, using photographs when unavoidable but essentially going straight to nature and rendering it with total truth. This got him into trouble, for he insisted that male models should pose even for mixed classes and he was sacked for his obduracy. The thousands of photographs of male nudes he used for his work, plus his friendship with Walt Whitman (of whom he did a remarkable bust-length portrait, now in the Academy in Philadelphia), have led many to regard him as a tortured victim of suppressed homosexuality. His most famous paintings, *The Swimming Hole*, in which nude young men dive from a jetty, and *Arcadia*, in which two nude boys listen to a third playing a pipe, seem to support this theory.

It is also true that his renderings of women are usually unhappy. *The Concert Singer* (1890–92) shows a local soprano Weda Cook, who was put through an appalling ordeal by Eakins, posing two hours at a time, four days a week, over two years, and gives the impression she is expiring rather than singing. She said that Eakins looked at

her 'as if through a microscope'. All the same, this is a fine painting. Indeed, it is hard to point to anything he did which is not first class of its kind, though many of his portraits were rejected by sitters, and at his death his studio was crowded with unsold work (all now housed with his entire archive in the Philadelphia Museum of Art).

Eakins's reputation is now rising, and the same can be said for Thomas Dewing (1851–1938), a subtle and enigmatic Bostonian who, after a thorough training in Paris, chiefly at the Académie Julian, returned to America to pursue a lifelong obsession with tall, willowy, seemingly aristocratic American women, in filmy garments, striking poses or making symbolic gestures against sylvan, horticultural or indeterminate backgrounds. Thus baldly summarised, his work seems lacking in weight. But it must be seen, indeed studied, carefully, something which is possible since an immense quantity of his best work is shown or stored in the splendid museum in Washington, D.C., created by his chief patron, Charles Lang Freer. Dewing's mood is melancholy, and his colours are greys, greens, silvers and misty shades of blue, with hints of Japanese arrangements about the composition of his pictures, which are in fact often presented as folding screens and make superb decorative pieces. There is perhaps something anomalous in the creation of art such as Dewing's in the period 1870–1910, when American industry and commerce was expanding at almost terrifying speed and society was often crass and materialistic in its response to culture. But it so often is: the Medici were crass and materialistic in many respects. If the fastidious and enigmatic Dewing ceased to paint about 1920, when barely seventy, it was not because he hated American society—he never had any difficulty in selling his work—but because he was horrified by what was happening in the art world, especially in Paris.

As we have seen, virtually all major American artists, however deep their roots in the New World, continued to visit Europe, if they could, to improve themselves. Three of the greatest went much further, and anchored deep in European waters for many years, without in any way forfeiting their Americanism. As with certain American writers, such as Nathaniel Hawthorne, Henry James and Edith Wharton, they needed the complexities, densities and patinas of European culture to get the finest polish on their art.

Leading this American contingent was James McNeill Whistler (1834–1903), who had a cosmopolitan upbringing, failed chemistry at West Point, made himself a great stylist in Paris, absorbing every influence from Velázquez to Japanese prints, lived mainly in London but remained egregiously American. More so even than Salvator Rosa, he was an outstanding self-publicist: dress, hairstyle, witticisms, books (*The Gentle Art of Making Enemies*, 1890), nomenclature—his night studies were 'nocturnes', his portraits 'arrangements in grey and black', etc.—public quarrels, lawsuits—all were deliberately designed to keep his name in flaming lights. In this respect he even outdid his contemporary, Oscar Wilde.

To ordinary people, Whistler was by far the best-known artist of the second half of the nineteenth century. In 1877 he foolishly attempted to paint a firework display, *Nocturne in Black and Gold: The Falling Rocket* (Detroit). Still more foolishly, Ruskin accused him of 'flinging a pot of paint in the public's face'. Whistler deliberately sued him for libel as a publicity stunt. The case was agonising and hastened Ruskin's descent into madness. Whistler got 'contemptuous damages' of a farthing and went bankrupt. This did not stop him launching further actions. He had first made himself notorious as the personification of the wild artist in Henri Murger's novel, *Scènes de la vie de bohème* (1848), later the basis for Puccini's opera. When his old student friend, the *Punch* artist George du Maurier, updated the theme in his bestselling *Trilby* (1894), Whistler again sued. He gobbled publicity. When he quarrelled with a friend, as he always did in the end, he leaked the news to the gossip columns. He invented, in fact, virtually all the ways in which twentieth-century artists, from Salvador Dalí to Andy Warhol, supplemented their talents with publicity. He was an odious man.

He was also a genius, and it is essential to leap over his character and concentrate on his work. It is, in the first place, impressively large and varied, for Whistler worked fast and industriously all his life and tried everything. The latest *catalogue raisonné* (1998) lists over 3,000 items. One recent calculation is that he produced 550 oils, over 1,700 watercolours, 450 etchings, 170 lithographs, plus countless drawings and pastels. In assessing his work, his portraits must come first because they occupied the bulk of his time, provided most of his income, and demonstrated his mastery and originality most fully. As early as 1861 he produced *Symphony in White, No.* 1 (Washington, National Gallery), featuring his model-mistress Jonanna Hefferman, the first of four white 'symphonies', in which Whistler, while getting the best likeness he could, composed and coloured the work to achieve a harmonious pattern. It was the beginning of modern abstract art.

Whistler used this technique to paint Courbet in *Harmony in Blue and Silver: Trouville* (Boston, Gardner Museum); the great dogmatist Thomas Carlyle (Glasgow, City Art Gallery), and his own mother (Louvre)—both paintings were called *Arrangement in Grey and Black*—and various society beauties. Most of these works are unforgettable images, painted with superb confidence. Some are ravishing. The wife of his patron, the Liverpool shipping magnate F. R. Leyland, became *Symphony in Flesh Colour and Pink* (New York, Frick), the wife of the beer baron Lady Meux (Honolulu, Academy of Arts) got the label *Arrangement in Black*—not since Goya had anyone used black to bring out feminine beauty so successfully. Whistler could bring to life a beautiful face, as in *Portrait of Miss Lillian Woakes* (Washington, D.C., Phillips), not least in the children he often painted, *The Little Rose of Lyme Regis* (Boston) and *Miss Cicely Alexander* (Tate Britain). All Whistler's portraiture was deceptively simple, delicate but monumental in posture, highly sensitive, often revolutionary. He did Lady Archibald Campbell with her head looking over her shoulder

(Philadelphia, Museum of Art): no one had ever thought of that before. *Rosa Corder* (Frick) was snapshotted rather than posed.

The second great element in Whistler's work was the paintings of the world of sea, beach, river and town, including water whenever he could because of the reflections, and night-subjects which few had done before. His earliest landscape, *The Coast of Brittany* (Hartford, Wadsworth Atheneum) shows a tendency towards abstraction, which increased with his magnificent *Blue and Silver: Blue Wave, Biarritz* (Farmington, Conn., Hill-Stead Museum), and culminated in his nocturnes of the Thames, such as his famous *Nocturne in Blue and Gold: Old Battersea Bridge* (Tate Britain). Abstract should not be taken too literally. These works were built up from many superb drawings and watercolours, done on the spot, and designed to achieve complete verisimilitude. But in the finished oil, Whistler stripped down all detail to achieve powerful simplicity of shape and colour. Many of the watercolours and oil sketches, of course, are works of art in their own right.

Whistler produced some wonderful glimpses of old shops and houses in Chelsea, and tremendously dynamic wave-and-water beach scenes in Normandy. These last, with their figures and huge skies (though done on a small scale), should be compared with the beaches of Eugène Boudin (1824–1898), done at the same time. Boudin was a

Whistler, in *The Storm: Sunset* (1879), made his solitary but striking way between American Realism and French Impressionism in depicting nature.

brilliant sketcher, who taught Claude Monet to paint in the open, and devoted his life to this kind of picture, whereas for Whistler it was only an episode. But there is no doubt that Whistler comes much closer to freshness and truth. A key to his work is to be found in his pastel and crayon drawings, often on brown paper (sometimes blue), and especially those he did on many extended visits to Venice. Though Whistler applied oil paint with deliberate care—he made little Cicely Alexander pose for over two hundred hours—he used pastels with such a light touch that some of his best sketches have only fifty or so lines in them, some so delicate as to be scarcely perceptible.

Whistler needs to be studied in his totality, which can be done at the Freer in Washington or the Hunterian Museum of Glasgow University, both of which have huge quantities of his art. What emerges from such scrutiny is his power as a decorator. More so than Morris and the Arts and Craftsmen (though he had affinities with both), he was the father of modern interior decoration. His paintings were designed not just to be seen but hung. He took great trouble with their surrounds, inventing the beautiful Whistler frame, and often designing the wallpaper behind them. His etchings were both strong (*The Lime Burners, Barges of the Thames*) and ultra-delicate (*Chelsea Houses, The Sea Shore, Dieppe*), and he liked them hung in specific combinations, with mounts and frames designed by himself. He saw his lithographs too in context, and produced a modified form, or lithotint (*The River at Battersea*) specifically worked on to hang in a new type of room.

Whistler designed complete rooms, down to the tiniest detail. His Peacock Room (Freer), done for F. R. Leyland, is the most famous, and still looks strikingly new and 'modern'—and elegant—but it is not the only one. All his home decorative schemes were highly prized: his skill in this art was one of the topics Oscar Wilde brought to America's attention during his notorious lecture tour of 1882. Whistler liked nothing better than to devise a colour combination for a particular room and some of these schemes survive (Glasgow), as do his designs for garden trellises, parasols, dresses, furnishing, vases and plates. Whistler studied such things intently. One of the most beautiful elements in his *oeuvre* is the grand series of watercolours he did of a collection of Chinese blue-and-white porcelain (Freer and Glasgow). Whistler, like Morris, had faultless taste. It is impossible to point to anything he did with his hands which is ugly or merely commonplace. Apart from John Singer Sargent he had no pupil but almost everyone who came into contact with his work benefited from his originality and style, and his influence has continued to seep into art in all kinds of ways. *Monstre sacré*—holy monster—the French phrase might have been coined for him.

Mary Cassatt (1845–1926) learned a lot from Whistler in the style and technique of delicate print-making, though she also studied French efforts with the help of her friend, the realist Edgar Degas (1834–1917). She tried etching, aquatint, lithography and combinations of softground and drypoint. She learned more about these

processes than any woman before her, and became ingenious and innovative in how she used them. She took in the work of the Japanese, but improved on it both by using drypoint for line and by a much greater fastidiousness in combining colours, especially greys, greens and blues. The famous group of eighteen colour prints which she first exhibited in 1891 are often referred to as 'Japanese style', but that is typical of the way in which Cassatt, being a woman, had her original genius taken away from her. In fact they are *sui generis*, done in a brilliant combination of drypoint, etching and aquatint, with the artist making careful adjustments, hand-wiping and inking the plates, with retouching in some cases. While there is no pretence to compete with Goya's power, these prints are by far the most beautiful set produced in the nineteenth century.

It is important to emphasise Cassatt's singularity and uniqueness because there has been a tendency to put her into convenient boxes. The daughter of a wealthy Philadelphia banker, she was able to get a thorough training both in French ateliers and by copying in galleries all over Europe. She remained all her working life (cataracts stopped her in 1915 and in her last years she was blind) an ultra-professional artist who made enough money to buy a splendid French château and live there in style. On her trips back to Philadelphia, the press referred to her as the 'clever' and 'gifted' daughter of 'a prominent local family', whose 'interest was sketching'. The French art world took her more seriously, recognising her undoubted talent, but tried to absorb her into their own schemes. Degas thought her the most gifted woman artist he had ever heard of, far more accomplished than Corot's pupil, Berthe Morisot (1841–1895), then the leading French woman artist. At that time Degas was associated with the Impressionists, as part of his campaign against the Salon establishment. Anxious to strengthen their faltering ranks, in 1879 he persuaded Cassatt to exhibit in their fourth annual show, something she did on three more occasions, 1880, 1881 and 1886.

However, that does not make her an Impressionist; far from it. By instinct she was a realist, a painter of contemporary life in detail and with the highest degree of verisimilitude, albeit in a limited sphere. She studied what was then the almost lost pastel art of Maurice Quentin de La Tour (1704–1788) to revive the form with a heightened palette, and she also worked, in oils, to capture the ability of the Spanish masters, like Velázquez and Murillo, to paint children. She then set herself to become the great master of domesticity, the painter of women and children in the home. She rarely painted men but did not hate them (that is a myth). She never married, not for lack of opportunities but because she wanted to work full-time at her art (in that respect she resembled Michelangelo).

Cassatt was part of a large extended family, and that gave her many opportunities to paint what she felt she could do best. She did not always include children. In fact two of her greatest works, a theatre scene, *La Loge* (Washington, D.C., National Gallery), and *The Cup of Tea* (Metropolitan) are not about children at all. But in general, what fascinated Cassatt, both as an aspect of life and as a problem in paint, was

the portrayal of children, including babies, with their mothers, nurses, aunts, minders and friends. She returned to this theme all her life, taking immense care in the posing (when that was possible; much of the work was necessarily based on hundreds of quick sketches) and rendering flesh tints with almost fanatical devotion. It was Cassatt's view that small children had a quite different range of expressions to adults, and what she liked best was to get a contrast between the consciousness of the adult and the unselfconsciousness of the child. Children yawning, awakening from sleep,

about to go to sleep, stretching out for food, caressing and being caressed— *The Caress* (Washington, D.C.) is perhaps her most notable achievement in sympathetic verisimilitude—and the responses of their mothers to these activities: this was her life-work. No one has ever painted a mother and child better, not even Raphael. Few other artists so abundantly reward the closest observation of detail and technique; or have more lessons to teach in rendering extreme youth. These are delightful and beautiful works, which irradiate the rooms in which they hang.

John Singer Sargent (1856–1925) did not paint babies but he took in walking children of all ages, including them in his grand portraits with the skill of Van Dyck, whom he resembled in countless ways: marvellous likenesses, bravura and style, ability to convey height, brilliant rendering of hands, effortless virtuosity in silks, satins, furs, linens and textile-glitter, and not least compositional ability to present complex groups of up to half a dozen figures with monumental simplicity. Sargent's family, like Cassatt's, was well-off, and he was fortunate to study in the atelier of Charles Carolus-Duran (1837–1917), the best French portraitist of his time and a wonderful teacher. But Sargent was always learning from the masters, anyway, and teaching himself, right to the end of his life. He could do the Big Thing, as he called it: his *Duke of Marlborough and His Family* (Blenheim) is a conscious echo of Reynolds's show-off and a much better picture, in whole and in part. His *Daughters of Edward D. Boit* (1882, Boston) is another virtuoso performance—never has girlhood been better displayed, all grace and humour and not a touch of seediness. *Mrs Carl Meyer and Her Children* (1896, private) was another huge success in

Mary Cassatt turned feminine activities into a new art form. *The Cup of Tea* (1885) turns routine into nobility and grace.

the difficult genre of a multiple portrait. (It is difficult primarily because, though each head and body may be superbly painted separately, combining them all together on one canvas, especially done from life, takes all the patience and courage of a genius.) *The Acheson Sisters* (1902, Chatsworth), *Mrs Fiske Warren and Her Daughter* (1903, Boston) and *The Wyndham Sisters* (1900, Metropolitan) are three more great paintings, of a quality few ages have been able to produce.

Like Van Dyck, Sargent never despised portraiture. But, unlike Lawrence, he was not content to be a portrait painter and nothing else. He saw it as a high-risk profession, which demanded his best efforts but sometimes put him under intolerable strain. In 1884 he painted a pushy French society woman called Mme Gautreau, or *Madame X* as the work is known (Metropolitan), full-length, in profile, with dangerous décolleté. Sargent foolishly slipped one strap off her shoulder (he later repainted it) and its appearance at the Salon caused a scandal, the artist being denounced as decadent. Sargent was already uneasy about the way the Paris art world was moving and this absurd incident persuaded him to move to London, where he remained, happily, for most of the rest of his life. There he painted one of the greatest portraits of modern times, *Lady Agnew* (Edinburgh, National Gallery), an almost miraculous confection in that difficult hue, mauve, which merits an exhibition in itself (and has had one). His complementary work, *Lord Ribblesdale* (London, National Gallery), is the swagger-portrait to end all others.

Sargent has often been dismissed (though no longer) as 'facile' and 'fashionable', but in fact there was nothing easy about his painting. He could draw with the brush with enviable freedom but all the evidence shows that he took immense care and was always stretched to his limits. Sometimes it is true he worked fast: his oil sketch of the artist Paul Helleu painting on a river-bank, cross wife impatiently waiting in the grass, was clearly done at top speed and is all the better for it (the rendering of Helleu's painting hand is a miracle). But when Sargent aimed at a deliberate and difficult effect, patience and industry were unequalled in modern times.

In the summer of 1885, deep in the English countryside, he decided to paint two beautiful little girls, daughters of friends, lighting Chinese lanterns in a bower of lilies. The reason he picked this was because he wanted to show the reflected light of the lanterns on their faces and necks, and contrast it with the light coming from the evening sky. So far from being 'fashionable', this was exactly the kind of problem with which great painters, like Rembrandt, Vermeer and Correggio, loved to grapple. The work is well documented, in eyewitness accounts and sketches, and ended by taking Sargent, on and off, the best part of two summers, much agonising and tremendous outpourings of energy and talent. The result, *Carnation, Lily, Lily, Rose* (Tate Britain), cannot be put into any particular category: but it is a painting of almost unequal charm and one of the most spectacular displays of skill, in the depiction of light, of the entire nineteenth century.

Sargent was essentially a simple man, not an intellectual. But he thought about art deeply and cared about it even more. Like Cassatt, he had no other life. It is evident he loved beauty and could see it in unusual places. One of the finest things he ever did was a careful oil of an outdoor staircase, *Steps in Capri* (private), a piece of pure poetry. He took risks for art. He would do multiple portraits indeed, the figures quite small, the interiors the real subject (his colleague Lavery could do interiors, notoriously difficult, very well, but not with figures), and in one case this led to trouble and rejection. His watercolours, as we have seen, were sensationally daring, and they were an important part of his life, for they obsessed him when he was on holiday. He made one serious error of judgement. In 1894 he agreed to a request that he provide a series of religious murals for the Boston Public Library, and from 1916 he was held to his promise. It would be difficult to think of a task or a subject more remote from Sargent's particular skills. Yet he worked on it for years and opportunities to paint great and original works, now that he was rich and no longer obliged to please, were thus missed. It may be that these Boston murals will in time be recognised as major works, though there is no sign of it. Until then, this misplaced commission must be regarded as one of the most painful tragedies of twentieth-century art, and brought to a close the first golden age of American painting.

Carnation, Lily, Lily, Rose (1885–86) gave Sargent more trouble than any other work. But the result is a triumph of observation, composition and love.

25

THE BELATED ARRIVAL
AND SOMBRE GLORIES
OF RUSSIAN ART

There are important parallels between the two great emerging powers of the nineteenth century, the United States and Russia—their infinite vastness, consciousness of immanent strength, and nervousness in confronting omni-triumphant European culture. Both produced great art during this period, but whereas American achievements are at last beginning to be understood, in all their magnitude, the process of exploring Russian painting has scarcely started. This is all the more surprising in that the great Russian writers of the century, like Turgenev, Tolstoy and Dostoevsky, were read and recognised at the time, and composers like Mussorgsky, Tchaikovsky and Rimsky-Korsakov quickly became part of the international repertoire.

Although an academy was established at St Petersburg in 1757, it was primarily a place where neo-classical sculpture of the most derivative kind, and portraiture with lingering elements of iconism, were taught and practised. Russia was a country with a long and terrible past, but no history in the sense of a heritage being consciously studied and commented upon. The Americans had the heritage of Europe, above all of Britain, to cherish, argue with and repudiate. Russia merely had a 'dark backward and abysm of time'. It needed a great history painter to illuminate it, and by bringing certain specimens into the harsh light of modern vision, to encourage the nation to explore the rest of the forest. That is exactly what was done by Vasily Surikov (1848–1916). He came from Siberia, and he brought to academic life in the capital, and formal society in Moscow (where he received his first major commission to decorate the cathedral, in 1876), a sense of the illimitable space of Russia, reflected in the size, depth and heroism of his canvases. His work is mainly to be seen at the Tretyakov Gallery in Moscow, and shows that, right from the start, he was obsessed by the past: the Christian past, as in *Saint Paul Explains the Faith to Agrippa*, and the conflict with paganism, in his study of rival marriage customs, *The Judgement of the Prince*.

In the 1880s, however, Surikov discovered and explored his real theme: Russia's struggle with its past in embracing Western civilisation. He did this by treating certain

key episodes on the largest possible scale, by paying detailed attention to accuracy of costume, physiognomy, architecture and custom, and by ignoring completely everything which was going on in European art at the time, concentrating entirely on the most dramatic and vivid presentation. This made him, at a stroke, a great history painter. Indeed, he can be considered the last of the great history painters. His *Morning of the Execution of the Strel'tsy* (1881), the first of the series, presents the grim public execution, by Peter the Great, of the soldier-patriots, the Old Believers, who stood between the monarch and his plans for progress. The background is the tremendous shape of St Basil's Cathedral. The martyrs are bound and bitter, exalted and fearful of eternity, trying not to shiver in the icy cold. Their wives and families are weeping and shouting prayers. The soldiers and executioners are half-expecting a thunderbolt from Heaven, and terrified. Peter sits on his horse, determined to see the dreadful task through, but nervous and superstitious also. There are over a hundred figures in the picture, which is painted with tremendous panache and reckless theatricality. There is something of Tintoretto in Surikov's courage and unselfconsciousness.

Six years later Surikov brought off an even greater *coup de main*. The *Boyarynya Morozova* tells the story of a Christian princess and mystic who fell foul of the Church-state authorities and was condemned. Surikov shows her being sledged off to solitary confinement (and death by starvation), surrounded by a vast crowd of people, some laughing, others rejoicing, many drunk, but many also screaming and praying to Heaven for vengeance and divine intervention, as they kneel to receive the princess's blessing. Her face is a study in exaltation, and might have been sculpted by Bernini. This is another vast collection of figures, and it is remarkable how the artist managed to impose order and instant recognition of his arguments on such a swarm of movement, for the whole canvas surges and shakes with powerful emotions. Here, Surikov is saying, is Russia, as she was, is and always will be: a theatre of tragedy, a cockpit of past and present, a brutal mingling of almost bottomless pathos and low comedy, with no winners—only losers—but somehow holy still. That is indeed a grand theme, and it is carried through to a tremendous climax as the saint on the brink of lunacy is borne off to death and eternity in the centre of the picture.

These are Surikov's two greatest works, but he painted others almost on the same level. His *oeuvre*, considering the time, care and preparation he devoted to each picture, is monumental. His *Subjugation of Siberia by Yermak* (1895), painted in a positive frenzy of emotion, shows the desperate crossing of a river by Russian troops faced with a heartbreaking display of savage resistance by tribesmen armed with arrows. Like all his work, it is wonderfully confident and well-organised, direct and vivid, suffused again with his tragic sense of doomed conflict between past and present. Progress moves forward like an unfeeling juggernaut over the crushed bodies of individuals who can do no other than to fulfil their historical destiny, of which in most cases they are unaware. In a sense, this is the same moral Tolstoy was illustrating in his stories: the helplessness of men and women in the grip of irresistible collective forces.

It is not true, however, that there are no heroes or heroines in Surikov's work. He produced a wonderfully dashing picture (it actually took ten months) of a famous episode in Russian military history, *Suvorov's Army Crossing the Alps* (1899), in which the popular marshal is presented as a laughing, almost homely figure, in realistic contrast to David's absurd presentation of Bonaparte doing the same thing.

In *Morning of the Execution of the Strel'tsy* (1881), Surikov has Peter the Great glaring in anger and fear at his aristocratic victims, with St Basil's Cathedral looming behind.

Surikov moved in close, for once, in his painting *Count Menshikov in Exile* (1883), which shows the former adviser to Peter the Great, in disgrace after Peter's death, crammed with his family into a small cabin in the Siberian outpost of Beryosovo. Unlike Surikov's open-air heroics, this painting, though also big, generates powerful claustrophobia alongside its inevitable pain. Surikov was a wonderful man with a brush, employing huge, majestic strokes like Rubens. He was also exact, as his numerous fine and sensitive portraits demonstrated (the Tretyakov has a ravishing example, *Siberian Beauty*), and he operated brilliantly in watercolour, as some late landscapes of Italy prove. But what drove him, and made him a great painter, was overwhelming emotion: his canvases are passionate, outraged, fearful and angry, bold to desperation.

There is something of the same emotional dynamite, as it were, in the first of Russia's major landscape painters, who grasped the possibilities open to them in showing raw Russian nature. Ivan Aivazovsky (1817–1900) came from the Crimea

and was brought up on the Black Sea. He might technically be described as a marine painter, since perhaps two-thirds of his immense output of mainly large-scale works deals with the sea. But he is a marine painter only in the sense that Turner was one too. He is essentially, like Turner, a painter of nature's extremes: of those conjunctions or convulsions, of the seasons, of the times of day, of snow and ice, altitude, depth, wind and sun, which produce extraordinary sights. He achieved his first big popular success with *Daryal Gorge* (1862). This presents one of Eurasia's grandest natural phenomena, the equivalent of the Yosemite valley (which Bierstadt was painting at exactly the same time), in all its staggering depth and precipitous, fear-generating drama. Aivazovsky loved these freaks of nature, just as Constable loved sluggish streams, rotten posts and rushy backwaters. He sought them out in Central Asia, where he went by horse and camel, like Bierstadt with his mule-train, to explore, pinpoint nature's extravagance and catastrophes, and record them.

Storm at Cape Aiya (1875), by Ivan Aivazovsky, is a summation of the skills and daring of Russia's finest marine painter.

The sea, and its unfathomable rages, had the same kind of appeal to Aivazovsky. *The Maiia in a Gale* (1893) is one of the best renderings of a storm at sea done in the nineteenth century. In scale and movement it reminds one of Turner. Yet it is in no way Turneresque: this is

a direct description of force, power and dynamism, not atmosphere, chemistry and elemental minglings. Ship, sea and sky do not dissolve into one continuum of varying light and colour, as with Turner. They are distinct and embittered protagonists, they fight each other with ferocity. Indeed, Aivazovsky aimed at clarity, in almost exactly the same manner as American marine artists like Lane. What he lacked, or repudiated, was their sense of calm. Next to storms at sea, he loved moonlight, because it produced a fresh set of dramatic circumstances which could be carried to the limits of credibility. Hence his spectacular *The Black Sea at Night*, a large-scale work whose sheer intensity makes the moonlighters of the West—Wright of Derby, for example, and Claude Vernet (1714–1789)—seem close to unaudacious.

However, it must be said that the principal actor in Russia's theatre of nature is neither sea nor mountain, gorge nor storm, but the forest. It is ubiquitous, endless, heartless and alarming always, but variously beautiful in its seasonal cycles. Again, one must go to the Tretyakov Gallery to examine how Russian painters coped with this overwhelming presence. The largest stretches of Russian forest were primarily of birch, and this with its white-silver bark gave the Russian painter spectacular opportunities to create light-effects. For the birch forest can never quite extinguish the light, even in its deepest recesses, and when the sunlight blazes in summer, each tree becomes a kind of mirror or intensifier of light. In 1879, when Arkhip Kuindzhi (1841–1910) exhibited his *Birch Grove* at the Academy in St Petersburg, his virtuoso presentation of light reflected off the birch trunks, against a background and foreground of deepest green, excited and puzzled spectators. They crowded round the canvas, not believing that the source of light came merely from the cunning used by Kuindzhi in heightening the natural *chiaroscuro*, insisting it was some kind of trick. Some Russian artists painted forests and nothing else all their career, and argued that the knowledge to be thus gained was infinite. A group of them, known as 'The Wanderers', promoted forest lore almost to the status of an artistic religion. Ivan Shishkin (1832–1898) helped to found it in 1871. He had trained in Germany as well as in Moscow and was an amateur botanist of the most fanatical kind, accumulating masses of books and specimens, and meticulous drawings of plants (and insects), which would have delighted Ruskin. He was called 'the Book-keeper of the Leaves'.

Shishkin did the forest (pine as well as birch) in all seasons, often spending the night alongside his equipment to get twilight or dawn effects. His *Pine Forest, Viatka Province* (1872) shows high summer. *Rain in an Oak Forest* (1891) is an astonishing virtuoso performance, presenting spring in saturated moisture and seeping, slithering, wetness and mud, as the downpour falls from the misty sky into the pattering leaves. His *Winter Pine* (1891), inspired by a verse of Lermontov, is a crunchy, moonlit December scene, the lone pine almost tottering from its weight of snow. *Winter*, painted the year before (St Petersburg, Russian Museum) conveys the claustrophobia of deep snow in limitless fir forest. It should be added, however, that Shishkin, like some of the Americans, liked to break out of the enclosing forest and show the sheer

breadth and depth of the great land. One of his earliest successes came in 1866 with *Midday: Countryside Near Moscow*, where tiny peasants with scythes walk near a cornfield under a towering cumulus sky which occupies four-fifths of the work. In *Across the Vale* (1883, Kiev Museum), he produced a gigantic canvas showing a lone high oak against a background of endless plain through which a river slowly curves. He gets the same effect of immense depth and distance in *On the Shore of the Gulf of Finland*, using grey-blue seas and skies, and the serrated cliffs over the beach, tiny figures walking along them. But in his last work, *Grove of Trees Like Masts* (1898; both Russian Museum), he is back in the forest again, in total silence, still light, infinite, semi-darkness, and stillness.

The only Russian painter to compare with Shishkin in depicting the forest was a Jew from Lithuania, Isaak Levitan (1860–1900), whom many, perhaps with justice, consider Russia's finest artist. He came from great poverty, was a lifelong depressive and suffered privation and internal exile during the worst pogroms of the 1880s and 1890s. In view of this, and his short working life, his record of achievement is noble. So is his versatility. Indeed, it is hard to think of any painter of nature, in any country or in any epoch, who grappled with such a wide range of subject matter, so confidently and well. In his forest scenes, Levitan moved in closer than Shishkin: his *Footbridge, Savvino Village* (1884) is almost a miniature of a village on the forest edge, and his *Birch Grove* (1885; both Tretyakov) is almost an orchard. He loved the autumn specially—it suited his sombre mood—and his September scenes, such as *Golden Autumn* (1895, Russian Museum), the *Vladimirka Road* (1892) and *Autumn* (1896; both Tretyakov), take us closer to the actual feel of a Russian village landscape near the end of the century than all the rest of the Russian school put together. He did some superb watercolours too, of which *Autumn Mist* (1899) and *Storks in Sky, Spring* (1884), are outstanding examples. Indeed the more one examines his work, the more one wonders at it, combining as it does all kinds of subject matter, all districts, all seasons, with impeccable virtuosity and genuine emotion—indeed love.

Levitan had no reason to love Russia or the Russians, but he did. And he celebrated his love in some magnificent canvases which used the beauty and grandeur of the Russian scene to express spiritual values hovering just beneath its surface. In the Russian Museum, St Petersburg, there is a superb, smallish canvas, *Golden Autumn in the Village*, showing a garden, manor house and farm sheds set against the background of the domes and spire of a monastery, with two small blond children in the foreground, the whole bathed in brilliant sunlight. Here is Russia as Arcadia, but painted totally without sentimentality or unreason: all is truth, though it is only one truth. By contrast, in the Tretyakov, there is a big picture, one of a series which Levitan did to celebrate that other monstrous Russian phenomenon, the Volga: he called it *Eternal Rest*, and the painting shows a little church on a high bluff overlooking the immense waters, under a huge and threatening sky. What Levitan did here, and on other occasions during the 1890s, was to use both the immensities and the intimacies

of the Russian landscape to hint or suggest—there is no tendentious- ness or ideology—that Russia was a country where the dramas and mysteries of human life were played out on an unusually heroic scale, and against a background of unrivalled grandeur. Or was it unrivalled? One thinks again of the United States, and is led to compare Levitan's work with Church's, to contrast it and also to wonder that the Earth could contain two such gifted and monumental artists at the same time, each seeking to use sub- lime natural phenomena to uncover human depths.

Levitan was a close friend of Anton Chekhov and it is tragic that he did not provide us with a portrait of the enigmatic playwright. It is not surprising that first- class portraits of the ruling élite during the nineteenth century are so scarce, for after the Decembrist revolt of 1825, a gulf opened between the Russian governing class and its intelligentsia. But good portraits of the cultural élite are rare too, compared with the record in France and Britain and even in America. There are some exceptions. In 1872, Vasily Perov produced a fine head and shoulders of Dostoevsky. Then, in the Tretyakov, there is a fascinating small oil painting, done in 1887, of *Leo Tolstoy Ploughing*. The novelist has a massive beard, not yet entirely grey, and he wears a white peaked cap, to match his two white horses. He is bent to his task, concentrating hard, his face weather-beaten and determined. The artist was Ilya Repin (1844–1930), who along with Isaak Levitan is Russia's most significant painter. He did a number of

sketches and watercolours of Tolstoy, and he also painted more formal portraits of Mussorgsky (1881, Tretyakov), Borodin (1888) and Rimsky-Korsakov (1893; the last two in the Russian Museum, St Petersburg).

Repin came from the Ukraine, and was a citizen of the Russian Empire rather than Russia itself, spending his last years (after the Revolution) in what had been the Russian province of Finland, now safe and independent. But there can be no doubt about his attachment to the higher values of justice, freedom and fairness. He was first trained as an iconist, in St Petersburg, and his early works were religious in theme. It was when he became one of the Wanderers, and met other fierce intellectuals, like Modest Mussorgsky, that he turned to secular subject matter and began to speculate in paint on Russia's plight and her future. In the years 1870–73, he worked on, and finally unveiled, a large and carefully prepared painting, *The Boatmen of the Volga* (Russian Museum), which immediately established his position as a serious and formidable artist. As with Surikov, the theme is large, the conception heroic, there are many figures and the mood is dramatic. There is also much of Surikov's dynamism. But the subject is contemporary: the hardships and plight of a depressed class. The authorities chose to

Repin's *They Did Not Expect Him* (1884) sums up Tsarist Russia in one picture, perhaps the greatest painted in the nineteenth century.

ignore this work; instead, they rewarded a Repin 'duty-picture', as he called it, *Raising the Daughter of Jarius* with a six-year bursary, much of which the artist spent in Paris. There he adopted open-air painting and did various landscapes but there is no other evidence that French art had any influence on his work.

Almost immediately on his return in 1876, Repin painted a striking picture, *On the Road of Mud, under Guard* (Tretyakov), showing a political prisoner, in a cart filled with straw, and with helmeted soldiers, their swords drawn, on either side of him, being driven to the station to board a train which will carry him into Siberian exile. It is a study in misery. The horses are exhausted, for the mud is axle-deep; the carter flogs and curses them; the soldiers are bored and cold, the man himself sunk in despair. The colours are brown and black, with a touch of gold in the helmets—all the shame of Mother Russia is here displayed, as she sends another of her children to solitude and death. Yet Repin painted other sides of the country too. In the years 1880–83 he produced what many judge his finest work: *A Religious Procession in Kursk Province*. It is huge, nearly 6 by 9 feet, with a multitude of figures, some garishly apparelled in vestments, others in rags, carrying high banners and immense golden reliquaries, scuffling up the dust under a brazen sun. All traditional Russia is there: madmen, cripples, insolent priests, credulous old women, ascetics, holy monks, the components of the fanatical mob which, Repin hints, follow God today but may turn to other leaders tomorrow. This great painting moves; it progresses, irresistible, almost menacingly.

Having finished this monumental work and taken it to St Petersburg for showing, Repin now openly associated with the opposition intelligentsia, and produced a monumental series of directly political paintings, which included *The Agitator's Arrest*, *The Refusal to Confess* and *Secret Meeting*. These fine works are highly personal, direct, beautifully painted, not at all documentary—impressions, rather—yet also with an icy edge, as of carefully controlled anger. Their great merit, springing from a skill which Repin possessed to a higher degree than any of his contemporaries (and which strongly reminds one of Caravaggio's best paintings), is the way in which the viewer is made to participate: he or she is actually in the room in which the events take place, or persuaded to feel so.

This feeling is particularly strong in the great work which Repin painted in 1884 (in its second version at the Tretyakov), *They Did Not Expect Him*. Here is the all-inclusive image of Tsarist Russia, an almost square (63 by 66 inches) painting which says it all. It is the drawing-room of a comfortable middle-class house. The servants have just admitted a ragged, emaciated, unshaven figure who advances into the centre of the room. His wife, facing us, looks up in astonishment. His children, doing their homework, are amazed, awed, beginning to shine with delight. In the centre is his elderly mother—is it, perhaps, the personification of Mother Russia?—who rises from her chair and fixes her gaze on her son. He has returned from Siberian exile. Characteristically the chaotic, hopeless and grotesquely inefficient state has given his family no warning and they, having had no news of him for years, had given up

hope. So here he is, raised from the dead like Lazarus; but there is no Christ to thank, and there is shock, surprise, bafflement, almost dread in the reactions—gratitude and happiness will come later. This is one of the greatest paintings produced in the nineteenth century—perhaps the greatest—which needs to be looked at again and again. The viewer is present behind the mother at the back of the room, and participates in this deep entry into the Tsarist state and society. It is a work people will turn to in hundreds of years' time, for an answer to the question 'What was it like?', as resonant in its own way as Tchaikovsky's *Symphonie Pathétique* or Dostoevsky's *The Brothers Karamazov*.

Having created this masterpiece, Repin concentrated on teaching and portraits. His later political works lack fire. It was as though the sheer hopelessness of doing anything effective to make Russia a happier and juster place had overcome him; he spent more and more time in Finland, where he bought a little estate and found a congenial companion, the writer Natalia Severova. A sketch of 1905 shows the kind of life they led: Maxim Gorky reading to a circle of friends his play *Children of the Sun*. Repin wisely stayed in this haven when the long-awaited deluge swept old Russia over the cataract of history—he had done his share. The house, 'Penaty', became a museum of his art.

America and Russia, with their vast expanses, inevitably tended to give priority to landscape in their art. It was the same in other parts of the world where space dwarfed the human personality. In Argentina there were artists like Cándido López and Ernesto de la Cárcova. In Canada, the Dutch-born Cornelius Krieghoff (1815–1872), though by instinct a painter of genre, found himself irresistibly drawn to the lakes and forest, ice and rivers of the limitless north. The Quebec Museum had his *Falls of Lorette*, his most considerable attempt to capture the country's natural grandeur. However, it was two native-born painters, Lucius O'Brien (1832–1899) and Homer Watson, who first grappled on a large scale with the grandeur facing them. O'Brien's *Sunrise on the Saguenay* (1880) is now the pride of the Ottawa National Gallery, an exercise in light and sublimity in the traditions of Turner. Near it hangs *The Flood Gate*, by his younger contemporary Homer Watson, a masterly presentation of elemental power and man's struggle to harness it.

However, it was Australian artists who most closely followed the Americans and Russians in giving the presentation of the wilderness the professionalism and passionate concentration it demanded. In 1885 two skilled and well-trained outdoor painters, Arthur Streeton (1867–1943) and Tom Roberts (1856–1931), set up an artists' camp at Box Hill, a 'bush suburb' of Melbourne. Later they moved to a more convenient site called Heidelberg, from which the name of their school derives. It was not, however, a school as such: more a collection of fiercely individual spirits who loved oil paint, the brush and the flora and fauna of Australia, so completely different to anywhere else in the world.

Some of these artists saw the country as a place where hard work and determination were making it the world's paradise (in the 1880s it had the highest income *per capita* on earth) and Roberts's masterpiece, *Shearing the Rams* (Melbourne, National Gallery), powerfully celebrates the industry which produced the wealth. But they all saw it as 'the blue and gold country', where a combination of millions of eucalyptus trees and their misty exhalations, bright sunlight, vast arid tracts broken by rare rivers, produce a unique landscape. Streeton's *Still Glides the Stream* (Sydney, Gallery of New South Wales) is a tribute to its beauty. Charles Conder (1868–1909) followed the Heidelberg men into their Australian rhapsody, and might have proved the best of them. But marriage to a rich widow, that curse of good young painters, removed the need to earn a living by frenzied work, and early death ended his dilemma. It was left to Streeton to produce the masterpiece of the group. His grand painting of the Hawkesbury River seen from above in the furnace of the Australian sun, *Purple Noon's Transforming Might* (1900, Melbourne), was an immediate success when shown and has remained the national emblem of Australian landscape. It is a wonderfully accomplished work with a grand compositional sweep, superbly brushed-in detail, and delicate colour which, nonetheless, makes you feel the terrifying heat radiating from the canvas—the finest landscape ever produced in the Southern Hemisphere.

Tom Roberts spent two years, on the spot, painting *Shearing the Rams* (1890), to portray the means whereby Australia became rich.

26

THE INTERNAL CONFLICTS OF
NINETEENTH-CENTURY ART

While in the four corners of the world the wonders of nature were dazzling painters whose only object was to capture them, the ideological centre of the world's art was Paris, where powerful and antagonistic forces were at work to determine its future. These forces, however, were blind. Paris, fantastically voluble and articulate though it was, often missed the point. It was a place 'where ignorant armies clash by night'. Though from now on, the history of art appears to proceed in a series of labelled 'movements', each generating the next, we shall find that what is admirable in it is usually an accident, springing from the genius of an individual, following his *daemon*. From now on, more often than not, the development of art was governed by what the philosopher Karl Popper called 'the law of unintended consequences'.

Thus, at mid-century, the revived Bonapartist dictatorship of Napoleon III was established and, for twenty years, it spent colossal sums of money patronising and subsidising the arts. The object was to buttress the ruling family by re-establishing overwhelming French cultural supremacy. For this purpose Napoleon appointed two overseers. The Paris prefect, Georges Eugène Haussmann, was given plenary powers to update the capital, and relentlessly pushed through building schemes which provided it with a network of grand boulevards and a grandiose new opera house (1861–74) by Charles Garnier, at its main intersection. It made Paris into the most modern, elegant and functional capital in Europe, the place where artists and intellectuals of all kinds most wanted to live. This may not have been Napoleon's intention, for once there, these talented but usually impoverished individuals schemed and plotted to overthrow all the existing orders by which they felt oppressed. Napoleon's object, by contrast, was to make a big noise for France, and himself. Impressed by the success of London's Great Exhibition of 1851, he organised two of his own, in 1855 and 1867, carried out on an even bigger scale. His reign, in fact, was one long *exposition*, and never before, or perhaps since, have so many paintings and sculptures by living artists been so prominently displayed in one capital.

The important work, however, was being done furtively and on a much smaller scale. Honoré Daumier (1808–1879) came from Marseilles, the son of a frame-maker. As an artist he was self-taught, but he learned the trade of engraving and lithography with great thoroughness, drawing directly on the stone with a skill that has never been surpassed. He thus produced over 4,000 illustrations, together with about 300 oil paintings, over 400 watercolours and countless drawings, as well as caricature sculptures in plaster, terra-cotta and bronze. As a draughtsman he was compared by Balzac to Michelangelo, but the truth is he was better. He had a natural genius which training, or the lack of it, could not disguise and no one else has done the human figure, in action or repose, with such fluency, richness of tone, animation, grace and solidity. Daumier was what the French call *un enragé*. He was *intransigéant*. He detested authority in any shape, whether it was the authority of government, the law or money. He savagely attacked Louis Philippe, who put him in prison for six months. He was again in trouble under Napoleon III. Virtually all the newspapers he was associated with were suppressed or censored.

Daumier's political works first made him famous, particularly his savage lithograph *Rue Transnonain, le 15 avril 1834,* showing a man murdered by the police, and his astonishingly varied and brilliant attacks on Louis Philippe. But when the satirical papers were effectively banned by law from political comment, they took up a variety of genre in their illustrations, and Daumier was thus forced into his true *métier:* scenes of ordinary life. He did the average middle-class man and his family. He did lawyers and their clients. He did shopkeepers, hawkers, clowns and mountebanks, musicians and actors, fanatics—including a marvellous though offensive series on women's rights activists—clerics, soldiers, ruffians and street-boys. He was as sharp and direct as Hogarth, as cunningly observant as Goya (and sometimes as despairing and cruel). His line was superb, but so was his wonderful *chiaroscuro,* whether in monochrome or colour washes.

Amateurs Looking at a Lithograph (Louvre), *Three Old Women on a Landing* (Paris, Carnavalet), *The Third-Class Carriage* (Baltimore, Walters Art Gallery), *The Connoisseur* (New York, Metropolitan), *Mountebank Playing a Drum* (British Museum)—these are only five examples out of scores, in a variety of techniques, which depict the human form, within a tenebrous universe of brilliant lighting and stygian blackness, with monumental power, and may fairly be described as Daumier's masterpieces. They are not illustrations, or caricature, or satire, or cartooning, so much as great art: art consciously designed to assert the dignity of men and women, whatever their material circumstances, often under privation. Daumier could always bring out man's nobility, even of an old tradesman, as in *The Butcher* (Harvard University, Fogg Museum). And he could produce pure and tranquil beauty, as in his shadowy watercolour of his fellow artist Camille Corot, *Corot Reading* (Metropolitan). Daumier exploited a number of pictorial devices—the use of silhouette, for example—to expand the vernacular of drawing, and many of his

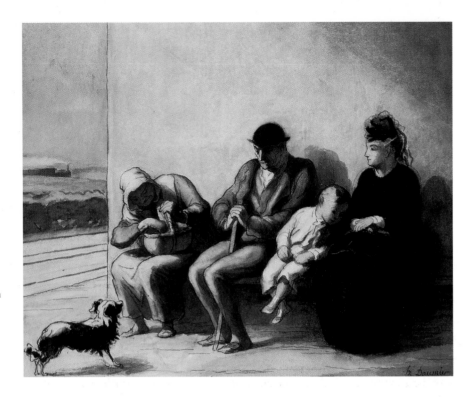

Self-taught, Daumier became Europe's finest draughtsman, especially on stone and in watercolour. Censorship forced him, happily, to do genre, as in *Wayside Railway Station* (1864).

inventions became the clichés of the next generation or two: the Symbolists and Post-Impressionists would have been impoverished without his work.

However, what mattered at the time was Daumier's close friendship with his younger contemporary, Jean François Millet (1814–1875). This connection has been intensively studied, with fruitful results. The two men drew together on many occasions, exchanged ideas and encouraged each other to more brilliant effects. Each intensified the other's realism and the power to depict it in line and shade, expanded into colour. It was one of the most creative relationships in art history. Together, they laid down the foundations of modern realism. The impact of Daumier's *chiaroscuro* on Millet can be seen especially in his beautiful black chalk drawing *Lobster Fishermen at Night* (Louvre) and his terrifying *Hunting Birds with Torches at Night* (Philadelphia, Museum of Art), but there are hints of it in almost all his work. Correspondingly there are many instances where Millet's passionate concern for human labour, and his ability to depict it with classical severity, forced Daumier to raise his sights.

Millet came from a Norman peasant family. Though he worked in Paris and Barbazon, at the same time as other artists who belonged to its so-called school, such as Théodore Rousseau, he was not a collegiate figure but a loner, his link to Daumier being the sole exception to his solitary pursuit of excellence (and even that was punctuated by quarrels). Millet is often inexcusably confused or conflated with Camille Corot (1796–1875), whose sunny townscapes and silvery, poetic forest scenes, are freshly painted, deservedly popular and enviably successful but do not suggest much concern for the human condition. But Millet, though an exact observer of

landscape—he never invented it as Corot did—rarely made it the centre of his universe. His concern was with the men and women who were its occupiers and slaves, the peasants from whom he sprang.

Millet made what eventually became a huge reputation with three monumental paintings of peasant life: *The Sower* (1850, Boston, Museum of Fine Arts), *The Gleaners* and *The Angelus* (both Paris, Musée d'Orsay). These three works, each beautifully painted with what one can only call the love which springs from deep knowledge and understanding, demonstrated the importance of exact composition and imagery in art. They were detested by the regime because they were thought to stress the poverty of rural France. The intellectuals hated them because they reflected Millet's profound religious beliefs. Because the public loved them, all were reproduced from the start, countless times, and are still making their appearance as illustrations, Christmas cards and the like, all over the world, all the time—and they survive even that. Daumier used to say that, in making a strong point, it is sometimes more effective not to show the face of suffering, and Millet, in both *The Gleaners* and *The Angelus*, has the peasants in shadow, their tiredness, harsh life and stoicism expressed, rather, in their postures. These are subtle works, which need to be examined closely, once their overwhelming immediate impact is absorbed.

Millet cannot be fully understood without a careful analysis of his drawings, however. His best oils are often an apotheosis of a brilliant sketch. His terrifying painting in the Victoria and Albert, *The Wood Sawyers* (1850), showing the almost desperate dynamism with which two sweating men are dealing with a monstrously large trunk of hardwood, was built up from many sketches (some in the Ashmolean, Oxford), the first of which, from life, sparked the vital imagery. But sometimes the draughtsmanship is so powerful that there is no need for paint. A black chalk drawing in Boston, *Faggot Gatherers Returning from the Wood*, with its brilliant use of endless vertical strokes, says all we need to know about their pain. We get the same economy of effort in a black chalk snow scene in the Louvre, showing a man hunting with his dogs against impenetrable vertical trees (*La Porte aux vaches*). Sometimes he uses only one pastel colour over charcoal, as in *Sheepfold by Moonlight* (Baltimore). Sometimes he is content with two, as in *Pine Crossroad* (Dijon, Musée des Beaux-Arts), perhaps the best pastel landscape ever created, full of desolate poetry. It seems at first empty of life, until we detect two tiny, burdened figures struggling in the background. In Millet's landscapes there is always human suffering as well as natural beauty. In *The Faggot Gatherers* (Cardiff, National Gallery), a late oil, done not long before his death, the women slaves are large, though almost impersonal in their twisted labour, faces blank with effort. But Millet may also put in a woman, doing something hard and repetitive, as he puts in a twig, or bed of rushes, or low cloud—just part of nature.

Gustav Courbet (1819–1877) was an *enragé* like Daumier and anxious to be a painter of peasant life like Millet, but his confused ambitions and extravagant

gigantism tended to blunt his effectiveness. His politics led him to organise the destruction of the Bonaparte Column in the Place Vendôme during the Paris Commune of 1870–81, and the French state savagely punished him for the rest of his life, mainly by exile. But he was always ready to be diverted from politics by his love of paint, shapes, wildness and visual extravagance. Everything about him is large, often heroic but liable to topple over into bathos. He was self-obsessed and painted almost as many images of his face as Rembrandt did, some of them very fine (see his *Self-Portrait as a Cellist*, Stockholm, National Museum). He was also obsessed with sexuality, both on his own behalf and for others. He had a passion for painting women with enormous bottoms, rendered with astonishing skill but grotesque to behold. One cropped up in *Torso of a Woman* (1863, Metropolitan), another in *The Spring* (1868, D'Orsay), a third—possibly the same one—in *The Bathers* (Montpellier, Musée Fabre). Théophile Gautier, otherwise friendly, denounced this last as 'a Hottentot Venus', and such extravagances often alienated those who were anxious to back Courbet's brand of reckless realism. What they did not know, fortunately, was that there was an even more troubling but deeply hidden aspect of his work.

Throughout the nineteenth century we come across cases of artists being procured to provide pornography for the great and the rich. A typical example is the young Theodor von Holst (1810–1844) in the 1820s. He came from Lithuania, was a pupil of Füseli (himself a pornographer) and was important in helping to inspire Rossetti to found the Pre-Raphaelite Brotherhood. He had been the first illustrator of Mary Shelley's *Frankenstein*, before he died of drink, and his works—Rossetti called him 'that great painter'—hung in rows in Campbell's Scotch Restaurant, where the PRB held its first meetings. Thomas Lawrence, then President of the Royal Academy, no less, persuaded Holst (who perhaps needed no persuasion) to supply George IV with obscene drawings, some of which, such as *Ithyphallic Man and Two Women*, are among the hidden treasures of the Victoria and Albert Museum.

Courbet's pornographic drawings have either been destroyed or are deeply hidden in the national archives, but at least three of his lubricious paintings survive. All were done for a rich Turkish diplomat, Khalil Bey, and had to be sold when he went bankrupt, after endless excesses. One is *Turkish Bath*, which Edmond de Goncourt compared to a Correggio (and it is certainly a long way from Ingres). Another is a notorious lesbian scene, *The Sleepers*, now in the Petit Palais. The third and most extreme, *The Origin of the World*, done in 1866, is a highly realistic close-up of a woman's pudenda, designed to be hung behind a green veil, itself concealed by a painting of a castle. It once belonged to the psychoanalyst Jacques Lacan, who hung it behind an abstract by André Masson.

Publicly, Courbet became best known for two enormous works. *A Burial at Ornans*, which he began in 1849, is over 12 feet by 20 and contains thirty-eight major figures. Another vast work, *The Painter's Studio* (both D'Orsay), shocked everyone because a voluptuous nude model is positioned in the middle of nearly thirty

clothed men and women. That Courbet was a major, potentially a great, painter is uncontestable. His range was enormous. He did some grotto and rock pictures (*The Rock at Bayard*, 1855, Cambridge, Fitzwilliam), genre (*The Peasants of Flagey Returning from the Fair*, 1850, Besançon, Musée des Beaux-Arts), penetrating portraits (*Proudhon and His Children*, 1853, Petit Palais), landscapes of all kinds, seascapes (*Low Tide at Trouville*, now in the Walker Art Gallery, Liverpool, is the best Normandy coast scene done in the nineteenth century), storm and waves scenes, cows and other animals—Boston has a wonderful *Hunting Dogs*—and snowscapes, such as the majestic *Fox in the Snow* (Dallas, Museum of Art).

Held in prison, Courbet painted himself, of course, but more important a superb set of still lifes, mainly of apples, which recall all the skill of Chardin, with added power, and make the later attempts to emulate them, by Paul Cézanne, seem anaemic. Courbet's last, incomplete picture, a big canvas entitled *Panoramic View of the Alps* (Cleveland, Museum of Art), has the makings of a masterpiece, to stand alongside works by Turner, Bierstadt and Church. Courbet is sometimes totally unsuccessful, often crude, unbiddable, ill-advised—or rather, rejecting all advice—and stupid. But many painters have plundered him for ideas and ways of doing things.

The Wood Sawyers by Millet (1850), the Raphael of the peasants. With his friend Daumier he created a new vision of labour, its griefs and glories.

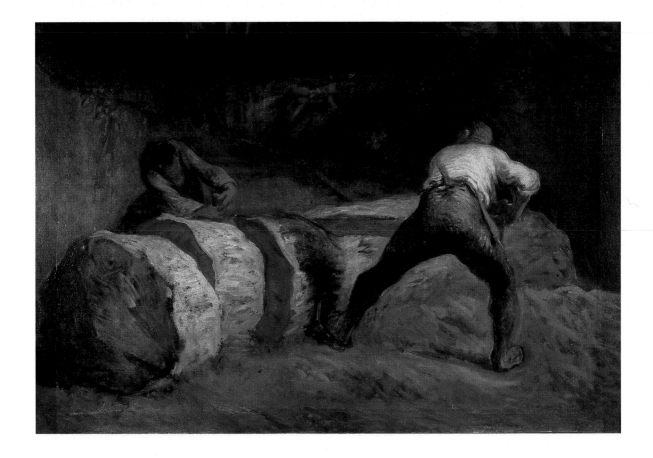

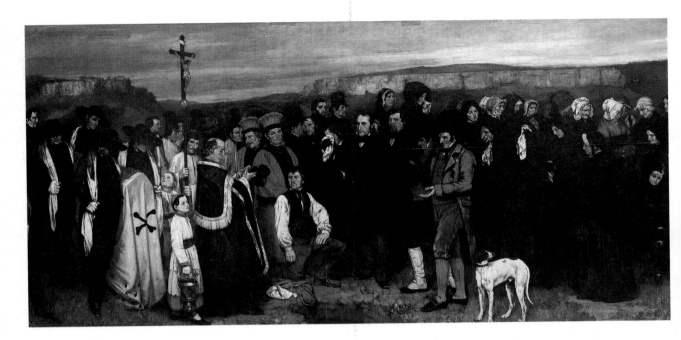

Courbet painted rural France on the grandest scale, as in *A Burial at Ornans* (1850). He was a good hater— of church, state and academy.

One who did so with the greatest success, and thereby established himself as the founder of 'modern painting', was Edouard Manet (1832–1883). Manet, like Millet and Courbet, was a rooted, inveterate realist, who never wanted to do anything else except paint the world as he saw it. He was the son of a magistrate, an upholder of law and order, a gentleman of exquisite refinement, who loathed bohemianism, disliked coteries of artists, avoided rows and simply wanted his pictures to be seen in the Salon or at the grand expositions which punctuated the Second Empire. In 1859 he painted *The Absinthe Drinker* (Copenhagen, Ny Carlsberg Glyptotek), thinking to make a moral point in favour of sobriety; the Salon rejected it as immoral. In 1863, thinking to combine his own version of Giorgione's *Fête Champêtre*, with a comment on Courbet's *Studio*, he produced *Déjeuner sur l'Herbe*, the naked model consorting with fully clothed artists. This was a highly provocative picture, which was not only frowned upon by the Salon but, when shown at the so-called Salon des Refusées, set up as an official symbol of rebellion against the art establishment, caused such scenes that the entire exhibition had to be closed down.

Two years later Manet managed to get his *Olympia* into the Salon, but another row followed: although he claimed it to be an updating of Titian and Velázquez, it looked to most people like a high-class whore, naked, being attended by her black maid. In 1867, not being a star of the Exposition, he held his own show alongside the official one. As he put it in the catalogue, 'Monsieur Manet never wished to protest. It is others who have protested against *him* much to his surprise.' When his personal exhibition received little attention, he made an immediate response to the news of the

death of the Emperor Maximilian, whom Napoleon had installed, then abandoned, in Mexico, by painting a big picture, *The Execution of Maximilian* (Mannheim, Kunsthalle), showing the firing squad in French uniforms. The emperor was angry and, not being able to get his hands on the painting (there are in fact five versions, the best in Boston), suppressed the print made from it.

All these reactions were to be expected, yet in each case Manet appeared genuinely surprised. He was a naïve man, an innocent; a little gormless despite his charming manners. It might be argued that he was also a cunning self-publicist. Certainly, few living artists, until the advent of Picasso, have ever been more assiduously promoted by prominent writers, from Baudelaire, then a leading art critic, to Zola, the biggest best-selling novelist in France, to Marcel Proust. Mallarmé and Verlaine, Leconte de Lisle and Anatole France all sang his praises. He was quickly taken up by writers in English too, led by the Irishman George Moore, who figures prominently in an extraordinary tribute, painted by another Irishman, William Orpen (1878–1931), called *Homage to Manet* (Manchester, City Art Gallery), and showing his admirers across the Channel, leading painters like Henry Tonks, Walter Sickert, Wilson Steer and D. S. MacColl.

There were two reasons why so many people liked Manet's work. He had had an excellent academic training and continued to practise what he was taught until the end. But he introduced an important change. In oil-painting, the practise at the time was to begin with a dark underlay and then build up lighter tones on it, using opaque layers of pigment and translucent glazes. Manet was an accomplished water-colourist and he preferred the technique of putting on the lightest tones first (or leaving blank spaces) and then putting in the darks. He applied this to oil, reversing the usual sequence or, alternatively, aiming for what is called an *alla prima* effect—that is, colouring from the start the tones he wanted at the finish. This was a momentous change in oil-painting for it was far quicker than the old method, making outdoor work much easier, and it led inevitably to a higher range of colours. It made the canvas look slightly unfinished, but also fresher; more, as it were, up-to-date. With most people it would not have worked at all, but with someone of Manet's skill and training, it appeared right, natural and wonderfully new.

Second, Manet had the gift of the image—so important in art, as we have seen time and again. This is demonstrated to perfection in his beautiful picture *The Fifer* (D'Orsay), where he reduces the figure to absolute simplicity by eliminating background altogether. Manet had a wonderful instinct for this kind of device, seeming to know without thinking when to clutter up his canvases and when to minimalise all. That he could clutter with genius is seen in his last major painting, *A Bar at the Folies-Bergère* (1882, London, Courtauld), a far from perfect work—the perspective is atrocious—which rises above its frailties by the sheer audacity of showing a lot of labelled bottles, with rows of indistinct faces behind them, clustered around a bored barmaid, dead centre, looking slightly off-canvas. This brings us to the third reason

for Manet's success with younger opinion-formers. He made obvious scenes some-how appear significant.

By 1882 history-painting was dead. Manet painted the historic present. He showed artists that there were alternatives to mere genre, which told the truth about

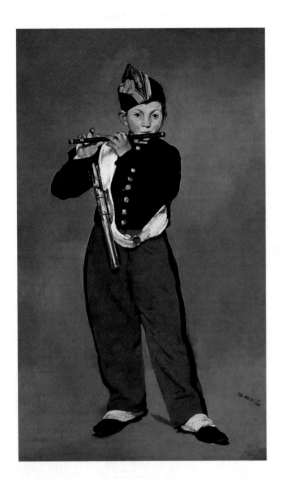

modern life but made it momentous. They could, Manet's pictures seemed to say, paint the present yet still be in the big-league tradition of Titian, Velázquez and Rembrandt. All they had to do was to use their eyes, pick their subjects carefully, and then paint them, with enthusiasm, putting on the paint fresh, fast and furious. This may all seem pretty obvious, even banal, to us now, but it was not so then; it seemed to come as a revelation, a release, a liberation. Manet painted about a score of canvases in which his message was successfully delivered. That sufficed. It did not matter that many of his other works are embarrassing failures. Seen in the perspective of art history Manet was a lucky man, who struck a decisive blow, with his limited resources, at just the right time. His older contemporary, Victor Hugo, wrote: 'Nothing is so powerful as an idea whose time has come.' Manet was an embodied idea, of high-palette, simplified, contemporary realism, expressed just when the younger generation needed it.

Manet came from a wealthy family and it is a curious fact that all three of his most important realist followers in France need never have painted for a living: they did it because they loved the act of seizing the real world and putting it on canvas or paper. Of them, the most gifted by far was Edgar Degas (1834–1917), who drew with the assurance and fluency of Daumier but, thanks to family money, was provided with an exceptionally long and thorough training. Of all the painters of the late nineteenth century, Degas was the most accomplished, fastidious and self-conscious. He learned how to paint in fresco, which lightened his palette. He mastered pastel, and became extraordinarily skilful in using it, especially for flesh tints, often mixing it with oleaginous liquids, such as petroleum. He taught Mary Cassatt pastel and she (as he admit-ted) excelled him in this delicate medium. As he grew older, fearing blindness, he learned to sculpt in wax, believing he could continue to produce solid forms even if he lost his sight completely. He aimed at total verisimilitude: *The Tub* (1889), of a woman bathing, had a real

Manet showed, yet again, that a striking image is the key to artistic success. But *The Fifer* (1866) was rejected by the Salon.

sponge, held by the woman, and the bath was filled. (The version in Edinburgh's National Gallery of Scotland is in bronze, cast after Degas's death: the latest *catalogue raisonnée* of his works, 1989, shows that editions of twenty-two were made by *cire perdue* of most of his waxes.) Degas sketched with astonishing rapidity—that is why he was so successful in depicting action: racehorses, ballet dancers, women ironing. He might accumulate hundreds of drawings before he decided on a painting, which was then carefully composed and done in the studio (he disliked using oils in the open). He said: 'No art was ever less spontaneous than mine.' In most respects he was an old-fashioned artist.

Indeed, Degas's early works were conventional too, and when they were not he made a mess of it. *The Gentlemen's Race* (D'Orsay), painted in 1862, an attempt to treat a traditional racetrack scene with modern informality, putting chimney-stacks in the background, is botched. Degas had learned a great deal copying Old Masters. It was while working on a Velázquez in the Louvre that he met Manet, and sought to emulate his choice of 'modern' subjects. But it took him a long time to break with old-fashioned sequences in applying oil paint. Four years later he had another attempt at a racing scene, *The Fallen Jockey* (Mellon, private), but even this had to be reworked in the 1880s, by which time he had mastered the problems of lightening his

Degas's *Dancer on the Stage* (1878) is the opposite of Impressionist, a term he hated. It is the product of meticulous studies and (his word) 'observation'.

foregrounds. His first successful painting followed a visit to Louisiana where his brothers were in trade: *The Cotton Exchange at New Orleans* (two versions: Pau, Musée Municipal, and Harvard, Fogg). Thereafter his confidence grew, and he did a variety of scenes of contemporary life: jockeys, dancers and theatre people, women doing household chores and bathing, café scenes and interiors. He created some wonderful group pictures of musicians and dancers: *Orchestra of the Opéra* (D'Orsay), *The Dance Class* (Metropolitan), *Ballet Rehearsal* (Kansas City, Kemper Museum), and many more. These were in addition to his individual studies of dancers, mostly in pastel, which were often radiant and exquisite: his *Dancer on the Stage* (Louvre), with its scintillating light-effects and masterly composition, has a strong claim to be considered the finest of all pastel works. These pictures were the result of hard, conscientious work: endless attempts, the study of failures and their correction, fierce self-criticism, and a certain dogged obstinacy, belied by his elegant appearance and offhand manner. Like Fragonard, whom he resembled in some ways, Degas worked heroically to achieve an effect of throwaway genius.

It is important to realise that he was never an Impressionist. The word, as applied to a group of artists with very different skills and objects, is misleading, and has confused art history ever since it came into vogue. On 27 December 1873, Degas joined with other artists—Claude Monet, Camille Pissarro, Alfred Sisley, Berthe Morisot and Paul Cézanne—to form a company, the Société Anonyme Coopérative à Capital Variable des Artistes, Peintres, Sculpteurs, Graveurs, whose stated purpose was to organise exhibitions without juries. These and other artists objected to the way the jury system worked at the Salon, and with reason. It was arbitrary, confused, unsystematic and often cruel. Degas hated it and that is why he joined the others. It was not because he shared with them any particular approach to painting, other than a willingness to experiment. The company was a protest: the first name commonly used of its shareholders was *les intransigéants*. But Monet had titled a recent picture of his *Impression, Sunrise*. Hostile critics pounced on it, used it of them all, and the name stuck. Indeed, it not only stuck but had a huge impact on art history, indeed on art itself. It is a classic case of Popper's Law. The company, as it happened, lasted less than six months; it was dissolved four weeks after the first exhibition opened on 15 April 1874. Over the next twenty-two years, seven more such exhibitions took place, and Degas not only participated but occasionally encouraged others, such as Cassatt, to do so. But he much disliked the term 'Impressionist,' which was increasingly used, being convenient for critics, newspapers and dealers. When pressed, he called himself a 'realist' or 'naturalist'.

All the same, Degas found himself abused, and in an unexpected manner. No episode in art has created more myths than Impressionism, and some are so deep-rooted now, after a century and a quarter of repetition and embellishment, that they may never be dispelled. One myth is that the public and many critics were hostile to these shows because they moved away from the verisimilitude of Salon 'finished'

pictures, into a miasmic world of sketchy painting in light colours in which brush-strokes are plainly juxtaposed and seen, thus replacing reality with decoration. But when Degas, at the Sixth Exhibition in 1881—by which time Impressionism was generally used to describe such shows—produced his *Little Fourteen-Year-Old Dancer*, his first wax sculpture and the only one shown in his lifetime (original in Mellon, private), it provoked outrage. To achieve realism, Degas clothed the wax figure in a real tutu of tulle, as he did not know how to sculpt one in wax—who does?—and he also provided the girl with a wig and satin ribbon. This was seen as the negation of art and there were cries for the thing to be removed to a museum of ethnological specimens. In fact 'scientific realism', as it was termed by hostile critics, produced as much hostility at the shows as 'unfinished' pictures.

All the same, Degas could be provocative. His *Absinthe Drinker* (D'Orsay), which proved he could paint much better than Manet on the same topic, was also designed to annoy. He did many beautiful pastels, and a few oils, of prostitutes inside brothels, though these were not publicly displayed as a rule. He also experimented, using only minute quantities of paint and a lot of turpentine mixed with other spirits, which heightened the viewer's consciousness of his drawing, as superb as ever. For an example, see the London National Gallery's *La Coiffure*. He experimented with wrapping paper, tracing papers, various forms of cardboard and linen, often using a mixture of crayon, pastel, paint and chalk. He tried to keep up with new develop-

Degas had a long, mournful face, like his aunt Laura, seen here in *The Bellelli Family* (1858). He was rich, classically trained and a master-draughtsman.

ments in art, and had a rather vertiginous friendship with Paul Gauguin, but he really preferred the company of Giovanni Boldini (1842–1931), the brilliantly successful portrait painter from Ferrara. The two men travelled together, sketching, Boldini's flashiness raising rare smiles from Degas, who was becoming increasingly depressed at the way the world was moving, and ceased to paint at all in his last years.

All artists who knew him respected Degas, seeing him as less innovatory than Manet but far more accomplished. Sensible ones tried to learn from both. An important member of this group was Gustave Caillebotte (1848–1894), who painted some of the most memorable realistic images of the 1870s and 1880s. Like Degas he was a collector as well as a painter, and their acquisitiveness made them fast friends. Degas's collection, an important key to understanding his work, included old as well as modern masters (it is now dispersed but there is a full catalogue of it), whereas Caillebotte chiefly collected what are now known as Impressionists: he left sixty-seven canvases to the nation, of which thirty-eight were accepted (1896) but now form an important unit in the Musée d'Orsay. For a long time, Caillebotte, having an absurd name (it means 'curd'), being rich and famous as a collector, was dismissed as an amateur painter, and it is true that he never attended the Beaux-Arts School in Paris, though registered there. But there was nothing amateur about his work. Three of his paintings are masterpieces by any standards.

Planing the Floor (best version in D'Orsay) Caillebotte stumbled on by accident, when he saw men redoing the parquet of his house, 77 rue de Miromesnil. This is a common occurrence in any Paris upper-middle-class home, but no one had ever thought of making it into a picture. Caillebotte grasped the challenge of the strong diagonals in the crouching, busy figures, the dynamism of floor carpentry and varnish. It is composed of unusual angles and viewpoints, and this is what makes it so distinctive. Indeed, he can be termed an angular painter. He realised that street-scenes can be made to produce original angles. In 1876 he produced some marvellous diagonals in *Pont de l'Europe* (Geneva, Musée du Petit Palais), which is made up chiefly of girders but has bent and postured figures to provide distancing and interest. The next year he produced an even more memorable image of umbrella-ed figures walking towards the viewer in a wet street, *Rainy Weather* (Chicago, Art Institute). These three paintings arrest you when first seen; they stick in the mind; they are a delight to view and examine closely again. They remind one that the essence of good painting is simple: it interests the mind, and delights the senses.

Another realist who saw life from unusual angles, because he had no alternative, being little over 4 feet high, was Henri de Toulouse-Lautrec (1864–1901). He had to look up to people even when they were sitting down. His beautiful early *Étude de nu* (Albi, Toulouse-Lautrec Museum, where a huge stock of his work is displayed) is done with his eye-level on the model though she is crouching on a bed. Again, his superb portrait of Van Gogh (Amsterdam, Rijksmuseum), so much more accurate than Van

Gogh's self-portraits, was done standing up, though the sitter is at a low table. In his terrifying study of prostitutes, *The Medical Inspection* (Washington, National Gallery), the painter, standing up, has his eye-line on the women's bared stomachs, which makes them monumental and the insult to their dignity catastrophic. As photographs show, Lautrec had to work standing right up to the canvas, usually not moving for hours, and this denied him the lures of Impressionist fuzz. So he had to make himself a linear artist and did so, becoming the greatest French draughtsman of this period, Degas alone excepted. His appalling disabilities also made him take an especial delight in colours, using them in curious combinations and shades. His pastel, *La Modiste* (Albi), is a masterpiece in green and olive-grey, lit by gold; and another pastel, *La Clownesse Cha-U-Kao* (D'Orsay), is a brilliant redeployment of chrome yellow, one of the most dangerous colours when dominant. His colouring is deceptively subtle too: *Maxime Dethomas at the Opera Ball* (Washington) is a virtuoso exercise in mauve-pink, which is mysteriously echoed in the man's black coat and pallid face. There is virtually no twentieth-century artist who has not been enlightened by a study of Lautrec's colouring.

Paris Street: Rainy Weather (1877), a superbly evocative scene by Caillebotte, whose wealth enabled him to paint as he wished and amass a superb collection.

Knowledge of the great master has been improved markedly in recent years by fresh information which emerged at the huge exhibi-

tion of his work held at the Grand Palais in 1992 and by publication in
1994 of the first full biography based on over a thousand hitherto
unseen letters. His is a moving case of triumph and tragedy, a life of
pain, shame and self-degradation redeemed by a mass of creative work
of superlative quality, a surprising quantity, nearly all of it first-class, considering he
never reached his thirty-seventh year and was often too ill to work at all. He came
from one of France's grandest families with a fatal propensity to inbreed: he and four
of his cousins were victims of the doubling of a recessive gene. One of them spent
her entire life in a large wicker baby-carriage. Henri had a normal torso but his
knock-kneed legs were comically short and his stocky arms had massive hands with
club-fingers. His bones were fragile and broke constantly, he limped, had over-large
nostrils, bulbous lips, a thick tongue and a speech impediment. If Lautrec had got on

better with his family, he would probably not have become a painter. As it was, his skills gave him a purpose and allowed him to create a life of his own. He found he was least jeered at, and most acceptable, in the egregious world of low-life Paris, among the singers, dancers, circus people, promoters, prostitutes and rootless types who made up its drifting population.

Hence he happily painted these people into a created world in two dimensions, in posters and prints, oils and pastels, in drawings and decorations (he painted La Goulou's tent when she set up her one-woman show, and much of this has now been rescued and restored, and can be seen at the Musée d'Orsay). His work is like an enormous *roman-fleuve*, but in line and colour: Yvette Guibert; Jane Avril; Aristide Bruant (hero of the finest theatre poster ever splashed in violent red, black and gold); La Goulue, who in *Entrant au Moulin Rouge* (New York, MoMA) is the classic portrait of the fragility of performing flesh; the amazing and formidable Valentin de Desossé ('the Boneless'); Oscar Wilde and Tristan Bernard; Lucy Jourdan (her smiling face, lit from below, as Lautrec saw her of course, in *Private Room at the 'Dead Rat'* [Courtauld], sums up all 1890s Montmartre); and some of Lautrec's own friends and relatives, such as the unforgettable Gabriel Tapie de Céléyran, who springs out of a deep red carpet in an explosion of eccentricity in *Dans un couloir de théâtre* (Albi). Lautrec also added to his portrait gallery the red-haired woman Rosa La Rouge who was his downfall (unable to resist redheads, he fornicated with her although told she had syphilis). She figures in the beautiful *Poudre de Riz* (Amsterdam), in his entrancing study of a naked back, *The Toilette* (D'Orsay), and, beginning to crumble from disease, in a horrifying comment, *Last Crumbs* (Boston). This private-public world of chancers and performers also provided Lautrec with material for his big set-pieces, such as his grand image of the Moulin Rouge, *Training the New Dancers*, showing the Boneless Wonder at work (Philadelphia), and his sinister presentation of *The Ball at the Moulin de la Galette* (Chicago), a very different view to the rosy one given by Auguste Renoir. Lautrec always told the truth. Like Goya, he never flattered. He looks through the greasepaint of his artistes to their coarse skins and sagging flesh. His prostitutes are bored, ugly and exploited, his lesbian couples desperate. But there is no cruelty. Lautrec appears to say, over and over again, we are all strange-looking, me especially, but lucky to be alive: let us enjoy ourselves. And we, scrutinising this world he created in two dimensions, catch piercing glimpses of joy too, and coarse, libidinous pleasure, satisfaction, fear and disgust, and hear shouts of grue-some laughter. No other painter gives us such overwhelming opportunities to live vicariously in his world, the Paris of the 1890s.

Lautrec refused to be inhibited by his appearance, having himself photographed surprisingly often, sometimes naked or in drag, once defecating on the beach. He was an exhibitionist as well as a *voyeur* (as all painters must be). The disease Rosa La Rouge gave him was treated with mercury, which made his teeth black, and he must have been vain about that at least, since he would never be photographed with his

mouth open. As syphilis strengthened its grip, he worked less hard, and eventually not at all. Drunk nearly all the time, incontinent, dirty, suffering from hallucinations and paranoia, shaking, often violent, seeking the company of other debased drinkers, in and out of asylums, he eventually died not of general paralysis of the insane, as is often said, but from a succession of strokes. He left us a heritage of sometimes beautiful realism, which delights, astonishes, moves and shocks us, and will continue to speak uncomfortable truth till the end of time. What more can we ask of any painter?

The kind of realism practised by Manet and Degas proved highly attractive to many foreign artists who trained in Paris or came there periodically to pick up new ideas. One constant visitor was Guiseppe De Nittis (1846–1884), who came from Puglia in the heel of Italy and achieved a reputation in Naples, when only twenty-one, with his astonishing *Crossing the Apennines* (Naples, Capodimonte), a 'modern' landscape showing a road covered in slush and snow against a background of dark buildings and lowering skies. Like Turner, he thought the railroad was a gift to painters and his *Passing Train* (1869, Barletta, Civic Museum), was the first of many attempts to exploit atmospheric effects. Degas bought his works and indeed it was in De Nittis's Paris studio that he met Caillebotte. It was almost certainly De Nittis who persuaded Caillebotte to try snow scenes, for his own were superb: *Effects of Snow* (1875, Barletta), is a virtuoso exercise in winter landscape, rivalled only by his delightful winter scene, *How Cold It Is!* (1874, Milan, private). He had been inspired to paint snow by Ippolito Caffi's masterpiece, *Snow and Fog on the Grand Canal* (1840) in the Ca'Pesaro in Venice.

If De Nittis had lived longer he might have become the greatest painter of his times, for his technique was flawless, his imagination strong and he could turn his hand to anything, including beautiful women. That is shown by his intriguing canvas *The Visit*, in the magnificent Giacomo Favretto Collection of nineteenth-century Italian art in Turin, which contains a large number of his canvases. These include a dozen of the sixty paintings De Nittis made in and around Mount Vesuvius, 1871–72, perhaps the most comprehensive attempt ever made to do the 'portrait' of this remarkable mountain. There are two big works in this series, *Rain of Ashes* and *The Descent from Vesuvius* (both Valdagno, Gaetano Marzotto Collection), which rank with anything produced in Paris during the 1870s. Degas invited him to join the first Impressionist show in 1874, and De Nittis sent five works but did not attend it—artistic coteries were not for this affable loner. Instead, having exhausted the opportunities of Paris townscapes, he went to London where he painted a masterpiece, *Piccadilly* (1874, Marzotto), a brilliant evocation of a typical-London-weather scene, looking west, with a multitude of figures and dashing brushwork, highly realistic but also, in its emotional way, romantic.

In London De Nittis met the Frenchman James Tissot (1836–1902), a jovial

Breton who had taken aboard Manet's kind of realism without altering his painting technique, which was firmly conventional and highly sophisticated. Tissot did not do low-life at all but his high-society paintings (e.g., *The Ball on Shipboard*, 1874, Tate Britain) are markedly accurate and pointed, for Tissot was a radical activist who left Paris for London in 1871 because he was terrified that he would be punished, like Courbet, for his activities during the Commune. Tissot's work is now highly regarded, and rightly, for its realism, though there is one weakness: all his principal women tend to look like Kathleen Newton, his wife, who died in 1882 of tuberculosis. Tissot was obsessed by her to the point when he turned to spiritualism and developed religious mania, thereafter painting mystical paintings of apparitions. However, it was Tissot who suggested to De Nittis that he paint London in its fogs and hazes, and De Nittis did two spectacular views of the Houses of Parliament at Westminster which anticipated and greatly excelled Claude Monet's efforts on the same subject.

Large-scale landscapes, painted slowly and carefully over months, in the manner of Constable, were being created in France too at this time. These artists worked mainly in the provinces, exhibited at the Salon (if they were lucky), and celebrated the grandeur, beauty and character of rural France. The state was often their chief patron, and their works are to be found in the museums of regional capitals (sometimes in the Paris D'Orsay), but most of them led penurious lives and in one or two cases died in poverty. Antoine Chintreuil (1814–1873), a hatter's son, worked mainly in Mantes in the Seine valley, where he produced 250 landscapes, many of them large, specialising in huge expanses and tremendous atmospheric effects, rather like the great Americans. His *Space* (1869) is an overwhelming evocation of the vast Seine escarpment. *Apple Trees and Broom in Flower* (1872), another big picture, shows an avenue of trees in blossom stretching to the horizon against a copper-and-gold evening sky. *Rain and Sun* (1873; all three paintings Musée d'Orsay) recalls late Turner in its elemental power, but is painted with extraordinary care for detail. Alexandre Ségé (1818–1885) worked in Brittany and the plain of Beauce, where he painted one unquestionable masterpiece—*In the Land of Chartres* (1884, Chartres, Musée des Beaux-Arts), showing the immensity of the cathedral silhouetted against the horizon, and a towering cloud dominating the sky which occupies two-thirds of the picture. A flock of sheep in the foreground completes a brilliant composition. However, both these fine painters experienced difficulties getting into the Salon, being judged 'extreme' and their effects 'extravagant'.

It is important to realise, in judging these artists, that France in the nineteenth century was a country which had once dominated Europe but now had a stationary population and felt itself increasingly threatened. Emphasising the solidity and endurance of its rural communities was important to its self-confidence. That is exactly what Charles Buisson (1822–1908) provided in *The Village of Lavardin* (1877,

Angers, Musée des Beaux-Arts), a vast painting of a tiny hamlet set against a steep hillside under a dark sky, which appears to threaten but also sends shafts of golden light on the stone houses and church. The quintessential France has never been so lovingly and accurately painted as in this wonderful work, perhaps the best landscape to emerge from Europe in the second half of the nineteenth century. It is challenged, however, by another huge canvas, *The Valley of Sernay* (1873, Dunkirk, Musée des Beaux-Arts), by Léon Pelouse (1838–1891), a self-taught textile worker who threw up his job to paint. This vast woodland scene, every twig and leaf painted in meticulous detail, dominates and overwhelms the room in which it is shown. Moreover, it has a companion piece, *October in the Woods* (Rennes, Musée des Beaux-Arts), completed in 1874, which is even larger; each took the artist eighteen months of hard work, in the open and in the studio.

Size can be very important too in landscape. For, as the work of Church and Bierstadt showed, while impressions can be recorded in small oil sketches, the realisation of the full grandeur of nature sometimes requires a 7-by-10-foot canvas, into which the viewer can peer and lose himself, stepping into the landscape space, and living there. You do not just look at Pelouse's woods; you are actually in them, feeling the branches brush against your cheek, hearing the stream. It was the same with the powerful artists who brought the immensities of Provence down into two dimensions. The grand panorama of the hills near Marseilles by Paul Guigou (1834–1871), called *The Hills of Allauch* (1863, Marseilles, Musée des Beaux-Arts), is strikingly successful in evoking the harsh, pungent vegetation, the blinding white rock, the eccentric shapes of the Provençal uplands and, above all, the penetrating and poetic light, never to be forgotten by those who experience it on their first trip south of Lyons. The sense of Provençal locality was conveyed even more powerfully in the works of Paul Sain (1853–1908), especially in his astonishing *September Morning near Avignon* (1889, Carpentras, Musée Duplessis), an explosion of blinding light so high-toned that the deepest shadows are light blue and the mass of the landscape is more brilliant than the blazing blue sky.

The group of paintings described here are of the greatest possible variety, in tone and treatment, in range of colours, brushwork and composition. All involved a great deal of open-air work, though in most cases the actual painting was done or at least finished in the studio. All had as their object total fidelity to nature. What they also had in common was size. These splendid paintings are all big, and many have a surface area not less than 70 square feet. That is one reason why most of them have never been seen outside the provincial museums where they are housed (an exception was the exhibition at the Hayward Gallery, London, in 1996). They were never commercial paintings. They were done for love of France since, even in those days, few individuals had houses large enough to accommodate pictures of this size. They were necessarily expensive since they involved one, two, even three years' work. The state, which had special funds for supplying provincial galleries with suitable

works, was virtually the only patron. If the state refused to buy, the artist might be in trouble. And the state often refused to buy.

If we turn from this group of painters to the Impressionists, and especially to the trio who formed the core, Camille Pissarro (1830–1903), Auguste Renoir (1841–1919) and Claude Monet (1840–1926), we find a quite different approach to marketing. Monet, a grocer's son from Normandy, began as a large-scale landscape painter, aiming at the Salon and the attention it received from the French government talent-inspectors. His first important pictures, *Seine Estuary* (1865, Pasadena, Norton Simon Collection), and *Pointe de la Hève* (1864–66, Forth Worth, Kimball Art Museum), were both huge and both got into the Salon. Indeed, as the significant New York Metropolitan show in the 1980s, *The Impressionists before Impressionism*, demonstrated, Monet—who had been coached by the able Dutch landscapist Johan Jongkind (1819–1891)—was an accomplished landscape artist in the realist style. But he broke down over his enormous project for the 1866 Salon, *Déjeuner sur l'Herbe* (fragments in D'Orsay), measuring 15 foot by 20, and had to abandon it. He was discouraged, and his relations with the Salon were soured by repeated rejections.

In 1869 he and the young Renoir were working together on the Seine at a fashionable boating place called La Grenouillère. Renoir did some brilliant sketches there, and he got the idea for what was to become his greatest work (actually painted at Châtou), *The Boating

Renoir's *Boating Party Lunch* (1881), painted at the height of his powers, on the spot by the Seine banks, is the perfect celebration of youthful joy.

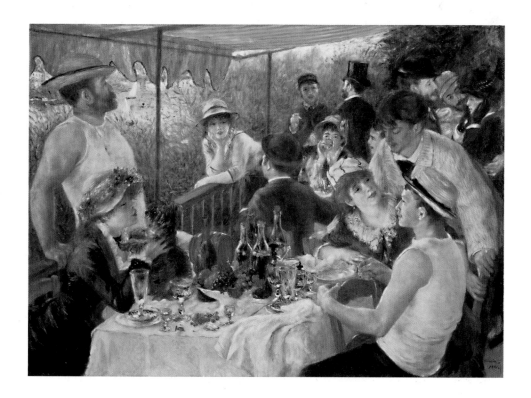

Party Lunch (Washington, D.C., Phillips Collection). Monet was less fortunate. He had planned another huge painting, which would out-Manet Manet, by showing up-to-date pleasures on the Seine on a scale to overwhelm the Salon jury. But he found he could not do it, and he abandoned ultra-large-scale work until the last years of his life, when he was world-famous and a millionaire and could do what he liked. Instead, he started to work on his sketches, which were comparatively small-scale, called them 'impressions', and raised them to a semi-finished state for sale. It is interesting that he referred to them at the time as 'bad sketches', though one, *La Grenouillère*, is now among the treasures of London's National Gallery.

Accident now intervened again. The Franco-Prussian war drove both Monet and Pissarro to London, where they became allies. Pissarro was a Sephardic Jew from the West Indies who was self-taught but became extraordinarily adept at putting what he saw down on canvas, simply, sincerely and effectively, and he tried to work out-of-doors right up to the finish. He was modest (and in figure-drawing he had much to be modest about) but with an inner self-confidence and authority which, in their own way, made him a formidable person and a fine teacher (as Cassatt said, 'He could teach a stone to draw'). In the 1860s, Pissarro, like Monet, had tried to produce large-scale works for the Salon, with mixed success, though some are excellent (the New York Metropolitan's *Côté du Jallais near Pontoise* is a good example). In London they discussed with Paul Durand-Ruel (1831–1922), also in exile, the possibility of selling smaller pictures to private customers. Durand-Ruel came from a family of dealers, of whom he was by far the most successful, and eventually, after many mishaps, was to sell Impressionist paintings in large numbers to wealthy Americans and Russians, and some French and British collectors too.

It is important to grasp that, in the 1870s, sophisticated taste was undergoing one of its periodic shifts from clutter to simplicity. The Gothic craze was over; the kind of interior decoration which Whistler promoted was pushing its way into the drawing-rooms of the rich. They were being cleared of half their furniture, and the wall-spaces stripped to accommodate fewer and spaced-out pictures, often small and simple ones like Japanese prints. There was room, however, for smallish, freshly coloured paintings whose high tonal values could make their point without the need for size. In this respect, then, Impressionism too, like Manet, was an idea whose time had come, though it took some years before its success was clear. It was the dealers, led by Durand-Ruel, who made the movement not only commercially viable but, in due course, perhaps the greatest financial success in the whole of art history. All the leading Impressionists who lived long enough died rich men.

But as always with artistic successes, there were drawbacks. One was a certain loss of individuality. Art is essentially a personal response to the visual world, and an artist should always be wary of belonging to a coterie. Of the artists commonly classified as Impressionists, it was those who were emphatically not impressionistic but realists who kept their individuality intact—Degas and Mary Cassatt, Toulouse-Lautrec and

Caillebotte. Camille Pissarro was very much his own man, and to an experienced eye his work can be instantly detected, even across a room. But similarities of subject matter and treatment, colouring and brushwork produce confusions even in Pissaro's case. His *Jardin des Mathurins* (1876) might easily have been painted by Monet. Equally, Monet's *Boulevard des Capucins* (1873; both Kansas City, Nelson-Atkins Museum), could be a work by Pissarro, as indeed could Monet's *Garden at Sainte-Adresse* (Metropolitan), painted in 1867 before the two men had worked together. A minor member of the group like Alfred Sisley (1839–1899) tended to lose his persona completely, as is shown by two paintings in the Musée d'Orsay. *Inondations à Port-Marly* (1876), in fact by Sisley, is mistakable for the work of Monet, while Monet's *Bridge at Argenteuil*, painted two years earlier, might be by Sisley. There is also confusion between Renoir's and Monet's landscapes of the 1870s, especially river scenes.

Fortunately for him, Renoir was essentially a figure-painter, and his young girls with their broad, smiling faces, full dresses and umbrellas or parasols, are unmistakable. With his uncertain draughtsmanship, he was probably the painter who made best use of Impressionist technique. Thus his beautiful *Torse de femme au soleil* (1876), a sun-and-shadow nude which once belonged to Caillebotte and is now in the D'Orsay, is a sketchily brushed-in 'study' (as Renoir originally called it), which would not have worked if done *à l'Ingres*, but does perfectly well as a light-toned impression. Renoir did brilliantly with such effects and showed also that he could organise a big picture with many figures in it. His greatest work, standing alongside his *Boating Party*, is *Ball at the Moulin de la Galette* (D'Orsay), where the strong sunlight is diffused by the tree-cover and makes fascinating patches on the young men and women enjoying the fun. Renoir, at his best, is the supreme painter of youth and pleasure. These two paintings conjure up all the voluptuous excitement and fleeting joy of being very young in the company of the opposite sex. They are heedless, hilarious, harmless and very beautiful. But Renoir, like all the core Impressionists, tended to become repetitive. These painters were inclined, from about 1875, to paint too fast, and the older they got the faster they painted, accuracy being replaced by a certain coarseness. In Renoir's case, the effects became apparent during the seventh Impressionist Exhibition of 1882, where he showed *Woman with Fan* (St Petersburg, Hermitage) and *At the Concert* (New York, Clark Art Institute), both vulgar paintings using tricks he had tried before, only more clumsily. Renoir suffered various ailments, including that painter's curse, arthritis, which eventually obliged him to paint with his brushes strapped to his hand.

Monet's repetitions were more systematic and quasi-ideological. All his life he had a tendency to become obsessive about certain subjects and light-effects. This began in the early 1870s with railway stations and steam (*Gare St-Lazare*, 1877, in the Musée d'Orsay, is one of the better examples). In the 1890s he did a series of haystacks showing them in different lights and at successive times of day. They gave his work a 'scientific' dimension and attracted comment, and in due course expanded into academic theses. Haystacks and grain stacks were followed by lines of poplars. Monet

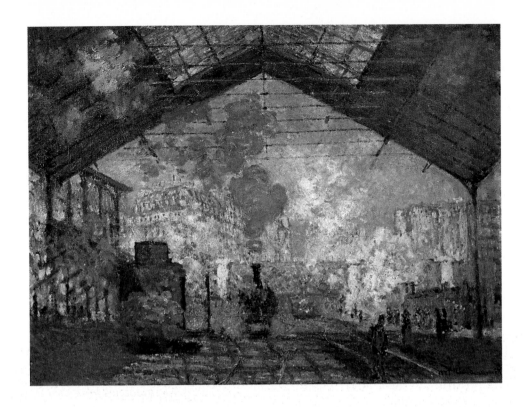

Monet's *Gare St-Lazare* (1877) demonstrates what Impressionism did best: a transitory glimpse of an atmospheric event, the colours changing with the light.

found that these series pictures were popular at Durand-Ruel's gallery, first in Paris, then at his shows in New York and London. In 1894, of the fifty paintings he produced for the dealer, no less than twenty were systematic studies of Rouen Cathedral in different atmospheres and light. He then made trips to London to produce a series on the Houses of Parliament, Westminster Bridge, Charing Cross and Waterloo Bridge, some in fog, some in sunlight, all linked by similarity of subject matter and treatment. Durand-Ruel showed them in 1904, and another set of Venice was displayed in 1912, though this time in the rival gallery of Bernheim-Jeune.

Monet had bought a property at Giverny in 1890, which he subsequently enlarged, and in which he created a magnificent garden, with a Japanese bridge and a large pond where he sowed waterlilies. He immediately started painting the garden, his first big picture, *Japanese Bridge and Waterlily Pool* (Philadelphia) being shown in 1900. Nine years later he showed forty-eight *Waterlily* canvases at Durand-Ruel. The project of immortalising the garden on the largest possible scale expanded until it became what he termed a *décoration*, intended for posterity and the state, and for which he built a specially large studio. In a way, this garden panorama was the fulfilment of his original ambition to paint on a huge scale for the Salon, and he carried it on till his death in 1926, the result being displayed both in the Orangérie and the special museum built at Giverny. By the end of the twentieth century, this kind of work had become immensely popular with a worldwide public, with a special travelling exhibition, mounted at vast expense, roaming the world in 1998. Monet had always been highly productive, sometimes in the 1880s and 1890s producing one or even two

canvases a day, of varying quality. But the final mass production was not to everyone's taste. In 1910, Cassatt, once a great admirer, denounced it as 'wallpaper'. And indeed, curiously enough, by the end of the century, it was possible to buy Monet Waterlily wallpaper, his images of lilies also being used for place mats, cigarette boxes, chocolate bars, tablecloths, curtains and T-shirts. Was this a sad degeneration into chocolate-box art? Posterity will give a verdict on that.

Pissarro was less repetitive than Monet but equally prone to obsessive enthusiasms, even political ones (in the 1890s he identified with the anarchists and produced poor-quality lithographs of beggars and homeless people). His work showed some fresh dangers of pushing Impressionist technique too far. In the 1870s, Pissarro had been painting superbly. His *Côte des Boeufs, Pontoise* (1877), now in the London National Gallery, is perhaps the most enchanting countryside view painted in the decade, a real piece of sorcery. In the 1880s, however, he was himself spellbound

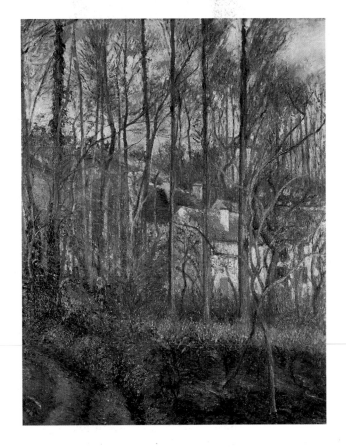

by a young artist-magician called Georges Seurat (1859–1891), attended by his acolyte, Paul Signac (1863–1935). Seurat believed that truth in form and colour was achieved not by line and mixing on the palette, but by putting in pure dots which were then rearranged to correspond to reality in the viewer's eye. This was an old idea which painters had played with at times since the sixteenth century (at least) and dropped as ultimately destructive of art. Seurat pursued it to his early death and produced several works variously described as *pointilliste* or *divisioniste*, such as *Bathers at Asnières* (1884, Tate Britain), the *Grande Jatte* (1886, Chicago) and *Honfleur* (1886, MoMA). Pissarro produced his own lamentable version of this artistic technology with his *View from My Window* (1888, Oxford, Ashmolean), before seeing it was a blind alley; on account of an eye condition known as dacryocystitis, his work was in gradual but irreversible decline.

By this point, collective designations for painters were in vogue: Neo-Impressionism and Post-Impressionism being favourite ones. They are best ignored. Two painters closely associated with such labelling, who were to achieve astonishing posthumous success in the twentieth century, were Paul

Côte des Boeufs (1877) by Camille Pissarro. A scene of Pontoise, carefully painted from life, with no genuflection to ideological 'isms'.

Cézanne (1839–1906) and Vincent van Gogh (1853– 1890). Each was *sui generis*; both could most accurately be described as would-be realists. Cézanne was the son of a wealthy landowner from whom he eventually (1886) inherited a large sum which made him independent of sales. He always found difficulty with drawings and perspective (he believed single-point perspective misleading and developed an alternative sometimes known as 'internal perspective'). He failed the entrance to the Ecole des Beaux-Arts and never got into the old Salon, but he received various kinds of artistic training and always worked hard and to the limit of his capacity. This is one reason why other artists have always liked his work. He tried four kinds of subjects: portraits, nudes, landscapes and still lifes. His early portraits are epitomised by his dark, striking and pitiful renderings of the dwarf-artist Achille Emperaire (1868, D'Orsay), a crude piece of work but an unforgettable image.

His later portraits, such as *Victor Chocquet* (private), were more conventional but excited laughter when shown in the 1877 Impressionist show. In the 1890s he painted a series called *The Card Players* (most important versions in the Courtauld; Merion, Pa., Barnes Foundation, D'Orsay and Metropolitan), which are built up in adjoining planes and illustrate his internal perspective theory. These images of two men in hats are striking and have notable solidity, which was Cézanne's object; he always said that Impressionism was too pretty and superficial, adding 'I wanted to make of Impressionism something solid and enduring like the art in museums.'

On nudes Cézanne was obsessed by themes of 'bathers', having occasionally sketched women on the beach. But, though he had a mistress and eventually married her, he was frightened of women and quite incapable of being alone in a room with a professional model, especially a naked one. This is a disadvantage if you wish to paint nudes. He found the practical difficulties over models insuperable, and eventually painted his big nude scenes from schoolboy drawings, old engravings and quick sketches he retained of naked soldiers bathing in a river near Aix. These works include three in the Barnes Foundation (*Three Women Bathers*, *Four Male Bathers*, *Five Women Bathers*), another in the Petit Palais (*Three Women Bathers*) and a general one (*Large Bathers*) in the London National Gallery. They are stiff and awkward, anatomically incorrect, virtually without faces and grotesquely posed, but as Cézanne's reputation has risen, theirs has surged upwards too—such is art, or commerce.

His third group of works were done mainly in the South of France, his home territory, near his mother's house at L'Estaque and around Aix. About twenty Estaque paintings, the best of which, *Rocks at L'Estaque*, is in the Museum of Modern Art at São Paolo, and thirty paintings (plus watercolours) of Mont Sainte-Victoire, which includes the famous version in the London Courtauld, testify to a characteristically dogged attempt to render the depth and solidity of nature in landscape paintings by a process of spatial analysis. Cézanne described it in a letter: 'Deal with nature as cylinders, spheres and cones, all placed in perspective so that each aspect of an object or plane goes towards a central point.' He then spoke of using colours,

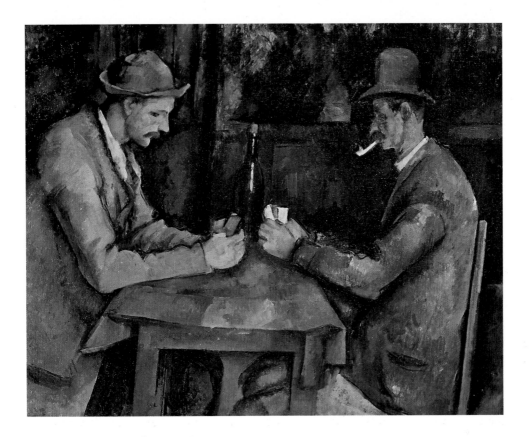

especially reds, yellows and blues, to produce 'vibrations of light', which would add depth to the surface of the paint. This is the nearest he came to articulating his theory of achieving solidity in painting, but his Mont Sainte-Victoire paintings in particular

Cézanne in the early 1890s painted several versions of *The Card Players*, searching for a new form of 'internal perspective', in which colour replaced line.

appear to be a demonstration in practise of what he meant, and artists have been studying them carefully ever since. His fourth and last large group, still lifes, chiefly of apples and fruit, were done in both oils and watercolour, of which Cézanne was an enthusiastic though unskilful practitioner, and to many eyes they are the most successful part of his *oeuvre*. His 1887 *Still Life* (Harvard, Fogg) and his *Still Life with Basket of Apples* (Chicago) are the most colourful and imposing of this group, though some of the watercolours, such as *Carafe, Bottle, Grapes and Apples* (New York, private) are pretty, an unusual term of praise for Cézanne. They are however clumsily painted compared with Chardin's similar studies, and lack the tremendous vigour of the various *Apples* which Courbet (whose skills Cézanne envied) produced in his final years.

Cézanne was in some ways the most influential painter of the late nineteenth century because of his powerful (and to many mysterious) appeal to other painters, during his life and, still more, since his death. In his final years he was exhibited widely all over Europe, his sales increased, his prices (he was skilfully handled by Durand-Ruel and others) were rising and he was beginning to be spoken of as a great master. His reputation continued to rise throughout the twentieth century. But he remains an enigma.

He was a depressive who lacked self-confidence, was quarrelsome, difficult and often repulsive to his new friends. He said, on many occasions, 'Life is fearful' and 'Nothing is easy.' A month before his death he claimed: 'I'm still painting from nature and it seems to me that I make slow progress.' He died virtually with the brush in his hand and one thing is clear: few artists loved painting more.

Vincent van Gogh was by profession an art dealer and it was in London, while studying such social realists as Frank Holl and Luke Fildes, that he first formed an emotional attachment to art, reinforced by visits to villages in northern France where he studied the hardships of the peasants. He was thirty before he began his own drawing and painting and was largely self-taught. Since his career was interrupted by illness, madness and depression—for a time he was in an asylum—and ended in suicide at the age of forty-seven, he had barely ten years in which to show his power. However, he was frenziedly active, and during this time produced about 1,300 paintings and up to 1,200 watercolours and drawings. Van Gogh lived on the edge of hysteria most of his life and was prone to sudden switches of mood and purpose. For a time, he thought of a religious career like his father. He lived with mine-workers, then peasants, to identify with their sufferings.

Van Gogh's *Starry Night* (1889) struck a note of liberation for many painters when the conventional rules of art were scrapped.

In 1886 he went to Paris and met the Impressionists. Like Pissarro, he became a *pointilliste* for a time. He found that imprisoning and switched

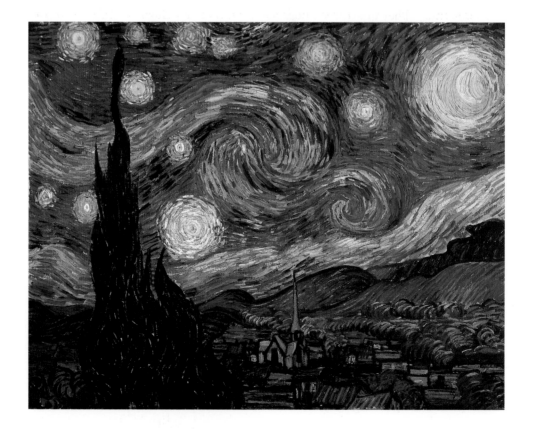

instead to huge, coarse brushstrokes and strong colours. He said: 'Instead of painting what I have before me, I pick the colours myself so as to express my inner feelings.' He painted what he considered to be 'the ugliest thing I have done', which he called *The Night Café* (New York, Clark), and said: 'These reds and greens show the terrible passions of human nature.' The blacks and browns showed 'the evil darkness in the café'. He studied prints by Hokusai and Hiroshige, then produced his 'Japanese portrait', *Père Tanguy* (Paris, Musée Rodin). He decided to live with the peasants again and went to Arles, where he painted two hundred canvases in eighteen months, mostly landscapes and scenes of peasant life. They included a series of *Sunflowers* and *Irises*, now in leading collections, which in the last quarter of the twentieth century sold for prices between $30 million and $60 million.

In 1889–89, Van Gogh went on to paint his most vigorous works: *Rooks over a Cornfield* (Louvre), *The Starry Night* (MoMA), *A Yellow Cornfield with Cypresses* (Tate Britain), and many others, 150 in just over twelve months. The lessons of the Impressionists over 'fast painting' had been thoroughly learned. Van Gogh could produce two or three in a single day. In the last two months of his life, between seventy and eighty pictures were done. But, as he rarely attempted to sell his works (it is a myth that only one was sold in his lifetime, but the number is probably less than a dozen), he suffered from poverty.

Paul Gauguin (1848–1903) joined him for a time in Arles, but proved a disturbing companion. They quarrelled and it was then that Van Gogh cut off his own ear, after which he painted his notorious *Self-Portrait* (Courtauld). His final lodging was with Dr Paul Gachet, who lived at Auvers-sur-Oise, and this produced a moving portrait (Louvre).

The end was probably inevitable and came in July 1890 when Van Gogh died from self-inflicted bullet wounds. In his life he wrote up to a thousand letters, mainly to his brother Theo, most of which have now been published. They are often eloquent and help to explain his crisis-punctuated life. Unlike Cézanne, Van Gogh has never been a favourite of other artists, who on the whole have felt that all he had to teach them was what to avoid, in life and art. Once his works became known and were widely reproduced, however, the public was attracted to his bright colours, crude but curiously effective brushstrokes, and simple, powerful images. They instinctively felt that, had they been painters, they would have tried to do something similar. His soaring popularity in the twentieth century, which revered him as the greatest modern artist, was therefore demotic, though dealers, critics, historians and collectors were quick to clamber aboard the rolling Van Gogh wagon. But there is much evidence that he, like Cézanne only much more so, was bitterly dissatisfied with his work, and that this was a source of mental disturbance. It is possible that both his emotional need, to share the sufferings of the poor, and his artistic drive, would have found more fulfilment if he had ignored Impressionism and worked with the other great force operating in painting at this time, naturalism, the subject of our next chapter.

ART AND THE REALITIES OF AN INDUSTRIALISED WORLD

The overwhelming amount of attention devoted to Impressionism in the last half-century, and the blurring of the public's sight by countless millions of colour reproductions, have obscured or even obliterated the work of many gifted, and some great, artists who were engaged in activities which were at least as important and rewarding—ways of painting the modern world in the hope of improving it. The Impressionists had given up the struggle for realism and had retreated into the quest for sensuous beauty, had plunged, as it were, into the lily-pond. But there was another tradition. It began in England. Its roots were in Hogarth, and it found expression in prints, and then in journals which made use of line-blocks. Among these were the *Illustrated London News*, founded in 1842, which might sell up to 250,000 copies a week, the *Illustrated Times* (1860) which specialised in exposing slum housing and conditions among the poor, and the *Graphic* (1869) which employed leading artists for this purpose. Artists in London who concentrated on what would later be called social realism were by no means all English. Two of the most powerful were French. Gustave Doré (1832–1883) produced *London: A Pilgrimage* (1872) which included harrowing scenes, engraved with horrific candour and dramatic force, in doss-houses, prisons and slums. Alphonse Legros (1837–1911), who came to London in 1863, created numerous fine drawings of poverty, and an outstanding painting, *The Poor at Their Meal* (Tate Britain).

However, the three leading social realists were English. Frank Holl (1845–1888) came from a family of engravers and had a passion for the sombre. 'Give me a grey day' was his favourite saying. His life was short and to make big money he took up society portraits, working himself to death by doing twenty or more a year. But for a decade he concentrated on suffering. His first big success, *The Lord Gave and the Lord Hath Taken Away* (1869, London, Guildhall), shows a poor family stricken by the death of the father—a dark symphony in gloom. Queen Victoria commissioned Holl to do a picture for her, and he produced *No Tidings from the Sea* (1870, Windsor, Royal Collection), in which hope is seen extinguished in a sailor's family after a storm.

It was the same year that Hubert von Herkomer (1849–1914) showed his dramatic workhouse picture, *Eventide in the Westminster Union* (Liverpool, Walker), old women in their standard-issue caps, reading their Bibles while fading light filters to them from a high window. An even better painting is his 1885 Academy effort, *Hard Times* (Manchester, City Art Gallery), in which an exhausted woman rests by the roadside (the sketches were done just outside London in Coldharbour Lane), while her husband leans against a gate; the pair are carrying all their possessions in bundles, and the man's tools, a pick and two shovels, are on the verge. Criticism, even from Ruskin, did not stop Herkomer, who went on to paint, for his diploma picture at the RA in 1891, his most famous work, *On Strike* (London, Royal Academy), an upright showing a grim man, his wife weeping on his shoulder, holding her baby son, who looks just as sullen, rebellious and obstinate as his father—a brilliant touch which makes this superb image live in the memory.

Luke Fildes (1844–1927) helped to launch the *Graphic* by providing for its first number a wood-engraving, *Homeless and Hungry*, showing the destitute on a bitterly cold day waiting to get into a hostel. Four years later, he used his original sketches, done from life, to construct one of the greatest of nineteenth-century paintings, *Applicants for Admission to a Casual Ward* (1874). This is by any standards a superb painting, as well as a profoundly moving one, and it is worth going to the Royal Holloway College in Egham, Surrey, just to see it. But Fildes was savagely attacked later for painting

Applicants for Admission to a Casual Ward (1874) by Luke Fildes, a huge success in both an illustrated weekly and the Royal Academy, showed Victorians wanted their consciences stirred.

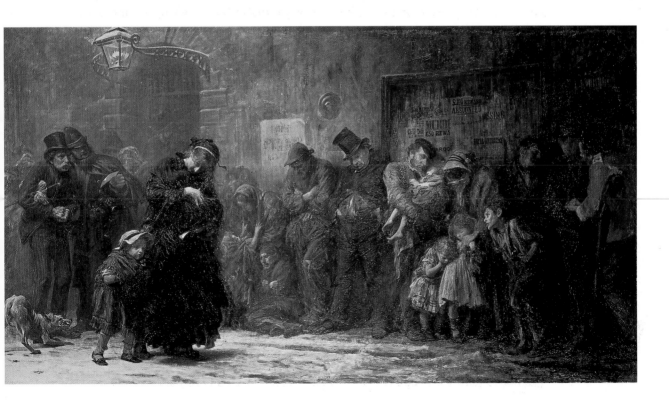

portraits and less distressing subject matter, and in the twentieth century he was discounted as a 'serious' painter for 'surrendering to mammon'. That charge is not true. An artist, in order to produce a fine painting, has to get not merely an idea but an image, and in social realism paintable images which are not merely documentary, sentimental or mawkish are rare. An artist often has to wait for them to happen. Both *Casual Ward* and *Hard Times*, as we know from documentary evidence, came about by sheer accident—as, be it remembered, did many of Dickens's most penetrating scenes. The works mentioned here have survived, and still move people to pity, precisely because they were the result of an acute artistic intelligence pouncing upon an opportunity which presented itself. Such opportunities can be sought but they cannot always be found, and that is the main problem with realism.

In France the problem was simpler because three-quarters of the population still worked on the land, and the misery and poverty which peasants experienced was continual, not episodic. The artist could go into the country knowing more or less exactly what he would find. All the same, it takes an acute eye, as well as strong sensibilities, to epitomise the theme. That was precisely what was possessed by Jules Bastien-Lepage (1848–1884), a peasant's son who struggled hard to become a painter at all, then made himself a great artist. He was a man of noble spirit, who felt passionately about the injustices of life, of which he himself was a victim: badly wounded in the Franco-Prussian war, he suffered severely from lung trouble as a result, and was then stricken with stomach cancer, which ended his life at the age of forty-six.

It was Lepage's view that a painter was endowed by God with gifts for a purpose, and that not to use such skills for the benefit of his fellow creatures was a sin against life. Of course, up to the eighteenth century most European painters had believed this, or felt they ought to believe it, but by the 1870s it was becoming rare. Lepage was a deeply religious man, though not in a conventional way. He felt there was an enveloping spiritual dimension in life and that the artist must bring it out in his work. That is why he painted his most famous image, *Joan of Arc Listening to the Voices* (1879, New York, Metropolitan). This is a history painting of astonishing realism, exquisitely painted, for which Lepage went to immense trouble to get the details right. He was repaid by a lot of savage criticism for his irreverent handling of a favourite national myth. It is true that the work has weaknesses, though irreverence is not one of them: Joan's gesture with her left hand seems feeble and the vision of her in armour emerging from the bushes is a mistake. But it is a transcendent painting all the same and the Metropolitan is lucky to have it.

Lepage's point was that the peasantry, though mute and poor, can produce the highest spirits, whose creation in the image of God is not a metaphor but a fact. His task, as he saw it, was to bring this fact to the public by creating pictures with the greatest possible care and truth. If the truth was there, the beauty would be there too (he often quoted Keats's lines). In 1878 he painted *The Haymakers* (Paris, Musée d'Orsay), in which a man and a woman rest between bouts of work. The horizon is

high, the lanky man is stretched out parallel to it, but the girl is sitting up, transfixed by her thoughts.

Bastien-Lepage was a powerful and charismatic figure, whose personality even more than his superb pictures attracted other artists, French and foreign. He was not so much a teacher as a strong source of encouragement and inspiration. While he lived, painters wanted his approval; after his death, they appealed to his judgement in their thoughts. His most gifted fellow worker was Léon Lhermitte (1844–1925), the son of a village schoolteacher, who accumulated an enormous archive of life-drawings of peasants. In an ideal world it ought to be published in full. The D'Orsay has a masterwork by him: *Paying the Harvesters* (1882). Four men and one woman are getting their money. But the main figure, clutching his formidable scythe, sits looking into space, like the girl in Lepage's *Haymakers*. It is a noble figure, like one of Millet's, but brought into sharp focus: a man tired to the point almost of insensibility but still master of his thoughts, if of nothing else.

A third French peasant-painter of distinction was Jean Dagnan-Bouveret (1852–1929), who came from the Franche-Comté like Courbet, and painted its people. He was a tall man with a huge bushy beard who regarded Lepage as the greatest modern painter and himself as his prophet. His scenes of rural life are clear, in pure colours, vivid and beautifully composed—*The Conscripts*, now hanging in the French Parliament building, a superb study of a Breton pilgrimage, *The Pardon in Brittany* (Metropolitan), and a country doctor at work, *An Accident* (Baltimore, Walters Art Gallery), being only three of a score of paintings of the highest quality. Dagnan-Bouveret had an unusual gift for facial expressions, so that each of his group pictures are, in addition to everything else, a portrait gallery: *Breton Women on Pilgrimage*, owned by the Gulbenkian, Lisbon, is a scintillating study of would-be or possibly actual saints in their black dresses and starched linen. He was an accomplished draughtsman and his brushwork was particularly fluent and suggestive, but he came to doubt his own mission as a naturalist and took refuge in religious symbolism.

As we shall see shortly, symbolism was a dangerous temptation for artists in an age when photography was spreading and beginning to take over from line drawings in magazines (and soon in newspapers). Bewildered, some artists asked: if photographs can do everything I can do by painting directly from nature, must I not do things the camera cannot do, like painting the essence of an idea, its symbol? The more confident artists rejected this defeatism, and sensibly employed photos as legitimate mechanical aids. Lepage, Dagnan and Lhermitte all made extensive use of the camera. Perhaps the cleverest at exploiting photography was the Swedish painter Anders Zorn (1860–1920), who came to oils from watercolours, which he used with enviable dash and bravura, making brilliant use of the white spaces and producing colour-washes of extraordinary novelty. When he started oil-painting he used thin washes varied by powerful paint-loaded strokes to give ravishing effects of freshness. He travelled all over Europe

and the United States, where he did some distinguished portraits, including one of Isabella Stewart Gardner, the great benefactress of the Boston museum, where it hangs, and of President Taft (Washington, White House). Impressed by Bastien-Lepage, Zorn decided that what he wanted to do most was peasant life, but soon became obsessed by the sturdy naked bodies of country girls, painting them in the open air. French peasants would rarely pose in this way, so he returned to Sweden where the girls were more willing (and, as he said, much prettier with much better figures).

Zorn supplemented his open-air drawings and oil studies by taking photos of these naked girls scampering over the rocks or through the woods at Mora, where he was born, and where he built a fine house which is now the Zorn Museum. In the Stockholm National Museum there are several of Zorn's most important works, including the one he considered his masterpiece—'I have put into it everything I have and know'—*Midsummer Dance*, which he painted, after endless sketches, photos and oil studies, in 1897. It celebrates the custom of dancing the night through by young Swedish people and ought to rank in celebrity, as it certainly does in skill, with Renoir's *Boating Party* in the Phillips Collection, Washington. It is an upright, crowded with vigorous figures exhilarated by the occasion and lit by the midnight sun low on the horizon, producing hallucinatory tones and colours, in flesh and dresses. The girl in

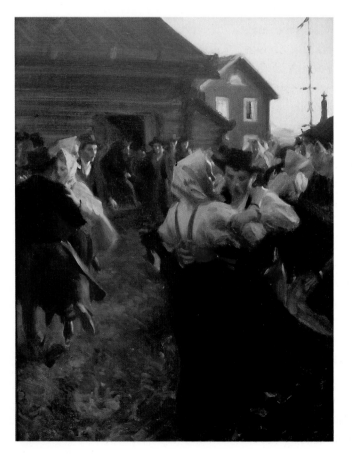

the foreground is one Zorn habitually painted naked, as in *Red Sand* (private). Here, in an uncompromising setting of reality painted with complete truth to nature, is a celebration of youth in its unfettered love and lust for life.

If Zorn is Sweden's great modern painter, Adolf Menzel is perhaps the most impressive German since Dürer, certainly the most versatile one. As with Dürer, you can make an endless list of the subjects which he painted or drew: unmade beds, camels, horses' heads, ballroom scenes, historical paintings (including a magnificent set dealing with Frederick the Great, a visual pendant to Thomas Carlyle's monumental *Life*), portraits, interiors, studies in oil of hands and feet, deformed and severed limbs, exhumed corpses, oysters, birds,

Midsummer Dance (1897) by Anders Zorn displays Scandinavia's greatest painter of nudes indulging in lighthearted decorum.

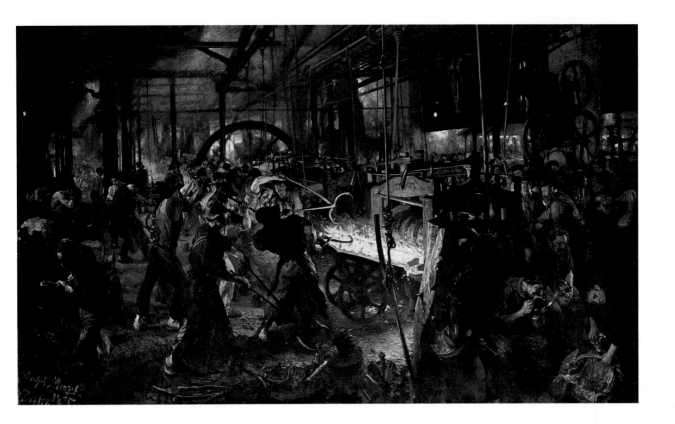

French prisoners of war, dying soldiers, armour, ostriches, Zulu dancers, torchlight processions—there were few topics this immensely industrious and diminutive man (he was less than five feet tall) did not tackle. He liked to stop in the street with his sketchbook and draw people at work: builders, postmen, milkmaids, sentries, shopgirls. He said: 'In real life there is always beauty.' He could make great art out of clutter. There is a fine pencil sketch, *Interior of a Fisherman's Shed*, at Stanford University, and another, *Moving Out a Cellar*, in the Berlin Cabinet of Drawings. The National Gallery in Berlin houses one of his most observant and beautiful oils, *Rear Courtyard and House* (1844), which is exactly what its title says, transformed into an enchanting study in greens and browns.

In the years 1872–75, Menzel collected material for and finally painted *The Iron-rolling Mill* (Berlin), a dense, powerfully and cunningly composed presentation of modern industry, which he thought 'a most difficult work' and brought off triumphantly. The way in which the white-hot steel, the sole source of light, irradiates this big picture with its multitude of figures, is worthy of Correggio or even Caravaggio. *Bricklayers at Work on a Scaffold* (Berlin), done two years later, is entirely different: an opportunity to paint a skyscape, townscape or treescape, with the workmen crowded into the foreground. Menzel always does the unexpected. His *Supper at the Ball* (1878, Berlin) was so well organised and brilliantly painted, and so difficult, that Degas thought it worth his while to make a full-scale copy of it. Menzel did the famous corn-market in Verona in full-pelt activity (Dresden, Gemäldegalerie Alte

Perhaps the most brilliant and moving depiction of heavy industry is *The Iron-rolling Mill* (1872–75) by Menzel, as versatile and gifted as Dürer.

Meister) and the same year a beautiful small painting, with a miraculous amount of detail, called *Breakfast Buffet Given by a High-Class Baker in Kissingen* (private), a delightful work only seen at the famous international exhibition of Menzel's works in 1996.

Menzel was the greatest but by no means the only German naturalist. Wilhelm Leibl (1844–1900) painted *Village Politicians* (Winterthur, Kunstmuseum) in 1876 as though eager to conjure up the spirit of that sixteenth-century realist Breugel. He could make monumental images from banalities, like *Three Women in Church* (Hamburg, Kunsthalle) or *Courting Couple in the Chalet* (Munich, Alte Pinakothek). Arthur Kampf (1864–1950) was the German answer to Luke Fildes, painting *The Last Confession* (1886, Düsseldorf, Kunstmuseum), the dying suicide lying on the floor of his miserable room, the policeman writing down his last words, neighbours crowding at the door. Max Liebermann (1847–1935), who succeeded Menzel as head of Germany's artistic profession, is often referred to as an Impressionist, since in the second half of the twentieth century dealers found that such a label raised prices, and so attached it to scores of inappropriate artists from Scotland, England, America and various countries on the European Continent. In fact Liebermann was like Menzel: he would turn his hand to anything which was real, lively and contemporary, and which

Stanhope Forbes founded a school at Newlyn, and struck a new note of realism with his open-air masterwork, *Fish Sale on a Cornish Beach* (1885).

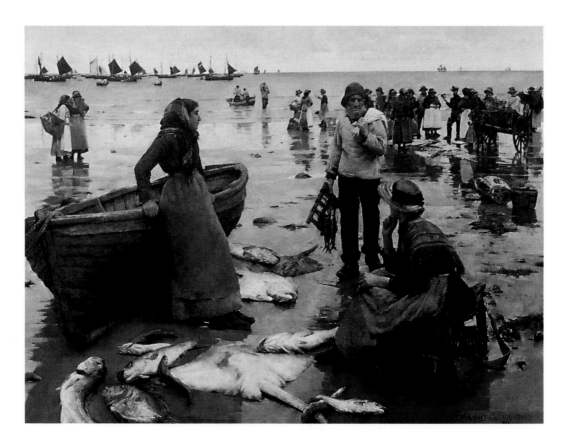

would make a picture. He painted *The Women Flax-spinners at Laren* (1887, Berlin), *Potato Gatherers* (1875, Düsseldorf), *Women Plucking Geese* (1872, Berlin), all good subjects done with assurance and truth.

The chief rival to Liebermann, at the time and since, was Lovis Corinth (1858–1925), one of many Germans who joined the international throng at the Académie Julian, where Bastien-Lepage was revered and his methods taught. His *The Artist's Father on His Sickbed* (1888, Frankfurt, Städelsches Kunstinstitut) is a superlative exercise in objective realism, though Corinth is often highly subjective too, indeed sinister, as in *Self-Portrait with Skeleton* (1896, Munich, Lenbachhaus). Inside every German naturalist there was a symbolist trying to get out. Certainly Corinth's nudes, as in *The Temptation of St Anthony* (1897, Munich, Neue Pinakothek) and *Bacchanal* (1899, Gelsenkirchen, Städtisches Museum), were a long way from those of Anders Zorn, though always striking and inclined to cling to the memory (as were the erotic pictures he did for private sale and circulation). Corinth, like so many fine painters, was a manic-depressive who suffered from alcoholism and the effects of a stroke in 1911. But he continued to paint, still searching for a style and a subject matter which suited him, ending up painting landscapes of the Bavarian Highlands, such as *Tree at the Walchensee* (1923, Zurich, Kunsthaus). These are likely to prove his most acclaimed work when critical opinion has reached a settled verdict on this difficult artist.

The history of art during these years will eventually be rewritten to accommodate the work of many gifted naturalist artists who have been crowded out by an overconcentration on Impressionism and its sequels. Artists' colonies were now common in Europe, North America and Australia, especially among realists or naturalists who loved open-air work. It was after visiting one at Veneux-Nadon, between Barbizon and Fontainebleau—places where artists had gathered before to paint forest and heath—that the Finnish artist Eero Järnefelt (1863–1937) painted a great picture. He called it *Burning the Forest Clearing* (1893, Helsinki Art Museum), but it is also known as *The Wage Slaves*. A mournful little girl, rake in hand, her face blackened by smoke, looks hopelessly at the viewer, as her ragged elders struggle around her. It is a spectacular image of toil, trouble, hardship and endurance.

Such an approach was shared by perhaps the most forceful of the painting colonies set up at Newlyn in Cornwall by Stanhope Forbes (1857–1947) in the 1880s, after he had worked with Bastien-Lepage in Paris and tried out his methods in Brittany. Forbes not only painted in the open but posed his models there, despite heat, flies, jeering boys and other distractions—his *A Street in Brittany* (1881, Liverpool, Walker) being the superb result. But when he settled in Newlyn, with his equally determined painter-wife Elizabeth, a Canadian, he started to work up actual scenes, without the use of models, by setting up his easel wherever he spotted them. This led to his masterpiece, *Fish Sale on a Cornish Beach* (1885, Plymouth, City Art Gallery), a work of quite extraordinary power, beauty and interest, which created a

stir at the Royal Academy and inspired many gifted men and women to join him. They included Frank Bramley (1857–1915), whose *A Hopeless Dawn* (1888, Tate Britain), showing an old woman comforting a young wife whose husband has been lost at sea, is perhaps the most powerful and moving work of the entire naturalist movement, and Walter Langley (1852–1922), who produced large, elaborate, tenderly painted story-works telling of the hardships of those who toiled to provide England's fish. The two best are *Disaster! Scene in a Cornish Fishing Village* (1889) and *Never Morning Wore to Evening but Some Heart Did Break* (1894), both dealing with losses at sea and both in Birmingham Art Gallery.

No other gathering of English painters has produced so many and such varied canvases of high quality. John Birch settled in nearby Lamorna Cove and became so closely identified with its fast-running and limpid waters that he was known as 'Lamorna Birch'. Norman Garstin fulfilled himself with one superb stormscape, *The Rain It Raineth Every Day* (1889, Penzance, Penlee House Museum), a magical painting of a rainswept seafront with bedraggled figures. The very young and promising came to Newlyn too. Laura Knight (1877–1970) painted there highly coloured, strongly modelled seascapes, with dashing girls and angelic children (as in *On the Beach*, Tate Britain), went on to do circuses, gypsies, ballets and other highly active scenes, and was still painting, against the contemporary grain, in the Swinging Sixties. Alfred Munnings (1878–1959) learned to be a realist of distinction in Newlyn, but turned away from the sea into farmland, did some superb rustic scenes of poverty and hard work, then developed a fascination with shire horses used for ploughing and carting. He graduated to become the finest painter of horses since Stubbs, outclassing Degas and even Géricault, employing skills which made him a fearless and rumbustious President of the Royal Academy.

We have mentioned here only a handful of the scores of fine artists who were inspired by the manner of Bastien-Lepage, himself in the tradition going back to Daumier and Millet. But the First World War and its horrors made many of them feel that the realities of life were so spectacularly unpleasant that an artist perhaps serves society better by averting his gaze and seeking beauty for consolation. Even during the sixty years 1880–1920, a multitude of fine artists sought escape from gritty reality by creating symbols of life rather than what they actually saw. An archetypal example is the Finnish painter Hugo Simberg (1873–1917), a Christian Nationalist, who turned away from the grim reality, so well expressed by Järnefelt, to allegory. In 1903 he produced one transcendant image, *Wounded Angel* (Helsinki), in which two troubled boys carry on a stretcher a blindfolded seraph through a devastated terrain. This acquired additional significance after the Great War, where it was felt to symbolise the expulsion of mankind from Paradise on account of unfathomable wickedness, the innocent being punished with the guilty.

As a rule, however, the symbolic message was less specific, and on that account

often more powerful—and enduring. The most successful symbolic image of all (though the word 'success' is inappropriate, since it was intended as a cry of despair) is *The Scream*, painted by the Norwegian artist Edvard Munch (1863–1944) in 1893. He wrote: 'I looked at the flaming clouds that hung like blood and a sword over the blue-black fjord and city. I stood there trembling with fright. And I felt a loud, unending scream piercing nature.' This work, which he elaborated in a number of versions and which was preceded and followed by a vast number of related drawings and paintings, was the central event of Munch's long life. It also became the most often-reproduced and influential single image of the twentieth century. Indeed,

as happens increasingly in the modern age, it has been seen so many times as to become a familiar cliché, which has lost its power to shock or even to interest. Munch was neither a good draughtsman nor a competent painter, though he showed great talent as a print-maker and poster-designer. He did create one or two remarkable works. His *The Sick Child*, an early oil of 1885–86 (Oslo), is a moving piece of sentiment, though the painting of the hands is so poor as to be disturbing. *The Madonna*, which he produced in various versions between 1895 and 1904, is almost as arresting as *The Scream*, but is too close to it in concept and treatment for comfort. So is *Despair*, which he also called *Deranged Mood at Sunset*, another work of the 1890s. (All Munch's themes, in one form or another, are to be seen in the Oslo National Gallery.)

The truth is, Munch was hovering on the verge of sanity all his life, aggravated by incipient alcoholism and what he believed to be nicotine poisoning. He first went into a private mental asylum in 1908. At times he appeared sane and carried out commissions. At other times he was in deep depression, though able to work except in brief periods of frenzy (he was never actually dangerous). From 1916 he led an entirely solitary existence at his estate outside Oslo. Like Van Gogh's work, *The Scream* has been acclaimed as a masterpiece by popular vote, since many people feel like it and can see themselves, granted the skill, actually painting it. Unlike Van Gogh, however, Munch was not an instinctive realist. He was self-obsessed. Everything had to come from

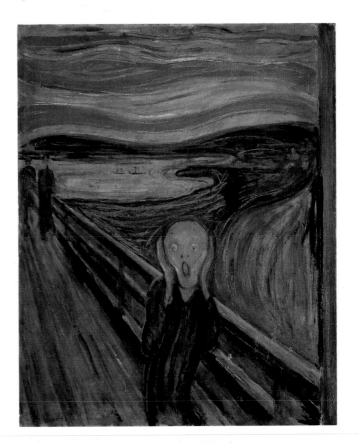

Munch painted *The Scream* in 1893 and, as the emblem of modern *angst*, it has been reproduced and adapted more often than any other painting since the *Mona Lisa*.

within him. That is why he is often seen as the founder of Expressionism, a term used to describe much German and Nordic art in the early twentieth century. This form of painting reversed the normal process, in which the eye sees, the mind registers and instructs the hands to draw and paint. In Expressionism, properly understood, the mind conceives, instructs the hands, and the eye then sees and corrects. Munch, however, really had only one dominant thought: despair verging on hysteria. At his death, his house was found to contain over 1,000 unsold paintings, many unfinished (or apparently so—who could tell?), 5,000 watercolours and drawings, a large number of copper plates, plus 15,400 prints drawn from them, and a few sculptures. Virtually all were left to the public, which now can enjoy—if that is the word—a rotating selection from them in the Munch Museum, Oslo.

The kind of Expressionism which the work of Munch (and to a lesser extent Van Gogh) gave rise to is epitomised in Emil Nolde (1867–1956), from Schleswig-Holstein on the Danish–German border. In 1905 he joined a group of German painters in Dresden known as Die Brücke (The Bridge), who were much struck by primitive artefacts they noticed in the local ethnological museum and wished to express their spirit, a convenient (though probably sincere) tactic, since they lacked sophistication in drawing and painting skills. From this point on, our account is liable to be punctuated by such group names, which are used for what they are worth—very little—since artists of any merit are always individualists who are carried into such coteries by brief enthusiasms but break away as soon as they feel their restraints. It may be useful, however, to deal with some of them now. Most had their origins in various 'secessions', which occurred from about 1870 onwards, from the Viennese, Munich, Berlin or St Petersburg academies. In these, groups of artists, infuriated by rejections and narrow-minded jury methods, held alternative shows on the lines of the Impressionists. From these secessions, splinter groups emerged, choosing names for themselves to attract attention in the press and, it was hoped, customers. One such was Der Blaue Reiter (or Blue Rider), formed in Germany in 1911 by the Russian Wassily Kandinsky (1866–1944) and called after his painting *Le Cavalier Bleu*. Its only important recruit was the Swiss artist Paul Klee (1879–1940), a black-and-white illustrator who eventually blossomed into an exquisite but fragile and over-sensitive painter of watercolours. That, it emerged, was also Kandinsky's strength, and his watercolours, with a tendency to abstract patterns, are now rightly seen as the core of his creative impulse.

The case of Auguste Rodin (1840–1917) is instructive because he has been variously classified as a Romantic, a Symbolist and 'the first of the moderns'. In fact he belongs in the ranks of those who form the largest category of great artists—the Individualists. Like Cézanne, he failed the entrance to the Beaux-Arts, not once but thrice. He had no money, being the son of a police clerk, and for two decades he earned his living as a craftsman, working for builders, masons and decorators: no bad training in itself, as the experiences of so many fifteenth-century sculptors showed.

His early works are unsigned, undocumented and hard to identify, though some can be seen both in the Musée Rodin in Paris and in the Rodin Museum in Philadelphia. Suddenly, in his late thirties, Rodin became famous with two sensational works. The first is a life-size standing bronze of a man, which Rodin called many names, though the version in the Victoria and Albert, the best, is known as *The Age of Bronze* (1878–80). It was done from the life but the modelling is so good that Rodin was accused of using a cast. It is a work of romantic realism of monumental dignity and great beauty, and eight leading members of the Académie rallied to Rodin's support and demanded that the state do something for him. So the government bought it and, in addition, commissioned Rodin to create a set of bronze doors for the new Musée des Arts Décoratifs, on the lines of Ghiberti's great *Gates of Paradise* for the Baptistry in Florence. This became what Rodin eventually called *The Gates of Hell* (Musée Rodin) and he worked on it for twenty years without finishing it. It is an extraordinary piece of highly emotional symbolism with over two hundred figures, forming the ideas for most of the works Rodin executed in the next quarter-century, beautiful in places, shocking and ugly in others.

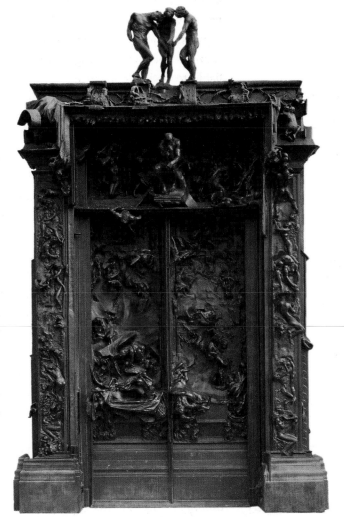

The titles of Rodin's subsequent works, most of them springing from *The Gates*, reflect his progress into symbolism: *Eternal Springtime, Sorrow, Meditation, Night, Day, Crouching Woman, Falling Man, The Thinker, The Kiss, Fugit Amor* and, not least, *Despair*. Both *The Thinker* and *The Kiss* caught the public imagination and soon became world-famous. Rodin was bombarded with commissions from all over Europe and North America and created a huge studio with dozens of assistants and complex machinery (he also made much use of photography). He was a difficult man. He never did exactly what he said he would do and various important commissioned works were rejected. His *Burghers of Calais* caused the town a great deal of trouble. His *Victor Hugo* was regarded

A cynical comment on Ghiberti's *Gates of Paradise*, Rodin's *Gates of Hell* (1880–1926) took even longer to complete, adding procrastination to the sins of modernity he depicted.

as an insult to a French cultural hero, and *Balzac* as grotesque, though both were eventually installed (in the Avenue Victor Hugo and Boulevard Raspail, respectively). Rodin was also ungovernable and lordly about his 'editions' or bronzes—that is, whether he would cast more than one and, if so, how many. There are, for instance, five *Gates of Hell*, two of them in America (Philadelphia and Stanford). *Springtime* was cast in three sizes, 151 appearing in 1919 alone. There are at least eleven *Calais*, one in the Victoria Tower Gardens, London, another in the Minneapolis Institute of Arts. *The Kiss*, regarded as scandalous, had none-the-less been sold in three hundred authorised casts by 1917, and in addition Rodin had carved to order six big marble versions (one in Tate Modern). There are also unauthorised replicas and forgeries of many works.

Rodin was always in the midst of rows, scandals and accusations of sharp practise. For his monument to Whistler he used as a model his current mistress, Gwen John (1876–1939), the gifted painter-sister of Augustus John (1878–1961). He came near to ruining her life, as he did that of many moth-like creatures who fluttered too near to his flame. There is a streak of unbridled sexuality in much of his work. In his sculpture, as in his life, he liked to display old men enjoying the favours of young girls (*The Minotaur, Triton and Nereid*). *Despair* (the best version is in the V&A) has been described as 'a metaphor for female orgasm'. *Iris, Messenger of the Gods*, where the female sexual organs are shown, is said to have alluded to lubricious gestures then practised by cancan dancers at the Folies-Bergère. There are many erotic and some pornographic sketches in his huge corpus of drawings and watercolours (the Musée Rodin inventory lists over 7,000 graphic works; there are, in addition, many forgeries). Like Courbet, Rodin celebrated lesbian love in his art, and was said to have organised orgies with gypsy women at the Hôtel Biron, formerly a nunnery. Oddly enough, his two best portrait-works are of Bastien-Lepage, whose work he despised, and Pope Benedict XV, whom he regarded as a humbug. There was nothing simple about this *monstre sacré*, apart from the fact that, at a time when artists were being divided into categories, he loomed over them all and really belonged to none. That is as it should be for a major talent.

Aristide Maillol (1861–1944), an admirer rather than a follower of Rodin, was part of a coterie, called Les Nabis, or Prophets, a group formed in 1892. The twentieth century was looming—what would it hold for mankind, for art? The Nabis claimed that their work would indicate the future. They included musicians like Debussy and writers like Marcel Proust. The two best painters of the group were Edouard Vuillard (1868–1940) and Pierre Bonnard (1867–1947), both of whom had been well-trained at the Académie Julian, especially in the depiction of the female nude. Indeed, if we go by subject matter alone, the future lay in the female torso. They had been impressed by the unposed canvases which Paul Gauguin (1848–1903) painted of native women during his first visit to Tahiti in 1891. We will be coming to Gauguin's advocacy of primi-

tivism in a future chapter; here it is relevant to note that Gauguin saw the nude not merely as a shape but as a source and receptacle of colour, which it both received from the light and radiated from itself. Vuillard painted such nudes but then discovered that he was more interested in the light-effects and coloured reflections in small interiors, which became his speciality (he also did town and village squares). Bonnard stuck to the nude, and painted his wife repeatedly, especially in the bath, producing endless variations, with great ingenuity and charm, on this homely and delicate theme.

Nudity haunted the imaginations of artists in the last part of the nineteenth century and the opening of the twentieth century. For many it replaced religion as the source of inspiration. At the same time, what collectors liked was a historical setting for provocative sexuality. An outstanding example, by Paul-Joseph Jamin (1853–1903), was *Brenn and His Share of the Plunder* (1893, private), in which the victorious barbarian, silhouetted in the doorway of the palace, contemplates the five naked women who await his attentions. Collectors also liked naked children. The youths painted swimming by Thomas Eakins (1844–1916) were straightforward, and he got into no trouble over them (his quest for naked women was his problem). Nor was any scandal raised by Henry Scott Tuke (1858–1929), who invented needless excuses for painting naked boys in Cornwall, where he was an important member of the Newlyn school. Thomas Cooper Gotch (1854–1931) painted young girls, elaborately but decorously clothed, but none-the-less alluring—his *The Child Enthroned* (private) is a masterpiece of the genre. An American who taught at Yale, William Sargeant Kendall (1869–1938), moved closer to the borderline in his naked-child-enticements, with titles like *Narcissa*, *Crosslights* and *Reflection*, the last showing a pre-pubescent girl looking at herself in a mirror. And Carl Larsson (1853–1919), a well-known illustrator of children's books, definitely crossed it with his often-reproduced work of 1895, *The Little Girls' Room*.

During the whole of this period, many artists assumed that society was too complacent and that their duty was to shock it. The social realists shocked by exposing poverty and cruelty. The Symbolists and their associates just tried to shock: *épater la bourgeoisie* was a phrase which came into vogue in the 1890s. There were many ways of doing this but sex was usually helpful. Gustave Moreau (1826–1898) tried to use biblical, historical and mythological ideas to portray women in revealing garments in exotic settings—*Salome* (1892, D'Orsay), was his favourite subject, as it was for so many artists and writers at this time. To understand his world, it is necessary to read J. K. Huysmans's mesmeric novel *A Rebours* (1884), the emblem of the decadents. It was said to have been inspired by the Conte de Montesquieu, so brilliantly portrayed by Boldoni and others, but much of it is devoted to Moreau's work. Moreau was a first-class teacher at the Beaux-Arts, instructing Marquet, Matisse and Rouault among others, and his studio, open to the public as a museum, is a wonderful window into 1890s Paris.

Another Symbolist whom Huysmans celebrated was Odilon Redon (1840–1916),

primarily a lithographer, who worked in black-and-white doing wonderfully dark and powerful illustrations for such contentious works as Baudelaire's poems, *Les Fleurs du Mal* (1890), and Flaubert's *Tentation de Sainte-Antoine* (1888). In the 1890s he took up colour and became dreamlike in his images, so that a generation later the Surrealists treated him as a founder. In fact Redon, a quirky but domesticated man, was never quite as decadent as he seemed: there is less in his works than meets the eye. Indeed, his prime follower, and pupil of Moreau, Georges Rouault (1871–1958), was essentially a religious painter, though he illustrated *Les Fleurs du Mal* too (who did not at that time?), and was classed as one of the Fauves (wild beasts) of art. He began in stained glass, sometimes returning to it, and the thick black line of the lead marks all his work, whether on glass or canvas (or paper), together with dark, strong, glowing colour. His weakness, as with so many of these highly individualistic Expressionists, is repetition: the black line becomes monotonous, the faces, whether saints or sinners, look disturbingly identical, and the deep reds jar. He is an artist whose work is best relished when seen one at a time.

However, there were some *fin-de-siècle* artists who were successfully provocative, usually because they had superb drawing skills and a lot of original ideas. The most important of them was the rich Belgian illustrator Fernand Khnopff (1858–1921) who appears to have been in love with his sister Marguerite (1887) and portrayed her in a tight-fitting costume, eventually turning the portrait into a religious shrine in his house. Her face appears as a tigress in *An Angel* (1889), tempting an armoured knight, and again in *Caresses* (1896), where she is a leopard, with her paws around a beautiful young man, naked to the waist (these, like most of his works, are in private collections except the last, in the Brussels Musée d'Art Moderne). Khnopff was a society portrait painter as well as a *provocateur*, but even his aristocratic ladies are made to fit into curious frames he designed himself, or frame-images within the picture, a device he invented—or rather resurrected— and which was widely imitated. His best works are in crayon.

Caresses (1896) by Khnopff had him labelled a *fin-de-siècle* decadent by an outraged Belgian public, but the Viennese applauded him as a Symbolist.

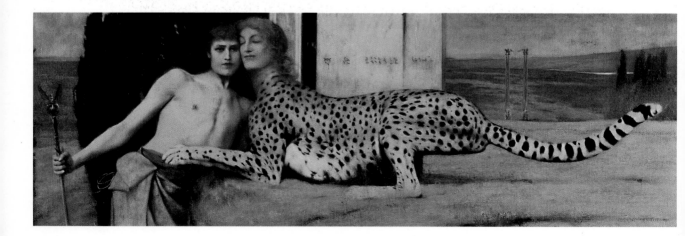

Khnopff, who spoke fluent English, was popular in London and held shows there. He was, however, most influential in German-speaking countries, and an idol of the artistic community of Vienna. His most resourceful follower there was Gustav Klimt (1862–1918), who was primarily a decorator—and a superb one—but who managed to insert provocative elements into his major decorative schemes, such as the *Beethoven Frieze*, painted for the Fourteenth Show of the Viennese Secession Movement in 1902. He was always a star at these shows, certain to attract hostile rage, which brought in visitors and patrons—his *Beethoven* was denounced as 'the utmost ever achieved in obscene art'. Some of his large-scale work has been destroyed; what is left can best be seen in the Vienna Secession Building. Klimt was not a homosexual, as some supposed: though he never married, he is said to have fathered fourteen illegitimate children. He certainly painted lesbian symbols, such as *Watersnakes*, also known as *The Girlfriends* (1901). He was a very slow and painstaking worker, though careless in his vehicles, so that some of his oils have flaked and crumbled. His drawing was exquisite, his colouring often new and arresting, and he learned from Khnopff how to 'frame' his images brilliantly. Every single work he produced—there are not more than fifty—is worth looking at carefully. His masterpiece, *Salome*, also known as *Judith* (1901), the languorous, sneering beauty peering out at the world from a decorative background, of which her dress—what there is of it—forms a part, has become almost as famous an image as Munch's *Scream*.

Another derivative from Khnopff was the Munich artist Franz von Stück (1863–1928), an all-rounder of prodigious talent who at one time or another produced sculptures, prints, magazine illustrations and posters, and designed and decorated houses. His favourite subject, however, was sin, and that is how he is remembered (and avidly collected). His original *Sin* (1893, Munich, Neue Pinakothek), shows a lustful woman, her face in shadow, her breasts in the light, apparently beckoning the viewer to take his place under her cloak: the magnificent frame, which Stück made himself, is part of the work. Fräulein Sin turns up again in Stück's best-known work, *Sensuality*, done four years later, where she is being encompassed by an enormous black snake, a frequent device of the *provocateurs* when presenting enticing women. To add to the provocation, Stück introduced the race factor. In both *Centaur and Nymph* (1895) and *Scherzo* (1909) the aggressive male or rapist is black, albeit the woman is compliant and egged on by naked companions. Stück did not mean his work to be taken too seriously. He was a joker as well as an eroticist, as he makes clear in his 1905 work, *Battle for a Woman*, which he painted over

Salome was the favourite subject for artists in the Art Nouveau period, as in Klimt's version. Though specialising in lesbian symbolism, he fathered fourteen bastards.

Schiele's self-portrait (1910) suggests how rapidly his artistry would have developed in a Freudian world. But flu carried him off in 1918, aged twenty-eight.

and over again (best version St Petersburg, Hermitage). He should be judged by a visit to the house he built in Munich, Villa Stück, now a museum of his large and varied (and often surprising) opus.

Of the outright pornographers (on occasion), the most interesting was the Belgian Félicien Rops (1833–1898), primarily an etcher, who actually produced an etching, *Pornokrates* (1896), showing a naked, blindfolded woman, in black stockings, leading a pig on a rope. His view of vice was two-sided: exploitative but also condemnatory, and it is fair to say that he also portrayed the results of vice, notably in *Mors Syphilitica*, an etching of 1892, otherwise known as *Death on the Pavement*, and in another exceptionally striking and moving etching, *The Absinthe Drinker* (1893). Klimt's follower Egon Schiele (1890–1918) had a brief career of less than ten years but left a powerful mark. He was primarily a linear artist and print-maker (only seventeen prints survive), but used colour in oils and a new and effective quasi-impasto, like Van Gogh only more judiciously. His best works, however, are his drawings, which are delicate, quite fierce at times, entirely original and idiosyncratic, just occasionally very beautiful, as good as Botticelli's. He appeared sex-obsessed and treated coition as a symbol of life and happiness. In 1912 he was publicly humiliated by having one of his drawings burned in a police court. This was part of a case in which he was accused of seducing an under-age girl, and actually convicted of inviting children to his studio and giving them access to 'immoral drawings'. He spent nearly a month in gaol and the Albertina in Vienna has his *Self-Portrait as Prisoner* (1912). His drawing *Two Friends* (1913), in pencil and tempera, is now a lesbian icon, and there is no doubt about his current popularity and influence among artists.

The artists described in this chapter form only a selection from the hundreds of well-trained and gifted men and women active in the half-century 1875–1925, perhaps the greatest efflorescence of European talent—though with few painters of genius—since the seventeenth century. They operated, sometimes in groups but essentially as individuals, in the twilight period before the great bifurcation into fine art and fashion art which will be described in Chapter 29. But before we come to that, it is necessary to look at the wider scene of architectural and decorative design which marked the beginning of the modernist epoch.

28

SKYSCRAPERS, ART NOUVEAU, ART DECO

After the Civil War, the expansion of American industry and commerce was so rapid that by the 1880s the United States had the largest economy and possessing class in the world; colossal sums of money were going into the commissioning and collection of works of art and especially into the building of palatial homes. At Newport, Rhode Island, and other resorts of the rich, Gothic developed into what was called the Stick style (1870–80), in which mansions with a hundred rooms or more were crowned by steep-pitched roofs framing exposed-timber gables in a dazzling array of pyramidal patterns. This was followed by the Shingle style (1880–1900), in which enormous roofs of wooden shingles descended steeply to arrays of verandas. But most multimillionaires built eclectically or followed European patterns of sumptuousness.

The archetype was Biltmore, designed by Richard Morris Hunt, who had trained at the Beaux-Arts in Paris. It was built at Asheville in North Carolina, centre of a 125,000-acre estate bought by George Washington Vanderbilt. The site was chosen by the American equivalent of Humphry Repton or Capability Brown, a perfectionist called Frederick Law Olmsted (1822–1903). He had designed Central Park, New York (1858), Prospect Park, Brooklyn (1871), and in the 1880s the 'Emerald Necklace' parks system of Boston. Olmsted, a disciple of Ralph Waldo Emerson, Thomas Carlyle and Ruskin, put 'moral principles' into what he called 'landscape architecture'. Well-designed landscape, he argued, had a 'civilising effect' on human beings. But: 'It must contain either considerable complexity of light and shadow near the eye, or obscurity of detail further away'—or, better still, a combination of both. In thirty-seven years in practise, Olmsted applied this to over 500 commissions, including 100 public parks, 40 university campuses, 50 residential housing-estates and 200 private gardens. (After his death, his firm designed 3,000 more, 1895–1945.)

Of the private projects, Biltmore was the most ambitious because the house site was on a hill 2,000 feet up, and to level it the hilltop had to be sliced off like an egg, producing an enormous series of terraces. A rail track was laid down, a quarry

Biltmore (1895), America's largest country house, with 255 rooms, was built by R. M. Hunt for a Vanderbilt, in a 125,000-acre North Carolina 'spread'.

opened, a brickworks set up and hundreds of thousands of tons of earth moved. The house itself was a combination of Francis I's Château de Blois and the Rothschild mansion, Waddesdon Manor, in Buckinghamshire. It had 255 rooms and was opened on Christmas Day 1895, the centre of a complex which comprised a new 'model' village, a church, 150 cottages and small industries—the whole giving permanent employment to 2,000 people. The approach road was 3 miles long and the plantations were carefully graded to take the eye progressively from formality to total wilderness, for the estate stretched 40 miles in one direction, and Vanderbilt spent a week riding round its periphery. The magnificent Beaux-Arts library housed 20,000 books and the staircase hall, modelled on Blois, has a chandelier three storeys high, hanging from one pin. Seen from afar, it is dramatic; its details are impressive; but like most such palaces, it is superhuman. The architect died before it was finished, Olmsted went mad, and when the owner arrived for the first time to take up residence, and asked for a glass of water, he was told the pump was not working.

Such creations reflected the peculiarities of the owner rather than the wishes of the architect or the canons of current taste, though many were based upon an influential book of patterns by Andrew Jackson Downing, *The Architecture of Country Houses* (1850). Between 1880 and 1920, more and bigger country houses were constructed in the United States than at any other time in history, on Long Island and up the Hudson River, along Boston's North Shore, Chicago's Lake Forest, Philadelphia's

Main Line, Sweickley Heights near Pittsburgh, Cleveland's Chagrin Valley, Miami and Palm Beach in Florida. They vary enormously in quality and charm. One of the best is Lyndhurst on the Lower Hudson, originally in Gothic but embellished by Jay Gould, one of the 'robber barons', and now run by the National Trust for Historic Preservation. It is in castle-style, made of light pink and grey granite. Another is Vizcaya in Miami, on the shore of Biscayne Bay, built by James Deering, the owner of the International Harvester company, to house his collections. He described it as an Italian-French-Spanish palace-fortress of the seventeenth century, and he kept a thousand craftsmen decorating it for two years. (It is now the Dade County Art Museum.)

Also in Florida is the Venetian-style Ca' d'Zan, a marble palace built by the circus-tycoon John Ringling, and now incorporated into the Florida State Parks system. At Palm Beach one of Rockefeller's partners, Henry Morrison Flagler, created another marble palace with a 100-foot ballroom said to be in the Louis Quinze style. In New Castle County, Delaware, the chemical millionaire Henry F. Du Pont made from an amalgam of American styles an enormous house called Winterthur. At San Marino in California, the collections of Henry E. Huntington were arranged in a vast, two-storey villa, now a centre of scholarship housing a million manuscripts, 200,000 rare books, 150,000 works of reference and a huge variety of paintings (including Gainsborough's *Blue Boy*).

Perhaps one-third of the 2,000 major houses built at this time have now become museums of one kind or another, open to the public. This applies also to the palatial town houses, especially in New York. An outstanding example is the house built by Henry Clay Frick, the coke-and-steel king, on Fifth Avenue, at 70th and 71st Streets, designed by the firm of Carrère & Hastings, who also built the New York Public Library. Its sumptuous rooms contain the 160 major works of art which Frick (who had an eye like Cosimo de' Medici) assembled into the choicest private collection of Old Masters on earth. Equally distinguished was the mansion built by J. Pierpont Morgan on 38th Street, revolving around its magnificent library, the famous room where he stabilised the 1907 Wall Street panic, and still the centre of one of the world's finest collections of manuscripts and Old Master drawings.

Such houses, in Scottish baronial, Palladian, Renaissance, English Regency, French Empire, Venetian, Florentine revival, Gothic or Spanish Colonial—or mixtures of several or indeed all of them—reflected the exuberance of sudden wealth. As John Maynard Keynes once remarked, capitalism was essentially a function of natural animal spirits, and its architecture tended to be an explosion rather than a refinement of taste. There was little originality, either, except in weird combinations, some of which, now they have acquired the patina of a century or more, charm and delight. One of the most original of them was the much-sneered-at San Simeon, built midway between San Francisco and Los Angeles in California, by the newspaper publisher William Randolph Hearst. It was on an estate which once included 245,000

acres of mountain and valley, and the palace, in the Spanish-Moorish-Indian-American style, is set on a hill in the Santa Lucia Mountains.

The more closely one looks at this construct (it has a vast main house, satellite houses and intricate surrounds), the more impressive it seems. The architect was a tiny, wizened spinster called Julia Morgan (1872–1957) who spent more than three decades on the project, 1919–57. She was a Beaux-Arts graduate of exceptional skills, both practical and ornamental, and designed over seven hundred major buildings in a forty-seven-year career: churches, schools, stores, houses and museums. Her specialty was work for the YWCA, for whom she did hostels. She always included swimming pools in her projects, when possible, and was probably the greatest creator of swimming-rooms in history. For Hearst she provided two at San Simeon. Within the main building (1922–26), with its west front like a cathedral and its two spectacular towers, she designed an indoor pool in the Roman style. Outside she created the Neptune Pool, more Greek in inspiration, with views for a hundred miles, which has a strong claim to be rated the most beautiful pool ever built (1935–36). She designed an assembly room and a refectory (the regime for house-guests at the palace was such that none came twice), a menagerie and animal pits, a theatre and art gallery. Not far away, on the wild Wyntoon River, there were fantasy houses.

All this is sometimes seen, in Europe, as American barbarism. In fact Hearst knew exactly what he was doing, and so did Miss Morgan, a thorough professional with an eye for fine detailing, who was exceptionally clever at finding the best craftsmen. They were, in fact, working in an old tradition of architectural exceptionalism which went back to the sixteenth century and which encompassed such nineteenth-century exemplars as Ludwig II, King of Bavaria, who patronised Wagner and helped him to build the great opera house at Bayreuth. Ludwig created a German version of Versailles at Schloss Herrenchiemsee (finer than the original in some ways), a Gothic-Palladian villa set in an English park, with Venus grotto and Moorish pavilion, in Graswangtal, and above all an immensely tall Romanesque-revival mountain-top castle at Schloss Neuschwanstein, begun in 1868 and designed for him by Eduard Riedel (1813–1885), a fantasy-architect of genius.

These efforts bankrupted Ludwig and the last two were never exactly finished. Hearst, likewise, had to abandon his plans for a vast east wing at San Simeon. However, it must be realised that both Hearst's and Ludwig's palaces, now restored and well looked after by public bodies, give immense delight to an ever-growing number of visitors. Architecture is a utilitarian art but it also offers the chance to create impossible dream-buildings, what might be called the Kubla Khan instinct, which runs deep in human nature and goes back to the ziggurats and the Tower of Babel. Only a few have the means to indulge these instincts directly; but millions can enjoy them vicariously, and that is what these structures now provide—the transmutation of artistic egotism into populist joy.

In any case it is not always easy to decide what is fantasy and what is utilitari-

anism. In the 1870s the French government, to commemorate the approaching centenary of American independence, commissioned a spectacular monument from a designer of lighthouses and fortresses, Frédéric Auguste Bartholdi (1834–1904). He chose Bedloes Island in New York harbour for what was to become the world's biggest statue (at the time) and has remained the most popular one. He designed a draped figure of Liberty, 160 feet high, which was made in Paris workshops. The material was beaten copper sheets riveted together and linked by steel struts to an inner armature, the structure being worked out by Viollet-le-Duc and the engineering by Gustave Eiffel (1832–1923). The complete statue was then dismantled and shipped across the Atlantic in 1886, reassembled and placed on top of a huge pedestal designed by Richard Morris Hunt, with a sonnet inscription by Emma Lazarus, beginning 'Give me your tired, your poor, your huddled masses.' The torch-lantern, lit by electricity, gave it lighthouse functions, linked it to the latest technology and invested it with symbolic importance as guiding immigrants to the promised land of freedom. Most people who saw it then found it beautiful—and they still do. It might be called the first major example of Symbolist art.

Three years later, Eiffel provided his famous tower as the centrepiece of the 1889 Paris Exposition Universelle. This was a technological feat of some power, for all the components were prefabricated, and then erected on site using four pivoting cranes, in the fantastically short time of twenty-six months, by a small workforce which never rose above 250. In the seven months of the Exposition, the Eiffel Tower attracted two million visitors and over the last 110 years has counted 500 million more, including those who just come and stare at what has become one of the world's most familiar and potent symbols. Here are two of the most popular buildings in the world, both of them fantasy works of art. Whether they are beautiful or not—objectively or subjectively—seems almost irrelevant.

It can be argued that there was always an element of the fantastic in American architecture, even at its most (apparently) utilitarian. Nothing brings this out more clearly than the story of the skyscraper. Here is another deep and ancient human instinct: to build houses of many storeys. Some of the biggest Chinese pagodas, from the early medieval period, had ten or more levels. In fifteenth-century Italy it was the fashion, in certain cities like Bologna, to build tower-houses to celebrate family pride and overtop rivals, with the equivalent of twelve storeys. That was also the fashion in southern Arabia, though somewhat later. In Sana in northern Yemen, nine-storey houses were built in the seventeenth century; in Shibam there are, even today, over five hundred such tower-houses, though the highest has no more than eight storeys. The Potala Palace in Tibet has twenty storeys in some places, though they exist within the entrails of a gigantic building. The term 'skyscraper' was a late-eighteenth-century invention applied both to the high triangular sails on ships and to high-standing horses—Skyscraper won the Epsom Derby in 1789. Its first recorded application to a

building was in 1880, when Queen Anne's Mansions were built in Westminster, ten storeys high, with perky roofs and spires, using traditional technology.

Really tall buildings, however, required three things: steel-frame construction; powered elevators; and strong financial pressure to concentrate office blocks in city quarters with high rentals. That meant Chicago was, almost inevitably, the first skyscraper city, especially since, unlike its main rival for the position, St Louis, it was outside the swathe of the Civil War. Here we come to another example, and a brilliant one, of technology creating art. The rise of Chicago was exceptional even by American standards, and right from the start was the result of using the latest technology. In 1830 it was a fort with a few farmhouses, and a population of two hundred. At the head of Lake Michigan it was the natural entry point for the great Midwest plains, but a half-mile sandbank blocked access. Army engineers, using new digging equipment and explosives, blasted a canal through. Two years later, a Chicagoan called George Snow invented the balloon frame. This was a house-construction system using milled lumber, quickly nailed together without need for mortice and tenon, which halved the time taken to build a house. The balloon frame plus railroads explains why, by 1848, Chicago was a first-class port handling the biggest inland-water ships in the world, with a hundred trains a day arriving on eleven different railroads. In 1856, it decided to jack itself out of the mud. Again using the latest equipment, the entire built-up town was raised 4 feet, by means of giant jacks. Briggs' Hotel, made of brick, five storeys high and weighing 22,000 tons, was jacked up while continuing to function. The jacking finished, the spaces were infilled and new roads and sidewalks laid down.

The appalling Chicago fire of 1871 helped matters. Lasting twenty-seven hours, it destroyed 17,000 buildings, a third of the total, and made 100,000 homeless. The city was then invaded by architects and engineers, who set about devising fireproof building systems. By 1874, Peter B. Wight and Sanford Loring had combined steel framing, brick flooring and cladding of terra-cotta and ceramic to make their buildings virtually proof against flames. Chicago had limitless access to land and shortage of space was never a factor in the skyscraper boom there. But accountants calculated that very tall buildings, erected in the financial-business sector of the city, could generate rents ten times higher per square foot of office space than low buildings only a few hundred yards away. Moreover, caissons developed during the national bridge-building phase of the 1860s and 1870s were discovered to be perfect for laying the foundations of immensely heavy buildings on Chicago's muddy surface. Chicago also seized eagerly on the new elevator, run first by steam, then much more efficiently by electricity. New York's Haughwout Building had put in a steam elevator in 1857, and it had come to Chicago in 1864, before the fire, in a store owned by Charles B. Farewell. By 1870 there was a hydraulic elevator, and in 1887 the first electric one. By that date Chicago had 800,000 citizens. Eight years later it had over a million, and 3,000 electric elevators, with elaborate safety devices—and in many

cases with beautiful wrought-iron and brass gates, mainly in the French Second Empire mode—had been installed.

Whether New York or Chicago built the first true skyscraper need not concern us, though the title probably belongs to New York's Equitable Life Assurance Company Building of 1868–70 by Arthur Delavan Gilman. It combined steel frame, the new kinds of cladding and lifts, though it was only five storeys high (and has long since been pulled down). Far more important was the fact that Chicago produced the first skyscraper architect in Louis Sullivan (1856–1924). Chicago was a utilitarian city which had to make every dollar pay and looked to a nine per-cent return on capital. New York was a headquarters city where prestige and self-advertisement were factors in buildings. The first Chicago building with iron pilasters, large windows and a proper skeleton façade was the Leiter Building by William Le Baron Jenney, but it was only five storeys, like the Equitable. Jenney built a ten-storey building in 1884–85 for Home Insurance, with reinforced iron frames on two façades. Meanwhile Sullivan and his partner had built the Borden Block, 1879–80, with a steel frame and more than one elevator. The Montauk Block of 1881–82, built by Burnham & Root, also had multi-elevators and was ten storeys but it lacked a steel frame. Such frames were used in six buildings in the early 1880s but not until the end of the decade did three big Chicago firms, Adler & Sullivan, Burnham & Root and Holabird & Roche use the combination of steel frames clad in masonry and served by multiple elevators which marked the mature skyscraper. Of these, the Monadnock, Fisher and Reliance buildings survive.

So much for the technique: it was Sullivan who gave the concept style, by going back to the first principles of architecture. He argued (and later set out his case in his essay 'The Tall Office Building Artistically Considered', 1896) that technique, function and decoration should all be organically integrated. A skyscraper was like a column, and therefore should have a base, a vertically accentuated shaft, and a capital. Since skyscrapers were mainly office blocks, and most offices were exactly the same, the tendency to monotony should be compensated for by use of varying materials, different colours and ornamentation. His buildings therefore made use of bricks, stone, tiles, ceramics and terra-cotta in delightful colours and he took enormous trouble with the decorative motifs. He had had a very wide and fortunate training. His mentor

Louis Sullivan, America's greatest architect, designed this Carson Pirie Scott store in Chicago (1899–1904). A century later, it still looks contemporary.

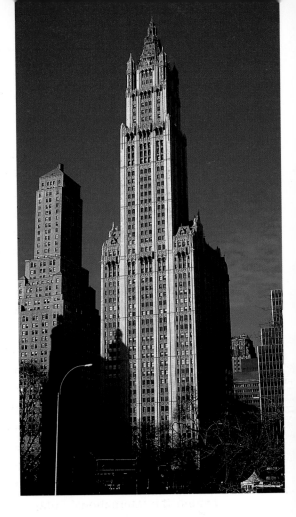

Cass Gilbert made Woolworth's New York headquarters (1913) the world's tallest building. The owner paid the $13.5 million in cash.

was the great architect Henry Hobson Richardson (1838–1886) who had built two of the finest churches in America, both in Boston: the Brattle Square Church, 1870, and the Trinity Church, 1872. Sullivan went to the Beaux-Arts, then studied the constructs of the great Philadelphia neo-Gothicist Frank Furness, and later worked in the office of William Le Baron Jenney, the top engineer-architect, who taught him large-scale construction. His boss, later partner, Dankmar Adler, taught him business methods, accounting and publicity, and as his lead draughtsman he employed the young Frank Lloyd Wright (1869–1959).

When Sullivan, a black-bearded, handsome, romantic and talkative Irish American, laid down that 'form follows function', he meant that the purpose of a building should be reflected in its decoration—thus a waterworks should express the essence of flowing water, a fire-station should convey ascending heat, a school should conjure up aspiration, a bank symbolise security and trust. To him, everything was organic. His masterpiece, the Chicago Auditorium Building (1886–90), then the largest building in Chicago, with 63,350 square feet of office space, though only ten storeys high, was organically organised like a garden, with a sixteen-storey tower like a tree, offices and shops like bedding plants, a 400-room hotel like a shrubbery, a 400-seat theatre and a 4,000-seat concert hall, then the largest in the world, like a great cluster of bushes, the whole making up an artificial but organically linked paradise of forms. One of his best buildings is the Guaranty in Buffalo, whose fourteen storeys embrace his column principle and introduce the maximum number of varied curves and circles, plus fourteen different colours, to compensate for the inevitable straight lines. There are over a hundred different decorative devices, and the great overhang of its cornice, with *oeils-de-boeuf* immediately underneath it, gives this massive work elegance and majesty. By contrast, Sullivan's New York Bayard Building, 1897–99, is an ingenious exercise in Venetian Gothic, where the spaces between the windows become the steel equivalent of marble columns.

Only nine out of twenty of Sullivan's skyscraper projects were built, and some of these have been demolished. But his example in treating tall buildings as an

opportunity for organic or stylish decoration was followed in New York, where cost factors were less restrictive. Already in 1876, the leading propagandist for science in Europe, Professor T. H. Huxley, on arrival in New York, had praised its 'secular sky-line'. He said, 'In the Old World, the first things you see as you approach a great city are steeples; here you see, first, centres of intelligence.' He was referring primarily to the hub of the electric communications industry: the ten-storey Western Union HQ finished in 1875, with its Gothic trim. There followed the eleven-storey classical *New York Tribune* Building, the sixteen-storey World Building, with its eighteenth-century flavour, built in 1889–90, and the twenty-storey Manhattan Life monster of 1893. New York pushed up the ceiling by ten storeys every decade, and most of these skyscrapers, with their height and topmost flourishes in twenty different styles, were giant sign-boards for their firms. The Singer Sewing Machine Building of 1902 paid for its cost by one year's extra sales in Asia alone. Frank Winfield Woolworth, who had by 1911 over a thousand five-and-ten-cent stores worldwide, finished his skyscraper in 1913— at the time, many thought it the archetype tall building, with its straight lines and Plateresque trim (the architect was Cass Gilbert)—and argued that, while it would never make a standard return on capital, it produced a hidden profit by acting as a gigantic billboard. The Metropolitan Life Tower, built by Napoleon Le Brun on the lines of the Venice Campanile, was another giant stationary advertisement. Robert D. Kohn's New York *Evening Post* Building, 1906, sported giant sculptures on its upper storeys to attract attention. The greatest advertising campaign of all was waged around the international competition to build the new *Chicago Tribune* Tower, eventually won in 1922 by John Mead Howells and Raymond Hood for an immense Flemish Gothic Revival tower of twenty-eight storeys, with square-topped flying buttresses around its crown.

Sullivan was essentially a product of the all-pervasive design style which had grown out of the Arts and Crafts movement, and in particular from the decorative designs of William Morris. It was known as Eel style in Belgium, Tapeworm style in Germany, Style Metro in France or Style Yachting, a coinage of Edmond de Goncourt. The Italians called it Stile Liberty after the prints from the famous London depart-ment store. The Austrians termed it Sezessionstil from the breakaway artists of their Academy. In December 1895, a Paris gallery owner, Samuel Bing, bought premises at 22 rue de Provence and displayed a fine collection of newish pieces he had carefully put together: stained-glass panels by the Nabis and Tiffany, prints by Walter Crane and Aubrey Beardsley, a Rodin sculpture, paintings by Pissarro, a boudoir by Charles Conder, and a lot of Tiffany glass pieces. He revived a term coined in 1881 by Octave Maus and applied to painters, and called his gallery L'Art Nouveau. The show was a huge success; the French cultural publicity machine—which had had such a triumph with Impressionism—got to work and within a short time the style had been perma-nently branded with this meaningless name.

The French, who had lost style-leadership after the fall of Napoleon I and had

struggled to regain it with the Second Empire, were relieved to be able to promote themselves to the epicentre of the new one. But by 1895 the style had already been flourishing for more than a decade. The French subsequently claimed that it was invented in the 1860s by Viollet-le-Duc. He certainly had a taste for working organic motifs into his Gothic decorations (but then so had the original church designers of the fourteenth and fifteenth centuries, for the ogee arch was a quintessentially Art Nouveau device). Sullivan has a strong claim to be considered the first major Art Nouveau artist, for designs as early as 1880, but then he was a follower of Morris anyway, and the priority of the Arts and Crafts movement in popularising organic designing is attested by overwhelming evidence from the late 1870s and early 1880s. The fact that the greatest Arts and Crafts designer, Charles Rennie Mackintosh, can also be classified as a leader of Art Nouveau, underlines the point.

But none of this matters. What matters is that Art Nouveau from the start was an international style. It did not so much originate in one centre, and spread, as demonstrate a convergence of artists from many different countries. What lay behind it were deep impulses, one emotional, the other cerebral. The emotion spread from a fierce desire to soften the implacable advance of machinery by giving it, wherever possible, organic forms which expressed the eternal growth-cycle of nature. That is why Sullivan made his earliest elevator gates into wrought-iron or bronze exercises in proto–Art Nouveau, and very beautiful they are, the few that have survived. That is why in France, the best of the Art Nouveau designers, Hector Guimard (1867–1942), was commissioned by the Paris authorities to design the surface entrances to the new Paris electric railway, the Métro. He produced some superb ironwork fantasies, some of which survive (the best are the stations at Parc Monçeau and Porte Dauphine, both 1900). The cerebral impulse was not to reject the modern world, of iron and steel, steam, gas and electricity, but to enfold it in the traditional world of art, with its age-old studio discipline of high craftsmanship. Hence Art Nouveau is distinguished by the way in which it unites an immense range of materials, including very ancient ones like stone, ivory and bronze, with the latest metals, ceramics and processing technologies, often producing combinations of astonishing beauty. Because the style was fundamentally so attractive, offering such wide opportunities, and incorporating natural forms of every kind, it appealed to a huge number of artists who practised it ardently in more than a score of leading countries. It was the international style *par excellence*, so it produced more than a dozen great practitioners, and three or four actual geniuses.

Leaving aside Sullivan, the man who dominated art in America, where more Art Nouveau pieces were produced than in any other country, was Louis Comfort Tiffany (1848–1933). Like Morris, he combined decorative genius and commercial acumen. His family firm had been making high-quality art objects, especially in silver, since 1837, but Tiffany himself was a good example of the way in which American designers

seized on technological developments to reinvigorate traditional crafts. As a young man he travelled in Europe and North Africa, 1868–70, studying oriental and Islamic designs and new coloured-glass techniques. Back in America, he was revolted by the low standards of the fine-glass industries, at a time when 4,000 new churches were being built in the United States, all demanding stained glass. From 1872, he experimented with the latest materials and technology in glass. He used new variations of metallic oxides to produce colour variations; he introduced custom-built furnaces to improve temperature control; and he managed to create the appearance of wrinkled or rippled surfaces, which he used for clouds and water. He produced an entirely new type of glass, which was iridescent and called Favrile, and which has been described as 'one of the greatest contributions to the stained-glass repertoire since the Middle Ages'. It involved treating hot glass with oxides to produce a nacreous effect. He invented the hot-seeming Lava glass; the cool, opaque, pitted glass called Cypriote, and many other variations.

Tiffany's discoveries were primarily intended to furnish large areas of stained glass, either in windows or screens. He had an amazing eye for décor, having studied painting under the brilliant American master George Inness (1825–1894) and watched Whistler at work on his Peacock Room. He was also in close touch with Arthur

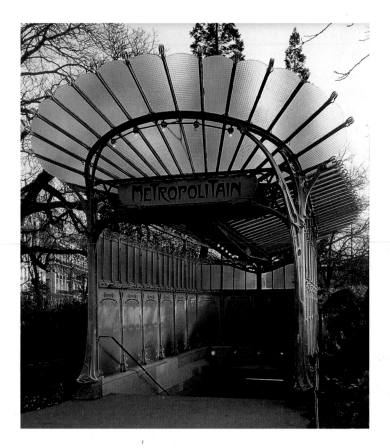

Hector Guimard used Art Nouveau style to make Paris Métro stations major works of art. Porte Dauphine (*c.*1900) is one of the few to survive the vandals.

Lasenby Liberty, who founded the London textile-and-dress shop in 1875. Tiffany recruited into his organisation Candace Wheeler, the embroiderer, and Samuel Colman, the textile designer. So Tiffany could design and furnish an entire interior, and this produced some of the most exciting schemes ever seen on the west side of the Atlantic. Tiffany redecorated Ogden Goelet's home at 59th Street and Fifth for the then record fee of $50,000. He charged even more for the Vanderbilt mansion on 58th and Fifth. He created the famous Veterans' Room for the Seventh Regiment Armory, Mark Twain's beautiful house in Hartford, Connecticut, the George Kemp House on Fifth Avenue, a gigantic glass curtain for the Palace of Fine Arts in Mexico City and a glass mosaic for Curtis Publishing in Philadelphia. When Chester Arthur moved into the White House he threw out twenty-four van-loads of furniture and got Tiffany to redesign the state rooms (1883), including glass-mosaic sconces in the Blue Room and a magnificent floor-to-ceiling glass screen in the dining-room. For himself, Tiffany built, at Oyster Bay, Long Island, an Art Nouveau palace he called Laurelton Hall (1902–1904). It had a copper roof, mushroom-shaped like a mosque, eighty-four rooms and twenty-five bathrooms. It had 'light' and 'dark' rooms, using

coloured domed skylights, glass, flowing water and tiles to produce astonishing colour-effects, Chinese and Indian rooms with artificial palms and tea-bushes, and a staggering array of coloured-glass windows in the drawing-room, 'the best I ever did'. Artists came from all over the world to study the chimney-piece in his New York studio (1889).

Tiffany's greatest coup was to turn stained-glass technology, including the metalwork, into table lighting. An outstanding example is his 'Dragonfly' electric lamp (1900) with leaded glass, bronze fittings and a twisted waterlily base. This is in the Chrysler Museum in Norfolk, Virginia, which, together with the Morse Gallery in Winter Park, Florida, has the best collections of his glass. Another big success was the 'Lily' lamp, 1902, with individual flower-heads of gold iridescent glass, held up or suspended from bronze branches. He had a production line for these pieces, though he employed the most gifted craftsmen for their detailing, and they were shockingly expensive for their day. A Tiffany table-lamp cost $750 at a time when Sears, Roebuck was selling a six-room house for $1,000. This exploitation of electricity was typical of Tiffany's modern-minded combination of technology with style and traditional skills.

He collaborated with the inventor Thomas Alva Edison in creating the world's first electrical-lit theatre in New York, Tiffany doing

'Lily' lamp by Tiffany (1902). Base in bronze, Favrile glass shades. Only a fraction of his superb output survives.

the design and decoration, Edison supplying the equipment. Both men took a close interest in the work of the Chicago dancer Loïe Fuller, the first to use electricity to produce spectacular light-effects on stage. Wearing diaphanous veils as her only garments, extended by hand-held batons, she danced at the Folies-Bergère in the 1890s against a constantly changing electric rainbow produced by the team of American technicians who accompanied her. This first example of performance art, done very much in the Art Nouveau style, brought artists from all over Europe to watch and record her performances, which thus survive in bronze and alabaster, marble and paint, a beautiful pastel by Toulouse-Lautrec (Charell Collection, New York) and a famous poster by Jules Chéret (Paris, Musée des Arts Decoratifs). The jeweller, glass designer and decorator René Lalique (1860– 1945), the nearest France came to producing a Tiffany, did the decorations for the specially created Loïe Fuller Theatre in Paris, including a spectacular spider-web parapet in bronze. That has gone but a brief early movie survives to show Fuller dancing.

In that respect she was luckier than the great Tiffany. When Art Nouveau went out of fashion, it was treated not merely with contempt but with positive hatred, and enormous quantities of its best artefacts were destroyed. Tiffany suffered most of all. As recently as 1957, at a time when the house created by another master, Rubens, was being lovingly restored down to the last tiny cornice, Tiffany's beautiful home on Long Island, with its superb contents—his one perfect masterpiece—was ruthlessly demolished and most of its contents smashed or sold cheaply. That was the culmination of many acts of vandalism. On Long Island he had made a powerful enemy in the shape of Theodore Roosevelt, head of the Oyster Bay branch of the Roosevelts, who claimed that Tiffany had 'laid his hands on other men's wives'. As soon as he took over the White House, 'TR' set about demolishing the Tiffany interiors, including the magnificent dining-room screen, perhaps the worst act of deliberate artistic destruction in America's history. Considering the immense amount of fine craftsmanship which went into the meanest Tiffany object, it is astonishing how many were smashed before taste changed (by the early twenty-first century a fine Tiffany lamp would fetch up to $3 million at auction).

Some Art Nouveau, fortunately, never fell completely out of favour. Dance was one of its key elements. Fuller's Salome Dance was among her most popular, and this sinister theme, loved by the Symbolists as we have noted, recurs again and again in Art Nouveau. In 1894, on the eve of his débâcle, Oscar Wilde's play *Salome* was produced to shocked acclaim in both London and New York. The text was issued with seventeen exquisite and sensational drawings by a young artist called Aubrey Beardsley (1872–1898). He was a child prodigy, brought up in genteel poverty by a widowed mother in Brighton, where he fluttered around the Pavilion, that precursor to Art Nouveau, like a delicate moth, and already suffering from the tuberculosis, which killed him when he was only twenty-six. Burne-Jones, when shown his work, said: 'I *seldom* or *never* advise anyone to take up art as a profession, but in your case I

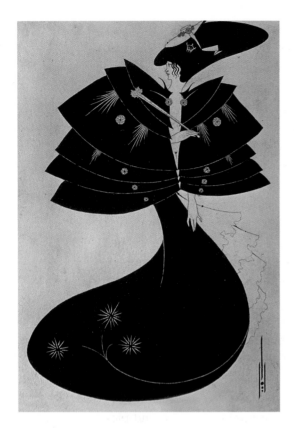

'Black Cape', illustration for Oscar Wilde's *Salome* by Aubrey Beardsley (1894). He made black-and-white sing, smell and thrill, but died aged twenty-six.

can do nothing else.' That was right. Beardsley was a genius, in the same way as his contemporary Kipling—that is, he had a *daemon*, which came from nowhere. Academic attempts to trace the origin of his peculiar style are pointless. It had no other antecedent. It was *sui generis*. The fact that it was invariably in black-and-white, with huge areas of black, gave it identity. If black can blaze, it blazed furiously. The line was thin but firm, exquisite but immensely powerful. As with the Symbolists, his women were dangerous and threatening but he could make them so—and infinitely sinful too—without any of the theatrical dodges of Von Stück, just with a careful flick of his bony wrists (it was one of Beardsley's fascinations that he himself, tall, thin, emaciated, with beautiful bones, looked like one of his drawings).

Beardsley was launched with the opening number of the Arts and Crafts journal, *The Studio* (1893), for which he did the cover and which contained a long article about him with eight illustrations of his work. He progressed to the *Yellow Book* (1894), supposedly the journal of the ultra-decadents. After the Wilde trial in 1895, which damaged Beardsley too, with guilt by association, he switched to *The Savoy*, which was comparatively respectable. In addition to *Salome*, he did a vast series for Mallory's *Le Morte d'Arthur*. One reason for his success was characteristic of the Art Nouveau fascination with new technology. Morris's Kelmscott Press produced the finest illustrated books on the market. But these were handmade and very expensive. Beardley's publisher used the new process whereby line-blocks, with all Beardsley's delicacy, could be made to seem like the original by a photo-mechanism. Moreover, his binding designs could be stamped onto to velvet cloth covers by a single metal matrix. The end product was not cheap but, unlike hand-produced work, well within reach of the middle class. One of the virtues of Art Nouveau, indeed, was that it followed the Arts and Crafts pattern of bringing art of the highest quality into ordinary homes.

After the Wilde trial, which forced Beardsley to flee to France for a time, he illustrated Alexander Pope's *The Rape of the Lock* (1896), perhaps his most beautiful work, and did eight large and highly controversial drawings for an edition of Aristophanes' comedy *Lysistrata*. Some of these are quasi-pornographic, and it is likely that Beardsley did some explicit pornographic drawings for private sale, since when he was received into the Catholic Church, on the eve of his death, he expressed

an agonised wish that such work should be destroyed. With few exceptions, all his work is *épatant*. But then, with virtually no exceptions, it is all first-class, and at times superlative. Few artists in the whole of history have managed to make black-and-white speak so powerfully. He was still very young, and emotionally quite immature, when he died, and what he might have achieved, given health, is one of the great speculations of all time. Why does God do these things to his gifted creatures? But then why does he give them such riches in the first place?

Beardsley was the greatest black-and-white artist since Daumier, better in some ways because purer in line. No one came close to him in the Art Nouveau age, without using colour. The best of them was the Czech Alphonse Mucha (1860–1939), another graduate of the Académie Julian, whose first work was in the theatre and who never strayed far from it. One warms to Mucha because he tried so hard to bring art into the lives of the people—his greatest passion—by designing first-class posters, advertisements, labels for soap, toothpaste and butter, mosaic panels for municipal swimming pools, crockery, textiles, jewellery (the snake bracelet and ring he designed for Sarah Bernhardt, executed by Fouquet, is perhaps the finest piece of costume jewellery ever created), postage stamps, calendars, letterheads and every conceivable kind of illustrative work. He loved Byzantine icons, collected them and copied them. He despised Art Nouveau, or said he did; not unfairly because his was really a style of its own. Anyone interested in design should study how ingeniously Mucha weaves into a single pattern frame and content, figures and decoration, lettering and picture. He formed a commercial love-alliance with Sarah Bernhardt, when he designed the poster for the play *Gismonda*, perhaps the greatest theatre poster ever created—along with Lautrec's *Aristide Bruant dans son Cabaret*—and thereafter designed all her posters, together with costumes, sets and personal knick-knacks. But Mucha needed the heady airs of Parisian cosmopolitanism: once he retreated to Bohemia in 1910 and became a Czech nationalist he fizzled out wastefully, rather like Sargent when he took up municipal wall-decoration in Boston.

If huge quantities of Art Nouveau works in glass, pottery, tiles, metalwork and on paper have perished—more so, alas, proportionately than any other style—the architectural heritage is more substantial. Some of Sullivan's buildings have gone, but there are surprising survivals of his decorative metalwork, for instance, the entrance decoration of the Carson Pirie Scott Store in Chicago, 1899–1904 (now Schlesinger & Mayer), a spectacular example of Art Nouveau at its most elaborate and fantastic. A big loss was the demolition of the Imperial Hotel, Tokyo, designed by Sullivan's draughtsman, Frank Lloyd Wright. On the other hand, we still have Wright's astonishing Unity Temple in Oak Park, Chicago, 1906–1907, with its red, gold and black interior, much in advance of its time and a projection forward from Art Nouveau since its straight lines, right angles and circles show no sign whatever of organic growth. Indeed, it adumbrates Art Deco or even the International Modern

style, into which Wright tumbled so precipitously after Sullivan's death. There are the same straight lines and angularities, as opposed to curves, in Wright's spectacular metal-and-glass *Window*, 1904, preserved in the Chicago Art Institute.

However, to see Art Nouveau architecture at its finest, the connoisseur has to go to Barcelona, stronghold of the style's third genius, Antonio Gaudí (1852–1926). He was the quintessential Art Nouveau artist in that the notion of organic growth is totally integrated with his design forms and dominates them completely—he is an aesthetic pantheist. But Gaudí is also in a sense bigger than the style, a solitary phenomenon, a *monstre-sacré-organique*. He had the right background, being the son of a coppersmith, and acquired a mass of knowledge both self-taught and acquired from art schools, which included the teachings of Ruskin and Viollet-le-Duc. He came up the hard and right way by learning metallurgy and by designing such humble but (on reflection) important items as street furniture, especially lamp-standards. His buildings, usually apartment houses, are scattered through Barcelona and you often come across them by accident in unexpected places. The wrought-iron ornamentation on his Palau Güell, 1886–90, is spectacular, creeping up its parabolic arches and bay windows. The Casa Calvet, 1888–92?, has beautiful balustrades of wrought iron and bronze, and the Torre Bellesguard sports a spectacular series of sculptured rooftop features which became a sure sign of this exuberant man's work. The Casa Milà, 1906–10, has a monstrous skyline, like a prehistoric being emerging from the depths, while its main façades are like cliffs with openings and curved indentations;

Frank Lloyd Wright died the year his New York Guggenheim Museum was completed (1959); whorls within whorls.

Gaudí's Holy Family Cathedral, Barcelona, is Art Nouveau on a colossal scale, and is still not finished.

the whole seething building, roof and all, appears to behave and lurch like a living thing. Every one of Gaudí's buildings has an animal character of its own. They are like beasts, sometimes dangerous and fierce beasts, often noble terrors of the urban jungle.

His masterpiece, the Expiatory Temple of the Holy Family, usually known as the Sagrada Familia, also in Barcelona, where it now ranks as a metropolitan cathedral, is the first important building of the twentieth century. In fact it goes back to 1866, when a design was produced for a Gothic Revival church crypt. Gaudí took over in 1883 and completed (1893) the crypt and the walls of the apse, then started to introduce his own design for the rest (1903), including immense triple portals on the west front, with four colossal spires superimposed. The structure is fundamentally Gothic but it is clad in every conceivable kind of natural form, which clings to its openwork bones like seaweed on the skeleton of a sunken ship. These steeples, or towers as Gaudí preferred to call them, are of stone, connected together by parabolic arches and metal spirals, and terminate in immense polychromatic finials with Venetian glass mosaics on their façades, each surmounted by haloed metal crosses. Gaudí, who had worked on the church for thirty years, had finished only one of the towers at his death in 1926. He set up this amazing building as an encyclopaedia of his motifs and methods and a compendium of all the materials he cherished. If he had lived to finish it, God himself might have been surprised by its contents. As it is, the cathedral has still to be completed and architects come from all over the world to goggle at it and speculate. It is the *stupor mundi* of the craft, a vast quarry of ideas and sensations. No artist ever introduced more novelties than Gaudí; none would be less likely to find employment today. As it was, he pushed Art Nouveau to its logical conclusions, and beyond.

There were two linked developments from this singular style. One of its features had been the combination of materials, old and new, with the object of producing interesting and colourful contrasts of surfaces. Although sculpture of stone had always been coloured in antiquity, and bronze-patinated, and although the painting of

images had continued in medieval churches until the end of the fifteenth century, Michelangelo had spurned colour as a distraction from the chaste majesty of the human form, and most sculptors had followed suit ever since. Indeed, they had tended to strip the human body of all its glitter, from eyes to hair. Many artists were impressed by descriptions from nineteenth-century archaeologists of the giant chryselephantine statue of Zeus by Pheidias at Olympus, whose combination of ivory and gilded bronze in a polychrome setting stirred their imagination. The point was publicised by two famous paintings of ancient Greek artists at work in colour, by Alma-Tadema and the French Academician Jean-Léon Gérôme (1824–1904): *Pheidias and the Frieze of the Parthenon* (1868, Birmingham), and *Painting Breathes Life into Sculpture* (1893, Toronto, Art Gallery of Ontario). Coloured statuary reappeared in the restoration of the Sainte-Chapelle, 1847, in the new Houses of Parliament in the 1850s, in Garnier's new Opéra, 1866–73, and in many palatial buildings, public and private.

Then there was the growing respectability of coloured wax sculpture, hitherto regarded as 'low' art. In 1882 the Musée Grévin in Paris opened its sensational new Galérie de la Revolution, and two years later Madame Tussaud's in London, which had been making realistic coloured wax statues since the eighteenth century, opened its present high-style galleries in the Marylebone Road to great acclaim. Was colour in statuary low art? That was the public view when Degas showed his little dancer in 1881. But the fuss soon died down and the colourists gained courage. Technology was on their side: all international expositions showed coloured work because it reflected the ability of craftsmen (and machinery) to achieve new combinations of iron, bronze, marble, ivory, precious stones and terra-cotta, as well as new oxidisation and electrolysis techniques for producing effects such as *vert antique, vert à l'eau, bronze florentin, teinte florentin fumé* and so on.

It was the English who seized most enthusiastically on the new opportunities. George Frampton (1860–1928), who had studied with the great realist Dagnan-Bouveret, regarded polychrome sculpture as a form of Naturalism (is not nature herself colourful?). He saw its practise, both for individual pieces made to order, and production-line replicas to be sold in shops, as a legitimate development of the Arts and Crafts movement, in which he was a leading figure, becoming Master of the Art Workers' Guild. His magnificent *Lamia* (1900), of bronze, ivory and opals, was his diploma piece for the RA, where it remains (there is a painted plaster version in Birmingham). He did some magnificent large-scale polychrome work for the new Lloyd's Building in the City and created, in Kensington Gardens, one of London's most popular statues, the Peter Pan memorial. His younger follower, Gilbert Bayes (1872–1953), worked not only in stone, metals and ivory, but in polychrome stoneware and ceramics. On the Albert Embankment he produced a sensational display for the headquarters of Doulton's, the ceramics manufacturers, and he then set to work on London's biggest department store, Selfridge's. From 1860 to the 1930s,

big shops, in Berlin, Paris, New York and London especially, were the largest single employers of artist-craftsmen, working in the latest technologies. Countless Londoners pass Selfridge's in Oxford Street every day without noticing its façade, especially its detailing, which is infinitely audacious and superbly crafted. Bayes's central clock, *The Queen of Time* (1908–31), standing on her stone prow, in blue enamel outfit with gilded wings, holding aloft her fantastic gold timepiece against a background of sculpted bronze, is a masterwork of elegant contrivance.

The most resourceful polychrome sculptor, and the finest artist, was Alfred Gilbert (1854–1934), who trained at the RA and Beaux-Arts but who also undertook a special study of Benvenuto Cellini. He was thus inspired to make himself a master of bronze and metal-casting, resurrecting the lost-wax process, though he also used its mechanical successors—and improved on them. He constantly experimented with new metals. Indeed, he probably had a more comprehensive grasp of metallurgy than any other sculptor, before or since. That was one reason why Rodin, who tried polychrome but could not make it work for him, admired him so much. When told that the English ranked Gilbert with Cellini, he said: '*Meilleure que ça*—better than that.' It was true. Cellini, with all his gifts, could never have produced the tomb of Prince Albert Victor, Duke of Clarence, at Windsor Castle, on which Gilbert worked between 1892 and 1928. This elaborate work, the greatest tomb of modern times, comprises a sarcophagus, the duke's effigy in dark bronze, with hands and face of white marble, resting on top of it and, above the body, a silver angel of aluminium holding a golden crown. There is an immense surround to the central figure, a grille of bronze and other metals, lit with gilt, and incorporating in its trelliswork twelve statues. Everything is done with the utmost elaboration, using materials of the highest quality, regardless of expense or time, simply because Gilbert thought them the most suitable for his effects.

The clock and winged temple on Selfridges' in Oxford Street, London (1907–28), plus other decorative touches, made it the cathedral of department stores.

Behind the tomb and its long gestation is a tragic personal story, recalling Cellini's troubles. Gilbert was an artist-scientist, not an accountant, and his perfectionism—including a reluctance to shock clients with the amount it was likely to cost them, for fear they might stop him—made him bankrupt, in

1901, with only the central part of the tomb done. He spent the next quarter-century in self-imposed exile in Bruges, then a ghost town known as Bruges le Mort. He did eventually return and finish his work at Windsor. But the royal family were shocked to discover that in his financial necessity, he had been selling versions of his twelve figures. That is our gain, however, because some of these marvellous figures are available for close inspection. The two most elaborate, in a Scots church (identity concealed for fear of theft), and done in 1899, are *Saint Elizabeth of Hungary* and *The Virgin*. Both include polychrome bronzes cast by Gilbert's special techniques, the Virgin having a white-silver robe, part of which is painted, but for St Elizabeth he used in addition semi-precious stones, ivory and tin inlaid with mother-of-pearl. These are sumptuous things, about 20 inches high, of breathtaking beauty, the perfect bridge between Gilbert's personal version of Art Nouveau and the world that was to come. (They were shown in the 'Coloured Sculpture' exhibition, Amsterdam–Leeds, 1996–97, with superb photographs in its catalogue.) The tomb as a whole would have dazzled the artists of the

Clarence tomb at Windsor, Alfred Gilbert's Art Nouveau extravaganza, took him thirty years (1892–1928).

Renaissance, but these two items within it (Gilbert never had the time to bring the other ten statues up to this standard of excellence) would have made even Bernini marvel.

Aluminium, first processed commercially in 1854, had been cast as the pyramidal cap of the Washington Monument in 1884, but Gilbert was the first artist to use it. He employed it again in his Eros Fountain in Piccadilly Circus, which he conceived as a monument to the famous Earl of Shaftesbury, who had befriended boy chimney-sweeps and factory workers. This may well be the best-loved statue in the world, but no one actually looks at it, blinded by the glare of the setting, and the crowds, night and day. In fact it is a trimetal masterpiece, of aluminium, bronze and iron, with stone setting, the four colours producing a sensuous polychrome harmony and the silver contrasting with the green pedestal and gold bronze of the basin.

Gilbert showed the way from the peak of Art Nouveau to what (late in the twentieth century) became known as Art Deco. These were not two separate styles but a continuum, one flowing into the other. They appear distinct only because the First World War provided an accidental punctuation. In the first decade of the twentieth century, there was increasing competition between New York, Paris, London, St Petersburg and Vienna (with Berlin, Brussels, Barcelona and Milan as also-rans) for the ever-growing trade in the highest-quality luxury goods, especially decorative arts of every kind. The range of materials was now almost infinite, the technology racing ahead, the number of skilled craftsmen greater than ever before in history. The French authorities, terrified by France's stationary population, its shrinking share of world trade and industry, and the threats to its domination of the fine arts as well as the decorative arts, decided in 1907 to hold, eight years later, the largest show of art-luxuries ever staged. Paris was the natural venue, for it had the biggest proportion of artisans in its total population of any city in the world. The show, scheduled for 1915, was abandoned when war came a year earlier, and reviving the concept was one of the first priorities of the French government when peace finally returned in 1918.

By then the luxury art trades were in a desperate plight. In Russia, Carl Fabergé (1846–1920), the greatest jeweller-craftsman since the sixteenth century, had by his genius reversed the value-ratio of skill to the intrinsic worth of precious stones, especially in his Easter eggs for the Tsar's family, twelve of which can be seen in the Hermitage. He had run four magnificent workshops, in St Petersburg, Moscow, Kiev and Odessa (as well as in London), employing over five hundred craftsmen of the highest calibre, but at the end of 1918, unable to cope with Bolshevism, he had closed them all down and left the country. There had been similar closures in Berlin, Vienna and Prague, as a result of revolution, republicanism and the departure of royal families into exile, the confiscation of aristocratic estates, and the proletarianisation of taste. Even powerful French firms like Lalique and Cartier felt odiously chill winds of change.

Hence the 1925 Exposition Internationale des Arts Décoratifs et Industriels Modernes was an almost despairing attempt to re-establish craftsmanship at its highest level. The French put all they had into it, and the show was a huge success. The stress was on 'modern'. Indeed, the results were known as *le style moderne* until the 1960s revival, when Art Deco replaced it. The pre-war prolegomenon was produced by the superb French designer Paul Follot (1877–1941), who showed at the 1912 Salon d'Automne a dining-room set in sycamore, ebony, amarinth and steel, in which Art Nouveau organicism was tucked away, and bold, straight lines were paramount. The strong colours took up a theme already trumpeted by Frank Lloyd Wright in his Oak Park church. By 1923, Follot was design manager for Le Bon Marché, the big Paris department store, and in that role he put up the Pavillion Pomone at the 1925 show, which became the lead indicator. The furniture looked ultra-modern in a way that Rennie Mackintosh's did not, rooted as it was in nature. For one thing, the 1925 exhibits used chromium, a metal discovered as long ago as 1797, and first processed for commercial use in 1854. It was produced from lead chromated by aqueous electrolysis, and got into the hands of decorators in 1924, just in time for the big display. The jewellers exhibited a new range of materials too, combining enamel with lacquer, and both with stained glass, lapis lazuli, onyx, coloured agate, jade and ivory, to produce a set of colours never used in the trade before: tango-red, a pale green called eau-de-Nil, buttercup, lavender, ultramarine and black. These became the dominant polychrome of the style.

However, it was in sculpture that the Art Deco style achieved its most spectacular results, taking up Alfred Gilbert's new metals and processes, and employing a dazzling range of colours. The actual manufacture of high-quality sculpture had now been made possible by a combination of developments. First was the development of the Belgian Congo, which had unleashed in Europe and North America, for the first time, large, regular quantities of elephant ivory. This led directly to the revival of chryselephantine pieces and their derivatives. Second, there was the pantograph which Achille Collas invented in 1850. This enabled a sculptor to create a work on his customary scale, and his manufacturer to reproduce it in various smaller sizes.

By 1920 this had been developed to the point where sculptors could carve ivory (especially for heads and hands) with the same precision as the original on entire editions. Of course the number in any one edition depended on the elaboration, and determined the price. The chryselephantine figures were basically of two materials: base and torso in bronze, often gilded or coloured; and exposed flesh, heads, arms, hands and feet in carved ivory, the two elements being assembled to create the illusion that the entire figure was ivory flesh clothed in bronze garments. To complete the polychrome effect, ivory lips and cheeks were tinted, then lacquered in several superimposed colours; a new technique known as cold painting. The whole was fixed on a base of onyx, malachite or coloured marble. The process was superintended by a new kind of artistic middleman, the sculptural editor. These ran foundries and firms

which originally specialised in reduced-size replicas of bronzes by greedy masters like Rodin, but they now took over the supply of high-quality Art Nouveau and Art Deco sculpture to the middle class. From the First World War, the number of individual pieces of sculpture produced for rich collectors was reduced by at least seventy-five per cent, but foundry editors multiplied high-quality replicas by ten.

Supplying this market tested the artistic integrity and aesthetic nerve of sculptors. A sculptor like Eric Gill (1882–1940), for instance, was probably the best and purest sculptor of the female nude in the 1920s. His etchings and woodblocks show a fineness of line unequalled since Beardsley, and these were produced in comparatively large numbers in some cases, especially his *Canterbury Tales* woodblocks for the Golden Cockerel Press (1928). His carved lettering in stone was of a quality unequalled since Roman times, and he designed two famous typefaces, the Perpetua and the Gill Sans-Serif, reproduced by the million. But he drew the line at mechanical sculpture-reproduction. His two sculptural masterpieces, the Westminster Cathedral fourteen Stations of the Cross, and his Prospero and Ariel on the front of Broadcasting House, a typical Art Deco building (1928), he would not allow to be reproduced at all. But then he was inconsistent in other ways, combining extreme devotion to Catholicism (he was a Dominican tertiary and founder of the Guild of St Joseph and St Dominic) with sexual congress, of an unusual kind, with two of his three daughters, a fact which came to light only in the 1990s. Nor was Gill alone in being squeamish about pantograph techniques and sculptural editing. The greatest American sculptor of the period, Paul Manship (1885–1966), was closely associated with Art Deco motifs, as is shown by his stylised animals for the Bronx Zoo and his magnificent centrepieces for Rockefeller Center in New York, another Art Deco concept. Nearly all his larger public statues and reliefs were reproduced in limited editions of smaller sizes, but he regarded foundry editors as unacceptable.

That left the field clear for men and women, classified as lesser artists but whom we can now see were often of outstanding talent, even genius. There were degrees of compromise. Thus the Italian Art Deco sculptor Carlo Olandini would make a plaster figure, *Flora* (1925), and have it reproduced in six signed copies by the French firm of Sèvres Porcelaine. But that was essentially like a bronze edition. A foundry editor might create twenty or fifty or even a hundred copies of a prize piece, putting them on the same kind of level as Tiffany's best lamps. Yet the beauty of these pieces, some of which now only survive in a few copies—such was the vandalism of the decades 1940–70—cannot be denied. Germany's leading sculptor in the 1920s was Ferdinand Preiss (1882–1943). He did not hesitate to submit to editing for his specialty figures, which include the marvellous *Lighter Than Air*, mainly in bronze and ivory (1930), of a girl holding a black glass balloon. Likewise the Berlin artist Otto Poerzl (1876–1963) produced an outstanding piece in *The Aristocrats* (1932), showing a bronze-and-ivory lady leading two borzoi dogs. There were a dozen other artists, mainly from France, Belgium and Germany, almost in their class. But two stood well

above them and must be ranked as the geniuses of Art Deco. The first was a young Belgian woman called Claire Jeanne Roberte Colinet, whose life-dates are unrecorded but who was active in the thirty years 1910–40. She specialised in exotic dancers—dancing women was the central image of Art Deco sculpture—and her *Ankara Dancer* (about 1924), in ivory and three kinds of bronze, cold painted, with an onyx and marble base, is by any standard a masterpiece of balance, form, colour and sheer delight in life. It is astonishing that so little is known about this major artist.

Even more exuberant, however, was the Romanian, Demeter Chiparus (1888–1950), who spent most of his life working in Paris. Romania, though non-Slavic, was part of the network of eastern alliances with the Slav world which France formed in the wake of her disastrous defeat by Germany in 1870–71. They did not do her much good politically or militarily in either world war, but they produced a valuable cultural immigration. Some emigrants were so poor that they actually walked as a means of transport. Constantin Brancusi (1876–1957), a peasant who took up wood-working, and remained attached to his carved chunks of timber until his death many rich and distinguished decades later, left Romania early in May 1904 and walked to Paris via Munich, Zurich and Basel, arriving in 'the city of light' on Bastille Day. He worked as a *plongeur* or dishwasher in a restaurant, then in Rodin's workshop,

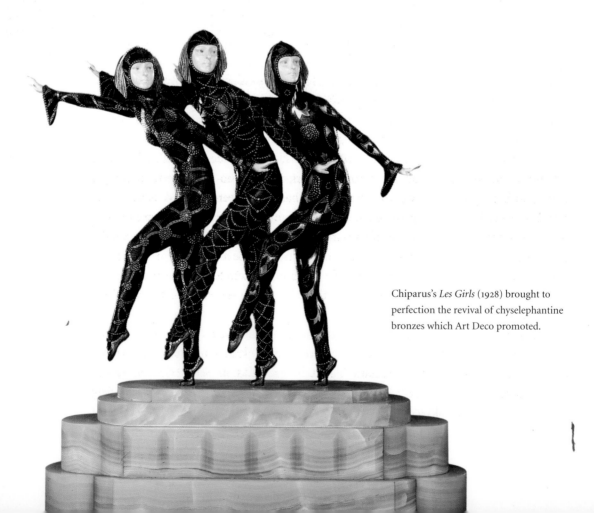

Chiparus's *Les Girls* (1928) brought to perfection the revival of chyselephantine bronzes which Art Deco promoted.

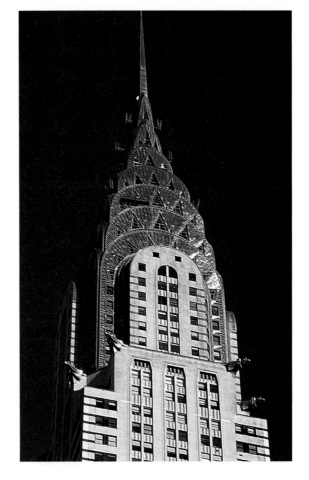

Art Deco spire of Chrysler Building, of stainless steel, by William Van Alen (1928–30), a 'masterpiece of mechanistic iconography'.

and in due course produced his semi-abstract *The Kiss*, his answer to Rodin's version, which made him notorious. He became world-famous as a scandalous leader of the avant-garde at the spectacular New York Armory Show of 1913. Brancusi produced sexual forms but not, strictly speaking, figures, and his role in Art Deco was peripheral.

By contrast, Chiparus, who had arrived in Paris by 1914, was its epicentre, producing acrobats, dancers, oriental beauties and actresses. His work was edited by the Paris firm of Edmond Etling, though some pieces of the 1930s come from other foundries, and the Austrian firm of Goldscheider. They are distinguished by beautiful bases of mottled marble or onyx with panellings of different materials, but above all by the bodies of his women, who are clothed in skin-tight bronze *couvre-touts* with elaborate gilt-and-silver patterning. The faces and hands, of course, being of ivory, of which Chiparus was a master carver, are the best of all. His *Fan Dancer*, 1924, shows the virtuosity of his bronze-work too—the fans themselves are moulded and cast with astonishing delicacy. Finest of all is his big three-figure piece, *Les Girls* (1928), whose ivory faces, each of a kind but each different, and whose spectacular decorative dark-brown-and-silver body stockings, with gold highlights, display a virtuosity which has never been equalled. Is this great art? It is certainly an exciting and exhilarating form of art. Indeed, perhaps excitement is the word which can most usefully be applied to the whole of this early-twentieth-century mode of using the highest craftsmanship to create a new kind of beauty, in which modern technology played a fascinating role. It was indeed modern, but it was also human, and it employed devices and motifs which were linked to traditions going deep into history.

It is not surprising, therefore, that the New York skyscraper architects of the 1920s made such dazzling use of Art Deco themes. When the Chrysler Motor Corporation commissioned William Van Alen to build its seventy-seven storey headquarters in the mid-1920s boom, he picked the Art Deco style, not only creating the best-loved of all skyscrapers with its quasi-oriental helmet-top (1928–30) but

equipping its ground-floor interiors with a spectacular display of marble and metal-work which demonstrates the unprecedented range of skills available at that time. The Empire State Building (1931) of eighty-six storeys, by Shreve, Lamb & Harmon, is also Art Deco in its top and fittings, though more demurely so, relying for its monumentality on the noble massing of its huge forms. It is as impressive now as when it was built nearly three-quarters of a century ago, something which can be said of very few buildings, especially enormous ones like this. The truth is, Art Deco, whether expressed in sculpture or in architecture, in jewellery or in furnishing, was the culmination of nearly a century of marrying scientific and technical advances to fine, highly adaptable craftsmanship. It had really begun with the Great Exhibition of 1851. It was to end with the Second World War. It was, and is, perhaps an unrepeatable phenomenon in human history. It rested, however, on the assumption that fine art could accommodate fashion without loss, and certainly without catastrophe. That assumption was now to be challenged.

Ladies' Powder Room of Radio City Music Hall, New York (1931), wall decorations by Yasuo Kuniyoshi, part of a scheme by Donald Deskey.

THE BEGINNINGS
OF FASHION ART

We now come to one of the key developments in the history of art: the rise of fashion art as opposed to fine art. In a sense fashion has always played a role in art, especially in the long term. We have repeatedly seen how art systems become overelaborate, thus provoking a change of fashion: the elaborations are swept away by a new purity and simplicity which, in due course, as fashion changes once again, develop elaborations of their own. These are the 'long waves' of fashion. But in such cases fashion is not so much whimsical or arbitrary as a responsible moral force, springing from the need to impose a human order on the chaos of nature, which is the deepest source of art. When art systems become so complex as to generate confusion rather than order, then the impulse to reimpose the discipline of simplicity is more than just fashion: it is self-preservation, part of the natural instinct of the human race to be in charge of its environment, rather than its helpless victim.

It is a different matter, however, when changes in art are forced through not by the quest for order but simply by the desire for novelty, itself enhanced by the needs of commerce. Then art becomes a fashion industry rather than a noble pursuit. It is no accident that this danger arose in Paris in the first decade of the twentieth century. As we have already noted, Paris had the greatest concentration of skilled artisans in the entire world. It had much more. In the Ecole des Beaux-Arts it had the world's most prestigious art school, financed by the state, with many private schools affiliated to it, such as the famous Académie Julian, which played a part in the training of more major artists, native and international, than any other academy in history. It also had studio-complexes, known as *cités d'artistes*, such as the Bateau-Lavoir and the Maquis. Good working studios could be rented more cheaply in Montmartre and Montparnasse than in any other capital. There were *c.*1900 about 250 private art galleries in Paris, plus many restaurants and cafés which displayed and sold art, as well as big official shows twice a year, of which the Salon d'Automne was perhaps the best shop-window for art in the world. Artists could learn, work and live cheaply in

Paris, and if they were gifted or cunning, preferably both, make a great deal of money quickly, since collectors and dealers came there from all over the world.

Paris was also the home of the world's fashion trade. That had been true since at least the mid-eighteenth century. At that time men spent as much on their clothes as women, perhaps more, but in the 1790s Beau Brummel had simplified men's fashions by eliminating colour and excess and had virtually confined evening menswear to black and white. The international trade then concentrated in London, around Savile Row, and Paris confined itself largely to female *modes*. But it did so on an increasing scale and with spectacular success. A close connection between women's fashion and artists was established in 1775 with the publication of the first fashion-plate book, *Le Monument du costume physique et moral de la fin du dix-huitième siècle* (republished 1777, 1783, with beautiful plates by a leading artist, Jean-Michel Moreau and text by the novelist-pornographer Nicolas Restif de la Bretonne). *La Gallerie des modes et costumes français* produced portfolios drawn by some of the best artists in France. (A recent study shows how closely Ingres followed women's fashions.) This in turn generated fashion periodicals, such as *Le Journal des dames et des modes*, from 1839. When photographs began to supplement, then replace, fashion drawing (the important magazine *Les Modes*, 1901–37, used only photos), artists continued to be part of the industry by designing clothes and making sketches of them for clients; they also attended fashion presentations, known as *collections*.

Under the Second Empire, and still more so under the Third Republic which followed, the women's fashion trade itself became highly organised. The leading spirit was an Englishman, Charles Worth (1825–1895), who had worked at the Piccadilly drapers Swan & Edgar, opened a dressmaking department within the Paris shop Maison Gagelin, then in 1858 got Swedish finance to establish a leading house of his own. The connection he formed with the ultra-fashion-conscious Empress Eugénie made his Maison Worth world famous and he became the first ladies' fashion dictator. This meant he could arbitrarily abolish old fashions and invent new ones, thus in effect forcing society ladies to change their wardrobes regularly, generating wealth for the industry of which he and colleagues were the apex, but which stretched deep down into the provincial textile trade in the area of Lyons. His commercial fashion artistry centred around skirt-lengths, waistlines and shapes. In 1860 he launched his first revolution by introducing the tunic dress. This was a knee-length gown worn with a long skirt (it was not yet acceptable for women to show their legs but the gown hinted at them). In 1864 he abolished the crinoline at a stroke, at the same time pulling skirts back and creating what was called 'the train'. In 1869 he pushed up the waistline eight inches and introduced the bustle, worn over the bottom. When the Empire ended in 1870 he shut up shop during the terrible days of the Commune, but reopened at the end of 1871 with a new *collection* for the following spring, concentrating his attentions on leading actresses like Sarah Bernhardt and Eleonora Duse.

During the next two decades Worth again transformed the fashion industry in three important ways. First, he induced the Lyons manufacturers to produce luxury materials specially created for the needs of the Paris fashion houses, employing skilled artists to design patterns and decorative pieces, or using artists from his own *atelier* to create them. Second, he produced entire outfits for rich and favoured clients, from evening gowns to tweed travelling clothes, the ladies allowing themselves to be 'created' by Worth. Third, he held periodic shows, twice a year, to introduce his new *modes*. The spring and autumn shows had marginal variations but every few years he introduced a revolutionary change to make all existing clothes unfashionable and boost the trade. Bonnet shapes changed radically, ruffles appeared and disappeared, waistlines went up or down, and skirts changed subtly (or not so subtly) to enable legs to generate erotic attention.

Charles Worth's son Gaston organised the trade into the Chambre Syndicale de la Haute Couture, of which he was the first president, its primary purpose to prevent piracy of valuable new 'revolutions'. High-fashion houses had to employ at least twenty people in their *ateliers* to belong and to conform to certain standards. Like the editors of chryselephantine statues, they were allowed to sell designs to big ready-to-wear firms in America and Britain, for instance, subject to timing and quality, but each had to produce at least fifty original designs a season. Between 1900 and 1910, Gaston Worth was organising the industry, now concentrated around the Avenue Montaigne, in order to co-ordinate their biannual shows during a specific week or fortnight in January (for spring), and the same in July (for autumn), the second preceding by about six weeks the opening of the art world's autumn Salon. By 1910 this process was complete, and the enormous Paris fashion business was in being, rising to its peak of 106 houses in 1946–56.

It attracted artistic talent of the highest order, including women and many foreigners. Callot Seurs, the first fashion house run by women, opened in 1895 and in 1900 it was joined by the outstanding designer Madeleine Vionnet (1876–1975). She invented the 'bias cut', one of the greatest of all innovations in the trade, which runs against the grain of the fabric and causes the material to fall into a smooth vertical down-shape or cling as desired. She virtually abolished the corset (for young women), introducing faggoting to make the shape more fluid, popularised the halter-neck, the cowl, the wraparound coat and skirt, and revolutionised the way in which high-fashion clothes were structured and lined. Her object was to make clothes more comfortable, and she succeeded, but in the process she periodically altered shapes, so changed fashions and sold more garments. Equally important was the arrival in Paris of Leon Bakst (1866–1924), born Lev Rosenberg in St Petersburg, a court painter who graduated to theatre scenery and then costume. In 1906 he came to Paris to direct the Russian section of Serge Diaghilev's Ballets Russes, one of the key art events of the century. Nijinsky's dancing and Stravinsky's music joined with Bakst's exotic and exciting costumes to produce a degree of aesthetic excitement which even

Paris had never before experienced. Bakst was a superb artist, in watercolour and gouache, and his drawings, as well as his actual costumes, had an immediate impact on both the Paris art world and the *haute couture* industry.

Bakst was never specifically a ladies' fashion designer but he inspired ideas in the experts. Thus he caused the brilliant Paul Poiret (1879–1944) to introduce the 'hobble skirt', which trapped the ankles orientally but freed the hips—part of Poiret's campaign to revolutionise fashion by abolishing restraints, scrapping most underclothes and allowing women to display their bodies as they pleased. From Bakst he also got harem-pants, aigrettes and a revived form of turban (first used during the Egyptian craze of the Bonaparte Empire). One of Poiret's best designers at this time was Raoul Dufy (1877–1953), who had been among the Fauves in 1905 and who participated in all the subsequent art 'movements'. Other leading artists who bridged the world of painting and fashion were Christian Bérard (1902–1949), who worked for the House of Schiaparelli, and Jean Cocteau (1889–1963), his bear leader, who, as an artist-writer of ultra-fashionable instincts, acted as impresario for anyone out to shock.

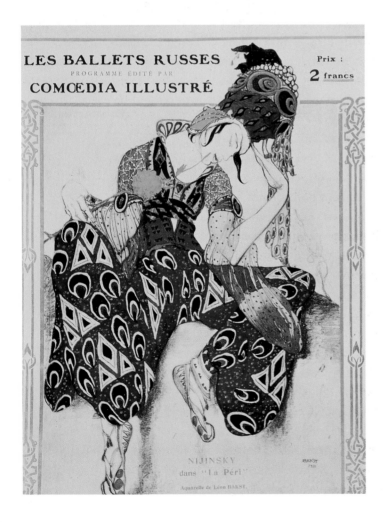

Bakst designed *La Peri* costume for Nijinsky in the Ballets Russes (1911), underlining the connection between fashion and art.

There was a strong influx from Barcelona, which, as the citadel of the most pungent and adventurous forms of Art Nouveau, held an important place in art history at this time. With its own language, history and aesthetic traditions, Barcelona stood apart from Castilian Spain and was in some ways a cultural metropolis in its own right, especially in the period 1890–1914. It attracted talented artists and designers (and wealthy patrons) from all over Spain to its workshops, studios and galleries. But since the Spanish Church was active and censorious even in Catalonia, there was a constant art drain to Paris in the north, Barcelona acting as a conduit to France from Spain, especially its more culturally backward parts like Andalucia and Galicia. One such emigré to France was the dress designer Mariano Fortuny (1871–1949), an Andalucian from Granada. He began as a painter but then took up high technology to improve electrical light-effects for theatre and opera sets and, more important, to improve the manufacture and chemical dyeing of new textiles, especially heavy silks which resembled velvets.

Dufy's design for Bianchini Textiles (*c.*1925), one of many forays by leading artists into 1920s high fashion.

Fortuny was the first dress designer of genius who systematically ransacked art forms of the past—Renaissance dresses as seen in Venetian paintings, Persian miniatures and tapestries, ancient Greek statue robes—to produce modern designs. What he produced, being new and exciting, had a feedback effect on contemporary artists. His 'Knossos' scarf of 1906, inspired by Cycladic forms, and his 'Delphos' dress of 1909, a cylindrically shaped garment, created by a special pleating process, were particularly influential among young painters. These were only two of twenty inventions which Fortuny patented in Paris from 1901 on. His success inspired the greatest of all twentieth-century dress designers, Cristóbal Balenciaga (1895–1972), who was taught to sew by his impoverished widowed mother when he was only three, and who was copying couturier clothes in his early teens. A Basque from San Sebastián, he too made his way to Paris and founded one of the great fashion houses. Balenciaga evening gowns, though made in the forties and fifties, in some cases even in the thirties, were so well designed and sewn that, when properly looked after, they were still being worn early in the twenty-first century.

Among the arrivals in Paris was an Andalucian who, like Fortuny, came through the Barcelona conduit. This was Pablo Picasso (1881–1973), who became one of the most influential figures in twentieth-century art. He came from Málaga, a great bull-fighting

town, and was a natural picador, who tames the bull (in his case academic art) by fatally weakening its neck muscles. Picasso raises problems of appreciation which are unique in the history of art, and it is important that everyone should make up their own minds about him. That is made difficult by the dense clouds both of hagiography and vituperation which have always surrounded him, and by his enormous output, probably the greatest on record, since he was producing saleable drawings in quantity at the age of nine. By 1900, Picasso was turning out a painting every morning and continued to be spectacularly productive until his death at the age of ninety-two, working on paper and canvas, in stone, ceramics and metal, in every possible variety of mixed media, and designing posters and advertisements, theatre sets and costumes, dresses and logos and almost every kind of object from ashtrays to masks.

The number of Picasso's creations probably exceeds 30,000, and although there is a thirty-three volume *catalogue raisonné*, 1932–78, it is far from complete, and has

to be supplemented by ten other catalogues. The literature on him is enormous, over four hundred books at the latest count, and is being supplemented by a multi-volume biography by John Richardson, comprehensive and essential but hagiographic in tendency. Intense emotion surrounds the subject and critical words do not figure in 'official' bibliographies. Picasso made a deal with the French government over death duties and, as a result, in 1985, a Musée Picasso opened in Paris, where his work of all periods can be studied, supplemented by the Musée Picasso in Barcelona, which has a large number of his earlier products.

It is important to realise that Picasso arrived at exactly the right time, never had to struggle for a showing or recognition, was never spurned or neglected, and became world-famous quickly. By 1914 he was a millionaire and a year later his annual income was calculated at 1.5 million francs. By the time he died he was the richest artist in history by far. What made Picasso so successful professionally and financially was not so much skill as commercial inventiveness, artistic originality, ruthlessness and extreme cunning, sometimes supplemented by intelligence of an unusual kind. He grew up artistically in a Barcelona, which swarmed with artistic talent, and was befriended by two painters of outstanding gifts. Rusiñol i Prats (1861–1931) was a writer as well as a painter specialising in interiors, whose *Interior with*

Black silk evening dress (*c.*1910) by Mariano Fortuny, a Spanish painter who saw designing garments in exquisite materials as high art.

Figures (1894, Barcelona, Museum of Modern Art) is a major work, its content comparable to the social realism of Zorn's in the 1890s. But he developed a passion for gardens which led him to concentrate on painting them almost to the exclusion of anything else. Rusiñol's *Pine Grove in Aranjuez* (1930, Barcelona, private) shows his wonderful skills, but rejoicing in nature, and depicting it with affection, were not highly rated in his time.

More significant was Ramon Casas i Carbó (1866–1932), who has a strong claim to be rated the best Spanish painter of modern times. Taught in Carolus-Duran's *atelier*, Casas oscillated between Paris and Barcelona, sharing for a time with Rusiñol the famous studio above the dance-hall in the Moulin de la Galette. In 1890 he painted a superb and sombre picture of this hall (Barcelona), following in the footsteps of Renoir and Toulouse-Lautrec. His most important pictures, however, were striking pieces of social realism with strong political implications—*The Garroting* (1894, Madrid, Museum of Modern Art) and *The Charge* (Olot, Museu d'Art Modern), showing rioting and a police attack on workers. Casas was a portraitist of exceptional skill: his *The Bohemian* (1891, Barcelona), showing the young Eric Satie, is an icon of the age, and he also produced, in 1901, the most beautiful and accurate drawing of Picasso.

Casas's superb full-length charcoal portraits of Barcelona personalities were famous, and inspired Picasso, then eighteen, to do a similar series, which he exhibited at his first one-man show at the Els Quatre Gats, along with about 135 other drawings and paintings. The show was not a success. Indeed, it was a foolish move, one of the very few in Picasso's career, for his portraits were and are manifestly inferior to Casas's in every respect (both can be seen in Barcelona). He had already been to Paris and in 1900 he challenged Casas in another way by painting his own version of *The Moulin de la Galette* (New York, Guggenheim), a spectacular piece of updated Renoir, again inferior to Casas's restrained study in light and gloom but calculated to make a splash. Picasso visited Paris twice more and had no difficulty in staging shows there, or indeed in selling his works. In 1904 he effectively left Spain for good, partly to escape endless comparisons with Casas, partly to avoid conscription (which he also avoided in 1914, pleading his Spanish nationality).

Picasso was restless, experimental and aware of the importance of change in setting fashions, attracting attention and selling work. He tried sculpture; facial masks; symbolism. From 1901 to 1904 he moved through what was later called his Blue Period, in which his palette was dominated by one colour, his subject matter more or less representational: beggars, prostitutes, prisoners. He tried etchings. From 1904 to 1905 he entered and emerged from his Rose Period, marked by pinkish flesh tints. The autumn of 1905 was the time of the Fauves, led by Henri Matisse (1869–1954), who produced in short order three paintings which made him famous: *Luxe, calme et volupté*, bought by Signac, *La Femme au chapeau*, bought by Gertrude Stein, the rich American who was the den mother of experimental painters, and a large work, *Le Bonheur de vivre*

(Merion, Pa., Barnes Foundation), all of them moving against representational art and notable for bold, simple shapes, strong pure colours and brilliant design.

Picasso had met Matisse, a man as clever as he was and equally anxious to push himself forward by novelty, in 1906 and now saw him as a rival for attention. He responded by making a study of primitive art, both archaic work from the Iberian peninsula and, following Gauguin, native art from the Pacific. The influence of such art we will examine in the next chapter. Its importance here is that it shifted Picasso still further from illusionistic art—that is, trying to paint exactly what he saw— towards shapes of his own imaginative devising. He made crude primitive figures and during 1906 he succeeded in producing a sub-illusionistic portrait of Gertrude Stein, after eighty agonised sittings, which distorted her face into a mask. He followed this in 1907 with a work later called *Les Demoiselles d'Avignon* (New York, MoMA), usually regarded as his most important painting. This reflected first his primitivism, in facial and bodily distortions, second the influence of seeing works by Cézanne, who had been given a special show at the 1904 Salon d'Automne and had been displayed again in 1907, and third a new factor: Picasso's attitude to women.

Picasso was a man with strong sexual drives, whose experience as a teenager had been limited to prostitutes in Barcelona, whom he frequented incessantly. He always tended to see women as objects rather than subjects, let alone partners, and though he formed relationships, and had children, his honoured friendships were always with men. The women in *Les Demoiselles* reflect his memories and sketches of prostitutes he had used and display his contempt for the degradation they had brought on him—that, at any rate, is one legitimate interpretation. He called it his 'first exorcism picture'. Picasso was not a Christian in any regular sense but he was highly superstitious and often feared and practised magic with hairs, pins and signs. The same year, he was introduced to Georges Braque (1882–1963), another experimental painter who had not only made an intense study of Cézanne's technique in producing solidity by placing blocks of colour alongside each other, and by making variations in perspective, but had actually gone to L'Estaque to paint the landscape which Cézanne had used for his advances.

Picasso and Braque are jointly credited with the invention of Cubism. It is likely that Braque produced the intellectual content—that is, the rationalisation that makes squared and linked planes in approximating colours a 'truer' representation of objects than the traditional verisimilitude of drawings, exact colours and scientific perspective. Picasso provided the rest of the kit, including the publicity. His friendship with Braque at this time was very close and they worked together. Braque afterwards described their relationship as being 'like two climbers roped together'. Picasso, on the other hand, later referred to Braque as 'my wife', which to him implied total inferiority and insignificance in art. Not that there was anything sexual in their friendship, though Picasso was quite capable of using his virility to oblige needy homosexuals whose professional help he exacted in return: critics, dealers,

publicists. That explains his friendship with a number of people who pushed his career, such as the writer Max Jacob. To a man from Picasso's background, there was nothing to be ashamed of in such activities, provided he played the 'husband'.

At all events, when Cubism proved popular among the élite, and influential among painters, Picasso was credited with inventing it with his 1907 *Demoiselles*. Stein, who followed it closely at the time, dated Cubism from Picasso's 1909 land-scape, *Reservoir at Horta de Ebro* (New York, private), though his *Three Women* (1908–1909, St Petersburg, Hermitage) also has a claim. The first scientific-historical study of Cubist origins, by John Golding, was not published until 1959 (revised editions 1968, 1988) and awarded the palm to Braque. However, it should be added that, at the time, Picasso's and Braque's works sometimes resembled each other closely, and both men claimed (not necessarily with truth) that they were not sure who had painted which.

Cubism was shortly expanded by many painters, the most important being Juan Gris (1887–1927), another Spaniard but younger than Picasso and treated by him with condescension, contempt and sometimes hostility; and Fernard Léger (1881–1955).

Gris pushed Braque's intellectualisation of the concept further, and really turned Cubism into a coherent 'ism'. Léger tied it to the machine age by making his shapes obviously tubular, cubic and metallic. It had thus become, by 1912, a recognisable phenomenon in art. Obviously, in retrospect, it was important because it changed the whole history of art, for whatever motive—good or bad, rational or irrational, deliberate or accidental. What is much more difficult to discern is why it seemed so important at the time. Though an enormous amount has been written on Cubism, no one has ever explained convincingly why it improved painting, if it did. If the object of Braque was to develop Cézanne's methods of transferring three-dimensional vision to a two-dimensional surface, by breaking up the forms and introducing multi-perspective viewpoints, why is it that, in 1912, he stuck cut-out wallpaper on to a still-life drawing, *Fruit Dish and Glass* (private), the first Cubist *papier collé*? Did this advance Cézanne's search for solidity still further? Obviously not. It was something quite different. Was it because, earlier in the year, Picasso had produced *Still Life with Chair-caning* (Paris, Musée Picasso), in which he stuck oilcloth onto a painted still life—and Braque did not want to be left behind? Late in 1912, Picasso produced two *Guitars*, of paper and string, which were not two-dimensional at all, but plainly three, thus defeating the purpose of the entire operation—if increased 'truth' was the purpose—and he followed this with actual solid 'constructions': his *Guitar* of 1917 (Cologne, Wallraf-Richartz-Museum) and *Bottle and Glass* of 1918 (Paris, Pompidou Centre). From being an 'advance' in representation, Cubism thus became a mere comment on the distinction between illusion and reality.

In any case, there were soon many forms of Cubism. Subsequent analysis has distinguished between True Cubism and Essential Cubism, between Salle 41 Cubists, who include Francis Picabia, Marcel Duchamp, Alexander Archipenko, Ossip Zadkine and Jacques Lipchitz, and the original quartet, Picasso, Braque, Gris and Léger. There is Early Cubism and Late Cubism, going into the 1920s, when it finally fizzled out; Optical Cubism and Primitive Cubism; and another esoteric kind termed Orphic Cubism by Guillaume Apollinaire, a homosexual publicist who had been boosting Picasso (and nearly got the painter gaoled in 1911 when the temporary theft of the *Mona Lisa* revealed a traffic in stolen goods from the Louvre in which Picasso had participated). There is Positive/Negative Cubism, Synthetic Cubism and Analytic Cubism, Constructional Cubism, Faceting or Passage Cubism, and many other forms, all of which have been exhaustively discussed without revealing any clear rationalisation of the phenomenon.

However, Cubism can fairly be classified as the first major instance of fashion art, as opposed to fine art. By traditional standards of measurement, going back over thousands of years in the Western tradition, fine art is a combination of novelty and skill. The novelty must be there, otherwise the work is unoriginal and lacks integrity. But it must also contain skill, otherwise the work is a mere invention, like a new electrical appliance. As we have seen, Ghiberti's bronze doors for the Florence Baptistry

exhibited novelties of great historical significance and outstanding beauty; they also demonstrated the skills of forty years' work at the highest pitch of craftsmanship, involving innumerable recastings to eliminate imperfections. Rodin's *Gates of Hell* and Gilbert's Clarence Tomb, at the turn of the nineteenth to twentieth century, displayed comparable combinations of novelty and skill. All three are unquestionably works of fine art. The distinction between fine art and fashion art is not absolute. All that can be said is that fine art becomes fashion art when the ratio of novelty and skill is changed radically in favour of novelty. That is what occurred with Cubism, especially when Cubism transmuted itself into collage and construction.

It is another characteristic of fashion art that it inevitably produces more fashion art since, when the novelty wears off and the low degree of skill becomes apparent, there is a demand for fresh novelties, and a new phase of art is produced to satisfy it. That is exactly what the different varieties of Cubism supplied. The rhythms of art then become not unlike the seasonal modulations of the fashion trade in clothes, with art exhibitions, as opposed to seasonal collections, to display the latest novelties. Certainly, the connection between Cubism, as practised in Paris, and the fashion business itself was close. As we have seen, the origins of Cubism lay partly in such fashions as Fortuny's cylinders. Still more striking was the way in which the Paris fashion industry quickly reproduced Cubist forms both in its shapes and outlines, and in its patterning. This point was fully demonstrated in an exhibition, *Cubism and Fashion*, held at the Metropolitan Museum, New York, in 1997–98, whose catalogue is worth studying for its ingenious comparisons. Such designers as Lucile, Vionnet of Callot Soeurs, Poiret, Chanel, Doucet, Nemser and Reboux plundered Cubist paintings, especially by Picasso, Braque and Gris, for colours, lines and combinations. It is also notable that Cubism colonised French fashion drawing in such magazines as the *Gazette du bon ton*.

Picasso himself never actually designed women's clothes for the market. But he came close to it because of his theatrical ventures. When the war broke out in 1914, most people in the art world of his generation, including the dealer who had made him rich, Kahnweiler, left for the Front; the war's chief impact on Picasso was that he moved to a new dealer, Léonce Rosenberg. He also began a direct association with the Ballets Russes, producing designs, including Cubist-style motifs, for *Parade* (1917). This was Picasso's first venture into costume art, which he celebrated by creating body-masks for the actors out of Cubist constructions. Jean Cocteau, in this and other ways his mentor in the latest fashionable activities, had adapted *Antigone* for the theatre, and he got Picasso to design the show (1922) in collaboration with the brilliant new *couturier* Coco Chanel. This completed the triangle theatre-art-fashion, which was to remain so strident an emblem of twentieth-century creativity.

The essence of fashion art is change, of necessity; and Picasso changed, as and when the need for fresh novelties arose, or the spirit moved him. Picasso was always a cynical manipulator of associates and the market, but he may also have been perfectly

sincere in his periods or phases, for most artists go through them, and for him, in particular, novelty was a passion—that is why he was so good at it. Having gone through both two-dimensional Cubism and its collage-construction phase, together with a variation of theatrical Cubism, he went through a 'neoclassicist' phase, with themes and images from ancient Greece, as in *Three Women at the Spring* (1921, MoMA). This was at the suggestion of Cocteau, who said the art world needed 'a return to order'— that is, representational art. Picasso, however, had no intention of heeding this exhortation for long; classicism was merely another fashion, and in the mid-1920s he entered his Expressionist phase. This was followed, in the early 1930s, by his Bullfight-and-Minotaur phase, by a fling with Surrealism, another phase of constructions, a phase of works on paper, chiefly etchings, and then a long political phase, coinciding with the Spanish Civil War, and epitomised by his big *Guernica* (1937), which he did at the request of the Spanish Republican government for the Paris Exposition Universelle. All these phases were punctuated by pictures of women which reflected the beginnings or ends of his numerous liaisons,

Matisse designed the altar and the Chapelle du Rosaire in Vence (1947–51) as a personal Modernist apotheosis.

or the battles between rivals for his affections (and wealth). Picasso believed that wars between women stimulated his creative powers. While he was painting *Guernica*, an old-fashioned (by now) Symbolist *pièce d'occasion* condemning a Nazi air-raid in Spain, Picasso was the amused spectator of an angry wrestling match between two rivals, Marie-Thérèse Walter and Dora Maar, on the floor of his studio.

Picasso marked the Second World War by a skull phase. He was also at his most manipulative. Despite his record, and the fact that his work had been condemned in Nazi Germany, he was permitted to work undisturbed at his Paris studio for four years, protected by his friendship with Hitler's favourite sculptor and gifts of his works to powerful people. His fortune continued to grow and Picasso must have been one of the few who emerged from the war richer than he had entered it. He played no part in the Resistance but was none-the-less hailed as a hero by his friends in the Communist Party, which emerged at the liberation in the summer of 1944 as the most powerful single unity in French society, not least in its cultural machinery. Picasso held that anyone, especially artists, who had collaborated with the Nazis and the Pétainiste regime should be severely punished, and at a meeting he called in his studio, he demanded the arrest of numerous people in the art world, including many of his critics and enemies. At the 1944 Salon d'Automne, he was accorded the honour of a special room set aside for his works, and the day before it opened he publicly announced that he was joining the Communist Party. This brought him the benefit, for the rest of his life, of the support of a huge cultural force, which in France alone owned over five hundred newspapers and magazines, some of them important in the art world. It also, in the South of France where he had his principal château, gave him the protection of the local Communist-controlled municipality, an important point for Picasso, who engaged in various illegalities but who had a terror of prison.

In the last thirty years of his life Picasso went through six distinguishable phases, though his later work was regarded by his supporters as less interesting. It is a curious fact that critical attention has tended to concentrate overwhelmingly on his activities before 1914. Indeed the market, reflecting the taste of the art establishment, which from mid-century onwards, and overwhelmingly in the last quarter of the twentieth century, regarded Picasso as the greatest artist since Michelangelo, placed the highest value on his works of 1901–1906, which fetched prices in the 1990s of up to $55 million. Since these were his most representative paintings, a certain mystery remains about the value of his entire *oeuvre*.

Of Picasso's collaborators, competitors and rivals in the field which, from the 1920s, was loosely called modern art, nearly all prospered in the increasingly liberal climate which developed as the century progressed. All of them became rich, if they lived long enough, and even Gris, who died when he was only forty, was wealthy in his last years, able to pick and choose among the countless commissions offered him. The most successful, and highly esteemed artist, after Picasso himself, was Henri Matisse (1869–1954). His delicate but powerful linear style, with pure, flat colours,

proved immensely popular in reproductions, for all purposes, and his various versions of *La Dance* (Moscow, Tretyakov; Barnes Foundation, etc.), and his innumerable nudes, which he called *Odalisques*, to be found in all the leading collections, became emblems of the modern style. He lived mostly in the South of France, and from 1943 at Vence, where he decorated the Chapel of the Rosary as his masterpiece. By then he was regarded, next to Picasso, as the world's greatest living artist—some thought him better—and sometimes his behaviour reflected his status. When he was showing a visitor round the chapel in 1955, with one of the nuns who ran it, Matisse was asked: 'What inspired you to create this wonderful place?' Matisse: 'I did it to please myself.' Nun: 'But I thought you did it for God.' Matisse, after a pause, 'I am God.' Was he serious? Picasso was quite capable of making the same kind of remark, such is the effect of unreserved praise and sycophancy on mortal artists. Picasso, indeed, for the last sixty years of his life, paid agencies to send him clippings, from all over the world, of any publications which mentioned his name.

Braque was badly wounded in the war and found it much more difficult than Picasso to keep up with the endless novelties of fashion art, though his still lifes of the 1920s and his *Oiseaux* (birds) series of the 1940s and 1950s are highly valued by collectors. Léger also lived into the 1950s but stuck to his tubular creations, making circus performers, motorists, cyclists and soldiers look like pieces of steel machinery. Of the minor Cubists, Marcel Duchamp (1887–1968) achieved a big success at the New York Armory Show of 1913 with his *Nude Descending a Staircase*, another emblem of modern art, and then concentrated on construction: he was the first but by no means the last to introduce a urinal as a work of art. He, and many other painters of his kind, are typified by his *The Bride Stripped Bare by Her Bachelors, Even* in the Philadelphia Museum of Art. Francis Picabia (1879–1953), a Spanish-Cuban esotericist, was a founder member with Duchamp of Occult Cubism, sometimes known as Orphism, which was based on a current pseudo-scientific fad known as the Fourth Dimension. He sought to create the Hypercube, a product of cabbala, alchemy and modern hermeticism. Picabia survived to participate in many phases of fashion art, and to invent several of his own.

Jacques Lipchitz (1891–1973) became a highly successful sculptor working for the international market, living in America, and producing simple, transparent shapes and primitive images. His colleague Hans Arp (1887–1966) moved from collage to a kind of sculpture he termed 'creative abstraction'. Amedeo Modigliani (1884–1920), in his pitifully short life dominated by tuberculosis, showed that simplified forms, especially of female nudes, which perhaps owed more to Matisse than Cubism, could be made ravishing. Indeed, he is one of the few painters of this group whose works can be described thus, as opposed to 'significant'. Max Ernst (1891–1976), self-taught but an enterprising figure in the fashion art world, went on from Cubist collage to a technique he called frottage, in which paper is rubbed on an irregular surface to produce patterns which then stimulate the imagination. He also engaged in photomon-

tage, as did several artists influenced by Cubist techniques. The only one to exploit the real possibilities of the camera, however, was the American Man Ray, a pseudonym for Emmanuel Radnitzky (1890–1976), who produced some spectacularly beautiful images he called rayographs.

Being the first form of fashion art, Cubism itself was soon abandoned by all its abler practitioners, who moved on to new styles. By 1930 there was no artist so out-of-date as a Cubist. It had, however, a curious persistence in the works of countless artists of the 1920s, 1930s and 1940s, who wished to paint in a figurative manner but who also wished to identify themselves as modern. This led to an awkward, but to some pleasing, compromise: they did figures from life, often with accurate and recognisable faces, but with tubular or deliberately stocky bodies. In England, first Post-Impressionism, then Cubism, was propagated by the art impresario and critic Roger Fry (1866–1934), who introduced the phrase 'significant form' to defend whatever he liked, such as Cézanne's landscapes and Picasso's collages. Two bodies of artists, the Camden Town Group, formed in 1911, and the Euston Road Group, 1939, perpetuated the stocky-body device, taken to its extreme by William Roberts (1895–1980). It became a prominent feature of the work of Stanley Spencer (1891–1959), a landscape painter of the greatest distinction who preferred to produce huge crowd scenes of religious or industrial events, such as the *Resurrection: Cookham* and the *Resurrection: Port Glasgow* (both Tate Britain), in which vaguely Cubist figures rise from their graves or build ships. Indeed, stocky-body reminiscences of Cubism cropped up right till the end of the twentieth century in the work of Balthazar Klossowski de Rola, professionally known as Balthus (1908–2000), and the Portuguese Paula Rego (b. 1935). All three were fine painters, Spencer a realist, Balthus a symbolist, Rego an anecdotalist (mainly of childhood), but they would have produced better pictures if they had drawn the human form as it is, rather than as seen through post-Cubist spectacles.

Cubism itself bifurcated into two opposing directions: anti-realism or abstraction and super-realism, known as Surrealism. Totally non-representational art had, of course, always played a part in primitive and oriental systems. Only in the Western art tradition had some form of nature been regarded as a prerequisite of any two-dimensional or three-dimensional object before it was considered a work of art. There were exceptions to the rule even in Western tradition. Symbolism, however, had been a systematic move away from realism to forms, and one of its ideologues had justified the process in 1890 by asserting that a picture was essentially 'a flat surface covered with colours arranged in a special order'. If that was all a picture was, then nature did not necessarily have any part in it. Cubism clearly hastened the process towards pure form. The Czech painter Frantisek Kupka (1871–1957) took Cubism to a form of complete non-representational abstraction in 1913, quickly followed in 1914–15 by the Ukrainian painter Kasimir Malevich (1878–1935), who invented a type of abstraction he called Suprematism, contending that pictures

should be composed entirely of geometrical forms, squares, rectangles, triangles, circles and crosses. In 1919 he exhibited in Moscow a white square on a white ground, called *White on White* (MoMA), the first example of Minimalist art, though it was not called so at the time. The equivalent of this movement in Italy was called Futurism, which dated from 1909 and was originally launched by the poet Marinetti, though the Italian Cubist Gino Severini (1883–1966) joined it in 1910.

An exhibition by Italian Futurists was held in 1912, inevitably in Paris, the home of fashion art. The object of Futurism was not strictly abstraction but the presentation of the speed, furiousness, anger, violence and mechanistic nature of modern life. It expressed itself in largely geometrical forms, and some of the painters in the group insisted that the only way to picture reality two-dimensionally was by presenting motion by what they called 'lines of force', a proceeding known as Rayonism. The British variety of this proto-abstractionism was known as Vorticism, invented in 1913 by Wyndham Lewis (1882–1957), an Anglo-American who edited its aggressive journal *Blast* (nearly all these movements had literary attachments and manifestos) and recruited one or two considerable painters, such as C. R. W. Nevinson (1889–1946). The latter produced one of the few memorable paintings to emerge from the First World War, *Les Mitrailleurs* (1915, Louvre), and Lewis in time painted several notable portraits, of Ezra Pound, T. S. Eliot, Edith Sitwell and other literary figures. But in general, these movements, though they were rich in verbal justifications, were poor in providing images that stuck in the mind. Few wanted to look at their pictures twice, the central and abiding weakness of fashion art.

This stricture does not apply to 'pure' abstract art at its best. The first such works were produced by Vassily Kandinsky (1866–1944) in the years 1909–11, and were entitled *Improvisation*, *Composition* and *Impressions* (Hermitage), the last a series which he described as deliberately created from a 'slowly formed inner feeling, tested and worked over repeatedly and almost pedantically'. He was a Russian lawyer who came to art late and was unusually articulate for a professional painter. In 1910, to accompany his works, he produced a book, *Concerning the Spiritual in Art*, which sets out his theory of abstraction and was the main literary source of the school for half a century. Kandinsky wielded a delicate and judicious brush, especially in watercolour, and many of his works give delight. His oil paintings in the Guggenheim, New York, such as *Light Picture* and *Black Lines* (1913) and *Several Circles* (1926), are not abstractions from objects in nature, but absolute geometrical forms, arranged with immense ingenuity and in delightful combinations of pure colour. They thus constitute an art form which is defined, distinctive and intellectually coherent, the only one of the early-twentieth-century categories which has these qualities.

When a collector justifies an abstract painting he has bought, he can do so honestly and logically; when he tries to defend a Cubist picture (except one which had a clear historical importance because of its date), he has to resort to jargon. Equally, perhaps more, important, the artist knows exactly what he is doing in an abstract

work—creating shapes and patterns to delight, excite or move—and does not need to deceive himself. That is one reason why abstract art has remained a permanent part of the repertoire of painting and sculpture, and will continue to do so in all probability, though it has never attracted more than a small minority of artists, at least permanently (Kandinsky himself worked and experimented in many styles). Abstract art is thus fine, rather than fashion, art, and among the abstractionists there have been a number of major, even great, artists.

It is tempting to include Paul Klee (1879–1940) in this group, for in the 1920s he taught alongside Kandinsky in the German Bauhaus and practised pure abstraction-ism there, producing enchanting images in coloured blocks and line which defy description but enthral the senses. They are often witty, as in his famous *Twittering Machine* (1922, MoMA), but to make such points he has to introduce a figurative element, in this case birds. Therein lies the weakness of abstract art, for any skilful painter is bound to be tempted, occasionally, to comment on life by creating an illusion of nature, thereby sacrificing his abstract principles. This is a point Klee does not deal with in his contribution to the brilliant teaching manual, *Pädagogisches Skizzenbuch*, which was produced at the Bauhaus in 1925 and which is the best introduction to modern art ever written.

By contrast, the Dutchman Piet Mondrian (1872–1944) passed through a number

of figurative and semi-figurative styles, including Cubism, to reach pure abstraction, 1917–20, a process he described in his work *Le Néo-plasticisme* (Paris, 1920) and various autobiographical writings, collected together, translated into English and published in New York in 1986. Like Klee's account, they provide useful insights into what modern art is all about, for Mondrian, though often combative and sometimes incoherent, was extremely conscientious in everything he painted and anxious to explain exactly what he was doing. Unlike Picasso, there is no trace of cynicism in his work or behaviour. To him, abstract art was essentially a rationalisation in two dimensions of an artist's intuition. This may be done quite simply, as in *Broadway Boogie Woogie* (1943, MoMA), Mondrian's last statement on the entire subject. Once engaged in his abstract experiments, he never abandoned them but kept himself pure from nature (as he saw it).

That was also true of the best English abstract painter, Ben Nicholson (1894–1982), who came from one of the most gifted artistic families in Europe, and who moved to abstraction, in the mid-1920s, from Cubist Constructionism. He created some beautifully carved and painted abstract low-reliefs, which might be described as a halfway point between Mondrian's high seriousness and Klee's whimsicality, but that would be unfair, for Nicholson was always his own man. A superb example, *White Relief* (1935), is in Tate Britain and Tate Modern in different versions. Sometimes there is a hint of a still life, but in general he kept to the abstract faith pure and unbendingly for over half a century. The fact that his best work is in relief rather than a mere two-dimensional

Henry Moore's *Shadowy Shelter* (1940), a sculptor's exercise in two dimensions, became the emblem of the London Blitz.

surface suggests that pure abstraction is more suited to sculpture than painting. The purest of abstract sculptors, and in one respect the best, was Nicholson's wife, Barbara Hepworth (1903–1975), who came to abstraction in about 1930 and remained there. Her famous wood-carving with strings, a whorl called *Pelagos* (in Tate Modern, which also has her best drawings), epitomises her work: superbly and lovingly carved, spare, smooth, elegant and always formidable in the best sense, even when on a small scale.

Henry Moore (1898–1986) was a greater artist than any other of the abstract sculptors, not merely because he worked on a larger scale but because he had a definite sense of the sublime, as defined by Burke, and a passion and fury which makes his best pieces savagely and sometimes horribly powerful. His abstract faith was never absolute. Most of his work reflects natural forms, usually human. Moore was a big man with big ideas, very strong hands, wonderful eyesight and old-fashioned notions of how art should be created. He thought deeply about what he was going to do, made innumerable drawings until he got the concept right, usually supplemented by elaborate models, in plaster or terra-cotta. He formed strong personal attachments to the stone he used, and to the quarries where it was found, and he was extraordinarily pernickety about the blocks he selected to carve. He was quite capable of abandoning or even destroying a work in its early stages because of imperfections in materials or his own workmanship.

It is significant that, by studying Moore's working methods, you can gain a much deeper understanding of other sculptors, especially Michelangelo and his unfinished work. All this was in such contrast to the usual methods of twentieth-century fashion artists as to constitute a splendid example of how an artist should conduct himself in the modern world. More important, his care and thoroughness helped to explain his eventually huge popularity, often among people who find themselves unable to explain why they are so strongly attracted to a mysterious Moore shape. They intuitively recognise the quality that springs from intense devotion to a craft, and a powerful mind. His *Recumbent Figure* in Honiton stone (1938) has long been the public's favourite sculpture in Tate Britain, and his bronze *Two Large Forms* (1965–70) plays the same role in the Toronto Art Gallery. But Moore's work is seen at its best in the open, under natural light, against a wild or hilly background, and that is why it appears more and more frequently in sculpture gardens.

At the opposite pole to abstraction was the other main development of Cubism, the form of figurative painting which in the early 1920s was called Surrealism. This came into existence on the back of an earlier wartime movement called Dada, the French slang for hobby-horse, itself a version of Futurism. It was invented by a Romanian poet called Tristan Tzara, who got the proto-abstract sculptor Hans Arp (1886–1966) to give it visual substance, in so far as it ever had any. (Arp liked to have a hand or foot, and if possible his head, in all the art-fashion camps.) Dada was pretentious, contemptuous, destructive, very *chic*, publicity-seeking and ultimately pointless.

It did attract the attention, briefly in Berlin at the end of the 1914–18 war, of the gifted German line-artist George Grosz (1893–1959), who moved through the era of totalitarianism and total war with a sharp pen (and a delicate colour sense) which recalled Goya and Daumier, though it had its immediate roots in pre-war Vienna Symbolism. It is now impossible to think of 1920s Berlin except in terms of Grosz's images of horrible capitalists, loose women and crippled war veterans (when he moved to New York in the 1930s these were much less penetrating). He was determinative at the time too, because, having abandoned Dada as unserious, he helped to form a German movement called Neue Sachlichkeit, or New Objectivity, which repudiated all that had happened in Paris over the last quarter-century and tried to depict the modern world in all its moods, including the ugliest.

This was the first attempt—there were to be many more—in the twentieth century to react against modern art, in this case to try to put the clock back to Dürer. Along with much else that was valuable, it went down in the general artistic débâcle which marked the world financial crisis, the slump and the arrival of Nazism, 1929–33. It produced one outstanding painter in Otto Dix (1891–1969), who did what Grosz was trying to do—reform a corrupt and materialistic society—but in oils and on a large scale. His *Metropolis* triptych (1928), a revival of fifteenth-century models (Stuttgart, Kunsthalle) is one of the great paintings of the inter-war period, epitomising the jazz age by using all the new freedoms of modern art, while keeping both the seriousness and humour of the old representational art.

Super-realism or Surrealism was also a reaction to Modernism, though it evolved from Cubism through Futurism and Dada. Like Dada it was originally a literary movement, founded by the French poet André Breton, in 1923–24, as a bastard compound of the new Freudian theories about the unconscious, then becoming popular among the rich, oriental mysticism, a current craze called automatic writing and other fads. As Breton produced three different manifestos, in 1924, 1930 and 1934, all flatly contradicting each other, it may be dismissed intellectually. Indeed in some ways it was a mere publicity stunt, designed to attract media attention and sell books and paintings. As such, Surrealism was characteristic of the excesses which the arrival of fashion art made inevitable. It was intermittently popular in the decade 1925–35, largely because of the work of two audacious and self-publicising operators. René Magritte (1898–1967), a Belgian Impressionist who turned to Futurism during the war, had actually worked in the advertising industry and knew its values. He insisted that his form of Surrealism, which he founded in 1926, was quite different to the French variety, in that it told stories, though not necessarily on rationalist principles. Like the work of Bosch, whom he admired, Magritte's pictures needed interpretation. Thus, *The Threatened Assassin* (1927), displayed at his first one-man show in Brussels and now in New York's MoMA, hints that a murder is about to be committed, though not how, why or of whom. Many of his works were outrageous comments on early masterpieces by David or even Van Gogh, designed to make a splash in the papers. In

1931, Magritte and his brother established a business, the Studio Dongo, which specialised in display stands, posters, advertising formulae and other aspects of the publicity trade. Some of his images stuck: *Liberty Comes* (1930) and *When the Hour Strikes* (1932) are usually cited when the topic of Surrealist art comes up. The truth is, he had been cruelly shocked, aged fourteen, when his mother killed herself, and he sought to shock the world in revenge.

Surrealism took many forms but Magritte's *The Wizard* (1951) illustrates the most enduring.

Even more shameless was Salvador Dalí (1904–1989), an accomplished painter who oscillated between academism and fashion art all his life. A Catalan, first and foremost, and from time to time a Catholic, Monarchist, Republican, radical and ultra-conservative, he first got himself into the news aged twenty, when he was expelled from the Madrid Academy of Fine Art for 'incitement to rebellion', using his notoriety to hold a one-man show of what he called neoclassical Cubist paintings. He learned from photomontage how to transform objects visually and when he adopted Surrealism in 1928 he specialised not only in dream sequences but in painting the metamorphosis of objects such as watches, human limbs, animals and what look suspiciously like penises. This of course was an idea as old as Ovid, but Dalí translated it into paint with a species of ultra-realism which attracted much attention. Hence his *Metamorphosis of Narcissus* (1936–37), now in Tate Britain. Dalí also produced objects, such as his Mae West–lips sofa and his *Lobster Telephone*. They contributed to the general amusement of the 1930s, that 'low and dishonest decade',

as Auden called it, and have been used as sources by countless solid-form artists in the last sixty years.

Dalí had plenty of ideas, like Picasso, and was thoroughly at home in the world of fashion art, both in terms of actual studio performance, and in extra-studio activities, often of an embarrassingly personal nature, which attracted the press and sold his work. Opinions vary on the intrinsic worth of his output, which was large and often highly finished, though curiously unattractive on account of its hard edges and lack of painterly mystery (one of the casualties of the twentieth century was Leonardo's *sfumato* and subtle *chiaroscuro*, which became lost arts). Dalí was not the first but made himself the archetype of the artistic con-men who punctuated the changing art fashions of the twentieth century. It must be said, however, that he lacked Picasso's adamantine cynicism, and was reassuringly hysterical and distraught on occasion. Indeed his bouts of religiosity may even have been sincere, as is suggested by his finest work, *The Christ of Saint John of the Cross* (1951, Glasgow, St Mungo Museum), painted from a viewpoint above the crucifix, which allows us to look down upon the Sea of Galilee. This ingenious image is his legacy, no mean one either, and the one example of sublimity which the entire Surrealist movement produced.

We have now traced some of the leading examples of fashion art as it developed in the decades up to the Second World War. By then, most of the artists who had created it were dead or, like Picasso, exhausted volcanoes. Traditional art had continued throughout this time, though with diminishing self-confidence and hope, as successful practitioners of Modernism became millionaires, and more and more important trend-setters in art, from collectors to museum curators, art critics and historians, swung into the camp of fashion. In France itself traditional painting had virtually collapsed by the 1920s, though one or two romantic painters, like Marie Laurencin (1883–1956), while genuflecting to modern styles, produced beautiful paintings in old styles. Laurencin's female waif-figures in lavender, rose and lime green, with wistful, dark-eyed looks, brought a touch of languid charm into an increasingly grim world, and her portraits, such as *Baroness Gourgand with a Black Mantilla* (1923, Paris, D'Orsay), were highly successful. So were the occasional portraits of Christian Bérard (1902–1949), such as *Cecil Beaton* (1938, private); Bérard in addition produced a notable piece of Freudian realism, *On the Beach* (1933, MoMA), as well as decorative schemes such as in the Left Bank restaurant *La Mediterranée*, which paid him in free meals, all dishes accompanied by *sauce Hollandaise*. The only other realist work of note was produced by André Dunoyer de Segonzac (1884–1974), whose poetical landscapes in watercolour recalled the vanished age of Corot. The sculptors defended academic standards more vigorously, helped by the 38,000 war memorials commissioned by the state in French towns and villages between 1919 and 1935. Their leaders included Paul Niclausse (1879–1958), Paul Landowski (1875–1951) and L.-E. Drivier (1878–1951), and they served an important function in keeping open work-

shops where pupils could be trained in traditional carving and casting skills, which the École des Beaux-Arts no longer taught.

War memorials also kept going the greatest English traditionalist of the twentieth century, Edwin Lutyens (1869–1944). Some were small, such as the famous Cenotaph in Whitehall, a brilliant essay in Greek entasis. Some were enormous, like the giant monument to the missing on the Somme, at Thiepval, 1927–32, an amazing creation to come upon unexpectedly, rising out of the mist, as happened to the author. It is based upon an ingenious and dramatic conjunction of arches and cubes—the greatest abstract work of the time, in fact, though it has reminiscences of Roman arches. Lutyens had been given the lion's share of the architectural work in the creation of the new capital of British India at New Delhi, choosing as his assistant Herbert Baker (1862–1946), who had all his soundness though none of his poetry. Lutyens rightly used Washington, D.C., as his model for the layout of a series of vast government buildings, and in many respects New Delhi is the best of all the new capitals created in the twentieth century. What decisively raises it above all of them, however, and makes the concept a work of genius is the enormous Viceroy's House, with its attendant Legislative Assembly and Secretariat Buildings (the latter owing much to Baker).

This is one of the largest groups of buildings ever constructed and what makes them so extraordinary is that, from whatever angle you survey them—front or back, laterally or diagonally, near-to or at a great distance, even from above—they keep the integrity of their design and their elegant monumentality. Lutyens rightly rejected pleas that they be built in 'Indian style', as there was no such thing, though he brilliantly incorporated many vernacular details, particularly on the roof-lines. Fundamentally, however, the Viceroy's House and its appendages are in the European classical tradition of domes, colonnades (for which Lutyens invented a New Delhi order) and vistas. The whole is beautifully crafted and made with a high degree of skill throughout, from the ceremonial staircase down to the last stable window. Despite its Indian setting—and the 10,000 monkeys who now live in and around it— it is the last great European masterpiece in the classical tradition, as amended and improved over 2,000 years, the final statement of what European civilisation, at its best, is all about; and also, of course, England's last gift to the Indian multitude, who have the finest government buildings in Asia, likely to remain so for a millennium.

Lutyens was a perfectionist who was often frustrated by bureaucrats, both secular and ecclesiastical. Sometimes, as in the British Embassy in Washington, he was able to carry out his original concept down to the last detail, and this delightful building creates an easy-going country-house atmosphere amidst much monumental squalor in the embassy quarter. Sometimes he was totally defeated. The Roman Catholic cathedral he began designing in Liverpool in 1929, in competition with Sir Giles Gilbert Scott (1880–1960), who was building a late-Gothic-Revival-Romanesque cathedral for the Anglicans a few hundred yards away, was to have been his finest building. The model survives and shows a classical basilica with a dome much bigger

than St Peter's and the alternation of cubes and arches in the Thiepval style. The crypt was actually constructed and remains a marvellous subterranean cathedral in itself. The rest was cancelled by the Catholic hierarchy in a fit of post-war panic, and a makeshift Modernist building, known locally as Paddy's Wigwam, was put up instead. This meanness, so uncharacteristic of Catholics through the ages, deprived England of what would have been Europe's greatest twentieth-century building. The Scott cathedral was eventually completed in the 1980s, and a marvellous piece of work it is, the last whisper of the Middle Ages, strong, purposeful and of generous size, its internal details worked out with immense skill and executed with exemplary craftsmanship. The thought that it could have been confronted by Lutyens's even larger basilica, two immense cathedrals in totally different but congruent styles, facing each other across a sea of rooftops in a vast industrial and commercial city—the only such duo in the world—is too painful to dwell on: the cancellation was perhaps the most bitter artistic tragedy of the modern age.

British painting has no such star as Lutyens. But it had many fine artists, for until the Second World War and even into the late 1940s, the Royal Academy defended tradi-

Lutyens's doomed masterpiece, Liverpool Catholic Cathedral (1934), with a dome larger than St Peter's, survives only in its crypt and its wooden model.

tional standards of excellence, both in its schools and its exhibits, and up to mid-century there were many schools, national and local, which taught the skills of drawing. But there was a fading sense of purpose, in face of the encroachments and hostility of fashion art. In the early years of the century, Sir William Nicholson (1872–1949), father of the abstract painter, produced some of the finest coloured lithographs ever made in England, including memorable images of Queen Victoria and Max Beerbohm, and some of his landscapes in oils were strange and unforgettable. But he failed to find the right subject matters to engage all his energies. That was a common weakness in the British Isles. Great hopes were entertained of the young Augustus John (1878–1961), a superlative draughtsman, but he frittered away his talent painting gypsies, in a vain attempt to introduce colour into modern life, a common error at that time, and he is now remembered chiefly for portraits, such as his striking *Madame Suggia* (1923, Tate Britain), the cellist. His quiet sister, Gwen John (1876–1939), did better by concentrating on cats and still life, which she painted slowly and exquisitely in pale colours; she appears to have starved to death in France at the beginning of the Second World War.

The most gifted of the painters working in London was William Orpen (1878–1931), who could do almost anything with his brush, and produced one of the few great paintings to emerge from the First World War, *The Signing of the Peace Treaty at Versailles* (1920, London, Imperial War Museum); this ranks alongside Sargent's *Some General Officers of the Great War* (National Portrait Gallery) as the last masterpiece of official art, a category which has since disappeared. Orpen produced some magnificent portraits, and the best nude since Zorn, *Morning* (1918, private), but he never found a subject matter to match his talents. Walter Sickert (1860–1942) also took refuge in portraits and did some memorable ones, such as *Lord Castlerosse* (1935) and *The Sea-Captain* (1938), though his reliance on photographs was blatant. He was more effective at striking a mood in a dingy background—his *Ennui* (1924, Tate Britain), depicting a bored suburban couple, is one of the most adhesive images of these years. Henry Lamb (1883–1960) was a draughtsman of exceptional skill whose portrait drawings were almost on a level with Ingres's. In 1914 he produced the most striking oil portrait of this epoch, the elongated Lytton Strachey lounging in an armchair (Tate Britain), but he disliked such work without finding a satisfactory alternative.

For the British, portraits and landscapes formed the only resource when inspiration failed. There was however a group, led by Graham Sutherland (1903–1980), who may loosely be classified as the Neo-Romantics, drawing on the tradition of Blake, Palmer and the Pre-Raphaelites. Sutherland was a fine painter, whose spiky and almost Surrealist landscapes did not do him justice, and he finally retreated into portraiture where he did very well, producing fine if eccentric images of Somerset Maugham (1949, Tate Britain), Lord Beaverbrook (1950, Fredericton, NB, Beaverbrook Art Gallery) and Winston Churchill (1954), the last of which survives only in photographs since the statesman's wife destroyed it. The most effective of the Neo-

Romantics, at least for a time, was John Piper (1903–1992), whose transformations of ruins and country houses, churches and monuments into poetic images got him recognition, if only because everyone knew what a Piper was. That was also true of another romantic, Rex Whistler (1905–1944), who knew exactly what he wanted to do: *capriccios*. He created the finest since the eighteenth century, at Plas Newydd in Anglesey, 1938, before the Second World War killed him. Another romantic, Paul Nash (1889–1946), tried Cubism and Surrealism before retreating into landscape. He produced some memorable wartime images of the Battle of Britain, comparable in quality to Henry Moore's Blitz drawings, such as *Vapour Trails* (1940) and *The Dead Sea* (1941), showing the wreckage of German aircraft; both these works are in Tate Britain, which has a large collection of Nash's best landscapes.

Two other painters of this group who produced fine landscapes were Ivon Hitchens (1893–1979), who worked in the Sussex countryside, like Palmer, and John Minton (1917–1957), who painted the West Country. However, it must be said that the best and most consistent landscapist of the first half of the twentieth century in Britain was the Scotsman James McIntosh Patrick (1907–1998), who led a solitary existence in and around Dundee, painting farms, and whose work is only just beginning to be appreciated. Surveying this rather meagre field—meagre not so much in talent (there was plenty of that) as in determination and a clear sense of direction—it is not surprising that younger painters, round the middle of the century, felt they had no realist leader to follow, and that to get recognition, and earn a living, it was easier to engage in fashion art.

The picture in the United States was quite different, for America is a big country, with vast regions and endless opportunities for polycentrism. It also developed, in the twentieth century, not only the largest art market in the world but one larger than all the rest put together, purchases coming not merely from private collectors and hundreds (eventually thousands) of public institutions but from corporations who, as the century progressed, increasingly engaged in art patronage, often on a generous scale. It was possible, therefore, for fashion art, both foreign and American versions, to be accommodated in all its growing amplitude, and for the market still to have room for every variety of realism. America was a self-confident society too, and this was reflected in the purposeful individualism of many artists, who were not always looking over their shoulders to see what was happening in Paris. Many of them realised that their most important task was to portray life as it was actually lived or seen in their country during the twentieth century—the American century as it was called from 1938 on—and that gave them a constant supply of subject matter.

In the early years of the century, some notable survivors of the nineteenth century were still active. One of them was Childe Hassam (1859–1935), who settled in New York and became its portraitist. He actually produced a book of reproductions of his work, *Three Cities* (1899), a superb compilation, comparing his visions of

London, Paris and New York; but it was the last to which he devoted much of his life, becoming the outstanding cityscape artist of the modern age. He worked in oils, watercolour and on copper, and although his famous *Allies Day 1917* (Washington, National Gallery) is the best-known of his skyscraper and avenue pictures, there are many better ones, including some sparkling night scenes. Hassam's New York, indeed, as a collective vision portrayed over many decades, comes close in accomplishment to Bierstadt's mountainous west or Church's northeast. It inspired other artists too.

Georgia O'Keeffe (1887–1986) was a woman of dazzling talent, much helped by the fact that she married (1924) the owner of New York's most enterprising gallery in the 1920s, Alfred Stieglitz, who saw it as his mission to promote a specifically American art idiom. O'Keeffe, having worked her way through various forms of European fashion art, and taken up photography, used what she had learned to make a spectacular series of skyscraper pictures, based on the light distortions produced by the camera lens. They include three masterpieces, *New York Street with Moon* (1925, Lugano, Thyssen-Bornemisza Collection), in which the areola of a lamp-standard illuminates dark skyscrapers under a threatening sky; *The Sheldon with Sunspots*, done the following year (Chicago Art Institute), where the sun, about to disappear behind a skyscraper, provides dazzling light; and the even more adventurous *City Night* (1926, Minneapolis, Institute of Arts), with foreground skyscrapers in semi-darkness, and the middle-distances moonlit, a daring concept brilliantly executed.

Georgia O'Keeffe's, *White Flower on Red Background* (1950) provided a naturalistic alternative to mechanistic Modernism: 'the Lady of the Curve'.

These works established O'Keeffe as a major artist, and she moved on from them into penetrating studies of plant and vegetable life, and new kinds of flower pictures, using modernist techniques to some purpose, and creating beautiful visions which, in the twenty-first century, seem just as startling as when painted fifty years ago. Moreover she inspired others. Charles Sheeler (1883–1965) had painted his first sky-scraper picture as early as 1922 but they were generalised images from photographs. He learned from O'Keeffe how to tilt, light and select, and eventually produced images which were even more exciting and dynamic than hers, culminating in *Windows* (1952, private), which produces sensational light-effects and distortions by placing the eye within the window system of one skyscraper and looking outwards at others. No other painting gets the essence of twentieth-century America quite so neatly.

Sheeler, who worked as a freelance photographer and film-maker as well as an artist, was commissioned by business magazines to investigate the visual possibilities of modern power and industrial plants. The result was some of the finest paintings of the century: *American Landscape* (1930, MoMA), which shows the Ford Motor Company's plant near Detroit—a brand-new factory turned into a vision of tranquil beauty; *Upper Deck* (1929, Harvard University, Fogg Museum), showing the ventilator system of the liner *Majestic*; and, most remarkable of all, *Suspended Power* (1939), showing a giant turbine being lowered into position at a Tennessee Valley Authority hydroelectric plant in Alabama. What is so interesting about these works is the way they show

painting transcending photography (which became a mere aide-memoire) by eliminating clutter, simplifying light-systems, organising the composition and its space and, above all, by inserting moral and aesthetic language. But these are paintings about machinery and buildings: people are mere staffage, as in Canaletto or Piranesi, whom Sheeler resembles in some key respects.

People, however, emerge strongly in the works of three notable artists of the first half of the twentieth century. The earliest important American work showing people faced with the predicament of modernity dates back as far as 1880, when Thomas Anshutz (1851–1912) painted a striking work, *Ironworkers' Noontime*, showing what young men did in their steel-mill dinner hour. He

Charles Sheeler showed how industrial gigantism could be turned into high art in *Suspended Power* (1939).

was followed by the powerful and versatile artist George Bellows (1882–1925), who just before his early death had painted some enthralling sports scenes, including prizefighting—*Ringside Seats* (Washington, Hirshhorn Museum) and *Dempsey and Firpo* (New York, Whitney Museum of American Art). He did some superb lithographs to publicise the YMCA, such as *Shower Bath* and *Businessman's Class, YMCA*, and one of the best paintings of the period showing what it was actually like to live in an O'Keeffe skyscraper, *Cliff Dweller* (1913, Los Angeles County Museum of Art).

Following in Bellows's wake, as a painter of American realities, was Edward Hopper (1882–1967), perhaps the greatest representational artist of the first half of the twentieth century. He came from the Hudson River, studied illustration at the New York School of Art (an excellent training) and then went to classes given by the famous portrait painter William Merritt Chase. (Hopper said he learned nothing from Chase but it is evident he learned much, including what not to do and how not to do it.) He went to Paris and rightly picked the one master who could help him most, Degas. For years Hopper lived as an illustrator until, almost by accident, he picked up watercolour technique, which he had hitherto rather despised as 'poster work'. He painted *The Mansard Roof* (1923, Brooklyn Museum), one of a series of roofscapes in the American idiom, moved to Gloucester, Massachusetts, taking up where Homer had left off, and in 1925 produced a famous oil, *House by the Railroad* (MoMA), in which he placed a typical old-style American house, in painted wood, next to a thrusting, incongruous rail track. Hopper showed that what is most important in making a great artist is not just clarity of vision, which he certainly possessed from the start, but intelligence and sensitivity, which he learned how to apply. They enabled him to grasp two things. First, that a commonplace object, like an out-of-date house, can arouse intense emotions, not always definable but none-the-less poignant. He applied this again and again to American roofscapes, townscapes and landscapes. Second, he appreciated that amid all the teeming activity and cosmopolitanism of American life, the predominant feeling, at times and for many millions, was loneliness.

Hopper's imaginative skills enabled him to treat the problem of solitary existence in unusual and penetrating ways. In 1927 he painted *Two on the Aisle* (Toledo, Museum of Art), showing an empty theatre, with one lady already sitting in a box, and a couple just arriving. *Early Sunday Morning* (1930, Whitney), has no figure at all; no one is up yet. Yet this street of shops, with accommodation above, does contain people behind its lace curtains. The early hour is indicated by the low angle of the shadowing, which provides the dynamism of the picture. In 1940, Hopper showed a solitary attendant working a petrol pump. It is night-time; the road is empty; the picture is lit by artificial light; the surrounding forest is dark and dense. It is called *Gas* (MoMA). No one had ever thought to paint a service station, to many the epitome of modern ugliness, yet one of the commonest sights in a modern country, and in its own way horribly potent. Hopper liked to dwell on, to emphasise, sights which an artist would traditionally dismiss as too ordinary to be significant, but which he

invested with meaning. In 1942 he painted *Nighthawks* (Chicago), a midnight urban exterior which, like a De Hooch, contains three different lighting systems, cleverly juxtaposed, because though the eye-point is in the street, the line of vision leads through the window of a night café, and then past its interior into the street beyond. The lit interior actually serves to emphasise the loneliness, shared by a couple who sit at the counter, looking straight ahead, unspeaking, the solitary cook, and a man seen from the rear, his hat crammed on his head, only a tiny portion of his face showing.

In 1953, Hopper reversed the light to get a glaring summer day, showing *Office in a Small City* (New York, Metropolitan), where a solitary clerk is seen from an adjoining building, and the viewer looks through the window into the office, then through it onto the roofscape. *Hotel Lobby* (1943, Indianapolis, Museum of Art), is a superficially simple interior, where three separate figures are waiting, the distancing which underlines the loneliness being skilfully provided by the electric lighting. Hopper's works, at their best, have three characteristics: a great deal of thought and ingenuity goes into their composition; he never tugs at the viewer's emotions or makes an obvious political, social or even aesthetic point; he understates. What he does is to interest the viewer, pull him into the painting and make him think for himself.

One of the main differences between fashion art and fine art is that the latter, if it is good, tends to last, both in time and in the viewer's attention—he is glad to return to it repeatedly. But in order to make the viewer work, the artist must work himself. Fine art cannot be dashed off. An outstanding example of the value of work, and attention to detail, in creating a memorable image, is the 1930 icon painting, *American Gothic* (Chicago) by Grant Wood (1891–1942). Wood had a varied training in America, under exponents of the Arts and Crafts movement, and was yet another graduate of the Académie Julian. He was taught to be thoughtful, systematic, and to work towards the finished painting stage by stage. In the case of this picture he applied the procedure to an unusual degree and with great thoroughness. His work on a memorial stained-glass window led him to make a trip to Germany where he studied late medieval architecture and painting.

Wood came across a building near his home in Cedar Rapids, Michigan, which had nineteenth-century Gothic Revival windows. At a time when many people in Iowa were leaving the poor life of the country to get higher wages in the city, he decided to paint a picture which emphasised the austerity and dignity of rural life. So he changed the building into a farmhouse. Then he did extensive picture research to discover what an elderly farming couple would have worn, perhaps a generation or even two generations ago. He dressed his sister, Nan, accordingly, and borrowed the local dentist, a man called Dr McKeeby, to pose as her farmer husband. The picture involved many preliminary drawings before the composition was judged right, and the actual painting, as anyone who examines it carefully will testify, is meticulous and sure. *American Gothic* enjoyed immediate and immense success, has remained the most

Morning at Cape Cod (1950), a characteristic Hopper exercise in suspended time, total stillness and loneliness.

popular single work in the Chicago Art Institute, and has probably been reproduced more often, and for a greater variety of purposes, than any other American painting of the twentieth century.

Another such case was provided by Norman Rockwell (1894–1978), who like Wood had been well trained, at the Chase School of Fine Art, the National Academy, the Art Students' League and a Paris school, the Académie Colarossi. Although he worked as a full-time professional illustrator as early as 1916, when he designed his first cover for the *Saturday Evening Post*, he repeatedly went back to school to improve his technique. Rockwell was an unusually simple, humble, unpretentious and unaggressive man, who delighted in draughtsmanship and all the procedures of painting—picking the subject, finding the location, choosing models, preliminary sketches and photographs, getting props, changing the composition in the light of drawings and oil sketches, and working on the actual finished painting itself. He never wanted to do anything else except paint *Post* covers, of which he did nearly four hundred over five decades. As he had to meet exacting schedules, and work extremely fast at them, he was forced to discipline himself to a degree unusual

in artists. He was also markedly self-critical, and quite capable of changing the entire design at the last minute, as we know he did on several occasions.

Rockwell's *Post* covers became so famous, and the detailed way in which he worked so notorious in an age of fashion art, that he was constantly photographed and studied and filmed at work, so we know exactly how he produced his covers. During his *Post* career, and in other works—his output of graphics was enormous— he covered the entire spectrum of American life: urban and rural, metropolitan and provincial, black and white, poor and rich—though predominantly middle class, the sector he knew best—and all kinds of trades and professions: barbers, railroad men, schoolteachers, factory workers, editors, soldiers and marines, sailors and shopkeepers, politicians and clerks, garage mechanics and students, men, women and children of all ages, and a fair sprinkling of clergymen, even an occasional artist. It is hard to think of any other artist, of any nation or at any period, who painted, in such meticulous detail, so wide a selection of scenes, each carefully researched.

Jan Steen, the painter Rockwell most resembles, was far more limited; so was William Frith, the great Victorian depictor of scenes like *Derby Day* and *The Railway Station*. Honoré Daumier probably comes closest to Rockwell's range, though even

Dutch genre transmuted into mid-twentieth-century America: Norman Rockwell's *Hasten the Homecoming/Buy Victory Bonds* (1945).

he allowed his obsessions—the injustice of the law, the excesses of feminism, the wickedness of Louis Philippe and his ministers—to give him tunnel vision at times. Rockwell had no prejudices, no obsessions, no politics, no particular preferences: he liked American life in all its variety, and portrayed it with all the fidelity in his considerable power. In doing so, he created a dozen or so memorable images, and a huge documentation of visual fact, which will still be examined in the fourth millennium as a record of American life centred round the second quarter of the twentieth century.

Rockwell was simple but not unsophisticated. Although his work appears to be totally accessible, it actually contains hidden references, jokes, jokes within jokes and sly philosophical points. His famous wartime industrial heroine, Rosie the Riveter, is a pastiche of a Michelangelo figure from the Sistine Ceiling; one of his most complex covers, *Shuffleton's Barber Shop* (1950, Pittsfield, Berkshire Museum), neatly employs a quadruple lighting system which makes De Hooch—and Hopper for that matter— seem an elementary practitioner of the art. Rockwell was a master of the interior, like Sargent and Lavery, and often employed his skill on massive buildings, like New York's Grand Central Station, which forms the background for one of his greatest Christmas covers. There can have been few artists, during a century in which fine art was in headlong, and often ignominious, retreat, who devoted such care and passion to maintaining and improving skills.

Rockwell has not been denied popular recognition; far from it. His studio in New York State has been turned into a place where his working methods can be studied, and it is now probably the most popular private museum devoted to an individual artist in the entire world, whose attendance figures rise steadily. But he gets scant mention, if any at all, in the art history books. The reason for this academic and critical neglect is identical with the cause of his continuing popularity; in most of his works everyone can see exactly what he was trying to do, and there is no need for mediation by a critical interpreter. He almost defies comment. It is held against him that he took too optimistic a view of life. But the same could be said of Rubens, another painter who was happy in his work and showed it. Art does not have to disturb. It can, quite legitimately, be reassuring, comforting, consoling. Rockwell is also accused of sentiment, indeed of sentimentality. But that too is a characteristic of Della Robbia and Raphael, of Correggio and Guido Reni—and many other fine artists. The hostility of the art establishment towards Rockwell in the second half of the twentieth century tells us a lot about the prevailing wisdom of those times. We will have a fairer assessment of him when the twenty-first century is over.

By mid-century, then, representational art was fighting a difficult battle against fashion art in the United States, and losing it elsewhere. But whether art should be about reality or fashion was only one of the questions which artists faced. There was also the role to be played by two other, extremely powerful, factors: primitivism and ideology. We shall now examine both in turn.

30

THE RESURGENCE
OF THE PRIMITIVE

An important factor in twentieth-century art was the growing interest in forms of culture outside both the Western tradition and the historic cultural system of Asia. As we have seen, serious interest in, for instance, pre-Columbian art goes back to the seventeenth century. But the Modern Movement really begins in the mid-eighteenth century, when both the French and British governments sent scientific and cultural expeditions to the Indian and Pacific oceans. These were geopolitical moves too, and in Britain's case the voyages of Admiral Anson and Captain Cook, conducted by the Royal Navy, led directly to the occupation of Australia, New Zealand and many of the Pacific islands. Popular interest came much later, stimulated by the writings of the great Scots novelist, Robert Louis Stevenson (1850–1894), a victim of tuberculosis, who lived in the South Pacific from 1888 to his death and wrote extensively about it.

Stevenson's picture of the Pacific as a paradise invaded by the serpent of the West stimulated the interest of Paul Gauguin (1848–1903), one of the most powerful personalities in French art during the last two decades of the nineteenth century. His personal form of Symbolism, figurative distortions, non-natural use of colour and aggressive radicalism (his father was a campaigning journalist and Gauguin himself was an expert at self-advertisement), made him a talisman of the young. His original motives in going to the Pacific, first to Papeete and Tahiti in French Polynesia, 1891–93, then again to Tahiti and the Marquesas Islands from 1895 to his death, was not so much to paint there as to find Utopia for himself. He discovered no such place—on the contrary, his Pacific years were marked by poverty, rows with the local authorities and great unhappiness. But his paintings of local life, and especially of the Pacific women, were immensely successful when seen in Europe and North America, having a decisive impact when a retrospective exhibition was held in Paris in 1906, three years after his death.

Gauguin had been interested in primitivism before he went to the Pacific. He carved a number of free-standing statues and objects of wood, and high- and low-

THE RESURGENCE OF THE PRIMITIVE

reliefs, and made ceramics, modelled on primitive art-works he had seen in Paris museums. The best of them, *Be in Love and You Will Be Happy* (Boston, Museum of Fine Arts) dates from 1889. But his Pacific experiences strengthened the perception of primitive innocence corrupted by Western civilisation, a concept going back to Rousseau in the eighteenth century but powerfully reinforced by the late-nineteenth-century anger of artists at the ugliness of modern machine-society. Much of his Pacific symbolism was directed towards contrasting primitive beauty with modern horror, as in *Savage Tales* (1902, Essen, Museum Folkwang), or questioning fundamental Western values, as in the work described as his 'last will and testament', which he entitled *Where Do We Come From? Who Are We? Where Are We Going?* (1897, Boston). Gauguin was a self-indulgent scoundrel as well as an idealist, but he asked questions which many artists put to themselves in the early twentieth century. One of the answers they provided was to return to nature: not nature as such—that had been done, the Impressionists and the Naturalists providing alternative versions—but nature as seen through the primitive and innocent eye.

Hence, in the first three decades of the twentieth century it became fashionable for artists to visit such places as the British Museum and the Musée d'Ethnographie in Paris (later the Musée de l'Homme) in search of primitive inspiration. One of the leading avant-garde artists of the decade 1900–1910, Maurice de Vlaminck (1876–1958), collected African art. Picasso visited the Ethnographical Museum just before he painted the *Demoiselles d'Avignon*, and other artists, such as Emile Nolde, actually went through a primitivist phase. Joan Miró studied Eskimo masks, Brancusi got inspiration from New Zealand Maori carvings and Alberto Giacometti copied Polynesian forms. About this time there circulated drawings and even photographs of giant heads found in Easter Island, one of the most remote human settlements in history,

Where Do We Come From? Who Are We? Where Are We Going? Good questions, posed by Gauguin in seeking the primitive to solve the problem of what art should do next (1897).

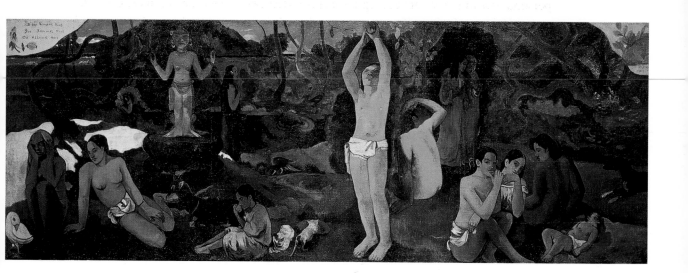

over a thousand miles from any other territory and, since 1888, claimed by Chile. These fascinated Max Ernst and were one of the stimulants to his creation of Surrealism. But it was one thing to use such objects to push forwards (or backwards) Western art: quite another to study them as artistic expressions in their own right. That took longer.

Easter Island is a case in point. Despite the astonishing nature of the finds there, no thorough study of them took place until the 1950s, when a Norwegian expedition, under Thor Heyerdahl, conducted a survey. These huge figures, or *moai*, created by primitive tools from soft volcanic tufa, have come to symbolise all that is grandest and most sublime in primitive art. Easter Island is not quite so hard to get to as it was, but for those who cannot go, there is an example in the British Museum (unusually, in hard basalt) which conveys all the brilliant stylishness and dramatic monumentality of these uncompromising versions of the human figure. The bodily and facial distortions are similar to those being worked out in Europe between 1905 and 1925; they are not reactions—there was nothing to react to—and they have a sincerity and unselfconscious genius not to be found in Western modern art. They were created between about 1000 and 1500 AD, appearing, flourishing and disappearing for reasons we do not know and probably never will. The British Museum specimen, one of the best in form, is only about 10 feet high. It was found in a cave in 1868; its location, and hard-stone strength, means it has not been eroded by the high-velocity Pacific rain-winds. Others have suffered, and it is tempting to institutionalise all of them; but the exposure on the barren hillside is part of their sublimity.

In New Zealand, which had been occupied by Polynesian canoe-invaders since about 900 AD, the focus of Western interest, from the early nineteenth century, was on art objects entered on customs manifests as 'Baked Heads'. They were the heads of enemies, severed, heavily tattooed, then cooked, stuffed with flax, and usually sold to Europeans in exchange for firearms. The heads of defeated chiefs were particularly elaborate, but naturally in short supply, and to meet Western demand (all museums were eager to have a selection of heads), slaves or other low-born persons were killed and decapitated. So the missionaries banned the custom, known as *moko*, as soon as they took over the islands (the first expedition landed

Life-mask of a Maori chief, showing the full facial *moko* design, dating from 1854. 'Tattooed heads' were swopped for guns.

there in 1814), as part of their campaign against cannibalism. The last *moko* heads date from the 1860s. *Moko* as an art form, including tattooing of the living, was carried out on an enormous scale and for a variety of religious-ritual purposes. Art tattoos denoted high rank and achievement, though when less elaborate they merely marked adult status. They were executed by highly skilled professional artists, known as *tobungas*, women as well as men, who used skin-chisels and operated under a complex series of art rules. For men, the tattooing covered the face, buttocks, hips, groins and thighs down to the knee, and sometimes the shins and feet.

The tattooing took place at intervals throughout a lifetime, so that an elderly man might be a complete work of art, often his face being enhanced by tattooing to bring out its more distinguished characteristics. A woman was not permitted a face tattoo unless she were a distinguished warrior in her own right, with a collection of chief-heads to her credit. As a rule, women were tattooed only in the chin area, upper lip and nostrils, the lines beginning there and travelling down to the shoulders and as far as the groin—genital tattoos, for both women and men, were unusual but a mark of distinction. The pigments, made from the soot of burned trees or fungus, were mainly dark blues and greens, and the decorative motifs were abstracts, such as spirals, whorls and cubes. The affinities with twentieth-century European art are disturbing until we remember that decorating the body was almost certainly the earliest form of all art (as we have noted) and clearly reflects a profound human urge to enhance natural beauty, dignity or fearsomeness.

Among the Australian Aboriginals, a people who arrived there at least 40,000 years ago, body art, including painting, tattooing, scarring or cicatrisation, was certainly the earliest and, until the Europeans appeared on the scene in the 1780s, the dominant form of art. Designs covered the chest, arms, shoulders, back and legs down to the knee (sometimes below it). The forehead was also used as a design area. (The past tense is used though this form of art is still practised in some parts of Australia.) The art had three purposes. First, enhancement of attractions: a man or woman was in a sense a walking art gallery, and the art was a form of wealth as well as an expression of beauty. Second, scarring or tattooing was used to record events, such as birth, marriage, the death of a wife, husband, parent or child, and other biographical landmarks. Thus an Aboriginal, especially a man, was a walking epitome of his career, rather as a Turkish grandee, until the sumptuary reforms of the 1840s, wore carefully designed clothes which advertised his *curriculum vitae* for all to see and admire. The idea of man as a painting, not only of himself but of his past, is clearly ancient, and it may be that early Europeans, even before they learned to decorate rock surfaces as canvas with representations of themselves and the animal world, were like painted books, in which their neighbours could read their progress through life.

In addition to biographical material, aboriginal body art also includes landscape: incisions and scarrings representing symbolically the characteristics of the

region from which the person comes. This form of decoration is linked to the mythological religion known as the Dreamings, and topographical scars often mean a special relationship between the person bearing them and mythical ancestors, known as Munga-Munga. However, it is important to realise that permanent scarring or identity art was, and to a great extent still is, supplemented by ephemeral body art for rituals and dances. On such occasions the participants assume the personality of a Dreaming creature. Hence the painting is part of the ritual, and takes place in the course of an entire day, accompanied by music and the chanting of Homeric-style legends. The body is depilated, scraped and covered in red ochre. Yellow ochre, black manganese or charcoal, and white pipeclay—and more red ochre—are then applied with brushes made of twigs, roots and stems (though human hairbrushes are also used in some places). Animal down, white cotton, birds' down and other white substances are applied to the ochre base, using human blood as adhesive. The pattern area embraces chest and stomach, the tops of the arms, and the thighs and buttocks, and is complemented with a tall headdress of the same patterning.

Careful examination of these dance-decors has revealed literally thousands of different patterns, relating to specific persons in the Dreamings, myth-happenings or actual events. Thus the actors in these ceremonies are the walking equivalents of Ulysses and Achilles, Jason or Hercules. A different, less elaborate, set of dance-decors is used for women's ceremonies, and yet a third for secret women's rites to which men are not invited. In these last, paint is supplemented by articles of clothing, themselves painted or decorated with beads and feathers. Strictly speaking, most Aboriginal body art is abstract, since nature is not directly represented even in the topographical information—all is symbolic. Yet in another sense, none of it is abstract, as each pattern, each line indeed, has meaning, which is known to the adult viewer or initiate.

The French, whose introduction to Africa came via the Maghreb (Algeria, Tunisia, Morocco), noticed biographical body art among the Tuaregs and other peoples as early as 1800. The African continent provides literally hundreds of different art systems, involving paint, incisions and gougings of great depth, and artistic scar-creations. This kind of art takes quite distinct forms. First, enhancement of natural good looks. Among the handsome Fulani of Senegal, there are regular Gerewols or festivals celebrating masculine beauty, charm and endurance. Dances last many hours and those performing them are not allowed to show fatigue (the judges are women). The men are elaborately dressed, and their body-paint is designed to display clear eyes, white teeth, huge smiles and straight noses, as well as beautifully formed limbs. As a result these young men, when painted, look like those attending a transvestite ball in San Francisco, though their clothes and adornments are emphatically masculine. Androgynous, cross-sexual and reverse-sexual body art is quite common in parts of east and central Africa. In the zone between the Saharan and Sudanese deserts and the tropical rain-forests, body art is particularly elaborate, and always has been (so far as we know), though in the twentieth century it was often concealed under clothing.

Among the Yoruba, where scarification of great complexity is practised primarily for aesthetic reasons, the legend is that Sango, the first ruler of Oyo, punished one of his slaves for negligence but found that the scars which formed were so beautiful that they were adopted by his entire royal household. In most cases, elaborate facial scarring is a form of aristocratic lineage identification, rather like a family tree or form of heraldry. In its most elementary form, it consists of incisions on a child's stomach of signs indicating its father's name (sometimes its mother's too). Until recently, the more markings carried by a person, man or woman, the more likely it was that such a person was well-born, rich or of peculiar accomplishments, hereditary or acquired. Slaves carried no markings other than those indicating their servitude.

From south Nigeria to Zaire, art systems involving the raising of lumps of skin and flesh to form patterns, known as keloid markings, are or used to be common, taking place in six stages among females, beginning at age five. They signified not just beauty but spiritual intervention. Early photographs (for instance, in the archives of the Missionaries of Our Lady of Africa, Rome) show these dowry markings in the most astonishing, and to us horrifying, form. Keloid marking is now frowned upon by authority—that does not mean it has disappeared, merely that it is less visible—but tattooing continues all over Africa. It is clearly one of the earliest art forms. Scarified hatches or razor tattoos were found on a skin from a Middle Nubian cemetery which has been dated around 1800 BC. In the Nuba Mountains, paint is used to transform the entire bodies of young men into leopard-skins, the paint being applied with astonishing delicacy and accuracy, to form one of the most beautiful kinds of body art still in existence. This kind of survival indicates what humanity has lost by the decay of such artistry, which must have risen to heights of splendour when it was virtually the only form of art.

The North American Indians, or Native Americans as they are now called, also practised body art of the most elaborate kind, including tattooing and painting, as we know from drawings of the 1580s and onwards.

Mask from Papua New Guinea, by a tribal artist who had never heard of Picasso. Early twentieth century.

In the West and the Plains, such adornment, biographical in nature, was supplemented by the most intricate featherwork, especially in headdresses, ever practised by humankind. This likewise provided personal information, though its primary purpose was glory and adornment. Feathers seem to have been banned for women, unless they were distinguished in battle, and nearly always had a martial significance, like medals in Western society. The Plains Indians classified a large variety of species as 'wear birds', including woodpeckers and flickers, eagles (the highest category), raptors, vultures and scavengers. The taxonomy of feathers in Plains Indian art is complicated. A high chief might make a point by wearing a single eagle's feather, rather like the chief of a Scottish clan; or he might wear an enormous headdress, reaching to the ground and giving his entire military biography. Feathers were art, but also records. The way in which they were trimmed, mounted and marked conveyed information.

The Plains Indians' feather headdress, with accompanying face-paint and tattoos, probably constituted the most graceful and striking form of body art ever devised. But it is now frowned upon as politically incorrect, and information about tattooing and body-painting tends to be edited out of historical accounts or contemporary surveys. There are ironies here. In one of his famous *Discourses on Art* (i, 231ff in the original edition), Sir Joshua Reynolds delivered a stinging rebuke to those who laughed at non-Western forms of art:

> If a European, when he has cut off his beard and put false hair on his head, or bound up his own natural hair in regular hard knots, as unlike nature as he can possibly make it; and after having rendered them immovable by the help of the fat of hogs, has covered the whole with flour, laid on by a machine with the utmost regularity; if when thus attired he issues forth, and meets a Cherokee Indian, who has bestowed as much time at his toilet, and laid on with equal care and attention his yellow and red oker on particular parts of his forehead or cheeks, as he judges most becoming; whoever of these two despises the other for this attention to the fashion of his country, whichever first feels himself provoked to laugh, is the barbarian.

William Hazlitt, England's first serious art critic, quoted this passage with glee in his essay 'On Vulgarity and Affectation' (1821), and it is worth repeating when efforts are being made, all over the world, to persuade tribal peoples to abandon traditional forms of art, and suppress evidence of their existence heretofore, in the name of political decorum.

Such efforts are ironic in view of the ways in which primitive art has influenced Western painting and sculpture since the beginning of the twentieth century. We have noticed some particular instances. But a more general impact has been felt in

Western body art, and this topic has received little attention. Body art was the earliest form of art, in the West as everywhere else, and it never completely died out. Tattooing remained a continuous tradition among sailors, for instance, and elaborate hairstyles, including wigs, and face make-up, were adopted by men and women of both sexes if they could afford them, from the fourteenth century onwards. The twentieth century, especially towards its end, saw a momentous increase in the use of body art, in the most advanced societies and among the most sophisticated portions of them. This is surprising since in primitive societies elaborate body art denotes high social status, and the tendency in the twentieth-century West was to eradicate distinctions of class, not least in appearance.

Clothes became democratic and classless, to some extent sexless, even ageless. At the beginning of the twenty-first century it is possible to see an elderly couple, dressed for a holiday, both wearing trainers, baggy trousers and zip-up blouses, with baseball caps, exactly like their grandchildren or great-grandchildren, their clothes giving no indication of their income group, profession or background. At the same time, more and more people are seeking to achieve bodily distinction by forms of art. One is the revival of tattooing, for both sexes, and especially among young women. London now has more magazines dealing with tatooing than with art. The second is the development of cosmetic surgery, now common among women in upper-income groups (and among men too). The cosmetic surgeons of the Western capitals used more elaborate instruments than the Maori *tobungas* with their skin-chisels or the experts who practise African forms of body sculpture or *hleeta*. But they were essentially carrying on the skill of body artists.

Far more important, however, was the development in the second half of the twentieth century of modern cosmetics, of a quality hitherto unimaginable and at competitive prices, which allowed women of all classes and ages (and not a few men) to improve their appearance radically. Highly ingenious skills in the use of these materials were practised by hundreds of millions of women and the result, combined with modern hairdressing and dieting, was to constitute the most widespread and successful form of body art in history. When we are surveying the art record of the twentieth century, so apparently barren in some respects, this positive achievement should not be overlooked. The fact is that, in the twenty-first century, more and more people wear the cunning mask of art.

Curiously enough, one form of primitive art which has been spared this kind of politically motivated attack is the African mask used in ritual ceremonies and dances. A strong case can be put that this is by far the greatest form of African art, the finest category of any primitive art which has survived into the twenty-first century. It is also the one with most to offer to the rest of us, since African societies have

carried it to lengths which even the Chinese, another society which has produced great art-masks, have never reached. These masks are a complete art form. They range in size from mere eye-coverings, not more than an inch high, to complex structures of 20 feet or even more. They involve every conceivable kind of material, from grasses and feathers to modern metals, including chrome, aluminium and titanium. Not least, they pass through all the phases of art, from simple classicism to the wildest Rococo, all the modern 'isms' from quasi-Cubism to Abstract Expressionism, and embrace the tragic, the comic, the romantic and the sublime. Some even contrive to look Gothic.

The Chambas of the Nigeria–Cameroon border perform a death dance which involves huge festoons of twisted fabric clothing the entire body in superimposed layers, crowned by a helmet mask with a dome top fringed by a lurid projecting peak-muzzle, which ends in horns round the back of the skull. The helmet is painted black, red or black-and-red (red signifies blood and hunting, black witches and women). Horns in one form or another are found in many mask-dresses. A typical one is the Kebul-type used by the Jola people: two huge cattle horns fixed in a thick raffia skull-hat, sewn with shells and big seeds, with a central peak running over the skull-top and projecting eye-visors of bone (one is shown in the Musée Barbier-Mueller, Geneva). The seeds are chosen because of their colour, flame-red, and the mask is known as an *ejumba*. Another type of horned mask, from Guinea-Bissau, consists of a cattle-head, made of hides, with horns, white eye-sockets and muzzle, and is worn on all fours, the performer being equipped with big cuffs on his wrists to resemble hoofs.

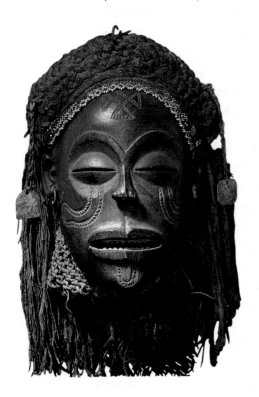

Murana Pwo–type mask (early twentieth century) from equatorial Africa, of idealised girl, showing facial scarifications and ritual headdress.

Metal masks include a brass one used for funerals by the Senufo, a zoomorphic design with huge curved horns, eye- and mouth-slits, and what appear to be dangling moustaches—all of brass—sewn into an enveloping triangular garment, which conceals every part of the body and is coloured red, white, green, black and purple, with fringes to conceal the feet.

Some metal or wooden masks, like the so-called Beautiful Lady mask of the Senufo, are about 4 feet high. A mask-mountain costume, used by the Ibo of Nigeria for their burials, is 20 feet tall, and has a high multi-coloured dome of cloth from which protrude hundreds of flag sticks and fly-swatters, wooden birds and human figures, the lower slope of the mountain being concealed by polychrome carpet-rugs. The Djerma

warriors of the Niger not only wear brilliantly coloured headdresses themselves, 4 feet high including plumes, but conceal the heads of their horses in polychrome carpet masks, rather like the horse-armour worn by fifteenth-century European knights.

In nearly all of these cases—and there are literally hundreds of others, each quite different—the costume is designed to conceal the identity of the wearer, which is essential for the success of the rite. For sheer ingenuity and variety, for exquisite beauty in some cases, for the ability to inspire terror, these masks have never been equalled in any other society. Where modern Western theatre masks appear effective, as in versions of ancient Greek plays, they nearly always turn out to be copies of African models. It should be added that such mask art is not theatre art or ballet, which would be outside the scope of this book, but is rather performance art, defined as visual rather than dance, where the intrinsic importance of the mask costume is more essential to the success of the enterprise than the movement of the performers. Twentieth-century performance art in the West is thus a puny and unimaginative (and often ugly) version of something which has existed in Africa for thousands of years, has successfully absorbed many new materials and modern accretions, and looks like continuing, to delight, amuse, terrify and instruct the people. What more can one say of any art form?

Such performances by elaborately masked figures are, and have been for millennia, one way in which Africans have sought to impose order, in the form of ritual, on a chaotic world. It is significant that in many varieties of African art an important role is played by a personage anthropologists call the Trickster, the personification of disorder. He tries to alter traditional territorial boundaries, to upset the ordained social hierarchy, to confuse sexual roles and to erode the law. Much of African art consists of wood-carving, and Tricksters feature prominently in the figuration. They can be identified by physical anomalies: an old head on a young body, or vice versa; disproportionate arms, legs and bodies; protruding stomachs and other spectacular forms of ugliness. The Mende of Sierra Leone construct a grotesque parody of male beauty called Gonde. The Yoruba of Nigeria have a Trickster mask called Big Nose. The most common Trickster art-personification, found in many African societies, and exported as part of the diaspora of slavery to Cuba, Brazil and Haiti, is called Eshu or Elegba, who has to be appeased by gifts and worship. He is an anti-art figure, the epitome of ugliness.

It is important to grasp that many aspects of African humanoid carving which strike the Westerner as ugly, are intended to be so, like the creatures which figure in a Hieronymus Bosch painting. This is a point which was not understood by some of the early-twentieth-century European artists, such as Picasso, who drew from African models they found in museums what they thought were new concepts of beauty, and reflected them in their works. They too were taken in by the Trickster.

The art of primitive societies, especially in Africa, is very ancient, among the

oldest in human history. A dozen important rock art sites have been investigated throughout the African continent, with work going back in some cases to before 10,000 BC. At Sefar in Algeria, there is a striking painting of a running archer, believed to date from about 8000 BC. At Fenga Hill in Tanzania, there are figures of elephants, trees and humans. In the Fezzan of Libya a rock carving displays two giraffes and an elephant, nearly 20 feet tall, their forms superimposed. There are other examples of what is known as the Large Wild Fauna style, which flourished about 8000 BC. Somewhat later, up to 6000 BC, Algerian wall-paintings show elaborately dressed human figures, with headdresses or masks, and wearing beads and skirts, performing a ritual dance. In South Africa, large numbers of rock- or cave-art paintings have been discovered, especially in the Drakensberg mountains, some of considerable beauty—including a polychrome painting of elands grazing, sleeping, running and mating, which must rank as one of the finest examples of prehistoric art, though it may not be older than about 1000 BC. All the evidence so far uncovered suggests that Africa is by far the largest depository of such art on earth. The first examples were not found until 1847, in the mountains south of Oran; and in South Africa, where the heaviest concentrations occur, exploratory work did not begin until the 1860s. The most important discoveries in the north (the Tassili sites) date only from the 1950s, and further important finds have occurred in the 1980s and 1990s. So the study of the ancient arts of Africa is only just beginning.

Portuguese mariners began bringing back West African ivory carvings, which they recognised as superlative, from about the 1450s, but appreciation of the merits of African fine art at its best really dates from the late nineteenth century. In 1896, a British party from the Guinea coast was massacred, and in reprisal a punitive expedition was sent to Benin. It returned with large quantities of artistic loot, which found its way into the British Museum or private collections such as the Pitt-Rivers Museum in Oxford. There was a mass of fine carved ivory, including tusks and horns, some 6 feet long, and human and leopard masks. That was not surprising, for African ivories were not only known in Europe but in some cases had been specifically carved for the European market by African sculptors. There is in the British Museum a fine example of this trade: a magnificent ivory salt-cellar, more than a foot high, with ten human figures grouped round the large bowl, surmounted by a lid carved with crocodiles.

What did astonish collectors was the high technical quality and artistry of the metalwork, evidence that the Benin artists had known of, and practised, the *cire-perdue* process for over a millennium. They used it to create superb heads of bronze and brass, the finest of which were of queens and queen-mothers, though there are also portrait heads of kings. The lost-wax process has seldom been used to more striking effect. The bronzes were made from about 1000 AD to the nineteenth century, growing taller as time passed. The early ones, only about 8 inches high, tend to

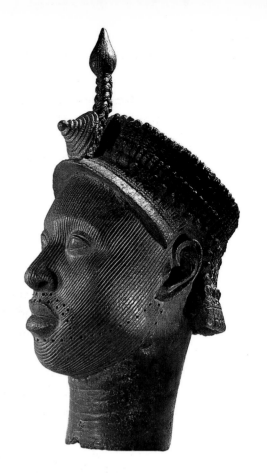

Head of the Ife king Oni or of the sea-god Olukun, bronze, lost-wax process, Nigeria, about 1200 AD.

be the best—there is a particularly fine one, from about 1500 AD, 8 1/4 inches high, in the Museum of the University of Pennsylvania. This is of brass and iron. So too is a queen-mother head, nearly 2 feet high, now in the Detroit Institute of Arts, though the modelling here is inferior to the older heads. The heads, and the finest ivories, were part of the furniture of altars on which animal and human sacrifices were made, and we have here a case where separating the objects, however beautiful, from their settings and putting them in museums makes it difficult to perceive the intentions of the artists, or the real quality of the art.

We can say, however, that these objects are fine in themselves, by any standards. In 1912 the German ethnologist Leo Frebenius told of fantastically beautiful heads at Ife in western Nigeria, capital of the Yoruba. They can now be seen in the Museum of Antiquities, Ife: heads and masks in bronze, brass, copper and iron, some cast by *cire perdue*, some sand-cast, and some in terra-cotta. Most are life-size, some smaller. They are more delicately modelled, and more sensitive in appearance, than the Benin bronzes. Some of the masks are pierced with holes to allow hair and beards to be put on, and others were part of more elaborate costumes for public performances. All the same, the art is essentially naturalistic—among the finest such sculpture to be produced anywhere.

The art of Benin and Ife raises difficult problems. Why did it slowly decline in quality from the sixteenth century onwards? Why did it confine its best efforts to heads? The Benin artists made statues of cocks and leopards, and sometimes of human figures. But these are inferior. Possibly under Portuguese influence, they made low-relief bronze plaques, of wars and hunting scenes. These were set into the walls of palaces, but very few have survived. Yet nothing that has survived comes remotely near to the quality of the heads in both naturalistic skill and aesthetic elegance. If the artists of Benin and Ife were so capable, why did they not spread their wings wider? Why did they not develop a degree of artistic autonomy, as for instance the Greeks did, around 700 BC? They do not seem to have pushed their art further than the strictly confining needs of the ceremonies for which the heads were made. This may have been the result of lack of patronage, or lack of competition between artists, or between art centres (though some scholars believe that Ife patterns and techniques

made their way to Benin, which implies some degree of artistic contact). Yet the skills of both centres eventually declined to the point where this high art was effectively lost.

Among the Aboriginals of Australia there is no equivalent to the high art of West Africa or, for that matter, of the giant stone-carvings of Easter Island. There is a good deal of rock art all over Australia and more emerges from time to time. Some of it goes back to about 13,000 BC and, as in parts of Africa, was being practised until quite recent times. In the Laura region of Cape York Peninsula there is a famous painting of an emu with her eggs, and such figurative work—none of high quality— is found elsewhere. What the Aboriginals produced best was abstract (or seemingly abstract) patterning, and it continues to this day: paintings in sand, on bark, on wood shields, on the coverings of huts, and designs in the creation of textiles. They also produced interesting and highly decorative mortuary sculptures, and sinister mortuary posts of wood, whose shapes sometimes comply with Roger Fry's definition that art must have a 'significant form'. These shapes are akin to painted wooden way-posts and direction markers, which are another category of Aboriginal art. Is any of this fine art? It is certainly not fashion art, for the patterns, designs and shapes do not seem to have changed over centuries, if not millennia. But if it is not fashion art or ephemera, neither does it seem to have the capacity to develop and evolve new forms, which is one characteristic of fine art.

The Native American art of the Western Hemisphere has no equivalent of the Benin and Ife bronzes either, though it produced—and still produces—a variety of art forms in textiles, bead and quillwork, 'false embroidery' as it is known (it is a form of elaborate twining), leatherwork and matting, pottery and carving in bone and wood. There are endless varieties of masks for performance art, which can be studied in New York's National Museum of the American Indian. The most striking art form is what also impressed the first European settlers—what they called totem poles and are now known as memorial poles. These are a form of the art of carving house-poles, which is practised all over North America. Memorial poles can be 20 feet high, often of fine cedar wood, and consist of dramatically carved and painted figures, standing on each other's heads, and surmounted (as a rule) by a ferocious bird of prey, with wings outstretched. The pole itself is an integrated piece of timber, but wings, arms, beaks and ears are usually of separate pieces of wood, and stick out at all angles. The sculpting (and subsequent painting) of eyes, lips, cheeks, chins and foreheads often display exaggerations and distortions of a highly imaginative kind, which makes these poles powerful objects, as was the artists' intention. Virtually all are now in museums, though some have been created in comparatively recent times and are found in burial grounds (there is a brilliant example in the Alert Bay Cemetery, British Columbia, by the Kwakiutl Indian artist who called himself Willie Seaweed, dated 1931).

It is likely that the study of primitive art (a term which may soon be banned) will be revolutionised during the twenty-first century, and that a much clearer picture of its

nature and value will have emerged by the end of it. In particular, we will have a proper assessment of the impact of Western civilisation and technology on the traditional art forms of the areas we have been looking at. Has it been wholly destructive, as Gauguin was never tired of complaining? Certainly, Western technology has ousted most traditional forms in architecture, for obvious practical reasons. In Guinea, the Great Mosque of the Futa Jallon region was built by Fulani craftsmen of notable skill in about 1883. It has a wooden frame, mud covering and is protected by a thick thatch. It is about 40 feet tall at its apex and looks like a gigantic beehive, a building of considerable elegance, not to say beauty. No one is going to build such an edifice now, except perhaps as an expensive curiosity, and attempts to make modern hospitals in Africa and Asia less daunting to villagers, by adopting local forms, have not succeeded. The great adobe mosque of Djenné in Mali, which goes back as far as the thirteenth century (it was substantially rebuilt in 1907), and has a distinctive Gothic appearance, is not going to be repeated either. The giant parabolic arches which were a feature of Moslem architecture in Nigeria, and were still being erected at the beginning of the nineteenth century (an example is the Friday Mosque at Zaria in Nigeria), are also an obsolescent art form, except as a conscious archaism.

In the last half-century, fifty-two separate governments in Africa have replaced the colonial empires, and their official policies about preserving or encouraging traditional art forms have varied enormously and are often contradictory and confused. So, for that matter, are the policies of the U.S., Canadian, Australian and New Zealand governments. It makes sense to help skilled craftsmen to produce, in traditional manner, art objects for which there is still a real use and demand. But any further subsidy, protection and bossing-about is foolish. The worst possible results have been obtained when native artists have been pushed to produce work in modern Western styles. They are far more likely to produce good work if they are treated like any other artist in the world today, where a large and infinitely varied free market in art exists and is constantly expanding.

In the United States in particular (though Australia is not far behind), an immense academic industry grew up in the second half of the twentieth century, ostensibly to protect native art and culture, but in effect to attach it to a progressive and political agenda of white scholars. If it was wrong, as they maintained, to try to absorb primitive cultures in the Western corpus, it was equally wrong to make them hostages of the current ideological climate. Yet that is what happened, especially from the 1970s, when numerous African governments, for example, fell into the hands of Marxists, who began harassing local artists and craftsmen, and in many cases actually destroying their art, and the art of the past, for ideological reasons. This was only one part of the impact of ideology on art during the twentieth century, and we must now look closely at the subject.

31

THE RULE AND RAVAGES OF
IDEOLOGICAL ART

Ideology is not necessarily the enemy of art but it tends to become so when applied relentlessly and obsessively. If France invented fashion art, Germany invented modern ideological art. Nor was this, initially at least, the work of politicians. They merely followed clumsily in the mud-tracks of the pedagogues, theorists and intellectual *exaltés* who had pioneered the way. The chosen field for the great ideological experiment in art was architecture, and the key event took place in 1907 (the same year Picasso painted *Les Demoiselles d'Avignon*) when the Deutscherwerkbund was formed in Munich. Its aim was to bring together industrialists, artists and craftsmen to improve the quality of design in German products, and superficially it seemed no more than a formal organisation along the lines of the British Arts and Crafts movement. However, its leading spirit or dogmatist was the Berlin-born Walter Gropius (1883–1969). As Gropius emigrated to England in 1934 and, permanently, to America in 1939, he is often spoken of as an American. But the truth is that all his influential work had been done by 1930, and is thoroughly German in every respect. His father was an official architect and his uncle (whom he resembled) was Director of Art Education in Prussia.

Gropius was not an artist in the usual sense. Indeed, he suffered from a peculiar physical defect. He was unable to hold a pencil and so could not draw. An architectural drawing was beyond him. What he could and did do was teach, laying down principles. They were fivefold. First, architecture must respond to the needs of industry, which was taking over the world, by adopting its methods: efficiency, uniformity, rationality and cost-consciousness. Second, its forms should be functional—that is, directly related—and seen to be so, to the purpose for which the building was ordered. Third, it should be built, as a rule, of modern materials: steel and concrete. Fourth, it should avoid any decoration not needed for its functional end. And, finally, it should stress its conformity to the machine age by basing its designs on straight lines, rectangles, right angles and cubes. These principles were put into operation by ten leading industrial groups, including the giant electric firm AEG, which put up

more than a score of large industrial buildings between 1907 and 1919, most of them designed by Peter Behrens; and Fagus, which built a large factory at Alfeld (1911–1913) designed for Gropius by Adolf Meyer. These constructs became emblematic of what was later called the Modern Movement. This in turn (from 1932) spawned the International Style, both forming what another ideologue, Nikolaus Pevsner, its architectural historian, called 'the recognised accepted style of our age'. The two together lasted over half a century, from 1910 to the end of the 1960s.

There were two things wrong with Gropius's ideology. First, industrial architecture was over a century old by the time the Werkbund was formed. The first custom-built steam-powered factories were erected long before the end of the eighteenth century, in industrial Lancashire, often on a huge scale. They were cost-efficient, made of the latest materials, and strictly functional. But they were also austerely elegant and, in places, decorative so that where they have survived they have been turned into high-priced flats, duplexes and houses for the fortunate middle classes, a process begun in the 1980s and continuing today. If Gropius had studied the output of the first great industrial designer, Thomas Telford (1757–1834), who built roads, canals and bridges, often on an enormous scale, all over England, Wales and Scotland, he would have found that Telford always operated efficiently, functionally and rationally, so that seventy-five per cent of his vast output is still in daily use, two centuries after it was built. But Telford, by training a stonemason, always had a high regard for beauty as well as function, believing that the two usually coincided, since he accepted Keats's maxim that truth, the moral expression of function, is also beauty. Virtually everything Telford designed and built is beautiful, if simple and economical, down to the road furniture like milestones, lock gates, bridge balustrades and workers' houses. Moreover, he set an example followed by the early railway engineer-designers, the Stevensons and the Brunels, who always sought to combine function and beauty, and who employed some of the best designers in Europe; one reason why early railway architecture and machinery, from stations to viaducts, is so highly regarded today and, where it has survived, is so carefully conserved.

So Gropius was anachronistic in this respect. He was also out-of-date in another, very significant way—a good example of how ideologists, when they strive most earnestly to be 'modern', often enslave themselves to the past. The Modern Movement, by placing the design stress on right angles, dismissed curves as outmoded. Its adherents were taught at school that modern industry reproduced in the practical world the theoretical basis of modern science, which itself was ultimately dependent on the straight lines of Newton's physics, describing how the universe worked. The movement was therefore attempting to make architecture 'scientific' by forcing it to comply with the rules of physics. But what were the rules? In 1905, two years before the Werkbund was formed, the Swiss mathematician Albert Einstein, then twenty-six, had published a paper entitled 'On the Electrodynamics of Moving Bodies', which became known as the Special Theory of Relativity. This was an attempt to correct

certain anomalies in Newtonian physics, hitherto unexplained, by showing that space-time did not operate in straight lines so much as in curves. In 1915, Einstein expanded his paper into the General Theory of Relativity, which was verified conclusively by astronomical observations as soon as the war was over. Hence, by a curious paradox, the curves of Art Nouveau, despised by Gropius and his colleagues, were closer to modern physics than the straight-line style they promoted as the Modern Movement.

In 1919, Gropius had been appointed head of a new art academy in Weimar, capital of the post-war German republic, which he called the Staatliches Bauhaus. He found its accommodation old-fashioned for a project which proclaimed itself a utopian scheme to found a 'total art', 'which will embrace architecture and sculpture and painting in one unity, and which will arise one day towards heaven from the hands of a million workers'. The stress on 'total' is significant. The word came from

The Bauhaus school in Dessau, view from interior (1926). So much for Gropius's opinion that the parameters of modern beauty were straight lines.

Wagner's 'total' theatre at Bayreuth, was being taken up by politicians and was producing the concept of the 'totalitarian state', which ordered every aspect of society from a single ideological viewpoint. Also significant was the stress on 'workers', another compulsory

word at the time. Middle-class intellectuals were anxious to identify themselves with the industrial proletariat, and though Gropius repeatedly stressed that his Bauhaus aimed to create craftsmen, and its very name suggested a medieval guild, the reference to the centrality of 'workers' was intended to suggest identification with socialism. The Bauhaus was, in effect, a modernistic design centre for mass-produced products of all kinds, from chromium-plated teapots to giant electric turbines, and for buildings which embodied Gropius's principles of impersonality, geometrical shapes and severity.

When Gropius moved the Bauhaus to Dresden in 1925 he designed the new buildings himself. They were strictly rectilinear and functional, of concrete, metal and glass, the last element being used in vast hanging planes, a trick soon taken up by other architects. Indeed, the whole complex was specifically designed to be, and became, an exemplar for the Modern Movement. Gropius's own office, from light fittings to carpets and wall decorations, including the specially designed furniture, contained not a single curve: all was linear, right angles, rectangles and squares. The only decoration in the entire building was the vertical sign BAUHAUS on the exterior, a genuflection to Gropius's profound belief in the importance of advertising in the modern world. Indeed, if Gropius and the Bauhaus were good at one thing, it was self-publicity, a skill which, as we have already noted in the case of French fashion art, was of central importance in the twentieth century.

That was a skill also possessed, to an unusual degree, by Charles-Edouard Jeanneret (1887–1965), the Swiss architect who now joined Gropius as godfather of the Modern Movement. Indeed, he had it to a degree that no other artist in the twentieth century could rival, Picasso himself excepted. He was brought up in the traditional Swiss craft of watch-engraving, then trained as an architect under Gropius's master, Peter Behrens, in Berlin. He set up his own business in 1922, at the same time changing his nondescript name for the arresting trade logo Le Corbusier (the Crow-Man). As Le Corbusier was a prolific and compelling writer on architectural matters, his practise immediately attracted immense attention. His central object was to house, on an enormous scale, the new industrial proletariat. He brought to this obsession an enthusiasm, based on a misunderstanding, for the theories of the American efficiency expert Frederick Winslow Taylor.

Taylor's aim was to do scientifically what Henry Ford did instinctively: to raise productivity in the process of maximising production. He was the first to make systematic use of time-and-motion studies, and his goal was the perfectly sensible one of persuading capital and labour to abandon their old struggle of who got most of the cake by working together to produce a bigger cake. That is what he called 'scientific management'. His notion was taken up by an American sociologist called Christine Frederick, whose book, *The New Housekeeping: Efficiency Studies in Home Management*, was published in New York in 1913, applying Taylor's principles to cooking, cleaning and child-rearing. Corbusier got hold of the idea during the war.

He thought 'Taylorism' was 'horrible' but also 'the ineluctable life of tomorrow'. He soon decided that it was not horrible at all but exciting, offering the chance to 'exploit scientific discoveries' to improve 'the business of living'.

This was the same emotional response to the war as Lenin's, who had been impressed by Marshal Ludendorff's application of 'war socialism' to maximise arms production in Germany, 1916–18, and produce a 'total effort'. Lenin made it the basis of the 'command economy' he was imposing on Russia at exactly the same time as Corbusier was applying Taylorism to architecture. Corbusier decided that, if Frederick's attempt to make the housewife as efficient as a well-trained factory worker was to succeed, her 'environment'—a neologism of Carlyle just coming into use—must be designed in an efficient way too. That is the origin of his concept of a house as 'a machine for living in'. The principle of efficiency, he argued, detonated an 'immense revolution in architecture' which 'automatically overturned' the old-style 'aesthetic of construction'. What is so sinister about Corbusier is not only his replacement of aesthetics by science and engineering, hitherto its servants, but his assumption that there was only one way of doing things in architecture. His writings are heavy with compulsive terms like 'must'. What must come, he said, were 'soldier architects' who could 'construct complete houses in three days', which, transported by road, would be 'habitable three hours after being put on site'. Corbusier pounced upon a French law of 1922, providing for low-cost housing, to try and persuade big car firms like Renault, Citröen and Creusot to join with him in creating entire new cities of mass-housing estates, what he called *La ville radieuse*. The workers' blocks were to consist of 'totally industrialised houses. . . . We extrapolated the house, so to speak, from clay and quarry and mortar. We transported it to the industrialised factory, the Taylorisation belt.'

Here again, as it happens, the scientific novelty was an old idea. When the new industrialised towns were being built in Lancashire, Yorkshire, the Scottish Lowlands and Birmingham between 1780 and 1830, semi-industrialised houses of brick and slate were put up in enormous numbers, very cheaply, by speculative builders who did not even employ an architect. Back-to-back, two-up-two-down, these houses were highly popular among rustics moving into urban spaces to become mill-workers. Most were destroyed by middle-class planners as part of 'slum-clearance schemes', 1945–60, the inhabitants being decanted into tower-block flats of the type Corbusier advocated in 1922. But where such houses survive, they are now, in the early twenty-first century, much sought-after and command high prices, precisely because they are houses, as opposed to 'dwelling units', to use Corbusier's term, and so can be personalised. What Corbusier wanted can be seen from his 1925 publication, *plan voisin pour Paris* (the neighbourhood scheme) which shows immense blocks fifty storeys high, each containing five hundred apartments, grouped in half-dozens around squares and circles.

These were fantasy-schemes, satirised by Fritz Lang in his movie *Metropolis* (1926) and Charlie Chaplin in *Modern Times* (1936). Corbusier himself did not succeed in getting any of his big schemes carried out until after the Second World War, when Communist-controlled municipalities in France allowed him to build them, as for instance in the Marseilles-Michelet complex, 1945–52. These Unités d'Habitation, as he called them, were oblong concrete blocks squatting on thick inverted rhomboids, each containing hundreds of machine-homes. Corbusier was not the only architect who thought in these dehumanising terms. In 1924, Ludwig Karl Hilberseimer produced plans and drawings (Chicago) for what he called the *Hochhausstadt*, the high-rise city, consisting entirely of twenty-storey rectangular blocks, in groups of ten, linked by high-level pedestrian walkways.

Another mass-minded architect was Ludwig Mies van der Rohe (1886–1969), who specialised in running housing exhibitions and succeeded Gropius at the Bauhaus in 1930. Mies designed individual houses as well as high-rise blocks. He ran the famous 1927 Stuttgart housing fair at which were exhibited plans for modernistic houses for the wealthy, designed by Gropius, Corbusier, J. J. P. Oud (1890–1963) and himself. His Tugendhat House, at Brno in Czechoslovakia, 1930, was regarded as the 'paradigmatic' house of the Modern Movement, along with Frank Lloyd Wright's own house, Fallingwater, at Bear Run in Pennsylvania (1936). Mies was even more of an ideological purist than Corbusier, and was the real godfather of building-block housing estates. He justified eliminating all decoration by his dogma: 'Less is more.' His 1921 concept for gigantic skyscraper housing in Berlin remained a mere drawing (New York, MoMA) and he had to keep down the levels of his 1927 housing estates at Stuttgart. But in the post–Second World War period he became the archetypal housing-block designer with such exercises in 'pure' functionalism as the Lafayette Park estate in Detroit, 1955–63. His designs were imitated all over the world for mass-produced high-rise work.

Even in the 1920s, German architects produced in German-speaking territories such daunting examples of ideological architecture. The largest and most dehumanised was the vast estate, the Berlin Siedlung, created 1925–31 by Bruno Taut and Martin Wagner, providing homes for 50,000 people in a series of tenement blocks and oblongs grouped round a central horseshoe. Ernst May's elongated blocks in Frankfurt, 1930, were of the same kind and characteristic of hundreds built during the decade 1925–35. Most sensational of all was Karl Ehn's 1928 Karl Marx Hof in Vienna, a vast modernistic structure built to house the workers in what was deliberately conceived as an ideological or communal dwelling.

While the architects were engaged in their own versions of totalitarian planning, the actual dictators were getting to work to change, among many other things, the way in which art was seen and created. We will look at Fascism first because this was

closely linked to an artistic movement, Futurism, Italy's contribution to Paris fashion art, launched in *Le Figaro* on 20 February 1909. Although pre-war, it adumbrated many of Corbusier's post-war emotions about the senility of the past and the opportunities of the future. The actual manifesto of Futurist painters, written by Gino Severini (1883–1966), their leader, the *Manifeste dei pitturi futuristi*, and published in 1910, announced:

> We want to fight ferociously against the fanatical, unconscious and snobbish religion of the past, which is nourished by the evil influence of museums. We rebel against the supreme admiration of old canvases, statues and objects and against the enthusiasm for all that is worm-eaten, dirty and corroded by time; we believe that the common contempt for everything young, new and palpitating with life is unjust and criminal.

This appeal to youth was popular at a time when the first youth movements were springing up all over Europe, and their leaders formed the most enthusiastic supporters of militarism, on both sides, when the First World War broke out.

Benito Mussolini, hitherto a fairly orthodox Marxist, much praised by Lenin, was a fervent supporter of Futurism, which coincided with his own ideas of turning 'somnolent Italy' into a machine of progress, and he saw the war as an opportunity to do it. He thus broke with official Marxism, became a socialist nationalist and announced his intention to 'velocitare l'Italia'—speed up Italy—which defined exactly what Futurism was about in three words. Its images were trains, aircraft, machines, explosions, cinemas, bullets—anything made of metal which moved fast. Like Severini, Mussolini's strongest personal characteristic was impatience. He also shared the violent instincts of the Futurists, many of whom joined his blackshirt movement, which by 1922 controlled Italy's streets, and led to his assumption of power. On 29 October, waiting on Milan station to take the night-train to Rome to form his dictatorship, he was observed furiously consulting his watch as the train was late starting. His words were much quoted: 'I want the trains to leave exactly on time. From now on everything must function perfectly.'

With Mussolini in power, most of the Futurists settled down to a life as exemplars of the art establishment. Severini himself produced wall-decorations and mosaics for some of the regime's prestige buildings, such as the Palazzo di Giustizia in Milan, the University of Padua and the big new post office in Alessandria (1936–37), though oddly enough his finest work was decorating the Sitwell family home in Italy, the Castello di Montegufoni. The destructive aspect of Futurism was abandoned both by its members and by the Fascist government: instead, both turned to ancient Rome as the exemplar of Italian greatness, the fasces themselves symbolising 'the return to order' after the 'idiocies' of pre-war fashion art in France, and the senseless

barbarism of the Great War, Rome replacing Paris as the arbiter of taste and beauty. Naturally, the modelling on ancient Rome placed architecture at the centre of the state's effort. Mussolini led the modern world in one respect. His state subsidised a vast amount of public buildings by those he regarded as the world's leading architects and this was reinforced by the Two Per Cent law, under which two per cent of all expenditure on public works programmes had to be spent on visual works of art.

Italy was then a comparatively poor country, with Europe's (and perhaps the world's) highest birth-rate at that time, producing a desperate flow of emigrants to Argentina and elsewhere. But it actually spent more money on the arts, under Mussolini, than did France, traditionally the state which backed the arts with big money. This expenditure was enhanced by the creation of the Sindicato Fascisti degli Artisti, which looked after the material interests of the profession, by the Ufficio per l'Arte Contemporanea, which promoted creative activities, and by a notable series of art shows, including the Biennale in Venice, the Triennale in Milan, the Quadriennale in Rome, and special exhibitions such as the 1936 Rome Convegno di Arte. The last was attended not only by Marinetti and Severini but by the Cubist Maurice Denis and by Le Corbusier, now regarded in Italy as the most significant exponent of 'total' architecture. Art in Fascist Italy was state-directed, in accordance with Mussolini's totalitarian doctrine: 'Everything for the state, nothing against the state, nothing outside the state', but it was inclusive rather than exclusive. Paris-style fashion art never got official approval because it could not be fitted into Mussolini's increasing preference for Roman-style classicism, but it was tolerated. Indeed, in the decade 1925–35 every style of art flourished in Italy.

The chief impact of Mussolini's support for architecture fell on the railways, as was natural. It can be argued that the greatest of all railway stations were built in Italy between the wars. The two outstanding examples were Milan Central Station, designed by Ulisse Stacchini (1871–1947) and finished in 1931, a monumental piece of inter-war classicism, shaking a columned and porticoed fist at what was going on in Gropius's Germany, and the Santa Maria Novella Station in Florence, 1935, by Giovanni Michelucci (1891–1991), whom some would rate the finest modern Italian architect. Its magnificent glass-covered entrance hall, both ends of which are open, is a *piano nobile* built to serve the twentieth century, made of the highest-quality materials crafted by superb workmanship, though all of its hard-stone murals, except two, have been destroyed by war and vandalism. The Milan station was one of the centrepoints of a restructuring of the city on a scale not carried out on any European town since the big avenues were driven through Paris by Haussmann, 1852–78. As under Napoleon III's dictatorship, Mussolini's quasi-absolute power enabled the plan to be carried into effect ruthlessly, and the result was to create in Milan one of Europe's handsomest cities, with the first modern peripheral road system, and what was for many years the best modern airport. But, as with every other aspect of

his regime, Mussolini's arts policy began to disintegrate once he came under the influence of Hitler and the Nazis from about 1934 on.

Fascism had been a broad-based movement in the early 1920s. It had included, for instance, many Jews in its upper ranks, and they had helped to keep it comparatively tolerant, especially in the arts. Once Mussolini embraced Nazi-style anti-Semitism, they and others drifted away from it. Mussolini became involved in extreme militarism, imperialism and the Pact of Steel with Hitler, and lost interest in the arts. The war finished him and Fascism, which had virtually ceased to exist as a coherent ideology by 1943. All the major arts projects had halted even earlier, and the last of them, Mussolini's vainglorious vast and caesarial triumphal arch, near Tripoli, was never finished.

Why did Hitler's Third Reich have such a corrosive impact on fascist arts policy, hitherto its most attractive feature? And why was Hitler's own arts policy so unsuccessful? These questions need answering, for Hitler was more interested in the arts than was any other twentieth-century dictator. Indeed, next to anti-Semitism, art was his greatest passion and occupied a high proportion of his mental energies. Hitler had been an artist and in many ways thought like one. There are three reasons for this failure. First, Nazi arts policy was negative. In this respect it merely perpetuated a tradition which went back to the sixteenth century but had become predominantly German. Machiavelli had first coined the phrase 'corrupt art' in his *Discorso*. Bellori had applied it to Michelangelo. Corrupt art was anti-nomial or irregular. Nietzsche used it in this sense. It was joined to the word *décadence*, or *Entartung*, much used in France and Germany in the nineteenth century. The Kaiser, Wilhelm II, had denounced Impressionism as *Gossenmalerei*, the work of guttersnipes and was in the process of imposing art censorship when the 1914 war broke out. The Weimar Republic permitted more liberty of artistic and literary expression than any earlier German regime. But opposition on this point was growing long before its collapse, since Weimar had replaced Paris as the international centre of experimental profligacy. The first move towards censorship came in 1930 when the Minister for Education, Von Thüringen Frick, ordered the removal of seventy paintings from display at the Weimar Museum. His policy was, he said, 'To oppose Negro culture and promote German traditions.' One museum director was removed for patronizing artists like Otto Dix, Emil Nolde and Oscar Kokoschka. The particular target was German Expressionist artists but a declaration by Bettina Feistel-Rohmeder, head of the German Art Society, calling for the removal of certain museum directors for promoting 'cosmopolitan and bolshevik' tendencies was clearly aimed at Jews.

There was debate among the Nazis as to what constituted degenerate art. Joseph Goebbels, who was in charge of culture as well as propaganda, wanted to label Expressionism as 'German' and therefore acceptable; he was impressed by the use

Milan Central Station, completed 1931, by Ulisse Stacchini, flamboyant and strutting but a genuine major art work from the fascist period.

Mussolini had made of Futurism. But Alfred Rosenberg, the Nazi art ideologist, who had run the Campaign for German Culture since 1927, was emphatically opposed to Expressionism, and he won the battle for Hitler's support. Hence, the big Nazi Entartete Kunst, or 'Degenerate Art' exhibition, which opened on 18 July 1937 in the Munich Archaeological Institute, was all-inclusive, showing 650 works by 112 artists drawn from 32 German collections. They included Corinth, Dix, Nolde, Grosz, Kandinsky, Chagall, Ensor, Munch, De Chirico, Gauguin and Matisse. Hitler always referred to degenerate art as 'Cubism and Dadaism', maintaining that it started in 1910, and the 'Degenerate Art' exhibition bore a curious resemblance to the big Dada shows of 1920–22, with a lot of writing on the walls and paintings hung without frames. As such, it was the most successful art exhibition ever held in Germany up to that date, with over 2 million visitors even before it left Munich to go on tour.

The success of the 'Degenerate Art' exhibition can be variously interpreted. What is indisputable is that the Nazis could never arouse the same enthusiasm for the 'positive' exhibitions they held, though they tried hard. Between 1933 and 1945, Germany had more state-organised art exhibitions than any other country in the world, including Italy. Hitler got his chief architect, Paul Ludwig Troost, to design a severely classical Haus der Deutschen Kunst, 1933–37, to be the centre of the German art movement, and when Troost died, Albert Speer was charged with the same programme of promoting German art through classical buildings. But Hitler was often indecisive and confused on art issues, as on other aspects of policy. He could not decide, for instance, whether to make Munich or his own favourite city, Linz, the art capital of the Third Reich, He was good at promoting some designs. Sports stadia,

led by Speer's big one in Nuremberg, were excellent, and Hitler made brilliant use of, if he did not actually invent, *son et lumière* techniques for his rallies. He was responsible for the Volkswagen, or 'people's car', a design which lasted half a century. The first expressways were built under Weimar, but it was Hitler who pushed the network to completion, one of his motives being to protect historic cities from destruction by traffic, something the British for instance were tragically slow to follow. Nazi sumptuary, especially uniforms, was first-classs, one reason why it is so avidly collected.

On the big issues, however, Hitler does not seem to have known his own mind. Positive Nazi arts policy was based on the Biedermeier style of architecture of Schinkel and the Romantic school of Friedrich, both of which were resurrected at this time. The ideologist of Nazi architecture was Paul Schultze-Naumburg, author of *Art and Race* (1928) and *The Face of the German House* (1929). This was violently opposed to the Modernist architecture of the 1920s, and indeed to urban styles of almost any kind. Equally, on paintings and culture generally, the key Nazi tract was Richard Darré's *The Peasantry as the Life Source of the Nordic Race* (1928), which preached the doctrine of 'blood and soil'. This was the foundation of the positive side of Nazi art policy, in so far as it had any.

Speer's model of the Great Assembly Hall (1937), based on a sketch by Hitler. The Reichstag is shown on the right for comparison.

In theory, then, Nazi effort should have concentrated on the countryside and developed a rural architectural style. But nothing was done. Rosenberg was a fool, and Goebbels, though clever and energetic, had been overruled and lost interest. Speer was obsessed

by the city and spent his time working on plans to rebuild Berlin on white marble classical lines, culminating in a colossal domed building nearly 1,000 feet high. He discussed with Hitler the spectacular garden cities which were to be built in eastern Europe, rid of Slavs and Jews, when they became German 'living space', but these were mere projects. In any case, Hitler soon put Speer in charge of war production which left him no time for architecture. Strictly speaking, Nazi architectural theory laid down that the only acceptable materials for buildings were stone in the cities, wood in the country and brick in the Baltic provinces. But Speer made brilliant use of ferroconcrete for his massive submarine pens which proved impervious to the heaviest Allied air assaults. Nazi policy was full of such contradictions.

There is a continuing mystery about the approved paintings and sculpture produced in the years 1933–45. The vast majority of such works has disappeared: destroyed by air-raids, looted by the Russians, confiscated by the Allies or simply suppressed. If the Nazis removed nearly 16,000 degenerate works from state institutions, the German Federal Republic has kept a much larger number in store, so it is impossible to say authoritatively what merit, if any, Nazi art possessed. What can be said is that the Nazi campaign against so-called degenerate art was the best thing that could possibly have happened, in the long term, to the Modern Movement. Since the Nazis, universally reviled by all governments and cultural establishments since 1945, tried to destroy and suppress such art completely, then its merits were self-evident morally, for the familiar if illogical reason that 'my enemy's enemy is my friend'. These factors, so potent in the second half of the twentieth century, will fade during the twenty-first, but they are still determinant today.

Careful analysis of fundamentals shows that Nazi Germany and Soviet Russia had far more in common than in antagonism, and certainly more than either cared to admit. It applied to arts policy and to the kind of art each produced. But this was not immediately apparent, and Hitler, who tended to get into time-warps, remained convinced that degenerate art was the fruit of Bolshevism, which he equated with 'international Jewry'. This conclusion had an element of truth at the time but the days of modern art in the Soviet Union were already drawing to a close.

In the last phase of Tsarism, experimental art had flourished in Russia, the Ballets Russes, with their stress on design, costuming and décor, being part of the fun. Apart from Leon Bakst and Marc Chagall, Russia produced no major artists. But many worked in modern idioms and were exhibited alongside works from Paris in several spectacular shows, the 'Golden Fleece' exhibition of 1908, the 'Knave of Diamonds' show of 1910 and the 'Donkey's Tail' show in 1912, which exhibited Kandinsky among other Russians. The Russians produced three varieties of fashion art: Rayonism, Suprematism and Constructivism. Some important collections were built up by wealthy Russians, now mainly gathered at the Hermitage Museum.

When the Bolshevhiks took over at the end of 1917, Lenin, who was not interested in art, allowed the show to go on. But individual artists, like Chaim Soutine

(1893–1943), Alexander Archipenko (1887–1964) and Bakst, who could make a living in the West, refused to identify with the new Russia. An exception was Kandinsky, who held professorships in art, 1918–21, and founded the Russian Academy of Artistic Sciences in 1921. But the next year he sensed a chill wind of change and left to join the new Bauhaus. There was a strong element of collectivism, even in the early days of the regime. Artists operated in groups: the Cubo-Futurists, the World of Art group, the Union of Russian Artists, the Society of Easel Painters, the Circle of Artists, the Makovets group, the Four Arts Society and the Association of Artists of Revolutionary Russia were some of these sects. Some first-class work was done in poster art, book illustration and the theatre, and it is now highly prized by collectors. But after the death of Lenin, and the rise to dictatorial power of Joseph Stalin, who was effectively the autocrat by 1926, experimental art gradually ceased and by 1930 was extinct.

The best work of the period was done by pre-war architects, like Ivan Fomin and Aleksey Shchusev, working in a variety of classical styles. And here it is again worth drawing attention to the strong propensity of dictatorial regimes to prefer the classical mode, especially for public works. The pull of Caesarism was irresistible. It was too strong for Bonaparte, who never allowed himself to indulge in romanticism. It was the preferred style of Mussolini and Hitler and it proved the only form of architecture with which Stalin felt himself at ease. In the early days of the regime it was dubbed Proletarian Classicism, and found expression in the Moscow Dynamo Club Building, essentially a football stadium, the Moscow Polytechnic, the All-Soviet Building, the Lenin Tomb in Red Square (all 1927–32) and other structures, though some of them were categorised Neo-Renaissance, such as the Intourist Building in Moscow (1933) by Ivan Zholtovsky. In the 1930s, modernised classicism, in which pilasters usually took the place of pillars, cornices were suppressed or simplified, capitals were plain and bases omitted, became the International Totalitarian style, and in Russia it persisted into the 1980s, the Lenin Museum (1988) by Leonid Pavlov being an example.

It is ironic to reflect that, if Hitler had actually conquered Russia, his garden cities would have been built in this style. There was plenty of it in the West too, such as the Musée d'Art Moderne and the Palais de Chaillot, both Paris and both 1937; in Britain there was the London University Senate House (1933–36) and the City Hall, Swansea (1930–34). The same triumphalist tendencies can be seen in 1930s designs for electric power generation. The gigantic Hoover Dam, the TVA infrastructure and such British power stations as London's Battersea are far better designed than their equivalents in Russia, such as the Volvograd Dam, but visibly spring from the same emotional form of classicism, the exaltation of brute strength. Russian design tended to lag half a generation or even a whole one behind the West: Art Nouveau motifs were still appearing in 1930s designs and Art Deco ones in the 1940s and even 1950s.

Moscow's underground stations of the 1930s, some on the most sumptuous scale, have interiors which were a mixture of French Second Empire and English Edwardian, with a touch of Art Deco added. Most extraordinary of all, as an obsolescent-original form, was the so-called Wedding Cake style of pseudo-skyscraper architecture, based on the Woolworth Building in New York and the *Chicago Tribune* Tower. It reached its apotheosis in the vast, seven-towered Moscow State University in the Vorobyov Hills outside the city, designed by a team led by Led Rudnev. Such being the vagaries of human taste, these archaisms are likely to be proved the most cherished creations of the Soviet Union in a hundred years' time (if still erect).

It is only right, at this point, to note that ideological culture was also highly destructive. In Russia, between 1917 and 1924, and leaving aside the ravages of the civil war, literally thousands of cathedrals, churches, chapels, monasteries and other religious buildings were destroyed, damaged, converted or brutalised for political reasons, and a detailed inventory of the loss has yet to be compiled: it is comparable to the destruction carried out under the French Revolution. In 1936–37, the Communist Party in Spain was likewise responsible for the destruction of hundreds of religious buildings, many of them medieval (though the Franco regime, which succeeded the Republic in 1939, was likewise responsible, 1945–70, for wholesale vandalism, conducted for corrupt commercial reasons; in Valladolid alone, for example, forty medieval buildings were demolished and replaced by cheap apartment houses). Ideological fanaticism was active in some of the Soviet satellites, especially in Romania, where large-scale destruction of ancient villages (some medieval) took place as late as the 1980s, while Wedding Cake public buildings, on a huge scale, were being constructed right up to the collapse of the regime in 1990. The worst ideological destruction of the entire century occurred in Communist China during the Cultural Revolution, 1966–76, a disastrous decade for humanity when 20 million people perished and immense quantities of art, from buildings and gardens to calligraphic scrolls, paintings, porcelain, bronzes and furniture were systematically destroyed. Here again, no inventory of the losses has been even roughly compiled, and a detailed one may never be possible. But it is clear that this event was without precedent in the whole of human history, in the number of people killed and the quantity of art reduced to ashes.

The Leninist-Stalinist dictatorships, from which all these evils ultimately sprang, led to an authoritarian control of art expression which was just as absolute and vicious as Hitler's Third Reich. In 1932 the Communist Party Central Committee passed a resolution, 'On the Restructuring of Literary and Artistic Organisations', which was the exact equivalent of Nazi legislation in 1933–34, itself almost certainly based on the Soviet example. Under this, all existing artistic organisations and groups were disbanded. Two years later, in 1934, Socialist Realism was declared to be 'the fundamental style', and for the next fifteen years was assiduously promoted by

the regime's cultural dictator, Andrei Zhdanov. A court painter was appointed, in the person of Aleksandr Gerasimov, whose double portrait, *I. V. Stalin and Marshal K. Ye. Voroshilov in the Kremlin* (1938, Moscow, Tretyakov), is indicative of the kind of painting favoured. The same year he painted it, Gerasimov told the Artists' Union (which monopolised all patronage) that it had been necessary to eliminate 'certain criminal artists' since 'enemies of the people, Trotskyist-Bukharinite guttersnipes, Fascist agents and others active in art, have been unmasked and exterminated by our security services'. This was the first art purge. A second in 1946, aimed mainly at Jewish artists under the heading 'rootless cosmopolitanism', led to the removal of hundreds of art-works from museums, and the death or imprisonment of many artists. A third was planned at the time of Stalin's death in 1953. Art censorship of the most implacable kind continued till 1956 when Nikita Khrushchev's Secret Session Speech introduced a limited relaxation, but official art policies remained nominally in force until 1989.

During these six decades the amount of worthwhile art produced in Russia remains conjectural because a good deal of it was produced privately and remains in private hands. As in Germany, 1933–45, there is a black hole into which work has disappeared and may never re-emerge. But it is not true to say that Socialist Realism produced nothing of merit. First, there was a revival of history-painting in the manner of Surikov. It was propaganda (as of course is most history-painting), but often has a gruesome fascination in providing imaginative reconstructions of events unrecorded by the camera. In this category falls Grigori Shegal's powerful *Kerenski's Flight* (1937, Tretyakov), showing Russia's first democratic prime minister dressed as a Red Cross nurse to avoid capture by the Bolsheviks, and the mesmeric *The End, or Hitler's Last Days in the Bunker* (1948, Tretyakov), apparently painted by a three-man team known as Kakruniksy. An attack on pre-1917 capitalism, Boris Ioganson's *In an Old Factory in the Urals* (1937, Tretyakov), is a superb realist painting by any standards. Second, there was a good deal of first-class landscape painting produced, of which Nikolai A. Abramov's *April in the Motherland* (1969, private) is an example. Some were produced by Gerasimov himself, who despite his sycophancy—reminiscent of David's under Bonaparte—knew how to paint, as is shown by his *An Orchard* (1935, private). There was also some moving genre painting, especially by Yuri P. Kugach, whose family-and-child pictures, such as *On Saturday, or Little Girl Having her Hair Done* (1964, Tver, Regional Picture Gallery) and *In the Family; First Steps* (1965, Nizhni-Novgorod, Art Museum) are as good as anything produced anywhere in that unfortunate decade.

Then, there is the work in the Surovyi Stil, or Severe style, produced between about 1950 and the end of the regime, especially by Gely Korzhev, the one major painter to emerge during the entire Soviet period. Surovyi means unbleached brown, and refers to the dark side of Communist existence. Korzhev was by position a conformist who held high office in the Soviet art system, like Gerasimov, and it is not

The End: Hitler's Last Days in the Bunker by Kakruniksy (1948): Stalinist propaganda art but better than nothing.

clear why he was allowed to paint heretical pictures which showed life in the workers' paradise to be hard, ugly, dirty, painful and ultimately hopeless. In a succession of immensely powerful pictures, *Lovers* (1959), *Wounded* (1964), *A Mother*, *Old Wounds* (1967; all in St Petersburg, Hermitage, or the Russian Ministry of Culture), he painted a view of Soviet life which was uncompromisingly honest, terrifying, and at the same time moving. His 1962 work *On the Road*, showing a woman with her baby framed against a lorry (Samara, City Art Museum), is a masterpiece of savage realism of a kind which has not been produced in Europe for more than half a century. Russian painters who detested and criticised the regime were attacked for their failure to 'move on' from Repin, and it is true that one of the best of them, Sergei Grigorev, consciously echoed the old master in *He's Come Back* (1954, Tretyakov), where a miscreant husband has returned to his sceptical wife and puzzled children—a fine piece of work. But such strictures of plagiarism do not apply to Korzhev, the awkward Courbet of twentieth-century Russia.

The year 1932, in which Stalin's art dictatorship was first fully imposed, was also

the year in which the Modern Movement graduated to the International Style, marked by a decisive exhibition of architectural designs at New York's Museum of Modern Art. There were connections as well as chronological coincidences. If ever a society set out to implement the kind of Taylorian mechanisation of life through mass-produced architecture which Corbusier wanted, it was Stalin's Russia. Styles and detailed plans were laid down centrally. Component parts of housing units were turned out in factories. Yet the results were almost universally deplorable, not just in quality, which is not surprising, but in quantity, which is. It remains one of the great cultural mysteries of the twentieth century that Russia, where there is no shortage of building land anywhere, which had a rapidly falling birth-rate throughout the Soviet period, and which at least could produce steel and concrete in vast quantites, contrived to have an acute housing shortage during the entire three-quarters of a century of Communist rule. Like the missing wash-basin plugs, there is no explanation. The Soviet Union even contrived to export its housing shortage to its docile satellite in Germany, a country with a long record of efficient housing construction not least under the Nazis. Shortage was accompanied by designs which repeated all the worst excesses of the Modern Movement and the International Style, but added an extra twist of collective ugliness. Among the most repulsive monuments of the entire twentieth century is the seemingly endless panorama of shops and flats built in 1951–57 in East Berlin, officially known as the Karl Marx Allee, usually called Stalin

Farewell, from the series *Scorched by the War Fire* (1967), by Korzhev, the one great painter produced by Soviet Communism.

Allee. This was not a specially depraved Soviet style but a Communist version of countless International Style buildings put up immediately after the war, as in (for example) the 1945–54 reconstruction of Le Havre in France, tower-block flats designed by Auguste Perret.

The three decades 1940–70, when the International Style ruled triumphant, appear from the perspective of the early twenty-first century as the most lamentable time in the history of architecture, from the early medieval period onwards. The style was truly international in that its dread manifestations appeared everywhere, not least in Asia and Latin America. A conspicuous example was Brasilia, the proposed federal capital (1956–86) of what was then regarded as 'the country of the future'. Federal capitals were not new. The concept of Washington, D.C., went back to 1786 and an early-twentieth-century experiment was carried out in Canberra, the new federal capital of Australia, from 1912, according to an urban design by the American architect Walter Burley Griffin (1876–1937). This was a pre–World War I concept when the garden-city type of suburban planning was still paramount. Though the city really only began to take shape after the lake, integral to Griffin's plan, was created in 1964, and though some of its most prominent buildings were in International Modern Style, the concept was still humanist and the results bearable, if tame. Canberra still bears the comfortable imprint of Arts and Crafts.

The Brasilia plan, however, was based on quite a different concept going back to 1933, just after the International Style took hold. That year, the Congrès Internationaux de l'Architecture Moderne (CIAM) held its Athens conference, which approved a charter outlining the new dogmas behind the 'social principles' of modern town planning. (Gropius was one of CIAM's presidents.) The dogmas included functional zoning and the creation of single-function buildings in isolated sites, linked by ultra-modern road systems. These dogmas were enunciated at the time when the Germans were planning the first car-only roads, or Autobahns, and the CIAM's model city was essentially one built for the automobile rather than the pedestrian.

The master-plan of Brasilia by Lúcia Costa specifically acceded to the demand by the then Brazilian president, Juscelino Kubitschek, that the city should be 'built for the motor car'. It thus spread over a huge area. The chief architect was Oscar Niemeyer, born in 1907, an associate of Costa, who had helped Corbusier create the Education Ministry at Rio de Janeiro, 1935–45, an outstanding example of the International Style at its most uncompromising. Brasilia, then, was the largest exercise in Modernism ever undertaken, and most of the central buildings had been completed by 1960. But nothing much was done for the workers, who either were living in homemade slums and *favelas* near the site or had to bus in daily from long distances. As late as 1985, only twenty-five per cent of the federal capital's population

lived within the planned area, huge though it was, and the accommodation problem was by no means resolved at the beginning of the twenty-first century, nearly sixty years after the project got going. Many of Brazil's leading politicians, who dislike living in a subtropical bush-jungle with few or no servants, the transport problem rendering domestic labour scarce and expensive, prefer to commute to Brasilia from Rio, the old capital, where much of the business of government is still done. It is significant that no other city has been built on CIAM principles.

By contrast, the major buildings designed according to International Style principles, and built in the 1940s, 1950s, 1960s and even the 1970s certainly exceed in number and financial cost the products of any other architectural style in history. They are to be found all over the world, though some have already been replaced and more will be in the near future. They range from Corbusier's own works, such as the curiously named Unité d'Habitation de Grandeur Conforme, built in Marseilles, 1948–54, and his daunting Chandigarh Secretariat, India, 1958, to countless mass-produced designs by lesser figures, built to supply the building infrastructure of the welfare states which sprang up in the post-war period throughout the world. They include vast numbers of hospitals and schools and countless housing units in uniform blocks, many of them high-rise or, in the English idiom, tower blocks. In one British exercise, for example, more than a hundred identical schools were built from a single plan. This of course is what Corbusier asked for, and in the post–World War II world, it is what the public got. They did not like it.

To pour salt into the wounds, Corbusier himself was responsible for the labelling of much of this architecture 'Brutalism'. He had written, in English translation, 'Architecture is the establishment of emotional relationships with raw materials.' In the original French it reads, 'L'architecture, c'est avec des matières brutes établir des rapports émouvants.' This unfortunate phrase was linked with the art of Jean Dubuffet, who said he preferred graffiti or the scrawls and splodges of untrained people, even psychotics, to the work of professional artists. He called this *art brut*, raw art. In architectural terms it came to mean not merely absence of decorative feature but stress on the untreated concrete of which buildings were increasingly composed. The term also suited much of the work of Mies van der Rohe and his followers, and it was in polemical circulation from the 1950s onwards, New Brutalism being an alternative.

What exactly constitutes a Brutalist or New Brutalist work is open to argument and few architects have admitted to designing such buildings deliberately, an exception being the Italian Vittoriano Viganó. An extreme example of Brutalism is the Buenos Aires headquarters of the Bank of London and South America, built in the 1960s. Whatever its merits, if it had any, the debilitating moral weakness of Brutalism was that it lent itself to ferocious cost-cutting, so that thousands of buildings, especially in the 1950s and 1960s, the worst period of the post-war 'mixed economy building boom', as it has been termed, were indeed raw, as well as brutal. Brutalism, being

cheap, enabled architects to endear themselves to politicians, who awarded them big commissions. That is the only explanation for the extent to which they were allowed, aesthetically, to do as they wished during the best part of a quarter-century.

Tower blocks in Brasilia, inspired by ideological urban-planning guidelines laid down in the Athens Charter of 1933. Masterplan by Lúcia Costa; built from the 1960s. Cathedral on right by Niemeyer.

Architects had never been popular since slum-clearance schemes began in the nineteenth century. From 1866 onwards, Joseph Poelaert (1817–1879) created his massive Palais de Justice in Brussels in roughly the same style as Garnier's Paris Opéra, but in a much coarser and heavier idiom and on a vastly larger scale. At the time of its completion, in fact, it was the largest single building in Europe, and to erect it a huge area of working-class housing was cleared, no adequate provision being made to rehouse its dispossessed inhabitants. This scandal led to the term *architecte* becoming one of common abuse in Belgium, which it still is, one court even ruling (1952) that it 'justified some, though not excessive, violence'. Post-1945, architecture was widely seen as so ugly, and proved by experience to be so ill-designed for use and so inefficient in many cases, as well as being liable to deteriorate rapidly, that members of the profession became even more unpopular, in many cases, than lawyers. One English social critic, Auberon Waugh, even wrote: 'All architects should be executed, on principle.' Brutalism put the cap on this monument of hatred. It was one thing for it to produce public buildings that were eyesores, like those curiously complementary sixties products, the FBI building in Washington, D.C., and the new Home Office in London. It was a different matter when people were asked to live in Brutalist blocks; or rather, not asked but forced to do so. Architecture is the most important of the arts in that it is visually inescapable. By the end of the 1960s everyone was tired of the Modern Movement, or whatever it was now called, and a new era was inevitable.

32

THE DANGERS AND OPPORTUNITIES OF TWENTY-FIRST-CENTURY ART

In 1984 the American artist Mark Tansey showed a painting in which a group of French officers are signing a declaration of unconditional surrender, watched by bored and cynical American commanders. It was called *Triumph of the New York School* and is now in the Whitney Museum of American Art. In fact, the transfer of leadership in the art world from Paris to the United States had really occurred a generation before. After the explosion of fashion art in the period 1905–25, art had begun to languish in France as early as the 1930s. The catastrophic defeat by Germany in 1940, followed by the degradation of the Vichy regime, had accelerated the decline. Desperate attempts to stage a revival after the *libération* of 1944 had produced only two successes: Jean-Paul Sartre's existentialism, launched in the autumn of 1945, had temporarily put France in the vanguard of popular philosophy, and Christian Dior's introduction of the New Look in January 1947 had begun an Indian summer for the French fashion industry, which lasted throughout the 1950s. But Sartre was soon embroiled in discreditable Cold War politics and, from the early 1960s, *haute couture* became polycentric, with American, Japanese, British and Italian designers as influential as French ones. It slid down-market too, so that the number of French high-fashion houses fell from its post-war peak of 106 to a mere 18 in 1997.

In the decade 1945–55, Picasso and Matisse were still working and occasionally visited Paris, but neither produced anything which was both new and significant and the art effort there went into seemingly irreversible decline. Attempts to work up international interest in new phases of fashion art did not succeed for long, or at all. In 1948, Jean Dubuffet (1901–1985), a businessman-turned-painter, assisted by the elderly Surrealist poet André Breton, launched the Compagnie de l'Art Brut. As we have seen, it had consequences for architecture, but in two-dimensional art its stress on the virtues of 'triviality, serendipity and the gestural' caused no more than a mild stir. Even less successful was Nouveau Réalisme, which dated from the early 1950s but

issued its manifesto in 1960. This said it was a reaction to *Art Informel*, otherwise known as *Abstraction Lyrique*, which few people had heard of. Such interest as it generated came from the publicity device of reversing collage to feature *décollage*, the art of torn posters mounted on canvas.

At the centre of the movement was the self-taught Yves Klein (1928–1962), who revived Dada under the name Au-dessous de Dada, and held a show called *La Vide* (Emptiness), in which the gallery, with windows painted blue and the interior white, contained nothing. Next came Dustbin art, in which the contents of wastepaper baskets were emptied into glass or plastic containers, which became 'exhibits'. But this, like Dada, had been done before. Indeed it was one of the central difficulties of 'experimental' artists in the second half of the twentieth century, anxious to create novelties and attract attention, that virtually everything they could think of had been done before, and usually more ingeniously, in the 1920s.

These efforts were directed by men usually known by a single name, such as Arman, Spoerri, Christo, Tinguely and César, but Klein's name was the only one to stick. He experimented with powerful flame-throwers left over from the war, and turned naked girl models into what he called 'living paintbrushes', an activity which in the 1950s became known as performance art, though this again had been a Dada idea going back to 1922. The best French artists of the period—the only ones remembered now—were individualists, like Nicolas de Staël (1914–1955), who varied his abstracts with touching landscapes done under the influence of Turner, and Bernard Buffet (1928–1999), who specialised in spiky figures. The rest hunted for publicity and clients in gangs, believing that was the best way of getting coverage. Such groups were called Flexus, Tel Quel, Figuration Narrative, Panique, Coopérative des Malassis and other fugitive fashions. But as Christian Dior once remarked sadly, in fashion there were really only three things you could do: raise or lower skirts, pull in or let out waists, and emphasise or conceal bosoms. When you had done all three, you had to repeat yourself. Once fashion art is preferred to fine art, the same essential limitations apply, and repetition is inevitable.

When General de Gaulle returned to power in 1958 he made a formidable (but in retrospect desperate) attempt to revive French culture by appointing the famous novelist André Malraux his Minister of Culture, and by placing him on his right hand in the Cabinet as its most important member. He also raised the arts budget to an unprecedented height. The one important consequence was the decision to use new power-hose techniques to clean public buildings, which produced the *blanchissement* of the Louvre, Nôtre-Dame and other famous Paris landmarks, and was adopted with immense popular success all over the world. Thus two centuries of coal-fired industrialisation were erased and thousands of stone masterpieces re-emerged pristine from their grime. But in the decade of pure Gaullisme, and the watered-down versions of revived grandeur that followed, under Presidents

Pompidou and Mitterrand especially, all that occurred were immense schemes of state construction, known as *les grandes projets*. These resembled the *grands travaux* of Napoleon III but were less coherent and useful. They began with a Brutalist reconstruction of Montparnasse, continued with a new business centre at La Défense, in the Paris suburbs, an art palace, the Centre Georges Pompidou (1971–77), designed by Richard Rogers (b. 1933), an Anglo-Italian, and his Italian collaborator Renzo Piano (b. 1937). Described as an 'urban machine' for 'mass culture', this was an exercise in what might be called Entrail architecture, in which the infrastructure and the services of the building were deliberately exposed, a device repeated in the Lloyd's Building of London (1978–87). The Parisians refused to call the Pompidou by its official name and referred to it as *le Beaubourg*, ironically. Other big projects included a triumphal arch (1983–90) to complete the Défense complex, an immense piece of vainglory by Otto von Spreckelsen, not unlike Mussolini's unfinished arch at Tripoli, and incongruous glass pyramids for the Louvre.

There were twelve other major projects under Mitterrand, including a new Opéra de la Bastille (1987) by Carlos Ott. Designing opera houses is not easy. About two hundred new opera houses were built between 1945 and 2000, not always success-fully. Sydney's spectacular Opera House, of stylised superimposed shells, cuts a fine figure on the edge of what has been called the world's most beautiful harbour, but its main stage proved inadequate for such big works as *Aïda* or *Götterdammerung*. Mitterrand's Bastille Opéra ran into comparable unresolved difficulties. There were other expensive mishaps in the programme, the biggest of its kind since the days of Stalin and Hitler. The most popular item was simply the adaptation of the old 1870s Beaux-Arts terminal station, the Gare d'Orsay, into the Musée d'Orsay (1982), which instantly became one of the world's best museums. But this had to be balanced by the closure of the École des Beaux-Arts itself, marking the end of traditional art training in France. Whereas, in 1900, there were over one hundred private academies and ateliers in Paris, co-ordinated by the Beaux-Arts, where artists from all over the world could get introductions of the highest class in drawing, painting and sculpture, by 2000 there was none.

Indeed, though, by the 1990s, France was spending, per capita, more on culture than any other country in the world, the results were not only meagre but virtually non-existent. That was a point made by Marc Fumaroli in his 1991 polemic, *L'État culturel*. Culture, he noted, was the modern religion, and was subsidised by the state in the way that religion once was, by concordats and other devices—indeed, in a far more extravagant manner. In addition to the *grands travaux*, France now enjoyed a national network of Maisons de la Culture, staffed by experts on high salaries and dispensing huge budgets. But where, he asked, were the painters and sculptors? Who were the architects? (Most of the *grands travaux* had been designed by foreigners.) As he put it, the money had been spent but where was the genius it was supposed to buy? 'One sees the Emperor Augustus and Maecenas, but where is Virgil? One sees Julius II

too, but where is Michelangelo? Where are the Mozarts, the Rimbauds, the Van Goghs who were supposed to emerge from the conveyor belt of our cultural engineering?'

In the second half of the twentieth century, therefore, the battle for the soul of Western culture—if it still had one—was waged primarily in the United States. By mid-century, many of the most celebrated European artists had come to live and die in America—Max Ernst, Arshile Gorky, Fernand Léger, Marc Chagall, Piet Mondrian, André Masson. It was a mark of the legacy of French cultural colonialism that, as late as 1952, New York's Museum of Modern Art felt it necessary to hold its first big display of contemporary American artists in Paris. But that kind of gesture was already out-of-date, because by the early 1950s, America's first dominant form of fashion art, Abstract Expressionism, had already been launched and taken hold. Historians have traced it back to Kandinsky in 1929 and its first post-war efflorescence to a New York exhibition by the Dutchman Willem de Kooning in 1948. But in fashion art it is perception that matters, and this form of art—a wild explosion of paint in random patterns—was created by the all-American Jackson Pollock (1912–1956), the most influential American artist since Whistler.

Pollock came from Wyoming though his family had moved restlessly nine times by his sixteenth year, ending up in Los Angeles, where he received some art instruction. He was really, however, a product of theosophy (and Krishnamurti), Jungian psychology, the Works Progress Administration's Federal Arts project, a New Deal body that kept him from starvation, David Siqueiros's Experimental Workshop (1936–37), where he learned about industrial enamels such as duco, and the effects of alcoholism, from which he suffered all his short adult life. Pollock, like Picasso, had a certain reckless confidence in his right and ability to carry things to extremes (though without Picasso's cynicism), and once he muddled his way towards abstraction in the mid-1940s, he started to put his canvases on the studio floor and pour or drip paint on them. This was first called action painting and again was not new, since the Dada artists had tried it in about 1923; the term 'Abstract Expressionism' was invented by the modern art establishment, and has stuck, though Pollock himself never used it. He got his point across by using very large canvases and a variety of ways of putting the paint on: brushes heavily dipped in big cans of paint, enamel, varnish and lacquer, turkey-basters from his kitchen, and thin sticks. He used vast quantities of Indian-red paint and claimed that his technique was akin to what he called 'Red Indian sand painting' (this was before the age of political correctness). He liked a dark red base of fabric, and then put on his colours in poured lines and drops, starting with pale grey or white and moving his way into the yellows, reds and blacks, with touches of silver. The public was intrigued because Pollock appeared to walk over his paintings while at work and did not mind being filmed doing so.

The results were curiously pleasing and confirmed the view of many people that non-figurative art was at its best and most sincere when it abandoned representation completely and became abstract. The skill with which Pollock obtained his effects became evident once his countless imitators tried their hand at the same thing. His best works, numbered from one to fifty, and now in most big public collections of contemporary art (MoMA has the finest), show some degree of control and self-discipline. But after about 1952, there was a precipitous decline into incoherence and alcoholism, ending in a fatal car accident in 1956. As with Gauguin and Van Gogh, however, Pollock's personal tragedies did his artistic reputation no harm; quite the contrary—the word most often used about him is 'heroism'.

The next phase of fashion art slipped neatly into the slot left vacant by the decline of Abstract Expressionism. Pop art dates from the mid-1950s, and originated almost simultaneously in the United States and Britain. In London the artist-printmaker Richard Hamilton (b. 1922) defined it as 'Popular (designed for a mass-audience); transient (short-term solution); expendable (easily forgotten); low cost; mass-produced; young (aimed at youth); witty; sexual-gimmicky; glamorous; and big business'. He was one of the last British artists to be properly trained, at the Royal College of Art, the RA and the Slade, which in the 1940s and 1950s still held life-classes and other forms of serious instruction. Indeed, some artists associated with this fashion for a time were of considerable merit. They included a superb draughts-man, David Hockney (b. 1937), who from the 1960s did some admirable graphic work and portrait drawings of the quality of Henry Lamb's. However, Pop art, the lure of California and the liberalisation of the laws on homosexuality persuaded him to specialise in Swimming-pool art, a sub-branch of Pop. Another gifted artist who oscillated between serious painting and Pop art was Ronald B. Kitaj (b. 1932). Kitaj, though trained at the Ruskin and Royal College, was an American by birth, and it was the Americans who took over the Pop art fashion and focused it on comic cuts, movies and junk-food labels.

Of the Americans, three were of consequence. Jasper Johns (b. 1930) invented a new trick, of turning familiar images, such as the American flag, into paintings, which allowed him to move from Abstract Expressionism, as soon as it went out of fashion, into Pop, which was *dernier cri* by 1960. From images he moved to stick-ons and constructs, then to sculptures of common objects such as light-bulbs and torches, old standbys of Dada since the early twenties. He achieved notoriety in 1960 with *Painted Bronze* (Basel, Kunstmuseum), a sculpture of two beer-cans, claiming: 'Parts were done by casting, parts were built up from scratch, parts by moulding, breaking and then restoring. I was deliberately making it difficult to tell how it was made.' From Pop he moved through lithography to Cross-hatching art, collage combined with encaustic, then to Minimalism and Referential art, in which images such as the

FACING PAGE: Jackson Pollock's *White Light* (1950s) illustrates the colour theory and practice of Abstract Expressionism. Much thought went into this inspired linoleum.

Mona Lisa were incorporated in pseudo-philosophical designs. The one constant in Johns's work was his ability to negotiate enormous prices. In the 1950s and 1960s and again in the 1980s, he achieved the highest prices ever paid for works by a living American artist, his *Out the Window* (1958) selling for $4.5 million in 1986 (private). The Whitney paid $1.5 million for a typical Johns, *Three Flags*, in 1980.

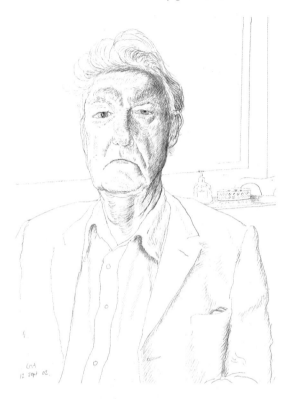

Johns's associate, Robert Rauschenberg (b. 1925) engaged in various forms of fashion art: happenings, usually with music; Minimalist art of simple, plain colour combinations or one-colour canvases; Neo-Dada and Post-collage; constructions in metal and mixed media; kinetic or moving art devices; and book illustrations, such as his *Dante* (1959–60, New York, MoMA), not so distinguished as Botticelli's efforts in the 1480s but considerably better rewarded. Rauschenberg produced most of his tricks from the Dada lucky-dip bag of the 1920s; on the other hand, his updating, enlargement and refinement of them, especially in such forms of fashion art as installations and performances, became the fountain-head for numerous fashions of the 1980s and 1990s and into the twenty-first century. Such commercially successful British artists as Damien Hirst (b. 1965), Gilbert and George (Gilbert Proesche, b. 1943, and George Passmore, b. 1942), the 'Resurectionist', Bruno Hat (b. 1968) and Tracey Emin (b. 1963) have followed in Rauschenberg's well-beaten track, though none has made anything like as much money.

The third of the trio was Andy Warhol (1928–1987), who made his mark on art history by summing up fashion art in one decisive phrase: 'Art is what you can get away with.' He certainly proved it in his case, establishing an international reputation and making a fortune by exhibiting images of Coca-Cola bottles, cans of soup, multiple photos of famous personages such as Mrs Jackie Kennedy and Marilyn Monroe, organising nightclubs and pop studios, and generally making himself famous for being notorious. He was not so much an artist, for his chief talent was for publicity, as a comment on twentieth-century art, and as such a valuable person, in a way.

By the end of the 1960s there was a growing weariness with fashion art and its excesses, not least among artists themselves. That does not mean fashion art went out of fashion. On the contrary; it continues to this day and will be manifesting itself for some time yet, for a number of powerful commercial and institutional

David Hockney (and some others) carried superlative draughtsmanship into the twenty-first century. Portrait of Paul Johnson (2002).

reasons we will examine shortly. As early as 1960 a New York exhibition was held by eleven professional artists, including America's best portrait caricaturist, David Levine, protesting against the drift of art into chaos, appealing for order and rationality, and adding: 'This exhibition is a beginning. We are only one group among many who are still pursuing a realist approach in painting.' This venture did not succeed, at least in the short term, for the artists involved did not grasp the importance of winning publicity by effective labelling.

The situation changed when the term 'Post-Modernism' came into circulation. It actually went back to 1934 but it came into general use only after the publication in 1971 of an essay by Ihab Hassah, fashionably entitled 'POSTmodernISM: A Practical Bibliography'. This confused matters by presenting it as an extreme form of modernism including what Hassah termed 'Pataphysics', 'Antiform', 'Anarchy', 'performance art', 'happenings', 'Deconstruction', 'Antinarrative', and so on. Although the traditional long waves of art, moving from clutter to simplicity, operated only feebly and fitfully in the twentieth century, after the endless clutter of fashion art there was a surge or slide into classical order and simplicity, not indeed as a replacement but as a competing alternative. In 1987, in the first historical study, *Post Modernism*, Charles Jenks—who subtitled his work *The New Classicism in Art and Architecture*— listed, dated and analysed five forms of Post-Modernism which had manifested themselves in the quarter-century 1960–85: Metaphysical Classical, Narrative Classical, Allegorical Classical, Realist Classical and Classical Sensibility.

What emerged from such analyses, however, was the obvious danger that Post-Modernism had become a form of fashion art itself, using tricks and labels which were rapidly replaced as they dated. It is more useful therefore to concentrate on a number of individual artists, from all over the world, but mainly from America, who in one way or another have rejected fashion art and (to use Warhol's phrase) 'got away with it'. As far back as the 1940s, the Australian artist Sidney Nolan (1917–1992) had revived, in an attenuated form, history or narrative painting by beginning a series of arresting works on the life of the bush-outlaw and hero Ned Kelly, who had made himself visually famous by constructing an iron helmet, used by Nolan with devastating effect. He did another series on the Queensland heroine Eliza Fraser, and a third on the first Trans-Australia explorers. These paintings by Nolan, especially the early Kelly pictures (best example in Melbourne), worked as images because he had thought long and painfully about what he was doing, and in visual terms. Attempts to write contemporary American history in paint, like Paul Georges's *My Kent State* (1971, private), dealing with a student riot, were less successful, because they were too glib. The same could be said of the German artist Jörg Immendorff, whose attempt at a George Grosz–type comment on the Third Reich, *Café Deutschland* (1978, Aachen, Neue Gallerie) was too obvious. So were the occasional attempts at religious painting, like Steve Hawley's *Descent from the Cross* (1988–90, St Louis, Art Museum), showing the Apostles and the women in contemporary dress

and based on a Van der Weyden in the Prado. It is vital in two-dimensional art to persuade the viewer to look deeply and carefully into the work. That was certainly the effect produced by the reconstruction of Velázquez's famous portrait of Pope Innocent X by the Anglo-Irish painter Francis Bacon (1909–1992), a chaotic artist of smudges, whorls and dislocations, who flourished mightily. Bacon had never been taught to draw and so could not paint, but he had a natural talent for using shapes to alarm, and in that sense was a visual narrator.

The only narrative artist of genius during the second half of the twentieth century was the Pennsylvanian Andrew Wyeth (b. 1917). His father came from the immensely professional illustrated paper tradition, painting covers for the *Saturday Evening Post*, like Rockwell. He taught his son himself, probably the best way of learning to paint, as the experience of Holbein, Dürer and countless others artists proves. Wyeth learned from his brother-in-law Peter Hurd how to make effective use of the old fifteenth-century method of egg tempera on a gesso foundation to get extremes of light and clarity, but he also used watercolour with a dry brush and other meticulous techniques. Wyeth was a true reactor to fashion art. He had no fashion. He painted what he saw, after countless preliminary studies and models, and he organised his compositions in ways which made them tell a story. As in Caravaggio's masterpiece *The Calling of Saint Matthew*, the viewer is invited to become a co-narrator. Wyeth's first successful work, *Christina's World* (1948, MoMA), depicted a crippled girl, seemingly abandoned in a deserted meadow, struggling towards a house on the horizon. It would be hard to think of a more compelling image created in modern times, to which the eye wanders again and again. Thirteen years later, Wyeth produced another key image of the century, *Tenant Farmer* (1961, Delaware Art Museum), showing the poor farmer's dark and unwelcoming house, in snow, with the carcass of a deer hanging from a tree outside.

Wyeth's work, which is extremely complex, falls into three main portraits and drawings of the crippled girl Christina Olson (who died in 1969); paintings of the farm and livestock belonging to Karl and Anna Kuerlner in Chadds Ford, and related works, some portraits of his own family; and paintings and drawings of a neighbour, Helga Testorf, of which there are about 250. Wyeth was everything the twentieth-century fashion artist was not. He usually worked in secret and shunned public notice. He never talked about his work if he could avoid it, believing it spoke for itself to those who would look and listen. He worked slowly, carefully, conscientiously, self-critically, and with absolutely no regard for commercial success, critical notice, contemporary trends or, for that matter, posterity. His popularity gathered momentum none the less, and in 1976 he was honoured by a large official retrospective held, significantly, not in the Museum of Modern Art but in the New York Metropolitan. In the quarter-century since then his reputation has risen steadily and there are now many practising American painters who take him as their master, an outstanding example being the leading black American painter, Dean Mitchell

(b. 1957), whose *Country Church* (1989, St Louis) and *Quality Hill* (1994, Kansas City, Nelson-Atkins) also reflect the continuing influence of Edward Hopper.

Much of the energy of Post-Modernist American painters was concentrated on photographic realism, involving gleaming surfaces and glass reflections, as in *Alitalia* (1973, Washington, Smithsonian) by Richard Estes, or mechanical shapes, using air-brushes and grids taken from actual photographs. But a lot of this work, and there was an increasing amount of it in the 1980s and 1990s, was really a *reprise* of Charles Sheeler, with less originality. Photorealism, a Post-Modernist art fashion of the 1970s and 1980s, was even more ineffective and ephemeral. Nude painting, of a rather brutal kind, also featured in Post-Modernism, though it had returned to fashion long before: the nudes of Larry Rivers, such as his *Double Portrait of Berdie*—his elderly, overweight mother-in-law—done in 1955 and now in the Whitney Museum, evoked shock-horror reactions from the more fanatical supporters of fashion art. Other painters in this genre were the Englishman Lucian Freud (b. 1922), who also created striking portraits from much-tried patrons (Freud sometimes required as many as ninety sittings), and Philip Pearlstein, whose

Andrew Wyeth's *Tenant Farmer* (1961) puts together ingredients of great art: unforgettable image, meticulous execution, moral purpose, a shock to the senses.

Two Models on a Kilim Rug with Mirror (1983, private) is characteristic of this kind of artist: painstaking and skilful but somehow unappealing. The human body can repel as well as attract, and works in this manner have been described as 'items from a butcher's shop catering for cannibals'. Eric Fischl also produced striking nudes, as in *Sisters* (1984), showing two women using a bidet, but his real skills emerged as a narrative painter of shocking incidents, as in his brilliant but odious canvas *Bad Boy* (1981; both Zurich, private), in which a delinquent teenager robs the handbag of the sleeping older women he has bedded.

What the experience of the last quarter-century of painting suggests is that shock-impact, in the manner of fashion art, does not work in realism: the reflective mood, as in Hopper and Wyeth, is always more effective. There is something of this in the work of the Spanish painter Antonio López García (b. 1936), whose 1986 exhibition showed striking drawings and oils, apparently evolved from Surrealism, always strong in Spain, but also human figures in painted wood and low-relief bronzes. Similarly impressive was the enormous drawing *Triumph of St George* (1974), based on a painting by Carpaccio, by the Italian realist Salvatore Mangione, who calls himself Salvo (b. 1947). But such works are rare in Europe. The Americans are more self-confident and less self-conscious in doing what they think right in art. Stone Roberts has produced a number of arresting genre pieces, which combine skilful realism with immensely subtle light-effects, *chiaroscuro* and thoughtful composition, such as *Janet* (1984, New York, Metropolitan), which raises unanswered but interesting questions. His big *Conversation* (1985), which is 6 by 7 ½ feet and is full of intriguing glimpses and enigmas, is one of the most accomplished works in oils to be produced in the last quarter-century, worthy of Sargent.

The resurgence of realist or naturalist art in the last decades of the twentieth century was fitful, uncertain and nervous, proceeding as it did without any encouragement and with very little patronage from official art establishments which, in all advanced countries, remain institutionally wedded to fashion art. That is true even of countries like Japan, which has its own powerful traditions—now dormant—or former Communist countries like Russia, where artistic expression is now free. It is even true of Communist China, still bruised by the Cultural Revolution, where artists in the last decade of the twentieth century, though comparatively free to pursue their own non-political paths, chose to enlist in the massed battalion of the current art ideology emanating from New York. The grip which fashion art still exerts in the world's main art centres has produced a lamentable paradox. Although more wealth was created during the twentieth century than in all previous centuries put together, by a considerable margin, and though eighty per cent of that wealth was produced in the half-century 1950–2000, the number of beautiful objects, in two or three dimensions, created in those last five decades is pitifully small. With one or two arguable exceptions already noted, no great painter or sculptor has emerged in the last five decades, there has been no master-style since Art Deco in the twenties

and thirties, and most of the century's *objets de vertue* of any quality were produced in its first quarter.

The reasons for this tragic poverty of art in our times are probably much more deeply buried than most of us writing about art imagine, and they may not be convincingly identified until our present century is almost over. But one factor is clearly the overwhelming power of money-values in determining the merits of works of art, and the ability of a small number of individuals and institutions to determine those values. The old academies no longer exist or, where they still do, as in the case of the English Royal Academy, peer through the accumulations of fashion art like a feeble palimpsest or a forgotten *pentimento*. As an institution, the RA is now active mainly in organising popular exhibitions, and its creative activities, such as they are, are usually presided over by second-rate architects, most of the skilled painters having departed. There has been some revival in the teaching schools during the last quarter-century, in big cities all over the developed world. This follows an abysmal period when art skills were not taught at all, and a sculptor looking for instruction in the techniques used by Gilbert or Rodin, for instance, had to consult late-nineteenth-century manuals if they could be found. The breaking of the skill-chain in places like Paris and Rome was particularly damaging to professional training. These studio-workshop disciplines can only be re-created over generations.

The reasons for the persistence of fashion art are entirely commercial. From the Impressionists onwards, artists broke away from the academies in a series of revolts. That did not, alas, mean that they acquired freedom. It has never been easy to sell works of art. Most artists have, over the ages, led a penurious existence. Many have almost starved. The academies were created precisely to help artists sell their products, and when the artists spurned them, they automatically placed themselves in the hands of the dealers, agents and private galleries. From the 1870s onwards, therefore, the power of the dealers has increased, is increasing and is likely to continue to increase. Unlike academies, which have all kinds of motives, some of them reprehensible of course but others honourable, dealers have only one: making money. It may be combined in some cases with a degree of aesthetic altruism, but unless the profit motive is uppermost, such businesses cannot survive. When objective standards of skill and merit in art, which can be perceived by the public and patrons, disappear more or less completely—as they did for most of the twentieth century and remain in abeyance in the twenty-first—the power of the dealer correspondingly increases, for he is the sole judge of merit by showing an artist's work. That of course is reflected in his share of the proceeds from sales. Whereas the academies charged the artist a tiny percentage of his selling prices, or none, the dealers' percentage has steadily increased until it is customarily sixty per cent, often eighty per cent. It is true that a few artists, because of their commercial popularity, are in positions of strength; but nearly all of them have been created by dealers in the first place, rather than by public taste.

The dealers do not work in isolation. They are part of an art establishment, a

self-reinforcing, self-perpetuating oligarchy, which includes art magazines, critics, professional patrons and, most important, museum directors. These work in conjunction with state bodies which dispense public funds to deserving artists, or the judges who award prizes, whether it be the Venice Biennale or the annual Turner Prize in London (there are over 3,000 art prizes in France alone). Virtually all these goodies go to fashion artists, as they have done for the past half-century. It is the same artists, thus elevated, whose works are acquired by the national institutions which spend money to make official collections. The artist becomes institutionalised in turn, and figures in the art histories and dictionaries of art and artists. Thus enduring fame is acquired in ways which would have astonished Raphael and Michelangelo, who innocently believed it was the result of creating beautiful works of art. The opportunities for intolerance and censorship are obvious.

Modern art establishments wield much more power than anything practised in the times, say, of Le Brun or David: power both to create and to render invisible. They do not burn paintings, as Hitler did, or send artists to the Gulag, as was the wont of Stalin. Nor do they manipulate mobs of Red Guards to butcher sculptors and craftsmen in the streets. But they break the hearts and impoverish the lives of artists who do not conform to their meretricious criteria. Writers and editors who resist these establishments quickly find themselves without jobs or platforms. The opportunities for corruption are also obvious. Indeed, fashion art, by its nature, is constitutionally corrupt. The way in which it operates is as follows. X, a professional collector, spots a likely young artist, and buys up his or her early work. He enlists the support of Y, a dealer-gallery owner, and Z, a museum director. Together the three 'create' the artist who, let us say, produces collages of artificial cat-skins. He/she is given grants and prizes, and a highly successful show at Y's gallery, followed by purchases for Z's museum. At that point X is free to unload his purchases to finance his next operation; Y makes a handsome profit too; Z does not (as a rule) make money but is paid in power.

Though fashion art remained dominant throughout the twentieth century and into the twenty-first, it was a different matter in architecture. Buildings are not luxuries, like paintings and sculpture. They are necessities. They have to work. One of the characteristics of the International Modern Style was that, being highly ideological and rigid, it was also inefficient. Its buildings, conceived on the principle of functionalism, were actually dysfunctional in many cases. High-rises created crime and other social problems. Glass-sheathed university libraries roasted their books. Brutalist hospitals killed their patients. Such buildings also disgusted younger architects with their lack of opportunities, choice and inspiration. In 1966, Robert Venturi (b. 1925) published an important book, *Complexity and Contradiction in Architecture*, which called for multiplicity and variety in the style of new buildings and answered Mies van der Rohe's fatuous 'Less is more' with 'Less is a bore'.

In paintings, such an attack would have been severely punished; indeed, the book would not have been reviewed. But Venturi's onslaught brought commissions. Clients were as bored as he was. Individuals wanted homes, not units. Corporations wanted images they could be proud of like the Chrysler or the Empire State buildings, not glass boxes. When Philip Johnson and John Burgee produced their design for AT&T's corporate headquarters in New York in 1979, its flashy classicism surmounted by a broken pediment acted like a slogan, and for the first time in the century, anti-Modernists got the publicity on their side. It would not be true to say that Modernism in architecture collapsed like a pack of cards, though some of its buildings came close to it before they were demolished. But by the 1980s it was dead.

Post-Modernism in architecture took many forms. Michael Graves reintroduced colour contrasts in the Portland Building, Oregon, designed in 1978. In the Republican Bank, Houston, Texas, Johnson and Burgee reintroduced the Gothic with Baltic stepped-gables and spires in an immense tower. In the Neue Staatsgalerie, Stuttgart, 1977–84, James Stirling and Michael Wilford experimented in what might be called New Mycenaean. Venturi's Salisbury Wing for the London National Gallery, 1980, was Baroque Pastiche. Spanish architects were particularly forward in producing new stylistic exercises. At Marne-la-Vallée near Paris, Ricardo Bofill (b. 1939) combined classicism with varieties of Baroque and even pseudo-Rococo. In the same vast development, Manuel Nuñez produced immense circles, curves and arches, 1980–85. Santiago Calatrava (b. 1951) reintroduced spectacular vaulting for a variety of internal purposes. Another huge 1980s–90s development, Canary Wharf in London Docklands, was predominantly Romanesque. The architects of classical Greece, ancient Egypt of the New Kingdom, Neo-Babylonia, Plateresque and *Sondergotik*, Palladio and Piranesi all arose from their graves to haunt the fleeing Modernists. Colour returned—gleaming classical white, blood-red from the hetacombs, pale green from Art Deco, the orange of the Pueblo Indians, shocking pink from the heyday of Schiaparelli and Raoul Dufy, yellows and browns of desert Islam. Much of the new architecture was silly and meretricious; much was the architectural equivalent of Pop art or Op art. But it created a multilingual hubbub—very different from the strident, authoritarian monoglot monotone of International Modernism—in which creative architects of genius could find their individual voices, as they were beginning to do, in increasing numbers, by the early twenty-first century.

With the return of exuberance in building, the skyscraper tower made a dramatic comeback, not only in the United States but all over the world and especially in the new economies of the Far East. Hong Kong, like Manhattan Island, was a natural skyscraper city. It grew to the skies, in the 1950s and 1960s, in the unfeatured block-style of International Modernism. The seventies introduced colour and variety. In the 1980s there came revolutionary changes with the introduction not so much of Entrail architecture as of Meccano towers, in which huge steel beams on the

outside provide the patterning and decoration and appear to constitute the structure—thus the 1986 Hong Kong Shanghai Bank of Norman Foster (b. 1935) jostles for attention with its immense neighbour, the Bank of China, 1990, by I. M. Pei.

Meccano architecture, both in its hard-edge and rounded-edge versions, became a particular favourite in East and Southeast Asia. It was used for the immense twin towers of the Tokyo City Hall, 1992, by Kenzō Tange (b. 1913), a late convert to Post-Modernism, who caused a sensation when he produced his plan for what looks like an 800-foot-high metallic west front of a late-twentieth-century cathedral, with square girder frames instead of spires. Nearly twice as tall were the twin Petronas Towers at Kuala Lumpur in Malaysia, 1,480 feet high when completed in 1996. Their Meccano serrations are rounded and there is a whiff of the pagoda about their spires. But one of the objects in building them was to produce for Asia in general, and mighty little Malaysia in particular, the title of the world's tallest building, at least for a time. This had been held by the Sears Tower in Chicago, about 150 feet lower, and by the time this book is published it will have been snatched from Malaysia by the Shanghai World Financial Centre, 2002, another 60 feet up, with its enormous decorative hole in the top,

Shanghai World Financial Centre, completion date 2005, an effort to achieve multi-faceted grace on the enormous scale now possible.

designed by Kohn Pederen Fox. It is worth reminding those who think it odd that Communism should produce the world's tallest building that for decades the record for the tallest building in Europe was held by a Wedding Cake tower built in Warsaw in the 1950s. It was beaten by Norman Foster's Kommerzbank headquarters building in Frankfurt, 1994–97, though its 1,300 feet is comparatively low by world standards.

Great skyscraper towers are never built for purely commercial reasons. They are advertisements, self-advertisements, corporate, personal or even national: in short, their motivation is akin to artistic; to use the current twenty-first-century jargon, they are 'statements'. Skyscrapers are still built with essentially the same technology used in the Empire State at the end of the 1920s. But increased knowledge of how they and their materials behave, when built, enables them to creep higher and higher. As long ago as 1956, Frank Lloyd Wright designed a mile-high skyscraper. Present towers are still less than a third that height. There is a proposal to build a Millennium Tower of ninety storeys and over 1,000 feet in London; for a Tour Sans Fin in Paris; for a Nina Tower in Hong Kong (called after the billionairess Nina Wang); and a tower in Melbourne which will be 2,250 feet high. Planning is going ahead on buildings of up to 2,600 feet, including a tower in Tokyo in the Entrail style. These projects depend on the economic climate; the Empire State, planned just before the Wall Street crash of 1929, was the last big skyscraper to be built for nearly two decades. But there can be little doubt that the mile-high skyscraper will be built during the twenty-first century. As is shown repeatedly in the cities of America, which has always built the best skyscrapers and grouped them profusely, a grove of varied tall buildings is one of the most exciting sights on earth. These airy and glittering city centres are perhaps the greatest achievements of twentieth-century art.

Yet the skyscraper is not necessarily the quintessential twentieth-century art form. During the nineteenth and twentieth centuries, perhaps the most startling fact in everyday lives was the increasing speed with which humanity moved, and this has been reflected in many art forms. The first modern road, London–Holyhead, built by Telford 1815–30, and still in use, included many vast and beautiful works on a scale that would have daunted even the Romans—the Chirk Embankment, the Glyn Diffwys Pass and the road through Nant Ffancon—and some superb bridges, including the Menai Bridge. This was the first suspension design built on a large scale with arches over 52 feet wide chained to towers 153 feet high, a total span of 579 feet with a clearance for ships of over 100 feet. A masterpiece of art and engineering, the Menai Bridge inspired Telford to propose the first roads built entirely for fast traffic, bypassing towns and adumbrating the modern expressway. He was almost exactly a hundred years ahead of his time. The first toll motor-only highways were built by Mussolini in Italy from 1924; he called them *autostrade*. But the first true expressways, framed by the Weimar regime in Germany in 1930–32, were actually built by Hitler, who had constructed 1,310 miles of Reichsautobahnen by 1942.

America did not build its first expressways, the Pennsylvania Turnpike and the Merritt Parkway in Connecticut, until 1941. These early efforts were ugly and paid little attention to siting. But from the 1950s onwards, the half-million miles of expressways built included some of the most beautiful stretches of road ever conceived by mankind, such as the crossing of the Apennines of the 500-mile Milan-Naples Autostrada del Sole in Italy (completed 1964), the road from the coast through the mountains to Caracas in Venezuela (1960) and the stretch of the English M6 across Cumbria (1980). Art-engineering of expressways, often by anonymous designers, became a scientific form of Expressionism. Moreover, by creating protected areas of grassland effectively banned to humans, the expressways offered new opportunities to blend art and nature. Thanks to a 1980 initiative by Ladybird Johnson, widow of the American president, and the English entomologist Miriam Rothschild, tens of thousands of acres of expressway verges are now sown with wildflowers, all over the world.

If the grandest railway stations, such as Bombay, were built in the nineteenth century, the twentieth century also contributed a score of masterpieces. The first, chronologically was the Helsinki Station in Finland, designed in 1904 by Eliel Saarinen (1873–1950) and built 1910–14. This bypassed all the Modernist ideology to produce a bold design of contrasting tower and semicircular hall, in striking colours of green and orange. Helsinki influenced Mussolini's two big stations, Milan and Florence. It also had an effect on the finest American work of the period, the Union Station, Cincinnati, designed by a Hungarian emigrant, Roland A. Wank (1898–1970) in 1928. This abolished the tower and enlarged the semicircle into the gigantic whole, with truncated towers at the sides—perhaps the finest of all Art Deco buildings, with sumptuous interiors involving craftsmanship of the highest order. The greatest thirties station, Rome Termini, designed in 1936–37 by Angiolo Mazzoni, an architect at Mussolini's Communications Ministry, but not actually built until after the war, was the first successful attempt to create an immense and efficient canopy of glass and steel, enclosing huge quantities of space and sheltering thousands of people, which does not look oppressive.

The International Style, used repeatedly for stations designed and built in the period 1950–75, left no masterwork in this genre. But in the quarter-century that followed, and especially in the 1990s, station architecture, dead since the thirties designs, suddenly came to life again. Its theme was light, and ways of making it dominate vast utilitarian sheds, which is what a railway station essentially is. The first great work was the 1,300-foot shed designed by Nicholas Grimshaw & Partners for the Channel Tunnel Terminus at Waterloo (1988–94). This was made possible by a new structural device, the bowstring truss, also used in the Rotterdam Blaak Station, 1989–93, by Harry Reinder. This truss is an excellent example of the way in which necessity can breed not just new technology but art too, the result being a new form of beauty.

Waterloo Station also involved the use of structural glass on a large scale. There are 12,000 yards of stainless steel in the roof, but much of the actual weight is carried by 245 tons of this new glass, the result being a scintillating distillation of light which takes away all the oppressiveness of a busy station. The ingenious use of structural glass was the specialty of the Anglo-Irish engineer Peter Rice (1935–1992), who set up a practise in Paris in 1984. He provided it for Entrail architecture (Pompidou, Lloyd's), in the stair towers of the Cité des Sciences et d'Industrie, Paris, 1981, and in other structures. His book on the new glass, *Le Verre structurel* (1990), opened many eyes; so did his brilliant roof on the mid-1980s Menil Gallery in Houston, designed by Rienzo Piano. The most spectacular example of Rice's structural glasswork is the wave-roof of Lille-Europe Station, designed by Jean-Marie Duthilleul and built 1990–94. Spain has also built some notable stations in the last quarter-century, the Santa Justa in Seville, by Antonio Cruz and Antonio Ortiz being the outstanding example. And it was the Spanish architect, Santiago Calatrava, who produced the most spectacular modern station of all, Lyon-Satolas, with its rib-cage interiors and arched dihedral fans on the exterior, which make it look like a giant butterfly enclosing the bones of a dinosaur. It is a significant fact that, while rail travel continues to produce architectural masterpieces, air travel does not. Of over a thousand airports built during the twentieth century, not one falls into the category of high art.

It is a totally different matter with bridges, which continue to astonish, delight and sometimes alarm people with their brilliant and heart-stopping use of the latest technologies. Bridges, built for use and carrying traffic twenty-four hours a day, have to be well-designed to survive, and if they are durable they are nearly always handsome and sometimes beautiful. It is a tribute to the Roman designers and engineers that the Ponte Sant'Angelo, embellished by Bernini, but structurally from the age of Vitruvius, still carries traffic over 1,850 years after it was built. It sits on powerful-looking piers, which are fascinating to draw, as the author of this book has often found. Piranesi was fascinated too; he not only drew them but took the trouble to investigate the piers down to river-bottom, and made a detailed scale drawing of the result. He discovered that the substructure, below water-level, is fifty percent taller than bridge and piers combined, and twice as wide as the piers at water-level. The project had been worked out with immense care, and great attention to detail, by the Roman engineers, and it illustrates the principle that lasting utility and great art are unlikely to be achieved without a willingness to combine hard-acquired skill with painstaking effort. Investigation of the later substructures of the Rialto Bridge in Venice (designed in 1587 by Antonio da Ponte), with their intricate combinations of brickwork, stonework and lateral and vertical piles, teaches exactly the same lesson: there are no short cuts. Both these instances of fine bridges which have lasted well demonstrate the close connection between art and good engineering.

The first bridge which looks as if it belongs to the twentieth century, because it made uncompromising use of steel on the largest possible scale and because its design reflects the fact, is the Forth rail bridge, actually completed in 1889. At the time, the scale of its spans, the volume of steel used, the height, length and depths of its cantilevers, and the amount of masonry employed in building its massive piers, broke all records. Sir John Fowler and Benjamin Baker, who created it, managed to turn stress-lines and colossal support-girders into an intricate piece of beauty, which forms an arresting image and still looks dauntingly modern 110 years after it was put up, especially now that it can be compared with the Forth road bridge, built 75 years later. The rail bridge, following the Tay Bridge disaster of 1879, made the maximum *display* of steel to emphasise safety and reassure passengers. The road bridge, taking advantage of immense American experience in building big twentieth-century suspension bridges, used the minimum amount of steel to emphasise efficiency of design. The two Forth bridges give us different, complementary and refreshing glimpses of aesthetic technology in two historic phases of its evolution, and plans to construct a third bridge, when realised, will take the story into the twenty-first century.

The truth is that bridges like skyscrapers are at their best when seen in conjunction, not isolation, either with other bridges or contrasting prominent objects. The bridges which link Manhattan Island to the mainland form a supreme picture gallery of aesthetic technology precisely because they vary in epoch, size, design language and construction techniques—their glittering whole is much bigger than the sum of its parts. The Golden Gate Bridge of San Francisco, by Joseph Strauss, begun in 1933, is pre-eminent among bridges not just because of the Art Deco design of its piers (by Irving Morrow, who insisted on their being painted red-lead, a favourite Art Deco colour), but because of its clean-lined contrast with the immense complexities of the two Carquinez Strait bridges. The wonderful Sydney Harbour Bridge, by Ralph Freeman and Dorman Long, 1924–32, has an ideal position as the one crossing of the world's most beautiful harbour, and it too benefits from the Art Deco design of its piers. But its lines are undoubtedly enhanced by the juxtaposition of the Sydney Opera House, and its curved shells, seated at its foot. Again, the two immense suspension bridges over the Tagus, in Portugal, the first completed in 1966 and the second in 1998, complement and set off each other.

Late-twentieth-century bridges have also made intelligent and romantic use of concrete, two examples being the Ikuchi Bridge in Japan, 1991, where the cable-stayed process was used, and the Skarnsynder Strait Bridge in Norway, 1992, of comparable design but with a larger span, 1,739 feet to 1,608 feet. These bridges are dwarfed in size but not in elegance by the Pont de Normandie over the Seine, 1994, with a 2,808-foot span, and the even larger Tatara Bridge in Japan, finished in 1999. But with very long bridges, such as the Humber Bridge in England, the towers or central supports tend to become insignificant in relation to the width of the span, thus numbing the effect. Such bridges, especially if they also require complex and

hard-to-design road-approach apparatus, tend to look merely utilitarian, like a petrol pump, rather than romantic, like a Venetian lamp-standard. An example is the Honshu-Shikoku bridge complex in Japan, which involves a number of bridges and immense road systems and constitutes the largest civil-engineering project in history, 1970–99. There are elements of beauty here, but the whole cannot be comprehended in one glance, rather like Tiepolo's enormous Treppenhaus in Würzburg. That does not mean there is an optimum aesthetic size for bridges. It does, however, play into the hands of an imaginative designer like Santiago Calatrava, who—as in his station architecture—is prepared to make the latest technologies work for him, and his fever-ish search for new forms, rather than becoming a willing galley-slave chained to its steel-and-concrete oars. Calatrava's Punta del Alamillo Bridge and his Médoc Bridge over the Garonne display ways of humanising shapes dictated by problems of stress and weight-carrying by looking to older models—he has studied rigging patterns of old three-masted sailing ships, for example, to get the answer.

As the twenty-first century opened, the expanding size of sus-pension spans made bridges seem not merely the means to cross rivers but also inter-country and inter-continental links. In the 1990s, Denmark developed its Great Belt link between Fünen and Zealand,

Oresend Bridge, opened 2000, links Denmark and Sweden for the first time since the Ice Age and suggests engineers are the top artists of the early twenty-first century.

the island on which Copenhagen stands, involving two vast bridges, the West Bridge, finished in 1994, and the East Bridge, with a central span ten per cent wider than the then record-holder, the Humber Bridge, in 1997. This was followed by another island link, the Aklashi Kaikyo Bridge in Japan (1998), increasing the suspended span by a further twenty-five per cent, and by three projects: the Messina Straits Bridge, linking Italy and Sicily, with a two-mile central span; the bridge linking Spain and Morocco across the Straits of Gibraltar, involving two spans of 16,400 feet each, with three piers reaching depths of up to 1,500 feet; and the so-called Inter-Continental Peace Bridge, the central series of elements, spanning fifty miles, in a 2,000-mile commercial road corridor between North America and Russia. In such projects, the length of span is so great in comparison with the height of the suspension towers (even though in some cases towers are as lofty as all but the very latest skyscrapers) that one-vision beauty-effects are hard to bring about. These bridges, therefore, should be seen rather in the category of expressways, where art is achieved, and the traveller ravished, more by the conjunction of route and scenery than by any actual building detail. But it is clear that such engineered scenery will be giving humanity some extraordinary artistic shocks by the mid-twenty-first century.

Building bridges may create novel artistic sensations, but it is essentially highly serious work where miscalculations of a thousandth of an inch can produce catastrophe. But frivolity also has a place in art, not least in architecture, and it can be combined with seriousness, as we have seen in the voluptuous confections of Austrian monasticism at the beginning of the eighteenth century. Serious frivolity is usually achieved in architecture by juggling with perspective, as Bernini did in his great Vatican staircase: since two-dimensional art began the twentieth century with the perspective-juggling of Cézanne and Picasso, it is curious that it made no appearance in architecture until the arrival of Frank Gehry (b. 1929), who manipulated forms to escape from the compulsions of linear perspective. Gehry's first major building was the California Aerospace Museum in Los Angeles, 1982, though his own house in Santa Monica, 1979, with its rakish asymmetry and vertiginous effects, is more characteristic of his obsessive designing: no one but an architect would think of living in such disorientating space. However, the people who run the Guggenheim Foundation were used to unusual curved shapes, as witness their museum in New York designed by Frank Lloyd Wright in the form of an upward expanding helix and built 1956–59. So they gave Gehry the job of building them a museum in Bilbao. He responded by illustrating his guiding principle of movement in architecture: 'buildings under construction look nicer than buildings finished', with 'shifting masses, collapsing solids, juxtaposed and twisted volumes'. In Bilbao he simulated movement by giving the appearance of solid forms collapsing or imploding, and perspective systems colliding with each other or interpenetrating to produce conflicts. The colouring of the forms in white and gold helps the concept, producing brilliant

reflections in the nearby water, night and day, and there is no doubt that this Higher Frivolity appeals to many people the first time they see it. Like all shock architecture, however, it cannot bear repetition. But not many people want to go to Bilbao more than once; too bad for the people who live there.

Guggenheim Museum, Bilbao (1991–97) by Gehry, displays the aesthetics of collapse and uncertainty by a master of collage.

On the other hand, people do live all their lives in Los Angeles, the Nowhere City, which has been practising the Lower Frivolity since the beginning of the century. Indeed, even in the 1880s it was experimenting with combinations of Greek Revival, Islamic Oriental and *Sondergotik*, for private dwellings. The Garfield School, Pasadena, 1901, had Romanesque arches, a Queen Anne roof, Tudor exposed beams, thirteenth-century spires, Early Modern windows and Georgian lead window-paning. Five years later a weird Spanish-American version of the Prince Regent's Brighton Pavilion appeared on the beach at Ocean Park. By the time the movies came, Los Angeles's taste for eclectic inventions was so developed that the colossal 1916 set of D. W. Griffith's epic film *Intolerance*, in Hindu-Assyrian style, blended in well with the surrounding villas and bungalows. A 1926 photo of the United Artists studio, with *The Thief of Baghdad* dominating its lot, and L.A. taste all around it, is a striking study in the congruity of the incongruous. Cecil B. DeMille's own house was in Italo-Spanish Renaissance, Harold Lloyd lived in an Indian cottage with twenty-six bathrooms and a golf course, and Gloria Swanson chose fifteenth-century Californian

American as designed by Alberti. The favourite style, at least for public buildings, was New Kingdom Egyptian, closely followed by Neo-Assyrian. Many houses were, in fact, designed by scene-painters and set-artists, often in what was known as Babes-in-the-Wood style with pointy roofs and gnome windows.

From the early 1920s, eateries (the L.A. name) appeared as windmills (not new: the French had done it in Montmartre, albeit those mills had once worked), dogs, hogs, owls (advertising: 'Hoot Hoot I Scream') and carrots. Frank Lloyd Wright fitted easily into this ambience, with his houses made from ornamental concrete blocks, what he called Textile Blocks. He also experimented with Meso-American block villas, of which the Ennis House, 1924, was the largest—the interior was spectacular but, as with virtually all Wright houses, difficult to live up to, or in. Some of the finest Art Deco buildings in the world decorated L.A. in the late 1920s, such as the Bullocks Wilshire store,

Las Vegas, New York Hotel (2000), a multi-perspective reminder that populism and fun have their parts to play in art.

which sported a marble-lined Cosmetics Gallery by Eleanor Lemaire, perhaps the finest room the style produced anywhere, and that is saying a great deal. But beauty was an L.A. aberration or an accident. What the place was about involved novelty, sensation, thrills and sentimentality, in that order. The city accommodated the International Style by engulfing it in schmaltz and eclectic trim. The J. Paul Getty Museum in Malibu was what its architects imagined the Villa dei Papyri in Pompeii looked like before Vesuvius buried it in 50 feet of lava and ash. Philip Johnson and John Burgee built the Crystal Cathedral, 1980, in Garden Grove, California, for a clergyman who said he wanted a church which did not come between 'your eyeball and the infinity of space'. It became one of the very few churches built after 1925 which have any claim to distinction.

It would not be true to say that, by 1980, Los Angeles was running out of ideas, having led the field in frivolity for a century. But Post-Modernism did nothing for it because the city and its surrounds had been practising Ante-, Post- and Supra-Modernism for decades, and Recalcitrant Unmodernism too. The problem, rather, was that L.A. was meeting unbeatable competition from Las Vegas, which had been practising frivolity ever since 1945 and in the 1990s finally hit the big vein. This was by developing on and around its Strip resort-theme hotels specialising in ancient Egypt, imperial Rome, Renaissance Italy and New York. The New York venture, like the work of Gehry or 1910-Picasso, replaces normal perspective with a collapsed version or multi-perspective viewpoint, and so is able to conflate a dozen different skyscrapers plus the Statue of Liberty and other incongruous landmarks in one joyous muddle. This is ephemeral architecture: it is built to entertain but not to last. It is cheaper to replace than to build solid and repair. Hence the difference between High Frivolity and Low Frivolity architecture is that, whereas the inhabitants of Bilbao will still have to look at the Guggenheim's eccentricities in fifty years' time, Las Vegas citizens will have been through another four or five phases. This is a point which Robert Venturi and his analytical team, in their *Learning from Las Vegas*, did not sufficiently consider: nothing in Las Vegas is built to last except the roulette wheels. It is a city which, architecturally, is always in the immediate present, never in the past or future. It is Ephemeropolis.

As such, it has important affinities with the world of Walt Disney (1901–1966). When critics write that Picasso was the most influential artist of the twentieth century, they forget Disney. His influence has operated at a number of levels for eighty years now, and one suspects it is only just beginning. That Disney was an artist is unquestionable, and part of the Modern Movement too, for the influence of Futurism on his early cartooning is obvious. A study of his *Alice's Wonderland* (1923) is instructive about his voracious artistic appetite and vocabulary. But Disney was a businessman of genius, and in his own way a moral force. Unlike Picasso, he was incapable of cynicism and his sincerity, like Della Robbia's, radiates from every line he drew. His masterpiece *Snow White and the Seven Dwarfs* (1937) is not only a

highly inventive piece of animation but the Ur-document of a school which had branched out into over two hundred different systems of animated cartooning by the end of the century. Disney himself trained over a thousand artists, almost as many as the Académie Julian. Cartoons were the basis of most fashion art during the second half of the century and they also had a direct influence on clothes, interior decoration, furniture and architecture. Post-Modernism is part of Cartoon Land.

Like Watteau, in his own way, Disney wanted to create a fantasy world in which people could imagine themselves living. He followed his animated experiment, *Fantasia* (1940), by laying down what he called 'theme parks': enclosed areas like studio sets where customers could enact their visions. He re-created his scenery in real life and peopled it with his animated animals, opening his first Disneyland in 1955 at Anaheim, California. Re-creating his own versions of Ludwig II's Bavarian castles or Hearst's San Simeon for a paying public, he revealed again his genius for supplying an unsatisfied human demand for popular art-as-entertainment. His next project, fulfilled after his death, was Disney World (1971) covering 27,000 acres of Florida. In the early decades of the twentieth century, visionary architects had planned ideal communities in which the latest technology would be used to create 'controlled environments', a twenties phrase. When Disney introduced Disneyland on TV in 1954, he hinted at such a project under the name of Experimental Prototype Communities of Tomorrow (EPCOT). Disney World, besides being a holiday centre on an unprecedented scale, was his first experiment in urban design, with non-polluting vehicles, a monorail system, the first pedestrian malls, novel uses of prefabrication and a Vertical Take-off and Landing Airport to eliminate aircraft noise. Surprisingly enough, EPCOT has survived the loss of Disney's drive and genius, with the creation of its test centre at Orlando. This project, completed in 1992, had three centres: Port Orleans, a simulation of a typical *quartier* of old New Orleans, Magnolia Bend, which resurrected a Deep South plantation, and Alligator Bayou, where moving through the Louisiana swamps without the danger became a holiday routine. Large and varied gardens, and all the facilities of resorts, from golf courses to swimming pools, were grouped round these theme-centres.

Landscaping on this scale, with parks and gardens combined with functional buildings, became increasingly common in the last two decades of the twentieth century. At the Tsunan-machi complex, in Niigata Prefecture, Japan (1985), the Nikken Sekkei Landscape Design team created a 1,000-acre Xanadu with a central garden enlivened by streams and seven different waterfall forms, worked by two huge submersible pumps. The resort is nearly 3,000 feet above ground level and has a heavy winter snowfall with an oscillating climate throughout the year, so advantage was taken of this to create dozens of different walks (mountain ridge; wetlands; valley, etc.) with vegetation installed to complete the illusion, or indeed the reality. This is essentially

an updated version of Le Nôtre's 'rooms' at Versailles, themselves now re-created using modern technology. The all-weather design means that each 'room' has four seasons. In the Netherlands there is an ingenious variation on this kind of landscaping. At Archaeon (1994), Alphen aan den Rijn, an outdoor museum takes the visitor through 5,500 years of Dutch history, from the end of the Stone Age to the beginning of the Dark Ages. This too makes copious use of theme-walks through intricate combinations of land, water, trees and buildings of wood, thatch, stone and earth. Some modern landscape gardeners simply reinforce or emphasise nature, fulfilling the old artistic purpose of imposing a degree of order on its chaos. Thus, during the 1990s, the Spanish landscape artist Lluis Vila adorned the Volcanic Area Natural Park with a series of installations of earth mounds, contained within rust-treated metal sheets. These form what he calls a 'conceptual route' through the volcanic area (1995). And since 1980, another landscape artist David Nash has been creating remarkable effects and vistas in natural settings with huge boulders, piles of stones and sharpened larch-posts. These are only half a dozen of many examples cited by Francesco Asensio Cerver in his survey of recent landscape architecture published in 1996.

Non-professionals have also made use of modern earth-moving equipment, such as JCBs, to create ambitious and beautiful landscape forms. During the 1990s the turf-mound garden became fashionable. Needless to say, this had a long history. Rock gardens come from China, where 'false mountains' of stones and soil were built at least a thousand years before Christ. In the park at Claremont in Surrey, where

Garden of Cosmic Speculation, Portrack, Dumfriesshire, by Charles Jencks. Radical twenty-first-century landscaping in the eighteenth-century tradition.

Vanbrugh built a house for himself, and Kent made a lake with an island, a temple and grotto, there is an immense 600-foot-long walled garden and a belvedere; and not far away Capability Brown and Charles Bridgeman installed a concentric amphitheatre, dug out of the soil and grassed over. This beautiful creation has inspired numerous recent examples of land-forming, as it is called. Some are the work of professional artists, like Kathryn Gustafson, who did the L'Oréal headquarters outside Paris, in the shape of a woman, and Kim Wilkie, who redid part of the gardens at Heveningham Hall in Suffolk, as grass terraces.

Turf mound gardening is only one example of new ways of re-forming natural chaos which have revitalised the old gardening passion in the twentieth century. Future historians may well conclude that, for countless millions of people in the advanced world, art gardening, in one form or another, has been the popular response to the failure of professional artists (and architects) to provide the world with beauty. In Britain, for instance, spending on gardens multiplied by over 2,000 percent during the second half of the century, as the new garden-centre industry provided a motorised public with a global range of plants for sophisticated 'rooms' and borders. Popular amateur gardening has often been inspired by innovative professionals. Thomas D. Church (1902–1978) created a new kind of California garden at Sonoma in the late 1940s and at Park Merced near San Francisco in 1950. Luis Barragán (1902–1988) developed in the 1950s and 1960s a variation on the Mexican water-garden, typified by his magnificent Plaza y Fuente del Bebedero de los Caballos, 1960–62, while the Brazilian Roberto Burle Marx (b. 1909) adorned Rio de Janeiro with a series of brilliant promenade gardens in a distinctive national style (1950–70), which have been copied all over the world.

Such examples, and there were scores of others, spread new ideas among private gardeners. More important, however, was the movement to open gardens to the public. These included not only great historic gardens like Vaux-le-Vicomte in France, Dunbarton Oaks in Washington, D.C., and Chatsworth and Stourhead in England, but smaller, privately owned gardens which had never been seen before except by owners and friends. In England, for example, the growth of garden societies since the 1950s means that countless village gardens now open one day a year and London square gardens also have regular summer 'days'. By 2000 it was calculated that over 100,000 gardens were open to visitors in western Europe alone. Garden history became a subject studied at universities, historic gardens were rediscovered and re-created, from Roman times to the nineteenth century, and it became possible to visit gardens in their medieval, Renaissance and eighteenth-century forms, with parterres, borders and ornamental orchards exactly as they were originally laid out, and with the same flora, shrubs and plantations.

To supplement this domestication of nature, one of the most important forms of art since it delights so many people and enables them to participate in the creative act themselves, there developed in the twentieth century a global movement to

protect the fast-disappearing wilderness and to turn its chaos into accessible areas for the enjoyment of multitudes. The national park was a U.S. invention and one of America's greatest gifts to civilisation. Legislation creating the first national park, the Yellowstone in Wyoming, was signed by President Ulysses S. Grant in 1872, and the Yosemite, Sequoia and Kings Canyon National Parks opened in California in 1890. Canada had followed with three similar parks in the 1880s. The creation of the National Parks Service in 1916 enabled the United States to develop the system on a huge scale and run it efficiently. By 1995 it administered over 350 separate areas of parkland, comprising 80 million acres (these included seashores and lakeshores, scenic trails, battlefields and historic sites). One, the so-called Gates of the Arctic, formed in 1980, encloses 11,756 square miles.

Following the examples of the United States, over a thousand large national parks have been created worldwide. One, the Tassili N 'Ajjer in Algeria, is of 27,799 square miles; another, the Great Gobi Desert Park in Mongolia (1975), is of 20,463 square miles; and the Greenland National Park (1974) comprises 375,291 square miles of superb Arctic landscape of ice-cap and tundra, with spectacular bird life. A detailed breakdown of these thousand national parks revealed that they included large areas of every kind of natural environment on earth, and every known animal and bird species. Is this art? It is a form of art in that it orders and protects natural beauty in such a way that countless numbers can see and enjoy it, study and paint it, write about and draw spiritual nourishment from it. For the world is a natural work of art and we are at last learning how to preserve and exhibit it.

The transformation of nature into gardens, the creation of landscape art and the ordering of the natural wilderness are some ways in which the immense wealth generated in the twentieth century has been put to the service of art. There are five other principal ways. The first is the conservation of works of art of all kinds, from cathedrals down to the smallest drawings. Conservation (and restoration) is almost as old as art itself—it certainly goes back to the beginnings of the Middle Kingdom in ancient Egypt (2040 BC)—but it is controversial and complex. In the twentieth century, it became highly professional, with the founding (1950) of the International Institute for the Conservation of Museum Objects, based in London and with about 3,500 members, mainly working in museums, from sixty-five countries. There is also a scientific body, founded by UNESCO in 1959, based in Rome, and known as ICCROM, with seventy member states and sixty-two associated institutional bodies. There is a third body, based in Paris, called the International Council of Museums. Probably more important than these overlapping and bureaucratic bodies is the Getty Conservation Institute, part of the Getty Trust in California, which actually trains people and helps to finance the *Art and Archaeology Technical Abstracts*, an important source which, together with *Studies in Conservation*, is published by the International Institute.

These useful developments are all in the field of higher technology. First, radiography, ultraviolet fluorescence and infrared photography now enable us to find out what is going on beneath the apparent surface of a work of art without damaging it. Other useful new tools are cleaning lasers, hydrogen plasma and freeze-drying. Light, which causes deterioration in almost every kind of art object, can be controlled by ultraviolet-absorbing varnishes, films of polyester, heat-resistant dichroic filters and the use of special artificial lighting such as tungsten halogen lamps. Methods have now been devised for determining automatically the level of lighting, natural and artificial, the temperature and the humidity in museums, by such devices as dial hygrometers and thermohydrographs. Museum rooms can be dehumidified by desiccants and refrigeration techniques. Air pollution, much more important than was realised up to about 1960—it has done enormous damage in Greek museums, for example—can now be reduced by modern air-conditioning. There has also been a revolution in the design of display cases to reduce all these evils. The disadvantage, of course, is that subdued lighting makes it difficult for many people to see the objects on display, especially watercolours, where extremely low lighting-levels are now the rule. In crowded special exhibitions, the pushing and shoving which goes on in consequence are extremely inartistic.

Even so, controlling the environment is the easy bit. Actual restoration (a word which is increasingly taboo) is a much more controversial matter, where modern technical devices are weapons with two edges. Within living memory, great paintings have been brutally damaged by audacious restoration, one example being the hapless *Rokeby Venus* by Velázquez in the London National Gallery, which now looks as if it were painted by Salvador Dali. There is still an argument about the cleaning and restoring of the Sistine Chapel ceiling, many reputable authorities preferring it as it was before the experts got to work; and the almost total failure to save Leonardo da Vinci's *Last Supper* in Milan, after long and expensive efforts, reveals the limitations of professional skill. Curators of famous institutions are not always as sensitive as they might be on this point. The head of one august museum was recently heard to blame the disappearance of the blue sky in an important work by Carpaccio on his 'awful propensity to use cheap paint'. The artist is, indeed, often to blame for untoward deterioration. As we have already noted, the *Last Supper* began to go downhill, quite fast, almost as soon as it was finished. Sir Joshua Reynolds and Whistler are two more painters who are largely responsible for the dreadful condition of some of their works.

There is also a growing problem of how to look after twentieth-century fashion art, much of which was originally intended to be ephemeral and is made of perishable materials like cheesecloth and cheap rubber bands. Some of it is, quite literally, rubbish. Early Cubist works, especially collages and those on paper, have manifestly deteriorated, and many Dada works of the 1920s, if unglazed, collect dust in huge quantities. The problem is such that in 2001 Harvard University and the Whitney

Museum of American Art set up a Center for Technical Study of Modern Art Conservation, under Carol Mancusi-Ungaro, who has made a special study of the difficulties. One hard-to-conserve fashion artist, Ad Reinhardt (1913–1967), typifies the problem: as a monochromatic Minimalist his works, though manifestly deteriorating, are difficult to restore to their original condition as no one knows exactly what it was and, even if they did, it cannot be replicated. Reinhardt mixed commercial paint with turpentine, allowed the mixture to settle, poured off the top and then used the remainder, a powder, which when it dried felt like suede leather. Restorers do not seem able to reproduce the effect. The point is not unimportant as a work by Reinhardt fetches $2 million.

This is one of the many problems, perhaps insupportable, which fashion art raises. Training restorers is becoming increasingly difficult, anyway, as the technology of their trade, or art, is advancing rapidly, and there are wholly unresolved arguments about how to define restoration and how to control, limit and legitimise its operations. Most restorers work in the commercial market as well as for museums, and there is a huge no-man's-land where morality fights a losing battle with lucre. Here again, twentieth-century fashion art raises difficult issues, for it is almost universally easy to fake, and inside some restorers there is an art criminal struggling to get out and often succeeding. On the other hand, the restorer is one of the most valuable persons in the entire art world: in the hierarchy of those who know most about paintings (and other works of art), the cleaner-restorer comes highest, followed a long way behind by the more educated and intelligent dealer, the museum curator, and the art historian, with the art critics at the bottom of the pole.

Knowledge of art is much greater among those who have the daily right to look at the back as well as the front of a painting, and that is not usually conferred on art historians, let alone newspaper critics. Not that art historians should be underrated. On the contrary. The second principal way in which increasing wealth has served the cause of art in the twentieth century has been the increase in the numbers and quality of those practising art history as a profession. Art history began in Italy in the fifteenth century, continued in France, and in the nineteenth century, like virtually every other branch of history, it was professionalised in German-speaking central Europe. The first professor of art history was appointed at Berlin University in 1834, followed by others in Bonn, Prague, Leipzig and Strasbourg. The German-speaking academic tradition produced most of the leading art historians from Jacob Burckhardt (1818–1997) to Erwin Panofsky (1892–1968), and including Aby Warburg (1866–1929), who expanded his great art library (1909) into the first proper art institute in 1926. The Anglo-American tradition was chiefly dominated by wealthy amateurs like John Ruskin and Kenneth Clark, who learned their art history chiefly on the spot in Italy. They were as good if not better than anyone else but there was only a handful of them.

Valencia, Arts and Science Museum (2000), by Calatrava: new discoveries in glass and metal give artists opportunities to create celestial effects.

The situation changed radically with the diaspora of German art historians which began in the 1920s but accelerated with the arrival to power of Hitler in 1933. Among those to come to England was Nikolaus Pevsner (1902–1983), creator of the most comprehensive architectural history, *The Buildings of England* (forty-six volumes, 1951–74; since extended to the British Isles), and E. H. Gombrich (1909–2001), author of the most successful general history of art ever written. The entire Warburg Institute moved to London in 1933, operating in conjunction with the Courtauld Institute in training art historians. Over four hundred German art historians emigrated to the United States, helping to create university departments and art foundations all over America. One difficulty with art historians is that, from the German origin of the discipline onwards, they have tended to embroil themselves in time-consuming controversies: first between universalist historicism and particularist historicism, then between

formalists and contextualists, next between unitarians and discontinualists (and dualists), and more recently between 'pure' art historians and those stressing the importance of social milieu, structuralism, semiotics, Marxism, feminism, psychoanalysis, race and other obsessions. Into the trackless obscurities of these disputes we need not follow them. It is however important to note that, even among pure art historians, there is a tendency to neglect the centrality of the artist in art history, since they are more interested in tracing influences than in identifying individual creativity.

However, what the expansion of the art-historical profession has undoubtedly done is to increase exponentially the quantity and quality of art history written, and published, with high-fidelity illustrations. This is the third great way in which the wealth-creating capacity of the twentieth century has been put to the service of art. More worthwhile books on art history have been published in the years 1960–2000 than in all previous history: they include countless monographs, over three hundred *catalogues raisonnés* of important masters, superb works of reference such as the thirty-four-volume *Grove Dictionary of Art* (1996) and important studies of every aspect of art practise, including materials, techniques, studios, movements, schools, patronage, training and commerce. There are over fifty authoritative biographical dictionaries of artists, some covering the world, others national schools, sixteen key encyclopaedias and six leading multi-volume dictionaries of iconography. There are three major cumulative bibliographies of art history, in both hard copy and CD-ROM electronic retrieval form. There are now between three hundred and five hundred serious art periodicals in the world, supplemented by many more electronic publishing ventures which promote dialogues and data-exchanges between scholars. Museums also provide outlets and electronic information services; for instance, the London National Gallery's computer information room gives all visitors access to 4,500 pages of art history covering every artist and painting in the gallery, typical of the services now provided by all major art institutions.

Here we come to the fourth major way in which increased wealth promoted art in the twentieth century: the development of the museum. More museums of international standard were created in the last century, around the world, than ever before, and important additions continue to be made; for example, the Los Angeles Museum of Contemporary Art, 1979, the Museum Ludwig, Cologne, 1986, Tate Modern, London, 2000, and the Pinakothek der Moderne, Munich, 2002. Many other museums, such as the Louvre and the National Gallery, Washington, D.C., have virtually doubled in size in the last two decades. Some great institutions, like the Cairo Museum, are starved of funds and their collections are deteriorating; others, like the Getty, Malibu, are flush with cash and compete voraciously in the international art market to extend their collections. Some institutions have too much: the British Museum has over 30 million items, only a tiny fraction of which

can be displayed. It is also under pressure to surrender some of its legally acquired treasures, such as the Elgin Marbles.

Indeed, international and national litigation is a problem likely to increase during the twenty-first century. The American Indian Zunis have already got the courts to return to them religious figures from various North American and European museums. Many French provincial museums retain property stolen from Germany and Italy during the Bonapartist wars. Similar problems may face numerous German and Russian museums, as a result of the Second World War. China has not yet begun to litigate about artefacts removed to European and American collections during her nineteenth-century impotence, but it has plans to do so; and where China leads, many African countries will follow. The *omnium gatherum* global collections of the world's principal museums were based on notions of legitimate acquisition which no longer prevail in many places and which may not survive testing in international courts. Museums are also beginning to debate fundamental questions about their purpose and display methods which until recently were taken for granted.

One growing difficulty which museums faced at the opening of the twenty-first century was the decision of many governments to push them into the numbers game—that is, to judge their success and quality by the number of visitors they attract. The game began in France under Bonaparte. Until then the Salon, during its three-week duration, had done well to sell 20,000 catalogues to visitors coming at the rate of up to a thousand a day. By setting up the Louvre as 'the museum of the world', and filling it with the loot of Europe, Bonaparte thought in terms of half a million visitors a year. The first London exhibition at the Society of Arts in the 1760s sold 6,582 catalogues. A different world opened in London in 1851 at the first International Exhibition: from 1 May to 11 October it attracted 6,039,195 people. This was a general exhibition which did not show paintings at all. The first in the series to do so was in Paris in 1855. A more significant event was the great Manchester exhibition of fine art in 1857, which introduced the public to early Italian and Flemish works, as well as to art of the High Renaissance, and brought in a million people over four months.

Thereafter twenty-six major international shows were held, some of them, like the Paris Art Deco exhibition of 1925, of notable artistic importance, culminating in the 1939 New York World's Fair. All these events numbered visitors in the millions. By contrast, the 1913 Armory Show in New York, though perhaps the most important in American art history, attracted only 250,000 people, including its tour to Chicago and Boston. During the 1930s, however, the official art shows organised by the Nazis in Germany and the Fascists in Italy scored huge attendance ratings. So did the big shows staged at the Royal Academy in London, especially those on Dutch art (1929), Italian art (1930) and Chinese art (1935). The figure for the Italian art exhibition was over 600,000.

During the last half-century the number, scale and attendance figures of big art shows in the main capitals have continued to increase, bringing in scores of millions of people who hitherto had remained outside the magic circle of art lovers. The number was significantly augmented from 1969, when Sir Kenneth Clark (1903–1983) presented his art programme *Civilisation* on the BBC. It was later shown in over a hundred countries and scored unprecedented ratings. It persuaded TV interests to take art seriously, or at least treat it lavishly, a move followed by the rest of the media. Big international loan exhibitions, assured of wide media promotion, thus proliferated, as did art exhibitions of every kind. By the first year of the twenty-first century, a survey of listings showed that in any one month, in seventeen major countries alone, those interested in art could see special exhibitions in 180 different venues, some of which held several simultaneously. All these exhibitions were carefully curated and most of them involved original research, reflected in catalogues. Indeed, during the last quarter of the twentieth century, the sumptuous catalogues accompanying special exhibitions became perhaps the single most important element in art publishing, because huge attendances justified large print runs enabling their production on the most lavish scale at low prices.

There were drawbacks, however. These big shows, where it was vital to recoup the often huge cost of staging them, tended to concentrate on already popular artists to the exclusion of others. (During the 1990s, Claude Monet raeked up the highest attendance figures, closely followed by Van Gogh.) Second, organisers tended to shape themes of exhibitions around works they knew they could secure and which would attract the crowds, and these distortions were reflected in the catalogues and so in art scholarship. Third, attendance figures became progressively more important than the content of the exhibition itself. And once curators, trustees, arts ministers and other grandees became obsessed with attendances at special shows, they all took an increasingly sharp interest in annual figures for visitors to the permanent collections. These figures soon became as important to the careers of museum curators as TV ratings to the programme producers. Odious comparisons were made, and curators with low figures were under growing pressure from trustees, and governments, to raise them by imitating the display and publicity methods of their more successful competitors. The problem first came into the open in 2000 when the success of London's new Tate Modern in attracting visitors led to accusations that it was winning them at the expense of other museums. At this point it became legitimate to ask: did Clark's *Civilisation* begin art's conquest of TV or was it, rather, the point at which the TV culture began to conquer art, and reduce it to its own deplorable level? It is likely, then, that the first half of the twenty-first century will see furious battles for the soul of the museum.

Museum and exhibition ratings, themselves inflationary, were inevitably linked to the expansion of the art market from the 1950s onwards and the spectacular sums paid for works of art at auction, especially after the Japanese entered the market in

the 1960s. This is the fifth way in which wealth influences art. Between 1951 and 1969 the price of Old Masters rose 7 times, of Impressionists 17.5 times, and of twentieth-century fashion paintings 29 times. That, moreover, was only the beginning of an inflationary surge which led a Japanese insurance fund to pay £39 million for Van Gogh's 1888 *Sunflowers* in 1987 and his *Dr Gachet* to sell for £83,900,000 in 1990. The prices of other art objects, such as furniture, also rose fast, though at a much lower level: the highest price paid being for the Badminton Cabinet, a 1732 piece, which fetched £8,580,000 in 1990. It should be added, however, that funds which invested in art from the 1960s onwards in order to make regular capital gains have on the whole fared badly and few now speculate on the art market. It is a consoling fact that, as a rule, it is only those who buy art for love who end up making a profit.

The most worrying aspect of art at the beginning of the twenty-first century was not its increasing commercialisation, for art has always had to live with commerce. It was the decline, and in some cases the disappearance, of effective training in art skills. It is not as though art education as a whole is suffering. Quite the contrary: in the United States and Britain, for example, more secondary school pupils take art history as an examination subject than ever before; the number of men and women taking degrees in art has multiplied a hundredfold since 1945; and Ph.D. students in arts subjects are also at their highest level. What is lacking are opportunities for would-be painters and sculptors to acquire first-class training. Many art schools do not actually teach pupils how to draw or paint. Teaching of sculpture in its traditional forms, as opposed to unskilled constructions, is even harder to obtain. More seriously, few established artists now take pupils. The studio chain, stretching back to the early Middle Ages, along which knowledge was passed from master to assistant or apprentice over countless generations, has been broken. At the heart of the process whereby beautiful objects are produced there is an abyss.

But there is no long-term cause for despondency. More people now love art, or what they think is art, than ever before. More of them see it regularly. More art is on display, all over the world, than in the whole of history. There are more books on art too: good books, with excellent illustrations. More young people than ever before want to create art, if only they knew how. The human need for art is greater than ever, for the world is more chaotic, and the demand for the ordering process which art supplies is rising. All the mistakes made in the last century can be corrected. In many ways the process has already started. The human race is in its infancy. The story of art has only just begun. Human life is short but the life of art is long and the best is yet to come.

INDEX

Page numbers in **boldface** refer to illustrations.

PICTURE ACKNOWLEDGEMENTS

A. F. Kersting: 177, 424, 425.

AKG London: 15, 113, 132, 199, 228, 249, 291, 315, 327, 334, 362, 371, 377, 385, 414, 451, 500, 524, 527, 559, 571, 572, 575, 576, 579, 589, 591, 593, 612, 622, 624, 654, 685; Cameraphoto 227, 257, 288, 290, 623; Christa Begall 613; Museum and Art Gallery, Plymouth © The Bridgeman Art Library 614; Eric Lessing 21, 25, 37, 46, 50, 61, 62, 88, 103, 107, 147, 191, 204, 245, 262, 278, 299, 302, 305, 345, 354, 365, 413, 512, 605; François Guénet 30; Gemäldegalerie Alte Meister, Dresden 275, 296; Jean-Louis Nou 119, 129; John Hios 45; 617 © Munch Museum/Munch-Ellingsen Group, BONO, Oslo, DACS, London 2003; Musée du Louvre, Paris/Erich Lessing 411, 517; Museo del Prado, Madrid 197, 462, 465; Rabatti-Domingie 211, 213, 223, 236, 237, 258, 267, 269, 270; St Louis Art Museum 553; Schutze/Rodemann 748; Stefan Drechsel 172; 659 © Succession Picasso/DACS 2003 Phillips Collections, Washington, D.C.

Angelo Hornak: 95, 218, 244, 402, 405, 431, 472, 542, 631, 636, 640, 643, 649, 650, 707; courtesy of the Dean & Chapter Durham Cathedral 151; courtesy of the Dean and Chapter Ely Cathedral 174; by kind permission of the Palace of Westminster Collection 529; by permission of the Dean and Canons of Windsor 644.

Arcaid: 406, 717; Paul Rafferty 748.

Art Archive: 133, 511, 602, 635, 682 printed by permission of the Norman Rockwell Family Agency © 1945 The Norman Rockwell Family Entities; Album/Joseph Martin 350, 353, 606; Alte Pinakothek, Munich/Dagli Orti 360; Dagli Orti 39, 40, 53, 63, 67, 83, 84, 92, 100, 125, 160, 184, 187, 216, 234, 395, 421, 456, 461, 586; Eileen Tweedy 136, 368, 568; 667 © ADAGP, Paris and DACS, London 2003 Guggenheim Museum/HarperCollins Publishers; John Webb 358; Louvre/Dagli Orti 518; Museum of Modern Art, New York/Album/Joseph Martin 606; Sally Chappell 585.

Art Resource: © Scala 86, 162, 168, 208, 212, 393, 410; © Giraudon 161; © Foto Marburg 170, 180; © Erich Lessing 417, 479; © Timothy McCarthy 632, 649; © Vanni 641; © Réunion des Musées Nationaux, Photo H. Del Olmo 662.

Bildarchiv Preussischer Kulturbesitz: 301; Jürgen Liepe 708; Staatliche Museen zu Berlin/National-galerie/Christa Begall 613.

Bridgeman Art Library: 13, 66, 131, 138, 188, 194, 202, 260–1, 284, 337, 375, 381, 387, 423, 491, 492, 507, 537, 539, 550, 563, 582, 588, 594, 603, 609, 619; British Museum, London 282, 638; Brooklyn

Museum of Art, New York 522, 554, 555; 671 © ADAGP, Paris and DACS, London 2003; Detroit Institute of Arts 552; Kunsthalle, Hamburg 382; Historical Society of Pennsylvania 440; Metropolitan Museum of Art, New York 566; National Gallery of Art, Washington, D.C. 378; National Gallery, London 448; New York Historical Society 548; Phillips Collection, Washington, D.C. 599; Rafael Valls Gallery, London 388; Sheffield Galleries and Museums Trust 668; State Russian Museum, St Petersburg 714; Victoria & Albert Museum, London 499.

Charles Jencks: 743.

Christie's Images: 477, 487, 488, 489, © ADAGP, PARIS and DACS, London 2003 648, 655, 656.

Constructionphotography.com/Mike Sheil: 737.

Country Life: 674.

Dallas Museum of Art: Charles Sheeler *Suspended Power,* 1939 oil on canvas 33 x 36 x 2 in (83.82 x 66.04 x 5.08 cm) gift of Mr Edmund J. Kahn 678.

David Hockney: 724.

Delaware Art Museum: Andrew Newell Wyeth *Tenant Farmer,* 1961, tempera on Masonite ™ 30½ x 40 in. Gift of Mr and Mrs William E. Phelps, 1964: 727.

English Heritage Photo Library: 165; Kenwood, The Iveagh Bequest 367.

Esto Photographics: 626, 739.

Eye Ubiquitous: Laura Jones 701; Pam Craven 432.

Freer Gallery of Art, Smithsonian Institution, Washington, D.C.: Gift of Charles Lang Freer, F1907.170: 521.

James Davis Worldwide: 346, 479, 740.

Kohn Pederen Fox, New York: 732.

Metropolitan Museum of Art, New York: 272 Gift of Robert Gordon, 1875. (75.7.2) Photograph © 1981 The Metropolitan Museum of Art; 546 Gift of Mrs Russell Sage, 1908. (08.228) Photograph © 1995 The Metropolitan Museum of Art; 556 Rogers Fund, 1907. (07.123) Photograph © 1985 The Metropolitan Museum of Art; 560 Purchase, The Alfred N. Punnett Endowment Fund and George D. Pratt Gift, 1934. (34.92) Photograph © The Metropolitan Museum of Art.

National Gallery, London: 281, 287, 295, 330, 333, 420, 437, 444.

Robert Harding Picture Library: J. H. C. Wilson 533; Richard Ashworth 18.

Scala: 10, 29, 65, 74, 79, 215, 220, 231, 240, 242, 243, 263, 265, 312, 321, 349, 357, 394, 399; Alte Pinakothek, Munich 285; 713 © DACS 2003 Tretyakov Museum, Moscow; 722 © ARS, NY and DACS, London 2003 Art Resource/Museum of Modern Art, New York; Art Resource/The Newark Museum 494; Art Resource/Pierpont Morgan Library, New York 134; Art Resource/Smithsonian Museum of Art, Washington, D.C. 681; © ARS, NY and DACS, London 2003 Art Resource/The Newark Museum 677; Ca'Rezzonico 220; Coll. Thyssen, Madrid 624; Galleria Colonna, Rome 318; Hermitage, St Petersburg 442; Museo Missionario-Etnologico Vaticano 689; Sta Maria del Popolo, Rome 311.

Skyscan Photolibrary: Bob Evans 429.

Sonia Halliday: 110; Sonia Halliday & Laura Lushington 104, 121, 158.

Tate Gallery, London: 502, 534.

The Frick Collection, New York: 372, 447.

Victoria & Albert Museum, London: 137, 515.

Werner Forman Archive: 57, 141, 343; British Museum, London 695; courtesy Entwistle Gallery, London 692; Idemitsu Museum of Arts, Tokyo 484; National Museum of New Zealand, Wellington 686; Theresa McCullough Collection, London 474.